Gothic and Renaissance Art
in Nuremberg

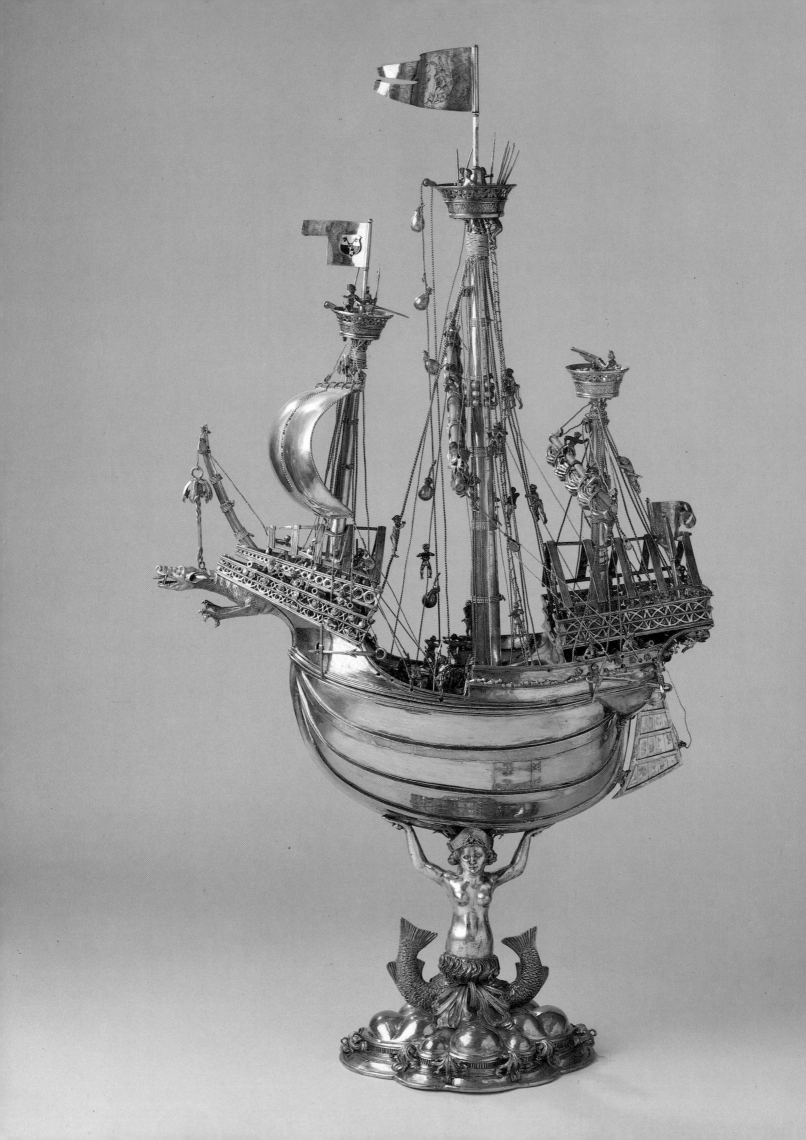

Gothic
and
Renaissance Art
in Nuremberg

1300-1550

The Metropolitan Museum of Art, New York

Germanisches Nationalmuseum, Nuremberg

Prestel-Verlag, Munich

This catalogue has been published in conjunction with the exhibition "Gothic and Renaissance Art in Nuremberg: 1300–1550" held at The Metropolitan Museum of Art, New York, April 8–June 22, 1986, and at the Germanisches Nationalmuseum, Nuremberg, July 24–September 28, 1986.

The exhibition was conceived and organized by Philippe de Montebello, Director, The Metropolitan Museum of Art, and Gerhard Bott, Generaldirektor des Germanischen Nationalmuseums, William D. Wixom, Chairman, Department of Medieval Art and The Cloisters, The Metropolitan Museum of Art, and Rainer Kahsnitz, Oberkonservator, Germanisches Nationalmuseum.

Contributors:

Martin Angerer, Nuremberg; Guy Bauman, New York; Barbara Drake Boehm, New York; Rainer Brandl, Essen; Jane Hayward, New York; Timothy Husband, New York; Rainer Kahsnitz, Nuremberg; Walter Karcheski, Worcester, Massachusetts; Kurt Löcher, Nuremberg; Otto Lohr, Nuremberg; Hermann Maué, Nuremberg; Helmut Nickel, New York; Klaus Pechstein, Nuremberg; Rainer Schoch, Nuremberg; Alfred Wendehorst, Erlangen; Leonie von Wilckens, Nuremberg; Johannes Willers, Nuremberg; William D. Wixom, New York

Library of Congress Cataloging-in-Publication Data
Main entry under title:
Gothic and Renaissance art in Nuremberg, 1300–1550.
Catalog of an exhibition held at the Metropolitan Museum of Art, New York, April 8–June 22, 1986 and at the Germanisches Nationalmuseum, Nuremberg, July 24–Sept. 28, 1986.
 Bibliography: p.
 Includes index.
 1. Art, German– –Germany (West)– –Nuremberg– –Exhibitions. 2. Art, Gothic– –Germany (West)– –Nuremberg– –Exhibitions. 3. Art, Renaissance– –Germany (West)– –Nuremberg– –Exhibitions. I. Metropolitan Museum of Art (New York, N.Y.) II. Germanisches Nationalmuseum Nürnberg.
N6886.N86G6 1986 709'.43'32 86-730
ISBN 0-87099-465-4 (U.S.)
ISBN 0-87099-466-2 (pbk.: U.S.)
ISBN 3-7913-0765-7 Distribution of the hardcover edition by Prestel

Published by The Metropolitan Museum of Art, New York
Bradford D. Kelleher, Publisher
John P. O'Neill, Editor in Chief
Ellen Shultz, Editor
Russell M. Stockman, Translator

Front cover/jacket: Albrecht Dürer. The Virgin and Child, with Saint Anne (cat. no. 144)

Back cover/jacket: Blackplate from a Door Pull (cat. no. 72)

Spine: Fountain Figure, the so-called "Hansel" (cat. no. 16)

Frontispiece: Schlüsselfelder Ship (cat. no. 81)

Color separations: Repro Dörfel, Munich
Typesetting: Fertigsatz GmbH, Munich
Printing: Karl Wenschow – Franzis Druck GmbH, Munich
Binding: R. Oldenburg, Heimstetten

Contents

Lenders List

AUSTRIA

Sankt Paul im Lavanttal, Benediktinerstift
Vienna, Akademie der Bildenden Künste,
 Kupferstichkabinett
 Graphische Sammlung Albertina
 Kunsthistorisches Museum, Sammlung für
 Plastik und Kunstgewerbe
 Kunsthistorisches Museum, Waffensammlung

CANADA

Toronto, Private collection

FRANCE

Paris, Musée du Louvre, Cabinet des Dessins

GERMANY, Federal Republic

Aachen, Suermondt-Ludwig-Museum
Berlin, Staatliche Museen Preussischer Kultur-
 besitz, Kupferstichkabinett
 Staatliche Museen Preussischer Kulturbesitz,
 Skulpturengalerie
Braunschweig, Herzog Anton Ulrich-Museum
Breitenbrunn, Kath. Pfarrkirche Sankt Mariae
 Himmelfahrt
Coburg, Kunstsammlungen der Veste
Constance, Städtische Wessenberg-Gemäldegalerie
Erlangen, Graphische Sammlung der Universität
Erlangen-Bruck, Evang. Luth. Pfarrkirche Sankt
 Peter und Paul
Hamburg, Hamburger Kunsthalle, Kupferstich-
 kabinett
 Museum für Kunst und Gewerbe
Hanover, Niedersächsisches Landesmuseum
Kassel, Staatliche Kunstsammlungen
Kirchheim unter Teck, City
Nuremberg, Evang. Luth. Pfarrkirche Sankt Jakob
 (permanent loan to the Germanisches
 Nationalmuseum)
 Evang. Luth. Pfarrkirche Sankt Johannis
 Evang. Luth. Pfarrkirche Sankt Lorenz
 Evang. Luth. Pfarrkirche Sankt Sebald
 Germanisches Nationalmuseum
 Freiherrlich von Grundherr'sche Familienstif-
 tung (permanent loan to the Germanisches
 Nationalmuseum)
 Freiherrlich von Hallersche Stiftung (permanent
 loan to the Germanisches Nationalmuseum)
 Freiherrlich von Harsdorf'sche Familienstiftung
 (permanent loan to the Germanisches
 Nationalmuseum)
 Freiherrlich von Kress'sche Vorschickung (per-
 manent loan to the Germanisches
 Nationalmuseum)
 Merkelsche Familienstiftung (permanent loan to
 the Germanisches Nationalmuseum)
 Museen der Stadt Nürnberg (permanent loan to
 the Germanisches Nationalmuseum)
 Friedrich von Praun'sche Familienstiftung
 (permanent loan to the Germanisches
 Nationalmuseum)
 J. C. von Schlüsselfelder'sche Familienstiftung
 (permanent loan to the Germanisches
 Nationalmuseum)
 Staatsarchiv
Nuremberg-Kornburg, Evang. Luth. Pfarrkirche
 Sankt Nikolaus (permanent loan to the
 Germanisches Nationalmuseum)

Nuremberg-Wöhrd, Evang. Luth. Pfarrkirche
 Sankt Bartholomäus
Schwabach, Evang. Luth. Stadtpfarrkirche Sankt
 Martin
Schweinfurt, Städtische Sammlungen
Wunsiedel, Fichtelgebirgs-Museum
Private collection

IRELAND

Dublin, National Gallery of Ireland

POLAND

Cracow, Muzeum Uniwersytetu Jagiellońskiego
 Collegium Maius

SWITZERLAND

Basel, Historisches Museum

UNITED KINGDOM

Cambridge, The Syndics of the Fitzwilliam
 Museum
London, Cyril Humphris
 Victoria and Albert Museum
 Rainer Zietz Ltd.
Oxford, The Visitors of the Ashmolean Museum

UNITED STATES

Baltimore, Walters Art Gallery
Boston, Museum of Fine Arts
Cambridge, Massachusetts, Harvard University
 Art Museums, Fogg Art Museum and Busch-
 Reisinger Museum
Cleveland, The Cleveland Museum of Art
Clifton, New Jersey, Professor and Mrs. Stephen
 K. Scher
Detroit, The Detroit Institute of Arts
Kansas City, Missouri, The Nelson-Atkins
 Museum of Art
Lakewood, Ohio, Heinz Schneider
Los Angeles, The Armand Hammer Collection
New York, Ruth Blumka
 The Metropolitan Museum of Art (including The
 Cloisters Collection and The Robert Lehman
 Collection)
 The Pierpont Morgan Library
 Ian Woodner Family Collection
Sacramento, California, Crocker Art Museum
Toledo, Ohio, The Toledo Museum of Art
Washington, D.C., National Gallery of Art
Worcester, Massachusetts, Higgins Armory
 Museum

Directors' Foreword

Both this book and the exhibition, *Gothic and Renaissance Art in Nuremberg,* document the artistic vitality of one of the most influential urban centers in Europe to arise at the end of the Middle Ages. The selection of specific works of art, and the essays that illuminate them, give a clear focus to the period from the fourteenth through the first half of the sixteenth century. This was a transitional and pivotal time for Nuremberg in its evolution from an important but artistically self-contained Late Gothic town to a Renaissance city, whose artistic, humanistic, technological, and scientific endeavors were of far-reaching consequence. The production of works of art — including some of the highest moments of human achievement — paralleled the city's strengthening commercial position. The benevolent yet firm hand of a patrician government produced a stable environment, while members of the great families became the leading patrons.

The present occasion is a special "first" in several respects. Never before has such a constellation of fine Medieval and Renaissance objects been permitted to leave Germany for exhibition in the United States. This event provides the American public with a unique opportunity to study and enjoy a historic sampling of Nuremberg's past. Included here are objects created by important anonymous masters, such as the so-called *"Hansel" Fountain Figure* and the *Schlüsselfelder Ship,* along with major groups of works by such celebrated Nuremberg artists as Veit Stoss, Albrecht Dürer, Hans Suess von Kulmbach, Hans Baldung Grien, Peter Vischer the Elder and his sons, and Peter Flötner. Much of this art, which belongs to the museums and churches of Nuremberg, and to the city itself, is the nucleus of both this catalogue and the exhibition that it accompanies.

The exhibition, likewise, is an especially valuable event for the Nuremberg public, who will see assembled in its city many well-known masterpieces that, over the centuries, have been dispersed to such far-flung locations as Aachen, Baltimore, Berlin, Boston, Cleveland, Detroit, Dublin, London, Oxford, Paris, and Vienna. To all lenders whose generosity has permitted this reunion, we are deeply grateful.

While there have been other efforts, both by way of publications and exhibitions, to examine significant portions of the art and culture of Nuremberg's history — the most recent being Jeffrey Chipps Smith's excellent *Nuremberg, A Renaissance City, 1500–1618,* Austin, The University of Texas, 1983 — the direction that the current project has taken, from its inception in 1982, has centered upon the inclusion of the widest possible range of works of art, diversified both in medium and in function, from the Late Gothic and the Renaissance periods (1300–1550), closing with examples by Peter Flötner and mid-sixteenth-century arms and armor. The result is unprecedented for its comprehensiveness.

Another milestone of *Gothic and Renaissance Art in Nuremberg* is that it represents the remarkable international collaboration between the Germanisches Nationalmuseum and The Metropolitan Museum of Art. The project, initiated by the Metropolitan Museum but quickly augmented and given impetus by the museum in Nuremberg, has been formed, carried forward, and refined by the two curators-in-charge, Rainer Kahsnitz and William D. Wixom. The selection of subjects and objects is theirs. This effort has resulted in a valuable overview of many aspects of the theme

of the exhibition and, at the same time, has led to intelligent reappraisals of a number of unfamiliar — as well as familiar — works of art.

The publication itself is an international endeavor, appearing in both English and German editions. The design was developed by Prestel-Verlag, in Munich. The exacting editorial task required for the English edition is the excellent work of Ellen Shultz, Editor at the Metropolitan Museum.

While we acknowledge that without the collaboration of all concerned on both sides of the Atlantic this project would not have been possible, its value resides firmly in the superb quality of the individual works of art and in the creative spirit of the artists, both known and unknown, who brought them into being and whom we celebrate in this exhibition and publication.

<div align="center">

Philippe de Montebello
Director, The Metropolitan Museum of Art

Gerhard Bott
Generaldirektor, Germanisches Nationalmuseum

</div>

Acknowledgments

This exhibition would not have been possible without the wholehearted support, vision, and friendship of the directors of our two museums. We are further indebted to the lending institutions and to the private collectors and dealers listed in these pages, as well as to the staffs of the participating museums in Europe, the United States, and Canada, for providing vital information and assistance. For the untiring efforts of the members of Prestel-Verlag we likewise offer our gratitude.

We wish to thank the authors of the essays and catalogue entries for their important contributions to the present volume. Drawing upon their respective areas of specialization, the curatorial staffs of the Germanisches Nationalmuseum and The Metropolitan Museum of Art contributed to the final concept of the exhibition with wide-ranging advice.

The restorers at the Germanisches Nationalmuseum, under the direction of Thomas Brachert, cleaned several works of art and took the necessary precautions for their safety during transport and display in the exhibition. To the restorer Eike Oellermann, who is responsible for the works in the possession of Nuremberg's Protestant churches, goes the credit for procuring and supervising loans from the city's churches. We owe a special debt of gratitude to Otto Lohr, in Nuremberg, who was largely responsible for the preliminary organization of the exhibition, and whose untiring efforts also contributed much to the catalogue.

At The Metropolitan Museum of Art, we wish to thank Ellen Shultz, who has edited the English catalogue with exacting care, keen understanding, and taste; Barbara Drake Boehm, who has worked expertly and selflessly on all aspects of the exhibition, as well as on various details of the catalogue, with the unfailing support of Anne V. Fischer, Catherine Hiller, and Katie Ray; and Renate Eikelmann, who participated intensively in many of our efforts, making extensive bibliographical searches, and offering many valuable suggestions to all. With exceptional diligence and alacrity, Russell M. Stockman translated the German texts. Michael Foster provided valuable assistance to the authors in Germany in reviewing the English versions of their texts. The installation of the exhibition in New York depended on the cooperative efforts of Roy Campbell, Franz Schmidt, and Linda Sylling, as well as of the staffs of the conservation departments headed by John Brealey, Tony Frantz, Nobuko Kajitani, and Helen Otis.

The New York exhibition has been made possible by Mercedes-Benz. Additional support has been provided by The National Endowment for the Arts, The National Endowment for the Humanities, and the Auswärtiges Amt der Bundesrepublik Deutschland.

Rainer Kahsnitz

Oberkonservator

Germanisches Nationalmuseum

William D. Wixom

Chairman of the Department of
Medieval Art and The Cloisters

The Metropolitan Museum of Art

Alfred Wendehorst

Nuremberg, the Imperial City:
From Its Beginnings to the End of Its Glory

Figure 1 Hans Wurm. View of Nuremberg, from the south. Watercolor, 1515–20. Germanisches Nationalmuseum, Nuremberg

Although Nuremberg is famous for its monuments dating from the Late Middle Ages, the city is not especially old — not when compared with those much smaller neighboring towns, particularly in the Regnitz Valley, where many of the churches, such as that at Forchheim, were dedicated to Saint Martin and, therefore, may be assumed to be from Early Frankish times. In the town chronicles compiled by the early Humanists, Nuremberg is provided with fictitious Roman origins, for it was the fashion, then, to attempt to heighten a town's prestige by reference to its great age. The first documentary mention of the later imperial city dates from the year 1050 (fig. 2), and although it may be that earlier references have simply not survived, the actual founding of the town cannot have occurred much before. Nuremberg's two main churches, the Sebalduskirche and the Lorenzkirche, were still under the jurisdiction of the older parish churches of Poppenreuth and Fürth, respectively, in the late twelfth and the thirteenth century. In 1471, when Giovanni Antonio Campano and Agostino Patrizzi visited Nuremberg in the entourage of the papal legate Francesco Todeschini-Piccolomini, they were astonished to note that, while no less populous than Florence, Nuremberg was without a bishop's church because the ecclesiastical organization of eastern Franconia was already virtually complete before Nuremberg attained any importance.

I. The City and the Empire

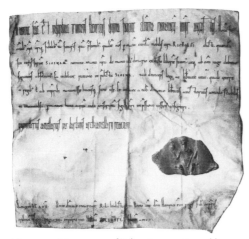

Figure 2 Document of July 16, 1050, issued by Emperor Henry III in Nuremberg, containing the earliest mention of the city. Stadtarchiv, Nuremberg

Nuremberg Castle was built by Emperor Henry III (r. 1039–56) on a rocky bluff above the Pegnitz Valley, at the edge of the vast imperial forest, in the northern part of present-day Bavaria. That first reference to Nuremberg, in 1050, is found in a charter issued by the imperial court held in the city on July 16 of that year. The castle became the administrative center for a diversity of imperial holdings, which had been considerably reduced some years earlier by donations from Henry II (r. 1002–24) to the new bishopric of Bamberg. With the assistance of his royal vassals, Henry III hoped to reorganize these possessions and to expand them into a bulwark of imperial might. Before his death, he moved the market that had formerly belonged to the town of

Fürth — a fief of Bamberg — to his newly established settlement of Nuremberg. Consequently, a number of merchants and craftsmen soon settled near the castle, and it was from this fledgling community that the stronghold drew its provisions. Enhancing the lure of the market was its proximity to the tomb of Saint Sebald (his name may be Slavic in origin), which is documented as early as 1072, and was made famous by tales of the miraculous cures that those who visited it received. Because of this, increasing numbers of people settled in the city.

The development of Nuremberg into an important administrative center of the empire began during the reign of the Hohenstaufen king Conrad III (r. 1138–52), who founded the Egidienkirche with its Scottish monastery, which, initially, seems to have served as a court chapel. Possibly from the same period is a second royal foundation, the Jakobskirche, presented to the Teutonic Order in 1209 by King Otto IV. Since the original castle had passed into the hands of the burgraves, Emperor Frederick I Barbarossa (r. 1152–90) erected a new one behind it, in 1183 and 1207, which extended to the edge of the promontory. Attached to the castle was a double chapel, the upper story of which was for the emperor's private use.

As representatives of the king, the burgraves administered justice, managed the imperial holdings, and were also responsible for the upkeep and defense of the castle (figs. 5, 6). The office of burgrave was hereditary, and under Emperor Henry VI, probably as early as 1191, it passed by marriage to the Hohenzollern, who were related to the Hohenstaufen line and, likewise, were originally from Swabia. About 1200, the king created two additional offices in Nuremberg: The first was that of imperial mayor (*Schultheiss*), who assumed from the burgraves all jurisdiction over the city itself (fig. 3); the second was that of royal cupbearer (*Butigler* in German; *buticularius* in Latin, from the same root as the French *bouteille*), who oversaw the imperial possessions in the vicinity of Nuremberg (fig. 4). The role of the latter proved to be relatively modest, however. His office ultimately came under the authority of the burgraves, and, after the end of the thirteenth century, seems to have been dispensed with.

A privilege granted by King Frederick II on November 8, 1219, encouraged the growth of the royal city into an imperial one. From then on, Nuremberg constituted an independent judicial district and also a separate tax authority, whose taxes went toward the empire, as a whole. The same king strengthened the position of the city's merchants through various legal and economic guarantees.

The future development of Nuremberg was determined by its mayor and its city council. Since the privilege accorded by King Henry VII on June 11, 1313, required that the mayor consult a panel of jurors before making judicial decisions, and because his office was, henceforth, to be filled by a citizen of Nuremberg, the council increased in importance.

Yet, progress was not always smooth. In 1256, the city became a member of the Rhenish League, whose aim was to secure peace within the empire. However, during the interregnum, it seemed, at times, that Nuremberg would become either a provincial Bavarian backwater, or the capital of the entire Hohenzollern territory. In an attempt to defend itself from its expansionist neighbors, the city supported the Habsburg king Rudolf I (r. 1273–91) and promoted his policy of revindication. Nuremberg, thus, became an imperial city. With regard to its services and taxes, it was solely obligated to the king. In Swabia, along the Rhine, and in Franconia, the absence of large territorial states tended to favor the development of such cities subject only to the king. From 1489 on, a special collegium represented these cities at the Imperial Diets. Membership in this body was regulated by the imperial register, which fixed a city's financial and military obligations to the empire.

On January 5, 1315, Ludwig the Bavarian (r. 1314–47; fig. 7), freed the city from the jurisdiction of outside courts (*privilegium de non evocando*), including the provincial court administered by the burgraves. The city was able to utilize this privilege as a

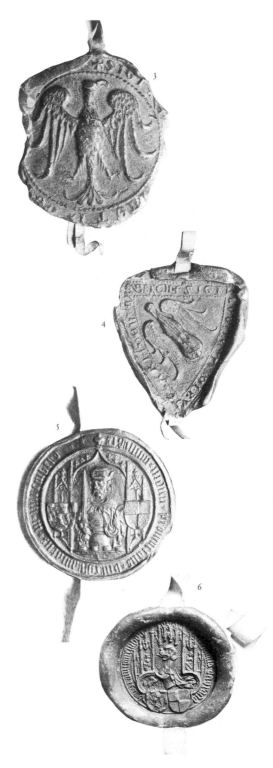

Figure 3 Seal of the *Reichsschultheissen* of Nuremberg, in use from 1246 to 1342. From a document of 1246. Staatsarchiv, Nuremberg

Figure 4 Seal of the *Reichsbutigler*, the Nuremberg imperial cupbearer, Leupold. From a document of 1246. Staatsarchiv, Nuremberg

Figure 5 Seal of the burgraves' court in Nuremberg. From a document of 1401. Staatsarchiv, Nuremberg

Figure 6 Seal of Burgrave Johann III von Hohenzollern (r. 1397–1420), in use from 1404 to 1416. From a document of 1408. Staatsarchiv, Nuremberg

Figure 7 *Emperor Ludwig the Bavarian* (r. 1314–47). Stone relief, about 1340; polychromy 19th century. From the Great Hall of the Nuremberg Rathaus (see cat. no. 13)

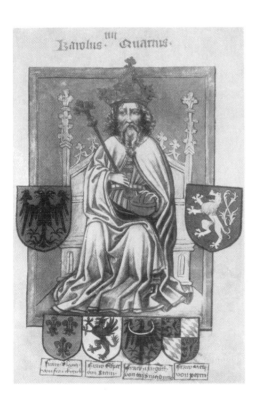

Figure 8 Emperor Charles IV (r. 1355–78) with the coats of arms of the empire (left), the Kingdom of Bohemia (right), and his four wives (below). Nuremberg, about 1430 (based on a 1360 original). Kupferstichkabinett, Staatliche Museen Preussischer Kulturbesitz, Berlin

vehicle for its emancipation, while developments in another quarter proved of assistance, as well. The burgraves had managed to enlarge their territorial power base considerably in the thirteenth century through purchases and inheritance. Emperor Charles IV (r. 1355–78; fig. 8) then made it easier for them to consolidate their territory, exclusive of Nuremberg, but in a manner that also proved advantageous to the city. The burgraves responded to the new situation by transferring the provincial court to the Cardolzburg, which, almost a century before, had become their chief residence. On March 17, 1363, Emperor Charles IV — who, in 1362, arranged for the betrothal of his three-month-old son Wenzel and a daughter of the burgrave Frederick V — elevated the burgraves to the rank of princes of the empire, intending to make them administrators for the crown in Franconia. In 1367, when it became evident that such an alliance was not to last, the city boldly walled off the burgraves' castle. Finally, in 1427, the Hohenzollern burgraves — then known as margraves, following their investiture with the margravate of Brandenburg in 1417 — sold their castle with its five-sided tower, which had recently been damaged by fire, to the city council. Included in the sale were a number of villages north of the city, and supervisory rights over the imperial Sebaldus Forest.

Although they had, thus, been ousted from the city, the burgraves remained neighbors. Tensions between the imperial city and the Hohenzollern would prevail in Franconian history, until the end of the Holy Roman Empire in 1806. On two occasions, the First and the Second Margraves' War (1449/50 and 1552/53), they reached the level of pitched battles.

In 1341, Ludwig the Bavarian appointed the city of Nuremberg caretaker of the Kaiserburg, but when the emperors visited the city, they rarely resided in the dilapidated castle. Ludwig, himself, accepted an invitation to stay at the house of Albrecht Ebner, and, in 1356, Charles IV enjoyed the hospitality of the Haller family. King Sigismund (r. 1410–37) complained to the council about the unfortunate condition of the imperial residence, and demanded that it be renovated. Under Emperor Frederick III (r. 1440–93), the castle was refurbished and expanded into approximately its present form.

During his quarrels with Pope John XXII (r. 1316–34), Ludwig the Bavarian had always been able to rely on the city of Nuremberg, but suddenly the patrician council transferred its allegiance to the rival king sponsored by the pope, Charles IV of Luxemburg. Nuremberg's craftsmen, most of whom remained loyal to the Wittelsbach line, succeeded in expelling the council and, for a short time, in running the city's affairs themselves. By 1349, however, Charles IV was able to restore the traditional council's authority. A master politician, he also managed to convince the council to settle the craftsmen's revolt of 1348/49 without bloodshed and to once again guarantee the peace of the city.

Charles IV's partiality to Nuremberg dated to his early days as a rival king. The records of his travels mention a total of fifty-two visits to the city, many of them for extended periods; he visited no other city outside of Bohemia as frequently. It was Charles who established Nuremberg's primacy among the several imperial cities, and the enduring Bohemian influence on the art of Nuremberg dates to his reign. The city was to become the chief base in the land bridge that he constructed between Prague and the Lower Main and Middle Rhine. It also served as a virtually extraterritorial meeting ground for the emperor and the officials of his empire.

It was in Nuremberg, in 1356, that he issued the Golden Bull, which, until 1806, dictated the method of electing the German kings. Its twenty-ninth chapter — actually issued in Metz sometime later — decreed that each newly elected monarch was to hold his first court, or Imperial Diet (*regalis curia*), in Nuremberg. With this requirement, Charles was appealing to a venerable tradition, which, in fact, had not been followed before; it was the Golden Bull that first awarded the city such a privilege. Nuremberg did, indeed, become the city in which the king met with his princes, but it was not

able to enforce its right to the first Imperial Diet any more than Aachen could ensure its role as the coronation city. Before his election, Charles v (r. 1516–56) promised to abide by the new regulation, but his first Imperial Diet was held in Worms (1521).

The imperial presence in Nuremberg, which Charles IV had tried to maintain, was strengthened still further by his son Sigismund, who designated the city the permanent repository of the imperial regalia; in so doing, he elevated Nuremberg to something more than merely a third capital after Frankfurt, the electoral city, and Aachen, the coronation center, for the empire was identified with the imperial jewels, which commonly were referred to simply as "the Reich."

During the period of the Salian rulers (1024–1125), the imperial regalia had been stored in a number of fortresses, monasteries, and towns — one rapidly replacing another — when the emperor did not take the treasure along with him when he traveled. Under the Hohenstaufen, the regalia had been left for safekeeping at the imperial castle of Trifels, near Annweiler, but, from the time of Rudolf I of Habsburg (r. 1273–91), each ruler had kept it in his own possession.

In a document dated September 29, 1423, King Sigismund entrusted the Nuremberg council with the guardianship of the objects in perpetuity, and on February 24, 1424, they actually arrived in the city — having come from Hungary disguised as a shipment of fish — where they were to remain until 1796. The king referred to the objects, consisting in large part of reliquaries, as the sacred treasure. With that designation, he helped to underscore the new significance accorded the treasures by Charles IV — the first to emphasize their sacredness. It had long been the tradition to display these holy objects to the public regularly, like any other precious relics. In 1350, at the urging of Charles IV, Pope Clement IV had bestowed an indulgence on all the faithful who beheld the empire's sacred treasure *(sanctuaria sacri Romani imperii)*. Then, in 1361, after a long-sought-after successor to his throne had been born in Nuremberg, and baptized as Wenzel in the Sebalduskirche, Charles IV had the imperial jewels brought from Prague and displayed in the Frauenkirche, where, from the ambulatory, they could be venerated by the public.

Beginning in 1424, the day on which the objects were displayed became known as the Feast of the Holy Lance (after the oldest and most famous relic of the imperial treasure). In response to a request by Charles IV, on February 13, 1354, Pope Innocent IV had introduced that holy day primarily to encourage veneration of the treasure, and, henceforth, the feast day was observed on the second Friday after Easter. The setting for the display of the relics was the main marketplace, then called the Fischmarkt, only a few steps away from the permanent repository of the imperial treasure — the church of the Heilig-Geist-Spital (fig. 9), endowed by the prominent Nuremberg citizen, and later mayor, Konrad Gross. There, across from the Frauenkirche, they were set out on a *Heiltumsstuhl* (fig. 11), a three-story fabric-covered wooden display tower, approximately twenty-three-feet tall, erected in front of the Schopperhaus (now Hauptmarkt 15).

On the eve of the day of their presentation, the imperial regalia and the sacred objects were brought to the Schopperhaus. From one of its windows, a walkway led to the gallery of the *Heiltumsstuhl*. On commission from the council, from 1511 to 1513, Albrecht Dürer painted portraits of the emperors Charlemagne and Sigismund in their coronation finery for the chamber behind this window; the portraits (now in the Germanisches Nationalmuseum; see cat. no. 128) were intended to demonstrate how the various ceremonial objects were worn. The portrait of Charlemagne — the only one of interest here because it contains the earliest authentic depictions of the imperial regalia and coronation vestments — has become quite well known through countless copies and reproductions.

After the close of the Mass of the Holy Lance — celebrated by an exalted prelate, usually the abbot of Nuremberg's monastery of Sankt Egidien (fig. 10) — and the reading of papal indulgences, another priest displayed the objects, most of them

Figure 9 Seal of the Heilig-Geist-Spital, Nuremberg, with God the Father (top), the Annunciation (center), and the coat of arms of the donor, Konrad Gross (below). Nuremberg, 1331–32. Preserved on documents of 1332–98; from a document of 1352. Staatsarchiv, Nuremberg

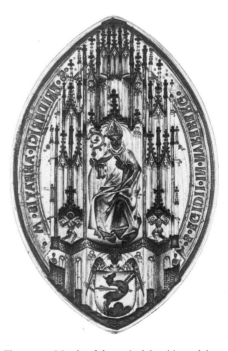

Figure 10 Matrix of the seal of the abbot of the Egidienkloster. The inscription was altered for the last abbot of the monastery, Fridericus Pistorius (r. 1521–25). Nuremberg, 1465. Staatsarchiv, Nuremberg

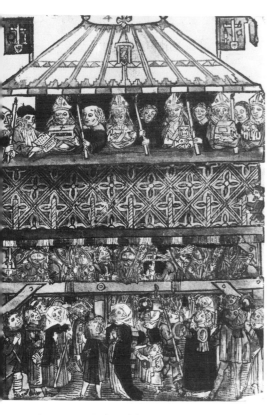

Figure 11 Display of the imperial treasure on the *Heiltumsstuhl* in the Hauptmarkt in Nuremberg: (above) bishops with part of the treasure; (center) guards; and (below) the faithful. Colored woodcut, after 1487

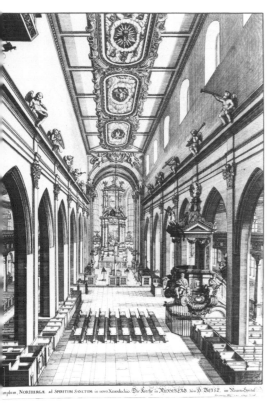

Figure 12 Johann Andreas Graff. Heilig-Geist-Kirche, Nuremberg, with the *Heiltumsschrein* suspended from the vault at the crossing (see cat. no. 47). Engraving, 1696. Germanisches National-museum, Nuremberg

encased in precious reliquaries; a third called attention to them with a pointer; and a fourth priest, the *Heiltumsschreier,* or "relic crier," provided brief explanations in a loud voice. Beginning in 1438, at the latest, a priest read a fixed text from a so-called *Schreizettel,* a sheet of parchment with a description of each relic. According to the earliest *Schreizettel,* the presentation was followed by prayers for Christendom, for the unity of Church and Empire, for Emperor Sigismund, for all of the various princes, lords, and cities, for the leaders of the city of Nuremberg — only later was a passage added referring to the diocesan bishop of Bamberg — and for deliverance from care, war, and affliction. The ceremony ended with a benediction with the imperial cross, the hymn "O Thou Blessed Cross . . . ," and the Easter anthem "Christ Is Arisen."

In 1487, the council issued a pamphlet about the treasure (similar ones appeared in other cities) printed by a certain Peter Vischer (not to be confused with Peter Vischer the Elder). It related the most important facts concerning the ceremony, with a view toward attracting larger crowds of spectators. Colored woodcuts show the *Heiltumsstuhl* and the various reliquaries (fig. 11). There are also precise calculations of the number of indulgences one could accumulate by witnessing the display in Nuremberg. For, in addition to those indulgences bestowed by the pope, the local ecclesiastical authority, the Bishop of Bamberg Frederick III von Aufsess, had instituted still others associated with the Feast of the Holy Lance. On April 13, 1424, shortly after the arrival of the treasure in Nuremberg, he decreed that indulgences would be granted to all who attended the display; to those who, in commemoration of the five wounds of Christ, recited the Lord's Prayer together with the Ave Maria and the Credo, on their knees, in each of five churches of the city — namely, the Heilig-Geist-Kirche, the Sebalduskirche, the Lorenzkirche, the Egidienkirche, and the church of the Carthusians — and, finally, to all who celebrated or attended the Mass at the *Heiltumsstuhl.* These rites were in keeping with prevailing practice in the pursuit of godliness.

The annual public display of the relics also attracted the secular and spiritual princes of the empire: counts, lords, and heads of monasteries. The vast number of ordinary pilgrims in attendance forced the council to take elaborate security measures at the time of the ceremony. The council rarely deviated from its policy of displaying the treasure only one day a year, but private showings to illustrious visitors were not uncommon at the Heilig-Geist-Spital.

On December 31, 1424, Pope Martin V had confirmed that the imperial relics were to be permanently kept at the Heilig-Geist-Kirche in Nuremberg, and had threatened excommunication to all who violated that arrangement (fig. 12). Nevertheless, Emperor Sigismund was required to renew Nuremberg's right of custody in 1433, as would King Albert II in 1438, for the Bohemian provincial Diet had repeatedly demanded the return of the treasure to Prague, where it had been kept — from the time of Charles IV until the Hussite uprising. Frederick III, however, would not confirm the city's custodial right when ambassadors from Nuremberg requested him to do so, in Vienna, in 1440, and, in May 1442, he again refused before the council itself, in Nuremberg. When still another legation from the city applied to Frederick, he finally demanded that the entire imperial treasure be surrendered to him. The council took its case before legal experts at the University of Padua. Their findings supported Nuremberg's claim. The transfer of the imperial treasure to Nuremberg had been sanctioned by the pope, after all, and that endorsement bore all the more weight inasmuch as the emperor had no say over sacred relics. Stubborn as he was, Frederick III remained determined to wrest the treasure away from the council. He relented only when he began to be pressured by various electors that the council had appealed to for help, for he did not wish to become involved in any test of strength.

The traditional solidarity of imperial city and emperor dissolved when Frederick III allied himself with the coalition of its powerful adversary, the margrave Albrecht

Achilles. The emperor's later visits to Nuremberg, in 1474, 1485, and 1487, were not intended solely to maintain ceremony. However, the friendly gestures on both sides, and anecdotes relating to Frederick III's last stay there, could hardly obscure the fact that Nuremberg's interests were no longer identical with those of the emperor and the empire.

For the coronations of kings, which took place in Aachen until 1531, and for those of emperors, which were held in Rome until 1452 and in Frankfurt beginning in 1562, the council, at its own expense, had two councillors carry the requisite objects from the imperial treasury to the coronation site, and also saw to any repairs that the treasures required. When it proved necessary to mend some of the vestments for the coronation of King Charles V, in 1520, the council entrusted them to the Poor Clares, whose abbess at that time was Caritas Pirckheimer (died 1532), the sister of the Humanist Willibald Pirckheimer. After acceptance of the Reformation in 1523, the council discontinued displaying the relics, and, henceforth, only special dignitaries were permitted to view them, in the Heilig-Geist-Kirche.

The adoption of the Reformation by the imperial city placed Nuremberg in potentially dangerous opposition to its ruler, the emperor in Vienna. This conflict limited Nuremberg's power in political maneuvering, made the city exceedingly anxious to keep peace, and led to a policy of neutrality in times of tension. Protestant Nuremberg sold arms and armor to both religious factions, and took great pains to avoid any undertaking that might be interpreted as being against the emperor and the empire.

II. The Council and Its Rule

With a decline in the power of the king's representatives, the council was able to expand its influence and to strengthen its authority. Beginning in the middle of the thirteenth century, in the wake of Emperor Frederick II's struggle with the papacy, the council's control became firmly established.

From about 1245 on, the citizenry had been referred to as the *universitas civium*, and its symbol was the seal of the city. The first documentary mention of ramparts and gates dates from 1256; soon after, those gates would be linked by a ring of walls surrounding the two halves of the city, to the right and left of the Pegnitz River, with their respective parish churches, the Sebalduskirche and the Lorenzkirche. These new fortifications protected the prosperous city from the envy of its neighbors, princely and otherwise, and meant that it was no longer necessary to erect turreted houses, such as the Nassauerhaus (the only one still standing today). Beginning in the 1260s, a designated official supervised the collection of the indirect taxes, raised from merchants' wares, that were used to finance the construction of the city walls. A direct tax levied against property, which the city itself was not likely to have initiated, is mentioned somewhat later, about 1300, at which time the city was required to pay a fixed sum in taxes of two thousand *Pfund* a year to the empire. From the late thirteenth century on, a full-time scribe handled the imperial city's correspondence.

In 1332, once the development of separate municipal authorities had begun, the city council acquired a site on which to build an imposing *Rathaus* (town hall), whose great hall was adorned with a polychromed stone relief of the town's patron, Emperor Ludwig the Bavarian (see cat. no. 13; fig. 7). A short time later, it began to replace the original ring of walls with a new one, about three miles long, which enclosed its rapidly growing suburbs and a certain amount of undeveloped land. At great expense, and employing a number of technological innovations, the city constantly maintained its fortifications in readiness.

About the middle of the thirteenth century, two separate panels of officers were formed: One was a board of thirteen jurors *(scabini),* which, initially, assisted the royal mayors *(Schultheissen)* in their administration of justice; the other consisted of

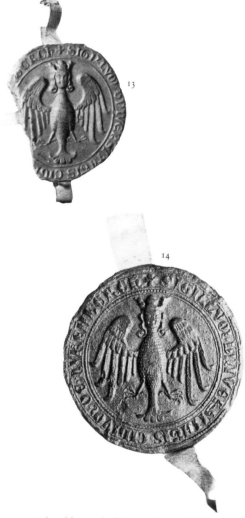

Figure 13 The oldest seal of Nuremberg, with the *Königskopfadler.* About 1240; in use until 1368. From a document of 1287. Bayerisches Hauptstaatsarchiv, Munich

Figure 14 Second seal of Nuremberg, in use from 1343 until 1808. From a document of 1384. Staatsarchiv, Nuremberg

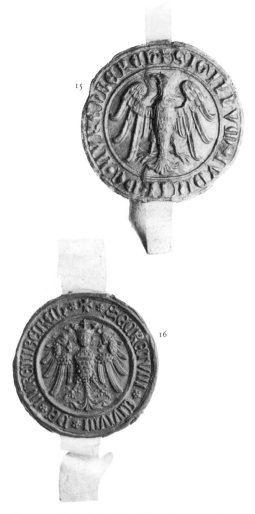

Figure 15 Seal of the Nuremberg law courts, in use from its introduction in 1343 until at least 1683. From a document of 1359. Staatsarchiv, Nuremberg

Figure 16 Privy seal of Nuremberg, in use until 1652. Matrix made in 1452, based on a 1440 model. From a document of 1454. Staatsarchiv, Nuremberg

councillors *(consules)*, likewise thirteen in number, who were responsible for representing and governing the city. The board of councillors, which was more independent of the mayor, soon exceeded the jurors in importance, and even managed to assert its authority over both the mayor and the cupbearer. Early in the fourteenth century, the board of jurors and the board of councillors, the actual governing body, were combined to form a city council of twenty-six members. The fact that, originally, it had been two distinct bodies soon became unimportant. Its members were recruited exclusively from the city's wealthy families, who, at about this time, began to segregate themselves politically and socially as the city's nobility.

This council was expanded in 1370 to forty-two members by the addition of sixteen delegates *(nominati;* the origin of the term has not been satisfactorily explained). Of these new members, eight were so-called "old delegates" *(Alte Genannte),* likewise drawn from the patrician families, while the remaining eight represented the city's craftsmen. Unless specifically summoned to the council's meetings, all members were at liberty to attend or not, but only the collegium of twenty-six, and the "old delegates," actually enacted legislation, and it was solely from among the original twenty-six that two new mayors were elected each month. These men represented the city to the outside world, convened the council, and saw to it that its decisions were properly recorded. The two receivers who administered the city's finances were joined by a third, who was chosen from among the eight craftsmen; they, likewise, were recruited from the original collegium — as was the later committee of seven *Alte Herren,* also referred to as the Privy Council, who deliberated on all important issues in advance and therefore exercised the real power.

The statute books, which were first compiled in 1302, reveal the increasing authority of the council, especially the expansion of its police jurisdiction and the ever-more-detailed attention it gave to the regulation and supervision of crafts and of trade.

The council's diverse offices were consolidated during the fourteenth century. Members of the twenty-six-man committee and the "old delegates" assumed various maintenance and supervisory roles, serving as overseers of the city's churches and lands; supervisors of public charities; inspectors of apothecaries, roads, weights and measures, grains, and bread; and fire marshals. They served on the board that oversaw the admission of new citizens and on the city's war council. They became building contractors, and were responsible for the maintenance of public buildings — including walls and fountains — as well as for all private construction and excavation within the city's walls. An office for complaints supervised the markets and the trades. Its quartermasters called the citizenry to arms in cases of war and supervised the armament and the defense arrangements of their own quarters of the city.

As in other southern German cities, a second governing body was formed in Nuremberg shortly after 1300 — the so-called Greater Council of Delegates, convened by the Lesser Council when the latter was required to resolve important legal issues and wished to be assured of the assent of the entire citizenry. Appointees to the Greater Council, whose size was not precisely fixed — at the beginning of the sixteenth century it was composed of about two hundred citizens — came from "honorable families," whose members engaged in wholesale trade or practiced one of the professions independent of the guilds. Albrecht Dürer was appointed a delegate to the Greater Council in 1509. In contrast to the Lesser Council, it could neither propose legislation nor appoint its own members; that was done by the regular council. The Greater Council convened for the annual election of the Lesser Council and for a vote on the tax rate; otherwise, it was consulted by a majority vote of the smaller council.

Despite the fact that, in all other Franconian and Upper German imperial towns, the guilds had been able to gain a share in municipal government, the Nuremberg craftsmen, although they exercised certain supervisory rights, had very little say in the regulations on trade imposed by the patricians. The craftsmen's revolt of 1348/49 was merely an isolated event; afterward, the craftsmen's guilds continued to be no more

than professional societies. At the end of 1382, when Rothenburg's mayor Heinrich Toppler appeared in Nuremberg with a legation, demanding that he be allowed to put his appeal for the city's entry into the Swabian League before the whole citizenry instead of just the council, the council vehemently refused to tolerate such meddling with Nuremberg's practices.

A medieval mistrust of appointments to office, of long duration, that were not legitimized by either blood ties or by religious confirmation originally led to annual elections of the most important officials. Only the eight craftsmen of the Lesser Council, whose influence was limited, were appointed for life; they were removed from office solely for incompetence or gross neglect of responsibility. In the course of the fifteenth century, reelection became the general rule.

Only members of the twenty "old" families, and the seven "new" ones recognized by the former as being of equal rank, could be elected to the Lesser Council and, hence, to the politically decisive Privy Council. Among the "old" families (some of which still exist today), were those by the name of Pfinzing, Ebner, Behaim, Stromer, Nützel, Haller, Holzschuher, Gross, Muffel, Koler, Schopper, Grundherr (fig. 17 a), Tucher (fig. 17 f), Tetzel (fig. 17 b), Groland, Geuder, Schürstab, Dörrer, Mendel, and Volckamer (fig. 17 c). The "new" families (several of which also still exist) were named Imhoff (fig. 17 d), Kress, Paumgartner, Pirckheimer, Pömer, Rieter, and Rummel. In 1440, fifteen families were added to these twenty-seven as potential council members; among those that were approved were the Löffelholz, Hegner, Reich, Harsdorfer (fig. 17 e), Hirschvogel, Meichsner, Prünsterer, Zingel, Rehlinger, Zollner, Topler, Wolf, Fürer, Fütterer, and Welser families. With the enumeration of these names in the "Dance Statute," of 1521 — which limited the number of families that could be invited to balls at the Rathaus — the patricians effectively isolated themselves socially from the so-called honorable families, as well, some of which were even wealthier than they.

The purely patrician composition of the council and the close family ties among its members assured political continuity, and doubtless fostered that wise moderation that characterized the council's policies.

As in Italy, some of the more powerful cities in Germany formed independent states. Urban development on imperial lands in southern Germany led to the rise of virtual city-states — whenever they could withstand pressure from their neighbors — alongside the territories of the dynasts and ecclesiastical princes, and the smaller holdings of knights of the empire.

Over a long period of time, the acquisition of estates, fiefs, and privileges, as well as capital investments by the patrician families — in combination with the council's right to inspect fortresses and its rights of superintendency — brought about a considerable concentration of authority to the south and east of Nuremberg; this was less so in the west and in the north, where the burgraves prevailed. By allying itself with other cities, Nuremberg gained political backing against its princely neighbors. Direct conflict with them was assiduously avoided. In the War of the Landshut Succession (1504/5), however, the city seized the opportunity to free itself from the Palatinate menace, expanding its holdings considerably. In his decree of May 1505, issued in Cologne, Emperor Maximilian I ratified Nuremberg's territorial gains with the towns of Lauf, Hersbruck, Altdorf, Velden, and Hiltpoltstein. Nuremberg now had more land than any other city in Germany.

The Humanist educations acquired by a number of Nuremberg's patrician and middle-class citizens in the fifteenth century — many attended Italian universities — led to a new self-awareness on the part of the city's leaders. Among other areas, this found expression in the council's patronage of the arts. At the same time, however, the city's hierarchical traditions began to weaken somewhat.

As elsewhere, with the spread of Humanism, new standards of piety and a new routine were introduced in the monasteries of Nuremberg. Together with the increas-

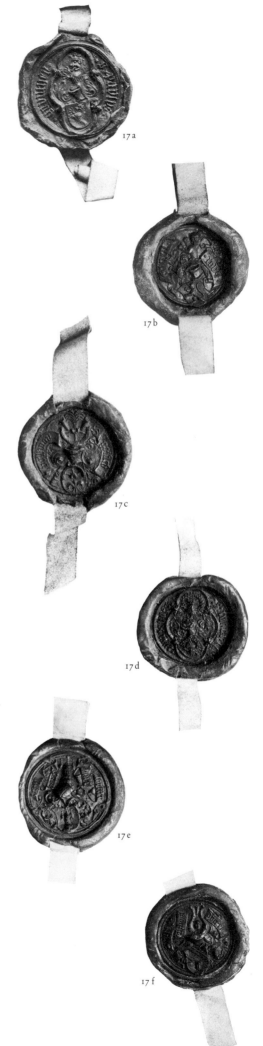

17 a

17 b

17 c

17 d

17 e

17 f

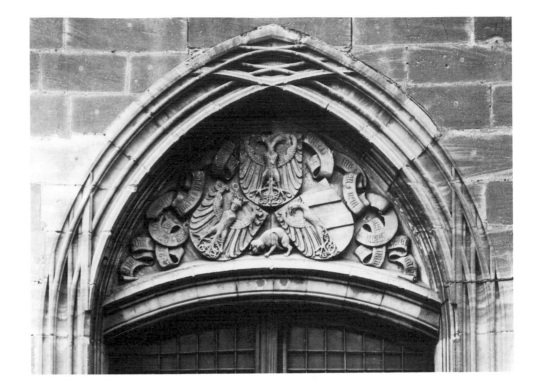

ingly comprehensive supervisory rights exercised by the council — which sought to establish something close to a Nuremberg state church — this led to a loosening of the traditional ecclesiastical ties with the city's monasteries.

Relatively early in its history, gradually and without opposition, the council had won the right to examine the finances of the city's parishes, monasteries, and hospitals: As early as 1341, delegates from the council reviewed the books of the Heilig-Geist-Spital. It was only much later, however, that the council managed to affect episcopal rights of patronage over the parish churches of Sankt Sebald and Sankt Lorenz. In 1475, Pope Sixtus IV granted the council patronage rights in the case of a vacancy during the papal (uneven) months, and, in 1477, he granted the pastors of both parish churches the title of prior; in 1513, the local ecclesiastical authority, Bishop Georg III of Bamberg (r. 1505–22), relinquished his patronage rights to the council in the episcopal (even) months. For these rights and for their confirmation alone, the city agreed to pay eighty thousand florins to Rome.

The council was not content to enjoy only supervisory and financial control over Nuremberg's religious foundations; it sought virtual religious independence for the city. As early as the thirteenth century, Sebald occupied the highest place among Nuremberg's panoply of saints as a helper in need and the patron saint of the city. With the council's championing of the cult of Sebald (who, however, was not canonized officially until 1425), the imperial city did not totally emancipate itself from the religious climate fostered by Bamberg, which was dominated by the imperial couple Emperor Henry II and Queen Kunigunde, along with Saint Otto of Bamberg. Nevertheless, religious devotion in Nuremberg assumed its own individual accent, as reflected in the city's distinctive baptismal names and in its liturgy. In 1507, the council commissioned from Peter Vischer the Elder's brass foundry the famous canopy above the shrine containing the remains of the city's patron saint (see cat. nos. 189, 190). The *Sebaldus Tomb* was installed in 1519, to the glory of both the saint and the city that he watched over. During the Reformation, the shrine was left untouched.

The council was hesitant to accept the Reformation, although the lower classes in the city and in its surrounding lands had favored it from the beginning. Doubtless, the council feared that any decisive support for the movement could unleash and encourage those forces seeking to effect social and political changes, as well as changes in

dogma and liturgy. The presence of the imperial regiment in the city (until 1524) also forced the council to be cautious, as did the comings and goings of countless princes of the empire and of the papal legate, in connection with the three Imperial Diets held in Nuremberg in 1522, 1522/23, and 1524.

It was only after a religious discussion convened in March 1525 before the delegates of the Greater Council that the council decided to regulate religious dogma and liturgy according to the principles of the Reformation. At the same time, the council dealt ruthlessly with iconoclasts and fanatics. Thus, eventually, the Reformation strengthened, rather than weakened, the social structures of the imperial city — especially since the Protestant clergy were merely servants of the council's authorities.

There was strong opposition to the Reformation from the prior of the Carmelite monastery, Andreas Stoss (died 1540), the son of the famous sculptor Veit Stoss; by the Dominican monastery of Sankt Katharina; and by the convent of the Poor Clares and its abbess Caritas Pirckheimer. However, the only Catholic stronghold capable of resisting for any length of time was the Nuremberg branch of the Teutonic Order.

III. The Economic Metropolis

Nuremberg's wealth in the Late Middle Ages was based on the industriousness and specialized production of its craftsmen, the quality controls demanded by its council, the innovative abilities of the trades that were not bound by guilds, and the farsightedness and adventuresomeness of Nuremberg's entrepreneurs in creating new markets for their products.

Nuremberg's development as a trade metropolis was not fostered by any special geographical features; rather, it was as a result of the growing economic importance of the city that new trade routes were established in addition to the older ones. Thus, the city's advantageous position derived from its own industry, not from any intrinsic phenomenon.

The oldest listing of Nuremberg's craftsmen, dating from 1363, includes fifty trades and 1,227 masters. Most were metalworkers, whose products were exported in great quantities. The majority of the iron came from the neighboring Upper Palatinate, where, by the fourteenth century, merchants already owned foundries, and, soon after, made investments of capital, as well. Following the War of the Landshut Succession, the city, itself, also began mining iron ore, in its newly won territories in the Franconian uplands.

As early as the fourteenth century, Nuremberg metalwork had already attained a higher degree of specialization than that of Cologne or Frankfurt; about the middle of the fifteenth century, it achieved the fine reputation that it managed to maintain for a long time. Among the objects manufactured in Nuremberg — some of them were only finished there — were a variety of tools, including knives, tongs, axes, spades, plows, and scythes; cooking utensils; such items for daily use as nails and needles; and, of course, weaponry: halberds, swords, helmets, chain mail, and suits of armor for both horse and rider. Many of the weapons were given to skilled craftsmen for engraving and other types of ornamentation. A number of the family names established in Nuremberg in the thirteenth and fourteenth centuries attest, to this day, to the specialization attained in the manufacture of armor. Because of its more advantageous location, Nuremberg's armorers, rather than their equally productive competitors in Cologne, were able to profit considerably from the threat of invasion by the Turks — a constant danger, from the second half of the fifteenth century on.

Nonferrous metals had to be imported from further away. Copper, which was also needed for the popular alloy, brass, came chiefly from Saxony (Mansfeld), Bohemia (Kuttenberg) — with which economic ties were interrupted, however, during the Hussite Wars, and for some time afterward — and from northern Hungary. A number

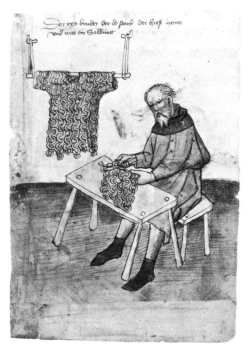

Figure 19 The craftsman Heintz making chain mail, from the *Hausbuch* of the Mendelsche Zwölfbrüder Stiftung. About 1425. Stadtbibliothek, Nuremberg, Hs. Amb. 317 fol., fol. *10r*.

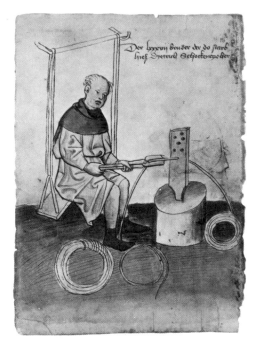

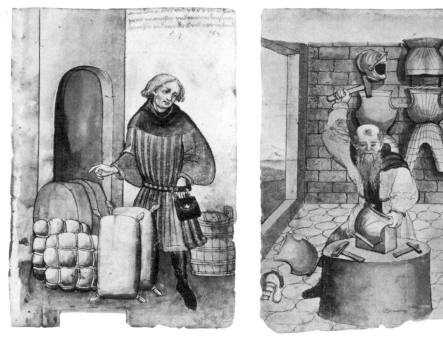

Figure 20 The craftsman Dietrich Schockent-
zieher drawing wire, from the *Hausbuch* of the
Mendelsche Zwölfbrüder Stiftung. About 1425.
Stadtbibliothek, Nuremberg, Hs. Amb. 317 fol.,
fol. 40 *v.*

Figure 21 The merchant Peter Neumeister, from
the *Hausbuch* of the Mendelsche Zwölfbrüder
Stiftung. 1440. Stadtbibliothek, Nuremberg,
Hs. Amb. 317 fol., fol. 63 *r.*

Figure 22 The armorer Conz Falck, from the
Hausbuch of the Mendelsche Zwölfbrüder
Stiftung. 1533. Stadtbibliothek, Nuremberg, Hs.
Amb. 317 fol., fol. 147 *v.*

of Nuremberg entrepreneurs had considerable capital investments in copper-smelting works abroad. The tin required for casting brass was, likewise, brought from Saxony and Bohemia. From the end of the fifteenth century on, Nuremberg was — with Aachen — one of the two most famous and productive sources of brass objects in the empire, holding a major share of the market for pots and pans, mortars, plaques, weights, and mathematical instruments. Cannon were cast mainly in brass. As raw materials and alloys were, for the most part, imported in a semifinished state, it was possible to keep the high energy demands of metalworking within bounds. Since the Pegnitz had only a modest fall, the availability of waterpower as an energy source was severely limited.

Even more profitable than the manufacture of tools and household objects was the production of mechanical instruments. The quality of the products of this type made in Nuremberg and the city's large share of the market for them were what established Nuremberg's fame at the beginning of the modern era. With Humanism, and the subsequent rediscovery of the sciences — especially mathematics, astronomy, physics, and geography — came a great demand for scientific instruments. This, combined with the well-known talent of Nuremberg's craftsmen for precision work, enabled the imperial city to exercise a virtual monopoly in many areas of instrument making. Compasses and precision navigational devices made in Nuremberg were used by ship captains; eyeglasses, combination locks, and chiming devices of Nuremberg origin could be found in princely residences and town halls all over Europe. Travelers to the holy places of Christendom, and to the fairs and marketplaces of Europe, relied on maps from Nuremberg. It was with Nuremberg instruments that Johannes Regiomontanus (died 1476) observed and calculated the movement of the stars. The Nuremberg merchant and explorer Martin Behaim constructed the first terrestrial globe in 1492 (it is now in the Germanisches Nationalmuseum; fig. 24, p. 24). None of the inventors working in Nuremberg at the beginning of the sixteenth century was to become — and remain — so well known as the locksmith Peter Henlein; about 1510, he made decisive improvements on a small, portable clock in the form of a box, with a forty-hour movement and a chiming device, which he then began to produce in quantity (see fig. 23). According to council records, the city bought a number of the small clocks as honorary presents for distinguished visitors. Philipp Melanchthon was given a clock in 1530, and Emperor Charles V received one in 1541.

About half of the crafts produced in Nuremberg in the fifteenth and sixteenth centuries were of metalwork. The manufacture of textiles first occurred there early in the fourteenth century. Although precious fabrics were imported from Flanders and England, tapestries (see cat. nos. 55–58, 67–69) and less valuable mass-produced goods were made in Nuremberg. Chief among them was a crude and relatively inexpensive loden cloth, which was spun and woven primarily in the suburbs of Wöhrd and Gostenhof. The wool was imported mainly from Flanders, at first; then, in the fifteenth century, when the importance of these loden-cloth mills had sharply declined, the wool generally came from the surrounding countryside. In 1488, the council recruited a number of fustian weavers from Upper Swabia who produced a cotton cloth usually used for shirts, trousers, shawls, and coverlets. However, the cloth made by the fustian mill scarcely found buyers outside the local market. After the turn of the century, the production of linen attained a much greater importance. Linen was imported chiefly from Saxony, Silesia, and Bohemia, then processed and dyed in Nuremberg for the export market. There were numerous dyers in Nuremberg; in 1363, there were some thirty-four masters in the trade, as compared with twenty-eight loden-cloth weavers and ten warpers.

At the end of the Middle Ages, Nuremberg was the third largest city in the Holy Roman Empire — after Cologne and Vienna — and its inhabitants numbered about thirty thousand. Large amounts of foodstuffs had to be imported. Of the edibles produced in any quantity for export, lebkuchen were the most important. The honey from which they were made was supplied by the beekeepers in the imperial forest, and the spices, by the city's own market.

In 1390, the Nuremberg patrician, councillor, and entrepreneur Ulman Stromer wrote in his family album: "I, Ulman Stromeir, was the first to start making paper." His mill just outside the city gate was, indeed, the first paper mill in Germany; before then, paper came primarily from Italy.

The production of paper in Nuremberg gained importance in connection with the printing of books. Nuremberg was not one of the first cities in which printing was developed; only in 1470 were the first books printed there, but, from the beginning, they were made by especially competent craftsmen in highly productive workshops. This was made possible as a result of the city's renowned book industry, even before Gutenberg's invention of movable type; by its highly developed metalwork trade; and by an assured supply of quality paper. Of Nuremberg's printers and publishers, Anton Koberger (died 1513) rapidly surpassed all competitors, for he had superlative knowledge of the market. A high proportion of his books were in Latin — a fact that ensured their widespread distribution.

The German word for publisher — *Verleger* — originally was used to designate a type of medieval wholesaler; only much later was the term applied to the book trade, when, despite strong opposition from the Nuremberg city council, the previously accepted definition of the term was finally changed, after the mid-fifteenth century. Early on, it was clear that producers functioned on a far smaller scale than did the sellers of their wares — hence, the separation of the two operations. This, in turn, led to the division of labor and capital — which is where the *Verleger* provided assistance. Traditional production methods, especially in the metalworking trades, were incapable of dealing with the new mass demand for production. The *Verleger*, therefore, would supply craftsmen with raw materials or semifinished goods and advance them the required capital. A contract assured the *Verleger* of either the craftsmen's entire production or a portion of it, agreed upon in advance. With a large stock of finished, marketable wares, he could then respond with speed and flexibility to sudden fluctuations in demand.

A charter signed by Emperor Frederick I Barbarossa in Nuremberg on March 13, 1163, had assured the city's merchants of imperial protection and freedom of trade throughout the empire. Along with other details, the document also reveals that

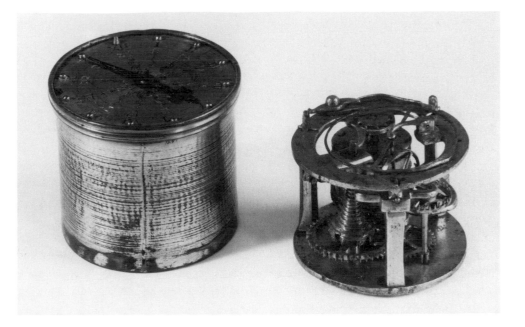

Nuremberg was then already an important exporter of manufactured goods, as well as a center of trade for all manner of wares, in transit; its development was given new stimulus by the growth of the iron industry in the Upper Palatinate.

Trade in Nuremberg was founded — with great diplomatic skill — on a system of reciprocal exemption from the payment of duties. Moreover, there were the imperial privileges, which were continually renewed, and which incorporated these same exemptions. In his privilege of November 8, 1219, Emperor Frederick II had endorsed all previous exemptions, and granted the merchants of Nuremberg the right to travel on the Danube from Regensburg to Passau without paying tolls. Emperor Ludwig the Bavarian summarily ratified the freedom from tolls that the city's merchants had managed to secure in some sixty-nine European cities. The number of cities affording merchants free access continued to grow. Reciprocal "most-favored-trading-partner" clauses opened up additional markets. Although Nuremberg was not a part of the Hanseatic League, its merchants enjoyed the rights of the league's members, in some of the cities in the league, as a result of such reciprocal agreements.

At first, the city's trade was focused more toward the west and north. Nuremberg merchants were represented at the fairs held in the Champagne in the thirteenth century, and likewise were involved in commerce in Lübeck and Bruges before 1300. Even later, when trade with eastern Europe took on increasing importance, the merchants of Nuremberg occupied a permanent place at the Geneva fair and, beginning in the mid-fifteenth century, were always represented in Lyons, as well — at that time the most important trade center in Europe.

There were Nuremberg merchants in Venice, the "Gateway to the Orient," from about 1300, as buyers of spices, precious fabrics, pearls, carpets, and cotton, as well as of Murano glass and wines from Friuli. At the beginning of the fourteenth century, in the Fondaco dei Tedeschi — which was modeled on Oriental examples, and in which the major German trading houses maintained branches — the Nuremberg merchants enjoyed an advantage over those from Regensburg.

With the extensive development of trade to the east, Nuremberg gained its central position in the European trade network. The kings of Bohemia and the Polish-Lithuanian rulers who imported German settlers into their territories in the thirteenth and fourteenth centuries dissolved all inconvenient barriers to trade from Nuremberg — which consisted primarily of shipments of metal wares and fustian cloth.

On the roads to Breslau, Posen, Frankfurt an der Oder, and also to Cracow — where some twenty people from Nuremberg enjoyed citizen's rights in 1396 —

Nuremberg shippers were continually transporting wax, furs, and leather from the East.

Farsighted policies adopted by the council assured the safety of the trade routes and encouraged the presence of Nuremberg's merchants in the chief trade centers of Europe. Exemption from the payment of duties, together with stringent quality controls, gave Nuremberg dealers a price edge over the competition. Even so, there were repeated setbacks. With the fall of Lemberg and the conquest of Constantinople by the Turks in 1453, the land route to the Orient — which passed through the Italian trading posts on the Black Sea — declined in importance, in favor of Venice. This fact, in addition to various obstructions to Nuremberg competition enacted in Prussia and in the cities on the Baltic, beginning in the mid-fifteenth century, led to a reduction in the exchange of wares with the East. Nuremberg is the city most often mentioned in commercial documents of the Late Middle Ages. Nuremberg's standards served as points of reference everywhere, in the confusing proliferation of European measures, coinages, and weights. During the Late Medieval period, cost estimates in the wholesale trade were frequently based on quotations on the Nuremberg market. One reason for this was Nuremberg's major role in the transport of goods. Only a portion of the products brought from the Orient and from the Mediterranean coast were destined for local consumption; the remainder was sent to other markets. As early as the close of the thirteenth century, the Nuremberg market offered for sale such exotic spices as pepper, anise, ginger, cloves, cinnamon, bay leaves, and saffron, which were sought after by the upper classes throughout Europe. (A merchant who had become rich in the spice trade, which operated with huge profit margins, was derisively known as a "peppersack.") Not long afterward, one could also buy rice, raisins, and almonds in the market in Nuremberg, although the supply of figs, oranges, and lemons was somewhat more limited.

Eastern European countries paid for Nuremberg's wares — for which there was an ever-increasing demand — with large herds of cattle, raised primarily in Poland and in Hungary. The inhabitants of densely populated areas of northwestern Europe and northern Italy consumed great quantities of beef. The high cost of meat resulting from increasing demand meant that there were large profits to be reaped from the sale of beef, despite the long distances involved in its transport; several of the routes passed through Nuremberg territory. Nuremberg merchants had the necessary capital with which to build up and maintain an organization for the transport of cattle across the Continent; watering and feeding places, as well as rest stops along the way, were required. The cattle drives were largest in the spring, for meat consumption rose dramatically at the end of Lent, and around the Feast of Saint Martin (November 11), when people took in supplies for the winter. This trade reached its peak at the close of the fifteenth century and the beginning of the sixteenth; it rapidly came to an end with the invasion of Hungary by the Turks in 1526. The sale of cattle in the Nuremberg market was of only minimal importance.

The oldest surviving commercial documents in Germany are those that were kept by the Holzschuher family in Nuremberg from 1304 to 1307. They note the purchase of woolens in Flanders and Brabant. A few decades later, fabrics were also being imported directly from England and, for the most part, marketed in Italy. However, after 1463, when the lucrative export of cloth was forbidden to foreigners, Nuremberg buyers had to withdraw from the English market and reestablish themselves in Flanders, where they were able to maintain a virtual monopoly in the wool and woolens trade, until the conquest of Antwerp by the Spanish in 1576. At the same time, Nuremberg merchants, through the heavy investment of capital, managed to attain a leading position in the European linen trade. Relatively inexpensive and lightweight cloth was brought to Nuremberg mainly from Saxony, Silesia, and Bohemia to be dyed and processed. The finished goods were then sold mainly in Italy, Spain, and Portugal, and, ultimately, in their various overseas colonies. The growing of flax and

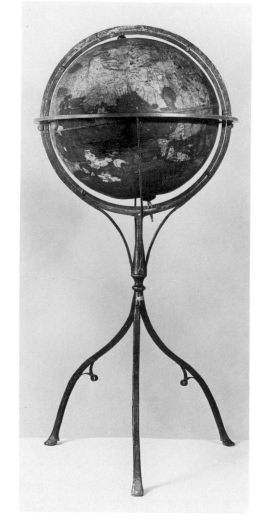

Figure 24 The globe of Martin Behaim (the so-called *Erdapfel*). Designed by Behaim, executed by R. Kolberger, painted work by Georg Glockendon. Nuremberg, 1491–92. This earliest representation of the earth as a sphere was made the year that America was discovered, and thus does not include that continent. Germanisches National-museum, Nuremberg

the spinning and weaving of linen fibers require a damp, moderate climate, and because linen clothing tends to be lightweight rather than warm, the demand for linen goods from Mediterranean and colonial countries was always sizable.

Nuremberg primarily traded in goods. Although there certainly was considerable capital on hand in the Late Middle Ages, and many of the city's merchants were able to make extensive investments, banking, as such, played only a minor role in business. There was a certain reluctance about lending money — even to princes. For that reason, Nuremberg was spared the sudden shake-ups resulting from capital losses suffered by the trading houses of Augsburg.

The city's far-flung trade network was carefully controlled. Advantageous transactions were made possible by a constant flow of information to and from the more important centers of trade, and by constant improvements in accounting. The earliest German example of double-entry bookkeeping, noting the flow of both money and goods, comes from Nuremberg: It is the balance sheet for the year 1484, kept by the merchant Langhans Tucher, who, doubtless, adopted the procedure directly from Italy.

The discovery of America dislodged Nuremberg from its central position in its network of trade coordinates. Up to that time, the city's markets had been ensured. Like Venice, the imperial city was one of the losers in the age of discovery. The effect of this new era on commerce was correctly anticipated in Nuremberg merchant circles, early on. Unlike the Fugger and Welser families in Augsburg, Nuremberg merchants refrained from making capital investments in the New World. The Thirty Years' War, thus, was not the cause of the decline of Nuremberg's economy; it only served to accelerate it.

Selected Bibliography*

Albrecht Dürers Umwelt. Festschrift zum 500. Geburtstag Albrecht Dürers am 21. Mai 1971 (Nürnberger Forschungen 15), Nuremberg, 1971.

Ammann, Hektor, *Die wirtschaftliche Stellung der Reichsstadt Nürnberg im Spätmittelalter* (Nürnberger Forschungen 13), Nuremberg, 1970.

Beiträge zur Wirtschaftsgeschichte Nürnbergs (Beiträge zur Geschichte und Kultur der Stadt Nürnberg 11/1–11), Nuremberg, Stadtarchiv, 1967, 2 vols.

Borst, Arno, "Die Sebaldslegenden in der mittelalterlichen Geschichte Nürnbergs," *Jahrbuch für fränkische Landesforschung*, 1966, 26, pp. 19–178.

Bühler, Albert, "Albrecht Dürer und die deutschen Reichskleinodien," *Mitteilungen des Vereins für Geschichte der Stadt Nürnberg*, 1971, 58, pp. 139–60.

—, *Reichskleinodiengeschichte im Überblick* (printed ms.), Karlsruhe, 1953.

Die Chroniken der fränkischen Städte. Nürnberg (Die Chroniken der deutschen Städte 1, 2, 3, 10, 11), Leipzig, 1862–74, 5 vols., reprinted, Göttingen, 1961.

Dannenbauer, Heinz, *Die Entstehung des Territoriums der Reichsstadt Nürnberg* (Arbeiten zur deutschen Rechts- und Verfassungsgeschichte 7), Stuttgart, 1928.

Diplomatarium Lipsano-Klinodiographicum S. Imp. Rom. German. ab A. 1246 ad A. 1764, in von Murr, Christoph Gottlieb, ed., *Journal zur Kunstgeschichte und zur allgemeinen Litteratur*, Nuremberg, 1784, 12, pp. 35–216.

Franz, Eugen, *Nürnberg, Kaiser und Reich. Studien zur reichsstädtischen Aussenpolitik*, Munich, 1930.

von Guttenberg, Erich Freiherr, and Wendehorst, Alfred, *Das Bistum Bamberg 11: Die Pfarreiorganisation* (Germania Sacra 11/1,2), Berlin, 1966, pp. 274–301.

Hans Sachs und Nürnberg. Bedingungen und Probleme reichsstädtischer Literatur. Hans Sachs zum 400. Todestag am 19. Januar 1976 (Nürnberger Forschungen 19), Nuremberg, 1976.

Heimpel, Hermann, "Nürnberg und das Reich des Mittelalters," *Zeitschrift für bayerische Landesgeschichte*, 1951/52, 16, pp. 231–64.

Hofmann, Hanns Hubert, "Nürnberg. Gründung und Frühgeschichte," *Jahrbuch für fränkische Landesforschung* 1950, 10, pp. 1–35.

Kircher, Albrecht, *Deutsche Kaiser in Nürnberg. Eine Studie zur Geschichte des öffentlichen Lebens der Reichstadt Nürnberg von 1500 bis 1612* (Freie Schriftenfolge der Gesellschaft für Familienforschung in Franken 7), Nuremberg, 1955.

* A more extensive bibliography may be found in the history of Nuremberg by Gerhard Pfeiffer (pp. 512–49) cited below.

31

32

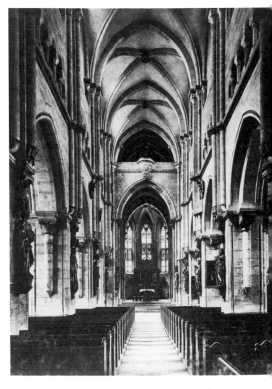

that it was a planned community, established by the Hohenstaufen rulers in the mid-1100s.

By the close of the twelfth century, Nuremberg thus consisted of two halves, separated by the swampy lowlands of the Pegnitz, each probably protected only by a ditch and palisades. A bridge, which connected the two communities, is frequently mentioned in thirteenth-century sources. Each side had its own parish church: the one on the north bank was consecrated to Saint Sebald, and that on the south, to Saint Lawrence. Although they were repeatedly rebuilt and enlarged in later centuries, the churches are not distinguished by impressive dimensions or by prominent towers, but, rather, by their rich interior and exterior sculptural and decorative ornament. The elaborate stained-glass cycles in these churches have survived the centuries, as have splendid furnishings now found only infrequently in medieval churches: altarpieces, figures of saints, epitaphs, candelabra, shrines, and baptismal fonts — all of which impart a sumptuousness to the interiors.

The older of the two churches is Sankt Sebaldus. On the site of the present structure there was a small chapel — dedicated, about 1050, to Saint Peter — on the south edge of the still quite modest settlement. Pilgrimages to the tomb of the hermit saint Sebald, which was inside the chapel, began about 1170, and soon the saint became a co-patron of the church, eventually supplanting Saint Peter altogether.

A new church was begun about 1230/40. The consecration of an altar was recorded in 1255, but construction doubtless continued until 1274. The new church was Late Romanesque in form, a vaulted basilica on a cruciform ground plan, with a tall nave and lower side aisles (fig. 33). It contained both eastern and western choirs, each built over a crypt and flanked by towers. Such a design, generally reserved for cathedrals, was unusual in a parish church. Its use at the Sebalduskirche may have reflected the fact that the church had two patron saints. The cathedral of Bamberg, completed in 1237, served as the model.

In the early fourteenth century, only decades after construction on the church had been completed, a major remodeling was undertaken. The side aisles were razed and then expanded to the width of the transept, although they remained shorter than the transept in height. The structural design of the side walls matches the Late Romanesque nave; the tracery that fills the large, Gothic, pointed-arch windows is

Figure 31 Jakobskirche, from the southwest (in 1935)

Figure 32 Sebalduskirche: East choir, from the northeast (in 1935)

Figure 33 Sebalduskirche: Nave and west choir, from the east (in 1935)

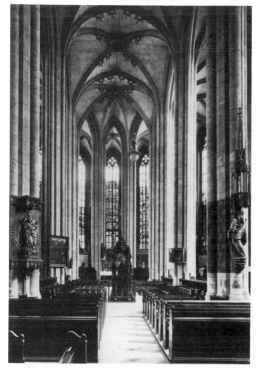

Figure 34 Sebalduskirche: Hall choir, from the west (in 1935)

Figure 35 Parish house of the Sebalduskirche: *Chörlein* (in 1935)

based on geometric forms. Rich architectural sculpture adorned capitals and key-stones. Simultaneously, the stonecutters employed at the Sebalduskirche began work on various figural cycles intended for the side-aisle portals (the Last Judgment portal and the Marian portal), and, later, for the pillars of the nave. The figures for the two portals were created by the so-called Saint Catherine master, one of the leading sculptors of his time, who may well have been familiar with the sculptural art of the Middle Rhine in Mainz, Worms, and Strasbourg (cat. nos. 1, 2). In 1345, and again in 1482/83, the towers were heightened by an additional story topped by a platform and a new spire.

One change that completely altered the effect of the church interior was the con-struction of a Late Gothic hall choir to replace the Romanesque east choir; it was begun in 1361 and consecrated in 1379 (fig. 32). The Romanesque transept was incor-porated into this three-bay choir, and largely determined its proportions. The eastern apse of the new structure describes nine sides of a sixteen-sided polygon. Inside, the choir's side aisles join to form an ambulatory tracing five sides of an octagon (fig. 34). The choir itself has cross-ribbed vaulting, while over the aisles are alternating tripar-tite and quadripartite vaults.

The roof of the hall choir stands noticeably higher than that of the Romanesque nave. The walls are largely given over to high tracery windows, which reach the level of the eaves; buttresses ornamented with blind tracery and baldachins with figures provide a visual counterbalance to the windows. A traceried gallery extends along the top of the wall, at its junction with the roof.

The hall choir of the Sebalduskirche is one of the most impressive structures of its time. Its architect is thought to have been associated with the Parler school, active in southern Germany and in Bohemia. The choir of the Cistercian collegiate church at Zwettl in Lower Austria has also been identified as a possible model. Regardless of such connections, the Sebalduskirche choir is an achievement in its own right, but also reflects the prevailing architecture of the period.

Many of the medieval appointments of the Sebalduskirche survive. In addition to figural sculpture both inside and out, the church still contains numerous altarpieces, epitaphs, memorial coats of arms, commemorative tablets, and wall hangings, as well as stained glass. Especially noteworthy are the tomb of Saint Sebald, in cast brass, produced by the Vischer workshop in 1519 (cat. nos. 189, 190), and the sandstone reliefs of the Passion, created by Veit Stoss in 1499 (see cat. no. 89).

North of the west choir of the Sebalduskirche is the parish house, a four-winged complex surrounding an open courtyard. Rebuilt in 1361 after a fire, its cellar and ground-floor rooms are vaulted. Projecting from the exterior on the east is the "Sebal-der Chörlein," a large bay window, or oriel, that opened onto a private chapel (fig. 35). The *Chörlein* describes five sides of an octagon; beneath its traceried open-ings are relief panels with scenes from the life of the Virgin. This windowed structure was the creation of a team of sculptors who, about 1370, also worked on the hall choir of the main church. A copy replaces the original, which is now in the Germanisches Nationalmuseum.

The existence of a chapel on the south bank of the Pegnitz was mentioned, initially, at a much later date than the Peterskapelle referred to above. It is first named in a papal document, of 1235, as having been consecrated to Saint Lawrence and the Holy Sepulcher. Originally, it was a dependency of the Pfarrkirche in nearby Fürth, pre-sumably becoming independent sometime in the last third of the thirteenth century. As a result, work began shortly after 1260 on a new building, for which the earlier Romanesque chapel was razed. Excavation has revealed traces of a slightly horseshoe-shaped apse from that structure and a few subsidiary walls. Its stones were incorpo-rated into the foundations and walls of the new church, a three-aisle vaulted basilica with nine bays, its nave exactly twice as wide as the side aisles. Clustered pillars support the narrow, rectangular vaults of the nave, each of which is adorned with a

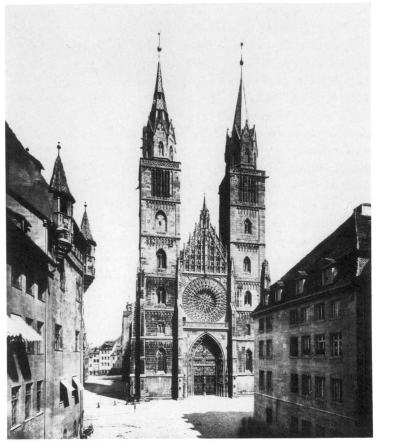

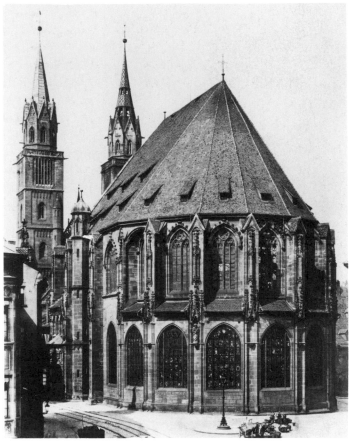

figural keystone. A pair of towers rises above the westernmost bay of the nave, which necessitated considerable strengthening of the last pair of piers. The contemporary choir, known only from excavations, consisted of a single bay ending in five-eighths of a polygon.

The most imposing side of the Lorenzkirche is its twin-towered west façade (fig. 36). The square towers, six unequal stories high, are crowned by a traceried balustrade that serves as a transition to the final, octagonal story, which, in turn, supports a spire. The area between the towers was given its present form shortly after the middle of the fourteenth century. The ground floor is dominated by a stepped portal with a pointed arch, double doors, and jamb figures, its tympanum divided into horizontal stripes. The figures and reliefs summarize the essential tenets of Christian redemption in a minimum amount of space. A balustrade divides this story from the upper wall, which is entirely occupied by a large rose window composed of two concentric circles of eight segments each. Traceried galleries surmounted by stepped finials follow in rapid succession to the tip of the crowning gable. A single finial, towering above the gable peak, accents the center of the church. This west façade displays virtually all of the decorative forms that were developed in France and along the Upper Rhine and then were subjected to further infinite variation, resulting in the so-called German Gothic style.

About 1400, the nave was widened. The original walls of the side aisles were removed, and the aisles were then enlarged by new walls that connected the buttresses, creating a row of relatively flat chapels between these outer piers.

As at the Sebalduskirche nearly eighty years earlier, a new choir was planned for the Lorenzkirche (fig. 37). Its cornerstone was laid in 1439, and it was completed in 1477. In the initial phases of its construction, the old Late Gothic choir was left in place, while the walls of the new one were raised some distance, on the outside. Thus, interruption of services was minimized, at least during the early phases of the work. The new choir is a hall structure with aisles forming an ambulatory whose outer wall

Figure 36 Lorenzkirche, west façade (before 1900)

Figure 37 Lorenzkirche: Choir, from the south-east (in 1935)

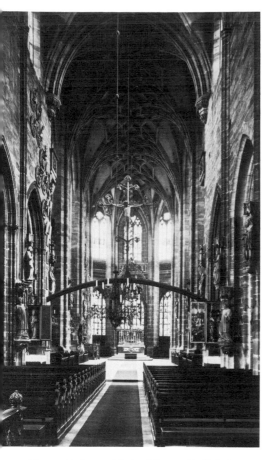

Figure 38 Lorenzkirche: Nave and hall choir, from the west (in 1935)

Figure 39 City defenses: Frauentor keep (in 1935)

traces seven sides of a fourteen-sided polygon, and whose inner wall describes three sides of a hexagon. This irregular space called for a complicated system of vaults, the weight of which was directed onto interior buttresses (fig. 38). Between the bases of these buttresses are shallow chapels; the walls above are pierced with tracery windows. Fine net vaulting graces the western portion of the elongated choir, and above this rises a massive saddleback roof considerably higher than that of the Late Gothic nave.

A succession of three architects oversaw the building of the Lorenzkirche hall choir. They adopted spatial concepts, already realized in the choir at the Sebalduskirche, which had their roots in the Parler family workshops. At the same time, they simplified and refined these precedents, creating the so-called Soft Style. In conception and execution, the net vaulting of the choir is a masterpiece of Late Gothic stone carving.

Like the Sebalduskirche, the Lorenzkirche still contains many of its medieval appointments: altarpieces, paintings, extensive stained-glass cycles, figures of saints in stone and wood, choir stalls, chairs, bronze and wrought-iron chandeliers, tomb monuments, epitaphs, and memorial coats of arms. Most famous, perhaps, is the elegant *Sacrament House* by Adam Kraft, of 1495 (figs. 60, 62, 63). This tower-like tabernacle of sandstone rises in several filigreed stories to the height of the vaulting, and is among the consummate artistic achievements of Late Gothic sculpture. Another important work of art in the Lorenzkirche is the *Angelic Salutation* by Veit Stoss, of 1517/18. This three-dimensional, over-life-size Annunciation group is suspended from the vaulting in the choir (figs. 60, 61).

By about the middle of the thirteenth century, each half of the thriving city of Nuremberg, to the north and south of the marshlands and floodplain of the Pegnitz River, was enclosed within an independent ring of city walls. The course of these sandstone walls for the most part may still be traced. A covered gallery, a deep outer moat, and numerous towers enhanced these defense works. Of this first ring of fortifications on the Sebalduskirche side, portions of the Tiergärtnertor and the Laufer Tor still survive; through these gates passed, respectively, the northbound road to Erfurt, Würzburg, and Frankfurt, and the eastbound road, via Eger, to Prague. On the Lorenzkirche side of the city, the Spittlertor led southwest toward Rothenburg and Stuttgart, and the Frauentor (fig. 39), southeast toward Regensburg.

Between 1320 and 1325, the two halves of the city were connected by walls linking the rings on the east and west. Particular care was taken to secure the places where the Pegnitz entered and left the city; here, the walls bridging the river were protected by additional towers. This complex of fortifications is generally referred to as the next-to-the-last city wall. It seemed advisable to close the ring for, in the meantime, the banks of the Pegnitz outside the original walls seem to have been settled. Moreover, a number of mills had been built along the river, and they also needed protection. Despite its abundance of water, the Pegnitz was not really navigable; fishing skiffs were the only vessels suited to it. This made feasible the establishment of mills, not only for grinding grain, but, more importantly, for powering metalworking machines such as presses, polishers, rollers, and wiredrawing equipment, as well as lathes used in woodworking. The first German paper mill and the earliest German wiredrawing mill were built on the Pegnitz about 1390.

The third ring of fortifications, about three miles long and still largely extant, was begun in 1346 and completed only in 1452, thus taking over one hundred years to build. The rapidly growing population — by the end of the sixteenth century the city numbered about fifty thousand inhabitants — and the need to protect buildings outside the next-to-the-last city wall made an expansion of the walls unavoidable. The course of the earliest wall was retained only to the north, in response to the varied terrain there, with its castle complex. During construction of this new wall, it was

necessary to ensure that the existing city defenses remained intact. The new wall, provided with countless embrasures, is approximately three-and-a-half feet thick, with a height of twenty-seven to thirty-one feet. A covered gallery extends along the inner face of the ring. Outside the actual wall, at a distance of some fifty feet, is a second, lower wall, producing an open bailey as an additional defense. Beyond the bailey there was a trench, some sixty-five feet wide and up to forty feet deep. A ring of 128 towers, the main gates secured by drawbridges and armories, and a ring of defense works as much as one hundred feet wide, protected the city to such an extent that it was unconquerable for centuries.

With the building of this last wall, a structure of supreme importance for the development of Nuremberg, physical expansion came to a halt, scarcely extending beyond the limits of the medieval city until well into the nineteenth century. At the same time, the effect of the walls on the overall design of the city was so profound that these next-to-the-last and final fortifications serve as points of orientation for further descriptions of the development of the city. Once the final walls were completed, the earlier ones were no longer required and could be razed, freeing a ring of building sites in the inner city for new markets and public buildings.

As early as the eleventh century, Nuremberg's merchants had been granted the privilege of operating a market, originally located below the castle, north of the Sebalduskirche. Although, at first, only goods required to supply the castle were to be traded, in time, the city's growth demanded an expansion of this first market and, eventually, the establishment of separate, more specialized ones. Today, only the names of streets that once functioned as marketplaces serve to recall some of the markets themselves: on the Sebalduskirche side, we know of the milk market, which occupied the site of the original general market, as well as the wine, goose, meat, fish, salt, fruit, and hay markets. An island in the Pegnitz was the site of the sow market. On the Lorenzkirche side, markets for horses, grain and hops, and wood and coal were held — the last three, on sites cleared by the razing of the city wall.

In the fourteenth century, the so-called Hauptmarkt (main market) became the city's central marketplace, its license granted in 1349 by Emperor Charles IV. In order to make room for the new central market, in the same year the city secured the emperor's permission to raze the Jewish quarter and its synagogue, situated in the low-lying area just north of the Pegnitz. Charles IV pardoned the city in advance for any harm that might come to the Jews under his protection, opening the way for a pogrom that claimed 562 victims — listed by name in contemporary records. The city council seized the estates of the Jews in order to settle pressing debts. On the land reclaimed in this manner the council established the Hauptmarkt, while the Obstmarkt (fruit market) was set up just to the east. Between these two markets, on the site where the synagogue had stood, the cornerstone of the Frauenkirche (fig. 40) immediately was laid. In his letter of endowment, of 1355, Charles IV notes that he "erected, founded, and created the new church or chapel to the honor and glory of his reign... in his imperial city of Nuremberg." The church was placed under the jurisdiction of the Augustinian canonical college in Prague Neustadt. It was presumably dedicated in 1358, by which time it was largely completed.

The structure, built of sandstone on a nearly square plan, is a three-aisle hall church with three rows of three bays each, and a long choir. The cross-ribbed vaults of the nave rest on tall piers. A high, saddleback roof over the nave, a lower one over the choir, and massive buttresses mark the simple exterior. Only the stepped gable on the west façade, facing the Hauptmarkt, is richly decorated with niches and blind mullions. Attached to the façade is a two-story porch flanked by stair towers, the ground floor of which serves as a vestibule. On the upper story, slightly set back, are a chapel dedicated to Saint Michael and an outside ambulatory. The walls of the chapel are almost completely filled with tracery windows. A graceful roof crowns this structure: set into the gable, created in 1509 by Adam Kraft, is a large ornamental clock — the

Figure 40 Hauptmarkt, with the Schöner Brunnen and the Frauenkirche (before 1909)

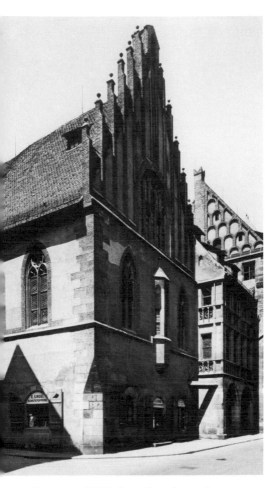

Figure 41 Old Rathaus, from the southeast (in 1935)

so-called *Männleinlaufen*. At noon, when the mechanism is set in motion, the figures of the seven imperial electors, preceded by heralds and musicians, file before the emperor. This ceremony commemorates the Golden Bull issued by Charles IV, which regulated the selection of the emperor by a number of electors and, at the same time, bound them to fealty to their overlord.

It was in the Michaelskapelle that Emperor Charles IV first displayed the imperial regalia in Nuremberg. The occasion for this showing of the treasure was the baptism of his firstborn son and successor, Wenzel, in the Sebalduskirche in 1361. Then, in 1422, the imperial regalia was placed in the permanent custody of the city. For several centuries, the jewels and relics were displayed publicly, once a year, on a specially constructed tower (fig. 11) in the Hauptmarkt. A fair accompanied the exhibiting of the treasures. In time, however, the sacred objects came to be regarded primarily as relics, rather than imperial insignia; after the city adopted the teachings of Luther, the council decided that such displays were no longer appropriate.

The Frauenkirche, in Nuremberg's Hauptmarkt, gave Charles IV an additional presence in the city: an ecclesiastical seat, in addition to his secular one in the castle. As the first hall church in Franconia, it introduced a Swabian-type structure, thus occupying an important place in architectural history. In planning this architectural gem, Charles IV presumably enlisted one of the most able architects from his capital in Prague — Peter Parler, who was in charge of Prague's cathedral of Saint Veit, after 1352, and who, more than any other architect, set the style of Gothic architecture in Germany.

The Hauptmarkt, itself, eventually became the commercial center for both sections of the city. Charles IV authorized the construction of this large, rectangular square "so that the people could buy and sell there without crowding." The trading firms and warehouses of the patricians lined the square, and on its north side were the offices of the official money changers. Two bridges across the Pegnitz connected the Lorenzkirche side directly with the market square. In the northwestern corner of the square stands the so-called Schöner Brunnen, or Beautiful Fountain (fig. 40), the planning for which was probably begun in the time of Charles IV (about 1370), but which was actually constructed from 1385 to 1396. The fountain has an octagonal basin; from its center a vertical structure rises to a point. It is made up of Gothic architectural forms: flying buttresses, arches, tracery, baldachins, and finials. A total of forty figures are arranged in five main groups. Around the edge are representatives of the Seven Liberal Arts and Philosophy, the four Evangelists, and the four Church Fathers. On the first level of the central structure are the Nine Heroes, three of whom are heathens, three Christians, and three Jews, and the seven imperial electors (see fig. 177). At the top are seven Old Testament prophets, and Moses. Both the figures and the architectural portions of the fountain were painted and gilded, so that the overall effect was like that of goldsmiths' work, but on a monumental scale (cat. no. 15). The figural program would suggest that the fountain was intended to symbolize Justice and the legitimation of worldly authority by its association of electors and heroes with prophets, Evangelists, and Church Fathers. Tradition has it that the fountain was executed by a certain Heinrich Beheim. Stylistically, the figures are late examples of Nuremberg sculpture influenced by the Parler school, yet it is not known whether the sculptors of the figures on the fountain were familiar with the sculpture of Prague, or simply belonged to a local workshop that had studied the figural decoration on the Frauenkirche and carried the style somewhat further.

The city's most important public building, the Rathaus (town hall), is not directly on the Hauptmarkt, but is slightly to the north, separated by a block of houses (fig. 41). This somewhat out-of-the-way location is explained by the fact that the Rathaus predates the market square. The earliest Rathaus and the Tuchhaus (Drapers' Hall) were under the same roof. After the two halves of Nuremberg were joined, the city council decided to erect a building of its own. In 1331, it acquired a site next to

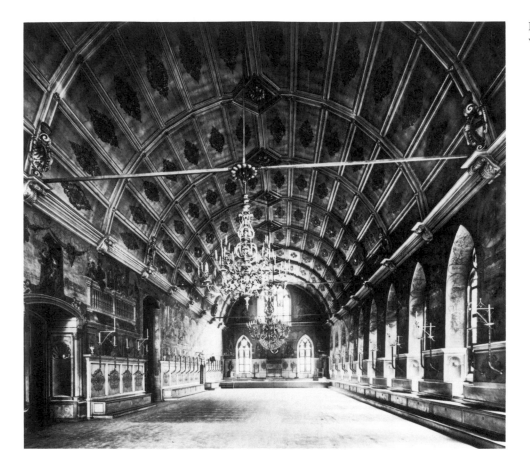

Figure 42 Old Rathaus: Great Hall, from the west (in 1935)

the former salt market, diagonally across from the choir of the Sebalduskirche. Here, the city architect Philipp Gross built the structure that survives to this day, with its showplace — the vast ceremonial hall on the second story. Barrel-vaulted shops occupied the ground floor; in 1480, Albrecht Dürer the Elder, the artist's father, owned a goldsmith's shop on the premises. In the cellar were the city dungeons and a torture chamber.

The great hall of the Rathaus is an elongated, rectangular room (cat. no. 13; fig. 42). Two-part tracery windows in the long, south side provide the hall with light; the north wall is closed off by adjacent structures. Deep window niches divide the space into sections of wall that are alternately light and dark, and projecting and receding. Stone benches line the side walls, functioning optically as a podium. The east end widens into a small, sandstone *Chörlein,* a projecting bay that may once have accommodated an altar or a crucifix. To the right and left of the *Chörlein* were reliefs depicting Emperor Ludwig the Bavarian enthroned as protector of the imperial city, and two figures that later were identified as "Norimberga" and "Brabantia." They symbolized the trade connections between Nuremberg and the Netherlands (cat. no. 13). A massive, pointed wooden barrel vault spans the width of the room. At the time of its restoration in 1520/21, Albrecht Dürer was commissioned to decorate the chamber with a cycle of paintings, the iconographic program having been devised by Willibald Pirckheimer (cat. no. 146). Later restorations considerably damaged Dürer's paintings, so that, today, only traces survive. A splendid brass screen, or grille, cast in the Vischer workshop, divided the chamber (see cat. no. 199). Although the work originally was designed for the Fugger Chapel in Augsburg, it was installed in the Rathaus in 1530/40, after the Fugger family in Augsburg withdrew the commission. In 1615, two superb wooden chandeliers carved by Hans Wilhelm Beheim were suspended from the ceiling of the hall. A chandelier in the shape of a dragon, after a design by Albrecht Dürer, was created in 1522 by Willibald Stoss for the smaller council chamber (cat. no. 150).

At the beginning of the sixteenth century, the council was able to acquire additional land to the north of the Rathaus, making expansion possible. The greater part of the present-day Rathaus derives from a plan by the architect Jakob Wolff. He envisioned a complex of four wings, the façades of which were to mask the various structures erected over a period of nearly three hundred years, including the west gable of the great hall. The cornerstone was laid in 1616, but only a few years later, in 1622, work was suspended on account of financial pressures occasioned by the Thirty Years' War. Therefore, the old Gothic Rathaus, with its ceremonial hall, was spared.

The demolition of the next-to-the-last city wall, which provided space for a series of markets, at the same time made possible the construction of a number of public buildings for the storage of supplies. Although the new wall provided security from attack, it was necessary to keep adequate stores on hand if the city were to withstand a protracted siege. The city architect Hans Beheim, therefore, was instructed to build a series of granaries. As a rule, these are long, simple stone structures of only a few stories, but with high, steep roofs that conceal a succession of attics used for the storage of grain. Each of these attics has several dormer windows to ensure adequate ventilation.

One such granary, built in 1490/91, later became the Unschlitthaus, where tallow was collected and stored. While only two floors high, the building has a saddleback roof that accommodates four attic levels. It was built in a former moat, outside the city wall; portions of the wall, itself, were incorporated into the granary's east side. Its main stories are completely unadorned, their only accent being the pointed-arched portal on the south side; architectural ornament is confined to the two Gothic stepped gables.

Another granary located along the course of the former city wall, next to the wood market, was built from 1498 to 1502, also by Hans Beheim. A weighhouse was added later, and, in 1572, the city's customhouse was moved to this building; for this reason, it became known as the Mauthalle (*Maut* meaning excise, or duty; fig. 43). The Mauthalle is a three-story structure of regular sandstone blocks. Its tripartite vaulted cellar, containing massive square pillars, was also built in what had been the moat, outside the city wall. The ground floor, remodeled in 1898, accommodates shops, while the high, saddleback roof, like that of the Unschlitthaus, shelters six attic floors.

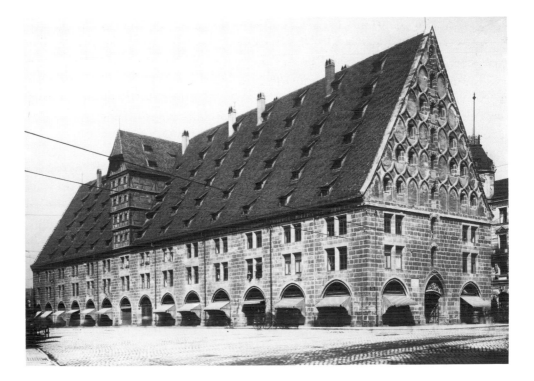

Figure 43 Mauthalle, from the southeast
(about 1900) (see fig. 18)

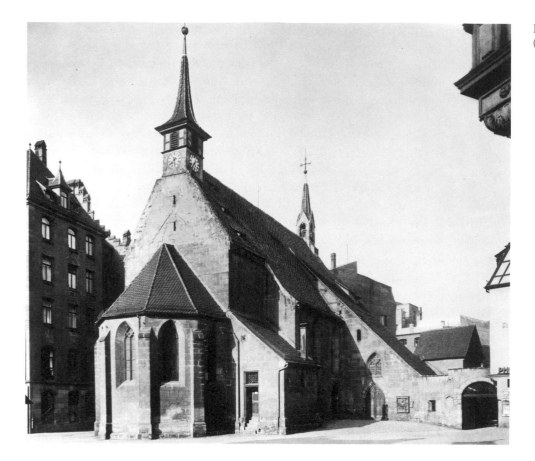

A network of interlocking blind ogee arches adorns the surfaces of each of its whitewashed pointed gables.

Two additional granaries, also with attic storage spaces, were located next to the Mauthalle on land formerly claimed by the city's defenses. These buildings were used as armories after 1572, and then as storage barns for hops in the nineteenth and twentieth centuries. Both were completely demolished during World War II. The same Hans Beheim constructed the granary on the castle hill and another for the community of the Teutonic Order on the west side of the city. Also dating from the late fifteenth and early sixteenth century, these were modeled on the Unschlitthaus and the Mauthalle.

Apparently, the city's need for public buildings was not great enough to put to immediate use all of the land reclaimed from the old defense works. It was not until 1588 that a new armory was erected opposite the Mauthalle, and nearly a century later, in 1672, a brewery was built on the site of the former moat. All the buildings mentioned here are on the Lorenzkirche side of the river, parallel to the next-to-the-last wall. Today, the exact course of the wall through the western portion of the Sebalduskirche side of the city is not known, but, to the east, it clearly occupied land on which the council built the vast Herrenschiesshaus in 1582/83. To the north, the city constructed a number of houses for the weavers of fustian cloth, brought from Swabia in an attempt to foster a new industry. This settlement, whose name, Sieben Zeilen (Seven Rows) is taken from its layout, consisted of twenty-one two-story structures on landfill in the former moat. Each has a brick cellar, which supports a half-timbered residential structure that afforded space for the weavers' looms, while the upper floors accommodated the master weavers and their families, assistants, and apprentices. The first of the settlement's houses was built in 1489; the remainder in 1524.

The enlargement of the city and the construction of its new ring of defenses also had an effect on Nuremberg's religious communities. Although all orders but the Carthusians had been established there before 1300, several, heretofore, had been

situated outside the city walls. The Benedictine monastery of Sankt Egidien, as noted above, had been erected on lands owned by the crown, as early as 1146, but most of the city's religious houses were established in the thirteenth century. Five communities for men and three for women had been granted charters to build in Nuremberg. By the middle of the thirteenth century, the city's ruling powers — namely, representatives of the king, the burgrave, and the citizenry — sought to gain control over these communities by appointing a procurator as administrator of the monastic holdings, thereby linking them to the city's overall judicial and administrative systems.

Although the Egidienkirche previously had been enclosed within the first of the city's walls, it was only with the construction of the final wall that the extensive properties of the Teutonic Order were protected; the community, which the order founded in 1209 on the property of the second royal estate, has already been described. The Franciscans may have settled in Nuremberg as early as 1224, before the death of their founder, Francis of Assisi. The Nuremberg chapter was one of the new order's first foundations in Germany. Inasmuch as the Franciscans ministered to urban populations, it may be assumed that, by the time of their arrival, Nuremberg had become a sizable city. The Franciscans built their monastery directly on the south bank of the Pegnitz, near the ford in the river. As the two halves of the city were not connected by walls at that time, the new monastery was situated outside the walls for nearly a century. In the mid-thirteenth century, construction began on their monastic church, the Franziskanerkirche, a three-aisle, Early Gothic basilica with a vaulted, single-aisle choir terminating in an apse describing five sides of an octagon. The churches of the mendicant orders are characterized by simple, austere forms and a dearth of ornament. Nothing is known about the layout or appearance of the monastery buildings themselves.

Another religious foundation located outside the walls was that of the *Magdalenerinnen*, an order of nuns under the protection of Mary Magdalene. These women settled southeast of the Lorenzkirche side of the city, next to the Frauentor. Their convent, the Magdalenerinnenkloster, was first mentioned in 1241. Founded in Germany in 1227, their order, which concentrated on the conversion of women of questionable reputations, had expanded rapidly. Toward the close of the century, it suffered a general decline, at which time the Nuremberg house became affiliated with that of the Poor Clares. The order's difficulties are reflected in the prolonged construction of the convent church; although begun about 1270, it was not completed until sometime in the 1330s. Nuremberg's most famous nun, Caritas Pirckheimer (1487–1525), sister of the Humanist Willibald Pirckheimer, served as abbess of this convent of Sankt Klara during the period when Nuremberg adopted Luther's teachings.

Although extensively restored, the church of Sankt Klara still preserves its late-thirteenth-century design (fig. 44). Its single-aisle nave has a wooden, barrel-vaulted roof. A narrower, rectangular choir terminates in an apse (half of a ten-sided polygon) supported by massive exterior buttresses. With its vaulted bay and polygonal apse, it is Nuremberg's earliest example of a typical Gothic choir, constructed by the Sebaldus workshop. The church was vastly altered in the first half of the fifteenth century, at which time Gothic windows with pointed arches replaced some of the Late Romanesque windows with their round arches, and still other windows were walled up. A square chapel and a sacristy were added on the north side, and the roof was raised to accommodate these new additions. Of the convent's other buildings, only a few unimportant fragments survive.

The Augustinians arrived in Nuremberg only a few years after the Magdalenes. Their monastery, the Augustinerkloster, at the edge of the Sebalduskirche side of the city, was founded about 1255. After the original structure was destroyed by fire in 1265, they moved somewhat further into the town, and, only ten years later, conse-

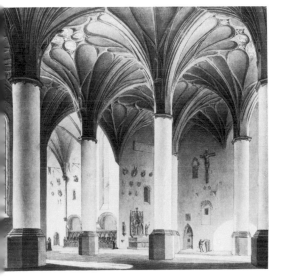

Figure 45 Christoph Wilder. The Augustinerkirche, from the northwest. Lithograph, 1816. Germanisches Nationalmuseum, Nuremberg

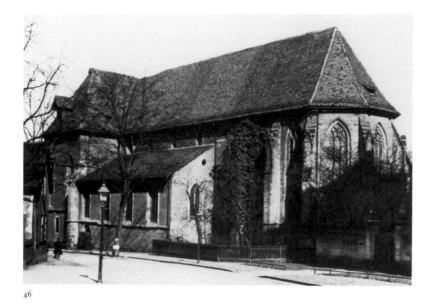

crated their monastery church to Saint Vitus. The nave of that structure was demolished to make room for a new one in 1479 (fig. 45). Nothing remains of the complex today.

Twenty years later, about 1275/76, the Dominicans also settled on the Sebaldus-kirche side. Their monastery, the Dominikanerkloster, too, was built quickly, for it was completed by 1288, although construction on the transept continued until 1328. Only a portion of the monastery, which was dedicated to the Virgin, survives. The existing structures, largely dating from about 1500, once enclosed two separate cloisters.

Another convent, the Karmeliterkloster — no trace of which remains today — was established by the Carmelites, whose church (known as Sankt Salvator after the Reformation) was dedicated in 1340. It had been founded about 1287 on the south side of the Pegnitz, within the boundaries of the wall enclosing the Lorenzkirche side of the city.

The arrival of the Dominican brothers was followed, twenty years later, by that of a group of Dominican nuns. Their convent, the Katharinenkloster, founded in 1295, lay outside the wall, on the Lorenzkirche side; its patrons were Conrad von Neumarkt, who was buried in its church in 1296, and his wife, Adelheid, née Pfinzing. Both the church and the convent were consecrated to Saint Catherine in 1297 (fig. 46). The church is a three-aisle basilica, originally flat roofed, with a choir made up of two vaulted bays and a polygonal apse (that describes five sides of an octagon). Stepped buttresses strengthen the choir on the exterior. A nuns' gallery, at the west end, is supported by vaults. A large, square cloister extends to the north; because the land slopes steeply down to the river, the north wing of the cloister required a high substructure as a foundation. Only the outer walls of the cloister survive.

The last religious house to be chartered by the city council was that of the Carthusians, who named their foundation the Marienzelle. Donated in 1380 by the Nuremberg merchant Marquard Mendel, the monastery, the Kartäuserkloster, was built on property added to the city with the building of the final wall (fig. 47). The Carthusians were the strictest order at the time; although they lived communally, they were virtually hermits. Each monk had his own house and garden. Since Carthusian monasteries required a great deal of land, they were often forced to locate outside fortified towns. In Nuremberg, however, the area gained by the city's expansion provided the Carthusians with an ideal location. To this day, the buildings number among the best-preserved medieval complexes of the Carthusian order, which, however, never attracted large numbers of novices on account of its strict way of life.

The focal point of the Carthusian foundation was its church — a single-aisle,

Figure 46 Sankt Katharina, from the southeast (about 1935)

Figure 47 H. Stelzner. The Kartäuserkloster, from the southeast, with the Lorenzkirche in the background. Pen and ink, and wash, on paper, 1857. Germanisches Nationalmuseum, Nuremberg

vaulted, but largely unornamented structure. Its choir, the same width as the nave, terminates in an apse that describes five sides of an octagon. A choir screen, no longer preserved, separated the lay church to the west from the monks' choir to the east. The church was consecrated in 1383 after only three years of building. To the south is a small cloister, around which are grouped the communal rooms: the chapter house, library, archives, kitchen, and refectory. A larger cloister, an extension of the south wing of the smaller one to the east, surrounds three sides of the church. Grouped around it are the individual cells, or hermitages. Construction of the complex was completed sometime in the mid-fifteenth century.

The city's first charitable foundations, in the form of poorhouses and hospitals, were administered by the various religious orders. Later, however, the council and some of the city's wealthier citizens founded new hospitals, homes for the elderly, and orphanages. The oldest and largest of these is the Heilig-Geist-Spital (Holy Ghost Hospital), and its church, located on an island in the river (fig. 48). It was founded in 1331 by the merchant Konrad Gross — who placed it under the supervision of the council — and completed in 1339. The extremely picturesque setting of the building owes much to its riverbank site. The main wing is situated on the north bank of the Pegnitz, but, from it, two smaller wings extend across to the island, each supported by low arches and dominated by a steep, saddleback roof. A small but exquisite *Chörlein*, with a tall spire, projects from the western façade of one of the wings of the building; it is adorned with the two Nuremberg coats of arms and a dove, the symbol of the Holy Ghost and an allusion to the hospital's name. The buildings are arranged around courtyards ringed with galleries.

The Heilig-Geist-Kirche served as the repository of the imperial regalia from 1424 to 1796. In 1420, a chapel dedicated to All Saints was added, and the original side aisles were widened — possibly in connection with the transfer of the imperial treasure. Today, very little remains of the church, but despite repeated destruction and remodeling, the hospital, as a whole, preserves its medieval appearance, and continues to serve as a home for the elderly.

Just outside the walls, on the road toward Regensburg, was the convent of Sankt Martha, and the Pilgerspital (Pilgrim's Hospital). Founded in 1363 by Conrad Waldstromer and his wife, Agnes, née Pfinzing, work on its church was begun at once; the

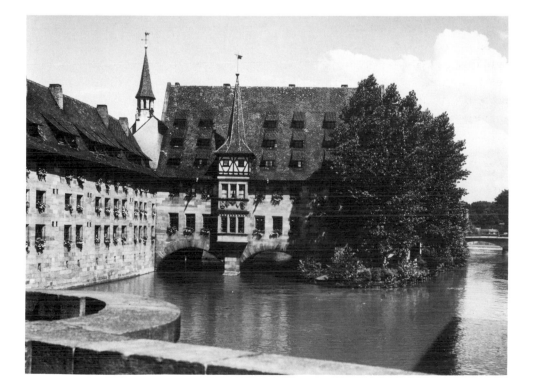

Figure 48 Heilig-Geist-Spital, from the west (in 1966)

dedication seems to have occurred in 1385. The administration of the hospital was taken over by the city in 1400. Sankt Martha is a three-aisle hall church with flat wooden ceilings over the side aisles and a wooden, barrel-vaulted center aisle. Its two-bay choir terminates in a polygonal apse, again, describing five sides of an octagon. On its western façade are traces of the adjacent hospital (now destroyed). The church preserves a substantial amount of its original stained glass, dating to as early as the close of the fourteenth century. These windows and those of the Sebalduskirche (fig. 99) comprise the earliest examples of stained glass in Nuremberg.

Two additional charitable foundations were the Zwölfbrüderhäuser (the so-called Twelve-Brothers Houses), both located in the former moat. They were named after their wealthy patrons; the Mendel house was founded in 1388, the Landauer house, in 1510. Each accommodated twelve elderly, indigent, and unmarried craftsmen who were cared for until death. The number was fixed at twelve — like that of the apostles — and merciful acts were to be lavished upon them in obedience to biblical admonishments. The idea of founding such homes for elderly men apparently originated in Flanders; from Nuremberg such establishments spread to other south German cities.

Although the buildings of the Mendel Zwölfbrüderhaus have wholly disappeared, the so-called Mendel *Hausbuch* survives (in the Stadtbibliothek, Nuremberg). The three volumes contain portraits of all of the men cared for by the Mendel foundation from 1425 on. Each is shown at his craft (figs. 19–22), and the collection, as a whole, therefore provides priceless documentation of the craftsmen's trades in the Middle Ages. The Landauer Zwölfbrüderhaus opened its doors in 1510, as soon as the founding bequest could be implemented. All that is still standing is the Allerheiligenkapelle (fig. 49), built by the city architect Hans Beheim, a nearly square room with two centrally placed, turned columns, which carry magnificent star vaulting. It was for this chapel that Albrecht Dürer painted his famous *All Saints Altarpiece* between 1508 and 1511; the splendid wooden frame presumably was carved by Ludwig Krug.

A short distance outside the gates, along the main approaches to the city, were four so-called *Siechkobel* (hospitals) for people with contagious diseases such as leprosy or the plague. It was the task of the city physician to ensure that anyone suffering from such an ailment be promptly expelled from Nuremberg. Each of these hospitals had its own small, single-aisle chapel with a polygonal choir, and an adjacent cemetery.

The oldest of the four establishments, named for Saint John, is situated along the road to Frankfurt. The first reference to it dates from 1234. An earlier Johanniskapelle was renovated in 1323, but the present chapel is essentially from the last quarter of the fourteenth century. It has a flat-roofed, single-aisle nave and a slightly narrower polygonal choir. Its stained-glass windows, mostly dating from the fifteenth and sixteenth centuries, are preserved, as are several Late Gothic altarpieces. Bronze epitaphs and memorial coats of arms attest to the burial there of various Nuremberg citizens. The present-day Johannisfriedhof incorporates several medieval burial grounds (fig. 51). It was greatly expanded from 1518 to 1520, after burial within the city limits was outlawed and residents of the Sebalduskirche side of Nuremberg began to be buried there. The Stephanskapelle, first mentioned in 1395 and originally outside the boundaries of the cemetery, was also later encompassed by them. The present structure is circular, with rich star vaulting, and a circular choir. Commissioned by the patrician Imhoff family, and erected in 1513 by Hans Beheim, it subsequently became known as the Holzschuherkapelle, when the Holzschuher family used it as a funerary chapel after 1523 (fig. 50). In the chapel is a life-size Entombment group made by Adam Kraft in 1507/8. It is the concluding work in the artist's seven-part relief cycle of the *Stations of the Cross*, which marks the funeral route from the Tiergärtnertor to the Johannisfriedhof. By 1520, it had become customary to cover the graves in this cemetery with flat stone slabs, a privilege granted at first only to the patriciate, but soon afforded other citizens, as well. To this day, these stone slabs give

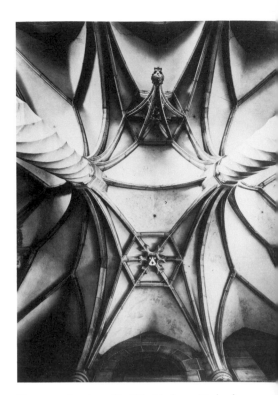

Figure 49 Landauer Zwölfbrüderhaus: Vault of the Allerheiligenkapelle (in 1935)

Figure 50 Johannisfriedhof, with the Holzschuherkapelle, from the north (in 1935)

Figure 51 Johannisfriedhof, with the Johannes-kapelle, from the south (in 1935)

Figure 52 Rochusfriedhof, with the Rochus-kapelle, from the northeast (in 1935)

the burial ground — and the graves of such famous Nuremberg artists as Albrecht Dürer, Veit Stoss, Peter Vischer and his sons, Pankraz Labenwolf, Benedikt Wurzelbauer, and Wenzel Jamnitzer, to name a few — its unique appearance.

The *Siechkobel* Sankt Leonhard was situated on the road toward Stuttgart. The hospital's chapel, the Leonhardskapelle, dedicated to Saint Leonard, was the gift of Hermann Schürstab, and was consecrated in 1317. The modern church occupies the site of the original chapel, but is much later in date. The adjacent cemetery preserves tombstones from the sixteenth century, but far more important was the nearby Rochusfriedhof, along the same road, closer to the city (fig. 52). During an epidemic of the plague in 1517/18, the council designated this site as the burial ground for the entire Lorenzkirche side of the city. Beside the Rochuskapelle were the earliest graves, marked by horizontal tombstones similar to those in the Johannisfriedhof. The Rochuskapelle, begun in 1520 and consecrated the following year, was built by the Nuremberg patrician Konrad Imhoff. It has a single-aisle nave with three bays and net vaulting, and a star-vaulted polygonal choir with interlacing ribbing. The keystones bear the Imhoff coat of arms. The exterior of the building is dominated by buttresses, which rise to the height of the eaves. Its interior preserves a number of altarpieces, paintings, and epitaphs, the majority of them from the early sixteenth century, and once included several works by Dürer; these, however, were replaced by copies in the seventeenth century. The stained-glass windows were created in the workshop of Veit Hirschvogel, who based them on designs by Dürer. The Rochuskapelle still serves as the funerary chapel for the Imhoff family.

A third hospital was located along the road to Regensburg, and, presumably, was founded by the patrician Ulrich Haller in 1327. Funds for the present-day chapel, dedicated to Saints Peter and Paul, were provided in 1440 by Gabriel Tetzel, but completion of the structure was delayed by litigation until 1470. Its nave is low and flat roofed, with only a single aisle, but the choir, which is nearly square and terminates in a polygonal apse, is considerably taller and is crowned by simple net vaulting. Only the choir is supported by buttresses. An altarpiece on its north side, a gift of Nikolaus Koler, may date from the time of the chapel's construction, but most of the other appointments are products of the late sixteenth and the seventeenth century.

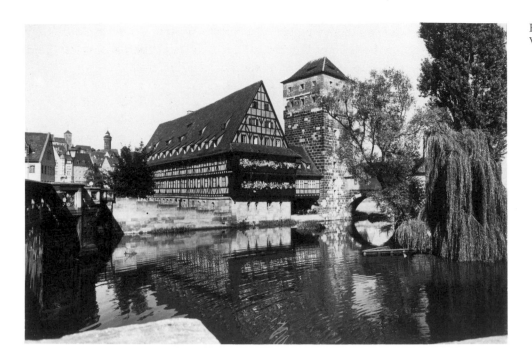

The fourth *Siechkobel* outside the city was on the road to Prague, and is thought to have been established in the first half of the fourteenth century by the rector of the Sebalduskirche, Hermann von Stein. Adjoining the hospital were a chapel consecrated to Saint Jodocus and superintendent's lodgings. Some decades after its founding, a municipal trustee took over the foundation's administration. The chapel dates from the mid-fourteenth century; its choir was consecrated in 1356. This chapel, too, consisted of a single-aisle nave, and a vaulted polygonal apse supported by exterior buttresses. Several of the numerous stained-glass panels that survive bear the date 1507, although most of the other medieval furnishings were installed later. The land surrounding the hospital and chapel has been used as a cemetery since the plague of 1483, but no medieval tombstones remain.

There was only a single hospital inside the city wall for victims of infectious diseases. The so-called Sondersiechenhaus (Special Hospital) was built between 1446 and 1448 on the north bank of the Pegnitz, on land formerly occupied by the moat (fig. 53). After 1528, the building was used by the city as a wine storehouse, and, thus, became known as the Weinstadel. Today, it is a student dormitory. Above its massive sandstone ground floor rise two additional half-timbered stories, which, on the south side, support a wooden gallery projecting out over the river. A steep, saddleback roof, its timbers dating largely from the original construction, accommodates additional residential floors. A bridge-like gallery extends from the second story to the so-called Wasserturm (Water Tower), a fragment of the next-to-the-last wall that survives at the point where the river left the city.

To a considerable degree, the structures, street plan, and configuration of Nuremberg's building lots preserve their medieval appearance. The cores of numerous houses date to the fourteenth and the fifteenth century, however much their exteriors may have been remodeled in later years. The special charm of the city was already appreciated by Late Medieval observers. Enea Silvio Piccolomini, later Pope Pius II, wrote, in 1457: "Approaching from Lower Franconia and first glimpsing the city from a distance, it reveals itself with a kind of majestic grandeur, which is then increased by the beauty of its churches and the breadth of its streets. The imperial castle looks down proudly from its mount, and the burghers' houses appear to have been built for princes. Surely the kings of Scotland would wish to live as well as the middle-class inhabitants of Nuremberg."

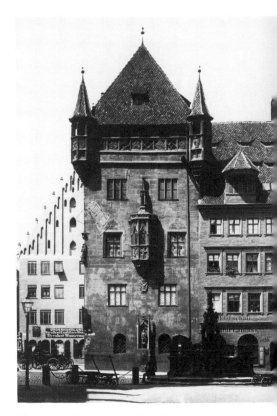

Figure 54 Nassauerhaus, from the east (before 1909)

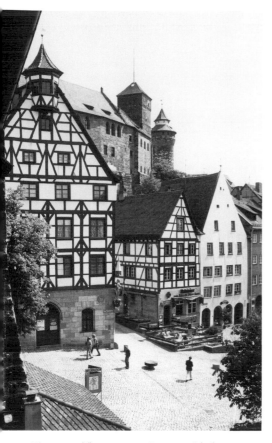

Figure 55 Tiergärtnertor Square, with the Pilatushaus, from the southwest (in 1981)

Building in the city was closely regulated as early as the fourteenth century, largely out of consideration for safety. Ultimately, not only new construction but even proposed alterations had to be approved by the municipal architect.

The structure later known as the Nassauerhaus is the one tower house remaining from among the city's medieval private residences (fig. 54). Such towered dwellings were characteristic of medieval European cities, before adequate walls and moats were developed. Because each building had to be able to withstand attack on its own, in size and strength such structures were virtually little castles. In Nuremberg, the tower house was the seat of the so-called *Ministerialen*, the king's liege men, who were obliged to render military service and to guard his castle. Almost all of the tower houses were located along the single main street leading from the castle to the river crossing.

The Nassauerhaus consists of five stories of sandstone ashlar on a nearly square foundation. Its two lower floors, each a single-vaulted room, supported by a central pillar and five-foot-thick walls, may have been built about 1200. The upper stories assumed their present form in the second quarter of the fifteenth century. A crenellated roof line, with polygonal corner turrets, crowns the block-like structure. From the fifteenth to the seventeenth century, the house was owned by a succession of Nuremberg's patrician citizens: the Haller, Imhoff, and, finally, the Schlüsselfelder families.

Stone tower houses were the exception among Nuremberg's Late Medieval dwellings; far more common were two-story, half-timbered houses. Masonry construction gained popularity only gradually; in the fourteenth century, only ground floors were constructed of stone, and, as late as 1598, the city council ruled that the top floors of all multistoried buildings could still be half timbered. However, by 1616, the council required that buildings be of stone, "in order to spare the forests and counter the danger from fire." This rule applied only to new building, so that a large number of houses whose top stories of half-timbering predate the decree remained unaffected, and still survive. Moreover, the city architect continued to sanction the construction of half-timbered houses in certain situations — for example, if the builder did not have the means to utilize only stone. A uniform façade extending across the entire front of a house was by no means a common Late Gothic convention. Only in Renaissance buildings dating from the mid-sixteenth century on did the idea of uniformity of design assume any importance. Fine examples of this are the Toplerhaus (of 1590), the Fembohaus (of 1591–96), and one of the most lavish of Nuremberg's merchant houses, the Pellerhaus (of 1601–7).

In Nuremberg, Gothic private structures had little or no exterior decoration. Only on their stone gables, which were sometimes stepped, were narrow strips of projecting wall — often built of brick that could be formed into pointed arches — used as shaping and ornamental devices. The eastern gable of the old Rathaus (1332–40) is an example of this type of decoration.

So-called *Hauszeichen* (house signs) of saints, the Virgin, or other representational figures were characteristic of Nuremberg's dwellings, and often lent their names to the structures (see figs. 73, 75; cat. no. 36). Adam Kraft created figures of this type, demonstrating how highly prized these house signs were. Besides such sculptural examples, a sign could be painted directly on the façade of a house. The practice of decorating the exteriors of houses with wall paintings, in general, is documented from the early decades of the sixteenth century on. The Reformation brought to an end the use of figures of saints on house façades.

The *Chörlein* (figs. 35, 54) is a further feature of Nuremberg's dwellings. The German term probably derives from the usually polygonal choirs of private chapels originally built in these locations. In the fifteenth century, the sacred character of these projecting windows, or oriels, subsided, as builders began to enliven the façades of houses with bay windows that were usually rectangular in shape.

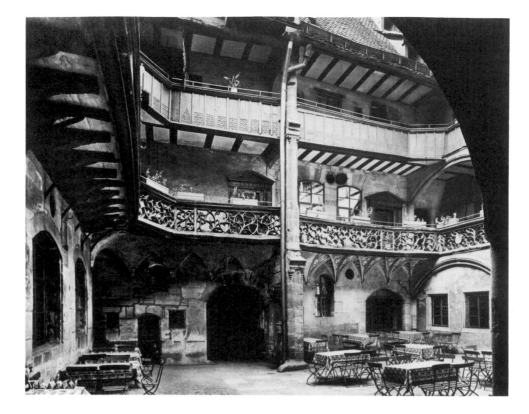

Figure 56 Tucherstrasse no. 20: Courtyard (in 1935)

While the restraint shown in ornamenting the exteriors of dwellings — even those belonging to well-to-do citizens — is virtually a Nuremberg hallmark, the costly and artistic decoration of their inner courtyards may come as a surprise (fig. 56). The main house was connected to the rear structure by a wing at the side, creating an inner courtyard, while open galleries afforded direct access on every floor. These galleries were made of wood, at first, but stone construction was the norm by the fifteenth century. In the great houses of the merchants, the hall-like ground floor of the main building usually served as business quarters, containing office and storage space. This hall could be roofed with decorated vaults or with carved beams resting on massive wooden columns. In craftsmen's houses, the workshop was located on the ground floor. On the second floor, reserved for the family, were reception rooms, frequently paneled in wood, and the kitchen. Less important rooms were relegated either to higher stories or to auxiliary structures behind the house. Originally, stairs led from the back of the ground-floor sales shop or workshop to the second floor, but later it became customary to provide a separate, closed stairwell.

Examples of the type of Late Gothic urban dwelling with a ground floor of stone and half-timbered floors above are the Pilatushaus (fig. 55), built in 1489, and the four-story house that belonged to Albrecht Dürer (fig. 57), dating from the second half of the fifteenth century.

An early example of Renaissance architecture in Nuremberg — and one of the most unusual structures in the Old Town — is the Tucherschloss (fig. 58). It was built between 1533 and 1544, presumably after plans by the city architect Paulus Beheim, who achieved a delightful synthesis of French palace architecture and German Early Renaissance style. Its decoration was entrusted to Peter Flötner. For Nuremberg, the small Tucher villa marks the end of Gothic variety in architecture — which often was related to the actual technique of half-timbering — and the genesis of the concern for uniform design, in even the most insignificant details. Of course, the transition from the Gothic to the Renaissance style was as gradual in Nuremberg as elsewhere.

Finally, the fate of Nuremberg's ecclesiastical and secular monuments over the past four hundred years will be examined. The council's acceptance of Luther's teachings

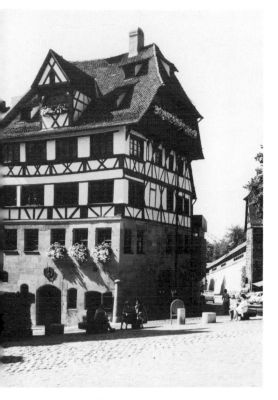

Figure 57 Albrecht Dürerhaus, from the northeast (in 1971)

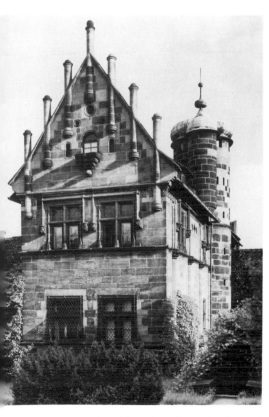

Figure 58 Tucherschloss, from the garden (in 1935)

in 1525 affected the city's parish churches and monasteries unevenly. The parish churches of Sankt Lorenz and Sankt Sebald survived. Neither radical movements nor the precepts of the Anabaptists took hold in Nuremberg, so iconoclastic excesses were avoided. On the contrary, the patrician families represented in the council — the same families that had donated many of the altarpieces and images of saints to the churches — used their influence to ensure that their donations remained unharmed. Thus, a large number of medieval furnishings have survived, even though they ceased to have any significant function in Protestant worship. Among these are the *Sacrament House* (fig. 62) by Adam Kraft, in the Lorenzkirche, and the *Sebaldus Tomb* (fig. 135), the reliquary shrine of the patron saint, in the Sebalduskirche. Those monasteries that accepted the Reformation were dissolved, and their buildings and property were taken over by the city. Where the monastic community voted against dissolution, individual members were permitted to continue their cloistered existence for the remainder of their lives, although the monasteries were prohibited from accepting novices. Thus, the Franciscan monastery persisted until 1562; the convent of the Poor Clares, until 1590; and that of the Dominican nuns, until 1596.

Only the Nuremberg community of the Teutonic Order survived as a Catholic institution. When its Elisabethkirche was on the verge of collapse in the early eighteenth century, the city council tried to suppress this last church by refusing to issue a new building permit, but then relented, allowing construction of the present church to begin in 1780.

After the Reformation, the Frauenkirche became known as the Predigtkirche. It was stripped of its furnishings in 1806, and was turned over to the Roman Catholic congregation in 1816 and refurnished largely with secularized works from Nuremberg's former monasteries. It was thoroughly restored, on various occasions, in the nineteenth and the twentieth century.

Sankt Klara, the church of the Poor Clares, served a variety of secular functions after 1806, until it became a dependency of the Roman Catholic Frauenkirche in 1854. The adjacent convent structures were not demolished until the late nineteenth century.

The monastic buildings of the Egidienkirche were to house Germany's first municipal *gymnasium* (secondary school), which was founded in 1526 following the recommendation of Philipp Melanchthon. Both church and *gymnasium* were almost completely destroyed by fire in 1696, and replaced with a new structure the following year.

After its dissolution, the former pilgrim's hospital church of Sankt Martha was used for dramatic performances. The Nuremberg Meistersinger convened there, from 1572 to 1620. After its restoration in 1615, the church was used once more for religious services. In 1800/1809, it became the parish church for the Reformed congregation, and has undergone repeated renovations over the past two centuries.

Sankt Katharina, the church of the Dominican convent, served as a center for Protestant preaching after the death of the last prioress in 1596. From 1620 to the close of the eighteenth century, it was the meeting place of the Nuremberg Meistersinger. From 1921 to 1923, it was remodeled as a concert hall, while the former refectory became a museum and the Stadtbibliothek (Municipal Library) was installed in the convent's other rooms.

The city council had the large Carthusian complex converted into apartments. Its church served intermittently as a powder magazine until it was again used for religious services from 1615 to 1810. After 1810, it became a military supply depot under the new Bavarian authorities. In 1857, church and monastery were placed at the disposal of the Germanisches Nationalmuseum, protecting the buildings from further depredations.

Although, with the dissolution of the monasteries, the buildings had all been converted to secular uses by about 1800, the council did its best to preserve the churches'

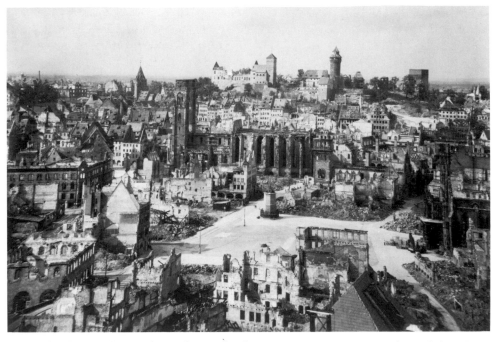

original roles as places of worship and religious instruction. A number of the city's churches were requisitioned for military purposes during the Napoleonic Wars, and four monastery churches were demolished during the decade after Nuremberg became part of Bavaria (1806) — both because the city could no longer afford to maintain the churches, and also in expectation of the income that could be realized from their sale to demolition firms. In some instances, the need for sites on which to build new public structures was the decisive factor behind demolition; in others, the buildings became so delapidated that they required demolition — as happened with the churches and monasteries of the Dominicans (in 1807), the Franciscans (in 1671, and from 1810 to 1913), the Augustinians (in 1817 and 1872), and the Carmelites (in 1557 and 1904/5).

Nuremberg suffered heavily in World War II (fig. 59). Only one of every ten buildings escaped unharmed, and each of its churches sustained some damage. Much of the destruction was repaired through painstaking reconstruction. Since most of the churches' furnishings had been stored elsewhere or been given special protection *in situ,* the better part survived the bombings unscathed. Among the churches in the Old Town, the damage to the Heilig-Geist-Kirche was so severe that restoration was impossible. The church of the monastery of Sankt Katharina, a ruin, is still standing.

The entire roof of the Sebalduskirche was destroyed, while a number of vaults and windows in the Lorenzkirche were lost. All that was left of the Frauenkirche and the Egidienkirche were the outer walls, while the Jakobskirche and Sankt Klara were largely destroyed by fire. Although the Johanniskirche escaped relatively undamaged, the western part of the Rochuskapelle was completely demolished. Only the outer walls and choir of the chapel dedicated to Saint Jodocus were left standing. Several vaults of the Carthusian church collapsed; the chapter house and south wing of the cloister, as well as portions of the former Augustinian monastery rebuilt nearby, suffered so badly that they had to be razed.

The extensive damage to the castle has since been repaired. Of the eighty-two fortified towers still in existence before the war, twenty-seven were destroyed by bombs. The surviving 2.17 miles of the city wall, itself, have been restored. Only the exterior walls of the medieval Rathaus survived, but the town hall has been rebuilt essentially as it was. None of the city's important medieval houses escaped unharmed; the Nassauerhaus sustained direct bombing on its upper floors.

Much of what had made the old Nuremberg famous could be saved, restored, or reconstructed, but many of its most beautiful patrician houses were lost forever.

Bibliography

General Works

Two comprehensive studies with extensive bibliographies are:

Geschichte Nürnbergs in Bilddokumenten, Gerhard Pfeiffer, ed., with the collaboration of Wilhelm Schwemmer, Munich, 1970.

Nürnberg — Geschichte einer europäischen Stadt, Gerhard Pfeiffer, ed., with the collaboration of numerous scholars, Munich, 1971.

Bier, Justus, *Das alte Nürnberg in Anlage und Aufbau,* Nuremberg, 1926.

Dehio, Georg, *Handbuch der deutschen Kunstdenkmäler Bayerns,* vol. 1: *Franken,* Tilmann Breuer, ed., et al., Munich and Berlin, 1979, pp. 541–641.

Endres, Rudolf, "Zur Einwohnerzahl und Bevölkerungsstruktur Nürnbergs im 15./16. Jahrhundert," *Mitteilungen des Vereins für Geschichte der Stadt Nürnberg,* 1970, vol. 57, pp. 242–71.

Fehring, Günther P., and Ress, Anton, *Die Stadt Nürnberg* (Bayerische Kunstdenkmale, vol. 10), Munich, 2nd ed., 1977.

Goepfert, Georg, "Nuremberc castrum oder die Altstadt nach den ersten Quellen," *Mitteilungen des Vereins für Geschichte der Stadt Nürnberg,* 1933, vol. 31, pp. 206–15.

Götz, Norbert, *Um Neugotik und Nürnberger Stil* (Nürnberger Forschungen, vol. 23), Nuremberg, 1981.

Grote, Ludwig, *Die romantische Entdeckung Nürnbergs,* Munich, 1967.

Handbuch der historischen Stätten Deutschlands, vol. 7: *Bayern,* Karl Bosl, ed., Stuttgart, 2nd ed., 1965, pp. 530–41.

Kriegbaum, Friedrich, *Nürnberg,* Munich and Berlin, 7th ed., 1978.

Kriegbaum, Wilhelm, and Schwemmer, Wilhelm, *Nürnberg. Historische Bilderfolge einer deutschen Stadt,* Nuremberg, 1955.

Mulzer, Erich, "Geographische Gedanken zur mittelalterlichen Entwicklung Nürnbergs," *Mitteilungen der fränkischen geographischen Gesellschaft Erlangen,* 1963, vol. 10, pp. 237–65.

—, *Der Wiederaufbau der Altstadt von Nürnberg, 1945 bis 1970* (Erlanger Geographische Arbeiten, vol. 31), Erlangen, 1972.

—, *Die Nürnberger Altstadt,* Nuremberg, 1977. *Nürnberg. Topographie und Entwicklung einer mittelalterlichen Stadt* (Schriften des Kunstpädagogischen Zentrums, vol. 2), Charlotte Weigert and Karl Georg Kaster, eds., Nuremberg [1977].

Die Parler und der schöne Stil 1350–1400 (exhib. cat.), Cologne, 1978, vol. 1, pp. 359–85.

Pfistermeister, Ursula, *Nürnberg,* Nuremberg, 1975.

Reicke, Emil, *Geschichte der Reichsstadt Nürnberg,* Nuremberg, 1896.

Seibold, Hans, *Die bürgerliche Siedlung des mittelalterlichen Nürnberg. Fränkische Heimat. Beiträge zur Heimat- und Volkskunde,* Nuremberg, 1959.

Smith, Jeffrey Chipps, *Nuremberg. A Renaissance City. 1500–1618* (exhib. cat.), Austin, The University of Texas, 1983.

1316 Kaiser Karl IV. 1378 (exhib. cat.), Munich, 1978.

CHURCHES AND MONASTERIES

The Augustinian monastery of Sankt Veit

Rosenthal-Metzger, Julie, "Das Augustinerkloster in Nürnberg," *Mitteilungen des Vereins für Geschichte der Stadt Nürnberg,* 1931, vol. 30, pp. 1–106.

The Benedictine or "Scottish" monastery of Sankt Egidien

Lösel, Alfred, "Die Euchariuskapelle in Nürnberg," *Mitteilungen des Vereins für Geschichte der Stadt Nürnberg,* 1951, vol. 42, pp. 54–97.
Pfeiffer, Gerhard, "Die Anfänge der Egidienkirche in Nürnberg. Ein Beitrag zur ältesten Stadtgeschichte," *Mitteilungen des Vereins für Geschichte der Stadt Nürnberg,* 1940, vol. 37, pp. 253–308.
Pilz, Kurt, *Die St. Egidienkirche in Nürnberg* (Einzelarbeiten aus der Kirchengeschichte Bayerns, vol. 4), Nuremberg, 1972.
Zahn, Wolfgang, "Schottenklöster. Die Bauten der irischen Benediktiner in Deutschland," Ph.D. dissertation, Freiburg, 1967, especially pp. 149–77.
Zankl, Hans Ludwig, *Die mittelalterliche Egidienkirche in Nürnberg* (Beiträge zur fränkischen Kunstgeschichte, n.s., vol. 5), Erlangen, 1935.

The community of the Teutonic Order, the Elisabethkirche, and the Jakobskirche

Hesslein, Hans, *Die Baugeschichte der Deutschordenskirche St. Elisabeth in Nürnberg,* Würzburg, 1925.
Pilz, Kurt, *Die St. Jakobskirche in Nürnberg,* Nuremberg, 1964.
Schrötter, Georg, *Die Kirche der heiligen Elisabeth in Nürnberg,* Nuremberg, 1903.

The Dominican monastery of Sankt Maria

Bock, Friedrich, "Das Nürnberger Predigerkloster. Beiträge zu seiner Geschichte," *Mitteilungen des Vereins für Geschichte der Stadt Nürnberg,* 1924, vol. 25, pp. 145–207.

The Dominican convent of Sankt Katharina

Fries, Walter, "Kirche und Kloster zu St. Katharina in Nürnberg," *Mitteilungen des Vereins für Geschichte der Stadt Nürnberg,* 1924, vol. 25, pp. 1–144.
Schwemmer, Wilhelm, "Das ehemalige Katharinenkloster zu Nürnberg," *Mitteilungen des Vereins für Geschichte der Stadt Nürnberg,* 1983, vol. 70, pp. 285–303.

The Franciscan monastery of Sankt Maria

Schmidt, Ulrich, *Das ehemalige Franziskanerkloster zu Nürnberg,* Nuremberg, 1913.

The Frauenkirche

Bräutigam, Günther, "Gmünd-Prag-Nürnberg. Die Nürnberger Frauenkirche und der Prager Parlerstil vor 1360," *Jahrbuch der Berliner Museen,* 1961, n.s., vol. 3, pp. 38–75.
—, "Die Nürnberger Frauenkirche, Idee und Herkunft ihrer Architektur," in *Festschrift für Peter Metz,* Berlin, 1965, pp. 170–97.

The Carmelite convent and the Salvatorkirche

Ulrich, Karl, "Das ehemalige Karmelitenkloster zu Nürnberg," *Mitteilungen des Vereins für Geschichte der Stadt Nürnberg,* 1979, vol. 66, pp. 1–110.

The Carthusian monastery of Sankt Maria

Heerwagen, Heinrich, "Die Kartause in Nürnberg 1380–1525," *Mitteilungen des Vereins für Geschichte der Stadt Nürnberg,* 1902, vol. 15, pp. 88–132.
Maué, Hermann, "Die Bauten der Kartause von ihrer Gründung 1380 bis zur Übernahme durch das Museum im Jahre 1857," in *Das Germanische Nationalmuseum Nürnberg 1852–1977,* Bernward Deneke and Rainer Kahsnitz, eds., Munich, 1978, pp. 315–56.

The convent of Sankt Klara

Eckstein, Rudolf, "Der Klausurkirchhof des Klarissenklosters und seine Gräber nach dem Totenbüchlein der Anna Ketzel," *Mitteilungen des Vereins für Geschichte der Stadt Nürnberg,* 1981, vol. 68, pp. 130–63.
Kist, Johannes, *Das Klarissenkloster in Nürnberg bis zum Beginn des 16. Jahrhunderts,* Nuremberg, 1929.

The Lorenzkirche

Bauer, Herbert; Hirschmann, Gerhard; and Stolz, Georg, *500 Jahre Hallenchor St. Lorenz zu Nürnberg 1477–1977* (Nürnberger Forschungen, vol. 20), Nuremberg, 1977.
Gerstenberg, Kurt, *Die St. Lorenzkirche in Nürnberg,* Burg bei Magdeburg, 1928.
Lutze, Eberhard, *Die Nürnberger Pfarrkirchen St. Sebald und St. Lorenz,* Berlin, 1939.
Schulz, Otto, "Der Chorbau von St. Lorenz in Nürnberg und seine Baumeister," *Zeitschrift des deutschen Vereins für Kunstwissenschaft,* 1943, vol. 10, pp. 55–80.

The Sebalduskirche

Fries, Walter, *Die Sebalduskirche zu Nürnberg,* Burg bei Magdeburg, 1927.
Der heilige Sebald, seine Kirche und seine Stadt (exhib. cat. no. 8), Svetozar Sprusansky, ed., Nuremberg, Landeskirchliches Archiv, 1979.
Hoffman, Friedrich Wilhelm, *Die Sebalduskirche in Nürnberg,* Vienna, 1912.
Lutze, Eberhard, *Die Nürnberger Pfarrkirchen St. Sebald und St. Lorenz,* Berlin, 1939.
Marx, Andreas, "Der Ostchor der Sebalduskirche," *Mitteilungen des Vereins für Geschichte der Stadt Nürnberg,* 1984, vol. 71, pp. 23–86.
Schulz, Otto, *Die Wiederherstellung der St. Sebaldkirche in Nürnberg,* Nuremberg, 1905.
Schwemmer, Wilhelm, *Die Sebalduskirche in Nürnberg,* Nuremberg, 1979.
600 Jahre Ostchor St. Sebald — Nürnberg, 1379–1979, Helmut Baier, ed., Neustadt an der Aisch, 1979.

The Castle and the city's defenses

Haeberlein, Fritz, *Burg Nürnberg,* Munich, 1942.
Hofmann, Hanns Hubert, *Die Nürnberger Stadtmauer,* Nuremberg, 1967.
Neubauer, Heinz-Joachim, "Der Bau der grossen Bastei hinter der Veste 1538–1545," *Mitteilungen*

des Vereins für Geschichte der Stadt Nürnberg, 1982, vol. 69, pp. 196–263.

Pfeiffer, Gerhard, "Studien zur Geschichte der Pfalz Nürnberg," *Jahrbuch für fränkische Landesforschung*, 1959, vol. 19, pp. 303–66.

Schreyl, Karl Heinz, *Die Nürnberger Kaiserburg in Aquarellen und Handzeichnungen aus städtischem Besitz* (exhib. cat., no. 2), Nuremberg, Museen der Stadt, 1972.

Schultheiss, Werner, "Die Burg zu Nürnberg. Geschichte und Aufgabe der Grabungen auf der Burg," *Mitteilungen des Vereins für Geschichte der Stadt Nürnberg*, 1963/64, vol. 52, pp. 440–57.

Schürer, Otto, *Romanische Doppelkapellen*, Marburg, 1929.

Schwemmer, Wilhelm, "Die Stadtmauer von Nürnberg. Verluste und Erhaltung im 19./20. Jahrhundert," *Mitteilungen des Vereins für Geschichte der Stadt Nürnberg*, 1969, vol. 56, pp. 424–44.

—, "Die Nürnberger Burg. Stufen ihrer Entwicklung," *Mitteilungen der Altnürnberger Landschaft*, 1972, vol. 21, pp. 1–8.

Hospitals and homes for the elderly

Ahlborn, Joachim, *Die Familie Landauer. Vom Maler zum Montanherrn* (Nürnberger Forschungen, vol. 11), Nuremberg, 1969, especially pp. 101–16.

Busse, Ingrid, *Der Siechkobel St. Johannis vor Nürnberg 1234–1807* (Nürnberger Werkstücke zur Stadt- und Landesgeschichte, vol. 12), Nuremberg, 1974.

Festschrift anlässlich des 600jährigen Bestehens der Hl. Geistspitalstiftung, Nuremberg, 1939.

Haller, Helmut Freiherr von, and Eichhorn, Ernst, *Das Pilgrimspital zum heiligen Kreuz vor Nürnberg. Geschichte und Kunstdenkmäler* (Nürnberger Forschungen, vol. 12), Nuremberg, 1969.

Herold, Max, *Die St. Johanniskirche in Nürnberg* (Beiträge zur fränkischen Kunstgeschichte, vol. 8), Erlangen, 1917.

Kreppel, Johannes, *Die neue St. Peterskirche in Nürnberg*, Nuremberg, 1901, especially pp. 13–17.

Kreppel, Ottmar, *Vor dem Frauentor. Nachrichten über St. Peter und die angrenzende Gegend*, fasc. 1–4, Nuremberg, 1924–26.

Mummenhoff, Ernst, "Die öffentliche Gesundheits- und Krankenpflege im alten Nürnberg," in *Festschrift zur Eröffnung des neuen Krankenhauses der Stadt Nürnberg*, Nuremberg, 1898, pp. 1–122.

—, *Das Spital zum Heiligen Geist in Nürnberg*, Nuremberg, 1926.

Pilz, Kurt, *Die Evangelisch-Reformierte St. Marthakirche und das Pilgrim-Spital St. Martha*, Nuremberg, 1979.

—, *St. Johannis und St. Rochus in Nürnberg. Die Kirchhöfe mit den Vorstädten St. Johannis und Gostenhof*, Nuremberg, 1984.

Rusam, Georg, *St. Jobst in Geschichte und Gegenwart*, Nuremberg, 1969.

Stegmann, Hans, *Die Rochuskapelle zu Nürnberg und ihr künstlerischer Schmuck*, Munich, 1885.

Vogt, Wilhelm, *Geschichte des Landauer Zwölfbrüderhauses*, Nuremberg, 1900.

Zahn, Peter, *Die Inschriften der Friedhöfe St. Johannis, St. Rochus und Wöhrd zu Nürnberg* (Die Deutschen Inschriften, vol. 13), Munich, 1972.

Municipal buildings, squares, and fountains

Bock, Friedrich, *Der Nürnberger Hauptmarkt*, Nuremberg, 1924.

Haas, Walter, "Neue Forschungen am alten Rathaus in Nürnberg," *Jahrbuch der bayerischen Denkmalpflege*, 1981, vol. 35, pp. 49–82.

Herkommer, Hubert, "Heilsgeschichtliches Programm und Tugendlehre. Ein Beitrag zur Kultur- und Geistesgeschichte der Stadt Nürnberg am Beispiel des Schönen Brunnens und des Tugendbrunnens," *Mitteilungen des Vereins für Geschichte der Stadt Nürnberg*, 1976, vol. 63, pp. 192–216.

Hofmann, Heinrich, *Die Getreidehandelspolitik der Reichsstadt Nürnberg insbesondere vom 13. bis zum 16. Jahrhundert*, Nuremberg, 1912.

Lutze, Eberhard, "Hans Behaim der Ältere," *Zeitschrift des deutschen Vereins für Kunstwissenschaft*, 1938, vol. 5, pp. 181–203.

Mende, Matthias, *Das Alte Nürnberger Rathaus. Baugeschichte und Ausstattung des Grossen Saales und der Ratsstube* (exhib. cat., no. 1), Nuremberg, 1979.

Mummenhoff, Ernst, *Das Rathaus in Nürnberg*, Nuremberg, 1891.

—, "Das Kornhaus bei St. Klara — die Maut — und die übrigen Kornhäuser der Reichsstadt Nürnberg," in Ernst Mummenhoff, *Aufsätze und Vorträge zur Nürnberger Ortsgeschichte*, Nuremberg, 1931, pp. 280–89.

—, "Studien zur Geschichte und Topographie des Nürnberger Marktplatzes und seiner Umgebung," in Ernst Mummenhoff, *Aufsätze und Vorträge zur Nürnberger Ortsgeschichte*, Nuremberg, 1931, pp. 194–279.

—, "Die Wasserversorgung in Nürnberg in ältester Zeit," in Ernst Mummenhoff, *Aufsätze und Vorträge zur Nürnberger Ortsgeschichte*, Nuremberg, 1931, pp. 148–55.

Schaper, Christa, "Studien zur Geschichte der Baumeisterfamilie Behaim," *Mitteilungen des Vereins für Geschichte der Stadt Nürnberg*, 1958, vol. 48, pp. 125–82.

Schnelbögl, Fritz, "Die Webersiedlung 'Sieben Zeilen' auf dem Schwabenberg," in *Norica. Beiträge zur Nürnberger Geschichte. Friedrich Bock zu seinem 75. Geburtstag*, Nuremberg, 1961, pp. 69–75.

Private buildings

Heussinger, Konrad, *Das Bauwesen in Alt-Nürnberg, erläutert an einigen Beispielen der Ein- und Zweihofanlage*, Nuremberg [1911].

Mende, Matthias, *Dürer Haus Nürnberg*, Nuremberg, 1971.

Mulzer, Erich, *Nürnberger Erker und Chörlein*, Nuremberg, 1965.

—, "Der Nürnberger Fachwerkbau," *Mitteilungen des Vereins für Geschichte der Stadt Nürnberg*, 1967/68, vol. 55, pp. 300–311.

Paeseler, Wilhelm, *Die Nürnberger Chörlein* (Beiträge zur fränkischen Kunstgeschichte, n.s., vol. 1), Erlangen, 1932.

Pöhlmann, Heinrich, *Der Schutz- und Trutzbau der ältesten Nürnberger Herrensitze* (Beiträge zur fränkischen Kunstgeschichte, n.s., vol. 4), Erlangen, 1933.

Schaffer, Reinhold, *Das Pellerhaus in Nürnberg*, Nuremberg and Berlin [1932].

Schultheiss, Werner, "Baukosten Nürnberger Gebäude in reichsstädtischer Zeit. Beiträge zu den Quellen der Baugeschichte der Stadt," *Mitteilungen des Vereins für Geschichte der Stadt Nürnberg*, 1967/68, vol. 55, pp. 270–99.

Schulz, Fritz Traugott, *Nürnbergs Bürgerhäuser und ihre Ausstattung. Das Milchmarktviertel*, Leipzig and Vienna, 1908–35.

Schwemmer, Wilhelm, *Das Fembohaus zu Nürnberg*, Nuremberg, 1955.

—, *Die Bürgerhäuser der Nürnberger Altstadt aus reichsstädtischer Zeit. Erhaltener Bestand der Sebalder Seite* (Nürnberger Forschungen, vol. 14), Nuremberg, 1970.

—, *Das Bürgerhaus in Nürnberg* (Das deutsche Bürgerhaus, vol. 16), Tübingen, 1972.

Sporhan-Krempel, Lore, and von Stromer, Wolfgang, "Das Handelshaus der Stromer von Nürnberg und die Geschichte der ersten deutschen Papiermühle," *Vierteljahrschrift für Sozial- und Wirtschaftsgeschichte*, 1960, vol. 47, pp. 81–104.

Rainer Brandl

Art or Craft?: Art and the Artist in Medieval Nuremberg

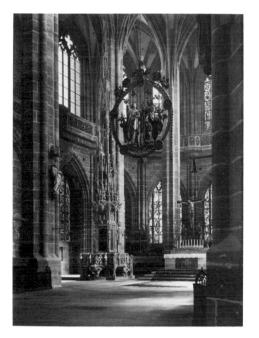

Figure 60 Choir of the Lorenzkirche, Nuremberg, with the *Sacrament House* (left) by Adam Kraft, and the *Angelic Salutation* (above) and the *Crucifix* (on the altar), both by Veit Stoss

In his biography of Albrecht Dürer, Erwin Panofsky pinpoints the reason for the continuous difficulties between the Nuremberg painter and his wife, Agnes:

> Agnes Frey thought that the man she had married was a painter in the late medieval sense, an honest craftsman who produced pictures as a tailor made coats and suits; but to her misfortune her husband discovered that art was both a divine gift and an intellectual achievement requiring humanistic learning, a knowledge of mathematics and the general attainments of a "liberal culture." Dürer simply outgrew the intellectual level and social sphere of his wife, and neither of them can be blamed for feeling uncomfortable. He loved the company of scholars and scientists, associated with bishops, patricians, noblemen and princes on terms of almost perfect equality, and generally preferred to domesticity the atmosphere of what might be called clubs ("Stuben"), studios and libraries. She could not understand why he left her alone in the house and went off to discuss mythology or mathematics with his learned friends, and why he spent hours on end composing treatises on the theory of human proportions or on descriptive geometry instead of doing what she would call practical work.[1]

We are familiar with Dürer's concept of an artist's work. However, it is not so easy to understand the professional standing of a "painter in the late medieval sense" — which is how Agnes Dürer preferred to regard her husband. Only after considering the situation of craftsmen in medieval Nuremberg, in general, is it possible to comprehend the specific working conditions of an artist in that city at that time.

The Organization of Crafts in Nuremberg: "Sworn Crafts" and "Free Arts"

The young Spanish knight Pero Tafur, returning from a pilgrimage to the Holy Land, stopped in Nuremberg in the fall of 1483 and described the free imperial city, where an Imperial Diet was in progress, thus: "Nuremberg is one of Germany's largest and richest cities. . . . Many craftsmen live there, especially those who specialize in all kinds of bronze work, and it is there that Nuremberg coats of mail are made. . . . The city is very rich, and because of its position in the middle of the continent, its trade routes are many."[2] Nuremberg's reputation for solid craftsmanship resulted, in large part, from working conditions that were unique to the city.[3] The legal organization of the crafts in Nuremberg differed from that of practically every other city: Most importantly, there were no guilds.

The guilds were associations of practitioners of a particular occupation, or craft. Such associations can be documented from about the year 1100 in Germany, while specific guild organizations existed from the mid-thirteenth century on, evolving along with the economic expansion of the cities. Obligatory membership was the rule — every craftsman had to belong to a guild, which supervised the activities of its members and the products that they turned out. The guilds' flexible admissions policies allowed them to protect their members' livelihoods, depending on the supply and demand in the marketplace.[4] During the fourteenth and fifteenth centuries, the requirements for admission to the various trades in the cities became more and more

1 Erwin Panofsky, *Albrecht Dürer,* London, 1948, vol. 1, p. 7. See also Peter Strieder, "Schri. kunst. schri. vnd. klag. dich. ser- Kunst und Künstler an der Wende vom Mittelalter zur Renaissance," *Anzeiger des Germanischen Nationalmuseums,* 1983, pp. 19–26 (p. 19 f.).

2 Quoted in Otto Anders, "Nürnberg um die Mitte des 15. Jahrhunderts im Spiegel ausländischer Betrachtung," *Mitteilungen des Vereins für Geschichte der Stadt Nürnberg,* 1960, vol. 50, pp. 100–112 (p. 104).

3 See Michael Baxandall, "Veit Stoss, ein Bildhauer in Nürnberg," in *Veit Stoss in Nürnberg. Werke des Meisters und seiner Schule in Nürnberg und Umgebung* (exhib. cat.: Nuremberg, Germanisches Nationalmuseum), Munich, 1983, pp. 9–25 (p. 15).

4 See also Edith Ennen, *Die europäische Stadt des Mittelalters,* 2nd ed., Göttingen, 1972, p. 144 f.

rigorous,[5] and a high degree of specialization developed among the crafts in those cities with an extensive trade network,[6] such as Frankfurt am Main, where, in 1440, about 190 different trades were practiced.[7] The guilds possessed full legal powers and judicial authority; their regulations determined artists' work hours and pay, the length of training periods, the apprenticeship of journeymen, and the requirements for the "master work" demanded of a prospective member in order to ensure his admission to the guild. The guild also had the final say in settling labor disputes. Guilds thus may be described in general terms as economic interest groups,[8] which, in the Middle Ages, sought to exert their influence over municipal governments, as well. Democratic civic constitutions were established in cities whose economic advantage derived from their immediate surroundings, but in cities involved in long-distance commerce, a handful of families managed to control the government, creating optimal conditions for the export of their products.[9] Nuremberg was such a city, in which a small patrician upper class kept the craftsmen well in hand, particularly those whose products were made for the lucrative export trade.

Nuremberg's craftsmen were able to exercise only limited influence when it came to participating in the city's government, and even in regulating their own affairs. The crafts important to the city's economic and military interests were subject to strict control by the city council. In the wake of the craftsmen's rebellion of 1348/49 — which the patricians had been able to put down[10] — the governing upper class suppressed the craftsmen's increasing demands for power. While, in many other cities, at the time, ambitious master craftsmen won a measure of participation in government affairs, the Nuremberg city council obstructed any legal or political independence for craftsmen's associations, and prohibited the organizing of guilds or any form of self-government. The patricians permitted the craftsmen eight representatives in the council, but their impact on political issues in the imperial city was nil. The bylaws of any association of craftsmen had to be submitted to the council for approval. In Nuremberg, the trades thus controlled by the council were known as "sworn crafts." They reported to a ruling body known as the *Rugamt*, composed of delegates from the Lesser Council — county representatives, who attended to the business of government. These officials *(Rugsherren)* nominated the foremen, or "sworn masters," of the city's most important trades, who, as officially appointed experts, were primarily responsible for controlling the quality of crafts produced in the city. The actual power remained in the hands of the *Rugsherren*, as Christoph Scheurl explained: " . . . in sum, what the guild masters are to other places, the five *Rugsherren* are to us."[11]

Certain trades in Nuremberg, however, were not "sworn," in this manner, but answered directly to the city council: Their members were not subject to regulations governing their education, master works, or working conditions, nor to the imposition of a foreman, or "sworn master," to whom they were responsible. Among the members of these trades were the painters and sculptors — although, of course, they were also forbidden to form guilds.[12] Their concerns were submitted directly to the city council. The "free arts," as opposed to the "sworn crafts," designated the painters' and sculptors' trades. The word "art" was used in a more comprehensive sense than it is today, to describe knowledge as well as skill. Thus, learning, the *septem artes liberales,* was also an art to the medieval sensibility, while the crafts were called *artes mechanicae,* for it was understood that architecture, painting, sculpture, book illustration, metal casting, and carpentry required a greater theoretical knowledge than did the other crafts.[13]

Although anyone was permitted to practice the "free arts" — to paint and to sculpt — in Nuremberg,[14] one could make a living only if one's workmanship were good; one had to be a master craftsman, who had completed his apprenticeship and his stint as a journeyman. Not until 1509 did the council, at the request of the painters and sculptors, prohibit foreign masters from practicing their trades in rented workshops or rooms in other quarters of the city, unless they had acquired Nuremberg

5 Erich Maschke, "Die Unterschichten der mittelalterlichen Städte Deutschlands," in *Die Stadt des Mittelalters,* Carl Haase, ed., vol. 3: *Wirtschaft und Gesellschaft,* Darmstadt, 1976, pp. 345–454 (p. 365 f.).

6 See also Horst Jecht, "Studien zur gesellschaftlichen Struktur der mittelalterlichen Städte," in *Die Stadt des Mittelalters,* Carl Haase, ed., vol. 3: *Wirtschaft und Gesellschaft,* Darmstadt, 1976, pp. 217–55 (p. 240 f.).

7 *Ibid.*, p. 249; Baxandall, p. 15.

8 Gerhard Betz, "Der Nürnberger Maler Michael Wolgemut und seine Werkstatt," Ph.D. dissertation, Freiburg, 1955, p. 168, n. 1.

9 Jecht, p. 252 f.

10 See also the partisan account in the Chronicle of Sigmund Meisterlin, in *Die Chroniken der fränkischen Städte: Nürnberg* (Die Chroniken der deutschen Städte vom 14. bis in's 16. Jahrhundert), Leipzig, 1864, vol. 3, pp. 133–48; Ernst Mummenhoff, *Der Handwerker in der deutschen Vergangenheit,* Leipzig, 1901, p. 42 f; Hans Lentze, "Nürnbergs Gewerbeverfassung im Mittelalter," *Jahrbuch für fränkische Landesforschung,* 1964, vol. 24, pp. 207–82 (pp. 226–31).

11 *Die Chroniken der fränkischen Städte,* n. 10, appendix XVI, p. 799; Lentze, p. 245; Walter Lehnert, "Nürnberg — Stadt ohne Zünfte. Die Aufgaben des reichsstädtischen Rugamts," in *Deutsches Handwerk in Spätmittelalter und Früher Neuzeit,* Rainer S. Elkar, ed., Göttingen, 1983, pp. 71–81.

12 Betz, p. 174 f.; Wilhelm Schwemmer, "Freiheit und Organisationszwang der Nürnberger Maler in reichsstädtischer Zeit," *Mitteilungen des Vereins für Geschichte der Stadt Nürnberg,* 1973, vol. 60, pp. 222–49 (p. 222); Rainer and Trudl Wohlfeil, "Nürnberger Bildepitaphien," *Zeitschrift für historische Forschung,* 1985, vol. 12, pp. 129–80 (pp. 139–40).

13 Fritz Krafft, "Artes mechanicae," *Lexikon des Mittelalters,* Munich and Zurich, 1980, vol. 1, cols. 1063–1065; Panofsky, p. 242.

14 Betz, p. 185.

15 Max Lossnitzer, *Veit Stoss. Die Herkunft seiner Kunst, seine Werke und sein Leben,* Leipzig, 1912, appendix II, p. LVI.

16 Schwemmer, p. 223.

17 Baxandall, p. 15.

18 Jörg Rasmussen, *Die Nürnberger Altarbaukunst der Dürerzeit,* Ph.D. dissertation, Munich, published, Hamburg, 1974, p. 8.

Figure 61 Veit Stoss. *Angelic Salutation.*
1517–18. Lorenzkirche, Nuremberg

19 Arnold Hauser, *Sozialgeschichte der mittelalterlichen Kunst* (rowohlts deutsche enzyklopädie, vol. 45), Hamburg, 1957, p. 115; Günther Binding, "Bauhütte," *Lexikon des Mittelalters*, Munich and Zurich, 1980, vol. 1, cols. 1629–1630.

20 Hauser, p. 117.

21 At the time of his imperial pardon, Veit Stoss tried to persuade the city council to call a general meeting of all master and apprentice wood-carvers. The document, dated October 20, 1508, reads: "Item, Veit Stoss has been refused permission to have a city official call together the masters and apprentices. Rather, he himself should open and read his royal letter and pardon. Let a consultation then be held as to whether they will then work with him or not. . . ."; it is reprinted in Lossnitzer, appendix II, p. LVI. As the document refers explicitly to masters and apprentices, it is addressed to all practicing wood-carvers in Nuremberg, not just to those who had been employed in Stoss's workshop, since the masters functioned as the foremen of their own workshops. See also Heinz Stafski, "Die Skulptur," in *Der Hochaltar der Schwabacher Stadtkirche*, Günter Bauer, ed., Schwabach, Evgl. Luth. Pfarrkirche Sankt Martin, 1983, pp. 69–82 (p. 78).

22 Max Hasse, "Maler, Bildschnitzer und Vergolder in den Zünften des späten Mittelalters," *Jahrbuch der Hamburger Kunstsammlungen*, 1976, vol. 21, pp. 31–42 (p. 31).

23 For an altarpiece to decorate its high altar, the Cistercian abbey at Heilsbronn, near Nuremberg, paid the sculptor, carpenter, and locksmith 268 florins in 1522, and 12 florins in 1523 for hinges and rods. See Hans Rott, *Quellen und Forschungen zur Kunstgeschichte im 15. und 16. Jahrhundert*, vol. 2: *Altschwaben und die Reichsstädte*, Stuttgart, 1934, p. 200; Rudolf Stillfried, *Kloster Heilsbronn*, Berlin, 1877, p. 323.

24 Hans Huth, *Künstler und Werkstatt der Spätgotik*, 2nd ed., Darmstadt, 1967, p. 51.

citizenship.[15] A formal regulation requiring the painters to produce a "masterpiece" prior to their full acceptance was not put into effect until 1596.[16]

The division of the crafts in Nuremberg into "sworn" and "free" was motivated by commercial and political reasons, to benefit the interests of the patrician families. Yet, the works of artists and sculptors, especially altarpieces, clearly could not be made in the same way as thimbles or brass bowls; their manufacture depended upon the varying wishes of their patrons. Furthermore, the leading patricians, who were often the donors of works of art, must have had an interest in perpetuating an "open market" for painters and sculptors, as that would attract able masters to the city. Because demand and the resulting commissions were so strong, there was no need to limit trade in order to protect the livelihoods of individuals. While, in other cities, the first concern of the guilds in regulating the crafts was the protection of the guild members, in Nuremberg the council controlled the crafts for the greater economic glory of the city. The patricians in the government were, after all, merchants, not craftsmen, and their policies were calculated to ensure the success of the crafts — and to promote good, inexpensive products, that could readily be sold — not to look after the interests of the workshop foremen.[17] The twenty-three altarpieces made in Nuremberg workshops between 1488 and 1491 attest to the widespread demand for the services of painters and sculptors.[18]

The Artist's Workshop

From about 1460 onward, commissions for large, complex altarpieces primarily occupied Nuremberg painters and sculptors. This required a restructuring of the workshops, and the addition of gilders and carpenters to the work force. During the twelfth and thirteenth centuries, the stonemason's shed at a building site served as the center of operations, in which the different artists and craftsmen worked together — for example, on the building of churches. The task of coordinating the progress of various projects and of unifying the standards of the artists' contributions belonged to the foreman *(Werkmeister)* and the master builder *(Baumeister)*.[19] "The goal was a smooth division and integration of work, allowing for the greatest possible degree of specialization along with a total standardization of the individual contributions. This could be accomplished only with all participants thinking in truly collective terms."[20]

Prospering cities, such as Nuremberg, attracted painters and sculptors, for the wealthy merchants fostered the growing demand for art. As was customary with the workshops of other crafts, the foreman of a painters' or sculptors' shop was called a master. Since no "masterpiece" was expected of the "free artists" for admission to these professional associations in Nuremberg, a master undoubtedly managed his own workshop of assistants.[21] Because competition in Nuremberg, within each trade, was considerable, these workshop foremen, or masters, must certainly have acquired training comparable to that of their colleagues in other cities. In his own workshop, each master could operate independently, as long as he abided by the local municipal regulations.

As already noted, with the increased desire for altarpieces, after 1460, masters in many cities were obliged to expand their workshops and to hire more craftsmen.[22] The creation of these large altarpieces necessitated the collaboration of painters, wood-carvers, carpenters, and gilders, although painters and carvers could usually do the gilding themselves. Locksmiths were responsible for hinges, locks, and keys, and for installing an altarpiece on an altar.[23] The organization of such large workshops, which produced these altarpieces, was almost exclusively the task of painters, who enjoyed more respect than sculptors, since they were responsible for the overall conception of an altarpiece[24] and employed costly materials in their work. Paintings had also achieved a certain preeminence during the fifteenth century, because of their

widespread dissemination through the graphic arts, these latter images serving as models for sculptors.

However, painters were also active as wood-carvers.[25] Indeed, the medieval custom of artists collaborating to produce works of art fostered a climate of artistic exchange that challenged an artist's versatility. Veit Stoss, for example, was not only a carver, but could paint, polychrome sculptures, and make engravings. Surely, many important masters of painting and sculpture practiced both disciplines.

Our knowledge of how an altarpiece was made, and under what conditions in the workshop, is incomplete. In those cities where trades were organized into guilds, commissions for altarpieces were awarded almost invariably to an established master in the painters' guild, who would then be responsible for the execution of the individual parts. The master had to turn to appropriate craftsmen for work that lay outside his area of competence, but this normally presented no problem, since the guilds were required to assist each other.[26] The patron who personally undertook the arrangements for the production of a commissioned altarpiece found that this required a substantial amount of his time, although, by seeking out the craftsmen himself, he could control the final price. As the demand for altarpieces grew steadily in the decades before the Reformation, some cities agreed to allow painters to employ apprentice wood-carvers, and apprentice painters, wood-carvers.[27] In Munich, this agreement, while against prevailing guild rules, was eventually legalized and written into the 1473 ordinance governing painters,[28] and in Strasbourg, too, apprentice wood-carvers were employed in painters' workshops.[29] Such agreements provide clear evidence that the supply of commissions was plentiful. If painters and wood-carvers reached such agreements in cities that were subject to guild regulations, they must have done so even more readily in Nuremberg, where there were no restrictive rules governing these trades. The workshop of Michael Wolgemut (about 1434–1519), in Nuremberg, employed excellent painters of wood sculptures, as proven by a 1490 city council commission to the artist to repaint the Schöner Brunnen in the Hauptmarkt (the fountain in Nuremberg's main square).[30]

Exact information about the number of artists employed in a painter's workshop and the training each received is not known; these conditions, again, can only be deduced or gleaned from the limited existing sources. Today, it is assumed that a flourishing workshop, about 1500, employed — in addition to the master — two journeymen, two apprentices, and perhaps a so-called "preparer," as well,[31] although the well-known shops, such as Michael Wolgemut's, surely hired more people. The detailed contract drawn up between Adam Kraft (1455/60–1509) and Hans IV Imhoff in 1493 for the *Sacrament House* (figs. 60, 62, 63), or tabernacle, for the Lorenzkirche, in Nuremberg, stipulates that Kraft, himself, was to work uninterruptedly on the project, assisted by four — or at least three — apprentices, and that he was to accept no other commissions. Work already in progress, and any new orders, would have to be realized by assistants. Kraft could supervise the assistants not involved in the project, and direct the other commissions for one hour a day, but if any additional time were required, it was necessary to obtain Imhoff's permission.[32] One may infer, then, that, given a large supply of commissions, painting and sculpture workshops could easily have engaged five or six journeymen assistants and more than two apprentices, as cheap labor.

However, painters and sculptors did not only work on altarpieces; their shops also expedited assignments that were less artistic in nature and demanded simple workmanship. Thus, the masters regarded themselves, equally, as craftsmen. For example, in addition to creating stone sculptures, reliefs, and architectural ornamentation of great artistic merit, Adam Kraft accepted, as well, such routine commissions as the renovation of the stone steps of Peter Imhoff's house.[33] Wood-carvers, too, produced objects for daily use, including chests adorned with scenes in relief, figures, or other ornamentation;[34] they made columns for altars, and candlesticks decorated with

Figure 62 Adam Kraft. *Sacrament House.* 1493–96. Lorenzkirche, Nuremberg

25 Hasse, p. 35; see also Huth, p. 82 f.

26 *Ibid.,* p. 36.

27 *Ibid.*

28 Peter Strieder, "Zur Struktur der spätgotischen Werkstatt," in *Der Schwabacher Hochaltar* (Internationales Kolloquium anlässlich der Restaurierung, Schwabach, June 30–July 2, 1981), Munich (Bayerischen Landesamt für Denkmalpflege), 1982, pp. 24–28 (p. 25).

Figure 63 Adam Kraft. Self-portrait, from the *Sacrament House*. Lorenzkirche, Nuremberg

figures.[35] Statues of saints for the façades and interiors of Nuremberg's houses were also part of the workshops' production: Anton Tucher presented a carving of Saint Sebald to his daughter-in-law, paying the painter Hans Albrecht 1 1/2 gulden for gilding the figure.[36] The masters accepted special orders and commissions, but they also were involved with production for the open market. Veit Stoss maintained a retail stand near the Dominican church, and sold his products at the Frankfurt fair.[37]

An entry in the household accounts of Anton Tucher demonstrates that only a fine line existed between wood-carvers and carpenters in Nuremberg: on January 13, 1515, Tucher paid a carpenter named Stengel six gulden for a towel rack decorated with four heads, intended as a gift for the provost of the Sebalduskirche; the painter Hans Albrecht received ten gulden for gilding the same object.[38] Painters, too, performed simple craftsman's jobs, decorating rooms or the exteriors of houses with painted ornamentation, or scenes,[39] although more routine painting tasks were the province of "whitewashers." Glaziers, such as Veit Hirschvogel, not only created elaborate stained-glass windows for churches, but also made simple windows for private houses.[40] Painters, sculptors, and, of course, glaziers also are known to have repaired works of art[41] — probably, rather frequently.

Artists and Patrons

Apart from small works, such as statues of saints, a supply of which was kept by the carvers to be offered for sale, works of art were generally produced on commission, for a specific location. The patrons were clergymen and rich burghers, who usually informed an artist of their own preferences for a work of art to be donated to a church. Traditional religious beliefs, or the intended use of the object in the church, determined the subjects; in the Middle Ages, these were confined to an established iconography. Of course, the art produced dealt with new subjects as well as with combinations of familiar themes, in response to the changing social fabric and the new concerns of the people, but the basic concept of a prospective work of art, often even extending to the smallest details of execution, was arrived at by the patron and the artist.

The contract between Hans Imhoff the Elder and the sculptor Adam Kraft for the *Sacrament House* in the Lorenzkirche (fig. 62) was sealed on April 25, 1493. Although the contract did not include a design for the work, the wording of the agreement makes it clear that Kraft normally prepared his own designs. Because there was no accompanying plan, the patron was careful to specify the religious subject matter of this "artistically beautiful and well-crafted sacrament house of stone," which was to be completed within three years. The figures in the upper part of the sculptural decoration did not have to be carried out as precisely as the lower ones, since they would be farther from the viewer. Imhoff also indicated his expectation that "the final product" was to be "artistic and beautifully made." Similar expressions were used to describe other crafts, as well. In 1547, Johann Neudörfer, a master calligrapher and mathematician in Nuremberg, reported, in his biography of the compass maker Erhard Etzlaub: "It is not my intention to write about refined, well-spoken men, or of those who are familiar with medicine, but only to describe those who produced handiwork of artistic worth, such as this Etzlaub, who was very knowledgeable and diligent in the art of making compasses."[42] Of Hanns Danner, a maker of screws, Neudörfer wrote: "...for he was so artistic that he produced, in iron and brass, spirals so perfect that they might have been made of a single piece of wood."[43] Instances of such admiration of an artist were not uncommon.

In the contract of 1493, Adam Kraft's *Sacrament House* is referred to as the "work" or the "handiwork." To ensure the quality of the commission, the merchant Hans Imhoff stipulated that each of the parties could procure two experts to judge it, upon

29 Hasse, p. 36.

30 Theodor Hampe, *Nürnberger Ratsverlässe über Kunst und Künstler im Zeitalter der Spätgotik und Renaissance (1449) 1474–1618 (1633)*, vol. 1: *1474–1570*, Vienna and Leipzig, 1904, p. 61, no. 417.

31 Hasse, p. 36 f.

32 Huth, p. 121.

33 Wilhelm Schwemmer, *Adam Kraft*, Nuremberg, 1958, p. 13; Huth, p. 31.

34 See *Anton Tuchers Haushaltbuch (1507–17)*, Wilhelm Loose, ed. (Bibliothek des Litterarischen Vereins in Stuttgart, vol. 134), Tübingen, 1877, p. 97.

35 *Ibid.*, p. 129.

36 *Ibid.*, p. 120.

37 "Item, Veit Stoss is granted permission to visit the Frankfurter *Vastenmess* [fair] with his wares. The eve of Saint Thomas Aquinas, 7 March 1506."; reprinted in Lossnitzer, appendix II, p. XLIX.

38 *Anton Tuchers Haushaltbuch*, p. 120.

39 *Ibid.*, p. 102; Schwemmer, p. 227.

40 *Anton Tuchers Haushaltbuch*, p. 131.

41 Berthold Landauer, 1413: "Repair the 'tafel' [table, or panel] in the council chamber and the 'tafel' [in the Rathaus]"; reprinted in Albert Gümbel, "Altfränkische Meisterlisten," *Repertorium für Kunstwissenschaft*, 1917, vol. 40, pp. 173–84 (p. 183).

42 *Des Johann Neudörfer Schreib- und Rechenmeisters zu Nürnberg Nachrichten von Künstlern und Werkleuten daselbst aus dem Jahre 1547 nebst der Fortsetzung des Andreas Gulden*, Georg Wolfgang Karl Lochner, ed. (Quellenschriften für Kunstgeschichte und Kunsttechnik des Mittelalters und der Renaissance, vol. 10), Vienna, 1875, p. 172.

43 *Ibid.*, p. 53.

its completion. If there were a difference of opinion, another judge would be consulted, after which this resulting committee would decide whether Kraft had earned the agreed-upon seven hundred gulden. This practice, common in medieval times, shows that both artists and craftsmen were subject to strict standards of quality, regarding both the formal technical demands made upon them and also the desired theological content of a work. The direct participation of the patron and the framework imposed by the religious subject matter provided the limitations as well as the point of reference for the artist, while leaving room for his own inventiveness. Adam Kraft was to finish the *Sacrament House* in three years. Hans Imhoff assumed the cost of the stone, but all other expenditures were borne by the master. Jörg Holzschuher and Michael Lemmlin were witnesses to the signing of the contract, which was made out in duplicate, and which they authorized with their seals.

In 1496, the *Sacrament House* was installed in the Lorenzkirche. The fact that deadlines were set for the completion of works of art is not only significant for what it tells us of the patron's patience or impatience to see his gift in place, but it also provides us with some idea of the medieval attitudes toward artistic activity, in general. Art was seen as a commodity that could be produced in a fixed amount of time — no different from the wares of other craftsmen. A deadline was not determined by the artist's creativity or by his personal considerations, but by his professional assessment of the time needed to complete the task.

Three-dimensional, life-size stone likenesses of Adam Kraft and two of his assistants kneel at the base of the *Sacrament House,* supporting the balustrade on their backs. The figure of Kraft (fig. 63), his head raised, occupies a prominent place when the structure is viewed from the front. The figure clearly can be related, iconographically, to representations of Saint Christopher; the kneeling positions of Adam and his assistants reflect their worship of the Sacrament. However, their awareness of their skills as craftsmen makes itself felt here, too. The figures do not seem to be burdened, although they carry their own work on their shoulders; dressed in simple craftsmen's clothing, they present themselves to the viewer in Nuremberg's grand patrician church. With his right hand, Adam Kraft presses his hammer against his right thigh; his left hand, clutching his chisel, rests on his left thigh, and his left knee is thrust far forward. None of the figures kneels with a humbly bowed head; instead, each looks the visitor in the eye. It is significant that Hans Imhoff, the donor, is not represented on the *Sacrament House,* but, rather, the craftsmen who made the tabernacle included their own likenesses, thus erecting an eloquent monument to their own creativity.

The Artist as Entrepreneur

More often than not, the masters of artists' workshops were also clever and industrious entrepreneurs. One of the largest Late Gothic altarpieces (figs. 64–68) is still in place in the chancel of the Stadtkirche Sankt Johannes der Täufer und Sankt Martin in the small town of Schwabach, south of Nuremberg. A guarantee[44] of April 27, 1507, documents that the altarpiece was made in the renowned workshop of Michael Wolgemut in Nuremberg,[45] although the original contract between Wolgemut and the town of Schwabach does not survive. Wolgemut had accepted the city council's offer of a set price of six hundred gulden for the altarpiece. For unknown reasons, an amendment to the agreement became necessary, and the additional stipulations were included in a separate document.[46] This document further states that Michael Wolgemut had already been paid four hundred gulden, and was to receive one hundred more, and "whatever further amount is due over and above that," within a year after the altarpiece was installed. The altarpiece, however, had to be in place, in the chancel, by 1508, the next anniversary of the dedication of the church. The document makes it unmistakably clear that originally Wolgemut had received four

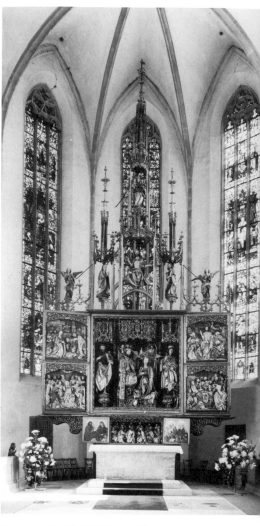

Figure 64 Pupil of Veit Stoss. The Schwabach Altarpiece (overall view, inner wings open). 1507–8. Evgl. Luth. Stadtpfarrkirche Sankt Martin, Schwabach

44 Reprinted in Karlheinrich Dumrath, "Die Bürgschaftsurkunde von 1507," *Der Schwabacher Hochaltar*, pp. 19–23 (p. 21 f.).

45 The interpretations of this guarantee are often motivated by the need to attribute the work. See Heinz Stafski, "Die Skulpturen des Schwabacher Altars und ihr Stilbezug zum Werk des Veit Stoss," in *Der Schwabacher Hochaltar*, pp. 102–8 (p. 107 f.).

46 The insert in the document ends with "etc.," a reference to an existing text that, logically, can only be interpreted as the original contract; this point has been overlooked in earlier analyses of the document. See Dumrath, pp. 19–22.

47 If the amount referred to two payments *totaling* 400 gulden, an "in summa" or a "total sum" would appear at this point in the text. The contract change concerning the price for the altarpiece corresponds to a 1536 report by the Schwabach city fathers, made at the request of the princely government in Ansbach, in which they (having recently converted to Protestantism) state that the endowment funds formerly were wasted on large bells and on liturgical vestments, church decorations, altarpieces (one of which, alone, cost almost 1,000 gulden), chalices, and monstrances. See Strieder, p. 28.

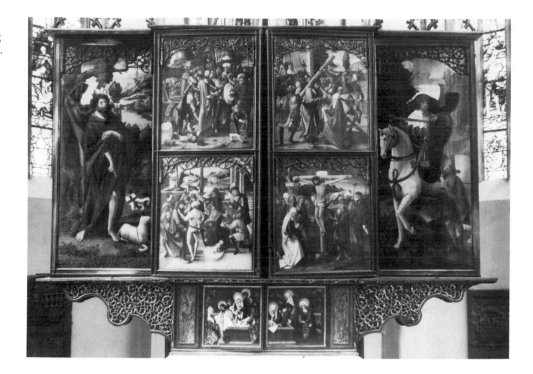

Figure 65 Michael Wolgemut, and other Nuremberg painters. The Schwabach Altarpiece, showing the fixed wings, and the outer wings (closed). Evgl. Luth. Stadtpfarrkirche Sankt Martin, Schwabach

hundred gulden, with another four hundred on April 27, 1507.[47] It is likely that the lost contract stipulated precisely the subject matter and the terms of execution of the altarpiece. The guarantee, of 1507, suggests that Wolgemut had, indeed, already delivered the painted panels, but demanded a further four hundred gulden for the sculptures and reliefs that would complete the work. The Schwabach city council, presumably under pressure to unveil the altarpiece at the annual ceremony in 1508, must have yielded to the increase in price. Obviously, the council drew up the guarantee in order to guard against any further demands for payment by the artist's workshop.

Wolgemut was paid fourteen hundred gulden for an altarpiece in Zwickau; Adam Kraft received seven hundred gulden and an honorarium of seventy more for his *Sacrament House*; Veit Stoss was able to ask for 426 gulden for his *Angelic Salutation* (a carved Annunciation scene, in the Lorenzkirche, Nuremberg; figs. 60, 61), and four hundred gulden for the so-called Bamberg Altarpiece (cat. no. 94). Altarpieces

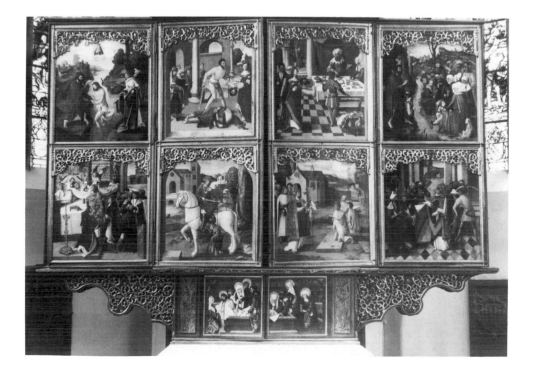

Figure 66 Michael Wolgemut, and other Nuremberg painters. The Schwabach Altarpiece (outer wings open). Evgl. Luth. Stadtpfarrkirche Sankt Martin, Schwabach

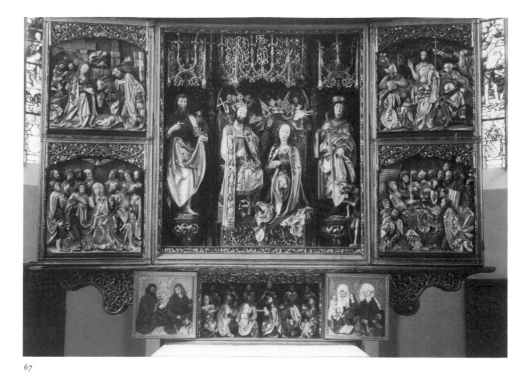

67

Figure 67 Pupil of Veit Stoss. The Schwabach Altarpiece (inner wings open). Evgl. Luth. Stadtpfarrkirche Sankt Martin, Schwabach

Figure 68 Pupil of Veit Stoss. *Virgin*, from the shrine of the Schwabach Altarpiece (in 1933). Evgl. Luth. Stadtpfarrkirche Sankt Martin, Schwabach

with painted wings and gilded polychromed sculptures were generally more expensive to make than monochrome wooden or stone statues alone, on account of the costliness of the paint and the gold leaf. Considering that wages at the time were quite low — an annual income of fifty gulden was considered extraordinarily high for a craftsman — the apparently modest sum of seven hundred gulden for Adam Kraft's *Sacrament House* seems a thoroughly reasonable fee; in contrast to modern practice, the cost of materials and a craftsman's hourly wages, not the artistic talent involved in the design, constituted the basis for payment. Certainly not every workshop master in Nuremberg was as prosperous as Veit Stoss, who left his heirs a fortune of approximately eight thousand gulden at his death in 1533, but the other masters all made good livings. Nor did the era of these shrewd business-minded artists end with Dürer, who, although he had learned his trade as an apprentice to Wolgemut, never headed a large workshop, himself. Instead, Dürer concentrated on producing his own paintings. Dürer's student Hans Suess von Kulmbach, however, operated a typical medieval workshop in Nuremberg, producing altarpieces of all sizes, in collaboration with both painter and wood-carver assistants. It is very likely that carpenters also worked in his shop, for, in a decree of 1482, by the Nuremberg city council, it was "Decided, that painters are allowed and permitted to take apprentice carpenters into their houses, and to have them make for their wages cases, panels, and other items necessary to their craft."[48] Dürer, by contrast, had an independent carpenter make the supports for his paintings, and a preparer prime, color, and gild them, before he painted them, in his own studio.[49]

The Artist's Individuality and Collaborative Efforts

It was common practice in the Middle Ages that a finished altarpiece, when signed, bore the name of the master of the workshop, for, although these altarpieces represented a group effort, they were, ultimately, the direct responsibility of the master. Thus, the Wurzacher altarpiece bears the following inscription by the master of the workshop: "Intercede with God for Hans Multscher von Reichenhofen, citizen of Ulm, who made this work in the year numbered 1437."[50] In isolated instances, parts of such altarpieces were signed by subordinate members of the workshop.[51] This

48 Albert Gümbel, "Altfränkische Meisterlisten" (conclusion), *Repertorium für Kunstwissenschaft*, 1922, vol. 43, pp. 273–323 (p. 284, n. 116); Lentze, p. 253.

49 See Dürer's letter to Jakob Heller of August 28, 1507, reprinted in *Dürer. Schriftlicher Nachlass*, Hans Rupprich, ed., Berlin, 1956, vol. 1, p. 64, no. 12.

50 "Bitten(n) got für hanssen muoltscheren vo(n) riche(n) hofe(n) burg(er) zu ulm haut d(a)ß Werk gemacht do ma(n) zalt mcccc xxx vii."; reprinted in *Katalog der ausgestellten Gemälde des 13. bis 18. Jahrhunderts. Gemäldegalerie Staatliche Museen Preussischer Kulturbesitz Berlin*, Berlin-Dahlem, 1975, pp. 287–90 (p. 288).

51 For example, the signatures of an Augsburg woodcarver, Hans Heberlin, appear on the back of a relief on an altarpiece of the Virgin, from the workshop of Hans Suess von Kulmbach. See Huth, pp. 66–69, 100, n. 127. Rainer Brandl, "A Marian Altarpiece by Hans von Kulmbach: A Reconstruction," *Metropolitan Museum Journal*, 1986, vol. 19/20, pp. 39–62.

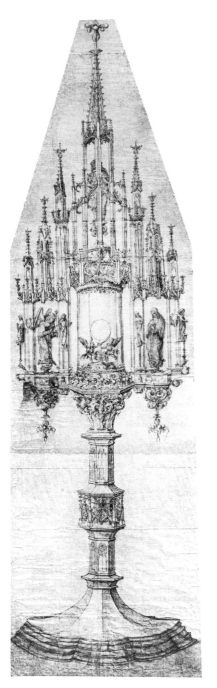

Figure 69 Hans Suess von Kulmbach. Design for a monstrance. 1510–15. Staatliches Museum, Schwerin

indicates that these craftsmen felt that the workshop did not provide adequate recognition of their personal achievements. However, instances of this desire for recognition by an individual were rare. Yet, the master's signature did not necessarily signify that his style prevailed in the finished work; it seems, rather, to have been intended as a kind of trademark of the workshop, not as a personal stamp. An undertaking by a single artist, working alone, such as occurred with Michelangelo's decoration of the ceiling of the Sistine Chapel, would have been unthinkable in the Middle Ages.[52]

The concept of an individual, artistic personality, whose work would be admired as an act of creativity, remained alien to medieval Germany for a long time, but in Italy, on the other hand, new developments in this direction had begun to take root in Dürer's day. Dürer thoroughly enjoyed the lionization of artists by Venetian society, and he was aware of the necessary preconditions and reasons for such a change in attitude toward art and artists. Thus, he set out vigorously to improve the situation of artists at home, with the aim of elevating painting from the status of a craft to that of a science.

Inscriptions on medieval works of art, it is true, frequently testify to the artist's pride in his accomplishment,[53] but the glorification of an individual, in recognition of his distinctive achievements, was still in the offing. The artist's workshop was too bound up in the prevailing collective production of crafts to allow such a development, and our modern concept of an artist's intellectual individuality was unknown to our medieval forebears. The fact that Dürer and his school regularly supplied glaziers with designs for church windows underscores the policy of collaboration among the various trades (see cat. nos. 117, 174). Stained-glass panels had been produced on quite a large scale in the workshop of Dürer's teacher, Michael Wolgemut (cat. nos. 43, 44), and in that of Wolgemut's predecessor, Hans Pleydenwurff; in fact, at times, such projects must have seemed to occupy Wolgemut's workshop to the exclusion of nearly everything else. Wood blocks and copper plates for book illustrations, likewise, were prepared in painters' workshops (see cat. nos. 86, 87). The dissemination of these widely reproduced engravings and prints served other artists as models and as inspiration. Dürer, like Hans Suess von Kulmbach and others of his pupils, also executed designs for goldsmiths' work (cat. no. 171; fig. 69).

Johann Neudörfer's biography of the goldsmith Melchior Baier demonstrates how different the modern perception of the artist is from the medieval one. As Neudörfer tells it, "This Bavarian is famous for making chased and engraved great works in silver. He made a heavy silver altar relief panel for the king of Poland, which weighed many marks. Peter Flötner prepared the wooden models and figures, but Pankraz Labenwolf cast these same wooden forms in brass, and the silver plates were hammered and worked over these brass tablets."[54] Hans Dürer, Albrecht's brother, supplied the designs for this silver altarpiece with painted wings, in the Sigismund Chapel of the cathedral of Cracow (fig. 70). Georg Pencz executed the paintings on the exteriors of the wings, and Georg Herten was responsible for the wood carving. As Neudörfer reports, after the wooden models for the silver reliefs were completed in the workshop of Peter Flötner, and the brass casts were made by Pankraz Labenwolf, the silver reliefs, themselves, were produced in Melchior Baier's workshop, using Flötner's and Labenwolf's models. This collaborative process may well cause the modern observer to wonder which artist was the most important, and to whom the work should be attributed. The altarpiece was finished in 1538, at a cost of 5,801 gulden and eight groschen. While the painter received 290 gulden and the woodcarver thirty gulden, Hans Dürer was paid only twelve gulden for his design.[55] The disparity in these amounts makes it quite apparent, again, that materials and labor, not artistic creativity, were remunerated best.

Johann Neudörfer saw nothing unusual in a collective effort by several artists, nor does he offer any opinion of the artistic merit of the individual components of the altarpiece.[56] This serves to further underscore how art and craft were two indistin-

52 Johannes Jahn, "Die Stellung des Künstlers im Mittelalter," in *Festschrift für Dr. h. c. Eduard Trautschold zum 70. Geburtstag,* Hamburg, 1965, pp. 38–54 (p. 47).

53 *Ibid.,* pp. 42, 44.

54 Neudörfer, p. 125.

55 Heinrich Kohlhaussen, *Nürnberger Goldschmiedekunst des Mittelalters und der Dürerzeit 1240 bis 1540,* Berlin, 1968, p. 456.

56 See Dieter Wuttke, "Methodisch-Kritisches zu Forschungen über Peter Vischer den Älteren und seine Söhne. Kunstgeschichte und Philologie," *Archiv für Kulturgeschichte,* 1967, vol. 49, pp. 208–61 (p. 238 f.).

guishable entities in Nuremberg in 1547 — as does the title of his book, ... *Nachrichten von Künstlern und Werkleuten ... (Accounts of Artists and Craftsmen).*

This discussion began with Erwin Panofsky's description of Agnes Dürer's inability to consider her husband as an artist in the "new" sense of the term. However, as presented above, our modern conception of art differs fundamentally from that of the Middle Ages — and even of the Early Renaissance. Like Agnes Dürer, others regarded the artist merely as a craftsman who produced practical objects, but it should be emphasized that crafts were held in more esteem in medieval society than they are today. The division between art and craft was still fluid; there was no qualitative difference between them, only one of degree. It was not the achievement of the individual that counted, but the works created through a group effort by a respected workshop, under the guidance of a responsible master.

A comment by Vincent van Gogh, in a letter to his brother Theo in December 1881, may serve to document how sharply the modern understanding of art differs from the medieval: "These are days of great beauty in tone and color; after I have made some progress in painting, I will succeed in expressing a little of it. . . . " [57] Michael Wolgemut and Adam Kraft are unlikely to have entertained thoughts of this kind, yet, the commissions that they executed — although the products of carefully run, well-organized workshops — have, nevertheless, succeeded in making an impression on people, even centuries later.

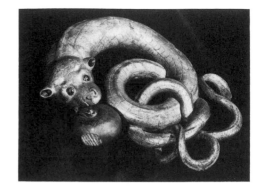

Figure 71 Veit Stoss. Serpent, from the *Angelic Salutation.* Lorenzkirche, Nuremberg

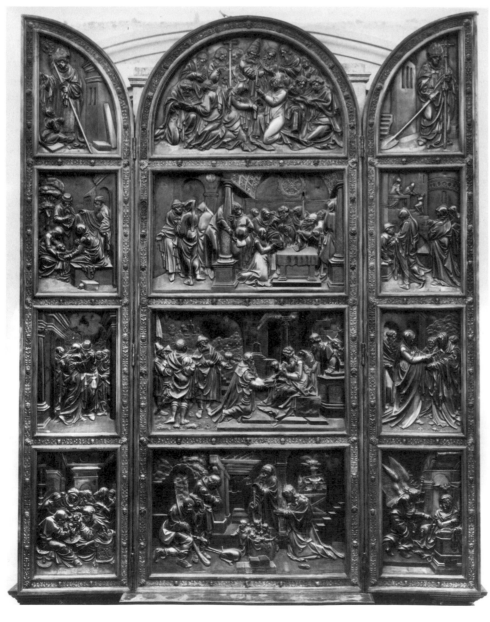

Figure 70 Hans Dürer, Peter Flötner, Pankraz Labenwolf, and Melchior Baier. *Silver Altarpiece.* 1531–38. Donated by King Sigismund I of Poland to Cracow Cathedral

57 Reprinted in *The Complete Letters of Vincent van Gogh*, 3 vols., London and New York [1958], vol. 1, p. 289, letter 165.

Rainer Kahsnitz

Sculpture in Stone, Terracotta, and Wood

The two hundred and fifty years represented by the sculptures presented here include the latter part of the Middle Ages — what is generally referred to as the Gothic period, although not encompassing its beginnings in the thirteenth century — and the extremely brief flowering of the Renaissance in Germany. The Romanesque period gave rise to an important phase in the development of German medieval sculpture, in the thirteenth century, that saw the creation of the extensive sculptural cycles in the cathedrals of Bamberg, Magdeburg, Naumburg, Merseburg, and Strasbourg, but there was, as yet, no sculpture at all in Nuremberg. The early structures of the castle complex and in the monastery of Sankt Egidien had only a small amount of architectural ornament (figs. 28–30).

I

It seems altogether typical of Nuremberg that the city only began to have some importance in the history of art after it had attained a certain power — when its merchants, grown increasingly wealthy through trade, assumed leadership in the realm of culture as well as of economics, and, to a great extent, excluded the king and the nobility from participation in government affairs. Nuremberg's economic boom in the fourteenth century was unparalleled. Certain of its patrician families accumulated fortunes the extent of which had not been known before. Conrad Gross, the founder of the Heilig-Geist-Spital, typified these wealthy entrepreneurs. Yet, none of them became members of the greater nobility — as was the case, for instance, somewhat later, with the Fuggers in Augsburg. The patricians remained burghers, and the artistic climate of Nuremberg therefore continued to be middle class throughout the whole of the medieval period.

Nuremberg had no cathedral and no wealthy chapters of canons, noble or otherwise, of the sort that had had such a major effect upon the art and architecture of Cologne and Mainz. Its only Benedictine monastery, that of Sankt Egidius, apparently played no particularly important role in the artistic life of the city, and the same can be said of the local community of the Teutonic Knights, at the Jakobskirche. The influential monasteries were those of the mendicant orders.

It is true that the great Nuremberg parish churches of Sankt Lorenz and Sankt Sebald were filled with more sculpture than many cathedrals in the Rhineland and elsewhere. However, as a rule, this sculpture consisted of single, isolated statues — for example, the countless representations of the Man of Sorrows, which are found at the Lorenzkirche. The sculptural program of the portals of the Sebalduskirche and of the west façade of the Lorenzkirche seem distinctly modest: The larger vision that determined the theological and artistic themes of other major sculptural cycles was almost wholly lacking there.

One of the most noble subjects of medieval sculpture, the tomb figure, is virtually nonexistent in Nuremberg. Whereas in Mainz or in Würzburg generation after generation left behind monuments of the highest artistic achievement in the form of magni-

ficent bishops' and archbishops' tombs, Nuremberg offers nothing to compare with them. In other cities, princes, members of the greater and lesser nobility, and even wealthy merchants commissioned memorials of this kind for themselves, thereby giving rise to a wealth of sculpture of high quality. The only such tombs in Nuremberg were those of the founders of the Heilig-Geist-Spital and of several of the city's religious houses.[1] Later, in the post-Medieval period, various patricians erected figural monuments on their estates outside the city — as did the Kress family, for example, at Kraftshof.[2] Basically, however, life-size portrayals of contemporaries or even of the deceased — whether in stone, bronze, or simply in wood — were apparently not deemed appropriate to the burgher class. The city council was extremely strict in its petty insistence that no one, not even a member of one of the ruling families, be allowed to elevate himself above his station. Nowhere in medieval panel paintings are the portrayals of donors as small as in those originating in Nuremberg.

On the other hand, it was possible to include one's coat of arms in all manner of works of art. Nearly every individual figure and every major monument thus became a testament to the family that commissioned it. It was characteristic of Nuremberg to refer to such donations as "memorials" to the patron or his family. Even in the Frauenkirche, the competing patricians managed to supersede imperial patronage, installing their own sculptural monuments — as we see from the numerous coats of arms on the bases of these works. Such competition occasionally assumed grotesque proportions in the Late Middle Ages, once the churches were virtually filled to overflowing. At times, the council was forced to settle disputes when a given commission, with its new coat of arms, tended to detract from an older one.[3] In addition to the ruling patricians, who were members of the council and guided the fate of the city by themselves, there were also patrons from among the so-called "honorable" families, all of them made up of well-to-do merchants. The Franconian nobility, who lived in castles and palaces in the nearby vicinity, or even at a further remove, was not a strong presence in Nuremberg. The clergy did not comprise a separate class, and, in fact, the only higher churchmen in the city were the provosts of the Sebalduskirche and the Lorenzkirche, and the abbot of Sankt Egidien. Almost without exception, the provosts belonged to Nuremberg's patrician class, and acted as representatives of their respective families, as they filled their churches with art.

In other cities, works with secular subjects were practically unknown, with the exception of tomb figures, but, astonishingly enough, this is not true of Nuremberg sculpture. In the great hall of the Rathaus, a major cycle of sculptures was installed about 1330/40, placed on consoles and beneath baldachins along the walls;[4] two of the large reliefs, one of the ruling Emperor Ludwig the Bavarian, and the other, depicting an important event in the city's history, survived until recently (cat. no. 13). A municipal monument in a class by itself is the Schöner Brunnen, which was erected in the Hauptmarkt from 1385 to 1396; its decoration included sculptures of the electors, the Nine Heroes, prophets, and other personages famous from antiquity (cat. nos. 14, 15). Another form of sculpture was the house sign, or emblem, so characteristic of Nuremberg: statues, or reliefs, on the façades of private dwellings. Many were portrayals of the Virgin (see cat. no. 36; fig. 120) or of saints, but among them were the heraldic eagle (fig. 73), a secular knight (fig. 75), and animal groups of various kinds.[5] Such secular subjects are encountered in sculpture from about 1300 up until the fifteenth century; in the sixteenth century, they became quite customary.

In the fourteenth century, the majority of sculptures donated to the churches by pious patrons were single stone figures. Over the course of the fifteenth century, carved altarpieces became more popular; single figures were still being made, but now they were generally of wood. To this day, there are still a number of altarpieces in Nuremberg's churches, even though a number have been lost. Some of them were disassembled following the Reformation, not so much out of iconoclastic zeal as for lack of space, for the main altars and pulpits were literally so obstructed by the

1 See Höhn, 1922, ills. 22–23, 51; Martin, 1927, ills. 166–171 (see also nos. 258–261); Stafski, 1965, nos. 20–23.

2 See Pfeiffer, 1971, ill. 168; Fehring and Ress, 1977, pp. 370–71.

3 Hofmann, 1912.

4 Haas, 1981. The precise subject matter of these sculptures is not known. They may have portrayed the German emperors, the prophets, or the ubiquitous Nine Heroes.

5 Lochner, 1855, pp. 48–61; Höhn, 1922, ills. 62–63, 73.

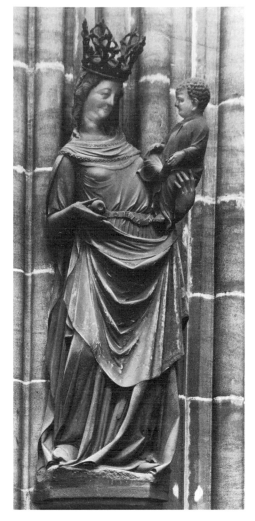

Figure 72 *The Virgin and Child.* About 1280–90. Lorenzkirche, Nuremberg

profusion of altarpieces that they could no longer be seen by the congregation. A surviving document from 1542 records that this was the situation in the Sebalduskirche. Countless panels and sculptures once in the churches have been removed to museums and private collections since the nineteenth century, but, even so, the Lorenzkirche and the Sebalduskirche still present a superb display of the wealth and quantity of ecclesiastical art from the fifteenth century. The Deichsler Chronicle provides an indication of the extent of the production of such altarpieces in the Late Gothic period, relating that some twenty-three were created in Nuremberg between 1488 and 1491.[6]

Altarpieces were the main commissions available to Late Gothic sculptors and painters. In Nuremberg, they generally took the form of a central shrine filled with carvings, to which were attached movable, painted wings (cat. no. 37; figs. 64–67, 121). In rare cases, the insides of the wings were adorned, as well, with reliefs (cat. no. 94; fig. 126). Simpler altarpieces, made to be placed against columns or in small side chapels, were often just painted. Yet, in Nuremberg, there were also a fair number of so-called baldachin altarpieces, comprising single sculptures — generally, a figure of the Virgin — that were set before a column and enclosed in a cupboard-like shrine whose painted wings served as doors. It was not uncommon for such doors to contain only paintings of angels, either worshiping or swinging censers. The large *Virgin in Glory* in the Sebalduskirche (fig. 77), created about 1420, had wings of this type, supposedly painted by Hans Suess von Kulmbach a century later.[7]

These altarpieces, whose richly carved and gilded superstructures often reached nearly to the vaulting above their center shrines (fig. 64), were collaborations of various artists and craftsmen. A cabinetmaker created the wooden case, and a locksmith provided the hinges for the wings, the lock, and whatever iron bands were required to secure the sculptures and the superstructure. The main work was, of course, done by sculptors and painters, the painter responsible not only for the creation of the wings but also for the expensive painting and gilding of the carvings, which generally accounted for the major portion of the cost. An overall design sketch was usually part of the contract; in a few cases these have survived (see cat. no. 94). As a rule, the sketches were made by the painter, but occasionally, they were provided by an architect. The patron could then organize the entire project himself, drawing up contracts with the individual artists for their various contributions. More frequently, however, a master artist served as the contractor, negotiating with others on behalf of the patron. Thus, only the name of the master appears in the relevant documents, and his signature, representing his workshop, often was inscribed on the finished work — although this was rare in Nuremberg. Most often, those who prepared such contracts were painters; sometimes cabinetmakers served this function, too, but only rarely did sculptors. In Nuremberg, the most important entrepreneur of this type was Michael Wolgemut. In 1477, he delivered an altarpiece to Zwickau, for the Marienkirche there, and, shortly before 1486, he completed the *Peringsdörffer Altarpiece* for the Augustinerkirche, in Nuremberg (fig. 80). The *Altarpiece of the Rosary* (cat. nos. 37, 38) probably was also commissioned and executed in this manner. Since painters and sculptors were regarded as representatives of the free arts ("freie Künste") in Nuremberg and were therefore exempt from the rigid civic regulations that applied to other craftsmen, Wolgemut had the option of having the carving done by independent sculptors working in their own shops, or by members of his workshop.

By the end of the Medieval period, the stronger artistic personalities obviously sought to avoid such collaborations. Veit Stoss, for example, only created altarpieces on which all of the work, in the shrine as well as on the insides and outsides of the wings, was carved. This is true of his Cracow and Bamberg altarpieces, and was doubtless the case with the lost altarpiece in Schwaz (in the Tyrol), as well. The painting and gilding of the Cracow Altarpiece was accomplished in Stoss's workshop, under his own supervision. In his later work — notably, the Bamberg Altarpiece — he

6 *Chroniken*, Nuremberg, 1874, vol. 5, p. 549.
7 Examples of this typical form of altarpiece appear in Müller, 1959, no. 164 (from Weissenburg); Schädler, 1983, colorpl. 9 (also from Weissenburg); Königer, 1965, no. 15, ill. (from Trautskirchen); Pilz, 1979, ill. pp. 112, 118 (a figure of the Virgin, of about 1480, with wings by Kulmbach, and a *Saint Catherine*, of about 1465, respectively; both from Schwabach).

was able to dispense with painting and gilding, inasmuch as public tastes had changed (see cat. no. 94). Albrecht Dürer never created painted wings for a carved central shrine, but only for altarpieces in which all the panels were painted. His first pupil, however, Hans Suess von Kulmbach, was apparently not above collaboration with sculptors.

Late Gothic carved altarpieces, especially in southern Germany, were huge assemblages with a number of often over-life-size figures in the shrine and at various levels in the superstructure. In addition, they occasionally had two pairs of wings, so that they could either be closed completely or adapted by means of various arrangements to the changing requirements of the liturgical calendar. With the Cracow Altarpiece — and probably also the one created for the church in Schwaz — Veit Stoss produced what would stand for decades as the largest altarpiece of the time. The overall height of $42^{1}/_{2}$ feet (13 meters) would not be surpassed until after 1520. Stoss was never given such a commission for Nuremberg. Although the Gothic altarpieces from the high altars of the Lorenzkirche and the Sebalduskirche did not survive — they were replaced with Baroque examples, and these, in turn, were removed in the nineteenth century — everything would suggest that the earlier ones were moderate in scale, as was the convention in Nuremberg, and that imposing works of huge dimensions were mainly commissioned for elsewhere. Even today, the largest altarpiece in the Nuremberg area is that of the Stadtpfarrkirche, in Schwabach (figs. 64–68). Aside from altarpieces, there was still a demand for single figures. (The fact that only five of the sculptures included here belonged to altarpieces [cat. nos. 32, 33, 37, 88, 96] is coincidental, and does not reflect the original ratio between ensemble and individual works.)

Sculptors found additional employment in the later fifteenth and early sixteenth century carving models for brass figures, which became increasingly popular. However, these sculptors continued to be anonymous, for only the signatures of the casters appear on the finished works. Few wooden models have survived; the *Saint Wenceslas* (cat. no. 233), and the model for the *Geeseman* (see cat. no. 234), are therefore exceedingly rare. As a rule, these models were eventually used to fuel the furnace in the casting workshop if there was no intention of making a second casting. The contribution of the carver of the model to the finished figure was greater than the caster's, even though the latter was responsible for the finely detailed chasing, as well as for the casting. An excellent example of the skill of these carvers of models is the tomb figure on the monument to Archbishop Ernest of Magdeburg in Magdeburg Cathedral; it was executed by the Vischer workshop in 1495, but, as yet, scholars have been unable to identify the artist responsible (see cat. no. 183).[8]

<center>II</center>

A study of the beginnings of sculpture in Nuremberg and of the course of its subsequent development,[9] commencing with the few surviving fragments of tomb figures from the thirteenth and fourteenth centuries — all, of only average quality — discloses that the city had no sculptural tradition: These works were created by migrant artists.

An isolated work is the over-life-size stone *Virgin and Child*, in the Lorenzkirche (fig. 72),[10] which was combined with figures of the Three Kings, about 1360, to form an Adoration group. Its provenance is not known, nor whether it was moved from the earlier church into the new nave of the Lorenzkirche — probably not begun until the fourteenth century — or simply acquired from some other city. It dates from about 1280/90, and in its monumentality, strong yet sensual physicality, and archaic, lifelike smile, it surpasses almost all Nuremberg sculpture like some curious survivor of an older, heroic tradition, whose final phase is linked to the Hohenstaufen period. The Virgin from the Fuststrasse, in Mainz, may have served as a model, but it is impossible

Figure 73 The *Königskopfadler*, the Nuremberg coat of arms. About 1310–20. Winklerstrasse no. 37, Nuremberg

8 See, most recently, Stafski, 1982, pp. 28–29. For the tomb of Archbishop Ernest of Magdeburg, see Beyer, 1960, ill. 19.

9 A good overall study, restricted to the fourteenth century, is that of Martin, 1927. For the period around 1400, see Graf Pückler-Limpurg, 1904, although in many respects this source is outdated; there is no general overview of this kind for the fifteenth century. See the wealth of illustrations in Höhn, 1922; Bier, 1922. For bibliographies relating to Veit Stoss and Adam Kraft, see notes 32–33, below.

10 Beenken, 1924, pp. 65–66; Martin, 1927, pp. 46–48, ill. 187; Königer, 1965, ill. 1. For an interesting view from the left side, see Lutze, 1939, ill. 68; for a view from the right, see Viebig, 1971, ill. p. 29.

Figure 74 *Prophet*. About 1350. Formerly in the Moritzkapelle, Nuremberg

to identify the actual locale in which this important work was made. The well-known references in the literature to Regensburg sculpture and to the art of the Erminold Master are surely misleading. Just as it is without precedent in Nuremberg, so was it without consequence for the sculpture later produced in the city. The sculptors who worked there in the following century failed to develop any of its formal vocabulary.

III

The first true continuity in the city's sculpture did not begin until 1309, when it was decided to ornament the widened side aisles of the Sebalduskirche with sculptural portals. For this purpose, a team of sculptors was apparently imported from the area of the Middle Rhine. Under the direction of its leading artist, the so-called Saint Catherine master, this group was responsible for the Last Judgment portal, with its statues of Saints Catherine and Peter on either side (cat. nos. 1, 2); the Portal of the Virgin, and its beautiful reliefs of the Dormition, Burial, and Coronation of the Virgin; and the Bridal Portal, with its attendant figure of the *Prince of the World* (cat. no. 4).

This same team must have also created the relief with the *Königskopfadler* (the eagle with the head of a king) on the house at Winklerstrasse 37, next to the Weinmarkt (fig. 73),[11] the oldest of the astonishing number of secular sculptures from the fourteenth century to survive. The original function of this structure directly opposite the west choir of the Sebalduskirche is unknown. It was once thought to be the earliest Nuremberg Rathaus, but that appears to be incorrect. It had to have served as some kind of official building to have been so adorned with the symbol of the city's sovereignty. The imperial eagle, in combination with the king's head, taken from the seal of Frederick II, had been the heraldic symbol of Nuremberg since the mid-thirteenth century (figs. 13–16). In this large tondo, it was given an artistic form directly related to that of the figure of Saint Catherine: a blending of sculptural mass and of that characteristically delicate and harmonious linearity that accounts for the charm and artistic excellence of the figure of the saint. The eagle's wings stand out dramatically against the rich molding of the circular frame. The creation of seals was a form of goldsmiths' work in the Middle Ages, and, although great works of art were occasionally produced in this medium, the translation of this subject to stone sculpture of such monumental form and size gave it particular status.

A number of other groups of sculptors worked in Nuremberg over the course of the fourteenth century, and the work of Kurt Martin (1927) has provided substantial information about their artistic development. The organization of the workshop remained consistent for the entire century: an association of an architect (or master builder) with a crew of sculptors and stonemasons. At that time, the master builder was frequently a sculptor, himself. All of the monumental sculpture that survives is of stone; only at the end of the century did sculpture in terracotta begin to gain importance, and almost no sculptures in wood have been preserved. One of the few exceptions, from about 1370, is a figure of Christ seated on a donkey — a so-called *Palmesel*,[12] which was used in processions on Palm Sunday. Such a work, intended to be carried in processions, would naturally have been carved of wood, and there were possibly other such sculptures made to be used in conjunction with the rituals of the Church.

The series of apostles in the Sebalduskirche is attributed to the so-called second Sebaldus workshop, which has been traced to the town of Rottweil in Swabia. One of the leading artists from this Rottweil group must have worked in Nuremberg himself, about 1340/50, and created the figure of a prophet (fig. 74) that was preserved in the Moritzkapelle across from the Sebalduskirche up until World War II.[13] The prophet was slender and fragile, almost emaciated, the figure dominated by an interplay of

11 Lochner, 1855, pp. 55–59; Schaffer, 1937, pp. 177–78, pls. III–IV; Müller, 1948, p. 34, ills. 7–9.

12 Stafski, 1965, no. 46, ill.

13 Martin, 1927, pp. 32–33, ill. 111; Beenken, 1927, pp. 132–33, ills. 71, 73; Beeh, 1959, pp. 105–6, n. 418, each, with a reference to stylistically related Nuremberg works; see also Stafski, 1965, nos. 48–49, ill.

curving folds and rippling edges of drapery. Although the knee of its free leg was visible through the thin fabric of the cloak, the sculptural form was not based on the ponderation of the body beneath the drapery, as in the older apostles group, but, essentially, on the rich linearity of the drapery, itself; even the body of the standing prophet describes a decorative curve.

A number of sculptors' workshops were active in Nuremberg in the course of the later fourteenth century: at the Jakobskirche, on the west portal of the Lorenzkirche, and, perhaps, on the east choir of the Sebalduskirche. Of all of them, however, most noteworthy are the workshops responsible for the portals of the Frauenkirche, and for the Schöner Brunnen. Both of these projects are composites of separate but related statues. Scholars have long debated just how they relate in style to the sculptures associated with the Parler family of architects, who were active in Schwäbisch-Gmünd, and at the Nuremberg Frauenkirche, and who produced their major work in Prague. The sculptures on the Frauenkirche appear to be especially close to the Parler style. The works in question are concentrated on the west portal and its three doors, the ribs of the vaulting, and the archivolts of the vestibule. In addition to these, there must once have been thirty-six figures in the niches on the façade, which now stand empty. The Annunciation group from the south portal (cat. no. 5) represents this sculptural style — one presumed to have developed at about the time that the building itself was erected, and which reached its peak about 1360. The Frauenkirche, built in the Hauptmarkt at the behest of Emperor Charles IV, was begun in 1349 — or, at the latest, 1352 — and was completed in 1358. Günther Bräutigam has linked the plans for the church directly to the young Peter Parler.[14] With some variations, and to differing degrees, the sculptures at the church also reveal the same blocky forms, and fleshy faces and bodies, that are characteristic of both the prophet figures in Schwäbisch-Gmünd and the later Parler sculptures in Prague. They have heavy and full heads, and almost no necks. Their garments hug their forms, and their draperies are not developed. They convey a sense not only of a new concept of masses and volumes, but also of a certain crudeness, both in the human types portrayed and in the artistic conventions employed.

After the Rathaus, the next major secular monument to be erected in Nuremberg — from 1385 to 1392 — was the Schöner Brunnen, located in the Hauptmarkt directly across from the façade of the Frauenkirche. On the whole, its sculptures are of higher quality than those of the Frauenkirche, but they are even more difficult to relate to other known works. The Frauenkirche figures represent a stage in the sculpture of the Parlers before the height of their achievement in Prague; the fountain's figures — especially, the electors and the Nine Heroes (fig. 117), with their stout bodies rigidly contained in restricting suits of armor, their flowing cloaks contrasting delightfully with their solid forms, their richer ponderation, and their subtler facial features — reflect the advances made by the Parler school in the meantime, in Prague.[15] Among the works produced in Prague in these intervening years are the standing figure of Saint Wenceslas that bears the Parler master's mark and was probably commissioned in 1373; the tomb of King Ottokar I, in Prague Cathedral, which is definitely a work by Peter Parler, from 1377; the tombs of other members of the Premyslide royal house, including those of Ottokar II and Bretislav I; and the famous busts from the 1370s or, at the latest, about 1380, on the triforium of the cathedral, which introduced a new dimension of psychological realism into sculpture. The sculptures of the Frauenkirche — primarily, the ten large standing figures from the inside — reveal distinct similarities to certain of the Prague works, even in their details. In the case of the Schöner Brunnen's figures, however, the links are more general; these sculptures simply capitalized on the developments achieved in stone sculpture in Prague during the seventies and eighties. The leading sculptor involved in the creation of the fountain was the one who carved the Nine Heroes, but it has so far proven impossible to determine his exact origins.

Figure 75 *Knight* (house sign). Terracotta, about 1380. East Berlin, Bodemuseum

14 Bräutigam, 1965, pp. 170–97. Regarding architectural sculpture, see Bräutigam, 1961, pp. 38–75, ill. See also Kosegarten, 1966, pp. 64–66, 71, ills. 23–27, 43–44; Martin, 1927, ills. 191–260.

15 Regarding Parler sculpture, see Schmidt, 1970, pp. 108–53, ills. 57–123; *Die Parler...*, Cologne, 1978, especially vols. 1, 2.

16 Wilm, 1929, pp. 44–54, ills. 31–58; Müller, 1930, pp. 196–200. Additional examples in Stafski, 1965, nos. 106–120, ill.

17 Lochner, 1855, p. 30, no. 6; *Bildwerke*, Berlin, 1972, no. 9, ill. 16 (see also the terracotta *Virgin*, no. 15, ill. 30); Edith Fründt, in *Die Parler...*, Cologne, 1978, vol. 1, p. 370.

18 Trenschel, 1980, p. 45, ill. p. 44. Professor Gerhard Bott graciously called my attention to the figure.

Figure 76 *Saint Andrew*. Terracotta, about 1420. Sankt Andreas, Ochsenfurt

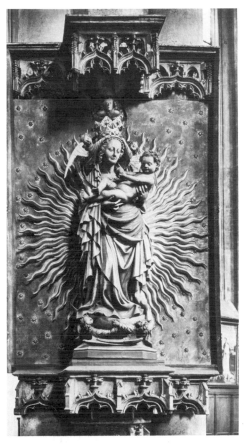

Figure 77 *The Virgin in Glory*. About 1420. Sebalduskirche, Nuremberg

After the Schöner Brunnen, for a long time stone sculpture ceased to predominate in Nuremberg, although, of course, occasional examples continued to be produced; at the end of the following century, one of the most famous of Nuremberg's artists, Adam Kraft, would make his name exclusively as a stone sculptor. The Schöner Brunnen was the last great collaborative effort by members of the same workshop — an alliance of master builders, sculptors, and stonemasons, of the type that had characterized the production of sculpture in Nuremberg from its very beginnings. Sculptors had been summoned from elsewhere for specific projects, or assembled to form teams of this type, *ad hoc*. There was a considerable turnover, for, after completion of a task, they went on to their next employment. The phenomenon in the following century of individual craftsmen with permanent membership in local workshops fostered the development of local traditions and stylistic peculiarities, although, at the same time, it led to a certain decrease in their receptivity to developments elsewhere.

IV

Works in terracotta took on a special importance at the end of the fourteenth century, when sculpture produced in stonemasons' yards was giving way to examples by individual craftsmen who were organized in workshops, and the so-called Soft, or Beautiful, Style of the International Gothic prevailed.[16] This was true in Nuremberg as well as in certain other regions of Germany — for example, in the Middle Rhine, also a major center for high-quality clay sculpture (see cat. no. 27). The soft, easily modeled material that was fired in a kiln was especially suited to the rendering of figures with softly flowing garments, which were favored at the time. The earliest monument from Nuremberg in this medium is the figure of a knight in contemporary armor and costume, which once adorned a house in the vicinity of the Sebalduskirche, at Halbwachsengasse 2, on the corner of Ellenbogengässchen; the sculpture (now in the Skulpturensammlung [Bodemuseum], East Berlin; see fig. 75)[17] is a typical example of a Nuremberg house sign. The knight probably once carried a banner in his right hand. This sculpture, created about 1380, so closely resembles the stone Heroes from the Schöner Brunnen that it can be assumed to be the work of the same master. Even in this artist's stone figures, he displayed a special fondness for costume and armor details, but, here, he makes use of the new medium in an attempt at even greater accuracy — as, for instance, in the laces of the tunic or the wide belt.

The terracotta apostles (cat. no. 24) have long been considered masterpieces both of German clay sculpture and of Nuremberg art, from about 1400. Their style is perpetuated in an over-life-size standing figure of the Apostle Andrew in the church dedicated to him in Ochsenfurt am Main (fig. 76).[18] Broad interlocking folds — presumably formed of large, thin sheets of clay, like those of the seated apostles — are gathered across the Apostle Andrew's torso, with cascades of fabric on either side. The concave portions of the drapery are in deep shadow. Tubular vertical folds, which widen toward the bottom, serve as lateral buttresses, providing stability and a structure for the drapery across the front of the figure's body. The area of the chest was left free, so as to provide sufficient room for the large, bearded head of the old man. His expression is more benign, and the drapery less angular than that of the *Apostle Bartholomew* (cat. no. 24). The individual details — the hair, for example — seem less sharp than those of the seated terracotta apostles, in general. This is the work of a different master, and is later in date, as well — as the symmetry of the lower portion of the figure suggests.

The same decorative richness; a thoroughly similar arrangement of drapery folds, including such specifics as the concave fold occasioned by the right knee; a like talent for portraying strong physicality; and even such particular facial features as the characteristically large eyelids are found, too, in the large figure of the *Virgin in*

Glory, in the Sebalduskirche (fig. 77), for which art historians have long sought related works in Nuremberg sculpture.[19] Both the *Saint Andrew* and the *Virgin* may be by the same master; at any rate, the *Saint Andrew* is much closer to the Sebalduskirche *Virgin* than any sculpture that has previously been associated with it, including the life-size terracotta figure of Saint John the Evangelist, from the *Tucher Epitaph* (also in the Sebalduskirche),[20] and even the *Schlüsselfelder Saint Christopher* (fig. 78). Just as, about 1380, the master of the Schöner Brunnen may have created the earliest terracotta figures in Nuremberg, about 1420 we find a sculptor of clay also working in wood.

Voluminous, squat figures, with large heads and stubby necks, and bodies completely shrouded in rich draperies of seemingly heavy fabric, continued to characterize the International Style in Nuremberg for an astonishingly long time — until the late 1420s, or perhaps the 1430s — although the date of 1437 that appears on the painted portions of the *Deocarus Altarpiece* may not apply to the carved apostle figures in its shrine.[21]

The *Deocarus Altarpiece,* in the Lorenzkirche, is the oldest surviving one with carved figures in the center. No complete altarpieces are extant from the fourteenth century, or from the height of the International Style, about 1400. It is regrettable that nothing is known of the central section of the large Marian altarpiece to which the painted wings with scenes from the life of the Virgin belonged (see cat. no. 23), and which possibly once adorned the high altar of the Frauenkirche. It is striking how few Nuremberg sculptures have been dated to about 1400, while 1420 appears to have been an important year for the genre.

An altogether different type of work, which would also seem to date from this late phase of the International Style, is typified by the delicate, lyrical Crucifixion group in the Germanisches Nationalmuseum,[22] clearly derived from Bohemian art. The group may once have formed the center part of the *Deichsler Altarpiece* (now in the Gemäldegalerie, Berlin-Dahlem), of 1419, which had painted wings that, too, were strongly influenced by the art of Bohemia. The style is developed in the over-life-size, stone Rieter *Man of Sorrows,* dated 1437, from the exterior of the Sebalduskirche.[23]

<div align="center">V</div>

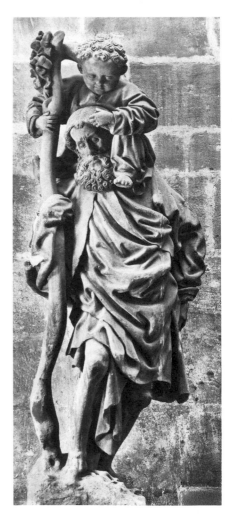

Figure 78 *Schlüsselfelder Saint Christopher.* 1442. Germanisches Nationalmuseum, Nuremberg

Only five years later, in 1422, the *Schlüsselfelder Saint Christopher* (fig. 78) — a monumental stone sculpture intended as a memorial, in conjunction with the Schlüsselfelder tomb — was installed on the exterior of the Sebalduskirche.[24] This nearly nine-foot-tall figure of the saint carrying the Christ Child through the water exhibits none of the soft, flowing lines and rippling drapery folds of earlier sculpture. In fact, in all of the works from this period, there is a trend toward greater severity. Three-dimensional volumes, which had been a more pronounced characteristic of Nuremberg sculpture, rather than of that made elsewhere, are here developed to the extreme. At the same time, in the *Saint Christopher,* the sculptural masses are clearly articulated, both the body and the drapery are contained, the ponderation of the figure is bold and inventive, and the modeling of the surface is lively and imaginative. Even the Christ Child, whose large, round head forms the apex of the group, has the proportions of a giant. One senses his weight resting on the shoulder of the saint. Art historians have developed various theories about the origins of this master and his art. It might be assumed that, in addition to a familiarity with the older art of Nuremberg, the sculptor knew something of how three-dimensional masses were developed in works from further west. Writing in 1966, Theodor Müller mentioned the name Claus Sluter, stressing, of course, the relationship to a long Nuremberg tradition in the execution of sculpted figures. Nuremberg art, as a whole — if such generalization is permissible — does, indeed, show a tendency toward the large and powerful. One

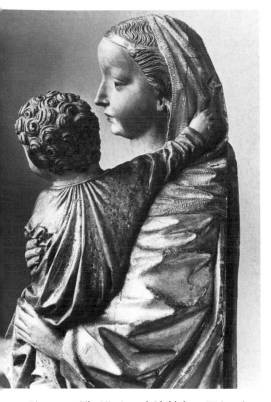

Figure 79 *The Virgin and Child*, from Weissenburg. About 1450–60. Bayerisches Nationalmuseum, Munich

19 André, 1930–31, pp. 167–74, ill.; Müller, 1966, p. 70, ill. 38; Schwemmer, 1979, ill. 28.

20 Höhn, 1922, ill. 44; Pinder, 1914–29, ill. 192; Willm, 1929, ill. 58; André, 1930–31, p. 172, ill. p. 171.

21 Pfeiffer, 1971, ill. 142. Regarding the date, see especially Zachmeier, 1956, pp. 16–19, 106–7, no. 17. Regarding the painting, see Zimmermann, 1931, p. 33, pls. 102–117; Stange-Strieder, 1978, no. 43 (with additional bibliography).

22 Stafski, 1965, nos. 124–126, colorpl. p. 137. Regarding the *Deichsler Altarpiece*, see Stange and Strieder, 1978, no. 20; on the link to the *Deocarus Altarpiece*, see Zachmeier, 1956, pp. 5–7, 104, no. 4.

23 Now in the Germanisches Nationalmuseum. See Stafski, 1965, no. 129, ill.

24 Now in the Germanisches Nationalmuseum. See Pinder, 1914–29, pp. 214, 307–9, ills. 283–284; André, 1930–31, pp. 167–74, ill.; Goldmann, 1935, *passim*; Stafski, 1965, no. 132, ill.; Müller, 1966, pp. 70, 71, pl. 80.

25 Müller, 1959, no. 164, ill.; Pilz, 1979, pp. 118, 124–26 (the *Saint Catherine*, of 1465); Schädler, 1983, no. 24, ill. See also the *Virgin* from the Oertel Collection, recently installed in the Burgkapelle, Nuremberg.

26 Stafski, 1982, pp. 23–30, ill.; Ramisch, 1985, pp. 52–56, ills. 7–9.

27 For the best collection of, and commentary on, the sources, see Lossnitzer, 1912, pp. 27–36.

28 Lossnitzer, 1912, pp. 27–36, attributes the Nördlingen altarpiece to Lainberger; see also Ramisch, 1979, pp. 65–88, 1985, pp. 58–60.

29 Stafski, 1968, pp. 149–77, attributes the sculptures to Veit Stoss, a proposal rejected by Stuhr, 1985, pp. 79–87.

need only think of the Master of the Tucher Altarpiece (cat. no. 30; fig. 92) or, ultimately, even of Albrecht Dürer. In less masterful works, this tendency often enough is combined with a certain dryness. Delicacy and ornateness, charm, exquisite detail, and inventiveness were apparently only rarely valued by the city's patrons, or by the artists who either matured in the same atmosphere, or at least adapted to it — thereby leaving their mark on the city's appearance and on its traditions.

Heavy, massive figures revealing the same tradition of daring command over great volumes as the *Schlüsselfelder Saint Christopher* were also created in the 1450s and 1460s. Their impressive sculptural presences can be seen in a series of life-size and over-life-size statues of the Virgin in the style of the celebrated example from Weissenburg (in the Bayerisches Nationalmuseum, Munich; fig. 79).[25] The baldachin altarpieces typical of Nuremberg doubtlessly frequently contained such sculptures of single figures. Also deriving from the same tradition is the *Saint John the Baptist*, of about 1470 (cat. no. 34), which has been singled out as one of the immediate sources of the art of Veit Stoss.

In 1982, Heinz Stafski demonstrated the lasting influence of the school of the Ulm sculptor Hans Multscher (active by 1427 — died before 1467) on the single statues and altarpiece figures created after the middle of the fifteenth century in Nuremberg.[26] The figures from the 1465 Hof Altarpiece — its wings painted by Hans Pleydenwurff — are typical of this genre (see cat. no. 32). As a rule, although such statues were produced in great quantity, their artistic quality is rather modest — as is the case, for example, with the *Landauer Altarpiece* (originally from the Katharinenkirche, and now in the Germanisches Nationalmuseum).

The first Nuremberg sculptor known by name has been linked to this type of work, but it remains conjecture. The mid-sixteenth-century biographer of Nuremberg's artists, Johann Neudörfer, wrote of a certain Simon Lainberger that "nothing [was] so artful that this man did not understand it fully. He was a sculptor, goldsmith, clockmaker, painter, and, in sum, almost more knowledgeable about artistic matters than any others." Neudörfer, nevertheless, did not know any of Lainberger's works — or, at the least, did not mention any by name. Other sources note only that Lainberger had to be reminded, in 1478, to deliver the sculptures promised to the Nördlingen city painter Friedrich Herlin, and that, in 1494, the Count Palatinate Philipp requested the Nuremberg city council to send Peter Vischer the Elder and Simon Lainberger to Heidelberg. The reason is not given, but it may be assumed that the visit had something to do with a planned brass casting. In 1503, Lainberger is spoken of as deceased; an unfinished work by him was completed by Adam Kraft.[27] All attempts to attribute specific works to Lainberger on the basis of these few facts have proven unsuccessful, although they have led to much speculation.[28]

In the 1480s, the sculpture of Nuremberg, like that of all of southern Germany, showed the influence of recent work from the Upper Rhine — especially, that by Nikolaus Gerhaert. Even when the originals were not known firsthand, local sculptors could obtain some idea of them from engravings by the Master E.S. and by Martin Schongauer. The *Archangel Michael*, from the Lorenzkirche (cat. no. 35), is the most important example of this new sculptural style in Nuremberg — one in which the contrast between the body and its billowing garments is fully exploited. The painter Michael Wolgemut must have employed sculptors who practiced this style in 1477, when he produced the altarpiece for the high altar of the Marienkirche, in Zwickau (still preserved there), with its carved figures and painted wings.[29]

The sculptural components of Wolgemut's altarpieces were of varying quality. In addition to independent sculptors, it is likely that he also engaged apprentices, to whom he might make his own suggestions and whose style he could more readily determine. This may have been his procedure with the *Altarpiece of the Rosary*, from the Dominikanerkirche (cat. nos. 37, 38). However, the most striking example of sculpture that bears the definite style of his own painting — itself, strongly influenced

by the art of the Netherlands — is the Lamentation, from the altarpiece commissioned by Sebald Peringsdörffer for the Augustinerkirche; the dedication took place there in 1486 (fig. 80).[30] This impressive group, of considerable dimensions — the fourth standing figure has been lost — reveals the compositional competence of this experienced painter and graphic designer, as well as his quite formidable sculptural ability. The sculptor may have been influenced, as well, by the somewhat painterly reliefs of Adam Kraft, who was, perhaps even at that time, already working as a stone sculptor in Nuremberg; by 1490, he had begun to execute major commissions there (fig. 81).

Wood sculpture, like sculpture in stone, was highly varied at the close of the fifteenth century, and is difficult to categorize. Many works have survived, and it is clear that there were numerous masters active in Nuremberg at that time. In addition to a number of rather poor works, there are good, solid achievements that have, nevertheless, been inadequately published up until now. Since they have received so little scholarly attention, they generally appear isolated from the artistic mainstream. Understandably enough, they have always been overshadowed by the works of the great masters Adam Kraft and Veit Stoss, who figured prominently in Nuremberg in the last decade of the fifteenth century.

<div align="center">VI</div>

Veit Stoss and Adam Kraft made Nuremberg one of the most important centers of Late Gothic sculpture in southern Germany in Dürer's time, although there were more gifted sculptors active in Germany then than ever before, many of them individual artists whose names are well known.[31] Among them were Erasmus Grasser (about 1450–1518), in Munich, Michel Erhart (about 1455–1522), in Ulm, Tilman Riemenschneider (about 1460–1531), in Würzburg, Anton Pilgram (about 1460–1515), in Vienna, Hans Leinberger (about 1470–1530), in Landshut, and Gregor Erhart (about 1470–1540), in Augsburg. Veit Stoss, of a more advanced age than the majority of these masters, was born in the first half of the century, and was a contemporary of the South Tyrolean sculptor Michael Pacher (about 1435–1498). This made him a full generation older than the most famous sculptor of them all, Tilman Riemenschneider, and also than Adam Kraft.

The early lives of Stoss and Kraft, the two celebrated Nuremberg artists, are obscure. Veit Stoss was born before 1450 — possibly in 1447, or, according to Neudörfer, as early as 1438 — in the town of Horb am Neckar. His name is first mentioned in documents of 1477, at which time he renounced his Nuremberg citizenship and moved to Cracow, where he remained for nearly twenty years. After his return to Nuremberg, in 1496, he still had a full three decades of creative life ahead of him. Stoss died at an extremely advanced age, in 1533.

Adam Kraft may have been born about 1460. Works known to be by him date from only the two decades between 1490 and 1509. His artistic beginnings have been traced to the tabernacle (of 1466–71) in the Ulm Minster, and to the pulpit in the cathedral of Strasbourg, which was completed in 1485 under the direction of Hans Hammer.[32] It is possible that Kraft may have worked for a time and learned his métier in the workshop at Strasbourg Cathedral. Whether he was originally from Nuremberg is not known. In any case, he is largely responsible for our conception of the art of Nuremberg and of Franconia. Kraft was a stone sculptor, and stone carving was regaining importance everywhere, at the close of the fifteenth century. Recently, it has been suggested that Kraft occasionally also worked in wood, but this remains uncertain. A major controversy among scholars is the attribution of the brass figure of the *Kneeling Man* (cat. no. 97): some regard it as by Adam Kraft; others insist that it is the work of Peter Vischer the Elder. Single figures appear only secondarily in Kraft's production. His major works were large architectural reliefs and tabernacles; the most important example of the latter is the one in the Lorenzkirche.

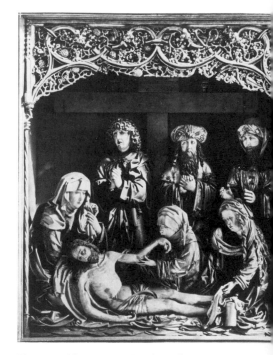

Figure 80 The Lamentation, from the *Peringsdörffer Altarpiece*. 1486. Friedenskirche, Nuremberg

30 Now in the Friedenskirche, Nuremberg. See Höhn, 1922, ill. 66; Pfeiffer, 1971, ill. 155. Regarding the painting, see Stange and Strieder, 1979, no. 130 (with bibliography).

31 On all of the German sculptors named, see, most recently, Baxandall, 1980.

32 Regarding Kraft, see Stern, 1916; Schwemmer, 1958.

From 1490 to 1492, Kraft filled the space between two buttresses on the exterior of the choir of the Sebalduskirche with one of his most important creations: For the area above the Landauer and Schreyer family tombs, he made three sandstone reliefs two-and-a-half meters high and nearly six meters long. The reliefs, which depict the Crucifixion, the Entombment, and the Resurrection (fig. 81), had been commissioned to replace a wall painting that had formerly occupied the space. The reliefs are characterized by a wealth of painterly features: artistically arranged crowds, but with the central figure of Christ strikingly accentuated. The background, lovingly detailed with countless plants, large trees, rocks, and houses behind tall fences, was surely designed to please the patron. The same might be said of the genre-like subsidiary scenes, and the reactions to the events taking place that are registered in the faces of the spectators. Especially impressive is the pair of dignified male figures with the crown of thorns, nails, hammer, and tongs in their hands; they occupy a large section of the composition at the right, below the cross, and are discussing the event they have just witnessed.

Kraft's renown has always derived from the *Sacrament House* (fig. 62), of 1493–96, that Hans Imhoff commissioned him to create for the Lorenzkirche. He was paid seven hundred guilders, plus a bonus of seventy guilders, for his work. The sixty-one-foot, tower-like construction, adorned with reliefs and figures, stands in front of one of the piers of the choir. The tabernacle terminates in a tall spire that bends forward as though to avoid hitting the vaulting; astonished visitors to Nuremberg in former centuries were told that Adam Kraft had the ability to soften stone and bend it. The structure is surrounded by a richly pierced balustrade, ornamented with figures, which provides access to the tabernacle proper, behind an iron grille. As supporting figures, the master portrayed himself, in his work clothes (fig. 63); his apprentice, on the right, closest to the altar; and an older man with a branch, on the left. This last figure does not seem to be a portrait. As in earlier likenesses of master builders, Kraft

Figure 81 Adam Kraft. *Schreyer-Landauer Epitaph.* 1490–92. Sebalduskirche, Nuremberg

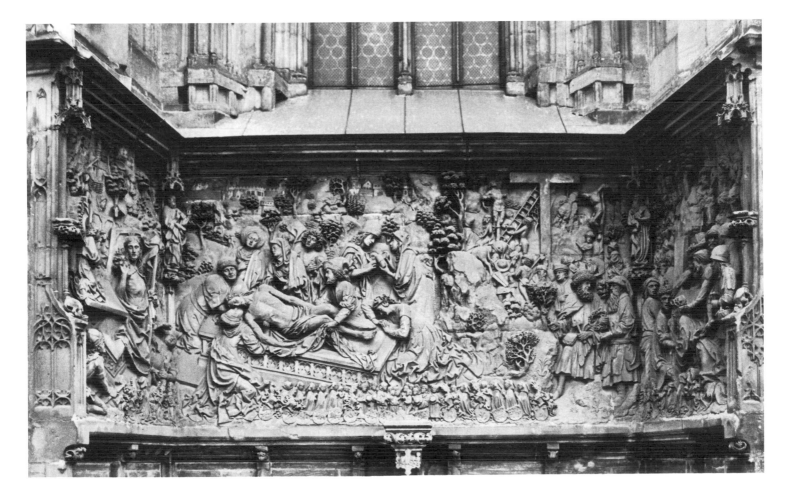

appears only as a subordinate, support figure, yet, given the size and the prominent location of the portrait, it is, nonetheless, an astonishing testimony to his self-esteem. The patron, Hans Imhoff, is only represented by his coat of arms. The male figures, with their intertwining arms and legs, are freely conceived in space, and are interesting precursors of the freestanding sculptures of the following century. In 1499/1500, Kraft created a second tabernacle (now lost) of considerable height, and also with many figures, for the Cistercian abbey of Kaisheim. A number of works in imitation of the Lorenzkirche tabernacle have been preserved in churches in the vicinity of Nuremberg — for example, in Schwabach. Kraft also executed reliefs and figures for house signs and epitaphs.

From 1506 to 1508, Kraft again demonstrated his compositional genius and his ability to represent faces imbued with deep psychological pathos, in his seven reliefs of the *Stations of the Cross,* which were mounted on individual pillars along the route from the city to the Johannisfriedhof. This series, commissioned by a knight from Bamberg, Heinrich Marschalk von Rauheneck, culminates in the richly figural portrayal of Calvary, with the crosses of Christ and of the two thieves. The final relief, the *Entombment,* is in the Holzschuherkapelle, which the patron erected as his own resting place in the cemetery.

VII

While the stone sculptor Adam Kraft seems to have been deeply rooted in Nuremberg tradition, Veit Stoss towered above it.[33] Stoss's whereabouts before his arrival in Nuremberg, and how he was occupied before he left the city in 1477 remain unclear. Nor are his teacher or any details about his training known. Yet, the influence of Nikolaus Gerhaert — who was from Leyden, in the Netherlands, but worked in Strasbourg, and in Vienna — and of the wealth of contemporary Netherlandish art on the sculpture of southern Germany and, especially, on that of the Upper Rhine must also have left their mark upon Veit Stoss. The new concept of figural sculpture, the development of energy in a sculpture out of the contrast between the body and its enveloping drapery, and the possibility of utilizing both convex masses and the negative spaces created by the folds of fabric must have been imparted to Stoss by way of such sources. Even though there is little similarity between the work of Stoss and of Gerhaert — for example, the latter's crucifix, of 1467, in the cemetery in Baden-Baden, or the tomb figure of Emperor Frederick III, of 1469–73, in the cathedral of Sankt Stephan, in Vienna — this by no means negates the assumption. The younger man's more violent temperament, which led him to seek not only dramatic effects of great pathos but also a style of increased virtuosity — "artificial" effects, as they were called at the time — sets him apart from Gerhaert. However, they were the two greatest sculptors active in Germany in the Late Gothic period.

During his nearly twenty-year stay in Poland, Veit Stoss executed a large, baldachin tomb of red-flecked marble for King Kasimir IV, tombs for archbishops and bishops, and the monumental altarpiece for the Marienkirche, in Cracow. When he returned to Nuremberg in 1496, his first major commission was the stone reliefs for the Volck-amer Monument (see fig. 125). These had to compete with the wealth of detail and narrative skill already demonstrated by Adam Kraft in the *Schreyer-Landauer Epitaph,* at the Sebalduskirche. Apparently, only rarely did Stoss carve stone, in Nuremberg, after this time; most of his works are of linden wood, some painted and gilded and others left plain, in accordance with a change in taste that became increasingly evident from the close of the fifteenth century on. The altarpiece that he created in Nuremberg for the Pfarrkirche, in Schwaz, in the Tyrol, has vanished without a trace. The only other one known is the so-called Bamberg Altarpiece, carved between 1520 and 1523, when he was a very old man, for the Karmeliterkloster, in Nuremberg,

33 For Stoss, see Lossnitzer, 1912; Dettloff, 1961; Lutze, 1968; Kępiński, 1981; *Veit Stoss...,* 1983; *Stoss,* 1985 (with comprehensive bibliography).

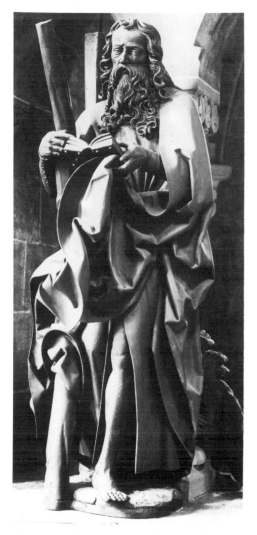

Figure 82 Veit Stoss. *Saint Andrew.* Wood,
1500–1510. Sebalduskirche, Nuremberg

where his son served as prior (see cat. no. 94). Yet, a small relief of the Dormition of the Virgin, made about this time or, more likely, even later, suggests that Stoss produced still other altarpieces. Additional extant works by him are single figures or Crucifixion groups.

Among the most impressive of his creations is the over-life-size statue of Saint Andrew, which was probably made shortly after 1500 (fig. 82).[34] The mass of this figure — its expressive head that of an old man, and its face and hands exquisitely rendered — is supported by the advanced leg. Its sculptural form is largely derived from the drapery and not from the body itself. The saint grasps one end of his cloak in front of his chest, producing an interplay of curving folds and angular reverses that gives structure to the surrounding space and culminates in the sweep of fabric — in the form of an ear — that has always been considered typical of the sculptor's compositions. Despite the dramatic and exuberant emphasis on the drapery, the work holds together. Especially when viewed from the right, where the full effect of the great cloak and the flowing lines of the hair and beard are most pronounced, it is reminiscent of International Style sculpture from the west — for example, from Burgundy and the Netherlands. Yet, of more immediate importance for Stoss was the Nuremberg tradition — dating back, via the wooden figure of *Saint John the Baptist* (cat. no. 34) to the *Schlüsselfelder Saint Christopher* (fig. 78), whose roots may also lie, ultimately, in that older art from the west. In the *Saint Andrew* and the portrayal of the dying King Kasimir IV on the royal tomb in Cracow, the sculptor attained a degree of grandeur and monumentality only rarely accessible to Late Gothic art, in the North.

For centuries, Veit Stoss's acclaim derived from his crucifixes: There is one, of stone, in Cracow, and three later ones, of wood, in Nuremberg. In them, his amazing knowledge of anatomy and sense of the tectonics of the human body were combined with the utmost reverence for Christian subject matter. Neither of these concerns precluded a conscious virtuosity in the execution of the carving — as is evident in the crucifix in the Lorenzkirche. It is documented that Stoss produced small figures for collectors (see cat. nos. 90, 91), but he also made larger works in a similar style. In addition to the Lorenzkirche crucifix, these include the *Archangel Raphael and Tobias* group, of 1516 (cat. no. 93), which exhibits the same deliberate display of formal inventiveness and virtuoso carving. The sixteenth-century Italian painter and biographer Giorgio Vasari would describe one such sculpture, the *Saint Roch,* in Florence, as a "miracolo di legno." By contrast, one of Stoss's most famous works, the *Angelic Salutation* (fig. 61), of 1517–18, seems strangely old-fashioned and Gothic, relying wholly on outlines, and less on its sculptural qualities than on the exquisiteness of its polychromy. It comprises figures of the Virgin and of the Archangel Gabriel, suspended, in space, from the vaulting of the Lorenzkirche, framed within the circle of the rosary.[35]

Everything in the documentary sources would suggest that Veit Stoss was a difficult, dogmatic, quarrelsome personality, although apparently, at the same time, a brilliant and successful teacher. It is obvious that in his larger commissions, such as the Cracow Altarpiece and the *Angelic Salutation,* he was required to employ numerous assistants and pupils. Even from Cracow, he definitely influenced generations of pupils and successors in Galicia, Poland, Silesia, Slovakia, Rumania, and as far afield as Siebenbürgen, in Hungary. In Nuremberg, as well, it appears that few could resist the appeal of his artistry, as attested, to this day, by the countless works by his school. Aside from such direct confrontation between teacher and student, Stoss opened up new dimensions for the last phase of Late Gothic sculpture — an unheard-of wealth of forms, and a manner of expressing movement, combined with the most subtle surface refinements — so that he has been referred to as a "leading phenomenon" of the Late Gothic period in southern Germany.[36]

While decidedly a Late Gothic sculptor, Veit Stoss was apparently able to cross the threshold into the Renaissance quite effortlessly, without having to give up, or even

34 Rainer Kahsnitz, in *Veit Stoss…*, 1983, no. 21, ill.; Kahsnitz, 1984, p. 53, ills. 13–14.

35 Jörg Rasmussen, in *Veit Stoss…*, 1983, no. 17, ills. 48–61, 127–35; König, 1985, pp. 193–206.

36 Oettinger, 1954, pp. 181–89; Legner, 1985, pp. 280–95. This designation was made by Theodor Müller.

radically change, his artistic principles. There should be no hesitancy in calling the *Raphael and Tobias* group a work of the Renaissance, although its unprecedented wealth of drapery details, and the abstract and ornamental linearity of the folds — in short, the decisive elements of its design — are clearly Gothic features. Stoss appears to have been strangely unaffected by Dürer's activities in Nuremberg and his efforts to introduce Italian forms into Germany, despite the fact that Dürer's entire life (1471–1528) paralleled the sculptor's late creative period, in Nuremberg.

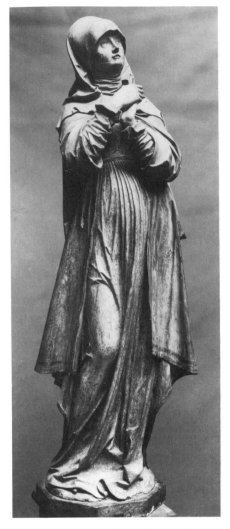

Figure 83 *Mourning Virgin* (the so-called *Nuremberg Madonna*). About 1515. Germanisches Nationalmuseum, Nuremberg

VIII

Little is known about Nuremberg sculpture under the influence of Dürer, although he, himself, produced various designs — for example, for a tomb in Römhild, and for the frame and painting of the *All Saints Altarpiece*. Much of the sculptural activity of the time was associated with the Vischer workshop. A number of sculptors were required to create brass-cast models after designs by painters who were contemporaries of Durer. The artists involved, and those who carried on such traditions, have remained as anonymous as their fourteenth- and early fifteenth-century counterparts. Heinz Stafski referred to the carver who prepared the models for the brass figures of King Arthur and Theodoric for the tomb monument of Emperor Maximilian I, in the Hofkirche, Innsbruck, as "Dürer's personal sculptor," and attributed a number of additional works to him.[37] In 1976, Alfred Schädler demonstrated that the famous *Nuremberg Madonna* (fig. 83); the *Saint Anne Altarpiece,* of 1510, in the Lorenzkirche; and the brass relief on the tomb of Cardinal Friedrich Kasimir Jagiello in Cracow, likewise from 1510, must all be by the same hand — by an artist who was even more indebted to Dürer's pupil Hans Suess von Kulmbach than to Dürer, himself.[38] The large standing figure of the Mourning Virgin from an otherwise lost Crucifixion group is one of the few independent wooden sculptures in this new style; it represents the greatest possible contrast to the works of Veit Stoss, for example, or to the entire body of sculpture of the Late Gothic period. Its distinct sentimentality and the cool refinement of its forms made this style so popular in the nineteenth century that it ultimately came to be known as the *Nuremberg Madonna* style — as the quintessence of the art of Nuremberg and of the German past.[39] In the twentieth century, however, it appears somewhat vacuous and expressionless.

A number of altarpieces — architecturally, German Renaissance in form — were also created in Nuremberg on the eve of the Reformation.[40] The most prominent of these works and the last to be produced was the new altarpiece for the high altar of the Frauenkirche, commissioned by the Welser family about 1525; it survives in its entirety only through an engraving. Its sculptures, sometimes attributed to Hans Peisser,[41] still exist, but these are less interesting than the architecture of the altarpiece. Once Lutheranism was adopted in Nuremberg, in 1525, ecclesiastical sculpture became virtually a thing of the past. Although it is true that in Nuremberg, unlike other cities, there was no widespread destruction of older church furnishings, no new commissions were awarded the local sculptors.

Through the remainder of the sixteenth century, secular sculpture took on increasing importance, but the preferred medium was brass; wood and stone were to be virtually ignored for some time to come.

37 Stafski, 1958, pp. 16–19; Stafski, in *Dürer, Nuremberg, 1971*, p. 379, nos. 699–711.

38 Schädler, 1976, pp. 63–71.

39 Mende, 1969, pp. 445–81.

40 Rasmussen, 1974, *passim*.

41 Stafski, 1951, p. 13; Pechstein, 1974, pp. 38–47.

William D. Wixom

The Art of Nuremberg Brass Work

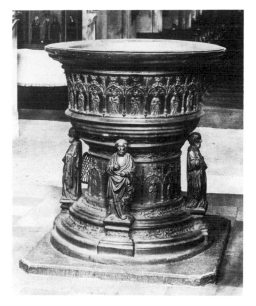

Figure 84 *Baptismal Font.* Bronze, about 1430. West choir, Sebalduskirche, Nuremberg

Brass, an alloy of copper and zinc, has been produced since Roman times by means of a process of smelting calamine ore (for the zinc), charcoal, and copper ore. The details of the process are described in the treatise entitled *Schedula diversarum artium*, from the first half of the twelfth century, by a Benedictine monk whose pseudonym was Theophilus and who probably was the Benedictine monk and goldsmith Roger of Helmarshausen (C. R. Dodwell, trans., 1961, pp. 120–26; J. G. Hawthorne and C. S. Smith, trans., 1963, pp. 139–44; Eckhard Freise, "Roger von Helmarshausen — Ein maasländischer Künstler und Mönch in Westfalen," in *Monastisches Westfalen. Klöster und Stifte 800–1800* [exhib. cat.], Münster, 1982, pp. 287–307). The proportions of copper, zinc, and trace elements in the brass varied as a result of such factors as the quality of the calamine ore, and the workshop practice of adding damaged and discarded brass objects during the smelting process. There are also some lesser variations (of one to two percent) within any single object, depending on what part of the object the samples are taken from. The metallurgical content of six of the brasses included here (cat. nos. 183, 190, 195, 196, 234, 248) averages 83.3 percent copper and 12.54 percent zinc, with the remaining 4.16 percent accounted for by the trace elements. The color of unpatinated brass objects results from the proportions of the alloy: If the amount of zinc was modest (seven to fourteen percent), the metal would be somewhat reddish in color; if the zinc content tended toward about thirty percent, the color would be more golden; if an even greater proportion of zinc were present, the color would be paler (E. Turner, 1982, p. 6).

The usual brass alloys have lower melting points than the common bronze alloys, which are primarily of copper and tin. In general, brass is easier to cast than bronze. Except for the bronze baptismal font, of about 1430, in the west choir of the Sebalduskirche (fig. 84), and the bronze bells cast in Nuremberg from the late fourteenth through the sixteenth century, Nuremberg foundries restricted themselves to castings in brass. All of the door pulls, aquamaniles, and sculptures included here are of brass — as is suggested by the color of their unpatinated or worn surfaces, or as is proven by metallurgical analysis. The preference for brass, and the composition of the alloys, besides certain stylistic features, distinguish Nuremberg works from those produced elsewhere (J. Riederer, 1982, vol. 36, pp. 44–45).

During the Late Middle Ages and the Renaissance, in Germany, the products of both bronze and brass casters were described as red casts *(Rotguss).* In Nuremberg, this term was traditionally and almost universally applied, even though the majority of objects might be more appropriately called yellow casts *(Gelbguss)*; this is especially obvious in relation to the unpatinated aquamaniles dating from about 1400 (cat. nos. 18–22).

The casting techniques of the objects shown here vary. The aquamaniles are direct casts in which the model of wax, molded over a clay core, is lost in the casting process. (This terminology conforms to that employed by R. E. Stone, 1982, vol. 16, pp. 89–116.) The *Saint Mauritius* (cat. no. 183), cast about 1507 by Peter Vischer the Elder, must be described as an indirect cast — in fact, as the second one — after a wood model made originally about 1495, probably by Simon Lainberger. The first cast was

incorporated in the brass tomb of Archbishop Ernest of Saxony (fig. 134), of the same date, in Magdeburg Cathedral. The wood model, kept in the Vischer workshop for about twelve years, was eventually discarded, but not as a result of the casting process. Each of the works by Peter Vischer the Younger, or from his circle, shown here (cat. nos. 190, 195–198) was cast from a wax model destroyed during casting and, hence, is probably a direct cast. The *Sebaldus Tomb*, itself, of which the *Saint Peter* (cat. no. 190) is but a part, was probably produced by one method or the other — depending upon the portion under study — and the various parts subsequently assembled. All of the figurative elements were cast directly from wax models, while some of the identical architectural members may have resulted from indirect casts of wood models that were reused for the repeated architectural elements. Similarly, Peter Flötner probably used both methods for the different parts of the *Apollo Fountain* (cat. no. 248), which were then assembled after casting. The brass *Seated Hercules* (cat. no. 236), of about 1535, is of special interest because it was cast after a wax-shell inter-model in a manner reminiscent of that employed for bronzes by Pier Jacopo Alari-Bonacolsi, called Antico, who worked in Mantua (R. E. Stone, 1982, vol. 16, pp. 95–116).

The color and patination of the Nuremberg brass sculptures and of other brass objects included here, like the casting technique, also varies. The aquamaniles were probably meant to retain their bright surfaces, from the moment of their completion. The *Fountain Figure, the so-called "Hansel"* (cat. no. 16), originally was painted with several colors. The *Sebaldus Tomb* was patinated a dark brown or black in emulation of North Italian Renaissance bronzes. Some of the dark patinas of the other brass works associated with the Vischer foundry fit into the same category. The situation with the earlier objects from this prolific shop is less clear; careful study is still needed to identify any traces of original polychromy — for example, on the *Saint Mauritius* (cat. no. 183). Some works have the translucent lacquer patinas that were favored in the late sixteenth and early seventeenth century, such as the *Pilgrim* (cat. no. 185) by Hermann Vischer the Younger. The patinas of other Nuremberg brass objects may be of much more recent origin. Definitive answers to the questions about the patinas that we see today are elusive because of the dearth of published laboratory analysis.

Brass casting for artistic purposes in Nuremberg did not begin until the second half of the fourteenth century. There may be several explanations for this: The large bulk of copper ore and the even greater quantity of calamine ore that were required were not available in the region. Before this time, the brass-casting industry was concentrated in northern Germany, particularly in Lower Saxony, and in the area of modern Belgium and western Germany between the Meuse and Rhine rivers. By the mid-fourteenth century, however, Nuremberg had started to develop an extensive trade in the export of brass basins. Door pulls (cat. nos. 9, 45), fountains (cat. nos. 16, 17), and aquamaniles (cat. nos. 18–22) are the earliest examples of Nuremberg artistry in brass.

The trades and crafts were strictly regulated by the city's Greater and Lesser councils. Since the abortive craftsmen's rebellion in 1348/49, and the attempted rule of the city by its skilled workers, all guilds and craft organizations — so powerful in other medieval towns — were abolished, never to be revived. Administrative controls and qualitative standards for work practices and products henceforth remained under the jurisdiction of the city council, which was dominated by the patrician merchant class whose capital enabled the importation of the needed copper and calamine ores. The council's rolls of master craftsmen registered all of the masters of the various foundries and workshops as redsmiths (*Rotschmiede*). These lists suggest the growth of the industry. The masters' list, of 1363, does not yet mention redsmithing as a special craft. The second list, covering the years 1370 to 1429, cites seventy-four masters. The third list, from 1429 to 1462, mentions 139 redsmiths, including — for 1453 — Hermann Vischer [the Elder], the initiator of the Vischer family foundry, and Ulrich Poppenrewter, who was visited by Frederick III when the emperor came to the

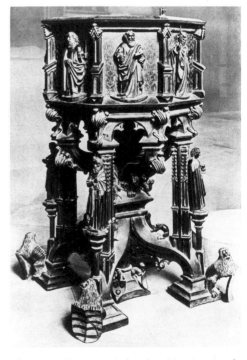

Figure 85 Hermann Vischer the Elder. *Baptismal Font*. Brass, 1457. Stadtkirche, Wittenberg

Figure 86 Peter Vischer the Elder. *Candelabra* (Kronleuchter). Lorenzkirche, Nuremberg

city in 1471. The book for 1462–96 designates 165 master redsmiths, including Peter Vischer [the Elder] for 1489 (U. Mende, 1974, 8–9, pp. 21–22). The specialties of these masters were often indicated, and not all were founders or casters. Some were turners who fashioned raw blocks into objects; others produced utility wares such as bowls, small scales, weights, thimbles, and fittings for harnesses and for armor. The caster of brass works of art, rather than the artist who created the model, seems to have always been given prominence. For example, only recently were the models for the figures on Peter Vischer the Elder's tomb of Archbishop Ernest of Saxony, in Magdeburg, attributed to other sculptors, including Simon Lainberger (see cat. no. 183).

In the middle of the fifteenth century, Hermann Vischer the Elder emigrated to Nuremberg, where he became a citizen. Some authors have suggested, without proof, that he came from the Netherlands (see D. Wuttke, "Methodisch-Kritisches zu Forschungen über Peter Vischer den Älteren und seine Söhne," *Archiv für Kulturgeschichte*, 1967, vol. 49, pp. 208–11). Hermann the Elder was an established Nuremberg master by 1453. His move may have resulted from two circumstances: the flourishing brass industry and trade (which included the earlier production of aquamaniles and basins) and the rich clay deposits in the vicinity, which were important for the molds that he would use. His main works were tomb monuments, epitaphs, and church furnishings, such as the baptismal font, dated 1457, in Wittenberg (fig. 85; see E. Meyer, 1965, vol. 19, pp. 97–116). Following his death in 1488, his son Peter the Elder was given permission by the city council to head the workshop, which was becoming

Figure 87 Peter Vischer the Younger. *Epitaph of Dr. Anton Kress*. Brass, 1513. Lorenzkirche, Nuremberg

Figure 88 *Lion Aquamanile*. Brass, about 1400.
Bayerisches Nationalmuseum, Munich, MA 2494

89

Figure 89 *Imhoff Epitaph*. About 1400.
Städtisches Museum, Lauingen an der Donau

one of the most important foundries in Germany. Peter became a master the following year. The brass candelabra *(Kronleuchter)* in the Lorenzkirche (fig. 86) traditionally is regarded as his masterpiece, even though the wood model undoubtedly was made by a woodturner (H. Stafski, 1971, p. 230). This was the beginning of the Vischer family dynasty of brass casters, who were responsible for a series of major monuments, including additional tombs and church furnishings not only for the city's churches but also for churches and chapels in towns as far away as Cracow. The Vischers' most famous and important work is the *Sebaldus Tomb* (cat. no. 190), in the Sebalduskirche in Nuremberg, which was already admired in the eighteenth century by Christoph Gottlieb von Murr *(Beschreibung der vornehmsten Merkwürdigkeiten in des h. R. Reichs freyen Stadt Nürnberg . . .*, Nuremberg, 1778, p. 38).

With each of these commissions, the question arises about the origin of the models. It is now generally assumed that Peter the Elder's sons — Hermann the Younger (1486–1517) (cat. nos. 184, 185, 199), Peter the Younger (1487–1528) (fig. 87; cat. nos. 190, 193–198), and Hans (1489–1550) (cat. no. 199) — were not restricted to casting, but also carved some of the required models in wood or modeled others in wax. About 1550, the Vischer workshop declined in importance. Hans's son, Georg, carried on the work in a more modest way (cat. no. 200). In the second quarter of the sixteenth century, Pankraz Labenwolf, trained in the Vischer shop, became the caster of Hans Peisser's and Peter Flötner's models (cat. nos. 233–235, 248, 250, 254–256, 261).

The stylistic development of this art in brass is well represented here. The range extends from the elegant examples of the so-called International Style, of about 1400, such as the *Fountain Figure* and the *Fountain Mask of a Youth* (cat. nos. 16, 17), to the heraldic flair of the aquamaniles of the same early period (cat. nos. 18–22; fig. 88), and the forceful and monumental realism of the Late Gothic art of Adam Kraft (cat. no. 97). The Late Gothic style was eclipsed by the Renaissance style adopted by Peter Vischer the Younger for his richly modeled and humanely expressive figures and reliefs on the *Sebaldus Tomb,* and for his restrained and idealized portrait of Dr. Anton Kress (fig. 87); the style was continued by Hermann the Younger, whose dynamic lunette figures (cat. no. 199), initially made for the Fugger Chapel in Augsburg, were adapted by Hans Vischer for the Nuremberg Rathaus. This style was imbued with elements of the North Italian Renaissance; it appealed to the tastes of a small but influential group of Humanists in Nuremberg, some of whom were collectors (for examples, see cat. nos. 193–198). Lastly, and with an extremely imaginative artist like Peter Flötner — who made models and designs for objects in several mediums — we see the full flowering of Renaissance Mannerism, which is noted for its own decorative elegance.

The Art of Nuremberg Brass Work 79

Bibliography

Dodwell, C. R., trans., *Theophilus, De diversis artibus [Theophilus, The Various Arts]*, London and Edinburgh, 1961, pp. 120–26.

Hawthorne, John G., and Smith, Cyril Stanley, trans., *On Divers Arts, the Treatise of Theophilus*, Chicago, 1963, pp. 139–44.

Meller, Simon, *Peter Vischer der Ältere und seine Werkstatt*, Leipzig, 1925.

Weihrauch, Hans R., "Bronze, Bronzeguss, Bronzeplastik," *Reallexikon zur deutschen Kunstgeschichte*, Stuttgart, 1948, vol. 2, cols. 1182–1216.

Meyer, Erich, "Hermann Vischer und sein Sohn Peter Vischer der Ältere," *Zeitschrift des deutschen Vereins für Kunstwissenschaft*, 1965, vol. 19, pp. 97–116.

Weihrauch, Hans R., *Europäische Bronzestatuetten 15.–18. Jahrhundert*, Braunschweig, 1967, pp. 255–57, 264–93, 318–21.

Stafski, Heinz, "Der künstlerische Messingguss im 15. und 16. Jahrhundert," in *Nürnberg — Geschichte einer europäischen Stadt*, Munich, 1971, pp. 229–35.

Mende, Ursula, "Nürnberger Aquamanilien und verwandte Gussarbeiten um 1400," *Anzeiger des Germanischen Nationalmuseums*, 1974, vol. 8–9, pp. 8–25.

Strauss, Gerald, *Nuremberg in the Sixteenth Century*, Bloomington, Indiana, and London, 1976, pp. 133–39.

Mende, Ursula, *Die Türzieher des Mittelalters (Bronzegeräte des Mittelalters, vol. 2)*, Berlin, 1981, pp. 109–18: "Nürnberg," pp. 170–77: "Technik: Gussmodell, Bronzeguss, und Ziselierarbeiten," pp. 182–94: "Formgebung und Verwendung von Modeln."

Riederer, Josef, "Die Zusammensetzung deutscher Renaissancestatuetten aus Kupferlegierungen," *Zeitschrift des deutschen Vereins für Kunstwissenschaft*, 1982, vol. 36, pp. 42–48.

Stone, Richard E., "Antico and the Development of Bronze Casting in Italy at the End of the Quattrocento," *The Metropolitan Museum of Art Journal*, 1982, vol. 16, pp. 87–116.

Turner, Eric, *An Introduction to Brass*, London, 1982.

Riederer, Josef, "Die Geschichte des Bronzegusses," in *Bronzen von der Antike bis zur Gegenwart* (exhib. cat.), Berlin, 1983, pp. 277–90.

Kurt Löcher

Panel Painting in Nuremberg: 1350–1550

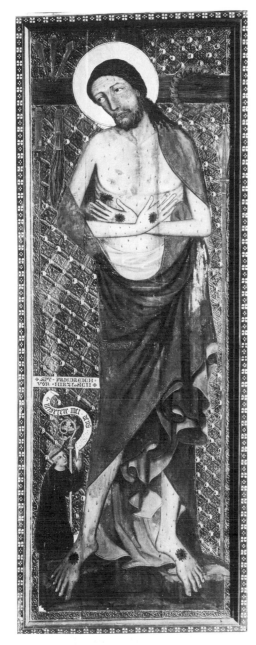

Figure 90 The Man of Sorrows, from the *Hirzlach Epitaph.* 1350. Pfarrkirche, Heilsbronn

The idea of the portable picture — no longer fixed to a wall like a mosaic or a fresco — spread from Italy to the whole of Europe. Churches and chapels were rapidly filled with such works, in the form of polyptychs, private altarpieces, epitaphs, and votive portraits. In Germany, the trend was supported by the specific tradition of piety nurtured in and represented by the religious foundations.

It is generally agreed that panel painting in Nuremberg began with the epitaph (see fig. 90) of Friedrich von Hirzlach, Abbot of Heilsbronn (died 1350). This painting of the Man of Sorrows displaying his wounds and being adored by the kneeling cleric has the imposing grandeur of a tombstone. As in the Gregorian type of crucified Savior, Christ here crosses his hands over his breast, yet his eyes are open, and he is suffering the Passion as a living man. In the former monastery church at Heilsbronn there is another wing of an altarpiece, which depicts episodes from the Passion and part of a Crucifixion scene. In that work, as in the Man of Sorrows, the simplicity and power of the pictorial concept, the undulating lines of the hems of the drapery, and the overall two-dimensional effect are most striking. The gazes and gestures of the figures focus attention on the central events. A small reliquary shrine with scenes from the Passion and, on the reverse, the *arma Christi* (cat. no. 6), appears to be closely related. The earliest panel painting in Nuremberg had its roots in Vienna, although it by no means attains the elegant outlines and delicacy of the panel paintings attached to the back of the Nicolas of Verdun altarpiece in Klosterneuburg.

The scenes from a disassembled altarpiece of the life of Saint Clare (cat. no. 8), and the miniatures of Saint Clare and Saint Francis, in a manuscript of 1362 — both of which come from the convent of Sankt Klara, in Nuremberg — reveal that, at that time, manuscript illumination and panel painting were still done in the same workshop. Figural types and the style of representation were identical. The decorative quality of these paintings is enhanced by their delicately tooled rinceaux designs and by the patterned fabrics, yet they are primarily narrative in nature. Characteristic of this particular workshop is the use of a very light flesh tone and spots of red on the cheekbones.

A multifigured altarpiece in the Jakobskirche depicts the prophets and apostles in a rich variety of poses and drapery. Its portrayals of the Crucifixion and the Adoration of the Magi — the latter, unfortunately, heavily damaged — suggest that the action takes place on various pictorial planes, for the figures appear in different sizes.

Even at this early date, it is possible to see the influence of Bohemian painting on the Nuremberg masters. The Bohemian school had assimilated the achievements of Italian art — namely, the illusion of three dimensionality in the figures, a continuous development of space, and a style of modeling that made use of strong highlights. As early as the time of Charles IV, contacts were close between the emperor's city of Prague and the imperial city of Nuremberg. Yet, Nuremberg was to be influenced even more by Bohemian painters, as many of them were forced by the Hussite uprisings to emigrate.

Panels from an *Altarpiece of the Virgin*, dating from about 1410, which may once have adorned the high altar of the Frauenkirche (cat. no. 23), provide clear evidence of

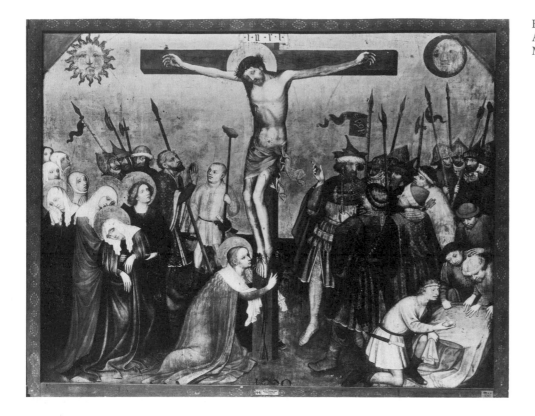

Figure 91 The Crucifixion, from the Bamberg Altarpiece. 1429. Bayerisches Nationalmuseum, Munich

such contact with Bohemian painting. At the same time, it is obvious that elements of painting from other countries had already become a part of the idiom of local artists. The Marian scenes have gold backgrounds; those of the Passion, deep blue ones. The transitions from one event to the next are fluid. The figures tend to fill the space, and modeling is achieved by the use of light and color. Each scene has a character of its own, appropriate to its subject matter. In the lovely depiction of Mary and Elizabeth with their children, the figures have the imposing dignity of statues, yet the mood is relaxed.

The next monument of Nuremberg painting is the *Imhoff Altarpiece* (fig. 119) in the Lorenzkirche, which can be dated to about 1420, on the basis of the donor portrait that it contains. This work has long been considered the most characteristic example of early panel painting in Nuremberg — the result of indigenous responses to outside influences. The center panel shows Christ placing the crown on the head of the Virgin. The faces are idealized, the movements restrained, and the folds of the drapery soft and fluid. An elaborate throne identifies the space as the realm of heaven. The figures reveal a refined aesthetic sense, and display a luxuriance of color previously unknown in Nuremberg painting. The reverse of the center panel of this altarpiece, the *Man of Sorrows, with the Virgin and Saint John* (cat. no. 29), was painted by another artist, called the Master of the Bamberg Altarpiece. While the Coronation of the Virgin on the front was intended to be seen by the congregation, the Man of Sorrows was painted with the solitary worshiper in mind, and appeals to his compassion. Paintings of the latter type were in the form of separate votive pictures (see cat. no. 28). Unique to this painter is his rational development of the composition and his reliance on straight lines and sharp angles to heighten the impression of suffering. He takes his name from the great altarpiece (now in the Bayerisches Nationalmuseum, Munich) that he painted for the Franziskanerkirche, in Bamberg, in 1429 (fig. 91). In the latter work, the throng of spectators at the Crucifixion is superbly organized: By making full use of the depth of the space, he created clear figure groups in which the character and importance of each individual are apparent. Scholars have compared his work to that of Italian painters, who frequently depicted statue-like figures with their backs to the viewer. The scenes from the Passion on the wings of the Bamberg

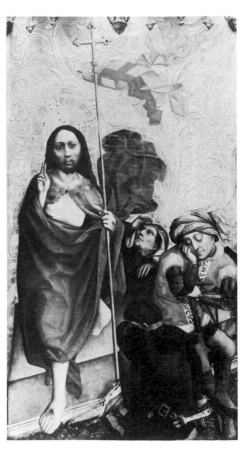

Figure 92 The Resurrection, from the *Tucher Altarpiece*. About 1450. Frauenkirche, Nuremberg

Altarpiece convey an unprecedented range of emotion. The familiar events were rendered with a great sense of drama, and the essence of each successive action is clearly captured. The artist concentrated on the overall forms rather than on the development of realistic detail.

A separate genre of panel painting is the epitaph; these were painted on panels that were curved to match the curve of the columns (in the church) on which they were hung. Typical examples of this type of memorial painting are the epitaphs for Walburg Prünsterer and for Conrad Winkler, both of which are in the Germanisches Nationalmuseum.

Nuremberg painting was given new life by the Master of the Tucher Altarpiece; the work from which his name derives was painted about 1450 (fig. 92). Originally in the Augustinerkirche, and restored in 1615 at the expense of the Tucher family, this altarpiece is now installed on the east wall of the north side aisle of the Frauenkirche, where it is almost too large for its setting. What the paintings lack in their representation of space, they make up for in the almost palpable three dimensionality of the figures: These are people of flesh and blood, stocky, clothed in soft, heavy fabrics, and characterized by earnest, almost somber, expressions. The realism extends to the details of their costumes and armor. The bookshelf in back of Saint Augustine was composed like a still life of books and other objects and is reminiscent of the bookshelf depicted behind the Prophet Jeremiah in a painting by the Master of the Aix Annunciation. This artist is frequently mentioned, along with the Master of Flémalle and the sculptor Claus Sluter, as a possible source of inspiration for the Master of the Tucher Altarpiece. The Nuremberg painter fully mastered the modeling capabilities of light and air, so that the gold background with its two-dimensional baldachins and design of lush, embossed tendrils appears rather old fashioned. Whereas in the *Ehenheim Epitaph,* of about ten years earlier, in the Lorenzkirche, what is most striking is the Herculean figure of the nude Christ, in the later *Circumcision* (cat. no. 30) it is the dynamic figure groups that are particularly impressive.

Hans Pleydenwurff was the next artist to enrich painting in Nuremberg with new developments derived from Netherlandish art. He moved his workshop from Bamberg to the imperial city in 1457. Under his influence, the Nuremberg school attained a superiority that brought it commissions from far beyond the borders of Franconia. Pleydenwurff had studied the works of Rogier van der Weyden and Dirk Bouts, and, from them, he learned to expand the space of his pictures by introducing it between the figures and to observe the effect of the atmosphere on the color of an object; he preferred to study nature directly rather than to employ traditional prototypes in his depictions of natural forms and landscape elements. Pleydenwurff's work has vitality, grandeur, and style, and he provided a new dimension to biblical illustration. With regard to his altarpiece for the Elisabethkirche in Breslau — installed in 1462, and clearly documented as being from his hand — the only portion to survive undamaged is the *Descent from the Cross* (now in the Germanisches Nationalmuseum; see fig. 93). The most personal example of his art is the diptych, with Christ as the Man of Sorrows (in the Öffentliche Kunstsammlung, Basel), and a portrait of Count von Löwenstein that is a moving portrayal of both his fragile condition and his deep humility (cat. no. 41). In some of Pleydenwurff's larger paintings, it would appear that much of the work was done by his assistants.

Michael Wolgemut studied in Munich with Gabriel Mälesskircher before he married Pleydenwurff's widow and took over the Pleydenwurff workshop in 1472. Wolgemut's contribution to painting in Nuremberg included a maximum of organization, a solidity of forms, and a linear precision. His figures look as though they are carved of wood — a quality that accorded well with the actual sculptural portions of the altarpieces for which he was commissioned to provide the painted panels. Wolgemut negotiated contracts with sculptors, cabinetmakers, locksmiths, and other artists involved in the creation of such altarpieces. His entrepreneurial achievements

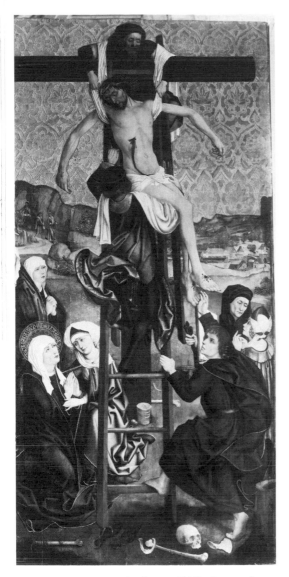

Figure 93 Hans Pleydenwurff. *The Descent from the Cross.* 1462. Germanisches Nationalmuseum, Nuremberg

Chapel, for which Hans Suess von Kulmbach created the cartoons, after drawings by Dürer (see cat. no. 160). Dürer, himself, apparently became involved once more in the composition of the Pfinzing window, in 1515 (fig. 102).[19] Without Dürer's intervention, its grandiose figures, landscape background, and the imaginative Renaissance architecture that give it the look of a festive triumphal arch would hardly have been possible. Considering the number of Kulmbach drawings that survive,[20] it would appear that work related to stained glass constituted a major part of his total artistic output. The same can be said of the much more inventive and versatile Baldung, not only when he worked in Nuremberg but also later, when he was in Strasbourg and in Freiburg, as well. The most important evidence of the participation of these artists in the creation of Nuremberg stained glass is the series of windows made between 1504 and 1510 for the cloister of the city's Carmelite monastery. Today distributed among the churches in Grossgründlach, in Wöhrd, and in Henfenfeld, this extensive stained-glass sequence — which possibly consisted of as many as thirty-four panels — contained scenes from the Life of Christ and from that of the Virgin (see cat. no. 174). Baldung, in particular — but also Kulmbach, and other members of Dürer's workshop — apparently provided cartoons and designs for the glass. Its coloring must have been determined, to a large extent, by Baldung, himself. His exquisite, subtle color sense, and his skill in achieving unusually choice effects and surprising, even harsh tonal combinations, is still clearly recognizable in the panels — especially, in those in Grossgründlach. These windows are among the finest to have survived from Dürer's time.

Accordingly, in the first decades of the sixteenth century, a wealth of stained glass was produced that, in its novelty and vitality, is fully equal to the best contemporary panel painting and graphics in Germany. A representative example, and one especially typical of the final phase of that art, is the Kulmbach design, preserved in Dresden, for the Welser-Thumer window in the Frauenkirche (fig. 103).[21] This commission resulted from the union of two important trading houses. The drawing is dated 1515, but the window itself, of which only fragments survive, appears to have been executed in 1522, when the Welsers also erected the last great carved altarpiece to be created in Nuremberg, in the same church.

The old stained glass was not destroyed after Nuremberg accepted the Reformation in 1525, but no new commissions were awarded. The art of monumental stained-glass painting was thus extinguished for centuries — not only in Nuremberg but also in the rest of Germany and in the major part of Europe — until the nineteenth century, when it became popular to try to recapture the glory of the past and to revive its long-forgotten arts.

Figure 103 Hans Suess von Kulmbach. Design for the Welser-Thumer window in the Frauenkirche, Nuremberg. Pen and ink, on paper, 1515. Kupferstichkabinett, Dresden

VI

Stained glass did manage to survive for some time, as a more intimate art. In the late fifteenth century, it had become customary to create single, small panels, often round or trefoil in form, to be set into the bull's-eye glazing of the smaller windows of churches or even those of private houses.[22] Most of these panels depicted coats of arms, but some incorporated religious figures and scenes in their designs; to a certain extent, they even adopted secular subject matter, generally as an accompaniment to the heraldic material, or as an embellishment of it (see cat. nos. 65, 66, 264). The two trefoil panels in which Death, on horseback, takes aim with his bow and arrow at the provost Sixtus Tucher standing beside his grave demonstrate what significant images could be created even in this modest genre if an important patron employed a great artist to furnish him with designs (see cat. no. 117).

19 U. Frenzel, in *Albrecht Dürer*, Nuremberg, 1971, no. 732.

20 Winkler, 1942, pp. 28–31, 33–35, nos. 61–81, 94–141, ill. See also *Meister um Albrecht Dürer*, Nuremberg, 1961, nos. 180–191 (G. Frenzel), 208–218 (Herwarth Röttgen).

21 Winkler, 1942, 81, ill.; *Meister um Albrecht Dürer*, Nuremberg, 1961, nos. 189 (G. Frenzel), 218 (Herwarth Röttgen).

22 Exhaustive material in Schmitz, 1913, vol. 1, pp. 150–72. See also Winkler, 1941; Landolt, 1962. On the entire genre — with, of course, only a few examples from Nuremberg — see Schmitz, 1923; *Das Bild in Glas. Von der europäischen Kabinettscheibe zum New Glass* (exhib. cat.), Suzanne Beeh-Lustenberger, ed., Darmstadt, Hessisches Landesmuseum, 1979.

Rainer Schoch

A Century of Nuremberg Printmaking

"It was by means of the graphic arts that Germany finally attained the rank of a Great Power in the domain of art, and this chiefly through the activity of one man who, though famous as a painter, became an international figure only in his capacity of engraver and woodcut designer: Albrecht Dürer."[1] If justification is needed, this comment by Erwin Panofsky explains why printmaking is represented in this exhibition almost exclusively by the works of Dürer. In his woodcuts, engravings, etchings, and drypoints, the techniques of the separate printmaking traditions converge for the first time. The standard functions of the graphic image are reevaluated in Dürer's works, combined, and given heightened artistic autonomy. Dürer was possibly the first artist to be fully aware of the new possibilities of printmaking and to know how to make use of them all. Generations of artists were to derive inspiration from his achievements.

No more than a century separates the first single-sheet woodcuts and Dürer's graphic masterpieces. In this brief span of time, printmaking developed from an inauspicious beginning, in which there is scarcely a hint of the revolutionary importance of the medium, into one of the main forms of artistic expression. This development is only in small part a matter of art history. The appearance and development of printmaking in the fifteenth century were a by-product of a comprehensive historical movement that affected in equal measure the economic, social, and religious spheres. At the same time, it served as a driving force in that movement. Before examining the stages of this development as they relate to Nuremberg, it is important to recognize that while Dürer's artistic beginnings are rooted in a local tradition, neither his antecedents nor his later influence can be adequately described and appreciated within the context of the history of the art of Nuremberg alone. Indeed, the example of Dürer makes it clear that the art of printmaking inaugurated a period in the history of art in which the narrow boundaries of local schools and regional idiosyncracies were dissolved.

Although it cannot be proven that any of the first single-sheet woodcuts were produced in Nuremberg, the city certainly was among the earliest printmaking centers in Germany.[2] There is documentary mention, as early as 1397, of a "cutter (*Formschneider*) Hans" active in Nuremberg; of a maker of cards in 1414; of a letter and card illustrator named Michael Wyener in 1422; and of two more wood-block cutters, Hans Pömer and Hans Hilgensmid, respectively, in 1423 and 1431−33.[3]

These different professional designations tell us something about the milieu of craftsmanship in which the first woodcuts were produced. The terms "cutter" and "pressman" could refer to makers of woodcuts as well as to craftsmen who printed textiles with the help of wooden blocks. It was in the medieval craft of printing textiles that the technical precedents for the art of the woodcut were established, long before anyone thought of using wood blocks for making large numbers of identical pictures on paper. The basic technique had been known since the late antique period, but it was only in the fourteenth century that it came to be employed in Germany for the printing of ornamental and figural patterns on cloth.

The profession of making cards became important in Germany only after the

1 Erwin Panofsky, *Dürer,* Princeton, 1948, vol. 1, pp. 3−4.

2 It is still extremely difficult to determine the place of origin of early single-sheet woodcuts; only in a few rare cases is it certain. The only sure indication is the inclusion in a print of recognizable coats of arms or local saints. Moreover, where a print was sold and used is not necessarily where it was made. Nor does the use of paper identifiable by its watermark provide reliable information; paper, like finished prints, was traded over a considerably vast territory.

3 See W. L. Schreiber, *Der Formschnitt. Seine Geschichte, Abarten, Technik, Entwicklung und seine ikonologische Grundlagen* (Handbuch der Holz- und Metallschnitte des xv. Jahrhunderts, vol. 8), Leipzig, 1929, p. 22; Hans Körner, *Der früheste deutsche Einblattholzschnitt*, Mittenwald, 1979.

Figure 104 *The Dormition of the Virgin*. Colored woodcut, about 1420–30. Kupferstichkabinett, Germanisches Nationalmuseum, Nuremberg

passion for card games — which probably originated in Italy — had swept across Europe in the late fourteenth century. In order to meet the great demand for playing cards, a highly specialized industry soon seized upon the potential of printing for mass production. The new, private forms of Late Medieval piety, and the growing need for small, inexpensive devotional images — referred to as "letters," along with other small graphic products — gave rise to the *Briefmaler,* or letter painters. Since they could no longer satisfy the demands of the market with their hand-drawn and colored sheets, about the turn of the fifteenth century, the letter painters began to employ the woodcut for the mass production of devotional images. They continued to be known as *Briefmaler,* until well into the seventeenth century.

One of the essential technical prerequisites for the printing of pictures was, of course, the production of paper, which provided an inexpensive substitute for parchment. The paper trade was native to Nuremberg; in 1390, the wholesale merchant Ulman Stromer established the first documented paper mill in Germany, on the Pegnitz River.[4] This mill not only produced paper to be used in packaging all manner of small metalwares from Nuremberg, for the watermark of the Stromer mill can be seen in the paper of some of the earliest surviving wood-block prints. One such example is the *Dormition of the Virgin*, dating to about 1420–30, in the Germanisches Nationalmuseum (fig. 104); with its rich, flowing lines it still may be characterized as belonging to the late phase of the so-called International Style.[5] Although the watermark does not prove that this important early print was made in Nuremberg, it tends to support the assumption that, in Nuremberg, a considerable quantity of prints was produced beginning about 1400.

The iconography of many of the early single-sheet woodcuts can be related to forms of monastic piety — particularly, to the mystical imagery that was widespread in convents. In Nuremberg, it is likely that the Dominican convent of Sankt Katharina occupied an important place in the early printing of devotional images. A number of mid-fifteenth-century woodcuts were discovered pasted into manuscripts from the convent library, and some of these — according to Weinberger — were printed in Nuremberg.[6] One of these is the fragment, datable to about 1430, of a large-format *Virgin in Glory* (fig. 105) printed in white on green-tinted paper. Technically, this woodcut represents an interesting transition from the art of printing on fabric, which we know to have been practiced in the convent.[7] Other evidence from the

4 Lore Sporhan-Krempel and Wolfgang von Stromer, "Die früheste Geschichte eines gewerblichen Unternehmens in Deutschland, Ulman Stromeirs Papiermühle in Nürnberg," *Archiv für Geschichte des Buchwesens,* 1963, vol. 4.

5 Germanisches Nationalmuseum, Nuremberg, no. H2. See Schreiber, 1929, no. 705.

6 Martin Weinberger, *Die Formschnitte des Katharinenklosters zu Nürnberg. Ein Versuch über die Geschichte des frühesten Nürnberger Holzschnittes,* Munich, 1925.

7 *Ibid.,* no. 1; see also Emil Ernst Ploss, *Ein Buch von alten Farben. Technologie der Textilfarben im Mittelalter mit einem Ausblick auf die festen Farben,* Heidelberg and Berlin, 1962, pp. 101–25.

Figure 105 *The Virgin in Glory.* Woodcut, about 1430. From the library of the Katharinenkloster, Nuremberg. Stadtbibliothek, Nuremberg

Katharinenkloster is a sheaf of fifty-seven woodcuts of images of saints, some of the sheets still uncut. Tradition has it that these rather crude prints, dating from the mid-fifteenth century, were pasted together on an altar retable in the convent — an early and unusual use of the woodcut.[8]

It is doubtful that the wood blocks for these prints were designed and cut by the nuns themselves. Since it can be assumed that the labor was divided even at this early stage between the *Reisser* (designer) and the cutter, it is logical to suppose that secular cutters were responsible for these works. It is more than likely, however, that woodcuts were printed and colored in the convent itself. Given the unique situation in Nuremberg, it is impossible to determine whether the first woodcuts were actually printed in monastic workshops or in municipal, secular ones, although the evidence seems to indicate that both were involved in woodcut production, either in competition or in collaboration with each other.

As these early Nuremberg prints show, the advent of the woodcut process was not the result of a single technical discovery. The same might be said of copper-plate engraving, documented as early as 1440, and the other early printing methods. The principles of printmaking had been known long before. What brought about the use of such methods was, rather, the great demand for inexpensive images. This desire — in many ways reflecting a basic need for education — was felt in the late fourteenth century by large sectors of the middle and lower middle classes. Fed by the ideals of mysticism, which promised union with God, through prayer, to all — even the uneducated — a Late Medieval lay piety developed in which private, individual, and highly subjective devotions became central. Such worship required private devotional images as objects of meditation, distinct from the liturgy of the Church and the public devotional pictures it offered.[9]

Small devotional prints of saints, which anyone could afford, were affixed to walls, doors, or one's personal possessions, ensuring blessings in one's house and the intercession of the saints on behalf of its inhabitants. Images with a strong emotional appeal to the faithful — as, for example, the Pietà, the Man of Sorrows, or Christ Carrying the Cross — served as effective objects for private meditation. Scenes from the Life of the Virgin and the Infancy and Passion of Christ provided patterns for living and dying in a manner pleasing to God. Plague broadsheets and apotropaic portrayals of saints were supposed to protect the faithful from illness and sudden death.

In one of his sermons, Geiler von Keysersberg, a priest at Strasbourg Cathedral, recommended the use of such images: "If you cannot read, then take one of those paper images on which the meeting of Mary and Elizabeth is painted. You can buy one for a penny. Look at it, and think of how happy they were and full of hope, and come to know that in your faith! Then show your extreme reverence for them; kiss the picture on the piece of paper, bow down before it, kneel in front of it! Call upon the Virgin, give alms to a poor person for her sake!"[10]

With the distribution of their woodcuts, the letter painters also brought about the commercialization of the art. Unlike traditional painters, who were prevented by the regulations of their guild from working in any way other than by commission, these men produced wares for the open market, and provided what the public demanded. With their production, they fostered not only private ownership, but also a new, popular availability of pictures. These are but two sides of the same coin. This notion of the dissemination of images for the public is especially apt in the case of prints intended to educate or to entertain: calendars, poems on household objects, bloodletting charts, alphabets, moral admonitions, playing cards, pictures of freaks and prodigies, and, later, news sheets and political broadsheets. These secular images became increasingly popular in the second half of the fifteenth century, as exemplified in the poem about household utensils by the Nuremberg wood-block cutter Hans Paur, which itemizes, through text and pictures, the various items a prospective married

8 See Johann David Passavant, *Le peintre-graveur...*, 6 vols., Leipzig, 1860–64, vol. 1, p. 33, no. 24; Walter Stengel, *Unedierte Holzschnitte aus dem Nürnberger Kupferstichkabinett*, Strasbourg, 1913, nos. 5–29.

9 See Edith Nockemann, *Der Einblattholzschnitt des 15. Jahrhunderts und seine Beziehung zum spätmittelalterlichen Volksleben*, Bottrop, 1940, pp. 18–30; Hans Körner, *Der früheste deutsche Einblattholzschnitt*, Mittenwald, 1979, pp. 32–46.

10 Quoted from O. Clemen, *Die Volksfrömmigkeit des ausgehenden Mittelalters*, Dresden and Leipzig, 1937, p. 14.

Figure 106 Hans Paur. The Household Utensils Necessary in Married Life. Colored woodcut, about 1480. Staatliche Graphische Sammlung, Munich

couple will need to set up housekeeping (fig. 106).[11] It is with prints of this kind that Nuremberg wood-block cutters first emerged, about 1470, from artistic anonymity.

Woodcuts in books — which, in the last third of the fifteenth century tended to be of higher artistic quality than single-sheet woodcuts — served the same functions: devotion and religious instruction, general education, and entertainment. Book illustration became the special domain of Nuremberg wood-block cutters, one in which they assumed prominence, toward the end of the century, over other printing centers at Augsburg, Ulm, Strasbourg, Basel, Mainz, and Cologne.[12] Gutenberg's invention came to Nuremberg relatively late, by way of the neighboring episcopal seat at Bamberg, and, by about 1470, there were several major printing houses competing with one another — among them, the one belonging to the famous astronomer and mathematician Regiomontanus. The earliest woodcut illustrations, which are relatively simple and insignificant, appear in the books produced by Johann Sensenschmidt in 1475: The *Codex Justinianus,* and *The Golden Legend* of Jacobus de Voragine, the 257 illustrations of which were copied from the Augsburg edition by Günther Zainer. Even in the first books produced by Anton Koberger, the most important of Nuremberg's printers and publishers, Nuremberg illustration is still clearly inferior to that of other printing centers. This is most apparent in the German-language Bible, of 1483, for which Koberger had to resort to using the wood blocks from the Cologne Bible, of 1478. Even so, it was precisely these woodcuts that were to influence Koberger's godson, Albrecht Dürer, in the conception of his *Apocalypse* series. Koberger, born in Nuremberg about 1445, established his printing house in 1470. By the 1480s and 1490s, it had become one of the most productive in Germany, with twenty-four presses and about one hundred apprentices. Koberger maintained branch offices in Breslau, Cracow, Vienna, Venice, Milan, Paris, and Lyons, to name only the main ones, and with his traveling salesmen operated an international business.[13]

Koberger's books attained outstanding artistic importance only after 1484, when he managed to enlist Michael Wolgemut, the most important Nuremberg painter of the period, as a designer of woodcuts.[14] The splendid title page of the first edition of the *Newe Reformacion der Stat Nureberg* (cat. no. 84) was Wolgemut's earliest design for him, and is considered to be the first book illustration by a professional painter. When the fifteen-year-old Dürer entered the busy Wolgemut workshop as an apprentice in

11 Munich, Staatliche Graphische Sammlung. See Schreiber, 1929, no. 1991.

12 See Max Geisberg, *Geschichte der deutschen Graphik vor Dürer,* Berlin, 1939, pp. 130–43.

13 Oskar Hase, *Die Koberger. Darstellung des buchhändlerischen Geschäftsbetriebs in der Zeit des Übergangs vom Mittelalter zur Neuzeit,* Leipzig, 1885.

14 Fr. J. Stadler, *Michael Wolgemut und der Nürnberger Holzschnitt im letzten Drittel des 15. Jahrhunderts,* Strasbourg, 1913.

Figure 107 Veit Stoss. *The Lamentation.* Engraving, about 1500. Staatliche Graphische Sammlung, Munich

1486, it is probable — if only as a result of urging on the part of Koberger — that he immediately became familiar with the illustrations being produced by his co-workers. Whether or not the young apprentice worked in this capacity himself is difficult to determine. The designs for the great Koberger book projects of the 1490s — the *Schatzbehalter* by Stephan Fridolin (cat. no. 86), and the *Liber chronicarum (Chronicle of the World)* by Hartmann Schedel (cat. no. 87) — were produced by Wolgemut with his stepson Wilhelm Pleydenwurff. Wolgemut's are decorative, balanced compositions, often influenced by Schongauer and Netherlandish models; Pleydenwurff's are more dramatic images, dependent entirely on the expressive power of the graphic line. Both artists succeeded in wresting from the woodcut a degree of subtlety heretofore unknown, and their illustrations, although still colored, as before, no longer required it. Their artistic influence is also evident in the overall layout of these books, with the welcome alternation of single- and double-column text pages, and a wide variety of illustrations, from full- and half-page woodcuts to smaller ones placed at random in the text, resulting in a far more dynamic relationship between words and pictures.

The *Liber chronicarum*, the most lavish publishing project and the most richly illustrated book of the incunabular period, appeared in 1493. It was produced at the instigation of, and with financial support from, the merchant Sebald Schreyer and his brother-in-law Sebastian Kammermeister. Wolgemut and Pleydenwurff were commissioned to design the woodcuts for it as early as 1487−88. The author, Hartmann Schedel, the city physician and a member of the city council, was one of the earliest and leading Humanists in Nuremberg. His text combined both medieval and contemporary chronicles, creating a summary of world knowledge at the transition from the Middle Ages to the modern era.[15] It would appear that the young Dürer was affected by the stimulating spirit of this project, a collaboration among entrepreneurial initiative, speculative capital, artistic innovation, Humanist scholarship, craving for knowledge, and didactic impulse — for all these characterize his later endeavors.

With its highly developed metalworking industry, Nuremberg, in the Late Middle Ages, was already one of the major centers for goldsmithing, the art so inseparably linked to the development of engraving. Dürer, himself, studied the goldsmith's craft for two years in his father's workshop, acquiring the skills for his later work as an engraver. It is surprising that, before his time, the imperial city had contributed so little to the refinement of the art. In this medium Dürer proved to be the direct successor of the celebrated engravers of the Upper and Middle Rhine — from the Master of the Playing Cards and the Master E.S., to Martin Schongauer and the Master of the Housebook. It is clear that he encountered the art of the last two masters long before his sojourn in the Upper and Middle Rhine, because graphic works were circulated — and repeatedly copied — as picture sources among all of the artists' workshops of the period. Even so, Dürer's nineteenth-century biographers struggled to discover the "missing link" from a local Nuremberg engraving tradition. Thausing, for example, tried to ascribe engravings by Wenzel von Olmütz, with their initial "w," to Dürer's teacher, Michael Wolgemut.[16] As it happens, only two engravers of any rank can be associated with Nuremberg.

First, there are the ten engravings by Veit Stoss, although it is, in fact, uncertain whether they were made before 1496, in Cracow, or — as has recently been once more assumed — about 1500, in Nuremberg (fig. 107).[17] As the works of a sculptor unpracticed in the use of the burin, they represent a special case within the fifteenth-century engraving tradition. They, too, are based on a knowledge of Schongauer and of the drypoint technique of the Master of the Housebook, but the relief-like compositions and freestanding isolated figures betray the vision of a sculptor. These images owe their artistic excellence to technical restraint, to their frequently exaggerated expressiveness of movement, and to their emphasis on drapery configuration for its own sake. Neither as sculptor nor engraver did Veit Stoss exercise any influence on Dürer.

15 Elisabeth Rücker, *Die Schedelsche Weltchronik: Das grösste Buchunternehmen der Dürer-Zeit*, Munich, 1973.

16 Moriz Thausing, *Dürer. Geschichte seines Lebens und seiner Kunst*, 2 vols., Leipzig, 1884, vol. 1, p. 203.

17 Max Lehrs, *Geschichte und Kritischer Katalog des deutschen, niederländischen und französischen Kupferstichs im 15. Jahrhundert*, 9 vols., Vienna, 1908−34, vol. 8, pp. 243−70; Fritz Koreny, "Die Kupferstiche des Veit Stoss," in *Veit Stoss: Vorträge des Nürnberger Symposions*, Munich, 1985, pp. 141−68.

Figure 108 Anti-papal broadsheet. About 1525. Kupferstichkabinett, Germanisches National-museum, Nuremberg

One link between Schongauer and Dürer was the artist who signed himself "L Cz." Now generally identified as the Bamberg painter Lorenz Katzheimer, the master of the *Strache Altarpiece,* who was active in Franconia from 1480 to 1505, he is unquestionably the most important engraver before Dürer from the vicinity of Nuremberg.[18] The resemblance between some of his later engravings and the woodcuts of the *Schatzbehalter* and of Schedel's *Liber chronicarum* has caused several scholars to suggest that the artist worked in Wolgemut's workshop at the same time as Dürer. This master's realistic style, and his virtuoso, freehand manipulation of the burin, may well have influenced the young Dürer.

For the first time, Albrecht Dürer's own work united the various traditional forms of printmaking, thus summing up their one-hundred-year history. He employed all the techniques that were known to him. As *peintre-graveur,* he managed to elevate the woodcut to the artistic level of the engraving, to use the two techniques virtually interchangeably, and to make the printed picture in some respects equal — or superior — to the painted one. In his well-known correspondence with Jakob Heller, the patron of Dürer's Marian altarpiece made for the Dominican church in Frankfurt, the artist remarked that he would have become incomparably richer had he spent his time on engraving rather than on the tedious work of painting. Although, clearly, his comment was made in the hope of securing a higher wage, it also reveals an understanding of the impact of the printmaking medium. Since prints could be made not merely for a single patron but for the open market, an artist might, indeed, make more money from them, and, in the process, achieve a degree of independence heretofore unknown.

After he returned from his first trip to Italy, during a time when relatively few commissions for paintings came his way, Dürer directed his initiative toward printmaking. Inspired by the example of Koberger, and following the tradition in the Late Middle Ages of creating edifying religious works, he produced the great series, *The Apocalypse* (cat. no. 108), *The Large Passion,* and *The Life of the Virgin* (cat. no. 127), in which the pictures clearly took precedence over the text. In his work for the open market, he resorted to the standard subjects of the popular woodcut: images of saints, devotional works, and religious and secular broadsheets. At the same time, he

18 Lehrs, 1908–34, vol. 6, pp. 314–42; Alan Shestack, ed., *Fifteenth-Century Engravings of Northern Europe* (exhib. cat.), Washington, D.C., National Gallery of Art, 1967, no. 125.

19 See *Meister um Albrecht Dürer* (exhib. cat.), Nuremberg, Germanisches Nationalmuseum, 1961.

20 *Ibid.*; see also Emil Waldmann, *Die Nürnberger Kleinmeister,* Leipzig, 1910.

Figure 109 Georg Pencz. *Tomyris with the Head of Cyrus.* Engraving, first half of the 16th century. Kupferstichkabinett, Germanisches National-museum, Nuremberg

endowed them with such superior artistry that they ceased to be mere objects of everyday use and became, instead, works of art suitable for collecting.

Dürer's speculative printmaking allowed him an unanticipated freedom in the selection and treatment of his subjects. In his prints far more than in his paintings, he dealt with the typical secular and mythological themes that were popular in the Renaissance. A work with a philosophical subject as personal as that of his *Melencolia 1* (cat. no. 132), for example, would have been virtually unthinkable in painting of Dürer's time. Thus, in his graphic works something of the modern artist's self-awareness may be detected — a quality that is not found in painting until much later. Dürer's fame as an artist derives far more from his graphic work than from his painting. One hundred years earlier, with the development of printmaking, individuals were provided with a new form of affordable pictures, for their own use, but Dürer became aware of the highly public potential of the print. He realized this as he set about publishing his scientific and theoretical works, and he saw that it was especially true of the printed portrait, which, he knew, would not only capture the interest of a far wider public than would a painted one, but could also fulfill the need created by public functions. The *Triumphal Arch of Maximilian 1* and the *Great Triumphal Chariot,* made for Emperor Maximilian 1, for example, demonstrate the extent to which prints were valued as instruments of propaganda. At the same time, their excessive size suggests the limitations implicit in their use as a public pictorial medium.

Dürer's pupils also played a role in the flowering of Nuremberg printmaking in the master's time. Hans Suess von Kulmbach, Hans Leonhard Schäufelein, Hans Springinklee, Wolf Traut, and especially the brilliant Hans Baldung Grien all produced important woodcuts during their apprenticeship in Dürer's workshop and later, when, as painters, they were on their own.[19] Nuremberg was both the center of the book industry and of European trade, providing a most favorable environment for printmaking in the age of Humanism and on the eve of the Reformation. Printmaking also served the needs of the proponents of the many social and religious debates of that era; Nuremberg artists such as Hans Sebald Beham and Erhard Schön were among the chief producers of anti-papal propaganda prints for the Reformers (fig. 108).

Nevertheless, the victory of the Reformation in Nuremberg in 1525 dealt a severe blow to printmaking, as it did to all of the other pictorial arts. Once the new teaching had made the majority of religious devotional pictures superfluous, artists were forced to concentrate on other subjects. Hoping to cater to the tastes of the middle-class public, the generations of artists that followed Dürer turned increasingly to secular subjects. The so-called Nuremberg minor masters — Barthel Beham, Hans Sebald Beham, and Georg Pencz, for example — specialized in popular genre-like woodcuts and small-format engravings with mythological, Humanistic themes (fig. 109).[20] In these areas, as well as in the realm of the ornamental engraving, they could look to the example of Dürer. The universality manifest in Dürer's graphic work, however, gave way to an art of increasing specialization.

Figure 110 Albrecht Dürer, Three views of a jousting helmet. Watercolor and body color, on paper. About 1498. Cabinet des Dessins, Musée du Louvre, Paris

Johannes Willers

Armor of Nuremberg

Nearly all of the world's major armor collections, whether based on working arsenals of the Middle Ages or assembled only in the nineteenth or twentieth century, contain a surprisingly large number of examples from Nuremberg. Yet, the scholarly literature on such works points up the gaps in our knowledge. Nevertheless, the following exploration of the subject is drawn from present research in the field.

There are very few references to the beginnings of the craft in Nuremberg. However, from the fact that the original settlement in that city was located around a castle, it may be concluded that armorers must have found employment there at an early date. Body armor from before the fourteenth century has been found in various places in Germany; but, having survived only as small fragments, these armors cannot be identified as products of any specific metalworking center.

Nuremberg was not poorly situated as a locale for important ironworking trades. Although there were no rich iron deposits in the immediate vicinity of the city, the important medieval iron district of the Upper Palatinate lay not far away. Later, it was possible to import very high-quality iron from Styria in Austria. From 1498 on, the armorers' raw materials, which consisted of fifty percent iron and fifty percent steel, were produced in special hammer mills within the territory of Nuremberg; the export of this material was prohibited.[1] The vast forests surrounding the city provided practically unlimited quantities of excellent charcoal. The Pegnitz River, which fanned out into various streams within the city limits, powered a large number of mills; among these, the polishing and finishing mills were of great importance in the production of weaponry.

The helm smiths are among the earliest groups of craftsmen concerned with the manufacture of defensive armor in Nuremberg to be documented. They are mentioned as early as the thirteenth century. The helm from the funerary coat of arms of Hans Rieter von Kornburg (cat. no. 11), which dates from the middle of the fourteenth century, was probably made in their workshops. Its angular, high raised crown reveals an astonishing proficiency for the time in the working of this difficult metal.

Medieval armor was, at first, only an arrangement of protective plates for the particularly exposed parts of the body — the head, torso, arms, legs, and hands. During the fourteenth century — after some initial attempts in the thirteenth — an advance took place that would ultimately lead to the cap-à-pie plate armor, as it is known from the Late Middle Ages and the early modern period. This integrated, full body armor is commonly, although somewhat loosely, referred to as "knights' armor." In the period before the development of plate armor, the separate elements, with the exception of the helmet, generally consisted of lamellate segments secured by straps of leather or textile in the manner of East Asian armor — that of Japan or Tibet, for example. The evolution of full plate armor was the response to a single underlying motive — namely, to employ the largest possible plates with a maximum amount of mobility. The arm and leg defenses, with ingeniously articulated joints, were attached to the torso, and, ultimately, the helmet was attached as well, a circular swivel joint securing it to the collar. Full plate armor from the fifteenth and sixteenth centuries is nothing less than movable sculpture, and works by leading armorers possess all the

1 Clemens Böhne, "Werkstofftechnische Fragen bei deutschen Plattnerarbeiten," *Waffen- und Kostümkunde,* 1961, vol. 3, ser. 3, pp. 47–53, especially, p. 47; Alexander Freiherr von Reitzenstein, "Die Ordnung der Nürnberger Plattner," *Waffen- und Kostümkunde,* 1959, vol. 1, ser. 3, pp. 54–69, especially, p. 60.

artistry of more conventional sculpture. While the traditional sculptor portrayed a figure in suspended animation, the armorer created a figure expressive of the artistic tastes of the time and, more importantly, capable of full movement. Today's static museum display of armor does not reveal the full artistic eloquence that the armorer gave to his creations. In motion, these steel plates — with their curves, angles, fluting, etching, and various colors and linings — must have provided an extraordinarily rich play of reflections and colors.

The regulations governing the armorer's trade in Nuremberg provide clear insight into the manufacture of the individual elements that made up the complete cap-à-pie armor. Well into the sixteenth century, these regulations continued to require of potential masters only specific pieces: either helms, body armor, leg and arm defenses, or gauntlets.[2] Each armorer was examined in a specialized area and became a master at making that one item. It was permissible for one master to make several masterpieces, but very few undertook to make all five. It is as yet unclear whether the masters' marks on Nuremberg armor mean that one master produced all of the sections himself, or at least had them fashioned in his workshop, or whether, as in the making of firearms, a craftsman — in this case, the barrel smith — simply supervised the creation of the entire object and was then permitted to affix his master's mark to it.

In the realm of armor, as in other areas, Nuremberg craftsmen rapidly attained not only great skill but also the ability to produce large numbers of objects of the required quality, in a short time. Together with the town of Sulzbach (in the Upper Palatinate), which was somewhat less powerful economically, Nuremberg completed a commission in 1362/63 for 1,816 sets of armor for Emperor Charles IV. The finished works were delivered to Prague and to Pilsen.[3] The armorers' regulations from 1358 do not mention a quality control for armor; this appears only in the regulations from 1499.[4] Apparently, the pieces made in 1362/63 were inspected by two *capitanei*, the masters in charge of the guild who later became known as jurors or "sworn ones," since they were required to take a special oath of allegiance and service to the city.[5] The inspection introduced in 1499 required that all masters present their work for judging by the jurors before the final polishing and finishing, or while the hammer marks were still visible.[6] If the pieces passed inspection, the city mark was struck deep into the metal. In later years, two inspections were required, one before and one after the polishing and finishing.[7] However, this inspection was only for armor made of steel or of fifty percent steel. Works in iron were not subject to inspection, and, for this reason, they were not stamped with the city's mark.

Fortunately, two illustrations, of about 1425, have survived showing a plate worker and an armor polisher in their workshops (see figs. 19–22); these, in the so-called *Hausbuch* of the Mendel Zwölfbrüdershaus,[8] are among the rare illustrations of workshops from that period. The plate worker Bernhard is seated at the anvil, forming a two-part armguard with a special pointed hammer. Behind him hang another armguard, a gauntlet (mitten type), and a breastplate. It would seem that he had therefore passed the master's examination for those three elements. In front of him is a large pair of shears, obviously for trimming the sheet of metal before giving it its final form on the anvil. The picture of the armor polisher Georg is even more interesting, for considerably less is known about his craft than about plate making. Georg is seen standing over his work at a workbench to which an object, possibly a greave, or shinguard, has been clamped. He holds a spindle-shaped wooden tool with both hands, and from his posture it is clear that he is exerting pressure on it as he draws it back and forth across the metal. An identical spindle lying on the floor reveals the underside of this tool, to which a strip of leather has been secured. Next to it is a small, tied bag. On the table behind Georg are two helms, a pair of gauntlets, and a little jar, indicating that Georg employed a process that would still be widespread much later. He kept some kind of polishing powder in the small cloth bag; when he patted the bag against the metal surface, it released a fine dusting of powder. He then

2 Reitzenstein, "Ordnung," pp. 55–56.

3 Wilhelm Georg Neukam, "Eine Nürnberger-Sulzbacher Plattenlieferung für Karl IV. in den Jahren 1362–63," *Mitteilung des Vereins für Geschichte der Stadt Nürnberg*, 1956, vol. 47, pp. 124–59.

4 Alexander Freiherr von Reitzenstein, "Die Nürnberger Plattner," *Beiträge zur Wirtschaftsgeschichte Nürnbergs*, 1967, vol. 2, pp. 700–715, especially, p. 703; Reitzenstein, "Ordnung," p. 62.

5 Neukam, p. 128.

6 Reitzenstein, "Plattner," p. 703; Reitzenstein, "Ordnung," pp. 62, 63.

7 Reitzenstein, "Ordnung," p. 63.

8 In the Stadtbibliothek, Nuremberg: Ms. Amb. 317, fol. 7 v. (armor polisher), and 42 r. (plate worker); Wilhelm Treue, Karlheinz Goldmann et al., *Das Hausbuch der Mendelschen Zwölfbrüderstiftung zu Nürnberg*, Munich, 1966, 2 vols.

bound the dust with grease or oil from the jar, and polished the piece with this paste, rubbing it with the leather lining of his wooden spindle. Before he could do this, of course, another worker first had to smooth over the plate worker's hammer marks with a file and a polishing stone. No depictions of this intervening step exist.

The first important Nuremberg armorer recorded in contemporary documents is Hermann Grünewalt, who became a citizen in 1434.[9] However, no armor known to have been made in his workshop has survived. Because of the work of his son Hans (about 1440–1503) and of Hans's children, he is considered the patriarch of most of the important Nuremberg armorers. Wilhelm von Worms the Elder (about 1450–1538), Wilhelm von Worms the Younger (about 1500–1573), Sebald von Worms (1530–1567), Valentin Siebenbürger (about 1510–1564), Endres Kolb (died 1550), and Heinrich Lochner (about 1505–1580) were all related to Hermann Grünewalt. Although no works can be attributed definitively to Hans Grünewalt, given the circle of his clients — which comprised a number of noblemen and princes, even including Emperor Maximilian I, himself — it is certain that he was one of the most important armorers of his time. Further evidence of this is provided by his reputed financial status, for he owned no fewer than six houses — among them, the one still standing on the Tiergärtnertorplatz, once known as "zum geharnischten Mann" ("at the man in armor") and now called the Pilatushaus (fig. 55), after a station in the Good Friday procession. The earlier name for the house referred to a statue, on its exterior, of Saint George, the patron saint of knights, wearing an actual suit of armor, possibly one made in Hans Grünewalt's workshop.[10] This armor was similar in style to that depicted by Albrecht Dürer in a 1498 drawing of an equestrian figure.[11]

After 1500, Renaissance forms were adopted by Nuremberg's armorers. The typically pointed, angular Late Gothic plate armor was replaced by a design more closely patterned after the anatomy of the human body. For a short time, quite plain, smoothly rounded armor was in vogue, but after about 1505 this style gave way to fluted armor, a specialty of Nuremberg armorers: The great majority of the surviving suits of fluted armor were made there.[12] This fluting, which developed from Late Gothic prototypes with borrowings from the pleated costumes then in fashion, had an important functional significance. It served to strengthen thinner sheets of metal — corrugation is a similar modern process — and thus permitted the manufacture of lighter armor, with no loss in protective rigidity.

Etching as a means of decorating armor reached its artistic peak in the sixteenth century. Designs by Nuremberg artists such as Barthel Beham and Virgil Solis, as well as Peter Flötner, were increasingly used. Beginning in the 1630s, ornamental gilded etching was a virtual mark of rank on armor made for princes, kings, and emperors, as well as for generals and politicians. Even Dürer became involved in the formal problems of designing armor, as evidenced by his splendid drawings of jousting helmets (fig. 110) and of a silver armor for Emperor Maximilian I (see cat. no. 136). His interest also extended to forms that were very much outdated in his time, examples of which are his work on the bronze figure of Count Albrecht von Habsburg for the projected tomb monument for Maximilian in Innsbruck,[13] and the woodcut of the Arrest of Christ, from the Large Passion (before 1511), in which he depicts a hound's-skull helmet.[14]

The leading Nuremberg armorers of the mid-sixteenth century were Hans Ringler, Valentin Siebenbürger, and, most distinguished of all, Kunz Lochner the Younger (about 1510–1567). Lochner was appointed ducal armorer in 1544 by Archduke Ferdinand, later Emperor Ferdinand I (r. 1556–64); he also worked for Ferdinand's son Maximilian II (emperor, 1564–76).[15] His versatility is particularly evident from the commissions he executed for Polish patrons. The armor that he made for King Sigismund of Poland and for Nikolaus IV "The Black" Radziwill (1515–1565)[16] is lavishly ornamented with gilded etching and enamel work (cat. no. 278). With such creations, Lochner was clearly accommodating himself to his Polish clients, whose

9 Reitzenstein, "Plattner," pp. 711–15.

10 This armor was destroyed by a direct hit on the Germanisches Nationalmuseum in the spring of 1945; illustrated in Fritz Traugott Schulz, Nürnbergs Bürgerhäuser und ihre Ausstattung, Leipzig and Vienna, vol. 1, part 2, n.d., p. 547, ill. 672.

11 Alexander Freiherr von Reitzenstein, Rittertum und Ritterschaft. Bibliothek des Germanischen Nationalmuseums zur Deutschen Kunst- und Kulturgeschichte, vol. 32, n.d., p. 37.

12 Bruno Thomas, "Nürnberger Plattnerkunst in Wien," Anzeiger des Germanischen Nationalmuseums 1963, Nuremberg, 1963, pp. 89–99, especially, p. 91.

13 Johannes Karl Wilhelm Willers, "Bemerkungen zu Albrecht Dürers Interesse an Waffen, Kriegstechniken und Festungsbau," Anzeiger des Germanischen Nationalmuseums 1976, Nuremberg, 1976, pp. 72–75.

14 Albrecht Dürer, 1471–1971 (exhib. cat., Germanisches Nationalmuseum, Nuremberg), Munich, 1971, no. 597 (4).

15 Thomas, 1963, p. 92.

16 Helmut Nickel, Ullstein Waffenbuch, Berlin–Frankfurt–Vienna, 1974, pp. 88, 89; Thomas, 1963, pp. 92, 93.

tastes differed from that of Western Europeans. In Hungary and Poland, armor and weapons of the period tended to resemble those of their Turkish enemies. In fact, a group of helmets that Nuremberg armorers executed in the Turkish style may have been made for nobles living on the eastern borders of Europe.[17] There are also helmets of this type that bear Turkish arsenal marks; it is not altogether impossible that they came into the hands of the Turks as Hungarian or Polish booty, but there are also indications of trade relations between Nuremberg and Turkey at this time, politically awkward as such a connection may have been.[18] If this link existed, the helmets in question were possibly presentation pieces.

Despite frequent documentary references to ceremonial armor from Nuremberg and the large number of such presentation pieces that survive, it must not be overlooked that these represented only a small fraction of the armor produced in the imperial city. Contemporaneous documents record an extraordinarily large amount of "ordinary" military armor. In the sixteenth century, the majority of this was blacked armor whose sole ornaments were contrasting, highly polished stripes. Most impressive is the quantity of Nuremberg armor from the second half of the sixteenth century in the arsenal of the province of Styria, in Graz,[19] which, today, probably has the most important collection of conventional Nuremberg armor in the world. In actuality, Augsburg was the chief producer of ceremonial armor, with Nuremberg a serious competitor, but in the mass production of armor, Nuremberg surpassed Augsburg by far. In the mid-sixteenth century, Ferdinand I and his son Maximilian II preferred armor made in Nuremberg and Innsbruck, while Charles V and his son Philip II favored the products of Augsburg and Landshut.[20]

Nuremberg's economic and political decline began at the end of the sixteenth century. Armorers were especially affected by this, and, even more, by the fact that armor had lost its military significance by the seventeenth century. Etched decoration for armor experienced a second flowering in Nuremberg in the early seventeenth century, however, as evidenced by a group of seven lavishly ornamented sets of armor[21] whose etchers are known by name.[22] Of the four of these in Vienna, three were already old when the ornaments were added. Although the masters who executed these ornaments are known, no information exists about the armorers who created the armor itself. The last large commission from Nuremberg's armorers that is documented was placed about 1640–60. This was for 120 breastplates and backplates, with lobster-tailed helmets (Zischeggen); they still survive.[23] These simply made pieces, uniformly blued, are preserved in Schloss Forchtenstein in Burgenland, Austria, and all bear the Nuremberg inspection mark. The last set of regulations was imposed on the armorer's guild in 1624.[24] A notice from 1740 records the rapid decline of the armorer's trade; in the same century, it was absorbed into the plumber's trade. Sometime before 1832, the heirs of what had been a rich and productive craft made an armor to be worn by their chief master in a procession honoring the king of Bavaria.[25] This was the last work created in the tradition of Nuremberg's armorers.

17 Heinrich Müller and Fritz Kunter, *Europäische Helme aus der Sammlung des Museums für Deutsche Geschichte*, n.d., p. 337, ill. 115; C. O. von Kienbusch, "A Nuremberg 'casque'," in *A Miscellany of Arms and Armour Presented . . . to Bashford Dean*, New York, 1927, p. 57.

18 Four bronze-casters had set up a foundry for the Turks in Sofia (Bulgaria); see Johannes Karl Wilhelm Willers, "Die Nürnberger Handfeuerwaffe bis zur Mitte des 16. Jahrhunderts: Entwicklung, Herstellung, Absatz nach archivalischen Quellen," *Nürnberger Werkstücke zur Stadt- und Landesgeschichte*, Nuremberg, 1973, vol. 11, p. 300.

19 Helfried Valentinisch, "Nürnberger Waffenhändler und Heereslieferanten in der Steiermark im 16. und 17. Jahrhundert," *Mitteilungen des Vereins für Geschichte der Stadt Nürnberg*, 1977, vol. 64, pp. 165–82.

20 Bruno Thomas, "Kaiser Ferdinands I. Harnisch von Kunz Lochner," *Jahrbuch der Kunsthistorischen Sammlungen*, 1953, vol. 50, pp. 131–36, especially, p. 136.

21 Four in the armor collections in Vienna (see Thomas, 1963, pp. 93, 97, 98); three in the Germanisches Nationalmuseum, Nuremberg (*Germanisches Nationalmuseum: Führer durch die Sammlungen*, Munich, 1977, p. 238, ill. 581).

22 Hans Boesch, "Der Streit zwischen den Nürnberger Flachmalern und Ätzmalern 1625–1627," *Mitteilungen des Vereins für Geschichte der Stadt Nürnberg*, 1901, vol. 14, pp. 205–26, especially, p. 210.

23 Thomas, 1963, p. 99.

24 Reitzenstein, "Ordnung," p. 69.

25 *Die Meistersinger von Richard Wagner: Die Rezeptionsgeschichte einer Oper von 1868 bis heute* (exhib. cat., Germanisches Nationalmuseum, Nuremberg), Cologne, 1981, no. 33.

Hermann Maué

The Development of Renaissance Portrait Medals in Germany

The neighboring imperial cities of Nuremberg and Augsburg were the earliest centers of medal production in Germany at the beginning of the sixteenth century, and for centuries they continued to rival each other in this art. The very first German medals were cast in the Nuremberg workshop of the Vischer family, in the first decade of the century. These were small, occasional works that did not give rise to any direct successors (cat. nos. 187, 188). It was not until ten years later, in Augsburg, that the sculptor Hans Schwarz launched the tradition of portrait medals in Germany by producing them for a number of different clients.

This new art form had been created nearly eighty years before, in Italy, by Antonio Pisano, known as Pisanello. In 1432, he provided the mold for a large, two-sided cast medal in bronze of the Byzantine emperor John VIII Palaeologus, who had attended the Council of Ferrara. On the obverse of the medal is a bust of the emperor in profile, with an inscription in Greek giving his name and title; the reverse shows the emperor on horseback, and its Greek and Latin inscription identifies the medal as the "work of the painter Pisano." His later medals, as well, bear the same inscription: Opus Pisani Pictoris.

It seems especially surprising that the custom of producing portrait medals, which originated in Italy, did not catch on in Germany right away, given the extremely close commercial ties between Italy and Nuremberg, or Augsburg, for example. In a letter to the Augsburg *Bürgermeister* Sigismund Gossembrot from his son Ulrich, who was studying in Padua in 1459, we learn that Italian medals were certainly known in Germany. The student reports that he has sent his father a number of portrait medals in lead — among them, likenesses of some of his university professors. The relatively late appearance of the portrait medal in Germany was not a result of the lack of the necessary technology; it was simply that the appropriate intellectual climate was not yet developed there. Only with the spread of Humanism at the beginning of the sixteenth century, with its emphasis on the specific characteristics of an individual, did it begin to seem desirable to leave behind a record of one's ideas and deeds, and something of one's appearance and character, as well. This new philosophy was even expressed by Emperor Maximilian I: "The man who makes himself no memorial in life is forgotten with the tolling of his death bell." The wish to perpetuate memories of oneself — here championed by the emperor, himself — soon spread beyond the narrow confines of the ruling nobility. In no time, patricians and merchants from the cities eagerly took up the practice; Humanist scholars, artists, and, occasionally, even respected craftsmen began to commission portraits of themselves in either paintings or prints, the latter easily duplicated with the invention of the printing press. More durable than these portraits, however, were those in metal; when executed in gold or silver, their actual material worth gave them added value.

The emperor and those sovereign rulers authorized to issue coinage had the opportunity to immortalize themselves on minted coins — either on actual currency, or on *Schaumünzen* ("presentation medals") whose monetary value was only secondary. Thus, their appearance, as well as their various titles and offices, became widely known. The middle class had no such privileges; if one of its members wanted a

portrait medal, he had to commission a painter, sculptor, goldsmith, or founder to produce one.

There were no fixed rules about the manner in which a sitter might be portrayed. Although it is true that the great majority appear in profile, it seems to have been typical of one of the masters of the group known as "Nuremberg 1525/26," for example, to represent his subjects in three-quarter view (cat. no. 219). Frontal portraits, rare prior to 1550, became more frequent after the middle of the sixteenth century. The portrait length portrayed also varies: Depictions can be limited to only the head, in imitation of antique coins — as in the case of the *Medal of Sebald Rech* (cat. no. 202); these medals exclude all indications of the rank or wealth of the sitter, and are often regarded as memento mori. Many commemorative medals present the head alone (cat. no. 231); others depict a bust of the subject, either bareheaded and simply clothed, in the garb of a cleric (see cat. nos. 215, 218, 224), or with some distinctive head covering, such as a hat trimmed with feathers, or an ornamented cap or bonnet (see cat. nos. 213, 214, 230). The *Medal of Barbara Ketzel* (cat. no. 219) shows its subject in a bonnet adorned with a wreath of flowers, thereby indicating that she is either unmarried or engaged. On the *Medal of Johannes Stabius* (cat. no. 201), the sitter wears a laurel wreath, and the inscription underscores the fact that he is "poeta laureatus."

Medals from the first decades of the sixteenth century are frequently single sided. Those with two sides usually show the subject's coat of arms on the back, and perhaps a helmet with mantling and crest, and trophies of armor. Far less common are figural designs, such as allegories of Death or of the Virtues (see cat. nos. 231, 232). Inscriptions, in Latin or in German, whether in a straight line or in a circle around the edge, generally give the subject's name; they also may record his place of birth, his occupation, and both his age and the date of the portrayal — which may commemorate a specific event in his life. In addition, they may include a personal device, or motto. Earlier in the sixteenth century, with the new concern for the teachings of the Reformation, inscriptions were often taken from the Bible, in order to underscore the subject's faith in God, his yearning for salvation, or his religious devotion (cat. no. 218). Other inscriptions, in keeping with the spirit of Humanism, incorporate Latin mottoes either borrowed from the writers of antiquity or newly composed for the medals; for the most part, these stress *virtus* — an exemplary, irreproachable way of life (cat. no. 225). In some cases, the commissioner of a medal set such store by the inscription that he chose to have no pictorial matter, only writing on the reverse (cat. nos. 217, 226, 230).

Before a medal could be cast, it was necessary to produce a model. In the first half of the sixteenth century, in Germany, this was generally the province of the sculptor, or — as contemporary sources frequently refer to him — the "Konterfetter" (portraitist). Portrait sketches would be made in preparation for the carving of the model — as was the practice of Hans Schwarz. If the medal called for images on both sides, two such models were required. The model could be made of wood or of a variety of soft stone; wax models, in use first in Italy and later in France and in the Low Countries, did not appear in Germany until the end of the sixteenth century. Although it was common in Augsburg to carve a model in wood, the Nuremberg medalists tended to prefer Kelheim or Solnhofen stone. The model was impressed into a form of clay or some other substance whose composition was kept secret by each workshop. The molds for the two sides were then fitted together, leaving a cavity that would then be filled with molten metal. In the beginning, the models sometimes did not include any writing; in these cases, each letter of the inscription would have to be impressed separately into the mold using an alphabet of punches. This method was especially favored when the reverse of a medal called for writing only. Inscriptions could be easily changed using this technique, but it also happened that spelling mistakes might be introduced — as, for example, in Hans Schwarz's *Medal of Albrecht Dürer*, of

1520, whose punched-letter inscription includes the word "PICTORTS" instead of "PICTORIS" (cat. no. 216). (The wooden model of this medal, without its inscription, is preserved in Braunschweig.)

Wooden models tended to be preferred for the casting of larger bronze medals — these frequently were single sided and slightly crude — while, for finer work, primarily in silver, stone was more common. We learn from accounting records that the "Konterfetter" either cast the medal himself — often coming into conflict with the regulations of the goldsmiths and silversmiths — or was paid only for the preparation of the model, while specialists did the actual casting.

The account book of the Nuremberg legal advisor Dr. Christoph Scheurl contains an informative entry regarding a commission for a medal and the calculation of its costs. In 1533, he records a payment to the master Matthes Gebel of four guilders for the preparation of models for a medal with a portrait of Scheurl himself on the obverse and one of his wife, Katharina, on the reverse. Scheurl had Gebel cast five copies, and, in addition, he ordered two casts of an earlier medal, of 1527, of his brother Albrecht (cat. no. 223), who had died in 1531. Scheurl provided the silver for the casting in the form of seven "Joachimstalern." The account book documents what we can assume are standard practices, and, moreover, reveals that the number of medals contracted for by private individuals was generally quite small, due to the considerable expense of the material. When required, examples could be cast from earlier molds, as was true of the Albrecht Scheurl medal, if the casting models or — in the case of those medals produced by the lost-wax method — the original molds were preserved. As a rule, the models were kept by the person who commissioned the work, and, occasionally, they were gilded and then mounted in frames and displayed as cabinet pieces (cat. nos. 223 a, 232 a).

In the same record book, only a month later, Christoph Scheurl noted that he had sent one of these medals with a portrait of himself, along with some Nuremberg cakes, to Christina, the wife of his business partner Jörg Neusesser, in Joachimsthal — a clear indication that such medals were intended to serve as mementos for one's friends and associates. They were often exchanged among people who had never seen each other, or had been apart for a long time, but who maintained a friendly or scholarly correspondence: A letter of thanks from Erasmus of Rotterdam to the Nuremberg Humanist Willibald Pirckheimer shows this to have been a customary practice. The will of the Nuremberg goldsmith Wenzel Jamnitzer, which dates to the end of the sixteenth century, specifies that the children of his sister Ursula should each receive a silver medal with his likeness to remember him by.

It was chiefly as a result of the ideals of Humanism that portrait medals began to be produced in Germany early in the sixteenth century. Peter Flötner's *Cornerstone* medal (cat. no. 258), which documents the improvement of the fortifications around Nuremberg Castle in 1538, enlarges upon the subject matter of this art form. This is only the first of many such examples created to commemorate significant events, generally in the history of a specific locality. While the Flötner medal was commissioned by the Nuremberg city council, it later became customary for artists, on their own initiative, to produce historical medals, which they would sell at fairs and markets. In some cases, these medalists enjoyed imperial protection against imitators.

In the early sixteenth century, however, portraits remained the most important subjects of the German medalists. The variety of sitters and, accordingly, of the concepts of portraiture reveals the breadth of possibilities that evolved from the consultation between patron and medalist. A sitter could be represented on the medal either as he saw himself or as he wished to be seen by his contemporaries and by future generations.

Catalogue

Overleaf:
Figure 111 The city of Nuremberg, from Hartmann Schedel's *Chronicle of the World*. 1493 (see cat. no. 87)

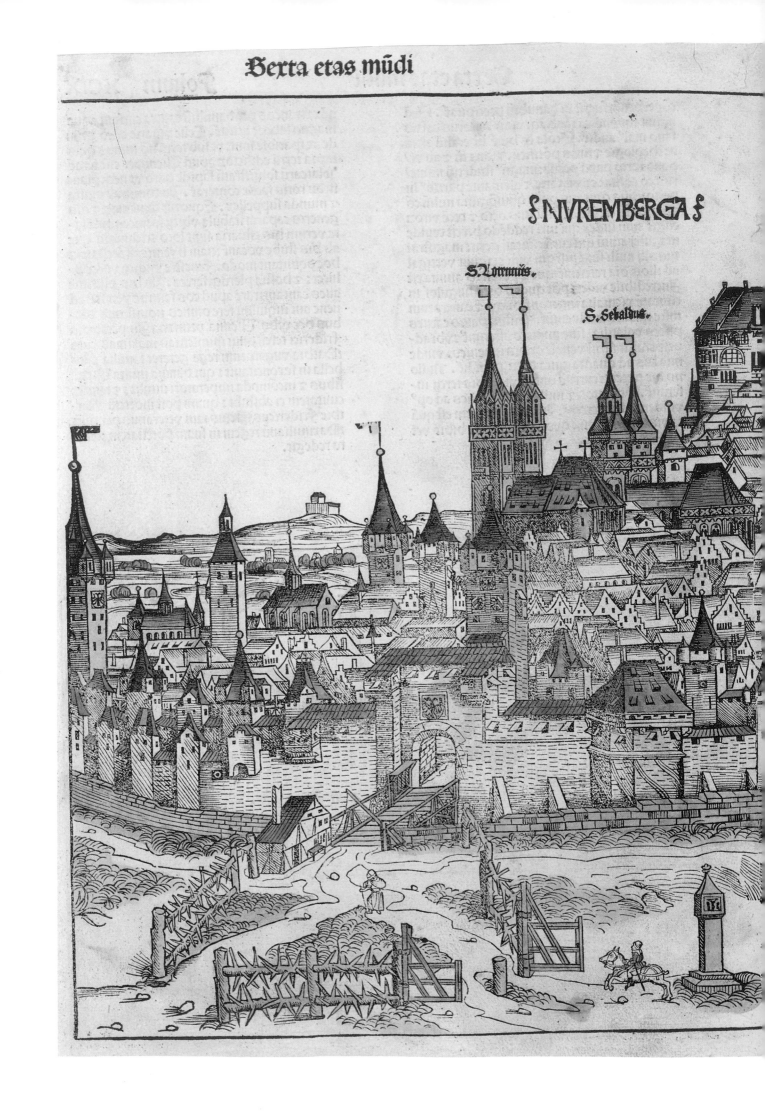

§NVREMBERGA§

S.Lorenius.

S.Sebaldus.

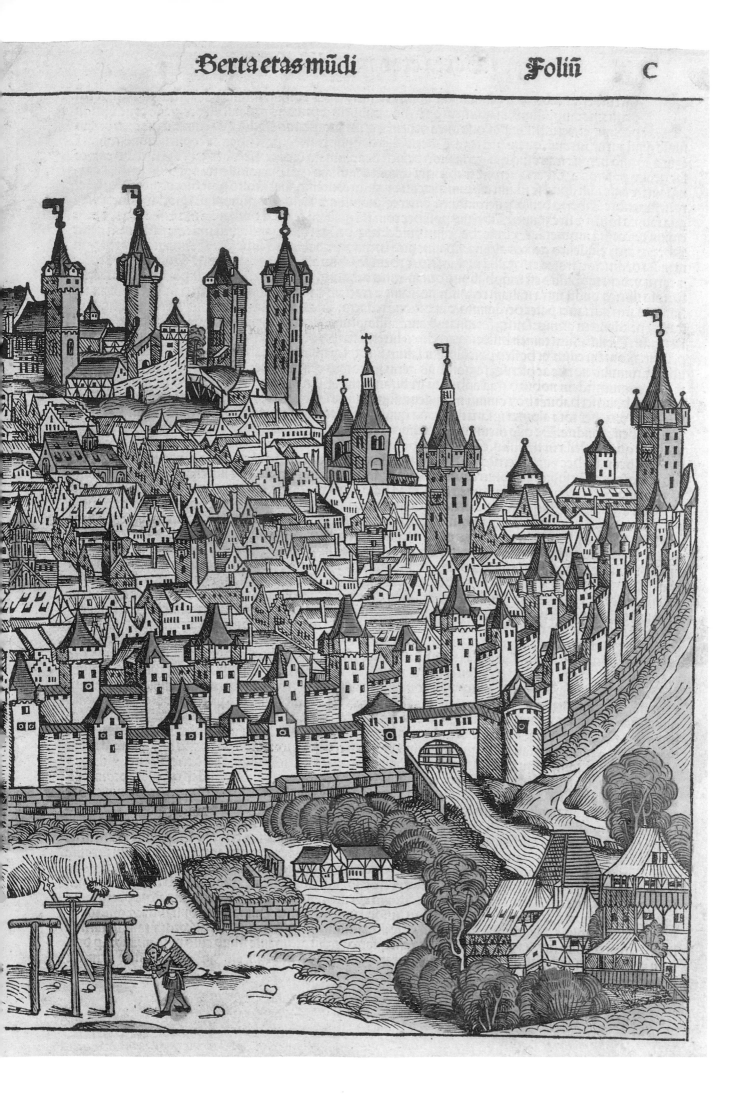

1 Saint Catherine

Nuremberg, about 1310
Gray sandstone
Height, 61 7/16 in. (156 cm.)
The polychromy is lost. The raised left hand, which, originally, held a small wheel, has broken off (prior to 1831), along with a portion of the drapery. The guard and the grip of the sword in the right hand, and major portions of the nose have been destroyed. Although the front fold of the gown has weathered away (prior to 1899), the remainder of the surface shows no visible traces of weathering.
Provenance: Sebalduskirche, Nuremberg, originally part of the Last Judgment portal; the sculpture has been inside the church since 1899.
Nuremberg, Sebalduskirche

The delicate, slender body of the saint is that of a young woman. Her torso leans only slightly to the side, at an angle to the vertical axis formed by the folds of drapery that cover her legs, but she bends back considerably. Her left hip is thrust forward and accentuated by the extra fabric caught up by her left hand, which once held a wheel, the instrument of her martyrdom. Catherine's gown — only visible at the shoulders, underneath her robe, and in front of her left leg — has long, tight sleeves. Over the gown she wears a full-length, unbelted, sleeveless robe. An open cloak, draped over her shoulders, is held together by a broad band across her chest, below the neck. The cloak falls in long, curving folds on either side, following the contours of her body. With her left hand she

clutches both her robe and her cloak, creating deep transverse folds in front, and vertical ones at the sides — the delicate, wavy lines of the fabrics of the two garments becoming almost indistinguishable. The only hollow in the folds is on the opposite, right side, between the torso and the taut hem of the cloak. Catherine's right hand, which hangs listlessly against her leg, holds the sword without actually gripping it, and also catches a bit of the cloak, so that it becomes part of the overall play of folds across the front of the figure. The only places in which one can detect the ponderation of the saint's body are in the dark area between the body and the fabric, and beneath the straight, rigid edges of the cloak. The gentle curve of the body, and the calm, yet highly detailed rhythm of the drapery are in keeping with the saint's delicate, animated face. Catherine wears a narrow crown atop her carefully curled, long hair. Precise curving lines define her arching eyebrows, eyelids, and her small pointed mouth, which, along with her high forehead, correspond to the fourteenth-century ideal of feminine beauty. The individual features are sharply delineated by curving lines, and, in combination with the highly sculptural quality of the surface of the face, grant the figure an overall sensual softness and a spirited vitality that constitute its beauty and its charm.

The lifelike quality of the leaning pose of the saint's body, its ponderation, and the three-dimensional richness of the drapery folds together make the figure a unified form. "It is

only the body that forms a gentle curve, not the block itself, and this gives her an air of lightness in her stance" (Martin, 1927). Just as the straight edge of the cloak checks the curve of the torso, on the right side — specifically, in the lower portion of the figure, and in the base — the limitations of the square stone block from which the sculpture was carved are still apparent. The hems of the garments that fall from the left arm, and the (missing) attribute mark the front edge of the stone. The lines of the drapery folds and of the limbs — especially the major verticals of the legs, beneath the gown — are realized on a plane that recedes from the edge nearly to the core of the stone block; this effect is magnificently balanced by the forward thrust of the pelvis and by the turning of the face to the right.

Art historians have long recognized that the Saint Catherine master — the most important sculptor in Nuremberg in the fourteenth century, and the leading artist of the so-called first Sebaldus workshop — must have come to Nuremberg from somewhere along the Middle Rhine, probably from Mainz. The definitive precursors of his style — characterized by the subtlest of artistic means — are the fragments from the tomb monument of Archbishop Gerhard II of Mainz, of about 1300, and the Virgin from the portal of the Liebfrauenkirche, in Mainz, dedicated in 1311. In the thirteenth century, there was, as yet, no native tradition of stone sculpture: Isolated tomb figures were created by craftsmen from outside Nuremberg. Only after 1309, when it was decided to enlarge the side aisles of the Sebalduskirche and to adorn the portals with figural sculpture, were there finally sufficient commissions to occupy artists and craftsmen for a full two decades. The first project undertaken was the Last Judgment portal on the church's south side (fig. 112); this was followed by the north portal, with the Dormition, Burial, and Coronation of the Virgin in the tympanum, and by the so-called Bridal portal, with the Wise and Foolish Virgins (fig. 113) — opposite which was the *Prince of the World* (cat. no. 4). Other, related works by the Saint Catherine master include a round, stone medallion bearing the Nuremberg coat of arms — an eagle with the head of a king — from a building directly across from the west choir of the Sebalduskirche (fig. 73), and the crowned head of a saint, quite like that of the *Saint Catherine,* preserved in the Heimat-Museum, in Schnaittach, near Nuremberg (Müller, 1948, ill.).

The Last Judgment portal, executed under the direction of the Saint Catherine master, although containing much sculpture that is less exquisitely detailed than his, parallels the subject matter of the choir screen of the cathedral of Mainz. That work was created about the middle of the thirteenth century by a master who is recognized — on the basis of his later works in Naumburg — as one of the leading German sculptors of the Middle Ages. Various elements from the Last Judgment portal of Bamberg Cathedral were also adapted for the Sebalduskirche — most notably, the general arrangement

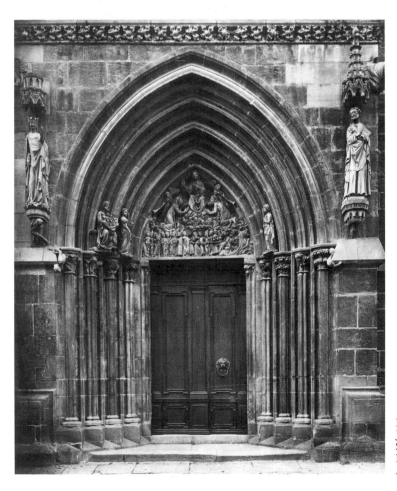

Figure 112 The Last Judgment portal of the Sebalduskirche, Nuremberg. About 1310

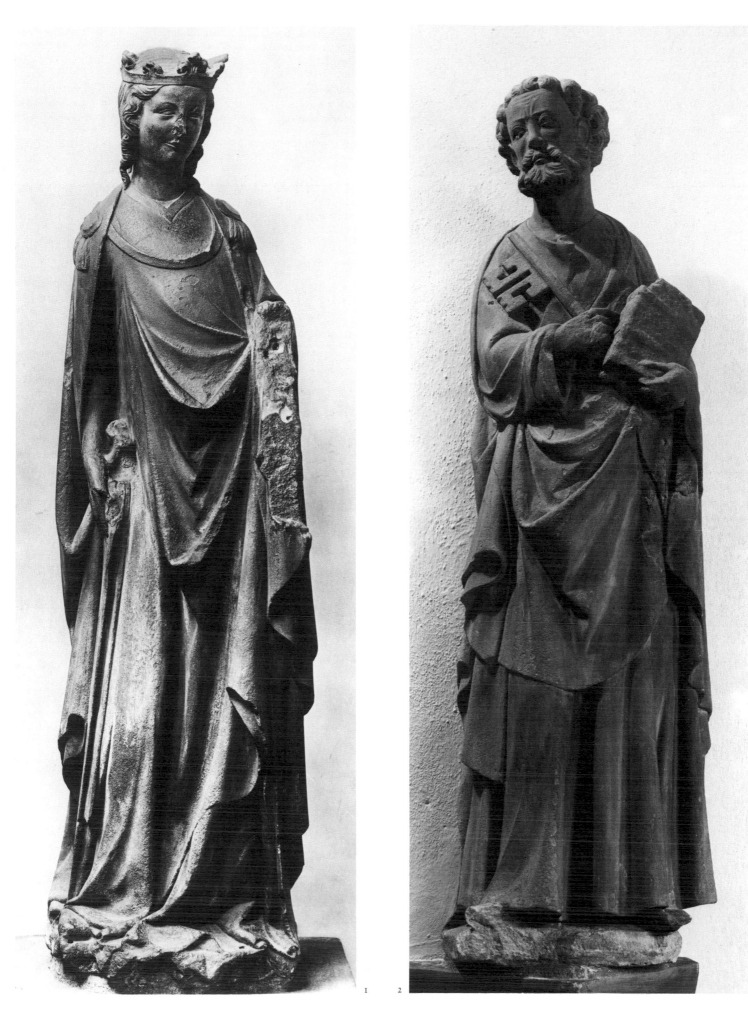

1 2

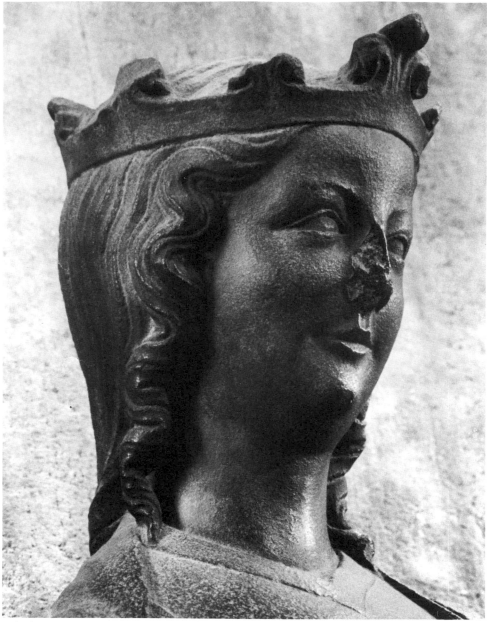

1: detail

of the tympanum and the figure of Abraham with the souls of the just in his lap, in the archivolts.

Following the compositional scheme in Bamberg — the Last Judgment in the center, and the figures of Ecclesia and Synagogue on either side, on their own bases and beneath their own baldachins — the Nuremberg sculptors introduced the figures of Saints Peter and Catherine, but they were unable to relate them to the subject matter of the Last Judgment either in terms of meaning or of composition. In Bamberg Cathedral, the iconographic program is more ambitious. Synagogue and Ecclesia, representing the Old and New Testaments, underscore the salvational, apocalyptic significance of the Last Judgment. In Nuremberg, in the more modest setting of a parish church, it seemed appropriate to substitute sculptures of two saints especially revered in the city, Peter and Catherine; special shrines in their honor were situated in the west choir, adjacent to the portal. The altar in the new west choir had been conse-

crated to Saint Peter in 1274, and in the crypt below it there was an altar dedicated to Saint Catherine; the latter altar was moved up into the church after the middle of the fourteenth century, when the Saint Peter altar was transferred to the east choir. In fourteenth-century documents, the west choir is alternately referred to as the Saint Peter or Saint Catherine choir.

Entwined around the console of the *Saint Catherine* is an unidentified, slender, youthful figure, whose dance-like movements once again demonstrate the master's ability to create individual figure types out of rhythmically organized sculptural forms.　　　　R K

BIBLIOGRAPHY: Mayer, 1831, p. 17; von Rettberg, 1854, p. 24; Hoffmann, 1912, p. 151, ills. 137–138; Pinder, 1914–29, p. 36; Bier, 1922, pp. 8, 12, ills. 12–13; Höhn, 1922, pp. V, 113, ills. 1–2; Pinder, 1924, p. 16, ill. 9; Martin, 1927, pp. 13–15, 18, 26, 144, no. 109, ills. 67, 69; Panofsky, 1929, p. 18; Müller, 1948, pp. 33–34; Pfeiffer, 1971, ills. 120 (console), 125 *(Saint Catherine);* Fehring and Ress, 1977, pp. 126, 128; Schwemmer, 1979, ill. 31.

2　Saint Peter

Nuremberg, about 1310
Gray sandstone
Height, 60 5/8 in. (154 cm.)
The polychromy is lost. There is damage to the book and to the hands, and crumbling of the stone on the hem of the robe below the left hand; the tips of the feet have broken off.
Provenance: Sebalduskirche, Nuremberg, originally part of the Last Judgment portal, but, about 1899, the sculpture was moved inside the church.
Nuremberg, Germanisches Nationalmuseum (on permanent loan from the Sebalduskirche since 1921)
Pl 0.2277

The sculpture of Saint Peter, designed as a counterpart to the one of Saint Catherine (cat. no. 1), was clearly intended to occupy a place to the right of the central portal, as indicated by the overall pose and by the turn of the head. Although less subtly carved, and even somewhat simpler in conception, it is, nonetheless, considered to be the work of the Saint Catherine master. The similarity in the compositions of the two works — with their masterfully nuanced forms — is more direct proof of this than is the treatment of their individual details (Martin, 1927). The present figure seems more solid and less delicate than the slender and graceful young woman. The ponderation of the body — with the left shoulder drawn back and the head emphatically turned aside — is achieved somewhat less obviously, here, than in the figure of the *Saint Catherine,* to be sure, and is virtually hidden by the long, vertical folds of the robe and, especially, of the apron-like cloak, yet it does determine the artistic invention of the figure in a similar way. The manner in which the extremely narrow shoulders and the small but quite independently developed head contrast with the fuller forms of the body and its drapery shows that both sculptures display the same basic conception of the human form. The saint holds his attributes of the book and key at an angle in front of his chest in such a way as to underscore the imposing effect of the head, betraying a kind of artistic calculation that is also characteristic of the composition of the *Saint Catherine.* Saint Peter's face — composed of a proliferation of graceful curves — when perceived in its totality, can readily be compared with the lovely face of the female saint standing across from him, however different the underlying theme of each work.

Regarding the original placement of the statue, see cat. no. 1.　　　　R K

BIBLIOGRAPHY: Mayer, 1831, p. 17; Hoffmann, 1912, p. 151; Schulz, 1922, p. 10; Martin, 1927, pp. 13–15, 25, 31, ill. 68; Stafski, 1965, no. 23, ill.; Fehring and Ress, 1977, p. 126.

3 Virgin and Child

Nuremberg, about 1310–20
Gray sandstone
Height, 40 1/16 in. (117 cm.)
There are traces of the original polychromy and
gilding: the cloak is red highlighted with gold, the
hair and crown of the Virgin golden. The head of
the Child is missing. There is a crack through the
center of the figure of the Virgin, and her nose is
damaged.
Provenance: church at Rosstal, near Nuremberg.
Nuremberg, Germanisches Nationalmuseum
(acquired, 1879)
Pl 0.1836

The Virgin's garments almost completely ob-
scure her form, the soft vertical folds of her
drapery covering her feet and the ground below.
She holds her active Child at the level of her left
shoulder. The dominant sculptural motif —
aside from the twist of her torso — is her arm,
which is bent at an angle across her breast and
enveloped in taut drapery, creating a bold and
highly decorative design element. Formally, this
gesture causes a tension in the fabric of the cloak
stretched tightly across the elbow, while draw-
ing attention to the essential content of the
group — the mother playing with her child.
While Mary holds fast to the baby Jesus with
both hands, her right hand against his bare
chest, the Child reaches out with his right arm
for his mother's crown, pressing it down onto
her forehead. This motif is found neither in the
earlier art of Franconia nor in that of later cen-
turies, and, thus, would appear to be unique to
the period. Certainly, it would be incorrect to
read the gesture as simply an expression of play-
ful mischief on the part of the Child; it hardly
seems possible that the Christ Child would
want to take Mary's crown from her, even in
play. A major theme of Medieval art, the coro-
nation of the Mother by her Son, clearly is
implied, even though, here, it is linked to a mo-
ment of spontaneous affection between the two.

The Virgin's narrow shoulders, receding tor-
so, and outer garment reaching to her knee, like
an apron — combined with the ponderation of
her draped form — together create an effect of
widening at the base that underscores the tri-
angular outline of the figure. In its conception,
the Virgin typifies the sculpture of the so-called
first Sebaldus workshop, which is encountered
repeatedly in the art of Nuremberg dating from
this period — most markedly, in the statue of
Saint Peter (cat. no. 2). Yet, the three-dimen-
sionality of this drapery, the fuller forms of the
Virgin's face, and the accentuation of her ges-
tures — specifically, of her arm extending across
her chest — contrast with the pronounced
linearity and the calm, restrained formal idiom
of the work of the Saint Catherine master.
Although the stylistic means of the two sculp-
tors basically are similar, we can recognize in
the master of the Rosstal *Virgin* a different,
more passionate temperament. RK

BIBLIOGRAPHY: Josephi, 1910, no. 11, ill.; Schulz, 1922, p.
11, ill. 8; Martin, 1927, pp. 27–28, 37, 150, no. 173, ill. 8;
Müller, 1951, pp. 25–26; Stafski, 1965, no. 24, ill.

3

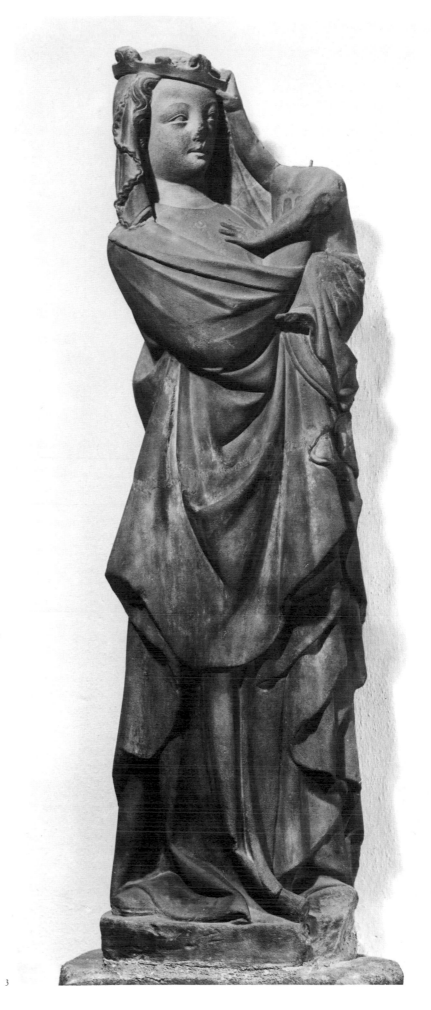

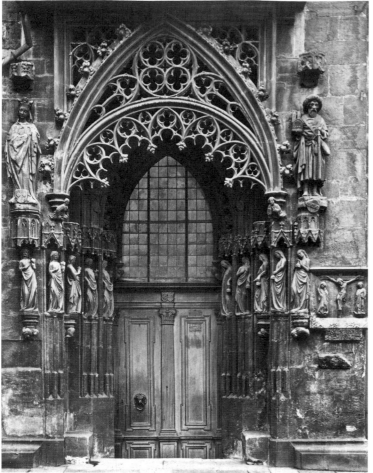

Figure 113 The Bridal portal of the Sebalduskirche, Nuremberg. About 1320–30

4 The Prince of the World

Nuremberg, about 1320–30
Gray sandstone
Height, about 55 1/8 in. (140 cm.)
The lower section of the cloak, at the right, has broken off. The surface is badly weathered and worn. The feet and base have been replaced, and it is possible that the hands have been reworked. Originally, the right foot was probably not placed so far to the side.
Nuremberg, Sebalduskirche

The figure of a young man stands with his right leg slightly to the side and his hands held at different heights in front of his body. He is dressed in a cloak with a number of slits up to the level of the underarm and with leg-of-mutton sleeves adorned with rows of buttons along the tighter forearms. It is possible that he is wearing gloves. His hair has been arranged in a fashionable style with corkscrew curls, and his face bears a distinct smile. When the figure is viewed from behind, one sees that the cloak is cut away; that entwined about his limbs are serpents, toads, and other such creatures, two of whom have eaten deep holes into his buttocks; and that, above, in his back, the flesh has been gnawed away from the bones.

The *Prince* is a personification of *Mundus* (the World), a popular figure in literature since the twelfth and thirteenth centuries. His outwardly seductive beauty is actually deceiving, and his true nature — deadly, revolting, and,

inwardly, totally corrupt — is only revealed to mortals after they have wallowed in and recognized the vanity of the pleasures of this world. Such an allegory of the World, in the form of a person who leads men astray and corrupts them, early on, was associated with Christ's adversary, whom he refers to as the "prince of this world" (John 12:31, 14:30, 16:11). These biblical passages imply — and medieval texts universally agree — that this prince of the world is, in fact, the Lord of Darkness, the Devil, the great Deceiver himself. He was first portrayed in about 1280, in the sculptural program of Strasbourg Cathedral, situated among the other figures on the south portal of the cathedral's west front, which is devoted to the Last Judgment. Wearing fashionable clothing and a coronet, and holding an apple in one hand, he faces one of the Foolish Virgins, who turns toward him obligingly and appears to be loosening her garments. There, too, he smiles seductively. The parable of the Wise and Foolish Virgins (Matthew 25) frequently was included among the images of the Last Judgment during the Middle Ages: The wise ones, cautious enough to provide themselves with oil, are led into Paradise by Christ, their heavenly bridegroom, while the foolish ones, who have wasted their time with useless things, are left behind. According to the usual interpretation of the story, the latter concentrated on singing, dancing, and self-adornment instead of on their salvation. Once they came to be included in the context of a Last Judgment

portal, as in Strasbourg, it was only logical that they be accompanied by the *princeps mundi*, just as the Wise Virgins were accompanied by Christ. The same subject appeared on the west façades of Basel and Freiburg cathedrals before the end of the thirteenth century. In Basel, a handsome, laughing youth, holding his gloves — the ultimate foppery — in one hand and a flower in the other, stands opposite one of the Foolish Virgins (the only one to have survived). In Freiburg, where the original sculptural program has been obscured by later additions, the counterpart to the Prince is an allegory of *Voluptas*, a beautiful, nude female figure with a goatskin as her attribute — a symbol of gross, sensual desire. At the cathedral of Worms, the counterpart to the Prince is a fourteenth-century representation of *"Frau Welt,"* a parallel that is commonly drawn in literature, as well (*Welt*, the German word for "world," is feminine in gender as opposed to the Latin *mundus*). As is the case with the *Prince* in Nuremberg and with the analogous *Frau Welt* in Worms, such figures are always shown being devoured by vermin — a fact that is hidden from the Foolish Virgins and, virtually, from those spectators who view the sculptures from the front.

The Nuremberg *Prince* has no crown. He once may have held an apple or a flower in his hands. For centuries, he has stood before one of the buttresses of the north wall of the Sebalduskirche, his face turned toward the portal of the Virgin and his back to the Bridal portal with the Wise and Foolish Virgins. This cannot be the original — or intended — arrangement. The Wise and Foolish Virgins are sometimes part of Marian portals instead of Last Judgment portals, inasmuch as the wise ones, with Christ as *sponsus* (spouse), take part in the coronation of the *sponsa* — Mary — in heaven, but there is also a precedent for them to appear independently, as in Nuremberg. In the Middle Ages, weddings were performed near the Bridal portal, and the parable was, thus, a fitting admonition to the bridal couple on such occasions. The Prince of the World, however, usually has no connection to a Marian portal, but only to the Foolish Virgins — if his smiling face is turned toward them: The Virgin on the edge of the group, in Nuremberg, like her sisters in Strasbourg and in Basel, appears to be attracted to him. In Nuremberg, too, he originally must have stood beside, or in front of, the Bridal portal, most likely alongside the outer corner of the abutment pier, so that — as was the case with earlier examples of the figure, elsewhere — only those who circled the *Prince* could catch a glimpse of his back. This would mean that the figure would have had to have been turned 180 degrees from its present position. Given its sculptural articulation, this would seem to have been quite possible, even though the drapery on the side of the figure now exposed to view appears to be slightly richer. In this diagonal position next to the corner of the buttress, the figure's extended right leg still would have been effective, and the imploring position of the hands easily seen. The viewer would have observed the *Prince* virtually

from the front, and not, as today, in profile. The Bridal portal was considerably altered as early as the fourteenth century, most notably, by the addition of a screen that was suspended before a small vestibule. At that time, the large figures of Saint Sebald and the Virgin also were added, above the Wise and Foolish Virgins. It is possible that the *Prince of the World* was moved from his original location at that early date, and that the small epitaph with the Crucifixion occupied his place until the church was damaged in World War II.

Stylistically, the *Prince of the World* belongs among the latest and most simply designed sculpture by the so-called first Sebaldus shop, which worked on the church until about 1330. Disregarding its iconography, the artistic invention and sculptural quality of the *Prince* are weak. The work must have been created immediately after the Wise and Foolish Virgins of the Bridal portal. RK

BIBLIOGRAPHY: Mayer, 1831, pp. 9—10 (with earlier interpretations); von Rettberg, 1854, p. 38; Hoffmann, 1912, p. 143, ills. 64—65; Schmitt, 1922, pp. 125—27, ills. 39—42; Martin, 1927, pp. 23—24, 145, no. 118 (with additional bibliography), ills. 93—95; Stammler, 1959, pp. 26—27, ill. 5; Pfeiffer, 1971, ills. 121—122; Fehring and Ress, 1977, p. 125; Schwemmer, 1979, ills. 19 (present position), 35.

5 The Annunciation

Nuremberg, about 1360
Gray sandstone
Height: of the Virgin, 54 5/16 in. (138 cm.); of the Archangel Gabriel (including wings), 55 1/8 in. (140 cm.)
The hands of the Virgin have been damaged and their position altered; her nose is bruised, and there is damage to the hem of her garment below her left hand. The archangel is missing his hands entirely, and the drapery folds across his body and over his feet are badly weathered. His wings, and the inscription on the ribbon, were restored in 1879/80. Originally, the group was polychromed, but no traces of pigment remain.
Provenance: south portal, Frauenkirche, Nuremberg.
Nuremberg, Germanisches Nationalmuseum (acquired, 1927)
Pl 0.2425-26

The Frauenkirche, erected by Emperor Charles IV, from 1349 to 1358, in the Hauptmarkt on the site of the demolished synagogue, contains much sculptural ornament, nearly all of which is related to the life of the Virgin. Christological motifs appear only on the keystones of the vaulting. Except for the choir figures inside, the lavish sculptural cycle is almost entirely limited to the vestibule, with its portals; the sculptures in the niches of the west pediment have been missing for a long time. The Annunciation to Mary by the Archangel Gabriel was depicted on both of the quite simply designed portals on either side of the nave, as well as in two more places inside the church.

The figures of the Virgin and of the angel of the Annunciation originally stood facing each other on their own consoles and beneath their individual canopies, separated by the width of the intervening doors. Their forms are heavy and compact, and their draperies lie flat against their bodies, falling to the ground in a few simplified folds, without creating the interlocking or transverse patterns of lines characteristic of older sculpture.

The Virgin is noticeably pregnant, her body protruding significantly beneath her robe. The angel's words, "The Holy Ghost shall come upon thee, and the power of the Highest shall overshadow thee" (Luke 1:35), originally, were translated even more directly into three-dimensional imagery, for the dove of the Holy Ghost was shown on top of the Virgin's stomach — on the place where her left hand now rests. To nineteenth-century sensibilities, this image seemed far too graphic; thus, during the restoration of the Frauenkirche in 1879/80, the prudish Church Fathers had the dove removed and the position of the Virgin's hand altered. Nevertheless, such an explicit portrayal of the conception at the very moment of the Annunciation, with the Virgin's pregnancy already visible, was uncommon in the fourteenth century, although not unprecedented. Examples of this iconography are known, especially in the art of Bohemia and in those works influenced by it (L. von Wilckens, 1965): According to medieval interpretation, Jesus was already fully developed in the Virgin's womb at the moment of conception — a body complete with all its organs and limbs.

Stylistically, the figures from the Frauenkirche are radically different from earlier Nuremberg sculpture of the first half of the fourteenth century: Their garments are no longer characterized by rhythmic lines, and the sway of their bodies also differs; instead, they are primarily solid forms. The ponderation of their bodies is suggested by the distribution of masses, but it is, nevertheless, restrained. Violent contortions are avoided, as are all configurations of drapery that do not conform to the shape of the original block of stone. The figures have heavy, broad heads with large oval faces set atop wide necks. The sculptures in the vestibule of the Frauenkirche — followed by the south portal figures of the Virgin and Gabriel — are related, stylistically, to the contemporary sculpture of Prague, from the circle of Peter Parler. Just as the architecture of the Frauenkirche reveals the influence of this celebrated Prague architect, it is clear that its sculptors also came from the artistic milieu that developed at the court of Charles IV. Although the emperor usually resided in Prague, he was especially fond of Nuremberg. As expressed in his founding document for the Frauenkirche, in 1355, he had "built, founded, and created the new church for the glory and renown of his reign . . . in his imperial city of Nuremberg." RK

BIBLIOGRAPHY: Martin, 1927, pp. 73, 75, 126, nn. 19, 140, nos. 54—55, ills. 220—221; Bräutigam, 1965, p. 180; Stafski, 1965, nos. 37—38, ills. 37—38; Wilckens, 1965, pp. 33—34, ill. 2.

emerges — above a skull — out of a hillock. The blood streaming down Christ's arms and side is rendered three dimensionally by means of hemp fibers glued in place. The leafy pattern of the tooled gold background reveals the outlines of the missing figures of the Virgin and Saint John.

On the inside of the left wing the Flagellation of Christ is represented, over which is a pelican piercing its breast in order to feed its young with its own blood. On the inner side of the right wing, above the Lamentation, is the legendary phoenix, which immolates itself and then rises, reborn, from its ashes. The exteriors of the wings depict Christ on the Mount of Olives with the attendant angel, and the Crucifixion with an angel wringing his hands. On the back of the central section, Christ appears as the Man of Sorrows amidst the *arma Christi* — the instruments of the Passion — that he turned into weapons against mortality and the devil with his own death: Included are — from left to right, and top to bottom — the column of the Flagellation, the ladder to the cross, the lance, the vinegar-soaked sponge, burning torches, the dice and the sacred robe, the cross, a scourge and a bundle of switches, a hammer and tongs, the lantern from the nocturnal arrest, the Mount of Olives, and the tomb,

6: wings closed

6

6 Reliquary Altarpiece

Nuremberg, about 1360
Tempera on chalk ground and canvas, mounted on linden wood
Height (overall), 55 in. (141.4 cm.); width (open), 34 3/4 in. (89 cm.)
The figures of the Virgin and Saint John, which once flanked the Crucifixion, are now missing. Thode (1891) referred to them; Josephi (1910), only to Mary; and the 1931 exhibition catalogue noted both figures were lost — as are the finials on either side of the altar gable, the crockets along its front edges, and portions of the tracery on the back edges. Very little of the tracery is preserved. The

frame around the Crucifixion has been restored.
Nuremberg, Germanisches Nationalmuseum (acquired by 1856)
KG I

The central part of the altarpiece, culminating in a gable that terminates in a cruciform pinnacle, rests on a high base ringed with molding. Along the sides of the base is a series of niche-like depressions painted alternately red and blue and topped by tracery canopies. The crucified Christ — all that remains of a Crucifixion group — occupies the central part of the altarpiece. The cross, decorated with vine motifs,

120

in the form of a sarcophagus. The symbol of Christ's resurrection is the lion, which breathes life into its stillborn cubs on the third day. Above, in a medallion, is the *vera icon* — the true image of Christ, which appeared on Saint Veronica's veil.

This small altarpiece of the Passion is unusual in being virtually complete. As for the form of the reliquary altarpiece, there are parallels in Cologne (see *Vor Lochner,* 1974); for the representation of the *arma Christi,* see Berliner (1955).

The painter limited the number of figures: Only one soldier administers the scourge; Simon of Cyrene, alone, accompanies Christ as he carries the cross. The focus is on the fundamental message rather than on a complete retelling of the story. In the portrayals of the pelican, the phoenix, and the lion, the significance of the Redemption is once more conveyed in symbolic form. There is no clear sense of space, and the only objects included are those required to identify the setting: the column, the cross, and the olive tree. A continuous horizon line curves through the Agony in the Garden and the scene of the Bearing of the Cross, suggesting a uniform background. The wealth of objects in the painting on the reverse side of the shrine is in keeping with the chosen theme — the *arma Christi.*

This reliquary altarpiece has always been thought to be Franconian in origin — specifically, from Nuremberg. Among earlier related works, the closest in style are the fragments of an altarpiece of the Passion in the church at Heilsbronn, believed to date from sometime between 1340 and 1350. Kurth (1929) addressed the entire group as "stylistic offspring of the Viennese school," calling the four painted panels attached to the back of the Nicolas of Verdun altarpiece in Klosterneuburg, in Austria, the most striking of all.

The slender and supple figures that stand like cutouts in front of the gold background, with its tooled leafy ornament; the fluid outlines of the hems of the garments; the idealized heads; and the attributes that are included because of their connections with the figures, not to promote spatial continuity — all, are purely Gothic elements. The lesser subtlety of the present paintings, as compared to those in Klosterneuburg — specifically, the softening and more pronounced shading of the colors, which makes the figures appear to be shrouded in mist — reveals not only their provincialism, but also the heightened realism of their conception. KL

EX COLLECTION: Hans Freiherr von und zu Aufsess (before 1856).

BIBLIOGRAPHY: Thode, 1891, p. 13; Josephi, 1910, no. 219; Kurth, 1929, pp. 45–46; Zimmermann, 1930–31, p. 24, pls. 30–32; *Nürnberger Malerei,* 1931, no. 30; Stange, 1934–61, vol. I, p. 200; von der Osten, 1935, p. 61, n. 7; Lutze and Wiegand, 1936–37, p. 113, ills. 1–3; Berliner, 1955, p. 56; Stafski, 1965, no. 45; Vetter, 1972, p. 214; Stange and Strieder, 1978, no. 4.

6: detail of reverse

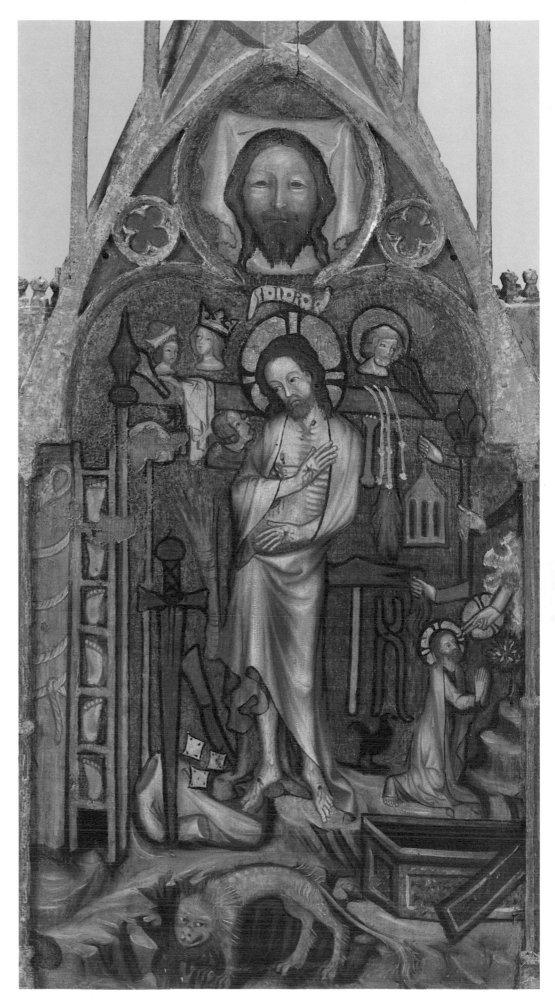

7 The Crucifixion, with Two Female Donors

Nuremberg, about 1330/40
Pot metal and white glass, with violet, light violet, green, light blue, and yellow, and flash glass in red
24 1/4 x 8 7/8 in. (61.5 x 22.5 cm.)
The paint on the body of Christ is somewhat worn. In the garment of Saint John, some of the red vitreous paint is missing. The background to the left of the crucifix has been replaced.
Provenance: Haus zum Goldenen Schild (Schildgasse 23), Nuremberg (until 1856).
Nuremberg, Germanisches Nationalmuseum (acquired by 1883)
MM 27

The Crucifixion scene in this tall and narrow, rather small window comprises only Christ on a tall cross and the two figures of the Virgin and Saint John against a background pattern of vines. There is no suggestion of space. At the bottom are two diminutive kneeling women — the donors of the work, who are neither identified by name nor by coats of arms. The inscribed banderoles above their heads contain only general appeals to the Savior: AVE·BENIGNE· THV·SALVA ME· and MISERERE·MEI·DEVS·. The body of the dead Christ hangs heavily from the slender, violet cross. His arms are stretched above his head, which has sunk down onto his right shoulder and arm. The expansive loincloth (also violet), with its rich folds, covers the lower body, extending far down to one side. Christ's feet are crossed and fixed to the shaft by means of a single nail. The figures of the Virgin and of Saint John, the favorite apostle, standing well below the cross, have been composed with a strict sense of symmetry. Their bodies are ponderous, although they lack three dimensionality. The figures, who have small heads, bend their torsos outward. Mary wears a red mantle over a green gown; John, a green cloak over a red undergarment. Each holds a gospel book — an attribute generally only associated with the Evangelist. The two donors, dressed in long flowing robes of violet and light blue and in white veils, gaze up at Christ with their hands folded. Most unusual is the color of the figures' skin — a genuine flesh tone, instead of the customary light violet.

This panel comes from a window in the chapel of a private house — to which its small format is most suited. The house in question traditionally was the one known as Zum Goldenen Schild; it belonged to the patrician Grundherr family in the fourteenth century. Its chapel was still in existence in the nineteenth century, but surviving illustrations of it do not show this particular window.

In the context of Nuremberg art of the fourteenth century, the style of this work is unparalleled. After two small thirteenth-century panels in the church in Henfenfeld, near Nuremberg (fig. 98), the next-oldest major examples of medieval stained glass from Nuremberg are the windows of the choir of the Sebalduskirche (begun in 1361), the majority of which survive (fig. 99). Most of these panels date from 1379 to 1386 (Frenzel, 1954). Only

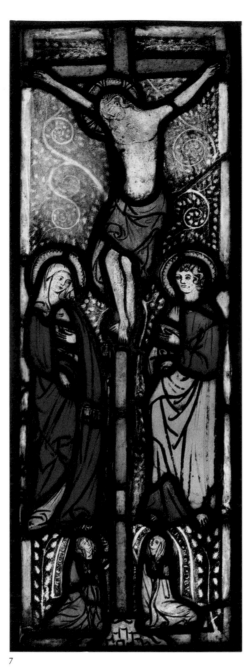

7

fragments remain from the somewhat older windows that Emperor Charles IV commissioned for the Frauenkirche in 1358 (Frenzel, 1962; Pfeiffer, 1971, ill. 22). In its distinct linearity, this earlier panel from the Haus zum Goldenen Schild bears no resemblance whatsoever to the definitive first flowering of the Parler style of Nuremberg stained glass, from the second half of the fourteenth century — nor can it be compared to contemporary panel painting or manuscript illumination, although, admittedly, only little is known of the former, and the latter has yet to be thoroughly studied.

RK

EX COLLECTIONS: Freiherrn von Grundherr (until 1856); the antiquarian A. Pickert, Nuremberg.

BIBLIOGRAPHY: Kantzsch, 1931, pp. 12, 27–28, 38–39, 60; Schulz, 1933, pp. 513–14, ill. 620 (on the Haus zum Goldenen Schild, see pp. 504–16); Ulrich, 1979, p. 278, n. 5.

8 a) The Bishop of Assisi Giving a Palm to Saint Clare

Nuremberg, about 1360
Tempera and gold on oak
13 1/4 x 8 5/8 in. (33.5 x 22 cm.)
New York, The Metropolitan Museum of Art, The Cloisters Collection, 1984
1984.343

b) The Death and Coronation of Saint Clare

Nuremberg, about 1360
Tempera and gold on oak
40 3/8 x 14 1/4 in. (102.5 x 36 cm.)
The work is pieced together from two fragments; the upper panel is gilded along the sides. On the reverse are lilies and stars against a green background.
Nuremberg, Germanisches Nationalmuseum (acquired, 1927 and 1928)
Gm 1161, 1187

These two panels are from an altarpiece devoted to the life of Saint Clare, from which a number of other paintings also survive: *Hortolana, Saint Clare's Mother, Praying before the Crucifix for a Successful Delivery* (in the Historisches Museum der Stadt, Bamberg); *Pope Innocent IV Confirming the Rule of Saint Clare* [the Fourth Rule] *on August 9, 1253*, and *Saint Clare Hearing the Voice of the Christ Child in the Ciborium* (both in the Germanisches Nationalmuseum, Nuremberg); and *The Dead Being Awakened through the Intercession of Saint Clare*, with, on the reverse, *The Christ Child Showing His Crib to Saint Clare* (in the Historisches Museum der Stadt, Bamberg).

Presumably, the panels were either painted for the convent of the Poor Clares in Nuremberg, or the one in Bamberg, which was augmented by the transfer of eight Nuremberg nuns at the time of its founding in 1342, and was initially under the direction of abbesses from Nuremberg.

After Kurth (1929) compared the paintings with a somewhat later manuscript devoted to the legend of Saint Clare (in the Zentrale Kunstbibliothek, Dresden; Ms. M 281), she concluded that the artist must have been influenced by illuminated manuscripts. Lutze (1932) then determined the settings and the chronological sequence of the paintings based on their similarity to miniatures in a 1362 document from the convent of the Poor Clares, in Nuremberg (now in the Bayerisches Hauptstaatsarchiv, Munich).

Saint Clare (1194–1253) founded the Order of the Poor Clares in Portiuncula in the year 1212 with the help of Saint Francis of Assisi. Its rule, confirmed by the pope in 1253, called for absolute poverty. The literary source for the paintings is the *Vita S. Clarae* of Thomas of Celano (died 1260), which was also available in a German translation. The selection of the chief events from the saint's life and the manner of depicting them were fixed shortly after her death (1253) and canonization (1255). Early pictorial evidence of this is a panel preserved in Santa Chiara, in Assisi, on which a portrait of

the saint is surrounded by scenes of the most important events of her life. In her humility, poverty, and chastity, Saint Clare patterned herself on the Virgin Mary, and both the *Vita* and iconographic tradition made much of such parallels. The portrayal of her death and obsequies and of her later exaltation in heaven, corresponding to the Coronation of Mary, are closely modeled after the life of the Virgin. Mary and various female saints surround Saint Clare's deathbed, while two of the sisters from her Order lament. Christ and John the Baptist point the way to the heavenly realm, and an angel bends down with Saint Clare's crown. In heaven, the saint is crowned by Christ and the Virgin, and her gown is strewn with flowers.

These illustrations from the life of Saint Clare are among the earliest panel paintings in German art. The figures stand out strongly against a gold background delicately tooled with a pattern of intertwining tendrils. The sequence of scenes is illustrated with precision and a certain freshness in the narration. The figures are identified by their distinctive garments and traditional attributes, for faces are as yet undifferentiated. Facial features are sharply indicated, and the light-colored flesh tone is enlivened by spots of red on the cheeks. Patterned fabrics play a prominent role. KL

Ex collections: (a) Robert von Hirsch, Frankfurt am Main and Basel (before 1931–1978); [sold, Sotheby's, London, no. 117 (June 21, 1978)]; [Thomas Agnew & Sons Ltd., London]; (b) Gm 1161: private collection, Munich; Gm 1187: Marczell de Nemes; [sold, Frederik Muller & Cie., Amsterdam (November 13–14, 1928)].

Bibliography: Thode, 1891, p. 13; Kurth, 1929, pp. 48–50; Lutze, 1930–31, pp. 10–14; *Nürnberger Malerei, 1931*, no. 33; Zimmermann, 1932, pp. 24–25, pls. 33, 35; Stange, 1934–61, vol. 1, pp. 201–3; Lutze and Wiegand, 1936–37, pp. 115–16, ill. 10; Stange and Strieder, 1978, no. 8; *Caritas Pirckheimer, 1982*, no. 61; Hall and Uhr, 1985, pp. 567–603; Wixom, 1985, p. 13, colorpl.

8a

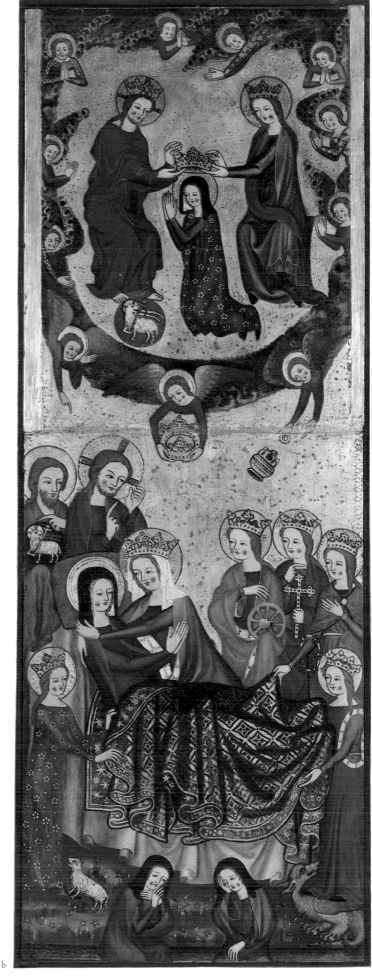

8b

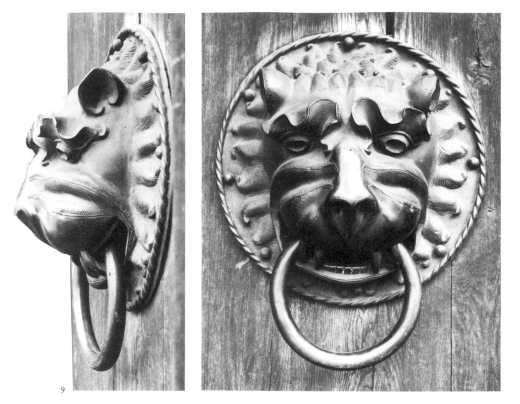

9

9 Door Pull

Nuremberg, second half of the 14th century
Cast and chiseled brass
Diameter: overall, 14 9/16 in. (37 cm.); ring,
7 7/8 in. (20 cm.)
Nuremberg, Lorenzkirche

The Lorenzkirche still has two medieval door
pulls, each now paired with a modern copy and
mounted on one of the modern doors of the
west portal of the church. Door pulls of this
type — large rings of bronze or brass held in
the mouths of lions, on the heavy doors of
churches — date from Carolingian times
through the Late Middle Ages. Usually, they
were made in pairs for use on double doors,
and, although largely identical in size and shape,
each pull was separately modeled and cast in its
own mold, so that there are always minor varia-
tions between them. Over two hundred medie-
val door pulls of this kind exist — many, how-
ever, only in single examples.

The present door pull from the Lorenzkirche
incorporates a lion's head whose highly stylized
form is almost Romanesque in appearance; for
this reason, it was long held to have survived
from the former church on the site. Neverthe-
less, it is within the Nuremberg tradition exem-
plified by the earlier door pulls of the Sebaldus-
kirche, which date from the beginning of the
fourteenth century (Mende, 1981, no. 180, ills.
285–286). The lion's head — with its charac-
teristic furrows perpendicular to the nose —
emerges from a wreath of radiating locks that
covers the plate. The holes drilled in the pupils
of the eyes are uncommonly large, and their
edges sharp. The eyebrows are typically wavy in
form, and their edges have been accented by
scoring. The lion's small, nearly circular ears are

minimized. Ursula Mende has noted similar
features in a pair of door pulls in the Rätisches
Museum, Chur, and in another pair also in
Switzerland, in the church of Saint-Nicolas, in
Fribourg; she is of the opinion that these door
pulls, too, were created in Nuremberg work-
shops. R K

BIBLIOGRAPHY: Pfeiffer, 1971, ill. 133; U. Mende, in *Die
Parler . . .* , 1978, vol. 1, pp. 375–76, ill.; U. Mende, 1981,
no. 182, ills. 291–292.

10 Speculum Humanae Salvationis

Franconia, vicinity of Nuremberg, about 1395;
binding, 3rd quarter of the 16th century
Ink and color wash on parchment
51 folios, 12 3/16 x 8 7/8 in. (31.5 x 22.6 cm.)
192 miniatures; 2 columns of 25 lines of text
below.
Binding: vellum-covered paper boards backed
with stamped pigskin.
New York, The Pierpont Morgan Library
M. 140

On folios 1–3 is a Prohemium (or preamble)
that is attributed to Nicolas de Lyria. Eight
scenes from Genesis introduce the *Speculum*
illustrations, which depict forty New Testa-
ment subjects, each accompanied by Old Testa-
ment parallels or prefigurations, totaling 160
scenes in all. Twenty-four representations of the
Passion of Christ and of the Seven Sorrows and
Seven Joys of the Virgin follow. (The Birth of
the Virgin and the Tree of Jesse [fol. 6 *v.*] and
the Liberation of Abraham from Ur and the
Flight of Lot from Sodom [fol. 34], are shown
here.)

Executed in a linear style, each illustration, in
clear narrative form, presents its particular sub-
ject with directness and animation. Color
washes in green, gray, red, salmon, orange-red,
and yellow are used selectively for emphasis and
for modeling. The controlled elegance of the al-
tar paintings from the monastery of Sankt Kla-
ra, Nuremberg (cat. no. 8 a, b), is lacking here,
even though the physiognomic types and ges-
tures in all are related.

This manuscript and a contemporary, sister
manuscript — a *Speculum,* as well, preserved in
the Bayerische Staatsbibliothek, Munich (Ms.
Clm. 23433) — were probably produced in the
same Dominican monastery in the vicinity of
Nuremberg, possibly at Auerbach to the north,
according to a note in the Munich manuscript
(J. Lutz and P. Perdrizet, *Speculum Humanae
Salvationis,* Mulhouse and Leipzig, 1907, vol. 1,
no. 107). The illustrations in both manuscripts
seem to share a common and distinct icono-
graphical source. The prototype may have been
the same as that used as a basis for a series of
windows, dating from about 1340, in Mulhouse
in Alsace (Lutz and Perdrizet, 1909, vol. 2, pl.
102).

The *Speculum Humanae Salvationis* was very
popular in Germany and in Netherlandish areas
beginning in the fourteenth century. The
Speculum tells, in words and pictures, the story
of human salvation from the Fall of Man to the
Last Judgment. Each New Testament illustra-
tion is always accompanied by three Old Testa-
ment prefigurations. From the middle of the fif-
teenth century on, printed books (block books)
continued this tradition. W D W

EX COLLECTIONS: Boone (1858); T. H. Horne (1858);
Richard Bennett (1896–1902).

BIBLIOGRAPHY: *Catalogue of Manuscripts . . .* , 1906, pp.
151–54, no. 102; Breitenbach, 1930, p. 35, no. 307 (no.
107, Munich Ms.); de Ricci and Wilson, 1937, II, p. 1392,
no. 140; Harrsen, 1958, pp. 52–53, no. 38, p. 56.

Anna · · maria · Ioachim · ysaie xi · yesse · ·stangentut dauidis·

Quartum capitulm

Si pce · ea · audiuimus d bte ugis annuciatoe
Osequnt audiam9 d ipi9 ortu siue geniacoe ·
Pgenies marie suu pcessu huit d stirpe yesse pus ·
D q ysaias plchre pspm uaticinauit ·
Pphia ysaie legitur hec ee pma figura
Egredietut uga d radice yesse
A flos de radice eius ascendet
Sup q septiformis gra spe st rqescet ·
h uirgo e maria fecundata p celeste rorem
De pduxit nob xpm amenissimu flore ·
Inhoc flore inueiuntut vii · medicamita bona
Pp q designatut sct spe septem dona ·
Inueiuntut inh flore tactus odor a fruct9
Color a folia succus a gustus ·
hec vii sunt egstanti aie ualde medicinalia
Contra septem pca mortalia oc oneratur
Tactu h9 floris hoe tumore supbie exhonorat
h duo timoris ad ognicoem siu humiliatur
Qe · n · cogitat qna tactus e lucif pp supbie tiorez
humilidt se a incipit hre dei timorem ·
Si · n · de a luciferis anglis noluit supbia stire
Mto minus uult homine supbiente secu hre
Ipi hebant grias un qp amodo potant glari
Quantum ht putredinos9 d q potuit eleuari
Odore hui9 floris duricia inuidi cordis mollifica

Et dono pietatis ad copassioe afflictor dilatat
Inuid9 n · ad nlli9 afflictom comouetur
Pi9 a9 omi afflicto opatitur a miser ·
Qe q suscepit odore · i · exempla siu saluatoris
Pi9 a copassiuus e afflictis omib9 horis ·
Exeplo · n · dni nri ihu x · flet cum flentib9
Et copatitur tam in aia qm icorpe pacientib9
fructus h9 floris yesame ure remouetur
a dono scie ho ddet cousari cu hoib9 cdceti9
ho uacund9 nllam ht mitis discrecom
a ideo nescit bona a decente cousacom ·
Donu scie mansuetu e et suaue
Et ddet bn cousari i medio nacionis sue ·
Qe q h9 floris frem · i · xpi opa noluit imitari
Ex ipis opib9 discit cu hoib9 debite cousari
Colore huius floris pallisis accidie pulsatur
a dono fortitudis ad sustinendu ho corroborat
Illam · n · sentit pena n fert labore
Qe intuet h9 floris ide crucifixi colore ·
Si · n · elephas aspecu sanguis uue adpugna aiat
Mto mag9 ho assupta sanguis x · adlabore fortificat
Qe q deuote respexerit roseum colore h9 floris
hylarit9 opatur a sustin in omnib9 horis ·
Flous h9 floris ydropisis auaricie pfugat
a p donu cosilii sitis pecuniar refrenatur

As protection against the heat of the sun, helmets were covered with a piece of cloth in the armorial colors of the wearer; therefore, only the front section, with its eye slit and its air holes, was visible. On the top of his helmet a knight wore an identifying crest, a figural ornament related to his coat of arms or, at least, displaying its colors. The crown of the present helm bears the holes used where this lightweight ornament of painted leather or canvas was fastened.

It cost a great deal to have a helmet made in the Late Middle Ages, and the helmet, therefore, became a status symbol. Although every knight, and doubtless many patricians, in the larger cities owned at least one helmet, helms of the type shown here are among the rarest examples of European armor to survive. It has been estimated that the total number extant, either complete or in fragments, is at most fifteen or twenty. Of these, the present helm and that of a certain Herr von Prankh (now in the armor collection of the Kunsthistorisches Museum, Vienna) are by far the best preserved. Since the Rieter von Kornburg family provided this helm from their own armory, and since it was counted among Nuremberg's patrician families, one can confidently assume that the helm was made in a Nuremberg armorer's shop.

JW

BIBLIOGRAPHY: Neuhaus, 1924–25, pp. 89–96; Pilz, 1936–39, pp. 57–112 (especially, pp. 73–76); Schneider, 1953, pp. 24–46.

Figure 114 *Memorial Shield of Hans Rieter von Kornburg,* showing the *Helm* (cat. no. 11). Allerheiligenkirche, Kornburg, near Nuremberg

11 Helm

Nuremberg, mid-14th century
Helm: iron, hammered, polished, riveted, and painted; chain mail: iron and brass wire, bent and riveted
12 5/8 x 9 x 11 in. (32 x 23 x 28 cm.); total weight, 7 lb. 2 oz. (3.3 kg.); weight, without chain mail, 6 lb. 8 oz. (2.9 kg.)
The present painting in darkened silver and gold dates from the 17th century; beneath it is older painting in black and gold. The padded lining is missing.
Provenance: Allerheiligenkirche, Kornburg, near Nuremberg.
Nuremberg, Germanisches Nationalmuseum (on loan from the Evgl. Luth. Kirchengemeinde, Kornburg)
W2801

This helm is composed of three pieces riveted together. The top section, the crown, extends down to the level of the eye slit. Riveted onto the front of it is a visor with air holes on the right side (the side facing away from an opponent) and a cross-shaped hole for the chain securing the helm. The half-round neckpiece is riveted on at its vertical front edges beneath the visor, so that a sword, a lance, or an arrow could not penetrate the point of junction. Around the

bottom edge of the helm a strip of iron chain mail with triangular tips of brass wire covers the place where the helm rested on the wearer's body.

The painting visible today probably dates from 1626, when the piece was used as a funeral helm. In the areas where the paint has chipped off, there are traces of earlier paint, which indicates that the helm was once black with a zigzag edging of gold around the bottom. It cannot be determined whether or not the latter was the original paint. The original padded fabric lining, now lost, was stitched, tied, or riveted in place, utilizing pairs of small holes drilled through the sides.

The present helm was discovered in 1924 on the funerary coat of arms of Hans Rieter von Kornburg (1564–1626). It had once been customary, upon the death of a nobleman or a patrician, to hang a shield bearing his coat of arms in the church in which he was buried. Originally quite simple, these coats of arms came, in time, to be adorned with three-dimensional ornamentation, and furnished with a matching helmet. Such helmets were generally ornamental ones, made of thin sheet metal. In a few cases, however, genuine shields or helmets, such as this one, were used.

12 Memorial Shield of Heinrich Grundherr

Nuremberg, 2nd half of the 14th century
Firwood: two boards, with intercalated edges;
oil and distemper on chalk ground and canvas
28 3/8 x 25 in. (72 x 63.5 cm.)
Provenance: Sebalduskirche, Nuremberg.
Nuremberg, Germanisches Nationalmuseum
(on permanent loan from the Freiherrn von
Grundherr by 1871)
KG 33

The wooden shield, in the form of an inverted
triangle with gently curving sides, shows half of
a silver lion facing to its right — the device of the
patrician Grundherr family, which was highly
influential in Nuremberg, in the fourteenth cen-
tury — against a red, damascened ground. The
lion, with its mouth open in a yawn and its
menacing claws outstretched, is carved from the
wood of the shield. The heraldic silver of the
animal's body is rendered in white, his tongue is
red, and his claws are gilded. On his highly styl-
ized head he wears a crown of tin that, origi-
nally, was gilded. On the raised border around
the edges of the shield is an inscription (some-
what damaged), in black on a white back-
ground, which begins at the bottom tip:
"Anno·dom[i]ñ[i]·M·CCC·LI·jar·starb·hainrich·
grundher·der·alt·selig·am·montag·nach·unser·
fraw[e]n·tag·als·syi·gebor[e]n·wart." ("In 1351,
the blessed Heinrich Grundherr the Elder died
on the Monday after the Feast of the Birth of
the Virgin Mary [12 September]"). The coat of
arms of Grundherr's wife, Margaret Gloetzel-
mann, appears on a small, tin shield behind the
lion: It is in the form of a silver bar on a red
ground, with a five-petaled, silver rose beneath
it.

The medieval memorial shield developed out
of the custom, documented from the twelfth
century on, of hanging a knight's armor — espe-
cially his shield, which contained his coat of
arms — above his tomb in a church. In time,
actual shields increasingly were replaced by
wooden ones — either painted or carved. Even
later, authentic battle or tournament shields
were still used occasionally, and were trans-
formed for this express purpose (cat. no. 11).
Ordinarily, family members always hung such
shields on the wall, in the same place as the
family's memorial or a common vault. Even to-
day, numerous examples of this practice may be
seen in Nuremberg's churches. The present
shield — along with three quite similar ones,
made for other members of the Grundherr fam-
ily who died during the 1370s — is one of the
oldest surviving funerary shields in Nuremberg.
Probably all four were made on the same occa-
sion, when it was decided to honor earlier fam-
ily members along with those recently deceased.

RK

BIBLIOGRAPHY: Biedermann, 1748, pl. LXI (the death date
erroneously recorded as 1348); Pilz, 1936–39, p. 78;
Wappen in Bayern, 1974, no. 4.

12

13 The Presentation of the Sword and Emperor Ludwig the Bavarian

Nuremberg, about 1560/70
Watercolor on paper, with gold highlights
Overall page, each, 19 1/2 x 13 9/16 in. (49.5 x 34.5
cm.); miniatures, each, 12 3/8 x 8 11/16 in.
(31.5 x 22 cm.); actual reliefs, 70 7/8 x 41 5/8 in.
(180 x 106 cm.)
These miniatures depict the reliefs, from about
1340, in the Great Hall of the Rathaus, Nuremberg
(figs. 115, 7).
Nuremberg, Staatsarchiv, Rep. 58 (Nürnberger
Karten und Pläne), nos. 148–149

These two painstakingly executed drawings
(discovered by Matthias Mende) depict the large
stone reliefs once on the end wall of the great
hall of the Nuremberg Rathaus. No information
survives as to when the drawings were prepared,
under what circumstances, to what end they
were made, or who the artist(s) may have been.
They were found in a portfolio along with five
additional sheets reproducing details of the
painted decoration of the hall executed in
Dürer's time; there is no accompanying text.
Their large size and their lavish use of gold
would indicate that these views of the great hall
were not made for any practical purpose — such

as the maintenance of the building — or for mere
historic documentation. Clearly, they are part
of a deluxe portfolio either commissioned by a
member of the city's patrician government for
his own use or, more probably, for presentation
to some high-placed personage.

Until World War II, when the two reliefs
were largely destroyed (they are being re-
stored), they were all that remained from the
fourteenth-century figural decoration of the
hall. The medieval Rathaus was built from 1332
to 1340. The great hall was its showplace, 127
feet long and nearly 40 feet wide (fig. 42). The
reliefs of the emperor enthroned and of the pre-
sentation of the sword were situated on the wall
at the eastern end, to the left and right of a
chapel-like choir, in which there possibly was
an altar. The most recent examination of the
ruins of the Rathaus, by Walter Haas, revealed
that there were high stone canopies above the
reliefs. From indications in the masonry of the
walls, it has also been determined that a row of
ten figures stood on separate consoles, beneath
their own baldachins, along the hall's south
wall, with eight or nine additional figures on the
north side. Each of them was about 49 1/4 inches
(125 centimeters) tall. We have no information
about what the sculptural program was meant

13

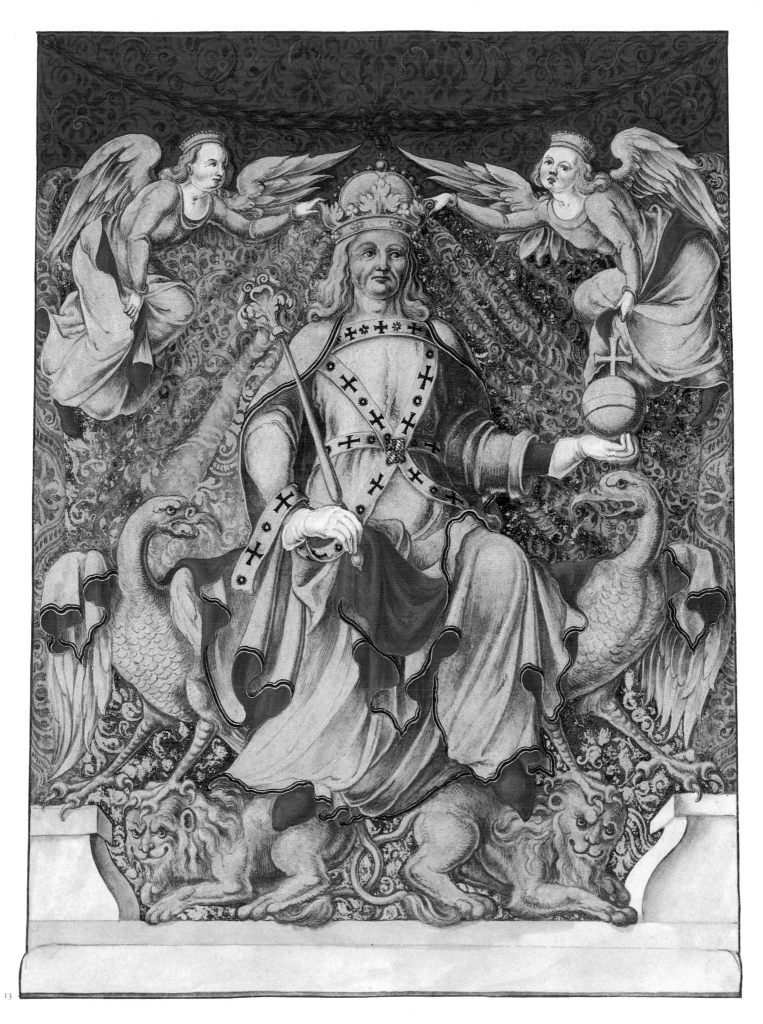

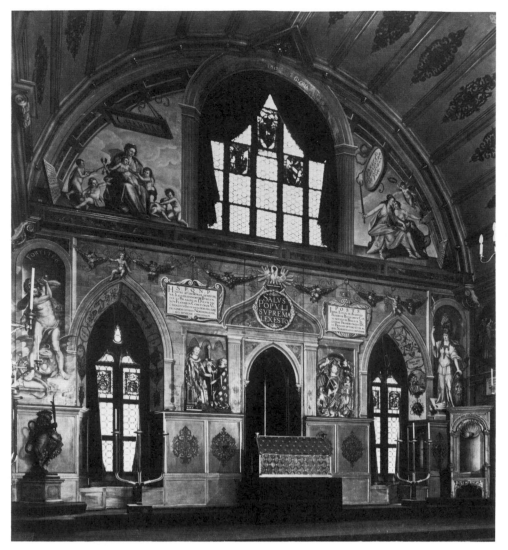

Figure 115 East wall of the Great Hall of the Rathaus, Nuremberg, showing the reliefs of *The Presentation of the Sword* and *Emperor Ludwig the Bavarian* and (center) the *Reliquary Shrine* (cat. no. 47)

to convey. The figures were removed in 1520/21 at the latest, when the great hall was completely redesigned, and the walls covered with paintings — most of them by Albrecht Dürer and his pupils.

It was also at that time — if not before — that the paintings with Justice as their subject, which had long decorated the walls of the room, were destroyed. According to the chronicle by Sigmund Meisterlein, from 1488 (*Chronik*, 1864, pp. 154–55, 245), the walls were adorned with painted "histories," based on the writings of Valerius Maximus, Plutarch, and Gellius, on the theme of Justice, which were to serve as reminders for the councillors and judges who presided in the chamber. "But the paintings have faded, and also what they represent is now despised," Meisterlein added. His wording makes it seem likely that the frescoes were created at the time that the Rathaus was built, during the reign of Emperor Ludwig the Bavarian (1314–47), even though a painter named Berthold was paid in 1423 for paintings in the hall. This fact would indicate that the paintings were the earliest examples of those moralizing scenes from ancient history that were frequently found in town halls

in Germany and in the Low Countries in the fifteenth century. As late as 1495, in a poem about the city of Nuremberg, Conrad Celtis (pp. 171–72) refers to the council room as "hystoriis et imaginibus vetustissimis imperatorum nostrorum et regum depicta." The "histories" (*hystoriis*) were, unquestionably, paintings, but perhaps the "images" of the emperors and kings of old were the sculptures along the sides of the room — the "pildlein" (small images) that the council had had removed from the walls in 1521, "except for the emperors up front near the windows" (the surviving reliefs). However, there is no way to prove this. Judging from other sculptural programs with secular iconography in municipal buildings of the fourteenth century, the statues may well have represented the prophets or the Nine Heroes.

There is also some uncertainty regarding the two surviving reliefs depicted in the present miniatures — especially the left-hand relief. The Latin inscriptions, which are reproduced in the drawings, were only added during the repainting of the Rathaus in 1520/21, replacing the ornamental baldachins, which were removed at

that time. The emperor may be identified as Ludwig the Bavarian, who, specifically, was extolled as a benefactor of the city of Nuremberg.

The composition of the relief is based upon Ludwig's imperial seal, which was created on the occasion of his coronation in Rome in 1327/28 — probably by an Italian goldsmith — and was in use until the end of his reign (Posse, 1909, vol. 1, pl. 50; Kahsnitz, in *Wittelsbach . . . ,* 1980, no. 322). As he appears on the seal, the emperor is shown enthroned in the relief and adorned with his insignia: the crown, scepter, and imperial orb. He wears a pluvial over a stole — a sign of his spiritual rank — and a girdle embroidered with crosses. He is seated on a throne that is supported by two ferocious eagles — instead of on the customarily depicted stone bench — each of which sinks a taloned claw into the head of one of the two crouching lions upon which the emperor rests his feet. The lion was an ancient symbol of majesty — especially familiar from tomb sculpture — and Ludwig's predecessor, Emperor Henry VII, had had himself portrayed seated on a throne supported by two lions and with his feet resting on a third, crouching lion (Posse, 1909, vol. 1, pl. 47, nos. 1, 3). Representations of this kind of throne — a faldstool, adorned with the heads of dragons or of lions — certainly derived, in part, from the type used by bishops, and which can also be seen on the seals of French kings. On such thrones, the beasts are only a minor detail — merely ornaments. On Ludwig's seal, however, they have been promoted to symbols of supreme imperial might. The replacement of lions by eagles — heraldic animals especially associated with the emperor — doubtless derived from the cult of the eagle that was popular in the thirteenth and the fourteenth century among Italians loyal to the emperor.

The majestic image of imperial dominion on the seal is enhanced in the Nuremberg relief by the addition of two hovering angels holding the ruler's crown, in imitation of contemporary portrayals of the Coronation of the Virgin. In the relief, with one hand each angel holds back the curtain behind the emperor — another motif that suggests his majesty. In the miniature, however, this gesture was misinterpreted and the angels appear, instead, to be gathering up their own robes. In earlier German art, the ruler is occasionally shown receiving his crown from the hand of God, or from Christ, in order to emphasize the direct relationship between imperial might and divine majesty.

No examples of such images from the Gothic period are known. This coronation by angels — who can only be emissaries of God — is altogether unprecedented, and must be seen as another of the attempts by Ludwig the Bavarian and his supporters to document the legitimacy of his empire and its divine origin. Throughout his reign, Ludwig was in conflict with the official representatives of the Church, especially with the pope, who was then ensconced in Avignon. Virtually none of the ecclesiastical authorities participated in his proclamation as emperor, in 1328, on the Capitol in Rome, or

attended his subsequent coronation. The composition of the Nuremberg relief recalls those late antique depictions of heroes, or of emperors, being crowned by tutelary spirits. Just as the costume of Ludwig the Bavarian emphasizes, in a striking and unique manner, the spiritual nature of his authority, the throne adorned with eagles and the motif of the crowning angels clearly refer back to representations of majesty from the antique. Even more so than the seal, the Rathaus relief reflects something of the glorification of ancient Rome that colored events before and during Ludwig's coronation in that city: the city's break with the pope, who was far away, in France; the founding of the Roman Republic; the representation of the people on the Capitol; and the proclamation of the emperor by the Roman populace.

There exists, as yet, no convincing interpretation of the second relief. The traditional explanation is that it depicts the personification of the city of Nuremberg, Noris, presenting a sword and gauntlets to Brabantia, in commemoration — or as confirmation — of a tariff agreement, but this is surely inaccurate. Both of the persons depicted are men, as is apparent from their distinct Adam's apples, and as is suggested by their clothing. Between them, they hold a large sword topped by a brightly colored staff, to which are attached a pair of white gloves and a belt — yet, it is not clear which of the men is presenting the objects, and which receiving them. In the Middle Ages, it was customary on the anniversary of the agreement between cities granting each other immunity from tariffs to exchange certain objects, often, in the form of gloves, which also played an important and varied role in the legal conventions of the period. To Mainz and to Worms, for example, Nuremberg traditionally presented gloves and a sack of pepper; to Cologne and to Strasbourg, a pair of falconer's gloves; to Brussels, a packet of needles; and to other cities, frequently a sword — as Liège offered to Nuremberg, in return. However, Nuremberg maintained trade agreements of this kind with numerous other cities, and there was, thus, no reason why it should single out the duchy of Brabant so prominently in the council room. It is far more likely that the relief depicts the granting of substantial royal privileges to the city of Nuremberg. The recent suggestions by Karl Kohn would seem to lead toward a more accurate interpretation: According to Kohn, the event represented may commemorate the acquisition by the city of the office of imperial mayor (*Reichsschultheissenamt*), of the assize jurisdiction that went with it, and of the tariff, which Emperor Ludwig the Bavarian pledged to Nuremberg's wealthiest and most influential citizen, Konrad Gross, on March 16, 1339 — at about the time that the relief must have been executed. Gross served as banker to the emperor, and Ludwig was deeply obligated to him for his repeated financial assistance. This explains the unusual pledge of imperial sovereign rights to an individual citizen — albeit an uncommonly wealthy one. Later in the fourteenth

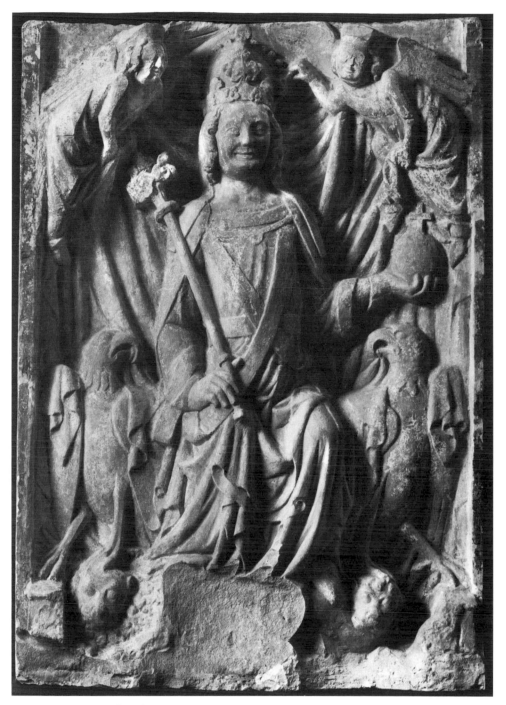

Figure 116 *Emperor Ludwig the Bavarian.* Plaster cast of the stone relief in the Great Hall of the Rathaus. Bayerisches Nationalmuseum, Munich

century, these crucial imperial rights ultimately were transferred to the city of Nuremberg. Countless examples are known of such transfers of royal privileges — enfeoffments, or the granting of market rights, for instance — accompanied, according to German law, by the presentation of the glove of the king or emperor (Schwieneköper, 1938, pp. 56–57, 82–83, *passim*), or of a sword and staff, which symbolized the transfer of legal authority (von Amira and von Schwerin, 1943, pp. 43–44, *passim*). This would mean that the smaller, kneeling figure in the relief depicts Konrad Gross, or some other member of the Nuremberg government, and that the larger, seated figure is a representative of the emperor, possibly the burgrave of

Nuremberg, who, himself, had held the office of mayor (*Reichsschultheiss*) from 1323 to 1339.

R K

BIBLIOGRAPHY: von Murr, 1801, p. 358 (presents the 16th-century inscription); Mummenhoff, 1891, pp. 32–37, ill.; Bier, 1922, pp. 5, 12, ills. 4–5; Höhn, 1922, pp. VII, 113, ills. 10–11; Martin, 1927, pp. 34–35, 152–53, nos. 211–212, ills. 112–113; Schwieneköper, 1938, pp. 115–16, n. 212; Pfeiffer, 1971, ills. 14, 248; Schädler, in *Karl IV*, 1978, no. 58; Mende, 1979, vol. 1, pp. 34–35, ills. 2, 27–29 (condition before and after destruction in World War II), colorpl. VIII (only mentions the miniatures), vol. 2 (in preparation), nos. 586, 600, ills. 193–202; Schütz, in *Wittelsbach...*, 1980, nos. 338–339; Kohn, in Lincke, 1980, pp. 44–45; Haas, 1981, pp. 50–54, ills. 3–9, 16–17.

Figure 117 Julius Caesar and the Prophet Joshua, from the Schöner Brunnen

Nuremberg, 1385–96
Gray sandstone
Height, 10 in. (25.5 cm.)
The right side of the head at the back and the points of the crown are missing. A certain amount of flaking on the forehead has been repaired. The entire surface, badly weathered, has been polished. No traces of polychromy remain.
Provenance: Schöner Brunnen, Nuremberg.
Nuremberg, Germanisches Nationalmuseum (on permanent loan from the city of Nuremberg since 1903)
Pl 0.251

Along with the sculptures and frescoes that adorn the great hall of the Rathaus, the Schöner Brunnen, located in the northwest corner of the Hauptmarkt — laid out in 1349 — was the most important monument to the civic pride of medieval Nuremberg. Plans for the fountain may date to the time of Emperor Charles IV (died 1378); at his instigation and expense, the Frauenkirche was erected on the Hauptmarkt, from 1352 to 1358 (fig. 40). The city, itself, commissioned the fountain. Bills relating to the work of builders, stonecutters, and painters survive from 1385 to 1396. Painting and gilding commenced in 1393, implying that, by that time, both the architectural sections and the sculptures were largely completed. Documents for the years 1389 to 1396 repeatedly mention a certain master by the name of Heinrich "Parlier," who, in 1396 — apparently as a last payment — received another sixteen guilders "on account of the work he has done on the fountain and is now finished." Total expenditures from the city coffers amounted to 4,500 guilders.

The term "Parlier" identifies Heinrich as the master builder. From the sources, it is impossible to tell whether he was responsible for the sculpted decoration of the structure in addition to serving as architectural supervisor and contractor. In the fourteenth century, architects and sculptors were occasionally still one and the same, and scholars have assumed that such was the case, especially, with the various members of the Parler family in Prague and southern Germany. It is probable that Heinrich Parlier is none other than Heinrich Beheim the Elder, documented as having been in Nuremberg from 1363 to 1406, who was supervising architect of the new choir of the Sebalduskirche, from 1361 to 1379. The architectural forms of that structure are quite closely related to those of the Schöner Brunnen. The name Beheim (= Böhme = Bohemian) may indicate that he — or, at least, his family — originally was from Bohemia. Whether or not that was so, there were very strong political and artistic ties between Nuremberg and Prague during the reign of Charles IV.

The adjective "beautiful" was applied to the fountain as early as the fifteenth century, if not before, and doubtless referred to its rich painting and gilding. The fountain was a constant worry to the city fathers over the next several

decades on account of the damage caused by weathering and by the lower portions being constantly in contact with water. The stone was simply not very durable. Countless repairs were required, especially to the polychromy. We know of repaintings in 1420, 1447, 1464, 1490 — at which time the workshop of Michael Wolgemut was involved — and in 1540/41. It was in connection with another repainting in 1578 that Andreas Herneysen produced a drawing of the fountain (cat. no. 15); he was paid 1,500 guilders for repainting and regilding the monument. At that time, the council also had the Augsburg locksmith Paulus Kuhn install the wrought-iron grille, which survived into the present century. The condition of the fountain was so poor by the early nineteenth century that it had to be completely dismantled and rebuilt, with a number of replacement parts, from 1821 to 1824. In 1897, it was decided to construct an entirely new facsimile out of more durable stone, and that work was unveiled in 1902. By then, the surviving portions of the original fountain, badly damaged and heavily restored, were placed in the Germanisches National-museum. Three of the heads of prophets were preserved in the Berlin museums until World War II, when one of the heads was destroyed. A total of thirty-six fragments still exists — namely, portions of eighteen or nineteen of the twenty-four large figures (prophets, heroes, and electors), and seventeen figural consoles (from the original twenty-four), as well as a number of architectural elements. By 1587, only fragments of the small seated figures of the Evangelists, Church Fathers, and representatives of the seven liberal arts survived; nothing remains of them today. Despite various lacunae, the 1578 drawing still gives us our best idea of the fountain's original condition.

The octagonal water basin tops a stepped pedestal, out of which rises a three-tiered, open-work pyramid nineteen meters high, with a pinnacle crowned with a cruciform finial. A ring of sixteen figures — the seven electors and the Nine Heroes — adorns the bottom tier. They stand in pairs, on figural consoles, beneath baldachins, against eight piers that emerge from out of the water. The tier above presents eight smaller figures — Moses with the Tablets of the Law, and seven prophets each holding a bande-role inscribed with his name; in the early literature, the latter are identified as Isaiah, Jeremiah, Ezekiel, Daniel, Hosea, Joel, and Amos. On freestanding double pillars just over the inner surface of the basin there were once sculptures of eight Christian writers: the Four Evangelists, Matthew, Mark, Luke, and John, and the four Latin Church Fathers, Jerome, Augustine, Ambrose, and Gregory. Next to them and slightly below were seated Philosophy and her daughters, the seven liberal arts: Grammar, Dialectic, Rhetoric, Arithmetic, Geometry, Music, and Astronomy. From the surviving sources it cannot be determined whether they were in the form of personifications, or were represented by their most noted practitioners — such as Aristotle, Donatus, Socrates, Cicero,

14

Nicomachus, Euclid, Pythagoras, and Ptolemy. The earliest descriptions of the fountain — those from the fifteenth and sixteenth centuries — give no details about the smaller figures, and, later, they were too badly weathered to identify with certainty.

The overall form of the fountain, with its stress on the number eight as its basic design principle, derives from the tradition of the Christian baptismal font, which influenced other fourteenth-century fountains in market-places, as well. Fonts were frequently octagonal, and represented the Early Christian notion of the *fons vitae*, the source of water and of life. A definite precursor was the fountain erected in the market square in Aachen in 1334. Apparent-

ly, it had much the same form, although with less openwork. The only clue to its appearance is a single, early drawing (Hoffmann-Curtius, 1968, pp. 75–76, ill. 93), and, unfortunately, nothing is known of its iconographic program. In German cities, in the fifteenth century, there were a number of similar fountains, often octagonal or polygonal, that were richly ornamented with sculpture, but most had a simpler super-structure. Moreover, it has been pointed out that the architectural form of the Schöner Brunnen must have been based on the design for a baldachin tomb for Saint Adalbert in the cathedral of Prague — an example of the Prague Parler style of the 1360s.

The fountain's sculpture follows the tradi-

133

tional iconography for secular structures — most notably, city halls — in the mid-fourteenth century. Sadly, almost no information exists about the sculptures and frescoes from the period around 1340 in the Nuremberg Rathaus (see cat. no. 13). The most useful comparison is therefore provided by the sculptural program of the so-called Hansasaal in the Rathaus in Cologne, where wall paintings portraying prophets and electors were positioned opposite relief sculptures of the Nine Heroes (Trier, 1952; 1957). The seven electors — shown, in Cologne, joined by the emperor, himself — represent the governmental organization of the Holy Roman Empire of the German Nation. From Nuremberg, Charles IV had issued the Golden Bull on January 10, 1356, in which the procedure for electing the king was fixed, once and for all. Henceforth, the only men to cast votes in his election were the archbishops of Mainz, Cologne, and Trier, the king of Bohemia, the count palatinate, the duke of Saxony, and the margrave of Brandenburg. As a result, they became, along with the emperor and the king, the chief guarantors of civil order within the empire. At that time, their coats of arms were placed on the west façade of the Frauenkirche — together with those of the emperor and the city of Rome — directly across from the Schöner Brunnen. The Nine Heroes, idealized representatives of knightly or princely virtues, were widely known in the fourteenth century from art and literature. Three were from antiquity: Hector, Alexander, and Julius Caesar; three, from the Old Testament: Joshua, Daniel, and Judas Maccabeus; and three from Christian history: King Arthur, Charlemagne, and Godfrey of Bouillon. These paragons of just leadership from the past were juxtaposed with the representatives of contemporary political power, the electors of the empire. The prophets on the tier above had always been regarded as champions of justice. In the Old Testament, they are not only prophets of the coming of Christ, but helpers and advisors to the kings of Israel. In the secular iconography of medieval city halls, they appear frequently as heralds of the Lord who symbolize heavenly justice and, at the same time, justice on earth. In Cologne, as elsewhere, they are accompanied by billowing banderoles inscribed with appropriate texts, which may have been the case in Nuremberg, too.

It is not surprising to find on a municipal structure such definite stress on imperial order along with an admonition toward justice on the part of all secular authority, for the imperial cities — Cologne as well as Nuremberg — were always among the most faithful vassals of imperial might, and, in the complex makeup of the empire, offered the best protection against the neighboring princes' lust for power. It is odd that the emperor, himself, is not depicted in the circle of the electors as the pinnacle and manifestation of imperial order. In Cologne, he is included with them as a matter of course. One therefore wonders whether a figure of the emperor originally appeared somewhere else on the fountain, possibly inside the main tier, so

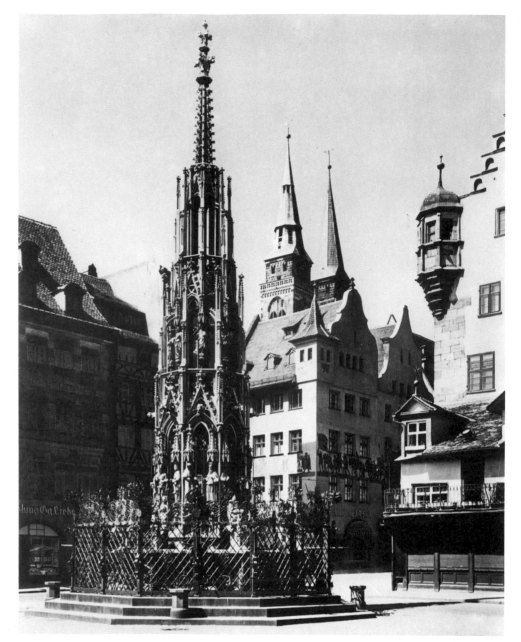

Figure 118 The Schöner Brunnen in the Hauptmarkt, Nuremberg

that he stood at and as the center, and, literally, was surrounded by the electors, as guarantors of imperial order, and by the venerable representatives of just rule. Yet, even in the earliest descriptions there is no mention of a figure of the emperor; perhaps it was destroyed at a very early date.

This secular, political sculptural program suggests something of universal history by its inclusion of rulers from antiquity as well as Old Testament prophets. Yet, by topping the small piers above the water with sculptures of the holy writers — the Evangelists, Church Fathers, and the representatives of ancient wisdom — the program truly acquires a significance within the context of the Salvation. Of course, in so doing, it enters into the nexus of tradition that determined all thinking about Order in the Middle Ages. In the above-mentioned hall in Cologne, the heroes and prophets were also joined on the side walls by additional men of authority from

antiquity. Some of their maxims relating to the just government of cities have come down to us.

The sculptures of the Schöner Brunnen are among the most important fourteenth-century works of art from Nuremberg. They represent the last great ensemble created by a stonemasons' workshop. Architecturally, the Schöner Brunnen is related to the east choir of the Sebalduskirche, which was the next major building project after the Frauenkirche. Although that structure was provided with numerous baldachins, it is not known whether there were ever sculptures beneath them. Certainly none has survived. They would have exemplified the style that immediately preceded that of the fountain.

Scholarship has long distinguished between the Prophet Master, who was relatively conservative, and the so-called Heroes Master, who must have also created the figures of the electors. Out of the large group of stonemasons and

sculptors who worked on the fountain, Kurt Martin felt that it was possible to identify a distinct personality who was responsible for the *Moses* and the ancient and Old Testament heroes. In general, the works of all of these masters reflect the influence of contemporary Prague sculpture — especially, the works of the so-called Heroes Master, including the head of King Arthur and the quite similar figure of Godfrey of Bouillon. This master most clearly reveals that new unity of sculptural form that was achieved in Prague in the sculpted busts on the triforium level of the cathedral. The faces of his figures have a softness heretofore unknown, achieved by a painterly fusion of the beard and the cheeks. Shadows become more important for the intended effect than a precise, linear definition of the individual forms. "One searches in vain for the boundary of a form or a mark from the chisel" (Martin, 1927, p. 114).

The *Head of King Arthur* seems to have been molded from soft, malleable clay. Its blurred, abraded contours do not merely describe a dense, inarticulate mass, but, rather, produce a surface configuration of extreme subtlety — one that relies on the effects of light and shadow. It suggests a certain tendency toward sentimental, deeply felt melancholy on the part of its creator. Medieval viewers doubtless were not so moved by the king's somber expression as we are today, with our knowledge of psychology, but it is that sadness about the sculptured head that has resulted in its being singled out and admired over the rest of the Schöner Brunnen sculptures ever since the Romantic period, in the nineteenth century. R K

BIBLIOGRAPHY: Wilder, 1824; Bergau, 1871; Gümbel, 1906, pp. 49–86; Josephi, 1910, nos. 12–28 (with earlier bibliography); Pinder, 1914–29, pp. 129–32; Bier, 1922, pp. 9, 13, ills. 18, 23; Höhn, 1922, pp. VII, 115–16, ills. 34–36; Pinder, 1925, p. 77, ills. 102–103; Martin, 1927, pp. 106–19, 137, 151–210, ills. 310–338; Kletzl, 1939, pp. 59–60, 124; Trier, 1952, pp. 203–11; Wyss, 1957, pp. 87–88; Rautenberg, 1965, pp. 104–13, 243–45; Stafski, 1965, nos. 62–94, ills. (and bibliography); Hoffmann-Curtius, 1968, pp. 76–78; Pfeiffer, 1971, ills. 16–17, 251; Herkommer, 1976, pp. 192–211; Fehring and Ress, 1977, p. 262; Stafski, in *Die Parler...*, 1978, vol. I, pp. 367–69; Bräutigam, 1982, pp. 202–7.

15 ANDREAS HERNEYSEN
Design for the Repainting of the Schöner Brunnen, Nuremberg

1587
Watercolor, on three sheets of paper pasted together
36 1/8 x 15 5/8 in. (91.7 x 39.6 cm.)
Inscribed (at bottom, in pencil, in a later hand): GP [monogram of Georg Pencz]
Nuremberg, Germanisches Nationalmuseum
SP 8817 (Kapsel 1054b)

This large-format watercolor of the plan for the repainting of the Schöner Brunnen (Beautiful Fountain) was commissioned in 1587 by the Nuremberg city council from the painter An-

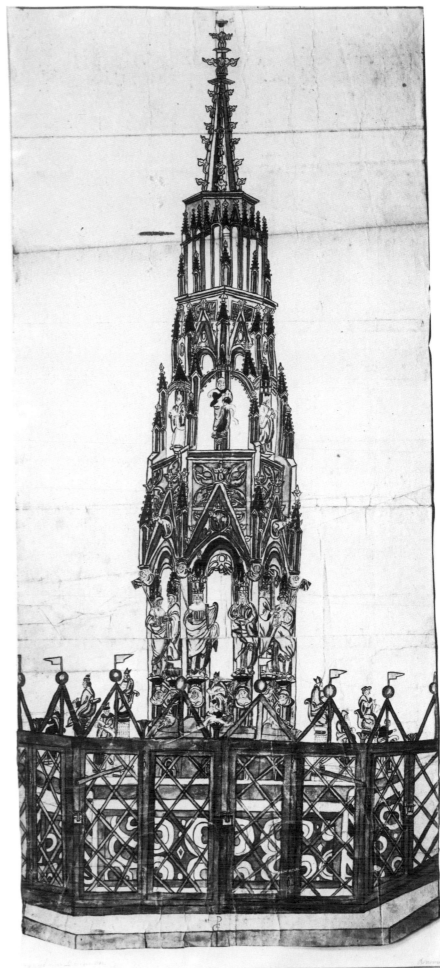

15

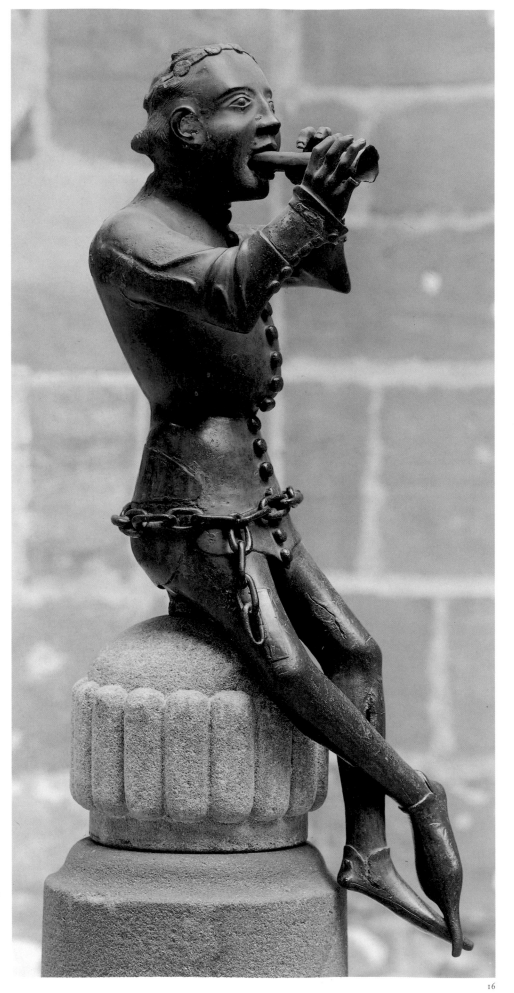

dreas Herneysen. It is based on an earlier drawing, now lost, whose subject was the restoration of the fountain in 1540–41, and which also bore the monogram of Georg Pencz in a later hand. The present drawing depicts the proportions and structure of the tower-like shaft of the Gothic fountain with a certain degree of accuracy, but, in accordance with its function, neglects the architectural and figural details in a rather clumsy way. The design calls for the use of three colors: gold, red, and blue. The violet tone probably represents the red of Nuremberg sandstone. Although the fountain had already been repainted several times in the fifteenth century, the drawing provides a certain impression of the polychromy of medieval architecture and sculpture. RS

EX COLLECTION: Hans Freiherr von und zu Aufsess, Aufsess and Nuremberg (Lugt, no. 2750).

BIBLIOGRAPHY: Bergau, 1871; Kurzwelly, 1895, p. 79; Wallraff, 1898, p. 9; Schulz, 1904, pp. 25–29; Pfeiffer and Schwemmer, 1970, ill. 17; Herkommer, 1976, pp. 192–216; *Die Parler...*, Cologne, 1978, vol. 1, pp. 367–71; Brix, 1981, n. 219, ill. 62.

16 Fountain Figure, the so-called "Hansel"

Nuremberg, about 1380
Brass, hollow cast, with black patina
47 5/8 x 15 3/4 x 22 1/16 in. (121 x 40 x 56 cm.)
Two sections of the little finger on the right hand are missing. The ears were replaced in the 17th century.
Provenance: fountain, north courtyard, Heilig-Geist-Spital, Nuremberg.
Nuremberg, Germanisches Nationalmuseum (on loan from the city of Nuremberg since 1913)
Pl 2204

Seated and cross-legged, the young man depicted in this sculpture plays an oboe-like instrument called a shawm. He wears a close-fitting coat, padded across the chest, with a series of heavy, round buttons extending down the front and also decorating the lower portion of the tapered sleeves, which are pointed at the elbows. A wreath of rosettes (*Schapel*) around his head, a low-slung chain belt, tight hose, and pointed shoes (*Schnabelschuhe*) complete his garb. This costume was international in the fourteenth century. Variations of it may be seen in Nuremberg, in the sculptures of the electors of Bohemia and Brandenburg from the Schöner Brunnen, the "Beautiful Fountain" (of 1385–92), in the main marketplace (H. Stafski, *Katalog des Germanischen Nationalmuseums Nürnberg, Die Bildwerke in Stein, Holz, Ton, und Elfenbein bis um 1450*, Nuremberg, 1965, p. 87, nos. 64, 65, pls. 262, 258, respectively). The freestanding flagellants, of 1375, on the Venetian silver-gilt *Reliquary of the Column of the Flagellation*, in the Treasury of San Marco, are similarly costumed (W. D. Wixom, in *The Treasury of San Marco*, Milan, 1984, pp. 306–9,

16

no. 46). Additional parallels for the details of the costume, and especially for the low-slung chain belt, may be found in south Tyrolese frescoes and sculpture of about 1390–1400. Thus, his fashionable costume is a key factor in the dating of the fountain figure.

Remarkable for its size, this hollow casting has many imperfections resulting from the uneven flow of the molten brass. Many of the flaws bear their original patches. Except for these repairs, and for the lead shawm and the chain belt, the casting appears to be of one piece — a notable feat for its time. The figure, therefore, represents an early stage in an evolving technique of brass casting in Nuremberg and must predate the technically superior castings made by the Nuremberg workshop that produced a series of aquamaniles and of door pulls about 1400 (see cat. nos. 18–22, 45; fig. 88).

The *"Hansel"* was intended as a fountain for the Heilig-Geist-Spital courtyard: The water issued from the shawm projecting from the figure's mouth. The ears were drilled through in the seventeenth century to accommodate two additional spouts, which have since been removed. Of the original polychromy — shown in a drawing of about 1600 — only red and white were recorded in the nineteenth century. While still in the hospital courtyard, the youthful musician (now replaced by a copy) sat in the middle of a large, round fountain basin covered with an iron grille. Water was supplied through a long and ingenious waterline from outside the city.

While the sculpture's symbolic significance is uncertain, its meaning must be related to its function and location. The hospital and church of the Holy Spirit, founded by the Nuremberg patrician Konrad Gross (died 1356) in 1331, was built between 1332 and 1339. The flower-bedecked, fashionably dressed, music-making youth — who supplied water for the sick and infirm — might be a symbol of hardy well-being and good health, intended to signify hope, or as Ursula Mende has proposed, the figure may be a personification of worldly music, meant to underscore the transitoriness of life.

In its overall proportions, costume, and elegance of pose, the fountain figure of the Heilig-Geist-Spital may reflect the widespread influence of the sculptural style associated with the Parler family of master builders. As a primarily secular figure, a freestanding sculpture in the round not designed to be viewed against a church pier or within an altar shrine, and as an early brass casting, this engaging work is especially rare. Since the nineteenth century, the figure has been called "Hansel." WDW

BIBLIOGRAPHY: Pückler-Limburg, 1904, 48, p. 87; *Anzeiger des Germanisches Nationalmuseums*, 1913, p. 33; Höhn, 1922, no. 37, ill.; Goldmann, 1935, pp. 21, 31, 37; *Europäische Kunst um 1400*, 1962, pp. 348–49, no. 396, pl. 160; Mende, 1974, 8–9, pp. 19, 20; *Geschichte Nürnbergs in Bilddokumenten*, 1977, pl. 194; Stafski, in *Die Parler . . .*, 1978, 1, p. 374, 1980, 5, colorpls. T-114, T-115; Mende, 1979, pp. 47–66; Mende, 1981, 2, p. 117; Schneider, in *Deutsche Kunst und Kultur . . .*, 1984, pp. 9–10, no. 1; Bräutigam, in *Germanisches Nationalmuseum . . .*, 1985, p. 43, no. 82.

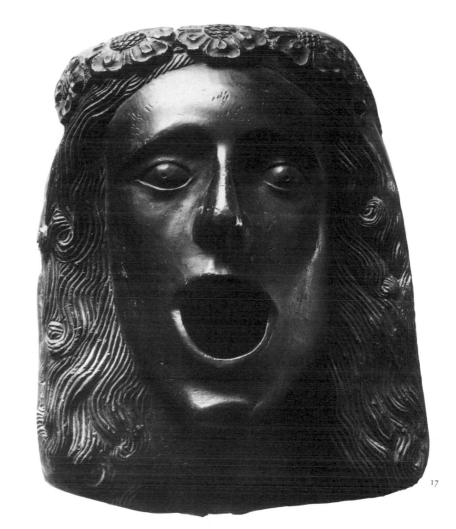

17

17 Fountain Mask of a Youth

Nuremberg, about 1400
Brass, hollow cast, with black patina
11 x 8 5/8 in. (28 x 22 cm.)
Provenance: fountain, exterior west wall, Unschlitthaus, Nuremberg.
Nuremberg, Germanisches Nationalmuseum (on loan from the city of Nuremberg since 1874)
Pl 0.225

This *Fountain Mask* is crowned with a wreath of large, closely spaced rosettes. Long locks, made up of roughly parallel wavy strands, extend along the sides of the head to the base of the neck. Occasional, irregularly placed curls enliven the pattern of these strands. Facing the spectator frontally, the face is wide eyed and open mouthed. Originally, the mouth must have been fitted with a water spout. The mask is now thought to depict a young man, rather than a young woman, because of the pronounced larynx visible in profile.

Until the 1860s, the mask was located — with a now lost counterpart — on a wall of the Unschlitthaus, which was built at the end of the fifteenth century; the whereabouts of the mask before that time are uncertain. A hole at the left side of the mask, in the last rosette of the wreath, is only a partial indication of the original method of attachment.

Although flawless in its casting and refined in its finish, this work has a number of important qualities in common — as well as some differences — with the technically inferior and earlier full-length figure of "Hansel," from the Heilig-Geist-Spital (cat. no. 16). The taut modeling of the flesh of the faces, the arched brows, the almond-shaped eyes with their pierced pupils, the rounded nostrils, and the rosette-decorated wreaths are similar in each. In the mask, the fold of flesh separating the brows and the eyes of the "Hansel" is abandoned in favor of a smoother transition between the brows and the lidless eyes, and the pupils are not so pronounced. The grooving of the hair in parallel strands with occasional curls has far more authority in the mask, and the details of the rosettes — specifically, their scalloped petals and crosshatched centers — are more fully and clearly realized. Thus, the style of the earlier figure is apparent in part in the mask, but, at the same time, there is a clear technical advance from the one work to the other, and a change in stylistic clarity.

The mask has been compared recently with several flame-tailed animal aquamaniles now attributed to Nuremberg and also dated to about 1400. The curvilinear treatment of the mane of a lion aquamanile in Munich (fig. 88; MA 2494) and of another one in Toledo (cat. no. 18) has

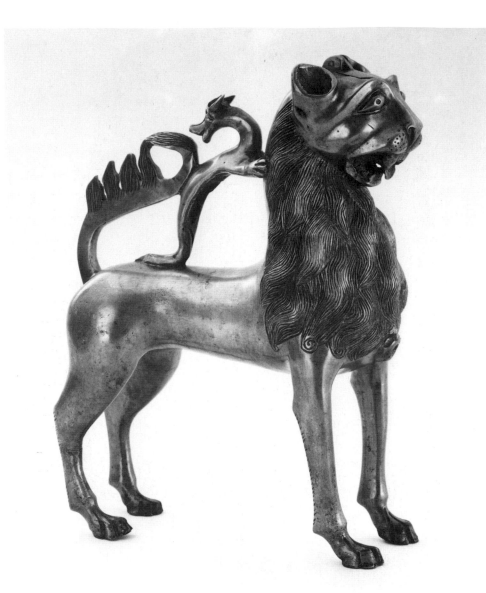

18

elements of similarity with the strands of hair on the *Fountain Mask of a Youth.*

The underlying meaning of this animated sculpture is no clearer than that of the *"Hansel."* However, one may suppose from the mask's expression, as well as from its role as a water fountain, that it was intended as a positive and optimistic symbol of a good life and of good health. WDW

BIBLIOGRAPHY: von Essenwein, 1887–89, II, p. 168; Pückler-Limburg, 1904, 48, pp. 87–88; Josephi, 1910, p. 77, no. 157; Höhn, 1922, no. 64, ill.; *Europäische Kunst um 1400*, 1962, p. 349, no. 397, pl. 74; Mende, 1974, pp. 18, 19, 21, fig. 12; Hirschmann, 1976, I, pp. 31–38; Stafski, in *Die Parler . . .*, 1978, I, p. 345; Mende, 1979, pp. 55, 56, 1981, 2, pp. 113, 117.

18 Lion Aquamanile

Nuremberg, about 1400
Brass, hollow cast, with natural patina
9³/₄ x 12¹/₂ in. (24.8 x 31.7 cm.)
Toledo, Ohio, The Toledo Museum of Art, Gift of Edward Drummond Libbey, 1953
53.74

Slender in proportion and elegant in profile, this lion aquamanile stands on tall legs, its neck arched vertically. The rear legs extend backward so that their lower portions are almost vertical. The back edges of all four legs are notched to suggest fur. A long mane, made up of a series of short, wavy clusters delineated by a rich pattern of grooves, nearly covers the entire chest and neck. The tail, with flat though grooved tufts on its upper side, arches forward and touches the back of the dragon handle, whose long-eared head is turned backward and whose feet rest on the lion's mane. The head of the lion is characterized by deep curving brows, almond-shaped eyes, punctuated pupils, puffed and punctuated glandular pads, open jaws with bared fangs and teeth, and an extended tongue.

Aquamaniles are water vessels used when washing the hands. This example, like others included here (see cat. nos. 19–22), was filled through the lidded aperture at the top of the head. An integrally cast base for the exit spout is centered in the lower chest (the spigot is missing). There is barely enough room for a hand to grasp the dragon handle, which, together with the elaborate silhouette of the tail, seems to indicate that decorative considerations were paramount in the aquamanile's design.

Hundreds of aquamaniles were made in the Middle Ages — at first, for liturgical hand washing during the Mass and, subsequently, for secular use, at princely and possibly also patrician tables (O. von Falke and E. Meyer, *Romanische Leuchter und Gefässe, Giessgefässe der Gotik*, Berlin, 1935; G. Szabo, "Medieval Bronzes in Prodigious Variety," *Apollo*, May 1969, 89, p. 359; W. D. Wixom, "A Lion Aquamanile," *The Bulletin of The Cleveland Museum of Art*, October 1974, 61, pp. 260–70).

The closely related lion aquamanile in the Bayerisches Nationalmuseum, Munich (fig. 88; MA 2494), served as the focus of Ursula Mende's important study, made in 1974; it is the basis for the attributions of all the aquamaniles included here. In fact, both the Toledo and the Munich lion aquamaniles are key works in Mende's larger group of flame-tailed lions and other animal aquamaniles, all ascribed to the brass founders' workshops of Nuremberg, of about 1400. These aquamaniles can be attributed to Nuremberg especially on the basis of stylistic comparison with the Imhoff memorial brass plaque in the Städtisches Museum, Lauingen (fig. 89), and the *Fountain Mask of a Youth* (cat. no. 16), both of which were probably made in Nuremberg. For example, the manes of the lions in Toledo and in Munich, and of another lion in Amsterdam (Rijksmuseum, R.B.K. 16913), are related to that of the heraldic winged beast on the Imhoff plaque and to the hair of the *Fountain Mask*. Thus, the dating of the Toledo aquamanile, and of the others discussed here, is based upon its subtle yet obvious interrelationship with all of the examples in Mende's group, as well as with the Imhoff plaque and the *Fountain Mask*.

The flame tails of the various lion aquamaniles, including that of the present one, are distinctive for their flatness, their almost cut-out quality, and for the virtual absence of modeling, in contrast to the rounded yet taut modeling of the bodies and heads. Except for the occasional rounded ends of the tufts, the tails impress us only when seen in profile or in silhouette, suggesting a derivation from heraldic animal representations — a supposition borne out by the profiles of the open mouths.

WDW

EX COLLECTIONS: Valmarana, Vicenza; von Frey, Vienna.

BIBLIOGRAPHY: Hutton, 1953, 16, p. 374, fig. 370; *Museum News . . . The Toledo Museum . . .*, 1964, n.s. 7, p. 5, ill.; "Medieval Art at Toledo," 1967, p. 440, fig. 6; Mende, 1974, 8–9, pp. 10–13, 15, 20, 22–23, no. 5, fig. 4; Bloch, 1982, pp. 12, 16, fig. 11.

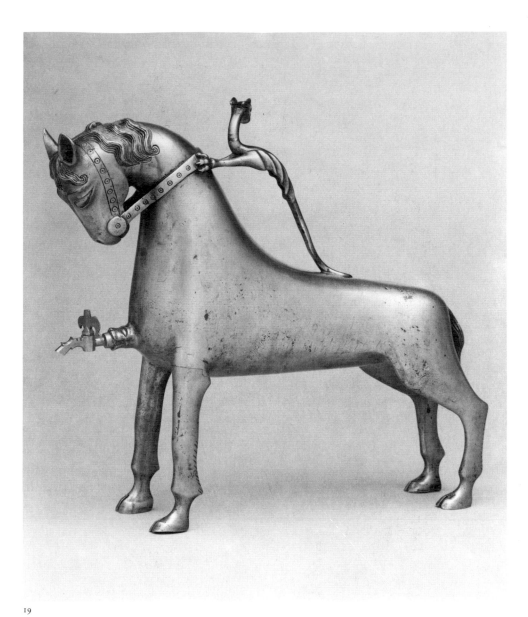

19

19 Horse Aquamanile

Nuremberg, about 1400
Brass, hollow cast, with natural patina
13 5/16 x 14 1/8 x 3 5/8 in. (33.8 x 35.9 x 9.2 cm.)
The rear left leg and the dragon head of the handle
were replaced and silver soldered; the spigot and
turncock are modern.
New York, The Metropolitan Museum of Art,
Gift of William M. Laffin, 1910
10.13.4

Slender and elegant in contour, this horse
aquamanile stands firmly on cloven hoofs, its
rear legs extended backward in a manner similar
to those of the Toledo lion (cat. no. 18). The
back edges of the legs are decorated with a series
of short notches. Lacking the lion's full mane,
the horse has three separate, distinctly modeled
and grooved curvilinear locks, which fall across
its forehead; there are three additional locks on
the left side of its neck. A short, grooved tail,
cast integrally and concave on the underside, is
the counterpart to the lion's flame tail. The
almond-shaped eyes of the lion are here trans-
formed into graceful forms composed of sweep-

ing curves. The horse's ears are elongated and
pointed versions of the lion's ears. The dragon
handles of both aquamaniles are extremely simi-
lar, although the returned head of the dragon on
the horse's handle is a replacement. The claws of
this dragon grip the sculpted reins. The incised
circles centered on dots on the reins continue on
the cheek straps, which, instead of being sculpt-
ed, are merely engraved on each side of the
horse's head. The snaffle terminals are simple
round disks with small, engraved circles also
centered on dots. The animal-head spout, cast
integrally, contains a later spigot, but the tip of
the snout, brazed to the rest of the head, may be
original.

This horse aquamanile is one of the most
characteristic of several from Nuremberg (von
Falke and Meyer, 1935, nos. 590–92, 596, 611,
figs. 540, 544; Mende, 1974, p. 24, n. 42, fig. 2).
Two additional examples are preserved in New
York, including one in The Cloisters Collection
(47.101.53; see J. J. Rorimer, "A Treasury at the
Cloisters," *Bulletin of The Metropolitan
Museum of Art*, May 1948, vol. 6, no. 9, p. 253,
ill.; V. K. Ostoia, *The Middle Ages, Treasures

from The Cloisters and The Metropolitan
Museum of Art* [exhib. cat.], New York, 1969,
pp. 122–23, no. 55), and a superb example in a
New York private collection (von Falke and
Meyer, 1935, pp. 88, 117, no. 578, fig. 531).

The overall form of this horse aquamanile and
certain details shared with the flame-tailed lions
(see cat. no. 18; fig. 88) argue for an attribution
to Nuremberg, about 1400.

WDW

BIBLIOGRAPHY: von Falke and Meyer, 1935, pp. 88, 117,
no. 583, fig. 534; Mende, 1974, pp. 12, 23, n. 12; Bloch,
1982, pp. 15, 19, fig. 37.

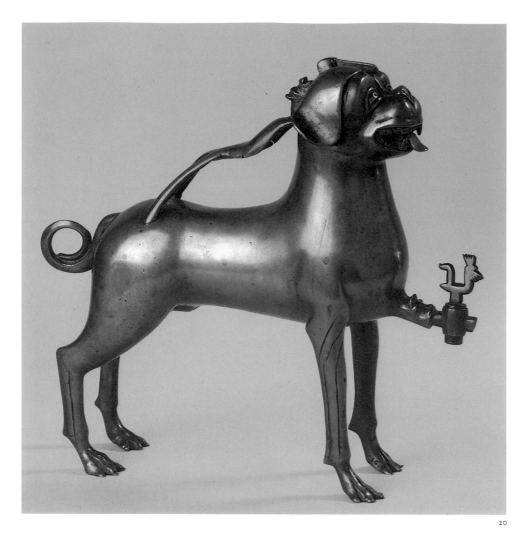

20

20 Dog Aquamanile

Nuremberg, about 1400
Brass, hollow cast, with tinned surface
13 3/8 x 12 1/16 x 2 3/4 in. (34 x 30.6 x 7 cm.)
Nuremberg, Germanisches Nationalmuseum
(acquired, 1876)
KG 583

The body of the dog is proportionally fuller than that of the horse aquamanile (cat. no. 19). The back edges of the dog's legs are furred, and the front legs, which are vertically grooved to vaguely suggest the musculature, are exceptionally long — as are those of the lion (cat. no. 18). The splayed toes are well developed. The dog's head is characterized by a foreshortened wide muzzle. His open mouth, extended tongue, and puffed cheeks are reminiscent of the lion's (cat. no. 18), but his broad, flappy ears and smooth glandular pads are the features that most clearly distinguish this aquamanile. However, both heads are marked by strong arched brows, and almond-shaped eyes with punctuated pupils.

This vessel was filled with water by means of the aperture at the top of the head, which is fitted with a lid. Its spout — as in the other examples shown here — is cast integrally, and extends from the animal's lower chest. The spout on the dog is in the form of a dragon whose ears are pointed alertly forward. While the spigot is thought to be a replacement, the bird finial of the turncock seems to be Medieval; a Roman numeral II is incised on the side. The legless dragon handle, cast integrally and connected to the dog's rump by two long tubular extensions, has been bent from the higher arch of its original position closer to the body of the dog. The dog's tail, also tubular, is curled in a circle.

Along with the three other dog aquamaniles preserved in Flensburg, Kiel, and Budapest, which share many of the same features (von Falke and Meyer, 1935, nos. 582, 593, 595, figs. 533, 541, 543), the present work may be attributed to Nuremberg, about 1400. The short, flame-like tail of the Flensburg dog, as well as its head and the head of the Germanisches Nationalmuseum example, argue for an attribution to the same workshop responsible for the lion (cat. no. 18). WDW

EX COLLECTIONS: von Pickert, Nuremberg (1876); Hahn, Hanover (1880).

BIBLIOGRAPHY: Reifferscheid, 1912, 2, pp. 23, 69, 92, no. 16, fig. 43; von Falke, 1928, 2, p. 564; von Falke and Meyer, 1935, pp. 89, 118, no. 594, fig. 542; Mende, 1974, pp. 21, 25, nn. 46, 51; Kahsnitz, in *Germanisches Nationalmuseum* . . . , 1980, p. 28, no. 49; Mende, 1981, 2, p. 176, n. 28; Kahsnitz, in *Deutsche Kunst und Kultur* . . . , 1984, p. 50, no. 144.

21 Unicorn Aquamanile

Nuremberg, early 15th century
Brass, hollow cast, with natural patina
15 1/4 x 12 1/4 x 4 3/8 in. (38.7 x 31.1 x 11.2 cm.)
The horn was cast separately; the turncock is later in date. Several casting flaws have been filled with lead.
New York, The Metropolitan Museum of Art, Gift of Irwin Untermyer, 1964
64.101.1493

Stouter than both the lion and the horse aquamaniles (see cat. nos. 18, 19), the present work is more closely related to the lion in the Bayerisches Nationalmuseum, Munich (fig. 88; MA 2494), and to the griffin (cat. no. 22), with which it shares a massive body and swelling chest, an upright neck, and a handsome curvilinear profile. The upturned, short flame tail of the unicorn ends in three separate grooved tufts, one of which touches the back of the dragon handle. Both the flame tail and the dragon are cast integrally with the body of the unicorn. The dragon rests his feet on the tip of the unicorn's carefully modeled and grooved mane. The undulating, swept-back ears of the unicorn are similar to the griffin's ears (cat. no. 22), but its almond-shaped eyes lack the elegance of the griffin's eyes. The separately cast horn is possibly later in date; if this is the case, it replaces an original that, undoubtedly, would have been given a similar twisted grooving reminiscent of actual narwhal horns. The traditional representation of this mythical creature is found in earlier and subsequent Medieval art (see R. Beer, *Unicorn: Myth, Reality,* New York, 1977 [trans. of German ed., Munich, 1972]; M. B. Freeman, *The Unicorn Tapestries,* New York, 1976; Einhorn, 1976). The depiction of the unicorn's head — a kind of hybrid of a goat and a horse — is also traditional (see M. B. Freeman, 1976, figs. 17, 38; Einhorn, 1976, pp. 99–101).

A lid — possibly a replacement — at the top of the head covers the access aperture. A stunted head, cast integrally, projects from the lower chest; fitted into its mouth is a separate spigot with an animal head that is probably Medieval.

The characteristics of the mane, almond-shaped eyes, flame tail, and dragon handle allow for the attribution of this aquamanile to one of the Nuremberg workshops active about 1400 or early in the fifteenth century. This workshop may have been the same one that produced the griffin (cat. no. 22). WDW

BIBLIOGRAPHY: Swarzenski, 1940, p. 83, no. 293; Hackenbroch, 1962, v, pp. XXXVIII, 25, pl. 93, fig. 96; Gómez-Moreno, 1968, no. 109, ill.; Mende, 1974, pp. 20, 25, n. 44; Einhorn, 1976, p. 455, no. 855 c; Gómez-Moreno, in *Highlights of the Untermyer Collection* . . . , 1977, no. 285; Bloch, 1982, pp. 16, 19, fig. 39.

22 Griffin Aquamanile

Nuremberg, about 1400
Brass, hollow cast, with natural patina
12 5/8 x 13 in. (32 x 33 cm.)
The repair in the right nostril is original.
New York, The Metropolitan Museum of Art,
Robert Lehman Collection, 1975
1975.1.1413

The full body and expanded chest of this griffin aquamanile are comparable to those of the lion aquamanile in the Bayerisches National-museum, Munich (fig. 88; MA 2494). The flat, incised imbrications of the feather-patterned neck and of the removable solid-cast wings are very different from the richly modeled and grooved curls of the Munich and Toledo lions (see cat. no. 18). The long flame tail of the griffin, integrally cast with the body, bends for-ward over its back, touching its head in a way that is very similar to that of the flame tails of the lions. The griffin's talons are striking: They are spread widely apart and are elongated at the front. The oversized beaked head — with its extended tongue, arched brows, almond-shaped eyes, and swept-back ears — is the special glory of this work.

A lid with a serpent-like tongue, in the grif-fin's upper forehead, covers the access aperture, and a stunted head, cast integrally, projects from the lower chest. The separate spigot, which fits into the mouth of this head, bears a stopper with a foliated finial.

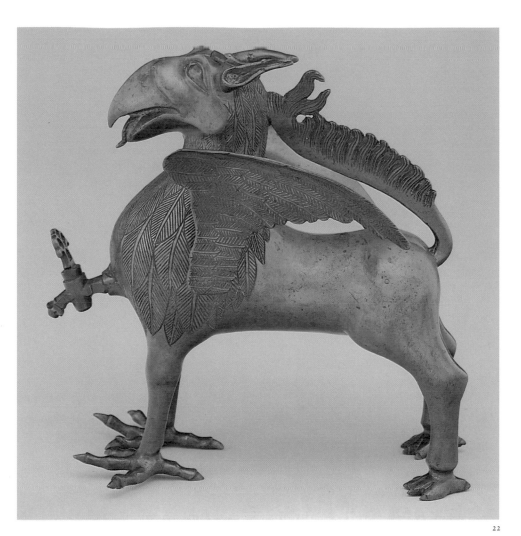

22

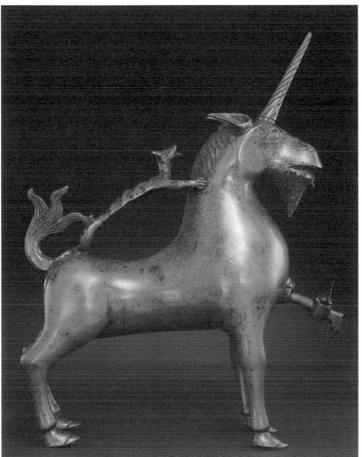

21

This griffin, along with others in Berlin, Cracow, and Paris having similar features (von Falke and Meyer, 1935, pp. 90, 118, nos. 610, 607, 608, figs. 558, 555, 556, respectively; Mende, 1974, p. 20), may be attributed to Nuremberg, from about 1400, chiefly on the basis of the flame tail. This does not mean that the griffins were made in the same workshop as the lions; the absence of a dragon handle, and the distinctive engraving of the feathers, the stouter legs, and the splayed talons suggest the possibility that another Nuremberg workshop may have produced them. WDW

EX COLLECTIONS: Maurice Chabrières-Arlès, Oullins, France; [Joseph Duveen, New York, 1928]; Philip Leh-man, New York; Robert Lehman, New York.

BIBLIOGRAPHY: Giraud, 1881, no. 8, pl. 13; Gay, 1887–1928, 1, p. 40, ill.; Reifferscheid, 1912, 2, p. 78; von Falke, 1928, 2, p. 564; von Falke and Meyer, 1935, pp. 90, 118, no. 609, fig. 557; *Exposition de la Collection Leh-man . . .* , 1957, no. 186; *The Lehman Collection, New York*, 1959, p. 38, no. 469, ill.; Mende, 1974, p. 20, n. 48.

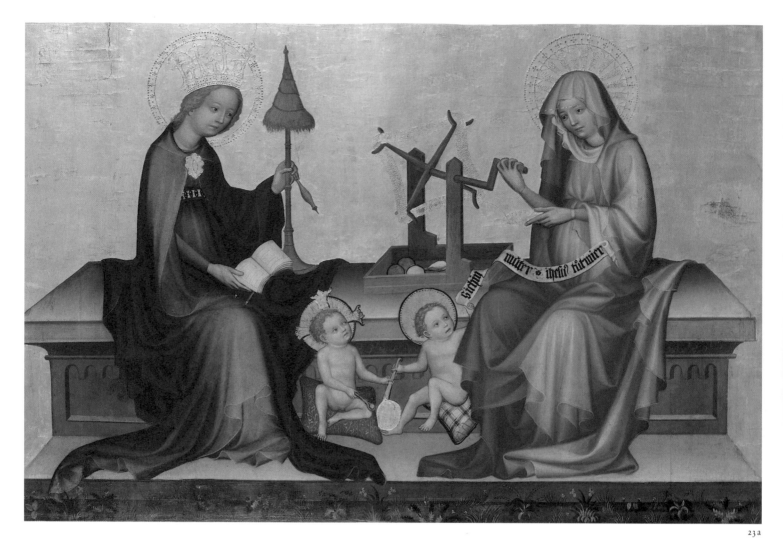

23 Mary and Elizabeth at Their Housework

(reverse): The Betrayal of Christ
Nuremberg, about 1410
Tempera on fir wood
27 x 54 in. (95 x 138.5 cm.)
Provenance: Frauenkirche, Nuremberg.
Nuremberg, Germanisches Nationalmuseum
(joint ownership with the city of Nuremberg)
Gm 1087

The panel, painted on both sides, belonged to an altarpiece on the interior of whose wings were scenes from the life of the Virgin, and, on the exterior, scenes from the Passion. Other surviving panels (in the Germanisches Nationalmuseum, Nuremberg) depict the Funeral of the Virgin, with the Flagellation on the reverse (later separated), and the Massacre of the Innocents, and (in the Städelsches Kunstinstitut, Frankfurt am Main), Christ on the Mount of Olives. The scenes from the life of the Virgin on the inside of the wings were only displayed on Sundays and feast days. They are recognizable by their gold backgrounds, and the Passion scenes, by dark blue backgrounds that now appear black. It is uncertain whether the lost center part of the altarpiece was a painting or a wood carving.

Mary and Elizabeth engaged in domestic chores is not a traditional subject in representa-

tions of the life of the Virgin. The women are seated on a stone bench. Mary, her hair undone as befits a virgin and wearing the crown of the Queen of Heaven, holds a distaff and lets her book slip from her lap. Elizabeth, her cloak pulled over her head, turns the crank of the reel as she winds on the threads from the spindle. In the box below are skeins of yarn and spindles. The infants sit on cushions at their mothers' feet, and, like their mothers, have golden haloes; that of Jesus is cruciform. He holds a spoon and, in his left hand, a pan that John also grasps as he addresses his mother, Elizabeth, with these words, which appear on the scroll that he holds in his other hand, "Sichin muter · ihesus tûtmier" ("Look, mother, what Jesus is doing to me"). Neither the inscription nor the image is easy to interpret. Is John complaining? If so, the children's dispute would have to be explained in terms of a complete humanization of Christ. If Pickering's reading is accepted, "Sie ihn, Mutter, Jesus deutet mir" ("Look at him, mother; Jesus is explaining to me"), and the pan is understood as a baptismal implement, then "the infant Jesus himself is investing and consecrating the future baptist, as well as instructing him in the rite."

The bench extends the full width of the picture, giving the composition a firm, tectonic framework. The grassy area in the foreground, strewn with flowers, indicates a garden setting.

With the symmetrical arrangement of the holy women and children and the festive gold background, the domestic scene attains a higher level than that of a genre picture. The artist does not resort directly to representations from nature, but his sensitivity in varying traditional artistic formulas is revealed in the fluidity of the drapery folds and in the warm glow of the color, which ranges from the pink of Elizabeth's cloak to an almost pure white in the highlights.

The *Betrayal of Christ* combines those elements of the subject that are familiar from pictorial tradition: Judas's kiss of betrayal and Christ healing Malchus's ear, which had been struck off by Peter. Christ is bound and is being led away, as two of the disciples try to escape from a soldier's grip. The candle in the officer's hand indicates that the scene is a nocturnal one — an impression strengthened by the dark background. The drama is vividly communicated, and the feelings of those involved are reflected in their various gestures. The stepped-cliff formation of the background, with the trees on a different scale from that of the figures, serves to enclose the groups on either side of Christ, restricting their movements in space. The large variety of figures demanded even more strongly differentiated color, the darkest shades employed in the background, and the brightest, in the white highlighting of some of the pink robes.

142

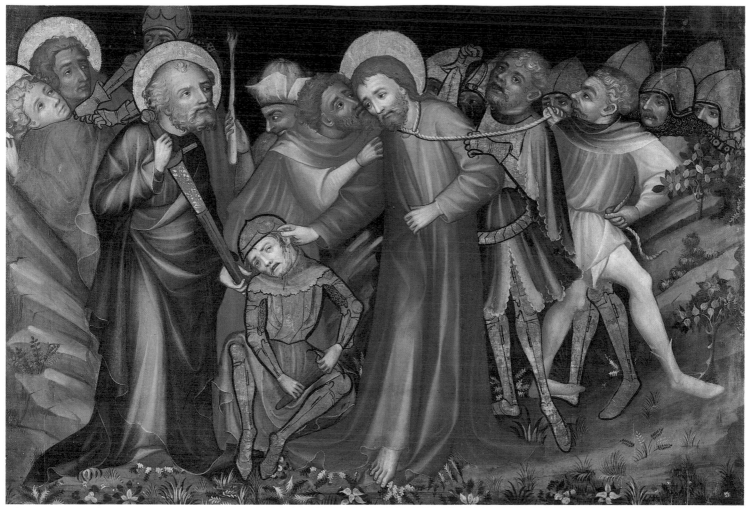

23 b

Thode (1891) recognized that the painting, then still in a private collection in Vienna, belonged to the same altarpiece as the panels in the Germanisches Nationalmuseum, and pointed out the similarities with works of the Bohemian school, particularly those of the Master of the Wittingau Altarpiece. The influence of Bohemian painting on countries farther west is also explained by the Hussite Wars, which caused many artists to seek work elsewhere.

The *Altarpiece of the Virgin* is dated to about 1400–1410. The question of its original location remains unresolved. The imposing size of the wings, which would have given the retable a total width of over 5.4 meters, would imply that it occupied a high altar — possibly that of Nuremberg's Frauenkirche, which was "modernized" after 1522 (see Gebhardt, 1908; Lutze and Wiegand, 1936). KL

EX COLLECTIONS: Przibram, Vienna; Goldschmidt-Przibram; [sold, Frederik Muller & Cie., Amsterdam, no. 1, (June 17–19, 1924)].

BIBLIOGRAPHY: Thode, 1891, p. 46; Gebhardt, 1908, p. 16; Abraham, 1915, pp. 9–10; *Goldschmidt-Przibram Collection...*, 1924, no. 1; Zimmermann, 1932, pp. 28–30; Stange, 1934–61, vol. II, pp. 170–72; Lutze and Wiegand, 1936, pp. 117–18, ills. 12–16; Schmidt, 1969, p. 317; Stange and Strieder, 1978, no. 13; Pickering, 1981, pp. 21–27.

24 Two Apostles: Bartholomew and Simon

Nuremberg, about 1400
Terracotta
Height: overall, 26 3/8 in. (67 cm.) and 25 3/16 in. (64 cm.); bases: width, 18 1/8 in. (46 cm.) and 16 in. (42 cm.); depth, 11 7/16 in. (29 cm.) and 11 in. (28 cm.)

On each of the heads are various holes that allowed air to escape during firing. All traces of polychromy have disappeared from both figures. The Bartholomew is missing two small locks of hair on his forehead (one on either side of the surviving one), as well as the tips of his right toes, the tip of his right thumb, the blade of his knife, and the upper section of the right side of his bench. The left hand, with the exception of the little finger, has been restored, as have considerable portions of the drapery, especially next to the hands, on the shoulders, and on the long folds that fall to the ground. The bench and the base have also been repaired. Even so, it is clear that the original form of the drapery of the robe has not been altered. The youthful apostle is also missing a lock of hair, most of the attribute in his right hand, and the rear left corner of his bench and base. The front edge of the base and the projecting ends of the robe have been restored — at which time the play of folds unquestionably was simplified.

Provenance: unknown monastic church, Nuremberg; Frauenkirche, Nuremberg (19th century, probably since 1816).

Nuremberg, Germanisches Nationalmuseum (acquired following the deposit of the objects in the museum in 1882)
Pl 0.232, 234

The two apostles are part of a series, of which six are now in the Germanisches Nationalmuseum (Stafski, 1965, nos. 106–111, ill.). Three others are part of the predella of the altarpiece on the high altar of the Jakobskirche, along with a Late Gothic statue of Saint John the Baptist, of wood (Wilm, 1929, ills. 39–40, 42; Pilz, 1964, p. 30, ill.). Another statue of an apostle, dating from about 1450 and, likewise, of wood, is also in the Germanisches Nationalmuseum (Stafski, 1965, no. 141, ill.). Most of these figures are missing their attributes. An enthroned Christ, which must have served as the central sculpture of the series, and three apostle figures all have been lost. One, at least, must have been destroyed in the fifteenth century and replaced by the carved wooden figure — at which time, at the latest, the Saint John the Baptist statue must also have been added to the group. In size, pose, and coloring, the wooden figures match the clay ones perfectly. The sculptures at the Jakobskirche preserve most of their polychromy, so that we know that the apostles' robes were white, with floral designs in red and gold and gold borders; the linings of the garments were primarily red or green.

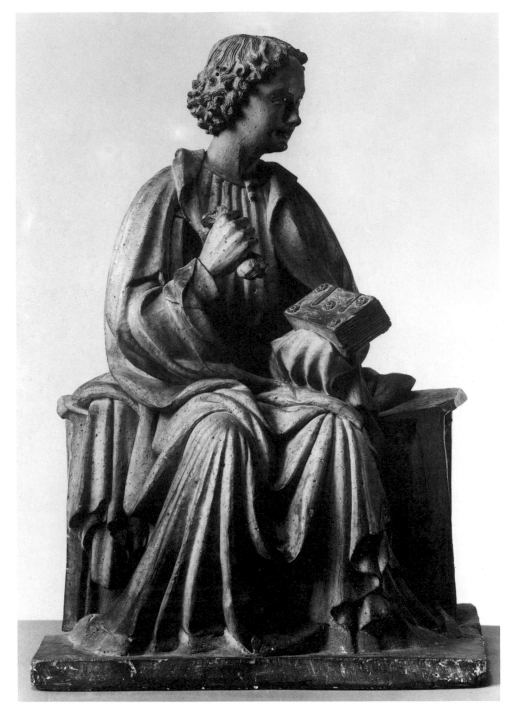

24: *Simon*

rosettes and other architectural tracery forms — that they must have been meant to be seen from behind, as well. Even the two supplementary wooden figures from the fifteenth century are completely carved on the backs, contrary to medieval practice, and are only slightly hollowed out at the bottom. At that time, then, the figures must still have been freestanding.

Of course, there is almost no precedent for freestanding figures in a medieval church. All of the surviving statues of apostles — the youthful one shown here, less than the others — quite clearly look downward. If they were, in fact, in a monastic church, they undoubtedly would have been placed along the top of a choir screen. This would explain the direction of their gazes. Such a location would have provided ample room for both the figures and their bases to be seen from the back as well as the sides. The group of Christ in the circle of his apostles would have been appropriate to grace the balustrade of a choir screen. Given the warped bases of the figures — as a result of the firing — it is clear that, after having been installed in such a tenuous location, already by the middle of the fifteenth century several of them would have had to have been replaced by new, wooden figures.

Saint Bartholomew, who is depicted as a powerful, expansive figure, seated on a wide bench, may be identified by the knife that he clutches — the instrument of his martyrdom — in his right hand, although the blade is missing. With his left hand he clasps the book to his chest. His right leg rests on his left knee, so that his toes are visible under his heavy robe. His strong head, framed by a quantity of curly hair and a lush beard, is turned to the side, and he gazes downward out of deeply shadowed eyes without a glance at his book. The full robe almost totally obscures his form, its numerous folds, especially on the sides, falling in such a way as to create a pyramid-shaped base for the figure. Because of the saint's crossed leg, the drapery lies heavily across his lap, its free end curving majestically across his chest and over his right shoulder, forming vertical folds down his back, and terminating in a wavy border at the hemline. His hands and his right foot appear to lift the weighty fabric, forming fixed points of reference for the uniformly rich flow of the drapery. The folds overlap across the figure's right knee so as to clearly exploit the fabric's heaviness, and on the ground they break and turn back, completely obscuring the left leg.

The youthful apostle is a much simpler figure, his gestures less expansive. His robe is thin and not as full, and his cloak, open at the front, forms a collar across the shoulders and drapes over his lap and knees, from which it falls forward in regular, nearly symmetrical folds to the ground. The fabric is gathered between the young apostle's knees, and some of it lies on the bench beside him. The young man is beardless. His short hair curls at the ends, leaving his neck free. He gazes off to the side. Resting on a cushion of fabric near his left hand is a small gospel book, fitted out in careful detail with embossed

Nothing is known of the precise origin of the figures in Nuremberg, or how they originally were displayed. The Jakobskirche apostles were brought there in 1824/25 by Carl Alexander von Heideloff "from an old monastery church" (Lösch, 1825, pp. 27, 28, 30); the six remaining ones stood below the *Tucher Altarpiece* in the Frauenkirche in the nineteenth century (von Rettberg, 1846, p. 78), having presumably been placed there in 1816, at the time that the Frauenkirche became a Roman Catholic church. Although it was once thought that they originally might have been part of the predella of an altarpiece, it has been pointed out — quite rightly — that, about 1400, there were no altars of such vast dimensions, with a predella at least six meters wide. A somewhat older set of terracotta

apostles in the small village church in Kalchreuth, near Nuremberg, was displayed, even in the Middle Ages, on an iron trestle, or stand, against the church wall (Sauermann, 1911, pp. 32–33; see also Wilm, 1929, p. 45, ills. 122–123). It has generally been supposed that the Nuremberg apostles were arranged in two rows, one above the other, in the center of an altarpiece, like the wooden apostles of the *Deocarus Altarpiece,* of 1436/37, in the Lorenzkirche (Pfeiffer, 1971, ill. 142). Walter Fries (1924, pp. 108–9) has drawn attention to a reference, in 1436, to a *Zwölfboten Altarpiece* (Twelve Apostles Altarpiece), in Sankt Katharina. However, the reverse sides of the figures are so richly and carefully finished — especially the backs of the benches, with their spiraling

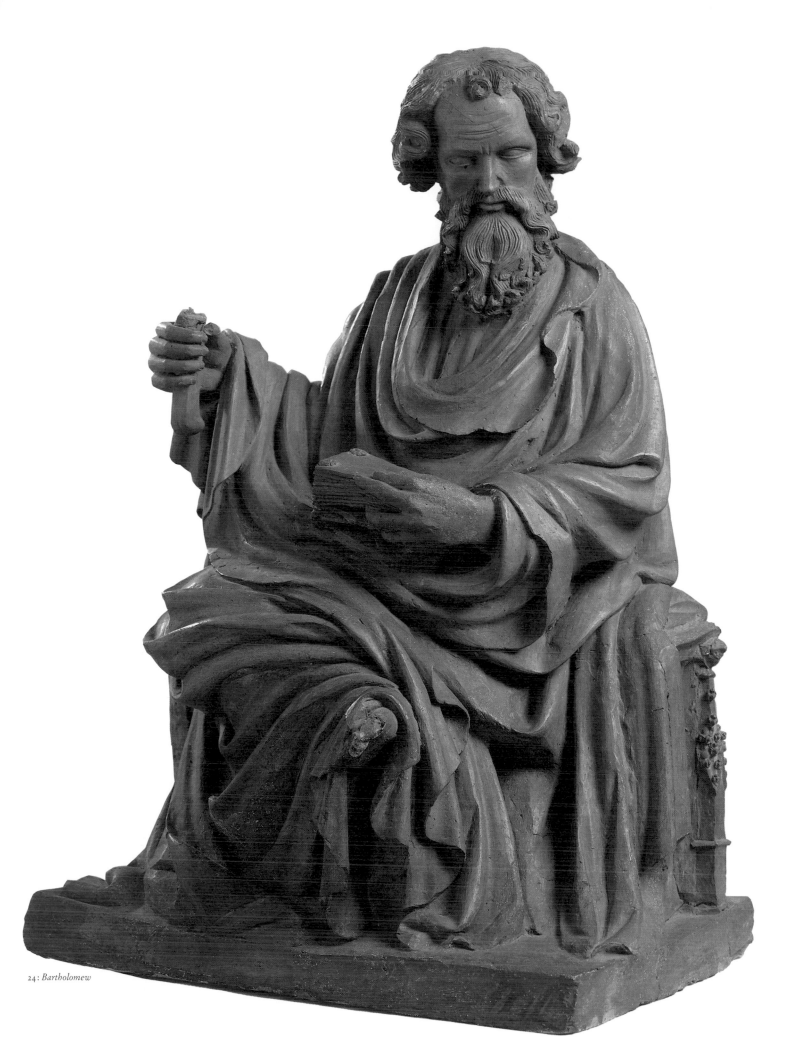

24: *Bartholomew*

24 : reverse
of *Bartholomew*

covers and leather hinges — the general attribute of an apostle. Originally, he held the instrument of his martyrdom in his right hand, in front of his chest, but all that remains of it are two knobs extending below his hand and the stumps of two attenuated objects above. The former can only be the pommels of two swords; no other attribute of an apostle is conceivable here, even if the rarest and most exotic ones are considered. Identification of the saint is extremely difficult. Saint Paul is occasionally depicted with two swords — clearly, an analogy to the two keys of Saint Peter — one, an instrument of his martyrdom, and the other, the sharp sword symbolic of his spirit (von Dobschütz, 1928, p. 11). There are even examples of this in the art of Franconia of about 1500 — as in a series of apostles by Riemenschneider, in Munich (Müller, 1959, no. 144, ill.), or on the *Sebaldus Tomb,* in Nuremberg (H. Stafski, 1962, fig. 58). On the other hand, a specific facial type was established for the Apostle Paul at a very early date. He is always portrayed as an older, bearded man, generally, with a long, pointed beard and a bald head. The only apostle who is usually represented in Western art as a young and beardless man is John the Evangelist, while, in the Eastern tradition, Saints Thomas and Philip are so depicted. Of the surviving clay figures from the Nuremberg apostles cycle, two are young men; the other is likely Christ's favorite. None of them can be identified as Paul, as he is usually portrayed. Yet, in Nuremberg, another tradition seems to have existed. One of the standing apostles, of about 1380, in the series in the Lorenzkirche, holds two swords. Because of his position in relation to Saint Jude, he may be identified as Simon Zelotes (Martin, 1927, p. 144, no. 105, ill. 295). In the older, and, admittedly, somewhat more provincial series of terracotta apostles, in Kalchreuth, there is also a second youthful apostle in addition to John, and he, too, holds a gospel and two swords before him. Here, as well, the saint cannot be Paul (Sauermann, 1911, p. 33) but must be Simon. Thus, it would appear that the master of the Nuremberg apostles did not commit an isolated error, but, rather, possibly initiated a certain local iconographic tradition quite unlike that generally encountered.

Sculpting in clay is, of course, quite different from carving stone, and the technique, itself, has much to do with the character of these figures. It is quite apparent, for example, how their robes were built up of thin, overlapping, and folded sheets of clay. Because these layers behaved much like the fabrics that they were intended to represent, and because the figures could be covered and, literally, dressed in them, there is a verisimilitude about the drapery that is seldom found in stone figures, where each detail, each fold, has to be carved out of the stone. Style and technique become one in these voluminous, flowing garments. One also sees how the surface has been worked with a knife and a tool somewhat like a comb — for example, the hand and the sword handles of the youthful apostle, or the hair of the Bartholomew. Most

of the tracery on the benches was carved with a knife, although parts of it were molded. The young apostle also reveals the technical problems of firing such large clay forms, for its weight has caused the bench to sag considerably in the drying and firing process, so that the figure, in his heavy robe, appears to be in danger of sliding off his seat — a characteristic even more apparent in some of the other sculptures in the series (Stafski, 1965, no. 111, ills.).

Fourteenth- and fifteenth-century clay figures — specifically those dating from about 1400, and not only in small scale, or in molded reliefs, but also separately formed figures of considerable dimensions — although they are rarely life size, are found in many areas of southern Germany. The Middle Rhine and Franconia were major centers for the production of such sculptures. The Nuremberg figures — especially the clay apostles, dating from about 1400 — were the first to receive scholarly attention. However, there were Franconian works in this material, from several decades earlier — among them, a standing figure of a knight that is quite closely related to the style of the Schöner Brunnen (fig. 117).

The Bartholomew has always been the most admired of these figures, for the richness and vitality of his drapery, the expressiveness of his features, and his expansive gestures. The feeling that the sculpture conveys, and its radiant energy set it apart from the rest of the apostles, which are more reserved, and comparatively more conventional works of art. It has been pointed out that the two youthful apostles and the style of their drapery appear to have been the patterns for the rest of the series, and, for that reason, some scholars have considered them, along with the Bartholomew, the works of a master whom they imagined to be the head of a workshop — whose own inventions were, accordingly, reproduced by lesser artists. However, in so doing, they have misunderstood the logic of the series. The very task of creating a sequence of thirteen seated male figures of identical size necessarily leads to the variation and development of a few basic formal ideas. Serial production is also well suited to sculpting in clay, and the ease with which the material can be worked. This is apparent in all such sculpture series. Apostle sequences were much in demand in Franconia about 1400 — as is obvious from the number of partial series that survive (see Wilm, 1929; Müller, 1930). Shortly before then, in the late fourteenth century, the Frauenkirche in Nuremberg must also have contained such a series of figures, of about half the height of the present one, for a fragment still exists (Josephi, 1910, no. 86, ill.; Wilm, 1929, p. 47, ill. 31). From what is known of such production, the artistic quality of the examples shown here appears not to have been achieved elsewhere.

Quite apart from the problem of "original artistic invention and the variation of a given composition," it cannot be overlooked that the Bartholomew stands out from the series because of the man who created it. Just where its specific artistic antecedents are to be sought is diffi-

cult to determine. Wilhelm Pinder (1924, pp. 10–11) suggested Bohemia. Theodor Müller, who has continually stressed the singularity of this figure, earlier proposed that its creator came from the Middle Rhine — or, in any case, not from Bohemia, where clay sculpture was unknown. Müller (1930, pp. 197–98; 1966, p. 33) later spoke of the series as deriving from the Parler style. Although admittedly of high quality, the artistic effect of clay sculpture from the Middle Rhine, nevertheless, is largely quite different (see cat. no. 25). A locale where a technique and a medium are established does not necessarily provide stylistic precedents. Clay sculpture had been common in Nuremberg long before this time. However, the existence of the Bartholomew master cannot be explained in terms of Nuremberg's waning artistic tradition in the last years of the fourteenth century — represented most clearly by the figures of the Schöner Brunnen — no matter how much the sculptures remaining from the series happen to accord with the more widespread production at the onset of the new century. Even the powerful, life-size clay figure of Saint Andrew, in the Pfarrkirche, at Ochsenfurt (fig. 76), is, by comparison, a milder, softer work — one that compares most favorably with the splendid *Virgin in Glory,* in the Sebalduskirche (fig. 77). According to Müller, the new freedom and intensity of feeling conveyed by the Bartholomew figure also betray a knowledge of the achievements of monumental sculpture in the West at the beginning of the fifteenth century. Pinder (1924, p. 13) already noted a resemblance to the works of Claus Sluter in Dijon. R K

BIBLIOGRAPHY: von Rettberg, 1846, p. 78; Pückler-Limburg, 1904, pp. 64–70, pl. IV; Josephi, 1910, nos. 91–96 (with earlier bibliography and ills.); Pinder, 1914–29, pp. 18–19, 149–50, ills. 18–19, 112–114, pl. VII; Bier, 1922, pp. 6, 14, ills. 32–33; Höhn, 1922, pp. VIII, 116, ills. 38–41; Pinder, 1924, pp. 10–12, pl. I; Martin, 1927, p. 120; Wilm, 1929, pp. 19, 44–49, ills.; Müller, 1930, pp. 197–98; André, 1930–31, p. 174, ills.; Goldmann, 1935, p. 28; Fillitz, in *Europäische Kunst um 1400,* Vienna, 1962, no. 398, pl. 70; Stafski, 1965, nos. 106, 108 (with additional bibliography and ills.); Müller, 1966, pp. 33–34, pl. 37; Pfeiffer, 1971, ill. 150; Clasen, 1974, pp. 148, 210, ill. 401; Stafski, in *Die Parler...,* Cologne, 1978, I, p. 370, ills.; Bräutigam, 1982, pp. 207–11, ills. 3–5; Liebmann, 1982, pp. 52, 55, 115; ill. 32.

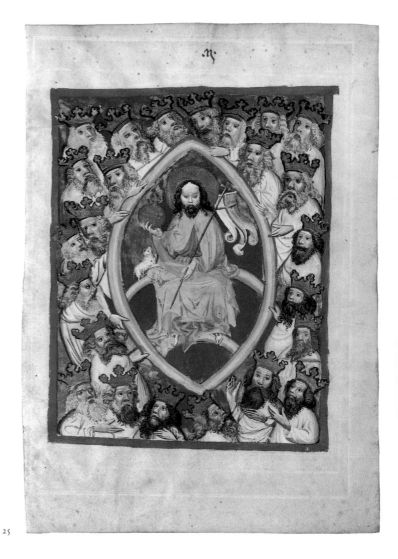

25 Saint John the Evangelist Gazing on Christ in Majesty Surrounded by the Twenty-Four Elders of the Apocalypse

Nuremberg, about 1430
Tempera and gold leaf on parchment
Two leaves, 11 9/16 x 8 1/16 in. (29.4 x 20.5 cm.)
and 11 5/8 x 8 in. (29.6 x 20.3 cm.)
Provenance: convent of Sankt Katharina, Nuremberg.
Nuremberg, Germanisches Nationalmuseum (acquired by 1903)
Mn 360-361

Saint John the Evangelist kneels before a heavenly vision, in the midst of a fantastic landscape on the island of Patmos: Christ has appeared to him, seated on a double rainbow within a rainbow mandorla, around which are crowded the crowned heads of the twenty-four Elders of the Apocalypse.

These two separate leaves come from an illuminated manuscript (Cent. IV, 44; preserved in the Nuremberg Stadtbibliothek) with a text, *The Twenty-Four Elders, or The Golden Throne of the Adoring Soul,* by the Franciscan monk Otto of Passau, written in Basel shortly after the middle of the fourteenth century. The text is a compilation of the maxims of various authors, arranged in twenty-four chapters, each attributed to one of the twenty-four Elders. At the beginning of each chapter is a miniature of the Elder in question. Obedience to the admonitions and commandments of this popular work of German mysticism guaranteed the purified soul a place in heaven. The book was circulated mainly in convents. This particular example came from the Dominican convent of Sankt Katharina in Nuremberg, where it is listed in the manuscript catalogue of the library (now in the Nuremberg Stadtbibliothek, Cent. VII, 79) under the signature "JX." We know that these two miniatures belonged in the book, for an entry on the recto of the Saint John painting reads: "this book belongs in the convent of Sankt Katharina in Nuremberg" ("das puch gehert in das clost[er] zu sant Katherein P[re]dig[er] ord[en] in nur[nberg]"), and the same inscription appears a second time, in the identical hand, on folio 359 v. of the book. Moreover, the numbers on the two leaves match the number on the first page of the book: The Saint John miniature is numbered *j,* the Christ miniature *ij,* while the book, obviously missing two pages, begins with *iij.*

This specific iconography of Christ in Majesty originated in Alsace at the beginning of the fifteenth century. There, the cult of the twenty-four Elders was widespread. These Elders stood above the saints in the hierarchy of heaven, and were considered as the mediators for all prayers addressed to God the Father. They are performing this function in the first of the two miniatures. Paired with the *majestas domini* is the miniature of Saint John. It seems plausible that there were Alsatian models for the two illuminations, possibly transmitted by the nuns who came to the Nuremberg convent of Sankt Katharina from their motherhouse in Alsace in 1428, yet the dialect of the text is Franconian.

There is little variation in the faces of the Elders, clustered in groups; all are similarly bearded old men, whose expressions and gestures are also stereotypes. Christ and Saint John, on the other hand, are distinguished by high foreheads and broad faces. John's experience of the vision is not mirrored in his face, but is only indicated by the fluttering tip of his cloak.

Separate elements of the imaginary landscape of Patmos are presented in a series of diagonals that reach to the top of the painting, directing the viewer's gaze toward the heavenly vision. Its bright, transparent colors contrast with the darker colors of the "earthly" landscape, which displays only a hint of perspective: Its more distant features are nearly indistinguishable in color and scale from those close to the kneeling figure of the saint, for whom the landscape serves merely as an attribute. This painted "cutout of the world," with its rugged cliffs, gnarled

148

trees, suggestion of a city, and overall stage-like arrangement, is reminiscent of works in the International Style of about 1400.

The assimilation of motifs of diverse origins — from Bohemia, Burgundy, France, and the Upper Rhine — and their adaptation to what was already local tradition, are characteristic of Nuremberg manuscript illumination in the first half of the fifteenth century. O L

BIBLIOGRAPHY: Bredt, 1903, no. 282; Raspe, 1905, no. 67a–b; Burger, 1917, p. 306; Fries, 1924, pp. 56–57; Fischer, 1928, pp. 43–49; Lutze, 1930–31, p. 19; Stange, 1934–64, vol. 9, p. 33; Schmidt, 1938, pp. 17–20; Grote, 1971, pp. 85–98.

26 Missal: Winter Section

Nuremberg, about 1420
Parchment, 228 leaves, with tooled pigskin binding and brass mounts and closures
13 5/16 x 10 1/16 in. (33.8 x 25.5 cm.)
Provenance: convent of Sankt Katharina, Nuremberg.
Nuremberg, Germanisches Nationalmuseum
(on permanent loan from the Merkelsche Familienstiftung since 1874)
Hs. Merkel 1121

The framed, full-page illustration of the Crucifixion (fol. 152 v.) depicts only three figures against a tooled-gold background: the crucified Christ, and Mary and Saint John the Evangelist, who stand on either side of the cross in silent mourning. The miniature appears in the winter section (pars hyemalis) of the Missal. An additional image of the crucified Savior, alone, occupies the lower painted border of the page.

A handwritten entry on folio 1r. reveals the provenance of the Missal, recording that Margareta Kartäuserin "improved" the book in 1452. Thus, it clearly existed at this time. In 1428, Margareta Kartäuserin, and other nuns from the Dominican convent of Schönensteinbach in Alsace, had come to Nuremberg to institute a reform of the convent of Sankt Katharina. Margareta is known as one of the convent's most important scribes.

The Canon page obviously dates from the time of the Missal's creation, while the Crucifixion below the *Te igitur* miniature (fol. 153 r.), in a style different from the canon illustration, is of a later date (about 1430–40), and possibly was inserted at the time that the book was "improved."

In the first half of the fifteenth century, a miniature and an image intended to be kissed were commonly combined on a canon page. The small Crucifixion, quickly sketched in grays and browns, was intended to receive the customary kiss of the priest during the Mass.

The rendering of Christ's head, the style of the crown of thorns, the manner in which his hands grasp the nails in the cross, the extreme

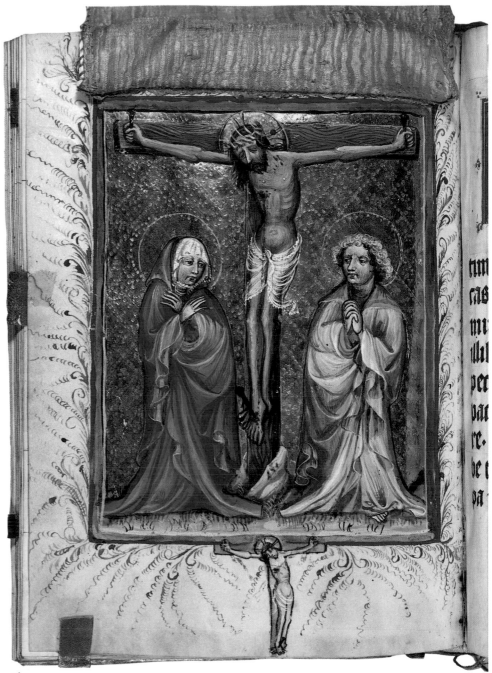

26

attenuation of his legs, and the transparency of his loincloth, are reminiscent of Bohemian-Italian International Gothic representations of the Crucifixion dating from about 1400. In some of its details, the present Crucifixion miniature resembles one from a Nuremberg manuscript dated about 1410, devoted to the legend of John the Evangelist, that is preserved in the library at Gotha (membr. I 68). In both miniatures, Christ inclines his head toward Mary, who crosses her hands over her breast, while John expresses his anguish by wringing his hands. A date of about 1420 for the Missal is suggested both by the modeling of Christ's body and of the faces of the figures — heightened, in part, by the black outlines — and by the attendant figures of Mary and Saint John, who are virtually mirror images, their full robes falling to the ground and forming broad bases that give them a statue-like appearance.

The concentration on only a few repeated colors serves to link the frame of the miniature, the narrow strip of landscape, and the figures in a harmonious composition, which, for the most part, dispenses with narrative detail. The Crucifixion miniature of the canon page, set against a gleaming gold background, emphasizes the theological import of Christ's sacrifice in a straightforward manner designed to appeal to our sympathy. In this, it is far removed from the more decorative, courtly manuscript illustrations of Bohemia, which had originated in several Prague workshops about 1400; the close relationship between the two cities determined the style of Nuremberg manuscript illumination in the first and second decades of the fifteenth century. O L

EX COLLECTION: Paul Wolfgang Merkel, Nuremberg (19th century).

BIBLIOGRAPHY: Wilckens, 1963, pp. 62–66; *Merkel*, 1979, no. D 1.

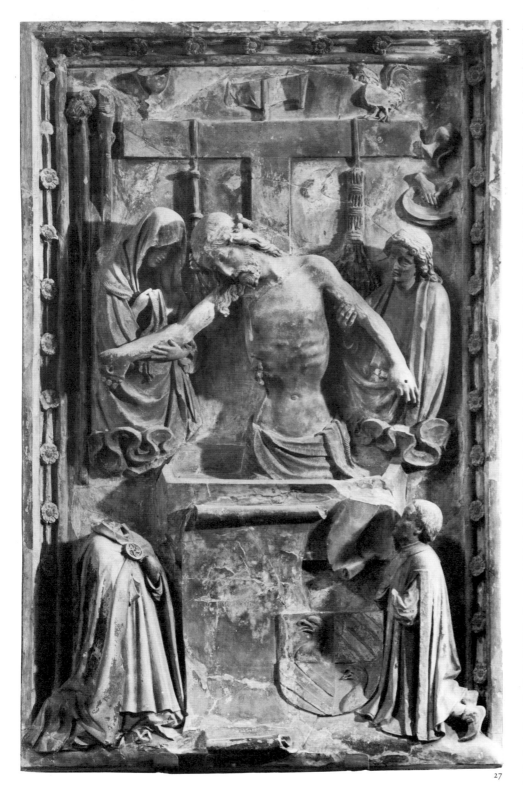

27

27 MASTER OF THE CHRIST BEARING THE
CROSS FROM LORCH

The Tondoerffer Epitaph

About 1425
Terracotta
36 ¹¹/₁₆ x 23 ⁵/₈ in. (93.2 x 60 cm.)
The head and hands of the kneeling Pope Gregory
are missing, as are the nose and hands of the donor,
portions of the crown of thorns, and the fingers of
Christ (already, by 1907). The inscription painted
on the large banderole apparently flaked off at an
early date. The work was broken in several pieces
in 1947, during the rebuilding of the church after

World War II. Since then, a portion of the ban-
derole over the donor's head — as well as parts of
the *arma Christi* and the inscription panel above
the arms of the cross — have been lost. The frame
has been partially restored. There are a few traces
of polychromy.
Nuremberg, Lorenzkirche (originally located on
the outside, next to the central portal of the north
façade; moved inside after World War II, and now
mounted on one of the columns on the north side)

A rose-studded frame surrounds this portrayal
of the Man of Sorrows standing in his open sar-
cophagus. Although collapsing in death, he is

supported by the Virgin and Saint John, who
are represented on clouds. Mary, whose face is
in deep shadow, is attempting to dry her tears
with the end of her veil. Behind the figure of
Christ are the cross and other instruments of the
Passion. Two scourges hang from the arm of the
cross; to the left, are the lance and the vinegar-
soaked sponge, atop a hyssop stalk; to the right,
are the hands of Pilate with a water pitcher and a
basin; above the crossarms are the chalice in
which the angel gave the Savior drink on the
Mount of Olives, and the cock, the symbol of
the denial of Peter. The three-quarter-length
figure of Christ is larger than the others. Mary
and John are next in scale. The two kneeling
figures in the foreground are smallest of all: the
one on the left, missing its head, wears a pluvial,
alb, and dalmatic, and reveals barely recogniz-
able traces of a tiara on his neck and shoulders;
he is Pope Gregory the Great, who, according
to tradition, experienced a vision of Christ as
the Man of Sorrows while celebrating the Mass
(see cat. no. 179 a). Across from him kneels a
representative of the Tondoerffer family, of
Middle Franconia, as the coat of arms makes
clear, dressed in a stylish, fur-lined costume of
the period, with high, buckled shoes. The Ton-
doerffer family came from the small village of
Dondörflein, near Herzogenaurach, not far
from Nuremberg. A certain Friedrich Ton-
doerffer is mentioned in 1413 as being a member
of the Greater Council in Nuremberg; he still
resided in the city in 1431. His brother, Hein-
rich Tondoerffer, was pastor of the Lorenz-
kirche from 1424 to 1438. It is not possible to
identify this particular donor more closely; his
secular dress would indicate that he is not the
pastor, himself. Presumably, he is either Fried-
rich, another brother, or even the father — of
whom nothing further is known.

Veneration of the Man of Sorrows is associ-
ated with the legend of the Mass of Saint Greg-
ory. As a subject for sculpture, the Man of
Sorrows was nowhere as popular as in Nurem-
berg. Many of the surviving portrayals of this
figure are associated with tomb monuments and
memorials to the dead. The Man of Sorrows
effectively summed up the whole of Christ's
Passion, and, therefore, the individual worship-
er's hopes for salvation could be concentrated
on him. He was depicted gazing directly at the
worshiping viewer, to whom he communicated
the promise of God's redemption and mercy. A
common name for pictures of this type in the
Middle Ages was "Our Lord's Mercy." The in-
dulgences to be gained through prayer before an
image of the Man of Sorrows could be trans-
ferred to the deceased as well. Portrayals of the
living Savior standing alone, wearing the crown
of thorns and displaying the wounds of his
crucifixion, were, therefore, altogether com-
mon, but in Nuremberg, especially, epitaphs of-
ten included the figures of the mourning Virgin
and Saint John, who supported the dead Christ.
In the chapel directly above the portal beside
which the *Tondoerffer Epitaph* was installed
was the *Imhoff Altarpiece* (see cat. no. 29). On
the Balcke and Wipplar family epitaphs —

likewise in the Lorenzkirche and dating to about 1420 — Christ, the Virgin, and Saint John are portrayed as half-length figures, occupying clouds above the kneeling patrons (Stange, 1934–56, vol. 9, ill. 2). The depiction of Pope Gregory, on his knees in adoration beside the donor, is also a common tradition in Nuremberg and elsewhere in Franconia — as, for example, on the *Hutten Epitaph*, of 1422, in the Moritzkapelle, in Nuremberg (Redslob, 1907, pl. 11). Later epitaphs included lengthy indulgence inscriptions beneath the portrayal of the Mass of Gregory (Lutze and Wiegand, 1937, ill. 32).

Although the *Tondoerffer Epitaph* is firmly rooted in the iconography of Nuremberg art, the sculptor who created it must have been from the area of the Middle Rhine. Alfred Schädler identified him as the master who made the figures for the altarpiece with Christ Bearing the Cross, from Lorch (now in the Skulpturengalerie, in Berlin-Dahlem), and for the Lamentation, from Dernbach (now in the Diözesanmuseum, Limburg). The sources of his art lie in earlier Netherlandish sculpture — and possibly also in painting, to judge from the figure of the Nuremberg donor. This portrait seems to be directly comparable to Netherlandish portraits, of the period. The sensitivity in the treatment of these figures and of the surfaces contrasts sharply with contemporary Nuremberg sculpture in terracotta — as represented, for example, by the series of apostles (see cat. no. 24), with their stocky proportions and massive volumes.

<div align="right">RK</div>

BIBLIOGRAPHY: Redslob, 1907, pp. 17–18, ill. 4; von der Osten, 1933, p. 99, n. 16, ill. 168, 1948, col. 470, ill. 13; Appelius, 1951, pp. 56–60, 87–89; Eichhorn, 1952, p. 279, ill. 4; Schädler, 1954, pp. 80–84, 87, ills. 1, 3; Ehresmann, 1966, pp. 306–13, no. 93; Müller, 1966, p. 32; Viebig, 1971, p. 35, ill.; Fehring and Ress, 1977, p. 107; Dettenthaler, 1979, p. 311, ill. 3.

28 MASTER OF THE BAMBERG ALTARPIECE

The Man of Sorrows, with the Virgin

About 1420
Tempera and oil on fir wood
42 3/4 x 18 1/4 in. (109.5 x 46.7 cm.)
The gold background is damaged.
Nuremberg, Germanisches Nationalmuseum
(acquired, 1951)
Gm 1531

Christ's forehead is covered with the blood left by the crown of thorns. He displays the wounds in his hands and feet made by the nails and the wound in his side caused by Longinus's spear. The Virgin, supporting and comforting her Son, clasps his right elbow and, with her left hand, grips his left shoulder; she seems to be covering and protecting him with her cloak. Her expression is filled with compassion. Christ's features reflect the agony of the Passion: His brows are furrowed in pain, and his lips are parted. Two

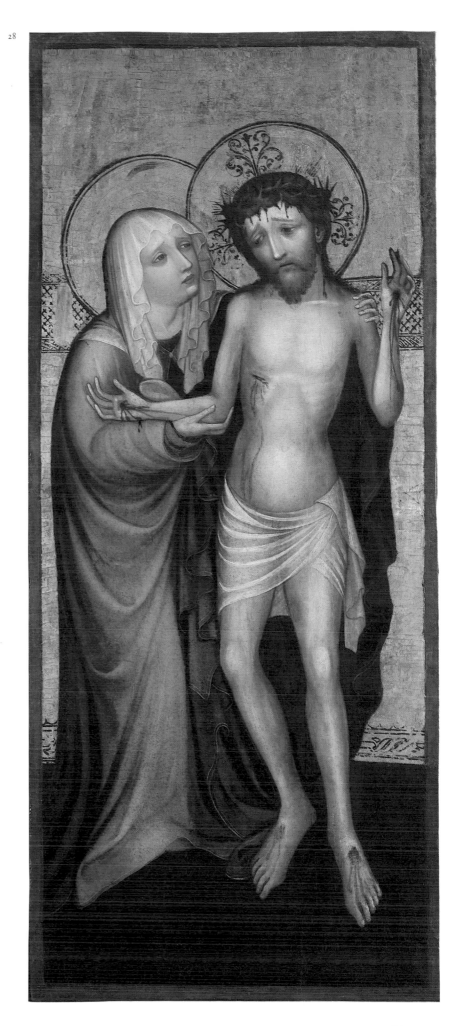

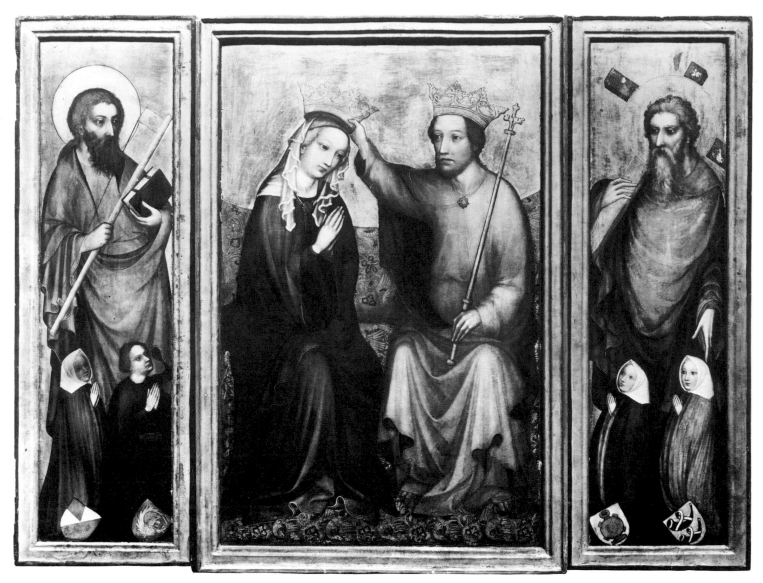

Figure 119 *The Imhoff Altarpiece* (wings open). About 1420. Lorenzkirche, Nuremberg

decorative borders in the gold background indicate the upper and lower boundaries of a wall hanging behind the figures.

The Man of Sorrows unites features of the living and the dead Christ — of the Christ who was crucified and the Christ who was buried. Whereas the son lamented by the mother in depictions of the *Pietà* represents a distillation of the historical events, the *Imago pietatis* presents "actions confined within a particular length of time," tending "to let each observer immerse himself in the contemplation of the image, for example, to let subject and object merge spiritually" (Panofsky, 1927).

In the Nuremberg painting, the Man of Sorrows stands on both feet as he experiences the agony of his Passion, and raises his left arm unaided. Just as he bares his wounds to the pious, offering them his compassion, so would he show them to the Just God, with whom he will intercede for sinful mankind.

The Bamberg Altarpiece (fig. 91) represents a further development over those Nuremberg paintings typified by the panels from an altarpiece of the Virgin (cat. no. 23). The artist

demonstrates an intensified study of nature. The draperies have more mass, and the use of shading at the edges of the objects heightens their three-dimensional effect. The forms are rendered in a painterly manner, and the color contributes to the mood. Although partly dictated by the theme, the spiritual quality of the figures is revealed in a compelling personal style.

Until the original work was rediscovered, the painting was only known from a later copy in the collection of a Dr. Nüsslein in Kissingen, and later in Nuremberg. The literature prior to 1951 refers to this copy. In the 1931 exhibition catalogue *Nürnberger Malerei*, the painting was attributed to the Master of the Bamberg Altarpiece. The copy differs markedly from the original: Christ's complicated stance was simplified, his left arm hangs at his side, the Virgin supports him under the arms, and the ground is covered with small plants. KL

BIBLIOGRAPHY: Panofsky, 1927, p. 274, ill. 18; *Nürnberger Malerei*, 1931, no. 49; Zimmermann, 1932, p. 35, pl. 139; Stange, 1934–61, vol. IX, pp. 12–13; Stange and Strieder, 1978, no. 31.

29 MASTER OF THE BAMBERG ALTARPIECE

The Man of Sorrows, with the Virgin and Saint John

About 1420
Tempera and gold on fir wood
45 ¹¹/₁₆ x 29 ¹/₈ in. (116 x 74 cm.)
The background is restored.
Provenance: Lorenzkirche, Nuremberg.
Nuremberg, Germanisches Nationalmuseum (on loan from the city of Nuremberg since 1880)
Gm 116

This painting occupied the reverse side of the central panel of the *Imhoff Altarpiece*, in the Lorenzkirche, in Nuremberg. Christ is seen upright in his sarcophagus, supported by his lamenting mother and Saint John the Evangelist. With loincloth, crown of thorns, and wounds, Christ is depicted as he appeared when lowered from the cross. His eyes are shut, and his expression mirrors the agony of the Passion. The Virgin has moved her face close to his, placing one hand under his lower right arm and one around his left shoulder. The intervention of Saint John is more timid. This may reflect the

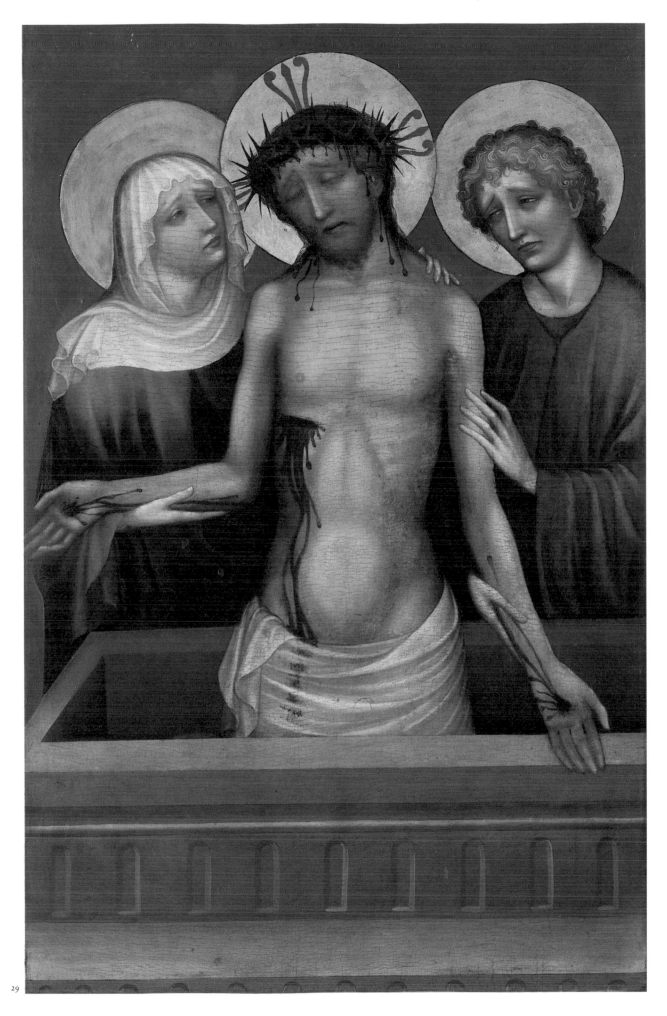

fact that in representations of the Man of Sorrows, unlike the Virgin, he is not traditionally included (see cat. no. 28).

The portrayal of the three figures was more typical of devotional pictures, but the painting remains faithful to the biblical narrative and its pictorial traditions. The tomb in which Jesus stands, his closed eyes, and his lowered left arm are all in accord with our concept of the dead Christ. The presence of the Disciple links the image to the historical course of events, from the Crucifixion, to the Descent from the Cross, to the Entombment.

The *Imhoff Altarpiece* (fig. 119), to which *The Man of Sorrows, with the Virgin and Saint John* belongs, is considered the most striking and artistically accomplished of the altarpieces created in the years between the *Altarpiece of the Virgin*, of about 1410 (cat. no. 23), and the *Tucher Altarpiece* (fig. 92), of about 1450 — the latter, in the Frauenkirche, in Nuremberg. When opened, it shows the Coronation of the Virgin in the center. On the inside of the movable wings are Saints James the Less and Philip. Kneeling at their feet are (on the left) the donor Konrad Imhoff (died 1449) with his wife Elizabeth Schatz, and (on the right) Imhoff's first wife, Anna Rotflasch, and his second wife, whose maiden name was Hornlin. On the (now separated) exterior panels of the wings were Saints Andrew (left) and James the Great (right), and, on the fixed wings, Saints Matthias and Paul (on the inside) and Matthew and Bartholomew (on the outside).

The marriages of the donor help to date the work. Konrad Imhoff married Elizabeth Schatz in 1418. She died in 1421, and, in 1422, he married Clara Volckamer, who is not represented on the altarpiece. Therefore, it must have been donated between 1418 and 1422.

The *Imhoff Altarpiece* is considered the work of the same Nuremberg artist who had made an altarpiece for Berthold Deichsler (died 1419) a few years before (it is now in the Gemäldegalerie, Berlin-Dahlem). Whether he is the same person known from documents as Berthold Landauer remains a matter of speculation. Thode (1891) described and praised the particular qualities of the inside panels of the *Imhoff Altarpiece*: the solemnity; the expression of the artist's sensibility in the feeling for beauty; and the classically idealized drapery of the figures, and their statue-like detachment from their surroundings, which are devoid of any traces of architectural or landscape elements. He also noted the painter's intelligent observation of nature; the deep, strong colors; and the gradations of light and shade, which give depth and roundness to the figures. Their bodies and their movements seem to have been adapted to the patterns of the softly flowing drapery folds, rather than to have produced them.

Because of the origin of the panels, the painter of the *Man of Sorrows, with the Virgin and Saint John* is known as the Master of the Imhoff Altarpiece. However, Koch and Stange detected a second hand, and described the deviations from the style of the principal artist. The composition is intended to be effective at a distance and strictly follows a system of verticals and horizontals. Angles and straight lines are emphasized — even in the faces, where eyebrows and the bridges of the noses are sharply angular. The spiritual expression is intensified, and the gestures are simple and striking. The Virgin and Saint John support Christ in such a way that the wounds in his hands are visible to the viewer. Spatial perspective is defined by the sarcophagus, while the half-length figures of the Virgin and Saint John, not anchored in space, stand out against the neutral background. The color helps to establish order, the blue and green of the garments set off by several shades of a brighter red on the sarcophagus and a more muted red in the background. The body of Christ also provides a color link between the various passages. This is the work of a sensitive artist, with a clear feeling for composition, the relief-like quality of which is emphasized by the large, flat haloes.

Koch (1931) attributed the so-called Bamberg Altarpiece to this artist's successors, while Stange considered it to be by the present artist, himself. The similarity to the painting of the *Man of Sorrows and the Virgin* (cat. no. 28) is clear, but, here, further advances are apparent. The knowledge of anatomy has increased, caesuras are introduced, and the skin shows the strain and interplay of the underlying bone and muscle. The symmetrical arrangement of the figures and the solid base of the sarcophagus give the composition its tectonic strength and calm, while nothing of the intensity is lost; on the contrary, the event is presented in a brighter, more rational light. KL

BIBLIOGRAPHY: Thode, 1891, pp. 19–22; Gebhardt, 1908, pp. 31–35; Zimmermann, 1932, p. 30, pl. 81; Panofsky, 1927, p. 275; Koch, 1931, p. 432; Lutze and Wiegand, 1936–37, p. 92, ill. 19; Stange, 1934–61, vol. 9, p. 12; Musper, 1970, p. 102, no. 32, colorpls.; Stange and Strieder, 1978, no. 32.

30 MASTER OF THE TUCHER ALTARPIECE

The Circumcision

About 1450
Tempera, oil, and gold, on soft-wood panel, partially covered with canvas
40 3/16 x 36 1/4 in. (102 x 92 cm.)
The painting is cut down on all four sides.
Aachen, Suermondt-Ludwig-Museum, Bequest of Weber van Houten, 1886
312

The painting, as the gold background attests, occupied the interior surface of the wing of an altarpiece. Its present, nearly square format suggests that, originally, the wing was more than twice as high, and contained at least two scenes, one above the other. From this sole surviving painting, it is impossible to reconstruct the iconographic program of the work, although the event depicted — crucial to representations of the infancy of Christ — would also have a place in a cycle of the life of the Virgin.

In this panel, the circumcision of Christ takes place in an interior space, and the priest is seated on a throne of carved stone. A cloth is draped over his hands, as he holds the infant under the arms. The child responds to the pain inflicted on him by the knife of the kneeling mohel with outspread fingers. The operation itself and the child's reaction are portrayed with a certain violence. A bespectacled Pharisee reads from a book. Although Mary and Joseph are separated from the actual procedure, they look on with concern and wonder.

The artist did not give the pictorial space any logical architectural form, nor is it possible to determine its size. The figures predominate, and all of the objects represented are related to them like props on a stage set, depicted realistically and with considerable expertise. This is true of the throne, with its richly carved molding at the base, but even more so of the furniture. The infant Jesus is being held above a metal basin placed on a folding table, which, itself, is a fine, functional, and most attractive example of the cabinetmaker's art; even the hinge on the top edge is depicted. The chair has a curved back and legs, which are joined by a stretcher secured on either side with a peg.

These furnishings are from the artist's own time and culture, and the note of realism that they impart makes the participants in the drama more believable, as well; they seem to leave no doubt that the event took place in precisely the way in which it is presented here. The men hover close to the child, their heads bent over their hands. The head of the man wearing glasses and the strongly modeled head of the kneeling mohel are over characterized. The shawls and the turban, the various ornaments, and the Hebrew letters lend an aura of magic and foreign mystique to the scene. (Dr. T. Kwasman of the Hochschule für jüdische Studien, in Heidelberg, has pointed out that the inscription is in Hebrew characters of Ashkenazic origin. Although a few words, from a psalm, are decipherable, the text, as a whole cannot be interpreted.)

In the tenth century, depictions of the Circumcision of Christ became common. At first, it was not the surgical act, itself, that was portrayed, but rather the preparations for it: Mary would be shown holding the Child, alone or with Joseph, as the mohel approached with his knife raised. Somewhat later, the temple became the fixed setting for the rite. In fifteenth-century altarpieces, the Circumcision frequently replaced the Presentation in the Temple. This may be explained, in part, by the increasing desire for a realistic effect, among painters; their delight in violent details; and their psychological interest in the horror of the Child and the pain of the mother. Yet, other reasons for this changeabout are rooted in the underlying meaning of the scene.

In images from the Late Middle Ages, the Circumcision of Christ is treated as a kind of

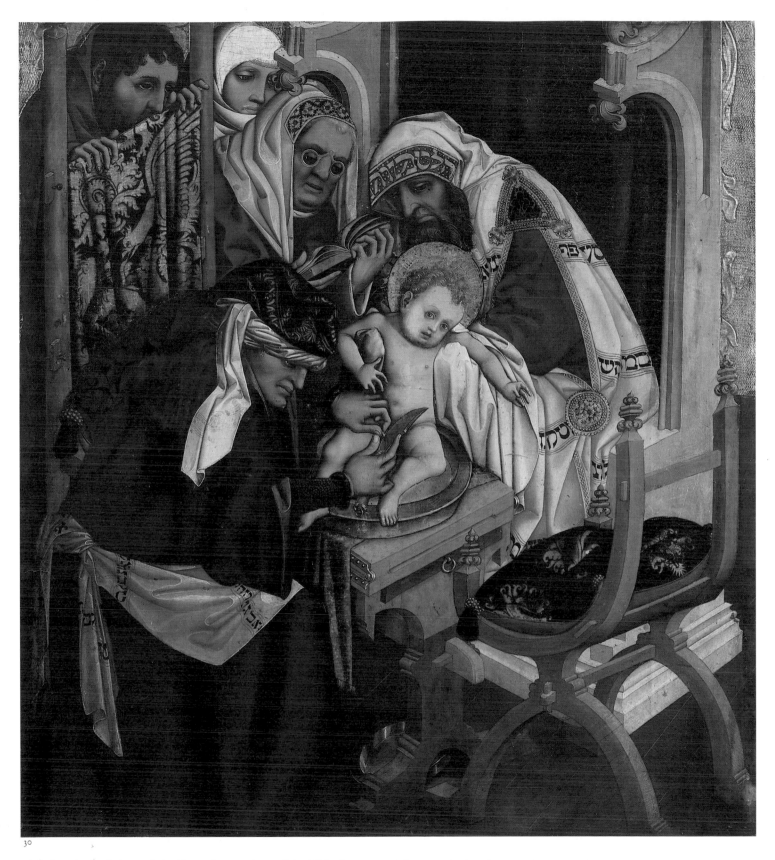

30

violation; in depictions of the Seven Joys and Seven Sorrows of the Virgin, it definitely counts among the sorrows. The Child registers alarm, or screams, and the mother suffers visibly. The representatives of the Old Covenant — namely, the priest and the surgeon — perform their task with determination, and, at times, even with a cruel delight. Because the Circumcision is seen as a prefiguration of the Passion, the neutrality

of the biblical account of the event is therefore abandoned. The foreignness of the Jewish world of the old Testament is conveyed with suspicion and repugnance. This interpretation prevailed as late as Jörg Ratgeb's *Herrenberg Altarpiece*, of 1519 (now in the Staatsgalerie, Stuttgart), and is registered in the expressions and gestures of the participants. By contrast, Michael Pacher and Albrecht Dürer acknowledged, and restored the

dignity of the ritual of the Circumcision — the former, in the carved altarpiece in Saint Wolfgang, Austria, and the latter, in his woodcut series *The Life of the Virgin* (see cat. no. 127; for the iconography, see Isermeyer, 1948, cols. 321–31, 1968, cols. 271–73).

Thode (1891) convincingly assigned the *Circumcision* to the late period of the Master of the Tucher Altarpiece, and also emphasized what

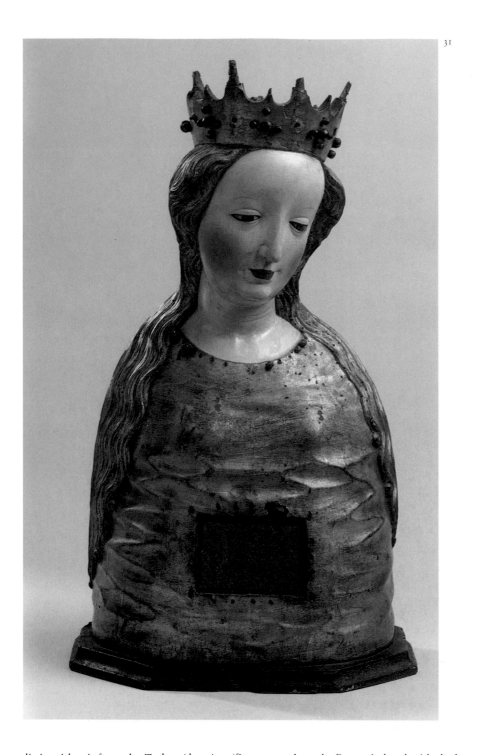

31

31 Reliquary Bust of a Crowned Saint

Nuremberg (?), about 1440
Linden wood, painted and gilded
Height, 23¹³/₁₆ in. (60.5 cm.)
Several points from the crown, as well as some of the carved pearls on the crown, at the neckline, and around the reliquary opening have broken off. The relics, themselves; the square glass panel that protected them; and the arched board that sealed off the reverse side have been lost.
Nuremberg, Germanisches Nationalmuseum (acquired by 1868)
KG 191

The origin of the reliquary bust is unknown. It was Heinz Stafski who determined that it is a Nuremberg work. The armless bust was conceived as a reliquary, rather than as a sculpture. Originally, it held the relics of a virgin saint, which were visible behind a pane of glass, or rock crystal, on the figure's breast. The saint's name is not known. Her crown does not necessarily mean that she was a princess; as was frequently the case with such representations of virgins, the crown can signify eternal life, and thus simply identify her as a saint. Reliquaries of this kind, often made of silver gilt but sometimes also of wood, were quite common in medieval churches. A list of reliquaries in Nuremberg's Frauenkirche prepared by the custodian Stephan Schuler in 1442 (p. 37) mentions four wooden busts and a bust-length portrait of Saint Barbara.

In the present example, as in most reliquary busts of its type, the body beneath the saint's gently inclined head is barely developed. Her long, wavy hair flows down almost to the base. There is only a slight suggestion of breasts; otherwise, the body is merely a formless base for the head, widening toward the bottom. The saint's golden gown, devoid of vertical folds or draping that would suggest the body underneath it, is, instead, enlivened by means of a regular pattern of horizontal depressions. The figure's charm derives entirely from her youthful, almost child-like face, its ivory-colored skin accented with a slight touch of pink on the cheeks; the high, Gothic forehead; almond-shaped blue eyes; delicate nose; red mouth pursed in a smile; and dimpled chin. Although the basic form was provided by the sculptor — the flap-like eyelids, like the hair and the tiny breasts, were carved quite crudely and schematically — it was the painter who gave this face much of its irresistible appeal. RK

BIBLIOGRAPHY: Essenwein, *Reliquiare*, 1868, p. 350; Stafski, 1965, no. 137, ill.

distinguishes it from the *Tucher Altarpiece* (fig. 92), itself — the coarseness of the figure types, and their violent movements. Nevertheless, he admired "the incredible boldness of its concept, its stormy, passionate inventiveness, and its sovereign mastery of technique." Stange advanced the notion that the painter was an apprentice in the workshop that produced the *Crucifixion* in Munich Cathedral — a painter who was schooled in Bavaria, and who also provided the Master of the Tucher Altarpiece with the tooled gold background incised with rinceaux.

The exceptional character of the picture doubtless derives from its subject matter, which inspired the painter to record unusually intense action and to differentiate among a variety of physiognomic characteristics. The holy parents

are the only figures imbued with the humanity, free of all excess, reminiscent of that of the figures in the *Tucher Altarpiece*, in the Frauenkirche. To ascribe the *Circumcision* to an anonymous Bavarian assistant of the Master of the Tucher Altarpiece is to reduce the strength and originality of the work to mere provincialism, and to deny the range of emotion of which the extraordinarily accomplished artist was capable. His greatness, after all, lay in his novel, gripping representation of a sacred subject and its protagonists. KL

BIBLIOGRAPHY: Thode, 1891, p. 72; Gebhardt, 1908, p. 162; *Nürnberger Malerei*, 1931, no. 64; Zimmermann, 1930–31, p. 46, pl. 175; Stange, 1934–61, vol. IX, p. 30; Stange and Strieder, 1976, no. 65.

32 Saint Lawrence

Nuremberg, 1465
Linden wood
Height, 43 1/4 in. (110 cm.); width, 15 3/8 in.
(39 cm.); maximum depth, 9 1/16 in. (23 cm.)
The figure is hollowed out at the back. The saint's
attribute, a gridiron, which, originally, he held in
his left hand, was missing by 1592. He probably
held the palm of martyrdom in the crook of his
right elbow. The polychromy and gilding are
original.
Provenance: altarpiece, high altar of the Pfarr-
kirche Sankt Michael, Hof (Upper Franconia);
Frauenkirche, Nuremberg, 19th century.
Nuremberg, Germanisches Nationalmuseum
(on loan from 1883; acquired, 1909)
Pl 0.184

Heinz Stafski was the first to note that this fig-
ure of Saint Lawrence came from the central
part of the high altarpiece of the Pfarrkirche, in
Hof. Previously, all that was known to have
survived from the altarpiece were its wings,
dated 1465 and painted in the Nuremberg
workshop of Hans Pleydenwurff. According to
Enoch Widmann's 1592 chronicle of the town,
the center of the Hof altarpiece contained sculp-
tures of Saints Michael (the patron saint of the
church), Peter, Paul, Nicholas, and Lawrence
(to whom the older church in Hof was dedi-
cated). Widmann reports that, "some time ago
wicked scoundrels broke off the gridiron from
the left hand" of the Saint Lawrence. The sculp-
tures of Peter, Paul, and Nicholas were acquired
by the Germanisches Nationalmuseum in the
nineteenth century. The *Saint Paul* has since
been sold, while nothing is known of the where-
abouts of the *Saint Michael*. The altarpiece
possessed two pairs of painted wings (now
owned by the Bayerische Staatsgemäldesamm-
lungen, Munich). On the exteriors of the outer
wings were the Archangel Michael, and the
Apostles Bartholomew and James. Opened,
these wings presented scenes from Christ's Pas-
sion: the Agony in the Garden, on the left; the
Crucifixion and Deposition, in the center; and
the Resurrection, on the right. The inner wings
opened to reveal the figures in the central por-
tion, and paintings of the Annunciation and the
Nativity (Stange, 1934–61, vol. 9, ills. 78–81,
89; Stange and Strieder, 1978, no. 108, bibliog-
raphy).

Saint Lawrence leans backward, his body
forming a gentle S-curve. His hidden right hand
lifts the dalmatic, emphasizing the convex arch-
ing of his abdomen. The head, with its thick
fringe of hair, turns from the body's axis, and
the saint's thoughtful gaze is directed toward
the right. The tip of his right foot is all that is
revealed of his body underneath the vertical
folds of his garments. Pronounced creasing
occurs only where the hand reaches up beneath
the dalmatic. The attributes of the gridiron and
palm would have lent the composition greater
variety.

The restrained composition is reinforced by
the figure's gentle and tranquil expression; the
stockiness of the torso and the strong head con-
tribute to its considerable sculptural presence,

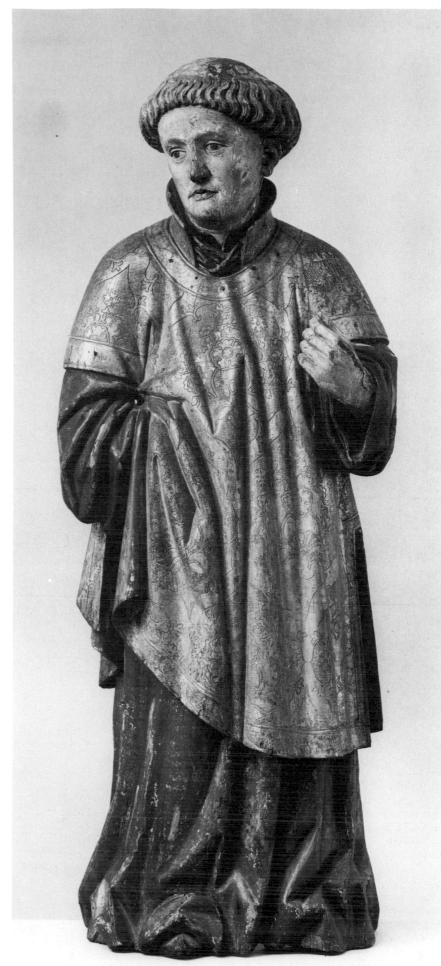

32

just as the figure's impressive compactness gives it an unmistakable monumentality. The sculpture, which has never been repainted, possesses an additional charm — its extraordinarily well-preserved polychromy, especially in the face, with its rosy cheeks, blue eyes, and red-rimmed eyelids. The cap-like ring of hair was originally golden, as was the dalmatic, with its elaborate, engraved brocade pattern; the red lining is visible only at the lateral slits. Beneath it, the alb was silvered; having lost its original protective coating, it has oxidized and become black. The reverse side of the dalmatic — which was not visible when the figure was in place in the center of the altarpiece — was silvered, too, presumably to conform to the appearance of the front by means of twisted gold. The embroidered rectangular decoration, above the hem of the alb — an ornament customary on such liturgical garments of the Gothic period, and often referred to in contemporary sources as a *parura* — retains traces of the elaborate embossed brocading.

The *Saint Lawrence* is among the finest examples of mid-fifteenth-century Nuremberg sculpture, whose style was influenced by the Ulm sculptor Hans Multscher (about 1400–1467). Recently, the figure has been ascribed to Simon Lainberger, a much-respected artist mentioned in Nuremberg documents from 1478 to 1494. This attribution must remain hypothetical, since no authenticated sculpture by Lainberger is known to exist. RK

BIBLIOGRAPHY: Widmann, in Meyer, 1894, p. 69; Josephi, 1910, no. 243; Stafski, 1982, pp. 24–27, ill. 7; Ramisch, 1985, pp. 54–55, ill. 9.

33 The Mystic Marriage of Saint Catherine, from the so-called *Behaim Altarpiece*

Nuremberg, about 1470
Poplar, painted and gilded
Shrine: 62 5/8 x 53 15/16 x 13 in. (159 x 137 x 33 cm.); figures: height, respectively, 40 15/16 in. (104 cm.) and 35 13/16 in. (91 cm.); group: width, 43 5/16 in. (110 cm.)
The figures are hollowed out at the back. The painting of the flesh tones is old, and that of large portions of the drapery is original.
Provenance: convent of Sankt Katharina, Nuremberg.
Nuremberg, Germanisches Nationalmuseum (acquired, 1859)
Pl 0.138

The altarpiece, originally in the north side aisle of the church of the Nuremberg Dominican convent of Sankt Katharina, was a gift from the patrician Behaim family of Nuremberg, and once must have borne their coat of arms. Funds for the maintenance of the altar had been provided by Fritz Behaim (1311–1379) "am Salzmarkt" ("next to the salt market"). One of his descendants presumably commissioned the present altarpiece as a replacement for an earlier one. The painted wings that served as the doors to the shrine have not survived. From old descriptions, however, we know that Catherine and another female saint were portrayed on the interiors of the wings, and that on the outside, apparently, were paintings of four female saints, among them, Barbara and, again, Catherine, on the left side. Relics were deposited in the predella, which also had two painted wings: The Mystic Marriage of Saint Catherine, Saint Catherine of Siena, and Saint Barbara were depicted on the right-hand door; the left-hand one presented Saints John the Baptist, Dominic, and Jerome. On the exterior of the predella wings were six panels with scenes of martyrdom. These wings were presumably lost shortly after 1800, and no copies of them are known.

The top of the central shrine is adorned with richly carved and gilded tracery. On the rear wall, against a blue background dotted with gilt paper stars, are three half-length figures of angels painted on paper, who hold up a curtain decorated with a red and gold brocade pattern. The central group is carved almost fully in the round. On the left is the Virgin, wearing a gold mantle with a blue lining over a red and gold brocaded gown ornamented with gold spangles. The Christ Child, seated on the Virgin's lap, places a ring on the finger of Saint Catherine, who kneels before him. She, too, is richly dressed, but the style of her garments, unlike the Virgin's, reflects the fashion of the time. Her dark green, flowing gown is also dotted with gold spangles. The brocade pattern of her under-dress, visible at the sleeves and through the wide slits in her gown, is mostly worn off. Her golden, red-lined mantle has slipped from her shoulders and falls in deep folds on the ground before her.

In the Middle Ages, Saint Catherine of Alexandria was the most widely venerated female martyr in both the Eastern and the Western Church. The daughter of a king, she is generally portrayed wearing a crown, and in the *Behaim Altarpiece* this crown rests atop a turban-like headdress. Beginning in the fourteenth century, the two most frequently depicted events in her life were her martyrdom and her betrothal to Christ — customarily represented as a small child seated on his mother's lap. The underlying significance of this legendary scene — a virgin's betrothal to Christ, and her vow to remain a virgin for his sake — was particularly appreciated in convents, for nuns also thought of themselves as the brides of Christ and often wore rings to symbolize their union with him. There are numerous illustrations of the theme in fourteenth- and fifteenth-century art from Nuremberg. A rather similar composition, although reversed, appears on an exterior wing of the *Landauer Epitaph,* of 1468–75, originally on the high altar of Sankt Katharina, in Nuremberg, and now in the Germanisches Nationalmuseum (Stange, 1934–56, vol. 9, ill. 82).

In the *Behaim Altarpiece*, this is the subject of the central section of the shrine, depicted with large, carved figures. Such scenes are not commonly the central images of Nuremberg altarpieces. Generally, shrines were composed of a number of standing saints grouped around the Virgin, while scenic representations like the present one were relegated to the painted wings.

The figures of the Virgin and of Saint Catherine reveal the prevailing angular style of the 1470s, which tends to transform organic forms into isolated, abstract constructions. This is apparent in the treatment of the fabric: The drapery, as rigid as though of metal, is represented with almost geometric precision — especially the folds of Saint Catherine's mantle, in the foreground, and those gathered across the Virgin's lap. Corresponding to the hardness and sharpness of the drapery is the rather precious, but equally stiff manner of portraying the gestures; note, for example, the position of Saint Catherine's hands. This same tendency toward a metallic rigidity also governs the rich patterns of the garments; the knife-edged, architectonic, and exquisitely detailed tracery of the baldachin; and the particularly lovely crowns of the two saints. RK

BIBLIOGRAPHY: Zion, 1733, p. 122; von Murr, 1778, p. 290, 1801, p. 114; Josephi, 1910, no. 251, pl. XXIV (with additional bibliography); Lossnitzer, 1912, p. 25; Fries, 1924, p. 103, ill. 20; Zachmeier, 1956, pp. 38–39, 113, no. 46.

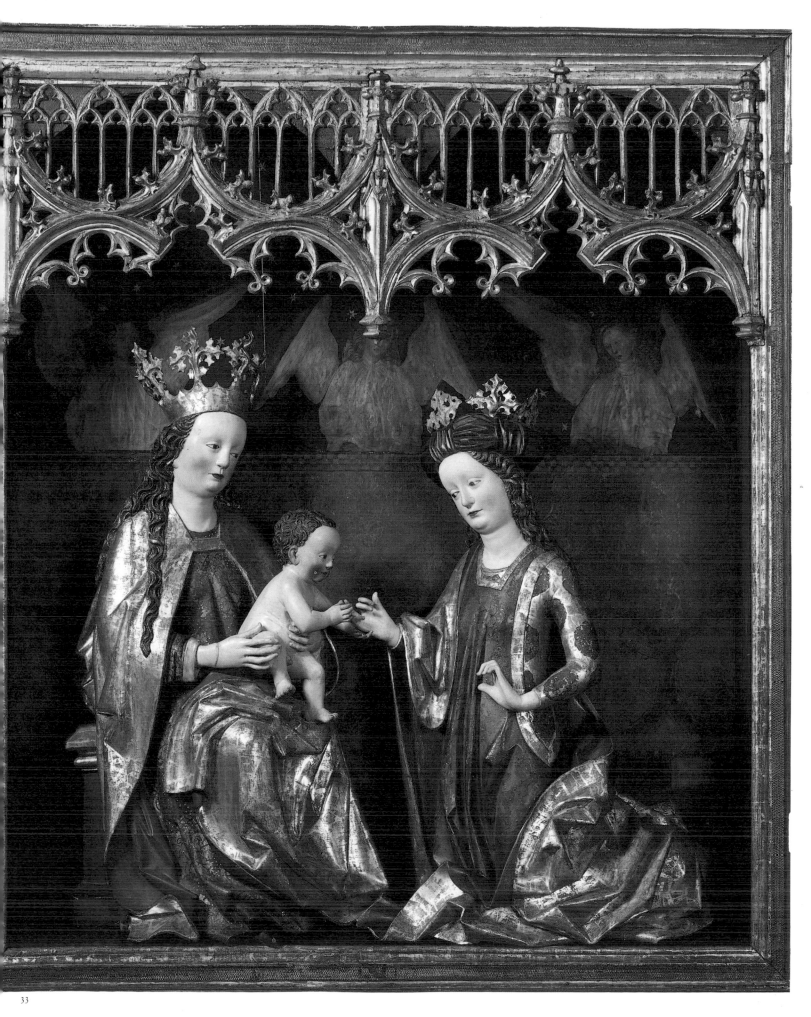

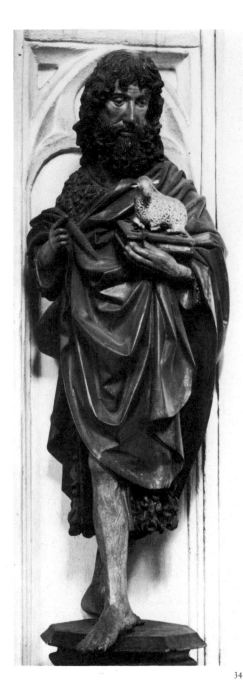

34

34 Saint John the Baptist
Nuremberg, about 1470
Linden wood
52 1/2 x 18 1/4 x 16 in. (133.5 x 46.4 x 40.7 cm.)
Except for the red cloak, the polychromy is original. The figure is carved fully in the round and hollowed out. The right hand is restored.
Nuremberg, Johanniskirche

Saint John steps forward, his feet at an angle to each other in conformity with the sculptural style typical of the period. Although it is the right foot that is advanced, the slender right shoulder is drawn back. The left shoulder, draped with the cloak, presses forward, placing the upper body at an angle to the front plane of the sculpture, as defined by the drapery. The saint's large head, buried in a virtual mane of dense hair that reaches to his shoulders, is turned toward his left. The ponderation of the

body shifts at the waist. The left leg is not simply positioned, as though at rest beside the right leg — which is visible through the parted drapery — but is placed well behind. From the side, therefore, the impression is of vigorous forward motion, accentuated by the forward inclination of the head. The figure only preserves its balance because the left foot is almost perpendicular to the right one — as is particularly apparent when the sculpture is viewed from the back. This posture, which could be duplicated only with great effort, is in some ways extremely artificial, but it is scarcely noticeable, inasmuch as the twisting of the form is obscured by the heavy masses of the drapery. The body of the slight, self-contained figure reveals only hints of its ponderation.

Over his "hair shirt" (mentioned in the Bible, but, here, resembling something closer to an animal skin), the Baptist wears a cloak that drapes over his left shoulder, forming broad curves across his back. The cloak is caught up on the left side by the hand that holds the book, creating the effect of a richly folded apron at the front. The forms are so highly developed at the back and the sides that the figure must have been meant to be freestanding. In the oldest views of the Johanniskirche, the *Saint John* is recognizable in one of the side altars.

The sculpture's distinct monumentality, the richness of its drapery, and the articulation of the body have led a number of critics to attribute it to the young Veit Stoss. If it were, indeed, by him, it would be one of the master's early Nuremberg works — long sought by scholars — which established his reputation and, in 1477, earned him the commission in Cracow; he was summoned to that city to execute the altarpiece for the high altar of the Marienkirche, as well as the red marble tomb of King Kasimir IV, and a number of other distinguished works over the course of his twenty-year stay. Critics have indicated the similarities of the *Saint John* to the figures on the altarpiece in Nördlingen, which we now know to have been created by Nikolaus Gerhaert van Leyden or a master closely associated with him — an artist from Strasbourg or the Upper Rhine, in any case — and completed in 1462. However, there are basic differences between the two works: The articulation of the bodies of the Nördlingen figures is more polished, and their gestures are more pronounced, fresher, and more full of life. The sculptural interest of the *Saint John,* by contrast, lies in the weight of his body and much less in the dynamic movement of his garments, which was the chief characteristic of the art of the Upper Rhine in this period.

Writing in 1938, Theodor Müller pointed out that the *Saint John* belongs to an earlier stage of artistic development than the Nördlingen sculptures, and that it is indebted to a specifically Nuremberg tradition based on the *Schlüsselfelder Saint Christopher* (see fig. 78). Müller went on to say that the boldly conceived figure showed how much even the work of Veit Stoss was based on Nuremberg models, despite all its borrowings from the art of the Upper Rhine.

Müller found that the present sculpture's austerity of movement, severity of expression, and solid, upright posture anticipated the figures on the Cracow altarpiece, but, at the same time, he was unable to grant it a place in the evolving art of Veit Stoss.

As it happens, the differences between the artistic temperament of the Saint John master and that of the creator of the altarpiece figures in Cracow could scarcely be greater. The *Saint John* displays a distinct calmness, the body and its drapery compact and well integrated; the latter figures are characterized by violent motion, jagged forms, dynamic treatment of the folds and mass of the drapery, and an effective emphasis on gestures. The intense feeling of Stoss's figures is wholly lacking in the *Saint John the Baptist.* The heaviness of the cloak and the summary formation of the hand are matched by the large facial features — scholars have called attention to the wart on the cheek, a decidedly realistic touch — devoid of the patient articulation of individual subtleties, and formed instead from the sharp and indelicate blows of the chisel.

A sense of strength and drama, gravity and weight, and of the monumentality of the striding human form is combined with the figure's carefully considered ponderation and with a wealth of design motifs found in only a few sculptures of the period. These elements were to play a decisive role in Nuremberg sculpture of the fifteenth century, beginning with the *Schlüsselfelder Saint Christopher* and culminating in the great masterpieces of Veit Stoss. R K

BIBLIOGRAPHY: Trechsels, 1735, p. 800, ill. opp. p. 773; Lossnitzer, 1912, pp. 28, 33, 181, n. 144, pl. 21; Bier, 1922, ill. 40; *Stoss,* 1933, no. 5, pl. 1; Müller, 1938, p. 132; Lutze, 1952, p. 10, ill. 27; Dettloff, 1961, vol. 1, pp. 220, 304, ills. 101–102; Fehring and Ress, 1977, p. 414; Skubiszewski, 1978, pp. 96–97, nn. 4, 1, and at the end; Kępiński, 1981, p. 15, ills. 24–25, pl. 7; Kahsnitz, in *Veit Stoss...,* 1983, no. 24 (with additional bibliography), ills. 172–174.

35 The Archangel Michael
Nuremberg, about 1470/80
Linden wood
Overall (including wings and sword), 70 11/16 x 53 15/16 x 16 in. (179.5 x 137 x 40.7 cm.); figure, 66 15/16 x 27 3/4 x 16 in. (170 x 70.5 x 40.7 cm.)
The figure is hollowed out at the back, the original polychromy and gilding preserved. The sword is original, although its pommel is lost. The scales that once hung from the angel's left hand are missing.
Nuremberg, Lorenzkirche

The archangel is dressed in a long, golden alb and a flared golden pluvial with a blue lining. His right leg is advanced forward so that the knee and shinbone are visible, although the exact position of the foot is not altogether clear.

His left leg, obscured by the gown, is set far back; the foot — only apparent when the figure is viewed from the side — can be seen emerging from under the hem of the gown at virtually a right angle to the axis of the body. The left leg would have to be the one supporting the figure, yet it scarcely is positioned in such a way as to bear the body's weight. However, because of the contained mass of drapery, this basic instability of the figure is hardly perceptible. The artificial, perpendicular placement of the feet was a favorite motif in the design of separate figures, in the 1470s and 1480s. The disposition of weight in the upper body, and the act of drawing back, on the right side, culminating in the sword brandished in the right hand and the left shoulder extended somewhat forward, oppose the position of the legs, in typical contrapposto fashion. The left hand once held a set of scales, on which there was probably a small figure of a devil. The slender body of the angel is outlined by the parallel, vertical folds of his gown and encircled by the pluvial. This outer cloak falls straight downward from the left arm, but the raised right arm lifts it so that the tip of the cloak extends over the area of the right thigh, functioning almost as a separate piece of fabric — a triangular shield that at no point touches the body. A pair of huge wings serves as a backdrop behind the angel's dynamic body.

Here, for the first time in Nuremberg sculpture, is an example of that formal principle, typical of the Late Gothic period, especially in the Upper Rhine: The surrounding space, in the form of deep areas of shadow, is incorporated directly into the figure, so that the tension and the force of the human form essentially derive from the interplay of the body mass with the free-floating fragments of drapery. Max Lossnitzer noted a precedent for such compositions in an engraving by the Master E.S. (Lehrs, no. 152), which also appears to be based on Upper Rhenish figural concepts, but cannot be considered the direct inspiration for the present work; countless similar fifteenth-century engravings have been lost.

Because of the strong impression of movement imparted by the figure; the inclusion of the arms and the ends of the cloak in its expansive motion, contributing to the intensity of the action; and the unquestionable artistic quality of the sculpture — which far surpasses what was being produced in Nuremberg at the time — some scholars have proposed that the *Archangel Michael* is an early work by Veit Stoss, predating his departure for Cracow in 1477. However, this attribution, advanced chiefly by Ernst Eichhorn and, most recently, by Ulrich Schneider, has been rejected by the majority of critics.

In contrast to the figure of Saint John the Baptist (cat. no. 34), which is thought by others to be an early work of the same sculptor, the *Archangel Michael* is, indeed, characterized by livelier — even more violent — movement, calculated to capture the imagination. Yet, when compared with the large standing figures of Veit Stoss's Cracow altarpiece, this movement seems strangely flat and far less impressive. Although

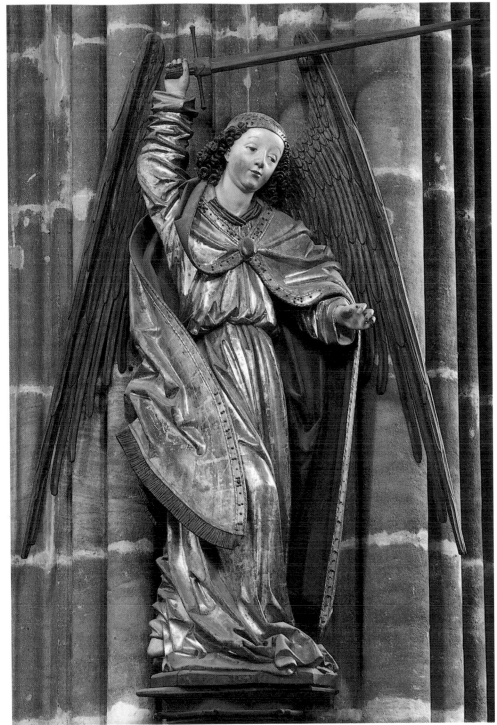

35

many elements of both compositions suggest the drama of the Late Gothic style, the archangel, nevertheless, lacks physical weight. In this regard, the figure of the Baptist, while quite different and still rooted in the earlier, established style, would appear more deserving of a place in Veit Stoss's stylistic development than the comparatively insubstantial archangel. The charm of the present sculpture derives partly from the gleaming gold that has been applied to it, and partly from its naïvely winsome, childish face, and soft, double chin, framed by lively curls. One responds to the fragility and grace of the youthful figure, sensing that the more striking elements are only grafted onto it. It has been

said that the razor-sharp cloak edges appear as though "frozen," and, ultimately, it must be admitted that the effect lacks genuine drama and conveys little feeling, just as the sword brandished above the figure's head seems to lack all sense of menace. The crystalline wrinkling of the fabric over the foot at the back looks artificial, and scarcely accords with the otherwise smoothly flowing lines of the alb. These are motifs taken from contemporary art of the Upper Rhine and simply applied to this work by a sculptor trained in another, gentler tradition. This quality distinguishes the present artist from Veit Stoss. Of course, it is difficult for the art historian to recognize an early work by a

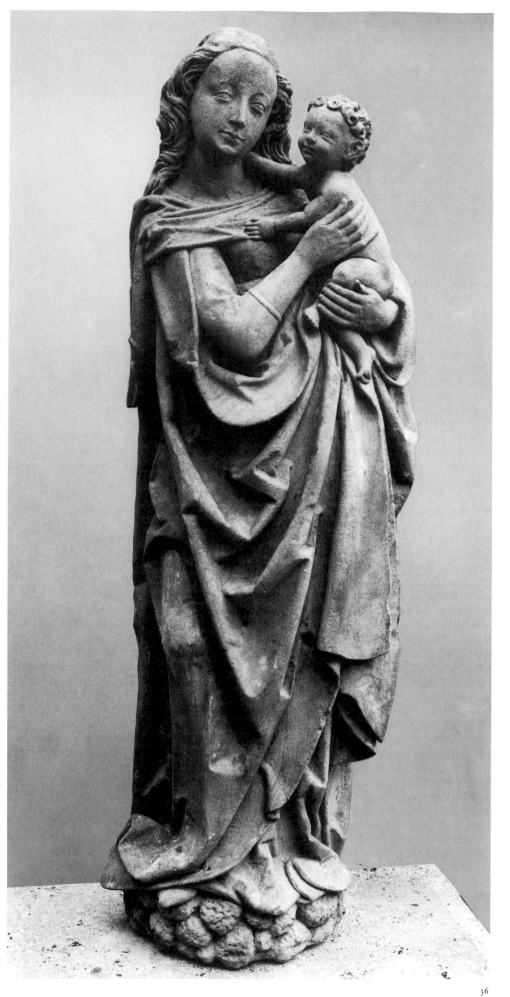

great artist when only works from his maturity survive. Even so, the *Archangel Michael* is too innocuous, too tame, to be the creation of the same sculptor who, only a short time later, conceived the extremely emotive and expressive apostles of the Cracow altarpiece. The work is altogether charming, nonetheless, and suffers unfairly from such unjustified comparison to masterpieces from the hand of Veit Stoss.

R K

BIBLIOGRAPHY: Hilpert, 1831, p. 24; Lossnitzer, 1912, pp. 34–35, 67, pl. 30; Pinder, 1914–29, p. 368; Bier, 1922, p. 15, ill. 50; Höhn, 1922, p. 117, ill. 59; Hessig, 1935, p. 101, pl. 94; Eichhorn, 1952, pp. 279–80, ill. 7; Zachmeier, 1956, pp. 58, 123–24, no. 87; Müller, 1966, p. 128; Viebig, 1971, ill. 31; Skubiszewski, 1978, p. 97, n. 4, no. 8; Ramisch, 1979, p. 85; Schneider, in *Veit Stoss*, 1983, no. 15 (earlier bibliography), ills. 45, 116–118; Kahsnitz, 1984, p. 49; Schleiff, 1985, pp. 333–35.

36 Virgin and Child

Nuremberg, about 1480
Red sandstone
Height, 61¹³/₁₆ in. (157 cm.)
The sculpture is flattened but not hollowed out at the back. Except for weathering, the entire surface is well preserved. The crown, probably of metal, is missing. There are no traces of original polychromy.
Provenance: house at Obstmarkt 22 (old number, Sebald 906), Nuremberg.
Nuremberg, Germanisches Nationalmuseum, Gift of the Nuremberg Industrie- und Handelskammer, 1953
Pl 0.2891

This sandstone figure is not from a church, but from the exterior of a private house near the Frauenkirche, in Nuremberg, at the place where what later became known as the Tucherstrasse branched off from the Obstmarkt. It graced the level of the second story, beneath a sheltering baldachin, precisely at the corner of the building. The house was preserved in its medieval form until World War II. In 1455, a certain Sebald Hornung, who maintained commercial ties to Breslau, was listed as the owner. Hornung died in 1481. The following year, his daughters Helena, Brigitta, and Anna sold the house to their brothers Jörg, Peter, and Endres Hornung, and it remained in the family until 1518. (The above information was graciously provided by Karl Kohn of Nuremberg.) During this time, the figure of the Virgin must have been installed at the behest of one of the members of the family. Statues of the Virgin on the exteriors of residences were common in Nuremberg in the fourteenth and fifteenth centuries, and continue to be so to this day. As late as 1855, Georg Wolfgang Karl Lochner drew up an inventory of some forty of them, many of which, doubtless, survived from the Middle Ages. The majority of these figures probably were lost in World War II. Sculptures of other saints intended to protect the home and bring

Figure 120 The Obstmarkt, Nuremberg, with (center) house no. 22, showing the *Virgin and Child* (cat. no. 36) *in situ,* and (at left and right) other House Madonnas (before World War II)

blessings upon it were also known, but were relatively rare. It was customary to place such statues of the Virgin on the projecting corner of a house (Wilckens, in *Veit Stoss...*, 1983, p. 115, ills. 76, 80, 103), so that, from their elevated position, they would appear to command an entire square or the length of a street, as though providing protection for the surrounding neighborhood and any passersby. There were similar figures on the corners of the houses on the opposite side of the Obstmarkt (see fig. 120).

This Virgin from the Obstmarkt, almost completely covered by her mantle, stands erect atop a heap of stones. Her left arm supports the Christ Child at the height of her shoulder, and, at the same time, lifts a part of her mantle. With her right hand she presses the Child close to her breast, so that the right arm, its elbow sharply bent, creates a triangular form. The Child grasps at his mother's throat with his right hand and places his left hand on her bosom, on the loose end of her veil that lies across it. Mary's head — from which thick, curly locks of hair hang down on either side — inclines toward the Child.

The sculpture is most richly developed in the upper part of the body. The spatial motif of the arm reaching across the breast, and the veil that extends, at an angle, between the Virgin's body and her head, are motifs borrowed from the art of the Upper Rhine. The effect of both elements is softened by the mantle, which covers the entire front surface of the figure, echoing the triangular motif in the way that it turns back at the top. This consistency produces the overall impression of gentleness and calm. Scholars have given little attention to the Obstmarkt *Virgin,* and have dated it much too late. Quite clearly, it lies within the tradition of Nuremberg

statues of the Virgin, of the middle and third quarter of the fifteenth century. Although the dramatic function of the Virgin's arm bent across her breast is not fully developed, that motif and the pose of the Child also characterize the mid-fifteenth-century figure of the Virgin that was incorporated into the new altarpiece for the high altar of the Frauenkirche; the altarpiece was donated by the Welser family about 1520 (Königer, 1965, fig. 10). The motif of the Virgin's arm reaching across her breast also dominates a statue, of 1465 (now in the Bayerisches Nationalmuseum, Munich; see fig. 79), from Weissenburg, in Lower Franconia. However, in both of these works the Child is clothed. Closest stylistically, and in its basic composition, to the Obstmarkt *Virgin* is a large *Virgin and Child Enthroned,* from about 1480 (in the Germanisches Nationalmuseum), whose provenance is unknown (Josephi, 1910, no. 266, ill.; Königer, 1965, fig. 16). The rendering of the drapery folds and the fashioning of the Virgin's face and eyes suggest that both sculptures were produced by the same master. The austere, yet — for a Nuremberg work – the relatively undramatic and gentle mood reinforces the link between the two figures. The Obstmarkt *Virgin* and the imposing carved example in the Germanisches Nationalmuseum are by a sculptor, active about 1480, who worked entirely within the tradition of earlier Nuremberg art, remaining completely uninfluenced by the two chief exponents of Late Gothic sculpture in Nuremberg — Veit Stoss and Adam Kraft.

R K

BIBLIOGRAPHY: Lochner, 1855, p. 11, no. 19; *Jahresbericht GNM,* 1953, no. 97, p. 18, ill. 6; Königer, 1965, p. 14, ill. 17.

37 The Virgin on the Crescent Moon

Nuremberg, about 1490–95
Linden wood, with original polychromy and gilding
Rosary and angel frame: height, 65³/₈ in. (166 cm.), width, 63³/₄ in. (162 cm.), inside diameter, 43⁵/₁₆ in. (110 cm.); figure: height, 35¹³/₁₆ in. (91 cm.)

The figures are hollowed out at the back. The infant Jesus, who once sat on the Virgin's lap, is missing, as is Mary's left hand; her right hand has been restored. The aureole is modern. Parts of the drapery that initially extended below the figure were cut off, probably in the nineteenth century, when the Virgin was detached from the frame and placed on a flat base. Portions of the wings and of the drapery of the angels in the frame are restored; most of the wings are missing. The gilding and the flesh tones of the Virgin were somewhat scratched in an early and unprofessional attempt to remove later layers of paint.

Provenance: *Altarpiece of the Rosary,* originally in the Dominican church of Sankt Maria, Nuremberg; in the 19th century, the figure of Mary was in the Jakobskirche, Nuremberg, and the frame belonged to the municipal collections.
Nuremberg, Germanisches Nationalmuseum (on permanent loan from the Jakobskirche since 1950; the frame, on permanent loan from the city of Nuremberg since 1875)
Pl 0.227, 227a

As late as the eighteenth century, the rosary altarpiece, with its painted wings, still stood in the north aisle of the Dominican church of Sankt Maria, which was demolished in 1807. In 1737, Johann Jakob Schwarz described "an altarpiece with Mary, the mother of God, and the infant Jesus inside a wreath, *cum signis passionalibus,* carved in wood. The two wings present, in painting, the worshiping figures of the emperor, kings, the pope, cardinals, and bishops, with no coats of arms. On the back is the Annunciation." Nothing has come down to us regarding the patron, creators, or the date of completion of the work. The paintings on the wings — of which only the right-hand one survives (cat. no. 38) — are generally attributed to Michael Wolgemut. It is probable that his workshop produced the entire altarpiece, including the carving of the center section, as was Wolgemut's practice.

All that remains of the center of the shrine are the carved figures. The structure that once held them has been lost. Fifteen angels with golden wings and wearing golden robes hold a wreath with alternating white (originally silver) and red roses. Superimposed on this wreath are five golden escutcheons bearing the marks of Christ's wounds. Initially, some of the angels held the instruments of Christ's Passion, as well, and possibly also censers. Mary, dressed in a golden, blue-lined mantle and a golden robe, hovers above a crescent moon, her arms outspread. The infant Jesus (now lost) sat on her lap. A white veil, tied loosely about her head, is draped below her neck and flutters down at the sides. The hem of her mantle bears the inscription: GEGRUSSET SEIS DV DV EDLE JUNGFRAV MARIA EIN MUTER GOT...EIN KONIGIN. / AVE

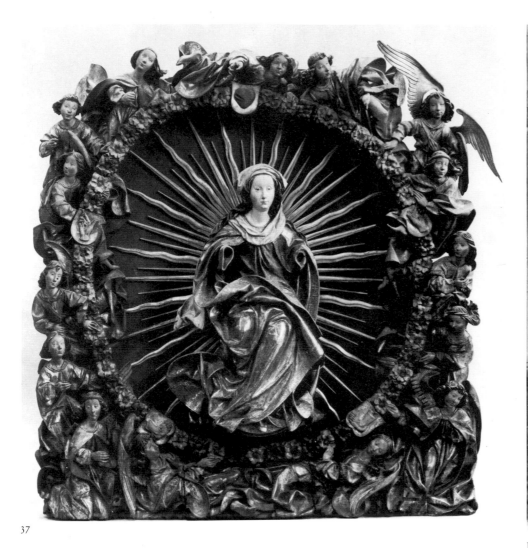

37

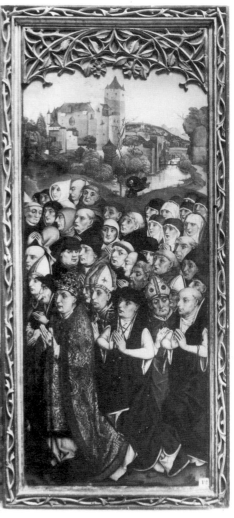

Figure 121 Right wing of the *Altarpiece of the Rosary*

MARIA GRACIA PLENA DOMINVS TECVM BENE-
DICTA JNTER MULIERIBVS. Similar praise of the
Virgin appears on the robes of the angels.

The fifteenth century marked the full flow-
ering of the cult of the rosary, as well as the
various rosary brotherhoods — numbering
among their members the emperor himself, and
the highest dignitaries — established to cultivate
and disseminate it. Prayers were offered to the
Virgin like a wreath of roses; as a rule, fifty *Ave
Marias* were recited in groups of ten, separated
by a *Paternoster*. At the beginning of the fif-
teenth century, the Carthusian monk Domini-
kus of Prussia had begun to augment these fifty
Ave Marias with a meditation on a like number
of mysteries from the life of Jesus — a form of
prayer that has survived to this day. Yet, at the
same time, there was a different way of reciting
the rosary prayer: The five *Paternosters* were
accompanied by meditation on the five wounds
of Christ, and the *Ave Marias,* by recalling
events from the life of the Mother of God.

Associated with this second type of prayer —
which was also practiced in Nuremberg about
1500 — is the depiction, in this work, of Christ's
wounds, in place of five of the large roses
(Beissel, 1900). This iconographic tradition was
quite common in woodcuts of the late fifteenth
century (van den Oudendijk Pieterse, 1939, ills.

18, 19, 35, 41), which may have inspired the
form of the rosary in the Dominican church.
On such woodcuts, which were widely circu-
lated as popular broadsheets and, among other
things, provided precise information regarding
the indulgences associated with saying the ro-
sary, there generally also were depictions of the
Christian estates, led by the emperor and the
pope, all united in prayer and thus under the
protection of the Virgin.

In terms of style, the *Altarpiece of the Rosary*
typifies Nuremberg sculpture immediately be-
fore Veit Stoss, at the end of the fifteenth cen-
tury, and, in terms of painting, displays the un-
mistakable influence of Michael Wolgemut and
his school. The attempt to identify the sculptor
of the present work more specifically is beset by
insurmountable difficulties. He must have been
a member of Wolgemut's atelier, which
specialized in the creation of complete altar-
pieces, or, at least, a freelance sculptor engaged
by Wolgemut for this specific project. His work
is of inestimable quality. In method and style it
may be compared to the *Peringsdörffer Altar-
piece* (from the Heilig-Kreuz-Kirche), also by
Wolgemut, dedicated in 1486 (see fig. 80). The
sculpture in the central part of this altarpiece
(now in the Friedenskirche, in Nuremberg) re-
veals much of Wolgemut's painting style, which

was based on Netherlandish models. It also re-
flects the influence of Wolgemut's contempo-
rary Adam Kraft, whose stone relief sculptures
exhibit definite painterly features. The Swabian
element purportedly distinguishable in the pres-
ent work is, doubtless, merely a certain soft-
ness and winsomeness that characterize the hov-
ering Virgin, in contrast to the austerity then
prevalent in Nuremberg sculpture. The turbu-
lent movement of Mary's drapery and the ex-
pansiveness of the fluttering robes and of the
wings of the angels anticipate developments that
would shape the art of Nuremberg — although
with greater force and with a different feeling —
after the turn of the century, under the
dominating influence of Veit Stoss. R K

BIBLIOGRAPHY: Zion, 1733, p. 117; Schwarz, 1737, p. 2;
von Murr, 1778, p. 55, 1801, p. 77; Lösch, 1836, p. 42;
Rée, 1889, p. 6, no. 27; Josephi, 1910, no. 286 (on the
rosary frame, with an older bibliography); Lossnitzer,
1912, pp. 131–33, pl. 48 (the frame only); Höhn, 1922, ill.
104 (the rosary frame and the crucifix long thought to
belong to it); Bock, 1924, p. 197 (the surviving wing
only); *Stoss*, 1933, no. 43, ill.; van den Oudendijk Pieterse,
1939, p. 228, no. 114, p. 267, no. 187, ill. 34; Zachmeier,
1956, pp. 77, 131, no. 115; Pilz, 1964, pp. 65–66; Ostoia,
1967, p. 365, ill. 20.

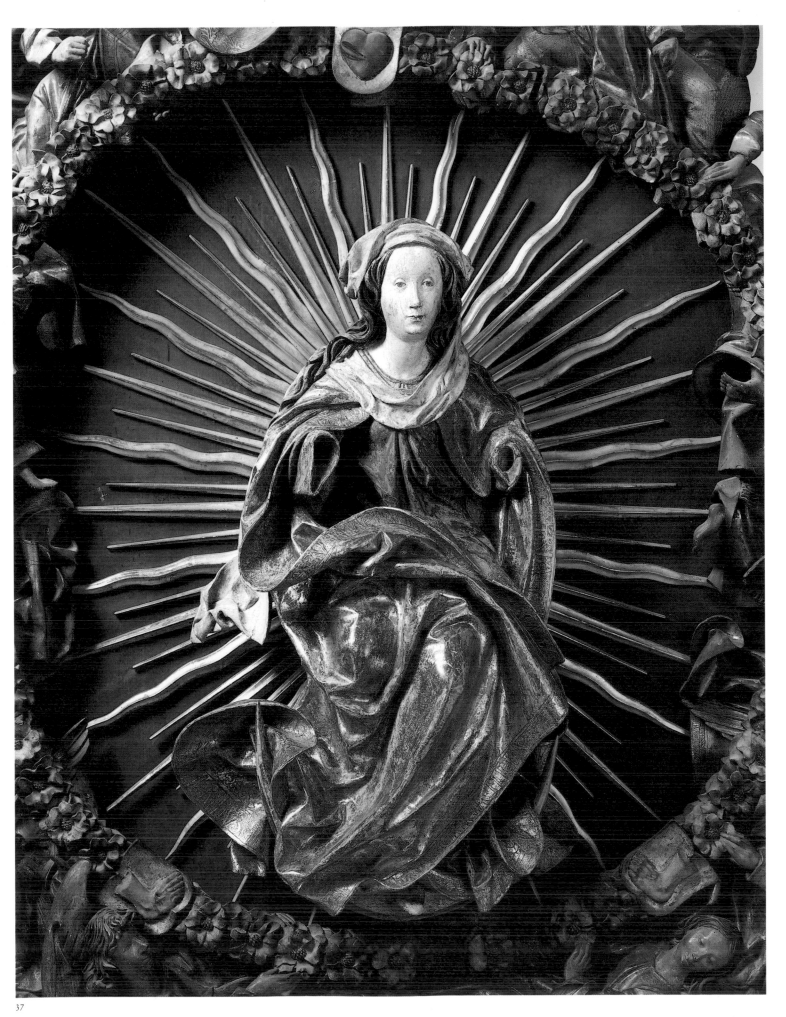

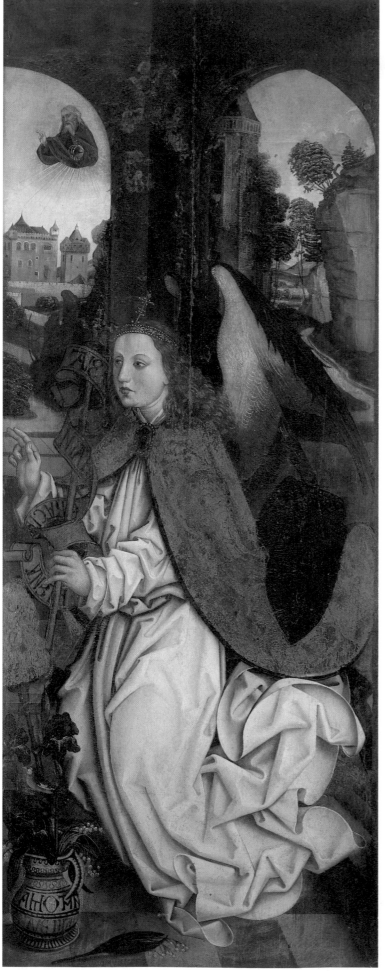

38

The Representatives of the Spiritual
Estate
(reverse): The Angel of the Annunciation
About 1490–95
Tempera and oil on pine wood
67 11/16 x 26 3/4 in. (172 x 68 cm.)
The panel is the right wing of an Altarpiece
of the Rosary.
Provenance: Dominikanerkirche, Nuremberg.
Nuremberg, Lorenzkirche

The altarpiece to which this wing once belonged
was still installed on the gospel side of the
Dominikanerkirche, in Nuremberg, in the eigh-
teenth century (Schwarz, 1737). The figure of
the Virgin of the Rosary, originally part of the
central shrine, is now in the Germanisches
Nationalmuseum (see cat. no. 37). The left
wing, which depicted the representatives of the
lay community, with the Virgin of the Annunci-
ation on the reverse, has been lost.

In Late Medieval art, the temporal and
spiritual estates were usually shown on opposite
sides of a painting or on two different wings of
an altarpiece. Examples of this are the portrayals
of the Virgin of Mercy and Dürer's famous
Feast of the Rose Garlands, of 1506 (in the
Národni Galeri, Prague). The clergy is led by
the pope, accompanied by cardinals, bishops,
and members of the religious orders, both male
and female. The temporal estate is preceded by
the emperor; he is followed by the king, along
with electors, knights, and ordinary citizens.
The founding of the Confraternity of the Ro-
sary in Cologne in 1475, and the participation of
Emperor Frederick III, considerably popu-
larized the cult of the rosary in Germany.
Rosenkranzbilder were painted or carved in and
around Nuremberg until the Reformation.

The altarpiece wing with *The Representatives
of the Spiritual Estate* is generally attributed to
Michael Wolgemut and dated about 1490/95.
Opinions vary as to its quality and whether or
not it is his own work, for the artist was a busy
entrepreneur who relied heavily on his appren-
tices.

Wolgemut was faced here with the difficult
task of showing the faithful at their devotions,
with their attention focused on the Virgin. His
solution was to place the leaders of the clergy in
the front ranks, either in full figure or with their
hands folded in prayer, while the remainder are
depicted as rows of heads one behind the other.
Head coverings, hairstyles, and tonsures differ;
the figures face in slightly different directions;
and there are variations in the colors of their
skin. Yet, despite these attempts at individuali-
zation, the artist soon exhausted his stock of
facial types.

The reds are deep, and the gold of the brocade
glows splendidly but, otherwise, the palette is
reduced to shades of gray and brown. The
glazes, which are built up layer upon layer; the
modeling; and the use of light and shade all
indicate the hand of an experienced artist. The
landscape setting ranks with those of the best
woodcuts in the *Chronicle of the World* (cat. no.

87). The way in which the river, cliff, and castle lead the viewer into the picture; the soft, rolling hills; the luxurious vegetation; and the impression of light and open air provide a representation of nature that is unique in early Nuremberg painting.

The *Angel of the Annunciation* on the exterior of the wing is not visible in the present arrangement of the panels in the church, and, consequently, is therefore hardly known. The artist used a stamped brocade for the pluvial, on the outside of the altarpiece, which suggests that the commission was a costly one. Unfortunately, the oxidation of the gold threads has dulled the effect of the brocade. The angel appears to fill the entire panel. The swirl of draperies, indicating a balance between the figure's inner and outer tension, is a masterpiece of imaginative draftsmanship and skillful modeling. The coherent use of space typifies Wolgemut's mature style. KL

BIBLIOGRAPHY: Schwarz, 1737, p. 3; Thode, 1891, p. 148; Dörnhöffer, 1906, pp. 451–52; *Historische Ausstellung,* 1906, no. 58; Abraham, 1915, pp. 125–26; Weinberger, 1921, pp. 72–73; *Dürer,* 1928, no. 26; Betz, 1955, pp. 315–17, cat. pp. 34–35; Stange, 1934–61, vol. IX, p. 58; Stange and Strieder, 1978, no. 136.

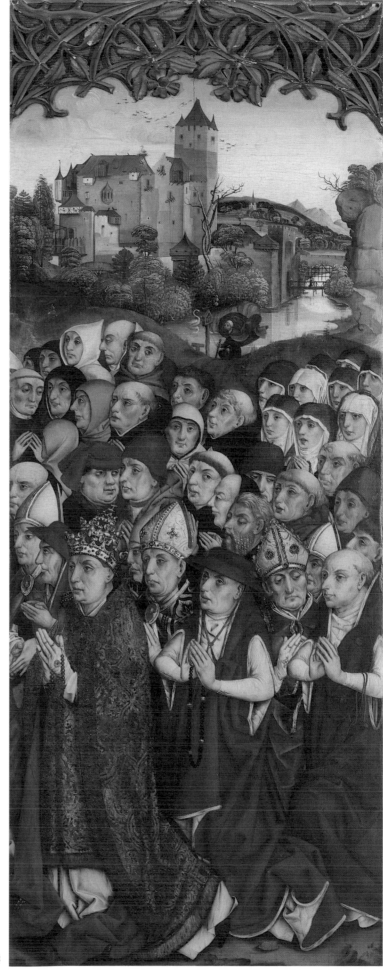

38

39 CIRCLE OF HANS PLEYDENWURFF

Bust of a Female Saint or Sibyl

About 1460–70
Pen and black ink with gray wash, on tinted paper
$7^{7}/_{8}$ x $5^{5}/_{8}$ in. (19.9 x 14.2 cm.)
Inscribed (at lower left, in brown ink): MW;
(on verso, in black ink): Jos Camesinaj/Pomal
1825
New York, Ian Woodner Family Collection

This female figure, depicted in three-quarter profile with an anguished expression on her face and with her hands resting on a parapet at the bottom edge of the picture, represents a type of bust portrait that was quite common in Italian and Netherlandish painting in the second half of the fifteenth century. She has been identified as Mary Magdalene, although she does not appear with her standard attribute, an ointment jar. For this reason, and because of the pseudo-Greek inscription around the edge of her hat, an alternative interpretation of the figure as a Sibyl seems more plausible.

A very similar bust portrait is that of Mary Magdalene on the right wing of the *Braque Triptych* by Rogier van der Weyden, a small altarpiece intended for private devotion, now in the Louvre. Two comparable silverpoint drawings after that work are in the British Museum (Sonkes, 1969, B. 23/24). The similarity is not confined to a pictorial type, but extends even to the costume — the laced bodice and the bizarre wheel-shaped head covering — and the shallow modeling of the face.

Among the elements that suggest that the sheet is a copy after a lost painting by Rogier or by an artist whose style is quite close are the foreshortening of the left hand and arm and the fine auxiliary pen shading around the mouth and eyes, which seems to contrast with the painterly softness of the rest of the face. Traditionally, the drawing is regarded as the work of a Nuremberg draftsman, and it has recently been attributed to the circle of Hans Pleydenwurff, from which, however, no authenticated drawings survive. Pleydenwurff's paintings from the period 1460–70 attest to intensive study of Netherlandish painting, especially that of Rogier van der Weyden. The drawing can therefore be seen to represent a parallel to Pleydenwurff's drawing for a *Descent from the Cross* (cat. no. 40) in Nuremberg. RS

EX COLLECTIONS: Cornelius Ploos van Amstel, Amsterdam (Lugt, no. 3002–3004); Josef Camesina de Pomal, Vienna (Lugt, no. 429); Baron Robert von Hirsch, Basel.

BIBLIOGRAPHY: *The Robert von Hirsch Collection...* (sale cat.), vol. 1, June 20, 1978, no. 9; Goldner, 1983, no. 38.

40 Joseph of Arimathaea and Four Men, from a Descent from the Cross

Franconia, about 1470–80
Pen and black ink, with areas of blue wash, on paper
15 1/8 x 11 1/4 in. (38.5 x 28.5 cm.)
Inscribed (on verso, in brown ink): Irem Hansen Hackenn Drahtzieher/schuldig 7.
Watermark: bull's head with double vertical line and triangle below (Piccard, watermark no. 818). The left corners are rounded.
Nuremberg, Germanisches Nationalmuseum Hz 36 (Kapsel 1531)

The drawing depicts five attendant male figures from a *Descent from the Cross,* among them Joseph of Arimathaea, who grasps the feet of the dead Christ with both hands. As Winkler determined, it is a partial copy after a Netherlandish painting from the circle of Rogier van der Weyden, the composition of which is preserved in a small panel attributed to Vrancke van der Stockt in the Alte Pinakothek, Munich. The same *Descent from the Cross* also influenced a panel painting in the Lorenzkirche, Nuremberg, attributed to Wolgemut and may already have been in the Bavarian–Franconian region at that time.

The Netherlandish elements are so predominant that Sonkes tentatively attributed the drawing to Rogier's successor as municipal painter in Brussels, Vrancke van der Stockt. The watermark suggests a date of about 1480 for the drawing, while the inscription on the back indicates that the sheet was in Nuremberg by 1530–60; this may well establish that the drawing was made in Nuremberg or its environs. Zink therefore classified the sheet, doubtless correctly, as "Franconia, third quarter of the fifteenth century," and had in mind the circle of Hans Pleydenwurff. Although Pleydenwurff is not documented as a draftsman, his paintings reveal a direct Netherlandish influence on Nuremberg painting in the period 1460–80. One can easily imagine that through such drawings a knowledge of Netherlandish masterpieces was transmitted, which would accord with workshop practice at the time. An unusual feature is the suggestion, in blue wash, of chain mail worn by the soldier on the right, while other parts of the drawing are left blank or rendered only in outline. This would confirm that the drawing is the work of a copyist. Further confirmation may be seen in the weakness of the drawing of the hands. RS

EX COLLECTION: Hans Freiherr von und zu Aufsess, Aufsess and Nuremberg (Lugt, no. 2750).

BIBLIOGRAPHY: von Falke, 1855, col. 147; Winkler, 1913, p. 89, pl. 18, ills. 49–50; Zink, 1968, no. 35; Sonkes, 1969, C 22; *Dürer,* Nuremberg, 1971, no. 204; Sonkes, 1973, pp. 98 ff., ill. 5.

40

Figure 122 The Man of Sorrows, the left wing of the *Löwenstein Diptych*. Öffentliche Kunstsammlung, Basel

41 HANS PLEYDENWURFF

Portrait of the Bamberg Canon and Subdeacon Georg, Count von Löwenstein

Probably 1456
Tempera and oil on linden wood
13 ¹/₄ x 9 ³/₄ in. (34 x 25 cm.)
Nuremberg, Germanisches Nationalmuseum
(acquired by 1856)
Gm 128

This portrait is the right half of a diptych whose left panel portrays Christ as the Man of Sorrows (fig. 122; the painting is in the Öffentliche Kunstsammlung, Basel, no. 1651). Until the left wing with the Man of Sorrows was rediscovered, the subject of the portrait was believed to be Canon Georg von Schönborn. The same cleric appears as a kneeling donor in a *Crucifix-*

ion in the Germanisches Nationalmuseum, Nuremberg (Gm 131). Since that work was ascribed to Pleydenwurff, Thode (1891) attributed the present panel to him, as well. Its superior quality was acknowledged early on, but Buchheit (1919) first recognized its relationship to the *Man of Sorrows*. The back of the Basel painting bears the Löwenstein coat of arms (fig. 123), and its original frame contains the count's pedigree in the form of the coats of arms of his parents and grandmothers: Löwenstein, Werdenberg, Kirchheim, and Wertheim; these made it possible to identify the cleric in the portrait as Georg, Count von Löwenstein. The diptych has been convincingly dated to 1456 (Thode, 1891; Weinberger, 1921; Stange, 1958), Pleydenwurff's last year in Bamberg. It was at that time that the count, who was

almost eighty, wrote his will. Buchner (1953) suggested a date of about 1464, when the count died. Count von Löwenstein became wealthy as a result of numerous ecclesiastical offices and benefices; he was a pious man, concerned for his own salvation, and, thus, he patronized the arts. The above-mentioned *Crucifixion,* which includes a donor portrait of von Löwenstein, is generally considered an epitaph that dates from after 1464, and is attributed to the Pleydenwurff workshop in Bamberg (Stange, 1958, pp. 87–89). Suckale tentatively dates the *Crucifixion* to about 1456, and regards it as the work of Pleydenwurff, himself. Still another portrait of Löwenstein is engraved on his tombstone in Bamberg Cathedral.

Christ occupies the right-hand, superior position in the painted diptych (in heraldic terms). He raises his hands and displays his wounds, from which the blood flows, as it does from the wound in his side; it also issues from the wounds on his forehead made by the crown of thorns. He gazes earnestly and ceremoniously over his shoulder at the cleric. Behind him there is an aureole, and a rippled blue ribbon embellished with stars represents heaven. Despite the painter's talent for observing nature, Christ remains an idealized figure.

Not so the canon. He appears in front of a deep-blue background in a fur-trimmed coat of pomegranate-patterned velvet. In his fragile left hand he holds a book — doubtless, a prayer book — his thumb tucked between its pages. A paper bookmark protrudes from the book, and a wrapper protects the cover. Von Löwenstein is an old man, with thin white hair; transparent, wrinkled skin; and puckered lips. He is toothless. His light blue eyes gaze inward, oblivious to what is before him; the cleric looks at Christ, but he does not see him. The obvious discrepancy between their respective levels of reality argues against a direct encounter; only in the devout man's thoughts is there a connection with the adored Man of Sorrows.

The representation of von Löwenstein is rightly considered the most important German portrait to predate the work of Dürer. It is masterfully studied, deeply felt, and rich, yet sensitive, in its coloring. The frailty of the old man whose death is approaching contrasts sharply with the vitality of his religious conviction and his spirit.

As part of an Adoration diptych, the portrait belongs to a distinct tradition that flourished principally in the Netherlands. The majority of such works depict the Virgin with the Christ Child, and were meant for the patron's private devotions (see Bäumler, 1983). However, Christ as the intercessor between the sinful mortal and the judging God, had been the subject of earlier Nuremberg epitaphs, such as that of the abbot Friedrich von Hirzlach (died 1350) in the former monastery church in Heilsbronn (fig. 90; Stange, 1934–61, vol. 1, ill. 208). In that work, Christ's hands are crossed over his breast in the Gregorian manner, but his eyes are open. The pose and gesture of Christ in the von Löwenstein diptych, however, are meant to

Figure 123 Coat of arms on the reverse of the *Löwenstein Diptych*. Öffentliche Kunstsammlung, Basel

underscore his role as mediator: The donor is not depicted in a smaller scale, only sketchily defined, as in the epitaph, but is portrayed the same size as the Savior, with his individuality and his unique personal characteristics intact.

KL

EX COLLECTIONS: Hans Freiherr von und zu Aufsess, Aufsess and Nuremberg.

BIBLIOGRAPHY: Thode, 1891, p. 109; Buchheit, 1919, pp. 26−29; Weinberger, 1921, p. 13, 24; Lutze and Wiegand, 1937, p. 148, ill. 34; Engel, 1950; Buchner, 1953, pp. 123−25, no. 137, ill. 138; Stange, 1934−61, vol. 9, pp. 42−44; *Dürer*, Nuremberg, 1971, no. 91; Stange and Strieder, 1978, no. 104; *Luther*, 1983, no. 458; Bäumler, 1983, pp. 95−102, no. 23; Suckale, 1984, pp. 423−38.

42 The Crucifixion, with the Virgin and Saint John (Epitaph for Georg Rayl)

Nuremberg, about 1494−95
Tempera and oil on fir wood
49 5/8 x 37 in. (126 x 94 cm.)
Nuremberg, Lorenzkirche

The kneeling cleric traditionally has been identified as the curate Georg Rayl. Since he died in 1494, this memorial picture must have been painted that year, or the following one. The donor addresses his prayer "miserere mei domine" ("Lord, have mercy upon me") to the crucified Christ. The Virgin and Saint John stand on either side of the cross. The skull and bones at the foot of the cross identify the setting as Golgotha, the "place of the skull," while the medieval city along the river represents Jerusalem. The flowers near the skull allude to the Resurrection, and to the guarantee of a new life brought about by the death of the Redeemer.

Memorial paintings — with which the deceased pleaded for the intercession of Christ and the Virgin — are common to Nuremberg. The donor always appears in reduced scale. In fifteenth-century examples, families of donors are often represented, usually physically separated from the biblical events, in their own area of the picture.

The Rayl *Crucifixion* was previously attributed to Michael Wolgemut or his workshop. The painting aroused particular interest in connection with the 1928 Dürer exhibition, for the catalogue points out the close similarities between the painting and a drawing by Dürer in the Louvre (see cat. no. 101), specifically mentioning the possibility that the painting might also be the work of the young Dürer. However, this theory has not been confirmed. The opinion that Dürer adapted the painting from his drawing is untenable, if only because the latter has been conclusively dated about 1490 (Winkler, 1936).

The artist of the Rayl *Crucifixion* belongs to the generation of Wolgemut's pupils. There are connections with the *Altarpiece of Saint Vitus*, dated 1487, from the Augustinerkirche, in Nuremberg (now in the Germanisches Nationalmuseum). This altarpiece presented the people of Nuremberg with a new concept of space and movement, and with a feeling of being close to nature and of the artist's personal involvement in the subject. In the Rayl *Crucifixion*, too, the landscape is not merely a two-dimensional background but it exists in space, the cliffs directing attention to the center of the picture. The anatomy of Christ's body is fully realized; it is portrayed with a feeling for structure and a use of light and shade that is as gentle as it is precise. His grayish flesh tones and bloodless lips set the dead Christ apart from the living. In spite of the blood, a crass realism is avoided; the face, with its half-shut eyes and mouth contorted in pain, is still full of majesty — as is the figure's overall bearing. Of the two mourners, Saint John, approaching the cross with his brows drawn together in pain, and his mouth slightly open, gives more lively expression to his grief than does the Virgin, compelling in her stillness, who clutches her veil as if about to dry her eyes. Saint John's warmer, ruddy coloring is finely distinguished from that of the Virgin's pale and almost transparent complexion. The echoing movements of the draperies of both figures make each appear as a self-contained entity. Mary's light blue mantle falls in a series of vertical, V-shaped folds. John's costume is marked by a multiplicity of creases, and by the contrast between the solid, muted red of his cloak and the softer green of its pleated lining. The landscape — with the highlights on the tops of the trees, the wisps of cloud, and the stepped, rocky slopes — reveals more of the draftsman's skills than those of the painter. All the forms seem to be resisting gravity and are without any suggestion of corporeality.

The artist responsible for this work was receptive to new currents in painting in Nurem-

berg, but the quality of the craftsmanship is not up to Wolgemut's standard. The finish is lacking in consistency. Among the figures, it is the crucified Christ who claimed the painter's attention. The landscape has been designed without much thought and the highlighting of the treetops displays a certain standardization of technique. The artist's personal contribution to the scene lies in its spiritual mood, which, in contrast to the more caustic approach of Wolgemut, enabled him to experience with greater intensity the pain of the crucified Christ and of the bereaved, and to portray it more touchingly. This links him with the principal artist of the Augustinerkirche altarpiece — whose *Vision of Saint Bernard* certainly displays a stronger sensibility — as well as with Dürer, who grew up among these examples of Nuremberg art, and went on to enlarge upon them, fill them with new life, and to reinterpret them in his own style. Dürer's drawing of the *Crucifixion* surpasses the Rayl *Crucifixion*. However, it is conceivable that bolder solutions to compositional problems were sought and were possible in a drawing, rather than in a painting, which was usually commissioned by one with more conservative tastes than the artist. Dürer succeeded in rendering a more integrated space, and in giving nature the appearance of vigorous growth, as well as in relating the mourners — here, free of their roles as intercessors — alongside the cross more intimately to the crucified Christ. The Rayl *Crucifixion* clearly indicates that Dürer's artistic achievements were acknowledged and understood in Nuremberg at an early date.

Stange attempted to link the painter of the *Crucifixion* with the name of Jakob Elsner. Little is known about this artist, who worked in Nuremberg as a manuscript illuminator (see cat. nos. 53, 54), and who died there in 1517. Elsner was also a panel painter. He signed his full name on the reverse of the 1499 *Portrait of Jörg Ketzler* (in the Germanisches Nationalmuseum). Closer in style to Dürer is Elsner's portrait of a bridegroom with long, curly hair, and a fresh, searching look (also in the Germanisches Nationalmuseum). Whether or not the same hand was at work in the comparable "angular style" of the head of Saint John and in the "slight distortion of the far side of [his] face" (Stange, 1958, vol. 9, p. 85), in the Rayl *Crucifixion*, remains to be decided. KL

BIBLIOGRAPHY: Thode, 1891, pp. 147−48; Abraham, 1912, pp. 138−39; *Dürer*, 1928, no. 102; Flechsig, 1928−31, vol. 2, pp. 384−85, ill.; Winkler, 1936−39, vol. 1, no. 19; Betz, 1955, text, pp. 313−15, cat., pp. 61−63; Stange, 1934−61, vol. 9, p. 85, ill. 177; *Dürer*, Nuremberg, 1971, no. 118; Machílek, 1972, pp. 97−99; Stange and Strieder, 1978, no. 223.

42

Provost Dr. Lorenz Tucher

1485

Pot metal and white glass, in red, blue, violet,
yellow, and green, with black vitreous paint
32⅞ x 18⅞ in. (81 x 48 cm.)

Above the round arch, the medieval pieces of glass
containing two dragons and a bridging section in
bluish green are not original to the work. There are
only minor modern restorations, including the
yellow triangular insert just below the book; the
second segment from the top, in the column at the
left; a small, yellow triangular section at the
bottom, in front of the lectern and the tip of the
cloak; and the lower half of the dragon, at the left.
An older rectangular stopgap of brown-and-white
striped glass, above the book, was painted over in
black in the latest restoration. All repair leads were
removed in 1984. The leads that mark the bound-
aries of the front corner of the white alb and the
left-hand side of the inscription panel are original.
The painting is in excellent condition.

Provenance: Michaelskirche, Fürth (Franconia), at
least until 1815.

Nuremberg, Germanisches Nationalmuseum
(acquired from Walter Bremen, 1968)
MM 811

The panel depicts a kneeling Dr. Lorenz
Tucher, provost of the Lorenzkirche, in
Nuremberg. Over a violet soutane, he wears a
full, white alb that is gathered about his knees,
on the floor. The fur almuce over his shoulders
identifies him as a provost. A red biretta covers
his head. He is leafing through a prayer book
resting on a yellow lectern, but he gazes past it,
into the space outside the picture, seemingly
focusing on nothing in particular. There is a
suggestion of an architectural niche, the back
wall of which is covered by a red brocade cur-
tain hanging from a yellow rod. In contrast to
other stained-glass portraits of patrons, from
Nuremberg, here, beneath the arch, no land-
scape is shown. Instead, the blue background is
filled with an abstract design of feathery vines.
A rectangular section above the lectern was set
apart from this panel even at the time that the
window was made; it must have consisted of
glass of a different color. The blue glass is origi-
nal — the edges are trimmed in the medieval
manner, and, moreover, it could not have bro-
ken in this shape. It would appear that some
object — possibly a crucifix — was depicted
above the lectern. Unfortunately, uniformity
among such patrons' windows does not exist, so
that its decisive reconstruction is impossible. In
the panel depicting the patron Lorenz Tucher,
in a window that he donated to the Lorenz-
kirche in Nuremberg in 1481 — restored by the
Zurich stained-glass painter Jacob Sprüngli in
1601 — there is, indeed, a crucifix in a corre-
sponding location, but the present panel is not
necessarily a reliable copy of the Late Gothic
original. Behind the provost is his family's coat
of arms, and below him, the inscription:
· laurencius · tucher · decretorũ[m] doctor /
canonicus · ratispoñ[ensis] · s[an]cti · laurencii /
In · Nürmberg · plebanus 1485· (· Lorenz Tu-
cher, doctor of canon law, canon in Regens-

burg, rector of St. Lorenz in Nuremberg,
1485·).

In 1485, Lorenz Tucher was thirty-eight
years old. He had studied liberal arts in Leipzig,
and ecclesiastical law in Basel and probably in
Italy, as well, attaining a doctorate in canon law.
His nomination as provost of the Lorenzkirche
by the Nuremberg council in 1478 was prompt-
ly confirmed by Pope Sixtus IV. However, this
led to long and bitter quarrels with the
bishop of Bamberg, his immediate superior,
which continued even after Sixtus IV rejected the
claims of the bishop's own nominees for the
post in 1481. Tucher, who was canon of the
cathedral of Regensburg from 1483, ultimately
resigned his Nuremberg post in 1496 in favor of
his cousin Sixtus Tucher (see cat. no. 117), and
withdrew to Regensburg, where he became cus-
todian of the cathedral in 1498. He died in 1503.
His name is associated with the Dr. Lorenz
Tucher Stiftung, still in existence, and with a
number of works of art — above all, with the
large epitaph in the Sebalduskirche, com-
missioned by his brothers in his memory, and
painted by Hans Suess von Kulmbach, in 1513,
after designs by Dürer from 1511 (fig. 96). To
his own church of Sankt Lorenz he donated one
of the choir windows on the south wall, east of
the sacristy, in 1481 — the window that was
completely restored by Sprüngli in 1601 with
funds from the Lorenz Tucher Stiftung.

Tucher was rector and provost of the Lorenz-
kirche, and, at the same time, rector of the
Michaelskirche, in Fürth, and head of the clerics
assigned to it. The choir of the Michaelskirche,
rebuilt in 1482, contained seven stained-glass
windows, but only this single pane survives.
The provost from Bamberg Cathedral donated
the glass for the central, three-lancet window.
The window south of it was given by Dr.
Lorenz Tucher; the one to the north, by the
pastor of the Michaelskirche, Conrad Held.
Each of these two windows had only two lan-
cets, consisting of five panes, one above the
other. Accordingly, there must once have been
ten painted panels in the Tucher window. The
Tucher family records describe the portrait of
Dr. Lorenz Tucher as still in place in 1764. The
design of the rest of the window is not known
to us. As early as 1573, only the top and bottom
panels of the choir window survived, the inter-
vening space having been glazed with bull's-eye
panes; thus, the restoration of the Tucher win-
dow undertaken in 1578 involved only these
panels. It is possible that the panel corre-
sponding to the present one pictured Saint Law-
rence, before whom the provost knelt. In 1815,
all of the surviving stained-glass panels were re-
moved from the choir, "and only a few quite
unimportant ones [were] left" — probably only
panels with coats of arms and portraits of pa-
trons, which could not be removed out of con-
sideration for their families.

The Tucher panel represents a long tradition
in Gothic stained glass. It was common for the
donor of a window to have himself portrayed
with his coat of arms — laymen were shown
with their wives — in the bottom register of the

design. For example, two previous rectors of the
Lorenzkirche, Dr. Konrad Konhofer and his
successor, Dr. Peter Knorr, had been depicted
thus in the choir windows from 1476 and 1477,
respectively — to the right and left of the Em-
peror's window (cat. no. 44) — that they do-
nated to the Lorenzkirche (Strieder, 1958, ill. 3
[Konhofer]; Lutze, 1939, ill. 65 [Knorr]). The
design and the nature of the Tucher panel's
accompanying inscription follows the pattern of
those that preceded it.

The conception of the portrait, however, is
quite different. The earlier ones remained
bound to the tradition of portraying the rector
as a type, indicating his individuality solely
through the inscription and his name, for glass
painters normally were not concerned with cap-
turing the characteristics of a specific person. By
contrast, Lorenz Tucher seems to be charac-
terized uncommonly clearly — not so much by
any emphasis on particular features as by the
overall feeling of the portrait. In the art of
Nuremberg at this time, even in panel painting,
there is no other portrait in which a person's
individuality is rendered so successfully — or,
for that matter, even addressed to such a degree.
It is for this reason that, in 1958, Peter Strieder
ventured to attribute the painting of this panel
to the young Dürer, who was active in the
workshop of Michael Wolgemut when the glass
was made. However, since the date in the in-
scription has now been accurately deciphered as
1485 — formerly, it was read as 1487 — that
possibility has to be excluded. Dürer, born in
1471, did not enter the Wolgemut workshop
until the end of 1486. Even so, this scholarly
error points up the high quality of the painting,
as well as the altered attitude toward portraiture
that gave rise to it.

The workshop conventions that led to the
creation of the Tucher portrait are those familiar
from the work of Michael Wolgemut, a number
of whose panel painting portraits survive. The
modeling is achieved primarily by graphic
means, producing a certain hardness and cold-
ness. The nose, eyebrows, almond-shaped eyes,
and the mouth, with its projecting lower lip, are
all described in sharp, severe lines. Typical of
Wolgemut's depictions of figures are the size
and heaviness of the head in relation to the
body, elements also found in his later panel
painting of the spiritual estate (see cat. no. 38),
the center of which, it has long been thought,
contains a portrait of Lorenz Tucher. The cleric
who stands in similar three-quarter profile to
the right and above the pope, wearing an alb,
almuce, and red biretta, gazes so intently out of
the painting that it is very probably a covert
portrait of a contemporary. Compared to the
linear severity of these heads, the earlier stained-
glass portrait seems more carefully modeled,
constructed with increased subtlety from areas
of light and shadow, of greater individuality,
less standardized in its sharply accentuated de-
tails, and imbued with an impressive earnestness
rather than with a defiant sullenness.

Scholars have long known that, in addition to
his activity as a panel painter — above all, as a

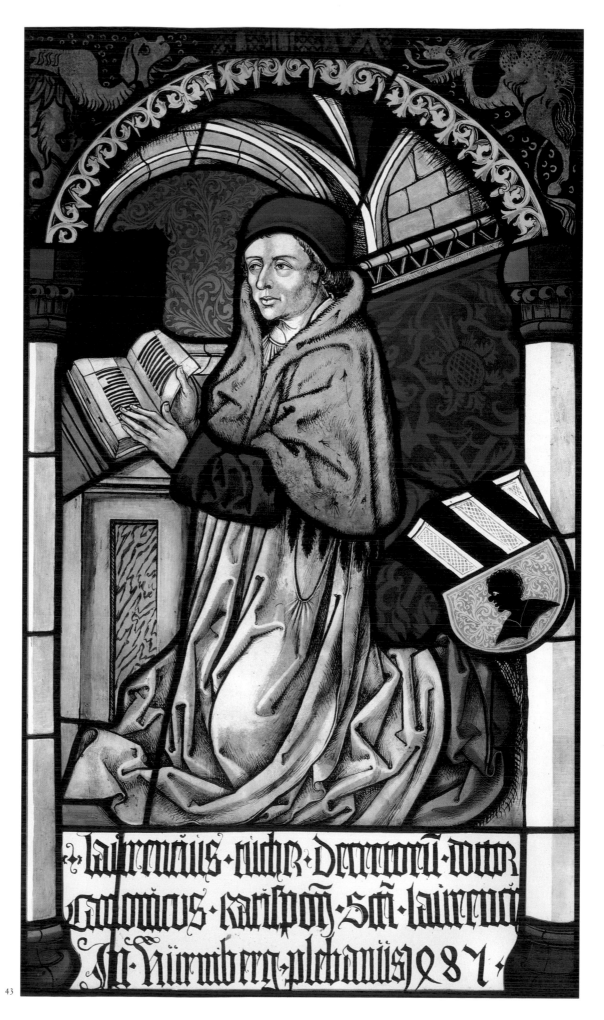

43

producer of large altarpieces comprising carved shrines and painted wings — and his organization of the extensive woodcut sequences for the major publications of the period, Michael Wolgemut also accepted commissions to produce works in stained glass. It is certain that he did not necessarily wield the brush himself, or that he was even the author of all of the existing designs in pencil, but he oversaw the activities of the workshop, with its numerous and transient employees, as was required in the process of executing major stained-glass cycles. Through marriage, Wolgemut had inherited the workshop of Hans Pleydenwurff. Although no stained glass by him has survived, he was identified as a glazier at the time of his death. Among the chief works attributed to Wolgemut and his workshop are the eastern choir windows of the Lorenzkirche: the Emperor's window (cat. no. 44), in which some authorities have recognized his signature, and the adjacent windows on either side of it, commissioned by the rectors Knorr and Konhofer. It is more than likely that other windows, of which only fragments now remain, came from the same workshop — as Ursula Frenzel so convincingly argued in 1970.

The preponderance of white over colored glass — so striking in the windows of the Lorenzkirche — is apparent in the present panel. Colored glass is only used on the periphery; the central figure of the provost is painted entirely on white glass, relying not so much on halftones and areas of deep shadow as on graphic details. The dominating outlines, the empty white spaces, and, above all, the countless tiny lines and hatchings contribute toward the three dimensionality of the face and of the drapery. The individual hairs of the fur almuce, which were then darkened with a halftone wash, are still fairly obvious. They become more concentrated in the shadows on the alb, although here, too, the darker areas consist of parallel lines or cross-hatchings. All of the light, projecting surfaces are surrounded by shadowy areas made up of a dense overlay of tiny lines. This is most evident around the knee and the face of the provost, where the modeling has been extremely carefully executed. Graphic elements came to influence the methods and style of stained-glass painters, in general, at the end of the fifteenth century. This panel of the patron Lorenz Tucher betrays most clearly the style of the artists and the workshop whose greatest achievements would be produced a short time later, in the early 1490s, in the form of graphics for printed books. RK

Bibliography: Tucher, 1764, p. 60; Strieder, 1958, pp. 175–82, ills. 1–2; Grote, 1961, p. 66, ill. 23; Schwemmer, 1962, p. 36; Bremen, 1964, no. 17, p. 163, colorpl.; Frenzel, 1969, pp. 157–66, ills. 1, 4; Koeniger, 1969, p. 223, ill. 10; Frenzel, 1970, pp. 27–46, ills. 1–2, 4; Ulrich, 1979, pp. 171–72.

44

44 WORKSHOP OF MICHAEL WOLGEMUT
The Battle of Regensburg

About 1477
Pot metal and white glass, in violet, green, light blue, and dark blue, with black vitreous paint, and halftones in brown wash
Two panels, each, 38 9/16 x 22 7/16 in.
(98 x 57 cm.)
Nineteenth-century restorations include the angel with the sword; the banderole bearing the inscription "karl"; large areas in the foregrounds of both panels; the left leg of the light-brown horse; the brown portions of the landscape, especially on the right; several gray replaced segments on the ground; and the back legs of the horse and the legs of the rider in the left-hand panel. The black paint is badly weathered. Overpainting from the 1836 restoration is fused to the glass.
Provenance: Emperor's window, Lorenzkirche, Nuremberg.
Nuremberg, Lorenzkirche

The two panels come from the central window of the choir of the Lorenzkirche, in which, in thirty-six panels — apart from the nine coronation scenes — the story of the discovery of the True Cross was retold. The two bottom registers were reserved for the donors and their coats of arms. Figures of Frederick III (r. 1440–93; emperor, from 1452) and his consort Eleonore of Portugal occupy the center of the window, beneath tall canopies; angels and wild men display the imperial couple's coats of arms. The upper registers contain various scenes relating the discovery of the cross by the empress Helena, the conversion and baptism of Emperor Constantine and his defeat of Maxentius under the sign of the cross, and the rescue of the relics of the cross from the Persian king Chosroes by Emperor Heraclius. The concluding scene, in the two panels on the extreme right of the third register, depicts Charlemagne's victory over the Avars at Regensburg (panes 1 3 e and f in the official numbering of the *Corpus vitrearum medii aevi*). The legend of that confrontation was popular in southern Germany, including Nuremberg, from the thirteenth to the fifteenth

century, and it was sometimes portrayed by contemporary artists (Schönberger, 1972). According to the legend, at the battle for the conversion of the heathen Bavarians outside the city of Regensburg, an angel led Emperor Charlemagne up on a mountain, where he was shown a cross that appeared to bode victory for his cause. The ultimate defeat came only three days later, however, when, in response to the emperor's prayers, an angel with a sword appeared in the sky and took an active part in the battle. The connection between this legend and that of the discovery of the True Cross is rather vague, and in these panels the cross is not even pictured. Presumably, the only real connection was the parallel with Constantine's battle at the Milvian Bridge, where he owed his victory to the sign of the cross that appeared to him in the sky. The composition focuses on two groups of warring knights. The emperor is seen on horseback in the right foreground, gazing up at the sky.

The window, itself — occupying the prime position in the apse of the choir of the Lorenz-kirche — would appear to have been a gift from the reigning emperor, although nothing is known either about the terms of the gift, or the details of the window's creation. Astonishingly enough, there is no actual donor's inscription. It had been a tradition in Nuremberg, from the fourteenth century on, for the emperor to donate the middle windows of the city's important churches. The center window in the Frauen-kirche, for example, was the gift of Emperor Charles IV. The original such window in the Sebalduskirche had been given by King Wenceslas; the later one, by Emperor Maximilian (G. Frenzel, 1962). There may have been such an Emperor's window in the earlier choir of the Lorenzkirche. The new choir was begun in 1439 and completed in 1477. From the latter year, there is mention of the window in a reference to the one above it, ornamented with the coats of arms of the empire and of the city, which the council donated for the clerestory. This glass was placed "above the window of our most gracious sovereign, the Roman Emperor,

in the choir of St. Lorenz." However, this does not necessarily mean that the Emperor's window had actually been installed by that time. Another council memorandum from 1477 may well relate to the financing of the emperor's gift, for it authorizes one of the council members "to compile a listing of what is to be requested from the emperor." Thus, it may be possible that the council, itself, commissioned the window, hoping to be reimbursed by the emperor at a later date — possibly in the form of a reduction in the amount of taxes that Nuremberg owed to the empire. In the imperial city, which always remained loyal to the emperor, it was doubtless considered a sacred tradition that the central windows of the major churches should contain a portrait of the reigning monarch, with his coat of arms. These portraits were far more grandiose than the customary kneeling figures of donors that prevailed in the Middle Ages and they provide some idea of the importance to the city of such a visible imperial presence. The subject matter of the window should be viewed in much the same context, for the legend of the True Cross provided an opportunity to portray the pious exploits of the older Roman emperors Constantine, Heraclius, and Charlemagne.

As has long been recognized (Thode, 1891), the window was made in the workshop of Michael Wolgemut. More recently, it has been suggested that the letter sequence "AEIOU" next to the emblem of Emperor Frederick III may even represent Wolgemut's signature (U. Frenzel, 1970, p. 41, ill. 20). In any case, the composition, as a whole, and the construction of the heads show similarities with other works by Wolgemut. Scholars have pointed out the parallels between the depiction of the Battle of Regensburg and battle scenes in the *Schatzbehalter* and in the Schedel *Chronicle* (cat. nos. 86, 87).

An overall feature of the window is its heavy dependence on white glass and black paint; hatching and washes applied with the brush give it a distinctly graphic feeling. This is most apparent in the impressive figure of the armored Avar in the foreground brandishing his sword. Colored glass is used only sparingly: dark blue for the background on the right; light blue for portions of the armor of both Charlemagne's army and that of the heathens; and intense violet for the emperor's cloak, the background of the left-hand panel, the garment of the man in the distance, wearing a morion and wielding a short sword, and for the horse blanket in the foreground. RK

BIBLIOGRAPHY: (on the Emperor's window, as a whole): von Murr, 1778, p. 305, 1801, pp. 126–27, Hilpert, 1831, p. 28; Detzel, 1885, p. 33; Thode, 1891, p. 149; Oidt-mann, 1907, pp. 25, 31–32; Schinnerer, 1908, pp. 22–27, 1910, p. 158, n. 3; Schmitz, 1913, vol. 1, pp. 138–39, ill. 229; Gerstenberg, 1928, p. 43, ill. 109; Lutze, 1939, p. 58, text ill. 20; Wentzel, 1954, p. 76; G. Frenzel, *Instandset-zung,* 1968, pp. 3–16, ills. 10, 15; G. Frenzel, *St. Lorenz,* 1968, pp. 31, 39–42, ills. 21, 24–25, 27–30; G. Frenzel, 1969, pp. 75–85, ills. 105–106; U. Frenzel, 1969, p. 169, 1970, pp. 33–34, 36–41, ills. 10, 12–15, 17, 19, 20; Viebig, 1971, pp. 67–68, ill. 69; Fehring and Ress, 1977, pp. 90–91; Ulrich, 1979, pp. 14–65.

Cross, imbedded in the Imperial Cross — a gold reliquary richly studded with gems that dated back to the Ottonian period. In addition, there were other relics that had been collected by the emperors over the centuries and housed in priceless reliquaries — among them, a splinter from Christ's crib; a scrap of Saint John the Baptist's clothing; links from chains associated with the Apostles Peter, Paul, and John; fragments of the tablecloth and of Christ's napkin from the Last Supper.

The city of Nuremberg kept the imperial regalia in the Heilig-Geist-Kirche, the church of the Holy Ghost Hospital, which had no ecclesiastical administration but was solely under the supervision of the council. While the coronation robes and imperial insignia were stored in carefully sealed chests and cupboards in the vaulting above the sacristy, the city ordered that a special silver-covered chest be made to contain the relics. It was suspended from two chains high above the altar in the choir of the church, protected from above by a wooden canopy, the so-called "hat" (fig. 12). The "hat" was open on the bottom, so that the worshipers could see the paintings of angels holding the most important relics — namely, the Holy Lance and the fragment of the True Cross — on the bottom of the chest. Just why the council adopted separate methods for storing the parts of the treasure is not clear. Evidently, it did not wish to keep these sacred relics out of sight, but, rather, to

make them available to the faithful — albeit, well out of reach, and securely locked inside a chest — for veneration in the church. Of course, the entire treasure, including the robes and the insignia, was exhibited to the public in the main marketplace each year, on the second Friday after Easter (fig. 11). These public displays of the relics regularly attracted princes, prelates, and scores of common folk from all over the empire. The council enacted the strictest security measures. All who came to view the objects were granted major indulgences by the bishop of Bamberg and by Pope Martin V. This annual exhibition continued until the Reformation. In 1796, when Emperor Francis II decreed that the jewels be moved to Vienna in advance of troops from revolutionary France, the empty reliquary chest was all that was left behind.

According to the surviving entry in the account books, the cabinetmaker Hans Nürnberger constructed the casket-like chest, with its high saddleback roof, and floor of oak planks, from 1438 to 1440. The painting on the bottom was executed by a certain Lucas, and the goldsmiths' work was shared by Peter Ratzko and Hans Schesslitzer. The name of the brass founder who cast the moldings for the base and the corner crockets has not come down to us. The project was completed in April 1440. Its cost of nine hundred guilders was borne by the Heilig-Geist-Spital, offset, in part, through the sale of older jewels and, in part, through special con-

tributions for the purpose, from the Nuremberg citizenry and from pilgrims.

The reliquary chest, referred to in the Nuremberg documents as the "Sarch" ("Sarg" = coffin), is supported at the bottom by heavy brass moldings. The more slender edging at the corners and on the roof is of silver gilt. The chains by which the chest was suspended in the church were attached to the two large consoles on the ridge of the roof. A door on one of the long sides is secured by three locks. The interior is painted blue and studded with gilded tin stars. The exterior is completely covered with embossed silver coats of arms, secured by diagonal ornamental strips whose diamond shapes are inscribed with quatrefoils. Where the strips intersect there are sunbursts of gilded and embossed copper. Each of the silver panels was hammered with a piece of lead into a negative die carved like a seal from specially hardened iron or steel. The manufacture of such dies was one of the most important tasks of the medieval goldsmith. On the panels, the so-called lesser Nuremberg coat of arms alternates with the greater one. The latter, the traditional *Königskopfadler* (king's-headed eagle), is included here for the first time in the form of the *Jungfrauenadler*: The long-haired king, who had appeared on the seal since the thirteenth century, was now thought to be female. Accordingly, the eagle was provided with breasts. The lesser Nuremberg coat of arms, documented to the mid-fourteenth century, frequently is shown alongside the greater one — a special Nuremberg tradition not found in other cities. The fact that the city had the chest decorated with its own coats of arms and not those of the emperor reveals something of its self-confidence as the keeper of the imperial treasure. It also placed its coats of arms on the various leather cases of individual reliquaries that it had made or refurbished. The reliquary chest thus has the appearance of a municipal treasure chest.

Reliquary shrines often resembled caskets — especially when they were meant to contain either the entire body of a saint, or major portions of it. The present example follows this tradition — best represented in Nuremberg by the *Sebaldus Tomb*, of 1397 (see fig. 135), and the tomb of Saint Deocarus (now lost, but similar in form), of 1437, once in the Lorenzkirche (Kohlhaussen, 1968, no. 168, ill. 159). The Sebaldus shrine, the tomb of the city's patron saint, was also adorned with the municipal coats of arms — which is actually more remarkable than in the case of the reliquary shrine. The Deocarus shrine was decorated with images of Saints Deocarus and Lawrence in similar rhomboid panels. RK

47: detail

BIBLIOGRAPHY: von Murr, 1778, pp. 150, 281, 1790, pp. 80–81, ill., 1801, pp. 107, 318; Eye, 1861, cols. 437–40, ill.; Gümbel, 1911, p. 493, 1920–21, pp. 31–36, 1925, pp. 90–97; Schaffer, 1937, pp. 180–81; Fillitz, 1954, p. 29; Schnellbögel, 1962, p. 100; Kohlhaussen, 1968, pp. 83–84, 504, 507, no. 169, ills. 159–161, 1970, p. XXVIII, no. 19, ill. 19; Veit, in *Dürer*, Nuremberg, 1971, no. 248; Fritz, 1982, p. 234, no. 341, ill. 341.

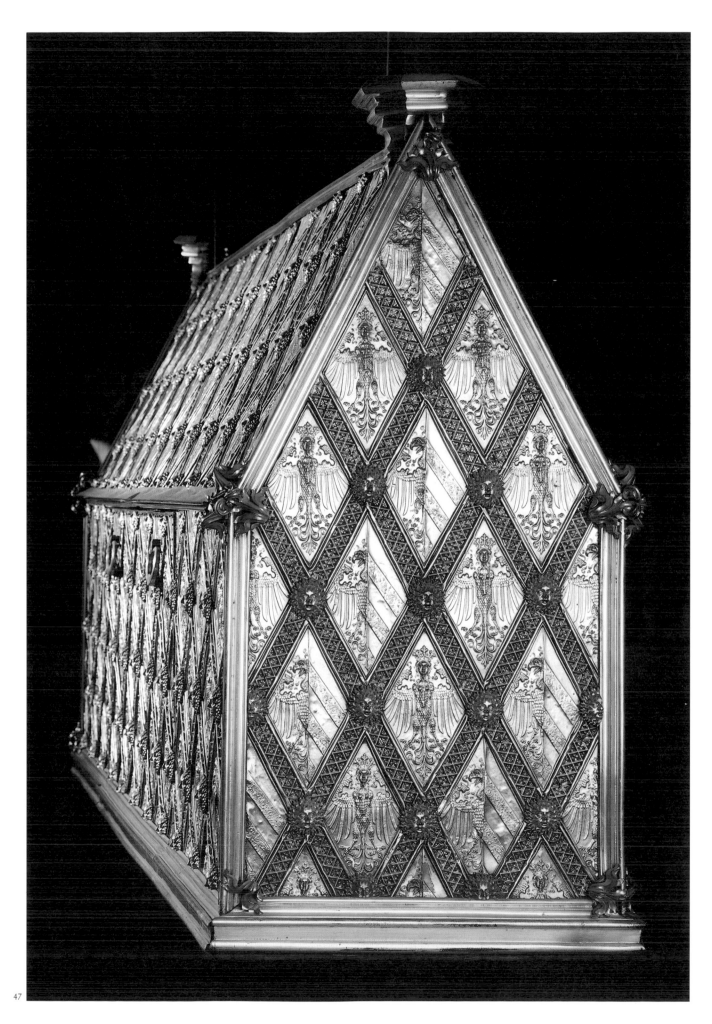

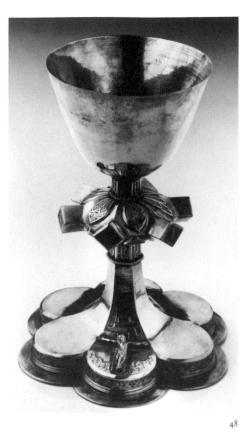

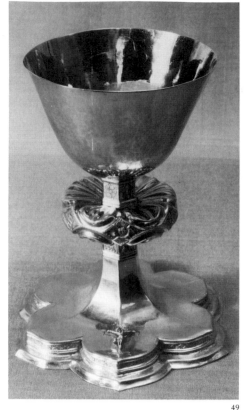

48

49

48 Chalice and Paten

Nuremberg(?), about 1450
Silver, embossed and gilded
Height, 8⁷/₈ in. (22.5 cm.); diameter of paten,
7⁹/₁₆ in. (19.2 cm.)
There are no markings.
Provenance: hospital church (founded by Sigmund
Wann), Wunsiedel, Upper Franconia.
Wunsiedel, Fichtelgebirgs-Museum

The sexfoil foot of the chalice is characterized
by a raised, pierced fillet with diamond shapes
in which quatrefoil openings are cut. The ex-
tremely flat knop with spiraling rosettes has six
lozenge-shaped vertical surfaces, two of which
are adorned with quatrefoils, and the remainder,
with the letters "inri" against a translucent,
blue-enamel ground. The six-sided collar above
the knop is engraved "maria hilf," and the one
below, "got hilf." A crucifix and a figure of
Saint Catherine are affixed to the foot. A large
head of Christ is engraved on the paten.

On the underside of the chalice is the mark of
Sigmund Wann, who was active as a leading
wholesale merchant and businessman in Wun-
siedel and Eger, and founded religious houses in
both cities. He also was the donor of the hospi-
tal in Wunsiedel, and died there in 1496.

This chalice is distinguished from other such
works by its high foot. Heinrich Kohlhaussen
identified its Nuremberg origins, even though it
bears no marks. It is also possible that it was
made in Bamberg, the center of the bishopric to
which Wunsiedel belonged. R K

BIBLIOGRAPHY: *Kunstdenkmäler Wunsiedel*, 1954, pp.
453–54, no. 3; Kohlhaussen, 1968, no. 267, ills. 302–304.

49 Chalice

Nuremberg, about 1480
Silver, embossed and gilded
Height, 6³/₄ in. (17.2 cm.)
The Nuremberg mark (Rosenberg, vol. 3,
no. 3687) appears on the base.
Erlangen-Bruck, Evgl. Luth. Pfarrkirche Sankt
Peter und Paul

The richly fashioned molding of the foot com-
prises a fillet engraved with a diamond pattern.
In contrast to the round lobes customarily
found among the decoration on Nuremberg
chalices, the foot of the present vessel has six
pointed lobes, and the motif is continued on the
hexagonal shaft. The flat knop, composed of
chased tracery forms, has six diamond-shaped
panels with a flower and the letters "ihs" (for
Jesus) in alternation. Engraved on the short,
hexagonal connecting piece above the shaft are
the letters "maria," and a rose, and, on the
corresponding element below, the letters
"ihsvs" appear, along with another flower. The
smooth cup of the chalice is funnel shaped — the
standard form for such vessels at the time. A
small cast crucifix is affixed to the foot. On the
underside of the foot is a coat of arms with a
bird's foot and the letters "ep" — a reference to
the Pessler family of Nuremberg, whose mem-
bers served on the city council, and, specifically,
to Erhard Pessler, who was a delegate to the
council in 1473, and was married to a Pirck-
heimer. He died in 1510. R K

BIBLIOGRAPHY: Kohlhaussen, 1968, no. 278, ill. 314.

50 Monstrance

Nuremberg, 1507
Silver, embossed, soldered, and engraved, with
gilded figures, some sections cast, and others
worked with tongs
Height, 32¹¹/₁₆ in. (83 cm.); width (at top), 7⁷/₈ in.
(20 cm.); diameter of base, 11⁷/₁₆ in. (29 cm.)
There is a Nuremberg mark (Rosenberg, vol. 3,
no. 3687), but no master's marks. The setting of
the ostensorium was restored in the 19th century.
Provenance: gift to the Pfarrkirche Mariae
Himmelfahrt, in Breitenbrunn, from the brothers
Albrecht, Alexander, and Martin von Wildenstein
(1507); deposited in Munich during the dispute be-
tween Bavaria and Pfalz-Neuburg over Breiten-
brunn's patronage rights (1593); returned to
Breitenbrunn through the intervention of Count
Johannes Tilly, then owner of the estate of
Breitenegg (1631).
Breitenbrunn (Oberpfalz), Kath. Pfarrkirche
Mariae Himmelfahrt

The six-part foot of the monstrance, which has
four round lobes and two, at the sides, with
pointed tips, is adorned with tracery and
foliage, as well as with engraved images of the
Virgin and Child, Saints Leonard and Sebastian,
and the name saints of the donors, Martin,
Alexander (inscribed s ALIX/SAN), and Albert
(inscribed s ALPR/ET). The escutcheon that Saint
Alexander holds beside him is engraved with the
date "1507 JAR." The three-quarter-length fig-
ures are all based on designs for full-length fig-
ures in the manner of drawings by Albrecht
Dürer in London (Winkler, 1936–39, nos.
722–723). The figure of Saint Sebastian follows
Dürer's engraving (Bartsch, no. 55), of 1497.

The hexagonal shaft has a flattened knop in
the center and capital-like moldings at the top
and bottom. Above the shaft, resting on an in-
verted pyramid, is the main section of the mon-
strance, which resembles an architectural
façade. At its center, surrounded by four tall
pillars, is the ostensorium, proper — originally
cylindrical, but now square. It is flanked by
small figures atop diminutive columns: the
mourning Virgin on one side, the Apostle John,
holding a girdle book (see cat. no. 83), on the
other. The pillars terminate in richly or-
namented finials, between which rise openwork
pinnacles of twisted silver wire. Directly above
the display glass is a similar but considerably
taller spire, inside of which is a tabernacle con-
taining a figure of the Man of Sorrows. At the
very top is a small, double-sided crucifix. Small
figures of Saints Sebastian and Christopher
stand on colonnettes that are attached to the
outer faces of the pillars. The figures are set
beneath decorative canopies, and the shaft and
the pillars are richly engraved with tracery. Sus-
pended from the base of the monstrance, itself,
is a frieze of cast grapevines — a traditional allu-
sion to the Eucharist — and, on either side, a
cruciform pendant.

In the Roman Catholic regions of Germany, a
relatively large number of Late Gothic mon-
strances have survived. They generally consist
of a high foot, which serves as a convenient grip

50: detail

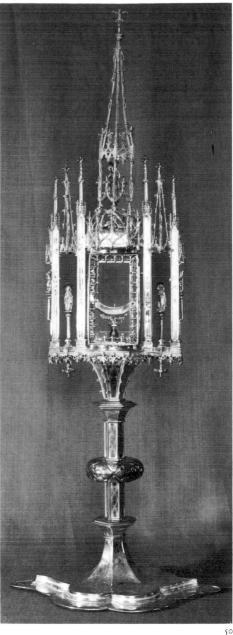

50

for the vessel, making it possible to carry it in processions, and a richly articulated architectural superstructure, in the center of which is the ostensorium in which the consecrated Host is displayed. Some twenty such monstrances made in Nuremberg have survived. Since the city itself, and much of the surrounding territory, became Protestant in 1525, thereby rendering such objects obsolete, most monstrances were melted down for their silver. The form of the Breiten-

brunn monstrance, with its carefully articulated base, ostensorium, figures, and retable-like architectural façade, is characteristic of numerous Nuremberg and Franconian works. The monstrance that most closely resembles the present one was made in Nuremberg in 1506 for Feldkirchen, in Austria's Vorarlberg (Kohlhaussen, 1968, no. 320, ills. 355–357; Fritz, 1982, ill. 788). The Breitenbrunn monstrance is among the most splendid and best preserved of the sur-

viving Nuremberg examples. Most of them have been considerably altered, many in the Baroque period, especially. In the present one, too, the ostensorium is not original: It was considerably embellished in the seventeenth or eighteenth century — possibly on the occasion of its return to Breitenbrunn in 1631 — and then in the late nineteenth century these additions may have been removed in an attempt to restore the work to its Gothic form. RK

BIBLIOGRAPHY: Kaiser, 1893, pp. 12, 21; *Kunstdenkmäler Parsberg*, 1906, p. 45 (with additional bibliography), ills. 19–20; Rosenberg, 1925, vol. 3, no. 3707; *Kirchliche Kunstschätze*, 1930, no. 113, ill. 30; *Eucharistia*, 1960, no. 187; Fritz, 1966, pp. 178, 183, no. 101, ill. 160; Kohlhaussen, 1968, no. 323, pls. 361–365; Suckale, in *Bayern*, 1972, no. 294; Fritz, 1982, p. 295, no. 789, ill.

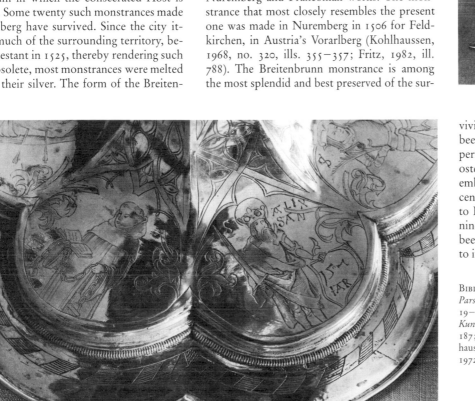

50: detail of foot

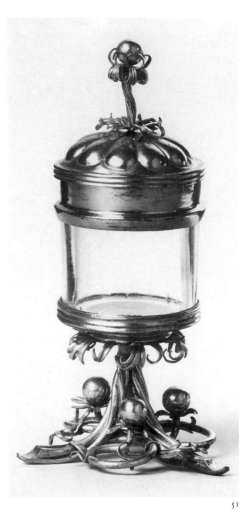

51

51 Reliquary

Nuremberg, about 1500
Copper, embossed, turned, and gilded, with a glass cylinder
Height, 7¹/₄ in. (18.5 cm.); diameter of cylinder, 2³/₈ in. (6 cm.)
The relics are missing. There are no markings.
Nuremberg, Germanisches Nationalmuseum (acquired by 1868)
KG 193

Neither the form nor the ornamentation of the relatively small, simple reliquary indicates what kind of relic it was designed to preserve. The reliquary consists of a cylindrical glass container, a foot in the form of twisted branches, and a lid that is also crowned with a small branch bearing a fruit. The three strong, twisted branches that curve down from a circle of curling leaves support the vessel. The base is made up of similar twisted tendrils that arch upward slightly in three places, terminating in fruits borne by small leaves. The curved lid has a circle of identical bosses surrounding a ring of curling leaves, from the center of which rises a slightly swaying branch supporting another spherical fruit above a wreath of leaves.

The faded, gilded coat of arms of the patrician Oelhafen family of Nuremberg is on the bottom of the glass vessel. The reliquary thus may be associated with Sixtus 1 von Oelhafen (died 1539), who lived in Nuremberg from 1499 on,

acquired citizenship in 1514, and served as first secretary and privy councillor to emperors Frederick III, Maximilian I, and Charles V. It was not uncommon for reliquaries to be privately owned in the fifteenth century.

Nuremberg goldsmiths' work of the time frequently is characterized by feet made up of vegetable forms like that of the present object — not necessarily a motif only associated with the workshop of Ludwig Krug. Heinrich Kohlhaussen called attention to reliquaries with similar feet, comprising an openwork design of branches and foliage, in the Halle treasure of Cardinal Albrecht von Brandenburg (Halm and Berliner, 1931, especially pls. 22 b, 23 c), which he therefore attributes to Nuremberg. Such feet also figure in Dürer's designs for goldsmiths' work. RK

EX COLLECTION: Sixtus 1 von Oelhafen (first in Nuremberg 1499; died 1539).

BIBLIOGRAPHY: Essenwein, *Reliquiare*, 1868, col. 352, ill. 7; Kohlhaussen, 1968, no. 327, ill. 373; Pechstein, in *Wenzel Jamnitzer...*, 1985, p. 230, no. 236, ill.

52 Saint Bartholomew

Nuremberg, 1509
Silver, the parts separately cast, soldered, and chased; the base cut and chased, soldered and engraved; with some gilding
Height, 17³/₄ in. (45 cm.)
On the flange surrounding the base is the mark of the city of Nuremberg, a reversed "N" (Rosenberg, vol. 3, no. 3687); there are no master's marks.
Nuremberg, Germanisches Nationalmuseum (on permanent loan from the Evgl. Luth. Pfarrkirche Sankt Bartholomäus, in Nuremberg-Wöhrd, since 1932)
Pl 0.2452

The compact figure of the apostle stands rather unsteadily on its high base. The right leg is free: The bent knee is visible under the robe, and the right foot is placed well to the side, where it emerges from beneath the folds of the saint's robe. The left hip is thrust outward, and the torso is inclined forward to balance it. The torso is short, and the shoulders slope pronouncedly. The head is framed by the dense curls of the hair and beard. There is virtually no neck. The limbs almost disappear in the fullness of the drapery. A cloak covers the figure's back and shoulders, over the long robe; its right edge circles the saint's right forearm and is then pulled across to the left side, producing a kind of apron, with two V-shaped folds and auxiliary vertical ones. The left arm, pressed close to the body, holds up this section of the cloak, so that its hem cuts diagonally across the figure at knee level. In his left hand, Saint Bartholomew carries a gospel book, which identifies him as an apostle; in his right hand, he holds the instrument of his martyrdom, a large knife. An aureole of pierced and gilded sheet silver is attached to the back of

his head, its outer edge displaying his name, S. BARTHOLOMEVS, between two rows of beaded wire.

The hexagonal base, with moldings at both the top and the bottom, is separately worked. At one time, it contained some relics (now lost), which could be viewed through a small piece of glass; they could be removed through a small door in the base (shown in Kohlhaussen, 1968, ill. 427). An inscription on the bottom tells of the making of the figure, the names of the representatives of the congregation responsible for commissioning it, and the date of its completion — but not the name of the goldsmith: "disser heilig ist gemacht 1509 jar was Lvdwig Schnod Kirchenpfleger vnd Richter Lorens Munch vnd Wilhelm Lengenfelder Kirchen vnd Gemein Meister" ("This saint was made in the year 1509 [at which time] Ludwig Schnöd was overseer and judge, Lorens Munch and Wilhelm Lengenfelder church and congregation warden"). In Nuremberg records from 1499 to 1521, there is frequent mention of Ludwig Schnöd, the judge and church official responsible for the suburb of Wöhrd. He was a man of considerable wealth. In 1778, von Murr noted that Schnöd commissioned the statue of Bartholomew, but, from the wording of the inscription, it seems more likely that it was a commission from the congregation of Sankt Bartholomäus, which then managed to preserve the silver image of its patron saint for centuries, despite the repeated destruction of its church.

Contrary to all contemporary practice, the figure is not embossed but cast, which also explains its excessive weight of 2.185 kilograms. The head, chest, front, back, and hands were made separately and then soldered together, the hands riveted on with pins. The softness of the drapery, especially along the hem of the robe, suggests that these parts, at least, were modeled directly in wax, and that a wooden model was not made for them, as was usually the case in Nuremberg. The soldering joints were carefully smoothed over, and the head given its present form by means of chasing. The hem of the cloak and the design on the book were engraved, and the hair, hem, book, and knife handle were gilded. The moldings of the base are embossed, its side panels cut from sheet silver and engraved. All the parts were then soldered together, and the characteristic twig-like edging was gilded.

Since Hampe (1928–29), the statuette has been attributed to the goldsmith Paulus Müllner, who became a master in 1502 and continued to be mentioned in Nuremberg documents until 1536. Beginning in 1501, he was repeatedly asked to produce works for the elector Frederick the Wise of Saxony (r. 1486–1525) — among them, statuettes. However, it is impossible to formulate any idea of Müllner's style, either from what we may learn of these figures from the Wittenberg reliquary book, of 1509; the woodcuts of Lucas Cranach the Elder; or the illustrations in a manuscript in Weimar. Although there are better and more reliable illustrations of the apostle statuettes in

the Halle treasury of Cardinal Albrecht von Brandenburg — Kohlhaussen attributed the figures to Müllner in 1968 — in 1976, Jörg Rasmussen demonstrated that they were more likely from another workshop, or, indeed, by various different ones. The statuettes of Saints Peter and Bartholomew, preserved in Bautzen (last shown in *Reformationszeit,* 1983, no. B 29–30, ill.), are definitely not the work of the sculptor of the model and of the goldsmith who made the Nuremberg *Bartholomew,* but may derive from the tradition in Saxony for such figures.

Scholarly discussion has also focused on a second argument. In 1517–18, Müllner was asked by the cathedral chapter in Würzburg to make a bust of Saint Kilian, after a model by Tilman Riemenschneider that he criticized for being "too child-like." While there is, unquestionably, a Riemenschneider quality to the head of the Nuremberg *Saint Bartholomew,* and the head of the figure bears an especially close resemblance to that of Emperor Henry II on the tomb monument in Bamberg Cathedral, the body and the drapery have nothing of Riemenschneider's style about them. The similarity is not enough to confirm the attribution to Müllner. Other goldsmiths also must have worked from Riemenschneider models, just as Müllner probably collaborated with other sculptors, especially those from Nuremberg, on his figural works. The fact that, almost ten years later, Müllner happened to use a Riemenschneider design — and one that he disapproved of, at that — reveals nothing about the maker of the present sculpture. We know of no single authenticated work by Müllner, who was also active as a dealer and agent for works by other masters. There were a great number of goldsmiths in Nuremberg, any one of whom could just as well have made the Wöhrd statuette.

RK

BIBLIOGRAPHY: von Murr, 1778, pp. 334–36, 1801, pp. 157–59; Bergau, 1886–87, pp. 17–19; Schulz, in *Historische Ausstellung,* 1906, no. 136, ill. p. 401; Montague-Peartree, 1906, pp. 112–13, pl. II; Redslob, 1922, p. 36, pl. 29 a; Rosenberg, 1922–28, vol. 3, p. 23, pl. 72; *Neuerwerbungen GNM,* 1925, pls. 57–58; Hampe, 1928–29, pp. 75–122, ills. 1–3; Schwemmer, 1933, p. 69, 1956, pl. 5; Kohlhaussen, 1968, pp. 282–83, no. 341, ills. 424–427; Rasmussen, 1976, pp. 80–85, ill. 21; Fritz, 1982, pp. 295–96, no. 795, ill. 795, p. 343, no. 73; Lüdke, 1983, vol. 1, pp. 78, 131, ill. 329, vol. 2, no. 72; Pechstein, in *Wenzel Jamnitzer . . . ,* 1985, pp. 210, 211, no. 3, ill.

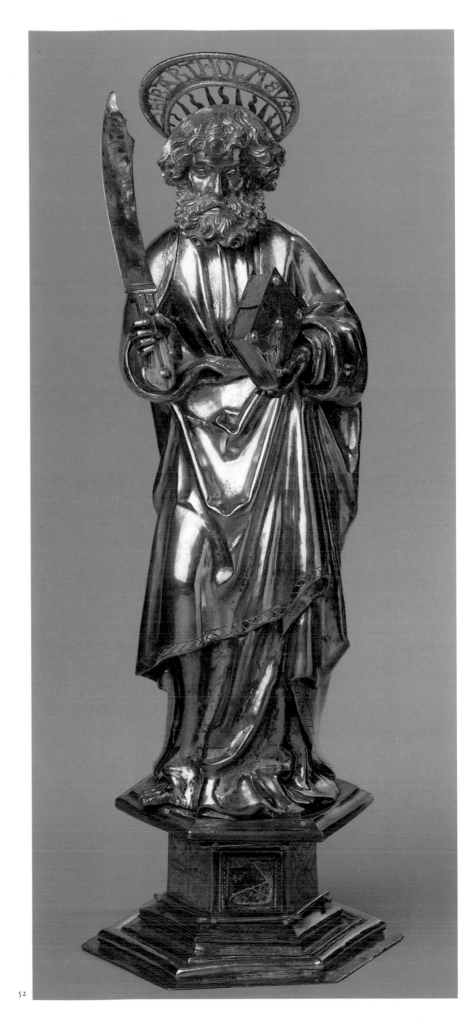

52

53 JAKOB ELSNER (paintings and
illuminations, 1507, 1510)
FRIEDRICH ROSENDORN (script, 1507, 1510)
ADLER WORKSHOP (pigskin covers for both
volumes, about 1510)

Gradual (in Latin)

Probably Nuremberg, possibly Workshop of Peter
Vischer the Elder (brass mounts, about 1510)
Volume I, 1507: 299 parchment leaves,
25 3/4 x 17 1/2 in. (65.4 x 44.5 cm.)
Volume II, 1510: 261 parchment leaves,
25 3/4 x 17 1/4 in. (65.4 x 43.8 cm.)
Provenance: Sacristy, Lorenzkirche, Nuremberg.
New York, The Pierpont Morgan Library, Gift of
The Samuel H. Kress Foundation, 1962
M 905

This mammoth two-volume Gradual contains
the liturgical chants of the Catholic Mass for the
feast days of the entire year. The most impor-
tant feasts have historiated initials and elabo-
rately decorated borders. In the first volume are
eleven large historiated initials, eight illumi-
nated initials without figures, nineteen pages
with decorated borders, and eleven scenes in the
lower margins (bas de page). Volume II has
seven large historiated initials, eleven illumi-
nated initials without figures, eighteen deco-
rated borders, and eleven bas-de-page scenes.
The Gradual has been called the "Geese Book"
after one of the marginal illustrations (I, fol.
186 r.).

Each volume bears an inscription on the back
of the flyleaf that mentions Anton Kress, pro-
vost of the Lorenzkirche; Vicar Friedrich
Rosendorn, the scribe who was responsible for
the texts and musical notation; and Andreas
de Watt, the master of the church fabric. The
date when each volume was completed is also
noted — 1507 and 1510. The name of Prefect
Hieronymus Schürstab is given in the earlier
colophon; the name of Jacob Groland appears
in the second. The illuminator, painter, and
decorator is not recorded. These volumes were
commissioned for use in the services of the
Lorenzkirche.

The life of the donor, Dr. Anton Kress
(1478–1513), is known from a book published
by Friedrich Peypus in Nuremberg (Christoph
Scheurl, *Vita Anthonii Kressen*, July 24, 1515).
The son of Anton the Elder and Katherine
Löffelholz, the young Anton Kress studied ca-
nonical and Roman law with Dr. Sixtus Tucher
in Ingolstadt. He continued his education over
the next seven years at the universities of Padua,
Pavia, and Siena. He was ordained a priest in
Rome. He wrote numerous letters, not only to
his relatives but also to his friends who shared
his Humanist interests — among them,
Willibald Pirckheimer, the Humanist and col-
lector, and Dürer's friend, and Christoph
Scheurl, a prominent lawyer and author of
Kress's biography. His former teacher, Dr.
Tucher, for a time provost of the Lorenzkirche,
arranged for Anton's appointment to succeed
him as provost in 1504, at the age of twenty-six.
Anton Kress became, in time, a patron (*Mäzen*)
of his church, as exemplified by this *Gradual*,
and by the *Missal* (cat. no. 54).

Sweeping asymmetrical and foliated rinceaux
dominate the margins of the key liturgical pages
in the *Gradual's* first volume, of 1507. The same
pages also bear foliated initials with gilt sur-
rounds, either historiated or without figures.
Animal and/or figurative themes appear in
some of the margins, particularly the lower
ones. The various subjects and decorations on
these pages may be summarized as follows:

fol. 1 r.: Salvator Mundi in an initial *A*. In the
lower margin is a man wrestling with a
bear.

fol. 22 r.: The Nativity in an initial *P*. The lower
margin includes a fox stalking a brown
rooster as a black hen looks on.

fol. 38 v.: The Adoration of the Magi in an initial *E*.
The lower margin shows an owl with
wings spread, holding a small bird in his
beak.

fol. 47 r.: Illuminated initial *C*.

fol. 121 r.: Christ's Entry into Jerusalem in an initial
D. The lower margin includes a peacock.

fol. 156 r.: The Resurrection in an initial *R*. The
lower margin includes a duck in flight and
a quail.

fol. 176 r.: Illuminated initial *F*. In the lower and
right margins are four angels holding
instruments of the Passion.

fol. 186 r.: The Ascension of Christ in an initial *V*.
The lower margin includes a wolf, dressed
as a cantor, instructing seven geese in read-
ing music while a fox looks on.

fol. 194 r.: Pentecost in an initial *S*. The lower margin
contains a heron with a snake.

fol. 205 r.: The Trinity (Throne of Grace) in an initial
B. In the lower margin a wild man aims his
drawn bow and arrow at a reclining stag
(see Raspe, 1905, pl. IV).

fol. 209 r.: Two angels hold a monstrance in an initial
C. An inscription above the monstrance
reads: ECCE PANIS ANGELORV[M]. The
lower and right margins show four music-
making half-length angels with two lutes,
a portative organ, and a harp.

fol. 243 v.: Probably the Lorenzkirche is shown in an
initial *T*. The lower margin includes three
men seated and drinking at a table (see
Stange, 1958, fig. 182; Grote, 1959, fig. 1).

fol. 249 v.: Bust of Death in an initial *R*.

Illuminated initials without figures appear on
folios 15 v., 17 v., 47 r., 176 r., 216 r., 257 r., 275
r., and 287 r.

The sweeping asymmetrical and foliated rin-
ceaux in the margins of the second volume, of
1510, are occasionally augmented by symmetri-
cal decorations that do not appear in the first
volume. As in the earlier volume, these pages
also bear foliated initials with gilt surrounds,
either historiated or without figures. Again, ani-
mal and/or figurative subjects enliven some of
the margins. The decoration is as follows:

fol. 1 r.: Saint Peter's Miraculous Draft of Fishes in
an initial *d*. In the lower margin is a dog
pursuing a rabbit.

fol. 8 r.: Illuminated initial. The lower margin in-
cludes the Meeting of Joachim and Anna
with the Annunciation, framed by a circle
of twigs.

fol. 21 v.: The Presentation of Christ in the Temple
in an initial *S*. The lower margin shows a
seated monkey.

fol. 31 v.: The Annunciation in an initial *R*.
I NOMINE DOMINI is inscribed on the
canopy. The lower margin includes a dog
growling at a cat.

fol. 49 r.: Illuminated initial *G*. The left margin has a
symmetrical stem and flowers; the lower
margin, a classical laurel wreath enclosing
the Visitation.

fol. 88 r.: Saint Lawrence with two angels in an ini-
tial *C*. Inscribed on the curtain held by the
angels is: SANCTI LAURENCI ORA PRO
NOBIS. The right margin is a symmetrical
foliated trellis. The lower margin includes
a bear playing a viol and a boar reading a
sheet of music (see Raspe, 1905, pl. VIII;
Adams, Jr., 1963, frontispiece).

fol. 91 r.: The Coronation of the Virgin and the
Trinity (in two persons and a dove) in an
initial *G*. The lower margin contains a
seated monkey, with a red scarf, playing
bagpipes.

fol. 103 r.: Illuminated initial *N*. The lower margin
includes a lozenge-shaped laurel frame,
enclosing the Birth of the Virgin (see
Raspe, 1905, p. 62).

fol. 122 r.: Illuminated initial *G*. In the lower margin
is a wild woman wielding a club and pul-
ling the tail of a dragon holding a child in
its mouth (see Grote, 1959, fig. 4).

fol. 145 r.: Christ Commissioning the Apostles
in an initial *E* and the inscription PAX
VOBIS[CVM]. The lower margin includes a
man, hidden in a house made of boughs,
using a trap to ensnare birds, and an owl
sitting on a stump.

fol. 205 r.: The Virgin and the Christ Child on a half
moon in an initial *S*. The right margin
shows a symmetrical column fountain
with birds. The lower margin includes a
birdcage containing chicks, and a hawk
looking on from outside (see Bruck,
1903 a, fig. 4; Grote, 1959, fig. 3).

Illuminated initials without figures appear on
folios 8 r., 34 r., 49 r., 103 r., 122 r., 146 v., 166 v.,
177 r., 187 r., 230 v., and 244 r.

The biblical subjects in both volumes con-
tinue the iconography that prevailed through-
out previous centuries. Two forms of the Trini-
ty are shown — the Cruciform Trinity, or
Throne of Grace, in the 1507 volume (fol. 205
r.), and the Trinity as two persons and a dove, in
the Coronation of the Virgin scene in the 1510
volume (fol. 91 r.). It is probably the Lorenz-
kirche that is depicted in the first volume (fol.
243 v.). The 1510 volume (fol. 88 r.) shows
Lawrence, the patron saint of the church for
which this Gradual was commissioned, in the
initial C of *Confessio*.

The marginal subjects may be divided into
several categories: There are biblical themes,
such as the Meeting of Joachim and Anna (II,
fol. 8 r.), the Visitation (II, fol. 49 r.), and the
Birth of the Virgin (II, fol. 103 r.). The angelic
realm appears twice (I, fols. 176 r., 209 r.).
Simple humanity is represented in the rustic
scene with three drinkers (I, fol. 243 v.). Wild
folk strike active poses in two places (I, fol. 205
r., and II, fol. 122 r.). Animal life and animal

53: Vol. 1,
front cover

mimicry of human activity, especially music making, figure in several of the other decorated margins. Some of these may simply be reflections of contemporary life and humor. The geese choir has been interpreted as a reference to fables (Bredt, 1902–3, p. 482; Raspe, 1905, p. 50). Subjects of this type appeared in earlier Netherlandish art — as on the early-fifteenth-century enameled spoon in Boston (T. B. Husband and J. Hayward, 1975, no. 270; for the fable tradition, see also F. Klingender, *Animals in Art and Thought to the End of the Middle Ages,* Cambridge, Massachusetts, 1971, pp. 366–68).

In general, the style of the decoration is Late Gothic. Yet, despite the stylistic homogeneity that pervades both volumes, certain discreet differences can be seen when the various categories of decoration are examined in each. The sweeping asymmetrical foliate rinceaux may have evolved from late-fifteenth-century Middle Rhenish, as well as Bavarian, manuscripts (A. Boeckler, *Deutsche Buchmalerei der Gotik,* Königstein im Taunus, 1959, figs. 59, 66). Although these rinceaux are the dominant marginal decoration in both volumes, the 1510 book introduces certain exceptions: trellis work, and symmetrical flowery stems. Most startling in this second volume is the column fountain (fol. 205 *r.*), which combines Northern berry clusters with an Italian Renaissance fluted basin. The classical laurel wreath, which frames the Visitation scene (fol. 49 *r.*), is also an Italian Renaissance motif. The especially lush quality and the colorfulness of some of the initials in the 1510 volume are new developments.

The figure style in both volumes is based on the Late Gothic naturalism of fifteenth-century Netherlandish manuscripts. Contrary to some opinions in the literature, there is no demonstrable dependence on the art of Dürer in the present manuscript. The image in the first historiated initial of the 1507 volume, the Salvator Mundi, ultimately derives from a composition by Jan van Eyck that may have been conveyed

through Ghent manuscripts (P. M. de Winter, "A Book of Hours of Queen Isabel la Católica," *The Bulletin of The Cleveland Museum of Art,* December 1981, vol. 67, figs. 19, 20, colorpl. III). The style of the figures representing the Trinity that appear with the Coronation of the Virgin in the 1510 volume (fol. 91 *r.*) also depends upon that of Ghent manuscripts (P. M. de Winter, 1981, 67, fig. 22). The dramatic movement of the wild man seen from the back (I, fol. 205 *r.*), and of the wild woman (II, fol. 122 *r.*) may derive from the dynamic figures invented by Hugo van der Goes, as reflected in Ghent manuscripts, as well (P. M. de Winter, 1981, 67, figs. 84, 101, 103). While the evolution of the figure style in the *Gradual* is subtle, certain miniatures in the 1510 volume are especially rich in color modulations, in the suggestion of actual textures, and in the breadth of the compositions (fols. 88 *r.*, 91 *r.*).

Landscape settings accompany five of the figure groups in historiated initials in the 1507 volume: Three of these have traditional gold skies (fols. 38 *v.,* 121 *r.,* 194 *r.*), and two have more natural skies — one is shaded from yellow and pink up to blue (fol. 156 *r.*), and the other is blue with small white clouds (fol. 186 *r.*). The 1510 volume has two deep landscapes; one provides the setting for the Miraculous Draft of Fishes (fol. 1 *r.*) and the other is the background of the margin miniature of the Visitation (fol. 34 *r.*). The only traditional gold sky in this volume occurs in the scene with Christ's Commission to the Apostles (fol. 145 *r.*). The bluing of the elements in the distance, and the treatment of other landscape details derive from Ghent manuscripts of the fifteenth century, such as the *Hours of Engelbert of Nassau,* of about 1476, in the Bodleian Library, Oxford (Douce Ms. 219–220; J. J. G. Alexander, *The Master of Mary of Burgundy, a Book of Hours for Engelbert of Nassau,* New York, 1970, nos. 32, 34, 35, 65, 73, 75, 80).

The naturalistic details of the birds and animals in the Nuremberg *Gradual,* and their occa-

sional mimicry of human activity, are sustained with visual piquancy throughout the decorated pages of both volumes. The effect is especially similar to that created by the animals sprinkled in the margins of many pages of the above-mentioned Nassau Hours. Such comparisons suggest, again, that the Ghent school of manuscript painting exerted a major influence on the illuminator-painter of the Nuremberg *Gradual.*

A Nuremberg connection with Ghent manuscripts may reside in the imperial patronage and ownership of such manuscripts, and in the impact of imperial taste on Nuremberg artists. Both the *Older Prayer Book of Maximilian I,* a Ghent manuscript, of about 1486, now in the Österreichische Nationalbibliothek, Vienna (Cod. Vindob. 1907), and the Nassau Hours, of ten years earlier, have connections with Maximilian. Engelbert of Nassau was made Lieutenant of the Realm in 1487 by Maximilian. The second owner of his Hours was Philip the Fair, the son of Maximilian I and of Mary of Burgundy. Never crowned emperor by the pope, Maximilian assumed the title of emperor-elect in 1508. Nuremberg was a free imperial city and the custodian of the imperial relics and regalia. Maximilian was often in residence, and was a patron of art and artists — especially, of Dürer. Maximilian's taste for the deluxe books of hours painted by Ghent artists must have been nurtured through his first marriage to Mary of Burgundy, the daughter of the last duke of Burgundy.

In 1854, Ralf von Rettberg attributed (for the first time) all of the paintings in the *Gradual* to Jakob Elsner. Elsner had signed the *Missal,* of 1513 (cat. no. 54) — also commissioned by Provost Anton Kress. The attribution was based on the stylistic similarities shared by both manuscripts. The style of the *Gradual,* in fact, is continued and developed in the later commission.

Neudörfer tells us something of Elsner's interests and activities. He could play the lute, and he painted portraits of the organ players Sebastian Imhoff, Wilhelm Haller, Lorenz Staiber,

53: Vol. II, fol. 145 *r.,* detail

able for their symmetrical intersecting curves, cusped ogees, and outer points of symmetrical flowers bound by molded and beaded crossbands. Except for those on the lower cover of volume II, these brasses are mounted over pieces of blue leather cut to conform to the outlines of each brass. The four foliated clasps and two of the backplates are original. (The backplates on volume II have been replaced.)

The pigskin covers of both volumes may be attributed to the prolific yet anonymous Adler Workshop, active in Nuremberg from 1477 to 1514 (E. Kyriss, *Verzierte gotische Einbände im alten deutschen Sprachgebiet*, Stuttgart, 1951–58, 4 vols., 2nd pl. vol., 1956, p. 21, no. 112). This secular shop, the largest of several active at the time in Nuremberg, used seventy-seven single stamps, three rolls, and six plates. The name assigned to the shop by Kyriss derives from a stamp with an *Adler* enclosed in a rhombus that appears on fifty-eight bindings, including the covers of the present work.

The brass mounts, with their openwork designs, may be a product of the most famous brass-founding workshop of the day, that of Peter Vischer the Elder. The ogee arch, foliate cusps, and flower finial of the Throne of Grace in the Trinity scene (I, fol. 205 *r.*) are closely related in style to the clasps on the covers. This raises the possibility that Jakob Elsner could have made the designs for the brass mounts, which were then executed in the Vischer workshop. WDW

BIBLIOGRAPHY: von Rettberg, 1854, pp. 144, 145; Lochner, 1875, pp. 139, 140; von der Gabelentz, 1899, 15, p. 40; Bredt, 1902–3, 6, 2, p. 482; Bruck, 1903 a, 24, pp. 307–11, figs. 3, 4, 1903 b, pp. 189–92; Raspe, 1905, 60, pp. 48–63, text ill. p. 62, pls. IV, VIII; Hampe, in Thieme-Becker, 1914, vol. 10, p. 489; Stange, 1950, vol. IX, p. 83, fig. 182; Grote, 1959, pp. 155–59, figs. 1–5; Adams, Jr., 1963, pp. 14–17, 2 ills.; Plummer, 1964, pp. 22, 23, no. 22; von Tavel, 1965, ser. 16, pp. 57, 64, 68, 69, figs. 10, 11; Voelkle, 1974, vol. I, no. 48, ill., fol. 88 (det.); . . . *Dorothy Miner Memorial*, 1974, vol. II, no. 30, ill., fol. 36 (det.); Voelkle, ed., 1980, pp. 59, 60; Husband, 1980, pp. 110, 112, fig. 66.

53: Vol. II, fol. 88 *r.*, detail

and of some of their companions. He also painted miniatures in their books, and he painted their coats of arms for their letters of heraldry.

The pigskin bindings of the *Gradual* are decorated with blind-tooled designs that, on the front cover, include a tapestry-trellis pattern and a repeated stamp with an *Adler* (eagle). Brasses with projecting eight-sided bosses protect and decorate the center and the corners of each cover. The openwork designs of these brasses, each centered on a quatrelobe, are not-

53: Vol. II, fol. 122 *r.*, detail

191

54 Kress Missal: Covers, Box, and Bookmark

Binding: red velvet — probably replaced — over wooden boards; fittings and clasps: silver gilt, cast and tooled, the flat fittings engraved with tracery forms.
Diameter of medallions with the symbols of the Evangelists, $1^7/8$ in. (4.7 cm.); Agnus Dei, 2 in. (5 cm.); coat of arms, $2^1/4$ in. (5.8 cm.)
Box: wood, covered on the outside with tooled and engraved black leather, and on the inside with red leather and red suede; hinge bands and clasps: brass. The present plain brass corner fittings are probably not original.
$4^3/4$ x $16^1/8$ x $11^{13}/16$ in. (12 x 41 x 30 cm.)
Bookmark: six silk ribbons, two green, two light brown, two beige (probably originally white). The top bar and the six acorn-shaped ends are embroidered with tiny seed pearls.
Width of bar, $1^9/16$ in. (4 cm.); length of bookmark, $20^7/8$ in. (53 cm.)
Provenance: Provost Dr. Anton Kress, Lorenzkirche, Nuremberg.
Nuremberg, Germanisches Nationalmuseum (on permanent loan from Freiherrn von Kress zu Kressenstein and the Kress'sche Vorschickung since 1911)
Hs 113264 (manuscript), HG 7590 (book box), HG 7591 (bookmark)

Dated August 28, 1513, the last testament of Dr. Anton Kress (1478–1513), provost (from 1503) of the Lorenzkirche, in Nuremberg, contains information about the Missal's exterior decoration: "Item ich will auch, das mein pergamenes messpuch, das [ich] hab schreiben lassen, soll bei sant Laurentzenkirchen pleiben, dazu schick ich fünfzik gulden, das man es damit beschlachen lassen soll" ("Item, I also desire that my parchment Missal, which I had made, should remain in the Lorenzkirche. To that end I leave fifty guilders for the purpose of having it bound"). Kress died on September 7, 1513. The manuscript, apparently completed in his lifetime, may have been made for his own use — after all, he was only thirty-five at his death. The sum of fifty guilders seems extraordinarily high for an ornamented binding. Christoph Scheurl, author of a biography of his friend Kress, valued the entire manuscript, which he greatly admired, at one hundred guilders (Kress, 1892, p. 216). The executors of the will, Provost Hieronymus Ebner, Hans Imhoff, and the deceased's brother, Christoph Kress, commissioned the binding. The Kress coat of arms on the back of the manuscript includes the date 1513, suggesting that the binding, itself, was completed before the year's end, while the box bears the date 1514.

The front of the binding is adorned with the symbols of the Evangelists and the Agnus Dei, in cast silver, each encircled by beaded wire. Four large bosses in the corners protected the other decorations when the book was opened. The corner fittings and edging strips are covered with intricate, engraved architectural forms. On the back are identical bosses and edging strips, as well as the Kress coat of arms in the center — an escutcheon charged with a diagonal sword.

Like the medallions on the front, the coat of arms is also pierced and encircled with beaded wire. The silver clasps, too, are ornamented with engraved tracery forms.

Because similar symbols of the Evangelists appear as binding ornaments on two manuscripts dating from 1507, from the collection of the elector Frederick the Wise (and now in the Universitätsbibliothek, Jena, Ms. El f 1, f 2) — their miniatures also attributed to Jakob Elsner — and because it is documented that, on several occasions, Paulus Müllner worked for Frederick the Wise, the ornaments on the Kress *Missal* have also been attributed to this Nuremberg goldsmith. Bruck first proposed the connection in 1903. Yet, the similarity is not so great as to imply that the models were made by the identical carver. Nor was the carver necessarily the same goldsmith who made the casts. Meanwhile, regarding the statuettes of Paulus Müllner (see cat. no. 52), an idea of that artist's style is impossible, as no works of his have survived. The impressive three dimensionality of the emblems' animal forms, and their exquisite tooling, unquestionably betray the hand of a skilled Nuremberg goldsmith; in the quality of their inventiveness, they are superior to the medallions on the Jena manuscripts.

To protect the manuscript and its valuable fittings — silver ones were rare; most were of brass — the executors of the will also had a box made for the *Missal*. Such boxes were usually substitutes for more solid bindings, in cases when a manuscript was covered only in a soft leather; perhaps they were once more common, as well, as protectors for more valuable bindings. The top and sides of the box contain large, incised tendrils, the leather of their leaves pierced and slightly raised by means of embossing, which involved heating the wet leather — a common Late Gothic technique. The underside of the box is smooth. In the center, at the top, is the Kress coat of arms, below the date, 1514. Comparable tendril designs are found on tooled bookbindings of the period, from Nuremberg, but even more frequently on small boxes and cases — as, for example, on the case made, in 1503, for the *Schlüsselfelder Ship* (cat. no. 81). The shapes of the ends of the brass fittings are more ornate than was usual — especially the shape of the leaf on the clasp.

The manuscript was also provided with a precious bookmark. Such articles, known in the Middle Ages as either "registers" or "cordula libri" (book strings), were apparently prevalent, although only a few have survived (Wattenbach, 1896, pp. 396–97; Forrer, 1898, pp. 37–38). Consisting of ribbons of leather, or silk, with a thick knob at the top, they were far more necessary than they are today, for books, as a rule, were not paginated. Often, bookmarks for Missals or Antiphonaries — liturgical manuscripts that had to be opened to various chapters during the service — had a number of ribbons affixed to a single knob, forming what the medieval sources call a "tenaculum." The decoration of this tenaculum, and the acorn-shaped ends of the ribbons, with seed-pearl embroidery, seem unusually costly, although, of course, this accords with the luxuriousness of the *Missal*'s overall ornamentation. No other pearl-studded bookmarks are known from the period. R K

BIBLIOGRAPHY: (binding:) Kress, 1892, p. 213; Bruck, 1903, pp. 186, 193; Schulz, 1908–35, vol. 1, pp. 296–97, ill.; Hampe, 1928–29, pp. 91–101, ills. 9–10; Frank zu Döfering, 1936, col. 253, ills. 95–100; Kohlhaussen, 1968, pp. 285–86, no. 346, ills. 436–442.

text continues on page 196

54: *Missal*, box

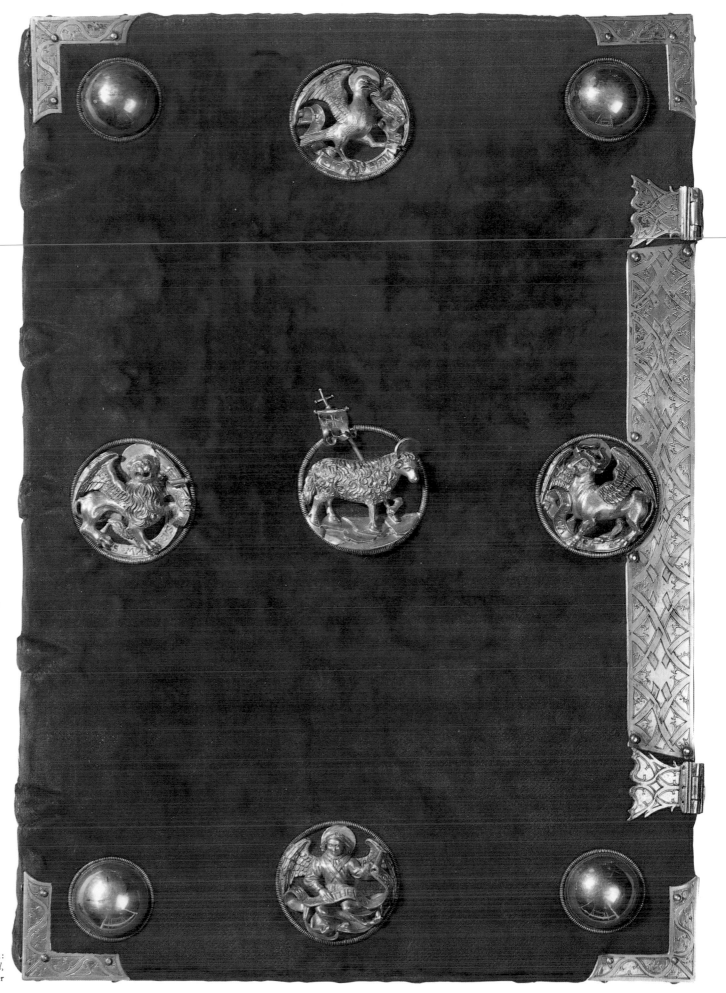

54:
Missal,
front cover

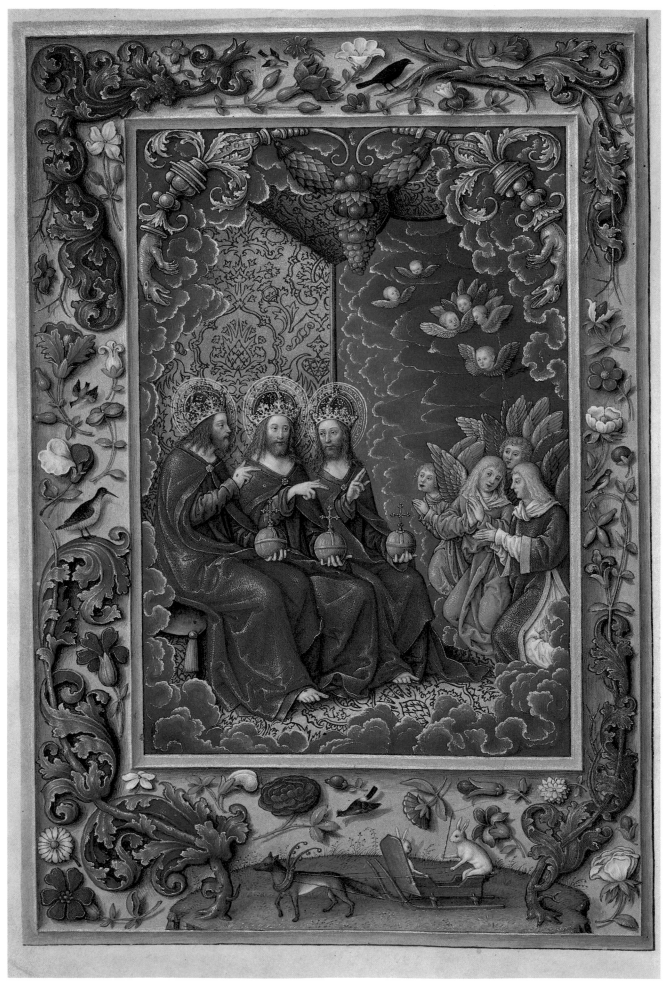

54: fol. 2 v.,
The Trinity

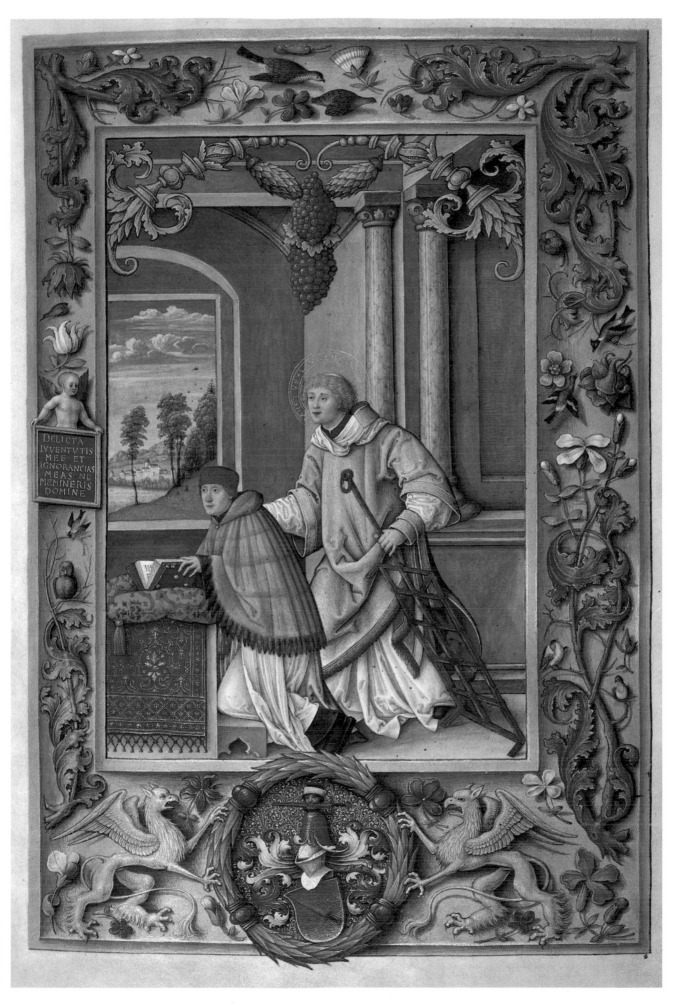

DELICTA
IVVENTVTIS
MEE ET
IGNORANCIAS
MEAS NE
MEMINERIS
DOMINE

54:
fol. 3 r.,
The donor,
Provost
Dr. Anton Kress,
with Saint Lawrence

195

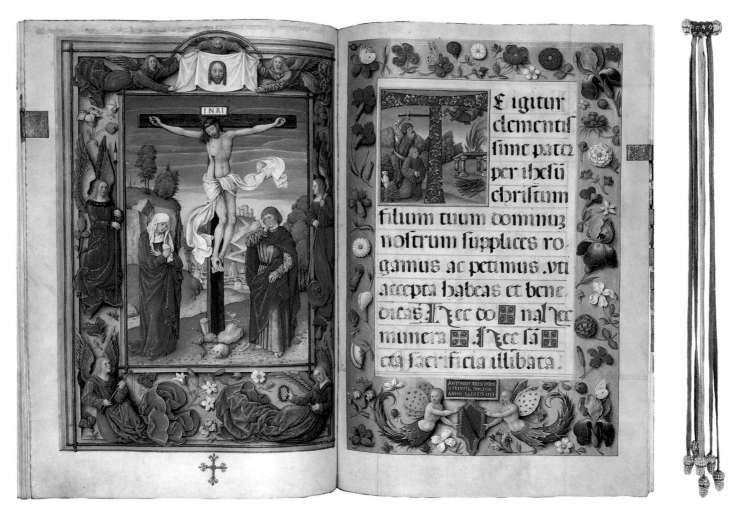

54: fols. 126 v. and 127 r., The *Crucifixion* and the *Te igitur*

54: bookmark

JAKOB ELSNER (paintings and
illuminations, 1513)
FRIEDRICH ROSENDORN (script, 1513)
Kress Missal (in Latin)
234 parchment leaves, unpaginated, each,
14 x 9³/₄ in. (35.5 x 24.7 cm.)

This liturgical book is a Missal, and was in-
tended for use on an altar by the celebrant of the
Mass (see cat. no. 26). The difference in scale
between the two-volume choir book (cat. no.
53) and the present work makes clear their re-
spective functions. Except on two pages (fols. 4
v. and 5 r.), the text pages here are divided into
two columns. The decoration comprises three
full-page paintings and a series of five foliated
historiated initials and four foliated and illumi-
nated initials without figures. Aside from the
full-page openings, there is only one image in a
lower margin (a *bas de page*), the Lamb of God
(fol. 136 r.) in the Canon of the Mass. The hori-
zontal margins on the pages with decorated ini-
tials are further enhanced by foliated rinceaux,
which extend barely more than the width of one
column of text. The vertical margins exhibit
occasional stems, sparsely foliated and sur-
rounded by delicate red pen work. The subjects
and decorations may be summarized as follows,
using a tentative pagination:

Facing frontispiece miniatures:

fol. 2 v.: The Trinity in three persons seated on a
brocaded throne, each crowned and hold-
ing a golden orb. Four angels kneel in
attitudes of adoration; above, are
seraphim in the clouds. There are concave
trompe l'oeil borders with curling red and
blue acanthus, strewn flowers, birds, and
a *bas-de-page* scene of a fox pulling a blue
sleigh with two white rabbits.

fol. 3 r.: Saint Lawrence is shown in a deacon's dal-
matic and alb, holding the grill of his mar-
tyrdom, and presenting the donor, in a red
biretta and gray cape, who kneels at a
cushioned prayer bench. The donor holds
a book that is extremely similar to this
very book, as suggested by the cover and
by the double columns of text. A putto in
the left margin in front of the donor holds
a plaque bearing a Latin inscription with
the donor's prayer: DELICTA / IVVENTVTIS /
MEE ET / IGNORANCIAS / MEAS NE /
MEMINERIS / DOMINE (Do not remember
the mistakes of my youth and of my
ignorance, O Lord).

 The two main figures occupy an interior
architectural setting with pink marbleized
columns and a window, which provides a
glimpse of the distant hills of an expansive
landscape and a shaded blue sky with
gathering clouds. The concave trompe
l'oeil borders are similar to those on the
facing page. The lower border shows two

rampant griffins holding a laurel wreath
that surrounds the arms of the donor.

 Fanciful foliate gold brackets with
balusters fill the corners of each miniature.
Dragons emerge from the brackets above
the Trinity scene. Strung between the
brackets are foliate garlands with sus-
pended fruit, including bunches of grapes.

fol. 15 v.: The Nativity in an initial *D*.

fol. 62 r.: The Resurrection in an initial *R*.

fol. 125 r.: A Latin inscription in large gold capitals
against bare parchment: IACOBVS ELSNER
CIVIS NVREMBERGENSIS HVNC LIBRVM ILLV-
MINAVIT ANNO D[OMI]NI * 1513 *

Facing pages for the Canon of the Mass:

fol. 126 v.: The Crucifixion, with the Mourning Vir-
gin and Saint John the Evangelist in a
landscape setting with a distant view of
Jerusalem. There are concave trompe
l'oeil margins, strewn flowers, and seven
angels holding the instruments of the Pas-
sion and the veil of Saint Veronica (the
Holy Face).

fol. 127 r.: The Sacrifice of Isaac in an initial *T*. The
trompe l'oeil margins contain strewn
flowers, a butterfly, and two winged putti
with multicolored and foliated tails bear-
ing the donor's arms and a plaque with an
inscription over a blue ground:

 ANTONIVS KRES IVRIS
 VTRIVSQ DOCTOR
 ANNO SALVTIS * 1513 *

fol. 136 r.: The final illustration of the Canon of the Mass, showing the Lamb of God with the banner bearing the cross and a chalice, framed by a lozenge of twigs with foliate extensions and berries.

fol. 156 r.: Two angels holding a gilt Eucharistic monstrance in an initial c with ECCE PANIS ANGELORVM inscribed against a blue background.

fol. 170 r.: Lazarus and the Rich Man in an initial C.

fol. 172 r.: The crowned Madonna and Child in the clouds in an initial G.

Illuminated initials without figures appear on folios 27 v., 14 r., and 163 r.

The Trinity in three persons, as depicted here, also occurs in the historiated initial on folio 91 r. of the 1510 volume of the *Gradual* (cat. no. 53). The prominence given to one of the six instruments of the Passion — the Holy Lance — in both the 1507 volume of the *Gradual* (folio 176 r.) and in the *Missal* (in the Canon miniature) is a reference to one of the imperial relics that had been in the custody of the city of Nuremberg since 1424 (see cat. no. 47).

A Latin inscription on folio 4 r. mentions that in the year 1513 Provost Anton Kress (1478–1513), doctor of both laws (canon and Roman), gave this book to the Lorenzkirche for the divine services and in praise of God, the Virgin, and Saint Lawrence:

Anno salutis christiane quingentesimo decimo tertio supra millesimum Antonius Kress, juris utriusque doctor, ecclesie sancti Laurentii Nurenberge prepositus, hunc librum pro decore cultus divini et ad laudem dei, beatissime virginis Marie atque beati Laurentii, martyris, prefate ecclesie contulit.

The donor was the same man who commissioned the two-volume *Gradual*, of 1507 and 1510 (see cat. no. 53).

We also can identify the painter-illuminator from the gold inscription in Roman capital letters preceding the Canon miniature of the Crucifixion. Jakob Elsner was obviously proud of his work because he used bold classical capital letters in gold in a manner in keeping with Humanist taste. The Gothic script on the other text pages is attributed to Vicar Friedrich Rosendorn on the basis of a detailed comparison with the script of the *Gradual* (cat. no. 53).

The style of the painted decorations and of the miniatures demonstrates a natural progression from the work already seen in the *Gradual*. Some of the same compositions appear — as, for example, the Resurrection scene and the Trinity. Yet, there is a heightening of the intensity of the color contrasts, as well as a subtler use of gold and of coloristic nuance. The foliate initials have been further enriched in color and in the discreet use of highlights. The regard for the varying textures of cloth, metal, flesh, and hair, and of the landscape settings continues. While a concern with the proportions and the modeling of the figures in the *Gradual* is also evident here, the visual context now is one of greater opulence and of the fullest exploitation of both the expressive and decorative aspects of color. Certain restrictions are adopted in the *Missal*, however — such as the marginal drolleries that are reduced down to one in the present manu-

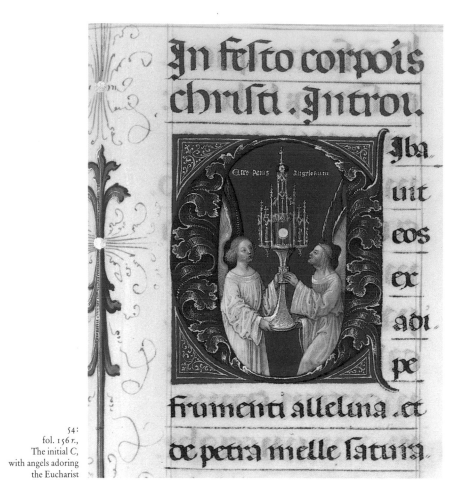

54:
fol. 156 r.,
The initial C,
with angels adoring
the Eucharist

script on the Trinity page, and the simplification and sparing use of the foliate rinceaux.

The emulation of elements in Ghent manuscripts is intensified in the *Missal* — as seen in the illusionism of the flower-strewn borders with shallow concave backgrounds and cast shadows. The butterfly, as well as the curling acanthus in these borders, is derived from the same source; so are the deep landscapes and the naturalistic skies — especially in the Crucifixion miniature. The angels with the instruments of the Passion in the borders of the same miniature and the angels in the 1507 volume of the *Gradual* share a common patrimony in Ghent manuscripts. This is clearer when they are compared with the angels in the border in one of the more famous books of hours, now in Vienna (Österreichische Nationalbibliothek, Cod. 1857, fol. 99 v.; F. Winkler, *Die Flämische Buchmalerei des XV. und XVI. Jahrhunderts*, Leipzig, 1925, p. 11, pl. 64; O. Pächt, *The Master of Mary of Burgundy*, London, 1948, pl. 11).

Certain features of the *Missal* are not characteristic of Ghent manuscripts. These include the particular emphasis on blues and reds (as on the Trinity page), the foliate and historiated initials, and the laurel wreath and the putto with an inscribed tablet (on the page with the donor portrait) — the last borrowed from Italian Renaissance manuscript sources. Especially Humanistic is the nearly blank page with only the exquisite, classical gold capital letters giving the name of the artist and the date.

Because the eclectic elements are melded into a visually unified whole, carefully composed and intensely colorful, this manuscript may be considered as both a pinnacle of Nuremberg manuscript painting and as Jakob Elsner's masterpiece. The manuscript displays all of the artist's abilities, as mentioned by Johann Neudörfer: making portraits, making the painted gold "so pure," and painting coats of arms, and also shows greater restraint and clarity of composition than the profusely decorated *Evangeliary*, of 1507, made for Frederick the Wise, and now in the Universitätsbibliothek, Jena (R. Bruck, *Friedrich der Weise als Förderer der Kunst,* 1903, pls. 22–25). Peter Vischer the Younger must have known this manuscript; he based his portrait of Anton Kress on Elsner's miniature (fig. 87; Stierling, 1918, vol. 11, pp. 259–60; Grote, 1959, fig. 18). WDW

EX COLLECTIONS: Lorenzkirche, Nuremberg (1513–1617); Freiherrn von Kress zu Kressenstein or the Kress'sche Vorschickung (since 1617).

BIBLIOGRAPHY: von Rettberg, 1854, p. 144; Lochner, 1875, pp. 139, 140; von der Gabelentz, 1899, 15, p. 40; Bredt, 1902–3, 6, 2, p. 481; Bruck, 1903a, 24, pp. 311–15, fig. 5; Raspe, 1905, 60, pp. 63–69, pl. IX; Kleinschmidt, 1906, 2, pp. 283, 284; Hampe, in Thieme-Becker, 1914, vol. X, p. 489; Stierling, 1918, 11, pp. 259–60; Schilling, 1946, 1, p. 144; Stange, 1950, vol. IX, p. 84, figs. 180, 181; Grote, 1959, pp. 159–67, figs. 6–15; Bühler, 1963, 16, p. 106, no. 24, p. 111; von Tavel, 1965, ser. 3, 16, pp. 57, 64, 71, fig. 12; Mojzer, 1966, 12, pp. 1–5, 111, n. 25, fig. 8; Behrends, 1983, pp. 73–79; Hellwig, in *Germanisches Nationalmuseum...,* 1985, p. 96, no. 221, ill.

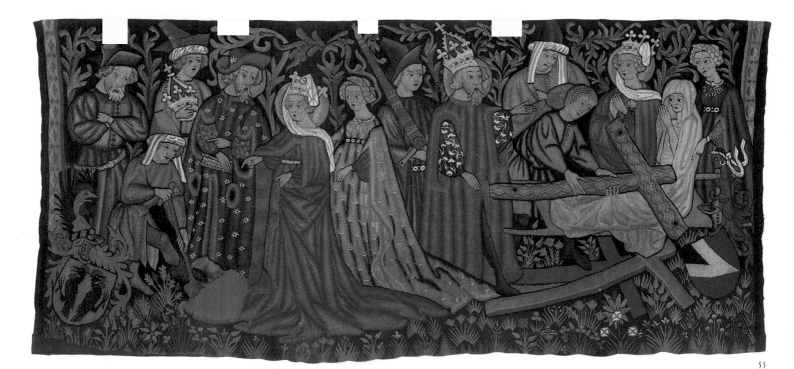

55 Scenes from the Legend of the True Cross

Nuremberg, about 1430–40
Tapestry weave: linen warp, and weft of colored wool and white linen
33 1/2 x 70 7/8 in. (85 x 180 cm.)
A section missing from the scene at the left, at Empress Helena's feet, was restored, about twelve years ago, with a plain insert specially woven to match the weave and the color of the original.
Provenance: Lorenzkirche, Nuremberg; Sebaldus-kirche, Nuremberg.
Nuremberg, Germanisches Nationalmuseum (on permanent loan from the Evgl. Luth. Pfarrkirche Sankt Sebald, Nuremberg, since 1926)
Gew 3715

At the left of the tapestry, Empress Helena, in the presence of Emperor Constantine, is indicating the place where the crosses of Christ and of the two thieves are buried. A young man in back of Constantine holds the imperial crown, which, in the scene at the right, the emperor wears on his head; there, the emperor's sword-bearer stands behind him. In the right-hand scene, the crosses are found, and one of them is proved to be the True Cross, after its touch restores a dead woman to life.

The tapestry, both sides of which are well preserved, includes the coat of arms of the Rummel family, well-to-do Nuremberg merchants, in the lower left, and, in the lower right, that of the patrician family named Haller. There were three instances of an alliance between a member of the Rummel family and a Haller during the time from which the tapestry dates, but the left-hand coat of arms is most likely that of Franz Rummel, who married Agnes Haller in 1421 and was knighted by the German emperor in 1433.

Originally, the tapestry may have belonged to the Lorenzkirche, whose 1466 inventory lists a woven antependium with the Legend of the True Cross; a subsequent inventory mentions a tapestry with the Rummel and Haller coats of arms. Yet, as late as the nineteenth century, the original locations of many works of art in Nuremberg were changed, so that the tapestry may have been moved, then, to the Sebaldus-kirche, where the memorial shield of Franz Rummel is preserved.

Most of the surviving Nuremberg tapestries from the first half of the fifteenth century have a plain, deep-blue background. The present tapestry is distinguished by the blue-green scroll decoration against the blue background, and by its narrow borders, evidently intended to imitate picture frames.

The Legend of the True Cross was a popular theme in the fifteenth century. A Nuremberg tapestry dating from 1475–80, which, about 1925, was in a private collection in Chicago, showed Emperor Constantine with the cross, as well as the Raising of the Dead. These scenes, among others, are still in place in the Emperor's window — donated in 1476–77 by Emperor Frederick III and Empress Eleonore — in the choir of the Lorenzkirche. The stained glass was made by the workshop of Michael Wolgemut.

LvW

BIBLIOGRAPHY: Kurth, 1926, vol. 1, pp. 180, 267, vol. 3, pl. 284; Luitpold Herzog in Bayern, 1926, vol. 1, pp. 40–41, vol. 2, fig. 18; Wilckens, 1977, p. 162, fig. 8.

56 The Last Judgment

Nuremberg, mid-15th century
Tapestry weave: linen warp, and weft of colored wool and white linen
95 5/16 x 57 7/8 in. (242 x 147 cm.)
Provenance: Sebalduskirche, Nuremberg (?).
Nuremberg, Germanisches Nationalmuseum (acquired by 1856)
Gew 671

Wearing the red robe of a judge, Christ is enthroned on a double rainbow, within an aureole. At Christ's feet, kneeling on rippling clouds, are his mother and Saint John the Baptist — the latter wearing a hair shirt under his cloak — who intercede with him on behalf of sinful mankind. Poised in mid-air between the Virgin and Saint John are two angels, blowing on long, curving horns to raise the dead from their graves. To Christ's left and right are four more angels, holding the instruments of the Passion: a spear, the cross, a scourge and a whipping post, the crown of thorns, and a switch. Borders filled with foliated staffs enclose the tapestry on both sides and below. In the lower corners are the coats of arms of the donors — or sponsors: at the left, that of the Volckamer, the husband's patrician family; at the right, that of the Schürstab, the wife's family. The husband may have been Berthold Volckamer (1397–1492), prominent in his own family, and in the history of the city of Nuremberg.

Most of the surviving Nuremberg tapestries were used as antependiums or dossals. Since these are less than one meter (about three feet) high, they could be woven on a narrow loom, with the result that, in the finished work, the warp yarns run horizontally — that is, at right angles to the vertical axis of the image. Funeral tapestries such as the present one, which is about two-and-one-half times wider and was woven in the same way, therefore required the use of a loom at least two-and-one-half meters wide. Until the middle of the fifteenth century, Nuremberg tapestries were characterized by deep, dark-blue backgrounds, against which the bright colors found elsewhere in the weaving were shown to best advantage. LvW

BIBLIOGRAPHY: Kurth, 1926, vol. 1, pp. 178–79, 265–66, vol. 3, pl. 277; Luitpold Herzog in Bayern, 1926, vol. 1, pp. 57–58, vol. 2, fig. 29.

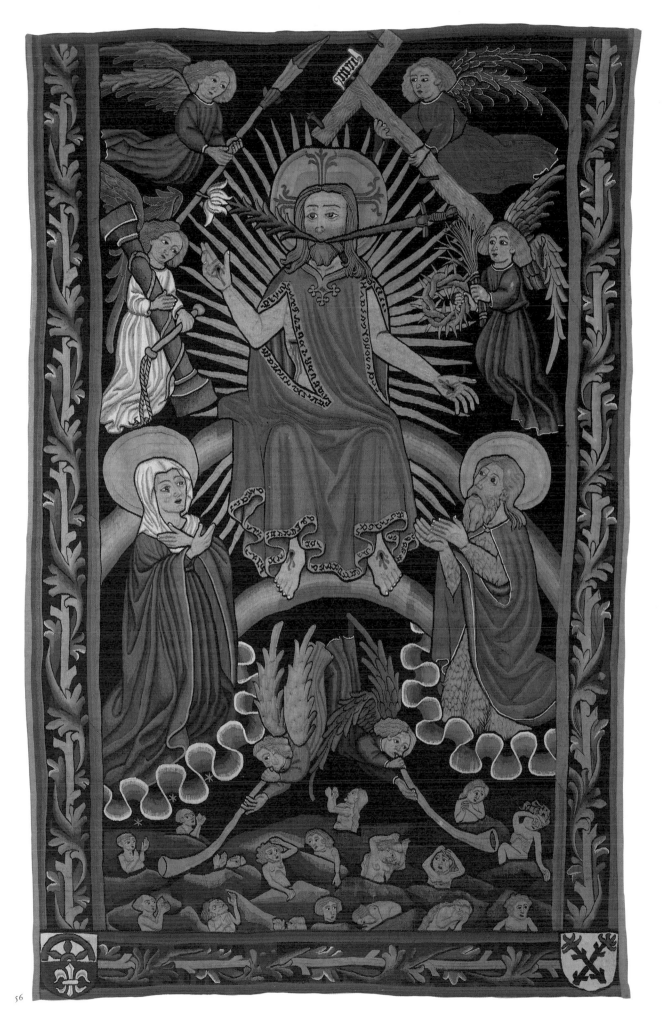

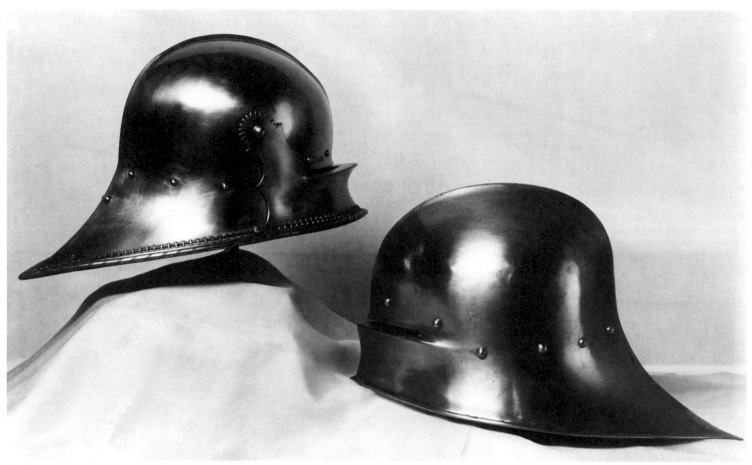

62–63

sa[nk]t Kath[arinen] v[er]schiet d[er] streng · Erhart Haller · ritter · dem · go[t] · genat [=gnädig sei] ("In the year 1457 on the Sunday before the Feast of Saint Catherine [November 25] the fearless Erhart Haller, knight, departed. May God be merciful to him").

Along with his cousin Paulus Haller and with Martin Hayd, Erhart Haller was one of Nuremberg's official ambassadors, charged with conveying the imperial regalia to Rome for the coronation of King Sigismund. On May 31, 1433, the day of the coronation, he was knighted by the new emperor on the bridge over the Tiber. At the same time, the emperor granted him the privilege of augmenting his coat of arms with a crowned helmet surmounting the shield. In Nuremberg, however, Haller was forbidden by the city council to use such a crown; the council insisted that no patrician family could claim superiority over the others. Nevertheless, the council was unable to keep him from eventually adding the helmet to his arms. The unusual splendor of his memorial shield — compared with other examples in Nuremberg — may well have been an expression of Haller's new class consciousness following his knighthood. Even before the end of the fifteenth century, the city council repeatedly was forced to take measures against such excessive display on memorial shields. Finally, in 1497, all shields costing over three guilders were forbidden: Henceforth, they were to consist solely of a flat, planed board, on which the coat of arms was to be painted. Ornamental carving was not permit-

ted, and the shield could not exceed certain prescribed dimensions. As we can see from the shields made after 1500 that survive, the council's restrictions were followed for a long time. It was not until the Baroque era that shields again took on more elaborate, sculptural forms.

RK

BIBLIOGRAPHY: Pilz, 1936–39, pp. 71, 94, ill. 9; Haller von Hallerstein, 1969, pp. 288–89; Kohlhaussen, 1970, p. LI, no. 136, pl. 136.

62–63 ATTRIBUTED TO HANS GRÜNEWALT

Two Helmets (Sallets)

Nuremberg, 1480–90
Steel, with applied brass borders
Vienna, Kunsthistorisches Museum,
Waffensammlung
A 60, A 93

The sallet (*Schallern* in German) was an alternative headpiece to the armet, or close helmet, which enclosed the knight's head completely. Comfortable to wear, the sallet covered only the upper half of the face, and was therefore often combined with the bevor, a chin defense attached to the top of the breastplate.

Sallets were of two basic types: one form had a deeply downturned rim and an eye slit cut out in front; the other, a movable visor privoted at

the temples. The visor, in turn, could be of two shapes: a full visor with an extension above the eye slit to reinforce the brow area, or a half visor, consisting only of a strip of steel with the eye slit formed by the space between the upper edge of the visor and the front rim of the helmet bowl — such as sallet A 93.

Both sallets are stamped with the control mark of a Gothic letter *n* and the "half eagle" city mark. Sallet A 60, originally owned by Archduke Maximilian (emperor, 1493–1519), also bears a master's mark, which has been tentatively identified as that of Hans Grünewalt, who was the only Nuremberg armorer at the time working for Maximilian. A sallet with the same armorer's mark is in the Metropolitan Museum (04.3.226).

Sallet A 60 is decorated with fleurdelisé brass borders, although these are nineteenth-century restorations. Sallet A 93 has a circular hole cut into its comb, for the attachment of a plume.

HN

BIBLIOGRAPHY: Thomas and Gamber, 1976, p. 97, nos. A 60, A 93.

64 a) Tilt Armor (*Rennzeug*)

Nuremberg, 1498
Steeled iron, hammered, filed, and polished
46 1/2 x 22 3/8 x 20 1/2 in. (118 x 57 x 52 cm.);
weight, about 52 lbs. (24 kg.)
The original padding is missing.
Nuremberg, Germanisches Nationalmuseum
(acquired, 1889)
W 1307

b) WILHELM VON WORMS THE ELDER
Vamplate

Nuremberg, about 1500
Steeled iron, hammered and filed
22 7/8 x 14 5/8 x 7 1/8 in. (58 x 37 x 18 cm.);
weight, about 17 lbs. (8 kg.)
Nuremberg, Germanisches Nationalmuseum
(acquired, 1889)
W 1311

This sallet-type helmet, known, in German, as a "Rennhut," is now missing the two brow-plates that gave it added strength. Also lost is the section called the "bevor," which covered the lower half of the face and the neck. On the right side, the massive breastplate, with heavily cabled edges, supports the rest and hooked queue used to anchor the tilt lance. Bolted onto the bottom of the breastplate is the placard, from which hang five faulds and two unarticulated tassets. The slightly fluted back terminates in a tailpiece. The heavy vamplate protected the right side of the body. The tilt targe for the left side has not survived.

The four suits of *Rennzeug* armor from the old Nuremberg armory shared the fate of the jousting armor in the same collection (see cat. no. 266). They constitute two pairs, of which one displays the Nuremberg coat of arms engraved onto the breastplates, along with a banderole inscribed with the date 1498. This pair — one of which is the present armor — has no master's marks. The other pair, however, carried the mark of the Nuremberg armorer Wilhelm von Worms the Elder (mentioned, 1497–died 1537). Since von Worms was not promoted to master until 1499, this marked pair has to be later than the other.

The German tilt differed from jousting in the type of lance employed. In this event, the contestants used sharp lances to strike the opponent's targe and thereby unseat him from his horse. As is the case with nearly all surviving tournament armor, only the metal portions of the Nuremberg suits have survived. However, there are numerous tournament books describing the extremely colorful appearance of the participants. They include not only the schedules of events at the tournament but also illustrations in color of the various participants.

JW

Ex COLLECTIONS: Nuremberg armory; Schloss Feistritz on the Wechsel, Austria.

BIBLIOGRAPHY: Thomas and Gamber, 1976, pp. 159–60 (solely regarding the tournament event called the "German joust").

64

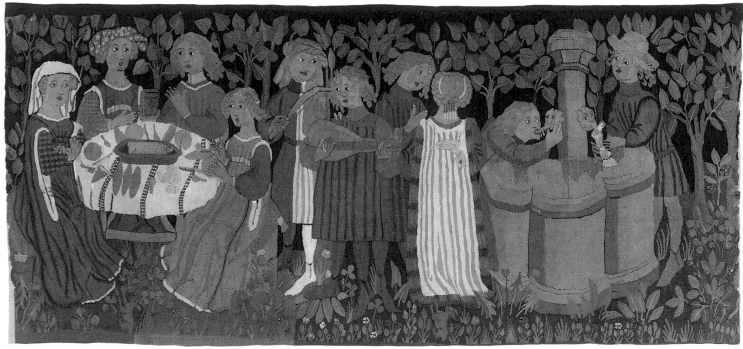

67

the feast was meant to illustrate taste; the suggestion of a reflection in the fountain, sight; music, hearing; the flowers and fruit, smell; and the young lovers near the fountain, touch.

Very few Nuremberg tapestries with non-religious themes have survived — possibly because they received harder wear than the wall coverings and altar frontals used in churches, on special occasions and holy days. The figures in the Garden of Love, with their fashionable clothing, may appear fragile, the mood unreal, and the event in which they are participating almost like a fairy tale. Yet, in its depiction of figures in a landscape setting, rendered in a few select colors whose effect is heightened by their interplay, this tapestry is clearly a fine example

of an art that flourished in Nuremberg for one hundred and twenty years.　　L v W

BIBLIOGRAPHY: Kurth, 1926, vol. 1, pp. 180, 266–67, vol. 3, pl. 282; Luitpold Herzog in Bayern, 1926, vol. 1, p. 66, vol. 2, fig. 42.

68　Wall Hanging, with Pomegranate Pattern

Nuremberg, last quarter of the 15th century
Tapestry weave: linen warp, and weft of wool in yellow and two shades of red
34 1/4 x 82 11/16 in. (87 x 210 cm.)
New York, The Metropolitan Museum of Art
49.144

There are only a few tapestries known with a repeat pattern, and, in these, different colors ordinarily are used. The pattern of the present tapestry shows two different pomegranate motifs, arranged in staggered rows. Nuremberg tapestries from about the middle and the third quarter of the fifteenth century make occasional

68

use of the pomegranate motif as a background (see cat. no. 57); other tapestries — for example, two in the Germanisches Nationalmuseum — although very similar, introduce tiny figures into the design, such as the Man of Sorrows or Saint Anne with the Virgin and Child. The tapestry shown here is more likely to have been employed in a secular rather than a church setting; it probably was used as a wall covering in a private home, where it provided warmth as well as decoration. LvW

Ex collections: Lorenz Gedon, Munich; Dr. Albert Figdor, Vienna; F. C. Iklé, New York.

Bibliography: von Falke, 1930, no. 5.

69 Wall Hanging, with Pomegranate Pattern

Nuremberg, early 16th century
Twill binding: linen warp, and weft in red, white, green, blue, and yellow wool, with metallic threads
106 $^5/_{16}$ x 40 $^{15}/_{16}$ in. (270 x 104 cm.)
New York, The Metropolitan Museum of Art
53.35.2

The wall hanging, set off at the top and bottom with a green, decorative border, presents two types of pomegranates in staggered arrangement, the pattern repeated nearly four times, against a red background. Another weaving in the Germanisches Nationalmuseum, in the same technique and of the same height but double in width, includes the pomegranate pattern only in the encircling borders; the fact that it came from Nuremberg's Heilig-Geist-Spital may well prove that the present one, at least, was made by Nuremberg weavers, for such a relatively simple example, made with locally available materials, hardly would have been acquired abroad. Similar hangings are in museums in Cologne and in Munich; one, long in the possession of Johann Wolfgang von Goethe's family in Frankfurt, is now in the Goethehaus, Weimar. The "Nürnberger Decken" (Nuremberg covers) that were exported as far away as Sweden, at the end of the fifteenth and the beginning of the sixteenth century, probably were weavings of this type. Italian silks are likely to have provided the inspiration for the pomegranate patterns.
LvW

Ex collection: Dr. Albert Figdor, Vienna.

Bibliography: von Falke, 1930, no. 131; *The Metropolitan Museum of Art Bulletin*, 1952–53, p. 283.

69

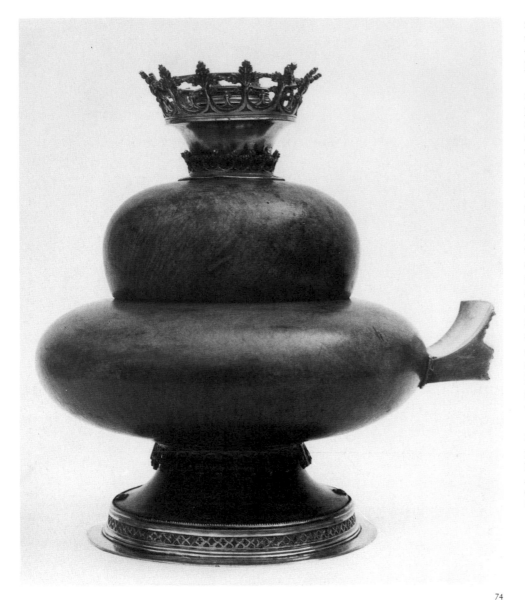

much smaller vessel in Sweden, although otherwise similar, consists of two wooden bowls with neither foot nor handle. The third example has only a very low wooden foot.

In the present instance, the goldsmith enriched the work of the woodturner in four places. Above a flat, circular base, he created a recessed fillet with quatrefoil rosettes, and around the upper end of the shaft he placed a wreath of hanging leaves. The wooden handle was wholly encased in silver, with a strikingly rich array of moldings on its outer surface. The nails securing this silver handle were driven into the wooden core so as not to damage the wall of the vessel itself. Finally, on top he placed a two-tiered crown, the upper one serving as a stand when the smaller cup is upended. The lower tier corresponds in form to the wreath just below the bowl of the larger cup. Openwork crowns of this type are frequently found on double cups, but by no means are all examples with such crowns of Nuremberg manufacture. The details of the fittings of the Schweinfurt double cup are so very similar to those of the cup once owned by the patrician Rieter family of Nuremberg that Kohlhaussen assumed that both were made in the same Nuremberg goldsmith's workshop. RK

Ex COLLECTION: Schweinfurt city council.

BIBLIOGRAPHY: Rosenberg, 1922–28, vol. 3, no. 3689; Ritz, 1935, p. 9, ills. 24–25; Kohlhaussen, 1959, p. 120, ill. 45 b, 1960, p. 33, ill. 8, 1961, p. 32, ill. 4 (with the upper cup removed), 1968, pp. 147, 507, no. 247, ill. 271; Fritz, 1982, p. 275, at no. 640.

74

74 Double Cup

Nuremberg, mid-15th century
Burled wood, turned, with gilded-silver fittings
Height, 8 1/4 in. (21 cm.)
On the handle is the Nuremberg mark, a reversed "N" (Rosenberg, vol. 3, no. 3687).
Schweinfurt, Städtisches Museum

In Germany, and in southern Germany especially, a characteristic form of turned-wood drinking vessel developed as early as the thirteenth century. It consisted of a more or less conical, often rather squat, vessel — with a low foot and a side handle — on top of which was a second, smaller, but similarly shaped cup, upside down. The upper one served as a lid, but could also be removed, turned right side up, and used as a separate drinking vessel. The term "Kopf" was used to describe such a drinking cup in the thirteenth century; the double one thus became known as a "Doppelkopf." In addition to wooden examples in this form, there were also versions in silver and, more rarely, other precious materials (see cat. no. 75). Certain types of burled wood were reputed to ab-

sorb poisons, or to intensify the flavor of the drink served in them.

Double cups were extremely popular in the later medieval period, and, at one time, many of them must have existed — frequently, with silver fittings on the foot, handle, and crown, and, occasionally, even on the rim. About fifty survive, but only two bear Nuremberg marks: the present cup, and a similar one, with a taller metal foot, in the Brahekyrkan, in Visingsö, Sweden (Kohlhaussen, 1968, no. 246, ill. 269; for a better illustration, see Kohlhaussen, 1961, ill. 2). In addition, there is a third mid-fifteenth-century cup — now privately owned — whose inscription identifies its former Nuremberg patrician owner (Kohlhaussen, 1968, no. 248, ill. 272).

The Schweinfurt double cup has a flat but very wide base with a smaller and deeper cup serving as its lid. The bottom vessel has a low foot that was turned out of the same block of wood. Kohlhaussen relates that the wooden core of the handle was also carved from this block. However, the turner did not always have such large pieces of wood to work with. The

75 Double Cup

Nuremberg, mid-15th century
Two twelve-faceted rock-crystal vessels, with embossed silver fittings, cast and gilded silver elements, and colored enamel
Height, 9 5/8 in. (24.5 cm.)
The Nuremberg mark (Rosenberg, vol. 3, no. 3686), a reserved "N" surrounded by a hexagon instead of a circle, appears on the rim of the lower foot; the hexagon probably was used only for a brief time, for it appears on no other piece. There is no master's mark. Some of the points of the upper crown have broken off.
Vienna, Kunsthistorisches Museum, Sammlung für Plastik und Kunstgewerbe (since 1872)
82

Of the few surviving examples of goldsmiths' work dating from before 1500 that bear the Nuremberg mark — therefore confirming that they were produced there — this vessel, consisting of two rock-crystal beakers placed one above the other, and provided with elaborate fittings, is certainly one of the most splendid. Unfortunately, neither the name of the man who commissioned it, nor of the high-placed

personage for whom it was likely intended as a gift, has come down to us. It is known, however, that at an early date, the Nuremberg city council began to honor emperors and princes with expensive gifts of gold and silver — often double cups — on the occasion of their visits to the city.

From existing evidence, it is impossible to determine the origin of such rock-crystal beakers, although it is certain that they were not made in Nuremberg, and are possibly much older. The Nuremberg goldsmith from whom the double cup was commissioned had to create two independent vessels, each with its own foot, which could then be fitted together at their rims. The lower one, which is 5 3/4 inches (14.7 centimeters) tall, rests on a sexfoil foot resembling that of a chalice. The receding fillet above the rim of the base is pierced with diamond-shaped openings; each opening has a quatrefoil inscribed within it. In the angles between the lobes are six dragons with raised necks and yawning mouths. Slight ridges in the centers of the lobes increase in height to form angles on the twelve-sided shaft supporting the crystal bowl. Two hanging

75: detail

wreaths mark the junction of the bowl and the shaft: an upper one, composed of tracery forms, and a lower one, of leaves. The silver molding enclosing the rim of the cup descends into a frieze of semicircles filled with tracery and separated by attached stylized lilies. A large, curved silver handle, divided down the center, projects from one side. The smaller, upper cup, only 4 1/4 inches (10.8 centimeters) tall, is similarly formed. The fitting at its rim is identical to that of the larger one. At the top of the shaft there is only a single wreath of leaves. Instead of a chalice-like foot, this smaller vessel rests on a pierced crown formed of lush, curling foliage. This crown was designed as the top of the combined vessel, and is not altogether satisfactory as a stand — as is the case with other such double cups. In some instances, the upper cup, too, has a fully developed foot. A blue-enameled six-petaled flower, set against a green background, has been placed inside the foliate crown, and at

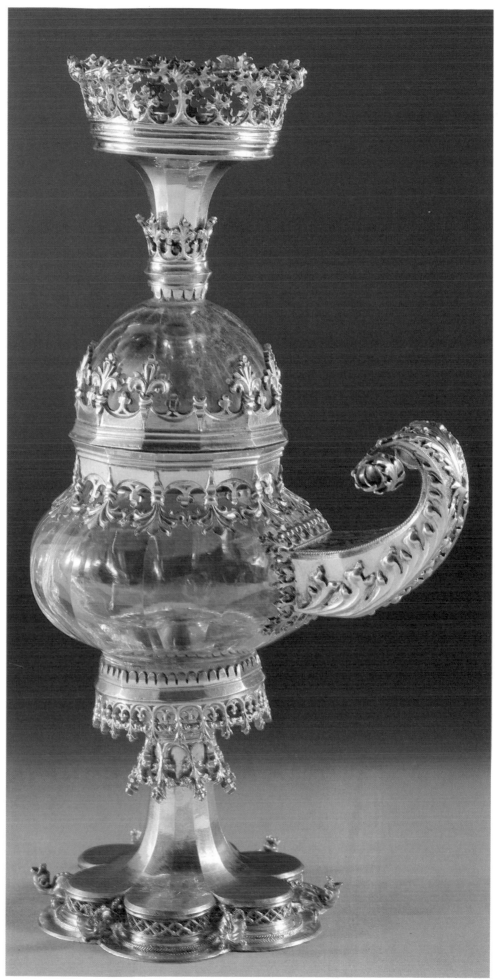

75

the bottom of the lower crystal bowl is a blue-enamel columbine with a yellow tip and a green shoot. The handle of the cup is also adorned with a blue-and-green enameled vine. The use of enameling on Late Gothic goldsmiths' work is quite rare, and only appears on exceptionally expensive and elaborate objects. It is not at all common in Nuremberg work. Parallels exist for the most modern of the present object's ornamental forms — the wavy leaves on the upper crown and on the underside of the handle — on the *Reliquary Shrine*, which dates from 1438–40 (cat. no. 47). RK

Bibliography: Leitner, 1870–73, pp. 13–14, pl. 56; Ilg, 1895, p. 7, pl. III; Rosenberg, 1922–28, vol. 3, no. 3688, pl. 69; Lamm, 1929–30, vol. 1, p. 237, vol. 2, pl. 86,3; von Falke, 1930, p. 127, ill. 17; Pazaurek, 1930, p. 188, ill. 128/2; Holzhausen, 1930, p. 217; Kohlhaussen, 1931, p. 163, ill. 7; Kris, 1932, no. 9, pl. 7; Kohlhaussen, 1960, p. 38, ill. 13, 1961, pp. 30–31, ill. 1; *Katalog*, Vienna, 1964, no. 27, pl. 39; Kohlhaussen, 1968, pp. 142, 507, 524, no. 238, ill. 259, 1970, p. XXIX, no. 24, pl. 24; Fritz, 1982, p. 275, no. 638, ill. 638; Leithe-Jasper and Distelberger, 1982, p. 62, ill.

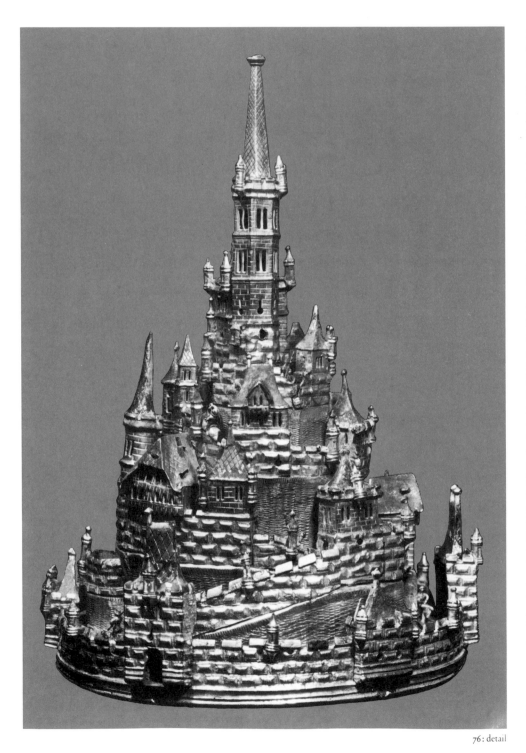

76: detail

76 Covered Beaker, in the Form of a Town

1475–1500
Copper gilt, with painted decoration
Height, 14 5/8 in. (37.1 cm.)
London, Trustees of the Victoria and Albert Museum
245-1874

A tour de force of Gothic goldsmiths' work, this conical vessel, whose walls are decorated with a pattern resembling rusticated masonry, stands on three feet, each of which is in the form of an architectural ensemble including a turreted wall with a portcullis and peak-roofed buildings. Bands of crenellated and turreted walls with gates and watchtowers encircle the base and center section of the vessel. The cover is in the form of a fantastical walled town made up of numerous buildings articulated with windows, turrets, gables, and colonnading, all lining a road that spirals upward, reaching a peak surmounted by a towered and pinnacled structure. Although without identifying marks other than an undeciphered one etched on the inside of the lid, this covered beaker has consistently been attributed to Nuremberg — in part, because of the general similarity of the surmounting architectural creation to the Vestner Tower, which, since at least 1313, has been known as the "tower in the center of the city" (Kohlhaussen, 1968, p. 294). Kohlhaussen (1968, p. 287) has unconvincingly ascribed the vessel to Sebastian Lindenast the Elder. Comparison can be made with a later example of goldsmiths' work in the form of a fantasy town, which bears the imperial arms of Nuremberg as well as those of the Harsdorfer and Reichel families of Nuremberg, and may be dated after 1531 (A. Schädler, *Die Fränkische Galerie: Zweigmuseum des Bayerischen Nationalmuseums*, Munich, 1983, p. 62, no. 75). A slightly later example dating from about 1535–40, with a Nuremberg punchmark — an urban architectural complex surmounting a stone — suggests a tradition of this type of goldsmiths' work in Nuremberg, inspired by and bearing the characteristics of the local architecture. TH

Bibliography: Oman, 1960, pls. 16–20; Kohlhaussen, 1968, pp. 287, 294, no. 349, figs. 347–348, pl. p. 292.

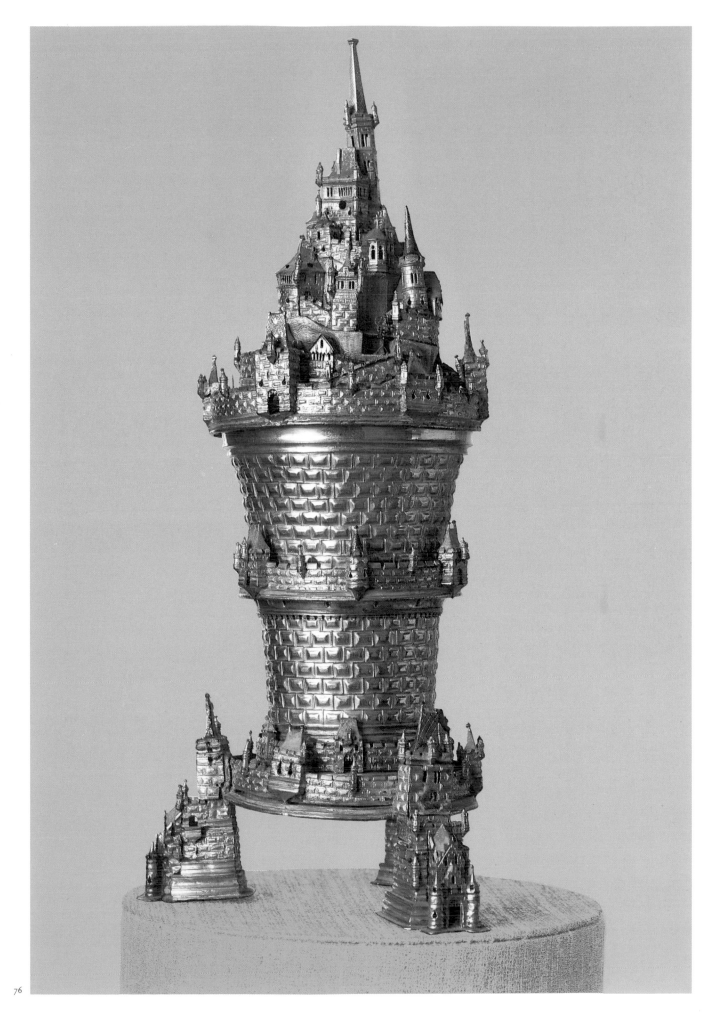

77 Harsdorfer Gold and Gem Scale

Nuremberg, 1497

Silver gilt, the balance beam of iron, with a painted wooden case

Height of scale, 9 1/4 in. (23.5 cm.), of base, 1 13/16 x 1 3/4 in. (4.6 x 4.4 cm.), of weight, 3/4 x 3/4 in. (2 x 2 cm.); length of tweezers, 5 9/16 in. (14.2 cm.), of case, 6 7/8 x 4 1/16 in. (17.4 x 10.3 cm.)

The small container with a sliding lid (which, along with the lid of the larger compartment, has been restored) was designed for 27 weights, 11 of which survive. Six larger weights occupy one of the compartments of the case. The silver tweezers are for handling the weights. There are no markings on the silver elements.

Nuremberg, Germanisches Nationalmuseum (on loan from the Freiherrlich von Harsdorfsche Familienstiftung since 1962)

HG 11 161

A low, silver rectangle with rich moldings, weighted with lead, serves as the base of the scale. From its center, a square post, fitted together from two pieces of iron, extends upward; attached to it is a short movable beam. From an eye in one end of this beam hangs a steel wire that holds the actual balance beam, from each end of which a weight pan hangs by three wires. The tip of the pointer on the balance beam contains a pearl. From the eye on the other end of the small top beam a long wire extends down to the base, where it passes under a wheel in the square post and is joined to a square weight. By sliding this weight forward or backward, it is possible to regulate the height of the balance beam. Engraved on the gilded silver base are the Harsdorfer and Nützel coats of arms; on a banderole, the initials "I.E.F.H."; and, on one side of the silver tweezers, in Gothic minuscule, a passage from Luke 4:30, which, in the Middle Ages, was thought to offer travelers protection from danger, and, according to Kohlhaussen, is sometimes inscribed on rings: "Ihs [Jesus] +

autem + Transiens + Permedium + Illorum + Ibat" ("But Jesus passing through the midst of them went his way"). On the other side is the old victory cry: "Xpvs [Christus] Vincit. Xpvs Regnat. Xpvs Imperat," here, probably used in a similar sense to the quotation from the Evangelist.

The accompanying case is designed to hold the disassembled parts of the scale and a variety of weights. The hemispherical depressions of varying size indicate that, in addition to the surviving weight pans, there were once a larger and smaller pair, as well. The tweezers slid into a slot behind the lock on the front of the case.

Both the exterior and interior of the wooden lid are covered with brightly painted paper. On the outside, two wild men are fighting, against a background of dark green vines. In front of them, just behind the silver lock, is a small rectangular panel with the date "1.4.9.7." in gold. On the inside, a pair of lansquenets dressed in vividly colored, tight-fitting trousers and doublets, with tall, curving feathers on their hats, and sporting halberds, pose against a design of gold vines on a blue ground. Between them they hold a golden laurel wreath. Within it, against a black background, again are the Harsdorfer and Nützel coats of arms, with a tilting helmet above them, against a richly billowing cloth. The Harsdorfer crest — a tower — crowns the composition. On the soldiers' shirts are the as yet unidentified initials "A T" and "K A G"; it is unlikely that they represent the signature of the "letter painter" (or *Briefmaler*) who decorated the case.

The scale is believed to be the oldest surviving medieval gold and gem scale. As attested by the coats of arms and by a slip of paper (not shown here) with a sixteenth-century inscription, it belonged to Hans Harsdorfer (died 1511), who, in 1481, married Margarethe, daughter of chief treasurer and imperial mayor Gabriel Nützel.

77: detail of the interior of the lid

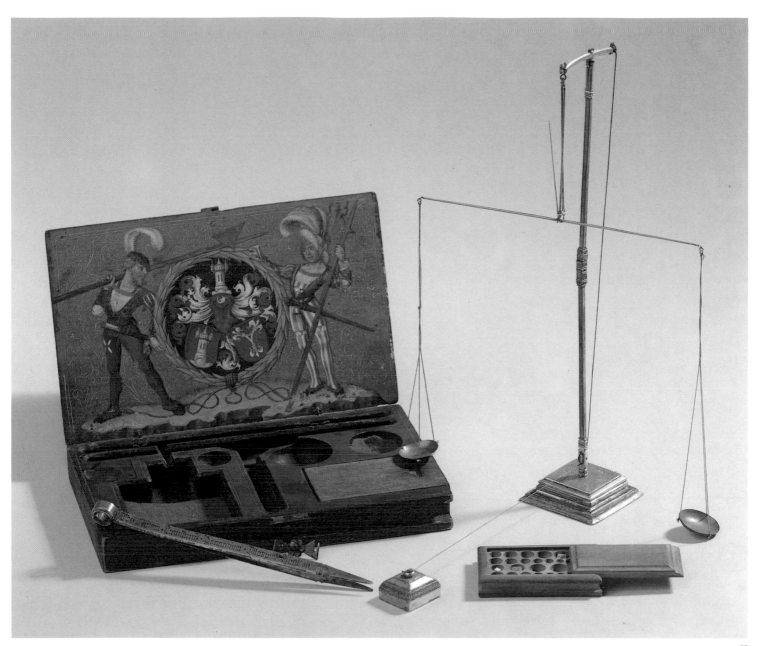

77

A good deal is known about Hans Hars-
dorfer: He owned the copper foundry in En-
zensdorf, near Nuremberg, and silver mines in
Bohemia, and was one of a small group of en-
trepreneurs and bankers who, by virtue of their
special knowledge and considerable fortunes,
occupied important posts in the financial ad-
ministrations of the empire, of various
territories, and of the imperial city of Nurem-
berg. From 1496 to 1499, during the reign of
King Ladislas II, he attained the position of
chief mintmaster for the kingdom of Bohemia,
which entailed not only the organization of
minting itself, but also the supervision of all the
mines in Bohemia. With the post came a resi-
dence in Kuttenberg, but, in any case, he had
inherited from his father the county seat of
Malesitz, near Mies, in western Bohemia. In
1497, he became chief mintmaster in Nurem-
berg, as well, and finally settled there in 1499. In
the following years, he held various high posts
in the city government, but he was especially

effective as a diplomat and as an expert in mint-
ing and coinage who was able to negotiate with
princes from other parts of the empire (Hars-
dorf, 1958, pp. 31–35; Klier, 1968, pp. 56–62).

RK

Ex collection: Hans Harsdorfer (died 1511), Freiherrn
von Harsdorf, Fischbach-Nuremberg.

Bibliography: *Edle Metalle,* 1885, no. 377; *Historische
Ausstellung,* 1906, no. 362, ill.; Rosenberg, 1910, p. 46, ill.
40, 1922–28, vol. 1, ill. 3; Schiedlausky, 1963, pp.
228–29, ill. 11; Steingräber, 1966, p. 80, ill. 18; Kohl-
haussen, 1968, no. 340, ills. 420–422; Steingräber, 1972,
p. 334, no. 341 b, ill. 341 b; Irsigler, in *Luther,* 1983, no.
20, ill.

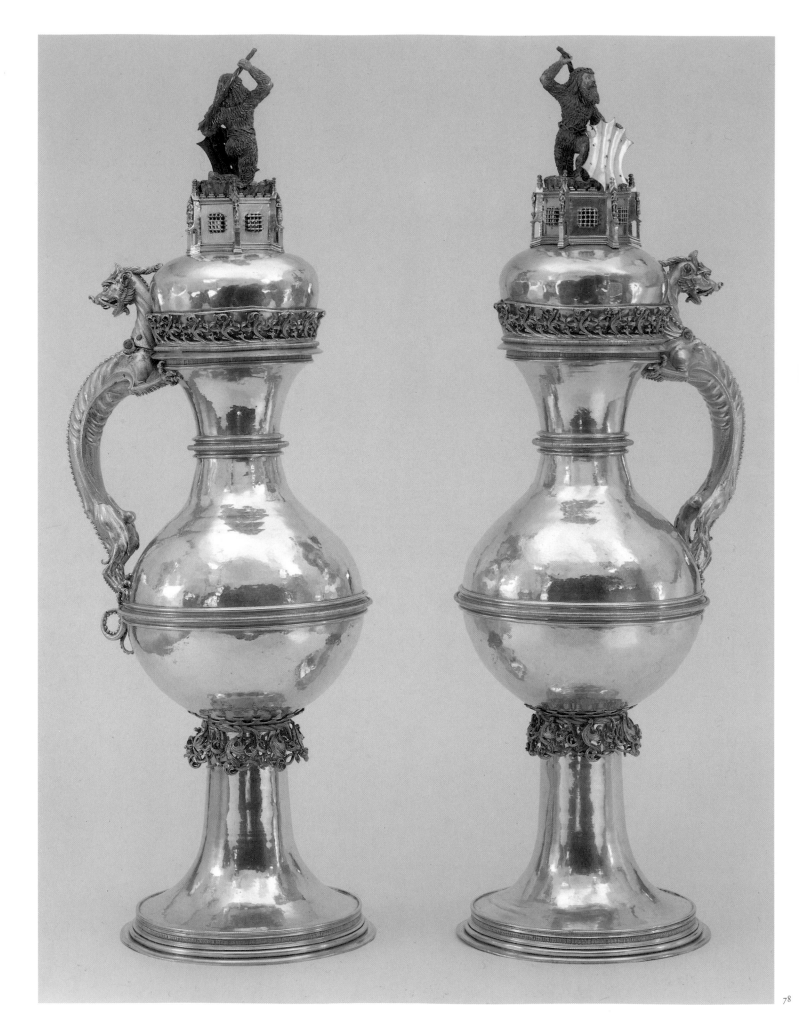

78 Pair of Ewers, with Wild Men

About 1500
Silver and silver gilt, with painted and enameled decoration
Height, 25 in. (63.5 cm.)
New York, The Metropolitan Museum of Art,
The Cloisters Collection, 1953
53.20.1,2

These ewers have long been identified with a pair cited numerous times in the inventories of the Order of the Teutonic Knights of the hospital of Santa Maria Latina in Jerusalem, although this cannot be taken as a certainty. The inventories date to 1524; those of 1526 and 1585 refer to "two silver presentation ewers with the coat of arms of Stockheim." The same pair is mentioned again in 1606 and 1619 without reference to the coats of arms; in 1619, as "two silver, highly gilt ewers, on each of these a wild man"; in 1632, as "in black cases"; and in 1757 the wild men are described as painted in green enamel.

The Teutonic Knights, along with the Knights Templar and the Hospitalers, were one of the three military and religious orders established during the Crusades. From its original seat in Acre, the Order moved its government briefly to Venice and then (1309–1457) to Marienburg on the Vistula, from where it was transferred (1457–1525) to Königsberg in East Prussia. With the advent of the Reformation, a Protestant faction of the Order established itself first in Mergentheim, and much later in Vienna. Hartmann von Stockheim, probably a native of

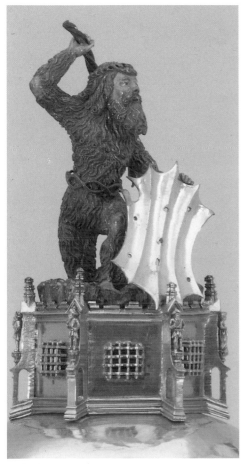

78: detail

Franconia, was the Grand Master of the Order from 1499 until 1510 or 1513; the ewers — assuming that they are the ones that were documented — were left to the Order upon his death.

The dissemination of pairs of ewers of this general shape makes a localization somewhat difficult; a similar pair, with architectural termini, appears on a ledge at the upper right of Petrus Christus's painting of *Saint Eligius*, of 1449, now in the Robert Lehman Collection at The Metropolitan Museum of Art. J. M. Fritz (1982, p. 86) noted, however, that, by the latter part of the fifteenth century, such ewers played a particular role in Cologne and cited the pair bearing the coat of arms of Cologne that had been given by the Bishop of Salzburg to the emperor Frederick III in 1483. A ewer with a similarly unusual dragon handle, and alike in profile, surmounted by a castellated finial — perhaps closest to the Cloisters ewers — is depicted in the background of a panel by the Master of Saint Severin representing the *Beheading of Saint John the Baptist* (Boston, Museum of Fine Arts; see A. Stange, *Deutsche Malerei der Gotik*, Munich, 1952, vol. v, fig. 216). There is a comparable ewer on a shelf in the background of *The Love Spell*, of about 1480, by an anonymous Cologne painter (Leipzig, Museum der bildenden Künste; see *Herbst des Mittelalters* [exhib. cat.], Cologne, 1970, no. 17, pl. II), but, as Fritz (1982, p. 227) points out, these correspondences are not conclusive. The attribution of the Cloisters ewers to Nuremberg was first made by Kohlhaussen (1968, p. 175), who noted that there were many connections between Nuremberg and the Teutonic Knights. The shape of the ewers recalls that of one depicted on a cupboard in the background of a panel representing *Saint Vitus Purging a Possessed Soul*, from the Augustiner Altarpiece, of 1486/87 (Germanisches Nationalmuseum, GM 142). Wild men function as heraldic supports on two vessels of Nuremberg production: a *Buckelpokal* now in Vienna, and a covered beaker in London (Kohlhaussen, 1968, nos. 381, 265, respectively). The wild men are also reminiscent of those in Dürer's compositions. The vertical reeding on the encircling horizontal bands is characteristic of Nuremberg goldsmiths' work of about 1470 to 1520 (Kohlhaussen, 1968, p. 175). The handle in the form of a dragon also appears on the ewer dated 1477, in the Rathaus, Goslar, which Kohlhaussen (1968, no. 353) assigns to Nuremberg. In addition, the tiny figures against the buttressing are stylistically close to Nuremberg, and bring to mind the small-scale metalwork figures of Sebastian Lindenast the Elder. TH

Ex collection: C. von Pannwitz, Amsterdam.

Bibliography: Dudik, 1865, p. 13, *passim*; Rorimer, June 1953, pp. 270–72; Borchers, 1958, XXXVI, p. 225; Rorimer, 1963, pp. 183–84, fig. 92; Kohlhaussen, 1968, p. 175, nos. 261, 262, figs. 294–296; Fritz, 1970, pp. 115 ff.; Ostoia, 1970, pp. 226–27, no. 107; Hayward and Husband et al., 1975, p. 268, no. 264, pl. 15; Hernmarck, 1978, p. 125, fig. 250; Husband, 1980, pp. 181–83, no. 52, pl. 14; Fritz, 1982, no. 649, pl. 649.

79 SEBASTIAN LINDENAST THE ELDER
Confection Dish

About 1500
Copper, embossed, the inside gilded, the outside silvered; the hillock in the center is of chased copper, plated with silver, and the figure of the stag is cast and gilded
Height, 1 5/8 in. (4.2 cm.); diameter, 6 1/2 in. (16.5 cm.)
Nuremberg, Germanisches Nationalmuseum
(Gift of Fräulein M. Pacher, Nuremberg, 1860)
HG 488

Nearly the entire surface of the shallow, circular dish is covered with three rows of twelve convex bosses — smaller at the center of the vessel and larger at the rim — that come to a point at both the top and bottom. At these points, the bosses are fully interlocking. Vessels with bossed decoration are among the most characteristic forms of goldsmiths' work from the Late Middle Ages, although goblets are far more common than flat dishes. Even in the fourteenth century, such embossed designs were applied around the rim of a vessel, but in the second half of the fifteenth century they increasingly cover an entire piece. Since a number of goblets with bossed decoration bear Nuremberg markings, and since these forms are highly evident in Dürer's designs for goldsmiths' work, some scholars have gone so far as to attribute all such vessels to Nuremberg craftsmen. Although it is true that this type of ornament was of major importance in Nuremberg, it is also found on goblets and on bowls made elsewhere, at an early date.

Beginning in the second half of the fifteenth century, silver dishes — some with and others without a foot — increased in popularity. They were used to serve sweets, which were so highly prized in the Late Middle Ages and were consumed in great quantities during and after meals. Some of these delicacies were produced by confectioners' shops, but quite a number of them were concocted by apothecaries. In the fourteenth century, small bowls without feet were also used as drinking vessels: Some of these older drinking bowls contain a tiny hillock in the center — in a different color, or possibly enameled — topped by a stag (Fritz, 1982, ill. 383). This motif became especially prevalent in candy dishes dating from about 1500. No fewer than three of these exist, in the municipal silver collection that belonged to the Lüneburg city council, now in the Kunstgewerbemuseum, in Berlin (Pechstein, 1971, nos. 19–20, ill.; Fritz, 1982, ills. 656, 854). A richly bossed, flat confection dish, with a Munich mark, from the early sixteenth century, likewise with such a stag, is preserved in the Victoria and Albert Museum, London.

This embossed bowl is in the same form as gilded-silver examples of the period, even though it is made of copper. In Nuremberg, as in most other cities, goldsmiths were categorically forbidden to work in copper — and, especially, to gild and silver copper vessels, so as to prevent deception. Even so, there were exceptions: It was permissible to produce liturgical objects of copper for especially poor churches,

although these works were then gilded. As for secular vessels, it was occasionally the rule that, if they were of copper, they might be only partially gilded. In fifteenth-century Nuremberg, the Lindenasts seem to have been the only craftsmen who made copper objects after goldsmiths' designs. Kunz Lindenast, who became a citizen in 1455, was given permission to produce gilded-copper wares; however, only a short time later, in 1464, a relative of his, Hans Lindenast, was forbidden to do so. At the end of the century, the council agreed to allow the gilding of copper vessels in imitation of the work of goldsmiths, but only on condition that a section of the copper be left exposed, so that anyone could immediately recognize the inferior metal. Sebastian Lindenast the Elder (about 1460–1526) even received an imperial privilege for this purpose from Emperor Maximilian in Brussels, in 1513 (Fries, 1932–33, pp. 78–80). Several works by him are known, among them, the copper figures that he made, from 1506 to 1509, for the mechanical clock on the Frauenkirche, some originals of which survive (Stafski, 1950, pp. 38–43). It is possible to gain an idea of the scope of his production from the inventory made at his death in 1526. There,

we read of silver-plated busts (probably reliquaries), a silver-plated panel depicting the fourteen helpers in need, and three small gilded "panels with the Life of Our Lady" and one "with a cross and the Mount of Olives." In addition, there is mention of "all kinds of vessels as though chased in gold or silver," tankards, confection dishes, silvered basins and plates, gilded goblets, monstrances, patens, and various kinds of silvered altar candelabra (Fries, 1932–33, p. 79).

Since there were no other Nuremberg craftsmen who produced goldsmiths' designs in copper, it is assumed that the present small confection dish was made in the workshop of Sebastian Lindenast — even though it does not have the prescribed penny-sized section of copper showing through the gilding. RK

BIBLIOGRAPHY: Kohlhaussen, 1968, pp. 287, 304, no. 348, ill. 466.

80 Double Goblet

Nuremberg, about 1500
Silver, embossed, cast, engraved, and gilded
Height, 14 5/8 in. (37.2 cm.); cups, each, 7 7/8 in. (20 cm.)
The goblet bears a Nuremberg mark, a reversed "N" (Rosenberg, vol. 3, no. 3687).
Nuremberg, Germanisches Nationalmuseum (acquired, 1932)
615 A/B

This object consists of two, nearly identical bossed goblets, each attached to a seven-lobed foot with a deep molding and seven bosses. The shafts and the cups are twisted, and both cups have three rows of bosses. Between the shafts and the bases of the cups are circlets of bent wire. The vertical rim of the slightly larger bottom goblet has an engraved frieze of Gothic foliage; the corresponding element on the smaller goblet has been left plain.

According to Kohlhaussen (1968, p. 296), the bossed vessel is one of "the most characteristic forms created in the waning Middle Ages." Although such objects were made elsewhere, even earlier, the form took on a special importance in Nuremberg. Not only did other cities tend to

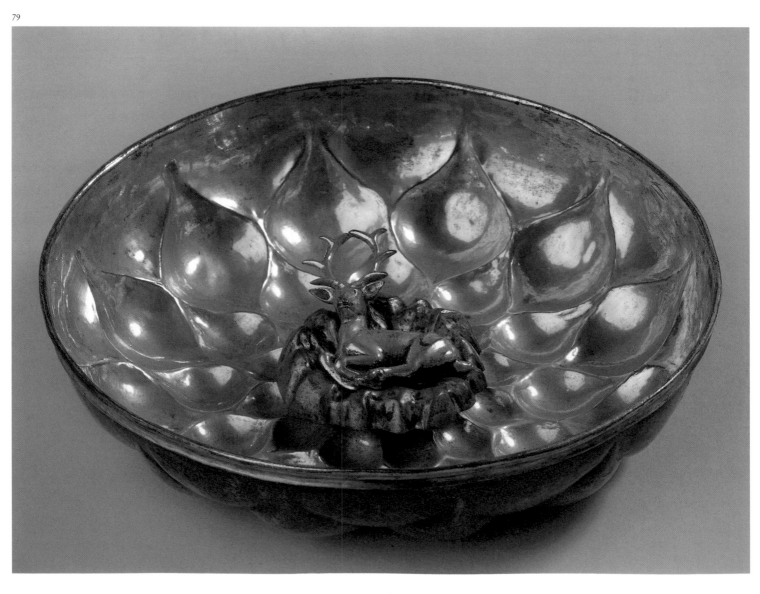

emulate Nuremberg, but, for special reasons, from the first appearance of such showy goblets, an extraordinary number were produced in that city, over a long period of time. When, in 1919, Otto von Falke observed that Nuremberg goldsmiths were making double goblets that were Neo-Gothic in form about 1600, he failed to recognize that there are double goblets that are Gothic in form from every decade of the sixteenth century — even some made by as great a master as Wenzel Jamnitzer, in 1562. Kohlhaussen convincingly dated the present one about 1500, pointing out quite closely related examples in Zwolle, The Netherlands; Leipzig; and Moscow (Fritz, 1982, ills. 864–865, 867).

This type of double cup is linked to several Nuremberg traditions. First, beginning in the fifteenth century — and possibly as early as the late fourteenth century — a bossed double goblet was the standard gift with which the city council honored an emperor or a new king on his first visit to the city. Accordingly, a bossed double goblet is painted on the cover of the council's gift registry, from 1494, which catalogues the presentation of countless examples of the genre. Moreover, from the fifteenth to the seventeenth century, one half of a double cup — a columbine cup — was one of three qualifying objects required of an aspiring master goldsmith. Lastly, it appears that, in the later sixteenth century, the double goblet became a traditional wedding gift exchanged among the city's leading families, for many of these vessels bear the coats of arms of Nuremberg patricians. It is possible that this presentation piece was among the silver that belonged to the Nuremberg city council. The medallions of King Adolf and Queen Marie Eleonore of Sweden set into the bases of the two goblets suggest the occasion marked by the council's presentation of the goblet in 1632. K P

Ex collections: A. Pickert, Nuremberg; private collection, Nuremberg.

Bibliography: Kohlhaussen, 1968, no. 357, ill. 471; Pechstein, in *Wenzel Jamnitzer...*, 1985, p. 210, no. 2, ill.

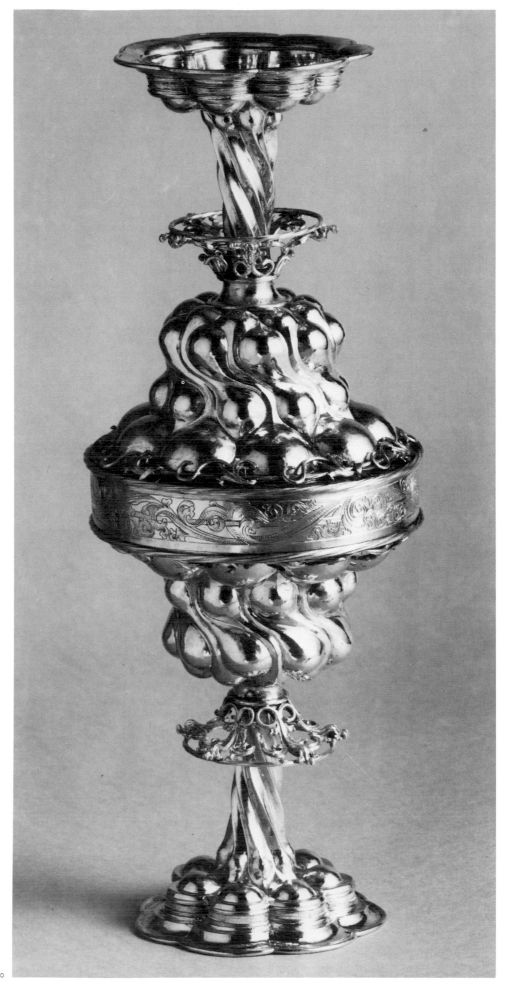

80

81 Schlüsselfelder Ship

Nuremberg, 1503

Silver, partially gilded, cast, embossed, and engraved; some of the 74 small cast figures are painted; the coat of arms on the burgee, atop the foremast, is enameled

Height, 31 1/$_4$ in. (79 cm.); maximum width, 17 1/$_4$ in. (43.5 cm.); weight, 5.935 kilograms; capacity of the hull of the ship, when used as a drinking vessel, 2.33 liters

Case: covered with several pieces of blackened leather, and lined with red leather and red velvet. On the front are carved and raised vines against a punched, beaded ground; on the back is a simple diagonal grid with random blind stamping

Height, 32 1/$_4$ in. (81.5 cm.)

The Nuremberg mark, a reversed "N" (Rosenberg, vol. 3, no. 3687), appears on the swelling foresail. There are no master's marks.

Nuremberg, Germanisches Nationalmuseum (on loan from the Schlüsselfeldersche Familienstiftung since 1875)

HG 2 146 (ship), HG 2 147 (case)

Although Wilhelm Schlüsselfelder (1483–1549) was the first documented owner of the silver ship, it is not known for whom, or under what circumstances it was executed. Since the case bears the date 1503, the ship must have been completed in 1502 or 1503, at the latest. Wilhelm Schlüsselfelder's father had died in 1493, and, in 1502, he was only nineteen years old, himself, so that it is unlikely that either of these men would have commissioned the work, although the young Schlüsselfelder had a considerable fortune. Heinrich Kohlhaussen proposed that the ship might have been commissioned by Wilhelm's wealthy uncle Matthäus Landauer (died 1515), who left a generous provision for his nephew in his will, and named him lifetime trustee of the Landauer Zwölfbrüderhaus, which he had founded.

The goldsmith who created the ship also remains unidentified. Kohlhaussen first advanced the idea that he may have been Albrecht Dürer the Elder, who was born in 1423 and died on September 20, 1502. The goldsmith must have been a respected one, but although much archival information about him exists (see Gümbel, 1915), no known work by him has come down to us. The presence of certain conservative features marks the work as that of an older master still rooted in the Late Gothic tradition. However, this is by no means enough to ascribe the object with any certainty, given the limited knowledge of the personal idiosyncracies of the goldsmiths active about 1500 — the greater number of them, in Nuremberg — and, especially, the fact that we are forced to deal with what is surely only a small fraction of their output. A double-tailed mermaid, who supports a large, three-masted sailing ship with her head and her raised hands, sits on a richly bossed base. Although the mermaid is cast, the body of the ship is embossed, its hull made up of four planks, on each side of which is a boarding hatch. The rudder actually turns, and the anchor and grappling iron hang down on either side. The dragon that

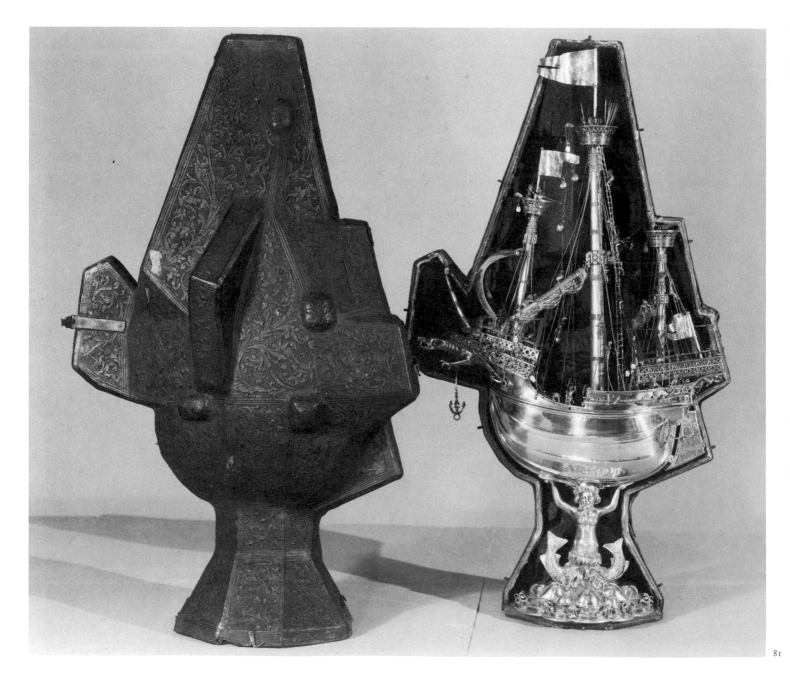

81

224

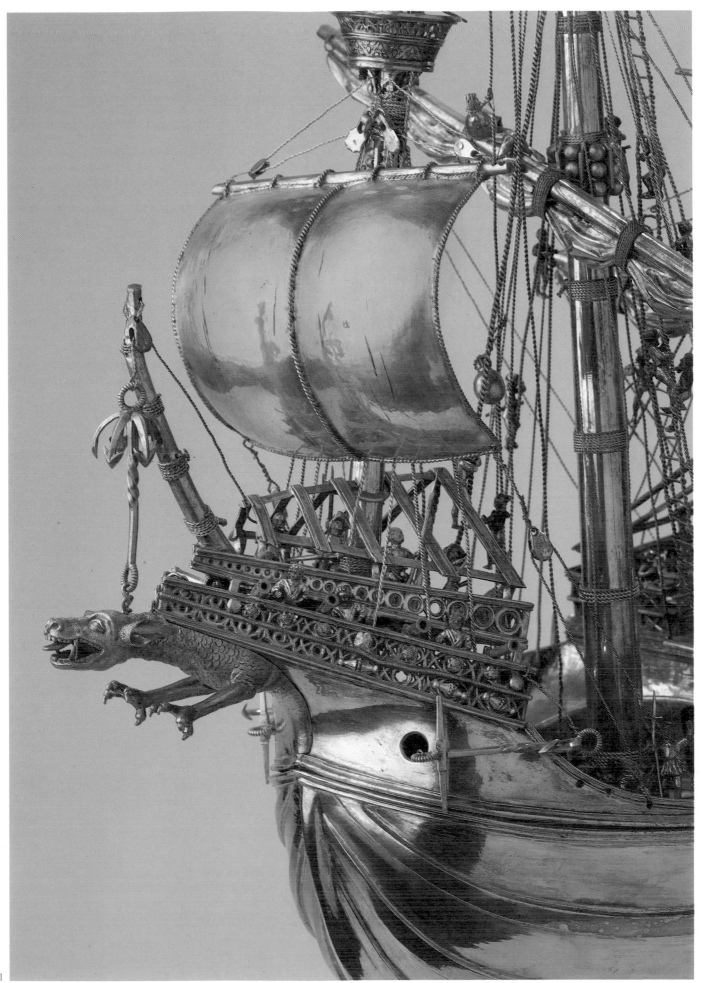

81 : detail

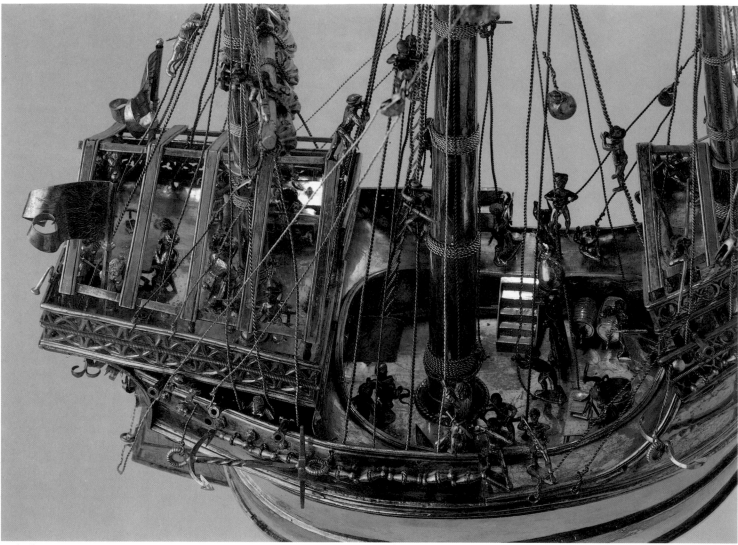

81 : detail

serves as a figurehead on the prow is especially beautiful. The foresail is inflated, the two sails behind it, furled. Each of the three masts supports a crow's nest peopled with armed sailors. Two burgees flutter in the wind above, and two small flags are affixed to the superstructure of the stern, all having engraved images of saints, and the foremost one also bearing the enameled Schlüsselfelder coat of arms. Sailors climb up and down the rope ladder against the mainmast, raising or lowering huge sacks as ballast. Both the superstructures of the prow and the stern, as well as that of the middle of the ship, are teeming with sailors and passengers. Altogether, there are seventy-four figures. In addition to the sailors who man the ubiquitous cannons, there are people eating and drinking; a cook; a washerwoman, bent over her tub; a pair of lovers embracing; a fool; two monks — one reading, the other meditating; drummers and pipers on the afterdeck, beneath the framework of lattice; two cardplayers; and the captain's station, identified by a folding sundial. Clearly, not all of the tiny cast and painted figures have survived.

Historians of shipbuilding have affirmed that the ship created by the goldsmith is a carrack, a seaworthy galleon and typical merchant vessel of the period, used in the Netherlands. The numerous cannon do not make the vessel any less a merchant ship, nor do they identify it as a warship; the heavy armor was necessary to protect cargo and passengers. An engraving by the Master W, with the housemark ⚓, pictures quite a similar ship with a rounded hull, three masts with crow's nests, similar superstructures of lattice on the prow and the stern, a dragon as its figurehead, the grappling iron, and countless other identical details (Oman, 1963, ill. 15). The goldsmith must either have had access to illustrations and descriptions, or gained his detailed knowledge from his own experiences.

The silver ship was conceived as a table ornament and a drinking vessel. The entire superstructure, with its masts and figures, lifts off like a lid, permitting the hull to be filled with wine. In an inscription on a colored drawing (in the Kunstbibliothek, Berlin) of the vessel made in the sixteenth century, once in the possession of the Hamburg goldsmith Jakob Mores (died 1610), this feature is emphasized: "The silvergilt ship weighs 26 marks. When you remove the upper part, the lower section becomes a drinking vessel that holds two measures of drink" (see Kohlhaussen, 1968, ill. 405).

This silver ship is in the tradition of those mentioned as wine vessels in French poetry as early as the fourteenth century. They also served as table ornaments in which the owner's cutlery, salt, spices, or even substances used to detect poison, could be stored. Silver ships also were sometimes made as reliquaries or as votive offerings commemorating rescues at sea. In 1963, Charles Oman compiled an inventory of the surviving medieval silver ships and of corresponding illustrations, which were largely French miniatures.

In addition to the *Schlüsselfelder Ship*, another very similar, although somewhat smaller, silver ship was made in Nuremberg. The latter example, in the treasury of Sant'Antonio, in Padua, probably was made as an ex-voto. It has generally been thought to be older than the Schlüsselfelder vessel, but better photographs of it, recently published, suggest that it is a copy (Fusi, 1977, pl. 10). Two other vessels, once part of the Halle treasury of Cardinal Albrecht von Brandenburg, only survive as drawings (Halm and Berliner, 1931, no. 286, pl. 176, no. 247, pl. 133). It is not certain whether they were made in Nuremberg.

Although minor losses to the rigging and the original complement of figures have occurred over the centuries, the fragile and complex

Schlüsselfelder Ship is extremely well preserved. This is due in part to the high regard documented as having been lavished on it by the Schlüsselfelder family, but, even more, to the superb case with which it was provided, from the outset. The maker of the case managed to create supports for the dragon figurehead, the mast and sails, the flying burgees, and for countless other projecting details. The case thus not only serves its function as protector of the vessel, but is an abstract form that also presents the negative imprint of the ship, thereby exhibiting an aesthetic charm all its own. R K

EX COLLECTIONS: willed by Wilhelm Schlüsselfelder (1483–1549) to his seven sons, who drew lots for it (1567); Endres Schlüsselfelder, Augsburg (1567); Andreas Wilhelm Schlüsselfelder, Nuremberg (17th century); following the death of Andreas Wilhelm, and the subsequent demise of the family in 1672, the ship became part of the Schlüsselfelder Familienstiftung, and was placed in the so-called Nassauerhaus, near the Lorenzkirche, in Nuremberg.

BIBLIOGRAPHY: Lessing, 1888, p. 384, ill.; Havard, 1896, p. 316, ill.; Lüer and Creutz, 1909, p. 343, ill. 305; Rosenberg, 1922–28, vol. 3, no. 3705; Oman, 1963, pp. 18–19, 21, 24, pl. XV–XVII; Hinderer, 1964, pp. 372–77, 416–19, 458–66, ill.; Gall, 1965, pp. 132–34, ill. 98 (on the case); Fritz, 1966, pp. 183, 564, no. 854, ills. 159, 365; Kohlhaussen, 1968, no. 338, ills. 406–412, 414–418, p. 561 (index), 1970, p. XXX, ills. 28–29; Schiedlausky, in *Dürer*, Nuremberg, 1971, no. 660; Steingräber, 1972, p. 323, no. 305, ill. 305; Fusi, 1977, pp. 89–90, 95, pl. 9; Hernmarck, 1978, p. 165, ill. 393; Fritz, 1982, p. 184, no. XV, colorpl. XV; Huard, 1982, ills. 1–2; Schiedlausky, in *Wenzel Jamnitzer...*, 1985, fig. 94, p. 125, no. 1, colorpl. 1.

82 Widerholt Goblet

Nuremberg (?), 1510
Embossed silver, gilded inside and out, the foliage turned with pliers, the coat of arms enameled
Height, 13 3/16 in. (33.5 cm.); weight, 1.232 kg.
There are no markings.
Kirchheim unter Teck, Rathaus

The completely smooth, egg-shaped vessel is supported by three twisting branches that issue from the molding ringing the base of the foot and appear to be gathered in at the middle by a twisted silver cord. Five small, lancet-shaped, serrated leaves cradle the base of the cup. Twisting vines grow out of the branches and fill the spaces between them, but without compromising the openwork of the foot. The bark on the branches is reproduced with great naturalism by means of careful chasing. On the relatively flat lid, a pair of lions stand upon a nest of similar foliage and support a shield displaying the double-headed eagle of the Holy Roman Emperor. A small inescutcheon superimposed upon the shield bears the coat of arms of the duchies of Austria and Burgundy — the arms of Emperor Maximilian I, who, through his marriage to Mary of Burgundy, the daughter and heiress of Charles the Bold, had assumed the title of duke of Burgundy. Engraved on the back of the

82

82 : detail

shield is the date 1510. In 1650, the Maximilian coat of arms was covered over with the arms of Conrad Widerholt, who owned the goblet at that time: a passant ram with the initials "c.w.v.v.z.n." (Conrad Widerholt von und zu Neidlingen). The illustration shows the original imperial arms.

The inside of the lid resembles a five-part vault with a pendant finial hiding the screw that secures the ornament. The cup, itself, whose capacity is 1.8 liters (about two quarts), has a double bottom. The screw that secures the vessel to its tracery foot does not pierce the inner wall.

Since there are many goblets and other vessels with smooth sides and a pierced foot with vine decoration in the works of Dürer — for example, the candelabrum from the *Apocalypse*, and the goblet held by Nemesis (see cat. no. 114) — the *Widerholt Goblet* has been regarded as the earliest work from a group of Nuremberg vessels that also includes the cup in the form of an apple (cat. no. 208). A number of somewhat later Nuremberg objects, whose openwork bases are ornamented with vines and leaves, have survived — or, at least, are known from illustrations. Of those preserved, the one whose branches and foliage are most similar is the covered goblet with a chrysoprase bowl (in the Iparmüvészeti Múzeum, Budapest), which, likewise, is without any mark. Johann Michael Fritz has recently expressed doubts about the attribution of the *Widerholt Goblet* to Nuremberg, inasmuch as similar vessels are also found elsewhere — in Antwerp, for example. It is true that the *Widerholt Goblet*, with its uncommonly precise and high-quality workmanship, even in the details, is distinguished from the typical Nuremberg objects associated with the Krug workshop by a certain severity and symmetry in the formation of the vines, and by a sharper contrast between the smooth egg shape and the supporting foliage. Normally, the foliage is more tangled, more irregular, and appears to be growing wild, and the overall design does not generally exhibit the precision and calculated austerity of the *Widerholt Goblet*. It is certainly not impossible that Maximilian purchased the vessel, or received it as a gift in the course of his travels. RK

Ex collections: Emperor Maximilian I; Conrad Widerholt von und zu Neidlingen, chief bailiff of Kirchheim (about 1650); given, along with the Widerholt estate, to the city of Kirchheim (1697).

Bibliography: *Kunst-Denkmale: Kirchheim*, 1921, p. 63, ill. 76; von Falke, 1933, p. 194, ill. 8; Kohlhaussen, 1968, no. 389, ills. 530–533; *Maximilian I*, 1969, no. 589, ill. 128; Schiedlausky, in *Dürer*, Nuremberg, 1971, no. 670; Mende, in *Dürer*, Brussels, 1977, p. 34, no. 38; Schramm and Fillitz, 1978, p. 96, no. 157, ill. 157; Fritz, 1982, pp. 305–6, no. 861, ill. 861.

83

83 Girdle Book of Hieronymus Kress

Nuremberg, 1471
Deerskin, with cast and engraved brass fittings, and blue and red parchment backing
Binding: 5⁵/16 x 4¹/8 in. (13.5 x 10.5 cm.); length of pouch with carrying knot, 9¹¹/16 in. (24 cm.)
The carrying knot is made up of woven leather strips. There are 311 parchment leaves, and 3 colored and gilded paste prints on paper, depicting Saints Jerome and John the Baptist, and the Feast of Pentecost (partially destroyed).
Inscribed with the name of the owner, and dated: Ieronymus Kress 1471.
Nuremberg, Germanisches Nationalmuseum (presented by the heirs of the Kress family, September 17, 1861)
Hs 17231

The Kress *Girdle Book*, containing a breviary written on parchment and dated 1471, is protected at each corner by a richly tooled brass fitting in the form of a pointed rhombus, with an openwork tracery design. The round center shield, pierced, like those at the corners, is surrounded by four cruciform leaf tips. The brass clasps ornamented with quatrefoil designs are backed with blue parchment; they are also engraved, and bear the sword coat of arms, backed with red parchment, of the patrician Kress family.

Girdle books generally were small. On top of a book's regular leather binding a second sheath of leather was provided, this one attached only to the top edges and extending well beyond the bottom to where it was gathered into a knot or a hook. The resulting pouch, usually as long as two books, could easily be carried in the hand or attached to one's belt. Occasionally, there was no knot, and the loose end of the pouch was simply tucked under a belt.

Girdle books are known from representations in art as early as the fourteenth century. Clearly, it was at that time that it became customary to bind frequently used books in this manner. During the fifteenth and sixteenth centuries, this convenient way of carrying books must have become common in much of Europe, for there are countless depictions of girdle books in the art of this period. Even so, only a very few examples appear to have survived. Possibly, this is because the majority of girdle books contained texts for daily use that, consequently, would wear out. A number of pouches must also have been cut away once the books came into the possession of libraries, as the extra leather only made them difficult to shelve. As a rule, the surviving girdle books, which tended to be prayer books and breviaries, are without any notable artistic embellishment. The present girdle book, which once belonged to Nuremberg's mayor Hieronymus Kress (1413–1477), is an exception. OL

Ex collection: Hieronymus Kress, Nuremberg.

Bibliography: Essenwein, 1889, no. 9; Glanning, 1926, no. 12; Loubier, 1926, pp. 93–95; Kohlhaussen, 1968, no. 191, 1970, no. 92; Hilg, 1983, pp. 110–11.

sulted in a generally heightened consciousness of legal matters, in this period.

The design for the title page is probably an early work by Michael Wolgemut. It shows the coats of arms of the city of Nuremberg beneath a Late Gothic canopy flanked by statues of Sebald and Lawrence, the patron saints of the city's two great parish churches. Nuremberg had two coats of arms, and, beginning in 1481, these were frequently combined with the imperial coat of arms to form a heraldic triad. The double-headed imperial eagle — here, augmented by the crown of the empire — indicates the city's special status as a subject solely of the empire, and, in the context of this legal reform, also reaffirms the superiority of imperial jurisdiction. Beneath it, the *Königskopfadler* (the eagle with the head of a king), the city's greater coat of arms, appears on the right (heraldically speaking), and is thus given priority over the second one. The lesser municipal coat of arms consists of a split shield with a half-eagle on the right and five diagonal bars ("bends") on the left.

The title page is a typical example of the Late Gothic, decorative woodcut style of the generation before Dürer — one that developed primarily in the service of book illustration. In addition to the heavy outlines that describe the figures and their features, numerous parallel hatchings are employed to indicate areas of shadow. Despite this initial development of a refined graphic idiom, coloring was still considered an indispensable element of a woodcut print.

RS

BIBLIOGRAPHY: Hain, 1826–38, no. 13 716; Stadler, 1913, p. 67, pl. 17; Schramm, 1920–43, vol. XVII, no. 46; Schaffer, 1937, pp. 179–80; *Fifteenth Century Woodcuts and Metalcuts from the National Gallery of Art*, 1965, no. 243; *Dürer*, Nuremberg, 1971, no. 231.

84

84 ATTRIBUTED TO MICHAEL WOLGEMUT
Saints Sebald and Lawrence with the Coats of Arms of the Imperial City of Nuremberg
1484
Colored woodcut, title page for the *Newe Reformacion der Stat Nureberg . . .*, published in Nuremberg by Anton Koberger on June 5, 1484
10 1/4 x 7 1/8 in. (26.3 x 18 cm.)
Nuremberg, Germanisches Nationalmuseum
Inc. 4° 5086

The *Reformation of the City of Nuremberg* was the first municipal code of law to be printed in Germany. It had been developed by a commission made up of members of the council and legal scholars in 1479, and was then produced in book form by Anton Koberger in 1484. The new code brought various aspects of civil and criminal law into line with Roman law, and clarified a number of legal ambiguities that had arisen as a result of economic and social changes. Although the intention was not to create a systematic reformulation of the law, the commission nevertheless made a major contribution toward the gradual introduction of Roman law into Germany, and its example was followed by numerous other cities. Expanded versions of the *Reformacion* were printed by Johann Schönsperger in Augsburg in 1498, by Hieronymus Höltzel in Nuremberg in 1503, and by Friedrich Peypus in Nuremberg in 1522. The public circulation of codes of law, made possible by the advent of printed books, re-

The Crucifixion

1484
Colored woodcut, with watercolor, body color,
and gold leaf, on parchment
11 1/2 x 7 1/4 in. (29.3 x 18.4 cm.)
Nuremberg, Germanisches Nationalmuseum
H 7485

This richly colored woodcut, adorned with gold leaf on the haloes, offers a traditional representation of the Crucifixion, with the Virgin and Saint John as participants. The stocky figures are placed against a background painted with blue body color, without any suggestion of landscape. Compared with other contemporary woodcuts of the Crucifixion, however, the print shows an astonishing wealth of detail: On the knoll at the base, separate leaves, blades of grass, and flowers are carefully reproduced, and the cross is intricately grained. An attempt has been made to give a three-dimensional look to the draperies worn by the figures. Between the strong lines of the larger folds there is rather schematic hatching, at times producing a herringbone effect. Obviously, the artist was conscious of the increasing contradiction between such fine detail and the still-prevalent use of flat color; therefore, contrary to the custom of illuminators, the Virgin's mantle was left uncolored.

The print, made the same year as the woodcut for the title page of the *Reformacion der Stat Nureberg* (cat. no. 84), is thought to be one of Wolgemut's earliest woodcuts. Wolgemut was the first painter to devote himself to the making of woodcuts for books. There are undeniable similarities between this work and his panel of the Crucifixion from the *Rayl Epitaph,* made for the Lorenzkirche (cat. no. 42).

Missals had been adorned with depictions of the Crucifixion since the eighth century. As allusions to the Eucharist, they preceded the Canon of the Mass. This tradition continued even as Missals increasingly came to be produced on printing presses after the 1460s. The present woodcut, printed by Anton Koberger in 1484, was executed for the *Missale Striegoniense* (Striegau Missal). The conservative composition, the rich coloring reminiscent of miniature painting, and the fact that the woodcut was printed on parchment are all explained by the tradition of manuscript Missals.

Woodcut Canon pictures, because they were printed on single sheets of parchment and often used as illustrations in various Missals, represent a unique transitional form between the single-sheet woodcut and book illustration.

RS

BIBLIOGRAPHY: Hain, 1826–28, no. 11429; Schreiber, 1891–1910, no. 4763; Stadler, 1913; Schramm, 1920–43, 17, pl. 45; *Dürer,* Nuremberg, 1971, no. 106.

85

86 ATTRIBUTED TO MICHAEL WOLGEMUT and
WILHELM PLEYDENWURFF (woodcuts)
ANTON KOBERGER (printer)

Schatzbehalter oder Schrein der waren
reichtuemer des heils vnnd ewyger
seligkeit (Treasury or Cabinet of the True
Gems of Salvation and Eternal Bliss)

1491
Printed book, with woodcut illustrations
New York, The Metropolitan Museum of Art,
Rogers Fund, 1919
19.49.4

The *Schatzbehalter* is an edifying religious text written for laymen. Its abundant illustrations allowed even the illiterate to understand the book's content. Consisting primarily of a catalogue of Christ's suffering as a means toward mystical contemplation of the sources of mankind's salvation, its ninety-one woodcuts illustrate scenes from the Old and New Testaments, as well as allegorical subjects with theological content.

The woodcut labeled "Die vierd figur." ("the fourth picture") combines two Old Testament

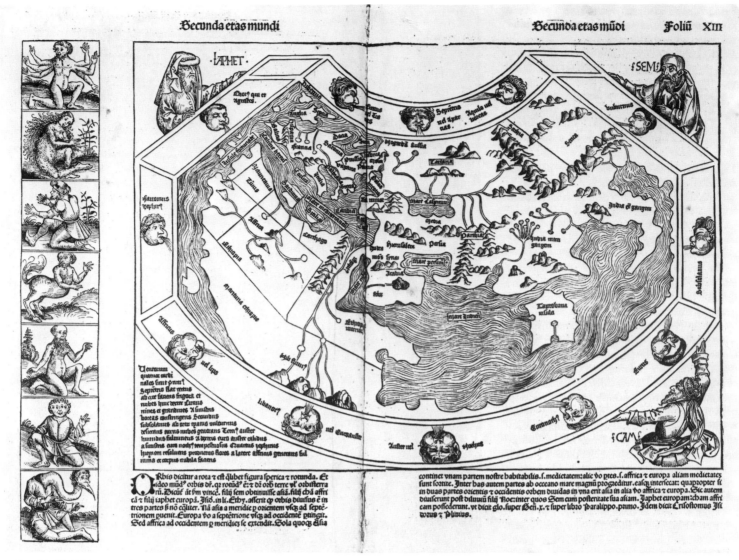

87: *Map of the World,* fols. XII *v.* and XIII *r.*

preliminary study for the title page survives in the form of a pen drawing, from 1490 (in the British Museum, London), of the Creator enthroned, which, except for minor changes, corresponds to the finished woodcut. The framing motif is reminiscent of the title page of Breydenbach's *Reise in das Heilige Land,* which was illustrated by Erhard Reuwich in 1486.

Despite all that is known about the making of the *Chronicle,* it is not possible to determine — any more than it is for the earlier *Schatzbehalter* (cat. no. 86) — which illustrator was responsible for which woodcuts. Nor is it known how many assistants worked on the project with Michael Wolgemut and Wilhelm Pleydenwurff, or whether Albrecht Dürer, who was apprenticed in Wolgemut's workshop between 1486 and 1489/90, had anything to do with the *Chronicle* illustrations.

Schedel's corrected manuscripts for both the Latin and the German editions survive (in the Stadtbibliothek, Nuremberg; Cent. II, 98, 99), and, presumably, these were used in the typesetting. The arrangement of the columns of text corresponds to that of the printed pages. In place of woodcuts there are pen-and-ink sketch-

es that largely resemble the finished illustrations in their compositions, but reveal countless differences in details. There are considerable discrepancies between the pen-and-ink drawing of the *Dance around the Golden Calf* (fig. 124) in the Latin manuscript and the woodcut in the Latin edition. In the manuscript, the tribes are moving past the idol, while, in the woodcut, they are dancing in a circle around its base. The trumpeters in the middle of the drawing disappear to permit the central placement of the Golden Calf, with the landscape appropriately split into two halves in the background. This later composition, with the two mountains and the idol in the center, appears in the quick sketch in the German manuscript (Cent. II, 99, folio XXXI *r.*).

The *Chronicle* is especially enriched by the inclusion of the numerous city panoramas, which were something new in the illustrations of world chronicles. These views, depicting biblical sites, cathedral cities, and, primarily, cities in southern Germany, southern Europe, and Italy, are presented in bird's-eye perspective, and often are double-page spreads. Some are pure fantasy substituting for actual loca-

tions; others portray landmark buildings in authentic settings. The view of Nuremberg (fig. 111) was drawn from the south. Visible is the dominating castle hill and the two main churches, Sankt Lorenz and Sankt Sebald. The increased interest in geography and cosmography since the mid-fifteenth century is also evident in the map of Germany by the cosmographer Hieronymus Münzer, probably the first map of Central Europe to appear in print.

This most profusely illustrated work from the early years of the printed book was to fascinate readers for centuries as a result of its highly developed, painterly woodcuts. Yet, it is clear that it was not regarded as an adequate reflection of the state of humanistic knowledge at the close of the fifteenth century, for, only four months after its publication, a contract was drawn up between Sebald Schreyer and Conrad Celtis, engaging Celtis to revise the text. The project, however, was never realized. OL

BIBLIOGRAPHY: Stadler, 1913, pp. 28–66; Sladeczek, 1955; Bellm, 1959, pp. 44–61; Wilson, 1969; Wilckens, in *Dürer,* Nuremberg, 1971, no. 117; Rücker, 1973; Pörtner, 1978; Smith, 1983, no. 3.

87:
God the Father Enthroned,
title page, fol. 1 *v*.

88 PUPIL OF VEIT STOSS
The Baptism of Christ

Cracow, about 1480/90

Linden(?)-wood relief; composed of two boards
47⁷/₈ x 39³/₁₆ in. (120.6 x 99.6 cm.)
The joint between the boards originally was
masked on the front and back with strips of canvas.
A narrow band of wood has been attached along
the right; the lower section, like the left side, has
been covered with parchment or linen. A small
section of the right wing of the angel and Christ's
left elbow have been glued back in place. The knot
of the loincloth was carved from a separate piece of
wood and affixed below its present position with a
nail that still survives, its point bent back against
the reverse side of the sculpture. The only losses
are the tip of John's left thumb and the middle
clasp of the book. The edges of the relief are the
original ones; at most, a small area of the cliff has
been cut away at the top. A modern strip of wood
was added at the bottom to make the sculpture
stand more securely. Portions of the original
polychromy survive, the flesh tones more than the
others. The gilding of the angel's upper body pos-
sibly is old, but that of Christ's loincloth, at least,
has been largely restored. All but the original bor-

der of Christ's robe — which is held by the angel
and, initially, was probably white — now reveals
the gesso undercoating; it has been painted over
with modern gold lacquer. Saint John's book and
the lining of the angel's sleeve are the original red.
The remaining areas of the relief, especially the
brownish background of the cliffs, have lost their
original polychromy — as have the angel's wings,
which were once gilded. On the Baptist's fur robe
there are only traces of gesso. The upper parts of
the angel's wings seem to have been recarved, but
this is not a certainty; in any case, the feathers of
the wings are uncharacteristically crude and
schematic in form.

New York, The Metropolitan Museum of Art,
Rogers Fund, 1912
12.130.1

The exact origin of the relief is unknown. It
must have belonged to an altarpiece, whose
appearance is difficult to reconstruct. The relief
would have been affixed to a wooden panel en-
closed in a frame. Pictorial tradition would sug-
gest that the half-length figure of God the
Father and the dove of the Holy Spirit at one
time probably appeared in the sky above the

surviving figures. Also, crowning the whole,
there undoubtedly was a tracery canopy. One
can, therefore, estimate the original height of
the relief to have been between 59¹/₁₆ and 63
inches (150 and 160 centimeters), the width,
about 39 inches (100 centimeters). This vertical
format makes clear that the relief could not have
been the center of a small altarpiece, although,
iconographically, it was common for the Bap-
tism of Christ to occupy the middle section of
altarpieces dedicated to Saint John the Baptist,
inasmuch as this was the central event in his life.
Most likely, it was found on the interior of an
altarpiece wing, with the shrine possibly con-
taining standing figures of saints — among them,
John the Baptist, and perhaps the Virgin and
Saint John the Evangelist. The proportions of
the relief also preclude the possibility that it was
but one of several that constituted the wing of
the altarpiece. Composite wings of Late Gothic
altarpieces normally incorporated reliefs that
were either horizontal or square. For that
reason, it must be assumed that the present re-
lief was the sole component of the wing. If we
accept the fact that the composition of the carv-
ing took into account its placement in the altar-
piece — which is by no means certain, given the
sculptor's rather unimpressive compositional
skills — it would seem the most plausible that
the relief formed the right-hand wing, for the
tall, squarish figure of the angel holding Christ's
garments functions as a kind of frame, or brack-
et, that could be imagined as marking the
boundary of the open altarpiece. The other
wing, logically, would have depicted the birth
of John the Baptist. If, in fact, the surviving
relief formed the left-hand wing, after all, the
right-hand wing may have represented his mar-
tyrdom.

The composition of the relief follows an en-
graving by Martin Schongauer (Lehrs, no. 8),
which, in turn, was based on a composition by
the Master E.S. (Lehrs, nos. 28, 29). It was
copied in an Augsburg woodcut that is dated
1485, and, therefore, must have been created
about 1480 (Flack, p. 95, ill. 113). Schongauer's
engraving would have appealed uncommonly to
the taste of the time, just as his other engravings,
to an unprecedented degree, inspired the art of
the Late Gothic period (Thöllden, 1938). In any
case, his engraving of the Baptism of Christ was
imitated in countless paintings and reliefs
throughout Germany and the neighboring
countries from the 1480s until well into the sec-
ond decade of the sixteenth century — in some
instances copied directly; in others, subjected to
variation. It is correct to say that the majority of
portrayals of the Baptism of Christ in the
following decades adopted the Schongauer
composition, while a second version, deriving
from Netherlandish painting — Rogier van der
Weyden's *Altarpiece of Saint John the Baptist*,
for example — is much less common. In this
alternate form, Christ stands frontally, at the
center of the composition, his feet in the river.
To his left is Saint John, either in profile or
turned away from the viewer, generally stand-
ing but sometimes kneeling, while, to his right,

is a small, kneeling angel holding his garments (see the painting by Wolf Traut, cat. no. 170). Works that parallel the New York relief — all of which are indebted to the Schongauer engraving — are, in addition to the Augsburg woodcut, of 1485, an altarpiece in Burghausen dated shortly after 1480 (Stange, 1934–35, vol. 10, ill. 178); the *Fridolfinger Altarpiece*, created in Salzburg about 1490 (Ramisch, 1964, ill. 144); a Saint John altarpiece, dated 1495, from the Dominican monastery in Bern, by the Bern Carnation Master (Wagner, 1977, pp. 25–39, ill.); and an altarpiece from the sixteenth century in the museum in Freiburg, Switzerland (Reiners, 1943, ill. 170). From Franconia, two works by the school of Tilman Riemenschneider deserve mention: the *Gerolzhofen Altarpiece*, of 1515, in the Bayerisches Nationalmuseum, Munich (Bier, 1957, p. 205, ill. 7; Müller, 1959, no. 149, ill.), and a relief, from about 1520, in the Universitätssammlung, Würzburg (Knapp, 1916–18, ill. 39). Especially close to the present relief is a wing from an altarpiece, painted by Wolf Traut, shortly after 1511, on the high altar of the Johanniskirche, in Nuremberg (*Meister um Albrecht Dürer*, 1960–61, no. 360). The composition appears, considerably varied, in the altarpiece on the high altar of the Stadtpfarrkirche, in Schwabach (*Veit Stoss...*, 1983, ill. 189), and is altered still further in the *Schnewlin Altarpiece*, from the workshop of Hans Baldung Grien, in Freiburg Cathedral (von der Osten, 1983, W 97a, pl. 189).

The carver of the New York relief took from Schongauer's engraving the basic arrangement of the figures: the kneeling Saint John; Christ standing in the water, somewhat below, and wearing a long, flowing loincloth; and the angel standing at the right, holding Christ's robe. Here, too, the half-length figure of God the Father and the dove of the Holy Spirit surely hovered above — as in all of the parallel examples where the figures have not been lost (as they are in the *Gerolzhofen Altarpiece*). The sculptor also borrowed from the engraving the position of the Baptist's hand as he pours water over Christ without using any kind of dipper, but two fingers are raised so that Saint John appears to be making a gesture of benediction. (Only in the *Gerolzhofen Altarpiece* does the Baptist hold a shell, but, along with his entire forearm, it is a later restoration.) Schongauer's Saint John, too, leans his left hand on a book.

The changes in the composition have to do mainly with its qualitative elements. The landscape, which allowed the figures a certain amount of space in the engraving, has been simplified and the figures crowded closer together. The angel and the garment of Christ, which he holds, have become a single form, and the parallel position of Christ's arms has been strengthened. Although, clearly, the intention was to portray the Baptist kneeling, his pose is actually somewhere between kneeling and standing. His face is turned toward the viewer, away from the action, and his right hand, a distance from Christ's head, is raised in a didactic gesture. Christ's torso also has been twisted in an *en face*

position so as to avoid the difficult foreshortening of his right shoulder in the background. Just as the figures and drapery appear to be two dimensional and the gestures angular and somewhat monotonous, so do the large, open faces seem somewhat vacant and inexpressive.

Especially in the faces of Christ and the angel, the noticeable constriction of the outlines at the level of the eyes is startlingly similar to the faces in some of the reliefs on the altarpiece in Cracow: for example, to the head of Christ in the Easter scenes, and to the face of Eve in the relief of Limbo (Kępiński, 1981, pls. 31–36). Theodor Müller had noted such parallels in correspondence dating from 1963. There is nothing comparable in works of the Stoss shop from the Nuremberg period. Moreover, the compositional and sculptural imperfections of the New York relief clearly distinguish it from examples by Veit Stoss. The faces are devoid of emotion, with none of the pathos that Stoss was so fond of expressing, and the flow of the drapery is flat and fussy, rather than infused with violent movement. Between 1477 and 1489, Stoss employed numerous assistants to work on the altarpiece in Cracow, many of whom were incapable of attaining the artistic excellence of the master. Among these sculptors probably was the one responsible for the present relief.

R K

BIBLIOGRAPHY: Shestack, 1967–68, introd. (unpaginated), ill. 2.

89 VEIT STOSS
The Man of Sorrows and the Mourning Virgin, from the Volckamer Monument
1499
Oak; an added section of drapery, above the arm of the Virgin, is of linden wood
Height: of Christ, 78 3/4 in. (200 cm.); of the Virgin, 77 3/16 in. (196 cm.)
The figures are hollowed out at the back. No traces of polychromy remain, not even on the lips and the eyes — in contrast to the figures in the related stone relief. The fingers of Christ's left hand were restored in 1903–4, following the configuration of the fingers on the right hand. The toes of his advanced left foot have been restored, as have small areas of the figure of the Virgin, mostly along the edges of her mantle.
Nuremberg, Sebalduskirche

Like monumental stone sculptures of the thirteenth and fourteenth centuries, these over-life-size wooden figures of Christ and the Virgin stand on consoles, and beneath tall stone baldachins, forming an integral part of the architecture of the choir of the Sebalduskirche. Although now completely faded, they may once have been painted to look like stone, so as to match more closely the sequence of stone reliefs belonging to the same monument. Such treatment of wooden architectural sculpture is known in Nuremberg from the period about 1500. From their form, it is obvious that the two figures were conceived as monumental works.

Figure 125 The *Volckamer Monument*. Sebalduskirche, Nuremberg

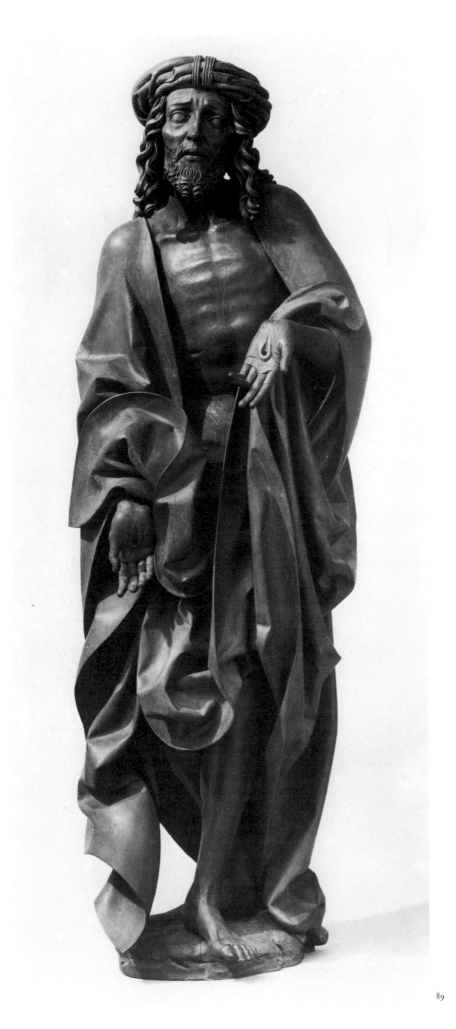

A limited number of large, simple, and impos-
ing motifs ensured their effectiveness when
viewed from a distance.

Christ is clothed only in the cloak that is
draped over his shoulders, leaving his chest ex-
posed. A corner of the cloak is bunched above
his left arm, so that his bare left leg is visible,
from the knee down. This leg is placed diago-
nally in front of the right one, the heel of the
foot turned inward against the direction of his
step in a manner typical of the period, causing
the figure to appear unstable. The right leg,
which must be the one supporting the figure,
has not been developed in detail, for, given the
height at which the statue was placed, it would
have been invisible in any case. At the front, the
drapery billows back in a series of large, arced
folds, an effect created solely to underscore the
impression of pathos — not of realism. Christ
has lifted the right hem of his cloak with his
right arm, but this is obscured by the large curve
of fabric above it, which, clearly, is part of the
left side of the garment. The hem lies across his
right wrist, then curves outward below the arm,
permitting a considerable creasing of the ex-
posed inner face of the cloth, then turns again
only to be lifted once more, as though by a puff
of air from below, before ending in a point. The
line of the left hem of the cloak is much more
complex. The edge that lies flat against Christ's
chest extends across the body at the level of the
stomach. It then describes a descending curve
before reversing its direction and billowing up-
ward, ending in the already mentioned corner
above the right arm. Quite independent of this,
Christ has raised the bottom hem of his appar-
ently rectangular cloak with his left arm, draw-
ing it up to the height of his chest, where it then
falls in a tight fold from his wrist. Since the
raised cloth is turned back on itself in the proc-
ess, the large, cascading fold in front of the left
side of his body actually presents us with the
inner face of the cloak. If the figure were origi-
nally polychromed like most wooden or stone
sculptures of the period, it is likely that the in-
side and outside of the cloak would have been
painted different colors, so that the drapery
would surely have been more comprehensible.
If, on the other hand, the entire figure had been
painted to look like stone, as has been suggested
above, the edges of the garment would certainly
have been traced in gold, which can only have
made it even more difficult to follow the drap-
ery's configuration. The billowing forms and
frequent reverses were simply more important
to the sculptor, given his sense of style and his
way of expressing feeling, than the desire to cre-
ate easily understood forms. The same can be
said of the last phase of Late Gothic art in Ger-
many, in general, but it is particularly true of
Veit Stoss.

On his head Christ wears a crown composed
of and bound with twigs. No visible thorns
protrude. His hair falls to his shoulders in long,
corkscrew curls. In the manner of such depic-
tions of the Man of Sorrows, he is decidedly
displaying the wounds in his hands made by the
nails. It is possible that the wounds in the origi-

89

nal left hand were not so vividly exposed as now, after restoration. The wound in his side is also portrayed, as was customary, even though, as the Man of Sorrows, Christ is still alive. There is no wound on his foot, simply because it could not have been seen, given the figure's elevated position. Despite his wounds and the crown of thorns, Christ shows no signs of suffering; he seems to have been transformed as though by the radiance of his resurrection.

By contrast, the Virgin's expression is distorted by suffering. She wrings her hands in a gesture of despairing helplessness, crushing the tip of her mantle between her fingers. The large, heavy mantle completely envelops her, enhancing the austere monumentality of the figure and her heroic appearance. The veil that covers her head falls below her left shoulder, only to disappear behind her hands and the folds of her lifted cloak. The two vertical edges of the cloak grip her as if she were a nut in a half-opened shell. They so dominate the overall appearance of the figure that one scarcely notices that the large section of fabric in front of the Virgin, at her left side, belongs to the inner side of the mantle, because of the way that she has raised its hem from the ground. The deep reversal of the bottom hem that is so effective a device in the statue of Christ is here omitted in favor of a figure with an overall elongated silhouette. A strip of crumpled cloth, draped over her right arm, can only be understood as the other end of her veil, which, until that point, had been hidden behind her arms. It is carved from a different kind of wood from that of the rest of the figure — linden wood, instead of oak — and must have been added as an afterthought. Its rather unconvincing integration into the overall pattern of the figure's drapery would suggest as much. Presumably, it was a subsequent correction undertaken by the artist himself, or at the urging of his patron. Once set in place, the sculpture may have seemed too empty or too plain from the front, as a result of the artist's striving for monumentality.

The two over-life-size figures of Christ and the Virgin belong to a monument (fig. 125) commissioned by Paulus Volckamer (died 1505), a leading representative of the city's government at the time; it was erected in the choir of the Sebalduskirche in 1499 as a memorial to Volckamer and his two wives. Ever since the building of the new choir of the Sebalduskirche, from 1361 to 1379, the patrician families of Nuremberg had been donating stained glass, sculpture, and occasional paintings for the various bays of the church, in conformity with its long-term decorative scheme. In most cases, the family's burial vault was in the corresponding bay. The three easternmost windows were reserved for representatives of the state and the church: The emperor had donated the center one; the Bishop of Bamberg, the one on the left; and the burgraves of Nuremberg and the margraves of Brandenburg, from the House of Hohenzollern, the one on the right — leaving the city's patricians to divide up the adjacent bays among themselves. The Volckamers' fami-

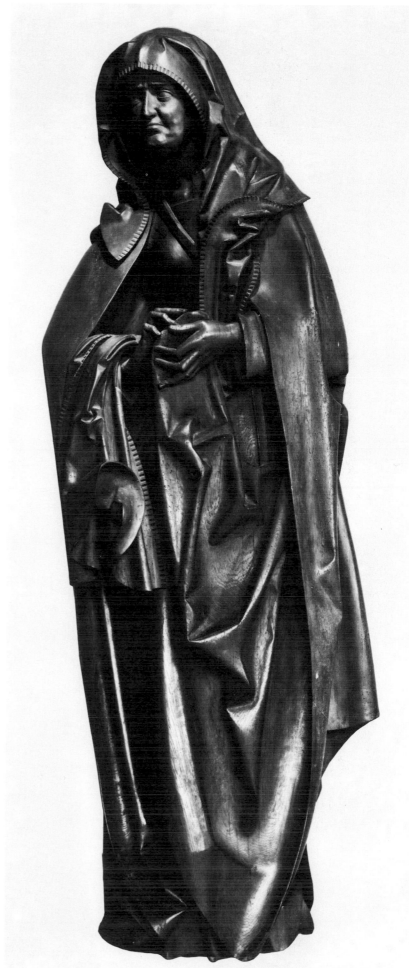

89

ly monument was at the rear of the choir, farther to the west. However, before the margraves restored their old, fourteenth-century windows in 1511, following the example of the emperor and the bishop, Paulus Volckamer succeeded in erecting a personal memorial, in addition to the family one, beneath the margrave's window, in that section at the front of the choir supposedly reserved for princes. How he was permitted to do so is not known.

Three sandstone reliefs portraying the Last Supper, Christ in the Garden of Gethsemane, and the Arrest of Christ fill the wall below the window. The present two wooden figures stand to the left and right of the window, beneath stone baldachins provided at the time that the choir was built. Presumably, these niches were as yet unfilled, for many of the corresponding sculptures in the choir were only installed in the course of the fifteenth century. Volckamer had himself portrayed as a tiny figure in the corner of the stone relief, along with his two sons, and, on the opposite corner, his daughters, and his two wives — Margarete Mendel (died 1492) and Appollonia Haller (died 1546). The sculptor of both the reliefs and the standing figures, Veit Stoss, carved his name, his master's mark, and the year on the soldier's saber in the relief of the Arrest of Christ, and also on each of the stone consoles supporting the large wooden figures.

At the time that these works were installed, Volckamer endowed a worship service commemorating Christ's Agony in the Garden, which was to be celebrated with great ceremony each Thursday evening by four priests and a choir, and accompanied by the ringing of bells. On these occasions, seven candles were to be lighted on the special angel candelabra he had also donated: "three in front of the three figures carved in stone that the gracious Herr Paulus Volckamer had made next to the altar of St. Peter," two on the altar itself, and two in front of the nearby tabernacle. On February 5, 1499, the Nuremberg city council approved the endowment of the services, and the first of them was held on March 7 of that year (for further details, see Kahsnitz, in *Veit Stoss*..., 1983, pp. 243–45). By that time, then, the sculptor's work must have been completed and installed, which means that, essentially, the sculptures would have been finished by the end of the preceding year. The endowment was to be secured by the deposit of a considerable sum of money with the city treasurer "so that it may thus be kept intact forever and last."

Services of this kind, dedicated to the contemplation of specific moments of Christ's suffering — here, the intense agony that he suffered shortly before his arrest — were not uncommon in the devotional life of the Late Middle Ages, and in Nuremberg and southern Germany, in general, Christ's agony was commemorated in numerous churches by special weekly devotions, with music. The custom of ringing the bells on Thursday in memory of Christ's fear of death survives in many places, to this day. According to the notions of piety that prevailed at that time, one could be greatly comforted through compassionate meditation on Christ's suffering in the garden. One would thus experience the humanity of Christ, and discover that the fear of dying could be overcome through prayer. Implicit in the gospel narratives is the assurance that man need not despair in the face of death. This subject matter, accordingly, was well suited to a monument erected to commemorate the donor's death and burial — although the Volckamer Monument is also, in large part, a memorial to the family's pride and to its desire to enjoy posthumous glory. The Last Supper, of course, at which the Eucharist was celebrated for the first time, inherently signifies the promise of eternal life.

The two figures placed above the reliefs — Christ as the Man of Sorrows and the Virgin sorrowing with him — are appropriate to the same context. Although the Christ figure seems to be transfigured in victory, the earlier literature incorrectly assumed that the scene depicted the resurrected Christ's appearance to his mother on Easter morning — as represented, for example, in Early Netherlandish painting. This latter scene has a solid iconographic history: Christ is portrayed not as the Man of Sorrows, but as the Savior, definitely without the crown of thorns. The setting is the Virgin's chamber, and, in her joy at the appearance of her Son, she kneels before him. Mary's pained expression in the present work would be wholly inappropriate on that occasion. What the sculptures do portray is a meeting, not recorded in sacred literature, between the Man of Sorrows and his devastated mother. In representations in art, the Man of Sorrows generally turns to the viewer, exhorting him to share his suffering. He appears as a harrowing reproach to the sinful soul, for the sake of which he has taken these sorrows upon himself, and as a rousing admonition, but, at the same time, as an assurance of salvation: as "Our Lord's Mercy" — the title often given such works in the Middle Ages. By analogy, Mary, who had taken part in the suffering of her Son and, through her willingness to give birth to him, had become a co-redemptrix, could be venerated as "Our Sorrowful Mother." A long tradition, especially in Netherlandish diptychs of the fifteenth century, combined half-length figures of the Man of Sorrows and the Mourning Virgin (Bott, 1965, pp. 345–60). In the art of Cracow, it was quite common to find the two standing figures adorning the sides of painted altarpieces, and in Franconia there are rare instances of this, as well (Dobrzeniecki, 1971, pp. 7–219, on the Polish examples). This linking of Christ and the Virgin also had a certain tradition in older stained glass. In German panel painting, it only appears about 1520: such as in the art of Cranach and of Baldung. As three-dimensional figures, moreover, of monumental size, these examples by Veit Stoss are without precedents or parallels.

In the overall context of the Volckamer Monument, the *Man of Sorrows* and the *Mourning Virgin* continued the theme of the contemplative experience of the suffering of Christ, and the forgiveness and salvation to be gained through such pious compassion — particularly, inasmuch as definite indulgences were awarded to those who prayed before Christ and the Virgin. Comparable portrayals of the conversation between the two holy figures, their dual lament over Christ's suffering and the unrepentant spirit of man, are known in Nuremberg prints from about this same time, their accompanying texts also referring in great detail to the indulgences to be earned from specific pious observances. Veit Stoss's image of Christ presents not the horribly mistreated man in distress, calling out for sympathy, but, rather, the victor, radiant after having overcome his sufferings, who, almost in triumph, displays his wounds as symbols of salvation.

R K

BIBLIOGRAPHY: Bode, 1885, p. 125; Daun, 1903, pp. 98–99, ill. 55; Pückler-Limpurg, 1904, p. 200; Daun, 1906, pp. 76–77, ill. 91; Hoffmann, 1912, pp. 119, 159, ills. 91–92; Lossnitzer, 1912, p. 91; Daun, 1916, pp. 87, 156–57, pl. 27.1; Fries, 1928, pp. 24–25, ill. 73; Müller, 1933, pp. 47–48; Lutze, in *Stoss*, Nuremberg, 1933, no. 6; von der Osten, 1935, pp. 127, 136, ills. 159, 161; Lutze, 1938, pp. 21, 23, ills. 27, 32; Dettloff, 1961, vol. 1, pp. 105, 110, 119, 298–99, vol. 2, ills. 167, 169–170, 174–176; Lutze, 1968, pp. 29, 31, 66, ills. 38–39; Oellermann, 1976, pp. 179–80, ill. 5; Kępiński, 1981, p. 64, ills. 107–110; Schädler, 1981, p. 92; Kahsnitz, in *Veit Stoss*..., 1983, no. 20, ills. 156–157 (with additional bibliography, primarily related to the whole monument and the stone reliefs); Kahsnitz, 1984, pp. 51–52.

Virgin and Child

About 1500

Boxwood, with traces of gilding on the hem of the robe and the veil, and on the crescent moon
Height, 8 in. (20.32 cm.)

The figure is not hollowed out. From the break below her elbow to her fingertips, the Virgin's right arm — as well as the Christ Child's right arm — was restored with dark wood. These restorations, were present in 1893, when the work was acquired by the museum. A number of cracks on the right side of the Virgin's face have been sealed with slender wedge-shaped pieces of wood. The tip of the veil on the right, and the end of one of the long strands of the Virgin's hair that hangs down her back have minor chips.

London, Victoria and Albert Museum
646-1893

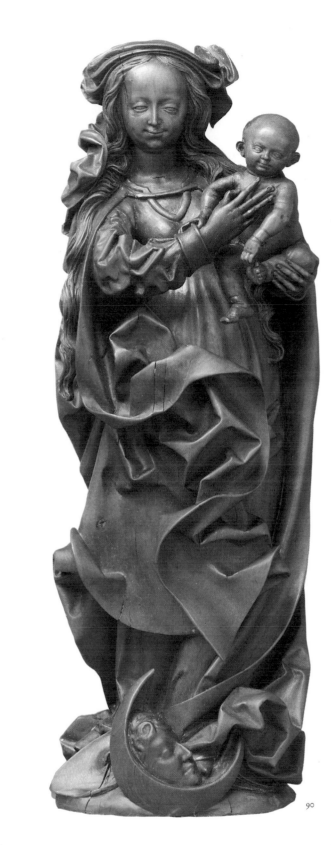

90

The slender, standing figure of the Virgin is enveloped in a voluminous mantle over a high-waisted gown that reveals her small breasts. On her left side, her mantle descends from her arm to the ground in a long curve, suggesting the sharp edge of a shell, behind which her hip and thigh constitute a single, swelling form. Because of the fullness of her hair and the veil draped in several layers over it, her head appears broader than it really is. Mary's torso is bent back somewhat, to balance the naked infant that she holds at the level of her shoulders. Although the Child is quite small and has no hair — so that he seems very young, indeed — he sits well apart from his mother, supported almost entirely by her wrist. His head, with its protruding ears, inclines away from the Virgin in obvious contrast to her pose. With his left hand, he plays with the toes on his left foot. His left leg, only lightly supported by his mother, is bent; his right leg and most of his body appear as if suspended in the air above Mary's arm and hand, so that the active Child is a fully developed and an uncommonly independent figure. The Virgin's lower right arm and hand, with which she supports the chest of the Child, is a reconstruction that is too large in relation to the rest of her body. Beneath the restoration, however, are traces of Mary's original hand, which show that the initial position of her arm cannot have been very different. Although a freer, more open pose might seem logical for the Child, it does not seem likely that mother and child once played with an apple, as one scholar has recently suggested. How close together mother and child would have to have been in the present work to permit such freedom of movement is demonstrated by the so-called Malberg Virgin, for example, by an artist from the circle of Nikolaus Gerhaert, in the cloister of the cathedral in Trier (Wertheimer, 1929, pl. 2). Mary's arm must always have been positioned across her breast much as it is now.

On the left side of the figure, the sharp edge of the mantle falls to the ground, where it turns back on itself, behind the crescent moon, and forms a cluster of folds. The other end of the mantle billows in front of the Virgin's body in a series of reverses and rich bunches of folds, with no apparent function. In so doing, the drapery projects well out into the space before the figure, which already has been developed as the area of emphasis — as a view of the statue from the side reveals. Admittedly, it seems astonishing that this section of drapery has not been swept up by the Virgin's hand or arm, but, instead, appears to have blown against her body with a sudden gust of wind. Mary's right leg, which carries the weight of her body, is completely hidden by the mantle. All that is visible of her left leg is the thigh, which shows through the long opening of the mantle and serves to suggest something of the form of the Virgin's body. The lower part of the leg is in front of the center of the figure; the diagonal position of the shin is suggested, just below the hem of the mantle. The heel is twisted to the right, while the point of the foot emerges from under the mass of fabric and rests on the section of the crescent moon alongside its chin. This positioning of the legs is artificial, and has not been integrated into the figure's overall posture —

241

particularly, with the inclination backward of the upper body.

The figure is fully developed in the round, the drapery as richly detailed on all sides. Two large, vertical ridges of fabric on the left at the back echo the line of the mantle's front edge. This is the same basic composition employed in the statue of the *Mourning Virgin*, in Cleveland (cat. no. 91) and — to make a comparison with a two-dimensional work — in Veit Stoss's engraving of the *Virgin with an Apple* (Kępiński, 1981, ill. 203; Lehrs, no. 5). The drapery at the back is organized into a series of vertical folds, across which fall long corkscrew locks of the Virgin's hair. The hem of the mantle lies in carefully constructed serpentine reverse folds — exposing compressed layers of the gown beneath it — on the low base, the almost complete circular edge of which is uncovered. The right side of the mantle is dominated by hollows filled with wrinkled folds. The Virgin's shawl swings back in a long curve, enclosing her head, and a large section of it is bunched on her shoulder. Midway down her body, the fabric of the mantle is drawn together, creating a funnel-like shape, as if the elbow were somehow pulling it, but, from the front, it clearly is only billowing upward.

Mary's face is rather strangely formed. Although most critics refer to the Child, with his bald head and protruding ears, as ugly, there are odd furrows around the mouth and in the cheeks of his mother, who has been given a small and prominent chin, a mouth drawn up on the right side, and narrow slit-like eyes. These eyes, moreover, are asymmetrical; the left one, with its heavy lid, angles down to the side, while the right one is nearly horizontal. The forehead takes up over half of the surface of the face, thus exceeding the propensity in late-fifteenth-century art for a high, shaved brow, forcing the features to be compressed below. Nowhere else in the work of Veit Stoss do we find such an unattractive face. The isolation of these forms, and their deliberate asymmetry can only be interpreted as a decided attempt to add life to the face of the youthful Mary — often, virtually expressionless in much of the art of the time — and to give it a modicum of individuality.

The richness of its forms and the extreme care in its carving — for example, in the contrast between the highly polished wood of the drapery and the rough textures of the hair; the virtuoso execution of the details; and the equal development of all sides of the small statuette — indicate that it was a collector's piece created for a connoisseur. It is known that Veit Stoss produced such works, and that those with both religious and secular subjects were extremely highly prized soon after his death. The only examples of these smaller works to have survived are this *Virgin and Child* and the *Mourning Virgin* in Cleveland (cat. no. 91), which once formed part of a Crucifixion group. However, Stoss also executed larger sculptures for churches with similar care, and in much the same spirit — most notably, the *Archangel Raphael and Tobias* group (cat. no. 93); the *Crucifixion*, now in Nuremberg's Lorenzkirche; and the

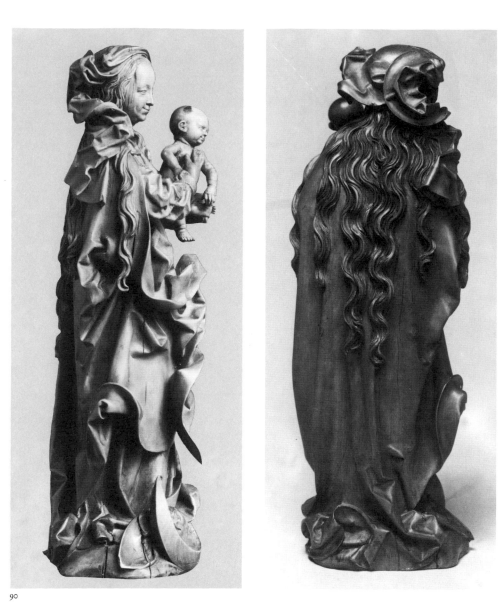

90

Saint Roch, in Santissima Annunziata, Florence. Such works were not limited to a given period in the sculptor's life. Indeed, it appears that Veit Stoss would always agree to produce works of the very highest artistic quality, displaying the most exquisite carving, at the request of special patrons who could pay for them. In most such cases, it is difficult to date these precisely.

Just what place the London statue of the Virgin occupies in the oeuvre of Veit Stoss has also been debated in the literature, even though there are an unusually large number of dated works by this master. Hermann Voss, who, in 1908, identified the sculpture as the work of Veit Stoss, placed it about 1520. This late date has largely been accepted, despite the fact that the figure of Mary in the Bamberg Altarpiece, of 1520–23 (see fig. 126), reveals a completely different sense of physical weight and a stronger sculptural presence that clearly designates it as a later work. Writing in 1961, Szczęsny Dettloff suggested a date of about 1510; by contrast, Jörg Rasmussen (1976, p. 108, *passim*) and Alfred Schädler (in *Veit Stoss...*, 1983, pp. 36–37) have argued that it is earlier, from about the turn of the century — which seems most likely.

Although conceived for a collector, made to be viewed in the round, and carved with exceptional virtuosity, the statuette, nonetheless, has several optimum angles. The separate clusters of forms have not been so fully integrated into a three-dimensional whole, as is true of the Raphael and Tobias group, of 1516 (cat. no. 93). Despite its function as a collector's piece, the statuette still retains a great deal of the angular Gothic style, most obvious when viewed from the left. The instability of the figure's stance can best be compared to that of the *Man of Sorrows*, of 1499, from the Volckamer Monument (cat. no. 89). One leg of that figure, as well, is free; its other leg, however, does not truly carry any weight, and its position is not fully integrated into the composition, as a whole. In the *Man of Sorrows*, too, a similar instability is created by the twisting of the torso in relation to the forward position of the free leg and the exaggerated turned-out feet. The composition of the Tobias figure is incomparably more stable, even though its feet are crossed. The preponderance of drapery motifs and a certain illogicality in their arrangement, and the way in which the smaller details have not been so perfectly related to the

242

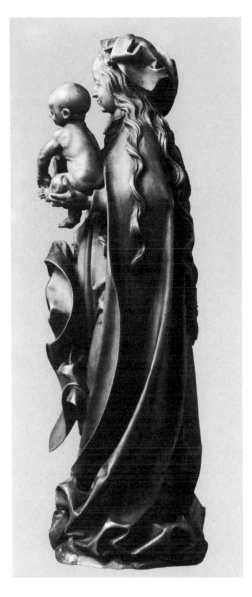

larger ones — as in the Raphael and Tobias figures — would indicate that the statuette is a relatively early work in the established oeuvre of Veit Stoss. Also, in comparison to the Cleveland Virgin (cat. no. 91), the present *Virgin and Child* surely seems earlier, inasmuch as the Cleveland figure displays a greater composure and serenity, and is more grandiose because of its limited number of motifs. R K

Ex collections: George Field (by 1862); sold, Christie's, London, 1893.

Bibliography: *Catalogue of the Special Loan Exhibition...*, South Kensington Museum, 1862, p. 578, no. 6742; *Catalogue of the George Field Sale*, June 12–13, 1893, no. 31; Voss, 1908, pp. 528–29, ill.; Lossnitzer, 1912, p. 128, pl. 45; Daun, 1916, pp. 139–46, pl. 44; Stafski, 1936–39, p. 132, ill. 7; Lutze, 1937, pp. 188–89, ill., 1938, p. 38, ill. 50b; Müller, 1938, p. 134; Dettloff, 1961, vol. 1, pp. 161–62, 302, vol. 2, ill. 239; Müller, 1966, p. 183; Baxandall, 1967, no. 1, ills. 1–3; Lutze, 1968, pp. 51, 67, ill. 64; Baxandall, 1974, no. 13, ill.; Rasmussen, 1976, pp. 108–9, ills. 1–2; Baxandall, 1980, pp. 271–72, pls. 43–45; Kępiński, 1981, p. 73, ills. 129–130; Beck, in *Dürers Verwandlung*, 1982, no. 123, ill.; Schädler, 1982, pp. 92–94; Rasmussen, in *Veit Stoss...*, 1983, p. 148, ill. 26; Schädler, in *Veit Stoss...*, 1983, pp. 36–37.

91 VEIT STOSS

The Mourning Virgin, from a Crucifixion Group

1500–1510
Pearwood
On the inside and outside of the Virgin's mantle are traces of blue polychromy — probably not original — and bright red flecks on her gown. There are numerous chips and abrasions on the edges of the drapery and on the base. Missing are the Virgin's arms and hands, the free-flowing end of her veil, and her metal brooch. The mantle, pierced in six places above and below the Virgin's arms — undoubtedly, during the mechanical removal of old paint — has also sustained a long crack, in the area of her left side.
Height, 12 3/8 in. (31.4 cm.); width, 3 13/16 in. (8.1 cm.)
The Cleveland Museum of Art, Purchase, The J. H. Wade Fund, 1939
39.64

Through the course of its history, the small statuette of the Virgin has suffered considerable damage. The cracks in the drapery are not easily seen, for, in many cases, they have been smoothed over and recarved. In order to judge the artistic quality of the figure, to understand the composition, and, especially, to appreciate the formal richness of the drapery, it is essential to reconstruct, by means of precise observation, the original form and outline of the mantle.

The sorrowing Virgin is standing, her torso bent well back. Her gown is belted just below her small breasts, and is draped primarily in vertical folds. A metal brooch was once affixed to her bosom. Her mantle, held together at the top by a loop of fabric, is otherwise open, and falls nearly straight down, although, at her right, in front of her thigh, the drapery is swept upward in a rich curve. Mary's head, inclined to the side, is covered by a veil that is wrapped loosely about her neck and throat. Under the veil, her hair hangs straight, inside the mantle, down to her thighs. The end of the veil is bunched on top of her upper right arm, and once certainly extended over her hand (both hands are now mere stumps), which was raised in a gesture of mourning. It is likely that Mary held the tip of her veil in order to dry the large (carved) tears that course down her cheeks.

Beneath the mantle, the Virgin is quite slender, her torso small and narrow, and the lower portion of her body uncommonly elongated — all usually characteristics of figures designed to be placed at an extreme height. In fact, the lower section of her body is nearly twice as tall as the upper part, and should actually end above the knees. While the left leg is completely obscured by the drapery, and appears to have no function in the composition of the standing figure — although the elongated hip section can be seen clearly, thrust to the side — the right thigh is quite prominent, the right knee protruding beneath the swirling curve of the mantle. The placement of the feet cannot be determined.

All that survives of the base, with its section of mantle touching the ground, is a small portion on the right side, at the back. The suggestion of grass there, and the tips of the drapery reaching the bottom edge of the block make it clear that the figure was carved as an independent, freestanding statuette and was not meant to be placed in a carved landscape setting, although the subsequent reduction of the base might provide that impression.

A number of significant changes have been made as a result of breaks and recarving along the vertical edges of the mantle — specifically, on the left side. The mantle enfolded the child-like, delicate figure like a shell, but, originally, not as much of the garment beneath it was as visible as it is now. This also explains the relatively crude carving of the long locks of hair. The only original segment of the left edge of the cloak is the area just above the knee, to the point above the ground where the fabric swings frontward. The entire upper portion has been badly broken away, and above the arms, especially, the mantle has been altered, creating an unnatural, zigzagged outline. In reality, this edge was once as sharp as a knife, standing out from the figure from the level of the breast to the ground — as it appears today in the lower third of the sculpture. Its front tip has been broken off, or removed, at the ground level, except for a few surviving fragments, which indicate that the hem of the mantle lay beneath the large, triangular section on the opposite side, where it must have terminated in a deep, reverse fold. Beneath the folds gathered at the right knee, then, there was a highly sculptural drapery motif — an extension of the left side of the hem. The odd effect of emptiness that now causes the composition to seem unbalanced is, therefore, only a result of damage.

The entire line of the right side of the hem of the mantle — with the exception of a segment about one centimeter in length above the thigh; the front tip, folded over at the knee; and the segment extending back to the side from the opposite corner to the present level of the base — is not original, although it is impossible to reconstruct its exact course in detail. Initially, the mantle was closer to the torso and obscured the figure's body and the locks of her hair, unlike the effect today. Nevertheless, the edge of the mantle, which was folded back at the bottom of her thigh, was probably not so severe as on the left side. The folds across the thigh have also lost their original form — the obvious broken edges make this perfectly apparent — both from the front view and from Mary's right side, where the edge of the mantle sweeps down beside the swirling curve of her gown.

The main damage to the upper body is, of course, the loss of the Virgin's hands. Her veil must have formed a detached band curving freely over her right shoulder from the break at the back of the head to the section resting on her upper arm, and nowhere touching either her mantle or her body — an example of virtuoso carving characteristic, as well, of the loincloths of Veit Stoss's figures of the crucified Christ. Thus, the shoulder area once appeared broader, and the curve of the veil emphasized the inclining of the head toward this side. The face was

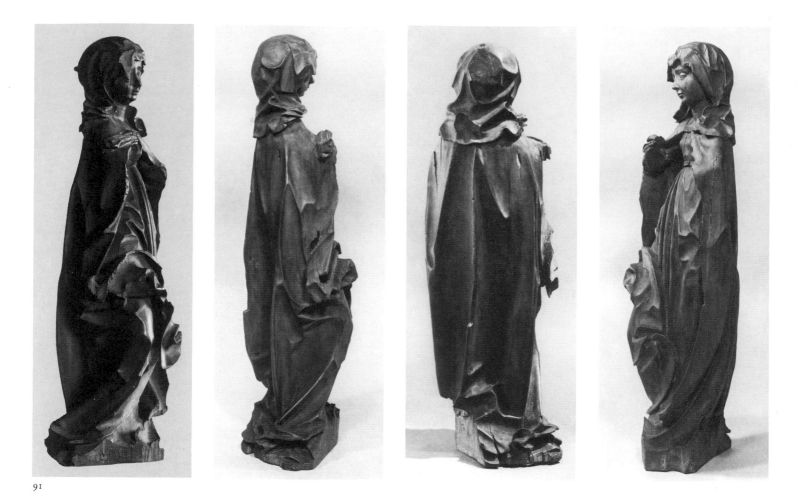

91

more deeply shadowed than now because the front of the veil has been cut off above the forehead. The points along the edge of this area of the veil are not original.

The back of the figure, with its broad ridges of drapery and concave surfaces, is relatively well preserved — although the section near the base, where the hem of the mantle undoubtedly folded back gracefully as it touched the ground, is now missing. Mary's veil is treated in the same way, forming slightly concave, curving surfaces between sharp folds. The long line of the vertical edge of the cloak on the left side, which terminated in a broad reverse at the Virgin's feet, is echoed by two long, flowing, parallel folds on the side and in back, which underscore its importance in the overall composition. The back was divided by a nearly straight, vertical fold.

The most important result of such painstaking consideration of the figure's present condition is a recognition of the crucial significance, for the composition as a whole, of the sharp left front edge of the mantle. It enclosed the Virgin's slender body like a husk, ending at her feet in a large hollow curve. As a result, the right edge of the mantle, which appears as if whipped up by the wind into an ear-shaped curve, was given a kind of base, and did not seem so isolated as it does now, nor was its configuration as flat. The upper edge projected farther forward, shadowing the forms that it enclosed. The part that remains, on the left side, once turned back on itself, while, at the right, the weight of the fabric

was indicated by the effect of having it fall to the side, creating a broad fold toward the back — as can still be seen, from the side view, despite the heavy damage to this portion of the sculpture. The bottom part of the figure, where the hem of the mantle touches the ground, is entirely lost, except for a small and seemingly relatively uninteresting fragment. The base probably was as richly developed as that of Stoss's statuette of a standing Virgin and Child, in London (cat. no. 90). In every way, then, the figure of the mourning Virgin now is less impressive than it once was.

In its original condition, the statue must have been one of Veit Stoss's unequivocally virtuoso masterpieces, imposing both in concept and in the excellence of its carving. Unfortunately, the *Virgin* in London is the only other surviving example of his smaller sculpture. The present figure is carefully polished, and was undoubtedly never meant to be painted. The only traces of carving are found on the underside of the arms, where, ordinarily, they would not be seen. In common with the London statuette is the generally rich and uncommonly detailed drapery of this mourning Virgin — here, somewhat more organized, and, thus, probably later in date. Both share the motif of a portion of the mantle folded over the thigh, the corner turned back deeply on the side, forming an ear-shaped curve; it is not because the mantle is raised up by the figure's hand that it takes on this elegant configuration. The Cleveland *Virgin* is better integrated with the surrounding space than is

the one in London. There is also a long vertical fold on the left edge of the mantle of the figure in London, but no areas of shadow result. The mantle, functioning like a shell enclosing the Virgin, and the sharpness of the folds on its left side, are elements in both statuettes that are shared by such figures as the *Mourning Virgin* of 1506/7, originally in the Frauenkirche and now in the Sebalduskirche (Kahsnitz, in *Veit Stoss...*, 1983, no. 22; Kahsnitz, 1985, ills. 15–17). The unrealistically elongated proportions nevertheless remain remarkable, although there are certain echoes of them in Stoss's sculpture of Saint Roch, in Florence.

The present statuette is developed essentially on three sides, intended to be seen from the front, from the Virgin's right, and from the back. From the Virgin's left, the sculpture is quite flat, and appeared so even when more of the mantle survived. The base of the figure is an elongated triangle, which becomes quite narrow on this fourth side. The forms at the left open outward toward the crucifix that probably was positioned there. The backward leaning of the torso and the inclination of the head to the side would be in harmony with the overall arrangement of a Crucifixion group. Balancing the Virgin on the other side of the crucified Christ must have been Saint John, the favorite disciple. Such small-scale Crucifixion scenes were not meant to be displayed in churches, but, rather, were objects of private devotion made for a family chapel or, even more likely, the study of a connoisseur, who was probably also a cleric.

244

Veit Stoss and contemporary sculptors must have created a number of such works. Nevertheless, very few groups from the late fifteenth century survive. Despite its lamentable condition, the Cleveland *Virgin* is eloquent testimony to Veit Stoss's mastery of the sculptor's art, which brought him fame in his lifetime and extravagant praise shortly after his death — specifically, by the biographer of the Nuremberg artists, Johann Neudörfer. Neudörfer (1547, p. 84) even mentions a small Crucifixion, only the height of a hand, which had long been in the possession of a collector who valued it highly. In it, he writes, one can see "what kind of understanding this Stoss possessed." R K

EX COLLECTION: Andreas Colli, Innsbruck (1933).

BIBLIOGRAPHY: *Stoss,* 1933, no. 12; Müller, 1938, p. 133; *Masterpieces...,* 1949, no. 24; Dettloff, 1961, vol. 1, pp. 113–14, 302, vol. 2, ills. 237–238; Lutze, 1968, p. 51, ill. 65; Rasmussen, 1976, pp. 108–9, ill. 3; Baxandall, 1980, ills. 122, 126–128; Beck, in *Dürers Verwandlung,* 1982, p. 200, ill. 53.

92 VEIT STOSS

Crucifix

1505–10

Linden wood; the original polychromy has partly been uncovered

The head and chest of the corpus are hollowed out. The head and arms were carved separately and then attached, because the proportions of the available tree trunk were quite slender. The projecting portions of the loincloth, the entire left shoulder, the right hip, the projecting part of the buttocks, and a diagonal section of the corpus, on the left side, at the back, were glued on before the wood was carved. The lock of Christ's hair that hangs down, on the right side, has been lengthened by means of a modern piece of wood inserted at the top. Except for a few traces, the crown of thorns has broken off.

Height, 79 1/8 in. (201 cm.); arm span of the corpus, 78 3/8 in. (199 cm.)

Provenance: Heilig-Geist-Spital, Nuremberg. Nuremberg, Germanisches Nationalmuseum (on permanent loan from the city of Nuremberg since 1898)

Pl 0.62

Christ is suspended from the cross with his arms in a nearly horizontal position, and his fingers curled around the nails. His legs hang straight down. His feet, one crossed over the other, are extended so that the toes curl backward. His head, inclined only slightly to the side, is bent well forward. A long lock has separated from the rest of the hair and falls down onto Christ's chest, on his right side. Christ's eyes are nearly closed, and his mouth is slightly open. He is obviously dead. An abbreviated loincloth, drawn across his buttocks, upper thighs, and the lower part of his stomach, is gathered into a knot over his left hipbone. The tip of this brief length of cloth billows outward,

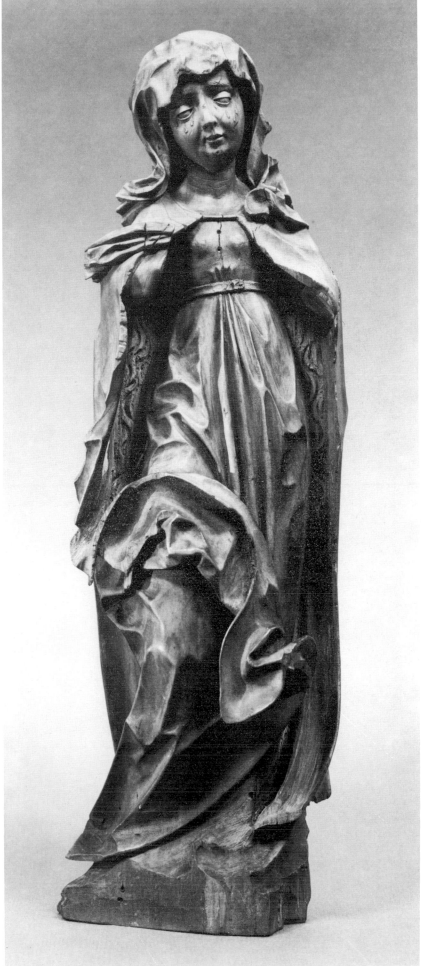

91

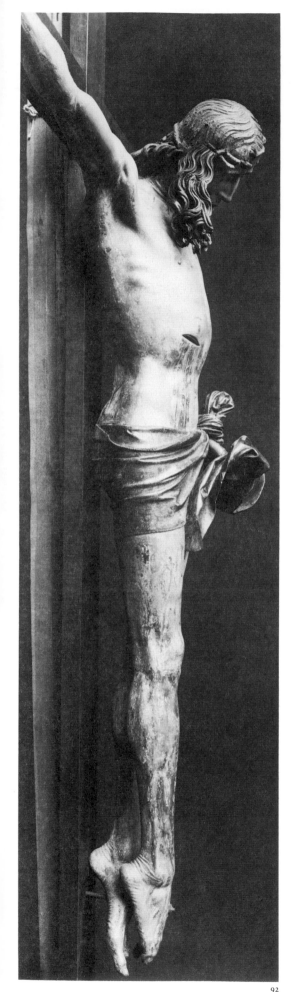

its folds like the configuration of an ear, without overlapping the body.

In contrast to earlier Gothic art, in which Christ is portrayed as a delicate, wispy youth, even in death (see, for example, the Man of Sorrows from the *Tondoerffer Epitaph*; cat. no. 27), here, he has been given the body of a strong, full-grown man — appropriate to one who suffered his death on the cross at the age of thirty-three. This body is truly formed of bones, sinews, and muscles. Its joints are accentuated — as, for instance, the kneecaps and the shoulders. Every form has been precisely rendered, and nothing has been understated to gain the effect of a long, flowing line. The trapezoidal rib cage is sharply set off from the stomach; the ribs, themselves, particularly the lower ones, are easily discernible, especially from the side. The small, flat belly is underscored at the bottom by the line of the groin, just visible above the edge of the loincloth. The hipbones protrude from the body, and have not been incorporated into the long line of the thigh. The lumbar erector muscles of Christ's back are developed as two prominent ridges, alongside of which the other muscles extend downward, from the shoulder blades. The tensor muscles of the neck and upper arms reveal quite explicitly how the sculptor envisioned the ideal form of a decidedly strong man. The shoulders appear to have been pulled from their sockets as the arms are stretched taut, between the nails. The attenuated tendons of the arms and the pectorals between the shoulders and the rib cage are visible. Each contour is carefully modeled, so that the body's forms are clearly distinguished from one another — almost as though they were dissected. The modeling is precise; distinctions are enhanced, smooth transitions avoided. This is particularly obvious from a right-hand profile view; the figure's remarkable line begins with the extreme angle of the head — in distinct contrast to the compact appearance of the figure, as seen from the front.

The suffering of the Crucifixion is presented through the aforementioned stretching and contortion of the body, itself, while the external wounds that traditionally document the horrors of the ordeal are almost completely ignored. There are no marks from the blows of the scourge, and the trickling of blood is indicated only in the polychromy. The wounds on Christ's hands and feet gape only slightly — again, so as to show how tautly the body has been stretched. The only bleeding wound is the one in Christ's side, from which a broadly painted stream trickles into the loincloth. Otherwise, the surface of the body appears unharmed. At one time, the sharp spines of the crown of thorns pierced through the temples, into the eye sockets — a gruesome motif that Stoss developed.

The sculptor of this crucifix was not interested in evoking the viewer's sympathy with the dead or dying Christ by means of horrifying details, no matter how firmly rooted these may have been in the traditional imagery of the Middle Ages. Instead, he wished to present Christ on the cross in all of his distinctly corporeal reality. Stoss's effort to portray the naked human form parallels Dürer's contemporary drawings of nude male and female figures, although the sculptor did not profit significantly from Dürer's studies of human proportions.

In general, Stoss adopted the type of crucifix that prevailed in Netherlandish art of the preceding period — most notably represented by the stone crucifix, of 1467, by Nikolaus Gerhaert van Leyden, formerly in the cemetery at Baden-Baden. There, as well, the body of Christ is suspended in perfect alignment with the vertical axis of the cross. There is no trace of the ornamental beauty of Gothic line. Instead of the heavy downward pull of the hanging body serving as his main motif, Stoss focused on the extreme stretching of the arms and legs — not for its theatrical expressiveness, but out of a fascination with the structure of the body, itself. Whereas Gothic art generally favored a swaying of the body to the right or left, and, especially, bent knees, Stoss consistently created figures of Christ that are stretched entirely straight. All of his known crucifixes, with the exception of the relief on the Cracow Altarpiece, show the Savior with extremely straight knees — as can best be seen from a left-side view of the present work. This is as true of the stone crucifix commissioned by Heinrich Slacker, about 1491 (now in the Marienkirche, in Cracow), as it is of such wooden examples as that in the Ognissanti, in Florence, and the famous ones in the Lorenzkirche and the Sebalduskirche, in Nuremberg; the distinct contrapposto pose of Christ on the last two indicates that they are much later in date.

Not only did Stoss attempt a stylized representation of the human body as a means of portraying the beauty of the man Jesus — which was demanded by contemporary literature — with his erect posture and controlled movement, but, clearly, the sculptor was also reacting to the edifying descriptions of the Passion, from the previous two centuries. In this literature, one constantly encounters the images of the harp and the bowstring, and — based on the words of Psalm 21:18 (22:17) "dinumeraverunt omnia ossa mea" ("they counted all my bones") — detailed descriptions of the cruelty with which Christ's body was stretched on the cross. In a number of Late Gothic portrayals of Christ being nailed to the cross, the soldiers pull at his arms and legs with ropes. Some accounts relate that Christ was stretched on the cross as no string was ever tightened across an instrument. Beginning with Cassiodorus, authors of tracts on the Passion tended to embellish the image of the harp strings, speaking of the harp as the mortal body of Christ, with its taut sinews (*tensis nervis*) and detached bones (*denumeratisque ossibus*), which, in its glorious passion, filled the universe with its mournful music. Thus, the artistic form of Stoss's crucifixes appears to have a deeper meaning, in accord with a long tradition surrounding the interpretation of Christ's death on the cross.

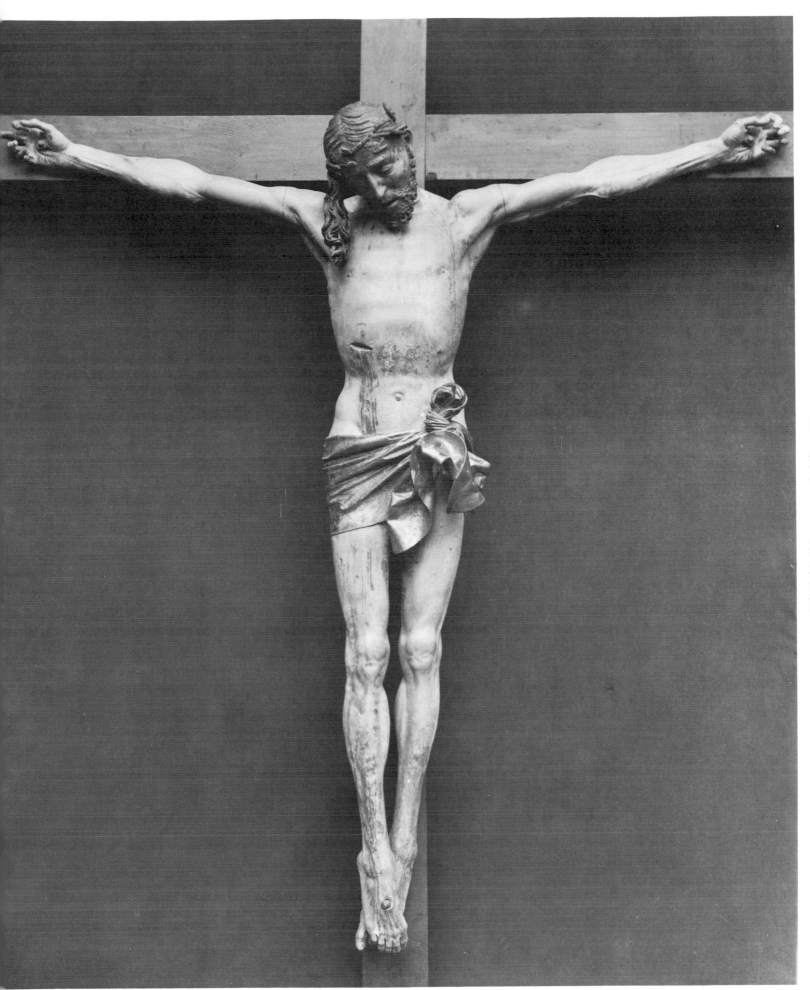

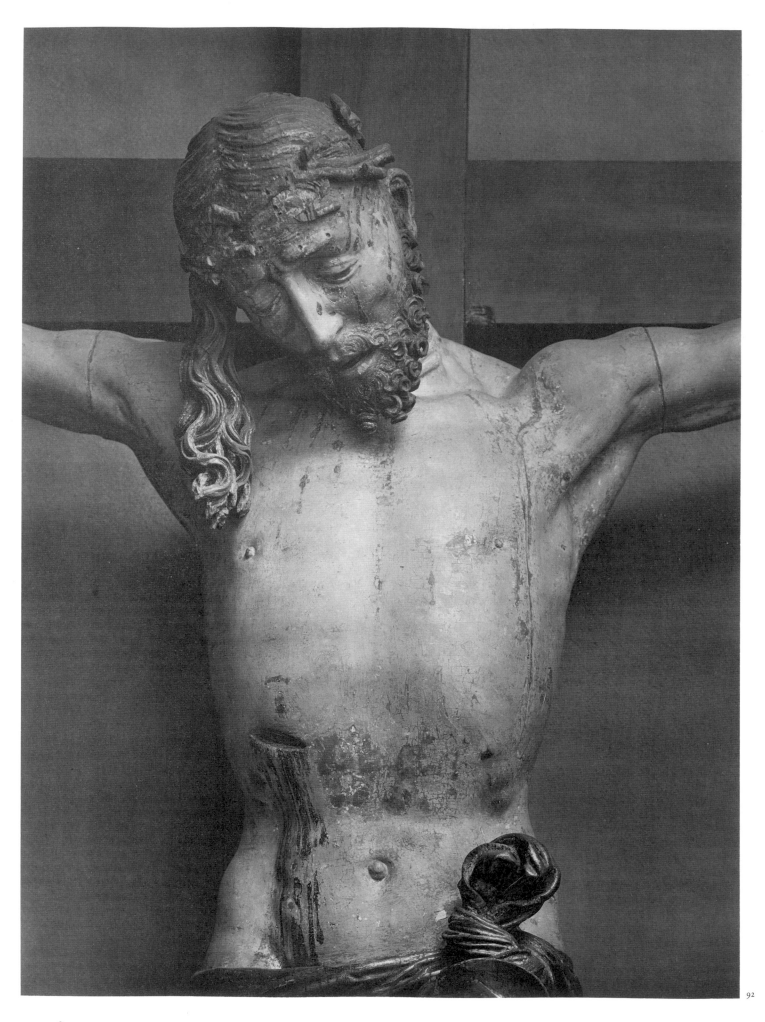

92

For centuries, Veit Stoss was famously primarily for his crucifixes, as his biographers have pointed out. For art lovers passing through Nuremberg in the eighteenth century, the *Wickel Crucifix* (of 1520) in the Sebalduskirche was one of the city's major sights, and it was said that the elector of Mainz had tried to buy it for a large sum. In the seventeenth century, a number of copies of it had been produced by, among others, Georg Schweigger. The crucifix from the Heilig-Geist-Spital lacks the deep pathos and the strong physicality so admired by proponents of the Baroque and exemplified by the *Wickel Crucifix*. The present example also is without the polished elegance and formal richness of the crucifix in the Lorenzkirche, which was given the finish of a collector's piece; the distinct contrapposto pose of that figure indicates that it cannot have been created before the second decade of the sixteenth century. Nevertheless, in the Heilig-Geist-Spital crucifix — at least a decade earlier in date — a new mastery in the portrayal of the nude is manifested, and this is combined with one of the oldest and most venerable subjects in Christian art. The image of the Savior dying on the cross is a virtual monument to the earnestness and rigor in the exploration of nature and the human body that are so characteristic of the dawning of the Renaissance in Germany. RK

BIBLIOGRAPHY: Lösch, 1836, fol. 22 v.–23 r. (already attributed to Veit Stoss); Mayer, 1843, p. 154; Bode, 1885, p. 124; Daun, 1903, p. 96, 1906, p. 76, ill. 86; Voss, 1908, pp. 28–29; Josephi, 1910, no. 316, pl. 39; Vöge, 1911, p. 278; Lossnitzer, 1912, p. 135, pl. 50,1; Daun, 1916, pp. 153–55, pl. 50,2; Bier, 1922, ill. 62; Höhn, 1922, ill. 90; Wilm, 1922, ill. p. 62; Lutze, in *Stoss*, 1933, no. 16; Lutze, 1938, p. 33, ills. 35, 39; Müller, 1938, p. 133, 1942, p. 199; Dettloff, 1961, vol. 1, p. 140, vol. 2, pl. 206; Müller, 1966, p. 182; Lutze, 1968, pp. 45–46, ill. 54; Kępiński, 1981, p. 69, ills. 119–120; Liebmann, 1982, p. 352; Schneider, in *Veit Stoss…*, 1983, no. 5, ills. 37, 83–89; Brachert, 1984, pp. 14–23; Kahsnitz, 1984, pp. 41–42.

93 VEIT STOSS

The Archangel Raphael and the Young Tobias

1516
Linden wood
Raphael: height, 37 3/16 in. (94.5 cm.), maximum width, 18 7/8 in. (48 cm.), maximum depth, 15 in. (38 cm.); *Tobias:* height, 33 1/4 in. (84.5 cm.), maximum width, 13 3/8 in. (34 cm.), maximum depth, 15 in. (38 cm.); width, entire group (in its most recent reconstruction): 30 11/16 in. (78 cm.) Each figure, carved from a single piece of wood with nothing added, is hollowed out at the back. Both were unpainted, but were given a light brown stain. The original polychromy on the lips and eyes has been removed. The wood of some of the locks of Raphael's hair is worm eaten, so that his head does not appear as asymmetrical as it once did. The box containing the fish gall is missing from his outstretched right hand, the thumb and palm of which have been restored. On the back of the Raphael figure are grooves to accommodate large wings; these must have been attached to the wall behind, rather than to the figure itself, but are lost. The fish that once hung by a string from Tobias's left hand is likewise missing; relatively small, it was positioned about 9 centimeters below his hand — as indicated by a small dowel hole. The front half of the base of the Tobias figure was cut away in the 19th century. Tobias's right hand was never finished, for, in the original arrangement of the group, it could not be seen.
Provenance: Dominikanerkloster, Nuremberg (demolished in the 19th century); *Raphael:* Jakobskirche, Nuremberg.
Nuremberg, Germanisches Nationalmuseum (*Tobias,* on permanent loan from the city of Nuremberg since 1875; *Raphael,* on permanent loan from the Protestant Vestry of the Jakobskirche since 1933)
Pl 0.1834

The group comes from Nuremberg's Dominican church, where, in 1737, Johann Jakob Schwarz described it as on the south side of the nave, next to the column closest to the choir. "Beneath this, against the same column, [is] a memorial carved of wood, a figure accompanied by an angel, and below it this coat of arms with the date 1516 and the two initials R.T." This entry was followed, in Schwarz's manuscript, by a line drawing of the coat of arms, and the initials, in an almost contemporary hand, which have been identified as those of "Raphael Thurisani." Raffaello Torrigiani (about 1480–after 1531) was a wealthy Florentine silk and jewel merchant who was frequently in Nuremberg during the years from 1516 to 1518, and is mentioned in 1518 in the Tucher account book. Like Veit Stoss, he attended the fair in Frankfurt, and, in 1521, in Leipzig.

The story on which the work is based is from the Old Testament book of Tobit. Tobit, old and blind, sent his young son, Tobias, on a long trip to collect his debts. Tobias found a traveling companion in the person of an elegant young man who was, in reality, the Archangel Raphael. The angel guarded him against the various perils of his journey, among other things, helping him to catch a dangerous fish in the

Tigris. They then carried the gall of this fish with them in a little box, so that they could rub it on Tobit's blind eyes and thereby restore his sight. As portrayed here, they are on their way back to the home of Tobias's parents. Raphael's outstretched right hand originally contained the box with the fish gall, and Tobias once held the string from which the fish, itself, would have been suspended.

The story of Raphael and Tobias is virtually nonexistent in German art, and the veneration of this archangel is uncommon — as is underscored by the fact that, in Germany, Raphael is not given as a Christian name. In Florentine art, however, paintings on the theme were a distinct tradition. In the church of Santo Spirito, near which the patron of the Nuremberg group lived, and where his family had its own chapel, there were a number of such paintings. In the same church, the "Compagnia Il Raffa" also had a chapel, and it was there that Francesco Botticini's altarpiece *The Three Archangels and the Young Tobias* once was found (it is now in the Gallerie degli Uffizi, Florence). Raphael — the name of the patron of the Nuremberg work — was especially venerated in Florence in the fifteenth and sixteenth centuries as the guardian angel of travelers. A play on the present subject was printed there in 1516, the "Rappresentatione del Angelo Rafaelo e Tobia." It was common for merchants whose sons were required to undertake long and dangerous journeys for business, or to work in foreign parts, to commission paintings of the scene as ex-votos. The most notable examples of this are a painting by Pollaiuolo, once in the church of Or San Michele, in Florence (and now in the Galleria Sabauda, in Turin), in which Tobias wears an ermine-lined cloak and a fashionable traveling cap; one by Andrea del Verrocchio (in the National Gallery, in London); and various versions by Francesco Botticini. It is possible that all of these were based on a painting by Neri di Bicci in Santo Spirito that was destroyed by fire in 1471. The commission for the Nuremberg group must be seen in this context, although, in fact, there was no precedent in Florence for a sculptural treatment of the theme. As Ewald M. Vetter suggests, Torrigiani's decision to purchase a sculpture instead of a painting — the obvious choice in Italy — may well reflect the Italians' widespread admiration for Northern carving. Personal acquaintance with Veit Stoss perhaps influenced Torrigiani, as well. In any case, he must have shown the sculptor something in the Italian tradition — either a painting, drawings, or an engraving — for the finished work clearly makes use of Italian iconographic motifs even in its details.

In all of the Italian paintings, the large figure of the archangel, with his powerful wings, leads, holding the box with the fish gall in his outstretched right hand, while the much smaller and younger Tobias grasps his arm or hand in an effort to keep pace with him. It is not uncommon for the archangel to be shown looking back at the boy with concern, and for Tobias to be gazing up at him full of trust. Raphael usual-

ly wears full robes, of antique style, but of no particular period, and has no head covering. Tobias, however, tends to be dressed in the height of contemporary fashion. In his left hand he carries the fish from the Tigris on a string or a wire. Although the Bible narrative refers to the fish as large and dangerous, it is portrayed as only a harmless attribute. Veit Stoss followed all of these details, only omitting the little dog that appears in the biblical account and is generally included in the Italian pictures.

The reconstruction of the presumed arrangement of Stoss's two figures is extensively discussed in the literature. Max Lossnitzer (1912, pp. 130–31) first identified the Raphael figure, which, in the nineteenth century, had been interpreted as a portrayal of Gabriel with a palm branch. Tobias, on the other hand, was thought to represent one of the three Magi, because of his princely costume, with its ermine collar, and distinctive hat. It was not until the Veit Stoss exhibition in 1933 that the two figures were seen to belong together. Ewald M. Vetter and Eike Oellermann finally suggested a likely placement of the pair that takes into account not only certain technical features of the two figures, but also the psychological relationship between the powerful guardian angel and his trusting young ward, as well as the Italian painting tradition. Their arrangement here follows this reconstruction.

The group was set against a column in the Dominikanerkirche, probably in a small shrine that consisted simply of a console, a flat back wall, to which the archangel's great arched wings were affixed, and a shallow baldachin. Such baldachins for epitaphs and similar memorials are known to have graced the church's columns. There were probably no projecting walls on the sides. The console displayed the patron's coat of arms, his initials, and the date 1516 — the year in which the group was installed.

The dominant figure is Raphael, who is enveloped in a cloak that swirls and billows in rich folds — an unparalleled example of virtuoso carving. The archangel's torso tips back slightly. The position of his legs can scarcely be made out beneath the wealth of drapery. His bare right foot, turned outward, projects from beneath the hem of his gown. The ends of his cloak are supported by his outstretched arms. Beneath the cloak he wears a long gown that is belted twice, like a Greek peplum, and falls in elaborate folds about his feet; at the waist, above a deep tuck of skirting, it appears to be tied with a thin twig; at the neck, it is gathered into a ruffle. His left sleeve is pushed back above the elbow, exposing the unusual cuff of the sleeve of an undergarment — seemingly of leather, and originally secured with thongs or cords, and sometimes seen in portrayals of angels by sculptors influenced by Veit Stoss (*Veit Stoss...*, 1983, ill. 183). Between these cords, the thin fabric of the undergarment is carefully indicated in neat ridges. The cloak scarcely deserves its name, for it does not "cloak" the archangel; its ends swirl about in free curves, to the side and in front of the figure.

With his left hand, the angel holds the hem of the garment. Drawn up from behind, at the height of the thigh, the cloak then falls in two sharp curves. Here, it is as thin as paper. The torso is perfectly free of the garment, which rests only slightly on the right shoulder before boldly curling, with its full width, around the arm. From the wrist, it falls in a free series of wrinkles and swirls as though twisting "around a core turned like a screw." It is in this passage that Stoss displays his most exquisite carving. The free-floating drapery touches the thigh in only a single place. Yet, the entire figure of the angel, including the seemingly detached sections of fabric, was developed out of a single block of wood; none of these elements was carved separately and then glued in place, as was altogether customary even with much simpler configurations and a practice by no means scorned by Veit Stoss elsewhere.

In the present and doubtless correct arrangement, Tobias stands next to the archangel in what is virtually a profile pose. His gaze is fixed on his companion's raised hand, which once contained the box with the fish gall, the priceless substance that would restore his father's eyesight. With his own right hand, which disappears into the shadow of the background and was left unfinished, he reaches for Raphael's protecting arm. His left hand formerly held the

fish by a string. His costume is strikingly modish, not to say eccentric. The outer garment is close fitting, and slit down to the belt. In back, the tail of it is tucked into his belt to keep it out of the way. The undergarment hangs down only to mid-calf, so that one can admire his fashionable boots. The full sleeves of the undergarment are gathered into cuffs. Although the rest of the outer garment is tight fitting, its sleeves expand to enormous size, their untold yards of fabric reaching the hem of his skirt. The left sleeve, especially, has been turned back, so that it forms a huge, oval-shaped opening, from the collar to the top of his boots — one that is only interrupted by the projecting hand that once held the fish. Crowning this overall effect is the boy's double-layered ermine collar that extends past the shoulder, and his biretta, doubtless intended to identify the biblical Tobias as a high-placed, genteel, and respected figure. The costume must also have been designed to reflect the luxury of the Italian jewel and silk merchant's own dress, and that of his son, and to thereby impress his German customers — assuming that the sculpture was meant to express concern and gratitude for his or his son's safety during their sojourn in far-off Germany, as was the Italian custom. Given the fact that the patron was a dealer in luxury goods, he undoubtedly could appreciate the virtuosity of Veit Stoss's carving. This particular example is even more astounding than the same sculptor's portrayal of Saint Roch (in Santissima Annunziata, Florence) — a work that Vasari later described as a "miracolo di legno," (a "miracle in wood"); the drapery folds of the *Saint Roch* were executed "con sottilissima intaglio tanto morbidi e traforati," as though made of paper, and arranged with a beauty of movement more wondrous than that seen elsewhere. Everything is of such perfection that the figure is deserving of the praise of all men, Vasari wrote, and the master who carved it (his name had been forgotten in Florence, by Vasari's time) had done so "a tanta sottigliezza, che el fanno stupire il mondo" ("with such subtlety as to amaze the world").

RK

Ex collections: *Raphael*: Jakobskirche, Nuremberg (19th century); *Tobias*: municipal art collections (19th century).

Bibliography: Schwarz, 1737, p. 18; Lösch, 1825, p. 42; Bode, 1885, p. 125; Schäfer, 1896, pl. 28; Daun, 1903, pp. 149–50, ill. 78, 1906, p. 91, ill. 100; Josephi, 1910, no. 305, ill.; Lossnitzer, 1912, pp. 130–31, 200, nn. 408–10, pl. 46; Daun, 1916, pp. 210–12, pl. 59.2; Bock, 1924, pp. 201–2; Lutze, in *Stoss*, 1933, nos. 23–24; Lutze, 1937, pp. 186–88, ill., 1938, pp. 36–37, ill. 51; Dettloff, 1961, vol. 1, pp. 132–33, 301, vol. 2, pl. 189; Pilz, 1964, pp. 66–67; Lutze, 1968, pp. 49–50, ills. 62–63; Weskott, 1974, pp. 18, 136, n. 59; Baxandall, 1980, pp. 272–73, pl. 47; Kępiński, 1981, pp. 79–80, pls. 141–146; Liebmann, 1982, pp. 357, 364, 365, ill. 197; Bräutigam, 1983, pp. 181–82, ill.; Rasmussen, in *Veit Stoss...*, 1983, no. 8 (with additional bibliography), ills. 38, 94–97; Kahsnitz, 1984, pp. 42–44, ills. 1–2; Vetter and Oellermann, pp. 311–19, ills. 2, 5–10; Rasmussen, 1985, pp. 121–22, ill. 70.

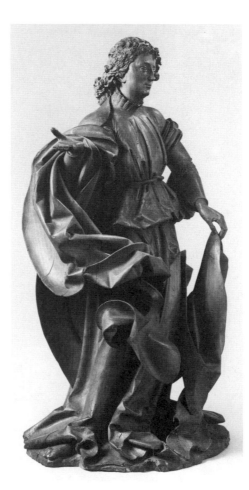

93: *Raphael*

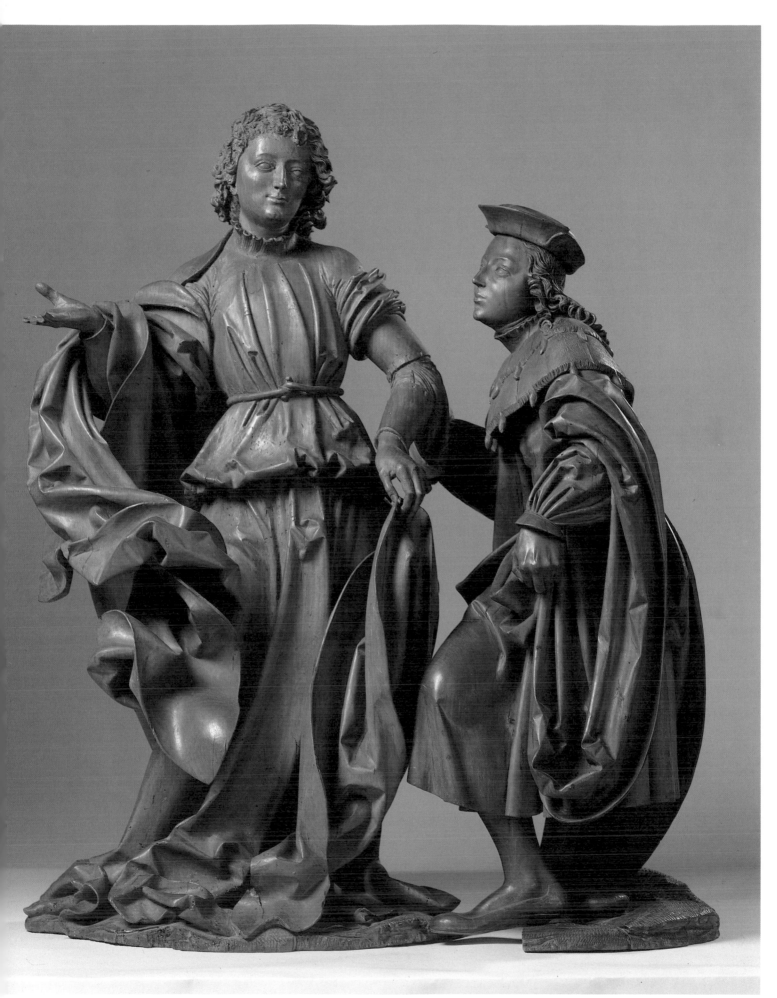

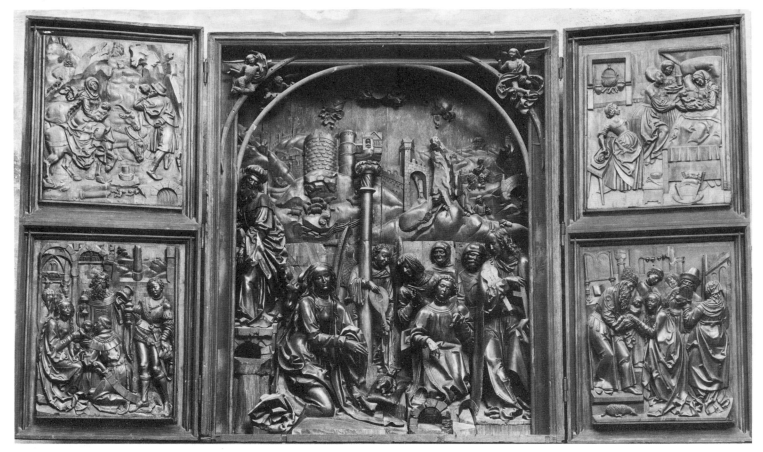

Figure 126 Veit Stoss. Altarpiece from the Karmeliterkirche, Nuremberg (wings open). 1520–23. Bamberg, Cathedral (on loan from the Obere Pfarrkirche)

Design for the Altarpiece for the Karmeliterkirche, Nuremberg

1520
Pen and brown ink, on paper
17 11/16 x 12 5/8 in. (45 x 32 cm.)
Inscribed (on the reverse, in an 18th-century hand): "Altar von Kalenberg in der oberen Pfarre zu Bamberg von Veit Stoß; das Hauptbild und die zwei Türen sind noch in dieser Kirche" ("Altarpiece from Kalenberg in Bamberg's upper parish by Veit Stoss; the central panel and the two doors are still preserved in that church"); affixed to the back is this excerpt from a catalogue issued by the Aumüller auction house: "Nr. 1787, Veit Stoss, Geburt Christi, Fol, Vorzügliche Federzeichnung" ("No. 1787, Veit Stoss, The Nativity, Fol, superb pen drawing").
Cracow, Muzeum Historyczne Uniwersytetu Jagiellońskiego (acquired from the museum of the princes Czartoryski, Cracow, in the 19th century)

On July 13, 1520, the sculptor Veit Stoss signed a contract with the prior and the chapter of the Nuremberg Carmelite monastery to create and install a new altarpiece for the high altar. The prior in question was Dr. Andreas Stoss, one of the sculptor's sons. Andreas had entered the Nuremberg monastery in 1502; then, after extensive study and teaching, he had served as prior of the order's establishment in Budapest from 1513 to 1520. In the spring of 1520, he had been recalled to Nuremberg as prior at the request of the Nuremberg council. The wording of the contract is preserved (Lossnitzer, 1912,

pp. LXI–LXII, no. 132 a; Dettloff, 1961, vol. 1, p. 262). Among other things, it specified that, for the sum of four hundred guilders, Veit Stoss was to create a wooden panel, or retable, for the altar of the choir within a period of three years — if God were to grant him such long life. The sculptor was, at that time, at least in his seventies. The figures of the central shrine, the superstructure, and the predella were to be fully three dimensional, the four scenes on the interiors of the wings were to be in high relief, and those on the exterior, in bas-relief. The stationary wings were to be plain. The master was to make any changes to the proposed design that might be desired by the chapter — at the least, all changes were to be fully discussed. Payment was to be in annual installments of fifty guilders each. In the event that either death or disability prevented Stoss from completing the work, the appropriate sums were to be deducted. This uncommonly low fee is due, in part, to the obviously poor financial condition of the monastery, and to the close relationship between the parties to the contract. The individual subject matter of the various sculptures and reliefs — the number of angels to be carved, for example — was not spelled out in the contract, as was frequently the custom. Clearly, this was because the design submitted was considered an integral part of the contract itself.

The altarpiece was completed and installed within the prescribed period, as is known from accompanying documents, and bore the date 1523 and Veit Stoss's master's mark. Although a

number of scholars have speculated that it was never, in fact, finished, this has now been refuted once and for all. The altarpiece was not painted or gilded, partly because such embellishments would have been impossible given the low fee provided, and also because such decoration apparently was no longer desirable. Tastes had completely changed by that time. Like other sculptors, Veit Stoss had become accustomed to achieving his effects solely through the mastery of his carving and the careful finishing of his surfaces. In this connection, it is particularly interesting to read an entry placed in the monastery's record book by Veit Stoss's son (Schaffer, 1928, p. 362): "Brother Andreas Stoss, born in Cracow, doctor of canon law and prior of this monastery, had the choir altar adorned with a new visage by his father, Master Veit Stoss, in 1523. No prior is to be so thoughtless as to have it painted in colors. All masters of this craft will be able to explain to him the reasons for this." No less astonishing are the following admonitions regarding the care of the work. The wings were to be opened only on specified high feast days, which was entirely customary, but to ensure that the carvings were not damaged by candle smoke, it was specified that only two small lights could be used on the altar, itself, the rest to be placed a good distance away. Obviously, a definite value was accorded the altarpiece as a work of art, a value to which even the splendor of the Mass in this monastery church was to be subordinated.

With the advent of the Reformation in 1525,

94

253

and the resulting dissolution of the monastery, the altarpiece was never fully paid for. A protracted dispute ensued between the city, which had taken over the monastery's estate, and the sculptor. After his death in 1533, it was continued by his heirs, chiefly, the above-mentioned son, Andreas Stoss, who, as head of the non-Reformers, was forced to leave Nuremberg. Ultimately, in 1543, the altarpiece was returned to the heirs of Andreas — by then, he had also died — and, a short time later, it was probably sold to Bamberg, which had remained Catholic. The altarpiece was installed in the Obere Pfarrkirche, and, since 1933, it has been on permanent loan to Bamberg Cathedral.

The central shrine, which depicts the Nativity, has survived, as have four of the original eight reliefs from the wings, all of them probably from the right-hand one. They include two panels in high relief of the Adoration of the Magi and the Presentation in the Temple, which once must have adorned the interior of the wing, and two in bas-relief depicting the Birth of the Virgin and the Flight into Egypt. The four are now displayed on the insides of the wings, although the latter pair surely were once on the outside. Also preserved are two groups of three kneeling apostles from the Assumption scene on the superstructure, an additional kneeling figure (possibly of Isaac, from the predella), and the lunette from the top of one of the stationary wings depicting the miraculous feeding of Elijah. (All of these fragments are now in the Diözesanmuseum, Bamberg.) Four reliefs from the wings have been lost: the two in high relief, from the left side, with the Annunciation and the Visitation — clearly visible in the present drawing — as well as the two bas-reliefs from the outside of that wing, whose subject matter remains uncertain. Also missing are the Christ and the Virgin from the Assumption; the large figures of Christ as the Man of Sorrows, the Virgin, and Saint John, from the very top of the altarpiece; and the lunette from the other stationary wing, which depicted Elijah on Mount Carmel. Only the figure of Isaac remains from the predella, which, according to the drawing, presented the creation of Eve, Adam and Eve being driven out of Paradise, and Abraham's sacrifice of Isaac. It is not known whether the altarpiece was already incomplete at the time that it was removed to Bamberg, or whether it suffered damage after it was installed there. An eighteenth-century illustration shows it in its present condition.

The present drawing is highly finished, befitting its official function: According to the basis on which the contract with the Carmelite monastery was concluded, the drawing was part of the very contract, itself. Three other drawings by Veit Stoss are known. Two quick sketches of the Virgin and Child with Saint Anne are preserved on the draft of a letter from 1512/13 (now in Budapest; Kępiński, 1981, ill. 194). These are typical design sketches, their free, spontaneous lines merely indicating in outline the three-dimensional forms of the projected figures. In addition, there exists an earlier drawing (now in Berlin), obviously a design for an engraving of the Presentation in the Temple, which is more finished in its indication of light and shadow (Kępiński, 1981, ill. 193). The Budapest sheet reveals that the drawing medium must have played an important part in Stoss's development of his ideas. Sketches like these, in which he worked out the overall composition of the altarpiece and the arrangement of the figural masses in the major scenes, must have preceded the present finished design. The drawing shows the decidedly Renaissance design of the structure of the altarpiece, for which it is clear that the artist resorted to the use of a straightedge and compass. Nevertheless, the drawing of the separate figures is both quite descriptive and free, and possesses a high degree of graphic charm. The figures are built up of small, thin, curving strokes of the pen. At times, specific configurations are suggested by simple checks or dots, rather than by solid outlines. The draftsman-like quality of the work sets it apart from other surviving sculptors' drawings from the Late Gothic period, which tend to be much more schematic. The sensitivity of its line also distinguishes it from the less skillful engravings that Stoss produced decades earlier — probably while he was still living in Cracow. Ten such engravings survive (see fig. 107).

The Cracow drawing documents the intentions of the sculptor and his patron at the time that the contract was signed in 1520. The contract, itself, called for one specific change: namely, that the carved predella also be provided with wings — a feature not reflected in the drawing. Discrepancies between the design and the finished altarpiece — especially regarding the central shrine, as it now appears in Bamberg — have been the subject of considerable scholarly discussion. In part, these discrepancies are the result of alterations to the arrangement of the various components over the course of the centuries, which make the original form of the altarpiece difficult to reconstruct. On the other hand, they are also clearly the result of the sculptor's own changes and possibly even reflect adjustments requested by the Carmelite chapter, as provided for in the contract. Of particular importance, although difficult to justify, is the way in which the center column has lost its connection to the overall composition, and its integral place in the architecture of the altarpiece. There have also been major changes in the Joseph figure, which has now been forced to the very edge of the composition, as well as in the grouping of the angels. It would be hard to determine the reasons for the latter alterations. Satisfactory answers to the questions could be provided only by a restoration of the Bamberg Altarpiece, which has long been planned. Perhaps it would then be possible, as well, to ascertain its original appearance. R K

EX COLLECTIONS (from the files of the city of Nuremberg on the altarpiece for the Karmeliterkirche, now in the Staatsarchiv, Nuremberg, S I L 103, no. 3): Aumüller auction house, Munich (19th century); Edward Rastawiecki (?); Izabela Czartoryska Collection, Museum of the princes Czartoryski, Cracow.

BIBLIOGRAPHY: Daun, 1903, p. 89, n. 146, 1906, p. 71; Tomkowicz, 1912, pp. 373–80, pl. III; Lossnitzer, 1912, pp. 140, 403, n. 431, pl. 55; Daun, 1916, pp. 159–62, pls. 54–55; Schilling, 1929, no. 9, pl. 9; Dettloff, 1935, pp. 89–107, ill.; Lutze, 1938, p. 44, ill. 58; Keller, 1959, pp. 5–8, ill. 1, p. 20; Dettloff, 1961, vol. 1, pp. 149–50, 263, 302, vol. 2, pls. 213–218; Lutze, 1968, pp. 58–59, ill. 74; Kępiński, 1969, passim (with numerous detail ills.); Bandmann, 1970, pp. 137–39, ill. 4; Stafski, 1970, pp. 48–54, ill. 2; Török, 1971, pp. 67–68; Rasmussen, 1974, pp. 64–71, ill. 13; Kępiński, 1982, pp. 111–12, pl. 195; Bräutigam, in Veit Stoss..., 1983, pp. 345–47, ill. 8; Kahsnitz, 1983, p. 2819; Hausherr, 1985, pp. 212, 214–18, ill. 143; Suckale, 1985, pp. 231–33, 238–39.

95 VEIT STOSS

Saint Vitus in a Caldron of Oil

Dated (on bottom of caldron): 1520, with Stoss's master's mark
Linden wood
Height, 19 7/8 in. (50.5 cm.); diameter of caldron, 8 7/8 in. (22.5 cm.)
The figure and the caldron were carved from a single block of wood, and not hollowed out. The caldron is flattened at the back. The claw foot of the caldron, at the viewer's right, is restored. The loops around the neck of the caldron once may have been fitted with a flexible handle. The original polychromy is faded, except for small traces: Originally, the caldron was gilded, with red and green tongues of flame; the boiling oil was a glittering red; and the saint's body was a flesh tone, and his hair gilded.
Nuremberg, Germanisches Nationalmuseum (acquired, 1965)
Pl 0.3013

The child-like young saint sits in a caldron of oil up to his navel. His face is full, and his body — at least his arms and his back — is distinctly fleshy. A wreath of thick, curly hair encircles his head. His hands are folded in front of his chest, tilting slightly downward.

According to legend, Saint Vitus was martyred in boiling oil at the age of twelve, during Diocletian's persecutions of the Christians in 303/4. He is one of the fourteen helpers in need, and enjoyed widespread veneration in the Late Middle Ages as a healer of numerous ailments in men and animals. He is portrayed in altarpieces among the fourteen helpers in need, in other groupings, or — especially in southern Germany and in the Alpine regions — often alone.

Although the flattening of the back of the caldron suggests that the figure was intended for a shrine, the presence of the date and signature implies that the Saint Vitus was an independent sculpture. Of course, it is possible that it was part of a work devoted to the martyrdom of the saint, such as the sculpture group by Christoph von Urach, of 1519, in the church of Sankt Blasius in Ehingen, in Württemberg (Baum, 1925, no. 81, ill.). In the latter series, Saint Vitus, in the caldron, is the central figure,

surrounded by Diocletian and two constables who are carrying out the emperor's sentence. Such a sculpture group might have been free-standing — or, perhaps, was part of a small shrine. Among the surviving works by Veit Stoss, a date and signature — like the date of 1523 that appears in the central panel of the Bamberg Altarpiece (cat. no. 94) — are rare, and, when present, are found on the front of the work, and not, as here, hidden from view.

RK

Ex collections: the sculptor Heinz Schiestl, Würzburg (died 1940); Augustinerkloster, Würzburg; Leo Weismantel (1941–64).

Bibliography: Lutze, 1968, pp. 63, 68, ill. 92; Rasmussen, 1976, p. 113; Kępiński, 1981, p. 91, ill. 175; Brandl, in Veit Stoss..., 1983, no. 11, ills. 44, 106–107.2.

96 PUPIL OF VEIT STOSS

The Virgin, from a Coronation of the Virgin Group

1522–23
Linden wood
Height, 58 1/4 in. (148 cm.)
The sculpture is flattened and hollowed out at the back. There are no traces of original polychromy, yet the poor quality of the wood, such as the knothole on the left side, and the doubtless original repairs that were made to it, would suggest that the figure originally was painted. The Virgin's nose, and portions of the lower part of her outergarment were restored.
Provenance: the Cistercian church, Heilsbronn (Middle Franconia).
Nuremberg, Germanisches Nationalmuseum (acquired on the Munich art market, 1886)
Pl 0.46

This sculpture of the Virgin kneeling on a cloud has a strong three-dimensional presence, and a distinctly sensual physicality, but, as the work of one of the numerous pupils of Veit Stoss, it was hardly noticed for a long time. Yet, as early as 1912, Max Lossnitzer praised its fine composition. In the catalogue of the Veit Stoss exhibition, held in 1983, Rainer Brandl made special mention of its artistic excellence, and of the fact that it came from one of the last great Coronation of the Virgin altarpieces of the Late Gothic period — a work that must have been created in Nuremberg shortly before the adoption of Lutheranism. The following is based, in large part, on Brandl's observations.

The Virgin faces forward, her hands modestly crossed over her breast. Her torso tips back slightly and her head bends forward and to the right, so that her body describes a long, gentle curve. The bottom of her mantle billows in two large swirls, as if caught by the wind and by the motion of her Assumption into heaven; otherwise, it falls smoothly from her shoulders over her simple gown. The right side of the mantle is

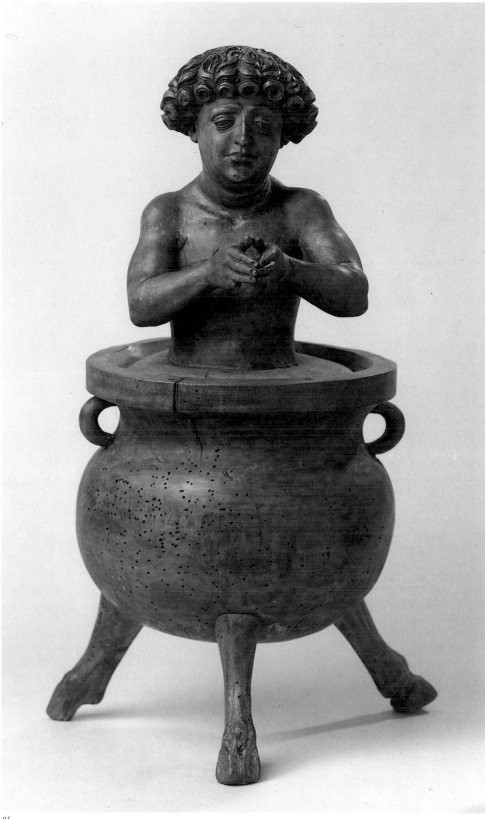

95

wound around her arm; the left side curves outward in broad bands, from the elbow. The Virgin's head is covered with a veil, the end of which falls from the shoulder across her breast and down to her left thigh. This presents a striking parallel to the small relief of the Dormition of the Virgin, by Veit Stoss, probably one of his last works, created after the Bamberg Altar-

piece, from 1523 to 1525 (Kępiński, 1981, ill. 174; now in an unidentified private collection). Carefully developed locks of hair emerge from beneath the veil and hang down across the Virgin's shoulders and her back.

The knowledge that the sculpture comes from the Cistercian church in Heilsbronn, in the vicinity of Nuremberg, is based on a statement by

the dealer from whom it was acquired in 1886. Although this fact cannot be absolutely confirmed by historical documents, it seems plausible. During his tenure as the last abbot of the Cistercian abbey in Heilsbronn (from 1518 to 1529), Johann Wenck had a monumental new altarpiece installed on the high altar of the church, at great expense, in 1522/23. Outlays of at least five hundred guilders are documented, but, unfortunately, there is no mention of the names of the artists involved nor of the iconographic program of the altarpiece. Up to now, it has also been impossible to find any adequate description of the work, from a later date. The high altar's "uncommonly wide grouping of statues nearly reaching up to the vaulting" was dismantled in 1711, as it was threatening to collapse. At the beginning of the nineteenth century, there were still sixty carved figures from dismantled altarpieces in the monastery church, most of which were sold after 1862. Some were preserved in Heilsbronn — among them, a figure of God the Father enthroned, which appears to have been part of a Coronation of the Virgin group. However, because of its modern gilding, its origins are difficult to determine. In the seventeenth century, the church still had twenty-eight altars; today there are only eight.

Like all Cistercian churches, the one in Heilsbronn was under the patronage of the Virgin. Its high altar was dedicated to her and to the Holy Cross. The new retable was therefore doubtless based on scenes from her life. The Assumption and the Coronation of the Virgin were among the most popular subjects for the numerous carved altarpieces that were made around — and, especially, after — 1500. Indeed, the majority of altarpieces that were not limited to single standing figures were based on these central Marian events. This was true of Veit Stoss's own Cracow Altarpiece, of 1477–89, which presented, one above the other, the Dormition of the Virgin in the presence of the apostles, the Assumption, and the Coronation of the Virgin by God the Father and Christ. The altarpiece by Michael Pacher, of 1471–81, in the Pfarrkirche in Sankt Wolfgang am Abersee, and the Coronation altarpieces by the Master H.L. in Breisach Minster and in Niederrottweil, as late in date as 1523–26, share the same subjects. Furthermore, the over-twenty-foot-tall altarpiece that Veit Stoss created in 1503 — it is now lost —for the Stadtpfarrkirche, in Schwaz, in the Tyrol, at a cost of 1,160 guilders, depicts the Assumption of Mary, with the apostles assembled below, around her open tomb. The Schwabach Altarpiece, of 1507–8 (fig. 67), the largest surviving example from the period, in the vicinity of Nuremberg, concentrates on the coronation of the kneeling Virgin by Christ, and therefore occupies a special place in Coronation iconography.

The standard manner of portraying the event, in the art of Nuremberg — and, for that matter, in the art of southern Germany — was to show Mary kneeling and facing front, with Christ and God the Father enthroned on either side of her, at a slightly higher level, and holding the crown

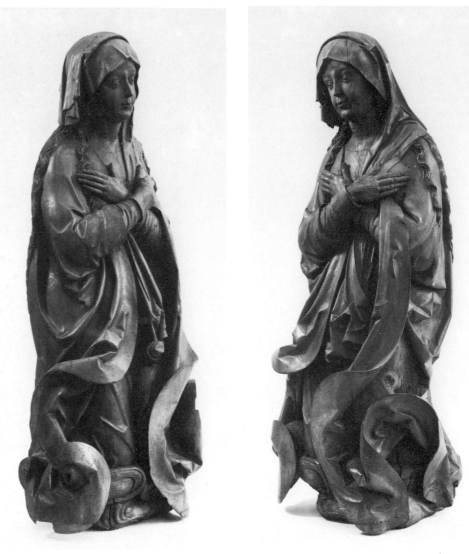

96

over her head. Such was the arrangement in the scene at the top of the Cracow Altarpiece (Kępiński, 1981, ill. 75), as well as on a painted wing, in the style of Hans Suess von Kulmbach, from the new altarpiece commissioned for the high altar of the Frauenkirche, in Nuremberg, by the Welser family, and installed in the same period — about 1522/23 (Lutze and Wiegand, 1937, ill. 116). The group in Heilsbronn must also have followed this scheme. The figure of God the Father preserved there probably occupied the space to the right of the Virgin, and a corresponding figure of Christ (no longer extant) would have stood to the left. Mary's kneeling posture and the way in which her arms are crossed over her breast suggest that the figure was part of a Coronation group. In portrayals of the Assumption, by contrast, she is shown either standing on a cloud, or supported by angels — as she appears in the scene between the Dormition and the Coronation, in Veit Stoss's Cracow Altarpiece, where she ascends to heaven with Christ at her side (Kępiński, 1981, ill. 74). Riemenschneider depicted the event, thus, in the Creglingen Altarpiece that he made from 1505 to 1510 (Baxandall, 1980, pls. 27–28).

In the art of Nuremberg there is also a tradition of combining the Coronation and the Assumption, so that Mary receives the crown from God the Father and from Christ, in the presence of the Holy Spirit, while still kneeling in the clouds, as the apostles, who actually belong to the iconography of the Assumption, stand or kneel around her open tomb, and gaze upward into heaven in astonishment, from the space below. Examples of this iconography are Albrecht Dürer's *Heller Altarpiece*, of 1503–9 (Panofsky, 1948, vol. I, pp. 123–24, ill. 168), the corresponding woodcut from the *Life of the Virgin* series, of 1510 (cat. no. 127), and an epitaph by Hans Leonhard Schäufelein, of 1521, in Nördlingen (Schiller, vol. IV, 2, ill. 750). That Veit Stoss also adopted this composition in the Coronation scene that he included in the Bamberg Altarpiece is evidenced by the drawing in Cracow (cat. no. 94). Stoss combined the traditional imagery of a Coronation group with that of the kneeling apostles — one of whom bends down into the Virgin's empty tomb, at the center of the scene. Works such as those by the Master of the Wolfgang Altarpiece (originally in Breslau and now in Warsaw), or by Michael Wolgemut, in the Jakobskirche, in Straubing

256

(Stange, 1934–56, vol. 9, ills. 55, 101), provide examples from older Nuremberg art of what was a firmly established tradition by the time of the creation of the altarpiece in Heilsbronn.

Judging from the way that the wind causes her mantle to billow, it would appear that the figure of the Virgin, from Heilsbronn, was part of a portrayal in which the Assumption and the Coronation were incorporated into one event. It is also likely that the lower space of the central portion of this uncommonly tall altarpiece was filled by the group of the twelve standing or kneeling apostles. As for the architectural form of this retable — which may well have been composed of Renaissance elements, like the *Welser Altarpiece*, from the Frauenkirche — nothing definite is known. Given the fact that the figures are slightly larger than life size, the center part would have been at least sixteen or seventeen feet high. Although these few details are skimpy, they provide some idea of one of the largest and most lavish Coronation altarpieces from the transitional period between the Late Gothic and Renaissance styles.

Its creator — no further examples of whose sculpture have been identified, heretofore — must have been a pupil of Veit Stoss. It is clear that Stoss's late work served as the point of departure for the sculptor of the present statue — as revealed by a comparison with the similarly weighty physicality of the kneeling Virgin from the Bamberg Altarpiece, or with the above-mentioned Dormition relief. This sculptor adopted such typical Stoss forms as the billowing mantle, although, inasmuch as his conception of the figure focused more on the body than on the drapery, the latter was of secondary importance. By emphasizing the forms of the human body in lieu of the fluttering drapery, with its interplay of light and shadow — which contributed greatly to the vitality of Late Gothic sculpture — he clearly surpasses Veit Stoss. His figure of the Virgin is marked by a certain physical ponderation that, however, has a decidedly sensuous appeal. Despite its few Late Gothic drapery motifs, the present work exhibits something of the impressive three-dimensional presence that characterized the new art of the Renaissance. Attempts have been made to identify the carver of the Heilsbronn *Virgin* with the master of the *Welser Altarpiece*, from the Frauenkirche, but, by virtue of his greater artistry alone, such attempts remain unconvincing. Only with the discovery of other works by this master can he be distinguished, at last, from the anonymity of the Veit Stoss school.

RK

BIBLIOGRAPHY: Münzenberger and Beissel, 1885–1905, vol. 2, pl. 89; Schäfer, 1898, pl. 14; Daun, 1903, p. 69, ill. 33, 1906, p. 56, ill. 59; Josephi, 1910, no. 317, pl. 40; Lossnitzer, 1912, pp. 120, 125; Höhn, 1922, pp. xv, 119, ill. 88; Lutze, in *Stoss*, 1933, no. 37; Lutze, 1938, pp. 35–36, ill. 50; Müller, 1938, p. 134; Lutze, 1940, p. 35, ill. 54; Stafski, 1951, p. 13, ill. 4; Zachmeier, 1956, no. 143; Kępiński, 1981, p. 90, ill. 173; Brandl, in *Veit Stoss…*, 1983, no. 14, ill. 114–115.2; Kahsnitz, 1983, p. 2818, ill. 6.

96

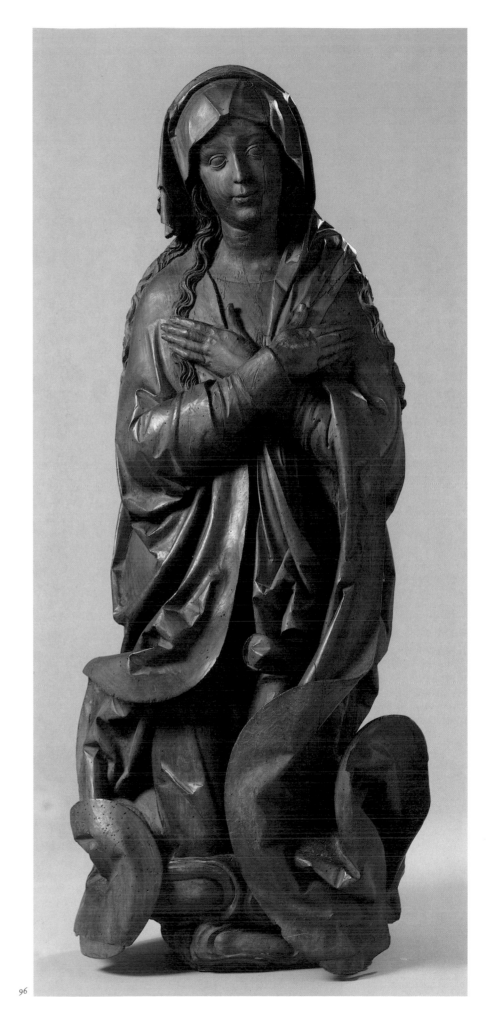

97 ADAM KRAFT (model?)
PETER VISCHER THE ELDER (cast)

Kneeling Man

Dated (on breeches): 1490
Brass, solid cast, after a wax(?) model; olive
brown, with a natural patina, and the remains of
black lacquer
Height, 14 1/2 in. (36.8 cm.)
There are small casting flaws.
Provenance: Residenz, Munich (Kunstkammer
Inventar, 1598, by Johannes Baptist Fickler,
Bayerische Staatsbibliothek, Munich, Cod. Germ.
2133, no. 2292).
Munich, Bayerisches Nationalmuseum
MA 1983

The young man struggles beneath an unknown
(and now lost) yet heavy burden, his left knee
pressed to the ground. His head is turned to his
right. The gnarled branch, however sturdy,
bends, offering insufficient help in counteract-
ing the weight, which was probably supported
on his right shoulder above the attachment hole
there. Dressed in the contemporary costume of
the craftsman class, the man is in shirt sleeves
with his short vest unbuttoned. He wears loose
hose below his breeches, and slipper-like shoes.

The traditional title for this work — "The
Branch Breaker" — is misleading, and should be
rejected because it misinterprets the action. The
torsion of the figure, including the position of
his legs and his upturned, contorted face, can
only be understood if one assumes that the
work was tectonic in conception, and was in-
tended to bear a heavy weight. Thus, while the
statuette today is often viewed as an independ-
ent sculpture, its original context must have
been a structural one.

It has been proposed that the figure may have
been planned as a support for a church furnish-
ing, such as a font, pulpit, or sacrament house.
Naturalistic support figures such as those by Jan
Aert van Maastricht on the brass font, of 1492,
in the Janskerk, at 's Hertogenbosch; on the
stone pulpits by Anton Pilgram: one, of
1485–90, formerly in the church at Öhringen,
and now in the Staatliche Museen, East Berlin
(8580d), and another, of about 1492, in the
Lorenzkapelle, Rottweil; and, most important-
ly, on the *Sacrament House* (fig. 62), of
1493–96, by Adam Kraft in the Lorenzkirche,
Nuremberg (K. Oettinger, *Anton Pilgram und
die Bildhauer von St. Stephen,* Vienna, 1951, p.
105, figs. 20, 21; W. Schwemmer, *Adam Kraft,*
Nuremberg, 1958, figs. 7–8, 10–11; Müller,
1966, pp. 161, 169, 185, pls. 160, 182, 183), may
be helpful in envisioning the present figure in a
related setting. Another possibility is that the
brass *Kneeling Man* may have been a trial piece
made in the shop of Peter Vischer the Elder
prior to the final casting of the *Sebaldus Tomb*
(fig. 135) for the Sebalduskirche, Nuremberg.
While the figure does not appear in the 1488
sketch for the project, on parchment (cat. no.
189), in the Akademie der bildenden Künste,
Vienna, a stylistic comparison can be made with
the nonsupporting statuettes of the seated Nim-
rod and Hercules by Peter Vischer's son, Peter
the Younger, datable about 1514 or before 1519,

when the shrine was completed. While these fig-
ures partially reflect the influence of their Italian
Renaissance counterparts and, ultimately, of
such sculpture from antiquity as the *Belvedere
Torso* (see also cat. nos. 197, 236), they are also
dependent on the naturalistic details of the pres-
ent work — especially, on the strong realism of
the head. Could the larger *Kneeling Man* have
been conceived at one point — for example, in
1490 — as one of a series of support figures
beneath the base of the *Sebaldus Tomb*, only to
be abandoned in favor of the oversized snails
and corner monsters supporting the shrine to-
day? Unfortunately, there is no evidence to
substantiate this hypothesis.

The iconography of the present sculpture is
also debatable. Rather than merely a representa-
tion of low or peasant life, or an "allegory of
oafishness" (von der Osten, 1963, pp. 75–76;
von der Osten and Vey, 1969, p. 20), it may
actually have been intended as an allegory of
strength and skill. The similarity of his crafts-
man's attire to the costumes of the two outer-
most support figures on Adam Kraft's *Sacra-
ment House* makes one wonder whether the
brass *Kneeling Man* is not a paean to applied
ability and masterly craft and, as such, whether
it was meant as a demonstration of its maker's
skill — as his masterwork. The brass figure,
described as "one of the most powerfully
expressive small bronzes [*sic*] of all time" (Rad-
cliffe, 1966, p. 54), may prefigure the underlying
proud defiance of Adam Kraft's stone self-por-
trait (fig. 63), carved scarcely more than three or
four years later, for the *Sacrament House*. The
motif of the branch in the present work may be
an attribute that is central to this multiple alle-
gory, anticipating both the leverage stick of
Adam Kraft's bearded assistant below the
Sacrament House and the club held by Peter
Vischer the Younger's Hercules just above the
base of the *Sebaldus Tomb*.

As a masterpiece of Late Gothic naturalism,
the *Kneeling Man* demonstrates the artist's keen
interest in the overall structure and movement
of the human body, with little concern for
anatomy and for the classically inspired forms
of the Italian Renaissance. The effect is not one
of realism in the modern sense, but, rather, of
verisimilitude — the result of observation and
then of simplification, for expressive purposes.
The origins of this approach lie in Netherland-
ish painting and sculpture. One of its foremost

exponents, whose works may have had either
direct or even indirect impact on Kraft, is
Nikolaus Gerhaert van Leyden (see cat. no. 98).
The sense of taut structure and of twisting
movement in the present work recalls
Nikolaus's presumed self-portrait in stone, of
1463; the psychological expression on the face
of the *Kneeling Man* may derive from
Nikolaus's experimentation with representing
various states of mind, as seen in the self-por-
trait, as well as in the several heads by or associ-
ated with him that are preserved in the Musée de
l'Oeuvre Notre-Dame, Strasbourg, and in the
Bayerisches Nationalmuseum, Munich (Wert-
heimer, 1929, pls. 11, 16, 17; *Spätgotik am
Oberrhein, Meisterwerke der Plastik und des
Kunsthandwerks, 1450–1530* [exhib. cat.],
Karlsruhe, Schloss, 1970, nos. 16, 21, 22, figs.
19, 22, 23).

The attribution is problematic. There is near-
ly universal agreement that the brass *Kneeling
Man* was cast in the workshop of Peter Vischer
the Elder (see cat. nos. 183, 186), but what re-
mains in question is the artist responsible for the
model. Over the years, the name of Adam Kraft
has been proposed and denied. The main argu-
ment against an attribution to Kraft — that he is
known only as a sculptor in stone — does not
preclude the fact that he could have made the
model for the present figure, which was cast by
his friend Peter Vischer the Elder. Johann
Neudörfer, the Nuremberg biographer of art-
ists, tells us that Kraft was familiar with the
making of models (G. W. K. Lochner, 1875, p.
11). A stylistic basis for this attribution is pro-
vided by a comparison of the *Kneeling Man*
with the heads of Saint John the Evangelist and
Nicodemus on the *Schreyer-Landauer Epitaph,*
of 1490–92; the slightly later support figures
and other figures on the *Sacrament House*; and
one of the merchants in the *Weighmaster* relief,
dated 1497 (Schwemmer, 1958, figs. 2–3, 21,
35). Recently, Klaus Pechstein has reaffirmed
the attribution of the model to Kraft based upon
a comparison with the artist's music-making
groups, of about 1505, from the house of the
Imhoff family at Tucherstrasse 20 (cat. no. 100).

WDW

97: detail

BIBLIOGRAPHY: Meller, 1925, pp. 37–40, figs. 11–13,
1926, pp. 11–12, fig. 1; Bange, 1929, 50, pp. 167–82;
Berliner, 1931, 8, pp. 143–45; Bange, 1949, pp. 12–14,
113, figs. p. 12, no. 1, fig. 1; Müller, 1955–56, 5, pp.
223–27; Weihrauch, 1956, pp. 14–16, no. 21, ill.; Stafski,
1958, 21, pp. 3, 10–12, figs. 3, 4, 1962, pp. 45–46; Pech-
stein, 1962, pp. 55, 63–70; von der Osten, 1963, pp.
71–83; Meyer, 1965, 19, p. 115, fig. 14; Radcliffe, 1966,
pp. 54–56, pl. 30; Müller, 1966, pp. 169, 185–87, pl. 185;
Weihrauch, 1967, pp. 62, 64, 275, fig. 67; von der Osten
and Vey, 1969, p. 20; Pilz, 1970, p. 48; Weihrauch, De-
cember 1970, XCII, no. 106, p. 465, fig. 1; Pechstein, 1980,
pp. 74–78; Schädler, 1983, p. 10, fig. 3; *Bayerisches
Nationalmuseum . . . ,* 1983, p. 64, colorpl.

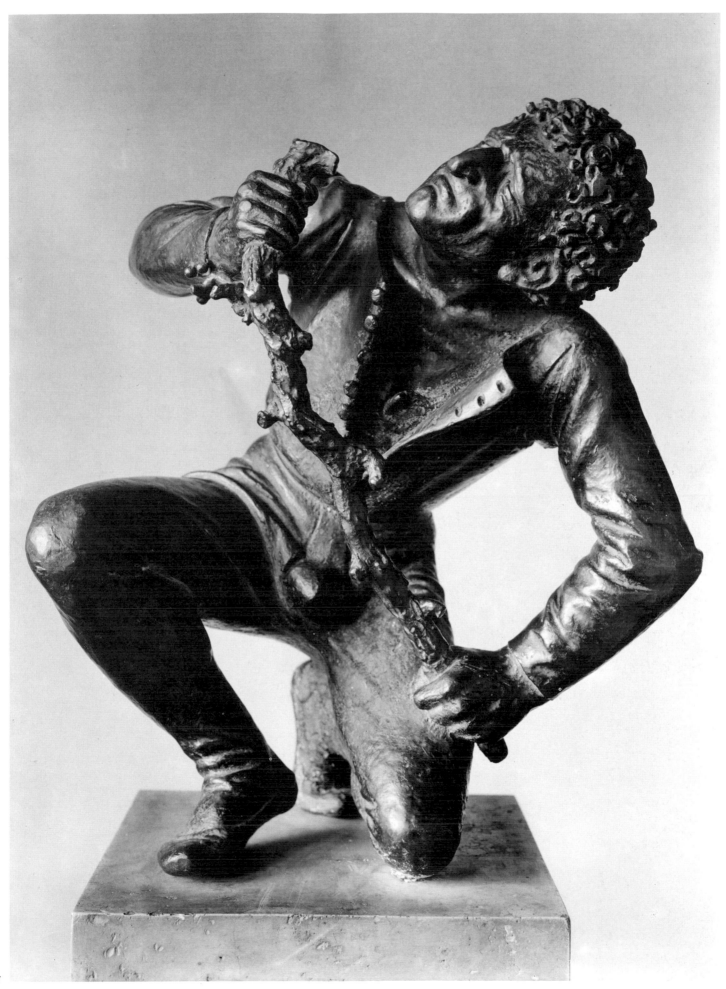

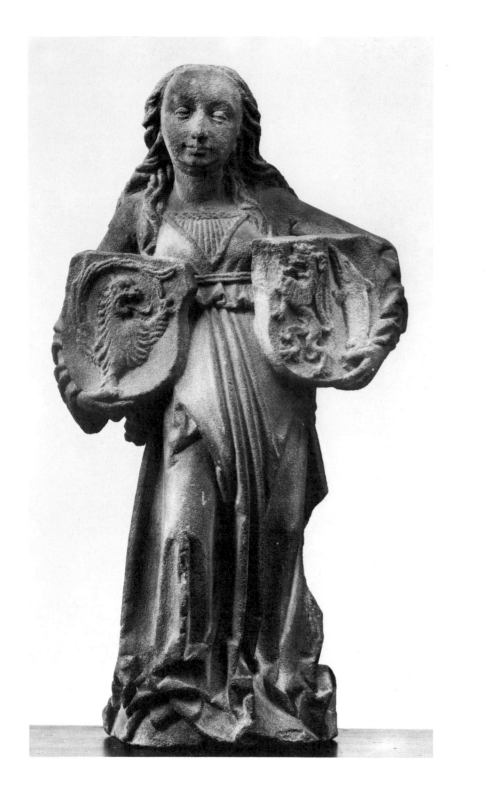

shields competes visually with the intricate carving of the pleated shirt visible within the V-neck of the dress and the short folds bunched just beneath her belt. The coat of arms in her right hand is that of the Imhoff family, and in her left, that of the Muffel family.

The sculpture was first attributed to the stone carver Adam Kraft by Theodor Demmler. The work originally was part of the stone staircase in the courtyard at Tucherstrasse 20, the home of the patrician Imhoff family.

While the combination of arms refers to the marriage of Hans Imhoff the Younger to Catherine Muffel von Eschenau in 1486, there is no proof that the sculpture was carved at this time. A dating at the end of the fifteenth century is more prudent. However, within Kraft's oeuvre, this figure belongs to the group of early works. The physiognomic type — specifically, the modeling of the eyes and the mouth — and the flowing angular folds of the drapery are similar to those of Kraft's earliest known works dating from 1490 to about 1496. The comparisons include the donor figures on the *Schreyer-Landauer Epitaph* carved from 1490 to 1492 on the exterior of the eastern end of the Sebaldus-kirche, Nuremberg (Schwemmer, 1958, pl. 5). The staircase figure by Kraft is also similar to the statuettes of standing angels holding the instruments of the Passion, in the upper reaches of the richly animated *Sacrament House* (fig. 62), dating from 1493 to 1496, and commissioned by Hans Imhoff the Elder for the Lorenzkirche, Nuremberg (see Schwemmer, 1958, fig. 18). A similar comparison may be made to the standing Virgin in the group of Saint Anne with the Virgin and Child *(Anna Selbdritt)*, of about 1496, by Adam Kraft (in the Germanisches National-museum, Nuremberg; see Schwemmer, 1958, pl. 45).

The staircase *Maiden* reflects the Netherlandish and Upper Rhenish stylistic sources of Kraft's art — a fact that also supports the early dating of the figure. In the present sculpture, his Late Gothic naturalism acquires mass and a sense of arrested movement, independent of architecture, borrowed from the work of Nikolaus Gerhaert van Leyden or his followers. Gerhaert was active in Trier in 1462, in Strasbourg in 1463–67, and in Vienna from 1467 to his death in 1473.

There is an initial, tentative indication, here, of Kraft's sensitivity to different physiognomic types and psychological expressions — both, ultimately dependent upon the work of Nikolaus Gerhaert — in the figure's pensive, almost sleepy-eyed expression. The prominent forehead of the *Maiden*, her full lips, and the folds of skin beneath her chin give further evidence of his powers of observation. Kraft's sculpture of the Virgin on the *Landauer Epitaph* of 1503, today in the Tetzelkapelle of the Egidienkirche, Nuremberg (see cat. no. 99), shares the same features. WDW

Ex collections: [Geuder, Paris]; [art market, Munich (1914)].

Bibliography: Demmler, December 1914, 36, cols. 45–50; Stern, 1916, p. 82; Schwemmer, 1958, p. 28.

98 ADAM KRAFT

Maiden with the Arms of the Imhoff and Muffel Families

End of the 15th century
Sandstone
Height, 18 1/8 in. (46 cm.)
Provenance: staircase, house of the Imhoff family, Tucherstrasse 20, Nuremberg.
Berlin-Dahlem, Staatliche Museen, Preussischer Kulturbesitz, Skulpturengalerie
M 135

With long twisting locks of hair falling below her waist at the back, and over her shoulders, this statuette of a young woman looks wistfully before her, with nearly closed eyes. Carved fully in the round, the figure stands with her weight on her left leg, which is hidden beneath the heavy folds of her long, fashionable, high-belted dress. Her right leg is flexed so that it presses out against this garment, which fans out below in angular folds about her feet. She manages to hold at her sides two awkwardly large shields, one in each hand. The design of the

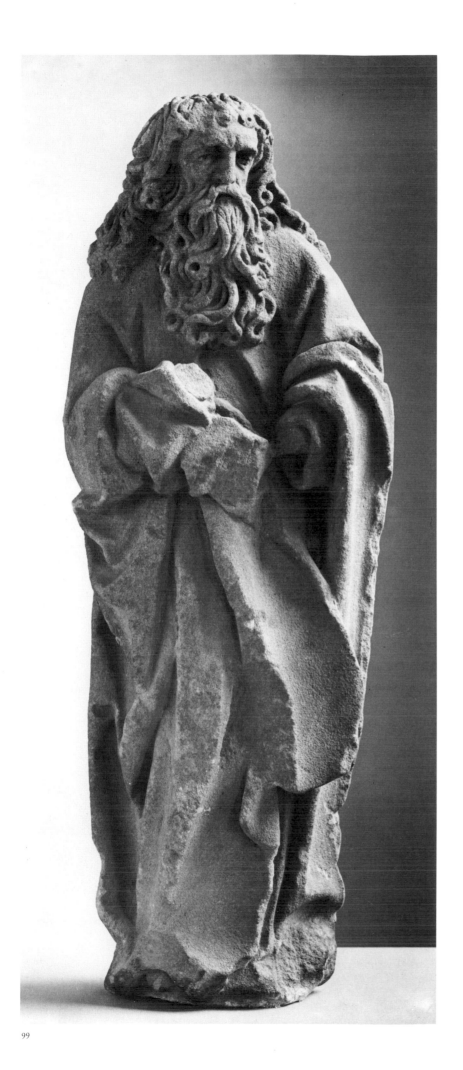

99 ADAM KRAFT

Figure of a Prophet or an Apostle

1503
Sandstone
Height, 24 ¹³/₁₆ in. (63 cm.)
The hands and the edges of several drapery folds
are missing.
Provenance: *Landauer Epitaph*, Cloister, Egidien-
kirche, Nuremberg.
Nuremberg, Germanisches Nationalmuseum
Pl 0.243

This statuette of an old man, with richly curled
beard, furrowed brows, and slanted eyes, gazes
sadly into space. He is enveloped in a heavy
mantle, which falls in full and deeply carved
folds, whose original eloquence is somewhat di-
minished by the losses that the figure has sus-
tained. His hands, now missing, once held a
bunch of these drapery folds in front of him.
His shoulders sloping, the figure turns to his left
in a gently contrapposto stance.

The *Landauer Epitaph*, originally in the clois-
ter of the Egidienkirche, today is in the Tetzel
Chapel of this monastic church. Commissioned
by Matthäus Landauer and dated 1503, this
monument comprises a large Coronation of the
Virgin group with an elaborate tracery canopy
and a three-part predella of kneeling church-
men, music-making angels, and kneeling donor
figures with armorial shields of the Landauer,
Landauer-Haller, Rotenhahn, Landauer-
Schlüsselfelder, and Landauer-Stark — all
Nuremberg patrician families. The larger armo-
rial shields added at the sides of the *Epitaph* bear
the arms of the Landauer-Rotenhahn and Land-
auer-Schreyer families. The crowning architec-
tural canopy, only partially preserved, is com-
posed of an intricate series of openwork ogee
arches.

The physiognomic type, treatment of the hair
and beard, and carving of the drapery of the
present work are similar to these elements in the
God the Father and the Christ in the *Landauer
Epitaph* that it may be assumed that the *Prophet*
belonged to the canopy of the monument. This
suggestion is supported by the fact that the
figure was discovered in the fountain of the
school *(Gymnasium)* next to the Egidienkirche.
A fragmentary bust of an angel, which was
found with it, probably also came from the
canopy (Stern, 1916, pl. XXIII).

The face of the figure shown here is an exam-
ple of Kraft's insight into the attributes of an old
man, as well as of his ability to suggest pathos.
Both the richly fashioned drapery and the ex-
pressive face recall Netherlandish and Upper
Rhenish art — especially the sculpture of
Nikolaus Gerhaert van Leyden and works pro-
duced under his direct influence (O. Wert-
heimer, *Nicolaus Gerhaert, seine Kunst und
seine Wirkung*, Berlin, 1929, pls. 2, 26; *Spät-
gotische Kunst am Oberrhein, Meisterwerke der
Plastik und des Kunsthandwerks, 1450–1530*
[exhib. cat.], Karlsruhe, Badisches Landes-
museum, 1970, no. 15, fig. 17). WDW

BIBLIOGRAPHY: Josephi, 1910, p. 23, no. 44; Stern, 1916,
pp. 83, 89, pl. XXIII; Schwemmer, 1958, p. 32, fig. 53.

99

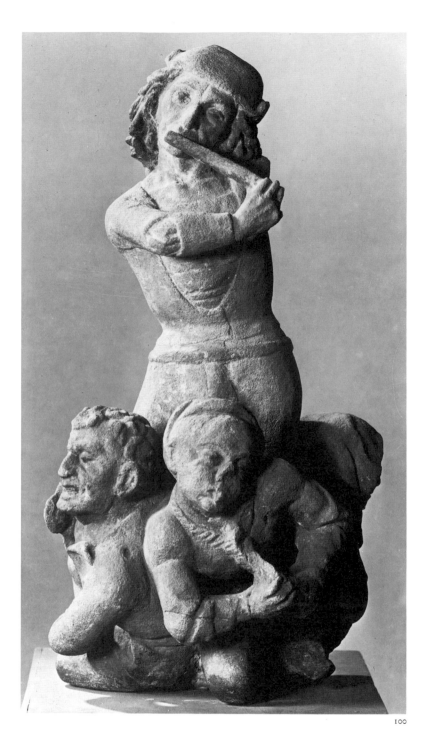

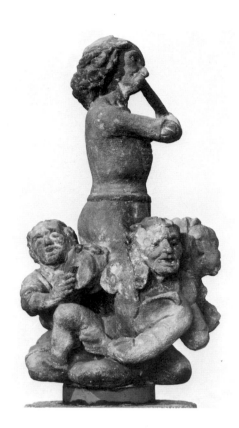

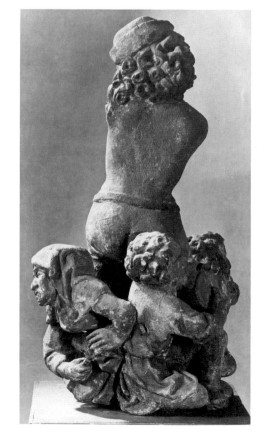

100

100 ADAM KRAFT

Flutist and Harpist

About 1505

Sandstone

Height, each, about 22 5/8 in. (60 cm.)

The color is renewed on both sculptures. Scattered losses include the flutist's left arm, which is missing; below, the musicians' instruments and lower legs are fragmentary.

Provenance: balustrade of the courtyard, house of the Imhoff family, Tucherstrasse 20, Nuremberg.

Nuremberg, Germanisches Nationalmuseum

Pl 0.2944/45

The compositions of both sculptures are tightly compact groupings of standing, crouching, and seated musicians, dominated, in each case, by a large three-quarter-length figure. A male flutist presides over one group. He wears tight hose, a V-necked vest slit at the elbows, a pleated shirt, and a cap atop his unruly mass of hair; below him are three short-haired male musicians in animated poses and a woman with a veil over her head. The young woman playing a small harp, who prevails over the other group, seems less animated because of her heavy-lidded, wistful gaze; her slightly more remote air is in marked contrast to the rustic strength of her

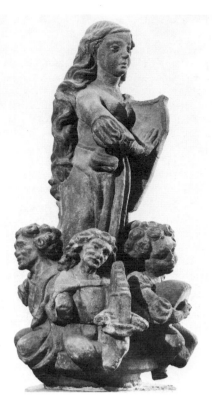

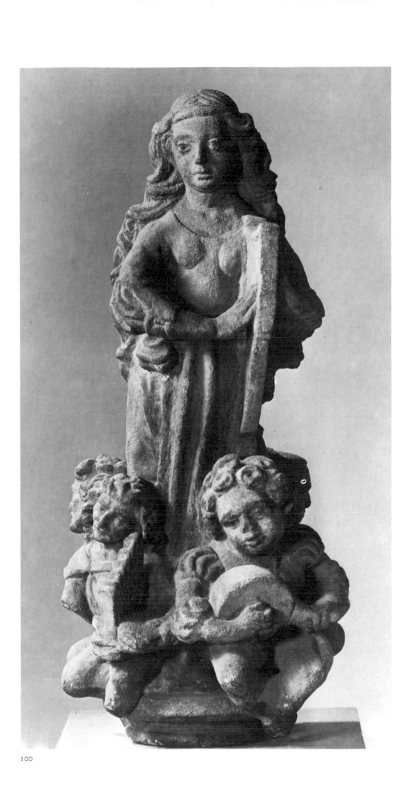

100

counterpart playing the flute. The harpist is dressed in a long, jewel-necked gown with slit sleeves, and has long curly locks, which tumble down her back to below her waist; at her feet are three curly-headed youths and a long-haired maiden, each playing a musical instrument, the best preserved of which can be identified as a portative organ and a lute.

As illustrated in an old photograph, each group once surmounted a tall column rising above the balustrade of the balcony in the courtyard of the house of the Imhoff family at Tucherstrasse 20. Thus, they each were meant to be seen in the round, and from the ground floor below. The strong animation in both the movement of the figures and in their facial features, as well as the intensity of each figure's music making, is understandable in this spacious domestic context. Kraft employs bold modeling, the bunching of masses, and rich textural contrasts, while distorting natural appearances — all for a dramatic and vigorous effect.

WDW

BIBLIOGRAPHY: Stern, 1916, pp. 81–82, pl. xxv; Schwemmer, 1958, p. 28, figs. 40, 41; Pechstein, 1980, pp. 75–77.

263

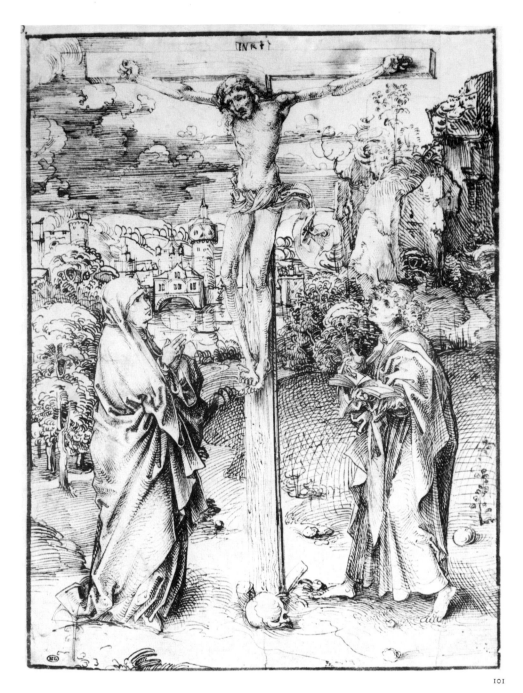

of other woodcuts produced by Dürer just before 1500.

The drawing is related to the Crucifixion panel of the *Rayl Epitaph* (cat. no. 42), from the Lorenzkirche — a work by an anonymous master whose style is linked to that of Wolgemut — which was doubtless created after 1494, the year in which its patron died. Tietze and others have suggested that the teacher painted this panel under the influence of his brilliant pupil, which seems highly plausible. Another early study that is quite comparable in style is the "Cavalcade" (Strauss, 1974, no. 1489/4, formerly in the Kunsthalle, Bremen), which is dated 1489. Strauss, on the other hand, prefers to see Dürer's drawing as a response to the work of his master, although he does not draw the necessary conclusion that it must then be dated somewhat later than 1494. RS

BIBLIOGRAPHY: Lippmann, ed. (Winkler), 1929, vol. VII, no. 596; Flechsig, 1931, vol. 2, no. 384; Bauch, 1932, vol. 7/8, p. 88; Winkler, 1936, no. 19; Panofsky, 1948, vol. 2, no. 586; Winkler, 1957, pp. 15, 24; *Dürer*, Nuremberg, 1971, no. 118; Strauss, 1974, vol. 1, no. 1490/1.

102 ALBRECHT DÜRER

Self-Portrait, Hand, and Pillow (reverse): Six Pillows

Pen and brown ink, on paper
11 15/16 x 7 15/16 in. (27.8 x 20.2 cm.)
Dated "1493" on verso and inscribed "AD" at top center in a later hand
New York, The Metropolitan Museum of Art,
The Robert Lehman Collection, 1975
1975.1.862

Albrecht Dürer produced three self-portraits between 1490 and 1494. In the Lehman Collection *Self-Portrait*, Dürer shows his face in three-quarter profile, as he commonly did in his early portraits, following contemporary formal convention. At the side of the face, the artist drew his own left hand, which would have been incorporated as a focal element in a more finished, half-length composition. Like the journeyman's cap that he wears, the hand might almost be considered an attribute of the artist — as is the hand of the elder Albrecht Dürer, grasping a small statuette, in a silverpoint portrait of Dürer's father, variously attributed to the goldsmith or to his son (Strauss, 1974, vol. 1, no. 1484/4).

The Lehman study is closely related to a painted *Self-Portrait* in the Louvre (Strieder, 1972, no. 19), dated, like the verso of this drawing, 1493. In the oil portrait, the same features are emphasized as in the Lehman drawing — the heart-shaped upper lip, puffy mouth, strong nose, and sparsely bearded chin. The Paris por-

101 ALBRECHT DÜRER

The Crucifixion, with the Virgin and Saint John

About 1490
Pen and brown ink, on paper
12 1/4 x 8 15/16 in. (31.2 x 22.7 cm.)
Watermark: High Crown.
Paris, Musée du Louvre, Cabinet des Dessins
18.995

Friedrich Dörnhöffer first provided an expertise ascribing this drawing to the nineteen-year-old Dürer, who was then serving the last months of his apprenticeship to Michael Wolgemut, and the attribution has been generally accepted. Even so, while this magnificently finished study occupies a special place among the artist's early drawings, it poses a number of difficult problems, especially with respect to the uncommon teacher-pupil relationship between Wolgemut

and his apprentice. If the strong lines of the modeling, so characteristic of Dürer, are ignored, the group of the crucified Christ and the two auxiliary figures represents a conventional pictorial type altogether common in works by the Wolgemut shop — as, for example, the 1484 woodcut from the *Missale Striegoniense* (cat. no. 85). It may be that Dürer was already influenced by Schongauer's graphic work during his apprenticeship, as the subtle lines of shading on the body of Christ seem to indicate. Winkler rightly pointed out the dramatic contrast between the traditional Crucifixion group and the landscape in the background, which is drawn with great assurance and emotion. The calm lake with the castle, on the left, and the rugged rock formations, on the right, echo the inner emotions of the two attendant figures. In its definite pictorial function, this landscape thus anticipates the landscapes of the *Apocalypse* and

trait, however, does not show the young man as a journeyman, but in rather festive attire. In all likelihood, the drawing preceded the painting. Flechsig's suggestion that the Paris portrait must predate the Lehman drawing on the basis of the season in which the sprig of Eryngium (sea holly) in the artist's hand would have been in bloom is unconvincing. The tightly clasped fingers in the New York drawing may indicate that Dürer studied his hand as it would have appeared grasping the stem of a flower — as in one of his drawings in the Albertina (Strauss, 1974, vol. I, no. 1493/8). It has long been recognized that the Paris *Self-Portrait* was executed in Strasbourg — which the dialect of its inscription reveals.

The artist apparently drew his left hand separately, here, by turning the paper horizontally. Yet, the placement of the hand, in larger scale, near the face gives the study an enigmatic quality akin to that of the roughly contemporary *Self-Portrait*, in black chalk, now in the Universitätsbibliothek, Erlangen (Strauss, 1974, vol. I, no. 1491/9). The abstruse quality of the Lehman drawing is heightened by the small, carefully sketched pillow underneath the portrait and studied six more times on the verso of the sheet. The juxtaposition seems odd, and it may be entirely fortuitous: Numerous drawings are two sided; the Erlangen self-portrait, for example, has a sketch of the Holy Family on its reverse. The soft contours of the pillows seem to have provided an artistic exercise similar to that of rendering drapery.

It has been observed that the pillows contain Dürer's earliest representation of "hidden faces" — an exercise in artistic humor that has been detected in many of his drawings, including the *Resurrection* (cat. no. 137). Only recently, however, has further analysis of the importance of the pillows been articulated. Szabo first noted the possible influence on Dürer of the pillows seen in the domestic interiors of Early Netherlandish paintings. He also provided provocative suggestions about the possible magical associations that the young Dürer might have intended by representing them with his own portrait on the eve of his wedding. Such interpretations are bolstered by the traditional analysis of the painted self-portrait as an engagement picture and by the attribution of magical properties to the sea holly. Although lately questioned by Strieder, such a reading is consistent with the pivotal time in Dürer's life when the portraits were done, and with the self-conscious nature of the artist's representations of himself, in general. BDB

EX COLLECTION: Lubomirski Museum, Lemberg, Poland.

BIBLIOGRAPHY: Reitlinger, 1927, vol. L, p. 154, pl. I; Gebarowicz and Tietze, 1929, p. 15; Lippmann, ed. (Winkler), 1927, vol. VI, p. 10, nos. 613, 614; Winkler, 1936, vol. I, p. 25, no. 27; Tietze and Tietze-Conrat, 1938, vol. I, p. 8, nos. 32, 33; Panofsky, 1943, vol. I, p. 24, vol. II, no. 998; Tietze, 1951, p. 37; Stampfle, 1955, p. 9; Winkler, 1957, p. 37; Talbot, ed., 1971, no. I, pp. 24–27; Strauss, 1974, vol. I, no. 1493/6; Szabo, 1978, nos. 22, 22a; Szabo, 1979, pp. 1–3.

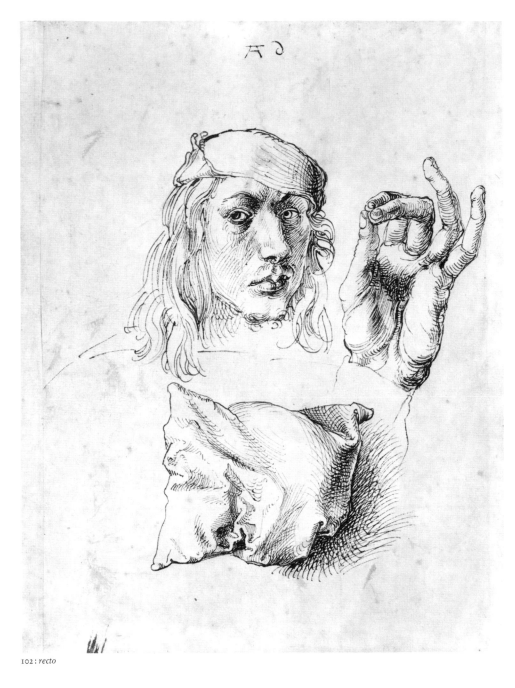

102: *recto*

103 ALBRECHT DÜRER

The Holy Family, with the Dragonfly

About 1495
Engraving
9¼ x 7¼ in. (23.7 x 18.5 cm.)
Monogrammed at bottom center
New York, The Metropolitan Museum of Art,
Fletcher Fund, 1919
19.73.52

During his apprenticeship and his years as a journeyman, Dürer was repeatedly occupied with the subject of the Holy Family. The verso of the Erlangen *Self-Portrait*, from about 1491, and a drawing in the Kupferstichkabinett, in Berlin-Dahlem, of about 1492–93, may be considered the preliminary stages of this first major portrayal of the Virgin, which is generally dated

to about 1495. It may have been Dürer's pride in the masterly composition that led him to place his monogram in Gothic letters at the bottom — the first time he signed an engraving. Thematically and artistically, Dürer brings to this lovely image of the Virgin happily ensconced in an earthly landscape all that he had learned in his travels through the Middle and Upper Rhine. The Netherlandish type of the Virgin on the Grassy Bench, widely employed in the Upper Rhenish circles of the Master E.S. and Martin Schongauer, here, has been augmented by the figure of Saint Joseph, somewhat humorously portrayed sleeping beside the Virgin. There is a similar portrayal of Joseph in a drypoint engraving by the Master of the Housebook. Motifs from the traditional iconography of the Holy Family and the Rest on the Flight into Egypt have here been com-

102: *verso*

as it adapted to the modeling of figures and drapery, into a universal and highly responsive drawing medium. R S

EX COLLECTIONS: Ernst Theodor Rodenacker, Danzig (Lugt, no. 2438); Karl Eduard von Liphart, Bonn and Florence (Lugt, no. 1687); Henry Studdy Theobald, London (Lugt, no. 1375).

BIBLIOGRAPHY: Bartsch, 1808, no. 44; Meder, 1932, no. 42; Panofsky, 1948, no. 151; *Dürer*, Boston, 1971, no. 2; *Dürer*, Nuremberg, 1971, no. 144; Talbot, ed., 1971, no. 2; Strauss, 1976, no. 4; *The Illustrated Bartsch*, 1981, no. 44, commentary, pp. 105–6.

104 ALBRECHT DÜRER

The Prodigal Son Amid the Swine

About 1496
Engraving
9⁹/₁₆ x 7⁵/₁₆ in. (24.3 x 18.6 cm.)
Monogrammed at bottom center
New York, The Metropolitan Museum of Art, Fletcher Fund, 1919
19.73.35

Luke's parable of the Prodigal Son (15:11–32) tells of the son of a wealthy man who receives his inheritance and soon squanders the money in bad company. Completely impoverished, he is finally forced to work for a farmer as a swineherd. It is this ultimate degradation that convinces him to approach his father and beg his forgiveness. A parable of God's infinite mercy toward the remorseful sinner, the story was included in various popular religious books of the Late Middle Ages. Dürer may have been familiar with the woodcut illustrations for Bernhard Richel's *Speculum Humanae Salvationis*, Basel, 1476 (Schramm, no. 21, ill. 224), and for Peter Drach's *Spiegel menschlicher Behaltnis*, Speyer, 1478 (Schramm, no. 16, ill. 503), although he gave to his image greater pathos than is present in either of these earlier illustrations, or, in fact, in the biblical text itself. He shows the Prodigal Son in front of a barnyard, kneeling at a trough among the swine and gazing repentantly toward heaven, his hands folded before him. The sinner has sunk to the level of the beasts. The pose of the pathetic figure is new in depictions of this subject and could have been based on that of a shepherd from an Adoration scene. It has been suggested that Dürer gave the Prodigal Son his own features, and indeed neither iconographic nor theological arguments would preclude this possibility.

Various surviving preliminary sketches indicate that Dürer made a number of nature studies in preparation for this engraving. The final design, reversed and with some characteristic variations, is in the British Museum; a separate study for the figure of the Prodigal Son is in the Museum of Fine Arts, Boston; and a study for the bull cut off at the left margin is in the Art Institute of Chicago. In addition to the above-mentioned illustrations, Dürer may have used Schongauer's engraving of a family of pigs (Bartsch, no. 95) in developing the genre-

bined. The garden wall and closed gate in the middle distance paraphrase the virginity of Mary in the image of a *hortus conclusus*. In the background, underscoring the idyllic nature of the scene, lies a broad, peaceful seascape with a castle and ships. Here, as well, it is possible to interpret separate motifs — the tower, the sea, the thornbush — as Marian symbols in the context of the Litany of Loreto. The insect that is placed so prominently in the foreground and has given the sheet its name is somewhat puzzling in form, and has been variously identified as a butterfly, a dragonfly, a locust, and a praying mantis. It, too, has been given a Marian interpretation.

The simple composition is based on two intersecting diagonals that form two triangles meeting point to point. Mary, the Child, and Saint Joseph are contained within a large upright triangle, whose tip lies above the horizon, giving particular emphasis to the head of the

Virgin. Balanced on top is a smaller, suspended triangle with God the Father and the dove of the Holy Spirit among the clouds, who shower the Virgin with rays of divine grace. Because of this strict, triangular arrangement, it has been suggested that, here, immediately after his return from Italy, Dürer was already making use of his experience of the Italian Quattrocento, but it is also possible to trace the compositional scheme to the Late Gothic tradition of Upper Rhenish portrayals of the Virgin.

In his use of the burin in the present engraving, Dürer is still somewhat indebted to the drypoint technique of the Master of the Housebook. Aside from the fine, often retraced outlines, the graphic structure is composed of the combination of a multitude of short strokes, which, however, are differentiated in form and width. Only in the following years did Dürer expand the possibilities of the burin, turning its gently curving line, growing thinner or thicker

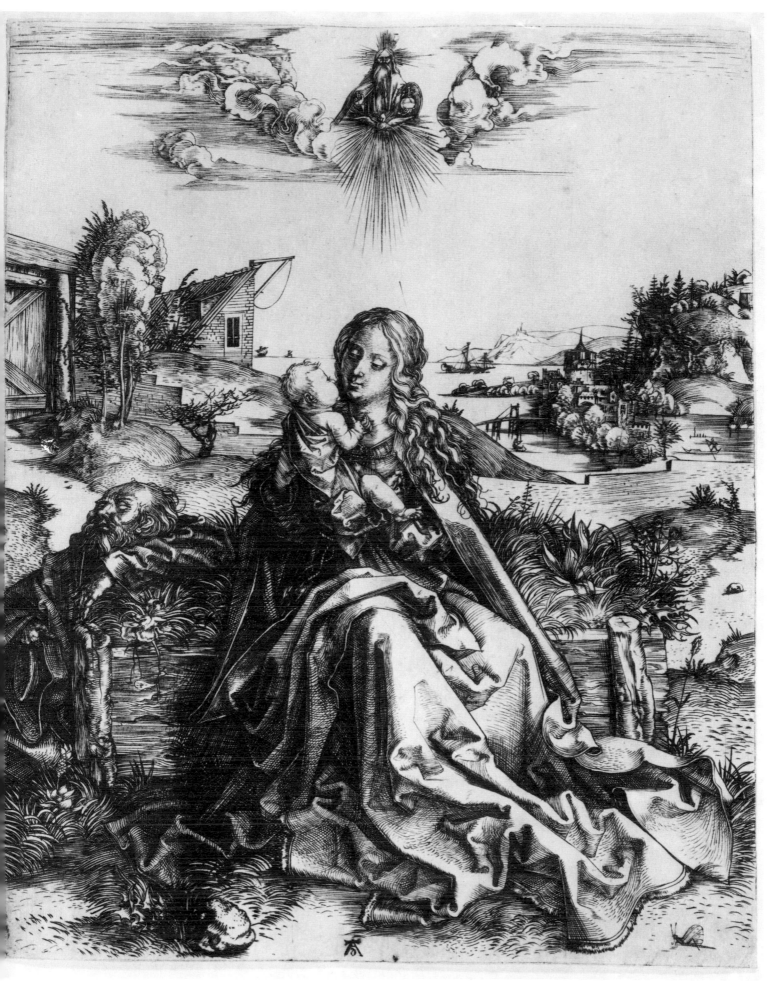

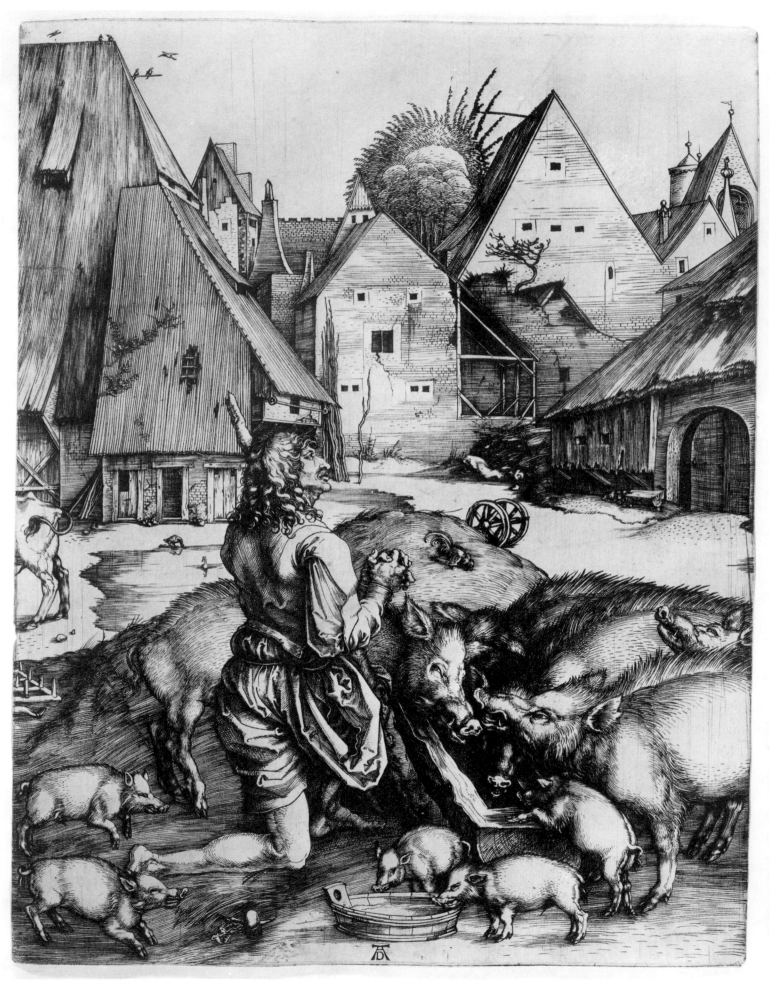

104

like naturalism of the scene. Dürer himself had made the engraving *The Monstrous Sow of Landser* (Meder, no. 82) in 1496 — according to Panofsky, immediately before the present engraving. He must have drawn the barnyard in the background from life somewhere in the vicinity of his hometown. Unlike his other prints from the same period, Dürer, in *The Prodigal Son*, presents the foreground and background, the figure and its natural surroundings, as a topographical continuity rather than as separate, contrasting elements. Accordingly, the image possesses a "poetic rusticity" (Panofsky, 1948) that fascinated Dürer's contemporaries. The work was copied not only by Italian engravers but even by a Persian miniaturist, and Vasari made special note of its realism. This realism, in its description of objective reality, not only anticipates the future but, at the same time, exemplifies the *sermo humilis*, which had a fixed place in the lay piety of the Late Middle Ages.

RS

BIBLIOGRAPHY: Bartsch, 1808, no. 28; Meder, 1932, no. 28; Panofsky, 1948, no. 135; Vetter, 1955, pp. 26–27; Zink, 1969, pp. 289–93; *Dürer*, Boston, 1971, nos. 3–5; *Dürer*, Nuremberg, 1971, no. 421; Talbot, ed., 1971, no. 5; Strauss, 1976, no. 11; *The Illustrated Bartsch*, 1981, no. 28, commentary, pp. 73–74.

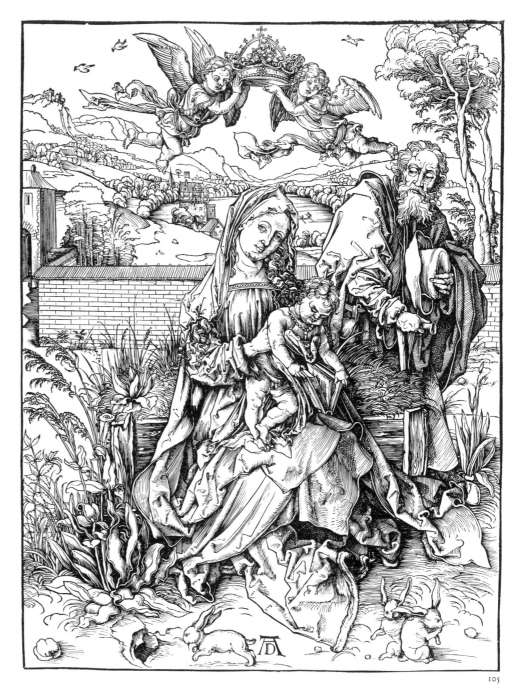

105

105 ALBRECHT DÜRER
The Holy Family, with Three Hares
About 1497
Woodcut
15 x 11 in. (38.4 x 27.9 cm.)
Monogrammed at bottom
Watermark: (Meder, no. 53).
New York, The Metropolitan Museum of Art,
Gift of Junius S. Morgan, 1919
19.73.168

The naturalism and solemn introspection of this portrayal of the Virgin are in sharp contrast to the dramatic visions of the *Apocalypse* (cat. no. 108) that Dürer made at this time. This is his first woodcut that is devotional in nature. *The Holy Family, with Three Hares* is in some respects a counterpart to the engraving *The Holy Family, with the Dragonfly* (cat. no. 103). Although the woodcut is enriched by the addition of the ceremonial motif of the crowning angels, the two prints are similar in composition, iconographic type, and in their conception of nature. Both were influenced by the work of Martin Schongauer and of the Master of the Housebook, and both are based on the same preliminary sketches: the *Holy Family*, in Erlangen, of 1491 (Winkler, no. 25), and those in Berlin-Dahlem, of 1492–93 (Winkler, no. 30), and in a private collection in England (Winkler, no. 24). In the woodcut the figure of the Virgin

is closer to the one in the Berlin drawing, while the Joseph has more in common with the versions in Erlangen and London.

A comparison to *The Holy Family, with the Dragonfly* is interesting not only from an iconographic point of view; it also demonstrates how Dürer, in a period of feverish concentration on the woodcut, approached the medium as an engraver, and thereby succeeded in wresting from it an unprecedented expressiveness. In the free, almost spontaneous flow of line in both contour and feature, in the crosshatched modeling of shaded areas, and in the representation of space as though by atmospheric perspective, with a lightening of the background, Dürer clearly uses techniques formerly available only to the engraver. The same is true of the wealth of variation he employs as he alternates between black against a white background and white against black — as in the lush foliage in the foreground.

This interplay between woodcut and engraving led to the total emancipation of the woodcut style in the *Apocalypse*, where Dürer managed to create an art that is true to the nature of the material: Each line has its own expressive force, and the structure of the image relates to the two-dimensional surface of the sheet. This latter feature is particularly apparent in the motif of the hovering angels who hold the Virgin's crown — a motif that is linked to the long tradition of the devotional woodcut in the fifteenth century.

The wood block for *The Holy Family, with Three Hares* is in the collection of the Princeton Art Museum.

RS

BIBLIOGRAPHY: Bartsch, 1808, no. 102; Meder, 1932, no. 212; Panofsky, 1948, no. 322; *Dürer*, Boston, 1971, nos. 19–21; Talbot, ed., 1971, no. 87; Strauss, 1974, p. 592; *The Illustrated Bartsch*, 1981, no. 102, commentary, p. 378.

106: detail

106 ALBRECHT DÜRER

Wood Block for Samson Rending the Lion

About 1497–98
Pearwood
15 3/8 x 11 in. (39 x 28 cm.)
New York, The Metropolitan Museum of Art,
Bequest of Junius S. Morgan, 1921
19.73.255

Quite a number of Dürer's wood blocks have survived. The Metropolitan Museum of Art owns two, *The Martyrdom of Saint Catherine* and *Samson Rending the Lion*.

Prints continued to be produced from this pearwood block until well into the seventeenth century. The block suffered considerably as a result, and it was reworked, possibly as early as the second half of the sixteenth century. The strong contour lines were recut, so that additional light lines appear beyond the outline on Samson's right leg, for example, and on the

lion's tail. The condition of the block deteriorated over the years, and various nicks, wormholes, and breaks appeared — especially along the border.

Despite these flaws, the wood block still conveys a clear impression of the woodcutter's technical mastery. Compared with contemporary woodcuts, the block exhibits an unparalleled intricacy, variety, and expressiveness of line, with a sculptural quality of its own. Generally, a wood block was the joint effort of the designer and the cutter. The artist made his drawing in pen and ink directly on the prepared wooden slab, then turned it over to a specially trained craftsman for cutting. R S

EX COLLECTIONS: Pierre-Jean Mariette, Paris; Pierre-François Basan, Paris; Jean Bernard père et fils, Paris; M. Alvin-Beaumont, Paris.

BIBLIOGRAPHY: Ruzicka, 1921, pp. 53–55; Ivins, 1929, pp. 102–11; *Dürer*, Boston, 1971, no. 25, p. XIX; Strauss, 1979, no. 33, appendix B, pl. 9.

107 ALBRECHT DÜRER

Samson Rending the Lion

About 1497–98
Woodcut
14 3/4 x 10 13/16 in. (37.4 x 27.6 cm.)
Monogrammed at bottom center
New York, The Metropolitan Museum of Art,
Gift of Junius S. Morgan, 1919
19.73.220

Panofsky maintains that Dürer's return from Italy signaled the beginning of the Renaissance in the countries north of the Alps. Dürer settled in Nuremberg as an independent master in 1495 and thus began a ten-year period of great productivity. The young master devoted himself primarily to printmaking — rather than to painting — which rapidly brought him fame, as he began to establish new standards in the various print mediums.

One of Dürer's most important woodcuts from the post-Italian period is the *Samson Rending the Lion,* of about 1497–98. It may be considered, in a sense, the counterpart to the *Hercules* (Bartsch, no. 127), which dates from about 1496.

The Old Testament hero is shown in fashionable costume. Seated astride the lion, he forces open the animal's mouth with his bare hands — a scene comparable to Hercules' struggle with the Nemean lion. Pollaiuolo's emotionally charged depictions of the Labors of Hercules may have inspired Dürer's woodcut. Other possible sources that have been suggested are the engravings on the same theme by the Master E.S., and by Israhel van Meckenem. It would appear that, here, Dürer was already following the principle that he formulated about 1508 in the introduction to his treatise on painting: "And out of Hercules we wish to make a Samson, and we desire to do the same with all the others." This equation of classical and biblical heroes and the transfer of mythological iconographic conventions to biblical subjects seems typical of the treatment of themes from antiquity by the early German Humanists.

Dürer's woodcut technique in the *Samson* attains a new level of artistry. Stylistically, it corresponds to that of the *Apocalypse* (cat. no. 108), also undertaken at this time. In its precision, intricacy, and formal diversity it surpasses everything previously accomplished in the German woodcut. Lines no longer serve merely to outline forms and provide schematic shading; rather, they assume a descriptive, modeling function that imitates the very substance portrayed. In their responsiveness and complicated overlappings they vie with the work of the engraver. The development of continuous spatial depth is achieved not only by compositional means but also by painterly effects, such as the exemplary application of atmospheric perspective. R S

BIBLIOGRAPHY: Bartsch, 1808, no. 2; Meder, 1932, no. 107; Panofsky, 1948, no. 222; *Dürer*, Boston, 1971, nos. 24–25; *Dürer*, Nuremberg, 1971, no. 513; Talbot, ed., 1971, no. 86; Strauss, 1979, no. 33; *The Illustrated Bartsch*, 1981, no. 2, commentary, pp. 244–45.

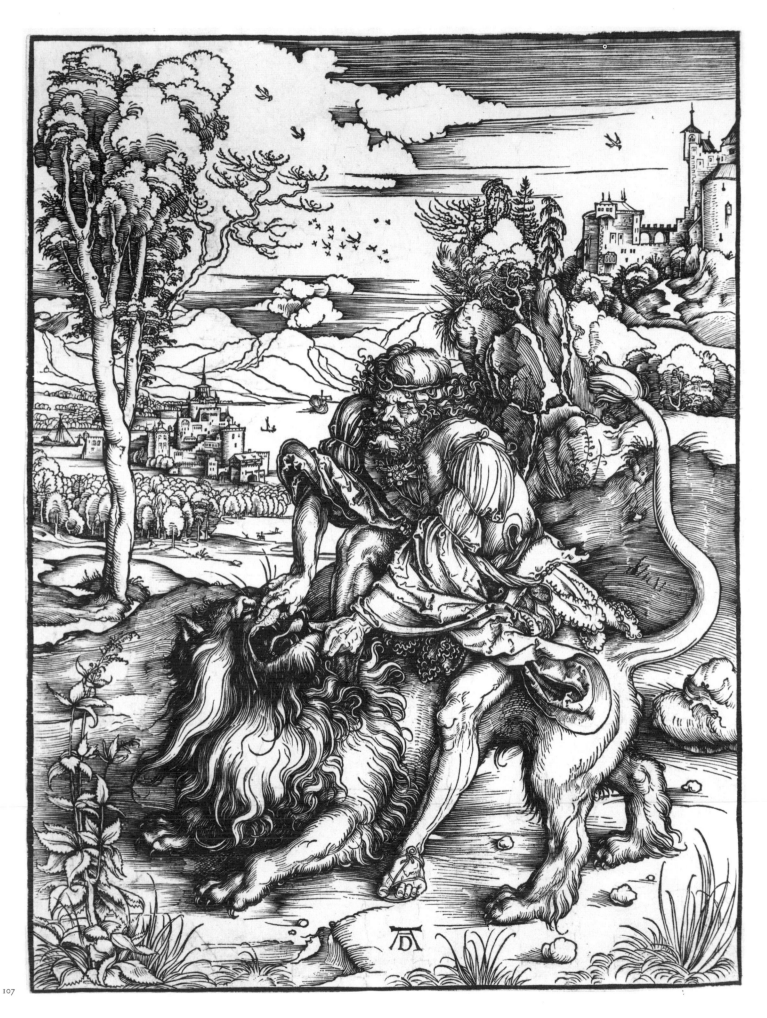

108: Title page of 1511 edition

After his return from his first sojourn in Italy, Dürer, then barely twenty-five years old, devoted himself increasingly to printmaking, producing works that could bring him fame more rapidly than the few commissions for paintings awarded him in this early period.

The *Apocalypse* was the first of Dürer's three "great books." After about two years in preparation, it was published in a German and a Latin edition in 1498. A second Latin edition followed in 1511, supplemented by a title woodcut depicting the vision of Saint John the Evangelist on Patmos. At the same time, the *Life of the Virgin* (cat. no. 127) and the *Great Passion* were issued in book form.

Although the woodcuts were book illustrations of a wholly new kind, many of the details of the external form and of the content of the woodcut cycles can only be understood in the context of the tradition of the illustrated book. With the exception of the title page and the final page, the versos of all the prints contain the two-column text of the Revelation of Saint John. The woodcuts were bound so that each image was across from a page of type. Dürer avoided juxtaposing his woodcuts directly with the corresponding portions of the text; basically, text and pictures proceed independently of each other. Thus, the woodcuts cannot be seen as literal illustrations; instead, they are separate and unique interpretations of the biblical text.

In designing the book, Dürer seems to have consulted carefully with his godfather, the great Nuremberg printer Anton Koberger. The format of the *Apocalypse* corresponds to that of Koberger's famous *Liber chronicarum*, of 1493 (cat. no. 87). In that work, as well, there are precedents for the novel juxtaposition of full-page pictures with full pages of text. Even the type face of the original German edition of the *Apocalypse* was the same as that of the *Chronicle*, and the text was identical to that of Koberger's Vulgate Bible, of 1483.

The text of the Apocalypse, which evolved in the first century after Christ as a response to the persecutions of Christians under Domitian, describes the end of the world in terrifying and highly puzzling images, and expresses hope for the coming of a just Kingdom of God. Chiliastic notions occasioned by the close of the first millennium had already evoked interest in the subject of the Apocalypse, as well as in the artistic treatment of it. Before 1500, that interest was fueled further by a wave of intense piety, in which contemporary disasters and seemingly miraculous events were regarded as harbingers of the events of Saint John's Revelation.

Dürer's *Apocalypse* revolutionized not only the woodcut technique, but also the iconography of the subject matter, rooted, as it was, in the medieval tradition. It was precisely because of his knowledge of the new attitude toward art in Italy that Dürer was able to bring to the theme of these images such sovereign and epoch-making interpretations, which he imbued, like few others, with the rigid piety of the Middle Ages.

It is unlikely that Dürer was acquainted with

108 ALBRECHT DÜRER

The Apocalypse

15 woodcuts, and 1 title page: 1) The Secret Revelation of Saint John (title page of German edition); 2) The Martyrdom of Saint John the Evangelist; 3) The Vision of the Seven Candlesticks; 4) Saint John Before God the Father and the Elders; 5) The Four Horsemen of the Apocalypse; 6) The Opening of the Fifth and Sixth Seals; 7) Four Angels Restraining the Four Winds; 8) The Seven Trumpeting Angels; 9) The Four Avenging Angels; 10) Saint John Devouring the Book; 11) The Apocalyptic Woman and the Seven-Headed Dragon; 12) Saint Michael Fighting the Dragon; 13) The Beast with the Lamb's Horns; 14) The Adoration of the Lamb; 15) The Whore of Babylon; 16) The Angel with the Key to the Bottomless Pit.

1) The Secret Revelation of Saint John (title page of 1498 edition)
5 5/16 x 7 1/16 in. (13.5 x 18 cm.)

5) The Four Horsemen of the Apocalypse
15 1/4 x 11 in. (38.8 x 28.1 cm.)
Proof, before text added
Monogrammed at bottom center
New York, The Metropolitan Museum of Art,
Gift of Junius S. Morgan, 1919
19.73.209

12) Saint Michael Fighting the Dragon
15 1/8 x 10 15/16 in. (38.5 x 27.7 cm.)
Proof, before text added
Monogrammed at bottom center
New York, The Metropolitan Museum of Art,
Gift of Junius S. Morgan, 1919
19.73.131

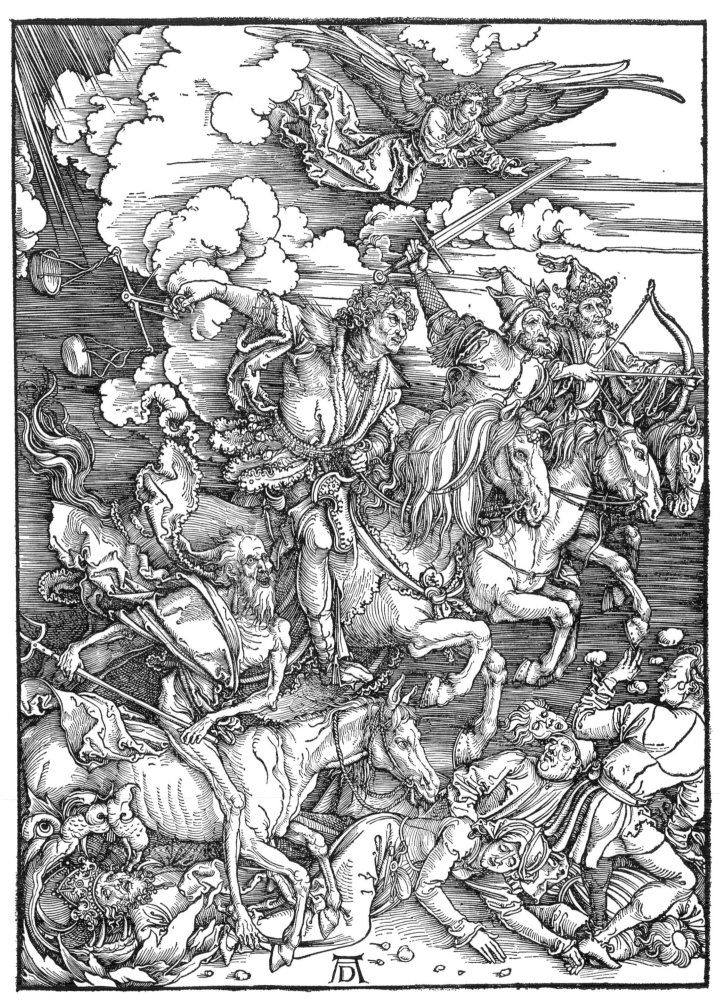

108: *The Four Horsemen of the Apocalypse*

the miniatures in medieval Apocalypse manuscripts, but he might have been familiar with a copy of the block-printed edition of the *Apocalypse*, of about 1440. Among his direct sources were the Apocalypse woodcuts from the Low German Bible printed in Cologne in 1479; Koberger had used the wood blocks for his edition of the Bible in Nuremberg in 1483. It is also certain that Dürer was aware of the similar woodcut illustrations in the Strasbourg Bible printed by Grüninger in 1485.

These older sequences of illustrations had been more extensive. Dürer reduced the number to fifteen, thereby compressing the material and heightening the dramatic effect. Such non-dramatic passages as the sending of the epistles to the seven congregations he simply ignored, preferring to include events from various chapters in a single, powerful print; an example is the *Seven Trumpeting Angels* (Bartsch, no. 68). As in the portrayal of the *Four Horsemen* (Bartsch, no. 64), or *Saint Michael Fighting the Dragon* (Bartsch, no. 72), the content of only a few verses was sufficient to inspire a strong image. Dürer's free manipulation of the text and sovereign juxtaposition of images in his compositions led various scholars to suspect that he consulted a theologian in preparation for the project. Juraschek suggested that it might have been Dr. Johannes Pirckheimer, while Grote proposed Provost Sixtus Tucher. Yet, such speculation is no more founded in fact than is Juraschek's supposition that the series was based on a sermon by Nicolaus Cusanus.

As a means of increasing the drama, along with the visionary Saint John Dürer included representatives of specific social classes as participants in the action. A number of times he employed a two-level composition, producing a maximum contrast between the earthly and the heavenly spheres. The earthly landscape appears as a narrow strip, while the visionary figures are portrayed in overpowering size. At times, there is a sharp opposition between the idyllic peacefulness of the landscape and the violence of the vision, which is thereby rendered even more overwhelming.

In connection with the *Apocalypse*, Panofsky spoke of the artistic principle of "realization," of the drastic manner in which Dürer interpreted the powerful symbolic language of the work literally, and translated it into pictorial images. Dürer's experience of the Italian Renaissance enabled him to infuse the hieratic medieval pictorial representations with a new naturalism and new vitality. His highly abstract and fantastical compositions are in distinct contrast to the extremely realistic individual objects. In the woodcut *The Vision of the Seven Candlesticks*, for example (Bartsch, no. 62), they appear as actual objects — products of the workshop of a contemporary goldsmith — hovering weightlessly above the clouds in absolute defiance of gravity; they are only restrained by the strict geometry of the composition. Panofsky described the quality of the vision as "miraculous" and "imaginary" at one and the same time: "It is miraculous in so far as the laws of ordinary physical life are temporarily suspended; it is imaginary in so far as this suspension is not supposed to take place in actuality...." In order to portray this ambivalent, surreal condition with any credibility, Dürer had to be equally familiar with the pictorial conventions of the Middle Ages and of the Renaissance. More than almost any of his other works, the illustrations of the *Apocalypse* demonstrate Dürer's fusion of the two traditions in a highly expressive synthesis.

Scholars since Thausing have repeatedly pointed out that, in his interpretation of the Apocalypse, Dürer incorporated a number of allusions to his own time. Dvořák called the *Apocalypse* a hymn of revolution directed against Rome. Dürer's portrayal of the emperor in Turkish garb, in the woodcut of *The Martyrdom of Saint John the Evangelist* — following the sketch that he had made in Venice — may be an allusion to the contemporary threat to Christendom by the heathens. His depiction of the Whore of Babylon in the gown of a Venetian courtesan, with a monk kneeling in front of her, is his accusation of the Roman, papal Church of depravity and false belief. Chadraba went even further in this search for contemporary allusions: He chose to see the figures as portraits of numerous contemporaries of the artist, and interpreted the cycle as a glorification of Emperor Maximilian I, couched in chiliastic concepts. However, much of his argument can in no way be verified.

Contemporary engravings exercised an even greater effect on the style of Dürer's woodcuts than did the precedents of book illustration. In the landscapes and in many of the individual figures — the Archangel Michael, for instance — it is possible to discern the influence of engravings by Martin Schongauer. The pathos in the expressions on the faces of the angels would have been unthinkable without the artist having been familiar with prints by Mantegna. In the tension, subtlety, and adaptability of its individual lines, Dürer forces the woodcut to compete with the engraving. This technical refinement of the woodcut had been unheard of before then, leading some to believe that Dürer must have cut the wood blocks for the *Apocalypse* himself, although, generally, the design and cutting of the blocks was undertaken by two separate artists. The fact that the Dürer monogram appears in different forms has also been interpreted as an indication that Dürer and some anonymous wood-block cutter collaborated in producing the blocks (see cat. no. 106). Despite the most precise stylistic analysis, however, this is a question that must remain as controversial as that of the chronology of the series.

Dürer's *Apocalypse* was a landmark, for it was the first book independently published by an artist. In addition to placing his monogram on each individual woodcut, he included his colophon at the end of the text, on the verso of the next-to-last sheet (Bartsch, no. 73); in the 1511 edition, it reads: "Impressa denuo Nurnberge p̄[er] Albertum Durer pictorem. Anno christiano Millesimo Quingentesimo undecimo."

The colophon ends with a reference to the imperial privilege that would protect Dürer's copyright, with an admonition to anyone who dared reprint the woodcuts and sell them within the boundaries of the empire. Nevertheless, Hieronymus Greff, in Strasbourg, soon copied the woodcuts and then reprinted them.　RS

BIBLIOGRAPHY: Bartsch, 1808, nos. 60–75; Schellenberg, 1923, *passim*; Dvořák, 1928, pp. 193–202; Ivins, 1929, pp. 102–11; Meder, 1932, p. 277, pl. x, nos. 163–78; Wölfflin, 1943, pp. 62–77; Panofsky, 1948, vol. 1, pp. 51–59, vol. 11, nos. 280–295; Juraschek, 1955; Arndt, 1956, *passim*; Chadraba, 1964, *passim*; Grote, 1970, *passim*; *Dürer*, Boston, 1971, nos. 28–46; *Dürer*, Nuremberg, 1971, no. 596; Talbot, ed., 1971, nos. 89–106; *Vorbild Dürer*, 1978, nos. 58–68; Appuhn, 1979, pp. 107–16, 158–79; Strauss, 1980, nos. 40–55, 158; *The Illustrated Bartsch*, 1981, nos. 60–75, commentary, pp. 327–45.

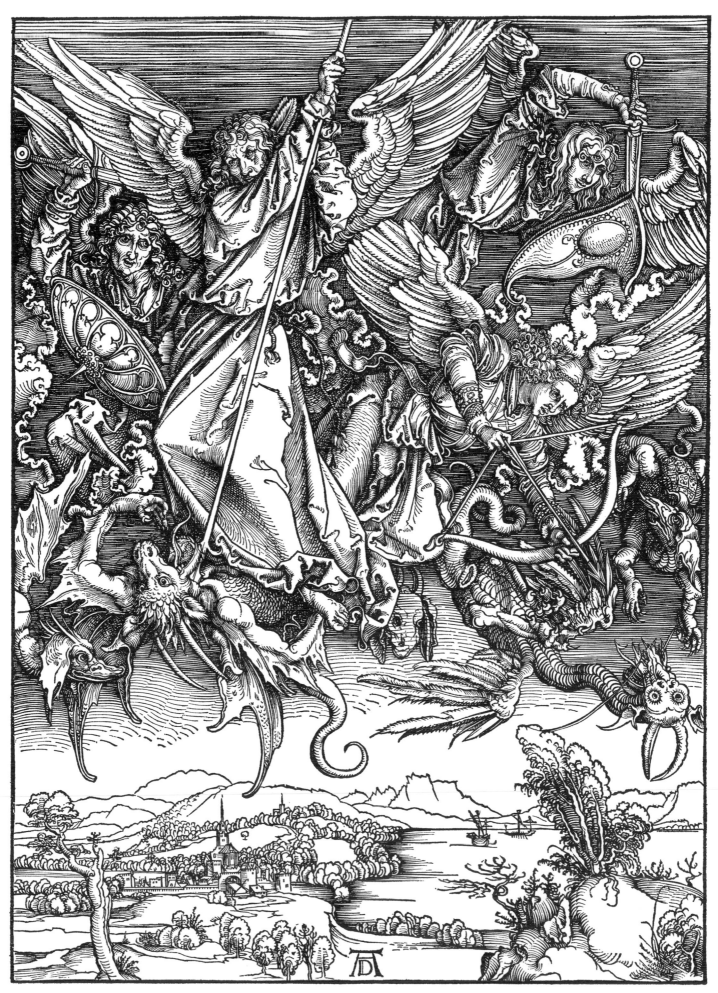

108: *Saint Michael Fighting the Dragon*

The Virgin and Child
(The Haller Madonna)
(reverse): Lot and His Daughters Fleeing from Sodom and Gomorrha

About 1498
Tempera and oil on linden wood
20 1/2 x 16 1/4 in. (52 x 41.3 cm.)
Washington, D.C., National Gallery of Art,
The Samuel H. Kress Collection (acquired, 1950)
K 1835 A, 1835 B

In 1932, Baron Heinrich von Thyssen-Bornemisza bought this two-sided painting on the London art market for his collection in Lugano. Max J. Friedländer introduced it into the art literature as the work of Albrecht Dürer in 1934. While still privately owned in England, it had been considered to be by the Venetian painter Giovanni Bellini. Until its sale to the Samuel H. Kress Collection, it was known as the "Thyssen Madonna." From the beginning, it was admired for its high quality and its superb condition, yet it was difficult to date the painting and to ascertain its special function as a two-sided work. Any attempt to envision a complementary worshiping figure (Anzelewsky, 1971) is foiled from the start, for both the Virgin and the Child would definitely seem to be turning away from any such adoring petitioner. More difficult is the question of whether the painting of the Virgin, on the front, and that of the biblical scene on the back are contemporary; the latter is generally considered the earlier of the two.

The Virgin stands holding her Child, in a room marked off in the foreground by a parapet and at the right side by an angled wall with a blind window, while the back wall contains a window opening on a spacious landscape. She is enveloped in a long blue shawl, and grasps the Child with both hands. He, in turn, stands playfully on one foot, cuddling against his mother with his right arm raised and bent. His left arm extends straight downward, and in his left hand, turned to the back, he holds an apple. According to Colin Eisler (1977), the meditative seriousness of the Virgin is meant to evoke the Passion, while the marble parapet prefigures the Tomb; the apple in Christ's hand identifies him as the "new Adam," and the raised right foot signifies the first step toward Golgotha. The enclosed garden viewed through the window symbolizes Mary's purity.

Of the two coats of arms in the lower corners of the work, the one to the left has been identified as that of the patrician Nuremberg Haller von Hallerstein family, while the one on the right, painted over, has not yet been deciphered.

On the reverse is a landscape. Lot is seen striding toward the right with a pilgrim's jar on his shoulder; his daughters follow behind, carrying a distaff and a coffer, and a bundle. In the path behind them stands Lot's wife, transformed into a pillar of salt, while the city of Sodom is consumed by fire and smoke in the distance. To the left, on a small rock, Dürer's monogram appears in its early form: the flourish of the small "d" is inscribed in the tall capital "A."

Dürer's *Haller Madonna* combines inspiration with an extremely calculating artistry in its infinitely painstaking execution. The inspiration is apparent in the richly inventive architecture, the verdant landscape, and the positioning of the mother and child, which juxtaposes playful innocence with a profound earnestness and majestic dignity. By the blue shawl tightly framing the mother's face and only permitting a glimpse of her loose, curly hair, an effect of sculptural severity is produced whose monumental effect is confirmed by the simplicity of the drapery folds and by the basic color harmony of blue against red.

Lot's flight appears as an illustration of the Bible (Genesis 19), a narrative picture of quite a different kind, with small figures occupying a spacious landscape — although concentrated in the foreground — of paths and green slopes, overgrown rock formations, and, next to the water, the virtually exploding, bursting city with flames as high as the buildings and clouds of smoke towering into the sky. Friedländer noted the proximity to Dürer's woodcut series of *The Apocalypse,* especially to the *Whore of Babylon* (Bartsch, no. 73), where the same burning city appears on the opposite side of the composition. He suggested that one study had been used for both the woodcut and the painting. Despite the drama of the narrative, the painting of Lot also reveals the painter's sense of organization and his eye for form. The broad path running parallel to the edge of the picture, the stone steps, the cliff, and the almost cosmic event of the city's destruction — all constitute a compositional frame that opens out only on the side of the sea. Unlike the painting of the Virgin, the Lot story was executed with speed and a flourish.

Eisler (1977) provides a full discussion of the debate over the chronological relationship of the paintings on the front and back of the panel. The dates suggested range from 1496/98 (Anzelewsky) to the artist's second sojourn in Italy in 1505/7 (Waetzoldt, 1935; Longhi, 1961). Friedländer dated the paintings between 1498 and 1502. Buchner considered the side with the Virgin to have been completed about 1504, comparing it with the *Adoration of the Magi,* in Florence, and the engraving of Adam and Eve. However, given the different style of the painting of Lot, its proximity to the *Apocalypse,* and the early form of the monogram, he placed it about 1496/97. Benesch considered a brush drawing with the Virgin and Child in the Wallraf-Richartz Museum, in Cologne, to be a preliminary study for the figure of the Virgin. Strauss attributed the Lot painting to the young Albrecht Altdorfer.

Friedländer demonstrated that Dürer could work simultaneously in a polished, painstaking manner, or in a style like his drawing — "swift, sure, even, and hurried" — thus underscoring the apt distinction between the painting on the front of the panel and that on the back. Buchner observed that the subject matter of the Lot painting comes close to the edges of the panel, and concluded that it was cut down on three sides before the painting on the front was undertaken. Technical research has failed to bear him out, and thus an important criterion for the early dating of the Lot picture has been discounted. Instead, it appears that Dürer selected the format for the painting of the Virgin, and adapted the Old Testament scene to the space available.

There is no discrepancy between the paintings that would have to be explained by a major lapse of time between them. The stylistic features of both works suggest that they date from about 1498. There are still echoes of the style of Giovanni Bellini, but the level of achievement attained with the *Madonna di Bagnacavallo* has been surpassed. Dürer invested the figures in the *Haller Madonna* with a grandeur and an inner serenity of form that he had not demonstrated before. His progress from the lively, earlier *Madonna,* with its seemingly improvised composition, to the almost chiseled classicism of his Madrid *Self-Portrait* appears to bear on the dating of the *Haller Madonna,* as well. With his *Oswolt Krell* of 1499 — if one may compare portraits, at all — Dürer's artistry advanced considerably.

The *Haller Madonna* was done on commission, and Dürer gave it his all. It does not seem logical that the artist would have used an already painted panel, or that his patron would have been content with that. Double-sided paintings were not meant to simply hang on a wall; they were portable. Thus, it seems unlikely that the work was intended for one of Nuremberg's churches (see Friedländer, 1934, p. 324, n. 1). The sliding covers normally used to protect painted portraits generally bore the coat of arms of the subject or his family, and the reverse side of a painting presented an allegorical scene. The *Avaritia* on the back of Dürer's *Portrait of a Man,* from 1507, in Vienna, is a perfect example. In the case of a diptych, one wing served as a cover for the other; a single painting required a sliding protective panel. The one for the *Haller Madonna* could have contained a more elaborate version of the coat of arms. There is no typological connection between the painting of the Virgin and the story of Noah. This may mean that the choice of the Old Testament subject represented a preference on the part of either the patron or the artist, himself.

KL

Ex COLLECTIONS: Colonel Charles a Court-Repington, Amington Hall, near Tamworth, Warwickshire; Phyllis Loder, London; Baron Heinrich von Thyssen-Bornemisza, Lugano-Castagnola, Switzerland (1932–50); [sold, M. Knoedler & Co., New York].

BIBLIOGRAPHY: Friedländer, 1934, pp. 321–24; Buchner, 1934, pp. 262–70; Tietze-Conrat, 1937, p. 15; *Sammlung Schloss Rohoncz,* 1937, no. 127, pls. 30, 31; Panofsky, 1948, vol. 1, p. 42, vol. 2, no. 25; Musper, 1952, p. 52; Winkler, 1957, pp. 77–78; Longhi, 1961, pp. 3–9; Benesch, 1966, p. 19; Anzelewsky, 1971, nos. 43, 44; Eisler, 1977, pp. 12–16.

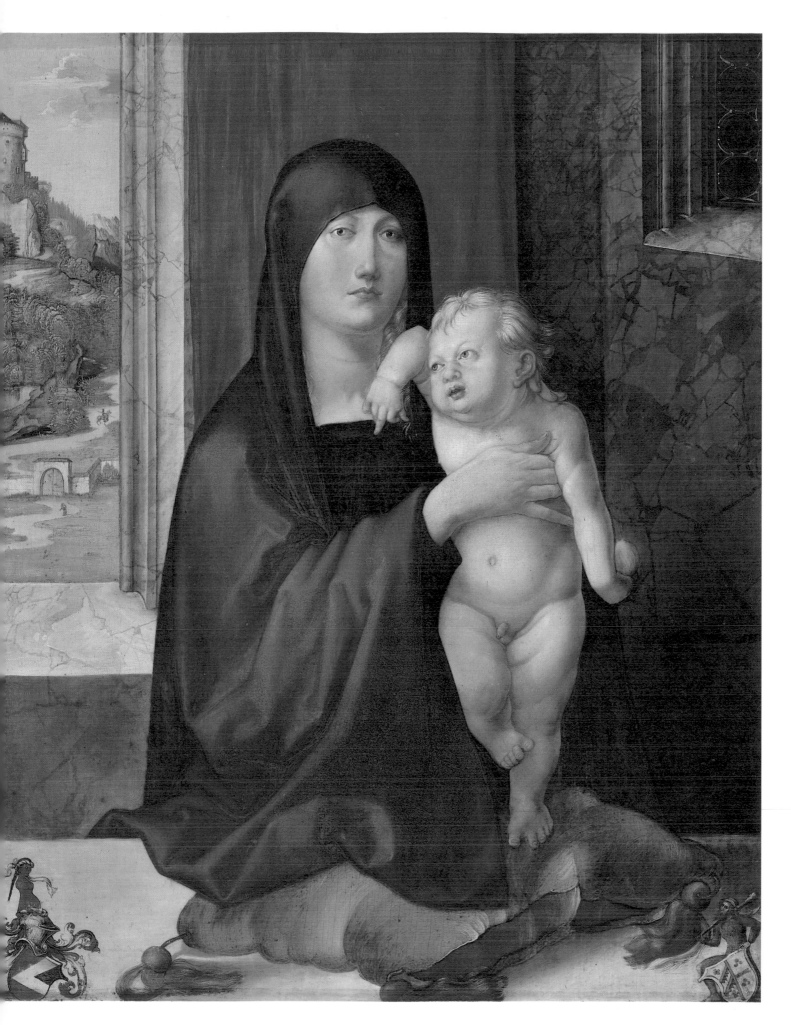

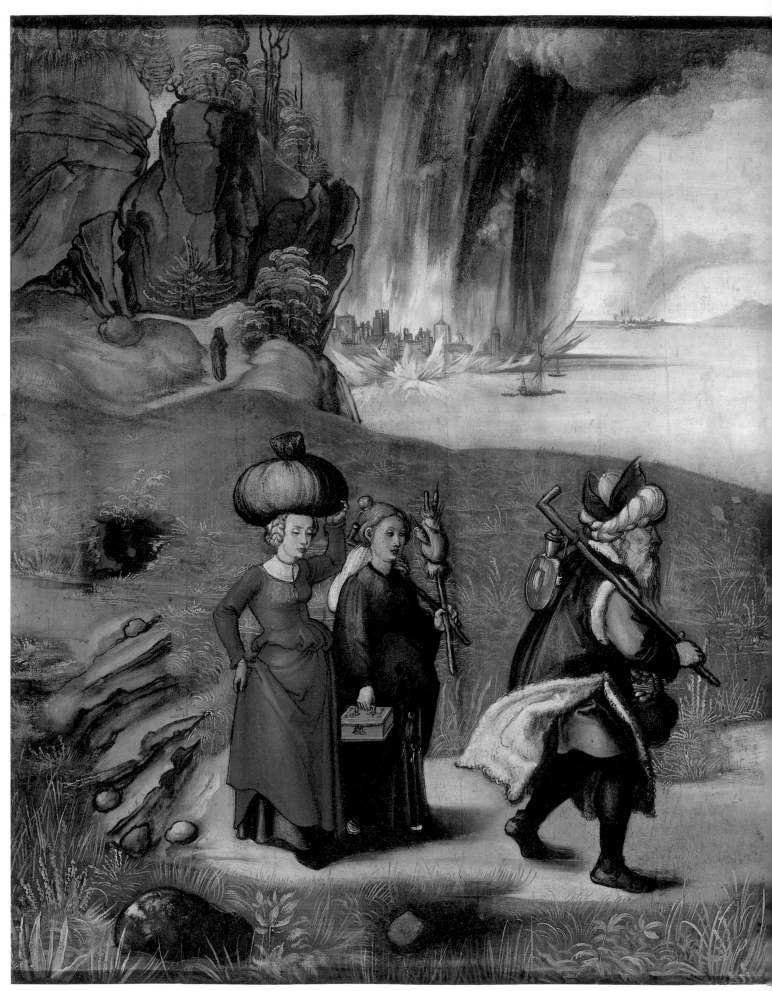

109 : (reverse) *Lot and His Daught*

Fortuna in a Niche

Monogrammed and dated "1498" at lower center
in a later hand
Pen and brown ink, on paper
New York, The Metropolitan Museum of Art,
The Robert Lehman Collection, 1975
1975.1.861

Flechsig identified the subject of this drawing as
Fortuna, who is traditionally represented stand-
ing on a globe. Unlike Fortuna, the woman is
not blindfolded, but she wears a band around
her head that is similar to one seen in Dürer's
engraving of *The Little Fortune*, of about 1496
(Bartsch, no. 78). The identity of the figure
cannot be confirmed by information about the
context for which the artist created this enig-
matic female nude. Such lifelike elements as her
quizzical expression and her unusually de-
veloped shoulder muscles detract from the
monumentality implied by the shallow niche
that surrounds her. Tiezte and Tietze-Conrat,
Winkler, and Sheard have tried to explain the
framing niche by likening the drawing to sculp-
ture that Dürer might have seen in Italy. The
highly finished study, however, served only
once as a model — for the lower part of the
figure of Venus in the *Dream of the Doctor*
(Bartsch, no. 76).

Strauss believes that the type of shading
around the breasts predates the concentric cir-
cles Panofsky recognized in Dürer's draftsman-
ship after 1497. Because of this analysis, the ear-
lier date of the engraved *Fortune*, and Strauss's
arguable conviction that the use of paper with a
crown, cross, and triangle watermark predomi-
nated about 1495, he redated the drawing no
later than 1496 and proposed that the mono-
gram and date, which were added in a different
hand, obscure an earlier inscription.

The type of nude is a curious mixture of Late
Gothic convention — illustrated by the figure's
elongated proportions, small head, and high
breasts — and of observation from life, as is ap-
parent in the face, the full thighs, and, presum-
ably, in the unusually prominent shoulder
muscles. While, in the literature, the beginnings
of Italian and classical influence on Dürer's ren-
dering of the figure have been noted, the type of
nude in the present work is clearly very distant
from the classical figural proportions of the Eve
in the Morgan Library study of 1504 (cat. no.
120). A comparison with that drawing reem-
phasizes how much Dürer was still indebted to
the Late Gothic style when he created the Leh-
man Collection nude. BDB

Ex COLLECTION: Lubomirski Museum, Lemberg, Po-
land.

BIBLIOGRAPHY: Reitlinger, 1927, p. 154, pl. II A; Winkler,
1927, p. 16; Lippmann, ed. (Winkler), 1927, vol. VI, no.
669, pp. 17–18; Flechsig, 1928, vol. II, p. 420;
Gebarowicz and Tietze, 1929, p. 16; Winkler, 1936, vol. I,
p. 104, no. 154; Tietze and Tietze-Conrat, 1938, vol. I, p.
44, no. 143; Panofsky, 1943, vol. I, p. 264, vol. II, no. 911;
Stampfle, 1955, p. 9; Winkler, 1957, p. 95; Talbot, ed.,
1971, no. VI, pp. 36–38; Strauss, 1974, vol. I, no. 1495/7;
Szabo, 1978, no. 23.

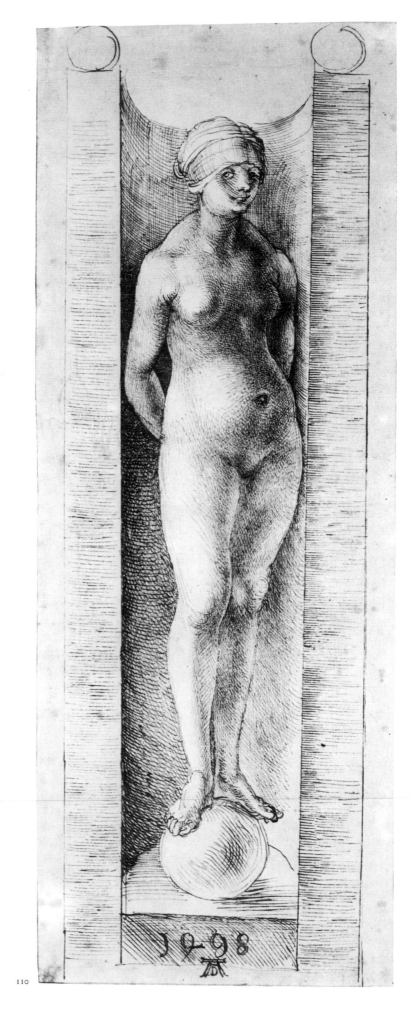

110

Elsbeth Tucher, née Pusch

1499
Oil on linden wood
11 7/16 x 9 1/8 in. (29 x 23.2 cm.)
Kassel, Staatliche Kunstsammlungen (Collection
of the Landgrave of Hessen-Kassel, 3rd supple-
ment to 1749 inventory, no. 1387)
GK 6

This small portrait was commissioned by the
Nuremberg patrician Niclas (Nikolaus) Tucher.
We can identify it by the inscription (added at a
later date): ELSPED NICLAS TVCHERN 26 ALT, and
the date 1499, at the top of the picture; by the
initial letters MHIMNSK on the gold rim of the
head covering; by the monogram NT (= Niko-
laus Tucher) on the gold clasp on the bodice; by
a double w embroidered on the shirt; and by the
artist's monogram above the fingers holding the
ring, although it is not known if it is in his own
hand. The sitter's costume—her gold chain, and
her balloon-shaped cap, with its fine lattice-
work pattern — helps to establish her social
standing. In contrast, the "likeness" required to
make the portrait recognizable was determined
by such artistic considerations as the accuracy
of the painter's skill in observation, identifica-
tion, interpretation, and empathy, through his
own life experiences.

Dürer posed Elsbeth Tucher before a velvet
fabric decorated with a pattern of pomegran-
ates. Behind her, beyond the window ledge, is a
landscape of ascending wooded hills and distant
mountains, which appear blue against the sky.
Dark clouds, reddened by the sun, are scudding
past. The sitter's head and shoulders are com-
pressed, their firm and clearly delineated
contours set off by her large, rounded cap,
drooping shoulders, and highly pronounced
physiognomy. The deep-set eyes, different in
size; the high cheekbones; and the dominant
chin lend the face character and austere charm.
The draftsmanship apparent in the edges of the
fabrics and in the modeling of the head show
Dürer's celebrated feeling for realistic detail, his
fineness of touch, and his engraver's precision.
Even in the shadows, the coloring is light and
transparent. The skin tones, the shades of the
velvet, and the subtle hues of the bonnet are so
well matched that an overall harmony of color is
at least partially achieved. The ring in Elsbeth
Tucher's right hand and her head covering pro-
claim her married status.

In 1499, the brothers Hans XI and Nikolaus
Tucher, had portraits of themselves and their
wives painted by Albrecht Dürer. Hans had
married Felicitas Rieter — also from a patrician
family — in 1482. Nikolaus married Elizabeth
(Elsbeth) Pusch, the daughter of an official of
the municipal artillery, in 1492. They had no
children, and Nikolaus, who was in the service
of Emperor Charles V, lost his life in the Sack of
Rome in 1527. The paintings of Hans and
Felicitas Tucher have been returned to the
museum in Weimar, after an absence of many
years. Of the second pair of paintings, only the
portrait of Elsbeth Tucher has survived. Each

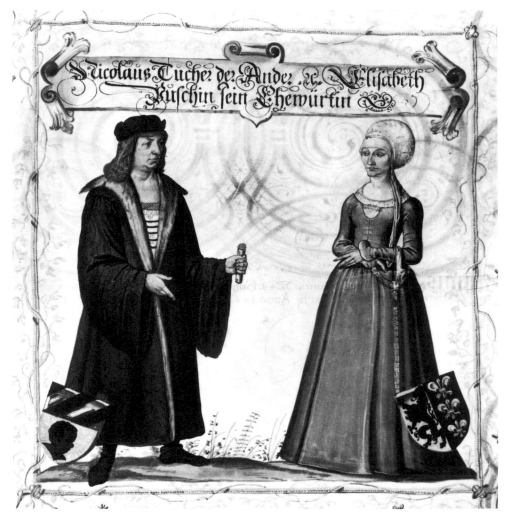

Figure 127 Nikolaus and Elsbeth Tucher, from the Tucher Family Chronicle. Nuremberg, 1590–96.
Tucherschloss, Nuremberg

pair formed a diptych. On the reverse of Hans
Tucher's portrait is the couple's joint coat of
arms. Such diptychs were kept in chests or cup-
boards as family documents, but could also be
placed, open, on a sideboard or window ledge.

The portrait of Elsbeth Tucher is certain to
have been the pendant to the portrait of her
husband. Ladies of her rank were usually only
portrayed as financées or as married women in
the company of their husbands. The Tucher/
Rieter portraits are a classic example of this. The
husband displays his ring, while his wife holds
a bunch of flowers, as signs of the marriage
bond. In the case of the Tucher/Pusch paint-
ings, the wife holds the ring, and it may be
assumed that her husband held the flowers. In a
book from the Tucherschloss (in the Freiherr
von Tucher family endowment at the Histo-
rische Museen der Stadt, in Nuremberg), both
couples appear again, in miniature, as full-
length figures with their respective coats of
arms, the painting of Nikolaus Tucher merely a
poor copy of the lost original.

In the Tucher portraits, Dürer demonstrated
the full range of his talents within the limits of a
formal commission. Intensive study of the sub-
ject, as was natural in his portraits of his father,
was not called for. The interior, with a window
set on a diagonal was a carry-over from Late
Gothic art, which Dürer did not employ furth-

er. For matching portraits of a married couple, a
unified space was required. This would result
from either a neutral background color or from
the division of the background into a blank wall
and an outside view, with the landscape beyond
integrated into the overall impression of the
work. The concept was not new, but no other
German artist adapted it in such an accom-
plished and well-balanced way. The fact that
Dürer did not render the design of the velvet as
precisely as he did the sitter's physiognomy
heightens interest in the person portrayed.

The art of Dürer's time is considered "mas-
culine"; consequently, portraits of women are
strong in character, austere, and restrained, with
scant homage to their "feminine" qualities — as
the Italians saw them. The cap that covered a
married woman's hair and the way in which her
duties were reflected in her expression make
even young women appear serious and somber
beyond their years. So it is with Elsbeth Tucher.
Dürer's artistic strength lay in his ability to por-
tray her inner life and spirited personality so
convincingly. KL

BIBLIOGRAPHY: Vischer, 1886, pp. 382–83; Panofsky,
1948, vol. 1, p. 42, vol. 2, no. 74; Buchner, 1953, p. 157,
no. 178, ill. 176; Grote, 1961, p. 74; Anzelewsky, 1971,
pp. 31, 84, nos. 63–65; Dürer, Nuremberg, 1971, no. 525;
Schneckenburger and Broschek, 1982, pp. 64–65.

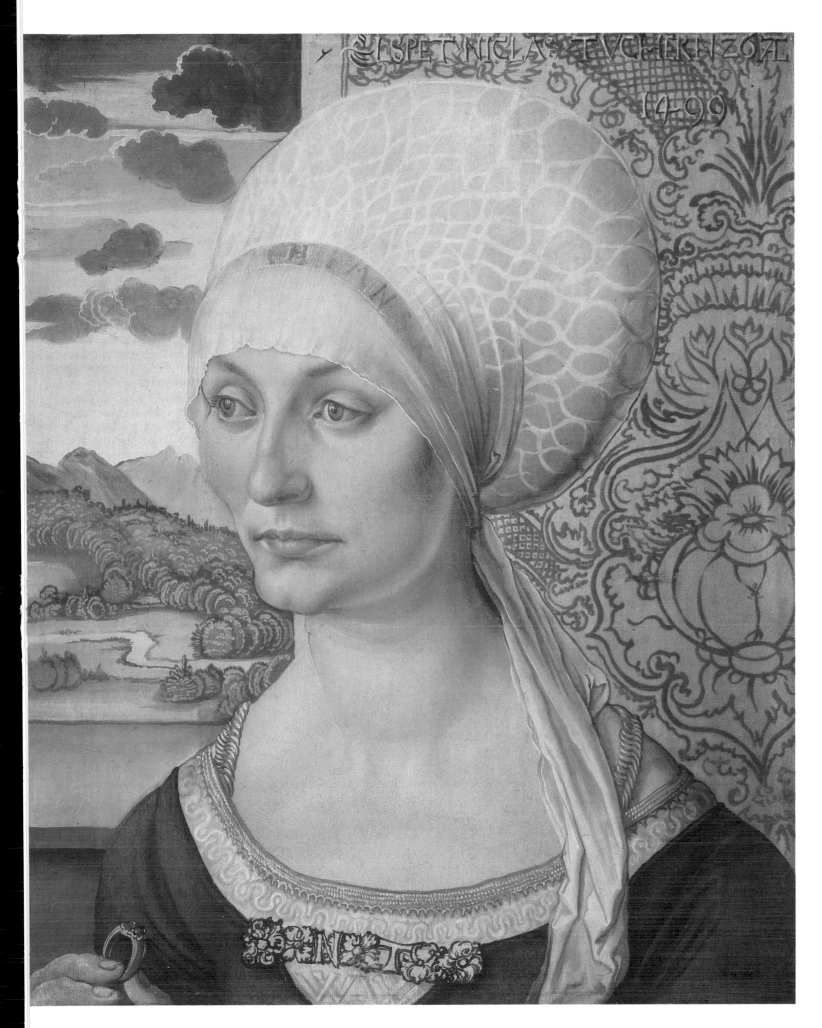

IST PET NICLAS TVCHERIN ZOLI
14 99

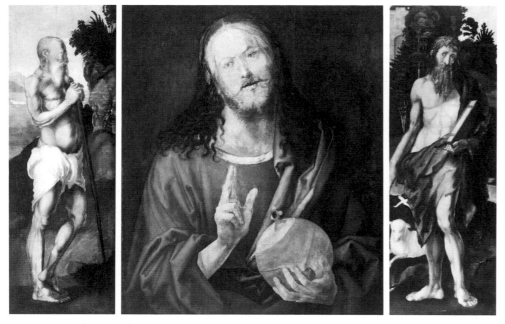

Figure 129 Catalogue number 118, as part of a reconstructed altarpiece

118 ALBRECHT DÜRER

Salvator Mundi

About 1503/4
Oil and tempera on linden wood
22 7/8 x 8 1/2 in. (58.1 x 47 cm.)
Unfinished
New York, The Metropolitan Museum of Art,
Bequest of Michael Friedsam, 1931, The Friedsam
Collection
32.100.64

In this unfinished painting, Christ, shown as a half-length figure, is depicted as Salvator Mundi, the Savior of the World. He holds a transparent glass globe in his left hand, and gives the sign of benediction with his right.

In order to evaluate the painting correctly, it is necessary to know something of its history. In the 1573 inventory of the Imhoff collection, it is listed as "Ein Salvator so Albrecht Dürer nit gar ausgemacht" ("A Salvator that Albrecht Dürer did not finish"). A listing from 1588, sent by the Imhoff heirs to Emperor Rudolf II in Prague, states: "Ein Salvator ist das letzte Stück, so er gemacht" ("A Salvator was the last work he undertook"). After the painting was sold, it was cleaned by Professor Alois Hauser in Bamberg in 1863. He noted that "the robe, the hair, and the green background revealed an ultimate degree of completion and an unusual fusion of the pigment. The contours of the face and hands had been completely sketched in, in careful black hatched lines on the white sizing, but not yet painted. Only on a few areas in the face — the forehead and nose — which would have been highlighted in the completed work, had these been applied already in flat oil pigment, which stood out darker than the bright sizing." One of the painting's later owners had the face and hands finished by the restorer Deschler in Augsburg. In 1907, this overpainting was partially removed, but the condition of the painting was still such that it was difficult

for scholars and connoisseurs to appreciate it fully. It was not until the picture was cleaned in 1942 that the parts that Dürer had originally only sketched in were again exposed.

There is no question that Dürer was the painter of the Salvator Mundi. The sole scholar to doubt this was Vischer (1886), who only knew the painting from a woodcut reproduction. He suggested that it was the work of Hans Suess von Kulmbach.

Even in its unfinished state, Dürer's Salvator Mundi is the work of a master. It is organized in the Renaissance manner, simple in its overall plan, grand in the configuration of the drapery. The luminosity of the colors and the tactile folds of the drapery cause the unfinished sections to appear flat, but it is precisely in them that one discovers the painting's sureness of design and the artist's precise observation of nature — especially in the sensitivity of the hatched underdrawing, which makes the hands and face of Christ true marvels of artistic creation. In the Salvator Mundi, Dürer attained an effect of extreme beauty and imitated the Italian tendency toward a harmonization of the pictorial elements.

The criteria for the dating of the work are provided by the picture's type, its uniqueness of style, and its unfinished condition.

The pose and gestures of Christ follow an engraving on the same theme by the Master E.S., which has come down to us in a reworking, of 1565, by Israhel van Meckenem (see Shestack, 1967, no. 79). However, the half-length figure of Christ as Salvator Mundi also appears in Venetian painting. Thausing (1884), who was the first to describe the proximity of the Salvator Mundi to the work of Barbari, deduced from the condition of the panel that at a point in his development when he could no longer follow the example of the Italian, Dürer turned away from his style and left the work

unfinished. Flechsig (1928) suggested that it was Dürer's departure for Venice in the late summer of 1505 that prevented the completion of the painting. It is generally agreed that the picture dates from 1503/4.

The original purpose for which the work was made is still unknown. It could have been intended as a separate devotional painting, or as the center panel of an altarpiece. Flechsig (1928) was convinced that two painted wings depicting Saints Onuphrius and John the Baptist (in the Kunsthalle, Bremen; the Saint John has been missing since 1945) belonged with it (fig. 129). He based his argument on their corresponding sizes, their unfinished condition, their indebtedness to Italian models, and their dating. His thesis had its supporters (Kuhn, 1936; Musper, 1965; and Anzelewsky, 1971) as well as its opponents (Wehle, 1942−43; Panofsky, 1948; and Strieder, 1981). Opposing Flechsig's thesis are various stylistic differences that would permit a dating of the two paintings of the saints to before 1500, their different designs, and their varying degree of completion. Even more difficult to determine is if, together, the content of the three pictures is convincing, and if they represent a satisfying composition.

Dürer's Salvator Mundi was created at a time when the artist, through intensified theoretical studies, sought to establish the appearances of objects and to bring his art into harmony with these laws. Also, the Christ-like Self-Portrait, of 1500 (in the Alte Pinakothek, Munich), owes its existence to this same yearning for a fundamental and authentic means of expression — in this case, of the creative artist's relationship to God. Although, by leaving the painting unfinished, not all traces of Dürer's struggles with the forms have been eradicated, the Salvator Mundi nevertheless reveals what a profound understanding of Renaissance art the master had attained even before he set out on his second journey to Italy in the autumn of 1505.

KL

Ex collections: Willibald Imhoff, Nuremberg; Haller von Hallerstein family, Nuremberg (about 1650); art market [Geuder, Nuremberg; Gustav Finke, Bamberg (1861)]; Franz R. Reichhardt, Munich (until 1869); Alexander Posonyi, Vienna (last documented, 1873); Eugen Feliz, Leipzig (1873, at the earliest – 1906, at the latest); Charles Fairfax Murray, London (about 1906−14); (sold, Galerie Georges Petit, Paris, no. 8 [June 15, 1914]); [F. Kleinberger, New York (1921)]; Michael Friedsam, New York (1921−31).

Bibliography: Gemälde älterer Meister, Munich, 1869, no. 60; Schmidt, 1869, p. 357; Eisenmann, 1874, pp. 155−56; Gemälde Alter Meister, Vienna, 1874, no. 190; Börner, 1880, p. 140; Thausing, 1884, pp. 304−5; Vischer, 1886, p. 221; Justi, 1898, p. 354; Early German Art, 1906, p. 96, no. 38; Friedländer, 1906, p. 586; Ricketts, 1906, p. 267; Flechsig, 1928, pp. 400−403; Hevesy, 1928, pp. 34−35; Tietze and Tietze-Conrat, 1928, no. 244; Winkler, 1928, ill. p. 30 (left), text p. 411; Burroughs and Wehle, 1932, p. 29; Tietze, 1932−33, p. 92, 1933, p. 263; Kuhn, 1936, no. 200; Wehle, 1942−43, pp. 156−64; Panofsky, 1948, vol. I, p. 94, vol. II, no. 18; Winkler, 1957, p. 138; Musper, 1965, p. 86; Zampa, 1968, no. 100; Anzelewsky, 1971, no. 83; Dürer, Nuremberg, 1971, no. 192; Strieder, 1981, p. 297, colorpl. 398.

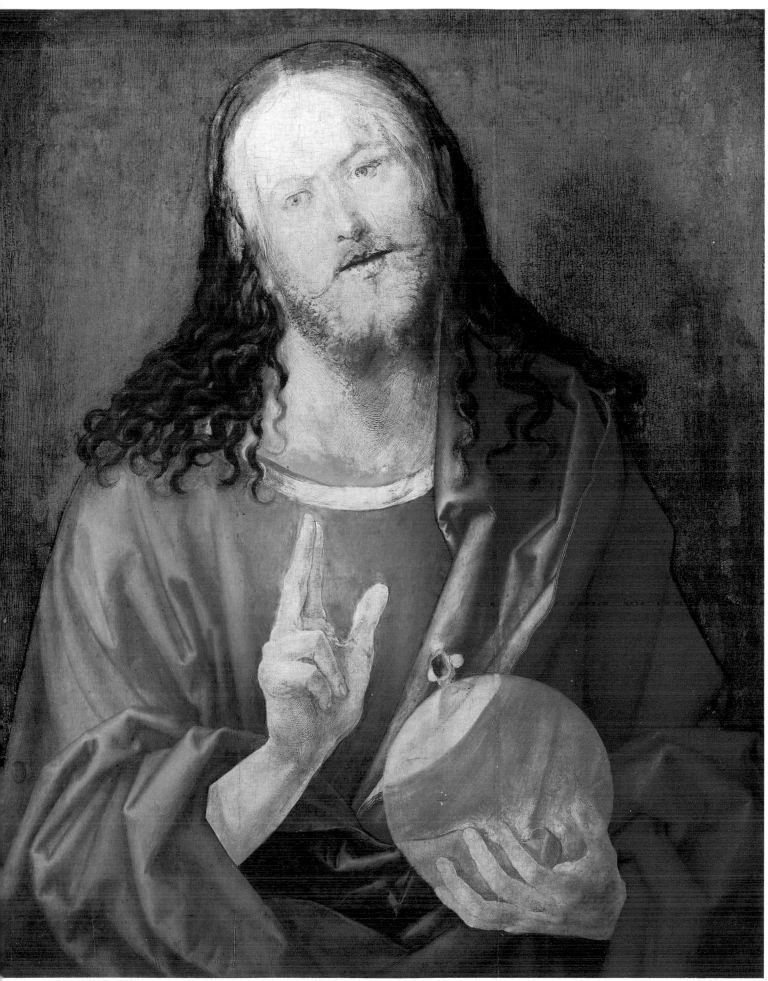

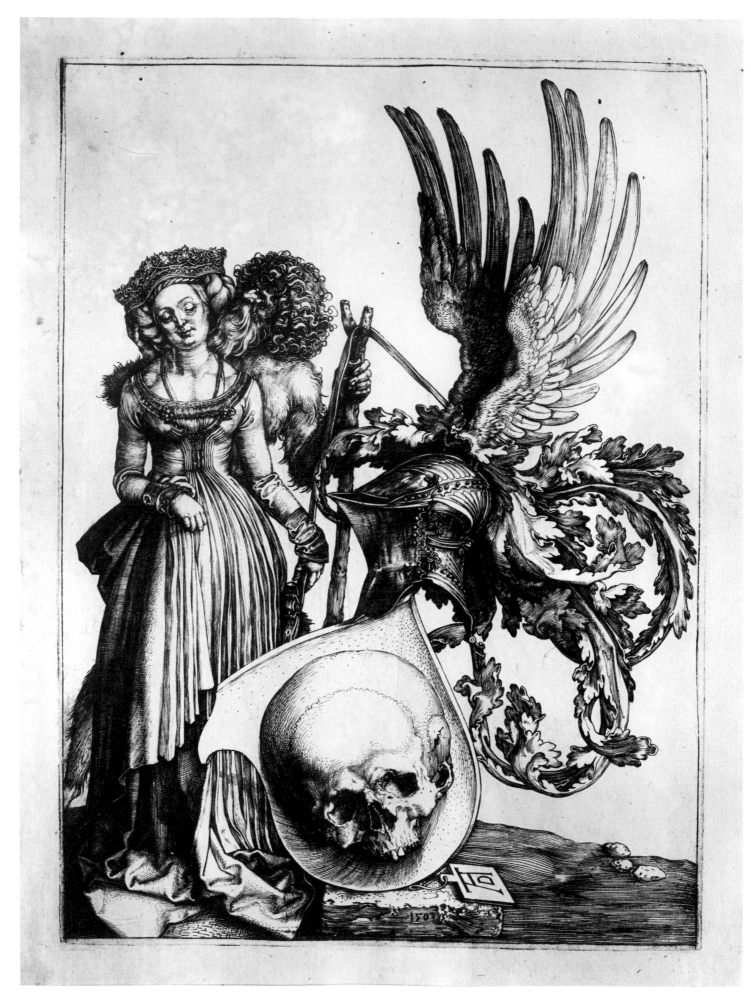

119 ALBRECHT DÜRER

Coat of Arms with a Skull

1503
Engraving
Plate: 8¹¹/₁₆ x 6³/₁₆ in. (22.1 x 15.7 cm.);
paper: 9⁹/₁₆ x 7¹/₁₆ in. (24.4 x 18 cm.)
Monogrammed and dated at bottom center
Watermark: (Meder, no. 20).
New York, The Metropolitan Museum of Art,
Fletcher Fund, 1919
19.73.113

The engraving of heraldic images was among the traditional tasks of printmaking as early as the fifteenth century. Before Dürer, Martin Schongauer, the Master of the Housebook, and Israhel van Meckenem had all made engravings of coats of arms, not only previously established ones but also a number of fanciful devices of their own invention, of an allegorical or satirical nature. Shortly before completing the present work, Dürer himself had dealt with such a subject in his engraving *Coat of Arms with a Lion and a Cock* (Bartsch, no. 100).

In the 1503 *Coat of Arms with a Skull*, a masterpiece of decorative graphic art, Dürer managed to give a new vitality to traditional heraldic forms. A wild man covered with matted hair has abandoned his heraldic function as a bearer of arms and is lecherously approaching a young woman, who coquettishly consents to his advances. A watercolor costume study by Dürer in the Basel Öffentliche Kunstsammlung (Strauss, 1974, 1500/7) indicates that she is a lady from a Nuremberg patrician family, dressed for the dance. Her precious bridal crown is part of the patrician wedding costume. While the demon woos her, with her left hand she grasps the strap attached to a splendid jousting helmet. She appears to be flirting with this elegant status symbol, unable to see that the wild suitor sports a death's-head on his coat of arms. By the way the skull is tilted, it is definitely meant to relate to the young woman.

Dürer had already used the same helmet, viewed from a different angle, in his *Coat of Arms with a Lion and a Cock*, and it is recorded in three separate views in a watercolor drawing (fig. 110), from before 1500, in the Louvre (Winkler, no. 177). It corresponds to the type of jousting helmet that was produced in Nuremberg about 1500. A number of such helmets were kept in the Nuremberg armory and lent to young patricians for their jousts in the market square in imitation of aristocratic custom. Helmets of this variety may be seen in the Germanisches Nationalmuseum, Nuremberg; The Metropolitan Museum of Art; and the Higgins Armory, Worcester, Massachusetts, among other collections (cat. nos. 265, 266, 275).

In his engraving, Dürer combined several motifs on the subject of Love and Death — a most popular one at the time — to create an impressive memento mori: The Ill-Assorted Couple, Death and the Maiden, and the Dance of Death are all suggested.

Many scholars have attempted to relate the print to an actual event. Panofsky (1948, p. 90), for example, suggests that Dürer was inspired by an epidemic of plague in his native city. Perhaps the engraving was even intended to convey a certain amount of criticism of the Nuremberg patriciate and its emulation of the customs of the nobility.

In terms of technique, the present work reveals the thirty-two-year-old Dürer's astonishing virtuosity in the use of the burin. Especially in the early prints, in which the burr had not yet been worn down, the impression of three dimensionality and texture, achieved by a highly refined modeling of the areas of light and shade, is obvious.

R S

BIBLIOGRAPHY: Bartsch, 1808, no. 101; Meder, 1932, no. 98; Panofsky, 1948, no. 208; Feinblatt, 1963, pp. 13–15; *Dürer*, Boston, 1971, no. 62; *Dürer*, Nuremberg, 1971, no. 467; Talbot, ed., 1971, no. 27; Strauss, 1976, no. 40; *The Illustrated Bartsch*, 1981, no. 101, commentary, p. 224; Husband, 1981, no. 58.

120 ALBRECHT DÜRER

Adam and Eve

1504
Pen and brown ink, with brown wash, on two sheets of paper pasted together
9¹/₂ x 7⁷/₈ in. (24.2 x 20.1 cm.)
Monogrammed and dated at lower left
New York, The Pierpont Morgan Library

The Pierpont Morgan Library's drawing, dated 1504, occupies a central place in Dürer's oeuvre. As a preparatory drawing for the engraving *Adam and Eve* (cat. no. 121), it represents the culmination of Dürer's years of investigation of the ideal proportions of the human body, and documents the triumph of Renaissance art in Germany. The sheet marks the decisive moment when Dürer combined his studies of the ideal masculine and the ideal feminine figure — previously pursued quite separately — in a single composition. Indeed, the drawing is a composite of two vertical strips of paper of different widths. The two sections are joined visually by means of the subsequently applied background wash. The figures thereby appear in relief, just as they are set against a dark forest in the engraving, so that the clarity of their outlines and their artificial, idealized nature are emphasized. The shading also serves to obscure a number of corrections. Beneath the wash, for example, one can see that Eve's left forearm was originally slightly lower. In areas where the wash left the shapes too narrow, as at Eve's left knee or Adam's calves, Dürer made corrections in white body color.

At this point, Dürer was obviously not yet certain how he would stage the confrontation between the two figures for, here, in contrast to the engraving, both Adam and Eve hold one of the forbidden fruits. In the drawing, Eve gestures with her left arm as she attempts to win Adam over. In the engraving, however, it is Adam who becomes the protagonist, defending his reluctance to taste of the fruit. The final position of Adam's hand is established on a sheet of studies in the British Museum.

Dürer's systematic study of the nude goes back to the period of his first trip to Venice and Northern Italy in 1494–95, where, initially, he was influenced by the work of Mantegna, Pollaiuolo, and the Venetian painters. His studies take on a new quality beginning about 1500, as he made his first attempts to determine the laws of human proportion through scientific measurement. The Venetian painter Jacopo de' Barbari, while staying in Nuremberg, showed Dürer various drawings in which the human figure was constructed according to a canon of ideal proportions. Barbari's engraving *Apollo and Diana* (Bartsch, no. VIII 23), and Dürer's study of Vitruvius, and probably his knowledge of the theoretical writings of Alberti and Leonardo, inspired him to embark on further research of his own.

The first male figures Dürer constructed betray at least an indirect knowledge of antique statues, such as the *Apollo Belvedere* in the Vatican and the Borghese-Piccolomini *Hercules* in Rome. The drawings of the so-called Apollo group — the *Apollo and Diana* in the British Museum, the *Poynter Apollo* in the Metropolitan Museum (cat. no. 115), and the so-called *Aesculapius* in the Kupferstichkabinett, Berlin-Dahlem — anticipate the ideal figure that would become Adam, which exemplifies the Vitruvian canon in its pure form.

Analogously, the figure of Venus in the engraving *The Dream of the Doctor* (Bartsch, no. 76), from before the turn of the century, incorporates several features repeated in the figure of Eve. Even the gesture of the hand in the Morgan Library drawing is anticipated in the earlier work. Such studies as the Venetian-style *Nude Woman with Mirror*, now in a private collection in Clarendon, England (Winkler, no. 410); the constructed *Female Nude with Staff* in Ottawa (Winkler, no. 265); and a preparatory drawing in the Ashmolean Museum, Oxford, are additional stages in the development of the Morgan Library's Eve.

In all these drawings, one senses Dürer's endeavor to supersede characteristics of the individual model to capture the abstract perfection of the ideal figure. In every respect, the *Adam and Eve* represents the artistic equivalent of Dürer's posthumously published theoretical treatise on the science of proportion (see Rupprich, 1966, vol. II, pp. 151–351).

R S

EX COLLECTIONS: Willibald Imhoff, Nuremberg; Antoine François Andréossy, Paris; Friedrich Jakob Gsell, Vienna; Adalbert Freiherr von Lanna, Prague; J. Pierpont Morgan, New York.

BIBLIOGRAPHY: Justi, 1902, pp. 9–10; Panofsky, 1920, pp. 359–77; Flechsig, 1928–31, II, pp. 181–88; Tietze, 1928–38, I, pp. 399–400; Winkler, 1936, no. 333; Panofsky, 1948, vol. I, p. 262, no. 458; *Dürer*, Nuremberg, 1971, no. 483; Talbot, ed., 1971, no. XII; Strauss, 1974, no. 1504/17.

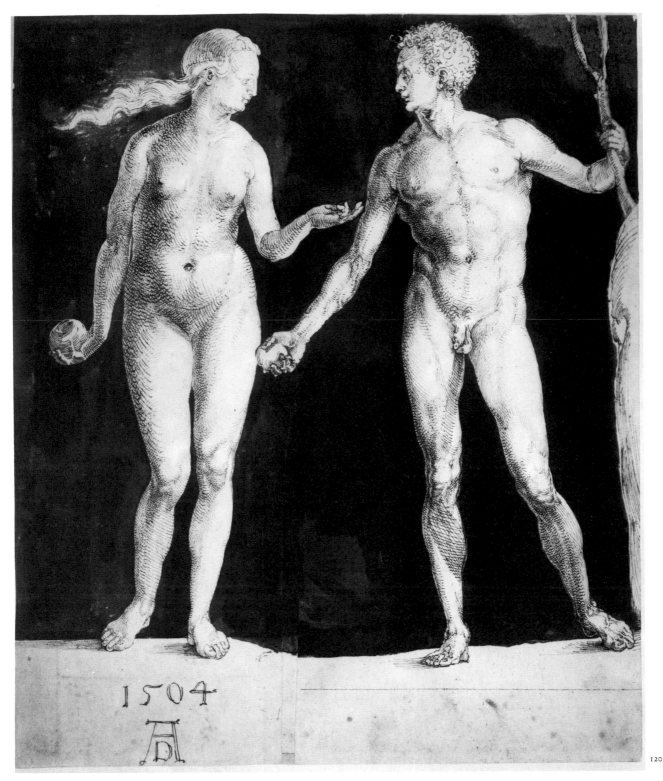

1504

120

121 ALBRECHT DÜRER

Adam and Eve

1504
Engraving
10³/₁₆ x 8 in. (26 x 20.3 cm.)
Signed and dated (at upper left, on tablet): ALBERT
DVRER NORICUS FACIEBAT A.D. [signifying both
Anno Domini and Albrecht Dürer] 1504
Watermark: (Meder, no. 62).
New York, The Metropolitan Museum of Art,
Fletcher Fund, 1919
19.73.1

With the uncharacteristic Latin signature, in-
spired by that on Pollaiuolo's engraving *A Bat-*

tle of Nude Men, Dürer underscored the special
significance that he gave to this print, the culmi-
nation of his studies of the proportions of the
human body. He presents the first man and
woman, created in God's image, as classic nudes
modeled after antique prototypes. Adam's pos-
ture is a variant of the contrapposto of the
Apollo Belvedere, in the Vatican; Eve recalls the
Medici Venus, in the Uffizi. In contrast to Late
Medieval portrayals of the Fall, the nakedness
of these figures is displayed not as an imperfec-
tion, but as the symbol of a new, positive, secu-
lar ideal of beauty, and as the deliberate result of
the artist's creative reasoning.

While, on the one hand, the engraving may
seem a demonstration of Renaissance art theory,
it has, nevertheless, been incorporated into a
highly imaginative iconographic program.
Adam and Eve stand out in relief against the
dusky background of a forest populated by
mysterious-looking animals. Their outlines are
distinct and do not overlap; their well-formed
bodies contrast sharply with those of the ani-
mals and with the gnarled trunks of the trees.
Tempted by the serpent, Eve has picked the
fruit from the Tree of Knowledge, while Adam
tries to dissuade her from the wicked deed. He
grasps the branch of a mountain ash, a tree from

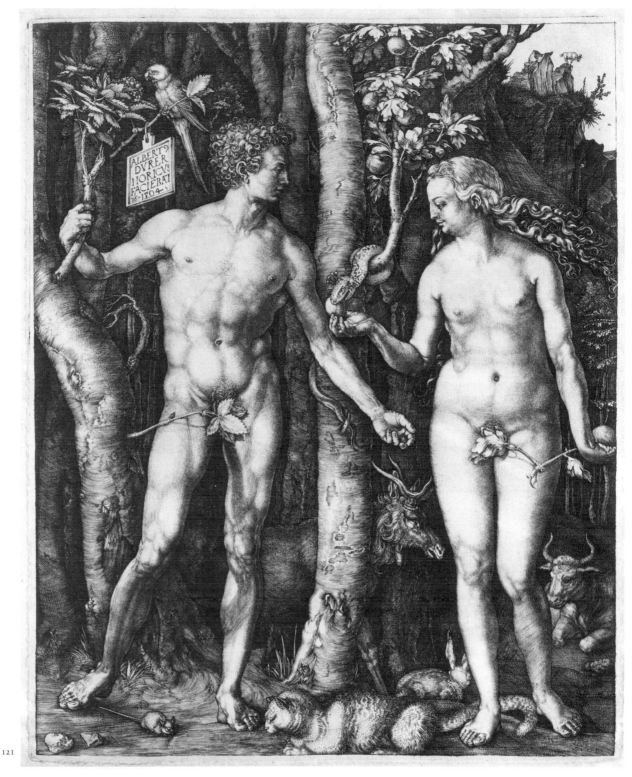

121

which snakes recoil, according to Physiologus, and which was identified in the Middle Ages with the Tree of Life. The parrot, a symbol of cleverness, serves as a counterpart to the wily, seductive serpent. While Adam and Eve appear to be still in a state of ideal purity, the awakening tension between them and the outcome of this conflict are suggested by the cat and mouse in the foreground. The elk, bull, rabbit, and cat embody the four humors: the melancholic, the phlegmatic, the sanguine, and the choleric. According to medieval doctrine, the balance of these bodily fluids was upset after the Fall, one or the other gaining superiority, making man

subject both to his instincts and to self-perpetuating sin.

Dürer produced preparatory drawings immediately before the engraving was made. Another indication of the special care that he took with this engraving is the fact that he made trial prints from the still unfinished plate. Two different states, as well as a number of the drawings (see cat. no. 120), survive. In addition, three further states, in which Dürer made minor corrections, are known (see Dodgson, 1922, pp. 51–55).

The engraving was copied, shortly after it was executed, by various artists, Italians as well as

Germans, and exercised a lasting influence on painters and sculptors of the sixteenth and seventeenth centuries.

R S

EX COLLECTIONS: Ernst Theodor Rodenacker, Danzig (Lugt, no. 2438); Junius S. Morgan, New York (Lugt, no. 1536).

BIBLIOGRAPHY: Bartsch, 1808, no. 1; Meder, 1932, no. 1; Panofsky, 1948, vol. 1, no. 108, pp. 84–87; *Dürer*, Boston, 1971, nos. 84–85; *Dürer*, Nuremberg, 1971, no. 484; Talbot, ed., 1971, no. 30; Strauss, 1976, no. 42; *Vorbild Dürer*, 1978, nos. 98, 102–103; *The Illustrated Bartsch*, 1981, no. 1, commentary, pp. 10–14.

man Late Gothic tradition, thus believed that the drawing was made in Nuremberg. Talbot notes that Dürer rarely abandoned the Northern tradition completely in his other chiaroscuro drawings. Even if the artist had returned to Nuremberg with a stock of Venetian blue paper, his supply was, at best, apparently limited. Later drawings with colored grounds, such as the *Woman in Netherlandish Dress* (cat. no. 148), are done on prepared paper.

BDB

BIBLIOGRAPHY: Heller, 1831, vol. 2, p. 125, no. 24; Ephrussi, 1882, p. 144; Thausing, 2nd ed., 1884, vol. 2, pp. 2, 3; Lippmann, ed., 1888, vol. II, p. 19, no. 164; *Exhibition of Albrecht Dürer's Engravings, Etchings, and Drypoints . . .* , 1888–89, p. 75, no. 278; Meder, 1919, pp. 154, 577, fig. 277; Flechsig, 1931, vol. II, p. 310; Tietze and Tietze-Conrat, 1937, vol. II/1, p. 38, no. 348, ill. p. 190; Winkler, 1937, vol. II, pp. 112, 113, no. 434; Panofsky, 1943, rev. eds., 1945, 1948, vol. II, p. 120, no. 1208; Tietze, 1951, p. 25; Winkler, 1957, p. 199; *Bulletin . . . of The Cleveland Museum . . .* , September 1966, vol. 53, no. 89, pp. 202, 203, 282; Stechow, September 1966, vol. 65, no. 5, p. 42, ill. p. 30; Talbot, ed., 1971, pp. 58, 59, no. XV; Strauss, 1974, vol. II, pp. 996, 997, no. 1507/1; Johnson, 1980, pp. 35, 36, fig. 32.

122

122 ALBRECHT DÜRER

Arm of Eve

Monogrammed, and dated 1507
Brush with brown ink, and pen with dark ink, heightened with white, on blue paper
13 3/16 x 10 9/16 in. (33.6 x 26.8 cm.)
The Cleveland Museum of Art, Accessions Reserve Fund, 1966
65.470

The *Arm of Eve* is the sole preparatory drawing for the life-size painted panels of *Adam and Eve* in the Museo del Prado, Madrid, dated, like the drawing, to 1507. Dürer made minor corrections to the drawing, changing the elbow axis and broadening the upper arm, and then carefully followed this solution in the Madrid panel. In the painting, above the area that corresponds to the drawing, the arm is in shadow, and the brightness at the elbow seems even stronger than the drawing suggests, although the pattern of light and shade in each is consistent.

The gracefulness that, in the drawing, is seen in the gently upturned arm and in the fingers lightly grasping the apple, extends in the painting to the portrayal of the entire figure. The move toward slender proportions is likewise evidenced in other related drawings of Adam and Eve (Strauss, 1974, nos. 1504/11–12, 1506/50–55). None of these is an actual study for the painting; however, it is generally assumed that other drawings were made. The Cleveland drawing is a study for the first critical action in the story of the Fall.

It is not certain whether the drawing was executed in Venice at the beginning of 1507, or a few months later, after Dürer's return to Nuremberg. The blue paper *(carta azzurra)* is Venetian, and this is the only Dürer drawing dating from after 1506 in which it is employed. Meder, who saw in Dürer's use of short, hooked lines and cross-hatching — as opposed to the long parallel lines more characteristic of Venetian shading — the continuation of a Ger-

123 ALBRECHT DÜRER

Female Nude Seen from the Back

1506
Brush and gray ink, heightened with white, on blue paper
15 x 8 3/4 in. (38.1 x 22.3 cm.)
Monogrammed at bottom center, and dated at top center, in brush and ink
Berlin, Staatliche Museen Preussischer Kulturbesitz, Kupferstichkabinett
KdZ 15380

Among Dürer's countless drawings of the nude human figure and his attempts to gain an understanding of the principles governing its structure, this extraordinary nude study occupies a special position. The work dates from his second sojourn in Italy, from 1505 to 1507, and consists of fine brushwork on blue Venetian paper. The nude is posed as though standing at a threshold, and appears before a dark, rectangular background that lends the figure a spatial

dimension beyond the volumes of the body, itself. The severe back view is somewhat softened by a slight suggestion of contrapposto. The right foot is advanced just ahead of the left, and partially obscured by it. As a result, the mass of the full body is set off center, requiring the extension of the left arm holding a biretta to balance the image. The right forearm is concealed in front of the figure. The head, in disappearing profile, tilts slightly downward, to the right.

Although the drawing seems to be a study from a specific model of by no means ideal proportions, one is aware of the artist's attempt to exclude individual characteristics as much as possible. The study, with its almost perfect bodily symmetry and minimal overlapping of limbs, recalls the Venetian-influenced back view of a nude, made nearly a decade earlier, which also appears in the engraving *The Four Witches* (Bartsch, no. 75), but, here, the extreme individualism of that earlier figure is replaced by a classicism typical of the High Renaissance.

The drawing was done at almost the same time and in the identical technique as the nature studies for the *Feast of the Rose Garlands*, 1506, in the Národni Galeri, Prague (Strieder, 1982, p. 122, fig. 139) and the *Christ Among the Doctors*, 1506, in the Thyssen-Bornemisza Collection, Lugano (Strieder, 1982, p. 127, fig. 144), yet it shares little of their immediacy. With its tendency toward abstraction, it occupies a position midway between the nature studies and the systematically constructed drawings of nudes that preceded both the engraving of Adam and Eve, of 1504 (cat. no. 121), and the panels, from 1507, in the Prado, Madrid. This study of a nude viewed from the back indicates that Dürer continuously tested in nature the principles that he had already discovered in his theoretical investigation of human proportions.

Despite the graphic, linear construction of its separate forms, the drawing of the nude clearly reveals a number of Venetian elements. Executed entirely in cross-hatching and fine gray and white parallel lines on blue paper, it owes its fascination to the wealth of nuances between its light and dark areas, to the subtle softness of its modeling, and to an extraordinarily vivid luminosity. The painterly and sculptural values seem to be perfectly balanced. It is quite understandable that Panofsky (1948) should have assumed that the works of Giorgione served as inspiration.

The drawing was adapted several times for reliefs, as, for example, in the frieze on the carved frame of the 1511 *Landauer Altarpiece* (Strieder, 1982, p. 314, fig. 415). R S

123

BIBLIOGRAPHY: Heller, 1827, II, p. 83, no. 68; Flechsig, 1928–31, II, p. 302; von Falke, 1936, p. 330 f.; Winkler, 1936–39, no. 402; Panofsky, 1948, vol. I, p. 119, vol. II, p. 1188; Winkler, 1957, p. 199; *Dürer*, Nuremberg, 1971, no. 698; Strauss, 1974, no. 1506/49; Strieder, 1981, p. 160; Anzelewsky and Mielke, 1984, no. 53.

124 ALBRECHT DÜRER

The Hands of the Twelve-Year-Old Christ

1506
Brush, with black ink, and wash, heightened with white, on blue Venetian paper
8 1/8 x 7 1/4 in. (20.7 x 18.5 cm.)
Monogrammed and dated sideways, at left center
Nuremberg, Germanisches Nationalmuseum
Hz 5482 (on deposit)

Dürer drew this "wonderful pair of eloquent hands" (Wölfflin, 1923) during his second stay in Italy as a study for the painting *Christ Among the Doctors*, now in the Thyssen-Bornemisza collection in Lugano. As in the roughly contemporary *Female Nude Seen from the Back* (cat. no. 123), he used black ink, and thinned the washes to a transparent gray, with highlighting in white. In combination with the blue tone of

the paper, this constitutes an uncommonly rich, painterly palette of light and dark values, one that lends a three-dimensional realism to the two hands. The right hand emerges only partially from the darkness of the sleeve to join the left hand. The earnest ticking off of the points of an argument on the fingers formed the focus of the unusual painting, where, defying tradition, Dürer treated the subject in a composition consisting solely of half-length figures. By contrasting the heads of the scribes — some of them virtually caricatures — with the youthful, calmly debating Christ, Dürer provided the theme with a novel psychological interpretation. In the eloquent gesture of these hands — *pars pro toto* — the whole of the dispute is condensed.

Although Wölfflin emphasized the individuality of Dürer's drawing style by referring to his "gnarled and un-Venetian" line, this study conforms to the working method of Italian Renaissance painters. The Renaissance theory of art held the realistic nature study to be of essential significance — in the interest both of artistic truth and of the desired conformity between the whole and its parts. Dürer made similar preparatory studies after nature from his second Italian sojourn, on — for the first time in great numbers, in anticipation of *The Feast of the Rose Garlands*, also dating from 1506.

Three other studies from nature, all executed in the same technique, relate to the painting *Christ Among the Doctors:* a head of Christ (Winkler, no. 404) and a hand holding a book (Winkler, no. 406), both in the Albertina, Vienna, and a study of hands (Winkler, no. 405) in the Germanisches Nationalmuseum, Nuremberg. RS

EX COLLECTION: Count Antoine François Andréossy, Paris; Sir Thomas Lawrence (?), London; William Coningham, Brighton (Lugt, no. 476); Bernhard Hausmann, Hanover (Lugt, no. 377); Rudolph Blasius, Braunschweig (Lugt, no. 377).

BIBLIOGRAPHY: Wölfflin, *Handzeichnungen*, 1923, pp. 13, 27, no. 27; Winkler, 1936, no. 407; Tietze and Tietze-Conrat, 1937, p. 30, no. 319; Panofsky, 1948, no. 550; Zink, 1968, no. 51; *Dürer*, Nuremberg, 1971, no. 198; Strauss, 1974, no. 1506/35.

no. 456), in which the individual features of a nude model are quite apparent. The pose of the torso, and the right arm outstretched, can also be discerned in the present study, although the two drawings do not correspond exactly. The heads of the angels sketched in outline at Christ's feet reveal that Dürer undertook his studies from nature only after the overall composition had been established. Presumably, he completed a sketch of the entire panel (although none has survived) and then set about checking and refining details of the figures against nature.

While in no other work did Dürer come closer to Italian models than in the *Heller Altarpiece,* a comparison of this study with contemporary Italian drapery studies reveals certain Late Gothic qualities in the Northern artist's approach. These are manifest in the way that the drapery appears to have a vitality of its own, in the intricate folds of the fabric between the knees, and in the decorative curves of its edges.

The imposing volumes of the drapery and the dramatic play of light on its folds are reproduced by means of a highly distinctive drawing technique that recalls the Venetian studies, of 1506 (see cat. no. 124), but surpasses them in perfection. Starting from the pale green middle tone of the paper, Dürer manages to suggest, by the use of painstaking hatching, all the subtleties of shadow, from the deepest black to the purest white. These cross-hatchings in black and white give the appearance of pen lines, but, in fact, they were executed with the finest of brushes — hence, the study's amazing precision.

In his informative correspondence with his patron, Dürer repeatedly remarked that he was taking extreme care in executing the work — especially the faces and the drapery. Altogether, some eighteen such studies for the *Heller Altarpiece* are preserved (Winkler, nos. 448–465), detailing heads, hands, draperies, torsos, and full figures. They are among the artist's most important drawings, and constitute all that remains, by his hand, of one of his major works — inasmuch as the finished painting was destroyed in a fire at the Residenz, in Munich, in 1729. Its composition is preserved in a copy made by Jobst Harrich in 1614, and is reflected in Dürer's own woodcut of the *Assumption and Coronation of the Virgin* from *The Life of the Virgin* series. RS

125 ALBRECHT DÜRER
Study for the Robe of Christ
1508
Brush and black ink, heightened with white, on green-grounded paper
10 x 7 3/4 in. (25.6 x 19.6 cm.)
Monogrammed and dated in brush and black ink, at bottom center
Paris, Musée National du Louvre, Cabinet des Dessins
18 597

This impressive drawing of drapery was done as a preparatory study for the figure of Christ in the central panel of the *Heller Altarpiece,* so named after its patron, the Frankfurt merchant Jakob Heller, who donated the work, upon its completion in 1509, to the Dominican church in Frankfurt. Dürer had signed a contract to execute the middle panel — an Assumption and Coronation of the Virgin — himself. In preparation for its demanding two-level composition, in which he was vying with examples by the great painters of the Italian Renaissance — in particular, Raphael — he completed a number of detailed individual studies of this kind.

It is clear that the robe of Christ was drawn from a nude model draped with cloth — a practice Leonardo had recommended and had himself followed. This is substantiated by the matching study for the upper body of Christ, formerly in the Kunsthalle, Bremen (Winkler,

EX COLLECTIONS: Baron Dominque Vivant Denon, Paris; Silvestre; Pierre Defer, Paris; Henri Dumesnil, Paris.

BIBLIOGRAPHY: Weizsäcker, 1923, p. 204, no. 8; Flechsig, 1928–31, vol. II, no. 336; Winkler, 1936–39, no. 455; Panofsky, 1948, no. 499; Winkler, 1957, p. 204; Strauss, 1974, no. 1508/11.

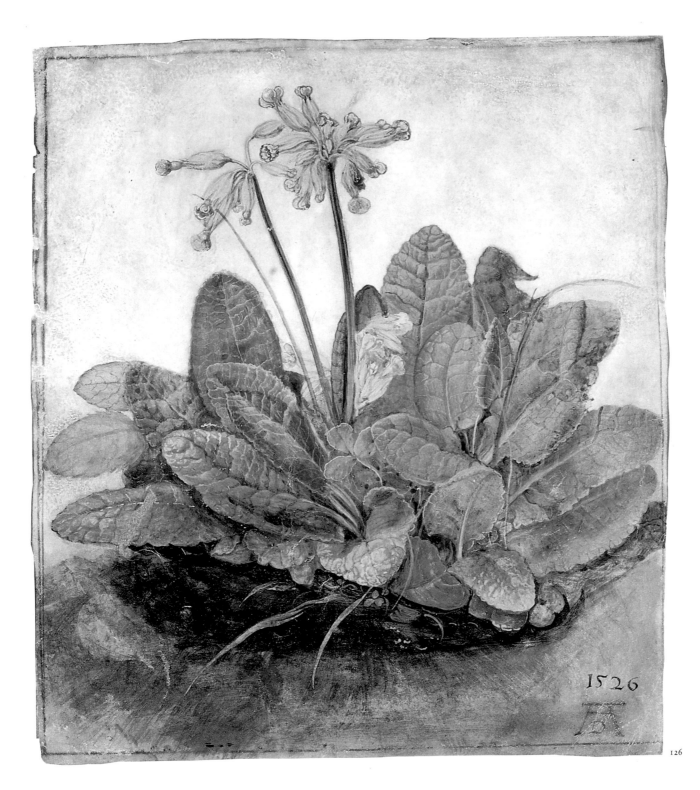

1526

126

126 ALBRECHT DÜRER

Primroses

About 1503–12
Monogrammed and dated 1526 at lower right in a
later hand
Watercolor and gouache on vellum
7 9/16 x 6 5/8 in. (19.2 x 16.8 cm.)
Los Angeles, The Armand Hammer Foundation

Dürer's fascination with nature is amply
documented by his work: He produced numer-
ous drawings of animals (see cat. no. 112), and
his engravings, such as the *Adam and Eve* (cat.
no. 121) or the *Saint Eustace* (Bartsch, no. 57),
often precisely depict animal and plant life. It is

not surprising, therefore, that Dürer should
have made studies of plants, which, like his ani-
mal studies, he might then adapt for his prints
and paintings. In this pursuit Dürer was not
alone, for, with the exploration of the New
World, and the expansion of European trade in
the sixteenth century came a new interest in bo-
tanical studies — as seen in Late Gothic manu-
script illuminations, and botanical texts, as well
as in individual studies from nature.

The *Great Piece of Turf,* of 1503, in the Al-
bertina, Vienna (Strauss, 1974, vol. II, no. 1503/
29), is the plant study most widely accepted as
an autograph work by Dürer. Consequently, it
has become a touchstone for the attribution of

all other plant studies. A group of seven of these
executed on vellum, bearing the date 1526 —
including the Hammer watercolor — must be
measured against this single gauge. The relative-
ly rough, textured surface of the vellum partial-
ly affects the character of the draftsmanship and
complicates the comparison to the *Great Piece
of Turf* and to Dürer's other works on paper.

In recent years, Konrad Oberhuber, Walter
Koschatzky and Alice Strobl, and Walter
Strauss have published the Hammer drawing as
an autograph work by Dürer, dating it within a
decade of the Vienna drawing. Oberhuber, after
comparing the drawing to the *Great Piece of
Turf,* noted particularly the green tones com-

mon to both studies, and the similar suggestion of spatial depth.

The early collection history of the Hammer drawing is not certain, yet the provenance of the group has been traditionally cited in favor of assigning it to Dürer. Most of these plant studies entered the Vienna public collections through the royal collection of Rudolf II. The emperor had purchased a large number of Dürer drawings from the descendants of Willibald Imhoff the Elder, who had inherited many Dürer works from the artist's younger brother, Andreas.

In the 1985 catalogue of the Vienna exhibition devoted to Dürer's animal and plant studies, however, Fritz Koreny concluded that neither the Hammer watercolor nor any of the related works on vellum could be ascribed to the master. Certainly, the date, 1526, on each — more than two decades after the *Great Piece of Turf* — was added later, perhaps after the drawings entered the Albertina collection (see Koreny, 1985, pp. 194–96). Although autograph works by Dürer do have dates or monograms that were later additions, this has provoked doubts about the entire group. Furthermore, at least one of the eight — the *Peonies*, in Berlin (Koreny, 1985, no. 14) — can be attributed to Hans Hoffmann, an early copyist of Dürer's work, because of its marked similarity to a signed Hoffmann drawing in Bamberg. Hoffmann was a close friend of Imhoff, who sold the collection of Dürer drawings to Emperor Rudolf. The friendship presumably provided Hoffmann with access to studies by Dürer in Imhoff's possession, and Imhoff likewise owned works by Hoffmann.

Koreny analyzes the character of Dürer's other nature studies as relatively static, citing, for example, the *Head of a Roebuck* (cat. no. 112) and its related drawings, or the renowned *Hare*, of 1502 (Strauss, 1984, no. 1502/2). He concludes that several artists must have produced the group of disputed plant drawings over the course of the sixteenth century.

Yet, assessing all plant studies against the single, accepted example in Vienna is problematical and arguably artificial. Given the interest in botanical drawing during the sixteenth century and the debt of later artists to Dürer's example, it is no surprise that his work was emulated and copied. Given Dürer's fascination with nature, however, and his prolific career, it would be surprising if the *Great Piece of Turf* and the *Iris*, of 1508, in Bremen (Koreny, 1985, no. 66), were Dürer's sole surviving plant studies. BDB

EX COLLECTIONS: Private collection, England; Hal O'Nians, London.

BIBLIOGRAPHY: *Old Master Drawings and Paintings*, 1956, no. 74, p. 11; Benesch, 1964, p. 337, at no. VI; Koschatzky and Strobl, 1971, p. 182, at no. 31; *The Armand Hammer Collection*, 1971–72, no. 70, 1979–80, no. 64; Rowlands, 1972, vol. 10, p. 384; Shestack, Autumn 1972, pp. 304, 305, no. 1; White, June 1972, vol. 95, pp. 457, 458, fig. 2; Strauss, 1974, vol. II, no. 1503/37, p. 726; *Master Drawings from the Collection of the National Gallery...*, 1978, p. 23; Piel, 1983, p. 142, no. 50, fig. 48; Koreny, 1985, no. 72, p. 206, ill.

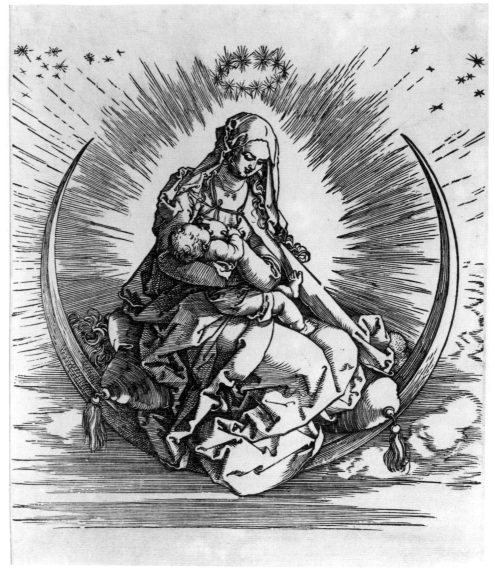

127: Title page

127 ALBRECHT DÜRER

The Life of the Virgin

1501–11; the complete set printed in Nuremberg, 1511

19 woodcuts and 1 title page: 1) The Virgin on the Crescent Moon (title page); 2) Joachim's Offering is Refused by the High Priest; 3) Joachim and the Angel; 4) The Meeting of Joachim and Anna at the Golden Gate; 5) The Birth of the Virgin; 6) The Presentation of the Virgin; 7) The Betrothal of the Virgin; 8) The Annunciation; 9) The Visitation; 10) The Nativity; 11) The Circumcision; 12) The Adoration of the Magi; 13) The Presentation in the Temple; 14) The Flight into Egypt; 15) The Holy Family in Egypt; 16) Christ Among the Doctors; 17) Christ Taking Leave of His Mother; 18) The Dormition of the Virgin; 19) The Assumption and the Coronation of the Virgin; 20) The Virgin Adored by Angels and Saints.

1. The Virgin on the Crescent Moon (title page)
7 7/8 x 7 1/2 in. (18.9 x 19.1 cm.)
Woodcut proof, before text added
New York, The Metropolitan Museum of Art, Gift of Junius S. Morgan, 1919
19.73.212

6. The Presentation of the Virgin
11 5/8 x 8 5/16 in. (29.5 x 21.1 cm.)
Woodcut proof, without text
Monogrammed at lower right
Watermark: (Meder, no. 62).
New York, The Metropolitan Museum of Art, Gift of Junius S. Morgan, 1919
19.73.150

14. The Flight into Egypt
11 3/4 x 8 1/4 in. (29.8 x 21 cm.)
Woodcut, with Latin text, 1511
Monogrammed at lower left
New York, The Metropolitan Museum of Art, The George Khuner Collection, Gift of Mrs. George Khuner, 1975
1975.653.3

20. The Virgin Adored by Angels and Saints
11 3/4 x 8 3/8 in. (29.8 x 21.3 cm.)
Woodcut proof, before text added
Monogrammed at bottom center
Watermark: (Meder, no. 20).
New York, The Metropolitan Museum of Art, Rogers Fund, 1918
18.65.19

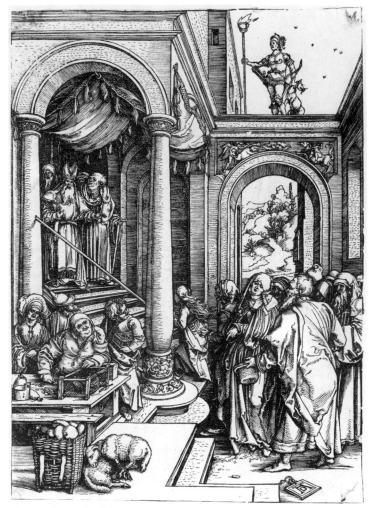

127/6: *The Presentation of the Virgin*

127/20: *The Virgin Adored by Angels and Saints*

The *Life of the Virgin* was published in 1511 under the title *Epitome in divae parthenices Mariae historiam ab Alberto Durero Norico per figuras digestam cum versibus annexis Chelidonii* (Excerpts from the Story of the Holy Virgin Mary Presented in Pictures by Albrecht Dürer of Nuremberg with Verses by Chelidonius). Its publication coincided with the second edition of the *Apocalypse* and with the *Great Passion*.

These three "great books" are similar in format and in the distribution of text and pictures. In their subject matter and imagery, together, they constitute a unified trilogy. The few extant bound copies, however, are great rarities among Dürer's graphic works. In contrast to the drama of the *Apocalypse* and the necessarily tragic tone of the *Great Passion*, the images in the *Life of the Virgin* are distinguished by a simple, touching humanity, conveyed in an epic yet contemplative style.

The text accompanying the woodcuts consists of nineteen Latin poems by Benedictus Chelidonius (Benedict Schwalbe), a monk from the monastery of the Egidienkirche, in Nuremberg. This Benedictine, Humanist scholar based his verses on various medieval versions of the life of the Virgin Mary — especially, on the *Golden Legend* of Jacobus de Voragine, and the *Life of Mary* by the Carthusian monk Philipp.

The book is dedicated to Caritas Pirckheimer — the sister of Dürer's Humanist friend Willibald Pirckheimer and abbess of the convent of the Poor Clares, in Nuremberg — a leading representative of what was known in Nuremberg as monastic Humanism. In contrast to the *Apocalypse*, the text and pictures, here, are closely united. Across from each of the woodcuts is a poem consisting of twelve Latin distichs. The wording on the title page makes it clear that the Dürer woodcuts have priority over the texts, which merely paraphrase their subject matter.

As compared with traditional pictorial series on the life of the Virgin — which, of course, also included scenes of the Passion — Dürer devoted only a very few scenes to the "Sorrows of the Virgin." They are only addressed in the woodcuts of the Flight into Egypt and of Christ Taking Leave of His Mother. Predominant are the "Joys of the Virgin," with scenes from her childhood and the infancy of Jesus. The deeply ceremonial depiction of domestic, family scenes, and the loving concentration on genre details were clearly meant to appeal to the middle-class viewer. Such Renaissance pictorial conventions as the frieze-like arrangement of figures, the space constructed according to the rules of central perspective, and the grandiose framing architecture heighten the ceremonial

tone of the narrative and contribute to the ennoblement of the middle-class elements in the scene.

The language of the poems, which are composed in classical meters, is on a level comparable to that of Dürer's woodcuts. Chelidonius employs countless phrases typical of the Humanistic sensibility of his time. For example, Mary is referred to as the "divine mother of Phoebus," and Joseph, as a "second Daedalus."

The woodcuts of the *Life of the Virgin* occupied Dürer — with interruptions — for an entire decade. In their stylistic development, they reveal the artist's constantly growing assurance in applying the artistic principles of the Renaissance to his treatment of the forms. Three of the woodcuts are dated: the Meeting at the Golden Gate (Bartsch, no. 79) was made in 1504; the Dormition (Bartsch, no. 93) and Coronation of the Virgin (Bartsch, no. 94) are from 1510. The concepts of the earliest of the prints were fixed by about 1502, however; one of these is the last in the cycle, the Virgin Adored by Angels and Saints (Bartsch, no. 95), which does not truly have a place in the series and may once have been intended as a title page. The figures in this *sacra conversazione* occupy a wholly imaginary setting that is further complicated by the arbitrary, artificial cutouts in the background architecture. It is as though, with

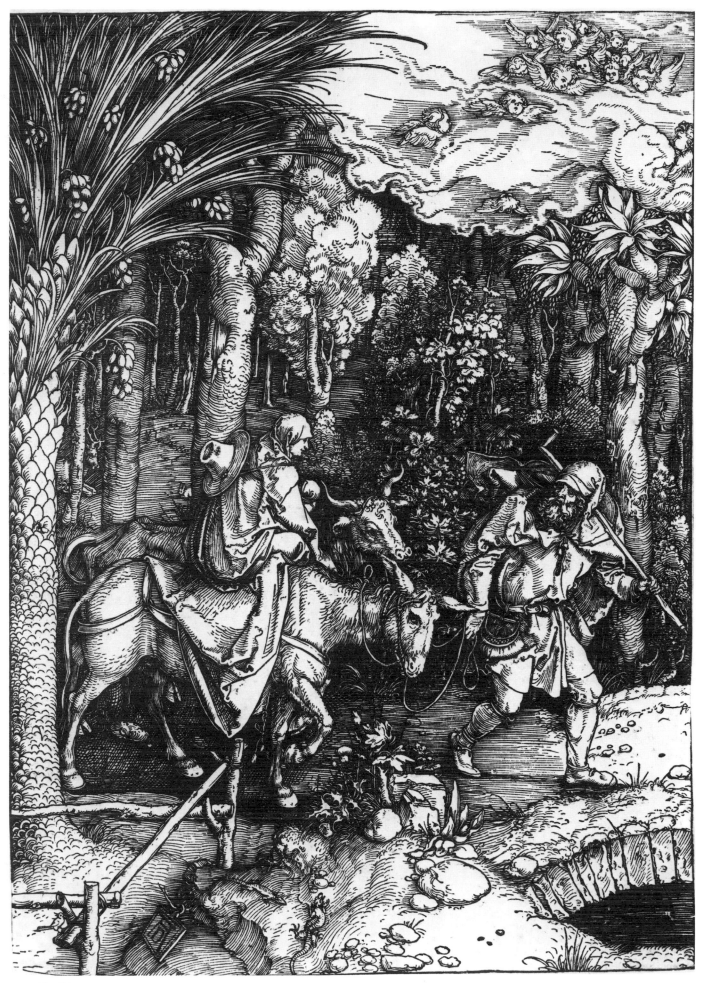

127/14: *The Flight into Egypt*

these, Dürer wanted to demonstrate his ability to portray even the most difficult interior spaces in perfect perspective. The result is a certain fussiness about the composition that also characterizes the earliest group of woodcuts: the Birth of the Virgin (Bartsch, no. 80), the Presentation of the Virgin (Bartsch, no. 81), the Annunciation (Bartsch, no. 83), the Nativity (Bartsch, no. 85), and the Holy Family in Egypt (Bartsch, no. 90). A second group is related, stylistically, to the Meeting of Joachim and Anna at the Golden Gate, of 1504 (Bartsch, no. 79): These were done before Dürer traveled to Venice for the second time, in 1505, and are characterized by a greater balance and increased simplicity in their compositions — relief-like, ceremonial friezes of figures set within clear, rationally constructed architectural frames. A typical example is the Presentation in the Temple (Bartsch, no. 88); its monumental columnar architecture was cited as a model of central perspective in Jean Pélerin's 1509 treatise, thus changing the course of how interior spaces would henceforth be depicted.

Following Dürer's sojourn in Italy, a number of major painting commissions, such as the *Heller Altarpiece* (of 1509), and the *Landauer Altarpiece* (of 1511), appear to have delayed the completion of the *Life of the Virgin*. The two last woodcuts, the Dormition (Bartsch, no. 93) and the Assumption and Coronation of the Virgin (Bartsch, no. 94), were not completed until 1510. The latter print closely imitates the composition of the central panel of the *Heller Altarpiece* (long since destroyed). Its grandiose, two-tiered arrangement is reminiscent of Raphael's *Coronation of the Virgin*, in the Vatican, and attests to Dürer's familiarity with High Renaissance art in Italy. An addition, however, was the conscious employment of light and of chiaroscuro effects as a means of unifying the figures and the space. This new painterly, illusionistic style imposed altogether different demands on the woodcut technique. From the example of the Dormition (Bartsch, no. 93), it is clear that the emphasis in a picture was no longer mainly a matter of the outlining and modeling of individual objects. The descriptive line receded in importance in favor of a quasi-neutral, grid-like network of hatching applied uniformly over the entire surface, registering areas of light or shadow through its lesser or greater intensity.

RS

BIBLIOGRAPHY: Bartsch, nos. 76–95; Heidrich, 1906, pp. 227–41; Meder, 1932, nos. 188–207; Wölfflin, 1943, pp. 95–110; Panofsky, 1948, vol. I, pp. 95–105, vol. II, nos. 296–315, 1955, pp. 90–94; Winkler, 1960; *passim*; *Dürer*, Boston, 1971, nos. 63–82, 161–165; *Dürer*, Nuremberg, 1971, no. 601; Talbot, ed., 1971, nos. 134–154; *Vorbild Dürer*, 1978, nos. 104–112; Appuhn, 1979, pp. 107–141; Strauss, 1980, no. 78; *The Illustrated Bartsch*, 1981, nos. 76–95, commentary, pp. 346–72; Troyen, 1982, *passim*.

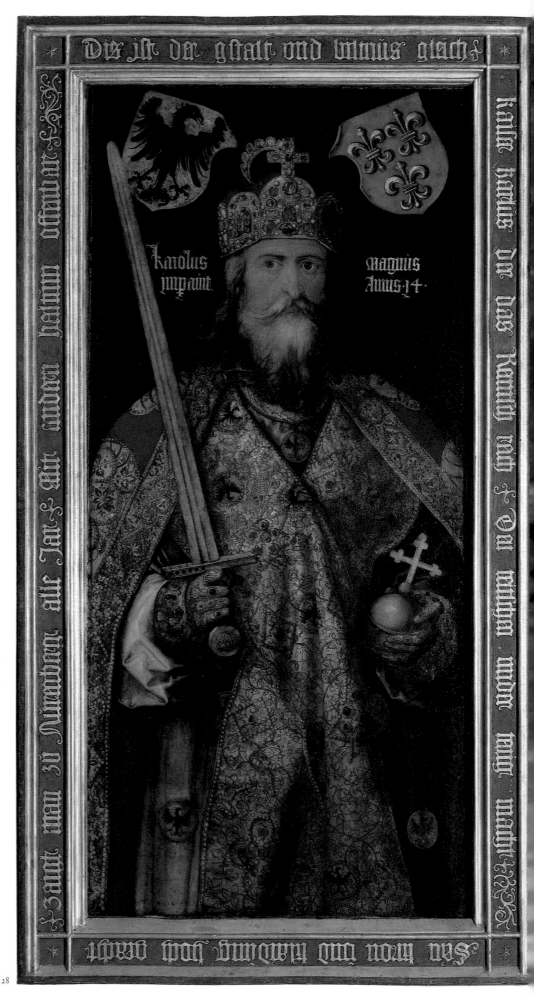

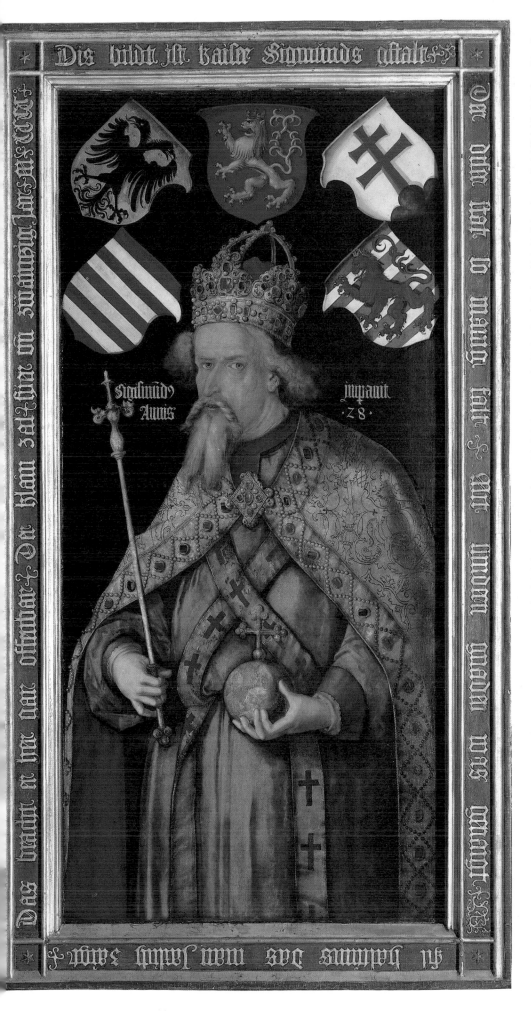

The Emperors Charlemagne and Sigismund

1512/13
Tempera and oil on linden wood
Height (with frame), 84 5/8 in. (215 cm.); width, 45 1/4 in. (115 cm.)
Provenance: *Heiltumskammer* (treasury), Schopperhaus, Nuremberg; Rathaus, Nuremberg.
Nuremberg, Germanisches Nationalmuseum
(on loan from the city of Nuremberg since 1880)
Gm 167, 168

From 800 to 814, Charlemagne established and ruled over the Holy Roman Empire. In the present painting, he is shown in an almost frontal pose, and, in his gloved hands, holds the imperial sword and orb. He wears the imperial crown on his head, and his dalmatic is adorned with a pattern of imperial eagles. A stole is draped across his chest and a cloak covers his shoulders. On either side of the emperor's head is a coat of arms with the German eagle (on the left) and the French fleur-de-lis (on the right).

Emperor Sigismund, who ruled from 1410 to 1437, is shown wearing a Gothic open crown, and holding the scepter and orb. Around his head are the coats of arms of his five territories: the German Empire, Bohemia, Old and New Hungary, and Luxembourg.

The panels, like the matching frames, bear inscriptions; those on the reverse sides are different, but the coats of arms are the same. Charlemagne's portrait is inscribed: "Karolus magnŭs imp[er]avit Annis·14·" and the frame, "Dis ist der gstalt und biltnŭs gleich / kaiser karlŭs der das Remisch reich Den teitschen ŭnder tenig macht / Sein kron ŭnd klaidŭng hoch geacht / Zaigt man zŭ Nŭrenberg alle Jar Mit andern haltŭm offenbar." The reverse of the picture reads: "Dis·ist·keiser·karlus·gstalt· / Sein·kran·und·kleidung·manigfalt· / zu·Nurenberg offenlich·zeige·wirt· / mit·anderm· heiltum·wie·sich·gepirt· / kung·pippinus·sun auß·franckreich· / und·Remischer·keiser auch geleich" ("Charlemagne reigned for 14 years. He was the son of the Frankish King Pippin, and Roman Emperor. He made the Roman empire subject to German rule. His crown and garments are put on public display annually in Nuremberg, together with other relics").

The portrait of Emperor Sigismund is inscribed: "Sigismund imperavit / Annis·28·"; the frame reads: "Dis bildt ist kaiser Sigmunds gstalt / Der dieser stat so manig falt Mit sunder gnaden was genaigt / fil haltŭms das man Jarlich zaigt / Das bracht er her gar offenbar Der klain zal füer ŭn zẇainczig Jar M CCCC." On the reverse is the inscription: "Dis·bildŭng·ist kaiser·Sigmund· / Der·Niernberg·zŭ·aller·stund· / In·sunder·gnaden·was·genaigt· / ·fil heiltums· des·man·järlich·zaigt· / Prach·er·v[o]ñ praug·auß·pehemer·lant· / Mit·sunder·gnaden·fil·bekant." ("Emperor Sigismund ruled for 28 years. He was always well-disposed to the city of Nuremberg, bestowing upon it many special signs of his favor. In the year 1424, he

brought here from Prague the relics that are shown every year").

Referred to in the inscription are the imperial relics, among which are the Holy Lance, whose tip was forged from one of the nails in Christ's cross, and the imperial regalia, consisting of the imperial insignia, as well as the coronation robes. As it was assumed that Charlemagne was the first to wear these, after the emperor was canonized they were regarded as relics. The treasures remained in the possession of the German monarchs as proof of their title to the throne. Emperor Charles IV transferred the imperial treasure to Prague. His son Sigismund, then king of Bohemia and Hungary and later emperor, presented them, in 1423, to the free imperial city of Nuremberg, "for all time, irrevocably and indisputably." The imperial treasure was moved to the Heilig-Geist-Kirche, and displayed publicly every year, on the occasion of the "Heiltumsweisung." A visit to this feast was rewarded with an indulgence, such as a remission of punishment for one's sins. The "Heiltumskammer," the treasury where the imperial regalia was kept the night before the display, was situated in the Schopperhaus, in the Hauptmarkt. Dürer was commissioned by the Nuremberg city council to paint portraits of the emperors Charlemagne and Sigismund, probably on the occasion of a completed or planned

renovation of the room. On February 16, 1513, Dürer received a payment of 85 florins, 1 pound in new pennies, and 10 shillings "fur zwo groß Tafel die pildnuß kayser Carls und kayser Sigmunds gestalt zu malen in die heilthums kammer" ("for two large panels for the treasury, painted with the likenesses of Emperor Charlemagne and Emperor Sigismund"). Between July 19 and 21, 1511, the artist had already received sixty florins from the city "für 2 pild" ("for 2 pictures"), possibly as a deposit for the paintings of the emperors.

The panels occupied a wall on either side of a kind of shrine, or niche, which contained the coronation robes and the imperial insignia. Open, the panels revealed both emperors, and closed, the inscriptions and coats of arms. The portraits were separated by a distance of twice their individual width. Allowance should be made for this when judging the overall composition.

The earliest evidence for the commission is the undated design from the collection of Count Seilern in London (Winkler, no. 503). The sketch, in pen and ink and watercolor, shows the portraits joined as a diptych. It does not presuppose any study of the imperial treasure in Nuremberg, and omits most of the coats of arms. In 1510, Dürer explored the subject again, this time under different conditions. A dated

pen and ink drawing in the Albertina, Vienna (Winkler, no. 504), of a standing male figure with the coronation robes and the imperial insignia, is inscribed: "Das ist des heilgen großen Keiser Karels habitus" ("These are the robes of the holy emperor Charlemagne"). Individual studies (those for the imperial crown, the sword, and the orb remained in Nuremberg) depict the objects from the same angle as in the final paintings.

An authentic portrait of Charlemagne, showing his features clearly and unmistakably, did not exist, but there were literary testimonials that conveyed an idealized impression of the ruler; in these, the power of his personality triumphed over the effects of old age. Dürer's selection of a frontal pose presents the emperor in his full dignity and sternness — the type derived from the *vera icon,* the true image of Christ, as well as from representations of God the Father. In the case of Sigismund's portrait, there was a model available to Dürer; preserved in a miniature copy in the portrait book of Hieronymus Beck, of Leopoldsdorf (now in the Kunsthistorisches Museum, Vienna), it must have exaggerated the facial characteristics almost to the point of caricature.

Following Nuremberg's acceptance of Lutheranism, the display of relics was discontinued. In 1525, the portraits of the emperors were transferred to the Rathaus. While the majority of Dürer's works are no longer in Nuremberg, these have remained "not sought after, as they were poor art." Despite the popularity of the portrait of Charlemagne, art historians have maintained reservations about the paintings of the emperors, regretting the conditions that had limited Dürer's artistic freedom, and criticizing the panels' state of preservation. Some of the bust-length copies were preferred, in a few of which scholars even claimed to detect Dürer's hand (see Stange, 1957; Musper, 1971; Winzinger, 1977). Following their cleaning in 1971, the Nuremberg paintings were shown to be excellently preserved. The portrait of Charlemagne, at any rate, refutes the opinion that Dürer carried out the commission without enthusiasm, largely with the help of apprentices. The figure is grandly conceived, the expression in the eyes compelling. The dark background causes the warm, glowing colors to stand out in rich yet solemn splendor. While the representation of Sigismund remains a portrait, Dürer's likeness of Charlemagne takes on a symbolic significance. By idealizing what was known of his physical characteristics, the artist has succeeded in producing a painting that has the effect of making us forget what Charlemagne might really have looked like. When we think of Charlemagne, it is as Dürer painted him.

Dürer's portrait of Sigismund may not have turned out exactly as the artist wished, but he was able to improve upon it in the portraits of Emperor Maximilian I that he painted shortly after the monarch's death (see cat. no. 140). He later took advantage of the opportunity of executing another painted memorial, in the form of a diptych — namely, the *Four Apostles* (in the

128: reverse of *Charlemagne* panel

128: reverse of *Sigismund* panel

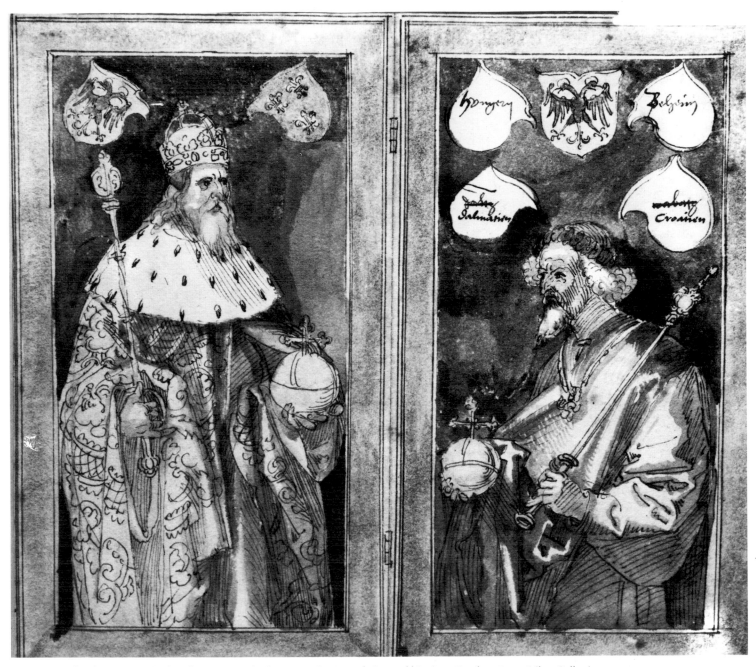

Figure 130 Albrecht Dürer. Design for *The Emperors Charlemagne and Sigismund.* Courtauld Institute, London, Count Seilern Collection

Alte Pinakothek, Munich). The portraits of the emperors in Nuremberg should, thus, be considered an interim stage in the artist's search for new, classical pictorial forms. KL

BIBLIOGRAPHY: Panofsky, 1948, vol. 1, pp. 132–33, vol. 2, nos. 51, 65; Rupprich, 1956–69, pp. 207, 243, 247, 257; Stange, 1957, pp. 1–21; Musper, 1969; Anzelewsky, 1971, nos. 123, 124; *Dürer,* Nuremberg, 1971, nos. 251, 252; Winzinger, 1977, pp. 17–50; Strieder, 1979, pp. 111–15; Löcher, 1982, pp. 305–30.

129 ALBRECHT DÜRER

The Holy Family in a Trellis

Pen and brown ink, on paper
10 7/16 x 7 7/8 in. (26.5 x 20 cm.)
Monogrammed and dated 1512 at top center
New York, The Metropolitan Museum of Art, The
Robert Lehman Collection
1975.1.860

The *Holy Family in a Trellis* does not relate directly to any surviving print or painting by Dürer. There are, however, a number of studies of the Virgin and Child with Saint Joseph, from various periods in the artist's career, in which, as here, Dürer recombines traditional iconographic elements while exploring graphic technique.

The Holy Family is seated outdoors. The Virgin, at one end of a long bench, holds her tiny infant, who is enveloped in her massive drapery. She rests one elbow on a mound, on which her husband Joseph also leans as he peers into an open book. Were it not for the trellis behind them, the subject could be interpreted as either a Nativity or a Rest on the Flight into Egypt. The garden-like setting created by the arbor, however, indicates that this is not merely a New Testament scene, but a symbolic one. The trellis suggests the enclosed garden (*hortus conclusus*), a visual metaphor for the virginity of Mary inspired by the Song of Solomon (2:2): "As the lily among thorns, so is my love among the daughters."

A number of paintings of the Virgin in a Rose Garden have been cited as possible influences on Dürer (Talbot, ed., 1971, p. 64). However, the iconographic tradition was widespread by the early sixteenth century in all mediums.

307

129

Joseph does not usually appear in representations of the Virgin in a Rose Garden. Dürer shows him reading — an activity commonly associated with the Virgin in scenes of the Annunciation, to suggest her devoutness. The composition continues a medieval preoccupation with portraying the rather lone figure of Joseph at the Nativity in a way that would simultaneously stress his protective yet limited role in the family. In Dürer's drypoint *The Holy Family,* of 1512–13, Joseph merely sits, hunched, at the side of the Virgin. The motif of the reading or writing Joseph appears in the background of a contemporary drawing in the Germanisches Nationalmuseum (Strauss, 1974,

no. 1511/8), and recurs with greater similarity to the Lehman composition in the drawing, dated 1521, of the *Virgin with Three Saints,* in the Musée Condé, Chantilly (Strauss, 1974, no. 1521/81).

Some areas of the drawing are summarily but deftly defined, such as the contained figure of Joseph, or the garden trellis. Other passages, like the truncated left arm of the Virgin, or her right hand, which grasps Christ, are even awkward. Considerable attention, however, has been given to the drapery of the Virgin, recalling Dürer's keen interest in its accurate rendering — as seen in the *Study for the Robe of Christ,* in the Louvre (cat. no. 125). Panofsky (1943, p.

191), noting the widely set parallel pen strokes, compared their effect to the "graphic middle tone" of woodcuts and engravings by Dürer, which the artist may have intended to create, later on, from this drawing. BDB

EX COLLECTION: Lubomirski Museum, Lemberg, Poland.

BIBLIOGRAPHY: Reitinger, 1927, p. 159; Gebarowicz and Tietze, 1929, p. 21; Lippmann, 1929, vol. 7, p. 11, no. 787; Flechsig, 1931, vol. II, p. 458; Tietze and Tietze-Conrat, 1937, vol. II/1, p. 81, no. 518; Winkler, 1938, vol. III, p. 12, no. 521; Panofsky, 1943, vol. I, p. 191, vol. II, no. 730; Tietze, 1951, p. 50; *Drawings and Prints by Albrecht Dürer,* 1955, p. 10; Talbot, ed., 1971, no. XVII, p. 64; Strauss, 1974, no. 1512/5, pp. 1306–7; Szabo, 1978, no. 24.

130

130 ALBRECHT DÜRER

The Holy Family with Saint John, the
Magdalene, and Nicodemus

About 1512
Drypoint, first state
8¼ x 7⅛ in. (20.7 x 18.2 cm.)
New York, The Metropolitan Museum of Art,
Fletcher Fund, 1919
19.73.51

This is one of a group of three drypoint engrav-
ings, Dürer's only works in the technique. Two
of them — *The Man of Sorrows with Hands
Bound* (Bartsch, no. 21) and *Saint Jerome by the*

Pollard Willow (Bartsch, no. 59) — are dated
1512. A related drawing in the British Museum
(Strauss, no. 1513/3) indicates that *The Holy
Family with Saint John, the Magdalene, and
Nicodemus* must date from only a short time
later. In various respects, in this work Dürer
drew upon his early career.

Thematically, the *Holy Family* is related to
other depictions of the same subject from two
decades earlier — the drawings in Erlangen
(Winkler, no. 26) and in Berlin (Winkler, no.
30), for example. As in those works from his
youth, Dürer portrays the Virgin seated with
her Child on a grassy bench. The bearded

Joseph has been moved to the left side, and
appears only as an auxiliary presence — as do
the standing figures pressed into the narrow
space at the right between the bench and the
enclosing wall — in what is actually a depiction
of the Virgin. At the right are Saints Mary Mag-
dalene, John the Evangelist, and Nicodemus —
all, witnesses to the Crucifixion. They tower
above Mary, forming a pyramidal composition,
and function as a foreboding of the Child's
eventual death on the cross. The use of drypoint
also represents a return to his apprenticeship
years, when Dürer was under the influence of
the style of the Master of the Housebook. The

latter artist, working in the Middle Rhine at the close of the fifteenth century, had developed the drypoint technique as an alternative to the severity and formal discipline of the engraving. As opposed to the burin, which required a great deal of pressure by the artist's hand as he cut into the copperplate, thus restricting freedom of movement, the needle made possible a freer style of drawing, with more of the feeling of a sketch about it. Thus, in many areas, the linear structure of the *Holy Family* resembles that of a delicate pen drawing. In the printing, these fine lines blur together, forming soft, subtle transitions, and a painterly, *sfumato* effect. This is especially true of the earliest proofs; in those, the burr raised up from the metal surface by the needle retained a greater amount of ink, producing deep, black velvety tones.

The sheet appears to be unfinished, not only because of the delicately suggested background landscape. Most likely, it is a product of Dürer's own experimentation with technique, which would explain why only a very few prints were made during his lifetime.

At this point in his creative life — namely, after the completion of his great graphic cycles — Dürer seems to have been especially interested in painterly nuances and light effects. In the *Engraved Passion*, of 1509–12, and certainly in the last sheets of the *Large Passion*, published in 1511, one can see his attempts to employ light as the integrating element of these graphic images. Although Dürer did not pursue drypoint, the results of his experimentation with the technique were certainly used in the "master engravings" of the following years.

RS

BIBLIOGRAPHY: Bartsch, 1808, no. 43; Meder, 1932, no. 44; Panofsky, 1948, vol. I, no. 150; White, 1961, pp. 20–23; *Dürer*, Boston, 1971, nos. 177–178; Talbot, ed., 1971, no. 38; Strauss, 1976, no. 55; *The Illustrated Bartsch*, 1980, no. 43, commentary, pp. 102–5.

131 ALBRECHT DÜRER

Knight, Death, and Devil

1513
Engraving
9⅞ x 7⅝ in. (25.1 x 19.4 cm.)
Monogrammed, inscribed, and dated at lower left, on the plaque: S. 1513.
New York, The Metropolitan Museum of Art, Harris Brisbane Dick Fund, 1943
43.106.2

Dürer created this work, the first of the so-called "master engravings," in 1513. The other two — *Melencolia I* and *Saint Jerome in His Study* (cat. nos. 132, 133) — were produced the following year. These three "idea pictures" (Kauffmann), all virtually identical in format, have often been considered as a trilogy, connected by their content. Scholars have chosen to see them as depictions of the moral, theological, and intellectual virtues. In the nineteenth cen-

tury, they were glorified as symbols of German national ideology, and this has made it more difficult to interpret them dispassionately. Dürer's entries in the journal that he kept during his trip to the Netherlands tend to refute the notion that the three works are interrelated, for he refers to the present engraving simply as "der Reuter" ("the Knight"), and does not mention it in connection with the other two.

The work portrays a splendidly armored knight riding through a barren defile, in the company of a pair of ghostly companions. To reach the castle in the background is apparently the goal of his journey. Death, brandishing an hourglass, rides beside him on a dispirited nag. The figure of Death derives from the charcoal drawing, of 1505, entitled *Memento mori*, in the British Museum (Winkler, no. 377), and presents a horrifying counterpart to the idealized knight. Following behind, on foot, is a devilish demon whose grotesque, mask-like face combines a pig's snout, goat's ears, and the horns of a sheep; the closest parallel is found in Schongauer's engraving of Saint Anthony (Bartsch, no. 47).

In general, of course, the work is certainly a memento mori, not unlike the woodcut *Death and the Lansquenet*, of 1510. The presence of the demon, and the fact that the knight apparently pays no heed to his unpleasant companions have led scholars to seek more specific interpretations. However, the ambivalence of the motifs and attributes in the engraving has precluded any definitive reading of it.

A constant feature in the literature, from Sandrart to Panofsky, has been the idea of the *Miles Christianus* — the Christian knight. In his letter to the Ephesians (6:10–17), Saint Paul compares the true Christian to a warrior who puts on the "armour of God" to resist the "wiles of the devil." Dürer may have been inspired by this New Testament passage, or possibly by a contemporary source. In 1503, Erasmus of Rotterdam, whom Dürer admired and later hailed as a "knight of Christ," had published his *Enchiridion militis Christiani*. Admittedly, this work only reached a wider public after it was reprinted in 1518. In a Christian context, the dog and the lizard might be seen as symbols of devotion to faith and yearning for God — virtues that also guided the knight on his laborious journey to the distant castle.

There is no certain evidence that such a Christian meaning was intended. It has even been debated whether Death and the Devil are the knight's adversaries or his retinue. Karling and Meyer, for example, interpreted the figure of the knight, in a negative sense, as an allusion to the actual political situation at the time — especially, to the curse of the robber knights. In so doing, they reinforced a tradition, dating to the seventeenth century — namely, the popular Nuremberg legend of the "ghost rider" Philipp Rinck.

Aside from all iconographic considerations, Dürer's *Knight* must also be regarded as the culmination of his years of study of the ideal proportions of the horse. Such a two-sided

drawing is preserved in the Biblioteca Ambrosiana, Milan (Winkler, no. 618/19), undoubtedly made immediately before the artist began this engraving. In the sketch, the position of the horse's raised hind leg has been corrected a number of times. A pentimento disguised by blades of grass reveals that Dürer only resolved the problem while working on the copperplate. The Milan drawing, constructed within a square grid, includes just the horseman and his dog. The background has been inked out, so that the added meaning provided by the secondary figures is not yet apparent.

Impressed by Leonardo and the great painters and sculptors of the Italian Renaissance, Dürer had occupied himself with a systematic study of the depiction of horse and rider — a classical theme in the art of the time — ever since he made his first sojourn to Italy. When developing his *Knight, Death, and Devil*, therefore, he not only referred to an early watercolor, of 1498 (now in Vienna; Winkler, no. 176), but also to anatomical drawings of the proportions of the horse, of 1503–5 — some of which may now be seen in Milan and in Cologne. It is possible to trace the artist's development from the engraving of *Saint Eustace* (of 1500/1501), through the *Small Horse* and *Large Horse* (of 1505) and the *Saint George* (of 1508), to the *Knight, Death, and Devil*. As a summary of his theoretical study of proportions, the *Knight* can thus be compared with the engraving of Adam and Eve. On both occasions, in order to make the positive, idealized figures stand out all the more clearly, Dürer provided them with negative counterparts. Unlike his theoretical treatise on human proportions, his study of the proportions of the horse was never issued under his name. It is almost certain that the textbook on equine proportions published by Hans Sebald Beham in 1528 is based on Dürer's notes.

RS

BIBLIOGRAPHY: Bartsch, 1808, no. 98; Kurthen, 1924, pp. 84–87; Meder, 1932, no. 74; Panofsky, 1948, vol. I, no. 205, pp. 151–54; Rox, 1948, pp. 67–70; Leinz-von Dessauer, 1961, pp. 1–45; *Dürer und seine Zeit*, Munich, 1967, no. 29; Karling, 1970, pp. 1–13; *Dürer*, Boston, 1971, nos. 179–182; *Dürer*, Nuremberg, 1971, no. 503; Talbot, ed., 1971, no. 58; Strauss, 1977, no. 71; Meyer, 1978, pp. 27–41; Theissing, 1978; *The Illustrated Bartsch*, 1981, no. 98, commentary, pp. 217–19.

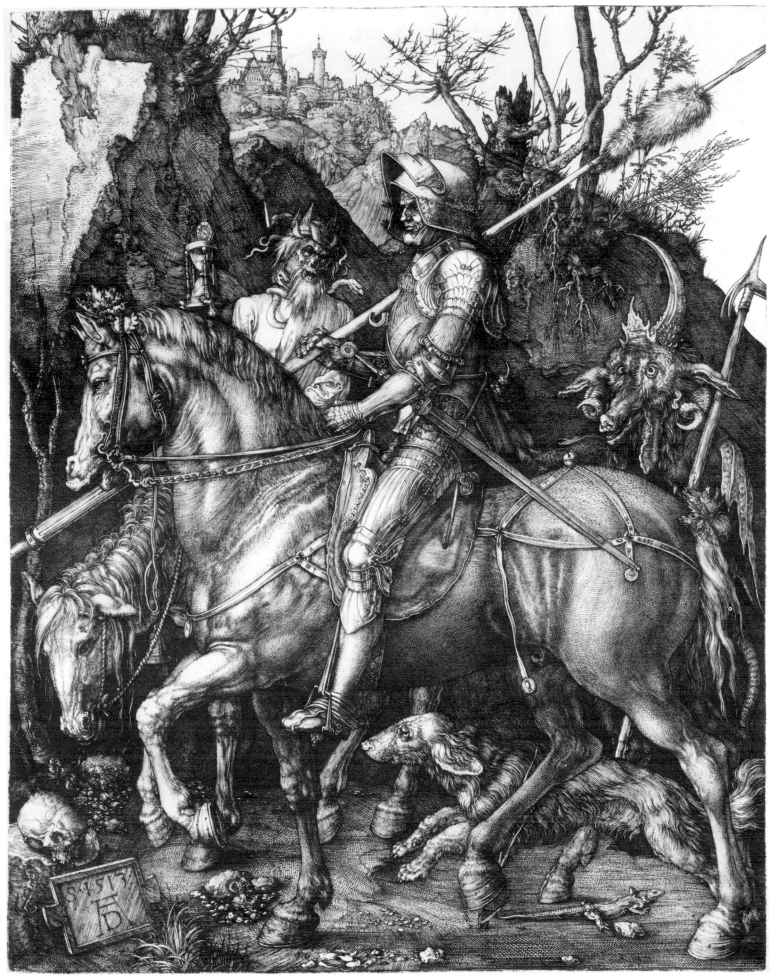

Melencolia I

1514
Engraving
$9^{1}/_{2}$ x $7^{5}/_{16}$ in. (24.2 x 18.8 cm.)
Inscribed (at upper left, on the wings of the bat):
MELENCOLIA I; monogrammed and dated (at lower
right, on step)
New York, The Metropolitan Museum of Art,
Harris Brisbane Dick Fund, 1943
43.106.1

The third of the so-called "master engravings," this work has long been considered one of Dürer's most puzzling compositions, precisely because it is among his most personal ones. It has inspired a vast body of conflicting interpretation from biographers, art historians, scientists, and philosophers, and its influence on artists over the centuries has been immense. Panofsky (1948, p. 171) called it "Dürer's most perplexing engraving...it is in a sense a spiritual self-portrait of Albrecht Dürer."

In contrast to the ordered introspection of the *Saint Jerome in His Study* (Bartsch, no. 60), this composition is characterized by the most tortuous dissonances. The richly gowned winged figure of Melencolia is seated on a step in front of a wall. Deep in thought, her head resting dejectedly on her hand, she is surrounded by a confusion of objects and tools that appear as though left on a building site. A book lies unopened in her lap, and in her right hand she idly holds a compass. A pitifully emaciated sleeping dog is curled up at her feet, intensifying the impression of painful inactivity, which even the busy scribbling of the putto seated on a millstone behind the main figure does nothing to dispel. A pale, frosty light, fueled by the flash of a mysterious apparition in the sky, suffuses the scene, causing the various objects to appear isolated and estranged from each other. Divorced from their proper uses, they become problematic; we perceive them out of context, like pieces of some vast rebus.

There are builders' tools, the tools of carpenters and stonecutters: a molding curve, tongs, a plane, saw, ruler, nails, ladder, crucible, and hammer. The turned sphere, the round millstone, and the conspicuously placed irregular polyhedron are allied structures, yet the tools depicted here are too crude to have been used in their construction. For that, theoretical knowledge is required — as, for example, of mathematics, represented by the compass Melencolia holds in her hand. The highest rank is accorded the measuring devices arranged above the main figure and directly related to her: a scale, an hourglass with a sundial, and a bell that chimes the hour. Together with the magic square, all of whose rows of figures add up to thirty-four, these objects represent an understanding of the measure and number — and of the finitude — of all things. The seeming chaos thus reveals a hierarchical arrangement, one in which the *artes liberales* prevail over the *artes mechanicae*, the intellectual over the purely technical. Unquestionably, Dürer was hereby

addressing a central problem of the artist's calling, the difficulty of reconciling practical skill with theoretical knowledge.

Such straightforward deduction gives a certain direction to interpretation, but it does not explain the artistic structure of the work, which is based on contradiction. It seems paradoxical that the main figure has wings but is nonetheless downcast, that, hanging from her girdle, she wears a bunch of keys and a purse, the traditional attributes of power and wealth, but persists in helpless inactivity.

Earlier writers regarded this allegorical figure as a dull, confused, and desperate creature given to gloomy thoughts at night, a symbol of "despairing human reason at the limit of its power" (Thausing, 1876, vol. II, p. 227). Also deriving from the negative conception of melancholy was the interpretation of the title inscription on the wings of the bat, first suggested by Passavant (1862, vol. III, p. 153). He interpreted the *I* in the title not as a number but as the — certainly most uncommon — imperative of the Latin verb *ire* ("to go"), and translated the title, accordingly, as "Melancholy away!" Warburg (1920, pp. 58–64), on the other hand, supported a positive interpretation, which perceived the figure's brooding posture as indicative of a condition of spiritual concentration and divination, an altogether productive activity. He also took pains to point out the cosmological associations and saturnine nature of melancholy. Finally, in a profound analysis that remains unsurpassed to this day, Panofsky and Saxl (1923) described the ambivalence of the motifs as the essence of the picture. To them, the figure of Melencolia represented the fusion of two distinct pictorial traditions: the negative medieval image, as it appeared in popular calenders, derived from allegorical depictions of *acedia*, the vice of sloth, and as the Typus Geometriae, found in portrayals of the *artes liberales*. They drew attention, for example, to a woodcut in the *Margaritha Philosophica*, of 1504–8, by Gregor Reisch, in which virtually every attribute of Dürer's Melencolia is shown in association with Geometry. If one supports this highly ingenious interpretation, then the complex figure of Dürer's Melencolia represents both a searching personification of the liberal art of Geometry, and an ennobling of the melancholic temperament into a positive intellectual force.

According to the scholastic theory of the four temperaments, melancholy was caused by a surfeit of black gall, resulting in an unhealthy complexion that led to dullness and depression, accompanied by the vice of sloth. The melancholic person was under the debilitating influence of the evil, slow, cold, and dry planet Saturn. Yet, even Aristotle had perceived in melancholy not only its depressive aspect but also its potential for great intellectual achievement. This latter concept was espoused by the Neo-Platonic philosophers in the Renaissance and applied to their reassessment of melancholy as a positive motivating influence on modern creative man. Saturn, the god associated with

Geometry and the surveyor's art, was, in this context, accorded new respect. The change was brought about most notably by Marsilio Ficino and his treatise *De Vita Triplici*, which was published in German by Anton Koberger in Nuremberg in 1505. The importance of Ficino for Dürer had already been pointed out by Giehlow (1904). In the notes to his treatise on painting, Dürer stresses the influence of the temperaments on artistic creation, and recommends that every would-be apprentice first be examined with regard to the "suitability of his complexion." Borrowing from Ficino, he traces melancholy, as a phenomenon commonly associated with artistic activity, to "too much practicing." For him, the frustrations of melancholy are induced by an excess, rather than a dearth, of knowledge. They are the curse of the modern, inquiring artist, one that not only imposes limits but also spurs him on to new efforts. Ficino, himself, had already distinguished various types of melancholy. Accordingly, the number in Dürer's title inscription has been explained as his attempt to ascribe to the artist the first type of melancholy — that having to do with the realm of the imagination.

The extensive literature on Dürer's *Melencolia I* shows that the picture's complex form and ambiguity of motifs tend to preclude an unequivocal interpretation, and, indeed, an artistic confession as personal as this one necessarily transcends the traditional system of types, signs, and symbols. Each detail has been infused with a meaning beyond its conventional significance — one that draws on the artist's subjective experience.

A number of preliminary drawings for the engraving survive, but they provide little assistance in interpreting its meaning. Perhaps the most informative is a seated female figure, in Berlin (Winkler, no. 621), which resembles nothing so much as a simple *Hausfrau*. A study for the mysterious polyhedron in the Dresden sketchbook is related to the mathematical studies that occupied Dürer at the time, and there are preliminary studies in London for the head of the putto (Winkler, no. 619) and in Berlin for the hanging scales (Winkler, no. 620).

The engraving exists in a rare first state, in which the figure "9" in the magic square appears backward. It would seem that Dürer reversed the number after making the first few prints.

R S

EX COLLECTION: J. Pierpont Morgan, New York (Lugt, no. 1509).

BIBLIOGRAPHY: Bartsch, 1808, no. 74; Passavant, 1862, vol. III, p. 153; Thausing, 1876, vol. II, p. 227; Giehlow, 1903, pp. 29–41, 1904, pp. 6–18; Warburg, 1920, pp. 58–64; Wölfflin, 1923, pp. 175–81; Panofsky and Saxl, 1923; Meder, 1932, no. 75; Panofsky, 1948, vol. I, no. 181, pp. 156–71; Horst, 1952, pp. 411–31; Klibansky, Panofsky, and Saxl, 1964, pp. 284–365; *Dürer*, Boston, 1971, nos. 188–189; *Dürer*, Nuremberg 1971, no. 270; Talbot, ed., 1971, no. 59; Mende, 1971, nos. 3954–4051; Schuster, 1974, pp. 409–11; Strauss, 1976, no. 79; Hoffmann, 1978, pp. 251–77; *The Illustrated Bartsch*, 1981, no. 74, commentary, pp. 163–67; Schuster, 1982, pp. 72–134.

MELENCOLIA§I

The magic square in the image reads:

16	3	2	13
5	10	11	8
9	6	7	12
4	15	14	1

like a sail. On it, the visage of Christ appears only in barest outline. Both the cloth and the flowing robe of the angel appear to be caught in a mysterious updraft of air, suspended in billowing weightlessness against the horizontal lines of the darker background. Never before had the condition of weightless floating been so convincingly portrayed.

In contrast to the precise, disciplined, and rationally organized linear structure of the engraving, the etched line — temperamental, supple, comparable only to that of a pen drawing — allows both spontaneous revision and the merest suggestion of form. This is most apparent in the shadowy lines between the angels at the bottom. The etching reproduces and intensifies many of the formal qualities of the preparatory drawing, which is preserved in the British Museum (Strauss, no. 1515/73).

Dürer's etchings represent the first great achievement in this new technique. It was, of course, only new as a printmaking procedure, for armorers and sword makers had long used etching in the decoration of suits of armor and sword blades. They would first coat the tempered steel with an acid-resistant layer of wax soft enough to permit a burin to cut through it. Lines traced in the coating were then etched into the metal in a bath of hydrochloric or nitric acid. Steel etching was first employed as a printing technique about 1510–15 by Daniel Hopfer, an armorer who lived in Augsburg.

RS

BIBLIOGRAPHY: Bartsch, 1808, no. 26; Meder, 1932, no. 27; Panofsky, 1948, vol. I, no. 133, p. 196; *Dürer*, Boston, 1971, no. 193; *Dürer*, Nuremberg, 1971, no. 340; Talbot, ed., 1971, no. 68; Strauss, 1976, no. 83; *The Illustrated Bartsch*, 1981, no. 26, commentary, p. 73; Smith, 1983, no. 23.

The Painter Michael Wolgemut

1516
Tempera and oil on linden wood
11 7/16 x 10 5/8 in. (29 x 27 cm.)
Nuremberg, Germanisches Nationalmuseum
(on permanent loan from the Bayerische Staats-
gemäldesammlungen, Munich, since 1910)
Gm 885

Michael Wolgemut was well advanced in years when his famous pupil painted this portrait of him. The small-format painting was meant to serve as a memento, and had no more formal function. Wolgemut's fur coat is a sign of the painter's bourgeois rank, but certainly not his head covering. The dark grey scarf tied like a turban — or bonnet — was only suited to be worn at home. It is conceivable that the master wore it in his studio to protect his hair from dust, or possibly only to keep his head warm in old age.

The fact that the inscription on the painting — "Das hat albrecht durer abconterfet noch/ siene[m] Lermeister michel wolgemut in Jor/ 1516" ("Albrecht Dürer made this portrait of his teacher Michael Wolgemut in the year 1516") — is in a Gothic hand and not in Roman letters also confirms the private character of the work. After Wolgemut's death, Dürer added three lines to the inscription: "vnd er was 82 Jor/vnd hat gelebt pis das man/zelet 1519 Jor do ist er ferschiede[n]/an sant endres dag frv ee dy/Sun awff gyng" ("and he was 82 years old, and he lived until 1519, when he departed this life on St. Andrew's Day [November 30] morning before sunrise"). At the lower right are the date 1516 and the Dürer monogram.

The word "Jor" in the second line was added by another hand, but it remains unclear whether the first part of the third line belongs with the original inscription or with the later one, and whether Wolgemut was eighty-two when Dürer painted the portrait, or only at the time of his death.

It is also uncertain just who commissioned the work. Wolgemut could have requested it, or Dürer could have painted it on his own initiative either as a gift for Wolgemut or as a memento of his teacher, for himself. The latter seems most likely. In any case, Dürer still had access to the portrait after Wolgemut died, as he was able to add to the inscription.

The portrait is limited in scope. Little can be seen of the shoulders and chest, and the top edge cuts through the head covering. Everything is focused on the head — on the narrow, angular skull, deep-set eyes, curving beak of a nose, and protruding lower lip. The wrinkled skin lies close to the bones — permitting the meandering course of the vein across the temple to be followed — and hangs loosely about the neck. The ear is partially hidden under the turban.

Dürer's eye is sharp, but not cruel. Out of these well-defined features he distilled a kind of obstinacy and inflexibility bordering on senility; although Wolgemut appears to be an un-pleasant person, Dürer's respect for the master is, nevertheless, apparent. He does not portray him as a needy and pitiable old man, but, rather, marvels at his indomitable spirit and strength of will. Like Dürer's own father had, somewhat earlier, Wolgemut here served as an object for the painter's eye, but, like the senior Dürer, he was, at the same time, something more — an important part of the artist's own life. Accordingly, this portrait of Wolgemut is distinguished from the majority of Dürer's portraits.

The name Michael Wolgemut is seldom mentioned except in connection with his famous pupil. Dürer honored his mentor, and, therefore, Wolgemut has our respect, as well. Since Dürer learned from him, we eagerly search for characteristics in the work of the older man that help to explain that of the younger. In general, Wolgemut is remembered as an "Old Franconian" master who was surpassed by his pupil — a painter of greater regional than national interest. Dürer's feeling for nature, his obsession with the study process, and his understanding of the harmony of elements in a painting — not to mention his creative genius — were lacking in the older man. However, Wolgemut had other, singular qualities. Since he coordinated the commissions for major altarpieces, he was capable of engaging the greatest variety of artists and craftsmen, and delivering finished works of the highest quality, and for that reason his workshop was sought out by patrons from abroad. As early as 1479, Wolgemut provided the Marienkirche, in Zwickau (Saxony), with a large altarpiece. At that time, it was required that an altarpiece contain carved figures in its central shrine. Together with his stepson Wilhelm Pleydenwurff, Wolgemut popularized the art of the woodcut in Nuremberg. His illustrations for the *Schatzbehalter* and for the Schedel *Chronicle of the World* (cat. nos. 86, 87) were innovative, in that they were composed like paintings — an approach that Dürer would continue. It appears that even many traditional motifs found in Italian art reached Wolgemut's workshop, in the form of tarot cards. There were periods when the businessman and entrepreneur was more dependent upon the collaboration of assistants, but, as the example of the Schwabach Altarpiece demonstrates, he maintained an appreciation for young assistants with initiative, and was capable of learning from Dürer even in his advanced age. His memorial painting for Anna Gross, of 1510, in which he portrayed the Virgin and Child, with Saint Anne (it is in the Germanisches National-museum, Nuremberg), compares favorably with the works of Dürer's pupils Baldung, Schäufelein, and Hans Suess von Kulmbach.

In the fifteenth century, it was common for painters to include their own likenesses or those of their colleagues in paintings of biblical and historical subjects. Most examples of this are Italian. Individual portraits of artists that are not self-portraits are relatively rare, although it may be that many of them have not been identified as such. At the beginning of the sixteenth century, it was not uncommon for the artists of a given workshop to paint portraits of each other; a series of portrait drawings of Augsburg painters survives (Winkler, 1948), and it is believed that Dürer produced a portrait of his Augsburg colleague Hans Burgkmair the Elder (Urbach, 1985). In such paintings, the approach tends to be more personal and direct, with less regard for a formal, imposing presentation of the subject. This is especially true of the Wolgemut portrait.

The present work is one of the few by Dürer from the years around and following 1515. He was then more involved with various forms of printmaking, partly induced by imperial commissions, and partly by his own personal inclinations at the time. His masterful engravings, which were created in this period, required the utmost, in terms of theory, design, and craft. His portrait sketches, like the one of his mother made just before her death (in the Kupferstich-kabinett, in Berlin-Dahlem) benefited from such concentration on graphic design, although many of the paintings reveal a loss of warmth and vitality because of it. The portrait of Wolgemut, on the other hand, in its concentration on the head of the old man and on the intransigence and willpower expressed in its features, could only profit from the artist's greater decisiveness and emphasis on clarity of form. A matching portrait, on parchment, in a private collection in southern Germany (Anzelewsky, 1971, no. 131, ill. 160), was mistakenly identified as a preliminary study for the Nuremberg portrait; however, it is, in fact, a late-sixteenth or early-seventeenth-century copy.
KL

EX COLLECTIONS: Praun, Nuremberg; purchased from the art dealer Frauenholz by Crown Prince Ludwig of Bavaria (1809).

BIBLIOGRAPHY: Flechsig, 1928–31, vol. 1, pp. 411–12; Lutze and Wiegand, 1936–37, p. 53; Panofsky, 1948, vol. 1, p. 192, vol. 11, no. 70; Rupprich, 1956–69, vol. 1, p. 209, no. 66; Winkler, *Dürer*, 1957, p. 267, n. 2; *Dürer*, Nuremberg, 1971, p. 288, no. 536, colorpl.; Anzelewsky, 1971, no. 132, ill. 162.

Figure 131 Albrecht Dürer. *Emperor Maximilian I.* Augsburg, June 28, 1512. Graphische Sammlung Albertina, Vienna

140 ALBRECHT DÜRER

Emperor Maximilian I

1519
Tempera on canvas
32 11/16 x 25 5/8 in. (83 x 65 cm.)
The background has been restored.
Nuremberg, Germanisches Nationalmuseum
(bequest of the Reichsfreiherr Haller von
Hallerstein, 1860)
Gm 169

Maximilian of Austria (1459–1519), the son of Emperor Frederick III, of the House of Habsburg, is known as the "last knight." Elected king in 1486, and emperor in 1508, Maximilian strengthened and extended the power of the Habsburgs through alliances of far-reaching significance. His son Philip married Joan (Juana) of Castile. His grandchildren Ferdinand and Maria were engaged to the children of King Wladyslaw of Bohemia and Hungary. His contributions to the intellectual life of Germany through the advancement of Humanism and the

arts are beyond dispute. Such books as the *Theuerdank* and the *Weisskunig*, the *Triumphal Procession* and Dürer's *Triumphal Arch*, and the tomb, in Innsbruck, with the life-size bronze figures of the imperial ancestors, all served to glorify the Habsburgs and the emperor, himself. Maximilian enlisted the services of the greatest German artists of his day — Albrecht Dürer, Hans Baldung Grien, Albrecht Altdorfer, Hans Burgkmair, and Lucas Cranach the Elder — for the marginal illustrations in his prayer book; the only artist omitted was Matthias Grünewald.

During his stay in Nuremberg in 1512, Emperor Maximilian established what was to become a lifelong contact with Dürer, which would bring the artist numerous commissions and an annual pension of one hundred florins. It was Dürer who created the definitive historical image of Maximilian.

In Augsburg, Dürer sketched the emperor "in a little room high up in the castle" (see fig. 131, for the study). This drawing is the basis for all

of the artist's subsequent portraits of the emperor. Dürer portrays the aging, ailing monarch as a still imposing man with a full complement of hair. The head is turned far enough for the aquiline nose to be seen to best effect, without, however, unduly emphasizing the less flattering receding chin and drooping lower lip. The lowered eyelids and the wrinkles at the corners of the eyes add a touch of benevolence to the face, although the impression of the sitter's restless spirit and overbearing authority is by no means lost. In the mirror-image woodcut portrait made from this sketch, the gold ground that was intentional, and the imposing size of 16 3/4 x 12 5/8 inches compete, for effect, with the painted portraits. The inscription gives Maximilian the title "DIVUS," which not even a Roman emperor was granted until after his death. The woodcut as well as the painted portraits were made in 1519, at the earliest.

The picture in the Germanisches Nationalmuseum is a *Tüchlein* — a painting in tempera or watercolor on a very fine, barely primed canvas. The image was expanded to include the hands, and extends about as far as the emperor's hips. The structure of the arms is lost in the voluminous orange-red cloak, with its wide collar. This brings into sharp relief the hands with the pomegranate, for which there is a preliminary study, dated 1519, in the Albertina, Vienna. Maximilian chose the pomegranate to symbolize the imperial orb, in memory of the conquest of Granada in 1492 by Ferdinand of Aragon, his son Philip's father-in-law, but further meanings came to be associated with it. Dürer left a large section of canvas unpainted, above the emperor. This was intended to accommodate a parchment inscribed in German Gothic letters: "Der Allergrosmechtigist vnuberwindlichist Kayser Maximilian der in vernunfft schicklicheit Weisheit vnd manheit / bey seinen Zeiten menigklich vbertroffen Auch merckliche grosse sachen vnd getatten geubt hat. Ist geborn den xix tag/Des monats marcy Im MCCCCLviiij. Jar. hat gelebt Lviiij. Jar. ix monat vnnd xxv tag. Vnnd ist mit tod ver/schiden Zu Welß seiner Mayestat erblannd Den. xii. tag des monats January in dem MCCCC.xix Jar· / Der Allmechtig geruche der Seele sein gotliche Barmhertzigkeit gnedigklichen mitzuteylen" ("The almighty, invincible Emperor Maximilian, whose judgment, skill, wisdom, and courage hardly find their match in his lifetime, has performed memorable great acts and deeds. He was born on the 19th day of the month of March in the year 1459. He lived for 59 years, 9 months and 25 days. He died in Welss, on his family's land, on the 12th day of the month of January in the year 1519. May God in His mercy grant his soul rest"). Under the inscription, to the emperor's right, is his coat of arms: the double eagle within the heart-shaped shield of the Habsburgs, framed by the chain of the Order of the Golden Fleece, the whole surmounted by the imperial crown. Maximilian wears the same chain.

The painting has suffered with time, the oil in the varnish has blackened, and the background

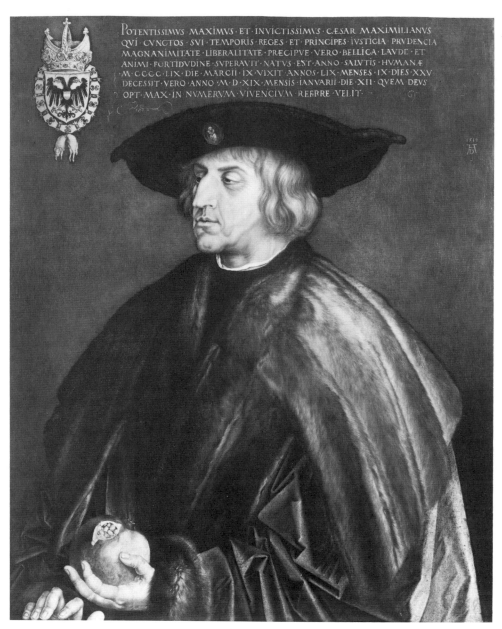

POTENTISSIMVS · MAXIMVS · ET · INVICTISSIMVS · CÆSAR · MAXIMILIANVS
QVI · CVNCTOS · SVI · TEMPORIS · REGES · ET · PRINCIPES · IVSTICIA · PRVDENCIA
MAGNANIMITATE · LIBERALITATE · PRECIPVE · VERO · BELLICA · LAVDE · ET
ANIMI · FORTIDVDINE · SVPERAVIT · NATVS · EST · ANNO · SALVTIS · HVMANÆ
M · CCCC · LIX · DIE · MARCII · IX · VIXIT · ANNOS · LIX · MENSES · IX · DIES · XXV
DECESSIT · VERO · ANNO · M · D · XIX · MENSIS · IANVARII · DIE · XII · QVEM · DEVS
OPT · MAX · IN · NVMERVM · VIVENCIVM · REFERRE · VELIT ·

Figure 132 Albrecht Dürer. *Emperor Maximilian I*. 1519. Kunsthistorisches Museum, Vienna

has been largely restored, but the portrait is still an impressive and sensitive likeness of the emperor. However, it also underscores how unsatisfactory was the inclusion of the documentary details of the inscription and coats of arms, which seem to hem in the figure, and thus partly diminish its effect. The flaws, however, were later rectified. Compared with the final version painted on wood, which is signed and dated 1519 (see fig. 132), the Nuremberg picture seems an interim development. The canvas of the *Tüchlein* and the materials used were not as expensive. The value of the picture, with its less than perfect craftsmanship, was further reduced by the addition of the strip of parchment, and Dürer saw no cause to sign the work. This cannot have been the painting that the artist, during his travels in the Netherlands, tried in vain to sell to Lady Margaret, the governor of the Netherlands, on June 6, 1521, and later gave in exchange (Rupprich, 1956). It seems just as unlikely that it was the Vienna painting — whose complicated format and careful execu-

tion indicates that it was a commissioned work — for it could in no way have alienated or offended a lover of the arts and an admirer of the late emperor, balancing as it does the personal and official man and his imperial office in an exemplary manner. The coat of arms is reduced to the same height as the inscription — now in Latin, written in Roman capitals. The figure of the emperor fills the width of the picture; the cloth collar has been replaced by a fur one whose texture we can almost feel; and the right hand no longer holds the pomegranate, but rests on the lower edge of the frame as if it were on a parapet. The chain of the Order of the Golden Fleece around the coat of arms identifies the emperor as head of the Order. Tighter pictorial control resulted in a greater emphasis on the portrait's function as a painted memorial by giving it more dignity and reducing the accessibility of the subject. The craftsmanship is incomparable. Dürer signed and dated the Vienna picture, but regarded the Nuremberg painting — as Stegmann and then Oberhammer have

shown — as a *modello* that he could revise; he used it to test the patron's reaction to the inscription, the coat of arms, and the insignia, and to establish their places in the finished work, for these were decisive elements in a state portrait. The incompleteness of the Nuremberg picture gives it something of the spontaneity of a first draft.

It may be assumed that the portrait of Maximilian was conceived as a gift, ordered by someone who had enjoyed the late emperor's favor, and who was possibly anxious to ingratiate himself with the successor. The Nuremberg city council could not have awarded such a commission, for the process of the working *modello* would hardly have been required; the patron undoubtedly would have been from outside the city. That it was Jakob Fugger of Augsburg, whose financial support ensured the imperial succession for Charles of Castile, Maximilian's grandson, does not seem a farfetched suggestion. A work by the famous Nuremberg artist would have been worthy of the new monarch, and a portrait of Emperor Maximilian would have reinforced the Fuggers' unshakable loyalty to the Habsburgs at a time when the disruptive effects of the Reformation were already being felt. The theory cannot be proven, but many facts support it.

In 1518, Dürer made drawings of both the emperor and Jakob Fugger in Augsburg — each of which resulted in a painting on canvas, which the artist did not sign, and which seems to have functioned as a *modello*. A second portrait of the emperor exists, painted on wood, which the artist considered a finished work, and to which he added his monogram; there seems to have been a similar one of Jakob Fugger, for the various later copies differ from the canvas version, but still are considerably similar to each other. The sitter wears a damask, not a fur cape. One of the works is dated 1520 (Anzelewsky, 1971, nos. 143, 144 K). Jakob Fugger, too, wanted to have a say in deciding which picture would serve as a record for posterity. If he commissioned Dürer's painting of the emperor, perhaps he also commissioned the sketch, or did not order the painted portrait until after Maximilian's death. The Augsburg Humanist and city clerk Conrad Peutinger might possibly have written the laudatory inscription, for as councillor he was close to the late emperor. It is conceivable that the less successful text on the Vienna painting was formulated by the Augsburg Humanist Conrad Peuttinger, and written by the Nuremberg biographer of artists Johann Neudörfer, who later added the biblical quotations that appear below Dürer's *Four Apostles*.

KL

BIBLIOGRAPHY: Stegmann, 1901, pp. 132–46; von Baldass, 1913–14, pp. 280–83; Lutze and Wiegand, 1936–37, pp. 53–54, ill. 92; Panofsky, 1948, vol. I, p. 205, vol. II, no. 60; Rupprich, 1956–69, vol. I, pp. 173, 176, 209, no. 68; Oberhammer, 1969, pp. 2–14, no. 105; Anzelewsky, 1971, no. 145; *Dürer*, Nuremberg, 1971, no. 258.

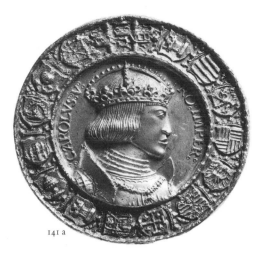

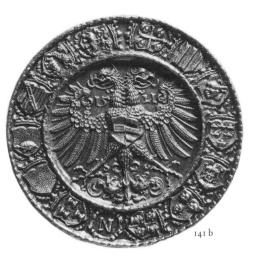

141 a 141 b

141 HANS KRAFT

Dedication Medal of the City of Nuremberg, for Emperor Charles V

1521
Cast silver, overstruck
Obverse: A crowned bust of the emperor in armor, facing to the right, wearing the chain of the Order of the Golden Fleece. Around the edge are fourteen coats of arms of the emperor's Spanish possessions, as well as his device, the two pillars of Hercules linked by a ribbon inscribed PLUS VLTRA ("even further beyond").
Reverse: The imperial two-headed eagle, with the escutcheon of Habsburg and Burgundy. On its field is the date 1521. Around the edge are thirteen coats of arms of the emperor's Spanish possessions, and a wreath at the bottom with the initial N (for Nuremberg).
Inscribed (on obverse): CAROLVS:V:RO:IMPER: ("Charles v, Roman Emperor").

a) Diameter, 2¹³/₁₆ in. (7.1 cm.)
Nuremberg, Germanisches Nationalmuseum (on permanent loan from the city of Nuremberg since 1866)
Med K 6

b) Diameter, 2³/₄ in. (7.2 cm.)
Coburg, Kunstsammlungen der Veste
II, 469,1

The Nuremberg city council intended to present the young emperor with as many as one hundred copies of this medal as a welcoming gift on the occasion of his first visit to the city. The Golden Bull, which regulated the manner of electing the emperor, moreover stipulated that every emperor was to convene his first Imperial Diet in Nuremberg. The coronation of Charles v took place in Aachen in 1520, and it was expected that an Imperial Diet would take place in Nuremberg in 1521. However, after a sudden outbreak of the plague, the emperor was forced to hold the Imperial Diet in Worms, instead. Preparations for the gift had proceeded to the point that probably twenty-four medals had already been struck, yet it remains unclear why these were never given to the emperor.

With the present large silver medal, whose artistry more than its material value was a credit to the city, the council hoped to demonstrate to the emperor Nuremberg's artistic and technical achievements. Albrecht Dürer provided the design, Willibald Pirckheimer advised him in heraldic matters (Petz, 1889, nos. 5829, 5831, 5832), and Hans Kraft executed the final work — first, casting the blank with the relief, which he then overstruck. Since stamping machines did not yet exist, and the required pressure could not be achieved with the blows of a hammer, it is presumed that Kraft made use of presses. Technically, no other sixteenth-century medal of this size is comparable. H M

EX COLLECTIONS: a) Christoph Andreas Imhoff (1734–1817); Johann Christoph Kress; the city of Nuremberg, since 1822, b) Chancellor Johann Conrad Scheres-Zieritz (died 1704), Coburg.

BIBLIOGRAPHY: Imhoff, 1782, vol. 1, 2, pp. 7–9, no. 6; Bernhart, 1919, no. 62; Habich, 1929, vol. I, 1, no. 18; Kohlhaussen, 1968, no. 453; Mende, 1983, no. 13; Smith, 1983, pp. 235–36, no. 138; Maué, 1984.

142 Virgin and Child on a Crescent Moon

Early 16th century (about 1520?)
Silver and silver gilt
Diameter, 2¹/₄ in. (5.8 cm.)
New York, The Metropolitan Museum of Art, The Cloisters Collection, 1965
65.68.1

Although this object was frequently described as a link for a rosary, its flatness and the originally open back of the repoussé Virgin suggest that it was intended as a pendant. The upper link would have attached to a chain and the lower one to a pearl, coral, or metalwork bauble. There is a comparable pendant with a seated Virgin of the Apocalypse in a female portrait by Sebastian Bopp that is now in the Thyssen-Bornemisza collection (A. Stange, *Deutsche Malerei der Gotik*, Munich, 1956, vol. VIII, pl. 212).

The Cloisters pendant is without maker's marks and its attribution rests on its design alone. The composition ultimately derives from a Middle Rhenish model. A stone relief, of about 1485, in the cloister of Mainz Cathedral, shows the Virgin and Child in precisely the same manner; the Cloisters example varies only in the angle of the Virgin's head and in the slightly different positioning of the Child. The artist of the relief has been associated with Erhard Reuwich, who, in turn, has been identified with the Master of the Housebook; this would not be the only case in which designs from the circle of the Master of the Housebook influenced Nuremberg artists of a generation later (see cat. nos. 65, 66). The iconographic type recurs in Dürer's *Virgin of the Apocalypse* (Bartsch, no. 60). Stylistically, the Cloisters pendant is more closely related to Baldung's *Virgin on a Turf Bench* (Bartsch, app. 13); there are similarities in the Virgin's crown and in the attitude of her head and the gesture of the Child.

Among the numerous designs by Nuremberg artists for jewelry that have survived is a drawing, dated 1514, for a pendant with the Virgin and Child on a Crescent Moon (in the Kupferstichkabinett, Berlin-Dahlem; 4415). Whether such designs were commissioned or were merely artists' studies remains unclear (G. Schiedlausky, in *Albrecht Dürer 1471–1971* [exhib. cat.], Nuremberg, 1971, pp. 364–65); it is possible that Dürer's renderings were employed by his brother, Andreas, who was a goldsmith (W. Schmidt, in *Deutsche Kunst*, 1971, p. 140, no. 162). A nearly identical pendant in the Kunsthistorisches Museum, Vienna (see E. Steingräber, *Antique Jewelry*, New York, 1957, p. 74, fig. 107, p. 76), suggests that a number of examples were produced from a single model. A similar pendant is in the Boston Museum of Fine Arts; another, in the Vienna Schatzkammer (H. Kohlhaussen, *Nürnberger Goldschmiedekunst des Mittelalters und der Dürerzeit 1240 bis 1540*, Berlin, 1968, no. 436, fig. 620), seems based on a related design. The open back of the Cloisters *Virgin* was fitted as a reliquary or capsule in the nineteenth century. TH

BIBLIOGRAPHY: Hayward and Husband et al., 1975, pp. 90–91, no. 100 b.

142

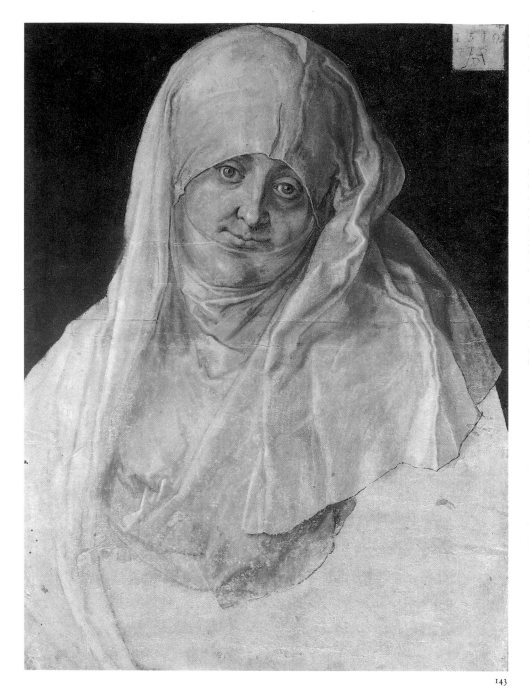

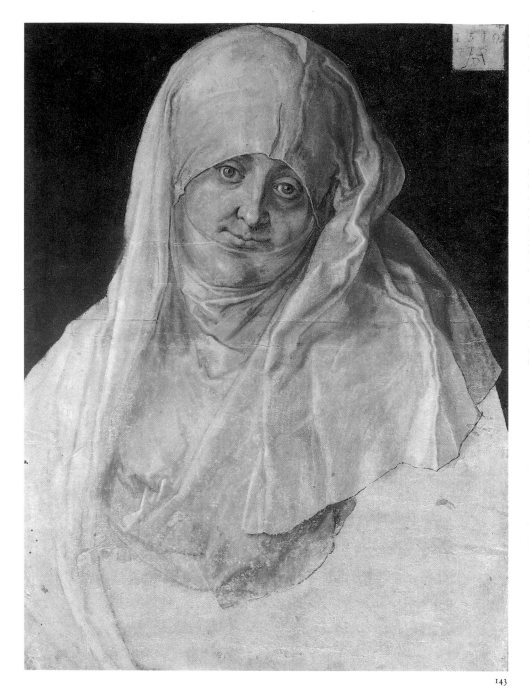

143

143 ALBRECHT DÜRER
Agnes Dürer as Saint Anne
1519
Brush and gray ink, heightened with white, on gray-grounded paper, the background subsequently blacked out
15 1/2 x 11 1/2 in. (39.5 x 29.2 cm.)
Monogrammed and dated on a small square of paper pasted in the upper right corner
Vienna, Graphische Sammlung Albertina
3160 D 136

This drawing, of 1519, executed with a brush in soft tones of gray heightened with white, is a preliminary study for the painting *The Virgin and Child with Saint Anne,* of the same year, in the Metropolitan Museum (cat. no. 144). A comparison of the drawing with the silverpoint portrait of Agnes Dürer now in Vienna (Winkler, no. 780), executed two years later, when Dürer returned from the Netherlands, makes it quite evident that the artist used his own wife as a model for the half-length figure of Saint Anne. The lower-right portion of Saint Anne has been omitted, since, in the painting, it would be obscured by the figure of the Virgin. This detail makes it clear that, at the time Agnes sat for him, Dürer had already planned the basic composition. It would also appear that the soft grisaille technique, which Dürer here employs for the first time, was selected in anticipation of the problems that he would encounter in the panel painting. It is possible that this procedure was suggested to him by Netherlandish precedents.

Despite the resemblance of the subject of the drawing to Agnes Dürer, it cannot be considered an independent portrait study, for the model's characteristic features have been accommodated to the type and role of Saint Anne. Such typical portrait elements as the sub-

ject shown gazing directly at the viewer were dropped, by and large, in the painted version, where, in addition, her features have been somewhat softened, so that she appears younger.

Saint Anne was especially venerated by barren women, inasmuch as she gave birth to Mary at a relatively advanced age. It is not known whether Dürer was influenced by this when he selected his childless wife as a model.

Equally precise preliminary studies for the figures of the youthful Virgin and her sleeping child have not survived. Nevertheless, two portrait-like heads of young women, formerly in Bremen and in London (Winkler, nos. 575, 576) and also in grisaille, can be related to the painting, and the drawing of a child's head, in Hamburg (Winkler, no. 577), can be compared to the Christ Child in the finished work. R S

EX COLLECTION: Imperial Collection, Vienna.

BIBLIOGRAPHY: Pauli, 1915, pp. 69–76; Winkler, 1936–39, no. 574; Panofsky, 1948, vol. I, no. 1049, p. 204; Grote, 1969, pp. 83–84; *Dürer,* Nuremberg, 1971, no. 86; Koschatzky and Strobl, 1971, no. 117; Strauss, 1974, no. 1519/5.

144 ALBRECHT DÜRER
The Virgin and Child, with Saint Anne
1519
Oil and tempera on canvas, transferred from wood
23 5/8 x 19 5/8 in. (60 x 49.9 cm.)
New York, The Metropolitan Museum of Art, Bequest of Benjamin Altman, 1913
14.40.633

This painting of the Virgin and Child with Saint Anne (the *Anna Selbdritt*) bears Dürer's monogram "AD" and the date "1519" next to the head of the Virgin. Duke Maximilian I of Bavaria, a great admirer of Dürer, purchased the painting in 1629.

Along with numerous other paintings, including examples by Altdorfer and Grünewald, the present work was sold at public auction in 1852 from the collection in Schloss Lustheim and Schloss Schleissheim. It was then obscured by a thick layer of varnish and was believed to be a copy; there were, in fact, a number of early copies of the composition, for several survive. The picture came into the possession of the painter Joseph Otto Entres, who had it cleaned by the restorer A. Deschler.

In the scholarly debate between Ernst Förster and Gustav Friedrich Waagen regarding the authenticity of the work (*Kunstblatt,* 1854), it was Waagen who won out with his conviction that it was only a copy. Then, in 1882, Ephrussi published a drawing by Dürer from the Albertina in Vienna (Winkler, 1937, no. 574) that was obviously a study for the head of Saint Anne. Wustmann, who, in 1910, traced the history of the debate, found himself siding with the majority of contemporary scholars and proclaiming the work a genuine Dürer.

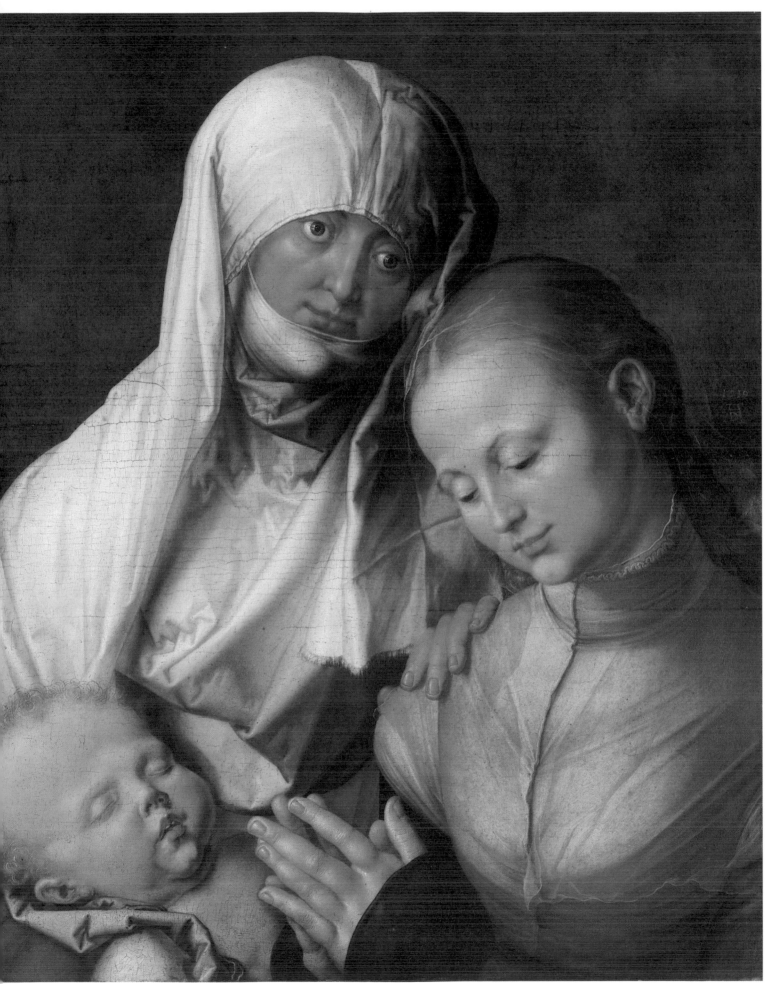

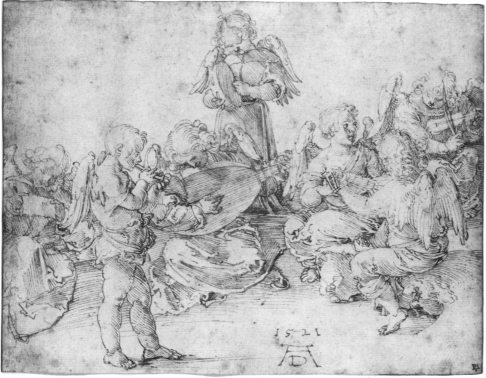

145

145 ALBRECHT DÜRER

Music-Making Angels

Pen and brown ink, on white paper
6⁵/₈ x 8³/₄ in. (16.8 x 22.2 cm.)
Monogrammed and dated 1521 at bottom
New York, The Metropolitan Museum of Art,
Gift of Mrs. William H. Osborn, 1961
61.257

In this finely finished and balanced composition seven angels are represented. One angel, at the far left, examines a sheet of music that he holds in his hands, while next to him, in the foreground, a standing angel grasps a diskant shawm. At the center is a seated, somewhat larger figure who leans forward, strumming a lute. Standing behind him is an angel with a timbrel. Seated to the right is a second lutist, grouped with an angel who holds a cittern-like instrument and one with a waisted fiddle.

Music-Making Angels is one of a number of surviving studies for a painting of the enthroned Virgin and Child flanked by standing saints that Dürer never executed. Nothing is known about the commission for the painted altarpiece, although there are more than a dozen carefully worked studies and six drawings of the overall format. Its proposed composition derived from the Italian *sacra conversazione* (Panofsky, 1943, p. 223). In a study for the composition of the painting, in the Louvre (Strauss, 1974, no. 1521/83), only a single angel with a lute is sketched in at the feet of the Virgin. The preparatory drawing in the Musée Bonnat, Bayonne (Strauss, 1974, no. 1521/91), however, indicates how a number of the angels from the Metropolitan Museum drawing would have appeared at the corners of a stage-like space.

Like the format of the *sacra conversazione*, the drawing of the musical angels, with their chubby faces and limbs, and tiny, fluffy wings, is strongly Italianate, reminiscent of music-making angels in paintings by Giovanni Bellini and Alvise Vivarini. The angel with the diskant shawm has been shown to be a direct quotation from Vivarini's *Pala di Belluno*, formerly in Berlin (Talbot, ed., 1971, n. 4, p. 98).

Unlike other preparatory studies for the altarpiece, none of the angels' faces has been identified with any of the artist's sketches from life. Dürer imparts an ethereal quality to these musical but incorporeal creatures by the alternate use of a pen filled with heavy ink and a scratchy, dry one.

BDB

Ex collections: Sir Peter Lely, London; Sir Thomas Lawrence, London; F. T. Palgrave, London; John Postle Heseltine, London; Johnston L. Redmond, New York; Mrs. William H. Osborn, New York.

Bibliography: Ephrussi, 1882, p. 348; Lippmann, 1888, vol. II, p. 21, no. 170; Hoff, 1898, p. 66; Conway, 1905, 28, pp. 147–48; Heidrich, 1906, p. 207; Flechsig, 1931, vol. II, p. 248; Tietze, 1932–33, p. 88, 1933, p. 259; Tietze and Tietze-Conrat, 1938, vol. II/2, p. 31, no. 845; Winkler, 1939, vol. 4, p. 48, no. 836; *Masterpieces of Art*, 1939, no. 92; Panofsky, 1943, vol. 1, pp. 225–29, vol. 2, no. 771; Stampfle, 1955, p. 12; Winkler, 1957, p. 321; Talbot, ed., 1971, no. XXXI, pp. 97–98; Strauss, 1974, no. 1521/84, p. 2150.

The condition of the painting, which, for a long time, fully justified doubts about its authenticity, is poor but not ruinous. Friedländer (1921) expressed his — and many of his colleagues' — aversion to the work: For him, the group was too "heavy, overly fussy in its conscientious exaggeration of formal illusion and the mirror-like smoothness of its surface, inharmonious in its coloring, the belated addition of colors to the high relief worked out in black and white." It was only in Winkler (1957) that the picture again found an ardent champion.

Saint Anne was venerated in all parts of Germany in the Late Middle Ages, and her cult was especially fostered by the existence of confraternities. Portrayals of her together with her daughter and grandchild were frequently composed in such a way that Mary held her child on her lap while she, herself, sat on the lap of her mother. Dürer's teacher, Wolgemut, solved the problem by placing the Virgin on a stool at her mother's feet (see the painting in the Germanisches Nationalmuseum, Nuremberg). Dürer, himself, chose to portray the three as half-length figures, or as busts, and thus avoided the matter of seating. Here, the Child is asleep. Mary adores it with folded hands and a lowered gaze, while Anne lightly touches her daughter's shoulder and stares meditatively off into the distance. The Virgin's hair is uncovered and gathered in a braid; her mother wears a matronly linen cowl that also covers her chin and accentuates the modeling of the visible portion of her face. The Child — of which little more than the head is seen — is sleeping with an intensity that augments rather than relieves the tension. His expression underscores the fine line between sleep and death, and this is not lost on the two women. The somber, agonized mood of

the whole is a clear foreshadowing of the Passion.

Dürer adopted the form of the half-length portrait, which concentrated the viewer's attention on the faces. This stood him in good stead in his private devotional works, as well — as in the *Salvator Mundi* (cat. no. 118) and the *Christ Among the Doctors* (Strieder, 1982, no. 144). What is new in the *Virgin and Child, with Saint Anne*, and obviously deliberate, is the compression of its arrangement, its pyramidal composition, the tension between the volumes of the heads, and the atmosphere of intense feeling. It may be that his experiences as an engraver, and the subsequent break from painting — there are only a very few panels from the years between 1516 and 1519 — helped to bring about the new style.

The number of copies of Dürer's *Virgin and Child, with Saint Anne* attests to its early fame. Intimate yet full of grandeur, humanly believable yet imbued with an abstract seriousness, it must have seemed, to Counter-Reformation tastes, a model devotional painting.

KL

Ex collections: Gabriel III Tucher, Nuremberg (until 1628); Hans von Furtenbach, Nuremberg; Duke Maximilian I of Bavaria (1629); Schloss Lustheim, near Schleissheim; sold at auction (1852); Joseph Otto Entres, Munich; Jean de Couriss, Odessa (1867); Mme A. de Couriss, Dresden (1909); Benjamin Altman, New York.

Bibliography: Wustmann, 1910, pp. 49–56; Pauli, 1913, p. 76; Friedländer, 1921, p. 170; Winkler, 1937, no. 574; Wehle and Salinger, 1947, pp. 186–89; Panofsky, 1948, vol. I, p. 201, vol. II, no. 36; Winkler, 1957, pp. 261–62; Benesch, 1966, p. 136; Anzelewsky, 1971, no. 147.

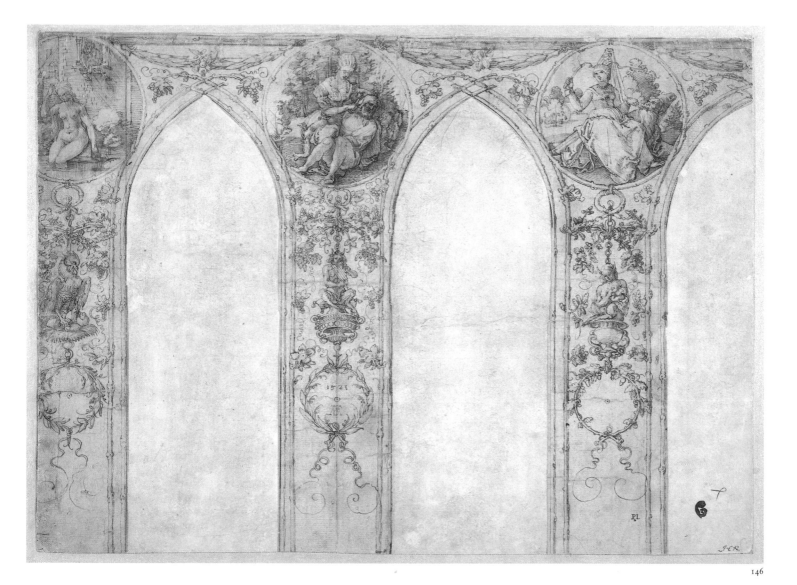

146

146 ALBRECHT DÜRER

Design for a Mural Decoration with the Power of Women Theme

Monogrammed, and dated 1521
Pen and brown ink, and brush and watercolor, on paper
10 1/16 x 13 3/4 in. (25.5 x 35 cm.)
New York, The Pierpont Morgan Library
I, 257

In August 1521, the Nuremberg city council commissioned Albrecht Dürer to provide designs for the interior of the town hall. The Morgan drawing, dated that year, is thought to represent part of the artist's plan. This theory was first advanced by Mummenhoff, in refutation of an earlier proposal by Friedländer that linked the drawing to an exterior wall design that Dürer executed for Tommaso Bombelli in Antwerp. Mummenhoff's theory is consistent not only with the proportions and shape of the windows in the medieval town hall, but also, as Smith has shown, with the iconography of the drawing.

The three medallions represent familiar images of the Power of Women, a popular and widespread theme in Late Gothic art and literature from the fourteenth through the early six-

teenth century. Numerous examples of the subject, from classical, biblical, and secular lore, were variously cited in contemporary literature and illustrated in art as exemplars of the power of women and, consequently, of the weakness of men. Dürer's roundels present, from left to right, the biblical king David, smitten by the beauty of the bathing Bathsheba as he gazes from his window; the Old Testament hero Samson being shorn of his strength-giving hair by the beguiling Delilah as he sleeps; and the classical scholar Aristotle, shamed by Alexander's queen or consort, who bridled him and rode him like a horse. Both the biblical stories and the thirteenth-century legend of Aristotle and Phyllis were well known and represented in various mediums, from prints and wood and ivory carvings to textiles. In Dürer's Nuremberg, the theme was elaborated upon in theater — notably, in Hans Folz's *Fastnachtspiele*, "A Carnival play concerning those who allow themselves to be made fools of by Woman" (see H. Adelbert von Keller, *Fastnachtspiele aus dem fünfzehnten Jahrhundert*, Stuttgart, 1853, vol. I, pp. 258–63, 283–87). Dürer's contemporaries Hans Baldung Grien and Peter Flötner, as well as several Netherlandish masters, were among the artists to illustrate the subject in prints.

Panofsky regarded Dürer's choice of this secular and rather playful theme as appropriate to the town hall's occasional use for social events. However, the Power of Women theme was not uncommon in earlier town hall decorations, elsewhere; examples are known in Frankfurt, Cologne, and Döbeln, and in Revel and Courtrai. Presented together, the three images underscore the weaknesses of all men — even the saintly, strong, and wise — serving, perhaps, as a humbling reminder to town officials of their human failings.

Dürer surrounds the three roundels with decorative ornament in a fully Renaissance idiom, reminiscent, as Talbot has noted, of the decoration of such works as the *Prayer Book*, of 1515, for Emperor Maximilian I, or the artist's contemporary design for the emperor's silvered armor (see cat. no. 136). The further meaning of the pelican, the satyr, and the nursing female satyr in relation to the *Power of Women* roundels directly above is somewhat elusive. While the pelican was chiefly a symbol of Christ's sacrifice, the bird was also associated with charity. Smith posits that, taken together with the female satyr, it may suggest that the power of women is ultimately maternal, while the satyr may simply be a symbol of lust.

The Morgan drawing, although trimmed, corresponds to only part of the full design for the hall, which contained ten windows. Other designs for the Nuremberg town hall, by or after Dürer, survive — a drawing in Dresden of *The Continence of Scipio* (Strauss, 1974, no. 1521/63) and another in the Albertina of *The Calumny of Apelles* (Strauss, 1974, no. 1522/12), for the north wall. It is not known whether the *Power of Women* design was ever realized. Dürer's student Georg Pencz executed the decorations for the north wall; even these, however, were replaced in the early seventeenth century. BDB

EX COLLECTIONS: Sir Peter Lely, London; unidentified collector (initial C at lower right); Sir John Charles Robinson, London; Sir Charles Fairfax Murray, London; J. Pierpont Morgan, New York.

BIBLIOGRAPHY: Friedländer, 1895, vol. XVI, pp. 240–43, ill.; Lippmann, ed., 1896, vol. IV, p. 23, no. 407; *Catalogue of a valuable collection of Drawings . . .*, 1902, p. 13, no. 108; Mummenhoff, 1904, vol. XVI, pp. 244–53; *A selection from the Collection of Drawings . . .*, *formed by C. Fairfax Murray*, 1905, vol. I, no. 257; *Exhibition of Early German Art*, 1906, p. 186 (no. 4); Giehlow, 1910, vol. XXIX/1, p. 58, no. 2; Bock, 1921, vol. I, p. 33, in no. 5018; Wölfflin, 1926, 5th ed., p. 301, ill.; Flechsig, 1931, vol. II, pp. 347, 348; Tietze, 1932/33, p. 87, 1933, XV, p. 259, fig. 8; Tietze and Tietze-Conrat, 1938, vol. II/2, p. 36, no. 870, ill. p. 178; Winkler, 1939, vol. IV, pp. 91, 92, no. 921, ill.; Panofsky, 1943, rev. eds. 1945, 1948, vol. II, p. 146, no. 1549; Tietze, 1951, p. 56; Musper, 1953, p. 248, fig. 205, p. 293; Stampfle, 1955, p. 12; *Morgan Library gästar Nationalmuseum*, 1970, no. 72, ill.; Talbot, ed., 1971, pp. 92, 93, no. XXIX; Strauss, 1974, vol. 4, no. 1521/62, pp. 2106, 2107; Smith, 1978, pp. 284–86, n. 26, pp. 310, 311; Denison and Mules, with Shoaf, 1981, no. 35, pp. 60–61, ill.; *In Quest of Excellence*, 1984, pp. 133, 154–55; *Drawings by Dürer and His School from the Pierpont Morgan Library*, 1985, p. 20, no. 7.

147 ALBRECHT DÜRER
The Lamentation

Monogrammed, and dated 1521
Pen and brown ink, on paper
11³/₈ x 8¹/₄ in. (29 x 21 cm.)
Cambridge, Massachusetts, Harvard University, Fogg Art Museum, Bequest of Meta and Paul J. Sachs
423.1927

Among the most emotive compositions of Dürer's career is this drawing of the followers of Christ huddled around his body on Golgotha. The masterful composition juxtaposes the pyramidal balance of the arrangement of the figures with the emotional and dramatic intensity of the event. The aging Joseph of Arimathaea, his eyes downcast, holds the winding sheet upon which Christ's body rests. The Virgin gathers her Son to her, while the Holy Women cluster around them; the kneeling Mary Magdalene holds the jar of oil for unction. A standing woman and the youthful Saint John the Evangelist, at the right, wring their hands as they look on. Another woman, at the left, flails her arms wildly in the air, arousing the concern of Nicodemus, who clutches what is apparently a spice jar. An old man at the back, in a pointed hat, somewhat disengaged from the figure group, stares mournfully ahead.

Representations of the Lamentation recur at rather regular intervals throughout Dürer's career — as part of the *Large Passion* series, of 1498–99; in the *Engraved Passion*, of 1507; in the *Small Woodcut Passion*, of about 1509; in another drawing, of 1519, now in the Albertina (Strauss, 1974, no. 1519/12); in 1521, in the Fogg Museum drawing; and again, in 1522, in a drawing in Bremen (Strauss, 1974, no. 1522/9). Certain artistic borrowings are apparent — notably, the debt to Mantegna for the woman waving her arms in despair. What is, perhaps, most interesting when comparing his six separate interpretations of the Lamentation, however, is not the artist's specific responses to the forceful stimuli of his travels or to his patronage, but, rather, Dürer's measured response to his own artistic tradition. The placement of the mourning figures varies somewhat in each attempt, as the artist juggles their positions to different effect. Many of the iconographic elements that are standard in Lamentation scenes recur in each version — such as the crown of thorns or the unguent jars. These details provide visual keys to the scene, but do not represent the focus of Dürer's interest. The wailing woman appears in all but the Bremen drawing, and, clearly, the drama of this figure was central to the artist's purpose. The figures are pushed to the foreground, so that only the lower beam of the cross is visible, and, in the Fogg drawing, Christ's toes occupy the front edge of the picture plane.

A number of scholars have attempted to link this study to Dürer's finished works. The drawing has been related both to the artist's own *Corpus Christi Altarpiece*, in Riga (Busch, 1931, p. 65), as well as to Schäufelein's tomb of Nicolaus Ziegler in the Georgskirche, Nörd-

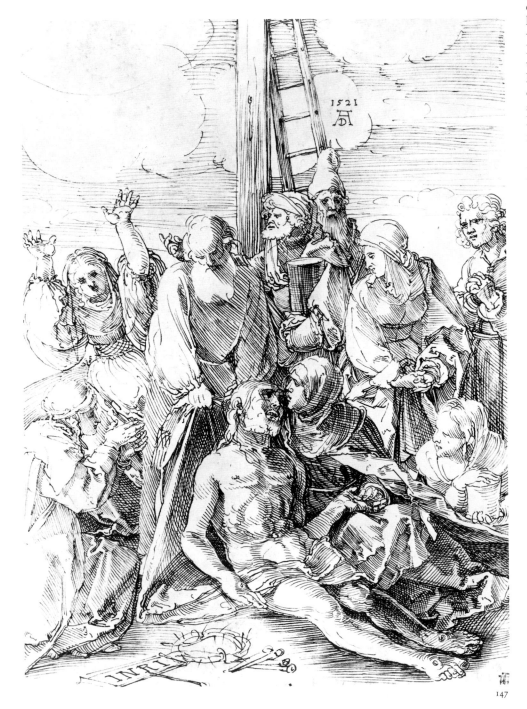

147

lingen, and Paulus Vischer's *Eyssen Epitaph* in the Egidienkirche, Nuremberg (see Tietze and Tietze-Conrat, 1938, vol. II/2, p. 40). The most convincing suggestion is that Dürer's drawing was a study for a print, since the subject occurred regularly in Dürer's work in exactly this context. The artist planned a new oblong *Passion* during the year (1520–21) that he spent in the Netherlands (Strauss, 1974, no. 1521/16–17). This drawing, likewise, dates from 1521 — either at the end of Dürer's travels, or shortly after his return to Nuremberg.

B D B

Ex collections: Baron Dominique Vivant-Denon, Paris; Sir Thomas Lawrence, London; Pierre Defer — Henri Dumesnil, Paris; Lebeuf de Mongermont, Paris; Féral; Paul J. Sachs, Cambridge, Massachusetts.

Bibliography: Ephrussi, 1882, p. 96, ill.; Lippmann, ed., 1896, vol. IV, pp. 11, 12, no. 379; Veth and Muller, 1918, vol. 2, p. 134; Waldmann, 1918, pl. 68; Wölfflin, 1919, 6th ed., pl. 70; Schilling, 1921, vol. I, p. 127; Busch, 1931, vol. IV, p. 65; Flechsig, 1931, vol. II, pp. 125, 344, 598, no. 1175; Tietze, 1932–33, p. 87, 1933, XV, pp. 254, 255, fig. 4; Winkler, 1937, vol. IV, pp. 328, 329, no. 881; Tietze and Tietze-Conrat, 1938, vol. II/2, p. 40, no. 881; Frankfurter, 1939, p. 185; Mongan and Sachs, 1940, vol. I, pp. 188, 189, no. 377, vol. III, fig. 192; Panofsky, 1943, rev. eds., 1945, 1948, vol. II, p. 71, no. 609; Sachs, 1951, pp. 51–55, pl. 33; Tietze, 1951, p. 55; Stampfle, 1955, p. 12; Winkler, 1957, p. 328; *Memorial Exhibition: . . . Collection of Paul J. Sachs*, 1965–66, 1966–67, no. 11; Wick, 1966, pp. 119–35; Talbot, ed., 1971, pp. 94–96, no. XXX; Strauss, 1974, vol. 4, no. 1521/69, pp. 2120, 2121; Hetzer, 1982, pp. 39, 237, 239, fig. 61.

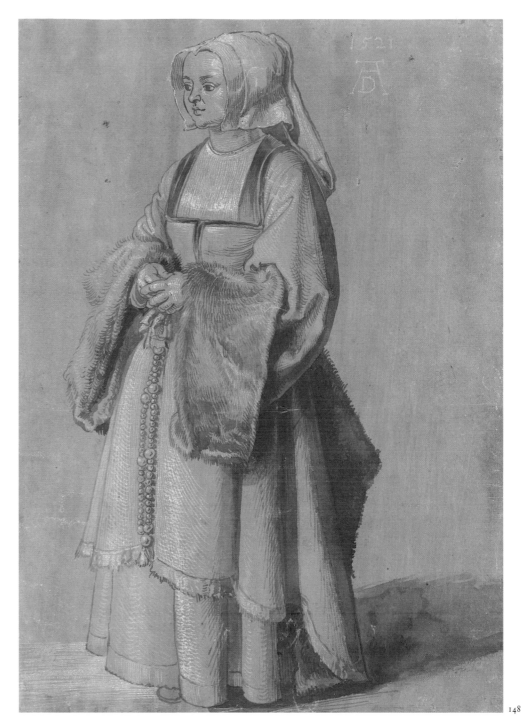

148

148 ALBRECHT DÜRER

Woman in Netherlandish Dress

Monogrammed, and dated 1521
Brush and brown ink, heightened with white, on a grayish violet prepared ground
11 1/4 x 7 3/4 in. (28.3 x 19.5 cm.)
Washington, D.C., National Gallery of Art, Widener Collection

B-493

Veth and Muller suggested that Dürer might have referred to this drawing, along with another in the Albertina (Strauss, 1974, no. 1521/24), in his journal entry of May 26, 1521, recorded in Antwerp, "I have also drawn with white and black on gray paper two Netherlandish costumes." However, there are inconsistencies between the two surviving drawings and the journal descriptions: In both drawings the ground is grayish violet and the ink is brown. In the Vienna example, Dürer concentrated on the accurate rendering of heavy, complicated drapery, while in the National Gallery drawing he focused his attention on the texture of the fur, and on such details as the square line of the bodice and the pendant rosary beads.

Both the entries and the drawings testify to Dürer's abiding interest in depicting costume. The artist sometimes adapted these costume drawings to his finished compositions, but the rendering of dress seems to have been a preoccupation of his, in its own right. It is interesting to compare the full figure of the Netherlandish woman with Dürer's drawings of Nuremberg ladies, of about 1500 (Strauss, 1974, nos. 1500/2–1500/7). These Nuremberg women, while studied from life, are rendered within the German Late Gothic mode, reminiscent of carved or painted female saints on contemporary altarpieces. Dürer has made the *Woman in Netherlandish Dress* much more solid than her Nuremberg counterparts. Winkler and Talbot attribute the stylistic contrast, at least in part, to the use of pen and thin washes for the pleats of the linen Nuremberg costume, as opposed to the chiaroscuro technique employed for the heavier fabrics worn in the Netherlands. It may, however, be as much an indication of Dürer's growth beyond the Late Gothic tradition as of regional variation of dress or technique.

B D B

Ex collections: Comte Antoine-François Andréossy, Paris; James Alexandre, Comte de Pourtalès-Gorgier; Baron F. Schickler, Paris; J. B. Widener, Lynnewood Hall, Elkins Park, Pennsylvania.

Bibliography: Ephrussi, 1882, pp. 299, 300, ill. opp. p. 300; Conway, 1889, p. 115; Lippmann, ed., 1896, vol. IV, p. 13, no. 385; Veth and Muller, 1918, vol. I, p. 44, pl. 71; Flechsig, 1931, vol. II, p. 232; Tietze, 1932–33, pp. 87, 88, 1933, XV, p. 259, fig. 15; Tietze and Tietze-Conrat, 1938, vol. II/2, p. 26, no. 823; Winkler, 1939, vol. IV, p. 41, no. 820; Panofsky, 1943, rev. eds., 1945, 1948, vol. I, p. 216, vol. II, p. 127, no. 1292; Stampfle, 1955, p. 11; Winkler, 1957, p. 310; Talbot, ed., 1971, pp. 86–88, no. XXVII; Strieder, ed., 1971, p. 238, no. 473; Strauss, 1974, vol. 4, no. 1521/23, pp. 2040, 2041; Strieder, 1982, pp. 165, 167, fig. 194.

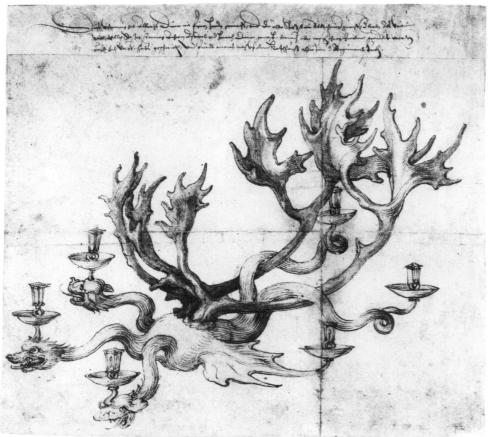

149

right-aligned under image

149 ALBRECHT DÜRER

Design for a Chandelier in the Form of a Dragon

1521/22

Pen and ink, with touches of watercolor, on paper
6⁵/8 x 8³/8 in. (16.8 x 21.3 cm.)
Glued on at the top of the drawing is a fragment of an engraving with which the entire drawing was backed, sometime before 1847 — namely, Heinrich Goltzius's *Venetian Ball or Antenor's Wedding*, of 1548 (Hollstein, 1953, vol. 8, p. 99, ill.). This strip of paper is inscribed in a late-sixteenth- or seventeenth-century hand identified as that of either Johann or Anton Neudörfer, grandsons of the famous Nuremberg calligrapher and mathematician Johann Neudörfer (1497–1563): "Diese Visirung hat Albrecht Duerer mit Eignen Handn gemacht, vnd der alte Stoß so ein Bildschnitz[er] gewest, d[er] beed[en] als Veit vnd Phillip Stoßn (so meins Anhern Discipel vnd hernach Diener gewest, hernach aber weg[en] Ihres schreibens geadelt word[en]) Leiblich[er] Vatt[er], hats geschnitt[en], vnd findt mans noch vf dem Rathauß alhie Inn d[er] Regimentstub[en]" ("This design was made by Albrecht Dürer himself, and old Stoss, who was a carver, the father of Veit and Phillip Stoss [who were my grandfather's pupils and later assistants and were subsequently ennobled on account of their writings], actually carved it, and you can still see it at the Rathaus here, in the governing chamber").
Constance, Städtische Wessenberg-Gemäldegalerie
35/92

Dürer drew a number of designs for chandeliers made of antlers. From his correspondence, and from comments by his friend Willibald Pirck-heimer, we know that both men were admirers and collectors of antlers, and that among their respective effects at their deaths there were sets of antlers that had been made into chandeliers. (See also cat. no. 150.)

Some have criticized the drawing for a certain flatness of line and a perfunctoriness in its hatching. Clearly, this is because it was intended as a working design for an object to be executed by another craftsman, who, naturally, needed a precise and simple illustration. Thus, the drawing's requirements differed from those of a sketch intended for Dürer's own use. Similar objections are constantly raised in connection with almost all of Dürer's designs for goldsmiths or for stained-glass workers.

The date of the present drawing is known from the fact that the design was for the dragon chandelier, completed March 1, 1522, and installed in the governing chamber of the Rathaus, in Nuremberg.

R K

EX COLLECTIONS: Johann (1567–1639) or Anton (born 1628) Neudörfer; Georg Kaspar Nagler (1847); [H. G. Gutekunst (1893)]; bank director Brandes; Städtische Wessenberg-Gemäldegalerie, with the rest of the Brandes collection (1898/1908).

BIBLIOGRAPHY: Nagler, 1847, pp. 143–44; *Catalogue...*, H. G. Gutekunst, no. 45, 1893, no. 1321; Tietze, 1928–38, vol. II, 2, p. 118, no. 334a, ill. p. 252; Pauli, 1937–38, pp. 41–44, ill.; Winkler, 1936–39, vol. 3, no. 708, ill.; Panofsky, 1948, vol. II, p. 147, no. 1562; Heikamp, 1960, pp. 44–46, ill. 3; Grote, 1961, pp. 76–77, ill. 35; Stafski, in *Dürer*, Nuremberg, 1971, no. 708; Strauss, 1974, vol. 3, no. 1513/29, ill.; for further bibliography, see cat. no. 150.

150 WILLIBALD STOSS, after a design by ALBRECHT DÜRER

Chandelier in the Form of a Dragon

1522
Linden wood, gilded, and reindeer antlers with thirty-four points
18⁷/8 x 49³/16 x 60¹/4 in. (48 x 125 x 153 cm.)
The animal's skull plate is set into the wood, the whole, suspended by three iron chains. The candle holders are lost.
Provenance: governing chamber, Rathaus, Nuremberg.
Nuremberg, Germanisches Nationalmuseum (presented by Johannes Zeltner, the owner of Gleisshammer Castle, near Nuremberg, in 1859)
HG 68

A golden dragon with a short, winged body; three long, twisting necks ending in dogs' heads; and two diverging, curling tails bears on its back the base of a large set of antlers. The small carved wings extending to the side are joined to the jagged antler palms. The monster's feet, drawn up against its body, and the explicitly rendered male genitalia are visible from below. The serpentine movement of the necks, with their snarling heads, is also best appreciated from below, while the bizarre configuration of the dragon and the antlers is more clearly seen from the side. In short, the variety of this fantastical object cannot be comprehended from any one angle, and, doubtless, the flickering of the candles and the shimmering gold were calculated to enhance the overall effect. As is known from the design (cat. no. 149), and from surviving traces of the candle sockets, the chandelier originally held seven of them, positioned on the dragon's heads, wings, and two tails.

The history of the chandelier's creation and the purpose for which it was made are uncommonly well documented. The inscription on the drawing cites Albrecht Dürer as the designer, and "old Stoss" as the carver, also stating, expressly, that at the time of writing, the chandelier still hung in the governing chamber of the Rathaus. Municipal inventories from 1585 to 1607 provide separate confirmation of the fact. Furthermore, a notice in the accounting book of the chief treasurer, Anton Tucher II (1457–1524) — discovered by Detlef Heikamp — gives the name of the man who commissioned the chandelier, the date of its manufacture, its cost, and how it was presented to the Rathaus. In 1522, we read, "Item adi primo Marzo vereeret ich mein hern von gemayner stat wegen in ir new gepautte obere stuben mit einem elchen kurn, hat 34 endt mit einem geschnitten vergullten wurm, der hat 7 liecht, gestett mich die verfassung 24 ff." ("Item, on March 1st I presented the city fathers with an elk horn of thirty-four points with a carved, gilded dragon holding seven lights and costing twenty-four guilders, for their newly built upstairs chamber."). The governing chamber was the meeting room of the septemvirs, the actual decision-making committee of the city council, and it was also reserved for the seven electors when Imperial Diets were convened in Nuremberg.

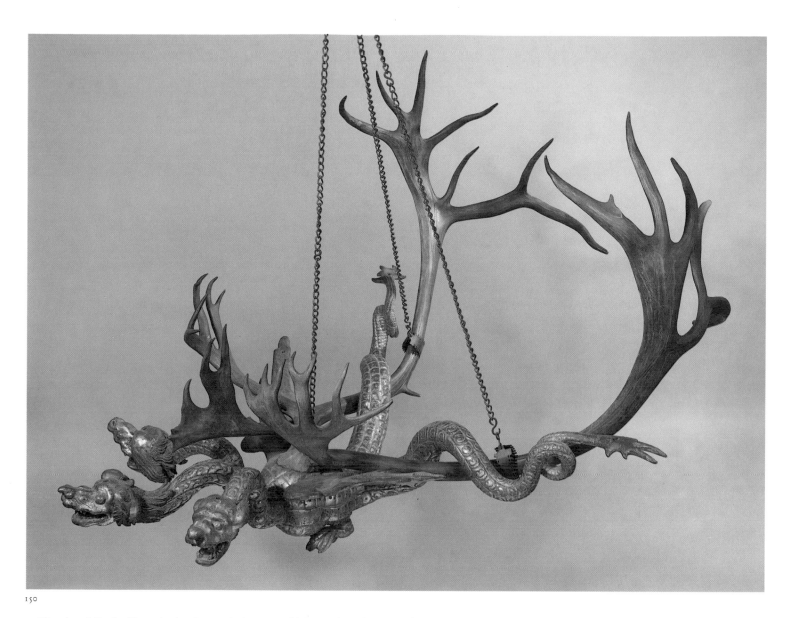

150

The chandelier had been in the Germanisches Nationalmuseum for a long time, but it was first identified by Heinrich Kohlhaussen in 1937. From then until now, there has been a certain amount of confusion about it, for some have interpreted the phrase "old Stoss" in the inscription on the drawing to mean the famous sculptor Veit Stoss (died 1533). Much of the misunderstanding stems from the well-known fact that Veit Stoss did, indeed, live to an uncommonly advanced age — although his precise birthdate is not known. The inscription on the drawing means something else entirely. In his rather clumsy way, its author combines information about the making of the chandelier with references to his own family, relating that "old Stoss" had carved the chandelier — it was then still hanging in the Rathaus — after the drawing by Dürer, adding, by way of explanation, that this Stoss was a sculptor and the father of Veit and Philipp Stoss. He then chooses to mention that these two had studied with his grandfather, Johann Neudörfer, and had subsequently been ennobled on account of their writing skills. Philipp and Veit Stoss were not the sons of Veit Stoss, however — as has been automatically assumed — but, rather, his grandsons: the sons

of his son from his second marriage, Willibald Stoss. The research by Adolf Jaeger (1958, pp. 96–104) provided much information about Veit Stoss's descendants. Veit Stoss the Younger (1533–1576) and his younger brother, Philipp Stoss (1537–1603), served as secretaries to the emperor, enjoyed certain imperial favors, and were eventually ennobled, as the inscription attests. Their father, Willibald Stoss, must have been born in Nuremberg in 1500/1505; he died in 1573 in Schweinfurt, where he had been a citizen since 1560. In his youth, Willibald was a sculptor and goldsmith, but later led a somewhat unsettled life. In 1534, when he acted as executor of his father's will, he was still definitely described as a sculptor. In 1522, at the time that the dragon chandelier was made, he was probably no more than twenty years old and, surely, still was apprenticed in his father's workshop. Apparently, he only became a master in 1530, the year in which we know that he married.

From the wording of the inscription on the Dürer drawing it is patently clear that this Willibald Stoss was the carver of the dragon chandelier, for Willibald was the father of the Veit and Philipp Stoss referred to there. It is

perfectly natural that the Neudörfer grandson, who penned his inscription after the death of the approximately seventy-year-old Willibald, should allude to him as "old Stoss," without thinking of the far-better-known Veit Stoss, who would later become such an important figure in the history of art, and who had died over half a century before. The text of the inscription was concerned with the brothers Veit and Philipp; compared to them, their father, Willibald, was, indeed, "old Stoss."

The inscription on the drawing has always been the only source linking the chandelier with any member of the Stoss family. Given the character of the work, there are naturally no stylistic features that would help to attribute it to any particular sculptor. RK

Ex collection: Gleisshammer Castle, near Nuremberg (after 1607).

Bibliography: Essenwein, *Leuchter*, 1868, cols. 127–128, ill. 12; Essenwein, 1877, pl. 73,2; Kohlhaussen, 1936–39, pp. 135–41, ills. 1–3, 1955, pp. 289–90, ill. 252; Heikamp, 1960, pp. 42–55, ill. 4; Dettloff, 1961, vol. 1, pp. 164–65, ill. 58, vol. 2, pl. 241; Grote, 1961, pp. 76–77, ill. 36; Kohlhaussen, 1970, no. 115, ill.; Stafski, in *Dürer*, 1971, no. 709; Pechstein, in *Veit Stoss...*, 1983, no. 13; Kahsnitz, 1984, pp. 48–49.

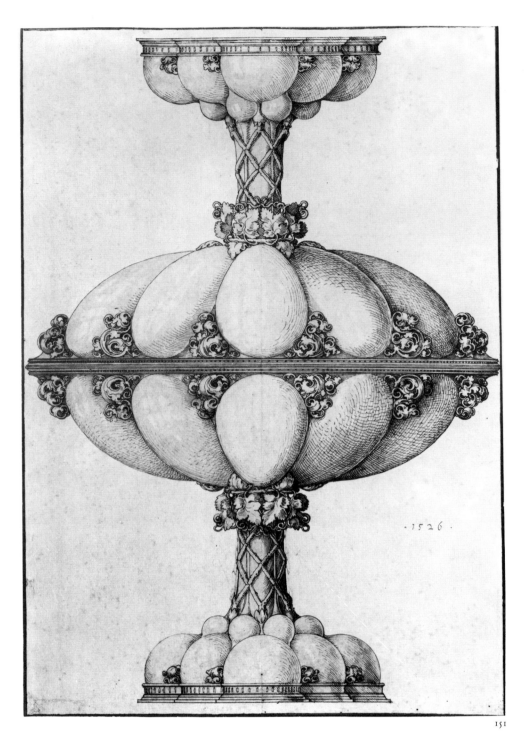

151 ALBRECHT DÜRER
Design for a Double Goblet
1526
Pen and black ink, with sepia wash, on paper
17 1/8 x 11 1/2 in. (42.9 x 29.2 cm.)
Watermark: coat of arms with two lilies and the
letter "B."
Vienna, Graphische Sammlung Albertina
3185 D 162

The double goblet, consisting of two identical
drinking cups attached at their rims, was a
standard commission for goldsmiths. They were
often made as wedding presents. This design by
Dürer obviously reproduces the double goblet
in full size, and was intended to give the gold-
smith an accurate idea of the finished object. It
provided a new structural form for a traditional
type of double cup.

The goblet rests on an embossed octagonal
foot. Branches that emerge from the onion-
shaped bosses wind around the short shaft of
the cup, creating a row of diamond shapes, be-
fore disappearing in a wreath of vines at the base
of the bowl. The spandrels beneath the rims are
filled with Late Gothic foliate designs. In con-
trast to the wealth of plant forms in the earlier
design for a table fountain (cat. no. 113), large
geometrical shapes dominate this late work. In-
dividually, the ornaments derive from the
standard Late Gothic repertoire, but they have
been reinterpreted with a Renaissance sense of
proportion. The prominent egg-shaped bosses
on the bowl of the cup, for example, bear a
greater similarity to an Ionic molding than to
their antecedents in Late Gothic goldsmiths'
work.

"Somewhat cool in its grandeur" (Wölfflin),
this design has caused some scholars to doubt its
authenticity. Tietze and Tietze-Conrat flatly re-
fused to accept it as a work by Dürer. Winkler,
however, recognized Dürer's late style specifi-
cally in the delicate, clean outlines and hatch-
ings. Kohlhaussen explained the cool precision
of the sketch by reminding us that it was in-
tended to serve the goldsmith as a detailed
working design. He suspected that Dürer pro-
duced the drawing for his brother, the gold-
smith Endres Dürer. R S

EX COLLECTION: Imperial Collection, Vienna.

BIBLIOGRAPHY: Wölfflin, 1905, p. 241, n. 1; Winkler,
1936, no. 933; H. Tietze and E. Tietze-Conrat, 1937–38,
vol. II, no. A 430; Panofsky, 1948, no. 1567; Kohlhaussen,
1968, pp. 362, 528; Koschatzky and Strobl, 1971, no. 139;
Strauss, 1974, no. 1526/12.

152 ALBRECHT DÜRER
Willibald Pirckheimer
1524
Engraving, first state
Plate: 7 1/16 x 4 1/2 in. (17.9 x 11.4 cm.);
paper: 7 1/2 x 4 13/16 in. (19 x 12.1 cm.)
Monogrammed at lower right, and inscribed at
bottom: BILIBALDI · PIRKEYMHERI · EFFIGIES / ·
AETATIS · SVAE · ANNO · L · III / · VIVITVR · INGENIO ·
CAETERA · MORTIS ·/· ERVNT ·/· M · D · XX · IV.
("Portrait of Willibald Pirckheimer in his 53rd
year. He will live on through his intellect, the rest
is destined to die. 1524.").
Watermark: (Meder, no. 158).
New York, The Metropolitan Museum of Art,
Fletcher Fund, 1919
19.73.119

Dürer's lifelong friendship with the Humanist
Willibald Pirckheimer began when both of them
were in Italy, the twenty-three-year-old artist
on a study tour in Venice, the nearly contem-
porary young patrician pursuing legal and
humanistic studies at the universities of Padua
and Pavia. In later years, Dürer made several
portraits of his closest friend and spiritual men-
tor. Of the three portraits to survive, this 1524
engraving, a three-quarter-profile bust, is the
latest. It represents the Humanist when he was
at the peak of his career, and has largely fixed
posterity's image of this prominent scholar. The
strained face, with its fleshy double chin, full
lips, gnarled forehead, and piercing eyes, be-
trays a personality of great intellectual force and
energy. As Panofsky put it, "the magnificent
bulldog head of Dürer's best friend is not so
much embellished as transfigured." The two
profile-portrait drawings, of 1503, in Berlin
(Winkler, no. 268/270), call attention to the
broken line of the nose, but in this three-quar-
ter-profile engraving, the less attractive facial
features have been softened. Here, Dürer is not
portraying his friend so much as the "vir illus-
tris": the important man. It is by no means
coincidental — and, moreover, extremely sig-
nificant for the social history of the portrait,
during the Humanist period — that Dürer was

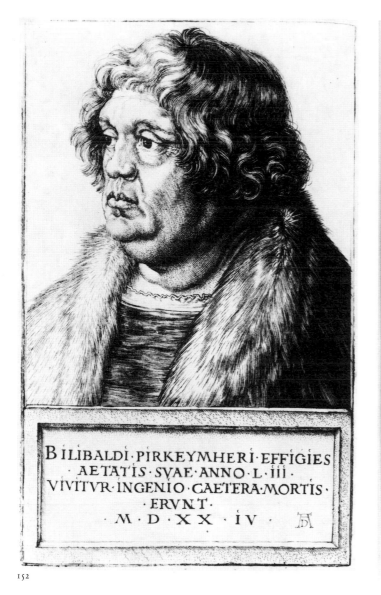

152

153

able to depict the scholar in much the same way as he did the Elector of Saxony, Frederick the Wise (cat. no. 153).

The inscription is reminiscent of those on Roman tombs, and stresses the public, commemorative function of the graphic portrait. Such portrayals from life were intended to ensure that the subject would be remembered after death. Also a memorial on paper, this portrait engraving resembles the 1507 woodcut portrait of Conrad Celtis, in the form of a Roman epitaph, by Hans Burgkmair. The inscription, a quotation from the so-called *Appendix Vergiliana* — a collection of classical verse — offers a humanistic image of man in which his creative spirit triumphs over his mortality. It is similar to the epitaph that Pirckheimer wrote, only four years later, for the grave of Albrecht Dürer in the Johannisfriedhof: "Whatever was mortal of Albrecht Dürer is covered by this tomb."

All of Dürer's portraits of Humanists present the relationship between mortality and immortality in emblematic fashion: They promise immortality to the sitter, in his lifetime. The ideas of transitoriness and immortal fame are reconciled in the formal combination of a realistic likeness and an inscription plaque in the classi-

cal style; the portrait of the living, but mortal, subject is accompanied by the cold, but lasting, commemorative stone.

Pirckheimer sent one copy of his portrait to Erasmus of Rotterdam, who displayed it in his study in Basel, and he used other copies as bookplates. RS

EX COLLECTIONS: William Sharp, Manchester (Lugt, no. 2650); Junius S. Morgan, New York.

BIBLIOGRAPHY: Bartsch, 1808, no. 106; Meder, 1932, no. 103; Panofsky, 1948, vol. I, p. 239, vol. II, no. 213; Rupprich, 1957, p. 100; *Dürer*, Nuremberg, 1971, no. 293; Talbot, ed., 1971, no. 77; Strauss, 1976, no. 102; *The Illustrated Bartsch*, 1981, no. 106, commentary, pp. 234–38; *Caritas Pirckheimer*, 1982, no. 33; Schuster, 1983, pp. 18–20.

153 ALBRECHT DÜRER

Frederick the Wise, Elector of Saxony

1524
Engraving
7⁹/₁₆ x 4¹⁵/₁₆ in. (19.3 x 12.6 cm.)
Monogrammed (at left center) with a reversed "D," and inscribed (at bottom, on the panel): · CHRISTO · SACRVM · / ILLE DEI VERBO · MAGNA PIETATE ·

FAVEBAT · / · PERPETVA · DIGNVS · POSTERITATE · COLI · / · D[OMINO] · FRID[E]R[ICO] · DVCI · SAXON[IAE] · S[ACRI] · R[OMANI] · IMP[ERII] · / · ARCHIM[ARESCHALLO] · ELECTORI · / · ALBERTVS · DVRER · NVR[IMBERGENSIS] · FACIEBAT · / · B[ENE] · M[ERENTI] · F[ECIT] · V[IVVS] · V[IVO] · / · M · D · XXIIII. ("Sacred to Christ. He served the Word of God with great piety, and deserves to be revered by posterity for all time. Albrecht Dürer of Nuremberg made this for Duke Frederick of Saxony, Grand Marshall and Elector of the Holy Roman Empire. He made it for the highly honorable one from life. 1524.").
New York, The Metropolitan Museum of Art, Fletcher Fund, 1919
19.73.116

The Elector of Saxony, Frederick the Wise, was in Nuremberg with other dignitaries of the empire for an Imperial Diet in the winter of 1522/23. Dürer made use of the opportunity to do a drawing of his first great champion — now sixty years of age — in silverpoint and black chalk. The small drawing, on which he then based this portrait engraving, is preserved in the École des Beaux-Arts, Paris (Winkler, no. 897). In the engraving, only the two Saxon coats of arms — that of the elector on the left, and that of the

1526
VIVENTIS·POTVIT·DVRERIVS·ORA·PHILIPPI
MENTEM·NON·POTVIT·PINGERE·DOCTA
MANVS

154

154 ALBRECHT DÜRER
Philipp Melanchthon
1526
Engraving
6⁷/8 x 5 in. (17.4 x 12.3 cm.)
Monogrammed and inscribed (at bottom, on the
plaque): 1526/VIVENTIS · POTVIT · DVRERIVS · ORA ·
PHILIPPI / MENTEM · NON · POTVIT · PINGERE ·
DOCTA / MANVS ("Dürer was able to depict
Philipp's features as though living, but the prac-
ticed hand could not portray his spirit").
New York, The Metropolitan Museum of Art,
Fletcher Fund, 1919
19.73.117

In type, the engraving of Philipp Melanchthon
is like those Dürer made from 1522 to 1524 of
the *Large Cardinal*, Willibald Pirckheimer, and
Frederick the Wise (cat. nos. 152, 153). It is the
earliest surviving likeness of the Wittenberg
professor, at that time a mere thirty years old,
who, as a scholar of classical languages and
a reformed theologian, was among Martin
Luther's closest allies. Dürer's profile portrait
captures Melanchthon's ascetic features: the
gaunt face with its domed forehead, high cheek-
bones, and sharp, hooked nose. It also com-
municates something of the youthful, passion-
ate faith with which the Reformation was prop-
agated in these years. Although Melanchthon
appears against the open sky, the mullions of a
window are reflected in his eye. Białostocki has
traced this motif, which is also found in Dürer's
other portraits of Humanists, to the concept of
the eye as the "window of the soul." The same
writer also interprets the presence of that re-
flected cross as a sign of the ultimate focus of
the reformer's attention. The Latin epigram ex-
presses the Platonic dualism between the body
and the spirit that had already been stressed in
the Pirckheimer portrait. Yet, at the same time,
it is given a different twist by its reference to the
artist's ability. The concept of the limited ex-
pressiveness of a mere physical likeness plays an
important role in modern portrait theory. It
may also be that the inscription conveys the
reformer's conviction that images are altogether
inadequate.

A preparatory pen drawing is preserved in the
Museo Horne, in Florence (Winkler, no. 901).
It must have been made between November
1525 and May 1526, when Melanchthon was in
Nuremberg on two occasions. He had been in-
vited by the council to help found the city's first
Latin public school. On these visits, the
"Praeceptor Germaniae," as he came to be
known, was a guest of Dürer's friend Pirck-
heimer.

Inasmuch as Dürer had been unsuccessful in
his attempt to make a portrait of Luther, he may
have seen Melanchthon, above all, as a leading
representative of the Reformation. Nuremberg
had officially converted to Lutheranism in 1525.
It has often been suggested that, in the same
year that he produced this portrait — 1526 —
Dürer also gave the Apostle John Melanch-
thon's features, in the left-hand panel of the
Four Apostles. However, this is mere specula-

Wettin family on the right — and the inscription
at the bottom suggest the subject's princely
rank. Although Frederick was the most power-
ful territorial prince in Germany, Dürer por-
trays him just as he did the Humanist Willibald
Pirckheimer (cat. no. 152). Frederick's large
head, presented in three-quarter profile, with all
of its irregularities and signs of age, is topped
with a simple biretta, and sunk deep into a fur
collar. In contrast to the dispassionate engraved
profile portrait of the *Large Cardinal* (Albrecht
von Brandenburg; Bartsch, no. 103), for exam-
ple, this depiction of an august personage also
radiates great human warmth.

Since their first meeting in 1496 — at which
time Dürer had also painted Frederick's por-
trait — the elector had secured important com-
missions for the artist. In Wittenberg, he assem-
bled the largest collection of Dürer's paintings.
Dürer revered him not only as the august prince
of the empire and as a man of great personal

integrity, but he also respected Frederick as a
patron and friend of the Humanists, the learned
founder of Wittenberg University, and Luther's
staunch protector. Dürer's dedicatory inscrip-
tion, which assures the elector of eternal fame
because of his service to the Word of God, may
well refer to the prince's support of Luther's
translation of the Bible.

Frederick the Wise died only a year after the
engraving was made, in 1525.

RS

EX COLLECTION: Junius S. Morgan, New York (Lugt, no.
1536).

BIBLIOGRAPHY: Bartsch, 1808, no. 104; Meder, 1932, no.
102; Panofsky, 1948, vol. I, p. 239, vol. II, no. 211; *Dürer*,
Boston, 1971; *Dürer*, Nuremberg, 1971, no. 547; Talbot,
ed., 1971, no. 76; Strauss, 1976, no. 101; *The Illustrated
Bartsch*, 1981, no. 104, commentary, p. 229.

tion. The copperplate of the Melanchthon portrait is preserved in Gotha. RS

EX COLLECTION: Junius S. Morgan, New York.

BIBLIOGRAPHY: Bartsch, 1808, no. 105; von Eye, 1864, col. 16; Meder, 1932, no. 104; Panofsky, 1948, vol. I, p. 238, vol. II, no. 212; Thulin, 1961, pp. 180–93; Białostocki, 1970, pp. 159–76; *Dürer*, Nuremberg, 1971, no. 409; Talbot, ed., 1971, no. 78; Strauss, 1976, no. 104; *The Illustrated Bartsch*, 1981, no. 105, commentary, pp. 230–32; *Martin Luther*, 1983, no. 430.

155 ALBRECHT DÜRER
Erasmus of Rotterdam
1526
Engraving
9 3/4 x 7 1/2 in. (24.7 x 19.4 cm.)
Monogrammed and inscribed at upper left:
IMAGO · ERASMI · ROTERODA/MI · AB · ALBERTO · DVRERO · AD/VIVAM · EFFIGIEM · DELINIATA · / ΤΗΝ · ΚΡΕΙΤΤΩ · ΤΑ · ΣΥΓΓΡΑΜ / ΜΑΤΑ · ΔᴇΙΞΕΙ · MDXXVI ·
("Portrait of Erasmus of Rotterdam drawn from life by Albrecht Dürer. / His writings provide a better picture. / 1526.").
New York, The Metropolitan Museum of Art, Fletcher Fund, 1919
19.73.120

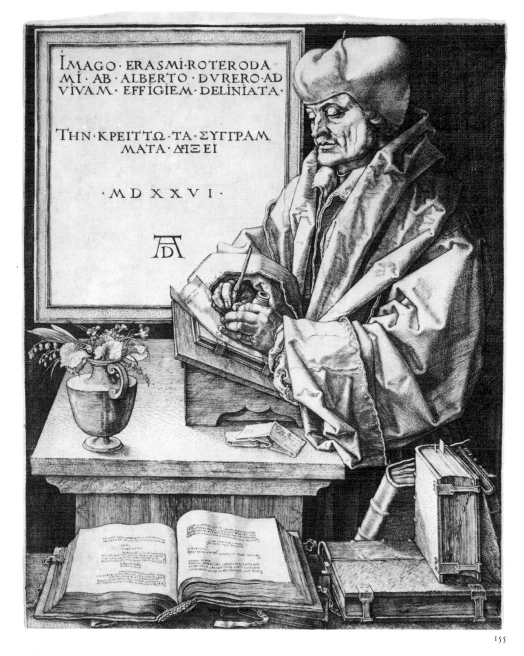

155

The 1526 engraving of Erasmus of Rotterdam was Dürer's last effort at printmaking. It surpasses his other portraits of Humanists (see cat. nos. 152, 154) in its large format, more elaborate composition, and richness of execution. It shows the gaunt scholar as a half-length figure, standing at his writing desk and wearing a full gown and a doctor's hat as symbols of his rank. He is surrounded by his books, which are arranged like a still life on a ledge in the foreground. With a reed pen in his right hand and an inkpot in his left, he is just about to write on a sheet of paper. On the desk is a small, antique vase containing a few violets and lilies of the valley. The composition of this engraving recalls painted portrayals of Saint Jerome, with whom the Humanists identified.

The various objects are arranged according to a strict system of right angles. Their vanishing points all converge on the Greek inscription centered on the plaque on the back wall — "His writings provide a better picture" — which becomes the true focus of the picture, and provides the key to its interpretation. The subject, himself, seems almost to have been dislodged from the center of the composition by the plaque as though it were, in fact, a window whose light he requires, to write by. The scholar's hands are at the intersection of the two diagonals; only after noticing his writings in the open book in the foreground does one become aware of their author. The portrait is thus an illustration of the Greek inscription, and, at the same time, a small treatise on the art of portraiture. It amounts to a confession of the inadequacy of the artistic likeness, even when taken, as the Latin inscription assures us, from nature.

The word is given precedence over the image. Schuster has pointed out that, for this reason, the inscription panel, which resembles a picture frame, ultimately constitutes the actual "portrait."

We know that Erasmus was disappointed with Dürer's portrait of him. In 1528, he wrote: "Pinxit me Durerus, sed nihil simile." Art historians have tended to agree with him, failing to appreciate Dürer's pictorial concept.

In his letters to Pirckheimer, Erasmus repeatedly expressed the desire for Dürer to execute his portrait. When Dürer finally agreed to satisfy that desire, in 1526, he was able to refer to two portrait studies that he had made of the great man in Brussels in the late summer of 1520. One of these, a charcoal drawing preserved in the Cabinet des Dessins, at the Louvre, in Paris (Winkler, no. 805), presents a bust of Erasmus, almost *en face*, again wearing his doctor's hat and gown, and gazing downward. The second drawing, now lost, was probably a three-quarter-profile portrait like the engraving.

Dürer adopted the Latin and Greek inscriptions from a 1519 portrait medallion by Quentin Massys, who also produced a portrait of Erasmus (a copy is in the Palazzo Corsini, in Rome) as a half-length figure, within an asymmetrical composition. The still-life elements and the naturalism with which the various materials are rendered also betray distinct Netherlandish influences, which prevail in Dürer's late style. RS

EX COLLECTIONS: August Artaria, Vienna (Lugt, no. 33); Junius S. Morgan, New York.

BIBLIOGRAPHY: Bartsch, 1808, no. 107; Haarhaus, 1899, n.s. 10, pp. 44–56; Meder, 1932, no. 105; Panofsky, 1948, vol. I, p. 239, vol. II, no. 214; Treu, 1959, pp. 35–36, figs. 8–9; *Erasmus*, 1969, no. 277; *Dürer*, Nuremberg, 1971, no. 278; Talbot, ed., 1971, no. 79; Strauss, 1976, no. 105; *The Illustrated Bartsch*, 1981, no. 107, commentary, pp. 238–40; Schuster, 1983, pp. 18–19.

156

156 HANS SUESS VON KULMBACH

Design for Stained Glass:
Saint Augustine

1507–9
Pen and brown ink, with gray wash, over
traces of chalk, on paper
13³/₁₆ x 12¹/₄ in. (33.5 x 31.2 cm.)
Watermark: a scale with a star (variant of
Briquet 2584).
Erlangen, Graphische Sammlung der Universität
II E 46c

Hans Suess von Kulmbach created a new form
of window composition in which small-scale in-
dividual panels — whether circular or rec-
tilinear, trefoiled or quatrefoiled — were set in a
field of clear, circular bull's-eye glass (But-
zenscheiben). Surrounded by light, the figural
panel gave the impression of a floating image.
This window design was first employed for the
Marian cycle in the Haus zum Goldenen Schild,
in Nuremberg; an example of this type of win-
dow, set with quatrefoils, is clearly depicted in
Kulmbach's *Disputation before Maxentius* from
the 1515 *Altarpiece of the Virgin* in the Church
of the Virgin Mary, Cracow.

Numerous designs by Kulmbach for small-
scale glass panels have survived. The present
example belongs to a series representing the
Church Fathers; the executed panel, based on
this design, is now in the Germanisches
Nationalmuseum, Nuremberg (see cat. no. 157),
and another from the same series, of Saint
Jerome in his study, is in the Museum of Fine
Arts, Boston (see cat. no. 158). Another quatre-
foil, depicting Saint Lawrence (see cat. no. 159),
with a similar foliate border, is also in the Ger-
manisches Nationalmuseum. A design with a
seated Virgin and Child (Winkler, 1942, no. 99);
an executed panel of the Virgin and Child on a
crescent moon (formerly in the F. E. Sidney
collection; see B. Rackham, *Old Furniture*,
1931, XXX, pl. 1), modeled on a drawing in Er-
langen of a seated Virgin and Child (Winkler,
1942, A. 5); and yet another panel, in the Vic-
toria and Albert Museum, London, may be add-
ed to this group.

The circumscribed line that runs through the
inhabited foliate border suggests that the pres-
ent design was employed as well for the execu-
tion of a roundel. The multiple and adaptive use

157

of designs was a common workshop practice of the period. The study for a roundel for the Haus zum Goldenen Schild, also representing Saint Augustine (Winkler, 1942, no. 104), is, inversely, inscribed with the outlines of a quatrefoil. Although the panel executed after the present drawing replicates the figure precisely, if rather dryly, the border with grapes and angels is based on that in the drawing of the seated Virgin and Child, demonstrating the interchangeable use of ornament.

TH

BIBLIOGRAPHY: Weinberger, 1921, p. 189, pl. XIII; Bock, 1929, 2 vols., no. 235; Winkler, 1929, 50, p. 42; Stadler, 1936, no. 44; Winkler, 1942, pp. 34, 89, no. 100, pls. 100, 100 A, B.

157 WORKSHOP OF VEIT HIRSCHVOGEL THE ELDER, after designs by, or attributed to, HANS SUESS VON KULMBACH

Saint Augustine, from a series of panels of the Church Fathers

About 1507
Pot metal and white glass, with silver stain
18 x 16 in. (45.7 x 40.6 cm.)
Nuremberg, Germanisches Nationalmuseum
MM 801

An exact model for the *Saint Augustine* panel exists in the form of a drawing (cat. no. 156) by Hans Suess von Kulmbach, now in the Graphische Sammlung der Universität, Erlangen. The *Saint Jerome* panel (cat. no. 158), identical in size and in the design of the frame, was also modeled on a drawing by Kulmbach, and both were originally part of a series representing the four Fathers of the Church. Kulmbach is known to have made drawings of the Church Fathers. The three that still exist in the Kupferstichkabinett, Dresden, are roundels, with the outlines of a quatrefoil inscribed within, indicating that they were intended as models for stained glass and, also, that their format could be changed and the design reused. The present stained-glass panels are standard representations of the two Church Fathers. Each is shown in his study, contemplating a book. Saint Augustine's room is furnished with a lectern and, in the background, there is a window glazed with round *Butzenscheiben* (the centers of disks of glass that still have the thick knob where they

158

were broken off the spinning rod, or pontil, during the blowing process). The panel with Saint Jerome shows a lion curled at his feet, but this lion is not to be confused with the new iconography invented for the Church Fathers in fifteenth-century Germany and employed by Kulmbach in his drawings, in Dresden, for roundels. Here, Saint Jerome's lion assumes a different meaning, symbolizing the lion of Saint Mark. The drawings of the other Church Fathers in the series also include Evangelist symbols, and there was once such a series in stained glass in Nuremberg in the chapel of the Haus zum Goldenen Schild (F. Stadler, *Hans von Kulmbach*, Vienna, 1936, p. 109, pl. 10). The most obvious change from the model (cat.

no. 156) to the finished work is in the simplification of the border; the profusion of monsters and human figures that vary in each lobe is standardized in the glass panel so that the design repeats in each foil. In the *Saint Augustine* panel, a small cherub grasps garlands of lilies and grapes; in the *Saint Jerome* panel, a female nude clings to stylized foliage while a cock pecks at clusters of berries. These panels were probably made in the Hirschvogel workshop.

JH

EX COLLECTION: Baron Eberhard Schenk zu Schweinsberg, Wiesbaden.

BIBLIOGRAPHY: Frenzel, 1961, 15, pp. 42–44, pl. 5; S.[warzenski], 1972, LXX, pp. 118–19; Caviness, ed., 1978, pp. 66–76, no. 30.

158 WORKSHOP OF VEIT HIRSCHVOGEL THE ELDER, after designs by, or attributed to, HANS SUESS VON KULMBACH

Saint Jerome, from a series of panels of the Church Fathers

About 1507
Pot metal and white glass, with silver stain
18 x 16 in. (45.7 x 40.6 cm.)
Boston, Museum of Fine Arts, Francis Welch Fund
1972,985

See catalogue number 157.

159

159 WORKSHOP OF VEIT HIRSCHVOGEL THE
ELDER, after a design attributed to HANS SUESS
VON KULMBACH

Quatrefoil Panel, with Saint Lawrence
About 1507
Pot metal and white glass, with silver stain
18 x 16 in. (45.7 x 40.6 cm.)
Nuremberg, Germanisches Nationalmuseum
MM 802

This stained-glass representation of Saint Law-
rence is another example of the quatrefoil type
of panel, also known as *Kabinettscheiben* be-
cause of their use in small-scale architecture
such as cloisters, chapels, chapter houses, and
even private apartments. The subject would in-
dicate that favorite or patron saints of the own-
ers were also depicted in these small stained-
glass panels that were completed in the window
aperture by clear-glass quarries, or *Butzen-
scheiben*. In this example, the saint wears his
customary ecclesiastical dress, the dalmatic of a
deacon, and clasps the handle of a grill, the sym-
bol of his martyrdom. He holds an open book
in his left hand, also symbolic of his sanctity.
When a book is carried by a saint, it is usually
shown closed, but, in this particular case, Law-
rence is seen in the act of reading, similar to the
way in which the Church Fathers are portrayed
(see cat. nos. 157, 158). It may be that Hans
Suess von Kulmbach, to whom this panel is also
attributed — although the drawing for it has not
survived — was overly influenced by his series
devoted to the Church Fathers when depicting
the series of saints to which this panel belongs.
This influence appears again in the border of the
panel, where acanthus-type foliage is wound
around a central stem — as in the Church
Fathers panels. In contrast to the other exam-
ples, however, the border that surrounds Saint
Lawrence differs in every lobe, combining styl-
ized leaves of various sorts, daisies, and a pair of
battling grotesques. As in the other panels, the
border ornament seems to have no symbolic re-
lationship to the central figure, forming, in-
stead, a decorative frame for the main theme.

JH

BIBLIOGRAPHY: unpublished.

160

160 HANS SUESS VON KULMBACH

Saint Michael, from The Fall of the
Rebel Angels
1508–11
Pen and ink and brush, on paper, with gray and
black wash
12¹/₂ x 16¹/₂ in. (31.8 x 41.9 cm.)
Boston, Museum of Fine Arts, Harvey D. Parker
Collection
97.623

This drawing constitutes the central portion of
the cartoon for the Fall of the Rebel Angels
window in the Allerheiligenkapelle of the
Zwölfbrüderhaus, in Nuremberg — an old
men's home founded in 1501 by Matthäus
Landauer and completed under the direction of
the architect Hans Beheim the Elder in 1508.
The decoration of the chapel was entrusted to
Dürer and his workshop. Dürer was commis-
sioned to paint the *Adoration of the Trinity*
(now in the Kunsthistorisches Museum, Vien-
na), for which he made a sketch in 1508 (the
drawing is in the Musée Condé, Chantilly), but
the altarpiece was not completed and installed
until 1511; whether Dürer was responsible for
the overall design of the glazing program is un-
clear, but Hans Suess von Kulmbach appears to
have served, at least partially, as immediate
supervisor. The glass itself is said to have been
produced by the workshop of Veit Hirschvogel
the Younger (see G. Frenzel, 1960, 23, p. 206).

The fenestration of the east end of the chapel
comprised a central triple-lancet window flank-
ed by two double-lancet windows. The central
window, dated 1508, was devoted to the Trini-
ty, while donor panels filled the northern win-
dow. The Fall of the Rebel Angels, paired with
the Sacrifice of Isaac, was placed in the left lan-

cet of the southern window. The windows were
removed in 1810 and subsequently made their
way into the collections of the Kunstgewer-
bemuseum, Berlin, where they remained until
they were destroyed during World War II.

According to Panofsky (*Albrecht Dürer*, 2nd
rev. ed., 1945, p. 125), Dürer was specifically
charged with sketching out the designs for the
stained glass. Reference has been made in this
regard to his 1509 drawing of the Fall of the
Rebel Angels (British Museum, London, Sloane
5218–190 [F. Winkler, *Die Zeichnungen Al-
brecht Dürers*, Berlin, 1936–39, 4 vols., II, no.
468]); while there are compositional similarities
between the drawing and the window, Smith
(1983, p. 131, no. 35) has pointed out that the
drawing was, in fact, produced for the Schilling
family, who had nothing to do with the Zwölf-
brüderhaus, and that the format of the window
design in the drawing does not conform to that
of the window in the chapel; thus, Hans Suess
von Kulmbach must have either produced his
own designs or based his drawings on lost com-
positions by the master. This does not take into
account, however, Dürer's highly expressive
drawing, dated 1511, of the head of Landauer
(in the Städelsches Kunstinstitut, Frankfurt,
6951 [F. Winkler, *Die Zeichnungen Albrecht
Dürers*, Berlin, 1936–39, 4 vols., II, no. 511]).
This may have been a study for the donor's por-
trait in the *Adoration of the Trinity* altarpiece,
although the figure there is seen from the rear in
three-quarter view rather than in profile, as in
the drawing. This, of course, could have been
simply a compositional adjustment made in the
course of painting the altarpiece. The head of
Landauer in the donor's stained-glass window,
on the other hand, closely follows the composi-
tion of the drawing. Whether it was intended to
or not, Dürer's drawing seems to have influ-
enced Kulmbach's designs. If this is the case, the
date of the donor windows would have to be
moved up to 1511.

The present drawing was ascribed to Dürer
by Dodgson, but this attribution does not enjoy
current acceptance. Winkler noted stylistic pa-
rallels with Kulmbach's graphic works, and
Smith (1983, p. 131) has convincingly compared
the drawing with Kulmbach's cartoons of Saint
Leonard (in the Universitätsbibliothek, Er-
langen) and of Saint Veronica (in the Kupfer-
stichkabinett, Dresden). These drawings are
generally dated 1510 or after, which would sug-
gest a later date for the Rebel Angels window, in
keeping with that of the donor windows.

TH

BIBLIOGRAPHY: Dodgson, 1930–31, 5, pp. 42–43; Wink-
ler, 1959, pp. 24, 27, pl. 13; G. Frenzel, 1960, 23, p. 206,
fig. 10; *The Graphic Work of Albrecht Dürer . . .*, 1971, p.
24, no. 133; Smith, 1983, p. 131, no. 35.

Figure 133 Fragment of the Fall of the Rebel Angels
window, from the Allerheiligenkapelle of the Zwölf-
brüderhaus, Nuremberg

161

161 HANS SUESS VON KULMBACH

Saint John the Baptist in the Wilderness

About 1510
Pen and brown ink, over black chalk, on paper
Diameter, 10 13/16 in. (27.5 cm.)
New York, The Metropolitan Museum of Art,
Harris Brisbane Dick Fund, 1953
53.112

Hans Suess von Kulmbach produced numerous designs for stained-glass roundels between 1508 and 1511, including two series — one, of martyred saints, and another, of the Church Fathers (see cat. nos. 156, 157, 158) — as well as designs for individual roundels of standing saints, among other subjects. Whether these were intended for silver-stained roundels or pot-metal glass is uncertain, but the scale of the drawings — all are between twenty-four and twenty-eight centimeters in diameter — suggests the former. Stylistically, this drawing is closely related to one of Saint Wenceslas in the Kupferstichkabinett, Dresden, but there is no indication that they belong to the same series. The present example is less finished and may have been a compositional sketch rather than a finished design, proper. TH

EX COLLECTIONS: Princes of Liechtenstein, Feldsberg Castle, and Vienna; Otto Wertheimer, Paris.

BIBLIOGRAPHY: Roettinger, 1927, n.s. IV, p. 17; Winkler, 1929, vol. 50, pp. 33, 44; Stadler, 1936, p. 115, no. 57, pl. 22; Winkler, 1942, p. 91, no. 110, pl. 110; Smith, 1983, no. 36.

162 HANS SUESS VON KULMBACH

Portrait of a Young Man

About 1508
(reverse): Girl Making a Garland
About 1510
Tempera and oil on wood
7 x 5 1/2 in. (17.8 x 14 cm.)
The portrait is poorly preserved, but the painting on the reverse is in excellent condition.
New York, The Metropolitan Museum of Art,
Gift of J. Pierpont Morgan, 1917
17.190.21

Ever since the discovery of this small panel, the depiction of the girl and the cat on the reverse has occasioned greater interest than has the portrait of the young man. Nevertheless, it must be assumed that the portrait was, indeed, intended as the front. Allegorical, mythological, or genre scenes were traditionally relegated to the backs of such panels, although painted coats of arms were even more commonly found on the reverse sides. Since many panels with portraits were later reduced in thickness so that they could be set into frames, the paintings on the backs have been lost.

The likeness of the youthful sitter is remarkable in various respects: It is a half-length portrait, without hands. The young man wears neither a cap nor any distinguishing attribute that would help to identify him — there is neither a flower, a ring, nor an embroidered monogram. The portrait acquires a certain tension from the fact that the lines of the man's coat point downward, while his face is lifted as he gazes into the distance, thus conveying an impression of movement, restlessness — even of improvisation — and, ultimately, of intimacy as well as vitality. The personality presented is boyish and immature, and the portrait, as a whole, is as unformed as is the child-like face, with its slightly parted lips and full cheeks.

Not so the picture on the reverse. There, the painted frame, the center post of the window, and the division of the window by the closed half-screen produce a system of coordinates in which the young woman and her cat have their fixed positions. The girl's hair flows freely, secured only by a band, as a sign of her marriageability. She is tying flowers around a hoop to make a wreath. The fluttering banderole that curls, like a heraldic ornament, about the more solid architectural forms, is inscribed with the legend: ·ICH PÌNT MÌT, VERGIS MEÌN NIT (in modern, standard German, "Ich binde mit Vergissmeinicht" ["I am tying with forget-me-nots"]). In the context of such a vow of faithfulness, the appealing cat seated beside her can

343

162: reverse 162: obverse

part would have been a portrait of the man's fiancée, which could have been commissioned some years later. It is conceivable that Kulmbach was asked to create a diptych at a later date, and, at that time, added the painting on the reverse of the bridegroom's portrait. This would explain the greater maturity of the former, and the deftness in the handling of its symbolic elements. KL

EX COLLECTIONS: Principe di Santangelo, Naples (about 1884); Dominic Ellis Colnaghi, London (in 1906); J. Pierpont Morgan, New York.

BIBLIOGRAPHY: Thausing, 1884, p. 366; *Exhibition of Early German Art,* 1906, pls. 39, 39 A; Friedländer, 1906, p. 587; Rauch, 1907, pp. 78–79; Winkler, 1930, p. 452; Tietze, 1935, no. 206; Stadler, 1936, p. 54, nos. 118 a, 118 b; Kuhn, 1936, no. 214; Schulz, 1939, p. 352; Wehle and Salinger, 1947, pp. 190–91; Winkler, 1959, p. 56; Oehler, 1973, p. 40; Butts, 1985, p. 222.

only be interpreted as a symbol of affection. The whole comprises a genre scene unmatched in painting of Dürer's time. The observation of nature is applied to a poetic concept; formal structure and painterly sensibility go hand in hand. Above the cat is the Dürer monogram — added later — and the date 1508.

It has long been recognized that the work is not, in fact, by Dürer (Thausing, 1884). In the 1906 catalogue of the London exhibition, the portrait was ascribed to a Nuremberg master influenced by Jacopo de' Barbari, and the painting on the reverse, to Wolf Traut. Rauch (1907) and Kuhn (1936) also considered Traut the painter of the *Girl Making a Garland,* and Oehler (1973), noting the form of the monogram, sided with them. Friedländer (1906) convincingly attributed both paintigs to Hans Suess von Kulmbach; Winkler (1930), Tietze (1935), and Wehle and Salinger (1947) supported that view.

The dating of the paintings, however, continued to be a matter of dispute. Because of the similarity of the portrait to the style of Barbari, Winkler (1930) called it "perhaps Kulmbach's earliest work." In 1959, he conceded the possibility that it had been painted after 1510, but noted the absence of the monogram Kulmbach was in the habit of affixing to his work by that time. On the basis of its treatment of space and its extremely painterly quality, Stadler (1936) dated the painting about 1515/18. The date on the work, 1508, may well have been transferred from the original frame, and doubtless reflects with some accuracy when the portrait of the young man was completed.

The two-sided panel implies some kind of connection between the paintings; more than likely, it is an engagement portrait. The fact that the young man turns toward the left suggests that the portrait was planned as an independent work, for, in a diptych the man customarily appears to the right of the woman (in heraldic terms). On the other hand, the painted reverse presupposes that the portrait was, indeed, one side of a hinged diptych. Its only likely counter-

163 HANS SUESS VON KULMBACH
Saint Nicholas
About 1511 (?)
Pen and ink, with gray, pink, and blue wash, on paper, cut out and glued to a second sheet
13 3/8 x 6 3/8 in. (34 x 16 cm.)
Cambridge, Massachusetts, Fogg Art Museum, Harvard University, Bequest of Meta and Paul J. Sachs
629.1927

The drawing of Saint Nicholas is an image that is at once traditional in its portrayal and distinctively representative of Hans Suess von Kulmbach's mature style. Nicholas (about 270–342), the Bishop of Myra, was widely venerated throughout Europe, and the legendary account of his life was, accordingly, well known. Here, the saint appears in full episcopal regalia: He wears a heavy cope held by a large clasp, or morse, and a miter, and clutches a crosier in his right hand. In his left hand he holds a book, a symbol of his knowledge, on which are set three

small bags — traditional attributes that identify him as Saint Nicholas. According to legend, Nicholas saved the three daughters of an important nobleman from prostitution by secretly providing each with a bag of gold as a dowry.

The pen-and-wash rendering of Saint Nicholas is one of a number of surviving drawings of bishop saints by Kulmbach, which the artist made as preliminary studies for other projects. The branch tracery at the top of the sheet indicates that this Saint Nicholas was to be framed in a larger stained-glass composition or painted altarpiece. Winkler suggested that a second figure may have been cut away from the right edge of the drawing where the paper's edge forms the outlines of the cope. The particular type of standing bishop is close to a drawing of Saint Othmar, of about 1510–15, now in Dresden (Stadler, 1936, no. 39), but it can also be compared to the figure of Saint Willibald, shown with Saint Benedict, in a painting, of 1523, from the dispersed *Altarpiece of Saint Anne,* once in the Lorenzkirche, Nuremberg, and now in Munich.

Kulmbach returned to the subject of Saint Nicholas a number of times. The same attributes as seen in the present work distinguish the depictions of the saint on the wing of the altarpiece, of about 1500, dedicated to him in the Lorenzkirche, Nuremberg (Stadler, 1936, no. 11); in a drawing in Berlin (Winkler, 1942, no. 46); in a window of the Upper Pfarrkirche (Frauenkirche), Ingolstadt (F. Winkler, *Hans von Kulmbach: Leben und Werk eines fränkischen Künstlers der Dürerzeit,* Bayreuth, 1959, pl. xv); and in the *Tabernacle Altar* in the Stadtpfarrkirche, Schwabach (Stadler, 1936, no. 142).

The dating of the Fogg drawing remains somewhat speculative, since the project for which it was created is not known. However, only Winkler has questioned the generally accepted date of about 1511 (the year that Kulmbach became a citizen of Nuremberg) and the kinship of the present work and a drawing of two bishops, for a stained-glass roundel (Stadler, 1936, no. 37), also assigned to about 1511. Given the more detailed rendering of Saint Nicholas's drapery — especially under the cope — the softer line, and the more finely delineated features, the comparison with the later painted figures in the Saint Anne altarpiece is perhaps more accurate.

BDB

Ex collections: The Rev. Dr. Henry Wellesley, Oxford (?–1866?); Ambroise Firmin-Didot, Paris (1866?–77); Baron Adalbert von Lanna, Prague (1877–1910); Max J. Bonn, London (1910–22); [Colnaghi, London]; Paul J. Sachs, Cambridge, Massachusetts.

Bibliography: ... *Collection Ambroise Firmin-Didot,* 1877, p. 4, no. 7; *Katalog ... Barons Adalbert von Lanna ...,* 1910, p. 20, no. 196; Bermann, 1922, p. 32; ... *Collection of Max J. Bonn ...,* 1922, no. 32, ill.; Winkler, 1929, 50, p. 43; Brooklyn, 1936, no. 134, pl. 134; Stadler, 1936, p. 112, no. 38, pl. 18; Mongan and Sachs, 1940, vol. I, no. 388, vol. III, fig. 198; Winkler, 1942, no. 141, p. 97; Smith, 1983, p. 133, no. 37, ill.

163

Study of a Nude Male Figure with a Bucket (recto)

About 1512
Pen and brown ink, on paper

Two Studies for a Virgin and Child (verso)

About 1512
Gray ink, on paper
7 x 3⁵/8 in. (17.9 x 9.1 cm.)
Nuremberg, Germanisches Nationalmuseum
Hz 82 (Kapsel 562)

This study of a nude depicts a young man with an athletic body in a spontaneous movement, bending forward, almost *en face*. With both hands, he grips a leather water bucket of the sort used in quenching fires and doubtless also in Nuremberg bathhouses. The distortions in the drawing of the left arm and the disproportionate feet indicate that the sheet is a rapid study from life — a common exercise among Dürer's pupils. In contrast to Dürer, however, Kulmbach lacked a tendency toward theoretical abstraction. He was far more interested in fleeting movements and expansive gestures, and was fascinated by the surfaces of the body, which, here, are modeled with fine shading strengthened by cross-hatching. The contour lines are short and frequently retraced.

Because of the fire bucket, the nude has been identified by various writers as Saint Florian, a Roman soldier who lived in the third century and, from the fifteenth century on, was invoked for protection against fire. Although it might seem unusual for a nude figure to represent a saint, it would not be the only such example in Kulmbach's oeuvre. His drawing of a nude Saint Christopher, in the Christ Church Library, Oxford (Winkler, 1942, no. 35), is quite similar to the present study and dates from about the same time.

On the verso of the Nuremberg sheet, two half-length figures of the Virgin and Child appear in outline, one above the other. Cautious, tentative strokes of the pen, which barely suggest the contours, show how Kulmbach developed his sketches at the earliest stages. Winkler correctly noted the relationship between these sketches and Kulmbach's most important painting, the *Tucher Epitaph*, made for Lorenz Tucher, in the Sebalduskirche, Nuremberg. In all probability it was Dürer himself who, in 1511, submitted the design — now preserved in the Kupferstichkabinett, Berlin-Dahlem — for a triptych in the manner of an Italian *sacra conversazione*. By the time he had completed the epitaph in 1513, Kulmbach had made numerous changes, even with regard to the central figure of the Virgin, who sits enthroned beneath a Renaissance baldachin and offers the infant Jesus a piece of fruit. Although in the Berlin design the Child is seated on the Virgin's left knee, in the finished painting he is nestled in her right arm. Because of a slight tilt of the Virgin's head in the painting, something of the hieratic severity of the overall composition has been re-

moved. It would appear that this change in concept was worked out in the present hasty sketches.

Because of their relationship to the *Tucher Epitaph*, it is possible to date these drawings to 1511–13. Although those on the recto and on the verso were done in different inks, and the one is far more finished than the other, there is no reason to assume — as Winkler does — that their execution was separated by any significant period of time.

RS

EX COLLECTION: Hans Freiherr von und zu Aufsess, Aufsess and Nuremberg (Lugt, no. 2750).

BIBLIOGRAPHY: Bermann, 1922, p. xxx, no. 58; Stadler, 1936, pp. 47, 130, no. 126, pl. 61; Winkler, 1942, p. 57, no. 33, p. 85, no. 90; Drecka, 1957, p. 71, no. 63; *Meister um Albrecht Dürer*, 1961, no. 206; Zink, 1968, no. 82; Smith, 1983, no. 38.

The Virgin and Saint John Interceding with Christ as the Man of Sorrows on Behalf of a Donor

About 1515
Pen and brown ink, on paper, with colored washes
5¹³/16 x 6⁷/8 in. (14.7 x 17.5 cm.)
New York, Ian Woodner Family Collection
WD-547

The risen Christ, wearing the crown of thorns and displaying his wounds and the scourges with which he was beaten, appears before the Virgin and Saint John the Evangelist, who intercede with him on behalf of a kneeling man escorted by an angel.

Winkler has dated this drawing to Kulmbach's mature period, about 1510–15, contemporary with the artist's drawings of the Virgin on a Crescent Moon, in Florence (Winkler,

164: recto

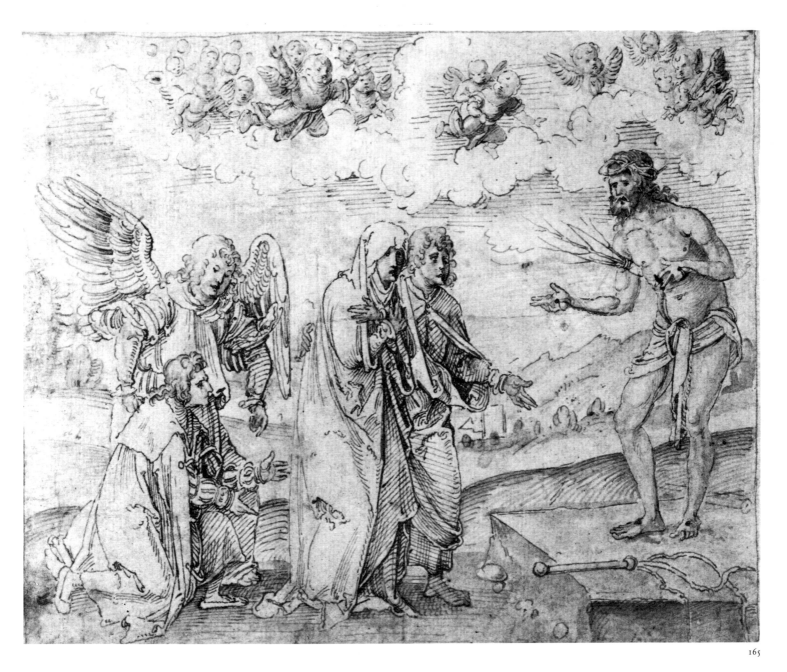

1942, no. 36), and of God the Father, formerly in Bremen (Winkler, 1942, no. 37). The Virgin's drapery here and in a Crucifixion drawing in Berlin (Winkler, 1942, no. 38) are comparable, especially the mantle, which forms a sling around her bent arm. The Berlin study was thought to have been done about 1514 — the date that was later added to the drawing.

The kneeling man at the left was surely the patron of the unknown commission for which Kulmbach prepared this design. Highly finished, with delicate colored washes, the drawing is unusual in the context of the artist's work, as Winkler has noted, suggesting that it was a study for a prayer-book illustration.

Scenes of supplicants praying to the Christ of the Passion, or the Man of Sorrows — very popular in Late Gothic German art in all mediums — are based on the apocryphal legend that the suffering Christ appeared to the sainted Pope Gregory the Great as he celebrated the Eucharist. Images of Christ above the altar were a visual confirmation of the doctrine of transub-

stantiation, according to which the bread and wine of the Mass actually become the body and blood of Christ. (See cat. no. 179. For a thorough discussion of the iconography of the Mass of Saint Gregory, see *Die Messe Gregors des Grossen: Vision, Kunst, Realität* [exhib. cat.], Cologne, Schnütgen-Museum, 1982; for the Man of Sorrows, in general, see "Schmerzensmann," *Lexikon der christlichen Ikonographie*, Rome, Freiburg, Basel, and Vienna, 1972, vol. IV, pp. 87–95.) In the Kulmbach drawing, the focus has shifted from the altar and its specific sacramental reference to the sacrifice and suffering of Christ, through which mankind can be redeemed. The Virgin and Saint John serve as intercessors, or advocates, on behalf of the kneeling donor.

Extra-biblical devotional images, such as the present one, especially, with its emphasis on saints as intermediaries between man and God, fell into disfavor after the rise of Protestantism in Germany, although Baldung depicted a celebrant priest kneeling before the Man of

Sorrows for a 1523/24 Strasbourg publication of one of Martin Luther's sermons (see C. Andersson and C. Talbot, *From a Mighty Fortress: Prints, Drawings, and Books in the Age of Luther, 1453–1546* [exhib. cat.], The Detroit Institute of Arts, 1983, no. 203, pp. 360, 361).

The broad horizontal format; the monumental proportions of the figures, who are set against a receding background; and the expansive, open sky, with its choirs of cherubim, suggest that the drawing is a study for an altarpiece, perhaps a painted epitaph for the donor, such as that by the Master of the Tucher Altar for Dr. Johannes Ehenheim (died 1438) in the Lorenzkirche, Nuremberg (see *Reformation in Nürnberg — Umbruch und Bewahrung* [exhib. cat.], Nuremberg, Germanisches Nationalmuseum, 1979, p. 79, no. 94). If so, the drawing falls at the close of a tradition in the city that was to adopt Lutheranism in 1525, soon after Kulmbach's death; the epitaph of Dr. Anton Kress (died 1513) by Peter Vischer the Younger (fig. 87) represents the kneeling Kress praying on his

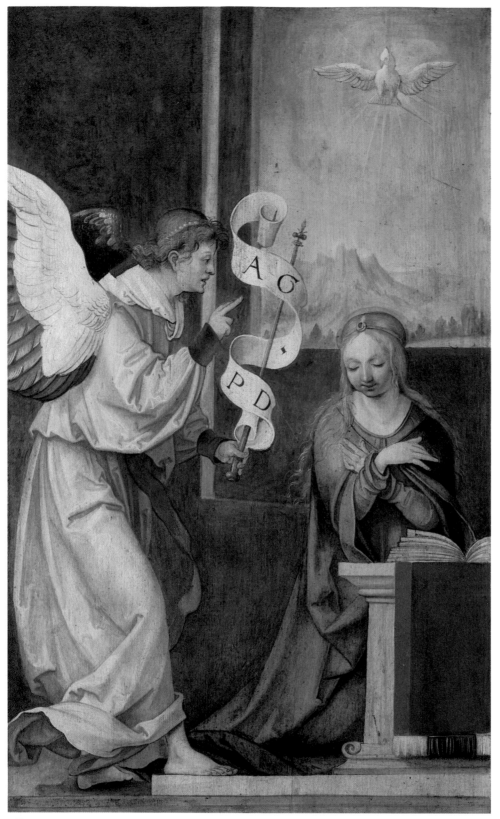

166a

a) The Annunciation
About 1512–13
Tempera and oil on fir wood
24 x 15 3/8 in. (61 x 39 cm.)
Nuremberg, Germanisches Nationalmuseum
(acquired from the Bayerische
Krongutsverwaltung, 1927)
Gm 1112

b) The Ascension of Christ
About 1512–13
Tempera and oil on fir wood
24 1/2 x 15 1/8 in. (62.2 x 38.4 cm.)
New York, The Metropolitan Museum of Art,
Rogers Fund, 1921
21.84

These small paintings are from the wings of an
altarpiece, each of which presented two scenes
from the life of the Virgin. The wings were orig-
inally painted on both sides; later, they were
split in two and divided horizontally. From the
grain of the wood and the remains of a gray
strip that divided the original scenes, it has been
possible to identify eight paintings as fragments
of this altarpiece of the Virgin.

Once Bermann (1922) had introduced the
Annunciation into the Kulmbach literature, it
was necessary to relate it to other paintings by
the artist and to attempt to reconstruct its origi-
nal context. Bermann considered the work a
fragment from a wing of the *Adoration of the
Magi Altarpiece*, of 1511, in the Gemäldegalerie,
Berlin-Dahlem. Buchner (1928) proposed a re-
construction of an altarpiece of the life of the
Virgin with the following scenes: *The Annunci-
ation, The Nativity* (in the Bayerische Staats-
gemäldesammlungen, Munich), *The Adoration
of the Magi* (The Samuel H. Kress Collection,
Allentown Art Museum, Pennsylvania), and
The Ascension. He considered the horizontal
Dormition of the Virgin (in the Bayerische
Staatsgemäldesammlungen, Munich) to be the
predella from the same altarpiece. Stadler (1936)
claimed that four other scenes in the Museum
der bildenden Künste, Leipzig — *The Birth of
the Virgin, The Visitation, Christ Appearing to
His Mother,* and *Pentecost* — were portions of
the identical work. He further asserted that a
Coronation of the Virgin in the Kunsthistori-
sches Museum, Vienna, was the corresponding
central panel, but did not think that the predella
with the *Dormition* belonged to that work.
Winkler (1959) and Strieder (*Meister um Al-
brecht Dürer,* 1961) supported Buchner's early
conclusions, although Winkler does not men-
tion the predella, and Strieder related it to the
Leipzig paintings.

The exhibition in Nuremberg in 1961, which
brought together all of the Marian paintings
mentioned, confirmed Stadler's thesis that the
Leipzig panels are also from the same altarpiece:
"All of the pictures have a gray border either at
the top or the bottom, which [establishes] their
correlation" (Winkler, 1961; Knappe, 1961;
Oberhuber, 1962). According to Peter Strieder,
in Nuremberg, the wings of the altarpiece may

own behalf, without the benefit of intercessors
(*Reformation in Nürnberg — Umbruch und Be-
wahrung* [exhib. cat.], Nuremberg, Germani-
sches Nationalmuseum, 1979, p. 80, no. 95).

BDB

BIBLIOGRAPHY: Winkler, 1942, pp. 22, 60, no. 42, pl. 42,
1959, p. 83; *50 Jahre Kunsthandelsverband der Schweiz,*
1973, no. 186; *Highly Important Old Master Drawings
from the Collection of Tobias Christ of Basel,* 1981, p. 31,
no. 10.

EX COLLECTIONS: noble German family; [Berlin dealer];
Dr. Tobias Christ, Basel; [Galerie Dr. W. Raeber, Basel];
[Sotheby Parke Bernet & Co., London].

be reconstructed as follows: One contained the *Annunciation* (above) and the *Adoration of the Magi* (below); on the reverse was the *Birth of the Virgin* (above) and the *Pentecost* (below). The other wing presented the *Nativity* (above) and the *Ascension* (below), with the *Visitation* (above) and the *Christ Appearing to His Mother* (below) on the reverse. However, it remains debatable which were the front sides and which the back. The center panel was probably a *Coronation of the Virgin.*

Eisler (1977) believed that the scenes from the life of the Virgin were from one altarpiece, but he did not consider the *Dormition* its predella, or the *Coronation of the Virgin* its center panel.

According to Brandl (1983, 1985), the panels grouped together by Buchner are from an altarpiece that von Murr (1778) described as in the Walpurgis Chapel on the grounds of the Nuremberg Castle. Its central scene was a carved and gilded *Coronation of the Virgin* that Josephi (1910) tentatively identified with a relief now in the Germanisches Nationalmuseum, Nuremberg (Pl o.212). Von Murr noted that the paintings comprising the wings represented the Visitation and the Presentation of the Virgin, while the predella consisted of a *Dormition of the Virgin* by Hans Suess von Kulmbach, dated 1513. Brandl proposed that the wings mentioned by von Murr now belong somewhat illogically to the *Altarpiece of the Rosary* in the Thyssen-Bornemisza Collection in Lugano (*Sammlung Thyssen-Bornemisza,* 1971, no. 157). Although the Meeting at the Golden Gate is portrayed there, instead of the Visitation, Brandl argues that von Murr was mistaken in his identification of the subject matter. The iconographic program of the work and the chronological sequence would, indeed, call for a painting of the Meeting at the Golden Gate.

In 1983, Brandl proposed that the small scenes from the life of the Virgin occupied the exteriors of the wings: the *Annunciation,* at the upper left, and the *Nativity,* below, with the *Ascension* at the upper right, and the *Adoration of the Magi* below. However, in 1985, after further investigation of the panels, he suggested that the *Annunciation* was originally at the upper left, with the *Adoration of the Magi* below, and that the *Nativity* was at the upper right, above the *Ascension.*

The Marian scenes that Buchner claimed belong together, and those added to the group by Stadler, present no overlapping themes, yet, at first glance, they fail to present a convincing argument. For this reason, Stadler posited a supplementary scene from the childhood of the Virgin (a Presentation of the Virgin?), two from the earlier life of Christ (the Presentation in the Temple and the Flight into Egypt?), and one from the life of the Virgin, after the Crucifixion: either a Dormition or a Coronation. However, if one considers the extant Marian scenes in the context of the Mysteries of the Rosary or the Joys of the Virgin, rather than as part of a series devoted to the life of the Virgin, the sequence is perfectly complete except for a representation of the Coronation. Dürer's panel of the *Seven*

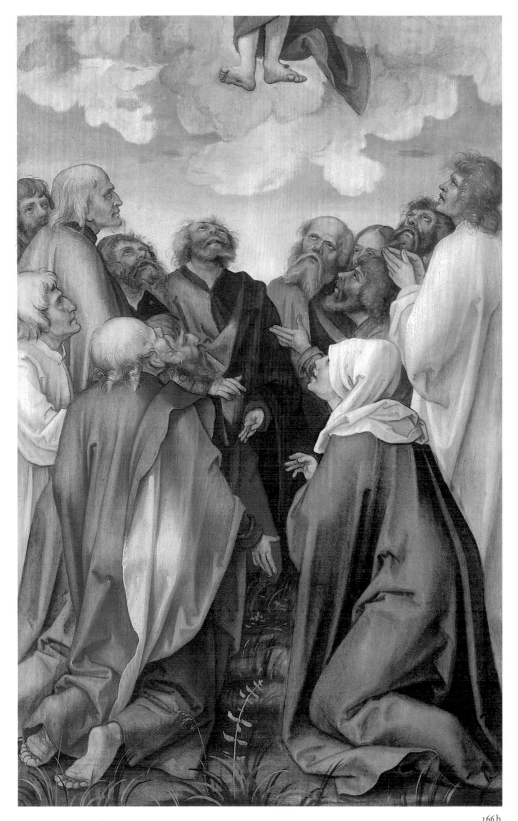

166 b

Joys of Mary, for example — only preserved in copies in the Graphische Sammlung der Universität, Erlangen — included the Annunciation, the Nativity, the Adoration of the Magi, Christ Appearing to His Mother, the Pentecost, and the Coronation, and also, presumably, the Visitation (see Anzelewsky, 1971, nos. 28 v–35 K, ills.). The main subject of Veit Stoss's *Angelic Salutation* (fig. 61), in the Lorenzkirche, Nuremberg, is the Annunciation; included in

the medallions of the Rosary are the Nativity, the Adoration of the Magi, the Resurrection, the Pentecost, the Ascension, and the Dormition and the Assumption of the Virgin (J. Rasmussen, in *Veit Stoss...,* 1983, pp. 194–209, no. 17). Also, an indulgence print by Wolf Traut, from about 1510, contains the majority of the now-familiar scenes among the mysteries of the Incarnation of Christ and those of the Resurrection (*Rosenkranz,* 1976, no. A 57).

The compositions of the *Annunciation* and the *Ascension of Christ* follow the traditional patterns. The *Ascension* is a variation of Dürer's woodcut in the *Small Passion* series, while the *Annunciation* resembles his woodcut of the subject in the series *The Life of the Virgin*. The angel wears a belted gown; the Virgin lowers her gaze and crosses her hands over her breast. The letters "AGPD" on the banderole can be deciphered as the abbreviation for A[ve Maria] G[razia] P[lena] D[ominus tecum]. The low angle of vision would accord with the picture's elevated position on the wing of the altarpiece. Kulmbach muted the pathos characteristic of Dürer's work, and he did little to clarify spatial relationships. His strength lay in his straightforward, intimate narrative style, and in his adjustment of his palette to render the effects of light and air.

KL

EX COLLECTIONS: *Annunciation:* Landauer Zwölfbrüder-haus, Nuremberg (1846); Castle, Nuremberg; *Ascension:* Frau Durner [Derner?], Schweinfurt (1884, or 1824, according to an inscription on the back of the panel); Stallforth, Wiesbaden; [sold, Helbing, Munich, no. 10 (October 1, 1919)]; [Julius Böhler, Munich]; Axel Beskow, New York.

BIBLIOGRAPHY: von Murr, 1778, p. 32; Rettberg, 1846, p. 167; Bermann, 1922, p. 66; Buchner, 1928, pp. 93, 94; Stadler, 1936, pp. 19–20, no. 63; Kuhn, 1936, no. 207; Wehle and Salinger, 1947, pp. 189–90; Winkler, 1959, p. 47; Knappe, 1961, p. 252; *Meister um Albrecht Dürer,* 1961, no. 161; Winkler, 1961, p. 266; Oberhuber, 1962, p. 65; Eisler, 1977, pp. 31–32; Brandl, in *Veit Stoss…,* 1983, no. 7; Brandl, 1985.

167 HANS SUESS VON KULMBACH
Portrait of a Young Man

About 1520
Tempera and oil on fir wood
14³/₁₆ x 10¹/₄ in. (36 x 26 cm.)
The panel has been cut down on all sides; an unpainted border of about ¹/₈ in. (.4 cm.) survives, at the bottom.
Nuremberg, Germanisches Nationalmuseum
(acquired, 1928)
Gm 1162

The young man wears a red damask doublet under a *Schaube*, the fur-collared cloak of a local burgher. The brim of his hat has several slits, according to the fashion of the time. Included at regular intervals in the embroidery on the portion of his finely pleated shirt exposed at the neck is the initial "M," which, apparently, refers not to the man's name but to that of his bride. His abundant blond hair is neatly coiffed. The young man's blue eyes gaze past the viewer, as

he points to his left with his right hand in a kind of countermovement to the turn of his head.

This *Portrait of a Young Man*, painted in Kulmbach's final period, displays his artistic maturity. The panel contains no identifying mark of the artist, which is surprising since Kulmbach's monogram appears on the majority of his works. Also unusual is the absence of an inscription with the date of the painting or the age of the man portrayed. This information possibly was included on the original frame (now lost), but it is also conceivable that it appeared on the top of the panel, which has since been cut down.

Portrait painting was popular in Nuremberg from the earliest times. The families permitted to serve on the city council were the first to take to this new art form, both for its documentary value and for the distinction that it bestowed upon their homes. Middle-class citizens — among them, the local craftsmen — soon followed their lead. About 1500 — encouraged by the cosmopolitanism of Dürer, and by his intense interest in all types of people — there was a flowering of portraiture in Nuremberg, lasting well into the period that Dürer spent in Venice. Hans Leonhard Schäufelein was especially inspired by Dürer, so much so that his works are sometimes mistaken for those of his mentor — for example, his *Portrait of a Man,* dating from 1507, in the National Gallery of Art, Washington. Hans Suess von Kulmbach achieved prominence only after this comparatively expressive phase of Nuremberg portraiture was in decline, with works that revealed a vision all his own.

From childhood on, Dürer made himself the subject of his art. He brought the experience of these self-portraits to his portraits of less familiar patrons, so that his paintings appear to be the result of intellectual exchange and of a creative force imposing order on contingency. Not so Hans Suess von Kulmbach. Kulmbach bided his time; he made no demands on his sitter, but, rather, left him undisturbed, only taking note of personal idiosyncrasies when the model volunteered them or happened to betray them. Such qualities are registered with delicacy, so that the boundaries of privacy are almost never overstepped. Kulmbach's subjects only rarely establish eye contact with the viewer. They are deep in contemplation, or daydream, and either gaze inward or appear to be distracted. The direction of their gazes, the twist of their heads, and the position of their bodies are rarely coordinated or balanced against each other, as they would be in a true contrapposto pose.

Kulmbach's aim as an artist was not to create solid, enduring forms, but to effect a kind of tentative balance. This often gives his figures a certain mobility, making their moods seem only temporary and their relationship to the pictorial field a matter of chance. The portrait in Nuremberg is an example of this, even though the bust nearly fills the space of the painting.

Kulmbach's colors are vivid. They are not merely applied to a form fixed by the drawing, but, rather, help to create the form; they have a

charm of their own. The modeling, delicately shaded in the light areas and vibrantly colored in those passages in shadow, nearly obscures the fact that a jaw is unusually angular or a neck uncommonly thick. Here, the large proportion of blacks contrasts with the harmonious coupling of red and green pigments. The bright flesh tones are given a further glow by the proximity of the light blond hair.

What is striking — and this has often been noted — is that Kulmbach painted mostly young people. He was unable to produce the character studies of subjects upon whom life had taken its toll, which so fascinated Dürer, as convincingly as the latter could. His preference for the young is not explained by the fact that he died at an early age — he lived to be forty — but was simply a part of his nature. Despite Dürer's interest in the specific personality of his sitter, he tended to regard an individual always as a representative of a social class. Kulmbach, on the other hand, veiled such distinctions, ignoring the motives behind the majority of portrait commissions in the Late Middle Ages and the Early Renaissance. Only very rarely, and as exceptions to the rule, can his works be thought of as portraits with social overtones. The male portraits, at least, appear to be testimonials to his personal friendship with the sitter; they are likenesses of men who have no exalted image of themselves. In this, Kulmbach differs from Wolf Traut and from the socially conscious Hans Brosamer, who, after 1520, became the most popular portrait painter in Nuremberg.

Barbara R. Butts (1985) is the only scholar who has questioned the attribution of the Nuremberg portrait to Kulmbach. She would like to fix the outlines of the Kulmbach oeuvre more clearly, but her attribution to Wolf Traut of a number of portraits associated with Kulmbach is unconvincing. This particular portrait has nothing in common with Traut's works — neither with their rigid compositions nor with their concealment of the inner life of the sitter.

KL

EX COLLECTIONS: aristocratic Viennese family; art market, Munich (1928).

BIBLIOGRAPHY: Buchner, 1928, pp. 140, 142; Stadler, 1936, pp. 55–56, no. 150; Lutze and Wiegand, 1936–37, p. 71, ill. 96; Lutze, 1941; Winkler, 1959, p. 88; *Meister um Albrecht Dürer,* 1961, no. 176; Butts, 1985, pp. 158–60, appendix I, p. 254, no. 34.

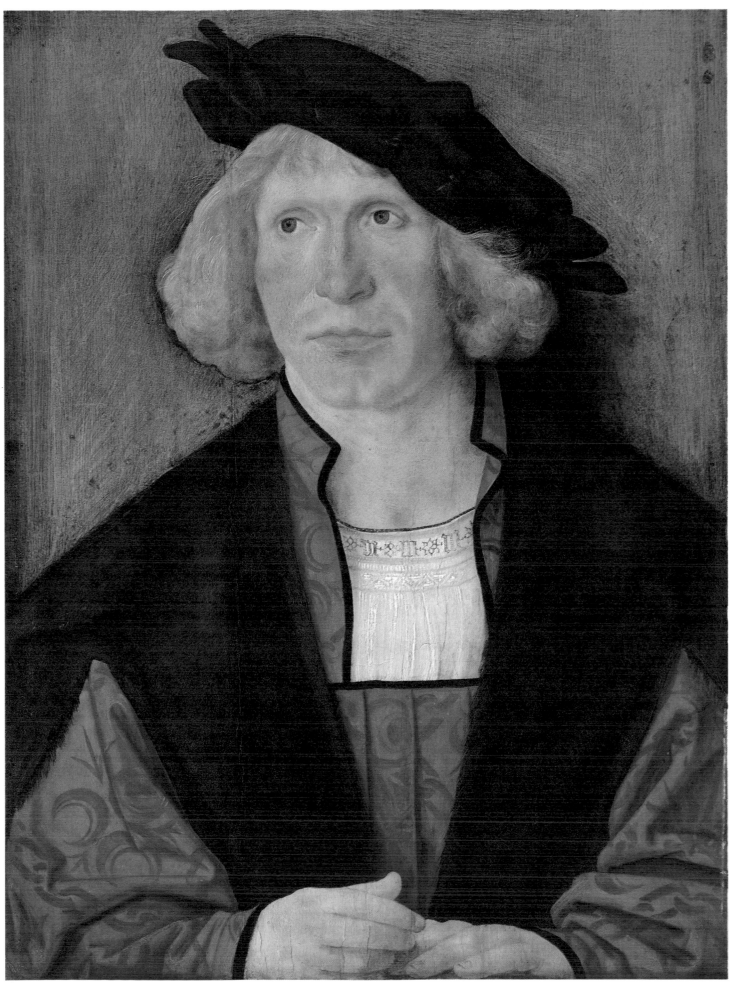

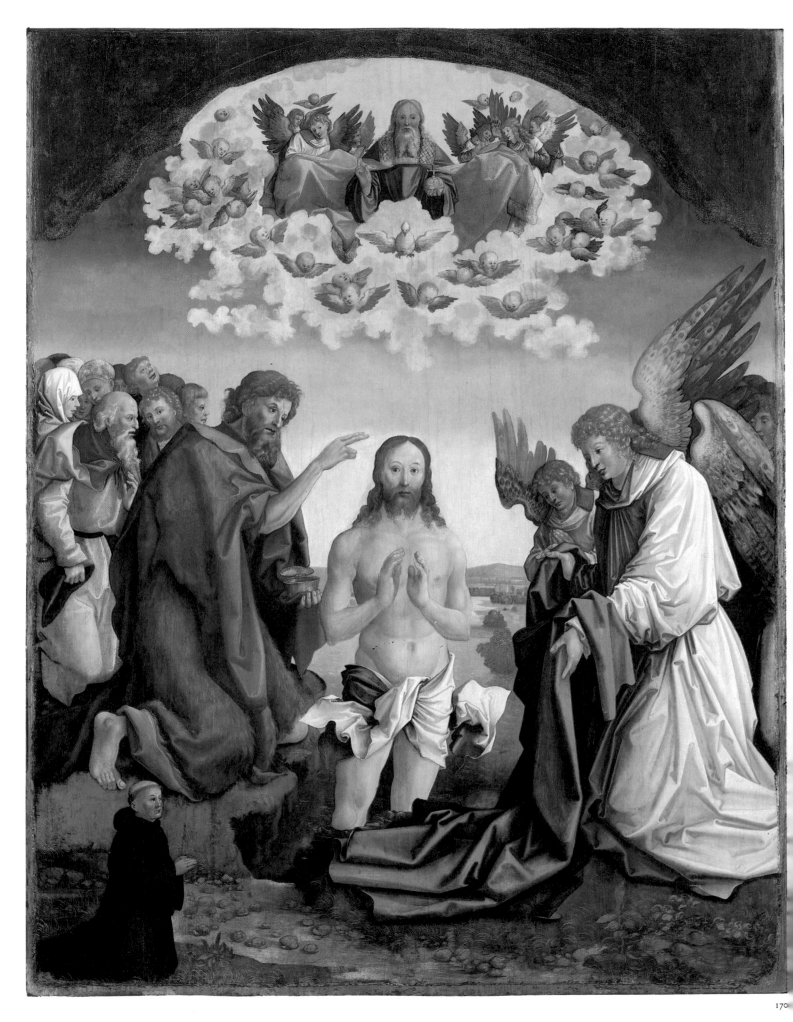

354

The Baptism of Christ

About 1516–17
Tempera and oil on fir wood
58 1/8 x 45 1/8 in. (147.5 x 114.5 cm.)
Provenance: monastery church, Heilsbronn
(Franconia).
Nuremberg, Germanisches Nationalmuseum
(acquired, 1903)
Gm 181

The symmetrical composition shows Christ standing in the River Jordan, the water up to his knees. At the left, Saint John the Baptist, a pyx in his left hand, kneels and gives Christ his blessing. At the right, an angel spreads his cloak over the ground. The townspeople, who, probably, include Traut's Nuremberg contemporaries, serve as witnesses to the holy proceedings. God the Father appears among the clouds, surrounded by angels, directly above the dove of the Holy Spirit. In the lower left corner is the kneeling donor, a member of a holy order.

The *Baptism of Christ* has been identified as the center panel of an altarpiece of Saint John the Baptist, which is known to have belonged to the monastery church in Heilsbronn: In 1517, Sebald Bamberger, abbot of the Cistercian monastery, paid eighty florins for an altarpiece with this subject. The money did not come from his private funds, but from those of the bursar, Johannes Wenck (Muck, 1879). The altarpiece was, therefore, not donated by the ruling abbot, but by his designated successor, who headed the monastery from 1518 to 1529. The figure of the kneeling monk — without an abbot's insignia — is, thus, Johannes Wenck.

Traut based his depiction of the Baptism of Christ on Dürer's *All Saints Altarpiece*, of 1511. The present painting is endowed with Traut's lively feeling for nature — a personal touch — particularly in the portrayal of Christ and in the landscape setting. Yet, for the rendering of drapery, he preferred to rely on the inventiveness of his great master. Like Dürer, Traut limited his palette to clear, pure tones, and emphasized the local color of specific objects, softening their brightness in order to give the figures a fuller, more sculptural three dimensionality. The landscape, breathing air and light, strikes a note of particular charm. Like Hans Suess von Kulmbach, Traut, too, assumed the task of adapting Dürer's artistic achievements to the art of painting altarpieces, for the master, himself, hardly executed any pictures with groups of figures after 1511.

KL

Ex COLLECTIONS: donated by Margrave Joachim Ernst von Ansbach to Emperor Rudolf II (1606); Emperor Rudolf II, Prague; [art market, Vienna (1903)].

BIBLIOGRAPHY: Muck, 1879, vol. 1, pp. 229–30, vol. 2, p. 249, no. 14; Stegmann, 1903, pp. 178–86, pls. VI, VII; Rauch, 1907, pp. 88–92, pl. 27; Lutze and Wiegand, 1936–37, p. 182, ill. 100; *Dürer*, 1928, no. 96; Schulz, 1939, pp. 351, 352; *Meister um Albrecht Dürer*, 1961, no. 365, pl. 19.

171

171 Drawing for an Altar Cross

Nuremberg, 1510–19
Pen and black ink, on unwatermarked paper
12 1/4 x 6 5/8 in. (30.8 x 16.9 cm.)
All the edges are trimmed, and a patch has been added on the left side behind the figure of the Virgin. The drawing bears the stamp of the collector von Lanna (Lugt, no. 2773).
Nuremberg, Germanisches Nationalmuseum
(acquired from a private collection in Amsterdam in 1930)
Hz 3979

The numbers "5 1" at the bottom of the drawing — clearly, a design for an altar cross — are all that remain from the original date, which would, thus, have been somewhere between 1510 and 1519. The hexagonal shaft of the cross rises out of a sexfoil foot. In the center and at the top of the shaft are flat, hexagonal moldings, between which is a nodule in the form of a flattened pomegranate. Above the shaft, supported by two short sections of branches, is a trefoil-ended cross with the crucified Savior. Two longer branches with leaves support bases for the figures of the Virgin and Saint John.

Crosses of this type were certainly made in many locations in Germany about 1500 and for a time afterward, although those that survive come mainly from eastern regions. The large silver cross with a Nuremberg mark, in the Wallfahrtskirche, Częstochowa (Tschenstochau), Poland, was a gift from King Sigismund I of Poland. The figures of Christ, Mary, and John can be linked, in general, to the style of Hans Suess von Kulmbach, and may have been based on one of his designs (Kohlhaussen, 1968, no. 334, ills. 384–387). Like other pupils of Dürer as well as Dürer himself, Kulmbach provided goldsmiths with a number of designs.

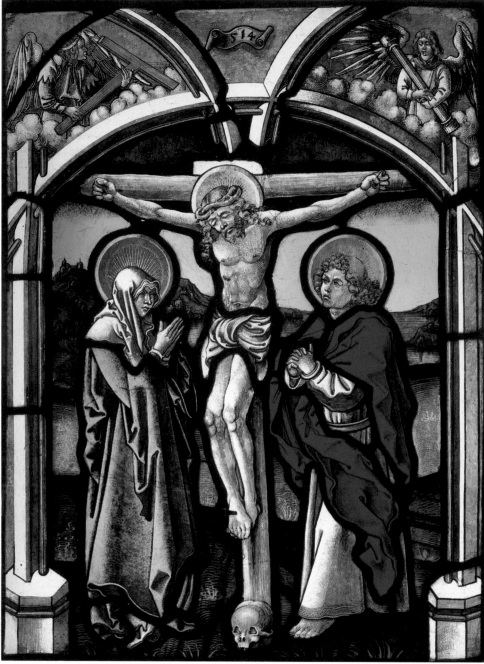

172

172 The Crucifixion
Dated 1514
Pot metal and white glass, with silver stain
18 x 13 1/2 in. (45.7 x 34.3 cm.)
The Detroit Institute of Arts, Gift of Mrs. Ralph
Harman Booth
37.35

The Hirschvogel family painted the glass com-
missions of most of the leading artists of the
town, including Albrecht Dürer, Hans Suess
von Kulmbach, and Hans Sebald Beham. This
small *Crucifixion* panel, with Mary and the
Apostle John standing at the foot of the cross
framed by fantastical Late Gothic architecture,
was probably made by the Hirschvogel work-
shop. Characteristic of their style, in the present
example, is this architectural frame that defies
the principles of an actual architectural setting,
yet provides a celestial zone for the two angels,
who hold the cross and the column — symbols
of Christ's Passion. Also common to the pro-
ductions of this shop are the striated modeling
of the plain in the background and the distant
lakeside landscape with its steeply rising cliffs
crowned by a city at the top. The drawing that
inspired this panel was probably by Hans Suess
von Kulmbach, since a pen-and-ink sketch of
the same subject by him, dated to 1514, is now
in the Kupferstichkabinett, Berlin-Dahlem (F.
Winkler, *Die Zeichnungen Hans Süss von
Kulmbachs und Hans Leonhard Schäufeleins*,
Berlin, 1942, pl. 38). Even closer to the glass
panel is a woodcut by Kulmbach, made for a
Würzburg missal in 1509 (F. Winkler, "Hans
von Kulmbach," *Die Plassenburg*, 1959, vol. 14,
pl. 10). A number of features in these drawings
are also noticeable in the glass. The type of
Christ is similar, although the pose is swung
slightly to the left in the glass panel, as it is in
the woodcut. Both figures have similar facial
features, foreshortened by the droop of the
head. In both, the hands are clenched over the
nails driven through the palms, the loincloths
are loosely knotted about the figure, and the
musculature of the body is exaggerated. The
weighty mantle of the Virgin, with its hard,
angular folds, is alike in all three cases. Saint
John's voluminous cloak spirals diagonally ac-
ross his body in the glass panel and also in the
woodcut, although its direction is reversed in
the drawing. Most convincing, however, are un-
usual details that are common to all three
works, such as the tau crosses that force the
omission of the *titulus* in the drawing and the
placement of it incongruously atop the crossbar
in the glass panel and in the woodcut. In all
cases, the skull of Adam at the foot of the cross
lacks the lower jaw. Given these elements that
appear to be peculiar to the work of Kulmbach,
the attribution to him of the design of this panel
seems convincing.

JH

EX COLLECTION: Mrs. Ralph Harmon Booth, Detroit.

BIBLIOGRAPHY: "Minutes of the Accessions Com-
mittee . . . Detroit Institute . . . ," 1937.

There is a drawing by Kulmbach of a large mon-
strance that survives in the museum in Schwerin
(fig. 69). The only similarity between the Polish
cross and the one in the present drawing is the
four-part branch supporting the cross and the
auxiliary figures. The author of the drawing's
compact figures, with their lively movements, is
clearly recognizable as from the Dürer school.
In 1929, Elfried Bock felt justified in attributing
the drawing to Wolf Traut, comparing it with a
design for a Renaissance candelabrum in Er-
langen. Writing in 1968, Zink then pointed to
similarities with another drawing attributed to
Wolf Traut — a design for a carved Crucifixion
group in the superstructure of an altarpiece — in
the former Koenig collection in Haarlem
(Winkler, *Traut*, 1936, pl. 32). However, such a
comparison with Traut's rather dry drawing
style only emphasizes the difference in quality

of the Nuremberg work. The deep, strong
shadows on the figures and a certain painterly
approach, especially evident in the figure of
Saint John, explain why earlier scholars sought
to place the artist in the circle of the younger
Cranach or in the Danube school.

RK

EX COLLECTIONS: Adalbert Freiherr von Lanna, Prague
(1836–1909); Erzherzog Friedrich of Austria; the Alber-
tina, Vienna, along with the collection of the Erzherzog
Friedrich of Austria (1917–22).

BIBLIOGRAPHY: *Katalog . . . Barons Adalbert von Lan-
na . . .*, 1910, p. 33, no. 309; Meder, 1922, pl. 27; Bock,
1929, text vol., p. 70, ill. XIV; Zink, 1968, no. 101, ill.;
Kohlhaussen, 1968, p. 248, ill. 388; Lüdke, 1983, vol. 2,
p. 678.

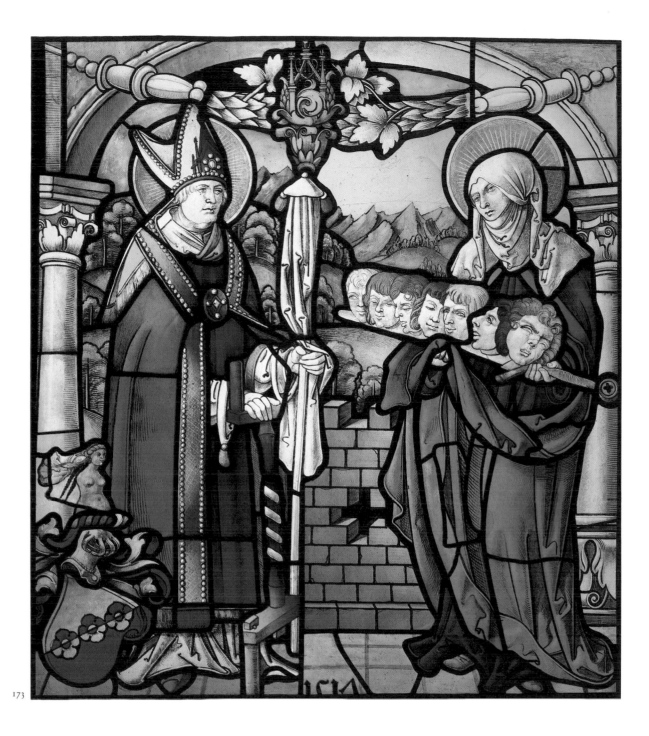

173

173 WORKSHOP OF VEIT HIRSCHVOGEL THE
ELDER, after a design by a PUPIL OF DÜRER
(WOLF TRAUT?)

Saints Erasmus and Felicity

1517

White glass and pot metal, in light blue, dark blue,
green, red, violet, and yellow, with silver stain
on the white and blue, and also in the form of the
so-called red stain

32 1/8 x 28 3/4 in. (81.5 x 73 cm.)

Provenance: Egidienkirche, Stöckach, near
Forchheim (Middle Franconia).

Nuremberg, Germanisches Nationalmuseum
(acquired, 1893)

MM 170

After the panel was acquired by the museum in
1893, a number of major restorations were
undertaken by Professor Johann Baptist Hasel-
berger (1840–1900) in Leipzig. Despite the ex-
tent of these restorations — which, incidentally,
were of the highest quality — the original areas
of the glass are in excellent condition; the panel
is one of the best-preserved examples of
Nuremberg stained glass from about 1500. It
displays the coat of arms of the "honorable"
Schmidmayer family, who arrived in Nurem-
berg in the fifteenth century. By the beginning
of the sixteenth, they were already among the
wealthiest merchants in the city, and many of
them intermarried with the leading patrician
families. The Schmidmayer brothers donated
one of the most valuable windows to the
Lorenzkirche: four panels, from 1509, depicting
the martyrdom of Saint Lawrence, based on de-
signs by Albrecht Dürer. One of these brothers
was Wilhelm Schmidmayer (died 1546), whose
first wife was Felicitas Fütterer (died 1530). In

this panel for a small village church in Middle
Franconia, he chose to have his wife's name
saint — one otherwise relatively unknown —
represented. According to legend, Saint Felicity
suffered much the same fate as the mother of the
Maccabees in the Old Testament (II Macc.
7:1–41): The seven sons of Saint Felicity were
all supposedly beheaded under orders from Em-
peror Marcus Aurelius for their Christian faith.
The especially gruesome portrayal shown here
— the mother holding her sons' severed heads
on the blade of a sword — is by no means com-
mon, although there is a Franconian precedent
for it in the woodcut on folio CXIIII of the
Schedel *Weltchronik*, of 1493 (cat. no. 87). Saint
Erasmus — a martyred bishop who was disem-
boweled with a winch — was one of the more
highly venerated saints in the Middle Ages.

Of the surviving examples of Nuremberg

357

stained glass from Dürer's time, the present panel most closely resembles the eleven windows from the Rochuskapelle, which were executed in 1520/21 in the workshop of Veit Hirschvogel the Elder, the preeminent contemporary stained-glass painter, and bear his signature. They, too, are characterized by a high degree of technical mastery and a certain spaciousness in their compositions. The outstanding qualities of the panels, however, are their exquisitely shaded landscapes and the virtuoso use of silver stain, which had to be fired at temperatures rarely employed in this period, so as to produce the brilliant reddish tone. This is particularly apparent on the edging of the pluvial, on the miter of Saint Erasmus, and in the hair of Saint Felicity's seven sons. RK

BIBLIOGRAPHY: Essenwein, 1898, no. 170; Schinnerer, 1909–10, pp. 335–36; Hahn, 1974, col. 222.

174 WORKSHOP OF VEIT HIRSCHVOGEL THE ELDER, after designs by HANS BALDUNG GRIEN and HANS SUESS VON KULMBACH

Scenes from the Life of the Virgin and the Life of Christ

About 1505 – about 1510

1) Joachim Taking Leave of Anna, with the coats of arms of Hieronymus Schürstab and his wife, née Ahl (at least according to Knappe, 1961), or, more likely, those of Behem von der Schlang (see Schöler, 1975, pl. 59.1) (Grossgründlach I 1 a)

2) The Virgin Weaving the Curtain of the Temple, with the coat of arms of a certain Herr Petz (?) (Knappe, 1961) (Grossgründlach I 1 b)

3) The Betrothal of Mary and Joseph, with the coats of arms of Anton Schürstab and his wife, née Petz (?) (Grossgründlach I 2 a)

4) The Presentation of Christ in the Temple, with the coat of arms of the Praunengel family, dated 1505 (Grossgründlach I 2 b)

5) The Massacre of the Innocents, with the coats of arms of the Tucher family (Wöhrd N I 3 b)

6) Christ Among the Doctors, with an indecipherable house sign in the coat of arms (Grossgründlach I 3 b)

7) The Temptation of Christ, with an indecipherable house sign in the coat of arms (Grossgründlach I 4 b)

8) Christ and the Woman Taken in Adultery, with the combined coats of arms of the Mangersreuth and Kötzler families (Grossgründlach I 3 a)

9) Christ Bearing the Cross; no coat of arms (Wöhrd S I 2 b)

10) The Crucifixion; no coat of arms (Wöhrd S I 3 a)

11) Noli me tangere; no coat of arms (Wöhrd S I 4 a)

12) The Supper at Emmaus, with a coat of arms (Grossgründlach I 4 a)

Stained glass, in white, dark blue, light blue (two different shades), red, light red, dark blue-violet, light pinkish violet, yellow, and green (two differ-

ent shades), with red enamel on white (for the unusual red-striped garments), black and brown paint, and silver stain on white and blue, in places changing from yellow to red. The way in which the red flashing ran has been exploited, especially in the portrayal of the Devil in the scene of the Temptation, and in the corresponding blue layer of sky in the scene with Joachim and Anna; portions of the red flashing were ground away.

Wöhrd panels: 33 1/16 x 26 in. (84 x 66 cm.); Grossgründlach panels: originally, as above, but cut down at the tops and sides to 27 9/16 – 27 15/16 x 23 – 23 7/16 in. (70–71 x 58.5–59.5 cm.)

The edging strips with the small white circles are 19th-century additions. The Wöhrd windows are more weathered, and some of them are more heavily restored than those at Grossgründlach, but their condition — particularly that of the painting — is quite good. Details of the panels' state of preservation are as follows (in the case of the Wöhrd windows, noted before their removal): 2) Parts of the angel's drapery are modern, especially the sleeve and above the knee. There is an early light red stopgap in the angel's red wing; 5) Modern replacement panes in Herod's robe and at the base of the figure. The lower body of the bailiff was incorrectly restored. The coat of arms, or at least a portion of it, together with the brownish section at the front of the angel's robe, was restored. A panel has been replaced in the upper right-hand corner of the frame; 6) A single piece was replaced in the wall to the right, and all of the paint is badly weathered; 8) Much of the paint on the face of Christ is worn away; 9) The violet panel in Christ's garment is a replacement, and the small, white corner of the robe in Saint Veronica's lap is restored; 11) There are disruptive replacements in the area of Christ's breast (this section was already badly damaged in 1929). The tip of the fluttering veil, and the white drapery above the Magdalene's feet were restored (after 1940, probably as a result of war damage). There are restorations in the floor at the left (?); the yellow-green replacement piece with the tree is probably from another context.

Provenance: cloister, Karmeliterkloster, Nuremberg (demolished, 1557); between 1557 and 1564, the panels were placed in the new village churches built in Grossgründlach and in Wöhrd, near Nuremberg.
Nuremberg-Grossgründlach, Evgl. Luth. Pfarrkirche Sankt Lorenz, and Nuremberg-Wöhrd, Evgl. Luth. Pfarrkirche Sankt Bartholomäus

These twelve panels; eleven others, and the fragment of a twelfth still in Wöhrd; and the Passion scenes in the small church at Henfenfeld, near Nuremberg — not to mention others now lost — constitute the most important and also the largest cycle of Nuremberg stained glass from Dürer's time. Closely related to this glass is a panel with the Last Supper, dating from about 1500, in the Victoria and Albert Museum, London, but the latter panel appears to have been made for the Augustinerkirche, in Nuremberg. The cycle begins with the Immaculate Conception and the Birth of the Virgin, continues with the life of Christ, and closes with the Mission of the Apostles, the Ascension, Pentecost, and the Last Judgment. (About 1960, Gottfried Frenzel and Karl-Adolf Knappe iden-

tified the various panels as belonging to a single conception, but Frenzel's promised publication on the work has not appeared.)

The panels were created for Nuremberg's Karmeliterkloster, during the administration of the prior Erhard Schürstab (1504–8), and of his successor, Friedrich Neuschel (1508–13). The glass was donated by a number of Nuremberg merchants and patricians, representatives of the Franconian nobility, and members of the monastery itself. The administrator of the Lorenzkirche, the Humanist Sebald Schreyer (1446–1520), a tireless patron and supporter of all manner of artistic undertakings in Nuremberg, had advised the newly appointed prior in 1504 to have the cloister decorated "with the matter or legend of St. Anne, the Blessed Virgin, and the suffering of Christ." Descriptions of his own donations relate that each of the seventeen windows had four lancets and two panels of "burned glass" (or stained glass) in the upper registers; the rest of the opening was glazed with bull's-eye panes. The production of the cycle extended over many years, and did not follow the life of Christ in chronological order. Apparently, the donors could exercise a certain amount of choice regarding the subject matter if it agreed with the overall program. According to the ground plan of the monastery, as reconstructed by Karl Ulrich in 1979, the cloister had seventeen bays. Thus, if stained glass were ultimately donated for all of them, there would once have been a total of thirty-four panels. Since there were two panels in each window, and, as a rule, both were donated by a single person, it is likely that only one of each pair would have contained the coat of arms of the donor and his wife. This would explain the absence of coats of arms in some of the surviving panels. Several of the donors had no coat of arms, and, instead, had a house sign placed in the escutcheon. All of the panels must originally have had a frame composed of either architectural forms or foliage — as do the Wöhrd panels. The panels from Grossgründlach, however, preserve only scant traces of such a frame.

Sebald Schreyer, himself, donated a double window in 1504, depicting the Birth of the Virgin and the Presentation in the Temple, at a cost of eighteen guilders, and, in 1508, he gave an additional pair of stained-glass panels — this time costing him sixteen guilders — with the Meeting of Joachim and Anna at the Golden Gate, and the preceding scene of the angel appearing to Joachim and commanding him to return home to Anna (Gümbel, 1908, pp. 122–23; K. Ulrich, 1979, pp. 22–23); all four of these have been lost. According to Schreyer's account, the adjacent window presented the opening scenes of the entire cycle — the gifts of the prior Erhard Schürstab and his brother (?) Hieronymus. The surviving panel with Joachim Taking Leave of Anna must have come from that window, for it represents the first scene in the cycle and its coat of arms indicates that Hieronymus Schürstab (died 1507) was the donor. The second panel undoubtedly depicted Joachim's sacrifice. Of all the extant panels only

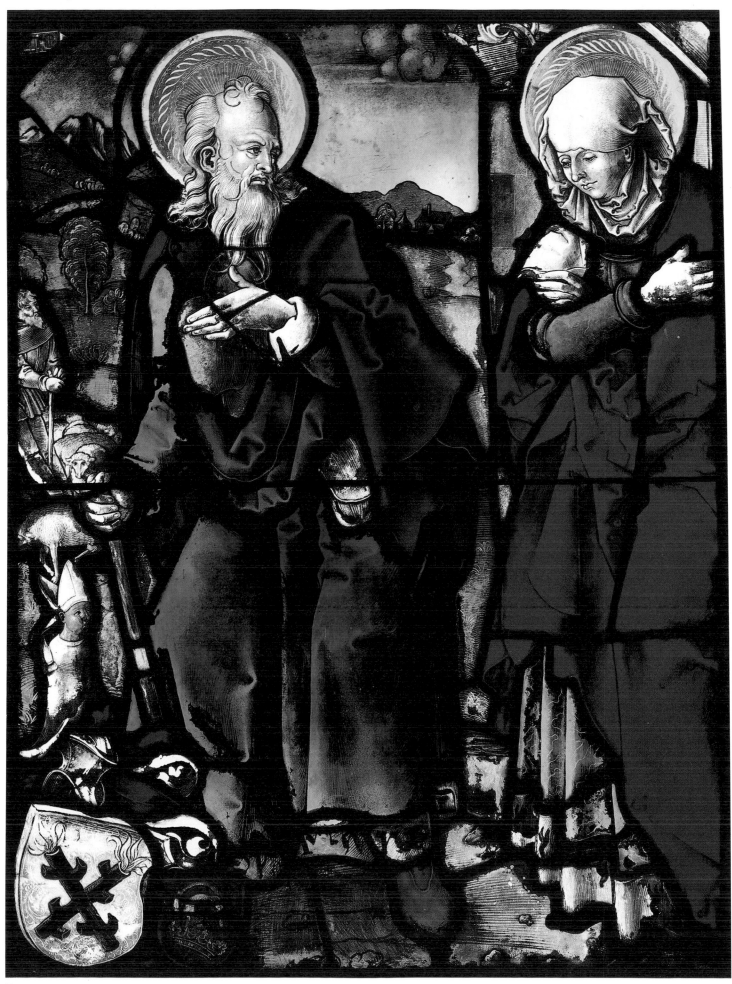

174: 1

359

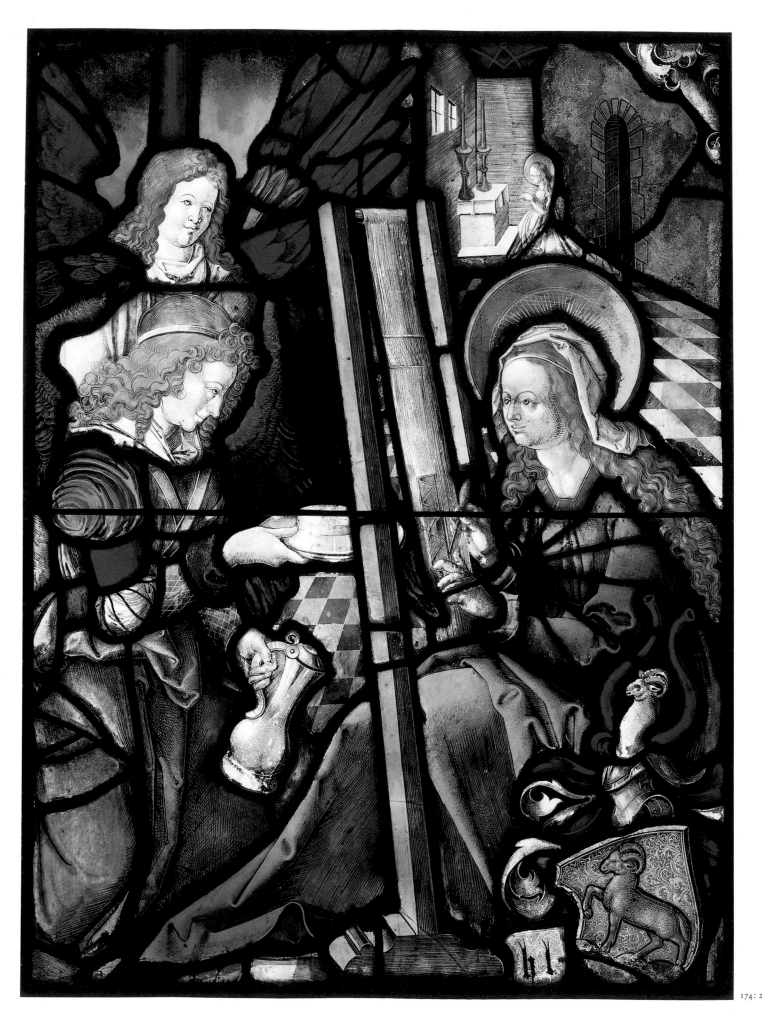

174:2

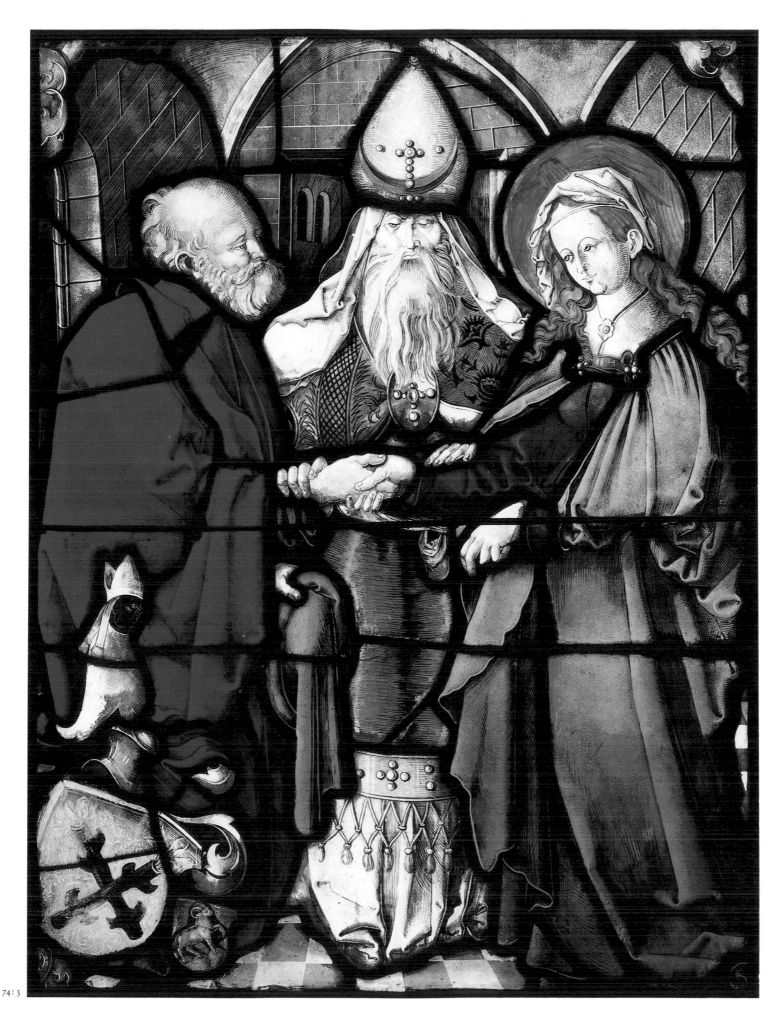

74:3

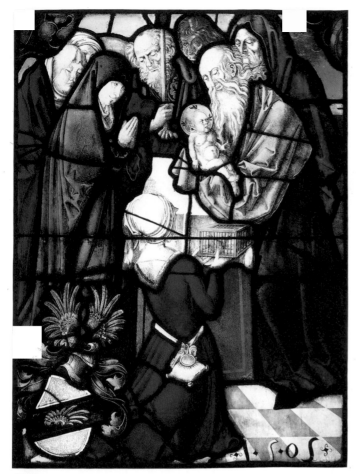

174:4

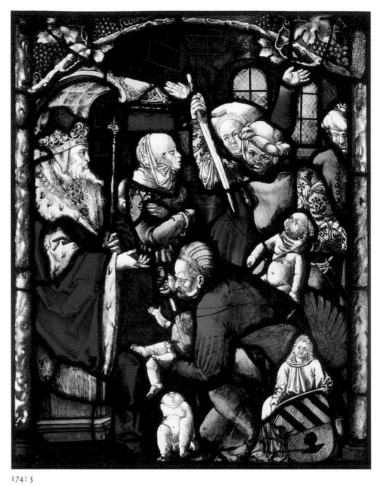

174:5

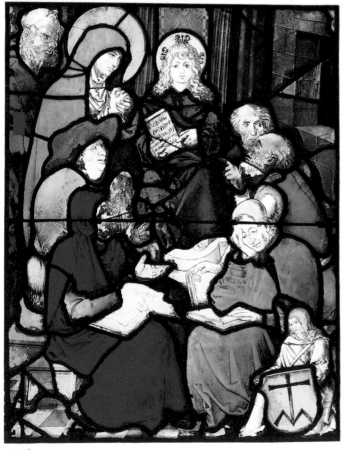

174:6

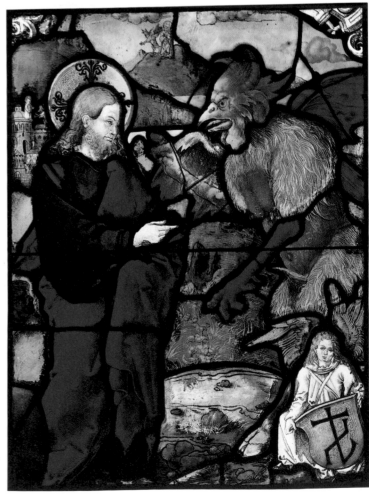

174:7

two are dated: the *Presentation in the Temple* (1505), in Grossgründlach, and *Christ Washing the Feet of His Disciples* (1511), in Wöhrd. The entire cycle must have been created between 1504 — the year that Erhard Schürstab became prior — and the beginning of the second decade of the sixteenth century.

Everything that is known about stained-glass painting in Nuremberg would suggest that the works must have been made in the workshops of Veit Hirschvogel the Elder. At this time, there appear to have been no other notable glass painters. The compositions, however, and the designs that were copied by the actual painters of the panels were by artists whose styles were close to Dürer's. He did not participate in the preparation of the designs, himself — or at least it would appear, from the surviving panels, that he did not. In any case, he was in Italy during the crucial period — from late summer 1505 to January 1507 — when Hans Baldung Grien apparently supervised his Nuremberg workshop.

Karl-Adolf Knappe has published various arguments showing to what extent the panels from the Karmeliterkloster were based on designs by Baldung. His opinions are founded on a detailed comparison with known works by Baldung, including drawings and the designs for the woodcut illustrations for Ulrich Pinder's *Der beschlossen Gart des Rosenkranz Mariä*, which appeared in print in 1505. According to Knappe, all the designs for the Grossgründlach panels, as well as the *Nativity* and the *Adoration of the Magi* from Wöhrd, may be attributed to Baldung, and he also identifies stylistic features reminiscent of those of Baldung in the *Crucifixion*. The scene in which Mary sits at her loom weaving the curtain for the Temple while being given food and drink by the Archangel Gabriel, her Betrothal to Joseph, the *Presentation in the Temple*, the *Temptation of Christ*, and the panel depicting Joachim and Anna reveal such similarities to works by Baldung's own hand, both in their designs and in the drawing of the heads, that it seems certain that he, himself, prepared the full-size cartoons. The glass painter needed only to transfer the designs, quite mechanically, to the individual panes. Stylistically, these compositions may be grouped more or less accurately around the year 1505 — the date given on the *Presentation in the Temple*. Knappe notes, however, that the monumentality of the figures of Joachim and Anna anticipate later works by Baldung, from 1508 to 1512, and represent his inventive genius at the height of its powers; this was just before he left Nuremberg, for good. Since the donor of this panel died in 1507, it is doubtless necessary to assign an earlier date to this work, as well.

The rest of the scenes in Grossgründlach — *Christ Among the Doctors*, and *The Supper at Emmaus*, the weakest panel of the cycle — could only have been based on small-format drawings by Baldung, which were then coarsened in the process of being enlarged into cartoons, and transferred to the glass by less competent artists. Although they do preserve elements of his art, they exhibit only little of his own hand. Knappe

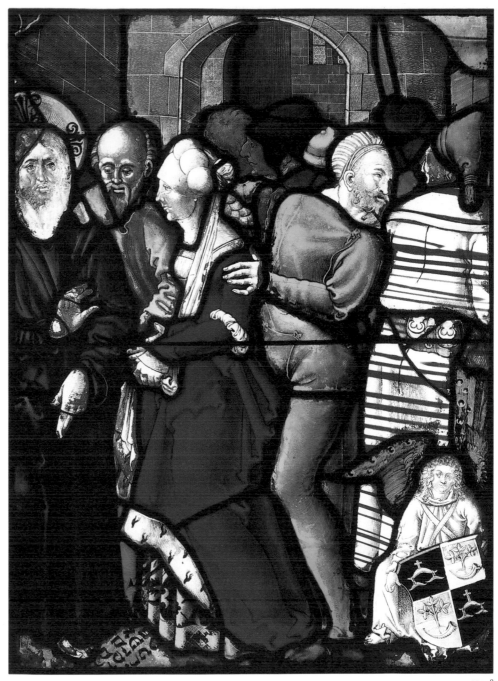

174:8

insists that the attribution of the *Christ and the Woman Taken in Adultery* is even more difficult, for its composition is very close to those of Baldung, but, because of the unimaginative treatment of the faces and the crudeness of the hands, the panel seems far removed from his style. This is true, in another sense, of the *Crucifixion*, as well — even though a comparison with Baldung's woodcut of *Christ on the Cross*, of 1505–7 (Mende, 1978, no. 2), makes it clear that Baldung had a part in its composition. Moreover, the splendid head and, in fact, the entire figure of Saint John, at the edge of the picture, reveal Baldung's touch.

The *Christ Bearing the Cross* in Wöhrd can be attributed with relative assurance to Hans Suess von Kulmbach, on the basis of a fragment of the cartoon with the figure of Saint Veronica, preserved in Dresden, which is generally thought to be his work (Winkler, 1942, no. 64, ill.). Finally, Knappe links the *Massacre of the Innocents* — with its confusing, even bizarre composition — to Kulmbach, rather than, as previous authors had done, to Baldung. The composition of the panel distinguishes it from the typical Baldung examples in Grossgründlach — as do its gloomy colors, which are in sharp contrast to the light, often shimmering yellow dominating those works. The same dark colors are used in the *Bearing of the Cross*. In the *Noli me tangere*, the uncertainty and carelessness in the drawing are most striking — for example, on the original, large sections of the Magdalene's white cloak — which, of course, can also be the work of the glass painter who executed the design.

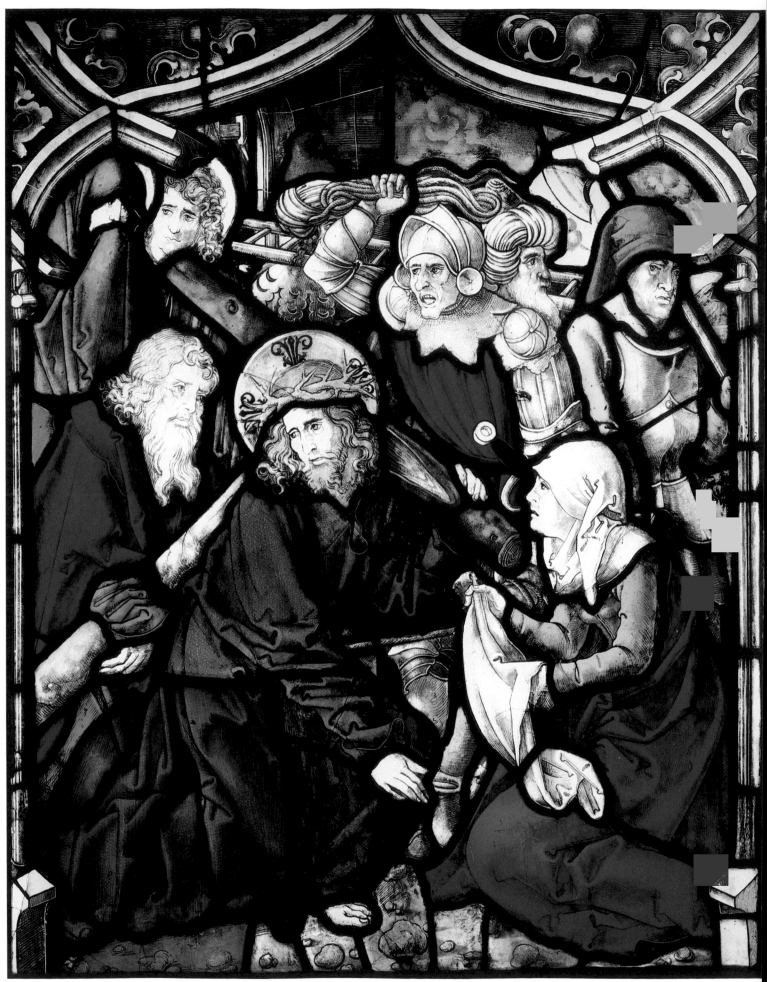

174:

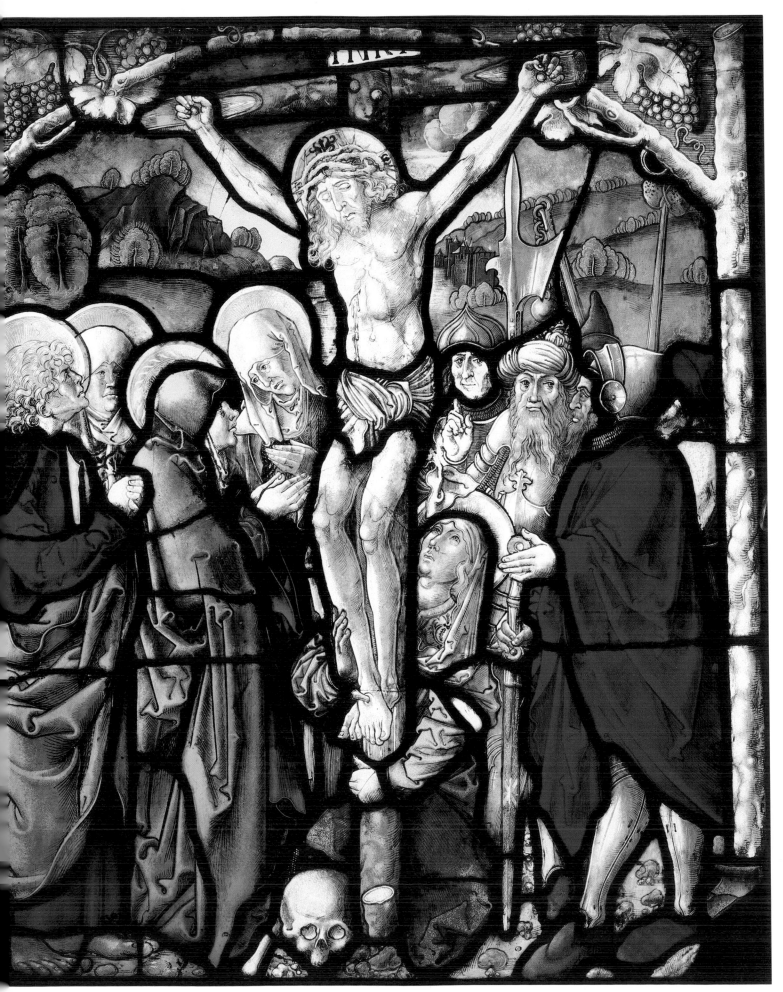

174:10

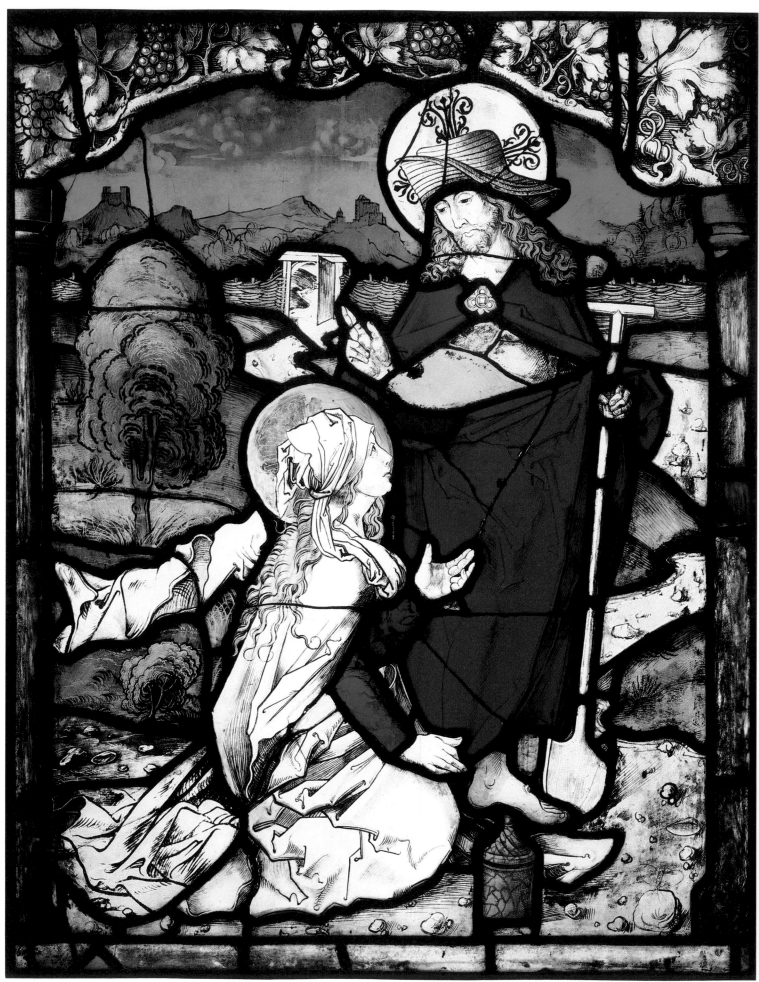

The difficulty encountered in attributing the designs of all of the panels to specific artists is a result of the way in which stained glass was produced in Nuremberg in the early sixteenth century. A number of hands were involved, not only in the stained-glass workshop of the Hirschvogels but in the design process in Dürer's studio, as well. As many as four artists might have participated in the creation of the design of any given panel: one providing the initial sketch, another transforming that sketch into a finished drawing, still another producing the full-size cartoon, and, finally, a last one copying from the cartoon onto the glass. It is understandable, then — given that the work of the artists in Dürer's shop was already quite uniform — that individual stylistic features should have been obscured beyond recognition. Added to this is the fact that study of the individual artists comprising the Dürer school is by no means so advanced as to permit them to be distinguished with any certainty — even at the drawing stage. Whatever personal idiosyncrasies might still have remained in the full-size cartoons were likely to have been lost in the transfer of the design to the glass. It is, therefore, not surprising that a sure identification of the designer and of the other artists who worked on each of the surviving panels is quite impossible.

Of course, the artistic importance of the Karmeliterkloster panels derives only in part from the originality of their compositions. Other contributing factors are the high quality of their execution, and the way in which color was employed as the primary means of expression. The scenes portraying the Virgin at her loom, the Betrothal, and Joachim and Anna are grandiose compositions, relying on only a few dominant figures. Yet, the subtle choice of the colors — at times, resulting in quite artificial effects — betrays Baldung's taste just as forcefully. It appears that he had ultimate control over the preparation of the cartoons, the selection of the glass to be used, and the style of the painting. The strong contrasts between the red and green and the blue and violet in the garments of Joachim and Anna, for example, are highly studied, and they have been exploited with great skill. The darker tones — especially the red — have been heightened by halftone washes to a velvety richness, so that the unpainted white sections stand out all the more strikingly. Another instance of the same taste at work is the prevalence of radiant yellow, both for its own transparency and brilliance as well as for the numerous shadings that were possible with the addition of silver stain. The scenes from the Virgin's childhood derive much of their charm from the masterful application of this technique. The daring use of color culminates in the multi-figured composition with *Christ and the Woman Taken in Adultery* — specifically, in the contrast between the showy red velvet, ermine, and black-and-gold brocade clothing of the sinful woman, and the cold, harsh, poison-green garment of the man who has brought her, and who is about to respond to the shaming words Christ

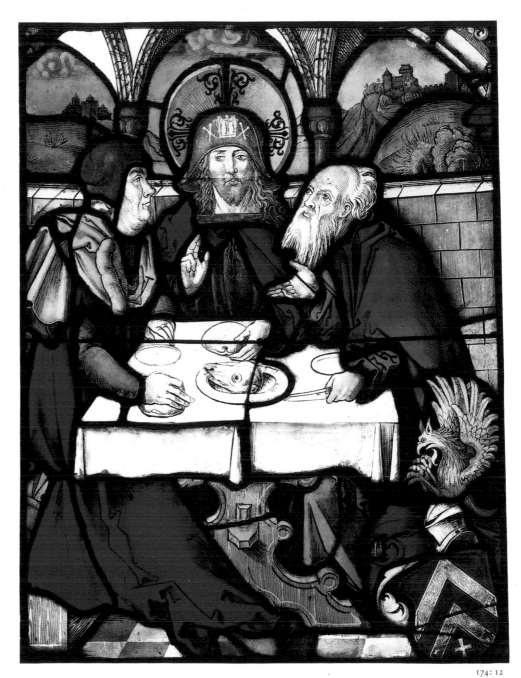

174:12

has addressed to him. The red-and-white striped robe of the man behind Christ is a triumph of the stained-glass painter's art.

Nothing demonstrates more vividly the strong influence of the designer on the final appearance of stained glass — when he, above all, controls the choice of colors and the technical production — than the striking difference between the panels just mentioned and the Emmaus scene. The design, itself, may have been Baldung's, as well, but the flat execution of the drawing on the glass is matched by a lack of excitement in the colors. Clearly, each was the work of a different craftsman. While this panel happens to be one of the best preserved of the entire cycle, as far as the paint is concerned, and although, as an example of technique, it is superb, it nevertheless displays none of the boldness, the spontaneity, or the effectiveness that so often characterizes the art of Hans Baldung Grien. RK

BIBLIOGRAPHY: Würfel, 1757, p. 194; Volkert, 1881, p. 15; Oidtmann, 1907, pp. 35–36, 50; Schinnerer, 1909–10, pp. 240–44, ill.; Schmitz, 1913, vol. 1, p. 142; Weinberger, 1921, p. 251, n. 79; Röttinger, 1926, pp. 94–95; Schwemmer, 1933, pp. 40–47; Knappe, 1958, p. 178; Winkler, 1959, pp. 27, 101; U. Frenzel, 1960, p. 64, colorpls. 26–28; Knappe, 1960, p. 186; G. Frenzel, 1961, p. 51; G. Frenzel, in *Meister um Albrecht Dürer*, 1961, nos. 5 a–o, pl. 32; Grote, 1961, p. 70, ill. 55; Knappe, *Grossgründlach*, 1961, pp. 60–80, ills. 1, 2, 4, 6, 7, 9, 11, 14, 16–18; Knappe, 1961, pp. 254–55; Winkler, 1961, p. 267; Knappe, 1962, pp. 355–62, ill. 1; Knappe, 1963, pp. 58–68, 106–12, 122 (with additional bibliography), ills. 25–41, 61–63, colorpl. x; Fehring and Ress, 1977, pp. 346, 487; K. Ulrich, 1979, pp. 22–25.

367

Saint Catherine and Saint Barbara

About 1505/6
Tempera on pine wood
Each, 61 $^{13}/_{16}$ x 23 $^1/_4$ in. (157 x 59 cm.)
Schwabach, Evgl. Luth. Stadtpfarrkirche Sankt
Martin

These painted wings from an altarpiece show Saint Catherine carrying the sword and the wheel, the instruments of her martyrdom, and Saint Barbara holding the chalice, the symbol of her conversion. They stand on stony ground from which only a few blades of grass sprout. The original deep blue background has darkened to black, and the grain of the wood is clearly visible through the thin priming. Saint Catherine raises her eyebrows and lowers her eyelids, while her mouth shows traces of a smile. Saint Barbara looks over her shoulder with her head inclined. Her rounded features, kindly expression, and full chin add to her femininity. The artist's feeling for the massing of large areas of the forms and for strongly delineated contours gives the figures a sense of weightlessness and avoids any impression of monumentality.

In the catalogue of the 1928 Dürer exhibition in Nuremberg it was proposed that the panels possibly were the wings of Dürer's *Paumgartner Altarpiece* (in the Alte Pinakothek, Munich). Carl Koch (1958) upheld a suggestion by Karl Oettinger and attributed the paintings to Hans Baldung Grien, which has generally been accepted. The dates offered vary from 1503 to 1506. Both the original setting of the altarpiece wings and the place for which they were intended must be considered. That the wings were fixed is certain, for the thinly primed panels are painted only on one side.

The theory that these painted wings belonged to the *Paumgartner Altarpiece* is based on Christoph Gottlieb von Murr's 1778 description of it. At that time, the altarpiece was installed at the end of the south aisle in the Katharinenkirche, in Nuremberg. The central panel and the movable wings, which had been sold to the duke of Bavaria in 1613, were replaced with copies. Von Murr wrote:

On the *Paumgartner Altarpiece* is the copy of a splendid Dürer painting showing the birth of the Savior of the World. The original has been presented to Elector Maximilian of Bavaria, after a most worthy councillor had ordered a copy, which is practically identical. On the right-hand wing is the knight Saint George; on the left is Saint Hubert, also by the same artist. The former is a portrait of Steffan Paumgartner; the latter, of his brother Lukas. On the outside is the Annunciation, with Saint Catherine on the right and Saint Barbara on the left. There are very ancient paintings on the doors of the reliquary: on the right, the wise men bearing gifts, and on the left, the death of Saint Anne; outside, on the right, Christ appears to Mary Magdalene in the garden, and on the left, between Saint Augustine and Saint Sebald, Jesus' mother sinks in grief over his corpse.

Von Murr was explicit in ascribing to Dürer only the *Nativity* and the paintings of Saints George and Hubert (Saint Eustace). The predella wings were from an older altarpiece. The paintings on the reverse of the movable wings of the altarpiece and on the fixed wings are not linked with any artist's name. Accordingly, the altarpiece was not the concept of a single master. If what von Murr described was the result of a late-sixteenth-century alteration, it must have involved the use of an older predella. The paintings on the fixed wings date from the beginning of the sixteenth century. They did not, however, belong to the original altarpiece, whose central panel is dated to about 1503/4. It is even doubtful that the present form of Dürer's triptych is the original one.

In 1503–4, Dürer executed a painting of the Nativity for Martin Paumgärtner's four children, in memory of their deceased parents. The birth of the Redeemer seldom appears as the central subject of an altarpiece — in contrast to the Adoration of the Magi — but was a common theme in Nuremberg on the epitaphs for Conrad Winkler (died 1431), Walburg Prünsterer (died 1434), Anna Imhoff (died 1449), and Georg II Dietherr (died 1464). Family groups, on a smaller scale, were also commonly depicted on epitaphs, although they were usually separated from the holy events and occupied another part of the picture. Dürer unified the pictorial space, but retained the different scale for the donors. In size, the *Nativity* does not vary much from the Holzschuher and Glimm epitaphs (in the Germanisches National-museum, Nuremberg, and the Alte Pinakothek, Munich), whose central subject is the Lamentation. The contained, architectonic composition of the Paumgartner *Nativity* precludes the existence of accompanying pictures. The connection with the Paumgartner paintings of the saints has always — correctly — been found unsatisfactory, leading to the suggestion of various dates for their completion (see Anzelewsky, 1971). The black background and the stony landscapes in the paintings of the saints not only implies another treatment of space; in size, the knights dominate the Holy Family, thus disturbing the usual hierarchical arrangement of the figures. The humility of the small figures of the donors (Lukas and Stefan Paumgartner) is reversed on the wings, where they appear self-confidently attired in lavish costumes.

It seems likely that the Paumgartner family incorporated the memorial painting of the Nativity into the center of an altarpiece, providing it with wings from another, existing, altarpiece. The wings with the holy knights were from an altarpiece that the brothers Lukas and Stefan Paumgartner donated to the Katharinen-kirche shortly before Stefan's pilgrimage to the Holy Land in 1498, and may have included a carved central shrine (see *Dürer*, Nuremberg, 1971, no. 590). The rearrangement also involved the enlargement and embellishment of the component parts: The backs of the new, movable wings had to be painted, and fixed wings were added. With the *Nativity* in the center and the *Annunciation* on the outsides of the inner wings, the result was an altarpiece dedicated to the Virgin. The fact that only the Virgin of the Annunciation is preserved on the reverse of the left panel and that there is no trace of a painting on the reverse of the right panel may indicate that this panel was covered by a second, painted one. It was natural that there should be a painting of the patron saint of the church, Saint Catherine, on one of the fixed wings.

The commission was given to Dürer, but he left its execution to members of his workshop — among them, the less gifted painter of the *Annunciation* and the highly talented Hans Baldung Grien. Evidently, there was no time to spare, and the work was done in a hurry. This may have been because of Dürer's journey to Venice late in the summer of 1505. He had two major projects still outstanding: the extensions to the *Paumgartner Altarpiece*, and an altarpiece of the Passion for Elector Frederick the Wise of Saxony. Work on the latter, the Ober St. Veit Altarpiece, was carried out from 1505 to 1507 by Hans Leonhard Schäufelein, at that time, Dürer's closest associate (it is now in the Diözesanmuseum, in Vienna). If Dürer only had time to supply sketches for a project of this importance, it is easy to understand why he let others assemble some of his older panels and create new ones for the *Paumgartner Altarpiece*, for Dürer found no satisfaction in work of this kind. However, it afforded Hans Baldung Grien the opportunity to show his skills at an early age. Panofsky assumed that Dürer's drawings of Saint Catherine (Winkler, no. 90) and Saint Barbara (Winkler, no. 194) were studies for the fixed wings mentioned in von Murr's description of the Schwabach panels. Baldung may have known the drawings, but, in any event, it was Dürer's representation of Saint Catherine that inspired him. Baldung's paintings do not attain the mastery of his single woodcuts of these female saints, or, indeed, of his finest series, the *Speculum Passionis*, of 1507. Here, there was more to be learned from Dürer, and the pupil was able to realize his own conceptions more boldly. The paintings of the four saints had to conform to what already existed. There are good reasons why they do not harmonize with the panels of the Annunciation: The latter paintings were executed at the same time, and Baldung took Dürer's *Paumgartner Altarpiece* saints as his models.

If the connection between the Schwabach panels and the *Paumgartner Altarpiece* is rejected, then, perhaps, the situation may be explained thus: two pairs of fixed wings were painted, for two different altarpieces of almost identical size — each pair depicting Saint Catherine and Saint Barbara, and one or both (?) pair(s) by Hans Baldung Grien. It is, however, indisputable that it was Dürer who received the original commission. KL

BIBLIOGRAPHY: von Murr, 1778, p. 291; *Dürer*, 1928, nos. 53, 88; Winkler, 1936–39, vol. 1, nos. 90, 194; Panofsky, 1948, vol. 11, nos. 5, 851, 854; Koch, 1958, pp. 157–62; *Hans Baldung Grien*, 1959, p. 39, nos. 2–3; *Meister um Albrecht Dürer*, 1961, no. 1; Oettinger and Knappe, 1963, pp. 21–22, 82, no. 1; von der Osten, 1983, no. 2.

175

178: wings open

le, which was consecrated by Cardinal Albrecht von Brandenburg in 1523. It is not known for what church it was originally intended. The work may well have been commissioned by the cardinal's predecessor, Archbishop Ernst von Wettin (died 1513).

The cult of Saint Sebastian was widespread in Germany. He was honored as the patron saint of archers' societies. His martyrdom was one of the most popular subjects of Late Gothic painting. The challenge for the artist was to portray the bound saint and the mercenary soldiers who shoot arrows at him in a plausible composition — although the arts of illustration and of painting offered different solutions. In an altarpiece, the martyr had to be presented to the worshipers so that they could direct their supplications to him without being too deeply distracted by the actions of his torturers. Even though he was to be pitied for his suffering, he still had to project an impression of strength, and of being able to act on behalf of all those under his protection. In the present painting, the soldiers have little more than a symbolic function, as a result of their foreshortened poses; although they are not presented at a great distance from Saint Sebastian, hierarchically,

they are subordinate to him. Their actions seem false, for they are so close to the saint that they could not actually draw their bows and release their arrows with any effect.

Baldung's Saint Sebastian, clad only in a loincloth, is a handsome, well-groomed young man, slender and well built, with curly hair and a beard. The pose, with his right arm tied above his head and his right leg bent, is somewhat precious. The saint is provided with a kind of "double," in the form of the earnest young man behind him, who wears a modish costume and a cap at a jaunty angle, and gazes out at the viewer. The figure is none other than Hans Baldung Grien, serving as a pious witness to the martyrdom. The artist depicted himself in a prominent position, as the confident creator of the altarpiece. Opposite these two men is a group of several figures: colorfully dressed archers, a halberdier whispering in the ear of a dignitary, and a man who appears uninvolved in the proceedings.

The artist described the event with realistic detail but without emotion. He made no more of the suffering of the saint than he did of the cruel delight on the part of the soldiers. The pensive-looking man with the gold cap, who is

pressing his hand to his breast either in entreaty or to underscore his words, supervises the martyrdom as Emperor Diocletian's prefect, but the artist has portrayed him with respect. Gert von der Osten (1983) identified him as the man who commissioned the altarpiece, Ernst von Wettin. The traditions of patronage and of Late Medieval piety would not preclude such an inclusion; the archbishop, thus, confesses himself to be a penitent sinner.

The deacon Stephen, represented on the inner left wing of the altarpiece, lifts his brocade dalmatic, containing the stones of his martyrdom, gazing, as though in meditation, past his open book. On the corresponding right wing, the giant Saint Christopher trudges through water up to his ankles, his cloak flowing in the wind; he carries a birch trunk that he has uprooted and, on his shoulder, the Christ Child, who raises his hand in benediction. On the reverse sides of the wings, Saint Apollonia, at the left, appears in the traditional pose, holding forceps and a tooth, and Dorothy, at the right, has the basket in hand, filled with roses, that a naked male child — Jesus — has brought her as assurance that the heavenly Paradise awaits her. Apollonia wears a crown and a courtly costume,

372

178: center panel

373

while Dorothea appears in a more ordinary dress.

The most striking features of the altarpiece are its large areas of glowing color and unusual tonal combinations, the realistic three dimensionality of its sturdy figures, the poses of the archers — which can only have been studied from life — the portrait heads, and the close observation of nature, in general. This last quality is evident in the depiction of the bark of the trees, the details of the meadowland, and the deep, airy space, with the hills appearing blue, in the distance. The artist himself is dressed entirely in green — an allusion to the name bestowed upon him by his contemporaries.

The *Saint Sebastian Altarpiece* — a work filled with the fire of youth — challenged all of Baldung's artistic abilities. It is remarkable how little it conforms to the academic style of the Dürer shop, as typified by the art of Hans Leonhard Schäufelein. Its unbalanced composition, the strength of its color, and the painterly brushwork distinguish it from the art of the master, himself. This has been explained by the fact that Baldung had received his training in the region of the Upper Rhine before he entered Dürer's atelier, and had been exposed to the influences of the art of Central Germany. Oettinger and Knappe (1963) noted similarities to works by Lucas Cranach the Elder — especially, to his *Saint Catherine Altarpiece*, of 1506, for Torgau (in the Gemäldegalerie, Dresden).

It has not been determined where the two painted altarpieces for Halle — the present one, and the *Adoration of the Magi Altarpiece*, in Berlin — were created. More than likely, Dürer secured the Wettin commission for Baldung, and the wings of the earlier, unsigned altarpiece of the *Adoration of the Magi* were painted while Baldung was still employed in the master's workshop. If this is the case, then the *Saint Sebastian Altarpiece* would represent the first independent work of the painter — as the presence of his monogram seems to suggest. The contrast between its colorful female saints and the more muted ones on the wings of the Schwabach Altarpiece is obvious, but, in the latter case, the artist had to relate the panels of Saints Catherine and Barbara to already existing paintings (see cat. no. 175). The imposing and highly original features of the *Saint Sebastian Altarpiece* are better explained as indications of Hans Baldung Grien's own strong, intense, and, as yet, not fully mature artistic personality, rather than as reflections of outside stimuli.

KL

EX COLLECTIONS: sold by Halle Cathedral (1838); Justizkommissar Wilcke, Halle; Hermann Goldschmidt, Brussels; [sold, Goldschmidt-Przibram auction, Frederic Muller & Cie., Amsterdam, no. 3 (June 17–19, 1924)].

BIBLIOGRAPHY: Eisenmann, 1874, pp. 156–58; Terey, 1894, p. 43, no. 51; Stiassny, 1897, pp. 225–37; Curjel, 1923, pp. 34–37; Lutze and Wiegand, 1936–37, pp. 18–19, ills. 234–236; *Baldung...*, 1959, nos. 4–8; *Meister um Albrecht Dürer*, 1961, no. 3; Oettinger and Knappe, 1963, pp. 32–35, no. 3; von der Osten, 1983, p. 20, no. 6.

178: interiors of the wings

178: exteriors of the wings

a) The Mass of Saint Gregory
Tempera and oil on wood
35 1/8 x 49 1/8 in. (89.2 x 124.7 cm.)
Inscribed (on halo, at center): S. GREGORIV . . .
The Cleveland Museum of Art, Gift of the Hanna
Fund, 1952
52.112

b) Saint John on Patmos
Tempera and oil on wood
Overall, 35 1/4 x 30 1/4 in. (89.5 x 76.8 cm.);
painted surface, 34 3/8 x 29 3/4 in. (87.3 x 75.6 cm.)
Signed (lower right, on rock): · HBG · [monogram]
New York, The Metropolitan Museum of Art,
Contributions from various donors supplemented
by Museum purchase funds, 1983
1983.451

c) Saint Anne, with the Christ Child,
the Virgin, and Saint John the Baptist
Tempera and oil on Masonite, transferred from
panel support
35 x 30 1/2 in. (89 x 77.5 cm.); original painted
surface, 34 1/8 x 29 7/8 in. (86.7 x 75.9 cm.)
Signed (upper right, on throne): HBG [monogram]
Inscribed (on haloes): S IOHANE, S ANNA, MARIA
Washington, D.C., National Gallery of Art,
Samuel H. Kress Collection, 1961
1961.9.62

Although these three pictures were seen to-
gether in the 1959 Baldung exhibition in Karls-
ruhe, they are here reunited for the first time
since von der Osten convincingly argued (1977,
pp. 51–61) that they originally comprised a
single work of art. Since its publication by Koch
(1951, p. 64), the Cleveland panel has been pre-
sumed to have been painted for the Order of
Sankt Johann in Jerusalem at Grünen Wörth in
Strasbourg, since a member of that Order (bear-
ing a Maltese cross) appears at the far right of
that picture. Baldung is documented as having
received payments from the Order in the first
half of 1511 — one, of ten gulden "vff dic tafel
zu malen," and another, of fourteen gulden,
"von dem fur altar zu malen" (see below for the
meaning of these records). These payments for-
merly were presumed to be for a single work,
The Mass of Saint Gregory, the style of which
agrees with the date 1511.

The New York and Washington panels have
been recognized as the probable wings of a
small triptych, following their publication by
Pariset (1934, pp. 13–23). Although the vertical
dimensions of these three paintings agree pre-
cisely, it was not realized initially that they be-
longed together because the combined width of
the lateral panels is considerably more than that
of the Cleveland picture. Von der Osten discov-
ered a document that virtually confirms that all
three were painted for the Order of Sankt
Johann in Strasbourg.

In a 1741 inventory of the possessions of the
Order (which had by then been removed to the
former Monastery of Sankt Marx, in Stras-
bourg), three paintings in the sacristy of the

375

179c: detail 179a: detail 179b: detail

church are listed separately but consecutively: a wide picture, the description of which exactly matches the Cleveland panel; a nearly square *Saint John on Patmos;* and another in the same format depicting Saint Anne, the Virgin, and the adult Baptist in an animal skin. There can be no doubt that the works in question are the present three. Von der Osten suggests that the original assemblage was dismantled about 1633 when the Order's church at Grünen Wörth was destroyed and its contents put in storage for the next fifty years.

The panels' original disposition is not certain, and depends upon one's reading of the records of payment. The greater probability is that they formed a small triptych with stationary wings,

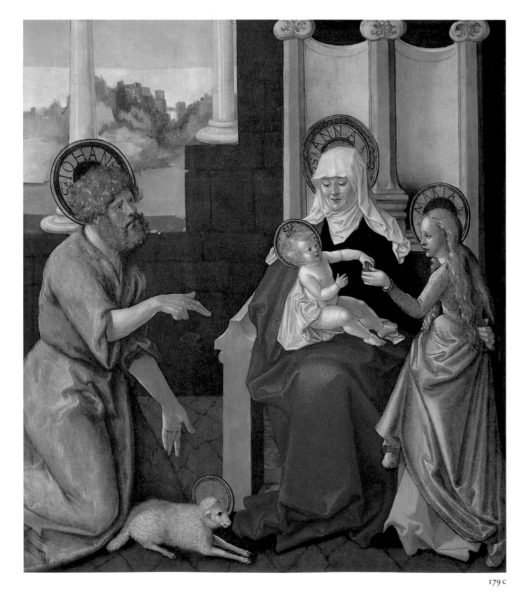

179c

an arrangement that allows for the narrowness of the center panel and for the fact that the backs of the wings were not painted (as is clear from the lateral panel in New York, which preserves its original support). "Die tafel" in the first record of payment could well refer to such a three-part altarpiece in its entirety. The lesser probability is that the paintings comprised an antependium (altar frontal), with the lateral panels on the sides of the altar. This would also explain the panels' irregular dimensions and unpainted backs, and is supported by the words in the second record of payment: "fur altar," or antependium. However, von der Osten observes that an antependium of panel paintings would be highly unusual, and suggests that the phrase might well be a notary's abbreviation for "von dem [ausgesetzten Geld] für [den] Altar zu malen" ("from which [money allowed] for [the] painting of the altarpiece").

In addition to physical evidence — similarly inscribed gilded haloes in the left and center panels, matching pine supports for the center and right panels (the left was transferred in 1953) — the unity of these three pictures is underscored by their integrated iconographic program. The central panel is explicitly Eucharistic. It depicts the mystic Mass performed by Saint Gregory, the fourth-century pope and Church Father, who is here assisted by a deacon and a subdeacon. Having learned of a disbeliever in his congregation, Gregory prayed to God for a sign of his divine power. At the moment of transubstantiation, the Man of Sorrows materialized on the altar — a corporeal manifestation literally embodying the mystery of the sacrament that commemorates Christ's sacrifice for Man's salvation.

Two other "mysteries" of Christian theology — one from the past (at the left) and one yet to come (at the right) — are the subjects of the lateral panels, which emphasize the role played by the Virgin in the drama of mankind's redemption. The left wing includes Saint Anne with the Christ Child and the Virgin *(Anna Selbdritt),* a subject concerned with the Immaculate Conception of Mary. The Christ Child, who appears to hand an apple to the Virgin — thus enacting the reverse of the Fall of

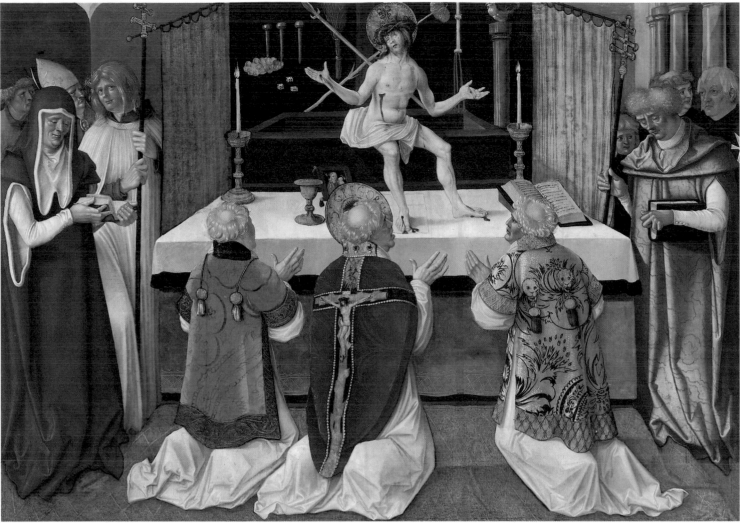

179a

Man — is the New Adam, and she, the New Eve, born without sin. To the left, John the Baptist (patron saint of the Order of Sankt Johann) gestures with one hand toward the Lamb of God, and with the other to the Christ Child, a dual action alluding to his pronouncements: "Behold the Lamb of God, which taketh away the sin of the world" (John 1:29), and "He must increase, but I must decrease" (John 3:30). The right wing features a moment from the apocalyptic vision of John the Evangelist (who was often included with the Baptist in works commissioned by institutions dedicated to the latter saint). The moment represented is that of the appearance of the Apocalyptic Woman — symbolizing, again, the Virgin's Immaculate Conception, and also God's promise of the possibility of Man's redemption at the end of time. In the center panel, the importance of Mary is suggested by her introduction in the form of a painted pax to the right of the chalice on the altar.

As first proposed by Koch, the figure bearing a Maltese cross at the right of the Cleveland painting is probably a portrait of Erhart Künig, Commander of the Order of Sankt Johann in Strasbourg from 1504 until his death on November 3, 1511. Von der Osten (1977; 1983, pp. 72–73) provides tentative identifications for the four men at the left, whose heads, he notes,

like those of the four figures at the right, are portrait-like in appearance. It is likely that the cardinal in the foreground is Raymundus Perault (Peraudi), Cardinal of Santa Maria Nuova, Rome, and Bishop of Gurk, who, about 1500, was appointed cardinal legate for all of Germany (which then included Strasbourg). The bishop behind him may be Wilhelm III von Honstein, Bishop of Strasbourg from 1506 until 1541. As suggested to von der Osten by Jean Rott, the bearer of the papal cross could be Dr. Hieronymus Baldung, recorded in 1512 as protonotary apostolic, and the man behind him, wearing a cap, could be his brother Hans Baldung, episcopal procurator in Strasbourg, who rendered legal services to the Order of Sankt Johann from 1506 until his death in 1511 or 1512. The brothers were relatives of the artist, probably his uncles.

The composition of the center section of the Cleveland picture is closely related to Baldung's woodcut of *The Mass of Saint Gregory*, for the *Hortulus animae*, published in Strasbourg on February 2, 1511. The composition of the New York picture and the figure of the Baptist from the Washington painting were adapted, about 1515/16, for the wings of the *Schnewlin Altarpiece*, by Baldung's workshop, in the cathedral of Freiburg.

G B

EX COLLECTIONS: (a) Monastery of Sankt Johann in Jerusalem, Strasbourg (by 1511–after 1741); Marquis de Villefranche, Château de Villarceaux, Chaussy, and Château d'Ambleville, Bray-et-Lû, Val d'Oise (for five generations [since about 1792?]); Henkell collection, Wiesbaden; [Fritz Fankhausen, Basel, 1951]; [Rosenberg & Stiebel, New York, 1951–52]; (b) Monastery of Sankt Johann in Jerusalem, Strasbourg (by 1511–after 1741); village church, Alsace (until shortly after 1870); Dr. Georges-Joseph Wimpfen, Colmar (shortly after 1870–79); his son, General Joseph-Émile Georges Wimpfen, Paris (1879–1949); [P. de Boer, Amsterdam, until 1955]; Dr. Heinrich Becker, Dortmund (1955–71; sale, Sotheby and Co., London, December 8, 1971, no. 28); [Claus Virch, Paris, 1971–83 (on extended loan to the Wallraf-Richartz-Museum, Cologne, 1975–83)]; [Eugene Thaw, New York, 1983]; (c) Monastery of Sankt Johann in Jerusalem, Strasbourg (by 1511–after 1741); village church, Alsace (until shortly after 1870); Dr. Georges-Joseph Wimpfen, Colmar (shortly after 1870–79); his daughter Marie Émélie Jeanne Siben, Paris (1879–1951); [Fritz Fankhausen, Basel, 1951–52]; [Rosenberg & Stiebel, New York, 1952–53]; The Samuel H. Kress Foundation (1953–61).

BIBLIOGRAPHY: Pariset, 1934, pp. 13–23, figs. 2, 3 (b, c), 1939, no. 86, p. 19, n. 3 (b); Fischer, 1939, pp. 9, 20 (b, c); Perseke, 1941, pp. 49, 67, pls. 8, 9 (b, c); C. Koch, 1951, p. 64 (a); Francis, 1952, pp. 184–87, ill. pp. 180–81 (a); C. Koch, 1953, p. 297 (a, b, c); Francis, 1954/55, p. 8, fig. 7 (a); *Catalogue of Old Pictures Exhibited at . . . P. de Boer,* 1955, n.p., ill. (b); C. Koch, ed. Heimpel, 1956, p. 406 (a); Suida and Shapley, 1956, p. 26, ill. p. 27 (b, c); Milliken, 1958, p. 33, ill. (a); Zimmermann, 1959, no. 14, pl. 6 (c), no. 15, pl. 7 (b), no. 16, pl. 5 (a); Möhle, 1959, p. 128 (a, b,

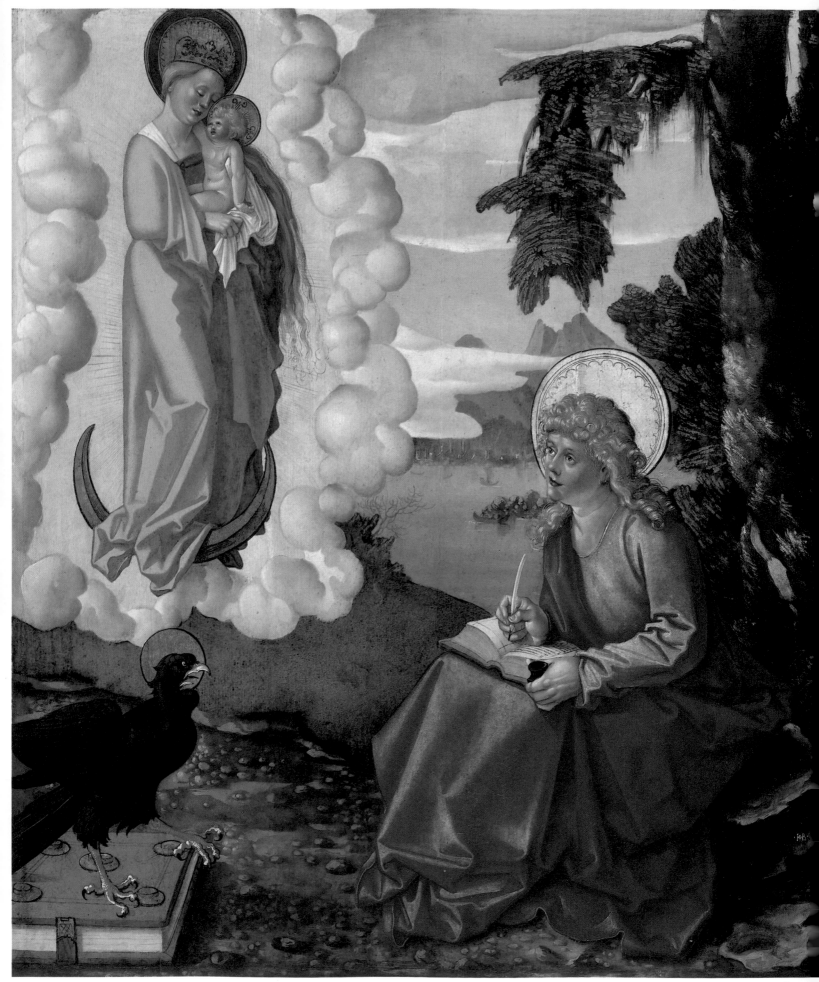

c); Oldenbourg, 1960, pp. 195–98, fig. 1 (c); Oettinger and Knappe, 1963, p. 105, n. 247 (c); Tolzien, 1964, pp. 185, 188 (a, b, c); von der Osten, 1965, p. 182 (a); Fritz, 1967, no. 1, ill. (b, c); R. A. Koch, 1974, p. 7 (a, c); Eisler, 1977, pp. 29–30, fig. 32, text fig. 8 (a, b, c); von der Osten, 1977, pp. 51–61, figs. 1–8 (a, b, c); Pariset, 1979, p. 2 (a, b, c); Cassill, 1982, pp. 160–62, no. 56 (a, b, c); von der Osten, 1983, nos. 12 a (c), 12 b (b), 13 (a), pp. 21, 75, 82, 84, 87, 116, 148, 184, 257 f., 261, 300, pls. 32–41; Borries, 1985, p. 98 (b).

180 HANS BALDUNG GRIEN

The Lamentation

Pen and ink, and brush and ink, on paper
Dated 1513, at lower center, and inscribed on verso, in a later hand: Andre[s] Pröglereütter beim Nürnberg
12 1/4 x 8 13/16 in. (31.6 x 22.4 cm.)
New York, The Metropolitan Museum of Art,
The Robert Lehman Collection, 1975
1975.1.856

In 1513, four years after leaving Nuremberg, Hans Baldung, then living in Freiburg, painted the *Lamentation* now in the Tiroler Landesmuseum Ferdinandeum, in Innsbruck. The Lehman Collection drawing, dated the same year, has generally been recognized as the preparatory study for the painting — a proposal that has been complicated by the existence of a very similar drawing in the Kunstmuseum, Basel. Although at the time of the major exhibition of Baldung's work in Karlsruhe in 1959 the authorship of both drawings was questioned, the Lehman study has subsequently been accepted by Hohl, Falk, and Szabo. The attribution of these two sketches to Baldung was again doubted on stylistic grounds in the catalogue of the 1981 exhibition of the artist's graphic work held in Washington, D.C. Certainly, the identical size of the drawings is cause for concern. If technical and stylistic observation suggest a later hand, however, it would be desirable for the intriguing theory that the Lehman Collection drawing and its counterpart in Basel were made as workshop records of the painting to be supported by evidence about the nature of Baldung's or his contemporaries' workshop practices. Without this kind of information to further competing arguments based on connoisseurship, it is difficult to give greater weight to disattribution than to attribution.

While disparate sources have been cited for compositional details, it is important to recognize Baldung's enduring debt, even as a mature master, to Albrecht Dürer. The *Lamentation* epitaph for Margreth Glimm (Strieder, 1982, no. 264), created by Dürer about 1500, probably inspired the present composition, as Szabo

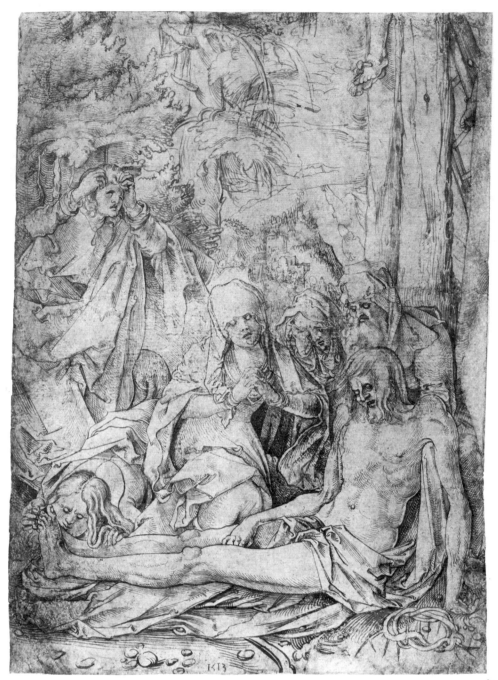

180

has noted; the representation of the Magdalene has been compared to Dürer's in the *Lamentation* drawing from the 1504 *Green Passion* and in the woodcut from the 1511 *Small Passion* (Marrow and Shestack, 1981, p. 193). The drama and immediacy of Christ's death are underscored by the menacing appearance of the two crucified thieves whose feet hover over the head of Christ. The despair of the Magdalene, the Virgin, and Saint John is heightened, in contrast to Dürer's 1504 composition, by the gesture of John, but also by the more frontal positioning of the mourning women.

Baldung's particular fascination with rendering the corpse of Christ follows logically from the artist's preoccupation with the subject of death, from 1509 to 1512 (see the summary in Marrow and Shestack, 1981, p. 9). A similar

rendering of the sagging body of Christ, with the skin folding over the bony armpits can be seen in Dürer's *Lamentation*, in Munich, and in Baldung's painting of the *Trinity*, of 1512, in the National Gallery, London. The body in the drawing seems even more cadaverous by comparison with the full bodies and voluminous drapery of the figures who surround Christ. The depiction of the body of Christ in Baldung's *Lamentation* drawing is in sharp contrast to his representation of the athletic, muscular figure in the *Dead Christ*, of about 1504 (cat. no. 176). BDB

BIBLIOGRAPHY: Halm, 1960, pp. 128–29; Hohl, 1966, pp. 1–2; Falk, in *Hans Baldung*, 1978, no. 28, p. 34; Szabo, 1978, no. 27, 1979, p. 3; Marrow and Shestack, 1981, pp. 193–94, no. 47.

186 WORKSHOP OF PETER VISCHER THE ELDER

Tumbling, Winged Putto

About 1508–10

Brass, cast after a wood model, with brown lacquer patina, chocolate-brown natural patina, and gilded wings

Length, 7 ¹¹/₁₆ in. (19.5 cm.)

Vienna, Kunsthistorisches Museum, Sammlung für Plastik und Kunstgewerbe

57.18

This small brass figure can be exhibited in two positions: In the first, as published in the literature, the winged putto is seated and raises his hands in the air; in the second, as shown in recent years in the Vienna Kunsthistorisches Museum galleries, the putto is face down, partially supported by both hands. In this second pose, the left foot also rests on the ground, and, while both legs are flexed, the right one is raised although caught by a length of drapery. This position allows the short end of the cloth to drape naturally with the fall of gravity.

The cutting of the short wavy locks of hair, the feathers of the wings, and the rounded flesh of the body suggests that a wood carving may have served as the model. The chubby features and the open mouth, among certain other details, may have been refined after casting in a way that was analogous to the finishing of the

figurative details of the tomb of Elizabeth and Hermann VIII of Henneberg, of about 1507–12, in Römhild.

If original, the tiny drill hole in the penis suggests that this small brass was to be part of a fountain complex. It is unclear whether the larger hole in the left heel would have provided access for the necessary plumbing, or whether this hole simply enabled the sculpture to be attached to a (now lost) base. The hint of gilding on the outer feathers and on the drapery, and the absence of corrosion on the other surfaces, indicate that the figure was never actually used as a fountain element, even if this was intended. In any case, the *Putto* is not a trial piece, for, like the *Pilgrim* (cat. no. 185), it is fully finished. Nevertheless, its original context must have been abandoned.

As a subject, the winged putto has its ultimate source in the Italian Renaissance. This motif could have been disseminated by Nuremberg artists returning from sojourns in Italy: Albrecht Dürer visited Venice from fall 1494 to spring 1495 and from summer or fall 1505 until January 1507; Peter Vischer the Younger probably traveled to Northern Italy in 1507/8 and 1512/13; Hermann Vischer the Younger was in Mantua, Siena, and Rome in 1515.

Yet, the modeling, details, and facture of the present work are not so Italianate as the nu-

merous putti on the *Sebaldus Tomb* by Peter Vischer the Younger produced by the lost-wax method and clearly indebted to the Paduan Renaissance bronzes by Andrea Briosco, called Riccio (1470–1532). Even more distant, from a stylistic point of view, are the larger Mannerist putti around the base of the *Apollo Fountain* (cat. no. 248), of 1532, by Peter Flötner, and another putto attributed to Flötner's workshop (cat. no. 250). From a technical and stylistic point of view, the tumbling putto, then, appears at a crossroads in the oeuvre of the Vischer family workshop. The modeling and the grooving of the hair of the putto are closest to those of the subsidiary figures and the manes of the lions on the sides of the tomb in Römhild, while its subject recalls the small putti by Peter Vischer the Younger. Other, still more Italianate parallels are the two putti in low relief holding the cloth of honor behind the Virgin and Child in the relief on the tomb of Cardinal Friedrich Kasimir Jagello, dated 1510, in Cracow Cathedral, by Hermann Vischer the Younger (S. Meller, *Peter Vischer der Ältere und seine Werkstatt,* Leipzig, 1925, fig. 67). WDW

BIBLIOGRAPHY: von Schlosser, 1910, VII, pp. 2, 3; Planiscig, 1924, pp. 190, 192, fig. 308 ("Peter Vischer the Elder [Workshop]"); Meller, 1926, pp. 27, 46, fig. 33 ("Workshop of Hans Vischer"); Bange, 1949, pp. 29, 120, fig. 55 ("Master of the *Apollo Fountain* [Workshop]").

tion, it is probable that the two medals were produced differently. While the mold for the medal of Hermann Vischer was taken from a model in either wood or stone, the much finer self-portrait was obviously created using the lost-wax technique. Since we can, as yet, form no clearly defined idea of the work of Hermann Vischer, it seems logical to continue to consider Peter Vischer the creator of both medals.

H M

BIBLIOGRAPHY: Seeger, 1897, pp. 8–13; Meller, 1925, pp. 17–18; Habich, 1929, vol. I, 1, no. 2, 1931, vol. I, 2, p. XLV; Bernhart, 1936, no. 70; Stafski, 1962, pp. 37–38; Pechstein, 1968, pp. 75–80.

187 PETER VISCHER THE YOUNGER

Medal of Hermann Vischer the Younger

1507
Cast lead
Diameter, 1 1/4 in. (3.1 cm.)
Obverse: The head of a male, including a small section of neck, facing to the left, his wavy hair close cropped.
Reverse: A male nude standing between two round columns on high bases, his right hand holding a rectangular panel, or shield; in his left is a staff or lance.
Inscribed (on obverse): HERMANVS · VISCHER · M · CCCCC VII ·
Basel, Historisches Museum
1905.4461

Hermann Vischer (about 1486–1517) learned the technique of brass casting in his father's workshop. He married in 1513, and in 1515, soon after the death of his wife, he traveled to Italy, where he studied architecture, primarily. Johann Neudörfer praises Hermann's skill at "casting, inscribing, tracery, and portraiture," placing him in the same rank as Peter Vischer the Elder, his father.

The present medal, only two copies of which are apparently extant, is the earliest German Renaissance one known — an occasional piece that the twenty-year-old Peter Vischer made to commemorate his brother. The obverse presents a head that is only lightly modeled and is thus rather flat. The connection between the portrait and the inscription has not yet been satisfactorily explained. The obverse is reminiscent of Roman bronze coins of the first century A.D.; the reverse, however, which also recalls Roman coins — those with depictions of a cult image in a temple, perhaps — rather than Italian Renaissance medals, represents a remarkable testimonial to the Early Renaissance in Germany. The male nude is a fully three-dimensional figure who stands firmly in an easy contrapposto, supported on either side by columns that provide vertical accents in the otherwise circular medal.

H M

BIBLIOGRAPHY: Seeger, 1897, pp. 8–13; Meller, 1925, p. 16; Habich, 1929, vol. I, 1, no. 1.2; Bernhart, 1936, no. 67; Pechstein, 1962, pp. 75–80; Stafski, 1962, p. 37.

188 PETER VISCHER THE YOUNGER

Medal with Self-Portrait

1509
Cast bronze, single sided
Diameter, 1 11/16 in. (4.3 cm.)
The head, including a small portion of the neck, of this beardless young man faces right. His hair is in short curls, and he wears a flat biretta.
Inscribed: EGO PETR[VS] FISCHER MEVS ALTER ZZ AN[N]O 1509. ("I am Peter Vischer at the age of 22 in the year 1509.").
Paris, Bibliothèque Nationale, Cabinet des Médailles
Méd. allemande 730

Peter Vischer, the younger brother of Hermann Vischer, was born in 1487 and died in 1528, a year after his promotion to master craftsman. He was survived by his father and namesake.

The medal's inscription — an odd mixture of Latin and German — has been regarded as an indication that this is a self-portrait. The differences between this example and Peter's medal of his brother Hermann (cat. no. 187), of only two years earlier, are immediately apparent. The medal of Hermann is, in many respects, clumsy and unbalanced. The size and thickness of the letters tend to crowd the small, relatively two-dimensional face. The hair, arranged in ornamental strands, looks like a wig. Peter Vischer's portrait represents a wholly different concept. The head is self-consciously posed, and the skin appears to be stretched taut over the well-defined cheekbones. The locks of hair are of varying size, and some are in higher relief than others. The section of neck, with the suggestion of the top of the shoulder, enhances the three dimensionality of the portrait, which, at the top and bottom, nearly touches the well-proportioned letters of the inscription. In its intensity and concentration, the portrait head seems almost to burst from the confines of the medal's field.

The obvious dissimilarities between the types of portraits on the Hermann and Peter Vischer medals have led some scholars to regard both as self-portraits. However, it is believed that Peter Vischer traveled to Italy after completing the portrait of his brother, and, while there, made a thorough study of Italian brass casting. This would explain the change in his style. In addi-

189 UNKNOWN NUREMBERG MASTER

Design for the Sebaldus Tomb

1488
Pen and ink, on three sheets of parchment, pasted together
Page: height, 68 7/8 in. (175 cm.), width (at top), 7 7/8 in. (20 cm.), (at bottom), 17 in. (43.1 cm.); drawing: 67 15/16 x 11 5/8 in. (172.5 x 29.5 cm.)
Vienna, Akademie der bildenden Künste, Kupferstichkabinett (presented by Johann II, Prince of Liechtenstein, 1884)

This drawing, which bears the date 1488 and the mark of the Vischer family workshop, shows the elevation of a long side of the *Sebaldus Tomb* (fig. 135), as later realized in the wooden model for the monument. The actual shrine, which was cast in brass by Peter Vischer the Elder and his sons between 1507 and 1519, differs considerably from the present drawing.

The design depicts a structure, somewhere between thirty-seven and fifty-six feet high, having three bays. Four supporting columns rest on a base with an extensive molding. Between the columns are three panels with scenes from the legend of Saint Sebald: the meeting of the saint with Saints Willibald and Winnibald in Northern Italy; the miraculous appearance of an angel bringing food for the saints; and the three saints sharing their meal. Above these scenes is a balustrade adorned with fantastic figures, dragons, and frolicking putti. The figures of six apostles stand on consoles, against the faces of the columns: one sculpture on each of the middle ones, and two on either side. On the reverse of the shrine there would have been four corresponding columns with statues of the remaining six apostles. The silver-covered casket containing the body of the saint was to be placed in the center of the tomb. While the design, of 1488, showed the scenes as bas-reliefs, the apostles — the main figures on the monument — are represented as fully three-dimensional figures. They were to function as guardians over the relics of the city's patron saint. Heretofore, that function had been served by twelve large candelabra, but since the casket had been broken into on several occasions, it was clear that stronger protective forces were required. The apostles are drawn in a broader style than that of the architectural sections,

189: detail

which were realized by means of a straightedge, but both elements were done at the same time.

Simon Meller rightly insists that "the design from 1488 initiates the series of triumphs of a new artistic epoch in Nuremberg." The city council's bold decision to erect a huge brass tomb monument to the patron saint was equaled by the designer's audacity in creating "a church within the church." Although the design and the wooden model based upon it influenced the planning of the *Sebaldus Tomb*, its execution in brass, begun in 1506/7, followed radical changes in the overall concept. Large portions of the monument were completed as the drawing envisioned, but what had been intended mainly as an architectural framework became, instead, a richly figured temple of German Renaissance sculpture.

Unfortunately it is impossible to attribute the 1488 design to a specific artist. If the date of 1488 is accepted as correct, then the decision to build the monument was made in the year that the most capable and best known of Nuremberg's brass casters — Hermann Vischer the Elder — died. At that time, his son, Peter Vischer the Elder, was still only an apprentice and would not have been entrusted with such a major commission. That a number of scholars nevertheless persisted in attributing the design to Peter Vischer the Elder is the result of the Vischer "legend" that developed in the nineteenth century. However, it failed to take into account the customary workshop practices of the period, and mistakenly assumed that the man who later cast the shrine must also have been the artist responsible for the 1488 design.

189

388

189: detail

189: detail

189: detail

Simon Lainberger, a sculptor who collaborated with the Vischer workshop during that time, conceivably could have been the designer, for its style conforms to his, but only sculptures by him are known.

Most likely, the designer was a sculptor who had grown up in the tradition of the stonemasons' workshops. This interpretation is based on the formal similarity of the tomb to such diverse architectural monuments as baldachin tombs and tabernacles, although neither direct comparisons nor definite models exist to support this hypothesis. KP

EX COLLECTIONS: Carl Alexander von Heideloff (1789–1865); acquired on the art market by Johann II, Prince of Liechtenstein (until 1884).

BIBLIOGRAPHY: Dettloff, 1915; Meller, 1925, pp. 28–36; Pechstein, 1962, pp. 49–62; Stafski, 1962, pp. 9–16; Meyer, 1965, vol. 19, pp. 97–116; Pilz, 1970, pp. 42–49.

190 PETER VISCHER THE YOUNGER

Saint Peter

About 1510–12
Brass, after a wax model, with black patina
Height, 21¼ in. (54 cm.)
Provenance: *Sebaldus Tomb*.
Nuremberg, Sebalduskirche, East Choir

Saint Peter is shown traditionally, here, in a long tunic and a mantle, one end of which is thrown over his left shoulder, while the other is caught by his right arm and book-bearing hand. A small rosette brooch is affixed to his collar, and a short sash is tied about his waist. Peter's left hand, with which he clasps his attribute, the large key, also gathers up part of the mantle.

The saint's physiognomy also is in keeping with traditional representations of Peter. He is balding, with a lock of hair in the center of his forehead and a fringe of rich curls. His moustache and rounded beard adhere both to con-

389

It was once encircled by twelve candlesticks that were meant to symbolize the twelve apostles. It is now surrounded and protected by the statuettes of the apostles, mounted on an elaborate casing of darkly patinated brass. The ensemble of the statuettes and the casing was commissioned by the Nuremberg city council, and was cast in multiple parts by Peter Vischer the Elder with the collaboration of his sons Peter the Younger and Hermann the Younger, between 1508 and 1519; between 1512 and 1514, work stopped, probably because of depleted funds and the competing commission from Maximilian I for the casting of two large brass figures for his tomb monument in Innsbruck (V. Oberhammer, *Die Bronzestandbilder des Maximiliangrabmales in der Hofkirche zur Innsbruck*, Innsbruck, Vienna, and Munich, 1935, figs. 228, 229).

The style of the *Saint Peter*, as well as that of the other apostles, is a remarkable melding of Early Gothic elements with more dominant Renaissance ones. The elegant sandstone sculptures, of about 1310, from the Last Judgment portal of the Sebalduskirche (cat. nos. 1, 2) may have had some distant impact on the conception — as, for instance, in the corresponding long lines of the drapery folds. The drawing of the shrine (cat. no. 189), of 1488, is only relevant for the placement of the apostle figures and their attributes; the drapery and the proportions of the apostles are too bulky to have served as a source of inspiration for the finished sculptures. More immediate to the artistic setting of the *Sebaldus Tomb* apostles are the squat apostles cast by Peter Vischer for the brass tomb of Archbishop Ernest of Saxony (fig. 134), of about 1495, in Magdeburg Cathedral (Meller, 1925, pp. 41–51, figs. 14–26). The contrast between the statuettes of Saint Peter in the two

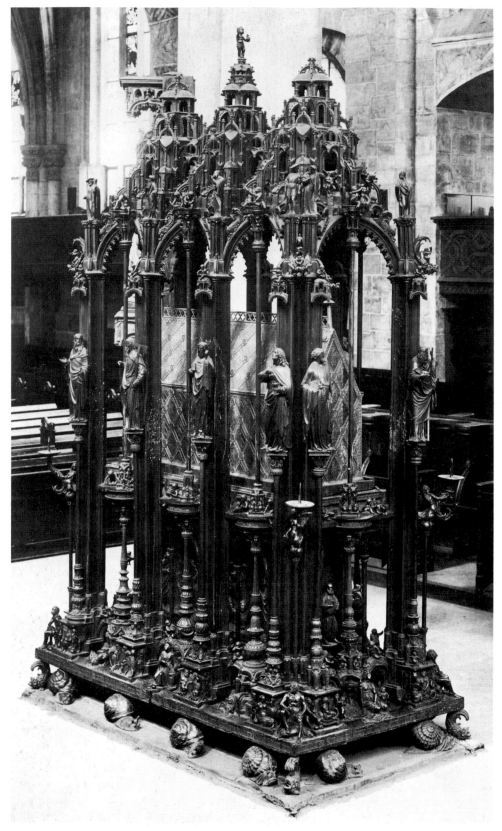

Figure 135 *Sebaldus Tomb*. Sebalduskirche, Nuremberg

Figure 136 *Sebaldus Tomb*, detail

vention and to contemporary fashion, while the mass of tight curls and the shape of the beard may be compared with those in the portrait of Peter Vischer the Elder on the tomb, and also with those of the *Wild Man* (cat. no. 191). These heads anticipate the similar heads in Paulus Vischer's *Tucher Epitaph*, of 1521, in Regensburg Cathedral, and in the *Eissensche Epitaph*, of 1522, in the Egidienkirche, Nuremberg (Meller, 1925, figs. 141–142).

The figure of Saint Peter is one of a complete series of the twelve apostles that stands above thin colonnettes at mid-level around the perimeter of the *Sebaldus Tomb* (fig. 135), in the Sebalduskirche. The shrine itself, silver and silver gilt over wood, dates from 1391–97.

monuments could not be more dramatic in underscoring the change from Late Gothic to Renaissance forms. The present figure is tall and elegant; he assumes an easy contrapposto stance as he turns his head upward and to the side. The Magdeburg Saint Peter is frontal, rigid, and abrupt, without any hint of movement or any sensitivity to the human form that is partially revealed through the drapery.

The proportions of the Peter from the *Sebaldus Tomb* probably derive simultaneously from Italian art and from Dürer's interpretation of ancient theories of proportion: The intermediary role of Jacopo de' Barbari with regard to these, as well as Dürer's own experimentation with proportion, cannot be overestimated (C. W. Talbot, G. S. Ravenal, and J. A. Levenson, *Dürer in America, His Graphic Work* [exhib. cat.], Washington, D.C., National Gallery of Art, 1971, pp. 39–40, 50–52, nos. VII, XII; W. S. Sheard, *Antiquity in the Renaissance* [exhib. cat.], Northampton, Massachusetts, Smith College Museum of Art, 1978, nos. 49, 50). However, it should be remembered that Peter Vischer the Younger must have directly experienced Italian art during his own postulated trips to Italy in 1507/8 and in 1512/14, and that he undoubtedly was able, at the same time, to combine influences from several sources.

Both the model and cast for the *Saint Peter* have been variously ascribed to Peter Vischer the Elder and to his son Peter the Younger. Recent opinion has favored the son — an attribution that is adopted here because the subtle expressiveness and spirituality of the figure seem beyond the father's capability and inclination.

The date of the apostle figures must allow for Dürer's probable contribution to their style to be taken into account — not only in terms of their proportions, but also with regard to his studies of drapery. Dürer's preparatory drawing in Berlin-Dahlem, dated 1508, of a standing apostle for the Heller altarpiece provides a graphic parallel for the draperies of the *Sebaldus Tomb* apostles (P. Strieder, *Albrecht Dürer, Paintings, Prints, Drawings*, New York, 1982, p. 308, fig. 409). (The Heller altarpiece, now lost, depicted the Coronation of the Virgin with apostles below; see P. Strieder, 1982, fig. 41.) Peter the Younger's probable first visit to Italy in 1507/8, when he learned the lost-wax process, also bears on the date. After his second trip, the *Sebaldus Tomb* figures become more Paduan, Ricciesque, and humanistic in character.

WDW

BIBLIOGRAPHY: Seeger, 1897, pp. 102–5, 108, 109, fig. 13; Daun, 1905, pp. 35, 36, fig. 28; Mayer, 1913, 8, pp. 277, 278, fig. 18; Stierling, 1918, XI, pp. 121–22; Feulner, 1924, p. 25, figs. 5, 6; Meller, 1925, pp. 93, 95, 102, 103, 104, figs. 44, 46, 1926, pp. 22, 45, fig. 8; Bange, 1949, p. 17, fig. 5; Stafski, 1958, 21, p. 21; Pechstein, 1962, pp. 80–88, 138–43; Stafski, 1962, p. 31, fig. 34; Müller, 1963, p. 10 (general discussion); Radcliffe, 1966, pp. 58, 61 (description of the *Sebaldus Tomb*); Müller, 1966, pp. 186, 187 (general discussion); Weihrauch, 1967, pp. 255, 272–77 (general discussion); Wuttke, 1967, 49, p. 247; von der Osten and Vey, 1969, pp. 22–24 (general discussion); Pilz, 1970, pp. 71–72; Stafski, 1971, pp. 231–32 (general discussion); Baxandall, 1980, pp. 280–90 (general discussion); Riederer, 1983, 36, p. 44.

190

191

191 WORKSHOP OF PETER VISCHER THE ELDER

Wild Man

About 1510–15

Brass, hollow cast, after a wax model, with a dark brown wax patina over a cuprite surface
Height (to tip of club), 7 $^{15}/_{16}$ in. (20.2 cm.); width, 4 $^{15}/_{16}$ in. (11 cm.); depth, 2 in. (5 cm.)
Loosely tenoned into a hole in the wild man's left hand is an intrusive figure of a child (not shown here).
London, Cyril Humphris

This wild man is represented in one of his most characteristic poses: He brandishes a club in his raised right hand and holds the other hand out in front of him. His body is covered with a hair suit plaited in a lozenge pattern. In keeping with Late Medieval tradition — as demonstrated by the finial figures on the Teutonic Ewers (cat. no. 78) — this wild man's knees, feet, and hands are free of hair, and he wears a belt of intertwined branches. The present figure's slight differences in appearance are in accord with contemporary

fashion: His hair is short and curly, his moustache is rolled, and his beard is rounded and bushy.

Statuettes that derive from the same model, or a closely similar one, exist in the Victoria and Albert Museum, London, the Carrand Collection of the Museo Nazionale del Bargello, Florence, and the Staatliche Museen Preussischer Kulturbesitz, Berlin-Dahlem (U. Bischoff, in *Der Mensch um 1500...*, 1977, pp. 161–66, fig. 125).

This wild man is the only example that, until recently, still held an object in one hand: a diminutive figure of an infant, of a different alloy from the wild man and poorly modeled. The child, therefore, could only be judged as intrusive, and has been temporarily removed. The wedge under the wild man's right heel is a later addition, too.

The original context of this statuette remains uncertain. The vertical hole in the clenched left fist may have been intended for the support of a candle socket. The symbolism is clear; since the later Middle Ages, the wild man was identified with superhuman power and virility. The multifaceted folklore of the mythical wild man has been fully explored in exhibitions in Hamburg, Berlin-Dahlem, and New York (see Lise Lotte Moller, *Die wilden Leute des Mittelalters* [exhib. cat.], Hamburg, Museum für Kunst und Gewerbe, 1963; U. Bischoff, in *Der Mensch um 1500...*, 1977, pp. 161–66; T. Husband, *The Wild Man, Medieval Myth and Symbolism* [exhib. cat.], New York, The Metropolitan Museum of Art, 1980). While the present figure wears the suit of a wild man, his face and pose suggest those of a Hercules figure. The face, in particular, resembles that of Hercules in Peter Vischer the Younger's illustration, of 1515, for the "Histori Herculis" by Pankraz Schwenter (1481–1555; see H. Stafski, *Der jüngere Peter Vischer*, Nuremberg, 1962, fig. 90).

While the figure's standing pose also is similar to that of the larger *Saint Mauritius* — the model for which (cat. no. 183) must date to about 1495 — the *Wild Man* displays a more convincing and subtle sense of movement. This change, which results from the slight twist given the figure, in combination with the sensitive modeling of the facial features, recalls North Italian bronzes, especially those by such Paduan masters as Bartolomeo Bellano, Andrea Riccio, and Severo Calzetta da Ravenna.

This observation suggests that the dating must at least follow one of Peter Vischer the Younger's trips to Italy, which probably took place in 1507/8 and in 1512/14. A convincing attribution to any member of the Vischer family is elusive, however. Bange proposed that the present statuette and the one in Berlin were by the fifth and youngest son of Peter Vischer the Elder, namely, Paulus Vischer, who was born about 1498 and died in Mainz in 1531. Bange related these two examples to two low-relief sculptures attributed to Paulus Vischer — the *Tucher Epitaph*, dated 1521, in the cathedral of Regensburg, and the *Eissensche Epitaph*, dated 1522, in the Egidienkirche, Nuremberg — on

the basis of a comparison with the head of Saint Peter in the first relief, and that of Saint John (actually the turbaned head of Nicodemus) in the second (S. Meller, *Peter Vischer der Ältere und seine Werkstatt,* Leipzig, 1925, pp. 212, 223, 225, figs. 141, 142). While these heads share the same style of hair and beard, the emphasis on the features of the *Wild Man* seems closer, although not identical, to that of some of the larger figures on the *Sebaldus Tomb,* such as the head of the *Saint Peter* (cat. no. 190) or of Peter Vischer the Elder (H. Stafski, *Der jüngere Peter Vischer,* Nuremberg, 1962, figs. 54, 44, respectively). The above-mentioned drawing of Hercules, of 1515, also provides an excellent stylistic comparison in support of the early dating of the *Wild Man.* WDW

Ex collections: Riedinger, Augsburg (until 1894); Guido von Rhò, Vienna.

Bibliography: Braun, 1908, pl. xxxvi; Bange, 1949, pp. 30, 121; Bischoff, in *Der Mensch um 1500...,* 1977, pp. 162, 163, fig. 126; *The Robert von Hirsch Collection,* 1978, vol. 2, pp. 146, 147, no. 324 (colorpl.); Avery, in *Objects for a "Wunderkammer,"* 1981, pp. 172, 173, ill. no. 87.

192 PETER VISCHER THE YOUNGER

Scylla (recto)

Orpheus and Eurydice (verso)

1514

Pen and brown ink, on paper

11 5/8 x 8 3/8 in. (29.5 x 21.3 cm.)

Inscribed by the artist (on recto and verso) with the names of the central figures; (on recto, at bottom left, in a later hand): A Mantegna f. 1514; and dated on verso

Nuremberg, Germanisches Nationalmuseum

Hz 5551

The mythological portrayals on the recto and verso of this sheet, dated 1514, represent early examples of works that reflect the influence of Italian Renaissance art in Nuremberg outside the Dürer workshop. It is not surprising that, on first publication, the page was credited to the Venetian painter Jacopo de' Barbari. Hind (1920, p. 162) recognizes it as a work by Peter Vischer the Younger, and Schilling (1932) calls it Vischer's most important drawing.

The recto shows a voluptuous mermaid amid cliffs and trees, with a view of the sea in the background, sitting at the edge of a pool and admiring her youthful beauty in a mirror, her bathing brush and ointment jar on the ground beside her. The figure, identified as Scylla in the inscription, is hairy about the hips, with a coiled, serpent-like tail and the legs of a frog. She is portrayed not as the man-killing monster of the *Odyssey,* but rather like the description by Ovid in the *Metamorphoses* (XIII, l. 900–XIV, l. 740) — as are Orpheus and Eurydice, on the verso. In Ovid's version, Scylla is a beautiful nymph who seeks help from the sorceress Circe in escaping from the demon Glaucos. Circe, however, is herself in love with Glaucos, and

192: recto

follows her rival to her hiding place, a rocky cave above the shore, where she casts poisonous herbs and potions into the small pool in which Scylla bathes. When the nymph steps into the water, she is transformed into the monster described by Homer, and, thenceforth, lures passing sailors and kills them. The drawing portrays the moment of Scylla's metamorphosis, before she, herself, has become aware of it; while she continues to admire her beauty in the mirror, it is already being destroyed. In this way, the scene improves upon the original motif, adding the element of *vanitas,* a moralizing approach to a classical subject typical of German Renaissance art. The drawing has been correctly related to the Vischer relief on the base of the *Sebaldus Tomb,* the completion of which was discussed in renewed negotiations with Peter Vischer the Younger and his brother Hermann, in 1514 — the year that the drawings were made.

In the bronze relief, as well, Scylla, courted by Glaucos, is conceived as an allegorical figure of *vanitas,* who sees in her mirror the grimace of Death.

The verso of the sheet presents a faithful rendering of the story of Orpheus and Eurydice as it is told by Ovid in the *Metamorphoses.* The spatial organization of the drawing is ill defined. The two central figures, depicted with elongated proportions in accordance with the classical ideal, appear on elevated ground in the right foreground. Eurydice, depicted in profile, follows her husband, Orpheus, with her hands raised in supplication as he leads her out of the underworld. Orpheus, who plays his viol, turns to look at her, and thereby loses her a second time. In the relief-like treatment of the figures and in their elongated, classical forms, they are quite similar to those on two plaquettes with the same theme by Peter the Younger; these exam-

192 : *verso*

ples (cat. nos. 193, 194), now in the National Gallery of Art, Washington, D.C., and in the Berlin Skulpturengalerie, are equally indebted to Dürer's *Adam and Eve* engraving (cat. no. 121). The rest of the drawing, with its many tiny figures, scarcely suggests the hand of a sculptor. The image has little in common with the illustrations of Dante's works, by Botticelli, for example, or by Francesco Francia, but rather reveals the complex medieval narrative structure. Fragments of architecture and landscape, placed on top of rather than behind one another, serve to characterize the setting without providing a realistic sense of space. In the middle distance is the Gate of Hades guarded by Cerberus. Crouched on the ruins of a wall are the Eumenides — Alecto, Megara, and Tesiphone — horned creatures with cloven hooves, clearly moved by Orpheus's music. Behind them towers a rock cliff opening into a fiery abyss. On the left, the tiny, roughly sketched figures of Pluto and Persephone, rulers of the underworld, are enthroned next to the river Acheron. Also included are Titius, Sisyphus, and Ixion's Wheel, all as Ovid describes them (x, ll. 40 ff.). The accurate presentation of the Orpheus legend attests to the artist's knowledge of Latin, and calls to mind Johann Neudörfer's *Nachrichten von Künstlern und Werkleuten...*, of 1547, in which he relates that Peter Vischer loved reading histories and epics, and created his drawings with the help of the Humanist Pankraz Schwenter. Other responses to these literary pursuits are his Boccaccio illustrations in Würzburg and in Paris, and his illustrations for the "Histori Herculis." R S

BIBLIOGRAPHY: *Vasari Society,* 1914–15, 10, pl. 8; Hind, 1920, p. 162; Hevesy, 1924, p. 144, pl. 1 a, 1925, pls. 24–25; Schilling, 1929, pp. 18, 33, no. 42, 1932, p. 154 f., ills. 118–119; Stafski, 1962, p. 75; *Anzeiger des Germanischen Nationalmuseums,* 1963, pp. 174–75; Zink, 1968, no. 103.

193 PETER VISCHER THE YOUNGER

Orpheus Losing Eurydice at the Gates of Hades

About 1516
Brass (?), cast after a wax model, with black lacquer, slightly rubbed
7 5/8 x 5 15/16 in. (19.4 x 15 cm.)
There is a suspension hole at the top center.
Washington, D.C., National Gallery of Art, Samuel H. Kress Collection
1957.14.565

This relatively large, rectangular plaquette shows two nude figures representing Orpheus and Eurydice standing frontally before a landscape. Holding his bow and viol before him, Orpheus pauses as he turns his head to look back at the nymph Eurydice, who has just emerged from the entrance to Hades within the rocky precipice that rises menacingly behind her. Clasping a scanty wind-blown veil in her hands, Eurydice makes an imploring gesture of farewell toward her husband, Orpheus.

Both the landscape and the two figures are sculpted in very low relief. The area in highest relief — the rocky strip across the foreground,

and the outcropping of rocks at the upper left — not only sets the stage for the action, but also almost engulfs it. The Vischer family mark, two fish transfixed by an arrow, appears at the upper right (see cat. no. 195).

The most dramatic episode in the Greek myth of Orpheus and Eurydice is depicted in this plaquette. Orpheus, the son of Oiagros (Apollo) and the muse Calliope, was well known as a singer and musician, who even charmed plants, animals, and stones. His wife, Eurydice, died from a serpent bite when she was fleeing from Aristaeus. Orpheus sought her in the underworld. There, he so moved Persephone and Hades with his music that he was allowed to bring Eurydice out, on condition that he not look backward until he had gone forth from the valley of Avernus, or else the gift would be in vain: "Ne flectat retro sua lumina, donec Avernus exierit valles; aut inrita dona futura" (Ovid, *Metamorphoses,* x, 51–52). The scene represented in the plaquette is the moment when Orpheus looks back at Eurydice as they near the margin of the upper earth: "Nec procul atuerunt telluris margine summae" (Ovid, *Metamorphoses,* x, 55).

Peter Vischer the Younger's ancient Roman literary source has to have been the *Metamorphoses* (Book x) by Ovid, and not the *Georgics* (Book iv) by Virgil — a conclusion supported by his drawing, dated 1514 (cat. no. 192), in which he represents the underworld; the inscriptions identifying all of the figures could only have come from Ovid. Peter Vischer the Younger must have gained this knowledge of ancient myths from his Humanist friends. (For the reception of the antique myth of Orpheus, in the Middle Ages and in the Renaissance, see K. Heitmann, "Orpheus im Mittelalter," *Archiv für Kulturgeschichte,* 1963, vol. 45, pp. 253–94; A. Buck, *Der Orpheus-Mythos in der italienischen Renaissance,* Krefeld, 1961.) The chronicler Johann Neudörfer tells us, "Dieser Peter ... hatte seine Lust an Historien und Poëten zu lesen, daraus er dann mit Hilf Pancrazen Schwenters viel schöner Poëterei aufriss, und mit Farben absetzt" — that Vischer made colored sketches of the stories that he received from Pankraz Schwenter, and interpreted with that Humanist's help.

The extraordinarily unified expression of this plaquette makes it one of the finest ever produced. With great economy of detail, remarkable subtlety in both modeling and movement, and keen restraint in the composition, the younger Peter Vischer conveys an elegiac mood in his interpretation of the most touching moment in Ovid's retelling of the Greek myth. This unity contrasts with the episodic details in Vischer's 1514 drawing (cat. no. 192), where the poignancy of the scene is dissipated by the many small figures scattered about the landscape. However, the rocky cliff above the entrance to Hades in the drawing does appear in the plaquette. A similar precipice recurs in one of the drawings that Peter Vischer made for Pankraz Schwenter's "Histori Herculis," in 1515 (Meller, 1925, fig. 127).

Dürer's drawing and engraving of Adam and Eve, of 1504 (cat. nos. 120, 121), suggest a source for the proportion, contrapposto, ponderosity, modeling, and gesture of Eurydice in the relief. Dürer, in turn, was indebted to Northern Italian Renaissance art, with which he was familiar through Jacopo de' Barbari's engravings, as well as possibly through direct observation during his first trip to Venice, when he may have seen the large marble sculptures of Adam and Eve by Antonio Rizzo, of about 1483–91 (J. Pope-Hennessy, *Italian Renaissance Sculpture*, New York, 1958, pls. 130, 131). Vischer must have had access to drawings or engravings by Jacopo de' Barbari, too, while the Venetian was in Nuremberg; not without reason, the present plaquette was first attributed to this artist (Ephrussi, 1876, 8, pp. 380–82).

Vischer's Orpheus in the relief cannot be related so easily to Dürer's Adam — as can Vischer's 1514 drawing. The Orpheus in the relief is more angular, his right elbow bent sharply and his left leg flexed sideways. The proportions and the naturalistic details of the narrow torso suggest a partial dependence on traditional Late Gothic conventions and a partial rejection of Dürer's Humanist ideal. The Orpheus in the relief recalls, in its angularity, the animated, nearly nude strong men bearing coats of arms on the tomb of Bernhard Lubranski (died 1499), a work by Peter Vischer the Elder's shop. Orpheus's legs are in the same position as those of the figure on the left on the Lubranski tomb (Meller, 1925, p. 84, fig. 40).

The date of this plaquette has been controversial, and its chronological relationship to the smaller composition of the same subject, which exists in several casts (cat. no. 194), has provoked discussion. A slight chronological precedence might be given the Washington plaquette on the basis of the angularity and the Late Gothic naturalism still evident in the figure of Orpheus, and its points in common with the 1514–15 drawings. A dating about 1514 would be compatible with Peter Vischer the Younger's postulated travels to northern Italy, when he could have had a chance to study those reliefs and plaquettes produced by Riccio and his circle prior to that visit. However, except for the use of landscape and the convention of low-relief perspective, Vischer's work does not show the full impact of the Paduan artist's style. On the other hand, the mark with the two fish, which seems to have appeared first about 1516, suggests that the plaquette probably was made closer to that date (D. Wuttke, "Methodisch-Kritisches zu Forschungen über Peter Vischer den Älteren und seine Söhne," *Archiv für Kulturgeschichte*, 1967, vol. 49, pp. 211–12).

Peter Vischer the Younger returned to the image of Eurydice in a drawing, dated 1519 and bearing his initials and the Vischer family emblem, preserved in the Louvre (Meller, 1925, pp. 190, 196, fig. 125). Many authors have sought to establish a close relationship among the plaquettes and this drawing, and, as a result, they have attempted to date one version of the plaquette or the other about 1519. Yet, the ges-

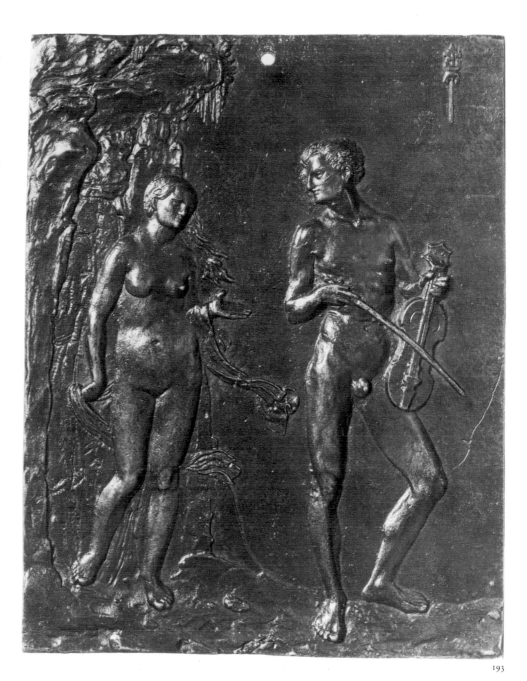

193

tures, position of the legs, and drapery differ in the Louvre drawing, which is highly finished and formal, and, because of this, there is no reason to suppose any direct connection with either plaquette. In relation to the plaquettes, the drawing is not a preparatory sketch, nor is it a copy.

The purpose for which the present plaquette was made is unknown. The subject and the Vischer family mark (see cat. nos. 194–196) suggest that it may have been intended as a gift to adorn the study of one of the artist's Humanist friends. WDW

EX COLLECTION: Gustave Dreyfuss, Paris.

BIBLIOGRAPHY: Ephrussi, 1876, 8, pp. 380–82; Giraud, 1881, pl. xvii; Molinier, 1886, vol. 2, p. 165, no. 685; Weizsäcker, 1891, 12, pp. 50–51; Seeger, 1897, pp. 65–72, 95, fig. 8; Daun, 1905, pp. 62–63, fig. 48; Bode, 1908, 29, pp. 33, 34, fig. 4; Migeon, August 1908, 80, p. 26, ill. p. 1; Mayer, 1913, 8, pp. 284, 286; Braun, 1915, 8, pp. 56, 57; Stierling, 1915, 8, pp. 368–70, 1918, 11, p. 249; Meller, 1925, pp. 189, 190, 197, fig. 126; Sauerlandt, 1928, pp. 14–21; de Ricci, 1931, p. 282, no. 431; *Renaissance Bronzes, Statuettes...*, 1951, ills. pp. 96, 159; Stafski, 1962, p. 38, fig. 76; Pope-Hennessy, 1965, pp. 117, 118, no. 435, fig. 441; Rasmussen, 1975, 12, p. 82; Weber, 1975, pp. 55, 56, no. 30, fig. 6; Hackenbrock, 1976, 21, p. 47, fig. 6.

Orpheus Redeeming Eurydice

About 1516
Brass, cast after a wax model

a) Natural brown and red patina
6³/₈ x 4⁷/₁₆ in. (16.3 x 11.3 cm.)
Hamburg, Museum für Kunst und Gewerbe
1887.265

b) Mottled natural brown patina
6³/₈ x 4³/₈ in. (16.2 x 11.2 cm.)
There is a casting flaw in Orpheus's left thigh.
Attachment holes are located at the top center,
near the edge, and between Orpheus's feet. On the
back are several marks, including a foliate motif,
chiseled hollows behind the figures, and a wide,
chamfered lower edge.
Berlin-Dahlem, Staatliche Museen, Stiftung
Preussischer Kulturbesitz, Skulpturengalerie
(acquired, 1830)
1464

c) 5⁷/₈ x 4⁷/₁₆ in. (15 x 11.3 cm.)
The missing two lower corners are casting flaws.
There is a suspension hole at the top center.
Sankt Paul im Lavanttal, Austria, Benediktinerstift

In contrast to the Washington example (cat. no. 193), the landscape in these three plaquettes is restricted to the grassy turf upon which the nude figures of Orpheus and Eurydice stand. Flames flicker upward at the extreme left, although the rocky entrance to Hades is not actually illustrated. Orpheus is shown playing his viol, which he rests against his left shoulder. Here, Eurydice also clings to her wind-blown veil, as in the Washington plaquette, but what differs is the position of her left arm and hand, with which she makes a gesture traditionally associated with sorrow. The remaining portion of the background is plain in the Vienna plaquette, but the backgrounds of the Hamburg and Berlin examples contain four lines of text in raised, Latin capital letters. On the Hamburg relief, the epigram, written by the Nuremberg Humanist Theodoricus Ulsenius, reads: ORPHEA

CVM SILVIS FLVVIOS ET SAXO MOVENTĒ / GRECIA LAETEOS FERT ADIISSE LAVIS / EVRYDICENILLIC VITAE REVOCASSE PRIORI / SERVASSET STYGIO SI MODO PACTAIOVI ("It is told in Greece that Orpheus, who [with his playing and songs] has moved the forests, rivers, and rocks, came to the river Lethe; he would have called back to life Eurydice if he would have kept his contract [not to look back] with the Stygian Jupiter").

The Hamburg plaquette has fewer mistakes in this text than the Berlin example. Just below the inscription, at the extreme right, is the Vischer family mark: two fish impaled upon an arrow. Other examples of this emblem appear on the plaquette in Washington, D. C. (cat. no. 193), and on the two inkwells in Oxford (cat. nos. 195, 196).

The unified expression, subtlety of modeling and movement, compositional restraint, and elegiac mood of the Washington plaquette recur here, even though the poignancy is tempered, conveying a sense of sustained yet remote sadness. A comparison with Peter Vischer the Younger's drawing, of 1514 (cat. no. 192), underscores once again its episodic character, as opposed to the clarity of expression in the reliefs.

The only similarity with the drawing among the present examples may be seen in the Orpheus figures, which are dependent on Dürer's drawing and engraving of Adam and Eve, of 1504 (cat. nos. 120, 121). The figures of Eurydice are not the same: Those in the present series, as well as the one in the Washington plaquette, are derived from various Dürer figure studies (see, for example, Dürer's drawing, of about 1501–3, entitled *Nude Woman with a Staff,* in the National Gallery of Canada, Ottawa; C. W. Talbot, ed., *Dürer in America: His Graphic Work* [exhib. cat.], Washington, D. C., National Gallery of Art, 1971, pp. 42–44, ill.). Both figures in all three plaquettes are in nearly perfect harmony — in proportion, contrapposto, and modeling — with Dürer's *Adam and Eve* com-

positions, yet the gestures and the direction of the heads vary to suit the different subject. Eurydice's left arm and hand are extended in sadness; Orpheus's arms and hands are fixed in the position of playing the viol.

The date of the model for these plaquettes has been much debated. The Orpheus figure in them and in the 1514 drawing share a common dependence on the work of Dürer, which argues for a date of about 1514–15 for the model of the present reliefs — a conclusion at odds with the date of about 1520, cited in some recent sources. Yet, here, the mark with two fishes again suggests a date of about 1516 (D. Wuttke, "Methodisch-Kritisches zu Forschungen über Peter Vischer den Älteren und seine Söhne," *Archiv für Kulturgeschichte,* 1967, vol. 49, pp. 211–12). The highly finished drawing of Eurydice, dated 1519, in the Louvre, often mentioned in this context, is just as irrelevant as it was in relation to the Washington plaquette (see cat. no. 193).

Also like the Washington example, the original purpose for which these three plaquettes were made is unknown. The subject, the Latin epigram, and the Vischer family device suggest that one cast at least may have been intended as a gift for a Humanist friend of Peter the Younger. Priority in this regard must be given to the largest example and the best casting — that in Hamburg; the other two shown here may have been aftercasts, because of their smaller measurements. The absence of attachment holes in the Hamburg plaquette makes clear that it could not have been hung without the addition of a frame; however, it might have been mounted on the lid of a book box, or set into a piece of furniture. WDW

EX COLLECTION: b) Königliche Kunstkammer, Berlin.

BIBLIOGRAPHY: Seeger, 1897, pp. 65–72, fig. 9 (c); Daun, 1905, pp. 62–64, fig. 49 (b); Bode, 1908, 29, pp. 33, 34, fig. 5 (b); Stierling, 1922, 15, p. 28, pl. 10.7 (b); Bange, 1922, pp. 49–50, no. 1464 (b); Meller, 1925, pp. 189, 195, fig. 124 (b); Sauerlandt, 1928, pp. 14–21; Ziegler, 1950, p. 242; Stafski, 1962, p. 38, fig. 77 (b); Müller, 1963, pp. 10, 35, ill. (a); Wuttke, 1966, 20, pp. 143–46, fig. 1 (a); *Preussischer Kulturbesitz,* 1967, no. 169, pl. 38; Ginhart, 1969, 37, p. 283, fig. 412; Rasmussen, 1975, 12, pp. 82–83, pl. 3 (a); Theuerkauff, December 1975, 102, p. 433, fig. 3 (b); Weber, 1975, p. 55, no. 29 (a, b, c); Theuerkauff, in *Der Mensch um 1500...,* 1977, pp. 151–55, no. 27, fig. 115 (b); *Museum für Kunst und Gewerbe Hamburg...,* Munich, 1980, p. 87, no. 166; *Das Tausendjährige St. Blasien...,* 1983, 1, pp. 332–33, no. 286, ill. (see also Bibliography, cat. no. 193).

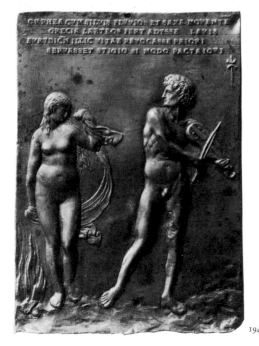

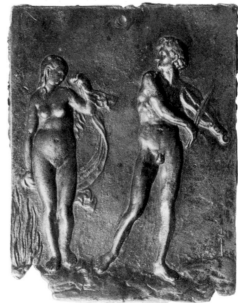

194b 194c

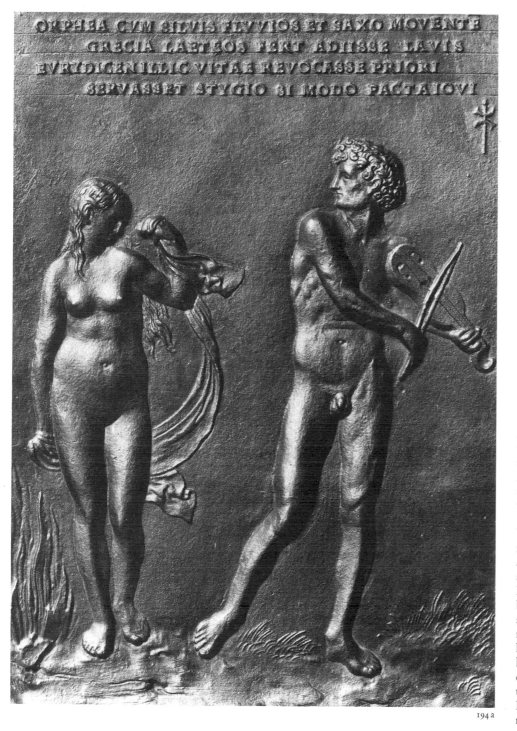

ORPHEA CVM SILVIS FLVVIOS ET SAXO MOVENTE
GRECIA LAETEOS FERT ADIISSE LAVIS
EVRYDICEN ILLIC VITAE REVOCASSE PRIORI
SERVASSET STYGIO SI MODO FACTA IOVI

194a

195 PETER VISCHER THE YOUNGER

Inkpot, with Allegory

About 1516

Brass, cast from wax and wood, with a natural
brass patina

6 9/16 x 4 1/2 in. (16.7 x 11.4 cm.)

Oxford, The Visitors of the Ashmolean Museum,
Fortnum Collection (acquired, 1899)

1085

A nude female figure wearing a winged helmet
stands with her weight on her left leg and foot;
with her other leg and foot, she pushes away a
skull that has rolled over into an upside-down
position. The young woman points to her eyes
with her right index finger, while her left hand
rests on a quadrate and angular inkpot whose lid

is in molded stages surmounted by a knob. The
inkpot, supported on lions' feet, is decorated
with foliated scrolls, four repetitions of a mark
of two fish impaled on an arrow, and four
medallions each with the same profile head in
relief, one against a fluted background. On the
back, a shield of "testa-da-cavallo" form, bear-
ing a Gorgon's head, is propped at an angle
against the inkpot. A thin staff, or scepter, with
two knobs and an inscribed plaque rests on a
square base with a dentelated edge. The nude
figure, and the skull, inkpot, lid, and base were
cast separately and assembled.

The iconography of the whole composition
has been variously interpreted in the literature
either as an allegory of earthly life, in a positive
sense, or of the vanity of earthly things. The

nude figure, in particular, has been described as
representing Vanitas, Minerva, or Fortuna.
Essential to the discussion is the inscription on
the plaque: VITAM NON MORTEM RECOGITA
("Reflect upon life, not death"). Dieter Wuttke
has pointed out that this motto appears on the
brass epitaph of Peter Vischer the Elder's third
wife, who died in 1522. Since there is no tomb-
stone for Peter Vischer the Younger with these
words — as has been previously and repeatedly
asserted — the inscription must be a family
motto not restricted to the younger Peter. The
VITAM in the motto, according to Wuttke, must
signify eternal life, in the Christian sense, espe-
cially because of the addition in German to the
epitaph: ... der leib hie ruet Ir sel in got lebet
("the body lies here, her soul lives in God").
Wuttke's interpretation — reflect upon eternal
life, not death — helps to explain part of the
underlying significance of the composition.

Yet, contrary to Wuttke's opinion, the nude
figure must represent the goddess Fortuna. This
identification is based upon the medallic source
for this figure — the reverse of a medal of
Isabella Sessa by the Veronese medalist Gio-
vanni Maria Pomedelli (1478/79−1537). This
medallic relief depicts a nude female figure
standing in an identical way with her right foot
on a skull and surrounded by the inscription
AETERNA FORTUNA (Mayer, 1913, vol. 8, p. 286,
fig. 42; Hill, 1930, vol. 2, pl. 108). Fortuna, a
frequently represented subject in the Middle
Ages and in the Renaissance, has, as one of her
attributes, a sphere, or a wheel, to indicate her
unsteadiness and inconstancy (H. R. Patch, *The
Goddess Fortuna in Medieval Literature*, Cam-
bridge, Massachusetts, 1927; A. Doren, "Fortu-
na im Mittelalter und in der Renaissance," *War-
burg-Vorträge*, 1922−23, pt. 1, pp. 71−144),
and she is often shown blindfolded. As on the
Pomedelli medal, the inkwell figure is without
blindfold, and a skull is substituted for the
sphere — a reference to the theme of the
memento mori. Her gesture of pointing with
her right hand, while ambiguous, could simply
have been adapted from the position of the
corresponding hand of Fortuna that grasps
three flowers, or nails, on the Pomedelli medal.
By pointing to her eyes, however, the figure
may be alluding to her blindness — a condition
mentioned in the *Tabula Cebetis,* a text from
the first century A.D. on the allegory of life, well
known to Nuremberg artists. Dürer may have
used this source, too, for his small engraving of
Fortuna (C. W. Talbot, ed., *Dürer in America:
His Graphic Work* [exhib. cat.], Washington,
D.C., National Gallery of Art, 1971, no. 6).
Thus, the imagery of this inkpot is a visual em-
bodiment of the Vischer family motto: It calls
attention to the vanity and uncertainty of earth-
ly fortune in contrast to eternal life.

The style of the nude is a three-dimensional
reflection not only of the nude on the Pomedelli
medal but also of Eve in Dürer's drawing and
engraving of Adam and Eve, both dated 1504
(cat. nos. 120, 121), because of the similarity in
proportions, contrapposto pose, and canon of
beauty. The medallion reliefs on the inkpot, re-

195

associate of the Vischer family. One room in Schreyer's house was decorated with paintings containing half-length figures of Orpheus, Apollo, and Amphion, below which were epigrams by the poet laureate Conrad Celtis (1459–1508); see L. Grote, "Die Vorder-Stube des Sebald Schreyer," *Anzeiger des Germanischen Nationalmuseums,* 1954–55, pp. 48, 52, 58, 59.

An almost identical but independent statuette of the nude Fortuna (about 6¹/₁₆ inches high) is in the collection of the Museum für Kunst und Gewerbe, Hamburg (see Schuette, 1951, pp. 107–72; Rasmussen, 1975, pp. 81–82, no. 2, ill.). Also a brass casting, this figure may have been abandoned because of its slightly flawed surface. The fire gilding in the hair, in the scrolls on the helmet, and on the skull may have been added to make this statuette more attractive to collectors.

WDW

EX COLLECTIONS: [art market, Paris (1867)]; C. Drury E. Fortnum, Great Stanmore, England (1883).

BIBLIOGRAPHY: Lübke, n.d. (c. 1878), p. 21; Bergau (Dohme, vol. 2), 1878, p. 38; Fortnum, 1889, 2, no. 1085; Seeger, 1897, p. 58; Daun, 1905, pp. 60, 61, fig. 46; Bode, 1908, 29, p. 33, fig. 2; Mayer, 1913, vol. 8, p. 284, fig. 41; Stierling, 1918, 11, p. 263, 1922, 15, p. 28, fig. 8; Meller, 1925, pp. 189, 191, fig. 121, 1926, pp. 26, 46, fig. 22; Hill, 1930, vol. 1, p. 152, no. 599; Bange, 1949, pp. 19, 116, fig. 45; Schuette, 1951, pp. 170–72; Stafski, 1962, pp. 10, 46, figs. 82, 83; Montagu, 1963, pp. 65–66, fig. 61; Wuttke, 1965, 39, pp. 144–46; Weihrauch, 1967, pp. 277, 281, fig. 328, 1967, 49, pp. 222, 250; Rasmussen, 1973, n.s. 4, p. 132; Theuerkauff, December 1975, 102, p. 434; Rasmussen, 1975, pp. 81, 82.

calling ancient coins and Italian Renaissance medals, refer to earlier medals produced in the Vischer family workshop (cat. nos. 187, 188) and to two of the portrait heads on the *Sebaldus Tomb* (Stafski, 1962, figs. 75 f, g). The four lion-claw feet are derived from Paduan bronze inkwells and writing caskets, of about 1500, from the circle of Severo Calzetta da Ravenna (W. D. Wixom, *Renaissance Bronzes from Ohio Collections* [exhib. cat.], The Cleveland Museum of Art, 1975, nos. 94, 95). The *testa-da-cavallo* shield is also an Italian form. The style of the inkpot therefore may be seen as fully Renaissance, completely abandoning the Late Gothic forms of some of the earlier products of the Vischer family workshop.

The attribution of this work to Peter Vischer the Younger has too often rested on the mark of the two fish impaled on an arrow. The fact that this mark appears on one of the two shields on the brass epitaph of his father's third wife can only mean that, like the motto, it belongs to the Vischer family and is not restricted to the younger Peter (see Wuttke, 1967, 49, pp. 211–12).

However, the attribution can be solidly affirmed on stylistic grounds. The nude's proportions, contrapposto stance, and canon of beauty noted above are also found in the younger Peter's drawings of female nudes in Pankraz Schwenter's "Histori Herculis," of 1515 (Stafski, 1962, figs. 90, 91). Furthermore, the inkpot figure is closely related in anatomy and physiognomy to the four harpy candle brackets at the four corners of the *Sebaldus Tomb,* which were completed between 1514 and 1519 (Stafski, 1962, figs. 32–35). Peter's knowledge of Paduan Renaissance art forms was undoubtedly gained directly during his visits to Northern Italy probably in 1507/8 and 1512/14. The combined stylistic evidence and the mark of 1516 suggest a date of about 1516 for the inkpot.

A figurative utensil-container in a Humanist mode, such as the present one, for use on a study desk, also derived from Renaissance Padua. Peter Vischer the Younger may have made this inkpot for one of his aspiring Humanist friends in Nuremberg, such as Sebald Schreyer (1446–1520), a patron and close

196 PETER VISCHER THE YOUNGER
Inkpot, with Allegory

1525
Brass, cast after a wax model, with a worn, black lacquer patina, and traces of old gilding on the hair and on the decoration of the vase
7⁵/₈ x 4¹/₂ in. (19.3 x 11.5 cm.)
Oxford, The Visitors of the Ashmolean Museum, Fortnum Collection (acquired, 1899)
1086

Christoph Gottlieb von Murr, who had seen a figured inkpot in the art collection of D. Johann Gustav von Silberrad in Nuremberg, published a description in 1778 that, despite a few errors, is sufficiently detailed to allow an absolute identification with this second inkpot belonging to the Ashmolean Museum: "One of them presents a reminder of the future life. Beside an urn [vase] which can be used as an inkpot stands a nude woman about six zoll high who points with her finger to Heaven. A beautiful thought. In front of her lies a skull. Behind her is a biret and a dolch [short sword]. Near the urn [vase] is a small tablet with the inscription VITAM NON

MORTEM [RE]COGITA. Under the base is the sign of the master with two fish, the letters PV, and 1525."

Several details, not described by von Murr, add to the interest of this object. The woman's hair is pulled tightly back at the nape of the neck into a knot from which extend two wavy strands. The large oval vase is decorated beneath its sharply curved rim with a continuous band of concentric and stylized acanthus leaves. Spaced rosettes occupy the next register, below which are pendant ovals alternating with circles. The vase is supported on four small animal feet with short foliate extensions. Resting obliquely against the vase is the plaque with the inscription in raised Latin capital letters, referred to by von Murr. On this plaque, rather than under the base, as indicated by von Murr, is the family mark of two fish transfixed on an arrow, on either side of which are the letters "P" and "v." On the base behind the figure, the short sword appears with a shield, not a "biret," as described by von Murr, that is embossed with a rosette. The almost square base has plain sloping edges. On the underside may be seen the inscribed date of 1525 accompanied not by the mark mentioned by von Murr but by ✝, a mark of the Vischer workshop (Daun, 1905, 75, pp. 59, 60). The figure, inscribed plaque, skull, vase, and base were cast separately and assembled.

This inkpot must be understood in close relationship to the artist's earlier inkpot (cat. no. 195). The gesture of pointing to heaven in the present work reaffirms the content of the motto, which, to von Murr, meant future life, and to Dieter Wuttke eternal life, in the Christian sense. The skull, again, is a symbol of death and vanity. This nude woman is lacking all attributes and cannot be identified with Fortuna, except by analogy: Since Peter Vischer the Younger returned to the theme of Orpheus and Eurydice a number of times (cat. nos. 193, 194), here, he may have been reworking an earlier treatment of the contrast of eternal life and of Fortuna. If the present nude figure is not Fortuna, she could be interpreted as a mediator between the earthly and the eternal world.

Like those of the other Oxford inkpot (cat. no. 195), the proportions and contrapposto of the nude woman here are similar to those of the Eve in Dürer's drawing and engraving of Adam and Eve, both dated 1504 (cat. nos. 120, 121). However, some changes have been wrought by Vischer: He makes the female head proportionally smaller and the figure's outstretched arms closer to Adam's, rather than Eve's, in the engraving. Incidentally, Peter Flötner's depiction of the scantily clothed woman in his drawing, of 1537, may have been based upon this inkpot figure pointing upward with her right hand while her left hand rests on the vessel beside her (H. Strieling, "Kleine Beiträge zur Peter Vischer, 10. Neue Vischerwerke in Baden-Baden," Monatshefte für Kunstwissenschaft, 1922, 15, fig. 10).

The present inkpot is vaguely evocative of Paduan Renaissance bronzes in such details as the shape of the vase and the animal claw feet

196

beneath it, and the black lacquer patina. It is clearly stylistically allied to Peter Vischer the Younger's work on the Sebaldus Tomb (fig. 135), completed in 1519 — as evidenced by the absence of chiseling and by the loose, sketchy modeling that accurately reflects that of the wax model (see H. Stafski, Der jüngere Peter Vischer, Nuremberg, 1962, figs. 21, 32–35).

Like the other inkpot with an allegory (cat. no. 195), this example was probably intended as a gift to grace the study of a Humanist friend of Peter the Younger. The vase must not be described as an urn; it is a container for ink, for which the artist simply adapted another Italian shape.

WDW

EX COLLECTIONS: D. Johann Gustav von Silberrad, Nuremberg (until 1778); M. His de Lasalle; C. Drury E. Fortnum, Great Stanmore, England (1833).

BIBLIOGRAPHY: von Murr, 1778, pp. 520–21; von Rettberg, 1854, p. 157; Lübke, n.d. (c. 1878), p. 22; Bergau (Dohme, vol. 2), 1878, p. 38; Fortnum, 1889, 2, no. 1086; Seeger, 1897, pp. 57–64, fig. 7; Daun, 1905, pp. 59–61, fig. 47; Bode, 1908, 29, pp. 32, 33, 34, fig. 3; Meller, 1925, pp. 189, 193, fig. 122, 1926, pp. 26, 46, fig. 23; Bange, 1949, pp. 19, 20, 116, 117, no. 46; Stafski, 1962, pp. 10, 46, 54–56, 72, n. 65, fig. 84; Montagu, 1963, pp. 61, 66, fig. 62; Wuttke, 1965, 39, pp. 144–46; Radcliffe, 1966, pp. 58, 61, pl. 34; Weihrauch, 1967, p. 281; Wuttke, 1967, 49, pp. 222, 250; von der Osten and Vey, 1969, p. 24; Rasmussen, 1973, n.s. 4, p. 132, 1975, pp. 81, 82; Gagel, in Der Mensch um 1500 . . . , 1977, pp. 149, 150, fig. 114.

Inkpot, with Adam and Eve

About 1520
Brass, solid cast, after a wax model, with a
chocolate- and yellowish-brown natural patina,
and remnants of a darker brown natural patina
5 3/4 x 4 3/4 x 5 in. (14.6 x 12 x 12.7 cm.)
Eve's left hand is missing.
The Cleveland Museum of Art, Norman O. Stone
and Ella A. Stone Memorial Fund
61.29

197

Seated, and with their heads partially turned
toward one another, Adam and Eve embrace. A
thin drapery extends across both their laps, sug-
gesting that the couple is represented after the
Fall. Eve also wears a tight veil over the back of
her hair, similar to that of the woman on the
right in Dürer's engraving of *Four Naked
Women*, dated 1497 (see E. Panofsky, *The Life
and Work of Albrecht Dürer*, Princeton, 1955,
fig. 97). A remnant of a gnarled tree branch is
attached to Eve's right knee. Both figures sit
back at an angle, with one leg stretched out and
on either side of an acanthus-decorated cor-
nucopia, which serves as an inkpot. The low
bench is ornamented on its concave sides with
acanthus leaves. At the back is a circular com-
position in low relief depicting two winged and
partially draped putti playing with a small ob-
ject, probably a snail.

The ensemble is solid cast in one piece with
the thin rectangular base, whose front corners
have been angled. There is little evidence of fil-
ing and chiseling after the cast was completed.
Many of the scumbles, accidental nicks, and
other irregularities of the model are reflected in
the cast. The freshness of the cast is especially
apparent in the heads — in the features and the
hair — of both figures. The work has all the
immediacy and vivacity of a sketch, represent-
ing an accomplished master's quick and deft
facility in modeling and cutting the model.

The erotic motif of the embracing Adam and
Eve was popular in the Renaissance. Dürer was
interested in this theme, as seen in the woodcut
(Bartsch, no. 17), of 1509, in the *Small Passion*
series, and in his drawing, dated 1510, in the
Graphische Sammlung Albertina (see F. Wink-
ler, *Die Zeichnungen Albrecht Dürers*, vol. II:
1503–1510/11, Berlin, 1937, fig. 470; Panofsky,
1955, figs. 194, 195). If the object held by the
two putti on the back of the present inkpot is a
snail, this may be a reference to the Original Sin.

Both Adam and Eve are roughly modeled,
creating an impression of mass, which is es-
pecially clear when the group is viewed in the
round — as was surely intended. The muscular
solidity of Adam, particularly apparent from
the side, recalls, however distantly, the *Belve-
dere Torso*, the famous Greek marble of the
mid-first century B.C., known since the 1430s,
in the Vatican (*The Vatican Collections, The Pa-
pacy and Art* [exhib. cat.], New York, The Met-
ropolitan Museum of Art, 1983, no. 21, ill.).

Its technical and stylistic characteristics
closely relate the *Adam and Eve* group to Peter
Vischer the Younger's work, in about 1514–19,

on the *Sebaldus Tomb*. The figure of Adam may
be compared with the larger seated male nudes
at the corners of the *Sebaldus Tomb* (fig. 136) in
their shared reference to the *Belvedere Torso*
(see H. Stafski, *Der jüngere Peter Vischer*,
Nuremberg, 1962, figs. 4–11). The winged
putti on the back are reminiscent of the Italiano-
ate putti in the round and in relief that frolic
about the base of the same monument (H. Staf-
ski, *Der jüngere Peter Vischer*, Nuremberg,
1962, figs. 12, 14, 16, 18, 20–23, 38–41). The
Eve is stylistically akin to the harpies holding
candelabra on the Sebaldus work (H. Stafski,
Der jüngere Peter Vischer, 1962, figs. 32, 33).

Anthony F. Radcliffe identified the subject of
the painting in Dublin by Georg Pencz (cat. no.
203) as a portrait of Georg Vischer, the nephew
of Peter Vischer the Younger, relating the clay
or wax group of Pan seducing Luna, in the

sculptor's hand in the painting, with preserved
works by Georg Vischer that are similar in scale
and character: a signed brass inkwell in Berlin
(cat. no. 200) and one in Florence (E. F. Bange,
*Die deutschen Bronzestatuetten des 16. Jahr-
hunderts*, Berlin, 1949, pp. 33, 122, fig. 73),
dated 1547 and 1556, respectively. Also com-
pared with the model in the painting were two
other works, a boy playing with a dog, dated
1542, in Nuremberg, and a figure assumed to
represent Andromeda, preserved in Moscow (E.
F. Bange, *Die deutschen Bronzestatuetten des
16. Jahrhunderts*, Berlin, 1949, pp. 32, 33, no. 73
a, b). To this group of four sculptures by — or
generally acknowledged as by — Georg Vischer,
Radcliffe added the Cleveland *Adam and Eve*,
which also has several persuasive characteristics
that parallel the model in the painting.

However, the attribution and date of the

Inkpot, with Adam and Eve depend on more than its very general similarity to the other small figure groups. The concept of modeling exemplified by the *Adam and Eve* in actuality is incompatible with the style of the four brasses by Georg, which lack the same sense of organic mass. Georg's figures are organized in terms of a series of sharply angled planes and abrupt turns. Absent is the easy, languid solidity of both the Cleveland *Adam and Eve* and the smaller figures around the base of the *Sebaldus Tomb*. An attribution to an earlier phase of the Vischer family activity, close in time to the completion of the *Sebaldus Tomb* — about 1519 or 1520 — is therefore reaffirmed.

The present work marks a highly Italianate phase in the Vischer family productions, in which something of the spirit and the style of the Paduan and Venetian Renaissance was adopted by Peter the Younger after his return from Italy. This influence is seen not only in the approach to the human figure — indicating an indirect knowledge of classical models — but also in lesser motifs, such as the acanthus leaves and the cornucopia. The two allegorical inkpots with female figures, signed by Peter Vischer the Younger (cat. nos. 195, 196), provide additional parallels for this style. The Italianate sense of form and the decorative motifs are almost entirely abandoned by Georg Vischer in his works of the mid-sixteenth century. WDW

EX COLLECTIONS: Duke of Arenberg; [Herbert Bier, London, 1961].

BIBLIOGRAPHY: *The Bulletin of The Cleveland Museum of Art*, 1961, 48, no. 13, ill. p. 240; Radcliffe, 1974, 99, pp. 128–30; Wixom, 1975, no. 166, ill.; Hackenbrock, 1976, 21, pp. 51, 52, fig. 9; *Handbook, The Cleveland Museum...*, 1978, p. 126.

198

198 CIRCLE OF PETER VISCHER THE YOUNGER
Incense Burner

About 1520
Brass, hollow cast, lid and putto solid cast, after a wax model, with dark brown patina
7 1/4 x 6 5/8 in. (18.1 x 16.9 cm.)
Lakewood, Ohio, Heinz Schneider Collection

Large, multilayered, six-petaled rosettes, and lions' heads with suspended rings, decorate the round, turned bowl of this container. Three sea horses support the bowl, and an irregular knob is situated on its underside. The lid, a separate casting with a series of turned moldings, is surmounted by a knob on which a winged putto is seated, holding a musical instrument in the form of a reed. The three spouts at the back of this figure, which open into its interior, provide outlets for the emission of incense smoke. Two additional openings appear in the turned portion of the lid — one of them at the back.

The general form of this container is related to the Paduan-Venetian tradition for such objects: a round container supported on three legs, with a winged cherub, or putto, sitting atop the lid as a finial figure. Behind these figures are usually several short, curved cylindrical spouts also used to release the incense in various directions. Examples of this type are found in the Walters Art Gallery, Baltimore (54.207), in The Metropolitan Museum of Art (41.190.45a–f) (see S. Rubenstein-Bloch, *Catalogue of the Collection of George and Florence Blumenthal, New York*, Paris, 1926, vol. II, pl. XLIX), and in Berlin (see K. Pechstein, *Bronzen und Plaketten. Vom ausgehenden 15. Jahrhundert bis zur Mitte des 17. Jahrhunderts* [Kataloge des Kunstgewerbemuseums Berlin, vol. 3], Berlin, 1968, no. 93, ill.).

In facture, style, and decorative details the present example is clearly not an Italian product, but, rather, must be a Nuremberg emulation of this Paduan-Venetian tradition. The absence of finishing work after casting, the bold modeling, and the omission of a lacquer patina are the first clues to this assessment. The putto with no neck, a high forehead, curly hair, pinched features, wings, and articulated toes occurs in a kindred way in many instances on

the *Sebaldus Tomb* (H. Stafski, *Der jüngere Peter Vischer*, Nuremberg, 1962, figs. 12, 14, 16, 18, 43), as does the musical instrument (Stafski, 1962, figs. 21, 43 b). The heads of the sea horses are like the head of a horse on the tomb (Stafski, 1962, fig. 27 a), and the lion masks are similar to the mask on the shield of Hercules, also part of the tomb (Stafski, 1962, fig. 4). These comparative elements on the *Sebaldus Tomb* are considered to be by Peter Vischer the Younger.

The distinctive rosettes, not found in the Paduan-Venetian works, appear in a simpler form on at least one of the columns of the *Sebaldus Tomb*, and on the side of the vase of the Oxford inkpot, dated 1525 (cat. no. 196). If not modeled by Peter Vischer the Younger, himself, the present object must have been made in his immediate circle and cast in his family's workshop, about 1520. This date may be assumed in relation to the completion of the *Sebaldus Tomb* in 1519.

WDW

EX COLLECTIONS: [Jacob Goldschmidt, Berlin]; [Antique Porcelain Co., New York].

BIBLIOGRAPHY: Wixom, 1975, no. 167, ill.

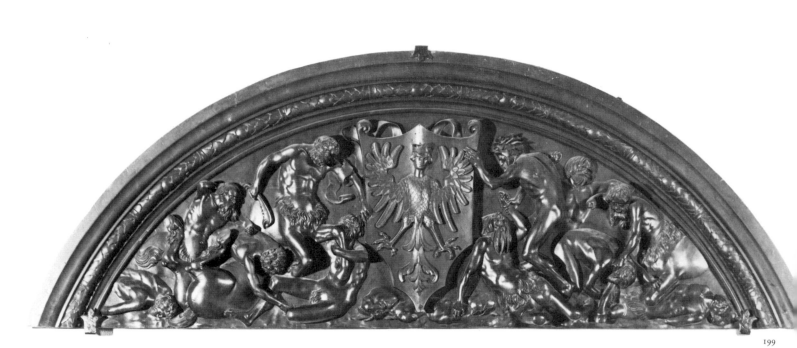

199 HERMANN VISCHER THE YOUNGER
(design and models of the lunettes, and the frieze
with the acanthus rinceaux, about 1515–17)
HANS VISCHER (casts of the lunettes, and the model
and cast of the frieze with figures in the river,
1536–40)

Two Lunettes and Two Friezes

Brass, cast after wood models
Lunettes, 29 1/2 x 104 5/16 in. (75 x 265 cm.);
friezes, 17 3/4 x 112 1/4 in. (45 x 285 cm.)
Provenance: Great Hall, Rathaus, Nuremberg
(until 1806).
Annecy, Musée Léon Marès, Château de
Montrottier

The two lunettes display agitated figure groups
in high relief. Some parts, being undercut, are
modeled in the round. In the center of each
lunette is a Nuremberg coat of arms held within
the firm grasp of the immediately adjacent
figures. One coat of arms shows a crowned,
human-headed eagle (a *Königskopf*, or *Jung-
frauenadler*); the other shows a split shield with
half an eagle and five diagonal bars. Streaming
curvilinear ribbons appear behind the upper
corners. In the lunette with the battle of the
bearded centaurs and bearded nude men, one of
these ribbons entangles the arm of a centaur.
The other lunette is completed with battling

groups of beardless nude men — some of them
on horseback — whose struggles take place in
the middle of a shallow river or lake, rep-
resented by wavy horizontal grooves that ex-
tend across the entire width of the composition.
The combatants' hair and the horses' manes are
windblown. Multiple moldings and fillets of
either stylized leaf work or repeated eggs with-
out darts frame the arched top of each composi-
tion.

The two friezes, whose decoration is in very
low relief, contrast with each other. The first is
dominated by elegant foliate rinceaux and fruit-
filled vases. Two battling beardless male nudes
with windblown hair stand astride dolphins in
the center. The man holding a shield with the
face of a bearded man brandishes a long pole;
the other man wields a tapered club. In the
second frieze, three sea centaurs, or ichthyocen-
taurs, battle two men at the extreme left, while
women flee to the right with some of their
children mounted on oxen that are guided and
pulled by three nude men. Two other nude men
who precede them blow on long horns. The
children seated on a litter borne by four men
play a viol and two horns. At the extreme right
of the entire frieze a satyr and a female satyr are
seated on the wooded bank of a river; he is
playing a shepherd's pipe, or panpipes, and

she plays a viol. All three of the sea centaurs
are bearded. Only one of the men — a litter
bearer — has a beard. Unlike those on the other
frieze and on both lunettes, the genitalia here
are explicit.

These two lunettes and two friezes are all that
remain of the large brass screen, or grille, which
Hans Vischer erected, by 1540, in the Great
Hall of the Nuremberg Rathaus. The saga of the
screen began in 1512 when Peter Vischer the
Elder received the commission for the Fugger
family funerary chapel at the church of Sankt
Anna, in Augsburg. According to Pankraz
Schwenter, the work on the grille began about
1515. Because of misunderstandings and the
dissatisfaction of the Fugger heirs, the project
was abandoned. An agreement was formulated
on August 2, 1529, in which ownership of the
completed parts of the screen was assumed by
Peter Vischer the Elder. Vischer was not re-
quired to pay back the money already advanced
by the Fuggers. The grille was subsequently
sold in 1530 to the Nuremberg city council for
the Great Hall in the Rathaus with the under-
standing that the Vischer workshop would sup-
ply the missing parts. In 1536, Hans Vischer
received the order to complete the screen exact-
ly after the old "model" ("gerissen muster").
Because of financial difficulties, Hans worked

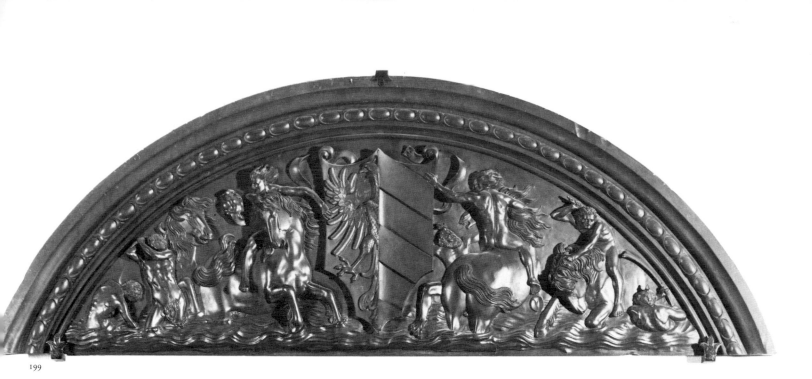

199

for four years before finishing the project — as is known from the surviving bills.

Some reliefs, already cast, had to be melted down and recast to replace the Fugger arms with those of the city of Nuremberg. Presumably, other portions of the screen were made from entirely new models provided by Hans. The horizontal dimensions of the screen that the Fuggers required were filled out at the sides by decorated stone pilasters carved by Sebald Beck to fit the wider space in the Rathaus. In 1806, the screen was taken down and sold at auction, and then later was acquired by a certain Frère-jean, from Lyons, the owner of a cannon foundry, who preserved the four portions described and illustrated here. The rest was melted down.

Sketches by Carl Freiherr Haller von Haller-stein made just prior to the sale (and now in the Germanisches Nationalmuseum) record many of the specific details of the reliefs (see W. Lübke, *Peter Vischers Werke*, Nuremberg, n. d. [about 1878], ill.; H. Höhn, *Nürnberger Renaissanceplastik*, Nuremberg, 1924, pp. 177–84). The overall appearance of the screen while still in the Rathaus is depicted in a painting on copper, of about 1614, by Paul Juvenel the Elder (M. Mende, *Das Alte Nürnberger Rathaus* [exhib. cat.], 1979, vol. 1, Nuremberg, Stadt-geschichtliche Museen, pp. 146, 178, 179, 180,

colorpl. 11). Several illustrations dating from the seventeenth and eighteenth centuries (fig. 137) show a colonnade of eight columns supporting an architrave with the frieze decorations, near the west end of the room. Above, the two lunettes flanked a tall, open triple arcade surmounted by an additional architrave and a decorated pediment. The main series of columns was connected by a geometric grille. There were three entrances: an open arched one in the center and, on either side, rectangular doors with a continuation of the grillework. The walls of the chamber were decorated with paintings: for example, there was a huge *Last Judgment* on the west wall behind the screen (see also cat. no. 13; Christensen, 1965, pp. 99–108). The room (fig. 42), built from 1332 to 1340, was rich in associations and function: It served as a meeting room for imperial assemblies, the western portion was used as a city tribunal, and it was the site of patrician dances. Its various decorations were subject to many alterations over time, only to be destroyed at the end of World War II.

The screen has been rightly hailed for its adaptation of Italian Renaissance architectural style in its overall form and in its details. With its alternating curving and triangular pediments, decorated friezes, and Corinthian columns, the German designer had clearly mastered the vo-

cabulary of Roman and Florentine architecture.

The extant reliefs display two distinct styles. On the one hand, the pair of lunettes and the frieze with the foliate rinceaux are extremely sophisticated, characterized by high relief (in the lunettes), vigorous movement, elegant line, balanced compositions, and Italianate figure proportions. The second style is seen in the second relief: The carver of the model and the finisher of the cast were not as conversant with the new freedom of figural movement and the new proportions of contemporary art in Italy. The classicism is diminished, the heads are too small for the oversized and neckless bodies, and the movement, always parallel to the relief, is abrupt, and lacks the involved twisting of forms in space of the lunettes.

The sources for the figural style and composition of each of the two manners have not been adequately explored. Louis Réau made a passing reference to the prints of Andrea Mantegna (1431–1506), the great Paduan and Mantuan painter and engraver. However, a study of the best impression of Mantegna's double-sheet engraving *The Battle of the Sea Gods*, of about 1485–88, which is preserved at Chatsworth, reveals a possible general source for the involved spatial movement of the figures in the two lunettes, as well as for the specific motif of the

199

199: detail

with the foliate rinceaux. The shaggy bearded heads in the lunette with the battle of men and centaurs may be a dual reference to the similar heads in both Dürer's and Jacopo de' Barbari's graphics with sea creatures (J. A. Levenson, K. Oberhuber, and J. L. Sheehan, *Early Italian Engravings from the National Gallery of Art*, Washington, D.C., 1973, p. 351, fig. 17-10; C. W. Talbot, ed., *Dürer in America: His Graphic Work* [exhib. cat.], Washington, D.C., National Gallery of Art, 1971, pp. 121, 122, no. 15, ill.). The heads in the lunettes also recall those of Kaspar, Saint Christopher, and Saint James on the tomb of Elizabeth and Hermann VIII of Henneberg in Römhild, which dates from about 1507–12 and is probably by Hermann Vischer the Younger (Meller, 1925, pp. 139, 141, figs. 76, 78, 79).

The restrained Italianate architectural studies for the *Sebaldus Tomb* made by Hermann Vischer the Younger after time spent in Rome led Simon Meller to postulate Hermann as the prime creative force behind the architectural scheme of the Fugger screen. The energetic figurative movement in the lunettes, and the elegance of the frieze with the foliate rinceaux, may also have been the result of Hermann's reaction to his Italian experience. As noted above, the bearded heads in the lunettes recall several of the Römhild heads, which were based on Hermann's own models. Because Hermann died only two years after his return from Italy in 1515, his work on the grille must have been restricted to the overall designs and to only a portion of the models. The severe Renaissance architectural forms and the suggestion of figurative reliefs in the sketch in the Louvre, mentioned above, support this assumption. Hermann's hypothetical work on the screen, then, was entirely an outgrowth of the Fugger commission for a funerary chapel at the church of Sankt Anna, in Augsburg. Its original purpose may explain both the discreet covering of the genitalia, as well as the possible symbolic significance of Hermann's imagery: The battles are funerary rituals on the death of a great man, which refer back to ancient practices in Tuscany, Etruria, and Rome — an idea that, perhaps, was conveyed via Pollaiuolo's *Battle of the Nudes* (W. S. Sheard, *Antiquity in the Renaissance* [exhib. cat.], Northampton,

horizontal undulations of the water in the foreground (J. A. Levenson, K. Oberhuber, and J. L. Sheehan, *Early Italian Engravings from the National Gallery of Art*, Washington, D.C., 1973, pp. 188–93, figs. 8–15; W. S. Sheard, *Antiquity in the Renaissance* [exhib. cat.], Northampton, Massachusetts, Smith College Museum of Art, 1978, no. 7, ill.). An example of the Mantegna print was known in Nuremberg — as documented by Dürer's copy of the right-hand sheet, dated 1494, in the Albertina (F. Winkler, *Die Zeichnungen Albrecht Dürers*, Berlin, 1936, vol. 1, no. 60). One of the figures in Mantegna's right-hand sheet recurs, but without being spatially convincing, in the frieze with the sea centaurs: the first sea centaur on the left, whose general outline and disposition of limbs is derived from the first sea centaur on the left in Mantegna's engraving. The shields differ: The bucrane in the Mantegna print becomes a tortoiseshell in the relief. The general horizontal distribution of the figures in the frieze, while probably partially based on a drawing made in 1516 by Hermann Vischer the Younger, preserved in the Louvre (Meller, 1925, p. 156, fig. 95), may have as its ultimate graphic source the engravings of Zoan Andrea, an imitator of Mantegna who was active in Mantua and Milan from 1475 until at least 1519 —

specifically, the frieze of figures below the basin edge of this artist's engraving *Fountain with a Statue of Neptune*, of about 1480–85 (J. A. Levenson, K. Oberhuber, and J. L. Sheehan, *Early Italian Engravings from the National Gallery of Art*, Washington, D.C., 1973, pp. 268, 269, no. 100, ill.). A seated satyr holding a viol, on a destroyed part of the grille, also is borrowed from an engraving by Zoan Andrea (Stierling, 1918, vol. 11, figs. 16, 17). The two sea centaurs holding a coat of arms are based upon similar figures in an engraving by Nicoletto da Modena (É. Galichon, "Oeuvre de Rosex, dit Nicoleto de Modène," *Gazette des Beaux-Arts*, 1869, 2nd per., vol. 2, p. 151). Since Dürer knew the engravings of the celebrated Florentine master Antonio Pollaiuolo (1431/32–1498) — as evidenced by Dürer's drawing *The Abduction of Two Women*, dated 1495, in Bayonne (F. Winkler, *Die Zeichnungen Albrecht Dürers*, Berlin, 1933, vol. 1, no. 82), and his painting *Hercules Kills the Stymphalic Birds*, dated 1500, in the Germanisches Nationalmuseum, Nuremberg (P. Strieder, *Albrecht Dürer*, New York, 1982, p. 189, fig. 223, colorpl.) — it is not surprising to note a quotation from the central pair of figures in Pollaiuolo's *Battle of the Nudes*, of about 1469–78, repeated in the center of the frieze

Figure 137 Johann Adam Delsenbach. The Great Hall of the Rathaus in Nuremberg, showing the brass screen in place. Engraving. Nuremberg, about 1715. Stadtgeschichtliche Museen, Nuremberg

Massachusetts, Smith College Museum of Art, 1978, no. 44, bibl.). The explicit representation of the genitalia in the frieze with the procession of figures indicates it was made by Hans Vischer for a location other than the Fugger Chapel — it was probably exclusively for the Nuremberg Rathaus.

The rinceaux frieze may be the original cast, even if overworked, of a model, of 1515–17, attributed to Hermann. The lunettes may be recastings based on Hermann's models, of the same early date, with only the coats of arms changed. The other frieze presumably is a cast of a new model provided by Hans in 1536–40.

WDW

EX COLLECTIONS: Frèrejean, Lyons (after 1806); Léon Marès, Château de Montrottier, Annecy (1916).

BIBLIOGRAPHY: von Murr, 1778, p. 394; Lochner, 1875, p. 21; Bergau, 1878, pp. 31, 32, 48, 53, 1879, II, pp. 50–62; Mummenhoff, 1891, pp. 97–107, 251–53, figs. pp. 99, 103, 6th pl. at back; Hampe, 1904, I, nos. 1752, n. 2, 1758, 1762, 1778, 1833, 2240, 2399, 2547; Stierling, 1918, II, pp. 260, 261; Buttin and Gerand, 1921, pp. 1–5; Halm, 1921, p. 35; Réau, 1921, 63, pp. 225–36; Meller, 1925, pp. 124, 154–63, figs. 61, 62, 93–100; Simon, 1929, pp. 134–36; Fries, 1934/35, pp. 66, 67, figs. 6, 7, 8, 9; Lieb, 1952, pp. 125–39; Wuttke, 1959, 22, pp. 334, 335; Stafski, 1962, pp. 47, 48, figs. 86–87; Müller, 1963, pp. 10, 11, ill. pp. 8, 9; Christensen, 1965, pp. 99–108.

200 GEORG VISCHER

Inkpot, with Allegory

1547
Brass, cast after a wax model, with natural brown patina, and traces of old gilding on the vase
Height, 6 15/16 in. (17.6 cm.)
Inscribed and dated (on underside of base): G.F. 1547
Berlin-Dahlem, Staatliche Museen, Preussischer Kulturbesitz, Skulpturengalerie
810

A female nude leans back, her weight supported by her left leg and her right elbow, which rests in the notch of a gnarled, leafless tree. Her right leg is so flexed that only her toes lightly touch on the skull that is on the ground behind the tree. The woman places her left hand on the edge of the relatively large oval vase — the inkpot, proper. A bow of hair is set atop her head, while twisted strands of hair frame her face and fall forward on each side of her neck. The vase, shaped with turned moldings, is decorated on the sides with alternating circles and symmetrical foliate motifs loosely resembling palmettes. A small dragon, with upturned head, lumbers across the base in the direction of a slithering snake. The artist inscribed his initials, G.F., and the date, 1547, on the underside of the base.

The arrangement of the hair probably derives from an engraving by Jacopo de' Barbari (P. Kristeller, *Das Werk des Jacopo de' Barbari*, London, 1896, pl. 1). The bow of hair occurs in an anonymous Nuremberg statuette, of about 1520/30, in the Museo Nazionale del Bargello, Florence (Weihrauch, 1967, fig. 338).

The figure and the vase with the left hand are each separate castings. These are tenoned into the base, which is cast integrally with the tree, dragon, and snake. The casting of the dragon is partially hollow, as can be seen from the underside of the base — the corners of which are angled.

This object served as an inkpot in a context similar to those of three other examples included here (cat. nos. 195–197).

The iconography represents a variation of that of the two signed examples in Oxford by Georg's uncle Peter Vischer the Younger (cat. nos. 195, 196). There are differences, however:

199

405

200

201 WORKSHOP OF PETER VISCHER
THE YOUNGER

Medal of Johannes Stabius
About 1520
Cast bronze, single sided and pierced
Diameter, 2 ³/₄ in. (7.2 cm.)
This bust-length portrait of Johannes Stabius,
facing left, shows the sitter with his hair
falling to the shoulders in smooth strands and
with a long, curly beard; on his head, he wears a
laurel wreath secured by a tasseled ribbon.
Inscribed: IOHANNES:STABIVS:POETA:LAVREATVS:
ET HISTORIOGRAPHVS ("Johannes Stabius: poet
laureate and historian").
Munich, Staatliche Münzsammlung

Johannes Stabius (died 1522) was born in Upper
Austria. He was a professor of mathematics in
Ingolstadt before moving to Vienna in 1497,
where he was celebrated as a poet and historian.
He was soon in contact with the court of Em-
peror Maximilian I. In 1502, he was crowned
with the laurel wreath by Conrad Celtis, and, in
1512, accompanied the emperor to Nuremberg.
A fruitful collaboration developed between
Stabius and Dürer, culminating in the magnifi-
cent *Triumphal Arch* for the emperor. In 1520,
the Nuremberg city council sent its scribe
Lazarus Spengler to Augsburg, so that Stabius
could make certain that the heraldic design on
the coat of arms and the motto to appear on the
city's dedication medal for Emperor Charles V
(cat. no. 141) were correct. Stabius's contem-
poraries regarded him as the best authority on
matters of heraldry and genealogy.

The continuing collaboration between Sta-
bius and Dürer would suggest that the portrait
medal may be based on a design by Dürer. The
letters of the inscription, struck into the cast
with punches — the Staatliche Münzsammlung,
Munich, owns a cast without the inscription —
are found in an identical impression on the Or-

the dragon, snake, and tree are new elements,
there is no plaque with the Vischer family
motto, and the date and initials appear on the
underside of the base. The skull, the obviously
lifeless tree, the snake, and the dragon are all
symbols of death and vanity. Because of these
attributes, the nude woman has been correctly
described in most of the literature as a personifi-
cation of Vanitas. The emphasis here is on the
vanity of life, whereas the two inkpots by Peter
Vischer the Younger stress the contrast between
earthly and eternal life.

The style of this work is also partially derived
from Peter Vischer the Younger's inkpots, but
only in connection with the proportions of the
figure and the compositional relationships of
figure to base, vase, and skull. However, the
nude figure lacks the older Vischer's expressive
modeling and his concept of organic figural
mass. By contrast, the sharply angled lines and
planes and the simplified treatment of the arms,
legs, and shoulders are typical of Georg's style,

as borne out by comparison with his small
brasses, some of them signed, in Florence, Mos-
cow, and Nuremberg (Bange, 1949, pp. 122,
123, nos. 73, 73 a, 73 b, ills. pp. 31, 32, 33). The
easy contrapposto and the convincing mass of
those works by Peter have been abandoned in
the known examples by Georg, the surfaces of
which are varied. The Berlin *Inkpot* combines a
highly finished nude and vase with the roughly
textured tree, dragon, and snake, which directly
reflect the wax model.

<div align="right">WDW</div>

BIBLIOGRAPHY: Bode, 1908, 29, pp. 35, 36, fig. 8; Meller,
1926, pp. 28, 47, fig. 35; Sauerlandt, 1927, pp. 15, 32, ill.;
Bange, 1949, pp. 30, ill., 32, 121, 122, fig. 70; Pechstein,
1962, p. 95, n. 150; Montagu, 1963, pp. 66, 67, fig. 67;
Wuttke, 1965, 39, p. 144, n. 14; *Bildwerke der christlichen
Epochen* . . . , 1966, no. 732, fig. 106; Weihrauch, 1967, p.
286; Radcliffe, 1974, 99, pp. 127, 128, 130, fig. 2; Gagel, in
Der Mensch um 1500 . . . , 1977, pp. 148–51, no. 26, fig.
113.

201

pheus plaquettes by Peter Vischer the Younger (cat. nos. 192, 193, 194), which would indicate that this medal was also cast in the Vischer workshop. It is possible that it was Peter Vischer the Younger, himself, who translated Dürer's design into a three-dimensional model.

H M

BIBLIOGRAPHY: Habich, 1929, vol. I, 1, no. 318, vol. I, 2, p. LXII; Bernhardt, 1936, pp. 15–16; Grotemeyer, 1957, no. 4; Kohlhaussen, 1968, no. 452; Schiedlausky, in *Dürer*, 1971, no. 694; Mende, 1983, pp. 46–50, no. 11.

202

202 WORKSHOP OF PETER VISCHER THE YOUNGER

Medal of Sebald Rech

About 1525
Cast lead
Diameter, ¹³/₁₆ in. (2.1 cm.)
Obverse: A male head, in the antique manner, with pointed beard and short hair, crowned with a laurel wreath tied with a ribbon, faces left.
Reverse: A view of the Rechenberg estate (which still bears the name), situated on a hilltop east of Nuremberg: a four-story rectangular crenellated palazzo, based on Italian models. Above the entrance portal of the otherwise-closed ground floor is a large bay window; a ring of battlements encircles the top of the structure.
Inscribed (on obverse): SEBALDVS · RECH ·; (on reverse): RECHBERGVM.
Nuremberg, Germanisches Nationalmuseum, Bequest of Maria Etz, 1956
Med 10597

In 1525, Sebald Rech (died 1557) acquired the "Kühberg," the hill upon which he promptly erected a manor house in the Italian style — one of the earliest examples of Renaissance architecture in Nuremberg. On orders from the city council, the mansion was set afire, and razed to its foundations, in the Margraves' War of 1553. However, because of financial difficulties, Rech had had to sell the house in 1540. He later became a dealer in works of art and printing presses (Zink, 1955, pp. 518–23).

As he had done with his manor house, Rech based his medal on antique or Italian Renaissance models. Habich, who could identify neither the house nor the subject of the portrait, correctly associated the medal with the Vischer workshop, but the Italianate influences led him to doubt this attribution. Only five copies of the work are known, all in lead; one, in Weimar, belonged to Johann Wolfgang von Goethe.

H M

Ex COLLECTION: Johann Cristoph Stahl (1839–1918).

BIBLIOGRAPHY: Imhoff, 1782, vol. I, 2, p. 874, no. 2; Habich, 1931, vol. I, 2, p. XLV, fig. 37.

203 GEORG PENCZ

Portrait of an Artist (Georg Vischer?)

1549
Oil on canvas
33¹⁵/₁₆ x 26 in. (86 x 66 cm.)
Dublin, National Gallery of Ireland (acquired in Paris, 1864)
1373

With his left hand, the young man shows us a small sculpture of Pan embracing the resisting Selene. The elegant clothes and casual manner of the twenty-eight-year-old sitter, and the blind gallery behind him, suggest that he is a nobleman and collector who wishes to capture the viewer's attention as he proudly displays a newly acquired work of art. Art lovers had themselves portrayed thus, in Italy, but not in Germany — all the more reason to suppose that the subject here is an artist or a craftsman.

Pencz's monogram, the inscription — AETATIS. S. XXVIII — and the date of 1549 on the painting serve as clues to help identify the sitter, as well as the sculpture. Gmelin (1966) proposed that the portrait might represent Albrecht Jamnitzer, a goldsmith who became a master craftsman in the workshop of his famous brother, Wenzel; had to leave Nuremberg in 1552 because of debts; and died in 1555. Radcliffe (1974) suggested Georg Vischer, a brass worker, who took over his father Hans's workshop in 1549, and who is known to have made small brass sculptures such as the Pan and Selene group. Vischer died in 1592. If the portrait is of Albrecht Jamnitzer, the original sculpture is likely to have been silver; if of Vischer, the sculpture would have been a wax model. However, in comparable paintings of Nuremberg goldsmiths, wax models are depicted in a reddish shade.

KL

BIBLIOGRAPHY: Gmelin, 1966, p. 72, no. 37, fig. 64; Radcliffe, 1974, pp. 126–29, fig. 1; Löcher, in *Wenzel Jamnitzer...*, 1985, p. 173, fig. 142; *Masterpieces from the National Gallery of Ireland*, 1985, pp. 52–55, no. 21.

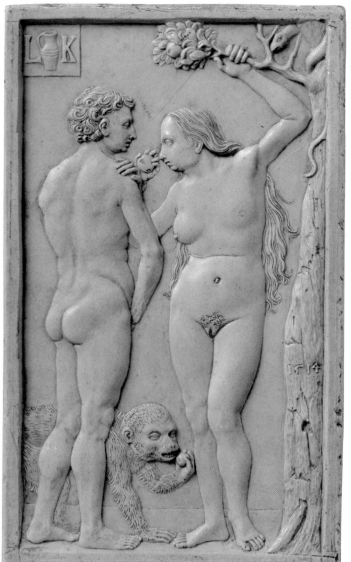

204

204 LUDWIG KRUG

Adam and Eve: The Temptation

1514
Solnhofen stone
5⁷/₈ x 3⁹/₁₆ x ¹/₂ in. (14.9 x 9 x 1.2 cm.)
Signed (upper right): LK; dated (right center): 1514
Berlin-Dahlem, Staatliche Museen Preussischer
Kulturbesitz, Skulpturengalerie
805

Seen in three-quarter view, from the back, a tousle-haired Adam looks at Eve, who stands facing him, her long hair streaming down her back to her waist. She offers Adam the apple with her right hand, while she grasps a tree branch above her that bears a second fruit. The serpent is curled around the tree trunk that fills the left edge of the composition. An ape crawls along the ground behind Adam, eating a third apple, which he holds in his left hand. A horizontal line in back of the three figures and the tree indicates the ground line. A raised plain border surrounds the scene. The artist's initials, LK, flank a tall jug, or pitcher — a pun on the German word for this type of container: "Krug." The date, 1514, appears in relief on the tree.

Carved in costly Solnhofen stone, this relief may have been intended as a model for a brass plaquette or for goldsmiths' work (Theuerkauff, 1975, 102, p. 433).

The subject of Eve offering the apple to Adam — the moment of temptation before the Fall — is a familiar one in Medieval and Renaissance art. The idea of using animals as symbols has a parallel in Dürer's engraving of Adam and Eve, of 1504 (cat. no. 121). The ape eating the apple symbolizes the Fall of Man (Janson, 1952, pp. 125–28). Both Adam and the ape hesitate to bite into the apple that each holds. Janson supposed that the ape as an accessory to the Fall of Man actually originated in Antoine Vérard's *Bible historiée,* published in Paris about 1499, and spread from France to Flanders and Germany. The serpent in the tree, the diabolical reptile that precipitated the Fall, is given a place of less importance in Krug's relief.

The style of the relief is almost fully Renaissance in the ponderosity given the figures, the contrapposto pose of Eve, and the three-quarter back view of Adam — although the naturalistic details still retain a slight trace of the Late Gothic. Except for her raised left arm, Krug's Eve corresponds in pose to Dürer's Eve in the

1504 engraving (cat. no. 121). Krug was intrigued with nude figures seen in three-quarter back views, as indicated by the female nudes in his prints (Rasmussen, 1983, 9, figs. 9, 10), as well as by the Adam in the Berlin relief. This interest was probably sparked by Dürer's experimentation with such representations — as, for example, in the engraving of *The Four Witches: Discordia,* dated 1497 (Theuerkauff, 1975, 102, p. 433). The psychological intimacy suggested by Krug's relief may be related in interpretation but not in formal composition to Dürer's drawing of Adam and Eve, dated 1510, in the Albertina (F. Winkler, *Die Zeichnungen Albrecht Dürers,* Berlin, 1937, vol. 2, no. 470).

WDW

EX COLLECTION: Königliche Kunstkammer, Berlin.

BIBLIOGRAPHY: Kugler, 1838, II, p. 106; Fischer, 1859, p. 43; Bode, 1887, p. 180; Braun, 1908, pl. LXVIII; Vöge, 1910, no. 191; Bange, 1928, pp. 7, 75–76, pl. 77; Janson, 1952, pp. 127–28, pl. XVIII b; *Bildwerke der Christlichen Epochen...,* 1966, p. 116, no. 673, fig. 104; Kohlhaussen, 1968, pp. 359, 368, 369, 505, 508, 527, 529, fig. 526; Theuerkauff, 1975, 102, p. 433, fig. 2; Weber, 1975, p. 54, no. M 27, pl. 4; Gagel, in *Der Mensch um 1500...,* 1977, pp. 155–61, no. 28, fig. 118; Rasmussen, 1983, n.s. 9, p. 138, fig. 7.

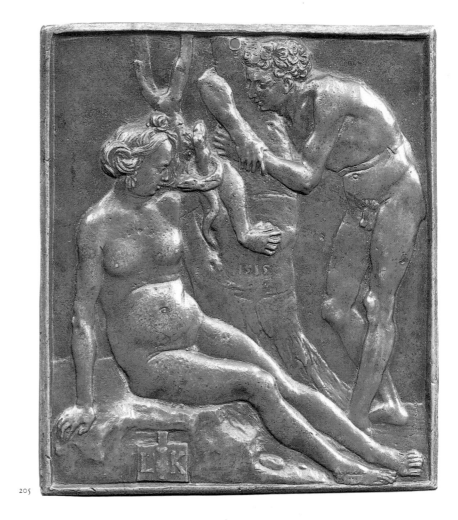
205

205 LUDWIG KRUG

Adam and Eve: The Temptation

1515 (model), 1518 (cast)
Brass, with natural brown and red opaque patina,
and remnants of dark brown lacquer
4^{13}/$_{16}$ x 4^{1}/$_{4}$ in. (12.2 x 10.8 cm.)
Signed (bottom left): LK; dated (at center): 1515,
(on reverse): 1518
The Cleveland Museum of Art, John L. Severance
Fund
48.359

The nude Eve sits on a low, rocky ledge to the
left of the base of a large tree at the center of the
composition. Her left arm is hooked over one of
the tree's leafless branches, which also supports
the serpent. Eve engages the serpent in conver-
sation at close range, while she surreptitiously
passes the forbidden apple to the nude figure of
Adam. Standing at the opposite side of the tree
and embracing it, Adam seems more intent on
listening to the conversation than on receiving
the fruit.

The drill hole at the top of the tree trunk, if
original, suggests that this plaquette was meant
to be suspended in a collector's cabinet.
Another version, measuring 5^{1}/$_{6}$ x 4^{5}/$_{16}$ inches
(12.8 x 11 centimeters), is preserved in the
Moravská Galerie, Brno. Both plaquettes are
signed on a plaque in the foreground with the
artist's initials flanking a jug — as in the case of
the Solnhofen stone relief (cat. no. 204). Both
are dated 1515, in relief, on the tree trunk — the
date of the model and of the Brno cast. The
Cleveland plaquette bears the date 1518, in re-
lief, on the reverse, which means that this cast
was made three years later than the Brno ex-
ample.

The subject, the moment of Temptation be-
fore the Fall, is depicted straightforwardly.
Another example of Krug's preoccupation with
the story of Adam and Eve, this composition
stresses the intimacy of the scene — a feature
shared by Krug's own woodcut, of about 1515
(Smith, 1983, p. 216, no. 114), and initiated by
Dürer in his drawing, of 1510, in the Albertina,
Vienna (F. Winkler, *Die Zeichnungen Albrecht
Dürers*, Berlin, 1937, 2, no. 470).

The relief exhibits a curious yet expressive
stylistic mixture of Northern Gothic naturalism
with an Italian-inspired interest in the nude as
an object of intrinsic beauty. Krug's figures find
three-dimensional parallels in Peter Vischer the
Younger's figures on the base of the *Sebaldus
Tomb*, which, considering the drawn-out saga
of that monument's evolution (1508–19), may
have been well under way at the time. Krug's
Adam may be compared with the spare and
sinewy heroes at the corners of the tomb (fig.
136). Krug's Eve bears some connection with
Vischer's female figures around the base of the
tomb, such as that of Scylla (S. Meller, *Peter
Vischer der Ältere und seine Werkstatt*, Leipzig,
1925, p. 176, fig. 113), and with Vischer's draw-
ing of the same subject (cat. no. 189). A compel-
ling similarity in approach to representing the
male nude is demonstrated by both Krug's
Adam and by Peter Vischer the Younger's Or-

pheus on the Washington, D.C., plaquette (cat.
no. 193). These artists must have been aware of
each other's current productions. The figural
compositions of Dürer were not necessarily the
only sources for Krug.

In any case, Krug's Cleveland relief is superb-
ly subtle in the way that the psychological in-
terrelationships among Eve, the serpent, and
Adam are expressed not only in the attitudes of
the heads but also by the bodies. While the
languid and ample body of Eve is in contrast to
the lean, although not entirely muscular, figure
of Adam, together with the tree, the rock, and
the serpent they form a tightly knit yet sinuous
composition of a high expressive order.

WDW

EX COLLECTIONS: Abbey of Klosterneuburg (near Vien-
na); Dr. Emil Delmar, Budapest; [R. Stora and Co., New
York, 1948].

BIBLIOGRAPHY: Ilg, 1886, n.s. 12, p. 65; *Kunst und Kunst-
gewerbe* ... (Delmar Collection), 1939–40, no. 12, ill.;
von Falke, 1940, 26, pp. 269–70, fig. 2; Milliken, 1949, 36,
pp. 6–7, 12, ill.; Kohlhaussen, 1968, pp. 359, 505, 527;
Wixom, 1975, no. 165, ill.; Weber, 1975, pp. 54–55, no.
28; Gagel, in *Der Mensch um 1500* ..., 1977, p. 158, fig.
120; Smith, 1983, p. 217, no. 115, ill.

206 LUDWIG KRUG

The Adoration of the Magi

About 1515
Pen and brown ink, on paper
Signed in ink (on verso): Ludw. Krug
9^{13}/$_{16}$ x 6^{7}/$_{8}$ in. (25 x 17.5 cm.)
Sacramento, California, Crocker Art Museum,
Crocker Collection
1871.1

Ludwig Krug, known chiefly as a goldsmith,
also worked as a sculptor, and, for a brief period
between 1515 and 1520, as a printmaker. The
Sacramento drawing of the Adoration of the
Magi and the one (cat. no. 207) in the Ger-
manisches Nationalmuseum, Nuremberg, are
both related to an engraved *Adoration* by Krug
dated 1516. The Nuremberg drawing is clearly
the final study for the engraving. The larger
Sacramento drawing is somewhat different in
design, but is nonetheless certainly contem-
porary.

The Nuremberg drawing and the engraving
show the Magi and a full complement of attend-
ants gathered around the Virgin and Christ,
while Joseph stands alone, off to the side. How-
ever, in the Sacramento drawing, the cast is
reduced to the essential figures of the Three
Kings, the Virgin, and the Christ Child. They
inhabit a crumbling, wood-roofed, stable-like
interior, with only vague suggestions of the

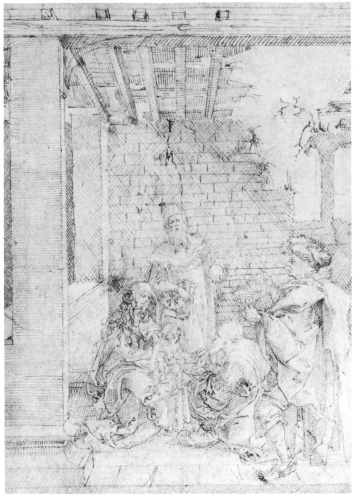

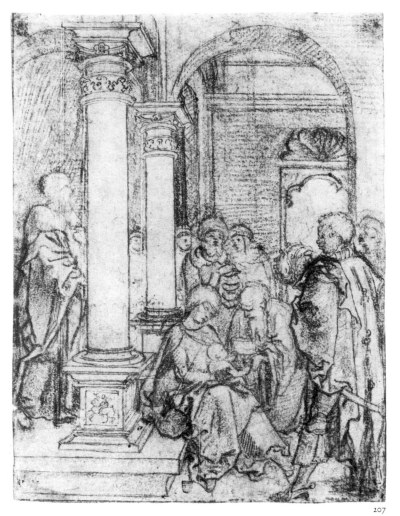

206

207

classical order in the pier at the left and in the arched windows; the Virgin and Child of the engraving are majestically set in a classical, colonnaded interior, complete with decorative frieze.

The Sacramento Virgin presents a more youthful image: Her head is only partially covered by the rather stern headdress of the engraving, revealing her hair, which falls over her shoulders. The Child appears more lively than in the Nuremberg drawing and in the engraving, where his back is to the viewer.

Common to both the Sacramento drawing and the engraving is the distinctive rendering of the drapery, with small lapping folds enlivening larger panels. Here, as in the final engraving, Krug delights in the Oriental costume of the kings — in their pointed shoes, their turbans and crowns, and in the ball fringe on their robes. While many costume elements are the same in the Sacramento drawing and in the engraving, Krug uses them to highlight different areas in each. (With the exception of the costume of the Moorish king, these details are not so precisely rendered in the Nuremberg drawing.)

Although the kings' garments are clearly Oriental, the gift offered by the turbaned king in the Sacramento drawing and in the engraving bears the mark of contemporary Nuremberg goldsmiths' work: He holds a covered cup decorated with repoussé lobes. (In the Nuremberg drawing, there is a similar cup, but it is only lightly sketched in.)

The Nuremberg preparatory drawing focuses on the composition — on perspective, drapery, and on the shading that would be used in the final engraving. Yet, many of the details in the Sacramento drawing that are less carefully delineated in the Nuremberg drawing are nevertheless important to the engraving, suggesting that both drawings predate the 1516 print. BDB

BIBLIOGRAPHY: *Old Master Drawings from the E. B. Crocker Collection; the German Masters . . .* , 1939, no. 1, ill.; *Master Drawings from Sacramento*, 1971, p. 1, no. 3, ill. p. 43; Smith, 1983, no. 112, pp. 214–15.

207 LUDWIG KRUG
The Adoration of the Magi
About 1515–16
Pen and brown ink, with charcoal (?), on paper
6 3/8 x 4 7/8 in. (16.1 x 12.3 cm.)
Nuremberg, Germanisches Nationalmuseum
Hz 85 (Kapsel 562)

This final study for Ludwig Krug's engraving *The Adoration of the Magi* presents the composition in the same size, but reversed. It is blackened on the back, probably with charcoal, and the main outlines have been scratched with a needle — either for the purpose of making a tracing or to transfer the composition to the copperplate. A classical-style portico forms the ceremonial setting for the homage of the Magi and their entourage. The structural delineation of the architecture focuses attention on the central grouping of the Virgin and Child. The needle-traced lines attest to the artist's concern for the central-perspective construction of the pictorial space. Various works by Dürer may have suggested the disposition of that space and even that of individual figures. By the use of an exaggerated perspective and the isolation of specific figures, however, Krug appears to have anticipated some of the expressive devices of Mannerism.

In several crucial details, the engraving does not correspond to the preliminary drawing. The

decoration of the bases and capitals of the columns has been changed, a figural frieze reminiscent of the products of the Vischer workshop added, and the number of auxiliary figures increased. Because of these differences, Schilling (1932–33) rejected this work as the final preliminary sketch for the engraving. Our knowledge of the drawing has long been limited to four stylistically quite similar sheets in the Germanisches Nationalmuseum. The fussy, somewhat hesitant pen strokes, nevertheless, have a certain connection to those of the drawing in Sacramento (cat. no. 206), which must have been made at an earlier stage in the development of the composition. R S

Ex COLLECTION: Hans Freiherr von und zu Aufsess, Aufsess and Nuremberg (Lugt, no. 2750).

BIBLIOGRAPHY: Schilling, 1932–33, pp. 109, 114–15, ill. 71; *Flötner*, 1946, p. 58, no. 344; Zink, 1968, no. 77.

208 ANONYMOUS NUREMBERG GOLDSMITH, MASTER OF THE KRUG WORKSHOP (HANS KRUG THE ELDER [?]), after a design by ALBRECHT DÜRER

Covered Goblet, in the Form of an Apple
About 1515
Silver, embossed, with some portions cast, and gilded (except for the underside of the foot and the lid ornament)
Height, 8 ¹/₂ in. (21.6 cm.)
Nuremberg, Germanisches Nationalmuseum (acquired, 1927)
HG 8399

A crooked and forked twig with blossoms and leaves, which rises from a trefoil base edged with a fillet and molding, forms the shaft that supports the cup of the goblet — a smooth, round apple, with, however, a few indentations at the bottom and on its lid. The lid, in the form of a skullcap, can be removed. The inside of the goblet is gilded throughout.

Heinrich Kohlhaussen and Günther Schiedlausky agreed in attributing the design for this goblet to Albrecht Dürer, yet Dürer was not the first to introduce the apple motif to the goldsmiths' art. Earlier inventories, from the fifteenth century, mention apple-shaped vessels, but Dürer established the type through its repeated use in his designs (as in the sheet with six goblets, in the *Dresden Sketchbook,* in the Sächsische Landesbibliothek, Dresden) and in his paintings (for example, the *Adoration of the Magi,* in the Gallerie degli Uffizi, Florence). The goldsmith who made this work — and it must be assumed that he was employed in the workshop of Hans Krug the Elder — almost certainly patterned it after a design by Dürer, for the goblet displays the master's carefully balanced sense of proportion.

Nevertheless, the goldsmith omits any allusion to the Fall by not including the snake that appears in Dürer's Dresden sketch. The incorporation of fruit shapes in the overall form of an object was especially common in Nuremberg goldsmiths' work of the Late Gothic period — particularly in the Krug workshop. "We see here a turning toward a naturalism free of symbols, one that becomes more widespread in the first half of the sixteenth century" (Schiedlausky, 1985, p. 211). Among the great variety of Late Renaissance vessels from Nuremberg there are goblets in the form of an apple or a pear. The connection between the naturalistic design of a goblet in the form of an apple — which, however, served a utilitarian function — and such likewise naturalistic, but solely decorative, objects as plants, fruits, and animals fashioned of cast silver, has yet to be elucidated upon. KP

BIBLIOGRAPHY: Kohlhaussen, 1968, pp. 351–78, no. 390; Schiedlausky, in *Dürer,* Nuremberg, 1971, no. 671; Pechstein, 1971, no. 48; Smith, 1983, p. 218, no. 116; Schiedlausky, in *Wenzel Jamnitzer...,* 1985, pp. 211–12, no. 4.

Covered Goblet, with a Lansquenet

Nuremberg, about 1510
Silver, cast, embossed, and gilded
Height, 12 5/8 in. (32 cm.)
There are no markings.
Vienna, Kunsthistorisches Museum, Sammlung für
Plastik und Kunstgewerbe
979

The scalloped, sexfoil foot of the goblet is characterized by six slightly convex, pear-shaped lobes that narrow to a point between ridges on the shaft. Directly above a nearly spherical knop rests the cup, which has six prominent, pear-shaped bosses, and narrows to a neck formed of nineteen vertical, elongated bosses — a motif repeated on the lid. The edge of the lid is encircled with braided wire.

Curled leaves appear between the lobes of the foot, on the knop, and in the spaces between the bosses on the cup. The lid is topped by the small figure of a lansquenet holding a shield. This enameled shield, bearing two as yet undeciphered coats of arms and the date 1582, is a later addition.

The goblet is distinguished from numerous other bossed vessels from sixteenth-century Nuremberg by its unusual shape. It appears to incorporate some of the ideas that Dürer explored in his *Dresden Sketchbook*. E. Kris convincingly attributed the goblet to Ludwig Krug, whose work, in form, reveals a special relationship to Dürer's.

With its swelling bosses, the vessel suggests a kind of burgeoning growth. Only a very few objects from the early sixteenth century display such "organic" lines — at least until the columbine goblet became a fixed form.

Kohlhaussen dated the completely unmarked goblet too early, basing his judgment on the costume of the lansquenet, which he placed about 1505. It is more likely that the small figure on the lid was made from an earlier workshop mold. The well-calculated attempt at contrasting forms from various perspectives — specifically, the six flatter, pear-shaped bosses on the foot; the full, rounded ones, on the cup; and the nineteen elongated ones on the neck and lid — reveals a desire for balanced proportions that only surfaced in the designs of Dürer, after 1510. KP

EX COLLECTION: Archduke Ferdinand II, Ambras Castle, in the Tyrol (inventory of 1596).

BIBLIOGRAPHY: Braun, 1915, pp. 37–57; Kris, 1932, no. 19; Wien, 1966, no. 256; Kohlhaussen, 1968, pp. 348–49, no. 386; Leithe-Jasper and Distelberger, 1982, p. 76; Pechstein, in *Wenzel Jamnitzer...*, 1985, p. 213, no. 5.

209

Covered Goblet, with a Woman Drawing Water

Nuremberg, about 1525
Silver, cast, embossed, and gilded
Height, 17 5/16 in. (44 cm.)
The goblet bears the Nuremberg mark, a reversed
"N" (Rosenberg, vol. 3, no. 3687).
Vienna, Kunsthistorisches Museum, Sammlung für
Plastik und Kunstgewerbe
895

The goblet is richly ornate in form, and displays a lavish use of decoration. Three crouching miners, wearing caps, serve as the feet of the round, domed, and bossed foot. The shaft is adorned with acanthus leaves, some of them left ungilded. The cup, itself, is deeply concave: The upper part is composed of a wreath of round bosses; the lower section is plain, encircled by twigs and foliage. The bossed lid, ringed by a gnarled branch, supports a variety of differentiated acanthus foliage crowned by the figure of a woman at a well.

This goblet is one of a small number of Nuremberg vessels that E. W. Braun directly linked to Dürer's designs for goldsmiths' work. All that remains of one object from this group, a ciborium, is a drawing of the Halle treasury of Cardinal Albrecht von Brandenburg, but even in that illustration the signature of Ludwig Krug — an "L K" with a pitcher (= *Krug*) between the letters (Halm and Berliner, 1931, pl. 73) — is visible. Also among this group are the *Covered Goblet, in the Form of an Apple* and the *Covered Goblet, with a Lansquenet* (cat. nos. 208, 209). Typical of these vessels is their combination of (and variation on) traditional and newly developed forms. Some have mother-of-pearl reliefs, and some incorporate genre-like figures on their lids — such as the woman at the well, here, or the peasant woman that adorns an egg-shaped goblet in the Kunstgewerbe-museum, in Berlin. Striking features in the art of Ludwig Krug, in general, are his deviation from tradition and his indebtedness to Dürer's ideas and designs. The work of Krug and his atelier possibly best demonstrates what direction Dürer's efforts as a goldsmith would have taken had he not become a painter, instead. K P

EX COLLECTION: Archduke Ferdinand II, Ambras Castle, in the Tyrol (inventory of 1596).

BIBLIOGRAPHY: Braun, 1915, pp. 37–57; Kris, 1932, no. 20; Kohlhaussen, 1968, pp. 395–96, no. 412; Leithe-Jasper and Distelberger, 1982, p. 76.

210

211 Necklace (*Stückleinkette*)

Nuremberg, about 1530–40
Gold, pearls, 19 precious and semiprecious individually mounted stones (agates of different colors, a carnelian, a moss agate, a light-green chrysolite, a lapis lazuli, a garnet, a sapphire, an emerald, a malachite, an opal, a topaz, an amethyst, a tourmaline, a Madeira topaz, a turquoise, a rock crystal), a coral, and a cameo
Length, 15 7/16 in. (39.2 cm.)
Nuremberg, Germanisches Nationalmuseum (acquired, 1940)
T 4188

Each of the stones, the coral, and the cameo are set in an octagonal gold mount, linked to one another by gold loops set with pierced pearls. Such a necklace and a matching pair of bracelets were part of the traditional jewelry worn by the patrician *kronbraut* ("crowned bride") in Nuremberg, as late as in the eighteenth century. The present necklace was not typical of Nuremberg jewelry, but was highly valued in the city. The *Stückleinkette* — singly set precious stones connected to form a necklace — seems, originally, to have been adopted from Italy; necklaces of this type are depicted in Late Quattrocento paintings. A necklace resembling this one is worn by Saint Agnes in the painting by the Master of the Saint Bartholomew Altarpiece, of about 1495–1500 (in the Germanisches Nationalmuseum), which represents the saint's betrothal to the Child Jesus. Similar bracelets are worn by Isabella Brant in Peter Paul Rubens's 1609 painting *"The Honeysuckle Bower,"* in the Alte Pinakothek, Munich.

LVW

EX COLLECTION: Johannes Seiler, Nuremberg.

BIBLIOGRAPHY: Kohlhaussen, 1966, no. 440; *Wenzel Jamnitzer...*, 1985, pp. 100–101, 105, n. 75, pp. 332–33, no. 275.

212 MELCHIOR BAIER

Pfinzing Bowl

1534–36
Gold, cast, chased, and engraved, with colored enamel
Height, 6 7/8 in. (17.5 cm.)
Nuremberg, Germanisches Nationalmuseum (on permanent loan from the Seyfried Pfinzingsche Wohltätigkeitsstiftung to the city of Nuremberg)
HG 8397

This small, gold, covered bowl, with its colorful enameling and controlled architectonic form, is an outstanding example of German Renaissance art. Of considerable value for its materials alone, and representing the highest degree of skill in its workmanship, the decorative elements of the vessel express the spirit of the early German Humanists. Four brothers are depicted in medallion portraits, as on a commemorative monument, along with a Latin admonition concerning moderation in the enjoyment of wine.

The distinguishing feature of the design of the present object is the carefully calculated relationship among the foot, shaft, and bowl — specifically, the various plain, colored, or engraved bands that contrast effectively with the areas in the relief. A branch with green and blue enameled leaves twines around the base of the foot. Next, there is a plain molding, above which is a row of grape leaves, also in colored enamel. This is surmounted by a narrow band with an inscription in different colored enamels praising the proper use of wine.

Over this is an enameled frieze of colorful flowers and foliage. The double knop of the shaft is adorned with two wreaths of tongue-shaped forms, and bears the date 1534. On the upper surface of the lower part of the knop are colored leafy tendrils inhabited by putti, as well as the coats of arms of the Pfinzing family and of the church of Sankt Alban, in Mainz. Around the top of the knop are the letters "ME," "PF," "PP," "S," and "A," and "Melchior Pfinzing. Praepositus Sancti Albani."

The shallow cup is decorated with short, engraved horizontal lines. The gently sloping lid contains panels with colored enamel vines. Putti frame the finely chased medallion portraits (by Matthes Gebel) of three of Pfinzing's brothers.

On the finial, supported by dolphins, is the Pfinzing coat of arms, and the date 1536. On the upper surface is the portrait of Melchior Pfinzing (1481–1535), with the inscription "MELCHIOR PFINCZING.PREP.S.ALBANI.MOG." He was provost of the Sebalduskirche, Nuremberg, dean of Sankt Victor, and provost of Sankt Alban, Mainz, as well as an imperial councillor.

Although the *Pfinzing Bowl* is not documented as the work of Melchior Baier, the attribution may be made on the basis of other, known works by this outstanding goldsmith, who collaborated with Peter Flötner.

KP

BIBLIOGRAPHY: Habich, 1931, vol. 1, 2; Kohlhaussen, 1968, pp. 440–42, no. 465; Smith, 1983, p. 65, ill. 38; Pechstein, in *Wenzel Jamnitzer...*, 1985, p. 215, no. 10, colorpl. 16.

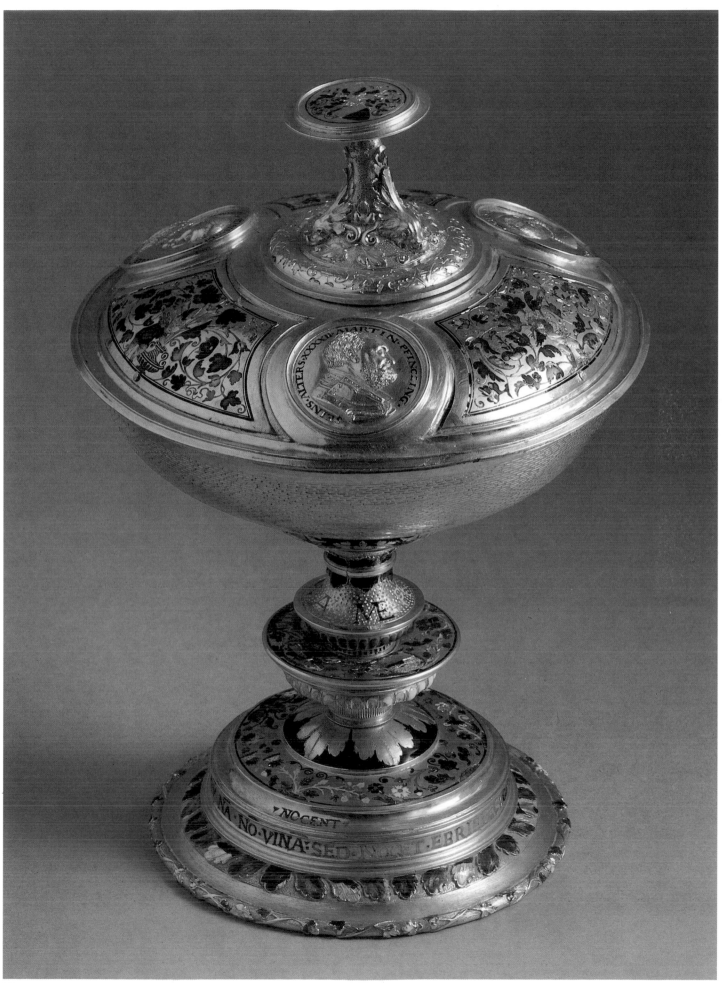

215: *obverse*

213 HANS SCHWARZ

Medal of Sebald Pfinzing

1519
Cast bronze
Diameter, 1⁷/₈ in. (4.7 cm.)
Obverse: A bust-length portrait of the sitter facing left, his hair contained in a net cap, on top of which is a hat with a turned-up brim.
Reverse: A shield with the Pfinzing coat of arms; in the field, considerably smaller, is the coat of arms of Pfinzing's wife, Katharina, née Plauen (Ploben).
Inscribed (on obverse): SEBALDVS [the L is inside the D]. PFINCZING. ÆTA.XXXI ("Sebald Pfinzing. Age thirty-one"); (on reverse): M·D·XVIIII·(1519·).
Nuremberg, Germanisches Nationalmuseum (acquired by 1856)
Med 422

Sebald IV Pfinzing von Lichtenhof (1487–1543) married in 1510, became a member of the city council in 1511, and was named elder *Bürgermeister* in 1522 and senior government officer in 1536. On a number of occasions he served as the council's envoy. He rebuilt the Lichtenhof manor house, which had been in his family for generations (Nagel, 1941, pp. 95–105, 112).

Sebald belonged to a different branch of the family than did the brothers shown on the medal in catalogue number 217. In 1507, his father, Sebald III, sold his house, which was down the hill from the castle, to Albrecht Dürer. Since Dürer's father had acquired hereditary rights to this house in 1475, Dürer, thus, grew up in a house belonging to Sebald III Pfinzing that he, himself, would later own.

The inscription, enclosed within a wide band, was carved in the model. In the same year, however, Schwarz abandoned this practice, and carved his models without inscriptions. He then pressed the letters into the still-soft clay form with punches. A preliminary drawing for the portrait is preserved in the Kupferstichkabinett, Berlin-Dahlem. HM

BIBLIOGRAPHY: Will, 1764–67, vol. 1, p. 8, no. 27; Imhoff, 1782, vol. 1, 2, p. 630, no. 20; Habich, 1929, vol. 1, 1, no. 149; Bernhart, 1934, no. 34; Smith, 1983, p. 238, no. 142.

214 HANS SCHWARZ

Medal of Magdalena Schlauderspacher

1519
Cast bronze, single sided
Diameter, 2¹/₄ in. (5.8 cm.)
The bust-length portrait shows a woman facing left, her hair contained in a high bonnet that signifies that she is a widow.
Inscribed: MAGDALENA SCHLAVDERSPACHERIN XXXXVI IAR ALT MDXIX ("Magdalena Schlauderspacher forty-six years old in 1519").
Nuremberg, Germanisches Nationalmuseum (acquired in Vienna, 1936)
Med 6946

Magdalena Schlauderspacher, née Voit von Wendelstein, married Georg Schlauderspacher (died 1512) in 1496. Her husband was from Graz, and had served as a councillor in Styria before moving to Nuremberg in 1493. Two years later, he was made a citizen of Nuremberg, and, in 1497, became a designate to the Greater Council. Will (1772, p. 39) refers to him as a very wealthy man, who, at his death, left a number of stipends and bequests to institutions.

As it was unusual at the time for a woman to have herself portrayed on a medal as a widow, one can therefore assume that a portrait medal of her as-yet unmarried son Georg, also by Schwarz, was intended as its counterpart (Habich, 1929, vol. 1, 1, no. 164).

Apparently, this is the only extant example of the medal; a preliminary drawing for it exists in Bamberg.

 HM

BIBLIOGRAPHY: Imhoff, 1782, vol. 1, 2, p. 902, no. 23; Habich, 1929, vol. 1, 1, no. 165; Bernhart, 1934, no. 63, 1936, p. 12; Neuhaus, 1936–39, pp. 156–57; Grotemeyer, 1957, p. 49, no. 13.

215 HANS SCHWARZ

Medal of Melchior Pfinzing

1519
Cast and gilded bronze
Diameter, 2³/₄ in. (7.2 cm.)
Obverse: This bust-length portrait shows the sitter facing left, dressed in clerical garb and a biretta, and holding a rosary.
Reverse: An allegorical female figure wearing a flowing garment, secured by a scarf, that falls in clusters of folds, occupies a hilly, wooded landscape. She lifts her face and hands toward heaven, where rays of sunlight break through dense clouds.
Inscribed (on obverse): MELCHIOR PFINCZIG PRE EC S ALB MO E SEB N ("Melchior Pfinzing Praepositus Ecclesiarum Sancti Albani Moguntiacensis et Sebaldi Norimbergensis"), (in the field): AET ANNO XXXVIII ("In his thirty-eighth year"); (on reverse): SPES MEA INDEVM · ("My hope is in the Lord.").
Nuremberg, Germanisches Nationalmuseum (acquired in Nuremberg, 1965)
Med 8904

Melchior Pfinzing (1481–1535) studied in Vienna, established contact with the court of Emperor Maximilian I, and was named privy secretary. He was one of the leading authors of the *Theuerdank*, a heroic epic describing the emperor's courtship of Mary of Burgundy. In 1512, he was named provost of the Sebalduskirche in Nuremberg, and, in 1517, he assumed the same position at the church of Sankt Alban in Mainz. He frequently traveled on the emperor's behalf. Pfinzing was unsympathetic to the new teachings of Luther. What makes his portrait medal most unusual is the rosary that he holds as a sign of his veneration of the Virgin: It may have been included to attest to his religious conviction. When the city aligned itself

215 : *reverse*

216

217

217 HANS SCHWARZ

Medal of Five Brothers of the Pfinzing Family

1519
Cast silver
Diameter, 1 5/8 in. (4.2 cm.)
Obverse: Five bust-length portraits, one behind the other, in order of sitter's age.
Inscribed (on obverse): CONCORDIAE · FRATERNAE · ("Dedicated to fraternal concord"); (on reverse): EFFIGIES ·/SIGISMVNDI · MELCH/IORIS · PREPOSITI · ECCLE/SIE · SANCTI · ALBANI · MO/GVNTINENSIS · VDALRICI ·/ABBATIS · SANCTI · PAVLI /VALLIS · LAVINII · SEYFRI/DI · ET · MARTINI · PFIN/CZING · FRATRVM ·.·/ANN · M · CCCCC /XIX.·.
Nuremberg, Germanisches Nationalmuseum (acquired by 1856)
Med 428

It is not known what motivated the five Pfinzing brothers to document their fraternal harmony on a medal. Only the two clerics give their titles, which makes it surprising, in such a context, that Melchior failed to include that he was also provost of the Sebalduskirche. These two brothers maintained a close relationship with the imperial court. While Melchior is described as a man deeply rooted in his faith, his younger brother Ulrich, as abbot of Sankt Paul im Lavanttal, in Austria, caused permanent damage to the monastery through his poor management and his corrupt conduct. Sigismund, the oldest of the brothers, was forty in 1519; Martin, the youngest, was twenty-nine.

Schwarz made separate medals of Melchior and Martin Pfinzing — also in 1519. The preparatory sketches for these, in Berlin, were used for the present work. Also preserved in Berlin is a drawing of Ulrich Pfinzing. Thus, there is every indication that the present medal, too, was made by Schwarz, although the sharpness, thinness, and technical virtuosity of the silver casting are unparalleled in the artist's work; for this reason, Ludwig Krug has been suggested as the possible author. HM

BIBLIOGRAPHY: Will, 1764–67, vol. 1, p. 7, no. 22; Im-hoff, 1782, vol. 1, 2, p. 621, no. 2; Habich, 1929, vol. I, 1, no. 177; Bernhart, 1934, nos. 50, 60, 115, 1936, pp. 14–15; Pechstein, 1968, no. 151; Smith, 1983, p. 238, no. 141.

with the reformers after the Diet of Worms in 1521, Pfinzing resigned as provost of the Sebalduskirche and moved to Mainz.

A preliminary drawing for the medal is preserved in Berlin. The following year, Schwarz reused the mold of the reverse, unchanged, for the portrait medal of Count Palatine Georg von Bayern, Bishop of Speyer and provost of Mainz Cathedral (Habich, 1929, vol. I, 1, no. 214). HM

BIBLIOGRAPHY: Will, 1764–67, vol. 1, p. 7, no. 17; Im-hoff, 1782, vol. 1, 2, p. 623, no. 5; Habich, 1929, vol. I, 1, no. 176; Bernhart, 1934, no. 50.

216 HANS SCHWARZ

Medal of Albrecht Dürer

1520
Cast bronze, single sided
Diameter, 2 3/16 in. (5.6 cm.)
A bust-length portrait of Dürer, facing left, wearing an open coat with a fur collar. He has a sharp, arching nose, deep-set eyes, and a trim beard; his hair falls to his shoulders in carefully groomed long locks.
Inscribed: ALBERTVS DVRER PICTORTS [*sic*] GERMANICVS.
Nuremberg, Germanisches Nationalmuseum (acquired in Frankfurt, 1975)
Med 9401

By 1519, at the latest, Dürer already had the idea of creating a medal with his own portrait. A preliminary sketch for the inscribed, reverse side, dating from that year, is preserved in the British Museum, London. However, Dürer abandoned the project presumably after he became impressed by the work of Hans Schwarz — whom he then commissioned to design a model without an inscription; the model still survives in the Herzog Anton Ulrich-Museum, Braunschweig. An entry in Dürer's diary confirms that from Antwerp, which he visited in the course of his tour of the Low Countries in September 1520, he sent payment to Schwarz: "Through the Fuggers in Antwerp, I have sent Hans Schwarz 2 fl[orins] in gold, for my portrait, in a letter to Augsburg."

The representation of the long-haired Dürer resembles the artist's early self-portraits but is far different from the so-called old-age portrait created only seven years later by Matthes Gebel (cat. no. 225). HM

BIBLIOGRAPHY: Will, 1764–67, vol. 1, p. 315, no. 8; Im-hoff, 1782, vol. 1, 2, p. 724, no. 35 (variants in the inscription); Habich, 1929, vol. I, 1, no. 201; Bernhart, 1936, p. 30, no. 10; Strieder, in *Dürer*, 1971, no. 76; Decker, in *Dürers Verwandlung*, 1982, nos. 44, 45; Mende, 1983, p. 190, no. 16; Smith, 1983, p. 239, no. 143.

218 Medal of Cardinal Albrecht von Mainz, Margrave of Brandenburg

Nuremberg, 1526
Cast bronze, single sided
Diameter, 4 1/4 in. (10.7 cm.)
A bust-length portrait of the sitter, facing right, with close-cropped hair. His full face is characterized by heavy-lidded eyes, a sharp nose, and somewhat saggy cheeks. The cardinal, whose expression is willful and determined, wears a biretta and an open cape with a meticulously rendered brocaded pattern.
Inscribed: DOMINVS MIHI ADIVTOR · QVEM TIMEBO ANN · ÆTAT · XXXVII · ("The Lord is on my side, whom shall I fear? In his thirty-seventh year.")
Nuremberg, Germanisches Nationalmuseum
Med 3871

Albrecht von Brandenburg (1490–1545) was a prebendary in Mainz in 1508, Archbishop of Magdeburg and administrator of Halberstadt in 1513, Archbishop and Elector of Mainz in 1514, and cardinal in 1518. Devoted to the precepts of Humanism, in 1523/25 he became a strong opponent of the Reformation. His motto is taken from Psalms 26 (27):1 and 117 (118):6.

It was Cahn's opinion that this very large medal, preserved in only the present copy, was intended as a casting model for a medal of less than half the size, made the same year. It has been suggested that it is either the work of Peter Flötner (by Cahn), Ludwig Krug (by Kohlhaussen), or the Master of the Group "Nuremberg 1525/26" (by Habich). The medal is distinguished by its distinctly sculptural effect — although executed in quite low relief, especially in the area of the shoulder. Its quality is without parallel in the work of this master, whose identity remains an open question. H M

EX COLLECTION: Eugen Felix, Leipzig (sale, Hess, Frankfurt am Main, 1895, no. 72).

BIBLIOGRAPHY: Cahn, 1906, pp. 161–67; Habich, 1931, vol. 1, 2, no. 922; Grotemeyer, 1957, no. 46; Kohlhaussen, 1968, no. 456.

219

219 Medal of Barbara Ketzel

Nuremberg, 1525
Cast bronze, single sided
Diameter, 1 7/8 in. (4.8 cm.)
A three-quarter bust-length portrait, in high relief, of a young woman.
Inscribed: WARBARA · GEBORNE · KECZLIN · M:D:XXV · ("Barbara, née Ketzel, 1525.").
Nuremberg, Germanisches Nationalmuseum (acquired by 1856)
Med 269

Barbara Ketzel (1505–1540) was the only child of Wolf Ketzel. The wreath of flowers and the wording of the inscription suggest that the medal was created in anticipation of her marriage. It may be that a matching bridegroom's medal was intended, but never executed, or that it exists but has not yet been identified as such. However, Barbara Ketzel died unmarried, as noted in the entry in the large death-bell register in the Sebalduskirche: "*Jungfrau* [Miss] Barbara, Wolf Ketzel's *Tochter* [daughter]" (Aign, 1961, pp. 79–80). H M

BIBLIOGRAPHY: Will, 1764–69, vol. 4, pp. 187–94; Imhoff, 1782, vol. 1, 2, p. 811, no. 19; Habich, 1931, vol. 1, 2, no. 907; Grotemeyer, 1957, no. 47; Aign, 1961, pp. 79–80, 127; Kohlhaussen, 1968, no. 455.

220 Medal of Johann Geuder

Nuremberg, 1526
a) Model of the obverse
Solnhofen stone
Diameter, 1 3/4 in. (4.5 cm.)
London, Rainer Zietz Ltd.
b) Silver
Diameter, 1 5/8 in. (4.2 cm.)
Obverse: A nude, bust-length portrait of the sitter facing left. He has short, wavy hair, and a square-cut beard.
Reverse: A trophy, composed of arms, a bow and quiver, and a sword and battle-ax, together with an escutcheon and helmet.
Inscribed (on obverse): IOANNES · GEVDER · AETATIS · SVAE · AN · XXX · ("Johann Geuder in his thirtieth year."); (on reverse): RECTE · AGENDO · NE · TIMEAS · M · D · XXVI · ("The man of just deeds need have no fear. 1526.").
Munich, Staatliche Münzsammlung

Johann Geuder (1496–1557), the oldest son of Martin Geuder (see cat. no. 227), served as senior *Bürgermeister* of Nuremberg in 1545.

The medalist, as yet unidentified, also made use of the military trophy from the reverse for a medal of Jakob Sturm (Habich, 1931, vol. 1, 2, no. 939). H M

EX COLLECTION: a) Eugen Felix, Leipzig (sale, J. M. Heberle, Cologne, 1886, no. 898, pl. following p. 166).

BIBLIOGRAPHY: Will, 1764–67, vol. 1, p. 159, no. 2; Imhoff, 1782, vol. 1, 2, p. 338, no. 3; Habich, 1931, vol. 1, 2, no. 941; Avery, in *Objects for a "Wunderkammer,"* 1981, no. 97 A.

220a

220b

218

221 Medal of Friedrich Behaim

Nuremberg, 1526

a) Model of the obverse
Solnhofen stone
Diameter, 1 9/16 in. (4 cm.)
London, Rainer Zietz Ltd.

b) Bronze
Diameter, 1 1/2 in. (3.9 cm.)
Obverse: A bust-length portrait of the sitter, facing left, with a straight-cut, curly, and full beard, his hair caught up in a net cap.
Reverse: The medal is divided by a thin, raised, horizontal line. In the upper segment is an inscription; in the lower segment, a helmet with mantling and crest, alongside the family coat of arms.
Inscribed (on obverse): FRIDERICH · PEHAIM · ALT · XXXV · IAR · ("Friedrich Behaim in his thirty-fifth year."); (on reverse): · GOT · DIE · ER · / · AVCH · SEINER · / · LER · M · D · XXVI · ("Honor to God and also to his teachings. 1526.").
Nuremberg, Germanisches Nationalmuseum
(acquired by 1856)
Med 42

Friedrich VII Behaim von Schwarzbach (1491–1533) joined the Nuremberg city council in 1518, and later served as *Bürgermeister* and as military advisor. The inscription on the reverse refers to Luther's teachings, and attests that Behaim was interested in theology — as we know from other documents.

The so-called "talking" family coat of arms is a rebus insignia: The rushing brook alludes to the surname von Schwarzbach (*Bach* = brook). On the reverse of the stone model is a Dürer monogram, added later.

There exists another example of the Nuremberg medal of Friedrich Behaim, made the same year, but it is smaller in diameter (1 3/16 inches [2.1 centimeters]) and may well have been created by a different hand (see Habich, 1931, vol. I, 2, no. 942). H M

EX COLLECTION: a) Behaim family.

BIBLIOGRAPHY: Will, 1764–67, vol. II, p. 87, no. 4; Imhoff, 1782, vol. II, p. 300, no. 3; Habich, 1931, vol. I, 2, no. 936; Avery, in *Objects for a "Wunderkammer,"* 1981, p. 190, no. 96 A.

222 Medal of Christoph Kress

Nuremberg, 1526
Cast silver
Diameter, 1 1/2 in. (3.9 cm.)
Obverse: A bust-length portrait, with only a minimum suggestion of the body. The sitter, facing right, has wavy hair.
Reverse: Recumbent armor, a helmet with mantling and crest, and an escutcheon above.
Inscribed (on obverse): CRISTOF · KRES · XXXXII · IAR · ALT · ("Christoph Kress at the age of forty-two."); (on reverse): LAS · MIRS · GEFALLEM [*sic*] · TREW · IN · ALLEN · M · D · XXVI · ("Let me stand for truth in all things. 1526.").
Nuremberg, Germanisches Nationalmuseum, Bequest of Maria Etz, 1956
Med 10589

Christoph Kress (1484–1535) was the most important negotiator for the city of Nuremberg during the debate over its adoption of the principles of the Reformation. He was educated in Milan, Antwerp, and London. In 1513, he joined the Nuremberg city council as junior *Bürgermeister,* and was immediately sent on various important missions to imperial diets and royal courts. In 1525, he served as a war councillor to the Swabian League, against the rebellious peasants; in 1530, he attended the Diet of Augsburg as an imperial councillor and emissary of Nuremberg, and was one of the signers of the Augsburg Confession. Subsequently, he became chief councillor and then military commander in Nuremberg (B. Moeller, in *Luther,* 1983, no. 189).

Matthes Gebel later paired the obverse of this medal with a different reverse, showing the new coat of arms with which Emperor Charles V invested Kress in 1530. H M

EX COLLECTION: Johann Christoph Stahl (1839–1918).

BIBLIOGRAPHY: Will, 1764–67, vol. 2, p. 159, no. 3; Imhoff, 1782, vol. I, 2, p. 466, no. 8; Habich, 1931, vol. I, 2, no. 945; Frank zu Döfering, 1936, cols. 265–303.

223 MATTHES GEBEL
Medal of Albrecht Scheurl

1527
Cast and gilded silver, with three soldered rings
Diameter, 1 9/16 in. (4 cm.)
Obverse: A profile bust. The sitter, facing right, is beardless, his hair contained in a string cap.
Reverse: An escutcheon with a helmet and elaborate mantling and crest.
Inscribed (on obverse): ALBRECHT · SCHEVERL · GE[BOREN] · IM · M · CCCC · LXXXII · IAR · AM · XXVII · NOVEMB · ("Albrecht Scheurl, born on the 27th of November in the year 1482."); (on reverse): OIIEKR [O HERR] · GOT · DVRCHRISTVM · ERBARM · DICH · VNSER · M · D · XXVII · ("O Lord God, have mercy on us through Christ. 1527.").
Nuremberg, Germanisches Nationalmuseum
(on permanent loan from the city of Nuremberg since 1866)
Med K 512

Albrecht Scheurl V (1482–1531) had a wide knowledge of silver mining. He was assayer and mint warden in Annaberg, in Saxony, and owned shares in the silver mine in Joachimsthal. From 1523, he served as a delegate to the Greater Council. Scheurl was on friendly terms with Albrecht Dürer, who became godfather to his oldest son, also named Albrecht, in 1525. Gebel may have used Dürer's woodcut, of about 1512/14, with the coat of arms of Christoph Scheurl (E. Panofsky, *Dürer,* 1948, vol. II, no. 410) as the pattern for the medal's reverse side. In 1531, while on his way from Joachimsthal to Nuremberg, Albrecht Scheurl was kidnapped and subsequently murdered by the robber baron Hans Thomas von Absberg.

When fitted with rings, the gilded medal could be worn on a chain. Scheurl most likely presented it to someone close to him. Will speaks of a gold version of this medal, weighing eight ducats, but apparently it has not survived. H M

EX COLLECTIONS: Christoph Andreas Imhoff (1734–1817); Johann Christoph Kress; the city of Nuremberg, since 1822.

BIBLIOGRAPHY: Will, 1764–67, vol. 3, p. 110, no. 1; Imhoff, 1782, vol. I, 2, p. 495, no. 5; Habich, 1931, vol. I, 2, no. 961; Mende, 1983, no. 48; Smith, 1983, p. 241, no. 145.

224 Medal of Conrad Reutter, Abbot of Kaisheim

Nuremberg, 1527
Cast silver
Diameter, 1⁹/₁₆ in. (4 cm.)
Obverse: This profile bust-length portrait shows the beardless sitter, facing right. He is dressed in a Cistercian habit, and wears a biretta.
Reverse: A coat of arms, and an abbot's staff with a sudarium. The inscription identifies the coat of arms as the abbot's, and refers to his motto, "I trust in God."
Inscribed (on obverse): CONRAD̄VS · ABBAS · M[ONASTERII] · CÆSARIENSIS · ÆTATIS · SVÆ · ANNO · L ·; (on reverse): INSIGNIA · EIVSDEM · IN · DOMINO CONFIDO · M · DXXVII ·
London, The Trustees of the Victoria and Albert Museum
A 382-1910

The Cistercian monastery of Kaisheim, or Kaisersheim, in Swabia, was founded in 1133. In 1370, Charles IV declared it solely under the emperor's jurisdiction, and soon it was among the wealthiest and most magnificent monasteries in the empire. It fell to Bavaria in 1803, and was suppressed in 1816 (Zang-Kuchenbauer, 1984).

Conrad Reutter (1477–1540) was born in Nördlingen, and, after studies in Heidelberg, became prior of the monastery, and, in 1590, abbot. "He is celebrated as an uncommonly learned man, a distinguished theologian and philosopher, and one well versed in law as well as in music and poetry" (Beierlein, 1851).

HM

BIBLIOGRAPHY: Beierlein, 1851, pp. 118–20; Habich, 1931, vol. 1, 2, no. 952; Hill and Pollard, 1978, p. 110, no. 20,10.

224

225

225 MATTHES GEBEL

Medal of Albrecht Dürer

1527
Cast lead, bronzed
Diameter, 1¹/₂ in. (3.9 cm.)
Obverse: A profile portrait bust of Dürer facing right. His smooth hair falls over his ears, and he has a full, square-cut beard.
Reverse: An escutcheon with a helmet and mantling and crest.
Inscribed (on obverse): IMAGO · ALBERTI · DVRERI · AETATIS · SVAE · LVI · ("Portrait of Albrecht Dürer in his fifty-sixth year."); (on reverse): INCLITA · VIRTVS · M · D · XXVII · ("His fame is widespread. 1527.").
Nuremberg, Germanisches Nationalmuseum
(on permanent loan from the Friedrich von Praunsche Familienstiftung)
Med 8987

In a letter of 1530 to Willibald Pirckheimer, the Tübingen Humanist, Andreas Rüttel mentions this medal of Dürer as the work of the "statuarius Mattheus" (H. Rupprich, ed., *Dürers schriftlicher Nachlass*, 1956–69, 3 vols., 3, pp. 458–59). It is the last authentic portrait of Dürer, and is thought to be an accurate depiction of him in old age. As early as 1528, it was used by Erhard Schön as the model for a woodcut portrait of Dürer, with verses by Hans Sachs, and, since then, it has been copied by a number of artists.

The reverse of the medal, with its rebus coat of arms — *Dürer-Türer-Tür* = door — alludes to a Dürer woodcut, of 1523, that Gebel was required to simplify because he reduced it in size. In addition, the medalist changed the angle of the helmet from a strict profile to a three-quarter view in higher relief, thereby attaining an effect of greater three dimensionality. He replaced the Moor in the Dürer original with a dwarf who has the same hair and beard as Dürer himself.

HM

BIBLIOGRAPHY: Will, 1764–67, vol. 1, p. 314, no. 1; Imhoff, 1782, vol. 1, 2, p. 719, no. 26; Habich, 1931, vol. 1, 2, no. 959; Bernhart, 1936, p. 31, no. 12; Strieder, in *Dürer*, 1971, no. 77; Veit, in *Dürer*, 1971, no. 6; Decker, in *Dürers Verwandlung*, 1982, no. 45; Mende, 1983, no. 32.

226 MATTHES GEBEL

Commemorative Medal of Albrecht Dürer

1528
Cast silver
Diameter, 1⁹/₁₆ in. (4 cm.)
Obverse: (see cat. no. 225).
Inscribed (on reverse, inside a laurel wreath tied with ribbons at the top and bottom): BE · MA · / OBDORMIVIT · IN · EXPO · / VI · IDVS · / APRILIS · M · D · / · XXVIII · / VI · C · VI [Beatis Manibus obdormivit in Christo VI Idus Aprilis M.D.XXVIII. Virtute Candida Vixit] ("He passed away to his blessed ancestors in Christ on 8 April 1528. His life shone forth in brilliance.").
Nuremberg, Germanisches Nationalmuseum
(on permanent loan from the city of Nuremberg since 1866)
Med K 665

To mark Dürer's death, the obverse of the 1527 portrait medal was combined with a new reverse side. Since the painter died shortly before his fifty-seventh birthday, his age as given on the obverse of the 1527 medal was still accurate in 1528. It is traditionally agreed that Dürer's death occurred on April 6; April 8, as given here, was apparently the date of his funeral.

The style of the inscription on the reverse suggests that it was composed by someone with a humanistic education. It was most likely provided by Willibald Pirckheimer, who also wrote an elegy on the death of his friend Albrecht Dürer, "the greater part of my soul." HM

EX COLLECTIONS: Christoph Andreas Imhoff (1734–1817); Johann Christoph Kress; the city of Nuremberg, since 1822.

BIBLIOGRAPHY: Will, 1764–67, vol. 1, p. 315, no. 4; Imhoff, 1782, vol. 1, 2, p. 722, no. 13; Habich, 1931, vol. 1, 2, no. 968; Bernhart, 1936, p. 31, no. 12, 2; Veit, in *Dürer*, 1971, no. 62; Decker, in *Dürers Verwandlung*, 1982, no. 46; Mende, 1983, pp. 86–87, no. 215.

226

227a

227b

228

227 MATTHES GEBEL

Medal of Martin Geuder

1528

a) Model of the reverse
Solnhofen stone
Diameter, 1 1/2 in. (3.8 cm.)
The Cleveland Museum of Art, Purchase from the
John L. Severance Fund
56.26 R

b) Cast bronze
Diameter, 1 7/16 in. (3.6 cm.)
Obverse: A nude bust-length profile portrait, the
sitter facing right, with long, wavy hair and a long,
rounded beard.
Reverse: A shield, to the right of which is an
escutcheon and a helmet with mantling and crest
enclosed within a laurel wreath.
Inscribed (on obverse): MARTINVS · GEVDER
AETATIS · SVAE · LXXIII · ("Martin Geuder at the age
of seventy-three."); (on reverse): SOLA VIRTVS /
· MDXXVIII · ("Virtue is all that matters / · 1528 · ").
Nuremberg, Germanisches Nationalmuseum
(on permanent loan from the Friedrich von
Praunsche Familienstiftung)
Med 9061

Martin III Geuder von Heroldsberg (1455–
1532) came from an old, established Nuremberg
family, whose members served on the city
council. He joined the council in 1483, serving
as junior *Bürgermeister* in 1488 and as elder
Bürgermeister in 1499. In 1509, he was named
Älterer Herr (senior councillor), and, in 1532,
attained the highest civic office, that of first
treasurer. His second wife was Juliana Pirck-
heimer, sister of Willibald Pirckheimer (for the
medals with Geuder's sons, see cat. nos. 220,
232). There is an identical medal of Martin
Geuder, also dating from 1528, but it is some-
what smaller — only 1 3/16 inches (3 centimeters)
in diameter (see Habich, 1931, vol. I, 2, no. 974).

HM

BIBLIOGRAPHY: Will, 1764–67, vol. I, p. 160, no. 11;
Imhoff, 1782, vol. I, 2, p. 336, no. 1; *Kunstsammlungen
Friedrichshof*, 1896, pl. following p. 20; Habich, 1931, vol.
I, 2, no. 973; Smith, 1983, p. 241, no. 146.

228 MATTHES GEBEL

Medal of Georg Hermann

1529
Cast silver
Diameter, 1 1/2 in. (3.9 cm.)
Obverse: A bust-length portrait. The hair of the
sitter, who faces right, is contained in a string cap.
The thick beard is cut straight across, just below
the chin.
Reverse: The field of the medal is divided into
three horizontal sections: At the top is a candle-
stick with a lit candle on a shallow ledge with the
date MD XX'X beside it; in the center section is a
two-line inscription; below are an escutcheon, and
a helmet and shield. A laurel wreath secured by a
ribbon frames the picture.
Inscribed (on obverse): GEORGIVS · HERMAN
ÆTATIS SVÆ · AN · XXXVIII · ("Georg Hermann in his
thirty-eighth year."); (on reverse): FVNGENDO /
CONSVMOR ("I consume myself in my work").
Nuremberg, Germanisches Nationalmuseum
(acquired, 1941)
Med 7791

(For further information about Georg Hermann
[1491–1552], see cat. no. 229.) Matthes Gebel
used the same model for two medals: The ob-
verse of the present one appears in combination
with three different reverse designs, one of
which, inscribed VSV CONSVMOR, is only a minor
variation of that described here.

There is another medal of Georg Hermann,
from 1529, likewise by Matthes Gebel, that
shows Hermann without any head covering and
with his straight hair covering his ears and curl-
ing slightly at the ends (Habich, 1931, vol. I, 2,
no. 1000). In the correspondence between
Georg Hermann, and Castulus Fugger and Jörg
Hofmann — the representatives of the Fugger
family in Nuremberg — regarding these two
medals, there is a discussion of the question of
the coat of arms, as well as of the emblems and
inscriptions. An accounting also survives, which
records that Gebel received sixteen-and-one-
third guilders (Hampe, 1918/19, pp. 36–38).
From this considerable sum we can conclude
that Gebel was paid not only for the preparation
of the stone model but for the casts, as well. In
Die deutschen Schaumünzen des XVI. Jahr-

hunderts, Habich includes more medals of
Georg Hermann than of any other sixteenth-
century citizen.
HM

BIBLIOGRAPHY: Hampe, 1918/19, pp. 9–41; Habich,
1931, vol. I, 2, no. 1001; Bernhart, 1936, p. 17; Theuer-
kauff, in *Der Mensch am 1500 . . .* , 1977, pp. 97–99.

229 MATTHES GEBEL

Medal of Heinrich Ribisch, Georg Hermann, and Konrad Maier

1531
Cast silver
Diameter, 1 1/2 in. (3.9 cm.)
Obverse: Three profile heads, one behind the
other, with the busts only minimally indicated.
Ribisch, in the foreground, is the oldest of the
three. He has short, wavy hair, and a beard that is
full at the sides and closely trimmed below the
chin. Gebel based the portrait of Hermann, in the
middle, on the same model that he used for his
1529 medal (see cat. no. 228). Maier, only a trifle
younger than Hermann, has a round face and is
beardless; his striking features include a straight
nose, thicker at the end, and a fleshy, slightly pen-
dulous lower lip. His long, straight hair is worn in
bangs across the forehead.
Reverse: Oval coats of arms of the three men, side
by side, just barely overlap each other, and narrow
to a point at the bottom. The helmets, with man-
tling and crests, are not viewed from the front, as
was customary, but from the side. Thus, to a cer-
tain extent, they repeat the motif of the profile
heads on the obverse, making it clear to whom the
coats of arms belong.
Inscribed (on obverse): HEN · RIBISCH · DOCTOR ·
GEOR · HERMAN · CVNRA · MAIR · ; (on reverse):
QVAM · IVCVNDVM · HABITARE · FRATRES · IN· VNVM
M · D · XXXI · ("How pleasant it is for brethren to
dwell together in unity. 1531." [Psalm 132
(133):1]).
Clifton, New Jersey, Collection of Professor and
Mrs. Stephen K. Scher

The three men were all employed in the Fugger
trading company. Heinrich Ribisch (about

421

1485–1544) was a lawyer, and served as the Fuggers' legal representative in Breslau from 1520 to 1531. He later was chief tax collector for King Ferdinand I in the duchy of Silesia and the margravate of Lausatia.

Georg Hermann (1491–1552), born in Kaufbeuren, studied in Tübingen before embarking on extensive travels. Through his marriage to Barbara Rehling, he became a brother-in-law of Anton Fugger, and immediately went to work at the Fugger company. First he was sent to Antwerp, and later to Schwaz, in the Tyrol, where the Fuggers owned rich silver mines. Hermann not only had close ties to the Humanists and artists of Augsburg, but also corresponded with the leading theologians of his time—notably, Erasmus of Rotterdam and Philipp Melanchthon.

Konrad Maier (about 1493–1565), a brother-in-law of Georg Hermann, was also employed in the Tyrol—namely, in Hall, where the Fuggers operated the main countinghouse of the Tyrolese "Mining and Smelting Company." After a brief stay in Antwerp, he transferred in 1536 to the home office in Augsburg, and, in 1538, was accepted into the city's patrician class. He subsequently held a number of important civic offices.

The three heads vary considerably in size. If Gebel had followed the rules of perspective, he would have placed the smallest head farthest away and the largest in the foreground, but he put the smallest one in the front. He thereby avoided having the front head obscure the ones in back. Another reason for the unequal size of the heads—and one overlooked up to now—is the fact that Gebel previously had created separate portrait medals of each of the three sitters, and apparently made use of his existing models here, although they were of different dimensions.

This is the only Renaissance medal to depict three business partners and—as the inscription attests—fraternal friends. Accordingly, the present work may be regarded as the very earliest friendship medal. H M

BIBLIOGRAPHY: Hampe, 1918/19, pp. 9–41; Habich, 1931, vol. I, 2, no. 1061; Theuerkauff, in *Der Mensch um 1500* . . . , 1977, pp. 93–96.

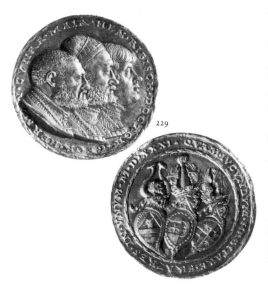

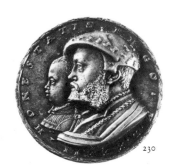

230 MATTHES GEBEL

Medal of Johann Fernberger and His Son Ulrich

1532
Cast bronze
Diameter, 1 1/2 in. (3.9 cm.)
Obverse: Profile portraits of Johann and Ulrich Fernberger, the son behind and in slightly lower relief than the father. The latter sports an imposing, square-cut, curly beard, which stands out in high relief. A fashionable cap with ornamental stitching accentuates the roundness of his head. The small, seven-year-old boy is bareheaded, and has short hair.
Reverse: An eleven-line inscription.
Inscribed (on obverse): HONESTATIS · ERGO · M.DXXXII · ("For honor's sake. 1532."); (on reverse):

> D · FERD · I ·
> ROMANORVM ·
> HVNG · BOIEM · Q · RE=
> GIS · A · CONS · SECRETAR ·
> PRIMAR · VICEDOMINVS ·
> AVSTR · VLS · ANASVM · IOAN
> FERENBERGER · AB · EGEN=
> BERG · PATER · NATVS ·
> ANN · XXXVIII ·
> VLRICH · EIL · SEP=
> TVFNN=

[Domini Ferdinandi I Romanorum, Hungariae Bohemiaeque Regis Archiconsiliarius Secretarius Primarius Vicedominus Austriae Ulterioris Anasum Johannes Ferenberger ab Egenberg Pater natus Annos XXXVIII. Ulrich filius septem Annos]. The last two lines are not altogether clear. Habich read them as VLRICH · FIL · SE · B(?)TYFNN ·, but it would appear that he studied a poorly preserved copy of the medal.
Nuremberg, Germanisches Nationalmuseum (acquired, 1963)
Med 8371

Johann Fernberger, born—according to the inscription on the medal—in 1494, was the fifth son of Ulrich Fernberger. The Fernbergers were an old Tyrolese family; a castle named "Vern mons" is mentioned in 1223 (*Regesta Boica*, vol. III, p. 202). In 1521, Johann moved to Upper Austria, where he became councillor and first secretary to King Ferdinand I. In 1532—the year that the medal was made—he took over the office of *Vicedominus*, and, in 1535, became

hereditary chamberlain of Enns, in Upper Austria. In 1531, he acquired the estate of Egenberg, and subsequently added its name to his own. He died in 1554, in Linz, leaving a number of descendants, the oldest being his son Ulrich, who succeeded him as chamberlain. From the medal we know that Ulrich was born in 1525; he died in 1573 (Wissgrill, 1797, pp. 31–36).

It is likely that Matthes Gebel came into contact with Johann Fernberger in Augsburg, where the latter took part in the Imperial Diet of 1530 as King Ferdinand's representative. Gebel went to Augsburg with the express purpose of acquiring commissions for medals. It is not known why Fernberger had himself portrayed with his son Ulrich, but this is the earliest child's portrait on a German medal.

The stone model for the obverse of the medal survives in Berlin; it was formerly in the Figdor collection, Vienna. H M

BIBLIOGRAPHY: Habich, 1931, vol. I, 2, no. 1076; Suhle, 1950, p. 60; Grotemeyer, 1957, no. 42.

231 MATTHES GEBEL

Funerary Medal of Georg Ploed

1532
Cast bronze
Diameter, 1 1/2 in. (3.8 cm.)
Obverse: A nude, bust-length portrait of Ploed, in the antique manner, facing left. His head is long and narrow, his face gaunt, his nose sharply chiseled. His trimmed beard ends in a point beneath his chin, and his straight hair falls in gentle waves to his ears.
Reverse: An allegory of death. A naked youth is seated on a stone, holding a large bone in his right hand and pointing with his left to a three-line inscription. A winged putto sits on the ground in front of the youth, gazing up at him, his right hand resting on a skull, and his left holding a bunch of flames. Beneath him is the date MDXXXII ·.
Inscribed (on obverse): GEORGIVS · PLOED · ÆTAIS[sic] · SVE ANNO · XXXVI [The E in Ploed is within the O]; (on reverse, around the edge): MISERERE · MEI · DEVS · SECVNDM · MANNAM [MAGNAM] · MISERICVRDIAM[sic] · TVAM · ("Have mercy upon me, O God, according to thy lovingkindness." [Psalm 50 (51): 3]).
Nuremberg, Germanisches Nationalmuseum (acquired by 1856)
Med 53

The medal relates that Georg Ploed, born in 1496, died at the age of thirty-six in 1532. The only other definite information regarding Ploed was an inscription—no longer surviving—on a tombstone in the Johannisfriedhof, Nuremberg (Zahn, 1972, p. 88): "Brigitha Plödin und Söhn. 1534./Was sterblich is am Erbarn Georgen Plöden ward hier begraben. 1532" ("Brigitha Ploed and son. 1534. / The mortal remains of the honorable Georg Ploed were buried here. 1532").

In Gebel's vast oeuvre, multifigured designs on the reverses of his medals are the exception; instead, he generally included only a subject's coat of arms. Habich remarked that the reverse of the Ploed medal was patterned after Italian examples. The reverse of a 1458 medal by the Venetian Giovanni Boldù presents a similar scene, except that the naked youth buries his face in his hands in a gesture of grief (*Kress Collection*, 1967, nos. 142, 143).

The motif of a sorrowing putto with a skull, which occurs widely in later Renaissance art, was thought by Janson to have been invented by Boldù. The flames in the hand of the putto symbolize the soul. According to Janson (1937, p. 440), the putto is the spirit of death "all'antica," who accompanies the soul into heaven; in the Christian sense, he is, of course, an angel. Boldù's highly sculptural, tightly compressed grouping virtually fills the circular field of the medal. On Gebel's work, however, the two figures are farther apart, creating a horizontal accent that contrasts with the medal's circular shape. The inscription only strengthens the horizontal orientation. H M

BIBLIOGRAPHY: Imhoff, 1782, vol. I, 2, p. 867, no. 22; Habich, 1931, vol. I, 2, no. 1082.

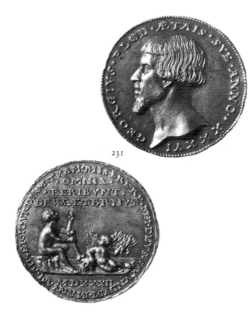

231

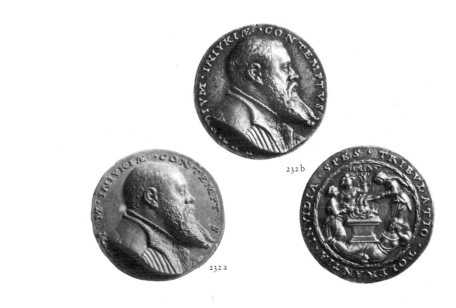

232b

232a

232 MATTHES GEBEL
Medal of a Son of Martin Geuder
1535/40

a) Model for the obverse
Solnhofen stone
Diameter, 1 7/16 in. (3.6 cm.)
The Cleveland Museum of Art, Purchase from the John L. Severance Fund
56.25

b) Cast silver
Diameter, 1 7/16 in. (3.6 cm.)
Obverse: A bust-length portrait. The sitter, facing right, has close-cropped hair and a beard, the ends of which are carefully twisted into points. The figure's chest and beard extend to the medal's edge, so that the inscription does not completely encircle the portrait.
Reverse: An allegory with four female figures, each identified by her Latin name. With a hammer, TRIBVLATIO (Affliction) forges a red-hot heart that INVIDIA (Envy) and SPES (Hope) hold in the flames of a fire, atop an altar, with a long pair of tongs. SPES extends her left hand toward the sky, begging for rain to extinguish the fire. The altar rests on top of the recumbent TOLERANTIA (Tolerance).
Inscribed (on obverse): REMEDIVM · INIVKIÆ[*sic*]. CONTEMPTVS ("Contempt is a remedy for injustice").
Nuremberg, Germanisches Nationalmuseum (acquired, 1975)
Med 9449

Another medal is known, also with an unidentified portrait on the obverse, but its reverse — although it has no inscription — shows the Geuder coat of arms within a wreath. These arms thus make it clear that the subject on the obverse of the medal discussed here is a member of the Geuder family.

The allegory on the reverse of the present example is based on a Dürer drawing in the British Museum, London, in which the Pirckheimer coat of arms occurs on an altar. It is presumed that the allegory was the invention of Willibald Pirckheimer. In the Dürer drawing, instead of the name Tribulatio we find Afflictio, and, instead of Spes, the designation Consolatio. Dürer's drawing was engraved — with

the names of the female figures altered — by the Nuremberg Master I.B. in 1529, and it was this engraving that served as a pattern for Matthes Gebel. A single-leaf woodcut, from about 1600, the "Neydharts Werckstadt," takes up the motif once again. It praises the "tolerantia" of those "who sorrow in innocent hearts despite the claims of justice." The inscription on the obverse of the medal expresses a similar sentiment.

The decision of one of the Geuder family to adopt the Pirckheimer allegory for the reverse of his medal perhaps was based on some kind of familial tie — and, in fact, the second wife of Martin Geuder (died 1532) was Willibald Pirckheimer's sister Juliana. Martin's portrait, known from other medals, is nothing like the one on the medal in question. Perhaps one of Martin's four sons — Johann (born 1496), Sebald (born 1498), Georg (born 1500), or Martin IV (died 1541) (Biedermann, 1748, pl. L; Kurras, in *Caritas Pirckheimer*, 1982, no. 31) — adopted his uncle's (Pirckheimer's) idea for the reverse of his own medal. H M

EX COLLECTIONS: a) Empress Friedrich; Dr. E. Delmar, Budapest.

BIBLIOGRAPHY: Will, 1764–67, vol. I, p. 160, no. 10; Imhoff, 1782, vol. I, 2, p. 339, no. 8; *Kunstsammlungen Friedrichshof*, 1896, p. 19, pl. following p. 20; Habich, 1931, vol. I, 2, nos. 1256, 1257; Suhle, 1950, p. 59; Kurras, in *Caritas Pirckheimer*, 1982, no. 31; Smith, 1983, p. 241, no. 147.

Saint Wenceslas

About 1530
Linden wood, with a dark brown painted finish
Height (excluding lance), 44 11/16 in. (113.5 cm.)
There is a vertical split through the breastplate, neck, and head.
Nuremberg, Germanisches Nationalmuseum (on loan from the city of Nuremberg since 1875)
Pl 0.216

The bearded Saint Wenceslas (Wenzel), wearing fluted armor of the Maximilian type (see cat. no. 267), stands with his weight on his right leg. He holds a lance with a banner, and a round shield, and wears a bulbous hat *(Herzoghut).* His shoes, with their wide fronts, are called "Kuhmaulschuhe," and his mantle, which hangs from both shoulders, is tied with a cord across the chest. Extra gathered folds fall from the left shoulder. The sculpture apparently was fashioned from a solid piece of linden wood, which may explain the vertical crack. Both the shield — embossed with the capital letters *S* over *P* and *R* — and the lance are carved from separate pieces of wood.

The present work was the model for the cast brass sculpture of Saint Wenceslas, of 1534, which is the centerpiece of the large brass *Wenzelsleuchter* (the candle base of Saint Wenceslas), in the Cathedral of Saint Veit, Prague; it was commissioned in 1532 by the Brewers' and Maltmen's Guild of the old city of Prague, in memory of the Hussite Wars of 1419–36. The capital letters on the shield probably stand for "Senatus Pragensis" (Senate of Prague). Wenceslas, a duke of Bohemia who was murdered in 929 or 935, is one of Bohemia's patron saints.

The flag, lance, and shield are of a different form in the final sculpture. The casting may have been one of the last works of the Vischer shop that followed shortly after the death of Peter the Elder in 1529. The baldachin, columns, and putti may be by the youngest son of Peter the Elder, Hans, because of their similarities to the baldachin of the *Sebaldus Tomb* (see cat. no. 190; fig. 135).

The creator of the model is unknown. In proportion, contrapposto stance, and modeling, this figure is so similar to the linden-wood model for the *Geeseman Fountain Figure* (in the Stadtmuseum Fembohaus, Nuremberg) that the same carver may have been responsible for both (see cat no. 234). The model for the *Geeseman* recently has been attributed to Hans Peisser (about 1505– about 1575), a Nuremberg stone and wood sculptor. WDW

BIBLIOGRAPHY: von Rettberg, 1854, p. 159; Essenwein, 1873, col. 302 (first mention that the Nuremberg figure was the model for the brass *Saint Wenceslas* in Prague); Lübke, 1880, p. 765; Frimmel, 1884, 19, pp. 221, 222, 223, fig. 6; Lind, 1885, n.s. II, pp. 59–61; Daum, 1905, p. 54; Josephi, 1910, pp. 291, 292, no. 479, ill. (detailed earlier literature); Meller, 1925, p. 210; Kletzel, 1931/32, 28, p. 296; Pechstein, in *Germanisches Nationalmuseum...,* 1985, p. 91, no. 206, ill.

233

234 HANS PEISSER (?) (model)
PANKRAZ LABENWOLF (cast)
Geeseman Fountain Figure
About 1540
Brass, hollow cast, after a wood model, with a
weathered green and gray patina
Height, about 27 3/16 in. (69 cm.)
The beaks of the geese are 19th-century
restorations.
Nuremberg, Obstmarkt, behind the Frauenkirche

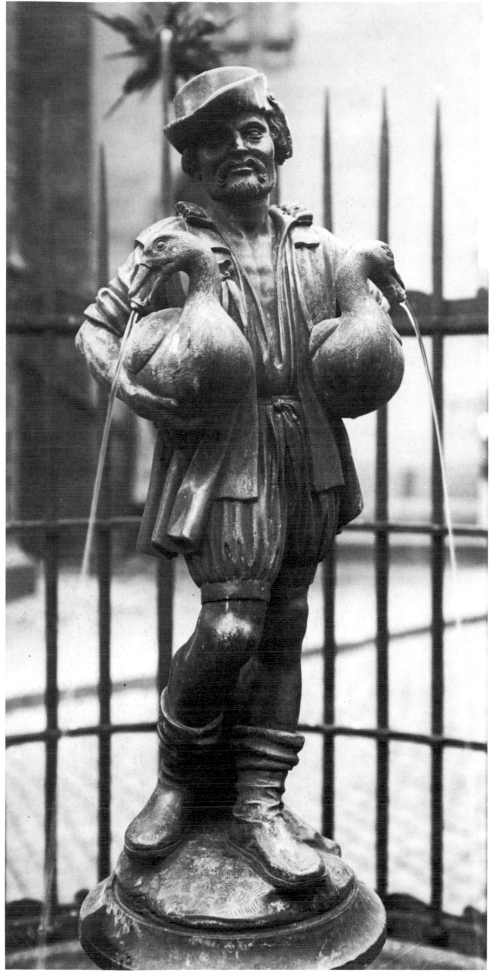

234

The large goose that this husky man holds in
each arm gained him the modern appellation of
the Geeseman. He stands in a contrapposto
pose, on an irregularly surfaced round base, his
weight borne by his left leg, his right leg flexed.
He is dressed in a pleated, open V-necked shirt,
with rolled-up sleeves; an open vest; a short,
sleeveless coat, with an elegantly ruffled collar;
and heavy boots with loose tops. His hat has a
wide brim that is tied up on one side with a
ribbon, and his hair is neatly cut and bobbed.
The beaks of the geese serve as spouts for water.

The sculpture is modeled in the round, so that
the details on the back are rendered with the
same care as those on the front. A forked tree,
which has been cropped, appears also at the
back. A heavy strap with bolts secures the trunk
and the base to the column base below. Two
additional spouts extend outward from opposite
sides of this column.

The fountain itself, frequently cited since the
early nineteenth century, was described by
Ernst F. Bange as the best-known German
Renaissance bronze — although the material
can now be more accurately described as brass
(J. Riederer, "Die Zusammensetzung deutscher
Renaissancestatuetten aus Kupferlegierungen,"
*Festschrift des deutschen Vereins für Kunst-
wissenschaft,* 1982, vol. 36, p. 44). The linden-
wood model for the fountain figure is preserved
in the Stadtmuseum Fembohaus, Nuremberg.

This work cannot represent what Gert von
der Osten and Horst Vey refer to as one of the
"common people." The ruffled collar, fashion-
able hat, and otherwise well-ordered garments
suggest that the man is well to do. The figure is
too stylish to be allied to the rustic, low-life
subjects of two well-known satirical drawings
for fountains — the drawing, of about 1500,
attributed to Hans Frey, Dürer's father-in-law,
of a standing bagpiper with unruly hair and
shabby, disintegrating shoes, and Dürer's draw-
ing, of about 1500, of an unkempt, seated older
man, holding a goose (E. Boch, *Die Zeich-
nungen in der Universitätsbibliothek Erlangen,*
Frankfurt am Main, 1929, 2 vols., text vol. pp.
45–46, no. 145, pl. vol. no. 145; F. Winkler,
Die Zeichnungen Albrecht Dürers, Berlin,
1936–39, 4 vols., vol. 1, no. 236; H. R.
Weihrauch, *Europäische Bronzestatuetten,
15.–18. Jahrhundert,* Braunschweig, 1967, pp.
266, 267, 270, figs. 316, 320). If only the circum-
stances of the commission were known, we
might have a better idea of the true meaning of
this fountain sculpture.

The most important stylistic qualities of the sculpture include the contrapposto stance of the figure, his sturdiness, and the clarity of representation of the costume. The most immediate source of the first two elements may be the Italianate engravings, of about 1528, depicting the gods of the planets, by a Nuremberg engraver who signed his name I.B. A combination of the contrapposto pose and the figural sturdiness is also apparent in several of the figures on the *Fountain of the Planet Gods*, in Linz, by Hans Peisser (about 1505– about 1575), a Nuremberg stone and wood sculptor. Unlike the *Geeseman*, but like the figures in the prints, all of the male figures on this fountain sport classicizing armor. Yet, the careful observation of the details, and the type of contemporary costume seen in the present sculpture are in line with those aspects of such earlier works as the *Kneeling Man*, of 1490; the *Saint Mauritius*, the model for which dates to about 1495; and the model for the *Saint Wenceslas*, of about 1530 (see cat. nos. 97, 183, 233).

Klaus Pechstein has attributed the wood model for the *Geeseman* to Hans Peisser. Although Peisser became a Nuremberg citizen in 1526, he renounced this citizenship in 1559, and by 1562 he was working in Prague. Pechstein also credits him with providing the wood model for the *Putto Fountain*, of about 1555, in the large courtyard of the Rathaus; the models and the final figures for the *Fountain of the Planet Gods*, in Linz; the market fountain, of about 1560, in Friesach (Kärnten), Austria; and the *Singing Fountain*, of about 1562–71, in the garden parterre of the Belvedere, in Prague. The model for the *Saint Wenceslas* (cat. no. 233), which dates from about 1530, may be attributed to the same carver who made the model for the *Geeseman* — Hans Peisser — on the basis of the similarity in figure proportions, contrapposto, modeling, scale, and material (linden wood).

Documentation of the date of the *Geeseman* model, as well as of the commission for the cast, is lacking. If the attribution is correct, the frame of reference must take into account the dates of Peisser's Nuremberg citizenship (from 1526 to 1559), the 1528 date of the engravings by the Master I. B., and the dates assigned to Peisser's other works. However, the comparison with the *Saint Wenceslas* model is most compelling, and this similarity would suggest an early date in the artist's career, perhaps about 1540, for the present work.

The casting of the *Geeseman* traditionally has been ascribed to Pankraz Labenwolf, who trained in the Vischer family workshop before establishing his own workshop in 1523, and his own foundry in 1537.

WDW

BIBLIOGRAPHY: Josephi, 1910, pp. 292–94, no. 480 (detailed earlier literature); Meller, 1926, pp. 31, 47, fig. 42; Bange, 1949, pp. 102, 146, fig. 171; Weihrauch, 1967, p. 319; von der Osten and Vey, 1969, p. 284, pl. 253; Stafski, 1971, p. 233; Pechstein, 1973, pp. 89–92, 94, fig. 7; Riederer, 1982, 36, p. 44; Smith, 1983, pp. 63, 248, 304.

235

235 HANS PEISSER (?) (model)
PANKRAZ LABENWOLF (cast)

Statuette of a Swordsman

About 1550
Brass, solid cast, after a wood model, with worn lacquer patina
Height, 8 3/4 in. (22.3 cm.)
The sword blade is missing.
Nuremberg, Germanisches Nationalmuseum
Pl 0.2851

This little-known sculpture depicts a striding nude youth whose arms are spread in the action of swordplay: His right arm is bent back in preparation for a thrust with his sword, of which only the hilt is preserved; his left arm is fully extended, and in his hand he holds a small shield. Heavy lidded and moustached, he tips his head slightly backward. His hair is arranged in multiple short ringlets. His feet, wide apart, rest on the edges of an oval, molded base.

This figure was probably one of several intended for a fountain: A statuette of a Turkish archer (8 7/8 inches high), in the Bayerisches Nationalmuseum, Munich (H. R. Weihrauch, *Die Bildwerke in Bronze und in anderen Metallen, Bayerisches Nationalmuseum München, Kataloge*, vol. XIII, 5, Munich, 1956, pp. 28, 29, no. 34, ill.), is so closely related in style and scale that it may have been part of the same fountain group. Dürer's sketch, of about 1500, for a table fountain (cat. no. 113), and the drawing and engraving of the Neptune fountain for the castle in Kronberg, Denmark, illustrate the type of composite fountain design favored by Nuremberg artists (L. O. Larsson, "Bemerkungen zur Bildhauerkunst am Dänischen Hofe im 16. und 17. Jahrhundert," *Münchner Jahr-*

236

archer. This statuette in Munich has been attributed to the Master of the Geeseman, now identified as Hans Peisser (cat. no. 234). If both statuettes come from the same ensemble, the present example undoubtedly was also made by Peisser. Both were probably cast by Pankraz Labenwolf.　　　　　　　　　WDW

EX COLLECTION: [Valentin Mayring, Hollfeld bei Bayreuth, 1947].

BIBLIOGRAPHY: Pechstein, in *Germanisches Nationalmuseum* . . . , 1985, p. 95, no. 218.

236　Seated Hercules

Nuremberg, about 1535
Brass, hollow cast, after a wax model, with a dark brown patina and a later, transparent greenish patina
Height, 9 in. (22.9 cm.)
New York, The Metropolitan Museum of Art,
Gift of Irwin Untermyer, 1964
64.101.1546

The nude and bearded Hercules is seated on a tree stump over which is draped a lion's pelt. The head of the lion in low relief may be seen on the back of the stump. Hercules turns his head to his left while raising his left arm in front of his chest, fist clenched, as if to protect himself. His right arm and hand are bent at his side; the clenched fist probably once held a club. Only the left leg and foot are extended.

A technical report (R. E. Stone, Department of Objects Conservation, The Metropolitan Museum of Art, June 10, 1985) has established through radiographs that this statuette was cast indirectly from a wax shell inter-model in a technique reminiscent of that used in Mantua by Pier Jacopo Alari-Bonacolsi, called Antico (about 1460–1528) (R. E. Stone, 1982, vol. 16, pp. 87–116). The brass alloy is consistent with the productions of Nuremberg brass workshops. Presumably, the artist, who had learned the Mantuan casting method, made this Hercules "at home," in a Nuremberg foundry.

Unlike Antico's statuettes, the present work met with several difficulties during the casting process. A large casting flaw is hidden under the beard. There are two irregular holes, one just above the left ear and the other, below, in the neck area; a hole in the side of the stump below the right buttock; and four holes in the base of the trunk, one of which is a casting flaw (the others were drilled for attachment purposes). The surfaces were extensively worked through filing and burnishing. The hair and beard were sharpened with a tool.

The *Hercules* may have been made for a humanistic setting, such as a Nuremberg scholar's study, emulating North Italian taste.

Another version of this figure was published as a work, of about 1505, by Peter Vischer the Elder (N. Pevsner, "A Bronze Statuette by Peter Vischer the Elder," *The Burlington Magazine*, 1942, vol. 80, pp. 90–93, figs. A, B; London, Sotheby and Co. [sale cat.], October 14, 1960, no. 29, ill. Two measurements are re-

buch der bildenden Kunst, 1975, vol. 26, pp. 178, 179, figs. 1, 2).

Our statuette depends ultimately on parallel subjects in ancient art, particularly, Hellenistic and Roman warriors performing various animated acts. The motif of a striding athletic male nude with his raised arms outstretched may distantly reflect the colossal Roman sculpture groups, of about 330 A.D., of the *Dioscuri* (or *Horse Tamers*) located, and visible, throughout the Middle Ages on the Quirinal hill in Rome known as the Monte Cavallo. These gigantic sculptures, over three times life size, were replicated in drawings, in the fifteenth and sixteenth centuries, by Pisanello, by the studio of Filippo Lippi, and by Maarten van Heemskerck (W. S. Sheard, *Antiquity in the Renaissance* [exhib. cat.], Northampton, Massachusetts, Smith College Museum of Art, 1978, nos. 47, 48). The

themes of these large sculptures or of other ancient figures engaged in dramatic action may have been conveyed to Nuremberg artists via Italian Renaissance medals such as that of the Diva Julia, by Pier Jacopo Alari-Bonacolsi, called Antico (about 1460–1528), who was active in Mantua. On the reverse of the undated Diva Julia medal is a battle scene of cavalry and nude soldiers, the central figure of which may be related to the present statuette (W. D. Wixom, *Renaissance Bronzes from Ohio Collections* [exhib. cat.], The Cleveland Museum of Art, 1975, no. 60, ill.).

The statuette is fully Renaissance in its allusions to ancient art; in its easy, twisting movement; and in its proportions. The style of the head, the character of the movement, and the molded oval base are related to these features in the above-mentioned statuette of a Turkish

Jug

1545–50
Lead-glazed earthenware
Height, 14 in. (35.5 cm.)
New York, The Metropolitan Museum of Art,
Gift of R. Thornton Wilson, in memory of
Florence Ellsworth Wilson, 1950
50.211.202

Among the finer large-scale jugs attributed to
the Preuning Workshop are those whose necks
are surrounded by miniature buildings and
walls, occasionally populated with figures. The
inset niche in the center section of the present
jug, with its freestanding figures, is an unusual
feature; applied, intaglio relief was the normal
means of surface decoration for such vessels.
The significance of the fighting figures, trum-
peting man, and two putti in the central scene is
unclear; this scene is flanked by three half-
draped women, one holding a sword and flail,
another, a cross and chalice, and a third, a ham-
mer and a column. It has been noted (Walcher
von Molthein, 1905, vol. VIII, p. 140) that the
buildings surmounting this vessel are reminis-
cent of the cells of the Carthusians, the most
conservative order in Nuremberg. The central
scene, then, may be an oblique reference to the
Carthusians' staunch resistance to Protestant re-
form. In 1524, the Carthusian brothers removed
their prior, Blasius Stöckl, accusing him of her-
esy; Stöckl reacted by demanding a debate. The
Nuremberg council, as protectors of the monas-
tery, entered the fracas and seized the oppor-
tunity to stage a public theological disputation
involving representatives of all the monastic or-
ders. This event, held in the Rathaus during
March 1525, heralded the imminent triumph of
Lutheranism and the dissolution of the monas-
teries. The oak leaves that decorate the surface
of the vessel were the badge worn by the peas-
ants during the religious uprisings, but they
were also a symbol of fidelity to the emperor —
a stance doggedly held by the Nuremberg coun-
cil in spite of increasing pressure from the Prot-
estant princes. While the specific meaning of the
imagery is unclear, an allusion to the religious
and political turmoil during the second quarter
of the sixteenth century seems to have been in-
tended. TH

Ex COLLECTIONS: Nathaniel de Rothschild, Paris; [Rosen-
berg & Stiebel, Inc., New York]; R. Thornton Wilson,
New York.

BIBLIOGRAPHY: Walcher von Molthein, 1905, VIII, p. 140,
ill. p. 142; Hannover, 1925, I, pp. 191–94; Hayward and
Husband et al., 1975, no. 272; *Metropolitan Museum . . .
Guide*, New York, 1983, p. 229, no. 65.

243 PREUNING WORKSHOP

Jug

1557–58
Lead-glazed earthenware
Height, 20¹¹/₁₆ in. (52.5 cm.)
Arms: of the Imhoff family.
New York, The Metropolitan Museum of Art,
Gift of R. Thornton Wilson, in memory of
Florence Ellsworth Wilson, 1954
54.147.50

The upper three zones of this jug are decorated with applied intaglio profile portraits: In the smallest of these, portraits of females alternate with those of males; in the central zone of the three, the larger busts have been identified as portraits of Charles v and of Johann Friedrich the Magnanimous, Elector of Saxony. The matrix for the bust of Johann Friedrich was published in 1905 (A. Walcher von Moltheim, "Arbeiten der Nürnberger Hafner-Familie Preuning," *Kunst und Kunsthandwerk*, vol. 8, p. 135). In the same zone as the portrait busts is a circular heraldic device with a lion rampant on a large shield, with a paw, or fleur-de-lis, and a crenellated band on the smaller flanking shields. These are all charges found in the arms of the Imhoff family of Bavaria and Switzerland. The devices are executed in oil paint and are not glazed; it is uncertain whether they are original, and when they were applied.

In the center of the lowest zone, Adam and Eve are separated by an apple tree, in front of which are a serpent and a lion. On one side of this scene is a drummer and, on the other, a Landsknecht playing the pipes; between these two figures, on the opposite side, is a pair of lovers. Walcher von Moltheim (1927, I, pp. 115–16) associates the drummer and the piper on this jug with another jug made by the Preuning Workshop, "mit ain crucifix und daneben ain trummelschlager und pfeyffer gemacht," which came to the attention of the Nuremberg city authorities in 1558. Following the battle at Mühlberg and the imprisonment of John Frederick of Saxony by the Holy Roman Emperor Charles v, Protestantism experienced a severe setback. The flanking of a crucifix by mercenary musicians was considered intolerable by the town fathers, who were gripped anew by the spirit of Catholic fervor. As a result, Paul and a certain Kunz Preuning were jailed briefly and the workshop was prohibited from employing this decorative arrangement in the future. The absence of the usual sword and elector's chain in the portrait of John Frederick suggests that the image was made during his imprisonment by the emperor. These observations, along with the apparent reliance on a dated print for the portrait of Charles v, have led several scholars to date this jug between 1557 and 1558. TH

EX COLLECTIONS: Lord Hastings; Baron Albert Oppenheim, Cologne; Oscar Bondy, Vienna; [Leopold Blumka, New York]; R. Thornton Wilson, New York.

BIBLIOGRAPHY: *Baron Albert Oppenheim Collection . . .*, October 28–29, 1914 [19 March 1918], II, no. 105, pls. 38, 39; Hannover, 1925, I, p. 191; Walcher von Moltheim, 1927, I, pp. 16–18, figs. 8, 9.

243

Portable Diptych Sundial

Nuremberg, 1511
Boxwood, the lines engraved, the letters and numbers punched, with red and black applied to some of the lines
4³/₈ x 3¹/₈ x ³/₄ in. (11.1 x 8 x 1.8 cm.)
The glass over the compass is a replacement.
Nuremberg, Germanisches Nationalmuseum (on permanent loan from the city of Nuremberg)
WI 28

The outside of the top leaf bears a map of Europe and Africa oriented to the south and extending to Ethiopia; along the edges are latitude markings. Other surfaces have various data for calculating time, and a compass.

Nuremberg was a center for the production of astronomical devices in the fifteenth century. The famed astronomer Johann Müller, known as Regiomontanus, moved to the city in 1471, for that reason.

The present sundial, which is attributed to the Nuremberg map maker and compass manufacturer Erhard Etzlaub on the strength of the map on the outside of the top leaf, is important precisely because of that map. Since a knowledge of one's approximate latitude was required to calculate the time, manufacturers of such devices customarily listed on them the latitudes of major cities. Etzlaub chose a different method; he provided a map of Europe and the important regions around the Mediterranean. At the edge of it he indicated latitudes, so that, with the help of a string or a piece of paper placed across the map, one could determine one's position relative to the markings. It is significant that the

245

intervals between the latitude marking become smaller toward the south. This indicates that Etzlaub recognized the geometric problems of distortion when the surface of a sphere is projected onto a plane surface. It was not until some fifty years after the creation of this sundial that the geographer Gerhardus Mercator developed the Mercator projection, thus introducing this refinement to the science of cartography.

This portable sundial was presumably designed for merchants active in the Mediterranean region, for this area is located in the center of the map. The inclusion of Mount Sinai among the possible positions for the style signifies that a brisk sale of such sundials to pilgrims was also anticipated. JW

BIBLIOGRAPHY: Kyewski, 1962, pp. 124–26; Zinner, 1967, pp. 309–10; Pilz, 1977, pp. 124–26; Willers, in *Schätze der Astronomie*, 1983, no. 10.

244

245 GEORG HARTMANN

Astrolabe

Nuremberg, 1532
Brass, cast, turned, stamped, and engraved
Diameter, 5 3/8 in. (13.7 cm.); thickness, 1/4 in.
(6 mm.)
Signed: GEORGIUS HARTMAN NORENBERGE
FACIEBAT ANNO MDXXXII
Nuremberg, Germanisches Nationalmuseum
WI 354

The raised edge soldered onto the front face of
this astrolabe is divided into 2 x 12 hours and 4 x
90 degrees. The perforated rete, whose thorn-
like points indicate the positions of fifteen inner
and twelve outer stars, turns above three inter-
changeable plates for the latitudes 39° and 42°,
45° and 48°, and 51° and 54°. Rotating above the
rete is a radial rule.

The reverse of the device shows the shadow
quadrant and the curves for hours of unequal
length. The margin on this side is provided with
divisions into 0°−90°−0°−90°−0°, the circle of
the zodiac, and the year. The alidade is missing.

The suspension ring is affixed to a throne
with two stylized flowers, which are typical of
Hartmann astrolabes.

The basic idea of the astrolabe is the projec-
tion of the earth and the celestial sphere onto a
plane. The rete of the instrument shows the
stars of the northern sky, which circle about the
apparent axis of the polestar. The plate beneath
the rete bears the terrestrial and celestial coor-
dinates for the latitude at which a given observa-
tion is made.

Such devices were used not only to measure
the altitude of the stars; with them, one could
also determine the changing positions of the
fixed stars relative to the horizon, or the posi-
tions of the planets, the moon, and the sun, rela-
tive to the fixed stars. Moreover, it was also
possible to determine the time of day and to
calculate distances and altitudes on the earth it-
self.

Georg Hartmann (1489−1564) was one of
Nuremberg's most important instrument mak-
ers. He was a cleric, but, with the coming of the
Reformation, he returned to the lay world. It is
presumed that his instruments were made to his
specifications by specialized craftsmen. He
wrote, however, that he himself engraved the
dials, rules, and scales — which is what made his
instruments so sought after by scientists. Hart-
mann maintained close scientific ties with
numerous princes, churchmen, and scientists.

JW

BIBLIOGRAPHY: Gunther, 1932, pp. 436−40; Zinner,
1967, pp. 109, 110; Pilz, 1977, pp. 169−76.

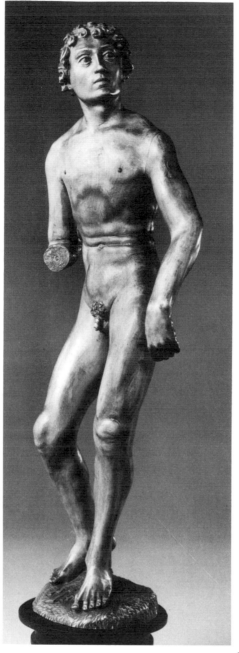

246

246 PETER FLÖTNER

Adam

About 1525
Boxwood
Height, 13 9/16 in. (34.5 cm.)
The lower right arm is missing, and four fingers on
the left hand are restored.
Signed (on base): PF, flanking a knife
Vienna, Kunsthistorisches Museum, Sammlung für
Plastik und Kunstgewerbe
3896

The male nude depicted in this wood carving
stands in a contrapposto pose with his weight
borne by his left leg. His head is turned slightly
to one side, and he has a wide-eyed gaze. Paral-
lel wavy strands of hair radiate from the top of
his head and end in short curly locks.

The torso, legs, and upper right arm are
carved from one piece of wood. The remnant of

a dowel indicates that the missing lower right
arm was originally a separate carving — as is the
entire left arm. A horizontal dowel connects the
left arm to the shoulder. The separately carved
base, textured with jagged, short cuts, repre-
sents a grassy hillock. The artist's monogram —
the letters P and F surrounding a wood-carver's
knife — appears in relief on this base, between
Adam's feet. (This knife appears at the center of
Peter Flötner's coat of arms on his stone tomb
monument in the Johanniskirchhof, Nuremberg
[K. Lange, *Peter Flötner, Ein Bahnbrecher der
deutschen Renaissance*, Berlin, 1897, p. 5, ill.].)

The figure is Renaissance in style, the con-
trapposto, distribution of weight, and sugges-
tion of underlying structure recalling Dürer's
depictions of Adam in the engraving, of 1504
(cat. no. 121), and in the painting, of 1507, in the
Prado. Because Flötner's figure is slimmer and
less idealized, a comparison may also be made

435

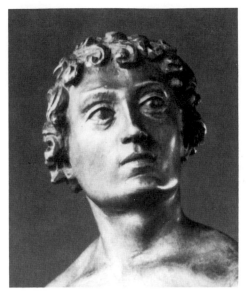

246: detail

with Peter Vischer the Younger's *Orpheus*, of about 1516, on the Washington plaquette (cat. no. 193) and with Ludwig Krug's *Adam* in the plaquettes, of 1515/18 (see cat. no. 205).

Flötner shows his mastery of wood carving in his subtle modeling of this figure. The fine parallel hatchings, for example, follow the form of the body and the limbs. These minute strokes were used to smooth away the broad horizontal cuts, which are still visible in portions of the left leg. The expressive richness of the surface that results suggests that the figure was never meant to be painted, except for the pupils of the eyes.

The original function of this statuette is unknown. It could have been made as a cabinet piece for a Humanist collector, or it might have served as a model for a cast.

The subject is most likely identified as Adam; perhaps the figure belonged to an Adam and Eve group of the type represented by the poly-chromed pearwood example, of about 1515, attributed to Nuremberg, in the Bayerisches Nationalmuseum, Munich (T. Müller, *Die Bild-werke in Holz, Ton und Stein von der Mitte des xv. bis gegen Mitte des xvi. Jahrhunderts [Kataloge des Bayerischen Nationalmuseums München*, vol. xiii, 2], Munich, 1959, pp. 192, 193, nos. 188, 189). Other possible subjects mentioned in the literature, such as David, Paris, or Orpheus, lack supporting parallels in the realm of three-dimensional statuettes. The less than satisfactory suggestion that the figure represents David rests on the possibility that Flötner saw Michelangelo's colossal marble *David*, of 1501–4, in Florence, during his travels in Italy from 1520 to 1522. The open palm of the Flötner figure's left hand, bent at an angle from the wrist, was probably meant to hold an apple, in contrast to the relatively small-er stone held in the angled right hand of Michelangelo's *David*. Most importantly, the contrapposto poses are completely different and

not even in mirror image. Julius von Schlosser rightly compared the pose of Flötner's *Adam* with Tilman Riemenschneider's linden-wood statuette of *Adam*, also in Vienna.

WDW

EX COLLECTION: Victor von Miller, Vienna (until 1872).

BIBLIOGRAPHY: Domanig, 1895, 16, pp. 1 ff.; von Schlos-ser, 1909, 31, pp. 69, 72, fig. 3; Bange, 1928, pp. 8, 77, pl. 81, 1949, p. 39, ill.; Weihrauch, 1967, pp. 288 (incorrectly identifies the wood as pearwood), 290; von der Osten and Vey, 1969, p. 268; Pechstein, 1984, 11, p. 94, fig. 3.

247 PETER FLÖTNER

Design for an Altarpiece, with the Transfiguration of Christ

1530–35
Pen and black ink, with brown and black wash, on paper
12 3/16 x 7 3/4 in. (31 x 19.6 cm.)
Erlangen, Graphische Sammlung, Universität
Bock 357

Peter Flötner's versatility as a designer is evi-dent in this unsigned study for an altarpiece with the Transfiguration of Christ. Earlier scholars have sometimes described it as a study for an epitaph. Although the subject matter of all three parts of the design supports this in-terpretation, there is no tablet with the name of the deceased, nor any room for one.

The ornamentation of the frame is complete only on the left; the right side shows the frame's underlying structure. A comparison of this de-sign with those by Flötner for the bases and capitals of columns confirms its attribution. Similarities can be found in the small, curling ribbons, which always end in two points, as well as in the types of leaves, which are peculiar to Flötner: The center leaf is pod shaped, surrounded by short, mostly stubby leaves, the whole forming a sort of cluster. In this sketch, the leaves appear in profile on the bases of the columns, while, on the frieze, those depicted right side up alternate with others represented upside down, with ribbons winding through them.

On the predella is a group of skeletons and ghouls in a grave. In an almost symmetrical composition, two recline in the foreground while two others crouch behind. Two of the demons have claw feet and bird's heads, and a third, a dog's head with bared teeth. The artist invokes the kingdom of hell and death, which was vanquished by Christ's death. The story is continued by the Resurrection, above the en-tablature, and by the Ascension, at the center.

The resurrected Christ has not risen from the sarcophagus, as he does in many contemporary representations, but still stands within it, hold-ing the banner with the cross in one hand and blessing with the other. The triangular compo-sition of the figures creates a kind of archi-tectonic pediment. Four guards recline, two on

each side of Christ, one sleeping, the second wakening, the third dazzled, and the fourth awed.

A diagonal line runs from the guards' raised arms, at the upper right, to the raised arm of the figure (Saint Peter?) at the lower left, in the center of the altarpiece. Next to this figure is a crouching disciple, seen from the back. The group is completed by two other mourners. In contrast to the bare arms of the guards, which express surprise or fear, the gesturing arms of the mourners, here, are clothed, and express grief, as does the covering of one mourner's face by drapery. In an extensive landscape, a rock rises from a small hillock, surrounded by trees. Christ stands on the top, his robes billowing, his arms open. Illustrated is the moment described for the first time in the Acts of the Apostles (1:1–12): "... the apostles whom he had chosen; To whom also he shewed himself alive ... being seen of them forty days, ... while they beheld, he was taken up; and a cloud received him out of their sight. And while they looked stedfastly toward heaven as he went up, behold, two men stood by them in white apparel." In a manner not common at the time, Flötner depicts an earthbound Christ. In most representations of the subject, a section of sky fills the space between him and the earth, or only his feet are visible at the top of the com-position. Here, the Holy Ghost floats above Christ's head and God and Moses point to him from two banks of clouds, surrounded by cherubs. Moses, the representative of the Old Testament, reappears on the architrave on the left part of the frame. One may assume that the figure outlined on the other side was intended to be Saint John the Evangelist, representative of the New Testament. Recent research has shown that the inclusion in German prints of Northern Italian architectural designs, either singly or in combinations — for example, those of Agostino Busti (Il Bambaia) — might pre-clude Flötner's hypothetical journeys to Italy.

The pictorial sections of the altarpiece could have been realized as stone reliefs, or in cast or hammered metal, like the reliefs in the Fugger Chapel at the church of Sankt Anna, Augsburg, or those in the Sigismund Chapel, in Cracow Cathedral. The subject of the latter, an Adora-tion, is also found in a cast-bronze relief in the *Feyerabend Epitaph* in the Gumbertuskirche, Ansbach.

MA

EX COLLECTION: Markgräfliche Bibliothek, Ansbach (un-til 1805).

BIBLIOGRAPHY: Lange, 1897, p. 53, no. 2, fig. 51; Haupt, 1902, p. 79, fig. 36; Friedländer and Bock, 1921, pl. 50; Bock, 1929, no. 357, ill.; Feurstein, 1930, p. 126 f., fig. 63; *Peter Flötner und die Renaissance in Deutschland*, 1946, no. 301; Rasmussen, 1974, p. 93 f., fig. 21; Smith, 1983, p. 224, fig. 58.

247

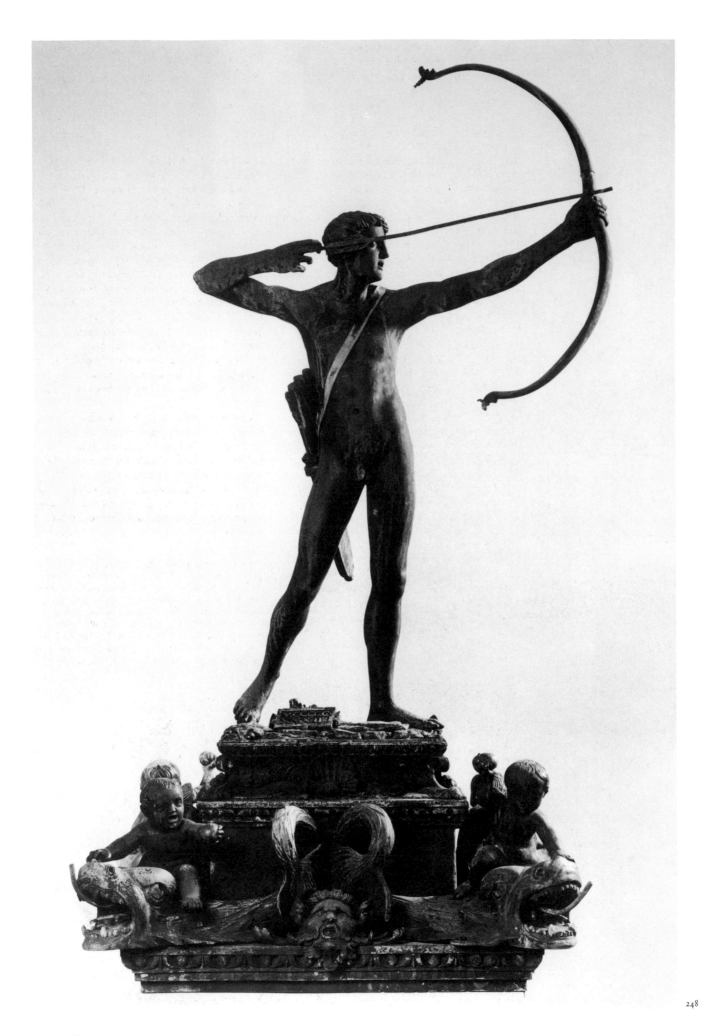

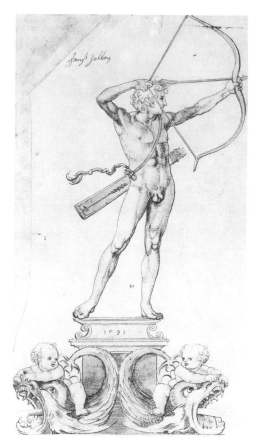

Figure 139 Peter Flötner. Drawing for the *Apollo Fountain*. 1531. Private collection

248 PETER FLÖTNER (model)
PANKRAZ LABENWOLF (cast)

Apollo Fountain

1532
Brass, probably cast in multiple parts, after wood
and wax models
Total height, 39 3/8 in. (100 cm.); height of *Apollo*,
30 5/8 in. (77 cm.)
Dated (on plaque): MCCCCCXXXII
Provenance: shooting yard, Herrenschiesshaus am
Sand, Nuremberg; courtyard of the Pellerhaus.
Nuremberg, Germanisches Nationalmuseum
(on permanent loan from the city of Nuremberg)
Pl 0.3146

This fountain sculpture is composed of two ma-
jor parts — the nude statuette of the god Apollo,
and the elaborately decorated rectangular
pedestal. The youthful god is shown in the ac-
tive pose of drawing his bow and arrow, his
weight borne on his advanced left leg. Sus-
pended from a diagonal strap is a quiver full of
arrows, which hangs behind him. The pedestal
has several stepped levels. The god stands on a
platform with simulated rocks, a lizard, and a
plaque with the date of the work in Roman
numerals: MCCCCCXXXII. Below this platform is
a narrow egg-and-dart molding supported by a
concave molding decorated with centered shells
surrounded by fronds, and claw feet with acan-
thus extensions at each corner. Conch shells and
other specimens of marine life are scattered
among these elements. The largest step below
sports centered leafy masks and, at each corner,
sea monsters with gaping jaws and bared teeth.

Putti holding balls straddle the backs of the sea
monsters. Below is a wide egg-and-dart mold-
ing, which repeats the same motif as the mold-
ing at the top.

Johann Neudörfer wrote in 1547 that the
fountain was commissioned by the archers'
company for their shooting yard: "But from his
[Peter Vischer the Elder's] hand is the cast foun-
tain in the Herrenschiessgraben." The com-
pany's house, the Herrenschiesshaus, was lo-
cated on the Grübelstrasse, on the east side of
the city near the northern branch of the Pegnitz
River. A preparatory drawing, dated 1531, for-
merly in the collection of the grand duke of
Weimar, shows the composition with a slightly
simpler base — as conceived a year before the
casting (fig. 139; Weihrauch, 1967, p. 289, fig.
347). The commission indicates the degree to
which Humanist taste had pervaded the patri-
cian class in Nuremberg.

Neither the drawing nor the completed foun-
tain is signed. The fountain has been variously
attributed: The statue has been ascribed to Peter
Vischer the Younger and the socle to Hans Vi-
scher; later, the entire work was given to Hans
Vischer, and, still later, to the anonymous Mas-
ter of the Apollo Fountain.

In 1531, Cardinal Bernhard von Cles, the
Bishop of Trent, wanted a fountain to be made
in Nuremberg for his castle in Trent because of
his admiration for either a drawing or the model
for the *Apollo Fountain*. Through an exchange
of letters and bills with the cardinal's agent in
Nuremberg, Dr. Christoph Scheurl, a Human-
ist and patrician, we can conclude that Flötner
was both the artist of the 1531 drawing for the
Apollo Fountain and the master of the model for
this work, and that Pankraz Labenwolf must
have been responsible for the cast. The attribu-
tion to Flötner is further supported by stylistic
comparison with his putti reliefs on the chim-
neypiece, of 1534, for the garden room of the
Hirschvogelhaus (Feulner, 1926, fig. 87).
Labenwolf had trained in the Vischer family

workshop, and is known to have collaborated
with Flötner, from the accounts by Johann
Neudörfer (Lochner, 1875, p. 125), and as dis-
cussed in relation to the Berlin *Design for a Wall
Fountain* (cat. no. 262).

The *Apollo Fountain* represents Flötner's
mature style after his return from his second
Italian trip of about 1530. In the fountain, he
fully assimilated the idealized form, propor-
tions, distribution of weight, and sense of sus-
pended movement that he learned in Italy, from
the work of Italian Renaissance masters. While
he must have been familiar with the art of Dür-
er, his sketch was undoubtedly based upon
Jacopo de' Barbari's engraving of *Apollo and
Diana*, of about 1503/4 (Bange, 1949, pp. 28,
119; J. Levenson, K. Oberhuber, and J. L.
Sheehan, *Early Italian Engravings from the Na-
tional Gallery of Art* [exhib. cat.], Washington,
D.C., National Gallery of Art, 1973, pp. 368,
369, no. 141, ill.). The *Apollo* statuette is slim-
mer and more graceful than the Apollo in both
de' Barbari's print and Flötner's preparatory
drawing, and this elegance represents an ad-
vance over Flötner's *Adam* of a few years earlier
(cat. no. 246).

The putti on the base, while possibly partially
inspired by Dürer's graphics (cat. no. 145) and
by Peter Vischer the Younger's putti on the
Sebaldus Tomb, more likely are the result of the
fresh and direct observation of works by
Donatello and by Andrea Riccio in Padua. The
sea creatures, both imaginary and realistic, also
were a response to Paduan sculptures by Riccio
and his followers. WDW

BIBLIOGRAPHY: Lochner, 1875, pp. 21, 30; Bode, 1908,
29, pp. 37–40, fig. 12; Höhn, 1924, p. 173, fig. 85; Meller,
1925, pp. 208, 209, fig. 135, 1926, pp. 27, 46, fig. 27; Kris,
1926, n.s. 1, p. 141; Feulner, 1926, fig. 86; Bange, 1949,
pp. 27–29, 118, 119, fig. 61; Braun, 3rd ser., 1951, 2, pp.
196, 202, fig. 2; Müller, 1963, pp. 11, 43, ill.; Weihrauch,
1967, pp. 288, 289, 318, fig. 348; von der Osten and Vey,
1969, p. 268; *Nürnbergs . . .*, 1977, pp. 48, 95, fig. 199;
Riederer, 1982, 36, p. 44; Smith, 1983, pp. 62, 224, fig. 35.

248: detail

249

Four additional heads on the column of the fountain spout water into the basin. Additional streams issue from the pitchers of the — presumably — four putti above. Perhaps the latter streams drain an upper reservoir, but it is not possible to determine whether there even is such a second basin.

The top section betrays its origins in a design for goldsmiths' work, as do the details of the overall structure. The artist has compressed the proportions of a covered goblet, transformed the cup into a virtual bowl, and extended the lid, with its handle typical of goldsmiths' work. A chubby little boy stands on its broad rim; in his right hand he holds a *T*-shaped staff with two pendant bells, which extends to the entire height of the top of the fountain and appears to pass through the ledge on which he is standing. Whether the stream from this "Manneken Pis" is intended to fall into the bottom basin or a possible upper one is unclear.

During the Renaissance many fountains were built, especially in southern Germany. Older fountains of wood were replaced by those of stone or bronze, revealing a definite Italian influence. In addition to the monumental fountains erected on public squares, in the sixteenth century smaller ones graced the courtyards of private dwellings, and even festive tables. Unlike that of their medieval counterparts, the practical function of the Renaissance fountain was secondary. What was important was its decorative effect, heightened and perfected by the play of water. It is in this context that the *Apollo Fountain* by Peter Flötner and Pankraz Labenwolf must be appreciated, as well (cat. no. 248). MA

BIBLIOGRAPHY: Weihrauch, 1967, p. 292, ill. 351.

249 Design for a Fountain

Nuremberg (?), about 1550
Pen and ink, on paper
7 3/4 x 5 7/8 in. (19.7 x 14.9 cm.)
Cambridge, The Syndics of the Fitzwilliam Museum
2129

This drawing has been largely ignored by art historians, although H. R. Weihrauch attempted to ascribe it to Peter Flötner. It is true that certain details — for example, the seated putto with an urn, on the top — might call to mind that artist, but the connections between individual parts show the work to be that of a lesser draftsman. It is difficult to determine his place of activity, but he probably worked in south Germany — possibly, in Nuremberg.

Considered more closely, the study for a fountain does not represent an integrated design, but seems, instead, a composite of a number of diffuse details. These were probably

adapted from various pattern sheets, so that the result represents a kind of compilation. It is doubtful that it was based on some previously unknown or lost design by Peter Flötner.

To save space, the two parts of the drawing represent two sections of a single fountain, split in half, rather than alternative designs: The top section, pictured as though viewed from below, is on the left, and the base, shown as if seen from above, is on the right. A shaft in the form of a squat baluster adorned with a wreath of leaves and faun masks crowns an unusually small base. The quatrefoil-shaped basin is supported by the heads of grotesques, each emerging from a flower that terminates in a snail shell. Even here, the hesitant line, unbalanced proportions, and basic impossibility of such elements to offer any kind of support make it clear that it cannot be the work of Peter Flötner. The disproportion among the parts suggests that the design was not meant to be executed, but only served the artist as a study.

250 WORKSHOP OF PETER FLÖTNER

Fountain Figure of a Seated Putto with an Urn

About 1530
Brass, cast after a wax model, with a dark brown natural patina
Height, 6 5/16 in. (16 cm.)
Germany, Private collection

A winged, seated putto looks down in the direction of his stream, which he guides with his right hand. The overturned urn and the left arm and hand balance the mass of the extended right leg. Textural contrast is given to the smooth, burnished fleshy surfaces by the partly chiseled grooves of the wavy hair and the engraved patterns on the wings. The punctuated pupils and full lips convey a certain piquancy.

The cast is technically excellent, with few flaws. The wings and urn are cast integrally with the putto's body. Small plugs are visible in the shoulders and the bottom of the urn.

250

This sculpture may have either crowned a fountain or may have been intended as part of a group of such fountain figures. The second possibility is made clear in the Cambridge drawing (cat. no. 249), in which a standing boy emits a stream from his penis. A bronze of this type is illustrated by Hans R. Weihrauch (1967, p. 291, fig. 352). The Cambridge drawing also includes another putto, who is seated on the edge of a fountain holding an inverted urn from which a stream of water flows. The absence of corrosive products on the present example suggests that the figure either never actually functioned as a fountain figure, or else was used only for a short time.

The style, ultimately derived from Italian Renaissance prototypes, was conveyed via the small putti who playfully inhabit the *Sebaldus Tomb*, in Nuremberg (see cat. no. 190). However, the smooth modeling and the spatial composition are developed here with a new freedom

and balance. This, together with the highly finished surfaces, gives the figure a special quality of fluidity and movement.

Recently, this fine work has been attributed to the workshop of the Master of the Apollo Fountain, now identified as Peter Flötner (cat. no. 248). Comparisons with the winged putti who frolic at the corners of the base of the *Apollo Fountain* provide a basis for this suggestion.

WDW

EX COLLECTION: Julius Böhler, Munich.

BIBLIOGRAPHY: Meller, 1926, pp. 26, 46, fig. 24 ("About 1530–40 . . . after a model by Peter Vischer the Elder, from the late period of the Vischer workshop"); Bange, 1949, pp. 29, 120, fig. 65 ("Workshop of the Master of the Apollo Fountain about 1532"); *Kunstschätze aus Münchner Privatbesitz . . .*, 1965, no. 164; *Handzeichnungen aus Fünf Jahrhunderten 1400–1900 . . .*, 1977, no. 44, ill. ("Workshop of the Master of the Apollo Fountain, Nuremberg, first half of the 16th century").

251 PETER FLÖTNER

Design for the Foot of a Goblet, with Frolicking Putti

About 1540
Pen and gray ink, with yellowish green wash, on paper
Diameter, 8 13/16 in. (22.5 cm.)
Braunschweig, Herzog Anton Ulrich-Museum
Z 33

This unsigned drawing, published first by Flechsig, for a long time was thought to represent the bottom of a bowl. However, the corresponding Solnhofen stone relief (cat. no. 252), in the Busch-Reisinger Museum at Harvard University, enabled Charles L. Kuhn to identify the Braunschweig design as a study for the foot of a goblet. Missing here, and in the bronze relief with the medal of Christoph Fürleger (in the Musée des Arts Décoratifs, Paris), is the group with six putti.

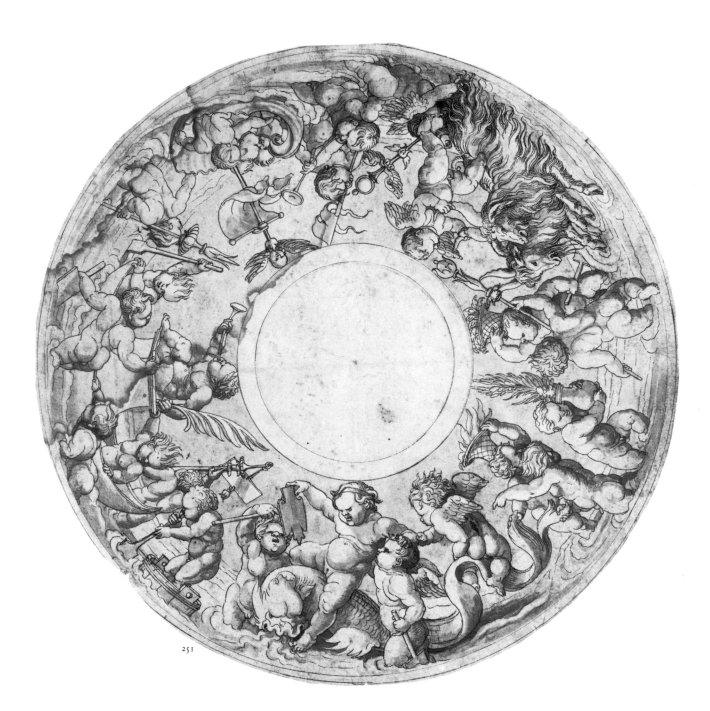

251

The yellowish green wash indicates that the present design was made for goldsmiths' work. Twenty-four frolicking putti are loosely arranged in five groups, near the outer circle. Linking these putti are others, at intervals, gesturing or holding such objects as a banner, a palm frond, or a candelabrum. A female putto wearing a diadem, or headband, reclines — like an intoxicated Bacchus — on a terrifying fish; she is supported by other putti, and carries a blank shield in her right hand. The male counterpart in this triumphal procession for a goddess or a nymph — a winged putto — rides on a pair of billy goats. The omission of the six putti places the emphasis on these two groups, which face each other, and, probably unintentionally on the part of the artist, creates a vertical axis through the procession, bisecting a design that, no doubt, was conceived as a whole.

The putti are afloat in boats and tubs in what appears to be shallow water, blowing on trumpets and carrying baskets of fruit on their heads. As in Italian art of the fifteenth century, in Germany putti were included in designs for goldsmiths' work, and in small-scale representations of the gods of antiquity. Examples are Flötner's plaquettes of the nine Muses, and the scenes carved in coconut wood on the *Holzschuher Coconut Goblet* (cat. no. 263).

E. F. Bange convincingly dated the drawing 1537–38. With one exception (Weber, 1975, p. 25: "about 1530"), recent scholarship has tended to support a date of about 1540.

MA

BIBLIOGRAPHY: Flechsig, 1920, no. 22; Bange, 1936, p. 183, fig. 26, no. 13, 1938, p. 231, fig. 1; Schmidt, 1955, no. 33, frontispiece; Weber, 1975, 2 vols. p. 25, fig. 17; Pechstein, in *Zeichnung in Deutschland* ... (exhib. cat.), Stuttgart, Staatsgalerie, 1979, vol. 1, no. A 19; Angerer, 1984, no. 32, fig. 55.

252 PETER FLÖTNER

Model for Goldsmiths' Work, with Frolicking Putti

About 1530
Solnhofen stone, varnished
Diameter, 6 7/8 in. (17.5 cm.), excluding the modern gilt-bronze frame
Cambridge, Massachusetts, Harvard University, Busch-Reisinger Museum
1951.213

The convex surface of this large carving is decorated with frolicking putti, in low relief, arranged in a continuous watery procession. They seem to be preparing the way for an especially plump female figure who wears only a fillet in her hair and who sits astride a scaly, long-tailed sea monster. The putti who precede this figure are engaged in a variety of activities. One paddles furiously, while standing in a wooden tub; others attempt to control a large,

442

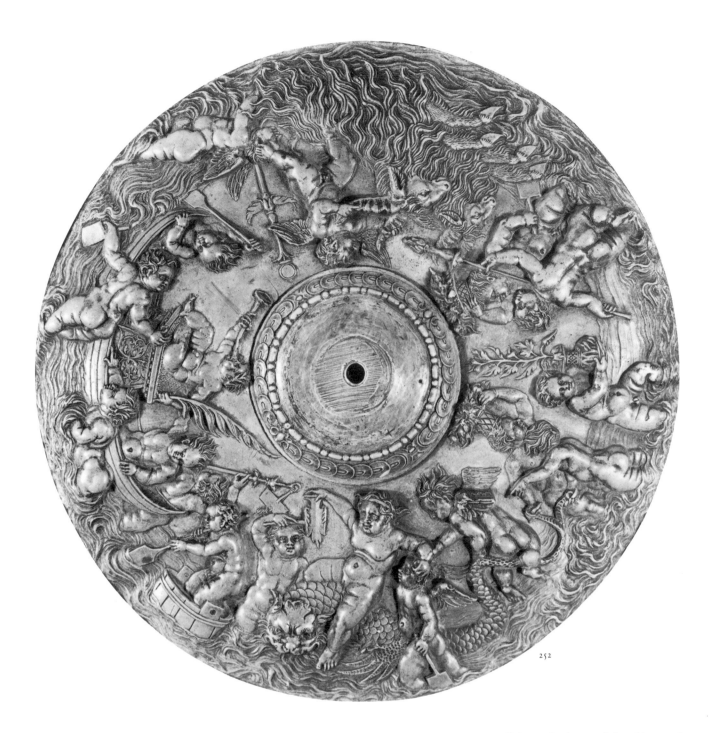

252

open boat. The one who wears a leafy crown and blows full force on a trumpet sits on a palmette-decorated stand placed in the center of the boat. A winged putto guides two goats, which ride the waves with their long hair flowing. Still other putti sport flower-filled baskets, a vase with a growing plant, and ornamented scepters. Another winged putto attempts to sit on the twitching tail of the sea monster.

The raised center of the relief is framed by a scaled and beaded border carved in one piece with the rest of the work. The underside of the center portion, which has been drilled, is cut away in a round hollow with sloping sides. Two rectangular notches on opposite sides punctuate the edge of this hollow.

The relief must have served as a model from which a cast for goldsmiths' work was to have been made. The cast relief may have been intended as either the base or the cover of a

vessel that would have been completed with metalwork in a manner analogous to the lid of the *Coconut Goblet* in the Germanisches Nationalmuseum (cat. no. 263). A bronze cast, possibly dating, at the earliest, from the early seventeenth century, is preserved in the Musée des Arts Décoratifs, Paris (Kuhn, 1954, 17, fig. 4; Farmer, 1969, p. 35). Many examples exist that prove the use of models of stone and other materials, for goldsmiths' work.

The subject of the medallion cannot be determined with precision, although the figure on the sea monster may be identified as a sea goddess. The putti, inventions of the ancient world, became a favorite motif in Italian and Northern Renaissance art that was adopted by Flötner.

While the relief is unsigned, the attribution seems clear on the basis of a comparison with Peter Flötner's putti in other mediums — as, for example, the male and female putti in the two

reliefs on the bases of the chimneypiece made for the garden room of the Hirschvogelhaus, of 1534, in Nuremberg (A. Feulner, *Die deutsche Plastik des sechzehnten Jahrhunderts*, Florence and Munich, 1926, fig. 87). An unsigned preparatory sketch for the relief (cat. no. 251), preserved in the Herzog Anton Ulrich-Museum, Braunschweig, has been accepted, in the literature, as by Peter Flötner. Most but not all of the figures and their activities seen in this drawing are repeated in the relief, except for the group of putti in the drawing in and around a small boat with a flapping sail. With the number of figures reduced from twenty-four to eighteen, the relief has a more unified composition.

Contrary to the opinion of Ingrid Weber, the central, classically inspired border has a basis in Flötner's oeuvre, as shown by comparison with a sketch for a bowl, in Erlangen (E. Bock, *Die Zeichnungen in der Universitätsbibliothek Er-*

253

253 PETER FLÖTNER
Design for an Ornamental Chair
After 1535
Pen and brown ink, with black and brown wash,
on paper
7 5/16 x 6 1/4 in. (18.6 x 15.6 cm.)
Berlin-Dahlem, Staatliche Museen Preussischer
Kulturbesitz, Kupferstichkabinett
KdZ 390

It is evident from Peter Flötner's surviving woodcuts that, between 1530 and 1535, he was occupied primarily with representing architectural forms. However, in addition to column bases and capitals, he also designed beds and doorframes. As a result, for a long time he was also thought to be a carpenter, and even articles of furniture were attributed to him. The demand for paneling and furniture and for decorative and useful objects in the "Italian manner" could not be satisfied by the Nuremberg craftsmen, and a new profession, that of the independent designer, developed. A novel form of ornamentation imported from Italy — the grotesque — prevailed, in a variety of combinations. Some forms, such as those found in goldsmiths' work, or else putti, could be used alone. Proof of Flötner's reputation as a designer outside of Nuremberg is the commission that he received from Cardinal Bernhard von Cles, Bishop of Trent, in 1531/32, for a fountain for the Castello del Buonconsiglio, Trent, after the cardinal had seen the artist's *Apollo Fountain* (cat. no. 248). In the same letter that mentions the commission for the fountain, the bishop also asks for an "amusing chair, made of wood and covered with leather, in which to rest and sleep during the day." When Edmund Wilhelm Braun published this correspondence, he took the reference to the chair, in the letter, to mean the one that is the subject of the Berlin design.

A drawing made after this design for a chair, signed P. FLOE, is in the Kupferstichkabinett, Basel. The construction of the lower part of the chair is hidden by ornamentation, but, upon closer examination, one can see that the elements of the grotesque in the design can be separated into various parts. The legs of the chair are in the form of winged putti sitting astride eagles (or dragons?) holding balls in their mouths. Winged, half-length figures personifying Old Age, on the right, and Youth, on the left — each carrying a blank shield — serve as supports for the armrests. The chairback, which extends almost organically from the armrests, consists of two lambrequins stretched between candelabra-like forms. On each side, at the top, a cherub with a bowl of fruit on its head holds in its mouth one end of a garland with a bunch of grapes. MA

Ex COLLECTION: G. K. Nagler.

BIBLIOGRAPHY: Hefner-Alteneck, 1852, pl. 65; Nagler, 1858 f., IV, p. 874; Hefner-Alteneck, 1886, pl. 477; Lichtwark, 1888, p. 146; Reimers, 1890, pp. 4, 101, fig. 2; Lange, 1897, p. 50; Haupt, 1905, p. 154; Friedländer and Bock, 1921, no. 390, p. 42; Braun, 1951, p. 198; Angerer, 1984, no. 24, fig. 48.

langen, Frankfurt am Main, 1929, pl. vol., fig. 360). (The outer border of the stone model is irrelevant because it is a modern, gilt-bronze addition.) The style of the stone model, so close to that of the drawing and to Flötner's representations of putti in other works, must indicate that the model is from the hand of Flötner, himself.

The Renaissance style of both the drawing and the relief is based on the inventions in North Italian engravings of the late fifteenth and early sixteenth century, in which the activities of numerous putti are featured. The works of such artists as Zoan Andrea (active from 1475 until at least 1519), Giovanni Pietro da Birago (active from the early 1470s until at least 1513), and Domenico Campagnola (1500–1564), among others, come to mind (see J. A. Levenson, K. Oberhuber, and J. L. Sheehan, *Early Italian Engravings from the National Gallery of Art*, Washington, D.C., National Gallery of Art, 1973, pp. 158–59 [no. 67], 268–69 [no. 100], 278–79 [nos. 108–111], 422–23 [no. 153]). Building on this tradition, the illusion of three-dimensional frolicking

putti in Flötner's drawing depends on the use of shading and the nervous outline. The sense of density and weight in the relief is achieved through the contrast of the modeling of the fleshy forms with the stringy patterns of the water and the smooth background. WDW

Ex COLLECTIONS: Rothschild, Vienna; [Blumka Gallery, New York].

BIBLIOGRAPHY: Kuhn, December 1952, 19, no. 2, pp. 19–20, fig. 4, 1954, 17, pp. 108–15, ill., 1965, pp. 22, 79, 80, no. 33, pl. XXXIV; Farmer, 1969 a, pp. 33–35, ill., 1969 b, vol. 171, fig. 1, pp. 51, 52, 53; Livie, 1971, no. 48, ill.; Weber, 1975, 2 vols., pp. 25, 40, n. 74, fig. 16; Smith, 1983, p. 224.

254

254 PETER FLÖTNER

Ate and the Litae

About 1535
Brass, cast from a wood or stone model
Diameter, 5 3/4 in. (14.6 cm.)
New York, The Metropolitan Museum of Art,
Rogers Fund, 1954
54.84

This plaquette depicts a vast landscape panorama above a blank scrollwork cartouche. At the top of the composition the small figure of Zeus may be seen emerging from the clouds. The winged figure of Ate, draped and with claw feet, flutters in the sky nearby. Within the deep forest at the extreme right a traveler is being murdered. Near the horizon a towered building is being consumed by fire and smoke. Three heavily draped female figures, the Litae, stand beneath a large tree in the foreground, mourning the events. The rest of the landscape is filled with boats in a river, a water-powered mill, lushly foliated embankments, a domed building, and a fortified castle on the distant mountain.

The subject, derived from antiquity and mor-

alizing in tone, may mean that this plaquette was made as a cabinet piece for a Humanist patron (Weber, 1975, vol. 1, p. 15, nn. 54, 55).

The story is based on Homer's *Iliad* (IX, 502–515). Ate, a daughter of Zeus and the personification of delusion, has been banished from Mount Olympus. She is the goddess of crime and an embodiment of evil, who led both gods and men to commit erroneous and wrongful acts. The lamenting Litae, also daughters of Zeus but the personifications of prayer, are always too late or ineffective in their attempts to mitigate the misdeeds instigated by Ate. Konrad Lange established the immediate Renaissance source of the subject in the 1534 Paris edition of Andrea Alciati's *Emblematum Libellus,* where a related composition is shown (see the 1534 Paris edition in The Metropolitan Museum of Art, p. 94; the illustration in the 1550 Augsburg edition; Henkel and Schöne, 1967, cols. 1791, 1792).

Flötner's gift for placing expressive figures within a composition characterized by a deeply receding space may have been inspired by Venetian figural landscapes, such as Giorgione's *The Tempest* (in the Gallerie dell'Accademia, Ven-

ice), or Titian's early *Noli me tangere* (in the National Gallery, London). Flötner's landscapes act as a foil for the figural action. Such panoramic settings become less important compositionally in Flötner's smaller plaquettes, of about 1540 (cat. nos. 255–257). Bange assigned the plaquettes with figures in vast landscapes to his first Flötner group, datable before 1537.

The model for this plaquette has been universally acknowledged as being by Flötner. The present plaquette is the artist's most ambitious, and one of his most successful works. It is a tour de force in its illusionism and in its balance of background detail and figures. This cast is one of the finest among about seventeen known, in either lead or brass. WDW

EX COLLECTION: [Blumka Gallery, New York, 1954].

BIBLIOGRAPHY: Lange, 1897, p. 125; Leitschuh, 1904, no. 88; Bange, 1921–22, III, pp. 46, 51; Weber, 1975, p. 63, no. 42; Rasmussen, 1975, pp. 24, 88; Smith, 1983, p. 229 (lead version, Morgenroth Collection, University Art Museum, University of California, Santa Barbara); *Wenzel Jamnitzer . . .*, 1985, pp. 426, 427, no. 542.

255

255 PETER FLÖTNER
The Temptation of Faith
About 1535
Brass, with a dark reddish-brown patina
4 x 4 ¹/₄ in. (10.1 x 10.4 cm.)
Lakewood, Ohio, Heinz Schneider Collection

Seated at the center of this plaquette is a bare-chested woman whose right shoulder and legs are enveloped in drapery in the antique manner. A crude cross identifies her as Faith (Fides). On either side of her are demon-like creatures. A fool emerges from a large, gnarled tree trunk at the right. Beyond, are a church and other structures set in an intricate foliated landscape. A tower, rising above the left horizon, is in flames.

The subject has been described as the Large Temptation of Faith because it is the larger of two related plaquettes by the artist. This relief of a bare-bosomed figure, surrounded by such motley abominations as a grotesque creature with the head of a monk, may be seen as a biting commentary — even a miniature tirade — against the degradation of the Church so abhorred by Luther. As such, this relief is an important satirical statement in support of the German Reformation, and it ranks with the artist's woodcut illustrations for *Die Pfaffenkirmes,* of about 1535 (*Martin Luther und die Reformation in Deutschland* [exhib. cat.], Nuremberg, Germanisches Nationalmuseum, 1983, p. 238, no. 299, ill.; J. C. Smith, *Nuremberg, A Renaissance City, 1500–1618* [exhib. cat.], Austin, The University of Texas, 1983, p. 226, no. 123, ill.). Neudörfer noted the ugly faces and the processions of monks, nuns, and priests in Flötner's works (Lochner, 1875, p. 115).

Peter Flötner's penchant for piquant expression within a richly textured and minutely detailed landscape setting that recedes deeply in space approaches that of his *Ate and the Litae* plaquette (cat. no. 254). Flötner's figure and landscape compositions may have been influenced by those in Venetian painting.

Ernst F. Bange ("Zur Datierung von Peter Flötners Plakettenwerk," *Archiv für Medaillen- und Plaketten-Kunde,* 1921/22, vol. 3, p. 46) placed this plaquette, like the *Ate and the Litae,* among Flötner's earlier landscape representations.

WDW

EX COLLECTION: William S. Tender, New York (sold, Parke-Bernet Galleries, New York, May 9, 1968, no. 93).

BIBLIOGRAPHY: Wixom, 1975, no. 171; Weber, 1975, 2 vols., p. 61, no. 38 (other examples); *Wenzel Jamnitzer . . . ,* 1985, p. 425, no. 538 (lead example).

256 PETER FLÖTNER
Allegory of Feeling, or Jealousy
About 1540
Brass, gilded
2 ⁷/₈ x 3 ³/₈ in. (6.2 x 8.7 cm.)
The Cleveland Museum of Art, John L. Severance Fund
52.460

In the center of this plaquette stands a blindfolded nude male child who brandishes a knife in the direction of a man and a woman who approach from the left. Curly haired and bearded, the man bends forward, spreading his palms outward in an imploring gesture. The woman, dressed in a long gown, bends forward, too, while, with her left hand, she pulls her hair in despair. The distant village in the center is framed by buildings, trees, and bushes on the left and right, closer to the foreground.

The original function for which this plaquette was made remains uncertain, but it may have been made for a Humanist collector, or, possibly, as a model. Wenzel Jamnitzer occasionally incorporated casts of Peter Flötner's plaquettes in his own works. The present composition is repeated on two brass mortars, of about 1550/60, from Jamnitzer's workshop; these are preserved in the Kunstgewerbemuseum, Berlin, and in the Victoria and Albert Museum, London (K. Pechstein, *Bronzen und Plaketten* [Kataloge des Kunstgewerbemuseums Berlin, vol. III], Berlin, 1968, no. 8, ill.).

The iconography is not clear. Konrad Lange suggested that the subject might be an allegory of feeling, or jealousy — an interpretation misconstrued in some collection catalogues as an allegory of touch (J. de Coo, *Museum Mayer van den Bergh, Catalogus 2, Beeldhouwkunst, Plaketten, Antiek,* Antwerp, 1969, p. 333, no. 2428; J. Leeuwenberg and W. Halsema-Kubes,

256

446

257

Beeldhouwkunst in het Rijksmuseum, Amsterdam, 1973, no. 816). Yet, Lange does indicate that the subject of this plaquette is not really clear. A similarity exists with the plaquette that he referred to, simply, as *"The Feeling,"* and which Weber more recently called *Amor as the Honey Thief.* However, it should be emphasized that Lange (1897, p. 156) also suggested that Flötner intentionally made his subjects ambiguous so that he could use them in different contexts.

The low relief, with its well-modeled draped and nude figures set against an intricate and lush landscape, is characteristic of the style of a number of plaquettes by Peter Flötner. Although Bange included this plaquette in his third Flötner group, which he dated about 1543 to 1546, Weber has dated it about 1540.

WDW

EX COLLECTION: [Herbert Bier, London, 1952].

BIBLIOGRAPHY: Lange, 1897, p. 131, no. 112, pl. XII (another example); Wixom, 1975, no. 169, ill. (this example); Weber, 1975, 2 vols., pp. 69, 70, no. 52 (list includes the Cleveland example and literature).

257 PETER FLÖTNER

The Prophet Hosea, Gomer, and Children

About 1540
Solnhofen stone
2 3/8 x 5/16 in. (6 x 8.4 cm.)
Toronto, Private collection

A woman and a bearded man, both clothed in voluminous robes, stand before each other in the center of this horizontal relief. The man,

with palms held outward, turns his head in the direction of a distant rainbow, which rises above the horizon at the extreme right. The woman directs the man's gaze with her outstretched right hand; her left hand clasps the hand of a small nude boy who stands between her and the man. At the right, a small standing nude girl clutches a bunch of grapes, while a reclining infant looks on. At the left, an older child clad in a shirt drinks from a flask. The figures are set against a receding landscape lush with foliage and punctuated by several groups of rustic buildings. Beyond a towered structure at the right, a river meanders in the direction of the rainbow.

This stone relief served as a model for a goldsmith or other craftsman. Neudörfer wrote, in 1547: "His [Flötner's] pleasure in his daily work was to carve in white stone, but these were nothing else but histories which serve goldsmiths for repoussé and casting so that they, with this, embellish their work." The present relief is a rare, surviving example of one of the artist's models for such plaquettes.

The subject is from the Old Testament. While the rainbow might be an allusion to the story of Noah (Genesis 9:12–20), the composition was described for the first time, in the 1592 inventory of the collection of Paulus Behaim the Elder, as "the prophet Hosea with a whore and four children" (Leitschuh, 1904, p. 17). The biblical source is Hosea 1:2: "...And the Lord said to Hosea, Go, take unto thee a wife of whoredoms and children of whoredoms: for the land hath committed great whoredom, departing from the Lord." Gomer bore Hosea three children; the fourth child may represent her infidelity. The relief — provided the identification is correct — may illustrate the sin of marital infidelity or of whoredom. The rainbow may be

excused as a part of Flötner's occasionally ambiguous imagery, referred to by Lange in relation to the *Jealousy* plaquette (cat. no. 256).

The style continues that of the earlier plaquettes (cat. nos. 254–255), with the profuse detail of the landscape providing a rich setting and a foil for the large figures in the foreground.

WDW

BIBLIOGRAPHY: Lange, 1897, p. 130, no. 110 (a cast); Leitschuh, 1904, p. 17; Weber, 1975, 2 vols., p. 69, no. 51 (lists six casts in lead); *Objects for a "Wunderkammer,"* 1981, pp. 194, 195, no. 98 (this example).

258 PETER FLÖTNER (model for the obverse)
HANS MASLITZER (cast)
JOHANN NEUDÖRFER (design for the reverse)

Medal Commemorating the Laying of the Cornerstone of the Improved Fortifications around Nuremberg Castle

1538
Silver
Diameter, 2 7/8 in. (7.3 cm.)
The obverse and reverse were cast separately, and then soldered together.

Obverse: Beneath the crowned, two-headed eagle of the empire are the two Nuremberg coats of arms, the *Jungfrauenadler* and the so-called small coat of arms; behind, are war trophies. Below, is a panel suspended from ribbons, with an inscription.
Reverse: A seventeen-line Latin inscription tells of the strengthening of the castle fortifications in

258

447

the time of Emperor Charles v, his brother Ferdinand I, and Christoph Tetzel, Leonhard Tucher, and Sebald Pfinzing.

Inscribed (on obverse): FVNDAMENTVM/SALVTIS NOSTRAE/CHRISTVS ("Christ is the foundation of our salvation"), with the impressed initials PF.
Nuremberg, Germanisches Nationalmuseum (acquired by 1890)
Med 1477

The fortifications around Nuremberg Castle were erected by Antonio di Vazuni (Vasani) between 1538 and 1545.

This is the first of the so-called cornerstone medals made north of the Alps. In commissioning the medal, the Nuremberg city council followed a custom that originally accompanied the heathen sacrifices preceding the construction of a building, but the practice was widespread in fifteenth-century Italy: In Rome, during the reign of Pope Paul II, for instance, several copies of a cornerstone medal would be created, and one would actually be cemented into the stone itself. Christoph Scheurl, who, presumably, had seen the ceremony in Nuremberg, reports: "The stone in question was round and hollowed out like a pestle, with a lid. Inside it they placed a silver coin" (he continues with a detailed description of the medal). The remaining copies would be distributed as mementos among the building's patrons and architects: Depending on their rank, they were given examples in gold, silver, or lead (Heerwagen, 1908, pp. 121–22). HM

BIBLIOGRAPHY: Imhoff, 1782, vol. 1, 2, p. 14, no. 11; Neudörfer, 1875, p. 160; Gebert, 1910, pp. 75–76; Habich, 1931, vol. 1, 2, no. 1831; Kohlhaussen, 1968, no. 457.

259 PETER FLÖTNER
Design for a Dagger

1539
Pen and ink, with blue wash, on paper
Height, 15³/₄ in. (40 cm.); width of quillon, 3⁹/₁₆ in. (9.1 cm.)
Berlin-Dahlem, Staatliche Museen Preussischer Kulturbesitz, Kupferstichkabinett (acquired, 1937)
16779

This design, dated 1539, and first published by Bange in 1938, provided a starting point for Flötner research, which, until then, had been incomplete for the years around 1540, when the artist created the majority of his woodcut designs for objects. Although Bange believed that the present design was a preliminary sketch for a woodcut, comparisons with actual daggers suggest that it is a finished design, made to scale. It is not clear whether this design was ever implemented, or whether, like the designs for goldsmiths' work in the Amorbachsches Kunstkabinett, Basel, it was withdrawn from workshop use, and preserved as a collector's item.

259

in similar activities — as in Late Gothic engravings, and on such examples of goldsmiths' work as a flask with screw top, they enliven the ornament and add to the overall decorative effect — stand out because they catch the light. There are two other putti below the locket, on either side of a crouching faun with a crossbar in his mouth, to which a cloth is knotted in four places; this pair may be seen as the draftsman's attempt at representing a "figura serpentinata." These two putti are in identical stances — one seen from the front, and the other from the back; aside from complementing each other, they are an indication of Flötner's ability to design figures in the round — unfortunately, only a few of which are known.

The two small turtles on the narrow branches issuing from the mouths of the two turnip-shaped creatures on either side of the bull's head are typical of motifs in art from north of the Alps in the first half of the sixteenth century. With the animal forms in this design, the art of Flötner becomes an intermediary between the Vischer workshop's *Sebaldus Tomb* (fig. 135) in the Sebalduskirche, Nuremberg, and Wenzel Jamnitzer's design for the *Merkel Table Decoration*. The gorgon's head (?) in the center of the quillon is flanked by winged lions and faun masks. The ornamentation of the grip, in contrast to that of the scabbard, is of greater clarity; it consists of two areas of Moorish design, and a disk-like trophy set between two ribbons.

On the fantastical pommel is a male figure atop a band with leafy ornamentation, surrounded by two fish cleverly represented in frontal perspective.

One can imagine the finished dagger made of silver, its gilded ornaments superimposed on a plain background, the quillon and pommel adorned with solid-cast figures. MA

EX COLLECTION: Thomas Thane, London (until 1846).

BIBLIOGRAPHY: Bange, 1938, pp. 231–32, pl. III; Angerer, 1984, no. 33, fig. 56.

The ornamentation of the scabbard is reminiscent of the series of twelve "candelieri" by Zoan Andrea and Fra Antonio da Monza, of 1495/1500. Various elements — swags, rods, festoons, and foliage — are arranged around an underlying central axis. The eagle with spread wings and the three winged putti above it, which surround a small tablet bearing the date 1539, are among the figural and decorative motifs that Flötner adapted from different designs on the *candelieri*. The putti here, engaged

Design for a Silver Flask with a Self-Portrait

After 1540
Pen and black ink, with yellowish green wash,
on paper
14³/₄ x 7 in. (37.5 x 17.8 cm.)
Hamburg, Hamburger Kunsthalle
52003

By the close of the fifteenth century, the naturalistic tendencies in Italian Quattrocento art were beginning to influence all manifestations of the decorative arts produced north of the Alps. Albrecht Dürer, who was trained as a goldsmith, designed a goblet in the shape of an apple (the design is in the *Dresden Sketchbook*). (There is an actual goblet of this type, although slightly different in shape, in the Germanisches Nationalmuseum; see cat. no. 208.) Thirty years later, Peter Flötner replaced the traditional embossed goblet with such natural forms as quince and shells — a type of ornamentation that would leave its mark on succeeding generations of goldsmiths and designers. In Nuremberg, animal forms in art appear for the first time on the *Sebaldus Tomb* (fig. 135). The shrine is supported by a series of small snails, and many other animals and shells enliven the severity of its classical-style figures. However, the natural forms are cast from free-form wax models, and not from nature — as was the practice of Wenzel Jamnitzer, at the middle of the sixteenth century.

As in Peter Flötner's design for a mirror (in the Graphische Sammlung, Universität, Erlangen), in the present unsigned design the foot of the silver flask is supported by blowfish. The teardrop-shaped flask is framed by two eagles that appear to grow out of cornucopias with acanthus decoration. The section between the body and the neck of the flask is outlined by symmetrical foliage configurations, while on the edge of the lip there is a wreath bearing fruit. The stopper is crowned by a winged putto holding a basket of fruit on his head. Two similar putti appear among the many who cavort in the water in the *Design for the Foot of a Goblet* (see cat. no. 251).

The decoration in the central part of the flask consists of a portrait medallion amid curling ribbons, suspended from a ribbon and bowknot that issue from the mouth of a mask made of leaves. The bust of a bearded man, set within several concentric circles, is turned to his left, his neck extending to the rim of the innermost circle. In a design for a bed by Flötner, signed "PF" and dated 1533, there is a seated figure that has always been identified as a self-portrait. The present design for a flask, only recently attributed to Flötner, is the first self-portrait among his drawings. The conclusive evidence can be found in the copy of a portrait signed "PF" and dated 1551 (in the Graphische Sammlung, Universität, Erlangen); there, face, hair, and beard correspond to such a degree with those in the Hamburg drawing that there can be no doubt

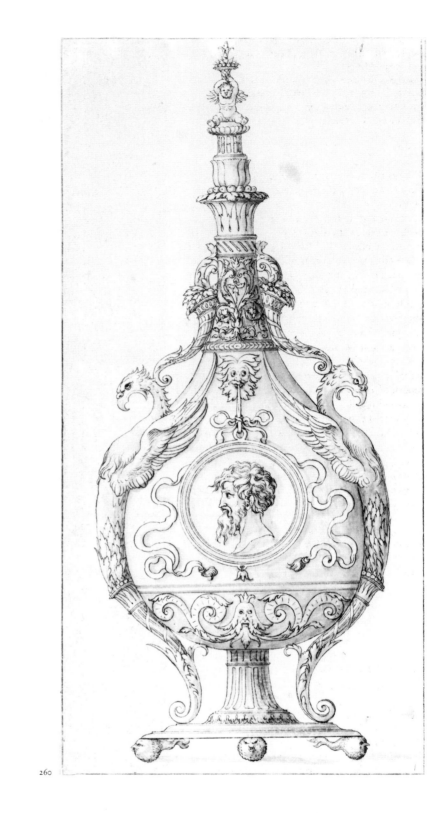

260

that we have before us an image of the master of the *Apollo Fountain* (cat. no. 248). Why he should have included a self-portrait in such a design is not clear, unless he merely sought some motif to fill an otherwise empty space.

With its economy of ornamentation, applied with a sure hand, the Hamburg design is in the tradition of Dürer's designs for silver flasks — copies of which survive in Basel and in Dresden. The handles at the base of the neck indicate that the present example derives from the flat

wooden or metal type of vessel known as a pilgrim flask. At the same time, the goblet shown here is an indication of how, during the Renaissance, objects lost their original functions, and were only collected to be displayed as works of art.

MA

EX COLLECTION: Ludwig Hermann Philippi, Hamburg.

BIBLIOGRAPHY: Angerer, 1984, no. 39, fig. 62.

261: *Clio*

261: *Temperance*

261: *Justice*

261 PETER FLÖTNER

Justice, Temperance, Pride, and Clio

About 1540
Brass, with dark brown patina
3 1/4 x 2 1/8 in. (8.3 x 5.4 cm.), 2 15/16 x 2 1/16 in. (7.5 x 5.2 cm.), 3 1/16 x 2 in. (7.8 x 5.1 cm.), and 3 3/16 x 2 1/4 in. (8.1 x 5.7 cm.), respectively
Lakewood, Ohio, Heinz Schneider Collection

Each of these four vertical plaquettes depicts a single female figure standing on grassy ground. In three of the plaquettes there is a distant landscape in the background, with a low horizon and bits of architecture tucked among the hills and trees; the fourth shows a high-walled courtyard, or garden. The figures are only partially covered by their draperies, notable for their multiple curvilinear folds. The hair of each figure is mostly gathered up on the top and back of the head with only an occasional twisted strand hanging down alongside the neck. Three of the women are shown frontally in contrapposto poses; the remaining figure, who is mixing wine and water, is in profile, facing left.

Occasionally, such plaquettes were duplicated in goldsmiths' work and in brass. Three brass mortars from the workshop of Wenzel Jamnitzer (Nuremberg, 1508–about 1586) contain in their decoration replicas of Peter Flötner plaquettes of this type (W. D. Wixom, *Renaissance Bronzes from Ohio Collections* [exhib. cat.], The Cleveland Museum of Art, 1975, no. 183). The mortar in the Cleveland Museum includes a cast of the *Pride* plaquette.

Each of these plaquettes is part of a larger series. *Justice*, with her sword and scales, and *Temperance*, with her wine and water cups, are part of a series of the seven cardinal virtues; the other virtues are shown similarly and against landscape backgrounds. The winged, half-nude *Pride*, who stands before a horse, and holds a mirror, is one of the seven deadly sins. The figure pointing to the books scattered beneath her feet is Clio, the Muse of history and one of the nine Muses. The virtues, deadly sins, and Muses were frequently depicted on metalwork, from the Middle Ages on (see, for example, J. Weitzmann-Fiedler, *Romanische gravierte Bronzeschalen*, Berlin, 1981).

While the frontal contrapposto poses of the figures on three of the plaquettes partially recall the inkpot figures of Peter Vischer the Younger (cat. nos. 195, 196; see H. Stierling, "Kleine Beiträge zu Peter Vischer. X. Neue Vischerwerke in Baden-Baden," *Monatshefte für Kunstwissenschaft,* 1922, pp. 27, 28), the specific figure proportions — small heads and torsos, and long legs — the stringy yet form-clinging draperies, and the hairstyles may derive from some of Jacopo de' Barbari's engravings (J. A. Levenson, K. Oberhuber, and J. L. Sheehan, *Early Italian Engravings from the National Gallery of Art*, Washington, D.C., National Gallery of Art, 1973, nos. 136, 139, 145), which were extremely influential in Nuremberg.

The *terminus ante quem* provided in the earlier literature in relation to the *Rappoltsteiner Pokal,* of about 1543, in the Schatzkammer, Munich, is not valid, because the virtues there are from a series of seated virtues (Weber, 1975, vol. 1, p. 72). The series of standing virtues might date to about 1540, since the figure style reflects the inventions of Peter Vischer the Younger, as adapted in Flötner's drawings, of 1537 (E. F. Bange, "Zur Datierung von Peter Flötners Plakettenwerk," *Archiv für Medaillen- und Plaketten-Kunde,* 1921–22, vol. III, p. 48, pls. VI, VIII). WDW

EX COLLECTIONS: Barsanti, Rome; [Alavoine, Paris, 1971].

BIBLIOGRAPHY: Wixom, 1975, nos. 173, 174, 175, 172, respectively; Weber, 1975, 2 vols., pp. 71, 72, 73, 77, nos. 55.6 (*Temperance*), 55.7 (*Justice*), 56.1 (*Pride*), 58.4 (*Clio*), pls. 13, 14, 16 (comparative examples and literature); *Wenzel Jamnitzer . . .*, 1985, p. 428, nos. 548 (*Temperance*), 549 (*Justice*).

261: *Pride*

262 PETER FLÖTNER
Design for a Wall Fountain

About 1540
Pen and black ink, with watercolor, on paper
14 7/8 x 12 1/4 in. (37.8 x 30.9 cm.)
The upper right-hand corner is missing.
Provenance: unknown.
Berlin-Dahlem, Staatliche Museen Preussischer
Kulturbesitz, Kupferstichkabinett
1263

Konrad Lange, who gave Flötner the somewhat
unfortunate appellation of "pioneer of the Ger-
man Renaissance," published this *Design for a
Wall Fountain* for the first time, in 1897. Four
nude men and two nude women are bathing in a
grotto. The influence of Dürer's depiction of
the nude on Flötner's has already been noted in
the literature. Figures from Dürer's *Men Bath-
ing*, of about 1496, might have served as models
for the corpulent man, seated at the right, the
man at the center, with his back to the viewer,
leaning on the retaining wall, and the man with
a fiddle, at the left in the present drawing. The
presence of the mountain goats might derive
from Dürer's engraving of *Adam and Eve*, of
1504 (cat. no. 121).

The grotto appears to have been man made.
The setting of this place of refuge is a rocky
landscape with trees, grass, and animals. Flötner
plays with the proportions of the tree trunk and
the group of trees opposite it, as well as with
those of the bathers and the goats high up on the
rock; with this artifice he removes all traces of
reality from the scene. Water spouts from the
mouths of two cherubs on either side of a ewer
set into a niche, and from a faun's mask in the
lower center of the composition. An opening at
the top of the grotto is the original source of the
water. Instructions — by Flötner(?) — below
the drawing state that the design is a first draft
and is not drawn to scale, and that the materials
necessary to carry out the work would be sup-
plied by "maister pangratz" ("Die fissirung Ist
nit die Recht gross Sunder Ein mainung dor
Von man muss dem prunenn Und Berckwerck
nach machenn Bei maiser pangratz findt/man
wol aller ley gaittung dor nach fein zwsamen
richt Und ordennir"). This must certainly refer
to the Nuremberg brass caster Pankraz Laben-
wolf (1492–1563), whose collaboration with
Flötner on the *Silver Altarpiece* (fig. 70) for the
Sigismund Chapel at Wawel Cathedral, in
Cracow, was mentioned in 1547 by Johann
Neudörfer (*Des Johann Neudörfer Nachrichten
von Künstlern und Werkleuten daselbst aus dem
Jahre 1547*). If one were interested, one could
contact the artist, and in his workshop one
would surely find the various actual architectur-
al components — perhaps even already existing
models for them. To what extent Labenwolf
was technically responsible for the source of the
water cannot be determined. Ernst Kris
supposed that the stones and minerals indicated
in Flötner's drawing would have been available
in the foundry. Often, such stones (*Handsteine*)
were presented to the owner of a mine by the
miners. During the sixteenth century, they were

262

much sought after as collectors' items for
Kunst- and *Wunderkammern* (art and natural
history collections). Sometimes a goldsmith
might make metal mounts for them, adorned
with small groups of figures. In the *Design for a
Goblet* (Paris, Bibliothèque Nationale), Flötner
shows the lid as a rocky landscape that, in the
finished work, would actually be composed of
different minerals. Thus, nature would be trans-
formed into art: An artificial world would be
created in miniature, in which a cast "after
nature" played an important part. "The trans-
formation in attitude — and that is what is
meant here — is fundamental. Man takes refuge
in nature that he creates artificially and trans-
forms into a hitherto unknown experience.
Dürer's people bathe and remain untouched by
romantic nature, utterly indifferent to their
surroundings, exhausting themselves in their
normal, everyday routines" (E. F. Bange).

MA

BIBLIOGRAPHY: Lange, 1897, p. 56 f., ill.; Bock, 1921, no.
1263, p. 42; Kris, 1926, p. 169 f., fig. 131.

263 PETER FLÖTNER (model)
MELCHIOR BAIER (?) (goldsmiths' work)
Coconut Goblet (with Case)
(the so-called Holzschuher Goblet)

Before 1540
Goblet: coconut, carved, with silver, cast,
embossed, chased, and gilded
Height, 17 1/8 in. (43.5 cm.)
Case: poplar, turned, with canvas, and sheepskin
stamped in black and gold
Height, 19 1/4 in. (48.9 cm.)
The goblet bears the Nuremberg mark, a reversed
"N" (Rosenberg, vol. 3, no. 3736); there are no
master's marks.
Nuremberg, Germanisches Nationalmuseum (on
permanent loan from the city of Nuremberg)
HG 8601

Coconuts were considered miraculous even in
antiquity, and were displayed as rarities in
Greek temples. They are found in reliquaries in
medieval treasuries and in the art and curio col-
lections of princes. Up until the beginning of
the modern era, and the discovery of the New
World, they were considered rare and inexpli-

cable objects that proved the existence of fantastic unknown regions (R. Fritz). Even in the Middle Ages, coconuts were credited with magical properties on account of their mysterious origins. Like many other substances, they were thought to expose the presence of poisons. In the sixteenth century, a burgher who owned a coconut thus exhibited something of his wealth and his humanistic interests. As in earlier times, goldsmiths were given the task of adorning these precious objects, and carvers delighted in working the hard, exotic material. Sometimes coconut shells were left practically in their natural state; in other instances they were highly polished. Some bear inscriptions or carvings in relief warning against the excessive use of wine. Other popular coconut-carving motifs were Old Testament stories, such as the Return of the Spies, the Drunkenness of Noah, or Lot and his Daughters. These are precisely the subjects of the relief medallions on a coconut beaker attributed to Peter Flötner (in the Kunsthistorisches Museum, Vienna, no. 912), which was probably made only shortly before the *Holzschuher Goblet*.

The low-footed vessel in Vienna, which is adorned with virtuoso figural and ornamental elements, was executed with considerable reserve on the part of the goldsmith. By contrast, the *Holzschuher Goblet* betrays the congenial collaboration of goldsmith and designer.

The Nuremberg mark on the bottom of the foot, a reversed "N," is the only marking.

In 1897, when the goblet was still in the possession of the patrician Nuremberg Holzschuher family in Augsburg, Konrad Lange first proposed that it represented the collaboration between Peter Flötner and the goldsmith Melchior Baier.

The carvings on the coconut, and the design of the figures on the foot and the lid of this unique example of Nuremberg goldsmiths' work from the first half of the sixteenth century, reveal such close similarities to designs and plaquettes by Peter Flötner that one can safely consider this his work. As early as 1547, Neudörfer wrote of Flötner: "His delight in his day-to-day work, however, was in carving in white stone, producing nothing but figures to be used for embossing or casting by goldsmiths in the decoration of their works." Neudörfer also mentions that Flötner collaborated with Baier on the *Silver Altarpiece* (fig. 70) in the Sigismund Chapel in Cracow's cathedral. Since the two artists had, indeed, worked together on such a project, it is conceivable that Flötner and Baier might have produced another major work like the *Holzschuher Goblet* together — although this hypothesis remains undocumented.

The round foot is composed of simple convex and concave moldings topped by a laurel wreath, above which is a plot of landscape, including large boulders and tree stumps, executed with great naturalism. From its center rises a thick vine stem, around which a slender shoot with grapes and leaves is twisted. These elements are cast — as are the various three-dimensional figures. A naked putto, his legs spread apart, stands in the middle of the landscape bearing a shield with the Holzschuher coat of arms, which he rests on a tree stump. The ends of the cloth draped around the shield cover his arms. Beside him is an exquisitely worked basket filled with grapes, and, on the

263: detail

opposite side, a cooling flask. On the opposite side of the foot from the putto, a woman sits, cross-legged, on the ground, holding a corner of her drapery in her right hand, in front of her face, so as not to look at the goat mounting a ewe nearby. In fact, however, she clearly peaks over the cloth and delights in the scene. To her left is another pair of figures. A bearded satyr leans against a tree stump sound asleep — or is he only pretending? A woman holding a tankard in her lap sits in front of him, and, with her free hand, attempts to rouse him in a rather unusual way. Nearly at the top of the vine-stem shaft is a squat knop formed of panicles and burst pea pods, which supports the capital-like base of the coconut. Three gilded-silver vertical bands with arabesques enclose the coconut cup and continue across its lid. The interior of the vessel was left virtually in its natural state. The coconut is astonishing both for its size and its nearly perfect spherical form. At the points where the silver rim, engraved with flower and acanthus-leaf ornamentation, intersects with the three vertical bands, it is decorated with cherub heads.

Two bands divide the nut horizontally. The resulting three panels on its lower third are filled with symmetrical designs of curling foliage and fruits emanating from both sides of the winged heads and masks.

In the larger panels above, Peter Flötner represented the Triumph of Bacchus in low relief, incorporating in the scene all of the debauchery and excess that result from the immoderate enjoyment of wine. The god of wine, a naked, shapelessly fat man, leads the procession. Crowned with a wreath of vine leaves, he sits atop a triumphal car like the one in the *Triumph of the Christian Church,* or in the small woodcut *The Triumph of Gluttony* that is signed "PF." The car is drawn by a goat, who conveniently passes through a gate at the point where

263: detail

the silver band crosses the scene, thereby entering the next panel. Two naked men help by pushing the car from behind. Another man fills Bacchus's outstretched wine cup from an antique pitcher. Next to him, still another nude figure is drinking from a second pitcher. There is a striking similarity between him and the figure drinking from a tall, stemmed glass in the *Design for a Fountain* (cat. no. 262). The only clothed participant is a man who walks next to the shaft of the car, seemingly uninvolved but still drawn along by the procession. In his right hand he holds a tall glass, and with his left hand he reaches for his sword. It has often been suggested that this figure is a portrait, but it remains unidentified.

The procession moves out of a wooded landscape with palace-like architecture into a space set aside for pleasure, in which all manner of drunken revelry is taking place. It recalls the bacchanal with the drunken Silenus, by Andrea Mantegna, which is also set in front of an espalier of grapevines. Mantegna's engraving was, in fact, copied by Dürer, and it would appear that Flötner adopted some of the figures either from the original or from Dürer's copy.

The explicitness of the second relief continues into the third, which, again, presents a landscape with a palace and stands of trees. In the background, to the right, is probably the earliest depiction of an antique glade in the art of the modern era, north of the Alps. A couple is seen making love next to a ball-footed obelisk, in front of a grove of trees flanked by two herms — the type of artificial, idyllic landscape that particularly appealed to eighteenth-century tastes. At the left is a scene reminiscent of Lot and his daughters: A drunken man is being supported by two women. Nearly a century ago, it was suspected that, at some point, the middle part of the man's body was deliberately struck off by some prudish soul "obviously on account of the obscene portrayal." The circle of the procession is closed by the naked man who steps through the posts of a gate and bumps into the group already described. A satyr crouching on the man's shoulders is being sick on one of the men pushing the car.

The top of the lid continues the same theme. A naked fat man lies on a grassy bank, amid a pile of vine leaves and grapes. A satyr stands in front of him with his legs far apart, pouring wine into the man's mouth from a fat wineskin. A second, full wineskin is at his feet.

Peter Flötner, who is unquestionably responsible for the models for the figures on the base, as well as on the lid, here reveals the uniqueness of his style of Northern Renaissance art, not only in his knowledge of the new "Italian ornament" but also in his treatment of the freely rendered human form. The high quality of these figures, and the way in which they were designed to be seen from all angles make it perfectly possible to imagine them life size and equally fascinating. Another example of Flötner's ability as a sculptor is his brass *Apollo* (cat. no. 248).

Because of the inclusion of the mining scenes

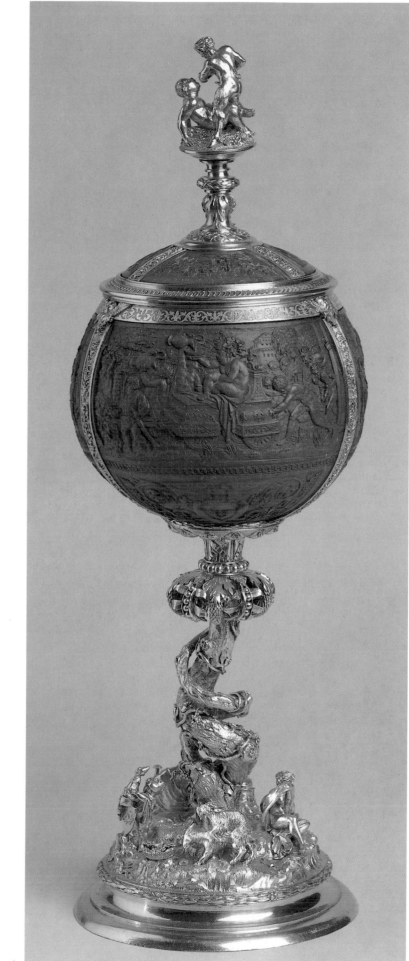

263

264

on the lid, Konrad Lange suggested that perhaps Berthold VIII Holzschuher, from the Hungarian branch of the family, possibly commissioned the goblet. Berthold's son Alexander was involved in mining and died in 1564 in Lettowitz, in Moravia. At the time that the goblet is thought to have been made, Alexander celebrated his marriage, "for which occasion the drunken wantonness of the decor would be suitable" (Kohlhaussen, 1968, p. 439). Erasmus, Berthold's oldest son, died in 1593. That date appears on the later (expanded) Holzschuher coat of arms painted on the reverse of the glass inside the lid. Thus, he was then the goblet's owner. The work is mentioned twice in seventeenth- and eighteenth-century documents, where it is attributed to Wenzel Jamnitzer.

The goblet's case is stamped in black on the rough inner surface of the leather, rather than on the smooth outer side, causing the designs — imitation ermine, medallions, and scales — to stand out against a velour-like background.

Gold was only used on a wreath of flames around the base of the top section. The stamps for the rippled scales and the heads also appear on the case made for the *Pfinzing Bowl* (cat. no. 212). MA

EX COLLECTION: acquired from the Holzschuhersche Familienstiftung by the Stiftung zur Erhaltung Nürnberger Kunstwerke (1905).

BIBLIOGRAPHY: Lange, 1897, pp. 93–103, pl. 1; Frankenburger, 1901, no. 124; Rosenberg, 1925, no. 3756; Kris, 1926, pp. 165 ff., ill., 120 f., 1932, no. 24, ill.; Braun, in *Flötner*, 1946–47, no. 407; Holzhausen, 1958, p. 151, ills. 224, 226–229; Philippovich, 1966, p. 484, ill. 324; Kohlhaussen, 1968, pp. 477–79, no. 469, ills. 677–681; Hernmarck, 1978, pp. 91 f., ill. 83; Pechstein, 1978, p. 182, ill. D, 1982, p. 396, ill. 3; Fritz, 1983, p. 38, pl. 26; Angerer, 1984, p. 171; Pechstein, in *Wenzel Jamnitzer...*, 1985, pp. 215, 216, no. 11, colorpl. 2.

264 Quatrefoil Roundel, with Tournament Scenes

Dated 1508
Pot metal and white glass, with silver stain
Diameter, 11 3/4 in. (29.8 cm.)
Arms: (top lobe) Or a double-headed eagle displayed sable crowned and nimbed of the first. Inescutcheon Austria impaling Burgundy [for the empire]; (central shield) In chief to dexter: Azure a *Jungfrauenadler* or [for Nuremberg]. In chief to sinister: Or a demi imperial eagle displayed sable impaling bendy of six gules and argent [for Nuremberg]. In base: Azure a triangular faceted stone or at each corner a six-pointed star of the same [for Geuder] supported by two amorini proper.
Baltimore, Walters Art Gallery
46.76

The familial arms displayed in the center of this quatrefoil roundel indicate that the panel must have been made for a residence of the Geuder family, members of the wealthy burgher class in

Nuremberg at the beginning of the sixteenth century. The arms of the family appear again on the crest of the helmet of the knight in the left lobe and on the caparison of his mount. The shield and the crest of his combatant display the melusine, the emblem of the Rieter von Kornburg family, also of Nuremberg. This identification of the arms in the tournament scenes with local families calls into question Schmitz's theory (1913, II, p. 11, no. 193) that the arms in these quatrefoil roundels are pure fantasy and have nothing to do with actual heraldry — a question that has still not been answered. More significant, however, is the difference in meaning of this roundel, and the absence of social ridicule that, in other scenes, is hinted at by the presence of fools imitating the actions of their overlords. Instead, a tournament staged by members of rival families of the same social class takes place beneath the protection of the imperial arms and those of the city of Nuremberg. The heralds who announce the start of the tournament complete the symbolism. Although later in date than the two quatrefoil roundels in the Metropolitan Museum (cat. no. 66), this example is also considered to be based on designs by the Master of the Housebook. In actuality, however, it is closer to the more exuberant Nuremberg style of the early sixteenth century. Other examples of this style are found in a drawing, attributed to a member of Dürer's school, of two lobes from a four-part roundel, now in the Graphische Sammlung, Universität, Erlangen, and in a pen-and-ink sketch by Hans Suess von Kulmbach in the British Museum.

JH

Ex collections: [H. G. Gutekunst, Stuttgart]; Eugen Felix, Leipzig; William Stillwell, New York; [A. S. Drey, Munich].

Bibliography: Schmitz, 1913, 1, pp. 155–56, ills. 257, 258, 2, pp. 11, 15, pls. 192, 266; Stadler, 1936, p. 104, pl. 3, no. 6 a; Winkler, 1941, 28, pp. 243–49, pls. 1, 7; Winkler, 1942, p. 88, pl. 97; *Walters . . . Bulletin*, 1960, 12/5, n.p.; Wentzel, 1966, no. 6, p. 360; Becksmann, 1968, 26, no. 6, p. 359, no. 35; *3000 Years in Glass . . .*, 1982, no. 6.

265

265 Jousting Helmet (*Stechhelm*)

Nuremberg, about 1500
Steel, with brass rivets
18 x 11 in. (45.5 x 28 cm.)
New York, The Metropolitan Museum of Art, Bashford Dean Memorial Collection, Gift of Edward S. Harkness, 1929
29.156.67a

This helmet does not bear any marks, but in construction and outline it is so similar to the helmets of a group of jousting armors (*Stechzeuge*), formerly in the Nuremberg city arsenal and now preserved in the Germanisches Nationalmuseum, that its Nuremberg origin can be safely assumed. It is, furthermore, practically identical to the helmet in Albrecht Dürer's

drawing of a *Stechhelm* seen from three different sides, all of its straps and points securing the thickly padded and quilted helmet cap inside (fig. 110; Strauss, 1974, no. 1495/49). The present helmet contains a modern replica of such a helmet cap, copied after one of the eight surviving originals in the Waffensammlung, Vienna, and strapped and tied according to Dürer's drawing.

The *Stechzeug* with its *Stechhelm* was strictly tournament equipment, much too cumbersome for battle or campaign conditions, although the *Stechhelm* was developed from the thirteenth-century battle helmet. In order to avoid whiplash or back injuries in the hazardous sport of jousting, the upper body of the jouster was corseted into a specially designed cuirass, and the helmet bolted on in front and back. The jouster's head was enclosed by the padded helmet cap, which was held away from the helmet walls by the straps and ties anchored securely in the strategically placed eyelets. The quarter-

inch-thick frontplate of the helmet was shaped like a ship's prow to deflect lance points; the many scars on its surface testify to the heavy use this helmet has seen.

Tournaments were a regular entertainment in the Nuremberg market square not only as part of Shrovetide festivities but also as celebrations of patrician weddings and other joyous occasions. The city arsenal kept a number of *Stechzeuge*, as well as *Rennzeuge* (for the German type of joust fought with pointed lances, instead of lances blunted with coronels), to be rented to young patricians eager to show their prowess in the lists. The last of these *Gesellenstechen* was held in 1561. A late-sixteenth-century illustrated manuscript in the Metropolitan Museum records important tournaments held in Nuremberg, such as the *Gesellenstechen* of 1446, 1539, 1546, and 1561.

In the center of the frontplate is a chiseled X-shaped mark; this was most likely an assembly mark to ensure that the helmet would be prop-

265: rear view

erly matched up with its fitted breast- and backplate, when stored in the arsenal. A pair of dots punched on the frontplate, on the outside as well as on the inside, might have been a kind of serial number. The absence of the "half-eagle" mark may indicate that this helmet was made before 1498. HN

EX COLLECTION: Count Erbach, Castle Erbach, Odenwald.

BIBLIOGRAPHY: Müller-Hickler, 1923, 2 vols., pl. XXII4v, no. 151; Pilz, 1932, pp. 74–80, ill.; Grancsay, 1933, no. 51, pl. XXXI.

266 VALENTIN SIEBENBÜRGER

a) Armor for the German Joust

Nuremberg, about 1535
Steeled iron, hammered, filed, and polished, with portions riveted to leather straps
40 1/2 x 32 1/4 x 29 1/2 in. (103 x 82 x 75 cm.); weight, about 88 lbs. (40 kg.)
The original heavy padding is missing.
Nuremberg, Germanisches Nationalmuseum (acquired, 1889)
W 1276

b) Targe

South Germany, about 1500
Leather-covered wood
14 1/8 x 14 1/8 x 3/4 in. (36 x 36 x 2 cm.); weight, about 4 lbs. 10 oz. (2.1 kg.)
Nuremberg, Germanisches Nationalmuseum
W 1311

The fluted jousting helmet is secured to the breastplate by several setscrews and to the back by a covered turnscrew. The beveled breastplate supports a queue and a lance rest. Screwed to the bottom of the breastplate is the skirt with tassets to protect the thighs. The fluted backplate ends in a *Schwänzel* (tail), which protected the pelvis in the event of a fall. The pauldrons, with their long wings at the back, are screwed to straps that fit over the shoulders and connect the breastplate and backplate. As was customary, only the left armguard is fitted out with a heavy tilting gauntlet, or *poldermitton*; the right hand was well protected by the vamplate of the lance. The armpits were covered by roundels, only one of which has survived. The targe is tied onto the breastplate. The main elements carry the master's mark of the famed Nuremberg armorer Valentin Siebenbürger (born, about 1510; named master, 1531; died, 1564), as well as the inspection marks of the city.

According to a sixteenth-century inventory, the Nuremberg armory once contained eight sets of jousting armor and four suits of armor for the German course *(Rennen)*. About 1800, during the threat to the city by the French, these were illegally sold by an Austrian officer to the military contractor Dietrich and were removed to Feistritz, his castle on the Wechsel, in Austria. By inheritance, seven of the jousting sets came into the possession of Prince Sulkowski, from whose collection the Germanisches Nationalmuseum acquired them in 1889; the museum also owns the four sets of coursing armor. Except for the collection in Vienna, this is the largest group of old, matching tournament armor in the world. The eighth jousting armor was not acquired by Dietrich, and it is highly probable that it is the one now preserved in the Higgins Armory in Worcester, Massachusetts (cat. no. 273).

In the Holy Roman Empire, only noblemen were allowed to take part in tournaments. Since ordinary citizens were excluded from them, the Nuremberg patricians, like those in a number of other cities, decided to hold their own. In Nuremberg, these events were known as "bachelor jousts" *(Gesellenstechen)*. The first one was held in 1446, and it greatly angered the aristocracy, who saw it as an affront to their own long-standing privileges. Nevertheless, even princes later took part in bachelor jousts in Nuremberg. Interest in the sport declined in sixteenth-century Nuremberg, and, in 1561, the last such event was held there.

Initially, jousting armor was privately owned, but at the end of the fifteenth century the city council bought a number of sets, which were then rented to the participants in the bachelor jousts. This purchase was apparently related to sumptuary laws that banned luxurious display — the patrician families were thus prevented from spending large sums for armor used solely for sporting purposes. These families had to pay only for the various ornamentations in their armorial colors, the crest, the horse trappings, and so on.

Jousting was a special tournament event in which the heavily armored opponents rode against each other in an open arena without a dividing plank and tried to unhorse each other by using blunt lances about twelve feet (3.7 meters) long and weighing about thirty-three pounds (15 kilograms). Despite heavy armor with considerable inner padding, combatants were often badly wounded, and accidental deaths were not uncommon. Because of the considerable weight of the armor, the contestants had to mount their horses by means of a kind of stepladder. Tournament armor was, to a certain extent, simply sporting equipment; it was impractical for use in warfare. Welcome interruptions of daily life, the tournaments themselves were social events of the highest order, and each one was talked about for years afterward.

Of the seven suits of jousting armor in the Germanisches Nationalmuseum, five date from 1480/90. About 1535, Valentin Siebenbürger made new pauldrons and armguards, or vambraces, for them, as well as a few other spare parts. Two of the late-fifteenth-century pauldrons and vambraces are preserved in the Germanisches Nationalmuseum. It appears that at the time that he modernized the older sets of armor, Siebenbürger was also commissioned to make three completely new ones. The jousting armor in the Higgins Armory is apparently one of these. JW

EX COLLECTIONS: Nuremberg armory; Schloss Feistritz, on the Wechsel, Austria.

BIBLIOGRAPHY: Essenwein, 1889, pp. 215–22; Thomas and Gamber, 1976, pp. 133–76 (solely regarding the history of jousting); Willers, 1978, pp. 833–59 (see pp. 840–42, on the history of the Germanisches Nationalmuseum's acquisition of the tournament armor).

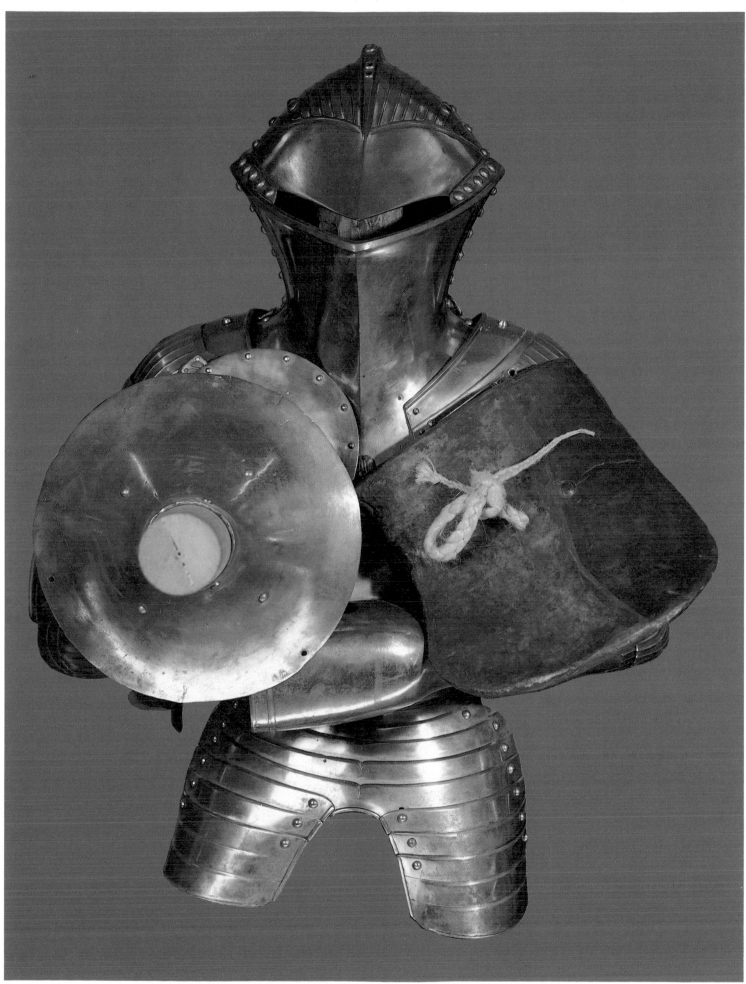

457

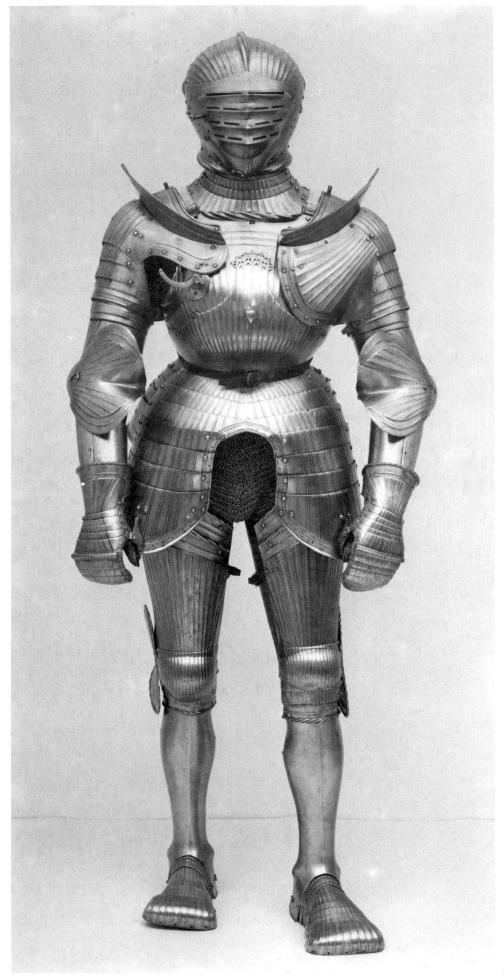

Armor

Probably Nuremberg, first quarter of the
16th century
Steel, with leather straps
New York, The Metropolitan Museum of Art,
Gift of Alan Rutherford Stuyvesant, 1949
49.163.1a—s

Armor plates with regularly fluted surfaces were very popular in Germany during the first decades of the sixteenth century. Such armor is sometimes called "Maximilian," because it was introduced during the reign (1493–1519) of Emperor Maximilian I. Perhaps created to achieve the dazzling effect of sunlight playing on rippling steel, the flutings turned out to be a strengthening device, similar to corrugated iron, which enabled the armorer to use thinner and, thus, lighter plates. However, the precision work involved drove the price of such fluted armor high enough that the fashion disappeared before the middle of the century, although it was revived for a short period some fifty years later.

The armorer's mark, stamped on the breast- and backplate as well as on one of the knee caps, is a shield shape with the initials "LB" surmounted by the head of a bear wearing a collar around its neck. Although the "half-eagle" mark of Nuremberg is absent, this mark of a bear — an animal called "Meister Petz" or "Betz" in German animal fables — might be tentatively attributed to a member of the Petzold (Bezold) family of Nuremberg armorers.

HN

BIBLIOGRAPHY: Cosson, 1890, p. 324, ill.; *Exhibition of the Royal House of Tudor*, 1890, no. 578; *Collection of Baron C. A. de Cosson*, 1893, no. 240, ill.; *Collection of Lord Stafford*, 1895, no. 102; Dean, 1911, no. 10, pl. VIII, 1914, no. 12, pl. VI, VII, fig. 12; Laking, 1920, vol. 3, p. 250, fig. 1036; Cripps-Day, 1925, p. 8 (Stafford sale); Grancsay, 1931, no. 5, ill., 1956, p. 217, ill.

Armor

Nuremberg, about 1530
Steel
Vienna, Kunsthistorisches Museum,
Waffensammlung
A 237

This armor, made for Duke Ulrich of Württemberg (1487–1550), is one of the finest in the Maximilian style in existence, and shows its attractive fluted surface to perfection. The dazzling play of light on the hollows and ridges when the armor was in motion would brighten the Northern Renaissance heaviness of the horizontal cabled borders and the hefty rounded forms.

The asymmetry of the shoulders, with the left pauldron much larger than the right, is due to their function in combat with lances. In order to accommodate the couched lance, the right pauldron had to be severely cut back, far above the level of the lance rest (the hook attached to the right side of the breastplate). The body area most exposed to lance thrusts was the left side, and the left armpit was particularly endangered. An opponent's lance slipping in under the armpit could easily dislocate or break the arm. The left pauldron therefore was made as large as possible in order to cover this vulnerable spot. Outward-turning guard plates attached to the shoulders protected the neck and chin against lance thrusts and sweeping sword blows. When, after the lance was broken in the initial shock charge, the knight had to fight with sword or mace in hand-to-hand combat, the lance rest could be safely folded away in order not to hamper the sword arm.

The visors of sixteenth-century German helmets are sometimes in the form of fiercely grimacing human or animal faces; these are called *Schembart* visors, after the masked revelers in *Schembartlaufen*, the medieval Shrovetide parades. Nuremberg, incidentally, was famous for its Shrovetide parades, often held along with a tournament in which the younger members of the patrician families participated. The studs that remain on the breast, left elbow, and left gauntlet of Duke Ulrich's armor indicate that it was designed for reinforcement elements that would have enabled it to be used for the tournament, where its *Schembart* visor would be appreciated. H N

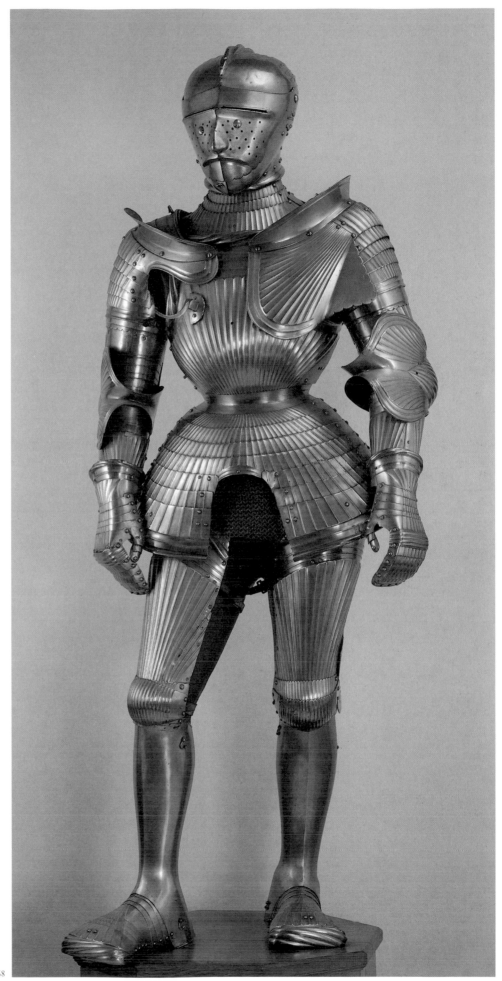

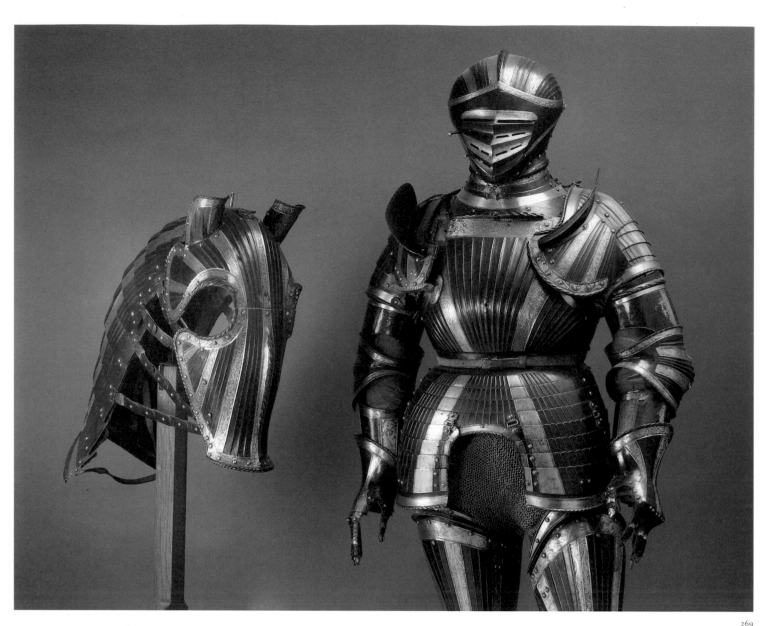

269 HANS RINGLER

Chanfron and Crinet

Nuremberg, 1530
Steel, etched
Vienna, Kunsthistorisches Museum,
Waffensammlung
A 347

This chanfron and crinet are parts of an armor
for man and horse made for John Frederick the
Magnanimous, Prince Elector of Saxony
(1503–1554). It is stylistically identical to an
armor garniture made for the Count Palatine
Ottheinrich (now in the Musée de l'Armée,
Paris, G 40, with additional elements in the
Wallace Collection, London, A 29), which is
signed by Hans Ringler (active 1520–1547). For
this reason, although the armor for John Fred-
erick is stamped only with the "half-eagle" city
mark of Nuremberg, it can be confidently
attributed to Hans Ringler.

The man's armor has a fluted surface in the
Maximilian style. This surface strengthened the
resistance qualities of the plates, which could

thus be kept thinner and lighter in weight. The
armor is also partly blackened in what was orig-
inally a rust-proofing process, but here, it was
also used for decorative effect, by contrasting
the blackened areas with brightly polished
stripes or borders.

John Frederick, as Prince Elector of Saxony,
was the hereditary arch marshal (commander in
chief) of the empire, and was also one of the
seven electors responsible for the selection of
the emperor. Despite this, John Frederick be-
came the leader of the League of Schmalkalden,
the confederation of Protestants that opposed
the Catholic Emperor Charles v. In 1547, at the
Battle of Mühlberg, the League was defeated,
John Frederick taken prisoner, and his offices
transferred to his cousin, Maurice of Meissen,
who, although Protestant himself, had sided
with the emperor.

HN

BIBLIOGRAPHY: Thomas and Gamber, Vienna, 1976,
p. 1238.

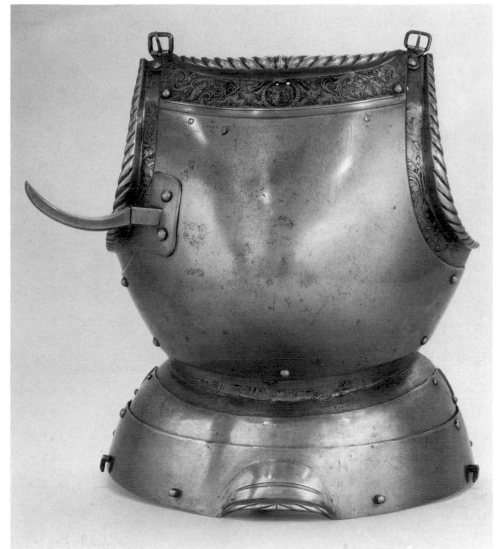

270 VALENTIN SIEBENBÜRGER

Breastplate

Nuremberg, about 1530–35
Steel, partly etched
15 x 13 ¹/₂ in. (38 x 34.5 cm.)
New York, The Metropolitan Museum of Art,
John Stoneacre Ellis Collection, Gift of Mrs. Ellis
and Augustus Van Horne Ellis, 1896
96.5.115

The only surviving piece of an armor cap-à-pie, this breastplate is rounded in the fashion of the German Renaissance; its globose form, with an emphasis on the horizontal, is in contrast to the vertical lines of fifteenth-century Gothic examples, and to the sharp lengthwise ridges of the Spanish-influenced style of the mid-sixteenth century. A wide band of decoration etched with floral scrollwork enlivened by cornucopias, musical instruments, and grotesques, and with a Renaissance medallion containing the profile portrait of a Roman imperator, flanked by fierce lions and playful amorini in its center, is found along the upper edge of the breastplate and around the arm gussets.

The breastplate's upper border is stamped with the "half-eagle" mark and the maker's personal mark: the helmet with a fleur-de-lis crest flanked by the "F" and "S" of Valentin (Falentin) Siebenbürger. Next to this mark is a group of one large and five small punched dots; this is an assembly mark to identify elements belonging together. A complete and homogenous armor by Valentin Siebenbürger, from the same period, preserved in the city arsenal of Solothurn, Switzerland, is stamped with the identical maker's mark and with an assembly mark of seven dots.

The lance rest on the breastplate is a modern replacement. H N

BIBLIOGRAPHY: Smith, 1983, pp. 250–51, no. 160, ill.

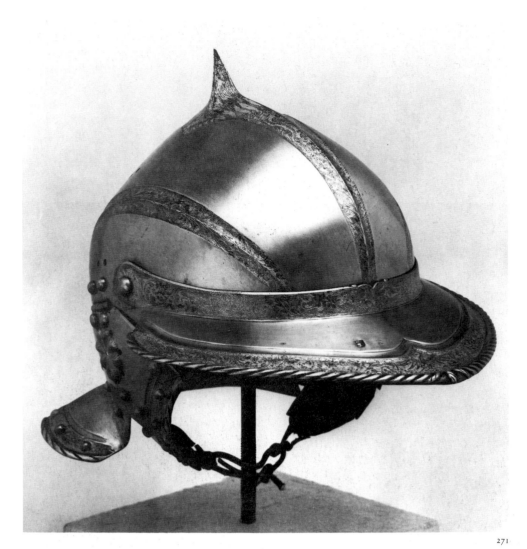

271 VALENTIN SIEBENBÜRGER

Burgonet

Nuremberg, 1532
Steel, etched
Vienna, Kunsthistorisches Museum,
Waffensammlung
A 376

Among the early-sixteenth-century helmet types, the open-faced burgonet with peak, hinged cheekpieces, and long neck-guard was the most practical and comfortable to wear. It became most popular with light cavalrymen, and particularly with foot soldiers, such as the lansquenets, the Germany mercenary infantry.

The burgonet is an adaption in steel of the peaked cloth cap worn by Spanish peasants, and it seems to have been introduced into Central Europe by the Spanish troops during the Italian and Netherlandish wars at the beginning of the sixteenth century. On the other hand, Eastern influences, through encounters with the Turks on the battlefields of Hungary, are evident in the structural details, such as the shape of the neck-guard and the spiked helmet bowl.

This burgonet is part of a half-armor, for infantry use, worn by Konrad von Bemelberg (1494–1567), a distinguished commander of the lansquenets. H N

BIBLIOGRAPHY: Grosz and Thomas, 1936, p. 47.

272 VALENTIN SIEBENBÜRGER

Pair of Gauntlets

Nuremberg, about 1535
Steel, etched and partly gilded, with brass rivets
Length, 11½ in. (29 cm.)
New York, The Metropolitan Museum of Art,
Fletcher Fund, 1911
11.145.1,2

A pair of gauntlets was one of the four compulsory *Meisterstücke* ("masterpieces") that were required in order to receive the rank of master armorer. Gauntlets were of two basic types — mitten and fingered — and garnitures of armor usually included one pair of each kind, to be used when appropriate.

These gauntlets, with seven metacarpal and seven finger lames, are one of the more elaborate specimens produced in this difficult form. Their smoothly curved shapes, with light touches of faceting and delicate gold-etched decoration, exemplify the restrained elegance of top-quality armor in the middle of the sixteenth century.

On the cuffs are stamped the "half-eagle" mark and the personal mark of the armorer, a shield shape enclosing a helmet with a fleur-de-lis as crest, flanked by the letters "F" and "s." Later works by Valentin Siebenbürger bear the same mark with the letters "v" and "s." For this reason, it is generally assumed that "FS" stands for Falentin Siebenbürger ("F" and "v" being pronounced alike in German), although it has been pointed out that an armorer named Friedrich Schmid was active at roughly the same time. H N

BIBLIOGRAPHY: Mann, 1962, vol. 1, p. 218 (FS mark of Valentin Siebenbürger and/or Friedrich Schmid discussed).

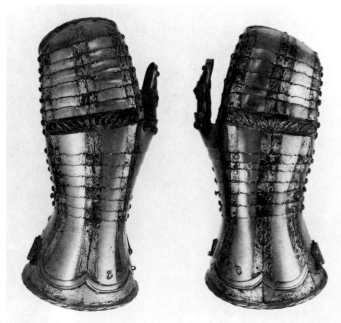

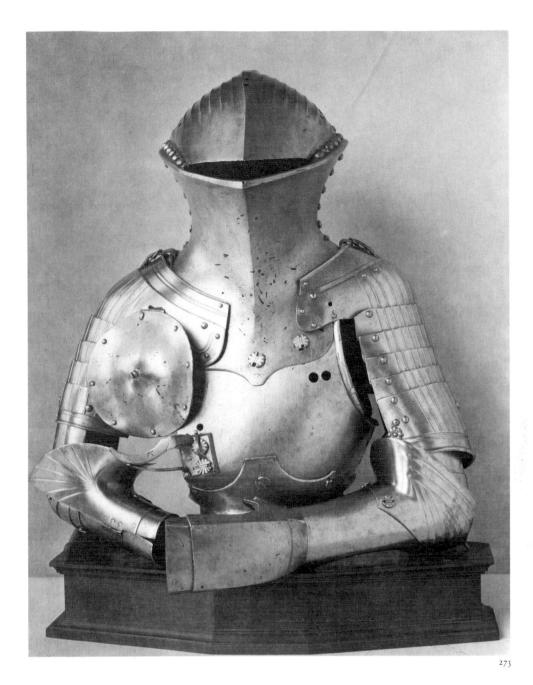

273 HANS GRÜNEWALT, VALENTIN
SIEBENBÜRGER, and others

Composite Armor for the German Joust

South German (Nuremberg), 1480–1540
Steel, brass, and leather
Height (as mounted), 29 3/4 in. (75.5 cm.)
Worcester, Massachusetts, The Higgins Armory
Museum
2580

This form of armor was used in the *Deutsche
Gestech* (German joust), in which the combat-
ant, armed with a lance with a crown-like tip,
attempted to unhorse his opponent by striking
the lance against a wooden shield fastened to the
breastplate. This particular harness, probably
from the Nuremberg Armory, passed through
the collections of the Count of Erbach, a Berlin
dealer, and Clarence Mackay of Long Island,
and then to the Higgins Armory.

The helm, perhaps by Hans Grünewalt, is late
fifteenth century and is similar to those depicted

in a drawing by Dürer (fig. 110; Strauss, 1974,
no. 1495/49). It is nearly identical to another
ex-Erbach helm in the Metropolitan Museum
(cat. no. 265). The front edge has bolt holes that
allow the helm to be fastened to the breastplate.
The skull is pierced on the sides and top for the
straps and cords of the arming cap. The nape is
incised with floral and heart-and-diamond
motifs. Deep gouges from lance blows scar the
throat.

The breastplate is contemporary, as is the
associated backplate. On the breast are threaded
holes for the lance rest, the restored queue, and
the helm. The holes at the left armpit are for the
shield.

The present arms are made from associated
components. The shoulders are by Siebenbürger
but are not a pair; they were probably made,
from 1535 to 1540, when he prepared defenses
for older helms and cuirasses. The *besague* at
the left armpit, like the arm defense below,
bears an inventory number of the Germanisches

Nationalmuseum, suggesting that components
from a very similar group in the Nuremberg
museum's collection were separated and later
incorrectly reassembled.

Also associated are the forearms, of about
1485–90. The right (*poldermitton*) was worn
without a gauntlet, as the hand was protected by
the funnel-like vamplate on the lance. The
heavy *manifer* on the left arm has a sixteenth-
century repair on its outer face. WK

BIBLIOGRAPHY: Müller-Hickler, 1922, 2; Kahlert, 1927,
n.p.; Grancsay, 1931, n. 4; *Art News*, 1940, 12, p. 20;
Grancsay, 1961, pp. 56–59, 1966, p. 212, n. 352, 1967, n.
4; Norman, 1971, 37, fig. 2, 1972, p. 172; Schedelmann,
1973, 26, n. 11.

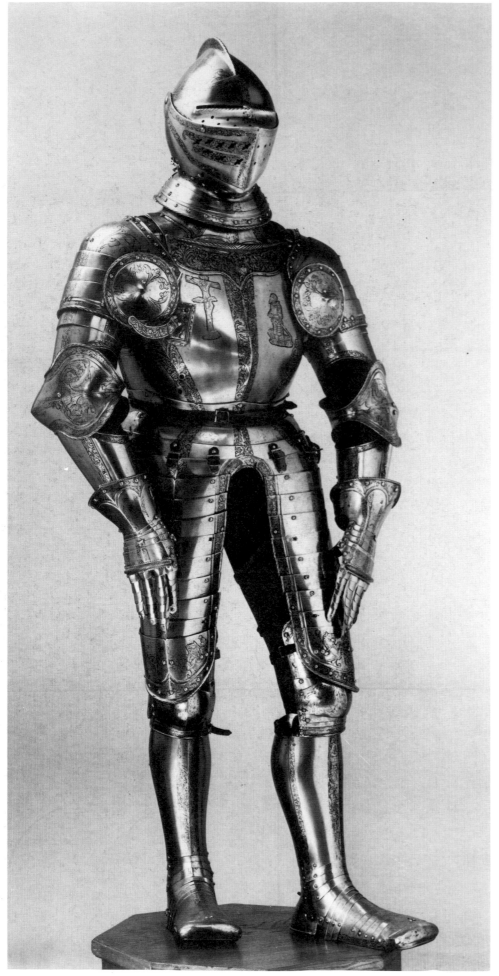

274 STYLE OF VALENTIN SIEBENBÜRGER
Field Armor
Nuremberg, about 1545–50
Steel, etched, with brass rivets
Vienna, Kunsthistorisches Museum,
Waffensammlung
A 2416

The collection of this armor is combined with
spaudlers (short shoulder guards). This indi-
cates that it is part of a once-larger field garni-
ture, which could be worn in alternate style as
armor for light-cavalry use *(Trabharnisch)* with
an open-faced burgonet and elbow gauntlets.
These and other exchange elements are now
missing. The armor was reconstructed in 1975
from its surviving elements in the Waffensamm-
lung.

The armor's etched decoration, although, in
part, very worn, is typical of the Northern Ren-
aissance grotesque style, with its interweaving
of floral scrollwork, human figures, and hybrid
monsters. The main decorative motif on the hel-
met is a man in armor, possibly Hercules, batt-
ling a lion; on the breastplate, the knight kneel-
ing before the cross represents a combination of
Humanistic and Christian motifs typical of
Renaissance iconography.

HN

275 KUNZ LOCHNER
Armor for the Horse
Nuremberg, 1548
Steel, embossed and etched, and leather straps
covered with velvet
New York, The Metropolitan Museum of Art,
Rogers Fund, 1932
32.69a–h

The horsemanship of the *chevalier* and the *Rit-
ter* gave each his name; therefore, the knight's
precious steed deserved as much protection as
his own body. As soon as the armorers' tech-
nology was sufficiently advanced, horse armor
was constructed that covered the head, neck,
and body of the knightly battle charger. Begin-
ning in the middle of the fourteenth century,
especially ambitious armorers even designed
cunningly articulated leg armor for horses, to
make them as invulnerable as a modern tank.

This paralleled the development of plate ar-
mor for the knight, which reached its peak by
the middle of the fifteenth century. By the close
of that century, it was the ultimate in elegance
to have the horse's armor match his rider's in
style and technique of decoration. The saddle,
as the connecting link between man and horse,
was also armored with plates of corresponding
design and ornamentation.

The present horse armor bears, on the center
of its peytral (breastplate), an elaborate three-
line inscription: "1 5 K 4 8 / 1 T G V G / H E H Z
Sachsen." Of these initials, only those in the
bottom row are unambiguous; they belong to
Johann [Hans] Ernst, Herzog zu Sachsen (the
Duke of Saxony). Johann Ernst (1521–1563)

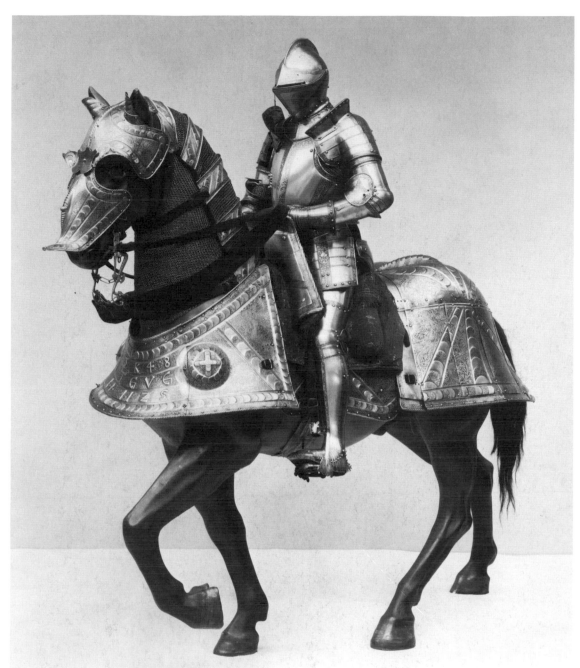

275

had acceded to the title of duke of Saxe-Coburg in 1541; he was the half-brother of the Prince Elector of Saxe-Wittenberg, John Frederick the Magnanimous, who was taken prisoner in the Battle of Mühlberg (1547), when he led the rebels of the Protestant League against the emperor Charles V. In 1548, Charles V called the Diet of Augsburg, which, under the circumstances, was a *geharnischter Reichstag* (that is, an assembly at which the delegates appeared in armor); it is most likely that this horse armor was ordered by Duke Johann Ernst for that occasion.

Of the other initials, "K" has been thought to stand for Koburg (Coburg), the capital of Johann Ernst's duchy, and "ITGVG[H]" for his motto: "Ich traue Gott von ganzem Herzen" ("I trust in God with all my heart").

The inscription panel is filled with elegantly etched floral scrollwork and is flanked by two

hemispherical bosses *(Streifbuckel)*, embossed with cross straps in a circle, built up in a high-relief scale pattern of alternately blank and floral-etched scales. A spider web of similar scale-patterned straps covers the other elements of the armor, the side plates of the peytral, the flanchards, and, most conspicuously, the crupper. The same scale straps border the chanfron and diagonally traverse the spaced lames of the crinet. The background spaces between the straps are filled with vigorously sketched, etched grotesques in scrollwork.

On the forehead of the chanfron is an escutcheon with the arms of Saxony: barry of sable and or, a crancelin vert in bend overall. The ear protectors are ornamented with a pattern of alternately blank and etched spiral flutings, which indicates that they have been cut down from what were originally boldly curved ram's horns. Such ram's horns — undoubtedly

an allusion to Alexander the Great's horned steed Bucephalus — are characteristic features of horse armors preserved in the Real Armería, Madrid, and in the Livrustkammaren, Stockholm; the armors bear the marks of Kunz Lochner, together with the Nuremberg "half eagle." The present horse armor contains the Nuremberg "half eagle" (three times) and the Nuremberg *Hammerwerk* mark of the letter "N" within a pearled border. Although it does not have the personal mark of Kunz Lochner, a heraldic lion in a shield, derived from the Lochner family arms, as illustrated in Jost Amman's *Wappenbuch* (of 1586), it can be confidently attributed to this Nuremberg master on the basis of style.

This horse armor was kept in the armory of the Wartburg until the duke presented it to Count Erbach, in 1785; it remained in Castle Erbach until 1932, when it was acquired by the Metropolitan Museum. It was first illustrated in

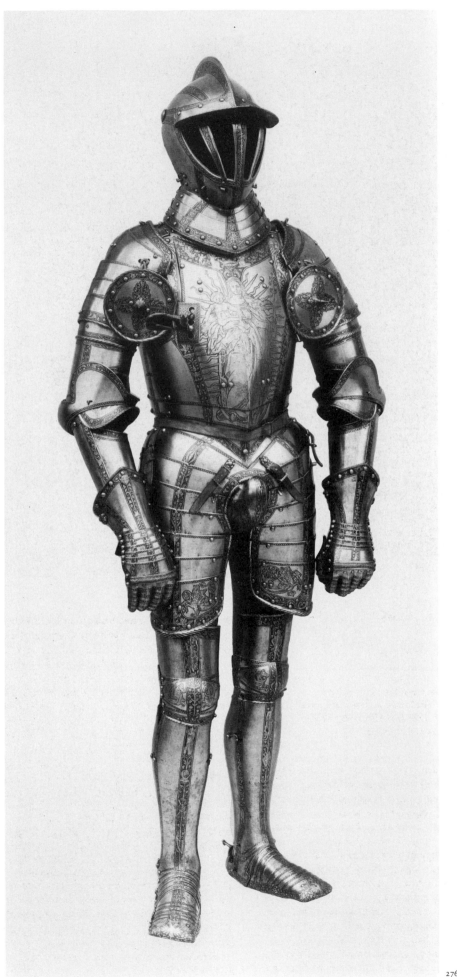

the manuscript catalogue (of 1807) of the Erbach Collection.

The horse armor is mounted with a man's armor (Metropolitan Museum, 29.151.2), stamped with Kunz Lochner's mark, and with a saddle (Metropolitan Museum, 32.69i–n), on the burr plate of which are the initials "K L."

HN

276 KUNZ LOCHNER

Armor

Nuremberg, 1549
Steel, etched, with brass rivets, and leather straps
New York, The Metropolitan Museum of Art,
Gift of George D. Pratt and Rogers Fund, 1933
33.164a–x

Because this armor was made for a man of very slight build with unusually long arms, Ortwin Gamber, director of the Waffensammlung, Vienna, believes that it belonged to Archduke Ferdinand (1503–1564), King of Bohemia, who later became Emperor Ferdinand I, King of Bohemia and Hungary (1526), and emperor (1558). When the armor belonged to the counts Erbach, at Castle Erbach, Odenwald (by 1812, until 1933), it was known as the armor of Albrecht V (1528–1579), Duke of Bavaria.

The most conspicuous motif etched on the breastplate is the large image of the Virgin and Child on a Crescent Moon (dated 1549), surrounded by an aureole of light *(Maria im Strahlenkranz auf der Mondsichel)*. On the backplate is a large saltire of ragged staves with the firesteel and sparks of the Order of the Golden Fleece; in the area of the shoulder blades are two oblong medallions in architectural frames, depicting Saints Peter and Paul. The decoration of three bands, following the fashion of the Spanish doublet, is filled with floral scrollwork interspersed with cornucopias, arms trophies, grotesques, and allegorical figures. The iconography of the Virgin on the breastplate and icons of the saints on the backplate is similar to that on a group of armor (in the Real Armería, Madrid) made for Ferdinand's brother, Emperor Charles V. On the toe caps are double-headed eagles surmounted by a royal crown, a combination most suited to Ferdinand rather than anyone else.

The helmet is not part of the original garniture. Although an open-faced bourgonet such as this one could be an alternate headpiece to the proper visored helmet, its etched decoration of purely floral scrollwork, without any figural motifs, differs from the pattern of the rest of the armor. The cabled strips edging the individual

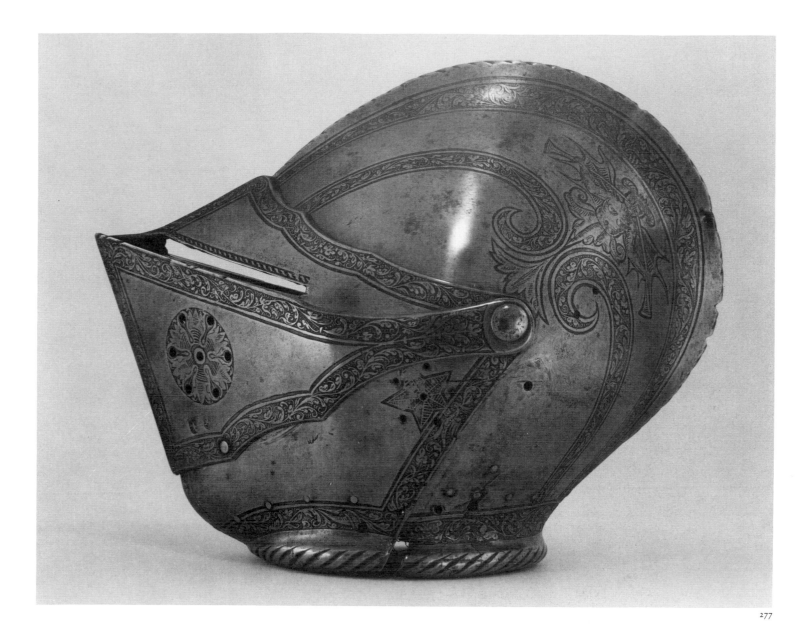

lames of the cuirass and arm and leg defenses are absent from the elements of the helmet.

This armor is stamped with both Nuremberg control marks — the "half-eagle" city arms and the letter "N" in a pearled border — yet, there is no personal master's mark. The attribution is based on the stylistic similarity to remnants of armor garnitures made by Kunz Lochner, about 1545, for Ferdinand's son and successor, Maximilian II (1527–1576; r. 1564–76), and for Ferdinand, himself, and preserved in the Waffensammlung, Vienna (A 529, A 824).

HN

EX COLLECTION: Count Erbach, Castle Erbach, Oden-wald.

BIBLIOGRAPHY: *Kurze Beschreibung des Rittersaales...*, 1812, p. 35, no. II.15 (mentions that this suit stood at Amberg); Kress, 1832, p. 20, no. II.16, pl. XVII; Schaefer, 1891, VI, pp. 69–70, fig. 40; Müller-Hickler, 1926, pls. XIV–XV; Grancsay, 1934, pp. 102–4, ill.; Mann, 1940, p. 15, pl. VIII; Thomas, 1944, p. 99, pl. I; Schedelmann, 1973, bk. I, p. 30, no. 15, ill.

277 KUNZ LOCHNER

Helmet

Nuremberg, about 1550
Steel, etched
Height, 13¹/₂ in. (34.3 cm.); width, 8¹/₈ in. (20.6 cm.); weight, 6 lb. 9 oz. (3 kg.)
New York, The Metropolitan Museum of Art,
Gift of Mrs. Theodore Offerman, 1939,
in memory of her husband
39.38

The helmet and body armor were joined by fitting the hollow lobe encircling the helmet's neck opening over a matching lobe on the top lame of the colletin. The fitted lobes permitted freedom of movement. Each of the moving parts here — upper visor, lower visor, and chin defense — pivots at the temples. All closing devices (most of them spring catches) are broken or lost, with the exception of one hook-and-eye catch and the visor prop, both on the right side of the chin defense. Stamped on the left side of the lower visor are the mark of Kunz Lochner and the "half-eagle" mark of Nuremberg.

Etched along the comb and around the edges of the visor and chin defense are bands of floral scrollwork on a dotted background. On either side of the helmet bowl is a pair of scrolls of the same foliate decoration, surmounted by a grotesque monster, with horns and batwings, blowing a double trumpet. On the right side of the visor are three circular rosettes pierced by groups of breathing holes; similar groups of perforations for hearing surround large five-pointed stars on the sides of the chin defense. These stars, an unusual decoration, might indicate a provenance from the arsenal of Castle Hohenaschau in Bavaria. The castle was owned by the counts von Freyberg, whose arms were per fess argent and azure, in base three stars or. Objects of Freyberg/Hohenaschau origin in the Metropolitan Museum (horse armor, 23.261; chanfrons, 14.25.1641, 14.25.1644; and a tournament targe, 23.261s) bear these arms. The star appears as a horse brand at Hohenaschau.

HN

EX COLLECTIONS: R. R. Hillingford; Theodore Offerman.

BIBLIOGRAPHY: Cosson and Burges, 1881, no. 53, fig. 50; *Loan Exhibition of European Arms and Armor*, 1931, no. 80, ill.; Grancsay, 1939, pp. 114–16, ill., 1953, no. 27; Smith, 1983, no. 161.

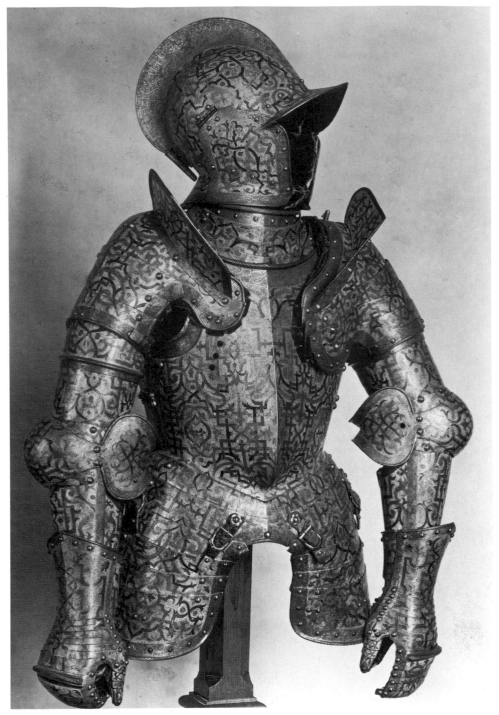

Figure 140 Armor of Prince Nikolaus "The Black" Radziwill. Waffensammlung, Kunsthistorisches Museum, Vienna

its exchange elements and accessories. By any standards it was the most opulent armor ever worn in Poland.

Unfortunately, this armor survives only in very fragmentary condition. Originally, it must have been a garniture of the kind called *Doppelküriss*, a specifically Nuremberg type. Consisting of a basic *Küriss* (full armor cap-à-pie), exchange pieces would turn it into a *Feldküriss* (light field armor), a *Freiturnierharmisch* (open-field tournament armor), and a *Ballien-Rüstung* (armor for the joust across the barrier, in the manner of the electoral court of Saxony). Armor for the horse was also included. The armor of King Sigismund II Augustus, by contrast, comprised only a full armor for man and horse, without any exchange pieces, as far as we know.

The surviving elements of the Radziwill armor include a half-armor in the Waffensammlung, Vienna (fig. 140; A 1412), composed of an open-faced burgonet (one out of at least five headpieces of the complete garniture), a cuirass, and arm defenses. A sallet (*Rennhut*) for the joust across the barrier is in the Musée de l'Armée, Paris (H 52); in addition to the present chanfron, a reinforcing shoulder, two tassets, a vamplate for a lance, and a single lame of the crinet (horse's neck armor) are in the Metropolitan Museum (14.25.854, 855, 856, 881).

As can be deduced from the horse armor in Stockholm, the present chanfron must have had ear protectors in the shape of ram's horns, a feature characteristic of horse armor from Kunz Lochner's workshop.

The decoration of the king's armor in Stockholm followed the standard mid-sixteenth-century pattern, with three wide, gilt-etched bands on breast- and backplate, in imitation of the embroidered seams of the fashionable Spanish doublet; black and gold strapwork on white fills the spaces between these bands. In the Radziwill armor, the strapwork of gold, black, and

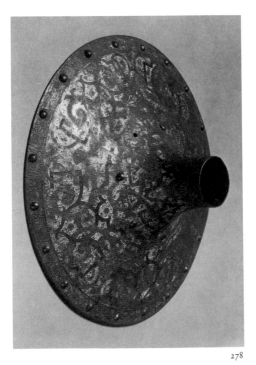

278

278 KUNZ LOCHNER

Chanfron and Vamplate

Nuremberg, about 1555
Steel, etched, partly gilded, and painted
22¹/₂ x 14¹/₄ in. (70 x 60 cm.)
New York, The Metropolitan Museum of Art,
Rogers Fund, 1921
21.42

This chanfron was part of a magnificently colorful garniture of armor for man and horse, made for Nikolaus IV "The Black" Radziwill (1515–1565), Duke of Nieswiez and Olyka, Prince of the Empire, Grand Chancellor and Marshall for Lithuania, Woiwod of Wilna, Starost of Schaulen, etc. Enormously rich, Nikolaus the Black was the most powerful magnate in the Polish realm. Significantly, the armor's sumptuous decorations of intricately interlaced arabesques in gold, black, and red, on a white background, are strikingly similar to those in gold and black, on white, on a garniture for man and horse made about 1555 by Kunz Lochner for Sigismund II Augustus, King of Poland (1520–1572; r. 1548–72), and preserved in the Livrustkammaren, Stockholm. The Radziwill armor, however, surpassed that of the king, by far, in its color effect as well as in the number of

468

red is spread evenly over the white background like a textile pattern, doubtless in imitation of the sumptuous Eastern carpets and robes, which were prized booty in Poland's century-long wars with the Turks.

Incidentally, in 1559 Kunz Lochner had to travel to Poland to collect the balance of the payments for the king's, and presumably also Prince Radziwill's, armor.

The composed half-armor in Vienna was acquired in 1580 from Nikolaus the Black's son, Nikolaus Christoph (1548–1616), by the avid arms collector Archduke Ferdinand of the Tyrol for his *armamentarium heroicum* at Castle Ambras near Innsbruck. The elements in Paris and New York were probably set adrift from the Radziwill armory during the Napoleonic Wars, which wreaked havoc on so many old armories. HN

EX COLLECTIONS: Prince Radziwill; Bachereau, Paris; Prince Peter Soltykov; William H. Riggs, Paris.

BIBLIOGRAPHY: *Collection H. P. de B . . .* (Count Kouchaleff-Bezborodko), 1912, p. 9, no. 17; Dean, 1921, pp. 80–82; Piotrowska, 1943, no. 44, pp. 8–10, ill.; Thomas, 1944, p. 115, pl. 47, 1947–48, pp. 61–92, figs. 41–47, 1971, pp. 66–68, figs. 55–58.

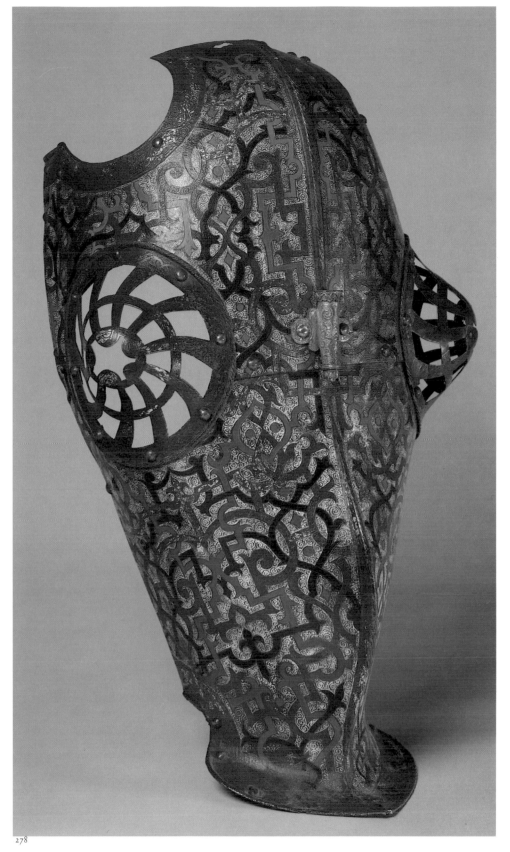

278

Adam Kraft

Adam Kraft, a stone sculptor in Nuremberg, was probably born there about 1455/60; he is known to have been active in that city from 1490 until his death (sometime between December 13, 1508, and January 10, 1509). Neudörfer reported, in 1547, that Kraft was acquainted, from childhood, with Sebastian Lindenast the Elder, the Nuremberg coppersmith, and Peter Vischer the Elder, the brass caster, with whom he remained friends in later life. While no information exists about his years as a journeyman, his work suggests that he traveled to Swabia and the Upper Rhineland. This is supported by a comparison with the tabernacle, dating from 1464–71, in the Ulm Minster; the pulpit, by Hans Hammer, of 1485, in Strasbourg Cathedral; and the sculptures by Nikolaus Gerhaert van Leyden (probably originally from the Netherlands but active in Trier, in 1462; in Strasbourg, from 1463 to 1467; and in Vienna, from 1467 until his death in 1473). Kraft's most important monuments, commissioned by members of Nuremberg's patrician families, include the *Schreyer-Landauer Epitaph* (fig. 81), of 1490–92, on the exterior of the Sebalduskirche; the *Sacrament House* (figs. 60, 62, 63), of 1493–96, in the Lorenzkirche; the *Pergenstörffer Monument*, of 1498–99, now in the Frauenkirche; the *Landauer Epitaph*, of 1503, now in the Tetzelkapelle at the Egidienkirche (see cat. no. 99); the *Stations of the Cross*, of 1506–8, now in the Germanisches Nationalmuseum; and the *Entombment*, in the Holzschuherkapelle at the Johannisfriedhof, Nuremberg.

Ludwig Krug

Ludwig Krug, a goldsmith, printmaker, medalist, and painter, was born in 1489/90 in Nuremberg, the son of the goldsmith Hans Krug the Elder. He became a master goldsmith in 1522. Krug died in Nuremberg in 1532. Although he was praised by his contemporaries for his artistry in various fields, very little is known about his life. His prints have been clearly identified, but his paintings must be considered lost. A stone relief of Adam and Eve (see cat. no. 204), dating from 1514, was copied in bronze and in lead. Of the important goldsmiths' work attributed to him, the most notable are the mounted shell carvings with scenes and figures, elements of which reflect the influence of Dürer.

Hans Suess von Kulmbach

The painter and designer of stained glass was born about 1480, presumably in Kulmbach in Upper Franconia, and died in 1522 in Nuremberg. He is thought to have studied with Jacopo de' Barbari, who was active in Germany after 1500. Kulmbach acquired Nuremberg citizenship in 1511. He was influenced by Albrecht Dürer, upon whose design his painting of the epitaph for Lorenz Tucher (fig. 96), of 1513 (in the Sebalduskirche), was based. He provided the drawings for the stained glass in the choir of the Sebalduskirche (fig. 102) and, on a number of occasions, worked for patrons in Cracow. The majority of his altarpieces were created in collaboration with sculptors.

Sebastian Lindenast the Elder

Sebastian Lindenast the Elder, born about 1460, was a goldsmith who mainly made figures and vessels of embossed copper. He was granted the special privilege of gilding his works, but was required to leave a penny-sized section exposed, a so-called "Spiegel" (mirror), in order that a potential buyer could immediately recognize the less valuable metal. In 1513, in Brussels, he was even given an imperial privilege to produce copper objects in the tradition of goldsmiths' work. His most well-known achievement, the *Männleinlaufen* ("Parade of the Little Men"), made for the mechanical clock on the façade of the Frauenkirche, in Nuremberg, was executed from 1506 to 1509. The figures include Emperor Charles IV, the seven electors, and trumpeters, horn players, heralds, and bell ringers; some of the originals, from Lindenast's time, are still preserved. He died in 1526.

Master of the Tucher Altarpiece

The name of the Master of the Tucher Altarpiece derives from an altarpiece (fig. 92), now in the Frauenkirche, in Nuremberg, that was moved in 1615 from the Augustinerkirche to the Kartäuserkloster, and was restored at the expense of the Tucher family (see cat. no. 30). The works associated with the artist suggest that he studied in Austria, in the circle of the Master of the Saint Lamprecht votive panel, and that he came into contact with the great masters of the west, Robert Campin and Claus Sluter. He was active in Nuremberg between 1438 and 1450.

Masters of the "Nuremberg 1525/26" and "1527" Group

In the three years between 1525 and 1527, some fifty medals were produced in Nuremberg. They were definitely not created by a single carver, yet they reveal a close association between workshops. It has been suggested that the medalists were Peter Flötner, to whom only two medals, bearing his initials, are still ascribed today; Ludwig Krug, whose work as a medalist is undocumented, with the exception of a reference in Neudörfer's biography of him; and, finally, Matthes Gebel, about whose activity in the years between 1523 and 1527 nothing is known.

As long as none of the medals in this group can be linked with certainty to a specific artist, it seems reasonable, when attributing them, to retain the anonymous designation Masters of the "Nuremberg 1525/26" and "1527" Group.

Georg Pencz

Pencz, a painter, engraver, and designer of woodcuts, was born about 1500. Dürer is believed to have engaged him to apply his talent for painting to the murals in the Rathaus, in Nuremberg. In 1525, together with the brothers Sebald and Barthel Beham, Pencz was expelled from the city for expressing his atheistic and anarchistic views, but he was allowed to return later that year. In 1532, he became a city painter. Pencz visited Italy several times. While there, he apparently was impressed by trompe l'oeil ceiling paintings, which he subsequently introduced into Nuremberg. In 1550, he was named court artist to Duke Albrecht of Prussia, in Königsberg, but died either in Breslau or in Leipzig, on his way to accept the appointment.

Hans Pleydenwurff

Hans Pleydenwurff was born probably in Bamberg, and died in Nuremberg in 1472. He was active in Bamberg before 1457, when he moved to Nuremberg and acquired citizenship there; his workshop associates remained in Bamberg. Pleydenwurff traveled along the Lower Rhine and in the Netherlands, where he studied the art of Rogier van der Weyden and Dirk Bouts (see cat. nos. 39, 41). One documented work by Pleydenwurff is the altarpiece installed in 1462 on the high altar of the Elisabethkirche, in Breslau; only portions of it survive (fig. 93). His son Wilhelm was active as a painter and designer of woodcuts (for the *Schatzbehalter*, and the *Chronicle of the World*; see cat. nos. 86, 87). His widow, Barbara, married the painter Michael Wolgemut in 1472.

Hans Schwarz

Hans Schwarz was born in Augsburg, where he trained as a sculptor in 1506. He subsequently practiced his trade in various workshops of the so-called Danube school. Beginning in 1516, he worked on his own, and, in 1518, produced his first portrait medals in Augsburg. His patrons were primarily members of the Imperial Diet in Augsburg. In 1519 and 1520, he worked in Nuremberg, and then at the Palatinate court in Heidelberg, but nothing further is known of him. Of the preparatory portrait sketches that Schwarz made for his numerous medals, 137 survive.

Veit Stoss

The sculptor Veit Stoss was born before 1450 (possibly in 1447; according to Neudörfer, as early as 1438) in Horb am Neckar. He died on or about September 20, 1533. Nothing is known of his training or of his arrival in Nuremberg. In 1477, Stoss gave up his Nuremberg citizenship to move to Cracow. While there, he created the altarpiece for the high altar of the Marienkirche,

between 1477 and 1489; the stone Crucifix for Heinrich Slacker, also in the Marienkirche, in 1491; the red marble tomb monument for King Kasimir IV Jagiello, in Wawel Cathedral, in 1492; and tombs for Polish bishops. His oldest surviving work, dating from after his return to Nuremberg in 1496, is the Volckamer Monument, completed in 1499 (see cat. no. 89). Between 1500 and 1503, he produced a large, carved altarpiece for the high altar of the Stadtpfarrkirche in Schwaz, in the Tyrol; it no longer survives. In 1503, in connection with some kind of speculative business scheme in which he felt that he was cheated, he forged a promissory note. For this, he was jailed, convicted, and branded on both cheeks. In 1504, he fled to Münnerstadt; then, after returning to Nuremberg in 1506, he was again thrown into prison. Once released, his work and travel were restricted. It is possible that he received a commission for the tomb of Emperor Maximilian I, in Innsbruck, but his attempts at casting figures in brass were unsuccessful. In 1516, he created the *Raphael and Tobias* group (cat. no. 93); in 1518, the *Angelic Salutation* (fig. 61), for the Lorenzkirche; and, between 1520 and 1523, the altarpiece for the Karmeliterkirche (see cat. no. 94). No works are known from the last decade of his life.

Willibald Stoss

Willibald Stoss, the sculptor, goldsmith, and cloth merchant, was the son of Veit Stoss and his wife, Christine Reinhold. He was born about 1500, and died in Schweinfurt in 1573. Originally a sculptor, he was still referred to as such by his stepbrother Dr. Andreas Stoss in 1534, but, subsequently, he concentrated increasingly on the minting of coins. For years he was involved in mining, and in later sources he is cited as a maker of clothing and as a fabric merchant. In 1555, he was elevated to the nobility along with his two sons, who worked in the imperial chancellery. From 1560 on, he was a citizen of Schweinfurt. Except for the *Chandelier in the Form of a Dragon* (cat. no. 150), no carvings of his are known.

Wolf Traut

Wolf Traut was born in Nuremberg about 1485, and died there in 1520. A painter and a designer of woodcuts and stained glass, he was apprenticed to his father, Hans Traut, a native of Speyer, who became a citizen of Nuremberg in 1477. From 1505, Traut is recorded as having worked in the atelier of Albrecht Dürer. Dürer employed him, in 1512/13, to make woodcuts for the *Triumphal Arch of Emperor Maximilian I*. From 1513 to 1518, he was commissioned to execute altarpieces for the monastery in Heilsbronn (see cat. no. 170). The *Artelshofener Altarpiece*, of 1514, his best known, formerly in the Tuchmacherkapelle, at the Lorenzkirche, is now in the Bayerisches Nationalmuseum, Munich.

The Vischer Family

The Vischers were a family of brass casters who were active from the mid-fifteenth until the second half of the sixteenth century, and whose foundry was the most important and famous in Germany during this period. The major works of the first two generations of Vischer masters were church furnishings and tomb monuments commissioned for the churches of Nuremberg — and, afterward, for those elsewhere in Germany and in foreign cities. Beginning in the early sixteenth century, the Vischers made smaller objects, including medals, plaquettes, and inkpots. The earlier church commissions were Late Gothic in style, whereas the later productions adapted important Italian Renaissance elements.

Hermann Vischer the Elder

Hermann Vischer the Elder became a citizen of Nuremberg in 1453, and was the initiator, there, of the Vischer dynasty of brass casters. He cast mainly tomb plaques and church furnishings, including the baptismal font, of 1457, for the Stadtkirche, Wittenberg (see fig. 85). He died in 1448.

Peter Vischer the Elder, and his sons

Peter Vischer the Elder, the son of Hermann the Elder, was born about 1460, and died in 1529. He became a master in 1489, having taken over his father's brass foundry. He is credited with casting numerous brass tomb monuments, including the Tomb of Archbishop Ernest of Saxony, of 1494–95, in Magdeburg Cathedral (fig. 134); the *Sebaldus Tomb*, of 1507–19, in the Sebalduskirche, Nuremberg (cat. no. 190; fig. 135); and the statues of Kings Arthur and Theodoric, of 1512–13, for the Hofkirche, Innsbruck. In 1512, he was commissioned to execute the monumental brass screen initially intended for the Fugger funerary chapel in Augsburg; the screen was completed by his sons, and adapted for the Great Hall of the Rathaus, in Nuremberg (cat. no. 199). After 1510, Peter the Elder's sons Hermann the Younger (about 1486–1517), Peter the Younger (1487–1528), Hans (about 1489–1550), Jacob, and Paulus (died 1531) figured in increasingly active roles in the workshop, not only casting, but also supplying models. Hermann the Younger and Peter the Younger, the most important, probably traveled to Italy, for it was they who introduced Italian Renaissance elements into the workshop's productions. It is likely that Hermann the Younger was the designer, and made the model, for the first phase of the Fugger Chapel screen. Peter the Younger must have been responsible for the major portion of the models for many of the figures on the *Sebaldus Tomb*. His *Epitaph of Dr. Anton Kress,* of 1513 (fig. 87), in the Lorenzkirche, Nuremberg, is remarkable for its Renaissance

restraint and elegance — characteristics shared, on a smaller scale, by his plaquettes and inkpots, which were undoubtedly made for his Humanist friends. Hans Vischer adapted and completed the Fugger screen for installation at the Rathaus. Hans's son, Georg (about 1520–1592), continued to operate the workshop until his death. He is known only for a series of small, signed statuettes and inkpots (see cat. no. 200), which were produced when the family workshop was in its last years, and diminishing in importance.

Michael Wolgemut

Michael Wolgemut, a painter of panels and glass and a designer of woodcuts, was born in Nuremberg in 1434 or 1437, and died there in 1519. He was a pupil of Gabriel Malesskircher in Munich. In 1472, he married the widow of the painter Hans Pleydenwurff in Nuremberg. As an entrepreneur, Wolgemut commissioned painters, sculptors, glaziers, carpenters, and smiths to work for him. The altarpieces that he produced for the Marienkirche in Zwickau and for the Stadtpfarrkirche in Schwabach (figs. 65, 66) are still *in situ*. His illustrations for Hartmann Schedel's *Chronicle of the World* and for the *Schatzbehalter* (cat. nos. 86, 87) raised the woodcut to new artistic heights. Albrecht Dürer, who painted Wolgemut's portrait in 1516 (see cat. no. 139), had served as an apprentice in the master's workshop.

Bibliography

A

Abraham, Erich, *Nürnberger Malerei der 2. Hälfte des 15. Jahrhunderts* (Studien zur deutschen Kunstgeschichte, vol. 157), Strasbourg, 1912.

—, "Über die Quellen des Stils in der Nürnberger Malerei um 1400," *Repertorium für Kunstwissenschaft*, 1915, vol. 37, pp. 1–14.

Adams, Frederick B., Jr., *Twelfth Report to the Fellows of the Pierpont Morgan Library 1962*, New York, 1963.

Aign, Theodor, *Die Ketzel, ein Nürnberger Handelsherren- und Jerusalempilger-Geschlecht* (Freie Schriftenfolge der Gesellschaft für Familienforschung in Franken, vol. 12), Neustadt an der Aisch, 1961.

Alte Meister aus deutschem Privatbesitz (exhib. cat.), Bremen, Kunsthalle, 1966.

von Amira, Karl, and von Schwerin, Claudius Freiherr, *Rechtsarchäologie. Gegenstände, Formen und Symbole germanischen Rechts, Teil 1: Einführung in die Rechtsarchäologie*, Berlin, 1943.

Anders, Otto, "Nürnberg um die Mitte des 15. Jahrhunderts im Spiegel ausländischer Betrachtung," *Mitteilungen des Vereins für Geschichte der Stadt Nürnberg*, 1960, vol. 50, pp. 110–12.

André, Gustav, "Der Meister der 'Schönen Madonna' in der Sebalduskirche zu Nürnberg," *Zeitschrift für bildende Kunst*, 1930/31, vol. 63, pp. 167–74.

Andréossy, Comte Antoine-François, *Vente de la collection* (sale cat.), Paris, Hôtel Drouot, April 13–16, 1864.

Angerer, Martin, *Peter Flötners Entwürfe. Beiträge zum Ornament und Kunsthandwerk in Nürnberg in der 1. Hälfte des 16. Jahrhunderts*, Ph.D. dissertation, Munich, 1983; publ., Kiel, 1984.

Anton Tuchers Haushaltbuch (1507–1517), Wilhelm Loose, ed. (Bibliothek des Litterarischen Vereins in Stuttgart, vol. 134), Tübingen, 1877.

Anzelewsky, Fedja, *Albrecht Dürer. Das malerische Werk*, Berlin, 1971.

—, and Mielke, Hans, *Albrecht Dürer. Kritischer Katalog der Zeichnungen* (Staatliche Museen Preussischer Kulturbesitz. Die Zeichnungen alter Meister im Berliner Kupferstichkabinett), Berlin, 1984.

Appelius, Peter, "Die plastischen Andachts-Epitaphien in Nürnberg. Von ihren Anfängen bis zur Mitte des 15. Jahrhunderts," Ph.D. dissertation, Erlangen, 1950.

Appuhn, Horst, ed., *Albrecht Dürer: Die drei grossen Bücher*, Dortmund, 1979.

The Armand Hammer Collection (exhib. cat.), Los Angeles County Museum of Art, 1971–72; Houston, The Museum of Fine Arts, 1979–80.

Arndt, Karl, "Dürers Apokalypse," Ph.D. dissertation, Göttingen, 1956.

Aufgang der Neuzeit. Deutsche Kunst und Kultur von Dürers Tod bis zum Dreissigjährigen Kriege 1530–1650 (exhib. cat., Nuremberg, Germanisches Nationalmuseum), Bielefeld, 1952.

Avery, Charles, in *Objects for a "Wunderkammer,"* London, 1981.

B

Bäumler, Susanne, "Studien zum Adorationsdiptychon. Entstehung, Frühgeschichte und Entwicklung eines privaten Andachtsbildes mit Adorantendarstellung," Ph.D. dissertation, Munich, 1983.

von Baldass, Ludwig, "Die Bildnisse Kaiser Maximilians I.," *Jahrbuch der kunsthistorischen Sammlungen des allerhöchsten Kaiserhauses*, 1913/14, vol. 31, pp. 280–83.

Hans Baldung Grien (exhib. cat.), Karlsruhe, Staatliche Kunsthalle, 1959.

Hans Baldung Grien im Kunstmuseum Basel (exhib. cat.), Basel, 1978.

Bandmann, Günter, "Höhle und Säule auf Darstellungen Mariens mit dem Kinde," *Festschrift für Gert von der Osten*, Cologne, 1970, pp. 130–48.

Bange, Ernst F., "Zur Datierung von Peter Flötners Plakettenwerke," *Archiv für Medaillen- und Plakettenkunde*, 1921/22, vol. 3, 45–52.

—, *Die italienischen Bronzen der Renaissance und des Barock, Teil 2: Reliefs und Plaketten*, Berlin, Staatliche Museen, 1922.

—, *Die Kleinplastik der deutschen Renaissance in Holz und Stein*, Florence and Munich, 1928.

—, "Die künstlerische Bedeutung Peter Vischers des Älteren," *Jahrbuch der preussischen Kunstsammlungen*, 1929, vol. 50, pp. 167–82.

—, "Die Handzeichnungen Peter Flötners," *Jahrbuch der preussischen Kunstsammlungen*, 1936, vol. 57, pp. 107–17.

—, "Eine unbekannte Zeichnung Peter Flötners," *Jahrbuch der preussischen Kunstsammlungen*, 1938, vol. 59, pp. 231–32.

—, *Die deutschen Bronzestatuetten des 16. Jahrhunderts*, Berlin, 1949.

Bartsch, Adam, *Le Peintre-Graveur*, Vienna, 1803–21 (vol. 7: *Dürer*, Vienna, 1808).

Baum, Julius, *Niederschwäbische Plastik des ausgehenden Mittelalters*, Tübingen, 1925.

Baxandall, Michael, *German Wood Statuettes 1500–1800* (Illustrated Booklet, no. 14), London, Victoria and Albert Museum, 1967.

—, *South German Sculpture, 1480–1530* (Museum Monograph, no. 26), London, Victoria and Albert Museum, 1974.

—, *The Limewood Sculptors of Renaissance Germany*, New Haven and London, 1980.

—, "Veit Stoss, ein Bildhauer in Nürnberg," *Veit Stoss in Nürnberg: Werke des Meisters und seiner Schule in Nürnberg und Umgebung* (exhib. cat., Nuremberg, Germanisches Nationalmuseum), Munich, 1983, pp. 9–25.

Bayern. Kunst und Kultur (exhib. cat.), Munich, Stadtmuseum, 1972.

Becker, C[arl], and Hefner, J[akob], *Kunstwerke und Geräthschaften des Mittelalters und der Renaissance*, Frankfurt am Main, 1852, vol. 1.

Becksmann, Rüdiger, "Das 'Hausbuchmeisterproblem' in der mittelrheinischen Glasmalerei," *Pantheon*, November–December 1968, vol. 26, pp. 352–67.

Beeh, Wolfgang, *Der Kapellenturm in Rottweil und seine Skulpturen aus dem 14. Jahrhundert*, Ph.D. dissertation, Bonn; publ., Zug, Switzerland, 1959.

Beenken, Hermann, "Süddeutsche Steinmadonnen um 1300," *Cicerone*, 1924, vol. 16, pp. 65–71.

—, *Bildhauer des vierzehnten Jahrhunderts am Rhein und in Schwaben*, Leipzig, 1927.

Behrends, Rainer, ed., *Das Fest-Epistolar Friedrichs des Weisen, Handschrift Ms. El. f. 2 aus dem Bestand der Universitätsbibliothek, Jena* (commentaries by Irmgard Kratzsch and Rainer Behrends), Gütersloh, 1983.

Beierlein, Johann Peter, "Medaillen auf ausgezeichnete und berühmte Bayern," *Oberbayerisches Archiv für vaterländische Geschichte*, 1851, vol. 12, pp. 118–20.

Beissel, Stephan, "Rosenkranzbilder aus der Zeit um 1500," *Zeitschrift für christliche Kunst*, 1900, vol. 13, cols. 33–42.

—, *Geschichte der Verehrung Marias in Deutschland während des Mittelalters*, Freiburg im Breisgau, 1909.

Bellm, Richard, *Wolgemuts Skizzenbuch im Berliner Kupferstichkabinett. Ein Beitrag zur Erforschung des graphischen Werkes von Michael Wolgemut und Wilhelm Pleydenwurff* (Studien zur deutschen Kunstgeschichte, vol. 322), Baden-Baden and Strasbourg, 1959.

Benesch, Otto, *Meisterzeichnungen der Albertina — Europäische Schulen von der Gotik bis zum Klassizismus*, Salzburg, 1964.

—, *Die deutsche Malerei von Dürer bis Holbein*, Geneva, 1966.

Bergau, Rudolf, *Der Schöne Brunnen zu Nürnberg. Geschichte und Beschreibung*, Berlin, 1871.

—, *Peter Vischer und seine Söhne* (Kunst und Künstler des Mittelalters und der Neuzeit, vol. 2), Leipzig, 1878.

—, "Peter Vischers Messing-Gitter im grossen Saale des Rathauses zu Nürnberg," *Repertorium für Kunstwissenschaft*, 1879, vol. 2, pp. 50–62.

—, "Ein Vergessener aus Nürnbergs Vorzeit," *Kunstchronik*, 1886/87, vol. 22, cols. 17–19.

Berliner, Rudolf, "Peter Vischer Probleme," *Münchner Jahrbuch der bildenden Kunst*, 1931, 2nd ser., vol. 8, pp. 133–54.

—, "Arma Christi," *Münchner Jahrbuch der bildenden Kunst*, 1955, 3rd ser., vol. 6, pp. 35–152.

Bermann, H., "Hans Süss von Kulmbach," Ph.D. dissertation, Leipzig, 1922.

Bernhart, Max, *Die Bildnismedaillen Karls des Fünften*, Munich, 1919.

—, "Die Porträtzeichnungen des Hans Schwarz," *Münchner Jahrbuch der bildenden Kunst*, 1934, 2nd ser., vol. 11, pp. 65–95.

—, "Kunst und Künstler der Nürnberger Schaumünze des 16. Jahrhunderts," *Mitteilungen der Bayerischen Numismatischen Gesellschaft*, 1936, vol. 54, pp. 1–61.

Betz, Gerhard, "Der Nürnberger Maler Michael Wolgemut und seine Werkstatt," Ph.D. dissertation, Freiburg im Breisgau, 1955.

Beyer, Günther, and Beyer, Klaus, *Peter Vischer*, text by Fritz Kämpfer, Dresden, 1960.

Białostocki, Jan, "The Eye and the Window," *Festschrift für Gert von der Osten*, Cologne, 1970, pp. 159–76.

Biedermann, Johann Gottfried, *Geschlechtsregister des Hochadelichen Patriciats zu Nürnberg*, Bayreuth, 1784.

Bier, Justus, *Nürnbergisch-Fränkische Bildnerkunst*, Bonn, 1922.

—, "Riemenschneider's Use of Graphic Sources," *Gazette des Beaux-Arts*, 1957, 4th ser., vol. 50, pt. 2, pp. 203–22.

—, *Tilman Riemenschneider*, vol. 4: *Die späten Werke in Holz*, Vienna, 1978.

Das Bild in Glas. Von der europäischen Kabinettscheibe zum New Glass (exhib. cat.), Suzanne Beeh-Lustenberger, ed., Darmstadt, Hessisches Landesmuseum, 1979.

Bildwerke aus sieben Jahrhunderten (Staatliche Museen zu Berlin, Skulpturen-Sammlung, vol. 2), Berlin, 1972.

Bildwerke der Christlichen Epochen von der Spätantike bis zum Klassizismus. Aus den Beständen der Skulpturenabteilung der Staatlichen Museen, Stiftung Preussischer Kulturbesitz, Berlin-Dahlem, Munich, 1965.

Binding, Günther, "Bauhütte," *Lexikon des Mittelalters*, Munich and Zurich, 1980, vol. 1, cols. 1629–30.

Bischoff, Ulrich, in *Der Mensch um 1500, Werke aus Kirchen und Kunstkammern* (exhib. cat.), Berlin-Dahlem, Skulpturengalerie der Staatlichen Museen Preussischer Kulturbesitz, 1977.

Bloch, Peter, *Aquamanili, oggetti medievali per uso sacro e profano*, Milan, 1982.

Bock, Elfried, *Die Zeichnungen alter Meister im Kupferstichkabinett*, vol. 1: *Die Deutschen Meister*, Berlin, 1921.

—, comp., *Die Zeichnungen in der Universitätsbibliothek Erlangen*, 2 vols., Frankfurt am Main, 1929.

—, "The Engravings of Ludwig Krug of Nuremberg," *The print-collector's Quarterly*, 1933, vol. 20, pp. 87–115.

Bock, Friedrich, "Das Nürnberger Predigerkloster. Beiträge zu seiner Geschichte," *Mitteilungen des Vereins für Geschichte der Stadt Nürnberg*, 1924, vol. 25, pp. 145–213.

Bode, Wilhelm, *Geschichte der Deutschen Plastik* (Geschichte der Deutschen Kunst, vol. 2), Berlin, 1885.

—, "Kleinbronzen der Söhne des älteren Peter Vischer," *Jahrbuch der Königlich preussischen Kunstsammlungen*, 1908, vol. 29, pp. 30–43.

Böhne, Clemens, "Werkstofftechnische Fragen bei deutschen Plattnerarbeiten," *Waffen- und Kostümkunde*, 1961, 3rd ser., vol. 3, pp. 47–53.

Börner, P. E., *Die Kunstsammlung von Eugen Felix in Leipzig*, Leipzig, 1880.

Bösch, Hans, "Der Streit zwischen den Nürnberger Flachmalern und Ätzmalern 1625–1627," *Mitteilungen des Vereins für Geschichte der Stadt Nürnberg*, 1901, vol. 14, pp. 205–26.

—, *Deutsche Schmiedearbeiten aus fünf Jahrhunderten*, 2nd ed., Leipzig, 1911.

Borchers, W., "Der Deckelbecher der Familie van Bar-Altbarenaue," *Westfalen*, 1958, vol. 36, pp. 218–26.

Bott, Gerhard, "Schmerzensmann und Schmerzensmutter nach Lucas van Leyden," *Festschrift für Peter Metz*, Ursula Schlegel and Claus Zoege von Manteuffel, eds., Berlin, 1965, pp. 345–60.

Brachert, Thomas, "Der Kruzifix des Veit Stoss im Germanischen Nationalmuseum," *Maltechnik-Restauro*, 1984, vol. 90, pp. 14–23.

Bräutigam, Günther, "Gmünd-Prag-Nürnberg. Die Nürnberger Frauenkirche und der Prager Parlerstil vor 1360," *Jahrbuch der Berliner Museen*, 1961, vol. 3, pp. 38–75.

—, "Die Nürnberger Frauenkirche. Idee und Herkunft ihrer Architektur," *Festschrift für Peter Metz*, Ursula Schlegel and Claus Zoege von Manteuffel, eds., Berlin, 1965, pp. 170–97.

—, "Bildwerke des Spätmittelalters. Der Bürger als Auftraggeber, der Künstler als Bürger," *Das Schatzhaus der deutschen Geschichte. Das Germanische Nationalmuseum. Unser Kulturerbe in Bildern und*

Beispielen, Rudolf Pörtner, ed., Düsseldorf and Vienna, 1982, pp. 199–225.

—, in *Gemanisches Nationalmuseum Nürnberg, Führer durch die Sammlungen*, Munich, 1985.

Brandl, Rainer, "A Marian Altarpiece by Hans von Kulmbach: A Reconstruction," *Metropolitan Museum Journal*, 1985, vols. 19/20, pp. 39–62.

Braun, Edmund W., *Die Bronzen der Sammlung Guido von Rhò in Wien*, Vienna, 1908.

—, "Die Handzeichnungen des jüngeren Peter Vischers zu Pankraz Schwenters Gedicht über die Herkulestaten," *Monatshefte für Kunstwissenschaft*, 1915, vol. 8, pp. 52–55.

—, "Eine Nürnberger Goldschmiedewerkstätte aus dem Dürerkreis," *Graphische Künste. Mitteilungen der Gesellschaft für vervielfältigende Kunst*, 1915, vol. 38, pp. 37–57.

—, "Ein Nürnberger Bronzebrunnen von 1532/33 im Schlosse zu Trient," *Münchner Jahrbuch für bildende Kunst*, 1951, 3rd ser., vol. 2, pp. 195–203.

Bredt, Ernst Wilhelm, "Zur Geschichte der Nürnberger Miniaturen und Kleinmeister," *Zeitschrift für Bücherfreunde*, 1902/3, vol. 6, pp. 481–87.

—, *Katalog der mittelalterlichen Miniaturen des Germanischen Nationalmuseums*, Nuremberg, 1903.

Breitenbach, Edgar, *Speculum humanae salvationis*, Strasbourg, 1930.

Bremen, Walter, *Die alten Glasgemälde und Hohlgläser der Sammlung Bremen in Krefeld* (Beihefte der Bonner Jahrbücher, vol. 13), Cologne and Graz, 1964.

Brix, Michael, *Nürnberg und Lübeck im 19. Jahrhundert. Denkmalpflege, Stadtbildpflege, Stadtumbau*, Munich, 1981.

Bruck, Robert, *Friedrich der Weise als Förderer der Kunst* (Studien zur deutschen Kunstgeschichte, vol. 45), Strasbourg, 1903.

—, "Der Illuminist Jakob Elsner," *Jahrbuch der Königlich preussischen Kunstsammlungen*, 1903, vol. 24, pp. 302–17.

Buchheit, Hans, "Das Bildnis des sogenannten Kanonikus Schönborn im Germanischen Museum in Nürnberg," *Jahrbuch des Vereins für christliche Kunst in München*, 1919, vol. 4, pp. 26–29.

Buchner, Ernst, "Hans von Kulmbach als Bildnismaler," *Pantheon*, 1928, vol. 1, pp. 140, 142.

—, "Die Sieben Schmerzen Mariä, eine Tafel aus der Werkstatt des jungen Dürer," *Münchner Jahrbuch der bildenden Kunst*, 1934, new ser., vol. 11, pp. 250–70.

—, "Eine unbekannte Zeichnung von Hans Baldung Grien," *Die Kunst und das schöne Heim*, 1949/50, vol. 48, pp. 447–50.

—, *Das deutsche Bildnis der Spätgotik und der frühen Dürerzeit*, Berlin, 1953.

Bühler, Albert, "Die Heilige Lanze," *Das Münster*, 1963, vol. 16, pp. 85–116.

Burger, Fritz; Schmitz, Hermann; and Beth, Ignaz, *Die deutsche Malerei vom ausgehenden Mittelalter bis zum Ende der Renaissance*, vols. 1–3 (Handbuch der Kunstwissenschaft), Berlin, 1913–19.

Burroughs, Bryson, and Wehle, Harry B., "The Friedsam Collection," *The Bulletin of The Metropolitan Museum of Art*, 1932, vol. 27, pp. 5–25.

Busch, N., *Abhandlungen der Herdergesellschaft*, vol. 4, Riga, 1931.

Buttin, Charles, and Gerand, J., "Les bas-reliefs de Montrottier," *Revue Savoisienne*, Annecy, 1921, pp. 1–5.

Butts, Barbara Rosalyn, "'Dürerschüler' Hans Süss von Kulmbach," Ph.D. dissertation, Cambridge, Massachusetts, 1985.

C

Cahn, Julius, "Die Medaillenporträts des Kardinals Albrecht von Mainz, Markgrafen von Brandenburg," *Studien aus Kunst und Geschichte. Friedrich Schneider zum siebzigsten Geburtstage gewidmet*, Freiburg im Breisgau, 1906, pp. 159–67.

[Carbach, Johann Jakob], *Nürnbergisches Zion, d.i. wahrhafte Beschreibung aller Kirchen und Schulen in . . . Nürnberg*, Nuremberg, 1733.

Caritas Pirckheimer, 1467–1532 (exhib. cat., Nuremberg, Kaiserburg), Munich, 1982.

Catalogue illustré des Dessins et estampes composant la collection . . . Ambroise Firmin-Didot (sale cat.), Paris, Hôtel Drouot, April 16–May 12, 1877.

Catalogue of a valuable Collection of Drawings by Old Masters Formed by a Well-Known Amateur [Sir John Charles Robinson] (sale cat.), London, Christie, Manson and Woods, 1902.

Catalogue of E. Kahlert u. Sohn [Berlin], 1927.

Catalogue of Manuscripts and Early Printed Books from the Libraries of William Morris, Richard Bennett, Bertram Fourth Earl of Ashburnham, and other Sources, Now Forming Part of the Library of J. Pierpont Morgan, M. R. James, comp., London, 1906, pp. 151–54, no. 102.

Catalogue of the Collection of Fine Old French Decorative Furniture and Objects of Art, Formed by the Late George Field, Esq. (sale cat.), London, Christie, Manson and Woods, June 12–13, 1893.

Catalogue of the LDM Sale, Paris, Galerie Georges Petit, June 16–19, 1919.

Catalogue of the Special Exhibition of Works of Art of the Mediaeval, Renaissance, and More Recent Periods, on Loan at the South Kensington Museum, June 1862, rev. ed. (January 1863), London, 1863.

Catalogue of the Very Important Collection of Drawings by the Old Masters, the Property of Max J. Bonn, Esq. (sale cat.), London, Sotheby, Wilkinson and Hodge, February 15, 1922.

Caviness, Madeline H., ed., *Medieval and Renaissance Stained Glass from New England Collections* (exhib. cat., Cambridge, Massachusetts, Busch-Reisinger Museum), Medford, Massachusetts, Tufts University, 1978.

Chadraba, Rudolf, *Dürers Apokalypse*, Prague, 1964.

Christensen, Carl Chris, "The Nuernberg City Council as a Patron of the Fine Arts, 1500–1550," Ph.D. dissertation, Columbus, Ohio, 1965.

Die Chroniken der fränkischen Städte, vol. 5: *Nürnberg* (Die Chroniken der deutschen Städte vom 14. bis ins 16. Jahrhundert, vol. 11), Leipzig, 1874.

Clasen, Karl Heinz, *Der Meister der Schönen Madonnen. Herkunft, Entfaltung und Umkreis*, Berlin and New York, 1974.

Clemen, Otto, *Die Volksfrömmigkeit des ausgehenden Mittelalters*, Dresden and Leipzig, 1937.

Collection Goldschmidt-Przibram. Catalogue des Tableaux . . . (sale cat.), Amsterdam, Frederic Muller & Cie., 1924.

Collection H. P. de B . . . [Count Kouchaleff-Bezborodko], St. Petersburg (sale cat.), Paris, Hôtel Drouot, May 21–23, 1912.

Collection of Baron C. A. de Cosson (sale cat.), London, Christie, Manson and Woods, May 2–3, 1893.

Collection of Lord Stafford (sale cat.), London, Christie, Manson and Woods, May 28, 1895.

Conradi Celtis . . . de origine, situ, moribus et institutis Norimbergae libellus, in Werminghoff, Albert, ed., *Conrad Celtis und sein Buch über Nürnberg*, Freiburg im Breisgau, 1921, pp. 99–204.

Conway, Sir William Martin, *Literary Remains of Albrecht Dürer (With Transcripts from the British Museum Manuscripts and Notes Upon Them by Lina Eckenstein)*, Cambridge, England, 1889.

—, "A Note on Dürer," *Repertorium für Kunstwissenschaft*, 1905, vol. 28, pp. 147–48.

—, *The Art of Albrecht Dürer* (exhib. cat.), Liverpool, Walker Art Gallery, 1910.

de Cosson, Baron C. A., "Armour and Arms at the Tudor Exhibition," *The Magazine of Art*, 1890, vol. 13, p. 324.

—, *Le cabinet d'armes de Maurice de Talleyrand-Périgord, Duc de Dino*, Paris, 1901.

—, and Burges, W., *Critical Notes on Ancient Helmets and Examples of Mail*, London, 1880.

Cripps-Day, F. H., *A Record of Armour Sales 1881–1924*, London, 1925.

Curjel, Hans, *Hans Baldung Grien*, Munich, 1923.

D

Daun, Berthold, *Veit Stoss und seine Schule in Deutschland, Polen und Ungarn, Beiträge zur Stoss-Forschung*, Leipzig, 1903.

—, *P. Vischer and A. Kraft* (Künstler-Monographien, vol. 75), Bielefeld and Leipzig, 1905.

—, *Veit Stoss* (Künstler-Monographien, Hermann Knackfuss, ed., vol. 81), Bielefeld and Leipzig, 1906.

—, *Veit Stoss und seine Schule in Deutschland, Polen, Ungarn und Siebenbürgen* (Kunstgeschichtliche Monographien, no. 17, 2nd ed., Leipzig, 1916.

Dean, Bashford, *Loan Exhibition of Arms and Armor* (exhib. cat.; objects lent by Mrs. Rutherford Stuyvesant), New York, The Metropolitan Museum of Art, 1911.

—, *The Collection of Arms and Armor of Rutherford Stuyvesant*, privately printed, 1914.

—, "A Part of a Radzivil Horse Panoply," *The Bulletin of The Metropolitan Museum of Art*, 1921, vol. 16, pp. 80–82.

—, "Seven Shields of Behaim," *The Bulletin of The Metropolitan Museum of Art*, 1925, vol. 20, pp. 874–77.

Demmler, Theodor, "Eine Wappenfigur von Adam Kraft," *Amtliche Berichte aus den Königlichen Kunstsammlungen*, December 1914, vol. 36, cols. 45–50.

Denison, Cara D., and Mules, Helen B., with the assistance of Jane V. Shoaf, *European Drawings 1375–1825*, New York, The Pierpont Morgan Library, 1981.

Description des objets d'art qui composent le cabinet de Feu M. le Baron v. Denon, part 1: *Tableaux, dessins, et miniatures* (sale cat.), Paris, May 1–19, 1826.

Dettenthaler, Josef, "Ein unbekanntes Werk vom Schöpfer des Tondoerffer-Epitaphs in der Nürnberger Lorenzkirche," *Mitteilungen des Vereins für Geschichte der Stadt Nürnberg*, 1979, vol. 66, pp. 310–12.

Dettloff, Felix (= Szczęsny), *Der Entwurf zum Sebaldusgrab. Ein Beitrag zur Geschichte der gotischen Kleinarchitektur und Plastik, insbesondere auch zur Vischer-Frage*, Posen, 1915.

—, "Krakowski projekt na ołtarz Bamberski Wita Stosza," *Rocznik Krakowski*, 1935, vol. 26, pp. 89–107.

—, *Wit Stosz* (with summary in French and German), Breslau, 1961, 2 vols.

Detzel, Heinrich, *Eine Kunstreise durch das Frankenland*, Würzburg, 1885.

Deutsche Kunst und Kultur im Germanischen Nationalmuseum, Nuremberg, 1960.

Deutsche Kunst und Kultur zwischen Mittelalter und Neuzeit aus dem Germanischen Nationalmuseum in Nürnberg. Eine Ausstellung des Germanischen Nationalmuseums im National Museum of Western Art, Tokyo, 1984 (exhib. cat.), Nuremberg, 1984.

Dobrzeniecki, Tadeusz, "Niektóre zagadnienia ikonografii męża Bolesci (Quelques problèmes de l'iconographie du Christ de douleur)," *Rocznik Muzeum Narodowego w Warszawie*, 1971, vol. 15/1, pp. 7–219.

von Dobschütz, Ernst, *Der Apostel Paulus*, vol. 2: *Seine Stellung in der Kunst*, Halle, 1928.

Dodgson, Campbell, *Albrecht Dürer, Engravings and Etchings*, London, 1922; reprinted, New York, 1967.

—, review of Gebarowicz, M., and Tietze, Hans, *Albrecht Dürer Zeichnungen im Lubomirski Museum in Lemberg*, in *The Burlington Magazine*, 1929, vol. 54, pp. 216–17.

—, "School of Dürer. The Fall of the Rebel Angels: Fragment of a Cartoon for Stained Glass," *Old Master Drawings*, 1930/31, vol. 5, pp. 42–43.

Dörnhöffer, Friedrich, "Beiträge zur Geschichte der älteren Nürnberger Malerei," *Repertorium für Kunstwissenschaft*, 1906, vol. 29, pp. 441–67.

Domanig, Karl, "Peter Flötner als Plastiker und Medailleur," *Jahrbuch der kunsthistorischen Sammlungen des allerhöchsten Kaiserhauses*, 1895, vol. 16, pp. 1–80.

Draper, James David, in *The Metropolitan Museum of Art, Notable Acquisitions, 1965–1975* (exhib. cat.), New York, The Metropolitan Museum of Art, 1975.

—, in *Highlights of the Untermyer Collection of English and Continental Decorative Arts* (exhib. cat.), New York, The Metropolitan Museum of Art, 1977.

Drawings and Prints by Albrecht Dürer (exhib. cat.), New York, The Pierpont Morgan Library, 1955.

Drawings by Dürer and His School from the Pierpont Morgan Library (exhib. cat.), New York, The Pierpont Morgan Library, 1985.

Drecka, Wanda, *Kulmbach*, Warsaw, 1957.

Dube, Wolf-Dieter, "Süddeutsche Bronzemörser," Ph.D. dissertation, Göttingen, 1961.

Dudik, B., *Kleinodien des deutschen Ritterordens*, Vienna, 1865.

Albrecht Dürer Ausstellung im Germanischen Museum (exhib. cat.), Nuremberg, Germanisches Nationalmuseum, 1928.

Albrecht Dürer aux Pays-Bas. Son voyage (1520–1521), son influence (exhib. cat., Europalia 77 Bundesrepublik Deutschland), Brussels, Palais des Beaux-Arts, 1977.

Dürer in America. His Graphic Work (exhib. cat., Washington, D.C., National Gallery of Art), Charles W. Talbot, ed., New York and London, 1971.

Albrecht Dürer: Master Printmaker (exhib. cat., Boston, Museum of Fine Arts), Greenwich, Connecticut, 1971.

Albrecht Dürer, 1471–1971 (exhib. cat., Nuremberg, Germanisches Nationalmuseum), Munich, 1971.

Dürer und seine Zeit. Zeichnungen und Aquarelle (exhib. cat.), Munich, 1967.

Dürers Verwandlung in der Skulptur zwischen Renaissance und Barock (exhib. cat., Liebieghaus Museum alter Plastik), Herbert Beck and Bernhard Decker, eds., Frankfurt am Main, 1982.

Dumrath, Karlheinrich, "Die Bürgschaftsurkunde von 1507," *Der Schwabacher Hochaltar. Internationales Kolloquium anlässlich der Restaurierung* (Bayerisches Landesamt für Denkmalpflege, Arbeitsheft 11), Munich, 1982, pp. 19–23.

Dvořák, Max, "Dürers Apokalypse," *Kunstgeschichte als Geistesgeschichte*, Munich, 1928, pp. 193–202.

E

Ehresmann, Donald L., "Middle Rhenish Sculpture, 1380 to 1440," Ph.D. dissertation, New York, 1966.

Eich, Paul, "Der Johannesaltar von Hans Baldung Grien," *Städel-Jahrbuch*, 1975, new ser., vol. 5, pp. 85–96.

Eichhorn, Ernst, "Zur Nürnberger Plastik der Spätgotik," *Das Münster*, 1952, vol. 5, pp. 277–82.

Einhorn, Jürgen W., *Spiritalis Unicornis. Das Einhorn als Bedeutungsträger in Literatur und Kunst des Mittelalters*, Munich, 1976.

Eisenmann, Oscar, "Die Ausstellung von Gemälden alter Meister aus dem Wiener Privatbesitz," *Zeitschrift für bildende Kunst*, 1874, vol. 9, pp. 28–30.

Eisler, Colin, *Complete Catalogue of the Samuel H. Kress Collection. Paintings, European Schools Excluding Italian*, Oxford, 1977.

Engel, W[ilhelm], "Georg Graf von Löwenstein," *Altfränkische Bilder*, 1953, vol. 52, pp. 4–10.

Ennen, Edith, *Die europäische Stadt des Mittelalters*, Göttingen, 2nd ed., 1972.

Ephrussi, Charles, "Jacopo de' Barbari," *Gazette des Beaux-Arts*, 1876, vol. 8, pp. 363–82.

—, *Albrecht Dürer et ses dessins*, Paris, 1882.

Erasmus en zijn tijd (exhib. cat.), Rotterdam, 1969.

von Essenwein, August, "Einige Leuchter für den Profangebrauch in den Sammlungen des germanischen Museums," *Anzeiger für Kunde der deutschen Vorzeit* (publ. of the Germanisches Museum), 1868, new ser., cols. 119–28.

—, "Die Reliquienbehälter in der Sammlung kirchlicher Alterthümer im germanischen Museum," *Anzeiger für Kunde der deutschen Vorzeit* (publ. of the Germanisches Museum), 1868, new ser., cols. 309–15, 350–54.

—, "Einige Ciborien in der Sammlung kirchlicher Geräte im germanischen Museum," *Anzeiger für Kunde der deutschen Vorzeit* (publ. of the Germanisches Museum), 1869, new ser., cols. 130–35.

—, "Modelle alter Erzgusswerke," *Anzeiger für Kunde der deutschen Vorzeit*, 1873, vol. 20, p. 302.

—, *Kunst- und kulturgeschichtliche Denkmale des Germanischen National-Museums. Eine Sammlung von Abbildungen hervorragender Werke aus sämtlichen Gebieten der Kultur*, Leipzig, 1877.

—, *Katalog der im germanischen Museum befindlichen Glasgemälde aus älterer Zeit*, Nuremberg, 1884; 2nd ed., 1898.

—, "Bronzener Brunnenausguss," *Mitteilung aus dem Germanischen Nationalmuseum*, 1887–89, vol. 2, pp. 33–48.

—, "Die Erwerbung der fürstlich Sulkowskischen Sammlung für das germanische Museum," *Anzeiger des Germanischen Nationalmuseums*, 1889, pp. 215–22.

—, *Katalog der im Germanischen Museum vorhandenen interessanten Bucheinbände und Teile von solchen*, Nuremberg, 1889.

Eucharistia. Deutsche eucharistische Kunst. Offizielle Ausstellung zum eucharistischen Weltkongress (exhib. cat.), Munich, 1960.

Europäische Kunst um 1400 (exhib. cat.), Vienna, Kunsthistorisches Museum, 1962.

Exhibition of Albert Dürer's Engravings, Etchings, and Dry-Points and of Most of the Woodcuts executed from His Designs.... Together with Eight Original Drawings from the Collection von Franck (exhib. cat.), Boston, Museum of Fine Arts, 1888.

—, *Goldschmiedearbeiten des Mittelalters, der Renaissance und des Barock*, pt. 1: *Arbeiten in Gold und Silber* (Publikationen aus den kunsthistorischen Sammlungen in Wien, vol. 5), Vienna, 1932.

Kugler, Franz Theodor, *Beschreibung der in der Königl. Kunstkammer zu Berlin vorhandenen Kunstsammlung*, Berlin, 1838.

Kuhn, Charles L., *A Catalogue of German Paintings of the Middle Ages and Renaissance in American Collections*, Cambridge, Massachusetts, 1936.

—, "Recent Acquisitions of the Busch-Reisinger Museum," *The American-German Review*, December 1952, vol. 19/2.

—, "An Unknown Relief by Peter Flötner," *The Art Quarterly*, 1954, vol. 17, pp. 108–15.

—, *German and Netherlandish Sculpture, 1250–1800, The Harvard Collections*, Cambridge, Massachusetts, 1965.

Die Kunst- und Altertums-Denkmale in Württemberg. Inventar. Donaukreis, vol. 2, fasc. 60/64: *Oberamt Kirchheim*, Hans Christ, ed., Esslingen, 1921.

Die Kunstdenkmäler von Oberfranken, vol. 1: *Landkreis Wunsiedel und Stadtkreis Marktredwitz*, Bernhard Hermann Röttger, ed. (Die Kunstdenkmäler von Bayern, pt. 8: Regierungsbezirk Oberfranken), Munich, 1954.

Die Kunstdenkmäler von Oberpfalz und Regensburg, vol. 4: *Bezirksamt Parsberg*, Friedrich Hermann Hofmann, ed. (Die Kunstdenkmäler des Königreichs Bayern, pt. 2: Regierungsbezirk Oberpfalz und Regensburg, Georg Hager, ed.), Munich, 1906.

Kunst der Reformationszeit (exhib. cat.), Berlin, Altes Museum, Staatlich Museen zu Berlin, 1983.

Die Kunstsammlungen Ihrer Majestät der Kaiserin und Königin Friedrich in Schloss Friedrichshof, Berlin, 1896.

Kunstschätze aus Münchner Privatbesitz (exhib. cat.), Munich, Stadtmuseum, 1965.

Kunst und Kunstgewerbe, Sonderausstellung 1938–40 (Emil Delmar Collection), Bern, Kunstmuseum, 1939–40.

Kurth, Betty, *Die deutschen Bildteppiche des Mittelalters*, Vienna, 1926, 3 vols.

—, "Die Wiener Tafelmalerei in der ersten Hälfte des 14. Jahrhunderts und ihre Ausstrahlungen nach Franken und Bayern," *Jahrbuch der Kunsthistorischen Sammlungen in Wien*, 1929, new ser., vol. 3, pp. 25–55.

Kurthen, Josef, "Zum Problem der Dürerschen Pferdekonstruktion," *Repertorium für Kunstwissenschaft*, 1924, vol. 44, pp. 84–87.

Kurze Beschreibung des Rittersaales in dem Schlosse Erbach im Odenwalde und der in demselben aufgestellten Rüstungen und Waffen, Amorbach, 1812.

Kurzwelly, Albrecht, "Forschungen zu Georg Pencz," Ph.D. dissertation, Leipzig, 1895.

Kyewski, Bruno, "Über die Mercator-Projektion," *Duisburger Forschungen*, 1962, vol. 6, pp. 124–26.

L

Laking, Sir Guy Francis, *A Record of European Armour and Arms through Seven Centuries*, London, 1920.

Lamm, Carl Johan, *Mittelalterliche Gläser und Steinschnittarbeiten aus dem Nahen Osten* (Forschungen zur islamischen Kunst, vol. 5), Berlin, 1929/30, 2 vols.

Landolt, Hanspeter, "Zu drei Zeichnungen Hans von Kulmbachs im Basler Kupferstichkabinett," *Öffentliche Kunstsammlung Basel, Jahresbericht 1962*, Basel, 1962, pp. 31–47.

Lang, Johann, and Kuchenbauer, Otto, *850 Jahre Klostergründung Kaisheim 1134–1984*, Kaisheim, 1984.

Lange, Konrad, *Peter Flötner, ein Bahnbrecher der deutschen Renaissance. Auf Grund neuer Entdeckungen*, Berlin, 1897.

Legner, Anton, "Das 'übergeordnete Phänomen' der Ausbreitung des Stoss'schen Stils," in *Veit Stoss. Die Vorträge des Nürnberger Symposions* (Nuremberg, Gemanisches Nationalmuseum, and Munich, Zentralinstitut für Kunstgeschichte), Munich, 1985, pp. 280–95.

The Lehman Collection, New York (exhib. cat.), The Cincinnati Museum, 1959.

Lehrs, Max, *Geschichte und kritischer Katalog des deutschen, niederländischen und französischen Kupferstichs im 15. Jahrhundert*, Vienna, 1908–34, 9 vols.

Leinz-von Dessauer, A[ntonie], "Savonarola und Albrecht Dürer," *Das Münster*, 1961, vol. 14, pp. 1–45.

Leithe-Jasper, Manfred, and Distelberger, Rudolf, *Kunsthistorisches Museum Wien*, vol. 1: *Schatzkammer und Sammlung für Plastik und Kunstgewerbe*, London, 1982.

Leitner, Quirin, *Die hervorragendsten Kunstwerke der Schatzkammer des Österreichischen Kaiserhauses (Tafelwerk)*, Vienna, 1870–73.

Leitschuh, Franz F., *Flötnerstudien. Das Plakettenwerk Peter Flötners*, Strasbourg, 1904.

Lessing, Julius, "Wunderliches Trinkgerät," *Westermanns illustrierte deutsche Monats-Hefte*, 1888, vol. 83, pp. 383–400, 432–50.

Lichtwark, Alfred, *Der Ornamentstich der deutschen Frührenaissance*, Berlin, 1888.

Lieb, Norbert, *Die Fugger und die Kunst im Zeitalter der Spätgotik und frühen Renaissance*, Munich, 1952.

Liebmann, Michael J., *Die deutsche Plastik, 1350–1550*, trans. from the Russian by Hans Störel, Leipzig, 1982.

Lincke, Julius, "Das Alte Rathaus und der Grosse Rathaussaal seit ihrer Kriegszerstörung, Teil II: Planungen und Massnahmen zur Wiederinstandsetzung des Innenraumes ab 1977," *Nürnberger Altstadtberichte*, 1980, no. 5, pp. 32–50.

Lind, K., "Der St. Wenzels-Leuchter im Prager Dome," *Mitteilungen der K. K. Central-Commission zur Erforschung und Erhaltung der Kunst- und historischen Denkmale*, 1885, new ser., vol. 11, pp. 59–61.

Lippmann, Friedrich, ed., *Zeichnungen von Albrecht Dürer in Nachbildungen*, Berlin, 1883–1929, 7 vols.

Livie, R. Bruce, *Auch Kleine Dinge: Dürer and the Decorative Tradition* (exhib. cat.), Cambridge, Massachusetts, Busch-Reisinger Museum, 1971.

Loan Exhibition of European Arms and Armor (exhib. cat.), New York, The Metropolitan Museum of Art, 1931.

Lochner, Georg Wolfgang Karl, *Die noch vorhandenen Abzeichen Nürnberger Häuser*, Nuremberg, 1855.

—, ed., *Des Johann Neudörfer Schreib- und Rechenmeisters zu Nürnberg Nachrichten von Künstlern und Werkleuten daselbst aus dem Jahre 1547 nebst der Fortsetzung des Andreas Gulden*, Vienna, 1875.

Löcher, Kurt, "Dürers Kaiserbilder," *Das Schatzhaus der deutschen Geschichte*, Rudolf Pörtner, ed., Düsseldorf and Vienna, 1982, pp. 305–30.

Lösch, Johann Christian Ernst, *Geschichte und Beschreibung der Kirche zu St. Jakob in Nürnberg nach ihrer Erneuerung im Jahr 1824/25*, Nuremberg, 1825.

—, *Sämtliche protestantische Kirchen Nürnbergs in der Stadt und in den Vorstädten mit ihren plastischen Werken* (manuscript Hs. 20 670, Germanisches Nationalmuseum, Nuremberg), Nuremberg, 1836.

Longhi, Roberto, "Una Madonna del Dürer a Bagnocavallo," *Paragone*, 1961, vol. 139, pp. 3–9.

Lossnitzer, Max, *Veit Stoss. Die Herkunft seiner Kunst, seine Werke und sein Leben*, Leipzig, 1912.

Loubier, Hans, *Der Bucheinband von seinen Anfängen bis zum Ende des 18. Jahrhunderts* (Monographien des Kunstgewerbes, vol. 21/22), Leipzig, 1926.

Lübke, Wilhelm, *Peter Vischers Werke*, Nuremberg [1878].

—, *Geschichte der Plastik*, Leipzig, 1880.

Lüdke, Dietmar, *Die Statuetten der gotischen Goldschmiede. Studien zu den "autonomen" und vollrunden Bildwerken der Goldschmiedeplastik und den Statuettenreliquiaren in Europa zwischen 1230 und 1530* (tudov-Studien, Reihe Kunstgeschichte, vol. 4), Munich, 1983.

Lüer, Hermann, and Creutz, Max, *Geschichte der Metallkunst*, vol. 2: *Kunstgeschichte der edlen Metalle*, Max Creutz, ed., Stuttgart, 1909.

Lugt, Frits, *Les Marques des Collections*, Amsterdam, 1921; supplement, The Hague, 1956.

Martin Luther und die Reformation in Deutschland (exhib. cat., Nuremberg, Germanisches Nationalmuseum), Frankfurt am Main, 1983.

Lutze, Eberhard, "Nürnberger Malerei 1350–1450, Teil A: Die Buchmalerei," *Anzeiger des Germanischen Nationalmuseums*, 1930/31 (1932), pp. 7–21.

—, *Katalog der Veit-Stoss-Ausstellung im Germanischen Museum* (exhib. cat.), Nuremberg, 1933.

—, "Die 'italienischen' Werke des Veit Stoss," *Pantheon*, 1937, vol. 19, pp. 183–89.

—, *Veit Stoss* (Deutsche Lande, deutsche Kunst), Berlin, 1938; 2nd ed., Berlin, 1940; 3rd ed., Munich and Berlin, 1952; 4th ed., text and illus. rev., Munich and Berlin, 1968.

—, "Hans Süss von Kulmbach. Bildnis eines jungen Mannes," *Deutsche Kunst*, Ludwig Roslius, ed., vol. 7, fasc. 10, Bremen, 1941.

—, and Wiegand, Eberhard, *Die Gemälde des 13. bis 16. Jahrhunderts* (Kataloge des Germanischen Nationalmuseums zu Nürnberg), text vol., Nuremberg, 1936, illus. vol., Leipzig, 1937.

M

Machilek, Franz, "Magister Jobst Krell, Vikar bei St. Lorenz in Nürnberg," *Mitteilungen des Vereins für Geschichte der Stadt Nürnberg*, 1972, vol. 59, pp. 85–100.

—, "Die Familie Schmidmayer in Nürnberg im 15./16. Jahrhundert," in *Mitteilungsblatt des Vereins zur Wiederherstellung der St. Lorenzkirche in Nürnberg*, July–December 1973, no. 73, pp. 1–3.

—, "Dedicationes ecclesiae Sancti Sebaldi. Die mittelalterlichen Kirch- und Altarweihen bei St. Sebald in Nürnberg," *600 Jahre Ostchor St. Sebald. Nürnberg 1379–1979*, Helmut Baier, ed., Neustadt an der Aisch, 1979, pp. 143–59.

Mahey, John A., *Master Drawings from Sacramento*, Sacramento, California, 1971.

Mann, Sir James G., *The Etched Decoration of Armour*, London, 1940.

—, *European Arms and Armour* (Wallace Collection Catalogues, vol. 1), London, 1962.

Marrow, James H., "Dutch Manuscript Illumination before the Master of Catherine of Cleves," *Nederlands kunsthistorisch Jaarboek*, 1968, vol. 19, pp. 51–113.

—; Shestack, Alan; and Talbot, Charles W., *Hans Baldung Grien: Prints and Drawings* (exhib. cat.), Washington, D.C., National Gallery of Art, 1981.

Martin, Kurt, *Die Nürnberger Steinplastik im XIV. Jahrhundert*, Berlin, 1927.

Maschke, Erich, "Die Unterschichten der mittelalterlichen Städte Deutschlands," *Die Stadt des Mittelalters*, Carl Hasse, ed., vol. 3: *Wirtschaft und Gesellschaft*, Darmstadt, 1976.

Master Drawings from the Collection of the National Gallery of Art and Promised Gifts (exhib. cat.), Washington, D.C., 1978.

Masterpieces of Art (exhib. cat.), New York, New York World's Fair, 1939.

Masterpieces of Drawing: Diamond Jubilee Exhibition (exhib. cat.), Philadelphia Museum of Art, 1950/51.

Masterpieces from the National Gallery of Ireland, (exhib. cat.), London, 1985.

"Masterpieces of Sculpture," *The Bulletin of the Minneapolis Institute of Arts*, February 5, 1949, vol. 38, no. 29.

Matouš, František, *Mittelalterliche Glasmalerei in der Tschechoslowakei* (Corpus vitrearum medii aevi), Prague, 1975.

Maué, Hermann, "Die Dedikationsmedaille der Stadt Nürnberg für Kaiser Karl v," *Medaglisti e Committenti. Atti del Quinto Convegno Internazionale di Studio sulla Storia della Medaglia*, Udine, 1984 (in press).

Maximilian I. (exhib. cat.), Innsbruck, 1969.

Mayer, Alexander, "Die Entwicklung Peter Vischers des Älteren," *Münchner Jahrbuch der bildenden Kunst*, 1913, vol. 8, pp. 263–86.

—, "Der Meister des Römhilder Doppelgrabmals," *Repertorium für Kunstwissenschaft*, 1915, vol. 37, pp. 95–109.

Mayer, Friedrich, *Nürnberg im 19. Jahrhundert mit stetem Rückblick auf seine Vergangenheit*, Nuremberg, 1843.

Mayer, Moritz Maximilian, *Die Kirche des heiligen Sebaldus* (Nürnbergs Merkwürdigkeiten und Kunstschätze, no. 1), Nuremberg, 1831.

Meder, Joseph, *Die Handzeichnung, ihre Technik und Entwicklung*, Vienna, 1919.

—, *Handzeichnungen alter Meister aus der Albertina und aus Privatbesitz. Neue Folge*, Vienna, 1922.

—, *Dürer-Katalog. Ein Handbuch über Albrecht Dürers Stiche, Radierungen, Holzschnitte, deren Zustände, Ausgaben und Wasserzeichen*, Vienna, 1932.

"Medieval Art at Toledo," *Apollo*, 1967.

Medieval Art 1060–1550, Dorothy Miner Memorial (exhib. cat.), Notre Dame, Indiana, Art Gallery of the University of Notre Dame, 1974.

"Sigmund Meisterlin's Chronik der Reichsstadt Nürnberg, 1488," in *Die Chroniken der fränkischen Städte*, vol. 3: *Nürnberg* (Die Chroniken der deutschen Städte vom 14. bis ins 16. Jahrhundert, publ. by the Historische Commission bei der Königlichen Academie der Wissenschaften, München), Leipzig, 1864, pp. 32–336.

"Meister um Albrecht Dürer," contrib. by Peter Strieder, Gottfried Frenzel, Herwarth Röttgen, Fritz Zink, and Stephan Waetzoldt, *Anzeiger des Germanischen Nationalmuseums*, 1960/61.

Die Meistersinger von Richard Wagner. Die Rezeptionsgeschichte einer Oper von 1868 bis heute (exhib. cat., Nuremberg, Germanisches Nationalmuseum), Cologne, 1981.

Meller, Simon, *Peter Vischer der Ältere und seine Werkstatt*, Leipzig, 1925.

—, *Die deutschen Bronzestatuetten der Renaissance*, Florence and Munich, 1926.

Memorial Exhibition: Works of Art from the Collection of Paul J. Sachs (exhib. cat.), Cambridge, Massachusetts, Fogg Art Museum, and New York, Museum of Modern Art, 1965–66.

Mende, Matthias, "Die Nürnberger Madonna. Zur Geschichte ihres Nachruhms," *Mitteilungen des Vereins für Geschichte der Stadt Nürnberg*, 1969, vol. 56, pp. 445–81.

—, *Dürer-Bibliographie*, Wiesbaden, 1971.

—, *Hans Baldung Grien: Das graphische Werk. Vollständiger Bildkatalog der Einzelholzschnitte, Buchillustrationen und Kupferstiche*, Unterschneidheim, 1978.

—, *Das alte Nürnberger Rathaus. Baugeschichte und Ausstattung des Grossen Saales und der Ratsstube* (Ausstellungskataloge der Stadtgeschichtlichen Museen Nürnberg, no. 15), Nuremberg, 1979, vol. 1 (vol. 2 in preparation).

—, *Dürer-Medaillen*, Nuremberg, 1983.

Mende, Ursula, "Nürnberger Aquamanilien und verwandte Gussarbeiten um 1400," *Anzeiger des Germanischen Nationalmuseums*, 1974, vol. 8/9, pp. 8–25.

—, "Der Brunnenhansel vom Heiliggeistspital in Nürnberg," *Anzeiger des Germanischen Nationalmuseums*, 1979, pp. 47–66.

—, *Die Türzieher des Mittelalters* (Bronzegeräte des Mittelalters, vol. 2), Berlin, 1981.

Der Mensch um 1500. Werke aus Kirchen und Kunstkammern (exhib. cat.), Berlin, Skulpturengalerie der Staatlichen Museen Preussischer Kulturbesitz, 1977.

Paul Wolfgang Merkel und die Merkelsche Familienstiftung (exhib. cat.), Nuremberg, Germanisches Nationalmuseum and Stadtarchiv, 1979.

The Metropolitan Museum of Art Guide, New York, 1983.

Meyer, Christian, *Quellen zur Geschichte der Stadt Hof*, Hof, 1894.

Meyer, Erich, "Nürnberger Bronzen der vor-Vischer-Zeit," *Eberhard Hanfstaengl zum 75. Geburtstag* (Festschrift), Munich, 1961, pp. 21–30.

—, "Hermann Vischer und sein Sohn Peter Vischer der Ältere," *Zeitschrift des deutschen Vereins für Kunstwissenschaft*, 1965, vol. 19, pp. 97–116.

Meyer, Ursula, "Politische Bezüge in Dürers 'Ritter, Tod und Teufel'," *Kritische Berichte*, 1978, vol. 6, pp. 27–41.

Migeon, Gaston, "La collection de M. Gustave Dreyfuss," *Les Arts*, August 1908, vol. 80, pp. 1–32.

Milliken, William M., "Recent Acquisitions in Bronze," *Bulletin of The Cleveland Museum of Art*, 1949, vol. 36, pp. 5–7, 12.

Minutes of the Accessions Committee Meeting, March 15, 1937, The Detroit Institute of the Arts, 1937.

Minutes, the Founders Society, December 7, 1936, The Detroit Institute of the Arts, 1936.

Mojzer, M., "Die Fahnen des Meisters MS," *Acta Historiae Artium*, 1966, vol. 12, pp. 93–112.

Molinier, Émile, *Les Plaquettes. Catalogue raisonné*, Paris and London, 1886.

Mongan, Agnes, and Sachs, Paul J., *Drawings in the Fogg Museum of Art*, Cambridge, Massachusetts, 1940, 2 vols.

Montagu, Jennifer, *Bronzes* (Pleasures and Treasures Series), New York, 1963.

Montague-Peartree, S., "The Historical Exhibition at Nuremberg," *The Burlington Magazine*, October–November 1906, vol. 10, pp. 111–19.

Morgan Library gästar Nationalmuseum (exhib. cat.), Stockholm, Nationalmuseum, 1970.

Muck, Georg, *Geschichte von Kloster Heilsbronn*, Nördlingen, 1879, 2 vols.

Müller, Hannelore, "Fränkische Plastik in der Zeit von 1300–1470," Ph.D. dissertation, Würzburg, 1951.

Müller, Heinrich, and Kunter, Fritz, *Europäische Helme aus der Sammlung des Museums für Deutsche Geschichte*, Berlin, 1972.

Müller, Theodor, review of Wilm, Hubert, *Gotische Tonplastik . . .*, in *Repertorium für Kunstwissenschaft*, 1930, vol. 51, pp. 196–200.

—, "Veit Stoss in Krakau," *Münchner Jahrbuch der bildenden Kunst*, 1933, new ser., vol. 10, pp. 27–58.

—, "Stoss, Veit, der Ältere, Bildhauer, Kupferstecher und Maler," in Thieme, Ulrich, and Becker, Felix, eds., *Allgemeines Lexikon der bildenden Künstler von der Antike bis zur Gegenwart*, Leipzig, 1938, vol. 32, pp. 131–38.

—, "Veit Stoss. Zur Geltung seiner Werke im 17. Jahrhundert," *Zeitschrift des deutschen Vereins für Kunstwissenschaft*, 1942, vol. 9, pp. 191–202.

—, "Fragmente zur Geschichte der frühen gotischen Plastik in Franken," *Zeitschrift für Kunstwissenschaft*, 1948, vol. 2, pp. 31–34.

—, "Der sogenannte Astbrecher des älteren Peter Vischer," *Wissenschaftliche Zeitschrift der Karl-Marx-Universität Leipzig*, 1955/56, vol. 5, pp. 223–27.

—, *Die Bildwerke in Holz, Ton und Stein von der Mitte des xv. bis gegen Mitte des xvi. Jahrhunderts* (Kataloge des Bayerischen Nationalmuseums München, vol. 13/2), Munich, 1959.

—, *Deutsche Plastik der Renaissance bis zum dreissigjährigen Krieg*, Königstein im Taunus, 1963.

—, *Sculpture in the Netherlands, Germany, France, and Spain, 1400 to 1500* (The Pelican History of Art), Harmondsworth, England, and Baltimore, 1966.

Müller-Hickler, Hans, *Führer durch die Waffensammlung des gräflichen Schlosses zu Erbach im Odenwald*, [Erbach], 1922.

—, *Die Waffensammlungen zu Erbach*, Erbach, 1923, 2 vols.

—, *Bezeichnung der Rüstungen und Waffen in dem Rittersaal Sr. Erlaucht des Grafen Konrad zu Erbach*, Darmstadt, 1926.

Münzenberger, E[rnst] F[ranz] A[ugust], and Beissel, St[ephan], *Zur Kenntnis und Würdigung der mittelalterlichen Altäre Deutschlands*, Frankfurt am Main, 1885–1905, 2 vols.

Mummenhoff, Ernst, *Das Rathaus in Nürnberg*, Nuremberg, 1891.

—, *Der Handwerker in der deutschen Vergangenheit*, Leipzig, 1901.

—, "Dürers Anteil an den Gemälden des grossen Rathaussaals und der Ratsstube," *Mitteilungen des Vereins für Geschichte der Stadt Nürnberg*, 1904, vol. 16, pp. 244–53.

von Murr, Christoph Gottlieb, *Beschreibung der vornehmsten Merkwürdigkeiten in des H. R. Reichs freyen Stadt Nürnberg und auf der hohen Schule zu Altdorf*, Nuremberg, 1778.

—, *Beschreibung der sämtlichen Reichskleinodien und Heiligthümer, welche in der des H. R. Reichs freyen Stadt Nürnberg aufbewahrt werden*, Nuremberg, 1790.

—, *Beschreibung der vornehmsten Merkwürdigkeiten in der Reichsstadt Nürnberg*, 2nd ed., Nuremberg, 1801.

Musper, Heinrich Theodor, *Albrecht Dürer. Der gegenwärtige Stand der Forschung*, Stuttgart, 1952.

—, *Albrecht Dürer*, Cologne, 1965.

—, *Dürers Kaiserbildnisse*, Cologne, 1969.

—, *Altdeutsche Malerei*, Cologne, 1970.

—, *Albrecht Dürer*, Cologne, 1971.

N

Nagler, Georg Karl, "Veit Stoss (Stuos) in Krakau und seine Ankunft in Nürnberg," *Kunstblatt*, 1847, vol. 28, pp. 141–44.

Nagler, Georg Kaspar, *Die Monogrammisten*, Munich, 1858–79, 5 vols.

Des Johann Neudörfer Schreib- und Rechenmeisters zu Nürnberg Nachrichten von Künstlern und Werkleuten daselbst aus dem Jahre 1547 nebst der Fortsetzung des Andreas Gulden, G. W. K. Lochner, ed. (Quellenschriften für Kunstgeschichte und Kunsttechnik des Mittelalters und der Renaissance, vol. 10), Vienna, 1875.

Neuerwerbungen des Germanischen Museums 1921–1924, Nuremberg, 1925.

"Neuerwerbungen des Germanischen Nationalmuseums 1962," *Anzeiger des Germanischen Nationalmuseums*, 1963, pp. 161–82.

Neuhaus, August, "Der Topfhelm der Rieter von Kornburg," *Anzeiger des Germanischen Nationalmuseums*, 1924/25, pp. 89–96.

—, "Drei frühe Nürnberger Schaumünzen," *Anzeiger des Germanischen Nationalmuseums*, 1936–39, pp. 154–59.

Neukam, Wilhelm Georg, "Eine Nürnberger-Sulzbacher Plattenlieferung für Karl IV. in den Jahren 1362–63," *Mitteilungen des Vereins für Geschichte der Stadt Nürnberg*, 1956, vol. 47, pp. 124–59.

Nickel, Helmut, *Ullstein Waffenbuch*, Berlin, Frankfurt, and Vienna, 1974.

Nockemann, Edith, *Der Einblattholzschnitt des 15. Jahrhunderts und seine Beziehung zum spätmittelalterlichen Volksleben*, Bottrop, 1940.

Norman, A. V. B., "Albrecht Dürer: Armour and Weapons," *Apollo*, July 1971, vol. 94, pp. 36–39.

—, "Amendments and Additions to the Catalogue of Armour in the Wallace Collection, London," *The Journal of the Arms and Armour Society, London*, September–December 1972, vol. 7, pp. 171–230.

Nürnberger Malerei 1350–1450 im Germanischen Museum Nürnberg, Walter Fries and Eberhard Lutze, eds., Nuremberg, 1931.

O

Oberhammer, Vinzenz, "Die vier Bildnisse Kaiser Maximilians I. von Albrecht Dürer," *Alte und moderne Kunst*, 1969, vol. 14, no. 105, pp. 2–14.

Oberhuber, Konrad, review of *Meister um Albrecht Dürer* (exhib. cat., Nuremberg, Germanisches Nationalmuseum, 1961), in *Christliche Kunstblätter*, 1962, vol. 100, p. 65.

Objects for a "Wunderkammer" (exhib. cat.), London, P. & D. Colnaghi and Co. Ltd., 1981.

Oehler, Lisa, "Das Dürermonogramm auf Werken der Dürerschule," *Städel-Jahrbuch*, 1973, new ser., vol. 4, pp. 37–80.

Oellermann, Eike, "Die monochromen Holzbildwerke des Veit Stoss," *Maltechnik-Restauro*, 1976, vol. 82, pp. 173–82.

Oettinger, Karl, "Die Schüler des Veit Stoss," *Jahrbuch für fränkische Landesforschung*, 1954, vol. 14, pp. 181–89.

—, and Knappe, Karl-Adolf, *Hans Baldung Grien und Albrecht Dürer in Nürnberg*, Nuremberg, 1963.

Oidtmann, Heinrich, *Die Glasmalerei im alten Frankenlande*, Leipzig, 1907.

Old Master Drawings and Paintings (sale cat.), London, Sotheby & Co., July 11, 1956.

Old Master Drawings from the E. B. Crocker Collection; the German Masters, 15th to 19th Centuries, Sacramento, California, 1939.

Oman, Charles, *German and Swiss Domestic Silver of the Gothic Period*, London, 1960.

—, *Medieval Silver Nefs* (Victoria and Albert Museum Monographs, no. 15), London, 1963.

Baron Albert Oppenheim Collection (sale cat.), Berlin, Rudolph Lepke, I, October 28–29, 1914; II, March 19, 1918.

von der Osten, Gert, *Der Schmerzensmann. Typengeschichte eines deutschen Andachtsbildwerkes von 1300 bis 1600* (Forschungen zur deutschen Kunstgeschichte, vol. 7), Berlin, 1935.

—, "Beweinung Christi (und Erbärmdebild)," *Reallexikon zur deutschen Kunstgeschichte*, Stuttgart, 1948, vol. 2, cols. 457–75.

—, "Über Peter Vischers Törichten Bauern und den Beginn der 'Renaissance' in Nürnberg," *Anzeiger des Germanischen Nationalmuseums*, 1963, pp. 71–83.

—, *Hans Baldung Grien. Gemälde und Dokumente*, Berlin, 1983.

—, and Vey, Horst, *Painting and Sculpture in Germany and the Netherlands 1500 to 1600* (The Pelican History of Art), Baltimore, 1969.

Ostoia, Vera K., "The Virgin and Child with Angels," *The Bulletin of The Metropolitan Museum of Art*, 1967, pp. 355–66.

—, *The Middle Ages: Treasures from The Cloisters and The Metropolitan Museum of Art* (exhib. cat.), Los Angeles and Chicago, 1970.

van den Oudendijk Pieterse, Frances H. A., *Dürers Rosenkranzfest en de Ikonografie de Duitse Rosenkransgroepen van de XVᵉ en het begin van de XVIᵉ eeuw*, Amsterdam, 1939.

P

Panofsky, Erwin, "Dürers Darstellungen des Apollo und ihr Verhältnis zu Barbari," *Jahrbuch der preussischen Kunstsammlungen*, 1920, vol. 41, pp. 359–77.

—, "Imago Pietatis," *Festschrift für Max J. Friedländer zum 60. Geburtstag*, Leipzig, 1927, pp. 261–308.

—, "Über die Reliefs an den Seitenschiffportalen der Sebalduskirche in Nürnberg," *Belvedere*, 1929, vol. 8, pp. 13–18.

—, *Albrecht Dürer*, Princeton, 1943; rev. eds., 1945, 1948, 2 vols.

—, *Meaning in the Visual Arts* (including the essay "Albrecht Dürer and Classical Antiquity"), Garden City, 1955.

—, "'Virgo et Victrix.' A note on Dürer's Nemesis," *Prints*, Carl Zigrosser, ed., New York, 1962, pp. 13–38.

—, and Saxl, Fritz, *Dürers Kupferstich "Melencolia I." Eine quellen- und typengeschichtliche Untersuchung* (Studien der Bibliothek Warburg, vol. 2), Leipzig and Berlin, 1923.

Parker, Karl T., "Ein neugefundene Apollozeichnung Albrecht Dürers," *Jahrbuch der preussischen Kunstsammlungen*, 1925, vol. 47, pp. 248–54.

Die Parler und der Schöne Stil 1350–1400. Europäische Kunst unter den Luxemburgern (exhib. cat.), Anton Legner, ed., Cologne, Schnütgen-Museum, 1978, 3 vols.

Die Parler und der Schöne Stil 1350–1400... Resultatband zur Ausstellung des Schnütgen-Museums in der Kunsthalle Köln, Anton Legner, ed., Cologne, 1980.

Passavant, Johann David, *Le peintre-graveur*, Leipzig, 1860–64, 6 vols.

R. von Passavant-Gontard Collection, Frankfurt, 1929.

Pauli, Gustav, *Die Kunst Albrecht Dürers* (exhib. cat.), Bremen, Kunsthalle, 1911.

—, "Die Bildnisse von Dürers Gattin," *Zeitschrift für bildende Kunst*, 1915, vol. 26, pp. 69–76.

—, "Eine neue Dürer-Zeichnung," *Münchner Jahrbuch der bildenden Kunst*, 1937/38, new ser., vol. 12, pp. 41–44.

Pazaurek, Gustav E., "Mittelalterlicher Edelsteinschliff, Teil II," *Belvedere*, 1930, vol. 9/2, pp. 185–94.

Pechstein, Klaus, "Beiträge zur Geschichte der Vischerhütte in Nürnberg," Ph.D. dissertation, Berlin, 1962.

—, *Bronzen und Plaketten. Vom ausgehenden 15. Jahrhundert bis zur Mitte des 17. Jahrhunderts* (Kataloge des Kunstgewerbemuseums Berlin, vol. 3), Berlin, 1968.

—, *Goldschmiedewerke der Renaissance* (Kataloge des Kunstgewerbemuseums Berlin, vol. 5), Berlin, 1971.

—, "Der Bildschnitzer Hans Peisser," *Anzeiger des Germanischen Nationalmuseums*, 1973, pp. 84–106.

—, "Zu den Altarskulpturen und Kunstkammerstücken von Hans Peisser. Studien zur süddeutschen Renaissanceplastik II," *Anzeiger des Germanischen Nationalmuseums*, 1974, pp. 38–47.

—, "The 'Welcome' Cup—Renaissance Drinking Vessels by Nuremberg Goldsmiths," *The Connoisseur*, 1978, vol. 199, pp. 180–87.

—, "Adam Krafts Harfenspielerin und Flötenspieler. Neues zum Astbrecher," *Anzeiger des Germanischen Nationalmuseums*, 1980, pp. 74–78.

—, "Von Trinkgeräten und Trinksitten. Von der Kindstaufe zum Kaufvertrag. Pokale als Protokolle des Ereignisses," *Das Schatzhaus der deutschen Geschichte. Das Germanische Nationalmuseum. Unser Kulturerbe in Bildern und Beispielen*, Rudolf Pörtner, ed., Düsseldorf and Vienna, 1982, pp. 385–429.

—, "Peter Flötner (um 1495–1546)," *Fränkische Lebensbilder*, 1984, vol. 11, pp. 91–100.

—, in *Germanisches Nationalmuseum Nürnberg, Führer durch die Sammlungen*, Munich, 1985.

Pfeiffer, Gerhard, ed., *Geschichte Nürnbergs in Bilddokumenten*, Wilhelm Schwemmer, collab. ed., Munich, 1971.

von Philippovich, Eugen, *Kuriositäten/Antiquitäten* (Bibliothek für Kunst- und Antiquitätenfreunde, vol. 46), Braunschweig, 1966.

Pickering, Frederick, "Zur Ikonographie der Kindheit von Johannes dem Täufer," *Anzeiger des Germanischen Nationalmuseums*, 1981, pp. 21–27.

Piel, Friedrich, *Albrecht Dürer: Aquarelle und Zeichnungen*, Cologne, 1983.

Pilz, Kurt, "Der Totenschild in Nürnberg und seine deutschen Vorstufen. Das 14.–15. Jahrhundert," *Anzeiger des Germanischen Nationalmuseums*, 1936–39, pp. 57–112.

—, *Die St. Jakobskirche in Nürnberg. Ihre Geschichte und ihre Kunstwerke*, Nuremberg, 1964.

—, *Das Sebaldusgrabmal im Ostchor der St.-Sebaldus-Kirche in Nürnberg. Ein Messingguss aus der Giesshütte der Vischer*, Nuremberg, 1970.

—, *600 Jahre Astronomie in Nürnberg*, Nuremberg, 1977.

—, *Die Stadtkirche St. Johannes und St. Martinus in Schwabach. Ihre Geschichte und ihre Kunstwerke*, Schwabach, 1979.

Pinder, Wilhelm, *Die deutsche Plastik vom ausgehenden Mittelalter bis zum Ende der Renaissance* (Handbuch der Kunstwissenschaft), Berlin-Neubabelsberg, 1914–29.

—, *Die deutsche Plastik des 14. Jahrhunderts*, Munich, 1924.

Piotrowska, Irena, "Polish Arms and Armor in the Metropolitan Museum of Art," *Polish Review,* 1943, vol. 3, no. 44, pp. 8–10.

Planiscig, Leo, *Die Bronzeplastiken, Statuetten, Reliefs, Geräte und Plaketten, Kataloge, Kunsthistorisches Museum in Wien,* Vienna, 1924.

Ploss, Emil Ernst, *Ein Buch von alten Farben. Technologie der Textilfarben im Mittelalter mit einem Ausblick auf die festen Farben,* Heidelberg and Berlin, 1962.

Plummer, John, *Liturgical Manuscripts for the Mass and the Divine Office* (exhib. cat.), New York, The Pierpont Morgan Library, 1964.

Pope-Hennessy, John, *Renaissance Bronzes from the Samuel H. Kress Collection,* London, 1965.

Popham, Arthur Ewart, "An Unknown Drawing by Dürer," *The Art Quarterly,* 1950, vol. 13, p. 338.

Posse, Otto, *Die Siegel der deutschen Kaiser und Könige von 751–1806,* vol. 1: *751–1347,* Dresden, 1909.

Post, Paul, "Zum 'silbernen Harnische' Maximilians I. von Koloman Colman mit Aetzentwürfen Albrecht Dürers," *Zeitschrift für historische Waffen- und Kostümkunde,* 1939, new ser., vol. 6, p. 253.

Preussischer Kulturbesitz (exhib. cat.), Düsseldorf, Städtische Kunsthalle, 1967.

Pückler-Limburg, Siegfried Graf, *Die Nürnberger Bildnerkunst um die Wende des 14. und 15. Jahrhunderts* (Studien zur deutschen Kunstgeschichte, vol. 48), Strasbourg, 1904.

—, review of Daun, Berthold, *Veit Stoss und seine Schule in Deutschland, Polen und Ungarn . . . ,* in *Kunstchronik,* 1904, new ser., vol. 15, pp. 198–202.

R

Raboff, Ernest, *Art for Children—Albrecht Dürer,* New York, 1970.

Radcliffe, Anthony F., *European Bronze Statuettes,* London, 1966.

—, "A Portrait of Georg Vischer," *Apollo,* 1974, vol. 2, pp. 126–29.

Ramisch, Hans K., "Der Fridolfinger Altar," *Jahrbuch der Staatlichen Kunstsammlungen in Baden-Württemberg,* 1964, vol. 1, pp. 145–63.

—, "Der Petersaltar von St. Sebald in Nürnberg und das Herlin-Lainberger-Problem," *Ars Bavarica,* 1979, vol. 13, pp. 65–88.

—, "Die Nürnberger Skulptur vor 1477 und während Stoss' Krakauer Aufenthalt," in *Veit Stoss. Die Vorträge des Nürnberger Symposions* (Nuremberg, Germanisches Nationalmuseum, and Munich, Zentralinstitut für Kunstgeschichte), Munich, 1985, pp. 49–60.

Rasmussen, Jörg, "Eine Gruppe kleinplastischer Bildwerke aus dem Stilkreis des Conrat Meit," *Städel-Jahrbuch,* 1973, new ser., vol. 4, pp. 121–41.

—, *Die Nürnberger Altarbaukunst der Dürerzeit,* Ph.D. dissertation, Munich, 1970, publ., Hamburg, 1974.

—, *Deutsche Kleinplastik der Renaissance und des Barock* (Bilderhefte des Museums für Kunst und Gewerbe Hamburg, no. 12), Hamburg, 1975.

—, "Untersuchungen zum Hallischen Heiltum des Kardinals Albrecht von Brandenburg, Teil 1," *Münchner Jahrbuch der bildenden Kunst,* 1976, 3rd ser., vol. 27, pp. 59–118.

—, "Zum kleinplastischen Werk des Veit Stoss," *Pantheon,* 1976, vol. 34, pp. 108–14.

—, "Kleinplastik unter Dürers Namen: Das New Yorker Rückenakt-Relief," *Städel-Jahrbuch,* 1983, vol. 9, pp. 131–44.

—, "'. . . far stupire il mondo.' Zur Verbreitung der Kunst des Veit Stoss," in *Veit Stoss. Die Vorträge des Nürnberger Symposions* (Nuremberg, Germanisches Nationalmuseum, and Munich, Zentralinstitut für Kunstgeschichte), Munich, 1985, pp. 107–22.

Raspe, Theodor, "Die Nürnberger Miniaturmalerei bis 1515," Ph.D. dissertation, Munich, 1905.

—, *Die Nürnberger Miniaturmalerei bis 1515* (Studien zur deutschen Kunstgeschichte, vol. 60), Strasbourg, 1905, pp. 1–78.

Rauch, Christian, *Die Trauts* (Studien zur deutschen Kunstgeschichte, vol. 79), Strasbourg, 1907.

Rautenberg, Anneliese, "Mittelalterliche Brunnen in Deutschland," Ph.D. dissertation, Freiburg im Breisgau, 1965.

Réau, Louis, "Un Chef-d'oeuvre de la renaissance allemande en Savoie, Les bas-reliefs de Montrottier," *Gazette des Beaux-Arts,* 1921, vol. 63, pp. 225–36.

Redslob, Edwin, "Die fränkischen Epitaphien im 14. und 15. Jahrhundert," *Mitteilungen aus dem Germanischen Nationalmuseum,* 1907, pp. 3–30, 53–76.

—, *Deutsche Goldschmiedeplastik,* Munich, 1922.

Reé, Paul Johannes, *Führer durch die St. Jakobskirche in Nürnberg,* Nuremberg, 1889.

Regesta sive Rerum Boicarum autographa, Karl Heinrich von Lang, ed., Munich, 1825, vol. 3.

Reifferscheid, Heinrich, "Über figürliche Giessgefässe des Mittelalters," *Mitteilungen aus dem Germanischen Nationalmuseum,* 1912, vol. 2, pp. 3–93.

Reimers, Joseph, *Peter Flötner nach seinen Handzeichnungen und Holzschnitten,* Munich and Leipzig, 1890.

Reindel, Albert, and Lösch, Johann Christian Ernst, "Vorzügliche Glasgemälde und Limousins im Besitz der von Tucher'schen Familie in Nürnberg," *Kunstblatt,* 1833, vol. 14, pp. 73–75.

Reiners, Heribert, *Burgundisch-alemanische Plastik,* Strasbourg, 1943.

Reitlinger, H. S., "An Unknown Collection of Dürer Drawings," *The Burlington Magazine,* March 1927, vol. 50, pp. 153–60.

von Reitzenstein, Alexander Freiherr, "Die Ordnung der Nürnberger Plattner," *Waffen- und Kostümkunde,* 1959, 3rd ser., vol. 1, pp. 54–69.

—, "Die Nürnberger Plattner," *Beiträge zur Wirtschaftsgeschichte Nürnbergs,* 1967, vol. 2, pp. 700–725.

—, *Rittertum und Ritterschaft* (Bibliothek des Germanischen Nationalmuseums Nürnberg zur deutschen Kunst- und Kulturgeschichte, Ludwig Grote, ed., vol. 32), Munich, 1972.

Renaissance Medals: from the Samuel H. Kress Collection at the National Gallery of Art; based on the Catalogue of Renaissance Medals in the Gustave Dreyfus Collection, by G. F. Hill, rev. and enlarged by Graham Pollard, London, 1967.

von Rettberg, Ralf, *Nürnberger Briefe,* Nuremberg, 1846.

—, *Nürnbergs Kunstleben in seinen Denkmalen dargestellt. Ein Führer für Einheimische und Fremde,* Stuttgart, 1854.

de Ricci, Seymour, *The Gustave Dreyfuss Collection, Reliefs and Plaquettes,* Oxford, 1931.

—, *Renaissance Bronzes, Statuettes, Reliefs, and Plaquettes, Medals and Coins from the Kress Collection,* Washington, D.C., 1951.

Ricketts, Charles, "Early German Art at the Burlington Fine Arts Club, German Art: Dürer and his Successors," *The Burlington Magazine,* 1906, vol. 9, pp. 264–69.

Riederer, Josef, "Die Zusammensetzung deutscher Renaissancestatuetten aus Kupferlegierungen," *Zeitschrift des deutschen Vereins für Kunstwissenschaft,* 1982, vol. 36, pp. 42–48.

Ritz, Joseph Maria, *Das Stadtmuseum in Schweinfurt,* offprint from the *Bayerischer Heimatschutz,* 1935, vol. 31, Munich, 1935.

The Robert von Hirsch Collection (sale cat.), London, Sotheby Parke Bernet & Co., vol. 1: *Old Master Drawings, Paintings and Medieval Miniatures,* June 20, 1978, vol. 2: *Works of Art,* June 22, 1978.

Röttinger, Heinrich, *Dürers Doppelgänger* (Studien zur deutschen Kunstgeschichte, vol. 235), Strasbourg, 1926.

—, "Handzeichnungen des Hans Suess von Kulmbach," *Münchner Jahrbuch der bildenden Kunst,* 1927, vol. 4, pp. 8–19.

Rorimer, James J., "Acquisitions for The Cloisters," *The Bulletin of The Metropolitan Museum of Art,* 1952/53, pp. 265–85.

—, *The Cloisters: The Building and the Collection of Medieval Art in Fort Tryon Park,* New York, 1963.

Rosenberg, Marc, *Geschichte der Goldschmiedekunst auf technischer Grundlage,* vol. 1: *Einführung,* Frankfurt am Main, 1910.

—, *Der Goldschmiede Merkzeichen,* 3rd ed., expanded and illus., Frankfurt am Main, 1922–28.

Rott, Hans, *Quellen und Forschungen zur Kunstgeschichte im 15. und 16. Jahrhundert,* vol. 2: *Altschwaben und die Reichsstädte,* Stuttgart, 1934.

Rowlands, John, "Dürer in America, His Graphic Work," *Master Drawings,* 1972, vol. 10, pp. 284–86.

Rox, Henry, "On Dürer's 'Knight, Death and Devil,'" *The Art Bulletin,* 1948, vol. 30, pp. 67–70.

Rubenstein-Bloch, Stella, *Catalogue of the Collection of George and Florence Blumenthal,* New York and Paris, 1926, 3 vols.

Rücker, Elisabeth, *Die Schedelsche Weltchronik. Das grösste Buchunternehmen der Dürer-Zeit* (Bibliothek des Germanischen Nationalmuseums Nürnberg zur deutschen Kunst- und Kulturgeschichte, Ludwig Grote, ed., vol. 33), Munich, 1973.

Rupprich, Hans, ed., *Dürer. Schriftlicher Nachlass,* Berlin, 1965–69, 3 vols.

—, "Willibald Pirckheimer. Beiträge zu seiner Wesenserfassung," *Schweizer Beiträge zur Allgemeinen Geschichte,* 1957, vol. 15, pp. 64–110.

Ruzicka, Rudolph, "Contemporary Prints from Dürer's Woodblocks," *The Bulletin of The Metropolitan Museum of Art,* 1921, vol. 16, pp. 53–55.

Ryskamp, Charles, ed., *Eighteenth Report to the Fellows of the Pierpont Morgan Library, 1975–1977,* New York, 1978.

S

Sachs, Paul J., *The Pocket Book of Great Drawings,* New York, 1951.

Sammlung Schloss Rohoncz. Plastik und Kunstgewerbe (exhib. cat.), Aaron Siegfried Drey, ed., Munich, Neue Pinakothek, 1930.

Sammlung Thyssen-Bornemisza. Katalog der Gemälde, Johann Conrad Ebbinge-Wubben, Christian Salm, Charles Sterling, and Rudolf Heinemann, eds., Castagnola, 1971.

Sauerlandt, Max, *Kleinplastik der deutschen Renaissance,* Königstein im Taunus and Leipzig, 1927.

—, "Orpheus und Eurydike," *Georg Habich zum 60. Geburtstag,* Munich, 1928, pp. 14–21.

Sauermann, H. N., *Die gotische Bildnerei und Tafelmalerei in der Dorfkirche zu Kalchreuth* (Beiträge zur fränkischen Kunstgeschichte, no. 1), Erlangen, 1911.

Neuzeit," *Form und Inhalt, Kunstgeschichte Studien Otto Schmidt zum 60. Geburtstag*, Stuttgart, 1950, pp. 239–56.

Zimmermann, Heinrich, "Über einige Dürer zugeschriebene Zeichnungen der Dürer-Ausstellung," *Albrecht Dürer Festschrift der Internationalen Dürerforschung*, Georg Biermann, ed., Leipzig, 1928, pp. 95–96.

—, "Nürnberger Malerei 1350–1450, Teil B: Die Tafelmalerei," *Anzeiger des Germanischen Nationalmuseums*, 1930/31 (1932), pp. 23–48, 83–255.

Zink, Fritz, "Hans Sachs am Rechenberg bei Nürnberg," *Mitteilungen des Vereins für Geschichte der Stadt Nürnberg*, 1955, vol. 46, pp. 518–23.

—, *Die Handzeichnungen bis zur Mitte des 16. Jahrhunderts* (Kataloge des Germanischen National-museums, Die deutschen Handzeichnungen, vol. 1), Nuremberg, 1968.

—, "Albrecht Dürer in Nürnberg-Himpelshof," *Jahrbuch für fränkische Landesforschung*, 1969, vol. 29, pp. 289–93.

Zinner, Ernst, *Deutsche und niederländische astronomische Instrumente des 11.–18. Jahrhunderts*, Munich, 1967, 2nd ed.

Index

497

Photograph Credits

AACHEN: Museum der Stadt, cat. no. 30/BALTIMORE: Walters Art Gallery, cat. no. 264/BAMBERG: Ingeborg Limmer, fig. 71/BASEL: Historisches Museum, cat. no. 187; Kunstmuseum (Öffentliche Kunstsammlung), cat. no. 41, figs. 122, 123/BAYERSDORF: Hans-J. Musolf, fig. 10/BERLIN: Jörg P. Anders Photoatelier, cat. nos. 98, 123, 194 b, 200, 204, 253, 259, 262; Staatliche Museen Preussischer Kulturbesitz, Kunstgewerbemuseum, cat. no. 160 b/BERLIN (GDR): Staatliche Museen zu Berlin, figs. 75, 133/BIETIGHEIM-BISSINGEN: Kurt Gramer, fig. 76/BOSTON: Museum of Fine Arts, cat. nos. 159, 160/BRAUNSCHWEIG: Herzog Anton Ulrich-Museum, cat. no. 251/BREMEN: Kunsthalle, fig. 129/CAMBRIDGE (England): Fitzwilliam Museum, cat. no. 249/CAMBRIDGE, MASSACHUSETTS: Busch-Reisinger Museum, cat. no. 252; Fogg Art Museum, cat. nos. 147, 163/CLEVELAND: The Cleveland Museum of Art, cat. nos. 57, 91 a–c, 122, 137, 179 c, 197, 205, 227, 232 c, 255, 256, 261/CRACOW: Muzeum Uniwersytetu Jagiellońskiego, cat. no. 94; Emil Rachwał, fig. 70/DAMMERHOF: Ursula Pfistermeister, fig. 61/DETROIT: The Detroit Institute of Arts, cat. nos. 65, 172/DRESDEN: Sächsische Landesbibliothek, cat. no. 183, fig. 134/DUBLIN: National Gallery of Ireland, cat. no. 203/ERLANGEN: Graphische Sammlung der Universität, cat. no. 247/FRANKFURT: Städelsches Kunstinstitut, cat. no. 117, fig. 128/GERMANY: Private collection, cat. nos. 198, 250/HAMBURG: Ralph Kleinhempel, cat. no. 260/HEROLDSBERG: Eike Oellermann, figs. 65, 66/KASSEL: Staatliche Kunstsammlungen, cat. no. 11/LAKEWOOD, OHIO: Heinz Schneider, cat. nos. 198, 255, 261 a–d/LONDON: British Museum, fig. 138; Prudence Cuming Associates Ltd., cat. no. 257; Cyril Humphris, cat. no. 191; Victoria and Albert Museum, cat. nos. 76, 90 a–d, 224 a, b; Witt Library, Courtauld Institute Galleries, fig. 130; Rainer Zietz Ltd., cat. nos. 220 a, 221 a/LOS ANGELES: Armand Hammer Foundation, cat. no. 126/MARBURG AN DER LAHN: Bildarchiv Foto Marburg, figs. 74, 84–87, 99, 102/MUNICH: Bayerische Staatsgemäldesammlungen, fig. 87; Bayerisches Landesamt für Denkmalpflege, fig. 64; Bayerisches Nationalmuseum, figs. 79, 88, 91, 116; Werner Neumeister, cat. not. 199; Staatliche Graphische Sammlung, figs. 106, 107; Staatliche Münzsammlung, cat. nos. 201, 220 b/NEW YORK: The Metropolitan Museum of Art, cat. nos. 8 a, 19, 21, 22, 58, 60 a–e, 66, 68, 69, 78 a, b, 84, 88, 102 a, b, 103–107, 110, 114, 115, 118, 119, 121, 129–134, 138, 142, 144, 145, 152–155, 161, 162 a, b, 166 b, 176, 177, 179 d, 180, 236–238, 239 a–c, 240–243, 254, 265 a, b, 267, 270, 272, 274–277, 278 b, c, 279; The Pierpont Morgan Library: cat. nos. 10, 53 a–d, 120, 135, 136/NUREMBERG: Archiv für Bildende Kunst (Germanisches Nationalmuseum), figs. 9, 13–15, 17; Hochbauamt, Stadt, cat. nos. 4 a, b, 9 a, b, 45, 189 g, 190, 234, figs. 2, 7, 8, 16, 18, 26–30, 46, 48, 59, 60, 63, 72, 73, 77, 80–82, 98, 101, 103, 112, 113, 115, 118, 120, 135, 136; Germanisches Nationalmuseum, cat. nos. 1, 1 (detail), 2, 3, 5 a, b, 7, 8 b, 12, 13 a, b, 14, 15 a–c, 16, 17, 20, 23 a, b, 24 a–c, 25 a, b, 26–29, 31–34, 36–37, 38 a, b, 40–43, 46, 51, 52, 54–56, 57 a, b, 59, 61, 64 a, 67, 70–73, 77 b, 79, 80, 81 c, 82 a, b, 83–86, 87 a, b, 89 a, b, 93, 95, 96 b, c, 97 a, b, 99, 100, 108, 116, 117 a, b, 124, 127 a–c, 128 a, b, 139, 140, 141 a, b, 143, 149, 150, 157, 158, 163, 166 a, 167, 169–171, 173, 174, 175 a, b, 178 a–c, 183 a, b, 184, 189 a–e, 192, 202, 207, 208, 211–216, 217 a, b, 218, 219, 221 b, 222 a, b, 223, 225 a, b, 226 a, b, 227 a, b, 228 a, b, 229, 230, 231 a, b, 232 a, b, 233, 235, 244, 245, 248, 258 a, b, 263 a, b, 266, figs. 1, 11, 12, 23–25, 47, 67–69, 78, 83, 90, 92–94, 96, 100, 104, 105, 108, 109, 111, 117, 119, 121; Gertrude Muss, cat. nos. 49, 50 a–c; Stadtgeschichtliche Museen, cat. no. 115, fig. 127/OXFORD: Ashmolean Museum, cat. nos. 113, 195, 196/PARIS: Bibliothèque Nationale, cat. no. 188; Réunion des Musées Nationaux, cat. nos. 101, 125/SACRAMENTO, CALIFORNIA: Crocker Art Museum, cat. no. 206/SANKT PAUL IM LAVANTTAL (Austria): Archiv des Benediktinerstiftes, cat. no. 194 a/SCHWEINFURT: Ursula von Mickwitz, cat. no. 74/SONTHOFEN: Lala Aufsberg, fig. 62/TOLEDO, OHIO: Toledo Museum of Art, cat. no. 18/VIENNA: Akademie der Bildenden Künste, cat. no. 189; Bildarchiv der Österreichischen Nationalbibliothek, cat. no. 151; Foto Meyer, cat. nos. 269, 271; Graphische Sammlung Albertina, fig. 131; Kunsthistorisches Museum, cat. nos. 62, 63, 75 a, b, 185, 186, 209, 246 a–c, 268, 274, 276, 278 a, figs. 132, 140/WASHINGTON, D.C.: National Gallery of Art, cat. nos. 109 a, b, 148, 179 b, 181, 182, 193, fig. 95/WORCESTER, MASSACHUSETTS: Higgins Armory Museum, cat. no. 273.

Works with the following catalogue numbers will not be exhibited at the Germanisches Nationalmuseum: 60, 97, 102, 106, 109, 110, 112, 118, 120, 125, 129, 135, 137, 144, 151, 179, 188, 190, 199, 234.

Works with the following catalogue numbers will not be exhibited at The Metropolitan Museum of Art: 47, 83, 84, 97, 101, 111, 124, 128, 139, 143, 163, 174 (1–4, 6–8, 12), 178, 188, 190, 199, 234.